ALSO BY MARK STEVENS AND ANNALYN SWAN

De Kooning: An American Master

Francis Bacon

Francis Bacon

REVELATIONS

Mark Stevens and Annalyn Swan

 ALFRED A. KNOPF · NEW YORK · 2020

THIS IS A BORZOI BOOK
PUBLISHED BY ALFRED A. KNOPF

www.aaknopf.com

Grateful acknowledgment is made to The Literary Executor of the late Sir Cecil Beaton
for permission to reprint an excerpt from *Sitting for Two Portraits* by Cecil Beaton.
Copyright © 2021 by The Literary Executor of the late Sir Cecil Beaton.

Library of Congress Cataloging-in-Publication Data

Names: Swan, Annalyn, author. | Stevens, Mark, [date] author.
Title: Francis Bacon : revelations / Annalyn Swan and Mark Stevens.
Description: First edition. | New York : Alfred A. Knopf, 2021. |
Includes bibliographical references and index.
Identifiers: LCCN 2020000325 (print) | LCCN 2020000326 (ebook) |
ISBN 9780525656746 (ebook) | ISBN 9780307271624 (hardcover)
Subjects: LCSH: Bacon, Francis, 1909–1992. | Painters—Great Britain—Biography.
Classification: LCC ND497.B16 (ebook) | LCC ND497.B16 S89 2020 (print) |
DDC 759.2—dc23
LC record available at https://lccn.loc.gov/2020000325

Jacket photographs: Portrait of Francis Bacon © Dmitri Kasterine; (studio) Snowdon/Trunk Archive
Jacket design by Chip Kidd

Manufactured in the United States of America
First American Edition

Once again, to Emmy, Pippa, and our families

Contents

Acknowledgments · xi

Prologue: The Dark Century · 3

"I"

1 Boy at the Window · 13

2 Weakling · 28

3 Arousal · 40

4 The Queerness of Cities · 54

5 Marvelous Women · 69

6 Gallant Men · 88

7 Stage Sets · 104

8 Starting Over · 120

9 Early Success · 143

10 Early Failure · 158

11 Breakdowns · 176

12 Wilderness · 190

13 Good Boys and Bad · 202

14 Sewer Boots · 216

Iconoclast

15 "I began" · 225

16 The Road South · 238

17 Mr. Hyde · 251

18 Soho Nights · 266

19 Brothers and Lovers · 278

20 Wilde Man · 291

21 Follies · 308

22 Homeless · 322

23 Love and Power · 335

24 The Violence of Grass · 354

25 Shades of Blue · 372

26 Tangier · 391

27 Limbo · 405

28 Bets · 421

29 The Fig Tree · 440

30 "Such Ardour" · 452

31 Settling In · 463

32 Younger Crowds · 480

33 Ancient Rhymes · 500

34 Hommage à Bacon · 518

"Icon"

35 A Toast to Death · 529

36 An Englishman Abroad · 548

37 Echoes · 564

38 Spectacle · 581

39 Friends and Rivals · 592

40 Love and Money · 607

41 Performance Artist · 623

42 The Last Picture Show · 635

43 Fresh Faces · 647

44 Suddenly! · 656

45 Curtain Calls · 672

46 Borrowed Time · 685

47 An Errand · 694

Notes · 709

Documentation · 813

Index · 833

Acknowledgments

We are fortunate in our debts. The Estate of Francis Bacon gave us a no-strings research grant, without which we could not have written this biography. The chairman of the Estate, the artist Brian Clarke, additionally provided us with rigorous help in certain areas of research. The catalogue raisonné, edited by Martin Harrison and published in 2016 under the auspices of the Estate, is today a model of its kind: an invaluable resource for scholars to which we have regularly turned with admiration and gratitude. Martin also made available to us the important diary of Bacon's cousin, Diana Watson. At the Estate, Elizabeth Beatty granted us hours of cheerful assistance, and we miss the late Peter Hunt and Christophe Dejean, who brightened our early years in London. Ben Harrison and Sophie Pretorius, now working for the Estate, are highly informed and eternally cheerful accomplices in all things Bacon. They smoothed the way toward this book's publication.

We have particularly benefited, of course, from the guidance of Shelley Wanger, our editor at Knopf, who is a model of forbearance—having also edited our biography of Willem de Kooning. Her deft observations and wry smile helped immeasurably over the many years, as did her astute questions. She led a team that was not only talented but also willing to take the necessary time. (And it could be a slog.) She was ably assisted by Tatiana Dubin, a marvel of organization and patience, and the sharp-eyed Kevin Bourke, who caught both mistakes and infelicitous phrasings and endured with good humor a constantly changing text. We are grateful to Chip Kidd for the elegant jacket and Maggie Hinders for the fine design; to Knopf's Daniel Novack for careful legal counsel; and to Paul Bogaards, Nicholas Latimer, and Erinn Hartman for organizing a creative launch during the time of COVID. For the U.K. edition of the book, Arabella Pike at HarperCollins assembled an enthusiastic and focused group. Our literary agent Clare Conville was a dynamo of energy and ideas in London, while Molly Friedrich and Lucy Carson offered valuable advice in New York. If a book could have godparents, this one's would be John and Jodie Eastman—who helped us during the writing of the de Kooning biography—and then, early on, encouraged us to write a biography of Bacon.

Apart from the Bacon Estate, other institutions with a special focus on the artist proved exceptionally generous. Majid Boustany—the founder of the Francis Bacon MB Foundation in Monaco and a tireless champion of the artist—is a remarkable man determined to collect (or correct) every possible fact and idea about the painter. Without his assistance and that of Aurélie Valion, who helped us delve into the foundation's vast collection of images and articles, this book would have been the poorer. At the Hugh Lane Gallery in Dublin, which displays *in toto* the Bacon studio that was once at Reece Mews, Barbara Dawson, Margarita Cappock, Jessica O'Donnell, Philip Roe, and Logan Sisley steered us through their rich archive and were unfailingly kind in pro-

viding us with documents and photographs. In Tangier, Gerald Loftus took us through the historical records of TALIM (Tangier American Legation Institute for Moroccan Studies). Anyone interested in English art will find the librarians and archive of the Tate Collection consistently useful, of course, and we owe special thanks to the descendants of John Rothenstein, who allowed us to examine his private diary.

At Marlborough Fine Arts—where Bacon exhibited for more than three decades—Gilbert Lloyd generously gave us access to the gallery archives and reminisced about the artist and his friends. He also arranged a meeting for us with the last living founder of the gallery, David Somerset, the Duke of Beaufort. Somerset provided droll and insightful views on Bacon and the gallery's history. Also in the London office of the gallery, Kate Austin unfailingly provided us with assistance (and cups of tea), and both she and Geoffrey Parton introduced us to people who knew Bacon. We are also grateful to Mary Miller for helping with images for the book. In the New York office of the gallery, Pierre Levai and David Robinson perceptively reminisced about Bacon. We also wish to thank Amy Baker at the Mayor Gallery in London, where Bacon made his debut as an artist: we gleaned many details about that early period from the Mayor archive and also from James Mayor, whose father founded the gallery in 1933.

Francis Bacon's family, now mostly living in South Africa and Zimbabwe, were remarkably hospitable. The artist's sister, the late Ianthe Knott, with whom we spoke at the outset of our research, was always cheerful and forthcoming when confronted by the annoying questions that a biographer must inevitably ask close relatives. In her understated and sometimes wry way, she provided us with a unique perspective on her parents and brother. Ianthe's sons Keith and Harley Knott—together with Wendy Knott, Keith's wife—shared without reserve many lively memories of Uncle Francis both in Africa and among his circle in London. The family added the kind of personal details that help a biographer locate the man behind the reputation.

Several individuals conducted research on our behalf. James Norton combed through English archives, interviewed sources, and located the Eric Allden diaries, which offer a fresh perspective on Bacon's early years. Together with the filmmaker Adam Low, James also generously made available to us the full transcripts of the interviews conducted with the artist's family and friends for Low's *Francis Bacon's Arena*, first broadcast in 2006. These interviews included information from many people who died before we began work. In France, Anthi-Danaé Spathoni searched out sources, among them some who helped us better understand Bacon's love of France—and France's love of Bacon. Nadine Söll helped with research in Germany. In Ireland, the late, delightful Harry McDowell offered us his extensive knowledge of the Anglo-Irish milieu in which Bacon grew up, and he introduced us to a number of "big house" owners. Eugene McDermott gave us access to Bacon's first home in Ireland, Cannycourt (now Kennycourt), while Marcus and Edel Beresford generously invited us to Straffan Lodge and shared valuable house deeds with us.

Every biographer of Francis Bacon must perforce depend upon earlier biographies. There have been three, all published within five years of Bacon's death in 1992: Michael

Peppiatt's *Francis Bacon: Anatomy of an Enigma* (1996); Daniel Farson's *The Gilded Gutter Life of Francis Bacon* (1994); and Andrew Sinclair's *Francis Bacon: His Life and Violent Times* (1993). To any Bacon scholar, the Peppiatt and Farson will prove vital: both writers were friends of Bacon, and each inhabited a different part of Bacon's world. Each therefore personally observed what the artist said and did under different circumstances. They are memoirists as well as biographers, in short, offering essential "primary source" material in addition to useful observations about the man and his art. The present biographers draw significantly, and gratefully, from both.

Other writers offered more glancing, but also useful, biographical information. In 2016, Jon Lys Turner published *The Visitor's Book*, an account of the volatile but important relationship between Bacon and the colorful Wivenhoe couple Dicky Chopping and Denis Wirth-Miller. Jon additionally made available to us the many unpublished Bacon letters in his possession, for which we are very grateful. Together with his partner Nikos Stangos, David Plante was for many years a friend of Bacon and, with his novelist's eye for character and detail, has written tellingly about Bacon. He also gave us a memorable interview (and meal). Hugh Davies, who came to know Bacon earlier than most other scholars and became a friend of the artist, generously provided us at the outset of our research with the richly detailed transcripts of interviews that he conducted with Bacon in 1975. Martin Hammer did much to flesh out the artist's important early relationship with Graham Sutherland in his *Bacon and Sutherland*, as did Heather Johnson with her biography of her great-uncle, Roy de Maistre.

The friends of José Capelo, who spoke to us anonymously, took enormous trouble to ensure that our research on José and Bacon was accurate. We cannot thank them enough. The indefatigable art dealer Maricruz Bilbao, the founding director of the Marlborough Gallery in Madrid, also located source after source for us in Spain. We could not have filled in Bacon's last years without her and are deeply grateful. Patricia Ferrer, Ana Gamazo, Cristina Pons, the administration of Clinica Ruber, where Bacon died: all provided insights, as did Manuela Mena at the Prado and the art dealer Elvira González, her daughter Isabel Mignoni and Michel Soskine. And personal thanks must go to José Moreno and Juan Cruz for helping us navigate the culture of Madrid.

In London, James Birch—the inspiration behind Bacon's groundbreaking exhibit in the Soviet Union in 1988—opened many doors for us, providing advice and the consistent pat-on-the-back encouragement that biographers require. So, too, did Charlotte Black, who introduced us to Terry Danziger Miles, the art dealer, to whom we are very grateful for interviews and many important details. In Paris, Eddy Batache and Reinhard Hassert—a couple who became close friends of Bacon in Paris—gave us a marvelous and stimulating account of Bacon's later years there. Bacon always appreciated Eddy and Reinhard's observations about art, culture, and the human comedy. So, too, do his biographers.

Bacon's neighbor in South Kensington, Barry Joule—unfailingly ready with an observation—enriched our view of the painter's last years at Reece Mews when Bacon often relied upon him for help. Danny Moynihan and Katrine Boorman's reminiscences

enlivened the narrative. So did the sharp eye and gift for recollection of the painter Anne Dunn. Not surprisingly, artists—among them Frank Auerbach, Claire Shenstone, Michael Clark, Anne Madden, Anthony Zych, and Virginia Verran—brought a special perspective to bear on Bacon, able to comment both on Bacon's art and what it meant to live as an artist in London during the latter part of the twentieth century. Fr. David Lacy and Gerald Towell—the nephews of Peter Lacy—stimulated new ideas about the man who was the love of Bacon's life. In Wivenhoe, Dan Chapman opened Dicky and Denis' house to us, spending hours talking about their lives, and the artist Pam Dan and the singer Celia Hirst brought vividly to life the artistic and social milieu of Wivenhoe during the 1970s and '80s. Paul Rousseau not only excited our interest in John Deakin, but brought us some fascinating photographs that Bacon and Wirth-Miller made together in Wivenhoe.

Some interviews became extended conversations over the years. Grey Gowrie, Richard Shone, James Birch, John-Paul Stonard, Barry Miles, and John Normile provided us with that kind of talk. So did the artist Alice Weldon, whose observations were always fresh and perceptive. Daniel Newburg—together with Anna and Huckleberry Smith—was remarkably welcoming and hospitable, as was Page Allen in Ireland. Some important help came by mail and email. We are grateful to Lisa Cohen, whose *All We Know* helped restore Madge Garland to her rightful place in the history of the period, and to Rev. Charles Whitney, the archivist of Dean Close School, which was the only school that Bacon ever attended. We would be remiss if we didn't mention certain friends and sources who have died, among them John Richardson, Margaret Fenton, Christopher Gibbs, Lindy Dufferin, Louis le Brocquy, Celia Hirst, Janetta Parladé, Annie Ross, and John Ashbery.

We learned much wandering in the ever-expanding universe of writing about British art, but want particularly to mention the smaller world of writers and people especially concerned with Bacon-related themes, which includes (among many writers) Richard Calvocaressi, William Feaver, Martin Gayford, Adrian Clark, David Cohen, and Geordie Greig. We owe special thanks to the New York Public Library not only for the invaluable collection we consulted, but also for the Cullman fellowship it awarded to Mark. The lively biographers' colloquium at the Graduate Center, City University of New York, inspired both of us. In England, our friends of many decades, Daphne Green and her family, provided a warm welcome. So did our daughters, who were in England during much of this period: Pippa, at The King's School, Canterbury, and Emmy, who was working in London. Visits with them enlivened drudgy days. Emmy spent many hours researching photographs for this book, while her husband Rory Green, a Dubliner, provided insight (seasoned with humor) into Ireland's history.

We remain grateful to all who found the time to be interviewed. It should go without saying that the book's failures belong to us alone.

Francis Bacon

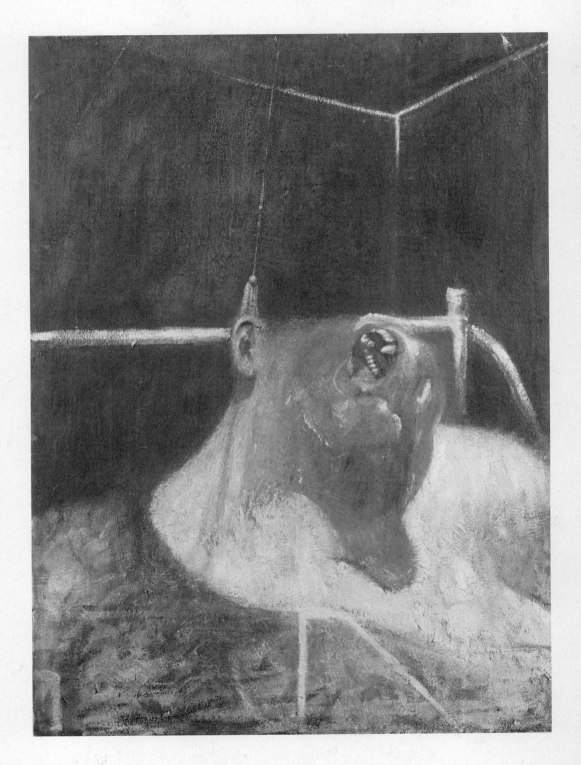

Head I

The Dark Century

*Nietzsche forecast our future for us—he was
the Cassandra of the nineteenth century. He told us it's all
so meaningless we might as well be extraordinary.*

IN THE SPRING OF 1945, with much of London in rubble, Francis
Bacon exhibited *Three Studies for Figures at the Base of a Crucifixion*. The
painter must be a "wild man," thought the critic John Russell, to loose
such monsters upon the world. It was not their darkness per se that
alarmed him. Who in 1945 did not despair? It was their peculiar dark-
ness that was troubling. The vulturous figures were gleeful, artless, and
grotesque. They all but smacked their lips. And the orange background
was vile. The Lefevre Gallery in Mayfair was exhibiting them in a group
show beside the work of England's two most admired living artists, Henry
Moore and Graham Sutherland, both of whom made art that sensitively
expressed "the terrible toll of war." The show was attracting large crowds;
the gallery reprinted the catalog three times. But the people who stepped
into the gallery hardly had time for the respectable Moores and Suther-
lands, not with these gloating ghouls to their left. They flinched "in total
consternation." So "shocked" was the writer for *Apollo Magazine* that he
felt "glad to escape." The colors made him think of "*entrails*, of an anatomy
or a vivisection."

A theatrical entrance. Who was this new wild man, Russell won-
dered. In what skull-dressed cave was he to be found? The critic was
astonished to discover a well-born gentleman—handsome, witty, and

amiable—living in an elegant town house a few minutes' stroll from the Victoria and Albert Museum. He had perfect manners when he chose, but also a laugh that—said a friend—"sounded like a Highland cock on heat." It soon became clear to Russell and others that this charming man was intent upon mercilessly attacking every comforting platitude of the twentieth century. And not just from the safe space of his studio. Four years after the Lefevre exhibit, Francis Bacon upstaged Princess Margaret at a white-tie ball just as she began to warble the Cole Porter song "Let's Do It," booing her to the wings as if she were a music-hall extra. Later, he drew himself up like a Victorian moralist and comically insisted that he was merely upholding the standards of the community. "Her singing was really too awful," he said. "I don't think people should perform if they can't do it properly."

Perform properly. Bacon was a man preternaturally attuned to the social stage. Proper form was no longer obvious midway through the century, not after the butcher's bill from two wars, and he took a demonic delight in the upended performance and the torn-away mask. He was creating two revelatory figures, one the powerful Wildean persona who booed Princess Margaret off the stage and the other the powerless figure writhing inside the paint. The Wildean Bacon—out and about in London—took delight in flinging open closet doors. His unembarrassed homosexuality helped loosen social constraint and bring a measure of light to those trapped in a difficult period for homosexuals. But he was no less interested in airing out the larger twentieth-century closet, exposing the intractable darkness he found behind the comforting covers of enlightened science, traditional religion, and modern art. The animal remained, as ever, inside the man.

Such an artist might easily have appeared unpleasantly arrogant to his contemporaries. Yet Bacon did not seem that way to friends. They readily forgave him his failings. There was something mysteriously sympathetic about his nature. He did not stand with the bullies, even as he asserted power; and he understood weakness. That living tension between power and powerlessness—a great theme also in modern Western history—would help Bacon become one of the few artists able to take the measure, glancingly, of a dark century.

He was born in the first, and died in the last, decade of the century. His sporty parents were part of Anglo-Irish society, then oriented around the great estates outside Dublin, and spent much of their time think-

ing about horses and hunting. Their second son, Francis, suffered from severe asthma. He was an indoors child allergic to animals who could not ride, fox-hunt, shoot, or do much of anything. He spent less than two years at a public school. He did not formally study art. And he was paralyzingly shy. Since he was not much of a boy, he was not considered very useful, except for talking to girls. As late as 1941, when he was in his early thirties, a woman recalled Bacon as a "rather sallow and podgy" observer looking on from the outside. His older partner at the time, a strong man of the world, made him appear, by contrast, "shambly."

The dramatic arc of Bacon's life, which made the art possible, was the creation of *Francis Bacon*, the commanding figure and "great original" who always knew that he was the most interesting man in the room. It mattered, of course, that he was homosexual; early on he mastered the arts of concealment and display. But no one could have predicted the careless abandon with which he stepped forward in the dreary gray of postwar London. The painter Lucian Freud, who was standing beside Bacon when he booed Princess Margaret, called him the most fearless man he had ever met. Bacon would even let others see the way sexual power and submission played across his body, not bothering to cover the bruises that darkly bloomed on his face and body when rough sex overwhelmed constraint. Wit and laughter, like sex, could elicit truth. So could needling, which might touch off a row that released buried feelings. Wine was a magic elixir, leading to exposures that could be disturbing and amusing. Bacon would have agreed with Winston Churchill that he took from the bottle more than the bottle took from him.

Not surprisingly, he understood the power of appearances, unmasking others while (usually) keeping his own looks in order. In the 1950s, Cecil Beaton wrote:

He appeared extraordinarily healthy and cherubic with apple-shiny cheeks, and the protruding lips were lubricated with an unusual amount of saliva. His hair was bleached by sun and other aids. His figure was incredibly lithe for a person of his age and occupation, wonderfully muscular and solid. I was impressed with his "principal boy" legs, tightly encased in black jeans and high boots. Not a pound of extra flesh anywhere.

Bacon focused on others with unfamiliar intensity, his eyes staring out from a pale and, as he aged, raggedly round moon face. "It was like looking into a light even if you'd only just met," said one acquaintance. "He could

make you feel as if you were the most important person in the world, and then if the light went off you were hardly there." He was not a giggly or simpering queen. One friend found him sexually ambiguous—a queen with masculine authority. His appetite for life was obvious. He moved on the balls of his feet, always precisely, as if there were some fine edge to negotiate. He could appear pleasingly Mephistophelian—the devil, as Chesterton said, was a gentleman—with white skin, reddish-brown hair, and a trim black leather jacket. (He would take your final bet and join you in the consequences.) It was often necessary to say what should not be said. Bacon reserved for friends or special occasions his free-form queening, when his voice would rise to a high flutey register, every "he" became a "she," and no saint escaped delirious violation. About late Matisse: "There she was, dear, shitting through her stomach, dear, cutting out these miraculous pieces of blue tissue paper, dear . . ."

Speaking freely led to outsized opinions, heightened by rage at the closeted present. Sometimes Bacon played the part of a twentieth-century prophet, but one who railed against religion. Like any prophet, he was rarely accused of moderation or tolerance. He would emerge from his legendarily messy studio-cave to castigate the comfortable, mortify the flesh, demand a return to first principles. Of what possible interest was an abstract painting or a pleasing landscape—to a prophet—during the dark age foretold by Nietzsche? There was no necessary reason, of course, to heed Bacon. Prophets easily become disagreeable. W. H. Auden, five years older than Bacon, was equally alarmed by the state of the twentieth century and, like Bacon, was a homosexual who cherished the past. In Auden's view, however, death was not always to be feared. Solace might be found, reconciliations achieved, even a certain lightness attained. Bacon and Auden disliked each other, but room can be found at the inn for both a wise king and a disruptive prophet.

Every morning, before he went out, Bacon flayed the figure. The pope became his best-known subject, though it was the idea of the Crucifixion that most attracted him. The pope symbolized not only religious power but the illusory authority of "fathers" generally in twentieth-century Western society. Bacon questioned all inherited power, even that of Western art. He revered certain masters, and his paintings were steeped in old-masterly touches. But he did not finally want to make an "old master" painting: the loss of that authority, too, must be revealed. Certain of his big triptychs possessed a mystical, impenetrable quality—his version of the Book of Revelations—and also echoed traditional history painting, a stagy genre in Western art in which the artist addressed a "grand" sub-

ject that reflected the highest ideals of society. In Bacon's history paint-ing, there remained the memory of a lost grandeur, a glimpse of "bare, ruin'd choirs where late the sweet birds sang."

He became a celebrity, of course, with all that portends in the twen-tieth century. Around the same age as Albert Camus, Samuel Beckett, and Jean-Paul Sartre, Bacon could sustain comparison with the existen-tial luminaries across the Channel, sharing their themes of alienation, helplessness, and godless despair. And like them he developed a para-doxical pop gravitas. The Bacon profile was: *By day he depicts the nightmare of postwar Europe; by night he drinks away the illusions of a failed society*. Eventually, he became surrounded by devotees who treated him as a modern saint whose every mark and remark was worth preserving. Bacon sometimes cultivated this attention. Celebrity was a light that, concealing more than it revealed, enabled him to slip in and out of his persona. It certainly did not displace any masks he wanted kept in place. Bacon put off most seri-ous efforts to write about his life. He resisted such efforts partly because he wanted to control his image, but also because he kept secrets, actually one big secret. Something that had nothing to do with sex, fame, glamour, violence, money, or art.

Friends sometimes noticed Bacon's tic: he would reach for his collar if a situation suddenly became difficult or the right word eluded him. A tug or two gave him a moment's respite. He might even shoot his cuffs. The tic was poignant less because it revealed a crack in the persona than because it suggested just how difficult it was for him to sustain the performance. He had many debilitating weaknesses. To keep going, he required extensive medical care, including drugs for both his physical problems—asthma and related illnesses—and his unremitting tension. He also required work to steady his day. (As early as 1932, when he was twenty years old, he was "glad" for work "so that the mind could lose its preoccupations.") And he required alcohol to relieve the pressure of the night. All three—alcohol, work, and drugs—could serve as intoxicants to elevate his mood, but they also paradoxically made it possible to imag-ine a more conventional life. It was Bacon's secret that he was not just a radical master of the twentieth-century stage who exulted in the dark arts. He was simultaneously an Englishman suffused with longing for the ordinary patterns of joy and solace denied him as a child and young man.

Like many people, for example, Bacon had a "love of his life"—Peter Lacy—who made him giddy with desire and whom he could never

quite leave. Lacy has usually been assigned a devilish supporting role in Bacon's life, described as a dashing fighter pilot during the Battle of Britain and a sexual monster in the bedroom. In fact, Lacy was never a fighter pilot, and he passionately loved Bacon. He became violent when he drank, but Bacon also intentionally provoked him, finding the eruption of his demon-riddled soul inexpressibly moving. After Lacy's death, Bacon, while an impossible partner—at once promiscuous, needy, and quarrelsome—continued to seek regular long-term relationships. He dutifully performed the traditional masculine roles—refracted through his homosexuality—of son, lover, and father. He kept up with his family. He frequently helped out with money and small kindnesses. He had life-long friends. He wrote innumerable letters of apology the morning after. When his friend Roald Dahl wrote to him to ask what he would choose for his last meal, Dahl—a gourmet—probably expected "Champagne and oysters." The answer was: "Two lightly boiled very fresh eggs and some bread and butter." After his death, his old friend David Sylvester wrote:

> Since he died, I've not thought about him as a painter. I've only thought about the qualities which have long made me feel he was probably the greatest man I've known, and certainly the grandest. His honesty with himself and about himself; his constant sense of the tragic and the comic; his appetite for pleasure; his fastidiousness; his generosity, not only with money—that was easy—but with his time; above all, I think, his courage. He had faults which could be maddening, such as being waspish and bigoted and fairly disloyal, as well as indiscreet. But he was also kind and forgiving and unspoiled by success and never rude unintentionally.

Bacon possessed the ordinary soulful feelings, however much he scoffed at religion, once referring without irony to "the great sea" within everyone. His brushwork sometimes suggested, in his quieter pictures, a gentle painter of melancholy and loss. His friends sensed his homespun loneliness; the painter R. B. Kitaj was surprised that he always seemed free for dinner. Like many people without much education or training, he felt insecure about work in conventional as well as existential ways, professing to like almost none of his own paintings. He constantly revised or destroyed them until, pressed by a deadline or the need for money, he was forced to let some go. Too many were mediocre, of which he was well aware.

He could appear as bewildered as anyone else by the changing atti-

tudes of the twentieth century. He detested the word "gay," and he was not pleased that so many homosexuals wanted to join the mainstream. Wasn't being queer problem enough without adding the problems faced by "the norms"? The strangest trick the twentieth century played upon Bacon was to turn him into a traditional authority. Once a commanding figure who attacked convention, he found himself the admired subject of scholarly disquisitions. The iconoclast developed, ironically, into an "icon." Even as a star in the postmodern era, however, he preferred to take the tube to Soho. He queued for the bus.

The grand note in Bacon came mainly from ancient culture. He relished the vibrato of tragedy and the moment of catharsis, which "unlocked the valves of feeling." He was especially drawn to the related ritual of blood sacrifice, of which the Crucifixion was an expression. Wasn't the sacrifice of the modern figure, on the dark altar of twentieth-century power, worthy of the same elevation? His art retained the pungent air of ceremony and incense: a chair could almost be a bloodstained altar, a bare bulb a torch, a dais an ancient stage. But the sacrifice could transcend deadened ritual only if the spilled blood mattered. It must belong not only to the fatted calfs of Western power and presumption but also to people going about their lives. It was finally Bacon's feeling for the ordinary that gave his invocation of the human sacrifice in the twentieth century an Everyman authority. The flesh under the knife was also his own. He shuddered with the meat.



"I"

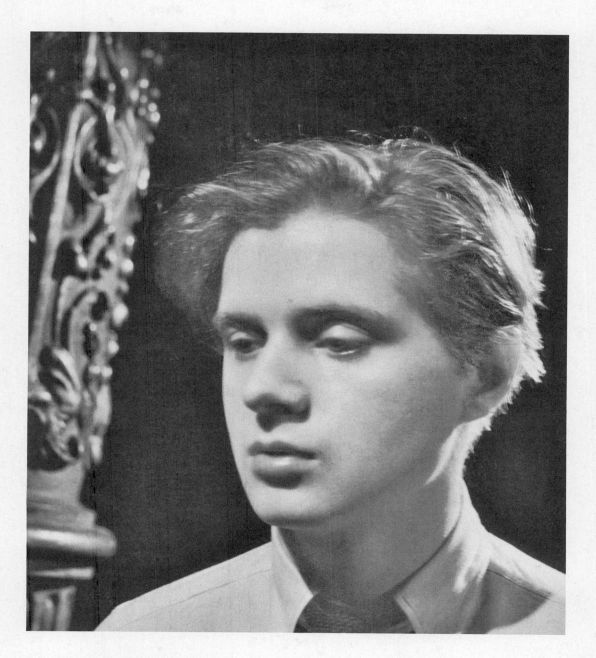

Young Francis Bacon in his early twenties

Boy at the Window

THE HOUSE SMELLED of Potter's Asthma Cure from the smoke of medicinal candles burning in the sickroom. Francis wheezed among the eiderdown pillows, his breath sometimes keening into an eerie whistle. The doctor came and went. Mummie and Nurse, too. His younger sister Ianthe wondered if he would die. In early-twentieth-century Ireland, children sometimes died of asthma.

The disease seemed to be a mysterious power come from nowhere to suffocate him. It made him leak, stain, sweat, and cough up his insides. There was no controlling the asthmatic cough.

Then, suddenly, he could breathe again. Care must still be taken. Dogs and horses must be avoided: The aromatic effluvia of animals, permeating the damp Irish air, could precipitate another coughing attack. (He would never forget "the dusty saddle lying in the hall.") Outside, the regular boys rode horses and shot birds and, when their voices broke, dreamed of girls. His father loved horses and regular boys.

Francis was not a regular boy. He began to dream of men, not girls. He liked rough male skin and his mother's soft underthings. His soldier father hardly looked at him. He was the runt of the litter, a boy whom girls wanted to adopt. Past the house and down the road, into the beautiful green beyond, men with guns threatened his English family. What was to be done? It was a difficult hand dealt to one who, when he became a man, said he "adored" the world.

In the beginning was Ireland, but not the Ireland of legend. Francis Bacon was Anglo-Irish, "a race inside a race," as the writer Elizabeth Bowen put it, "a sort of race carved out of two races." To know Francis Bacon, his friend Caroline Blackwood said, you must first understand that he was not an Englishman—and, equally, not an Irishman. He was instead that

hothouse stem the Anglo-Irishman, part of an English ruling class that was both privileged and alienated, set between two worlds and shadowed by each. Another friend, Anne Dunn, thought Bacon made important use of the "cover" of being from a place apart. "The Irish believe that you don't ever have to explain yourself. Because you're Irish you don't have to say more than that. I think Francis put that on like a robe and it gave him protection. Because he was not entirely English he could do what he wanted." Religion represented the defining line between the two peoples in Ireland, of course: the Protestant English who belonged to the Church of Ireland (as the Anglican Church was called) and the Catholic "other." There would be many powerful rooms in the art of Francis Bacon, but never a settled sense of place.

His parents were proud newcomers to this Anglo-Irish world, having moved to Ireland only in the early 1900s. Their first homes were leased. They were, as Dunn said, "honorary Anglo-Irish." The Bacons were an old English family—dotted with military men and the occasional title—that over the centuries exported many young Bacons into the Empire. It therefore seemed natural to move to Ireland, then still regarded as a colony. During the eighteenth century, which many Anglo-Irish called "the Great Century," the landed gentry constructed Georgian manors throughout the countryside. In Dublin, the wealthy built squares of Georgian town houses near the city's historic Trinity College. Until 1801, when England dissolved the Irish parliament and incorporated it into its own, Dublin had been the flourishing political capital of Ireland. It remained in Bacon's day the social capital of Anglo-Irish culture. The Kildare Street Club—founded in 1782 and well-known for whist and claret—was the symbolic heart of the Anglo-Irish world. The club served the so-called big houses in the countryside, keeping kennels so that members might bring their dogs to keep them company on the dull trip to town. In the counties around Dublin, called "the Pale," were numerous estates where life revolved around balls, fox hunting, tennis parties, and the Church of Ireland. Many of the manor houses were owned by the descendants of early English settlers. The Bacons easily fit into the Pale. They loved horses and fox hunting. They had money, style, and name enough.

Major A. E. M. Bacon, the father of Francis Bacon, set great store by precedence and appearance. He liked good breeding in horses, dogs, and children. He named his firstborn Harley, the patronymic of his grandmother, Lady Charlotte Harley, who was the family heroine and the treasured jewel of the Major's genealogical line. (The Harley men

were Earls of Oxford and Earl Mortimer.) The family china contained a dark-blue-and-gold H, a reminder of this connection. His second son—the artist—was named after another illustrious ancestor, the philosopher Francis Bacon. His third son the Major named Edward, after himself. His first daughter, Ianthe, took the name of the girl to whom Lord Byron dedicated *Childe Harold's Pilgrimage,* who was modeled—according to family lore—upon that same Lady Charlotte when she was eleven years old. Major Bacon allowed his last child and second daughter to be named after his wife, Winifred: accommodation must sometimes be made.

The Major was born in 1870. His full name was Anthony Edward Mortimer Bacon, but his friends, never many, called him Eddy. As a boy, he could not help dreaming of military glory. He himself was named after (among others) Lady Charlotte's swashbuckling husband, General Anthony Bacon (1796–1864). The General and Lady Charlotte were an astonishing couple: they could have been the heroes of a storybook for boys. Anthony, a superb horseman educated at Eton, was one of the Duke of Wellington's youngest officers at the Battle of Waterloo in 1815, where he was twice wounded. One bullet remained lodged in his thigh, an excellent calling card in the society of his time. A descendant later described him on horseback:

> Here he was in his element, whether it was riding to hounds, galloping bare-backed round the park, or helping to minister to a sick animal. The truth was that his love for horses was with him an absorbing passion. Naturally he became a magnificent rider, but far more than that he was a superb horseman; in a few minutes he would establish between horse and man that peculiar affinity which seems to exist between the two in some cases—not many.

General Bacon met Lady Charlotte while he was sailing his yacht, named the *Hussar*, off the coast of Weymouth. Her father was the 5th Earl of Oxford and Earl Mortimer, and her mother had been the celebrated mistress of many men, among them Lord Byron. The family possessed several important estates, including Eywood, whose manor house was built in the early eighteenth century. Once the couple married, they spent lavishly and fell into debt. In 1829 the General was even committed to King's Bench Prison for unpaid debts of more than four thousand pounds (a small fortune at the time). General Bacon then became a dreamer and developer of get-rich schemes. His most colorful military period came in 1832, when he served as a mercenary in the Portuguese Civil War of

1826–34. He hoped to make a fortune there and was named Colonel of Cavalry in the Queen's Army. Lady Charlotte, as plucky as her husband, not only followed the drum to Portugal; she sometimes rode with her husband during the campaign. A family history, no doubt treasured by Eddy Bacon, contained this recollection of his grandmother:

> Lady Charlotte issued from the porte-cochere and joined him, mounted on a highly spirited horse (a bay), which she rode and managed with perfect grace and ease . . . and it was to me perfectly marvelous that such a delicate reared and lovely woman, accustomed to her every comfort and luxury at home, could voluntarily resign herself to submit to the horrors, dangers, and hardships of a besieged town. Later that same day, when she and her husband came under enemy fire, [the observer noted] how "the colonel quickly turned his horse aside and leaped him over a high stone wall, her ladyship's horse also clearing it at the same time. The Colonel then gave us the order to follow. Our attempt at leaping was most ludicrous, and, I remember, afforded Lady Charlotte much merriment."

General Bacon later developed a plan to enrich himself as a "colonial promoter" in the south of Australia, near Adelaide. The attempt ultimately failed, but his family developed close ties to Australia, and Lady Charlotte herself—after her husband's death in 1864—spent twelve years there with members of her family. She kept up appearances, shipping a coach that once belonged to Lord Byron (and bore his coat of arms) to provincial Adelaide, where she became someone to be stared at. During this period one of her sons married an Australian woman, Alice Lawrence, who in 1870 gave birth to Eddy. Lady Charlotte and her family returned to England in 1877, where Eddy experienced the splendor of life at Eywood.

Although his dashing grandparents were his favorite ancestors, Eddy, as he grew up, could also take pride in certain other dramatic—sometimes rather roguish—relatives. An earlier Anthony Bacon (1718–86) was one of the first and most powerful of the eighteenth-century English industrialists, for example, developing coal and iron ore deposits on a vast tract in South Wales and dying one of the wealthiest men in England. (Merthyr Tydfil in Wales became, during the American Revolution, the iron-smelting center of Great Britain.) Anthony Bacon's five illegitimate children—all of them better at luster than at lucre—dissipated the family fortune. His eldest son and main heir, also named Anthony, lived like a

king, moving from estate to estate in the socially prominent Thames Valley area near London and honing his fox-hunting skills while fathering eleven children (one of them the general who married Lady Charlotte). Eddy could also take pride in the family connection to Sir Nicholas Bacon (1510–79), the Lord Keeper of the Great Seal during the reign of Queen Elizabeth. He was the father of the childless (and reputedly homosexual) Francis Bacon (1561–1626), the Tudor statesman-philosopher. Although Eddy was not a man of letters, he enjoyed this association with the first Francis Bacon, who was then believed by some to be the author of Shakespeare's plays. Wasn't it rather splendid, he might have thought, if a Harley man of action could also sport a bit of Shakespeare? The Bacon lineage even included a significant artist, Sir Nathaniel Bacon (1585–1627), the nephew of the original Francis Bacon. Besides being a wealthy landowner, Nathaniel was a painter of sumptuous, Flemish-influenced still lifes and self-portraits. The future Francis Bacon never expressed much interest in his ancestors, but he took some pleasure in its more eccentric members. "I know Francis liked being of that very interesting, quirky family," said his friend Christopher Gibbs. "I think he set store by the kind of romance of the Bacon ancestry. It's a wonderful name. People who love English literature know who Francis Bacon is."

Eddy Bacon, a taciturn man, took little joy in life. He was haunted by what might have been. He might have had a title and fortune. In 1853, the 6th Earl of Oxford and Earl Mortimer, Lady Charlotte's brother, died without an heir. Lady Charlotte's older sister, Lady Langdale, then inherited Eywood and, upon her death, Lady Charlotte succeeded (after lengthy litigation in Chancery Court) to the estate. Lady Charlotte's son Edward—Eddy's father—then became the first in the line of primogeniture. Lady Charlotte petitioned Queen Victoria to restore the now defunct title in favor of her son, to whom she would be willing to make over her entire estate. But the Queen refused on the grounds—said one of Lady Charlotte's descendants—"that it was no longer the whole estate which he would own. Had it been so, the Queen intimated she would have restored the title." In short, Eddy's father almost became the Earl of Oxford and Earl Mortimer. Eddy, as his eldest son, would then have succeeded to the title and the considerable (if reduced) fortune of the estate. All things being equal, which they never are, the painter Francis Bacon, whose older brother died early and childless, might himself have eventually succeeded to the title—and become, instead of a great artist, a forgotten Earl.

Eddy nonetheless had a taste of Eywood—his father eventually sold

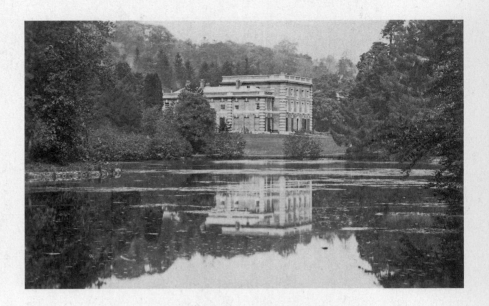

it—with its vast lawn, lakes, and Palladian manor house, an estate that a visitor the century before described as "a large house and a fine lawn, with a beautiful piece of water and great woods on the hill over it." The family also possessed a London town house at 6 Westbourne Crescent, just off Westbourne Terrace, an area north of Hyde Park then favored by aristocrats and members of Parliament. His parents sent Eddy to Wellington, a public school known for its military connections, where Eddy made the same decision that many boys with a good name but no great fortune made: he entered the army. His family purchased a commission for him in the Durham Light Infantry. The young lieutenant, a member of the 4th Battalion, was mounted and, like General Bacon, specialized in horses during his military career. He was posted here and there around the Empire. At one point, his regiment was stationed in Buttevant, a gloriously rugged part of County Cork, Ireland. There he rode with the local hunt, the Duhallow hounds, the oldest pack in Ireland. Eddy sat well in the saddle, and he was a welcome addition to local hunt society. He rose to the rank of captain in 1899.

Eddy's career in the army was honorable but ordinary. He served in Burma, where he contracted malaria and developed the stomach and digestion problems that would plague him for the rest of his life and perhaps contribute to his dyspeptic temper. For nine months in 1902, during the final stages of the Second Anglo-Boer War, he was in the Cape Colony and Transvaal area of South Africa, where he saw some action and spent much time in the saddle. In November of 1902, Captain Bacon

Eywood, one of the estates of the Harley family, the Earls of Oxford and Earl Mortimer, Bacon's paternal ancestors

was posted to the regimental depot in Newcastle upon Tyne. He was now thirty-two and likely worn down by malaria and the postings abroad. It was perhaps time to retire and find a wife. Like the other officers, he was welcomed into the local society of Newcastle, where he took a particular interest in Christina Winifred Firth. Born in 1883—thirteen years after Eddy—Winnie, as her friends called her, was a short, vivacious girl who loved parties and fox hunting. It was not surprising that a sheltered girl of nineteen should fall in love with an older officer who had bravely ridden horses across Asia and South Africa. He had a memorable name. He was an almost-earl. He appeared reserved but also confident, rather abrupt in his opinions, and he was considered "very good looking": about five foot ten, said his daughter, and "quite solid." On July 8, 1903, nine months after his posting to Newcastle, he married Winifred Firth in London, at St. George's Church in Hanover Square, which was well-known for hosting society weddings. Shortly before the wedding, he retired from the army with the honorary rank of major. A photograph taken a few years after the marriage shows Winnie looking down and appearing demure in a day suit while the Major sits squared off, elbows resting on his knees, his torso upright and thrust forward. His posture suggests a masculine, vigorous, self-assured man of action ready to jump to his feet or argue a point.

Major Bacon may have married for love. He certainly married for money. Both the maternal and the paternal ancestors of his son Francis Bacon made fortunes industrializing and arming England. But the Bacons always seemed to lose their money. The Firths kept theirs. Winnie's father, John Loxley Firth, came from the fabulously wealthy Firth family. (Bacon would later claim that his father, fortune-hunting, first proposed not to his mother but to another wealthy Firth girl.) A man like the Major—who admired bloodlines—may have even felt a twinge about this powerful connection to business: the word "gentleman" was still used in government records in the late nineteenth century to distinguish those men whose station did not require them to take up a trade. But a name was often in search of a fortune, and a fortune in search of a name. The money his new wife's family brought might go some way toward enhancing his social position. Thomas Firth & Sons had been founded in 1842 by Winnie's great-grandfather and two of his sons. Their steel business developed over five generations into one of the largest manufacturing concerns in the world, its main plant the immense Norfolk works in Sheffield.

At the time Winnie was born, the company specialized in armaments,

such as the manufacture of guns and the casting of ship's engines. At one point the company supplied the British government with all the steel used in the manufacture of guns and heavy artillery. (Francis Bacon would observe, wryly, that they were also known for making stainless steel cutlery.) Like many powerful families with a conscience, the Firths became enlightened philanthropists. Mark Firth, the family's most notable do-gooder, spent so much money improving Sheffield, for example—twenty thousand pounds, a prodigious amount at the time—that the Prince and Princess of Wales attended the dedication of both Firth College and Firth Park and stayed at Oakbrook, the Firth estate. There were few if any accounts of comparable acts of charity among the Bacons.

Winnie's maternal family—the Watsons—was also wealthy. Their fortune came from coal mines near Newcastle. The most important gift from the Watsons, however, was not money but Winnie's remarkable mother, also named Winifred, who became the powerhouse of the family and was eventually known to the youthful Francis Bacon as "Granny Supple." Born in 1859, Granny was a take-charge, horse-riding woman who was rich and independent enough to do as she liked. Her first husband, John Loxley Firth, was an asthmatic who died from heart disease in 1897 at the age of thirty-eight. (It may have been from his maternal grandfather that Bacon inherited asthma, a disease that can be genetically transmitted.) Granny then left her husband's Firth family behind and returned with her daughter, Winnie, and her sons, Edward Loxley Firth and Leslie Loxley Firth, to her family in Newcastle. She soon married a man about seventeen years her junior, Walter Loraine Bell, who shared her passion for foxhunting and was part of a prominent family in Northumberland whose fortune also came from coal. (Walter Bell lived at Woolsington Hall, an estate outside Newcastle.) Granny's sisters in Newcastle also married well. Eliza Highat Watson married the shipbuilding heir Charles William Mitchell, who along with his partner, Sir William George Armstrong, ran the vast Armstrong, Mitchell & Co., which built warships as well as regular ships. Yet another sister, Alice Edith, married the future head of the Victoria and Albert Museum, Cecil Harcourt-Smith.

Neither the Watson nor the Firth family would have been delighted with the younger Winnie's marriage to Major Bacon, probably suspecting that the weathered officer was a fortune hunter. Since he did not possess an English estate where he could settle down—his father having sold Eywood—the Major thought of Ireland. He had fallen in love with the life around the Anglo-Irish "big houses" during his posting at Buttevant. The passion there for horses and the racecourse matched his own.

The idea of moving to Ireland became a wider family affair. Granny, his wealthy mother-in-law, was willing to join them with her new husband (who was not that much older than her daughter). The younger Winnie's brother Leslie Loxley Firth loved horses and appeared equally keen on moving to Ireland with his sister, mother, and stepfather. English families with industrial fortunes often found Ireland attractive. They might not quite possess the social standing of those Anglo-Irish families who had lived there for centuries, but with money they could easily join a seductive, old-fashioned society that sometimes seemed more English than the English. The eighteenth century lived on in Ireland well into the twentieth, especially in the big houses. It did not hurt that the good life in Ireland cost less than what the same money bought in England.

Ireland was particularly well suited to a horseman and judge of horse flesh. In the future, Francis Bacon would often dismiss his father as a "horse trainer"—a "failed" one at that. But the phrase did not fairly convey what a man like the Major could become in Ireland. He was not only walking around the muddy ring training horses for the wealthy. He employed grooms. He was a connoisseur, adviser, and judge. An early photo shows him leading a horse into the ring at the Punchestown Racecourse in County Kildare, ridden by Leslie, a great rider and a noted amateur jockey. The society of the time was preoccupied with horses, as a symbol of status, much as similar people of a later day were preoccupied with art. Horses, like art, made most buyers uneasy. They did not trust their eyes. They were filled equally with pretension and apprehension. A confident opinion was welcome. Over port and cigars with friends, after the ladies left the room, Major Bacon could make connections—and a small fortune. Some friends required handsome mounts for foxhunting. Others were interested in racehorses. And, on another level altogether, the English cavalry in Ireland was always looking for spirited animals. Sometimes an art dealer will tell a client that he must "wait" to purchase a picture by a fashionable artist in order to whet his appetite. Eddy could similarly tell a friend about a horse with magnificent bloodlines that looked marvelous in the ring and might soon be ready.

The Major's wife also had reason to move to Ireland. Winnie enjoyed country life: she had grown up at Crabtree Meadow House in Hope Valley, a rural part of England, well coursed by rivers, that was not far from the family steelworks in Sheffield. She appreciated tradition and the old ways. She rode sidesaddle; and her husband could make certain she had an enviable horse. More important perhaps, mother and daughter could be together in Ireland. Both relished foxhunting, and none better was

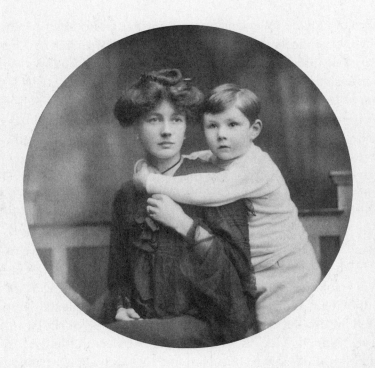

Francis Bacon around the age of four with his mother, Winifred Bacon

to be found than in certain parts of that country. Some packs went out two or even three times a week. Her new stepfather, Walter Loraine Bell, was particularly good at foxhunting. Granny and Walter Bell leased an immense estate of twenty-nine thousand acres near Ballinasloe, called Lismany, before renting Farmleigh, an estate in Abbeyleix, County Laois. Meanwhile, the Major and Winnie rented a small estate in County Kildare, some thirty-six miles away from Farmleigh in the heart of Irish horse country. The region's well-tended pastures and hedgerows were interspersed with bogs, notably the great Bog of Allen. And at its center was the Curragh—eight square miles of emerald-green plain a short distance from the Bacons' new home. The Curragh was renowned, then as now, for its stables and stud farms. The huge headquarters of the English military were located in the same area—a gathering place since ancient times—and was also called the Curragh. Across the great plain from the headquarters was a racecourse, also of the same name, which annually hosted the Irish Derby.

The newly married couple's house, Cannycourt (now called Kenny-court), near the town of Kilcullen, lay off the main road down a long, narrow lane. It had eighteen rooms—certainly ample, but not as grand as many houses in the area. It was boxy with a plain façade; only the dining room had the proportions of a stately house. But it was certainly a fine

beginning in Ireland, especially with Granny's "big house" not far away. The stables and outbuildings were astonishingly extensive—a thriving village of horses, dogs, and other animals. The census of 1911 listed twenty buildings on the property besides the house itself, consisting of "out-offices and farmsteadings." Grooms and stable hands outnumbered household servants nine to five.

Winnie gave birth to her first son, Harley, in Dublin, in December of 1904. Five years later she traveled back to the city, about eighty miles away, and entered a laying-in hospital favored by wealthy women. She gave birth there on October 28, 1909, to Francis Bacon. The hospital stood at 63 Lower Baggot Street, in a handsome Georgian building not far from Merrion Square and St. Stephen's Green. Lower Baggot Street was an older and more stylish street than its near-relative, Upper Baggot Street, where the buildings were mostly Victorian. The Dickensian name of the street would many years later delight a small, rumpled friend of Francis Bacon, the photographer John Deakin, who enjoyed teasing the artist for having been born on "lower Baggot, not upper Baggot." It was not clear whether he understood that where Bacon was concerned, the lower was often the higher.

Three months after his birth, the boy was baptized, on January 14, 1910, at St. Patrick's Church of Ireland near Cannycourt. It was the church of the La Touche family, the important landowners in the area. (Rose La Touche, the girl whom the writer and art historian John Ruskin famously idolized, was interred there after her early death in 1875.) When a fire gutted the La Touche manor in 1891, the family rebuilt the house and the church in a Gothic revival style. St. Patrick's then became a High Church jewel with a gilded reredos and a stained-glass window by Ninian Comper, the last great architect of the Gothic revival. The congregation, in 1910, set out for Bacon's baptism by horse and carriage. It went unreported whether or not the infant Francis behaved during his religious initiation.

In his early years, Francis Bacon spent most of his time in the nursery—a world unto itself located up the stairs and some distance off the main hall at Cannycourt. Each morning, servants would wake, wash, and dress Francis and his older brother, who did not take meals with their parents. After morning lessons, they were brought outside. Even a small and sickly child like Francis was put onto a pony; exercising one's pony, said his sister Ianthe, was a family obligation that began almost as soon as

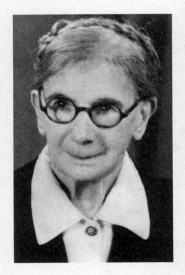

one could walk. At tea time, the children were dressed again, this time more formally, in order to sit with their parents. "We were taught to shake hands . . ." said Ianthe. "We'd sit on the sofa and have tea. We were dressed and I don't think we enjoyed it." Major Bacon was a stickler for rules. "He always wore a tie," she said. "He'd been in the army for so many years he was very meticulous in that kind of way." The Major did not, of course, concern himself with the nursery; and while Winnie loved her two boys, she was also a young mother—in her mid-twenties when Bacon was a bawling infant—distracted by hunting and the social whirl. Family photographs attest to the Edwardian aspirations of the house. In one, Winnie sits between Francis and his big brother wearing a smart skirt and long cardigan. Francis is standing on a bench and wears a long, drop-waisted, velvet dress with dramatic white lace collar and cuffs: it was the custom of the time to dress very young boys like girls. Harley is preening in a tweed suit and knee-high boots, with his right hand dropped casually in his pocket. He resembles a miniature country squire. Bacon, his round face already evident, stares straight ahead.

Much of Bacon's early emotional life was nourished by servants, in particular "Nanny" Jessie Lightfoot, whom the family probably retained after the birth of Harley in 1904. Bacon could not remember a time in his youth when Nanny was not nearby. She was born on June 28, 1871, in Burlawn, Cornwall, less than fifty miles from England's farthest southwest point, Penzance. Poor unmarried women in their thirties had few prospects then in Cornwall, and many, like Lightfoot, left the region to work as servants. Nanny would never entirely leave the Bacon family. She helped raise all the Bacon children, including his younger sisters, and she then lived with Francis for the last twenty years of her life. A photograph depicts Nanny as an old-fashioned figure with her hair braided atop her head, severe granny glasses, and a white-collared blouse buttoned up to the neck. The prim look belies the truth: Nanny Lightfoot was not starchy. She had a mischievous "No one's going to tell me what's what" spirit that served as a useful foil to anything too fancy or forbidding in the house. (It was probably with Nanny that Bacon first appreciated a more working-class perspective.) More important, day in and day out, Nanny was loving—albeit in a no-nonsense way. She did not favor one child over another. She was a soothing, sympathetic figure, especially to a sickly boy. "She was very kind to us," said Ianthe. "Not hugs, really. Not in an intimate way. But she was caring and looked after you. And you were tucked into bed."

Nanny Lightfoot, Bacon's nanny and, later, companion until her death in 1951

Despite the apparent formality of Cannycourt, Bacon—at three or four years of age—would have known deep in his bones the powerfully "animal" character of the house. There were servants and rules and daily domestic routines, of course, and his father did not tolerate disorder. But somewhere close—always—were the animals. There was even an internal doorway at Cannycourt, located off the bedroom corridor upstairs, which passed directly from the house to the stables, connecting the Bacon house to a large and noisy animal village—an alternative world of barns, sheds, and mysterious little houses. Horses and dogs were its most important citizens, but Cannycourt, like most such houses of the time, would also have included chickens, geese, pigs, a few sheep in the meadow, and a dairy cow or two. During the day the Major and Mrs. Bacon were often dressed in riding attire, and they smelled of leather, dogs, and horses. The Major raised Irish red setters both as gun dogs and for companionship. (Irish setters, then a vigorous hunting breed, later were much diminished when bred for looks.) The setters, especially the younger ones, were high-strung, jumpy, and full of wriggly love. It was not difficult to imagine the dogs hurtling toward the family, jumping with enthusiasm, and Major Bacon taking a moment to enjoy the adulation of the troops before snapping a command to settle them down. Like many aloof people, he generally found animals to be the most companionable members of a family.

Major Bacon did not have much conversation, though he was usually at a simmer, erupting into shouts and a soldier's oaths. He did not share his wife's love for society. He would usually spend his few words on stable news. What else was there to discuss except the daily reports on a horse or a pony or a dog? What was more exciting than the details of a fox killing a neighbor's chickens? (It was of great interest to the hunters in Ireland where the fox dens were located and if the foxes would be healthy enough to give the hounds a decent run before escaping or being killed.) Most small children love animals, which populate their play and imaginations. Not surprisingly, some of Francis Bacon's early memories concerned horses. He recalled the sound of military bugles in the night as cavalry soldiers from the Curragh performed maneuvers in the neighboring woods. In another memory, a line of cavalrymen on their jingling mounts trotted toward the house. The narrow lane to the house at Cannycourt, unspooling from the county road between narrow fenced paddocks, lent itself to wondrously precise horsemanship. The cavalry officers were doubtless acquainted with the Major. In the future, Francis Bacon would always display a sympathy for animals—more than that, an empathy—even though he did not present them in a romantic light. But

he could never give himself unreservedly to animal play. His illness, as a child, kept him apart.

His father nonetheless tried to orient Francis properly, placing him on a pony and letting the Irish setters jump and lick and squirrel about. What descendant of General Bacon and Lady Charlotte would recoil from an eager Irish setter? Or a docile pony with a bushy mane and tail? The boy's intractable body said otherwise. The dogs would approach him with love and his chest would close up. He would begin to turn blue. His father did not, of course, believe in babying animals or children. If you fell off a horse, you got back in the saddle. That's what boys with mettle did. If you were gasping for breath, you fought through it to the other side. Like many fathers of his time, the Major tried to punish, shame, and force the weakness out of his sickly second son. He thought he was being helpful. It was believed by many in the early twentieth century that asthma attacks were precipitated by nervous and emotional issues. Fix the character and you fixed the boy. Why couldn't Francis resemble his older brother, Harley, who leapt so easily into the saddle? It was likely that Francis, for a time, idolized his older brother. The five-year difference in age was significant: a nine-year-old will appear all-powerful and knowing to a healthy four-year-old, even more so if the child happens to be sickly. Like his father, Harley loved dogs and horses, and, just like his father, as an adolescent he would begin to train horses. There is a photograph of Harley at fifteen that shows him dressed for hunting, a shotgun broken casually across his arm. Any younger brother would have liked to possess Harley's ease and win some approval from a strict father.

Bacon often went outdoors—as a Bacon, he had no choice—but he would have known even as a small boy that he did not belong there. He would know that he could never become a hero on horseback like his ancestor General Anthony Bacon. Some of Bacon's earliest memories described painful moments of isolation and weakness when he took refuge in hidden places or was attacked by the powerful. There was one housemaid, for example, who found Francis a nuisance when her boyfriend called (and the Major and his wife were probably out). She would march Francis into a closet and, indifferent to his screams, shut him in the darkness for long periods; he later said the feeling of asphyxiation, which resembled an asthma attack, "made him." He also recalled hiding behind trees with two girls, pretending that an older boy named Reggie was coming to attack them. Once, he borrowed the cape his big brother wore when he went bicycling and marched up and down an avenue bordered by cypress trees, commonly seen near Anglo-Irish churches, imag-

ining himself protected by the magic cloak. Not surprisingly, he later looked back at his childhood with dread. "When I think of my child-hood, I see something very heavy, very cold, like a block of ice," he said. "I remember my shyness above all. I didn't feel good about myself. People frightened me."

By 1914, when Francis was almost five, the Bacon family had lived in Ireland for a decade. The Major had not become a successful horse trainer. He lacked geniality and the ability to woo a client. He could not, finally, be bothered. He dabbled in horses, but spent more and more time gambling and visiting the racecourse. (In a few years, Francis would post his father's bets for him.) His wife became pregnant again when Francis was five. Francis continued to suffer asthma attacks. The popular treatment of the time was often morphine or camphor, which reduced the urge to cough, but a local asthmatic woman whose family, the Prior-Wandesfordes, were friends of the Bacons, said that everyone used Pot-ter's Asthma Cure. "It was a candle," she said. "You'd poke it with a needle and then light it." The major ingredient was stramonium, a vegetable compound derived from thorn-apple leaves, which was part of the night-shade family. It had some hallucinogenic effects and may or may not have helped clear the lungs.

Decades later, Bacon remembered the rush of well-being that fol-lowed the injections of morphine. "It was certainly marvelous then, the relaxation that the morphia gave one," he said. For the rest of his life, he would place an almost childlike trust in the power of medicine. Major Bacon was not a caring man, but he was a soldier with experience in the field, and he was the person in the Bacon household who administered medicines. He would attend to Francis and then leave the sickroom, duty done.

Weakling

IN THE SUMMER OF 1914, during the macabre diplomatic prelude to World War I, Major Bacon closely followed the news. He was first and foremost a soldier. It was unthinkable that he should remain in the Irish countryside if his country joined the European war. On August 4, 1914, Germany invaded Belgium and Britain and the Commonwealth entered the war on the side of Belgium, France, and Russia. Major Bacon rallied to the flag. He moved to London, though his family did not immediately follow. Winnie was in the final month of her pregnancy. She gave birth to Edward, her third son, three weeks after England's entry into the war.

No doubt Major Bacon wanted to rejoin the Durham Light Infantry. His wife's brother Leslie joined the 5th Lancers, Royal Irish Regiment, and fought in France; he was awarded a medal. But the Major was too old for active duty, and he still suffered from the after-effects of malaria. No jobs were forthcoming from the regular army, so he became an administrator in London of the Territorial Force, the volunteer branch of the British military. Originally conceived as a civil-defense program to protect the home front, the Territorial Force (which included infantry and mounted troops) would soon see combat on the Continent. Its forces were needed to replenish and support the regular troops. Major Bacon worked at the Record Office of the Territorial Force, which helped oversee and centralize its manpower—at that time highly dispersed—in support of the larger war effort. A year later, at the end of 1915, the Bacon family, including Nanny Lightfoot and the infant Edward, left Cannycourt to join the Major at 6 Westbourne Crescent, the old family home in London. The Major's father had recently died, but his Australian mother, Alice, was living in the house.

It was an upheaval for the family. Francis, six years old, saw his father for the first time in months, and was introduced to a different nursery in a strange and noisy city. He now had a baby brother to think about—as distant in age from him as he was from Harley—upon whom everyone

naturally doted. He was no longer surrounded by animals, and during the day his father left the house to go to a job in an office. No effort was made to put Francis in school. His asthma was the main reason: schools were unprepared to deal with a child who might start wheezing. But the disturbance of the war also put an end to normal routines. "I read almost nothing as a child," Bacon said. "As for pictures, I was hardly aware they existed." Nanny Lightfoot typically took Francis to Hyde Park, a three-minute walk from the house, with Edward in the baby carriage.

During the war, Winnie often visited her relatives in Northumberland. She remained devoted to her extended maternal clan—far more than to the Firths, her father's family—and she took her children with her. In Newcastle, Bacon was exposed to extraordinary wealth and luxury. Foremost among Winnie's relatives was her aunt Eliza Highat Mitchell, the widow of the shipbuilding magnate Charles Mitchell. As a young man, Mitchell had become an artist: he studied in Paris and exhibited his Pre-Raphaelite paintings at the Grosvenor Gallery in London. But he gave up his dream after his father's death in order to run the family business, one of the great shipbuilding empires of the late nineteenth century. He then assembled a large collection of academic paintings and built an expansive, light-filled picture gallery in his mansion, Jesmond Towers. The space was certainly imposing: photographs of the gallery show paintings double-hung, museum-style, with sculpture dotting the long gallery. The young Francis may have seen the pictures in the gallery, as he later spoke about Mitchell's collection, but it is more likely that he knew of them only through family recollections. Charles Mitchell died in 1903, and in 1912 Eliza Mitchell sold the house to the Daughters of Wisdom, an order of Roman Catholic nuns, who established a school on the grounds.

Eliza Mitchell—like her sister Granny Supple—remained a formidable force. By 1914, Mitchell, along with her son, Major Charles Henry Mitchell, and his family, had moved to a new estate in Cornhill-on-Tweed near the Scottish border. Pallinsburn, whose great house was built in 1763, encompassed several farms, racing stables, and nine cottages, all spread over fifteen hundred acres. The house itself had nine bedrooms, a squash court, and a gilded ballroom. Francis and his family probably kept to Pallinsburn during their visits. But they also stayed at least once with Eliza at the legendary Bamburgh Castle, which was owned by the family of William Armstrong, her husband's partner in Armstrong, Mitchell & Co. The imposing fortress, the sort of place the nostalgic nineteenth century loved, had been a seat of power for more than fifteen hundred years. It was situated on an outcropping overlooking the sea and looked like something Sir Walter Scott might have invented under the influence of

opium. Before his death in 1900, Lord Armstrong, a renowned inventor who had been raised to the peerage, added early versions of central heating and air-conditioning at the then unimaginable cost of one million pounds. The castle made an impression on the young Bacon.

On trips north, Francis sometimes played with his cousin Diana Watson, the daughter of Winnie's uncle, John. It was the beginning of a lifelong friendship. Diana's family lived in Bishopthorpe Garth outside York, in a sprawling brick house notable for its leaded windows, brick decoration, Jacobean revival interiors, oak paneling, and an imposing open-style stairway. Four years older than Francis, Diana was an eccentric girl full of opinions who appeared eager to put the luxury of the North Country behind her. She longed for the big city; the younger Francis was her willing audience. During his lifetime Bacon spoke of only two family members with true affection, both of them women. Diana was one, and the no less eccentric Granny Supple was the other.

Bacon's memories of his time in London mostly concerned oddities of the war, which were imbued with a nightmarish quality. He would watch gardeners with watering cans spread phosphorescent liquid onto the grass in Hyde Park. The liquid glowed at night and, it was hoped, would trick the Germans into thinking that the park was a heavily populated area and therefore draw bombs away from inhabited buildings. He would also sometimes see enormous zeppelins float silently across the sky. The zeppelins, mainly employed for aerial warfare, were then also considered a powerful psychological weapon. They usually left Germany around dusk, arriving over England under cover of darkness to drop incendiary bombs. They flew so high that their engines were barely audible, which made early warnings impossible.

The first zeppelin raid on England came in January of 1915, five months after the outbreak of hostilities. The raids represented a new era for England, one in which the island was no longer an impregnable fortress protected by the world's most powerful navy. Initially, London was unprepared for the monsters but soon, at night, windows were being covered, illuminated advertising banned, and a mandatory blackout imposed. Clusters of searchlights sent powerful beams sweeping back and forth across the sky. In the end, the zeppelins proved ineffectual, but they impressed Francis. So did the great sweeping searchlights. They may have influenced, to a small degree, some of his paintings from the late 1940s and early 1950s in which vertical stripes of ghostly white beam up from the bottom of the canvas.

In 1918, at the end of the war, the Bacons returned to Ireland. Canny-court, which they had earlier leased, was not available. There had also been changes in the family. During the war years, Granny decided to leave her second husband, Walter Loraine Bell. She had remained with him for seventeen years in an increasingly unhappy marriage, withstanding bursts of temper and occasional sadism. Francis, as a boy, found him terrifying: he would cut the claws off cats before a hunt and then throw the cats to the hounds to rouse their blood lust, and would also string up cats when he was drunk.

At the outbreak of the war, Bell returned to his family's home, Woolsington Hall, near Newcastle, and enlisted in the Inns of Court Officers' Training Corps, part of the same Territorial Forces that Major Bacon helped to administer. Granny did not accompany him. She had both the means and the character to live her life as she chose. The separation proved permanent: she divorced Bell and then on June 6, 1917, married Kerry Leyne Supple. Supple was a thin, imposing county inspector of the Royal Irish Constabulary, which was the armed police force that the English employed to keep order in Ireland. She married Supple in a Church of Ireland ceremony, a sign of both her power and her persuasiveness, as the church generally refused to marry the divorced. In the Bacon family, she now became known forever after as Granny Supple.

After her marriage Granny could not remain at Farmleigh, in County Laois, since her husband was the inspector of the neighboring County

Kerry and Granny Supple, Bacon's marvelously high-spirited maternal grandmother

Kildare. Instead, she bought a house in County Kildare—Straffan Lodge, a small (by Anglo-Irish standards) but lovely second house on a vast estate near Naas. That left Farmleigh vacant, and Francis's family moved there in 1919. The updated Georgian house had a central door and portico and elegantly rounded rooms at the back. It also came with a fine barn and stables. "Farmleigh was a beautiful house," Bacon said, "where the rooms at the back were all curved. I suppose one never knows about those things, but perhaps this may be one of the reasons why I have often used curved backgrounds in triptychs." The first of Francis's two much younger sisters—Ianthe—was born at Farmleigh, once again about five years after the birth of the previous child, Edward. Winnie herself was now in her mid-thirties, with a second generation of children on her hands.

Major Bacon may have intended to pick up where he left off—trying to establish himself in the Irish horse world. But nothing much seemed to develop, and he soon gave up any serious professional ambitions. He had probably already done so at Cannycourt, with the war offering him a chance to escape a losing proposition. At the age of fifty, without much to do, Eddy became (said Ianthe) "irascible, a little bit" and "judgmental." She considered him "argumentative," and said "he always thought he knew better than everyone else." He was also increasingly rigid, demanding that his house be run along military lines, a difficult proposition with young children about, and he sometimes frightened the household. Pamela Firth, Leslie Firth's daughter and Bacon's first cousin, remembered that her uncle "flew into violent rages if anything in his structured life went wrong."

The Major's marriage frayed. He was often ill at ease at the lawn parties and tennis matches that Winnie enjoyed. She liked to entertain at home; he could do without another party. And he could not bear Granny, whose eccentric character offended his feeling for place and decorum. There was no escaping her. She burned with energy. She loved Winnie and the children. She was forever about and underfoot. Worse, she possessed the fortune upon which they depended to live according to their station. Not only were his wife and mother-in-law interested in parties, attending and giving them: they also loved fine clothes, fashion, and women's talk—what seemed to an old soldier nonsense and frippery. He quarreled with his wife, a deeply conventional woman, but with energy and spirited conversation—exactly the kind of woman who would have made a good-humored old soldier proud. Ianthe described her as rather short, with "quite a sort of square build in a way. She wasn't overweight,

but a solid build. But she dressed very well and dressed for her size. She rode beautifully. And she looked stunning."

While the Bacon family always had a cook, Winnie herself loved to get into the kitchen. "She was a very clever cook," said Ianthe, with her skills on particular display during the family's annual grouse-hunting holidays in the west of Ireland. "She would make wonderful pies and that sort of thing, for the shooting guests." It was cooking, in fact, that first brought Bacon and his mother closer together. "I was quite a good cook because my mother was an extremely good cook," Bacon later told David Sylvester in one of his many interviews with the art critic. (He kept a copy of *Mrs. Beeton's Cookery Book*, published in 1923, in his studio for years: it no doubt originally belonged to his mother.) A lady cooking, not to mention a son? The Major of course would not approve. "I can't remember him getting really cross," said Ianthe. "Except at my mother. There used to be rows. My mother was very social and she loved going out. And loved entertaining. And I don't think he liked it all that much. And they'd fight over food. Very often there'd be a fight at the table. But I think that's ridiculous because my mother kept a very good table."

Without much else to do, the Major became the master of the local hunt, which helped put Farmleigh near the center of social life in County Laois. This pleased his wife but represented—in a subtle way—another defeat for the Major. At Cannycourt, the Major had not played an important part in the local hunt but had instead focused on more soldierly preoccupations, notably breeding and training horses and gambling at the racecourse. He possessed the natural superiority of the cavalry officer who supposes that once you have hunted hussars on horseback, your interest in chasing bushy foxes with ladies and gentlemen must diminish. At Farmleigh, however, he spent his time on the local Queen's County Hunt and, probably, gambling.

To his daughters the Major appeared remote but well-disposed: a second daughter, Winifred, was born at Farmleigh in August of 1921, two years after Ianthe. To his sons he was a difficult judge and taskmaster. Although the Major's firstborn, Harley, briefly trained horses in Ireland like his father, he emigrated to South Africa in 1921 to work in the apple farms on the Cape. He was only sixteen when he left. (He later joined the Rhodesian police force, anticipating, perhaps, a quasi-military career like that of Kerry Supple.) The Major, who had served in South Africa, probably influenced Harley's views on where to settle. Harley probably also noted, however, that South Africa was very far indeed from Ireland.

Local gossip had it that even Harley, the child who most resembled his father, could not get on with the dyspeptic Major.

Francis Bacon was ten years old in 1919, after the family's return to Ireland, and entering that lambent period of "middle childhood" or "pre-adolescence" when a child's dreaming eye first looks past parents and home to focus on the larger neighborhood and world. Friends, social rules, cliques, and concerns about status increase in importance. Boys often become more like boys, girls more like girls. What is just or unjust, what makes sense, what others may think or feel: these begin to matter in more complex ways. For the young Bacon, the return to Ireland was inevitably difficult. He was thrust backwards into his early childhood, only barely remembered, to live once more in an animal-teeming world ruled by a tyrant. His father continued to try and make a man of him, setting him on horses, urging him toward the hunt, and assigning him jobs around the stables and farm. But sometimes, Bacon later said, the Major ordered the grooms to give him a thrashing. Eddy would not have thought this cruel. A boy—like a dog, horse, or soldier—required discipline. The Irish climate only worsened Bacon's asthma. He was regularly placed in the sickroom, his father as usual administering the medicine.

Bacon's loneliness intensified. Baby Edward was now the favorite—of course—and while Winnie loved Francis, she did not know how to comfort her sickly boy. She often looked past him to the horses and parties. Now, as Francis approached adolescence and observed people his own age, he became aware that he must face further isolation. "I felt like I wasn't normal . . . I didn't have any friends. I was very alone. I remember crying a lot." He would later compare being shy to his asthma: the one led to a physical, the other to an emotional, suffocation. He did not know how to join the boisterous boys his age who were now beginning to hunt. (There was no mention in early accounts of Bacon's life of his ever playing with other boys.) Those boys were also being sent to public school, a great if rather frightening adventure denied to him by his illness, while he was left behind with the girls and small children. Could there possibly be a more useless boy? And yet . . . Bacon was becoming a survivor. He began to act in ways to protect himself. He learned to be polite to strangers, shake hands at tea, and play with the girls and smaller children. He found that certain adults were more sympathetic than his own parents were, notably Granny and her husband. And strangely, as he grew older, he developed a more forceful individual presence. He was still sickly and subject to regular asthma attacks. But he also had his mother's vitality and solid build and, despite his paralyzing shyness, an interest in social life.

The society around Farmleigh continued to revolve around the hunt, typically a neighborhood affair that took much of the day. Bacon found other ways to amuse himself among those left behind, who were dimly overseen by the servants and a few elderly people. One childhood friend, Rosemary Van der Kiste, said that once, when the grownups went bugling off into the wherever, Francis and his six-year-old brother, Edward, scavenged the remnants of the hunt breakfast for them, doling out scraps and drinks to Rosemary and her sister. Afterwards, she remembered, the children squared off in a game of Roundheads and Cavaliers.

It soon became apparent that the Bacons had left one war to return to another. What the Anglo-Irish termed "the bad times" the Irish themselves called a gathering revolution. The Bacons and their class lived amidst a resentful Irish Catholic population that far outnumbered the Anglo-Irish and particularly resented the wealthy landowners. Caroline Blackwood recalled a time when "the murder of a landlord was considered a hallowed act, and the Irish children played games of 'Kill the landlords.'"

The conflict between the "Irish Irish" and their English overlords was hardly new, of course: it had been going on for centuries. "Eighteenth-century Ireland was a Protestant kingdom, governed under a Protestant constitution; and the whole Protestant population, from the members of parliament at College Green to the linen weavers of County Armagh, was convinced of its right to a position of ascendancy in Ireland," wrote J. C. Beckett in *The Anglo-Irish Tradition.* In 1800, the Irish legislature was abolished altogether and the government moved to London as part of the new United Kingdom of Great Britain and Ireland. The Catholic Emancipation of 1829 opened parliament to Irish Catholics, but that was not enough for the Irish, who, increasingly toward the end of the century, also sought home rule. As the Roman Catholic majority "made good its claim to be regarded as the Irish nation," wrote Beckett, "the Anglo-Irish were now seen as no more than a colonial ruling class, battening on the spoils of conquest and oppressing a native population."

Two years before the Bacons' return, the country had erupted into violence in the Easter Rising of 1916. Now the adults around Bacon could not be certain of the views of the servants or the Irish families they had lived beside for generations. The world began to fill with whispers, secrets, and murmurs. Bacon's mother believed that the family groom at Farmleigh, a Mr. Moody, was a member of the Irish Republican Army

but that because he was very fond of women, "he wouldn't allow them to come near our house," Ianthe said. According to Marcus Beresford, the 7th Baron Decies, who later owned Straffan Lodge, "so much depended on individual families' relations with the local IRA. There's a story told about a family in Cork where the local IRA would guard their house against the Cork terrorist IRA group that wanted to burn it." The IRA behaved with theatrical flair, in ways designed to be talked about. Partisans killed the father of a friend of one of Bacon's sisters by burying him up to his neck on the beach, a gruesome way to die as the tide rolled in. It became a drawing-room horror story.

To instill dread, the partisans selectively burned big houses. No one knew which would be next. The houses, isolated on large grounds, were easy targets. In her novel *The Last September* Elizabeth Bowen wrote, "The British patrolled and hunted; the Irish planned, lay in wait, and struck." The result of all the "ambushes, arrests, captures and burnings, reprisals and counter-reprisals" was, she noted in the preface to her novel, a sense of endless foreboding that "kept the country and country people distraught and tense." The IRA made special and dramatic use of the night. They would create unexpected noises and flash lights in the woods, spooking the people shuttered in the big houses. Sometimes, they sent men to the houses in the middle of the night to pound ferociously on the door and demand money for the "dependents of the Irish Republic."

Bacon's father particularly dreaded a sinister nocturnal visit, seeming to anticipate the terrible knock on the door. He told his children that if the IRA came, they must "say nothing." The dark and moody atmosphere of the time pervaded Bacon's early adolescence. It was both magical and unnerving—thrilling and dreadful—to go to bed knowing that somewhere in the dark field beyond the window there might be strangers waiting and watching, phantoms who lit flares and sang songs. (Watchers would appear decades later in many of Bacon's pictures.) Francis was particularly aware of the Troubles whenever he visited Granny Supple and her husband at Straffan Lodge in Naas. He was visiting them more and more often now, sometimes without his parents, perhaps to escape from his simmering father. The Supples feared assassination, reasonably so, as the IRA in 1919 began to target the Royal Irish Constabulary, in which Granny Supple's husband held a prominent and highly visible position. Many in the force resigned, which led the British government to recruit a paramilitary police group to help maintain order. Known as the Black and Tans for their cobbled-together uniforms, the irregulars only made things worse. They were not infrequently violent, ill trained, and difficult

to control. They infamously carried out arbitrary reprisals against civilians, including burning and sacking small villages.

To protect the Supples, the Constabulary sandbagged Straffan Lodge and assigned a pair of policemen to guard the family. Each day, the policemen bicycled the four miles from the neighboring hamlet of Johnstown to the area where the big Anglo-Irish houses stood. One pair was ambushed and killed on their way to Straffan Lodge. On another occasion, the Supples barely survived a night attack as they sat side by side in their sitting room with their backs to a multi-paned window. Granny had removed her wig (many women of the day wore false hair to supplement their own), and the gunmen could not distinguish her from her husband. They did not want to "take a chance and shoot the lady." For the rest of her life, Bacon's own mother refused to sit at night with her back to the window, remembering, with dread, what almost happened to her mother. And once, when an eccentric neighbor came to visit Supple in the high open cart that she favored, Supple dove under the dining-room table, mistaking her cart for one of the sidecar motorcycles often used by the Black and Tans; he assumed that the IRA hijacked one in order to kill him. The Bacons did not appear particularly concerned that their son would often visit his grandmother, probably imagining the house to be well guarded and their own situation at Farmleigh to be no less dangerous.

One night, as Inspector Supple drove Francis across the great Bog of Allen—probably either picking him up or taking him home—he suddenly braked to a stop: the IRA had dug a pit in the road to ambush automobiles. Supple and Francis leapt out of the car and set off across the fields in the darkness, all the while surrounded by cries and flashing lights. Supple led Francis to the nearest "big house," where they were questioned at gunpoint before being allowed inside. Bacon, in retrospect, relished the experience. The "bad times" would, of course, have stimulated the imagination of almost any boy approaching adolescence. It was not only ghostly partisans hiding in the night that excited Francis. He felt he could also hear, while passing Irish prisons, the screams of men being lashed in blood-spattered cells. He might well have visited prisons, in fact, with Supple. The fighting even provided a troubled boy with a kind of unexpected recognition. They confirmed for him that his inward feelings of isolation, alienation, and foreboding were not an anomaly. He might be a weakling in Anglo-Irish society, but that society itself was an island of weakness in Ireland.

Under the stressful circumstances, the health of Inspector Supple began to deteriorate. The Supples decided to withdraw to Newcastle,

leaving Straffan Lodge vacant. Inspector Supple retired in March of 1921, but his illness worsened: he died the following August. His last days were spent in a place well-known to the family—Jesmond Towers, Eliza Mitchell's old house in Newcastle, in the care of the Daughters of Wisdom. In December of 1920, not long before the Supples left Ireland, Major Bacon bought Straffan Lodge from his mother-in-law. The Major and his family then moved from Farmleigh to Straffan Lodge. They were uncertain whether or not they would remain in Ireland. A thread seemed to have dropped: the Bacon family did not know where it belonged. They were not part of the ancient Anglo-Irish. Should they perhaps return to England, joining Granny and many others, and escape from the Troubles? "We vacillated very much between England and Ireland," Bacon said. "For some reason my father and mother were never satisfied with where they were." The moves they now made over the next years, usually in and out of Granny's houses, led Bacon's cousin Pamela Firth to describe his branch of the family as having no sense of solidity or roots.

By 1922, a year after moving into Straffan Lodge, the Major and Winnie began to plan their departure to England in earnest. The Treaty of December 1921 officially ended hostilities between Great Britain and Ireland, and an Irish Free State was formed a year later. But the violence continued between the Irish who supported the state and the Irish Republican Army, which did not, and helped precipitate the Irish Civil War. The violence against the Anglo-Irish intensified because of the internecine fighting. At least 139 "big houses" were burned in 1922 and 1923. At one point the IRA gave Winnie's brother Leslie Firth three days to remove his family from Carnalway Lodge before they burned it. (The practice of providing a warning was common: the rebels were intent on burning the houses of the overlords but did not want to harm their families.) In the end, Carnalway Lodge was occupied but not burned. However, Winnie's brother and his family fled to England, settling at Cavendish Hall in Suffolk, about thirty miles southeast of Cambridge. They would never return to Ireland.

There was one other consideration for the Bacons. Something really must be done, Major and Mrs. Bacon realized, about the formal education of their children. Francis was now thirteen and Edward eight. Francis's asthma continued but was now becoming more intermittent, as often happens to asthmatic children when they reach adolescence. Neither Francis nor Edward had yet spent a day in school, and the selection of Protestant schools in Ireland was limited. The Bacons also had to consider their daughters' prospects. The education of daughters was then of

no great concern, but could they find husbands in this new Ireland? Perhaps the Bacons should move to England until the Irish situation resolved itself, or at least retain a base of operations there. The Major's main interest was now gambling and racing, and as he considered where in England to alight, he focused upon an area known for its racecourse, in the Cotswold region. The Cheltenham Racecourse, one of England's best, specialized in steeple-chasing. Several well-known schools were in the area, and the family could easily travel back and forth to Ireland: the Holyhead ferry to Dublin was nearby. But where was the money to come from? The answer was to exchange houses yet again. In October of 1921, two months after the death of Inspector Supple and nine months after he bought Straffan Lodge, the Major sold it back to Granny Supple. She liked being there, and as a widow did not fear the partisans. As a result, the Major could now buy a place in England, Granny regained the house she had happily shared with her husband, and the Bacons could without difficulty move to and from Straffan Lodge whenever they wished.

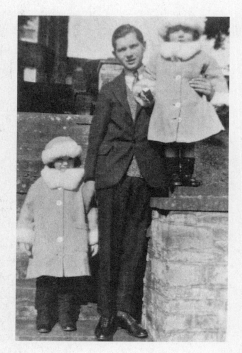

In January 1923, the Bacons finally made the move back to England. They initially settled at Linton Hall, near Newent in Gloucestershire, about eighteen miles from the Cheltenham Racecourse. Francis recalled going with his mother to the local market town of Newent, and his sister Ianthe remembered him noodling endlessly over the piano in the house, a desultory adolescent practice that can drive any household mad. But Francis never quite made the move to England with the rest of his family. For the next year and a half, he spent most of his time not with his immediate family, but with Granny Supple at Straffan Lodge. He was beginning—just beginning—to see a way forward on his own.

A teenage Bacon with his two younger sisters, Ianthe and Winifred, around 1925

Arousal

Francis bacon first comes into sharp focus early in 1923 when his parents left for England. The thirteen-year-old asked to stay behind at Straffan Lodge in Naas, where he had begun to develop relationships with two adults, one a man and the other a woman, whose respect for him suggested that he could indeed survive (and perhaps even enjoy) the world. They did not replace his parents, but provided him with a different adult outlook.

In Naas, the Major—perhaps prodded by Granny—had engaged a local clergyman to tutor Francis, a throwback to an era when many sons of wealthy county families were taught either by the local parson or by recent graduates of Oxford and Cambridge. The Anglo-Irish houses in Naas stood near to one another (and separated by parklands from the local Irish farming community, which was called Irish Town). The manor of Straffan House gave onto the much smaller but elegant Straffan Lodge, where the Bacons lived, and, just beyond it, to the rectory. To reach the rectory Francis had only to walk down a short path through the woods. The rector, Lionel Fletcher, was appointed in 1894 to serve the Anglo-Irish enclave in Naas. Then fairly young, he settled comfortably into the local parish, which had a typical country church and a graveyard lined with yew trees. He was an old-fashioned sort of country parson. He came from a good family, enjoyed life, and was himself reasonably well-off. He knew better than to trouble his congregation with too much religion. "I didn't know him," said Grey Gowrie, a descendant, "but I knew his brother, my uncle Dudley. They were the very classic archetypal figures of hard-drinking, hard-hunting Anglo-Irish parsons—decent fellows. They both had a good classical education. They administered to their parishioners and then climbed on a horse. But these rather eighteenth-century kind of Protestant Anglican parsons were not very holy." Unlike Bacon's father, Lionel Fletcher did not mock Francis or force religion upon him,

or display impatience with any perceived lack of manliness. Nor did he disdain books and learning. He probably determined that it was too late to start the boy on Latin and Greek—he was not in any case preparing him for Eton or Oxford—but young Francis was highly intelligent and old enough to begin reading some of the classics.

It was probably Fletcher who first kindled in Bacon the love for books that helped sustain him for the rest of his life. He probably introduced Bacon to Shakespeare, English poetry, and the Greek tragedies. Fletcher was too sociable a parson to be censorious, given Gowrie's recollection, and he would not therefore assign reading the way some tutors did, as something to be taken like medicine for your moral health. Instead, the older man likely drew the shy boy into conversation. Suddenly, unexpectedly, the boundless universe of books opened up his highly circumscribed world. His sister noticed, as if it were rather odd, like a facial twitch or a lisp, that Francis was a "tremendous reader. It made up for his lack of education."

Bacon's reading and curiosity became yet another way, however, that he did not fit into his family. "People like my father consider a mental desire to be the most immoral of all," he said in 1931. The only literary interest that Eddy had displayed was for Shakespeare—and that owed more to Eddy's fascination with his lineage than to his appreciation for Shakespeare's writing. (There may have been no serious library or study in Bacon's childhood homes—a room that many upper-class men of the time would have taken for granted—since he never mentioned such a place.) Bacon later said that he had "a sort of familiarity" with Shakespeare that came from a story his father used to tell:

> When I was young, people used to ask all sorts of questions about the exact identity of Shakespeare. . . . Amongst all the people whom they thought might have masqueraded behind the name of Shakespeare was the Francis Bacon who lived at that time, and to whom my family is related, according to my father. . . . He was a politician, scientist, philosopher and inventor all at the same time, entirely in the spirit of the great figures of the Renaissance. . . . He really was an astonishing person, a free spirit. Perhaps my father's story about this genius busybody helped to make Shakespeare all the more familiar to me.

Shakespeare and the Greeks probably excited his imagination. No less important, the reading gave him the sealed-away hours of escape, knowl-

edge, pleasure, and solace that have saved many isolated lives. "I suspect no one knew quite what to do with Francis," said Gowrie. "Obviously my uncle must have had an intuition that he was very intelligent—you know, intelligence is not easy to conceal." Bacon may also have thought seriously about religion, however easy-minded the parson might have been on the subject. Many sensitive and introverted children develop in adolescence a kind of romantic crush on religion. Bacon later said that he lost his faith when he was seventeen or eighteen, which suggested that he was once a believer. The discovery of his loss of faith, he later said, "tormented me for months."

The inspirational woman in Bacon's life was, of course, Granny Supple. She was then in her sixties, and while she tried to keep her distance from Major Bacon, she loved her daughter and grandchildren with the same conviction that she brought to everything in her life. The young Francis had enjoyed visiting Granny and her husband while they lived at Straffan Lodge and he and his family lived at Farmleigh. After his family moved to Straffan Lodge, he saw more of her: Granny likely returned to Ireland in the autumn of 1921 after her husband's death, and lived with Francis's family until they moved to England. Although Granny also spent some time in England with the family after their move—even buying or leasing a substantial property, Prescott House in Cheltenham, to be near them—she, like Francis, generally preferred Ireland. (Granny Supple collected grand houses the way other ladies collected fancy hats.) Francis kept her company at Straffan Lodge and could continue to see his tutor. It was a sensible arrangement for all concerned, since neither Francis nor Granny wanted to spend much time with the Major.

Francis and his grandmother became "confidants" who shared everything. Granny Supple appeared to be all that Francis was not: bold, imperious, fun-loving, indifferent to expectations. She was easily the most dramatic and interesting person in his life. He admired her "marvelous ease" and "vitality." His sister Ianthe described her as "a wonderful free spirit." Granny Supple would, for example, "mow the lawn. And she would wrap herself up—her head and everything—so that she [would sweat and] stay slim. She used a push mower. She also had a little wooden thing in her bathroom, the beginning of a sauna. She used to get in there with hot steam and get red hot. She was tall and slim and very elegant really. But she wanted to keep her weight down." Granny Supple did ladylike things, but never in a ladylike way. She enjoyed needlepoint, for example, but not in a grannyish spirit. To busy her fingers at teatime, she would unroll an enormous canvas, mostly set with Jacobean designs. One of her canvases won a medal.

Granny Supple was a merry widow who did not stop entertaining after her husband's death. She liked "having lots of people around her all the time," said Ianthe, who called her "a very well-known socialite." Her parties raised eyebrows in the neighborhood. She once invited the Aga Khan to a party—his love of horses led him to purchase an estate near the Curragh—which left her conservative friends arching their eyebrows. She began to ask Francis to escort her on the Anglo-Irish social circuit. As a boy of fourteen he accompanied her to hunt balls, tennis parties, and many other social occasions. Bacon later described himself as quite useless: "I never knew what to do when we got there, of course. She went off dancing, and I just stood around and looked ridiculous, I suppose, because I was so shy at that time."

But Bacon surely exaggerated. Granny Supple would not have dragged around an adolescent dullard. She had known enough tiresome men who lacked sparkle and dozed off over the port and cigars. Bacon was amusing, and handsome in a pretty sort of way—increasingly so as an adolescent, with his enviable complexion and big blue eyes. Granny Supple could draw him out, teaching him how to behave, and perform, in a social setting. He came to realize that he had a certain charm. He could hide behind the mask of fine manners, indulge in gossip, and say amusing things. It was not so very difficult. The wives were always desperate for lively conversation. If the Reverend Fletcher recognized Bacon's intellectual gifts, Granny Supple saw the future life of the party.

Francis continued to make friends with interesting girls who liked him for the same reasons that Granny and Diana Watson did. He was a sympathetic male companion. He could talk about something besides horses and hunting. He even played tennis, Ianthe said, as his asthma receded. One friend remembered him as "very good tennis player, ruthlessly running a fat lady opponent from side to side of the court with remorselessly placed shots on a hot day." One tennis partner was Doreen Mills Molony, with whom he passed the hours during the interminable tennis parties, tournaments, and dances. Another close friend was Maeve (Billie) Kennedy, from one of the great Anglo-Irish families and about his age. The family seat, Bishopscourt, was a preposterously enormous pile near Straffan Lodge. The flamboyant Billie took Bacon under her wing. Her family contrasted dramatically with his own. It included four boys and five girls who continually filled the house with noise and play. Since her father was master of the Kildare hunt, the house would also sometimes have an air of important-seeming rush and hubbub.

Billie and Francis would go off by themselves to talk and gossip. They "adored dressing up and talking about clothes." At his own family events,

Bacon sometimes sparkled unexpectedly in ways that probably did not please the Major. During a visit to the Firth family at Cavendish Hall in Suffolk—Granny Supple maintained a close relationship with her son Leslie, despite the distance—Bacon appeared at a costume party as a flapper waving what seemed to be a foot-long cigarette holder. He wore a beaded dress and he styled his hair in a fashionable Eton crop, cut chin-length on the sides and close in the back. One of the elder Firth women commented, "Isn't Francis wonderful? Isn't he just like a girl?"

Francis never shook his feelings of isolation, however. His best friend during adolescence continued to be his childhood playmate Diana Watson, now an awkward, often solitary girl, who would never marry. Diana also knew about isolation. She and Francis could be isolated together. At the outbreak of the war, her father, Arthur Toward Watson, who owned a colliery and loved country sports—he lost an eye in a sporting accident—volunteered to serve in the army. He was wounded, recovered at home, then returned to service. He was killed in 1917 at Passchendaele under particularly upsetting circumstances, dying on the very day he was to go home when, on a whim, he returned to the front for a moment to say goodbye to friends and take their post to England. A shell landed beside him. Diana's older brother could look forward to working in the family business, but Diana would now be expected to look after her widowed mother in the gloom of the large, echoing house. Diana was not sporty. She disliked the country. Visits from her bright cousin Francis were, for Diana, "an oasis in the middle of a desert."

What Francis really wanted to do, he told Diana when he was fourteen and she was eighteen, was to become an actor. "Its [sic] great fun I have made up my mind to go on the stage," he wrote in 1924, already using the unschooled grammar and looping baroque hand (a florid escape from penmanship) that he employed throughout his life. Like many young actors, he was an introvert who found in social performance a kind of giddy relief. The sensation of taking control of a stage, of making an impression, could be revelatory. "I suggested it to Mummie and Daddy and after they had got over the first shock they were quite good about it. So as soon as we get to Cheltenham, I am going to have lessons in elocution."

But the Major and Mrs. Bacon were not serious about the acting. A son of theirs on stage? It was bad enough that Francis had never been formally schooled. After their move to England, the Bacons had sent Francis's younger brother, Edward, who was eight years old, to Palmerston House School in Ross-on-Wye, about ten miles from Linton Hall, to

study Latin and prepare for matriculation at a prominent school. Edward was then accepted to Cheltenham College, a public school with a national reputation. His parents believed that Edward showed promise. They later proposed, on a school form, that the position of "royal engineer" would suit him. His parents also wanted to send Francis to Cheltenham College, but, asthma aside, at fourteen he was not prepared for an academically rigorous education. Not only did he lack formal schooling: he had never seriously studied Latin. In September 1924, as he neared his fifteenth birthday and dreamed of escaping into the theater, he wrote to Diana Watson, "There is no chance of me getting into Cheltenham as Latin is the thing they go in for most." His parents then cast around for a lesser school willing to accept Edward's older brother, a humiliation for all concerned.

That autumn, Bacon was enrolled at the Dean Close School in Cheltenham as his younger brother matriculated at Cheltenham College. The contrast between the two schools rankled. Dean Close was smaller, less important, and substantially less expensive than Cheltenham College. Only two miles apart, the two schools were worlds apart in feeling—one expensive and manicured, the other sturdy and straightforward. Bacon later dismissed Dean Close as "a very minor public school."

Dean Close had been founded in 1886 as part of the evangelical move-

Dean Close, the public school that Bacon attended for a year and a half in Cheltenham

ment in the Church of England; Cheltenham College by contrast was Old Boy and High Church. The intention of Dean Close was to counter papist tendencies in the church establishment. Its Christianity was fused with military rigor: the soldiers of Christ must be physically as well as mentally fit. The school hoped "chiefly to educate boys of parents of limited means for the spheres they are to occupy upon Scriptural, Evangelical and Protestant principles. . . ." It offered "a particular discipline," said the school archivist, Charles Whitney. "It was prayer book based—the 1662 version of King James. . . . That, coupled with having an army corps here. School plus army discipline." The school's main redbrick building was purpose-built, with the classrooms below and the dormitory halls above. Students came mainly from "evangelical aspiring middle-class parents," Whitney said. Many were Anglo-Irish boys—so many, in fact, that the school arranged special, end-of-term transport for them. They were not typically the sons of "big house" society but of merchants, lawyers, and doctors. Their families were often Methodist rather than Church of Ireland. Bacon would have had next to nothing to do with such boys growing up.

Bacon remained remarkably touchy, for the rest of his life, about matriculating at Dean Close. He retained a few prejudices of his class; or they shifted, in his case, into a demand for the best. (If he should have to make do with less, then it must be by his own choice and not by imposition.) He blamed his father for imposing Dean Close upon him in order to save money. That was untrue. He also blamed his father for enrolling him there out of spite, which was equally untrue. Bacon's description of his first day at Dean Close, which he reported to Michael Peppiatt, captured the absolute terror of every shy child who has ever been placed in a school as a new boy, knowing no one, as the other children chatter comfortably to one another. And Bacon had not, of course, even been at any previous school. Nor had he spent much time with boys. He hardly knew what to expect but hated what he found. He described being brought to the school at midterm, with the embarrassing result that his family was paraded down the length of the dining hall as the boys turned and gawked at them from their long tables. "Of course what's called all conversation stopped and everybody just sat and stared at me. I felt I was finished after that and, once I was there, I just went wandering up and down the corridors, up and down the whole time, not daring to talk to anyone."

The story was likely exaggerated. School records indicate that Bacon arrived in September 1924, the usual time to begin the Michaelmas term. (He may have undergone the parade of shame the previous term when

visiting the school with his family.) But the story beautifully conveyed his intense, painful, and shaming self-consciousness. He had a horror of being publicly observed in a vulnerable circumstance. Francis was placed in Ellam, the most popular of the four houses and also the most "upmarket," according to one classmate, A. L. Jayne. But he did not become a member of the all-important Officers' Training Corps, which attracted the most successful and popular boys, and he did not appear to study much. "He took little or no part in games or at his desk work while efforts in School and House runs were moderate from all he told me. Put another way, he 'didn't fit,' as he admitted to me some years later," wrote Jayne in a school reminiscence. Bacon was also not sporty, tantamount to social death in many schools, and he participated in no athletic contests, according to school records, either for the school or in the interhouse games (rivalries between houses being encouraged as a way of building loyalty). Nor did he participate in school concerts or plays.

Perhaps most surprisingly, he never took an art class. The art teacher was Adrian Daintrey, who later became a well-known painter. He had recently joined the school staff, and he and Bacon would later crisscross in London. (In 1934, for example, Daintrey exhibited at the Mayor Gallery, where Bacon had been part of two group shows the year before.) But Bacon did not sign up for Daintrey's class. He later called Daintrey "very arrogant" and said he was afraid of him. It was only the first of many

The boys' "common room" in Bacon's house at Dean Close school, circa 1924, when Bacon was a student there

times in his life that Bacon would recoil from academic instruction in art. Instead, he took music lessons as an "extra subject" since he had begun to dabble at the piano.

Bacon spent fewer than two years at Dean Close, departing at the end of the Lent term in April 1926 as part of the "IV-B" or second group—which, according to Whitney, "suggests that he was not perceived as being particularly bright." And yet in the eyes of some classmates, Bacon was not the hideously shy misfit that he later described. One remembered him walking around with several friends looking unhappy, but he knew Bacon only distantly. A. L. Jayne, with whom Bacon continued to stay in touch, had a much more positive recollection of Bacon. "As I well recall him Francis was a pleasant-mannered, fresh-faced youth always affable but clearly seeking a friend and already fit to take his place with panache at any London Dinner Party or weekend House Party," wrote Jayne. In other words, Bacon had already developed a bright and amusing social manner that concealed his private suffering.

Some adolescent boys, pimpled and melancholy, may even have envied him his posh social background and dinner-party "panache." Francis could also talk with authority about gambling and the racecourse, a slightly disreputable subject certain to impress many classmates. Bacon himself acknowledged that while he was a fool at Dean Close, he was a "sophisticated fool, and so I became a sort of clown and I got by because I amused the other boys." That he was "clearly seeking a friend" suggested not only social insecurity but also, perhaps, a desire for a relationship with another boy. Bacon recalled one Persian boy who had "developed early"—Bacon himself was then extremely young-looking and boyish—and befriended him at Dean Close.

Bacon later described his departure from school as a kind of ghastly drama. He repeatedly attempted to run away, he said, sounding as if he were an orphan trapped in a Dickens novel. One time he got as far as Paris, he told a friend—possibly while he and his family were in London visiting relatives—before being brought back. He finally left because the school wanted to expel him, he said, which may well have been the case—though the school had no such record. An unhappy Bacon might have tried to force the school to expel him for leaving the grounds. And perhaps his "seeking a friend" was construed by the Christian masters as possibly having a harmful influence upon others. He was certainly unpromising material for an onward Christian soldier.

In Bacon's case, "running away"—except for the trip to Paris—amounted to walking home. His parents lived nearby. A much simpler

explanation exists, in any case, for his withdrawal from Dean Close. The previous October, Bacon turned sixteen. In 1926, compulsory education ended at the age of fourteen. His parents had never indicated any interest in his education. Their eldest son, who had no academic interests, left home for South Africa at sixteen, providing Francis with a model of escape. Why should Francis, this difficult boy, waste more time and money at a minor school that he hated? His parents had performed their duty.

In the end, Bacon's months at home after leaving Dean Close proved even more difficult than his schooling. It was then that Bacon's latent homosexuality began to emerge in a more obvious way. But his growing awareness that he was attracted to boys, not girls, was complicated by the fact that he suddenly found himself sexually attracted to a strong older man—his father. That was something almost unimaginable. His father was "aggressive . . . an old bastard," Bacon later told Francis Giacobetti—"an emotionally disturbed person." The major liked nothing about his son except that he could successfully run bets to the bookie. And so Francis was understandably disturbed, and astonished, by these new feelings. "He didn't love me and I didn't love him either," he said. "It was very ambiguous though, because I was sexually attracted to him. At the time, I didn't know how to explain my feelings."

Bacon's first sexual experiences, he later said, occurred with grooms in his father's stables when he was around fifteen. But he was never precise about his early sexual life. He sometimes suggested that he was raped, as if the grooms had stood him up against the coarse barn door. There was, besides, the more ordinary possibility that the grooms were simply teasing a girly boy who himself invited taunting and playing around. What was certain was that some volatile sexual compound—father, groom, animal, discipline—gave Francis a physical jolt that helped make him into the painter Francis Bacon.

The Major was unimaginable without his attributes. The horses and dogs, the paddocks and the stables, were his domain. The close animal presence of this world—where the grooms worked and laughed—now beckoned to Bacon with the paradoxical allure of those things one cannot finally have. "I don't like the smell of horse dung, but I find it sexually arousing, like urine," Bacon later said. "It's very real, it's very virile." Something in Bacon loved the forbidding figure his father presented— the stiff collar around the fleshy neck, the gruff and stern manner. There was even something inescapable for Bacon about the pagan religion of foxhunting, however much he detested it. It might be populated by well-

dressed fools, but foxhunting was nevertheless a blood sport of tempered violence in which an animal pursued for unknowable reasons was "sacrificed" in a ritualized manner. It included elements of danger; riders were often hurt and sometimes killed in falls. To an imaginative boy kept apart, the hunt presented a bizarre panorama—the hounds baying with blood lust, the overpowering horses, the formal costumes of the celebrants, the creaking of leather and crop. "That's definitely why I have never painted horses," he once observed. "I think it's a very beautiful animal but my childhood memories are quite negative and the horse brings back a distant anguish. . . ." Later, Bacon would be drawn to bullfights. There, too, an animal was sacrificed, with some danger to a human being, in a ritualized manner. Blood and glamour mingled in the elegant swirl of the cape, the blood drawn by the banderillos, the final definitive thrust.

Pain became part of the young Bacon's sexual nature. He would later dramatize through sexual acts essential parts of his life: sensations of absolute power, shameful weakness, hopeless love, fierce excitement, bestial rage, and animal warmth. There was a jagged connection to be made in the sexual act, and a beauty to be found in the bloody carcass. Doreen Mills Molony never forgot the pleasure that Bacon took in visiting an Irish butcher shop as they were on their way to a tennis tournament. Among the lush grays and greens of the Irish landscape, the rich interior reds appeared luminous. There was a pagan spirit present in a simple Irish butcher shop. The formal hanging of the carcass, the redolent smell of meat, the sawdust on the floor. It was a paradox that a butcher shop, where the animals were dead, could also seem so alive.

A cruel irony attended Bacon's sexual awakening. His longing for physical connection could only increase his isolation. Not only would Bacon's parents oppose homosexual acts: they would regard them as an abomination, morally unfathomable among civilized people. They probably did not know the word "homosexual," then uncommonly used. They certainly knew the words "pederast" and "sodomite." It was understood, of course, that some sexual horseplay occurred among boys at school, but that amounted to nothing because the boys eventually discovered women. A sodomite who actively sought out other men to engage in homosexual acts was a monster who deserved prison. George V (1865–1936) captured the prevailing view when, after hearing that someone he knew was homosexual, observed, "I thought that men like that shot themselves." Until 1861, the official penalty for sodomy in England was death, and periodically the nation still erupted in hysteria about sodomites. During World War I, a campaign against homosexuality had

been waged with much publicity. Lord Alfred Douglas—the former lover of Oscar Wilde, who brought ruin to the writer—proclaimed that "it is just as important to civilization that Literary England should be cleansed of sex-mongers and peddlers of the perverse, as that Flanders should be cleared of Germans."

Major Bacon probably considered his son sexually effete. He knew about such matters. He had attended a public school, and he had traveled the world in the army. "Most upper-class Englishmen were pretty bi," said Grey Gowrie. "Most of us were in boarding school until we were nineteen. We didn't lead totally celibate lives. The first people we fell in love with were usually men." It would not have occurred to the Major, however, that homosexuality in a grown man was anything but a choice made by someone determined to be disgusting. He would not have discussed the issue—one didn't, especially with women, and especially with one's wife. And Bacon's mother never imagined that her son had such desires. "I don't think she had any idea that Francis was homosexual," said Ianthe. "She never ever said the word to us. Not one word. She would say, 'I wish Francis would get married and settle down.'" Even Ianthe, who would move to South Africa during World War II, did not realize that her brother was homosexual until, on a trip to England in 1970 when she was in her fifties, her husband informed her of this surprising fact. The legendary cross-dresser Quentin Crisp, who was Bacon's age, flaunted his homosexuality, and yet his mother never appeared to notice. Perhaps he should have told her, he later mused in his autobiography, but "she would not have believed me, because in those far-off days a homosexual person was never anyone that you actually knew and seldom anyone that you had met."

During the summer of 1926, which Bacon spent at Straffan Lodge with Granny Supple and his immediate family, he went to tennis parties and the like, and he was photographed with the family of another of his girl companions, Doreen Prior-Wandesforde, in a grouping in front of Castlecomer House in County Kilkenny, the family's imposing neoclassical estate. In the photograph, Francis is dressed in a fine suit and holds the family's dog, Billie. According to Phyllis Prior-Wandesforde, Doreen's niece, "Doreen played the piano, and because Bacon liked it, she used to jazz up the hymns for him."

There was little in the photograph to convey that Francis was an asthmatic misfit or that his homosexuality would force him to leave home. Bacon, in good company, now easily passed as an amusing young man from a fine family. But as the jazzy hymn-playing suggested, he was also

subversive and fully capable of rejecting, with the fresh authority of ado-
lescence, the world of his parents. There were reported rows with his
father (though his sister did not recall them) that were unlikely to have
been simple or one-sided. Francis was no longer a defenseless victim.
Later in his life, Bacon often pricked the powerful or puffed-up—he
became a master of that form of needlepoint—and he was not too young
now to goad the bull in the house.

During that same summer, Francis likely displayed in various ways his
contempt for his father's life and viewpoints. It would not have been
difficult for a bright sixteen-year-old to convey his utter boredom with
horses and hunting. He did not just dislike hunting. He "*loathed*" it, he
later told friends, and he probably made sure his father knew it. "Those
hunting people are so cruel to their children," he said. "They are ruth-
less about making them hunt." It would not be difficult to bait his father,
through a shrug or a moment's silence, about how little he cared for good
names, big houses, or impressive ancestries. He began to steal small sums
of money from his father, a small repayment, perhaps, for what was sto-
len from his childhood. The thefts surely gave him an unseemly plea-
sure. He also spoke cozily with his mother, perhaps the subtlest way of
all to provoke the Major. Although Ianthe agreed with her brother that
their mother could be selfish—"She was a good mum, but she was more
interested in herself, herself and socially"—Ianthe also emphasized how
remarkably well Francis got along with their mother. "I think Francis
embroidered a lot of those stories about the family," Ianthe said. "We
[she and her sister, Winifred] were very second as far as my mother was
concerned. She adored Francis. . . . She spent her life writing to him and
saying, 'What are you doing?'" Bacon's own letters to his mother in the
1920s and early 1930s were warmly written. He addressed her in a sweet,
confiding tone as "Mummie." Bacon's mother certainly found it much
easier to talk to Francis than to her husband.

The Major would observe his son talking easily and playfully to his wife
and Granny about this and that: fashion, perhaps, and women's clothing.
Of what possible use was such nonsense to a man? The Major might recall
that his son stole the show on that family evening—to applause from the
women—with cross-dressing and something called an "Eton crop." He
might remember that his son once wanted to be an actor and now spent
time cooking with his wife in the kitchen. Sons not infrequently steal
their mothers from their fathers. As Francis chattered with Mummie
and Granny, the stern and awkward Major also became isolated. Francis
probably sensed even then that there was no real escape from his past.

"I think artists stay much closer to their childhood than other people," he said. "They remain far more constant to those early sensations." Ireland would foreshadow aspects of Bacon's later paintings—the sense of simmering violence and foreboding; the earthy physicality of both man and beast; the Nietzschean shadow falling across the cultivated garden. He would always rely upon the impeccable manners that he learned in Ireland, and the attendant ease of someone who can deal with a dustman or a duchess. "He often used to say, 'Well, I'm awfully glad I was brought up properly and I learned proper table manners,'" said Ianthe. "Not that he always used them, but that's another thing. . . ."

There was little now to keep him at home. He could purchase a train ticket at any time. But there was hardly drama in that. Did his father suddenly banish him for trying on his mother's silky underthings? That was a story Bacon later told, and he had a taste for women's undergarments. His father probably found him out; perhaps he wanted to be caught. The Major never told his wife, of course, who could never suspect her son of such a thing. But Francis was not expelled penniless into a heartless world. He wanted, like his cousin Diana, to live in London. If his mother and Granny were reluctant to see him go, his father was surely relieved. His mother provided him with a decent allowance of three pounds a week, enough for living expenses, and the Bacon family had friends and connections in London. Granny Supple was also the kind of grandmother to put fifty pounds in his pocket. He set out.

The Queerness of Cities

AFTER WORLD WAR I, three cities came to symbolize what being modern meant to a still-young century. New York exemplified the modern metropolis: grids, skyscrapers, flappers, money. Paris enticed modern writers and painters with fresh ideas steeped in Old World charm. Berlin was a city of edgy art, performance, and unconventional sex. (Christopher Isherwood described the difference between the Americans in Paris and the English in Berlin as "for them, drink; for us, sex.") If less resolutely modern than these cities, London was also rapidly changing. Bacon, as he arrived at Paddington, was a boy turning seventeen. He possessed little education or know-how. And yet only two years later, as many of his contemporaries were entering university, Bacon would be familiar not only with London but also with the two most forward-thinking cities in Europe, Berlin and Paris.

Although Bacon knew little of London, he surely sensed, with his first breath of Thames air, that he was newly free. Cities had always provided a refuge for those who felt that they did not "fit"; they were places where outsiders found others like themselves, discovering in the not-home of the metropolis another kind of family. As the young Bacon walked through London, he may have felt lonely, but he was no longer isolated the way he had been in Ireland. He could also depend upon an allowance to cover his living expenses, and he could call upon relatives and family connections. His great-aunt Alice Harcourt-Smith, the sister of Eliza Highat Mitchell, lived in London with her family. Eliza Mitchell herself had a house in Mayfair, and his cousin Diana Watson and her mother now lived in London for extended periods.

In the city Bacon found not only a refuge but a reflection—even an affirmation—of many of his deepest instincts. He had lived inside a sealed world of secrets and, like most homosexual boys from disapproving families, he knew how to perform in public. London was often a place of

wonderful display, costume, and performance. Bacon was also naturally drawn to the sexual show around him. He soon discovered a fact that—while obvious in retrospect—was vitally important to a boy of his age and experience: there were actually many other homosexuals in the world, some flamboyantly so.

Bacon probably did not act upon his desires during his first months in London. He later told his friend David Plante that his first sexual experiences did not occur until he visited Berlin the following year, though he also spoke of moments with his father's grooms. Both could be correct. Bacon may have engaged in some early adolescent sex, perhaps with grooms or with the Persian boy at Dean Close, that he did not consider important. It seems unlikely that a very shy boy, in his first six months in London, would be sexually adventurous. Not only was he just seventeen: he looked about fourteen. (A photograph, taken when Bacon was in his early twenties, shows a remarkably doe-eyed young man with nothing but soft edges.) But he certainly paid attention to the behavior of others. His goal in the early days, he said, was "simply to drift and follow my instinct."

To supplement his allowance, Bacon looked for a job. In June of 1921, more than three million unemployed workers were receiving government benefits. High unemployment continued throughout the decade. Ronald Blythe wrote in *The Age of Illusion: England in the Twenties and Thirties* that "all of the events of the inter-war years took place against a huge, dingy, boring and inescapable backcloth—unemployment. By 1935 it had existed for so long and had proved to be so irremediable that it came to be regarded as a normalcy." Even so, in late 1926 and early 1927 Bacon found work. He became for a time the "cook and general servant" to a solicitor in Mecklenburgh Square. No doubt his cooking skills, honed by his mother, were adequate. His main duty, together with preparing breakfast and dinner, was to clean the house. "I had to arrive at seven o'clock in the morning," he later said, "to get what is called the boss's breakfast." But Bacon did little besides cook. "I can't say that I did a lot of housework. I turned the bed over and left very early." All his life Bacon had been looked after by servants. He was not likely to become one himself. When he gave his employer notice, the solicitor observed with wry good humor—he probably considered Bacon an amiable boy—"I can't think why he's leaving because he doesn't do anything."

Bacon also worked on Poland Street in a clothes shop for women. "I knew nothing about the business," he said. "They more or less employed me to answer the telephone." He soon took a dislike to the owner, wrote a poison-pen letter, was discovered and sacked. One aspect of the shop

may have intrigued him: it was located in Soho, the scruffy bohemian district edged by Piccadilly and the West End theaters. Soho then teemed with immigrants, refugees, and working-class people trying to make a living; but it was also known as the district in London where the usual social conventions did not apply. Gentlemen from Mayfair would cross Regent Street and enter a world where (for the knowing) almost any kind of sex, drink, or drug could be located. Newsagents sold dirty books under the counter, and girls entertained customers in "walk-ups." Unusual music sometimes floated up from basements.

In Soho, the seventeen-year-old Bacon had a vantage point from which to watch the Roaring Twenties, as old rules loosened and a fevered party atmosphere, tinged with despair, enveloped those with money to waste. What was left, after the slaughterhouse of the Great War, but to dance on the grave? It was the heady era of the so-called Bright Young Things. A former BYT named Dennis Myers described the milieu. "We were children of the jazz age, a period when we tried to blame the last war for our hysteria and stupid follies. Parties! That was the keynote of the 'twenties. Parties night after night, and each trying to outdo the other in fantastic originality." Myers described "night scavenging," for example, in which "dozens of cars with noisy exhausts and filled with screaming young men and women would rush through London and the suburbs in the early hours of the morning." The Charleston arrived in London in 1925, the year before Bacon did. The high-kicking dance from America, which originated in African American culture, became a European craze.

That was also the year "that the rich showed up," as Hemingway once put it, and that David Tennant founded the Gargoyle Club in Soho. The Gargoyle became the leading nightclub in London between the wars. It would not become a regular haunt of Bacon until the late 1940s, but he would have noticed even as a young man the flamboyant way the arty rich began to mingle at such places in Soho. It was Tennant's standing in both society and the arts—his father had been raised to the peerage as the first Lord Glenconner, and his parents were part of the "Souls," a group of wealthy, well-connected aristocrats—that helped make the Gargoyle Club a welcoming place for Bloomsbury artists and intellectuals, politicians and socialites. Tennant himself was "exceedingly handsome, rich, clever and had, at a time when they still counted for much, enviable family connections," wrote Michael Luke. His club's location in the heart of Soho gave it an alluring whiff of danger. (A Police Commission report in 1913 had already singled out Soho as a den of vice.) The Gargoyle was, as the celebrated interior designer and antiques dealer Chris-

topher Gibbs put it, "the last proper gasp of Mayfair Cockney"—where the upper classes went to "slum" and act like the lower classes: "Mayfair Cockney was how people in the thirties used to drawl along like minor characters in Evelyn Waugh novels."

Some pubs, dives, and clubs—as Bacon would note—even welcomed homosexuals. By the mid-1920s, wrote Ronald Blythe, "sex taboos were falling like fig-leaves and the majority of those who crowded the noisy, stifling backrooms and cellars called night-clubs, often did so because these places represented a kind of healthily ribald answer to the soul-sickening platitudes of the 'as you were' faction." In the evening, as Bacon left his work on Poland Street, young male prostitutes were beginning to cruise the West End along Piccadilly and Shaftesbury Avenues. They were not inconspicuous. "Here they were for all the world to recognize—or almost all the world," wrote Quentin Crisp of his early days as a prostitute. "A passer-by would have to be very innocent indeed not to catch the meaning of the mannequin walk and the stance in which the hip was only prevented from total dislocation by the hand placed upon it."

Bacon also found many reflections of his father on the city streets: most Englishmen remained at heart quite conservative, their culture often insular and sometimes blinkered. In *World Within World*, Stephen Spender wrote that "the England of the English upper and middle classes of the between wars period seemed cut off not only from America but also to a great extent from the Continent. . . . They were much more concerned with Empire, particularly with the Indian Empire." Homosexuality remained a morals crime that could send a man to jail despite some loosening of social inhibition. As Bacon arrived in London, the police were engaged on a vigorous morals crackdown led by Sir William Joynson-Hicks (known as Jix) who became home secretary in 1924. Jix had a horror of all illicit sex and wanted to clean out any place where people enjoyed being naughty. "Sex was a beastly invention which was fast turning London into a sewer, but he would destroy it," wrote Blythe. "Male homosexuals tended to congregate together in certain pubs and were driven from bar to bar across the capital like pheasants before the beaters as each new haunt was discovered and raided. There were endless prosecutions and it was believed that Scotland Yard kept a register of male homosexuals in which much of *Who's Who* was duplicated, and running to many thousands of names."

Bacon's escape to London was interrupted by a family tragedy. On February 21, 1927, six months after he left home, his younger brother Edward died. During the previous autumn, Edward became ill at his school, Chel-

tenham College, and dropped out sometime during the fall term. He returned to school at the beginning of 1927 as a boarder but died not long afterwards of measles and capillary bronchitis or pneumonia. Upon hearing the news, Bacon's parents—now living again at Straffan Lodge—left their two daughters in the care of Winnie's relative Mabel Mitchell and rushed to Cheltenham. They brought Edward's body back to Ireland, where he was buried in the filled-to-overflowing cemetery at the local Anglo-Irish Straffan Parish Church. He was only twelve. Bacon attended the funeral. It was his first intimate experience with death.

Edward had been born when Francis was almost five. They had lived together daily for ten years until Edward went to England with his parents in 1923 and Bacon chose to spend most of his time in Ireland with Granny Supple. They had not appeared particularly close. The difference in age separated them, as did Edward's position as the Major's namesake and favorite. But the death of a brother was never simple. It was around this time that Bacon struggled with and lost his religious faith, though he never publicly linked his loss of faith to his brother's death. He rarely spoke of Edward's death, but what he said was both unexpected and poignant. Never before had he seen the Major devastated—not in the way that the death of a beloved son and namesake can affect a father. "I remember the only time that I ever saw my father show any emotion was when my younger brother died. He was really very, very fond of my younger brother," Bacon later said. "Very, very fond": Bacon would not use the word "love"—always a difficult word for him and also not particularly popular in the Edwardian society to which his family belonged—and felt obliged in the next sentence to contrast his own relationship to his father with Edward's: "But I had no real relationship at all with my father."

Bacon almost sounded jealous of the affection, and he went on to describe Edward's death almost as if it were his own. Having himself long suffered from asthma, a disease of the lungs, he mistakenly claimed that his brother had died from tuberculosis, also a disease of the lungs that, like asthma, was often thought to be influenced by the mental state of the sufferer. (Tuberculosis, he told Michael Peppiatt, "as you know can be an emotional thing.") He also wrongly suggested that Edward had attended Dean Close, Francis's own school, and that the school had requested Edward's withdrawal because he was becoming sexually involved with other boys. Perhaps the twelve-year-old Edward was, like Francis, becoming homosexual by the time he died. But Cheltenham College records contained no indication that he was asked to leave.

Francis would naturally wonder, as anyone might in his position: *Why not me?* It was always Francis, not Edward, who had been ill. Certainly, the Major would have rather lost Francis, as his rare display of feeling for Edward indicated. In the next two years, there would be two more deaths in Bacon's immediate family. His doting grandmother, Granny Supple, died during a trip to America to visit her son Peter, who was Winnie and Leslie's brother, in Syracuse, New York. She ventured across the Atlantic at least twice to see him—once in 1927 and then a second, and final, trip in 1928, from which she never returned. (Family stories had it that Peter early on escaped to America after getting in some kind of trouble.) And then, the year of Granny Supple's death, Harley—the healthy older brother who hunted birds and trained horses and went adventuring to remote South Africa—suddenly died of tetanus in Rhodesia. The three significant deaths, concentrated in two years, dimmed the bright lights Bacon was discovering in the larger world: he would later claim that he thought about death every day of his life. Francis now became his father's only son.

In the spring after Edward's death, Bacon embarked on a revelatory trip. It marked his passage from a boyish observer to a man who could discern the radical edges of the modern world. A cousin, well-known to Bacon's family, was planning to visit Berlin. Highat Cecil Harcourt-Smith, ten years older than Francis, would seem to Bacon's parents an ideal traveling companion for their son. He had served in the war as a lieutenant commander in the Royal Navy and was honored by King George VI as a Commander of the Royal Victorian Order. His military background would certainly please the Major. Perhaps this fine fellow, a man of the world, could make a man of his disappointing son. It remained customary for wealthy young men to tour Europe, and Bacon's mother may have been concerned after Edward's death that Francis was drifting around London without purpose.

Harcourt-Smith's mother was Winnie's maternal aunt Alice. His father, Sir Cecil Harcourt-Smith, was a distinguished archaeologist who served as the director of the Victoria and Albert Museum from 1909 until 1924. Even better, as far as the Major was concerned, the young Harcourt-Smith took an interest in horseracing. (Bacon would later identify Harcourt-Smith as a trainer of racehorses.) There were, however, certain troubling signs about Harcourt-Smith that the Major and Mrs. Bacon did not notice. On January 31, 1921, he had married Ursula Maud Wyndham Cook, whose family lived in fashionable Cadogan Square in Chelsea. The newly married couple moved to Ormonde Gate, not far

from her parents, and lived in a town house near the Royal Hospital in Chelsea. Only one year later, however, Maud petitioned for "restitution of conjugal rights," an indication that they lived separately and that she had likely been abandoned. In 1924, she petitioned for a divorce, a move that was rather unusual at the time.

The Major and Mrs. Bacon probably regarded this as just a "spot of trouble" in the life of a presentable young man who served in the war. They were not the sort to probe too deeply into the personal life of a family member. The Bacons also probably had no idea what the desire to visit Berlin signified in the 1920s. "The two sons [Cecil Harcourt-Smith and his brother, Simon] were very, very weird," said the art historian and biographer John Richardson. "I worked for Simon Harcourt-Smith, the younger one, who was very sort of precious, very sort of overcultivated, chichi, bit of a diplomat, but always penniless. He was a tremendous one with the ladies—a very beautiful wife whom he treated appallingly." As for his big brother, he "was put in charge of Francis. Cecil Harcourt-Smith was going to Berlin, of all places. And he took Francis with him, and Francis said to me many years later that Cecil Harcourt-Smith was the most vicious man he'd ever met."

Bacon enjoyed observing in later years—to Lucian Freud, among others—that his father "sold" him to Harcourt-Smith as if he were a prize colt. "You know, my father and my mother were disgusted with me, when I was sixteen, as I was a pederast, so my father offered me to his friend," he said. "Then he fell in love with me and took me to Berlin." Bacon was being wryly disingenuous. His mother certainly did not consider him a "pederast." Nor was she "disgusted" with him. And his father neither sold nor "offered" him. But Bacon's sardonic aside contained, as usual, a measure of truth. Harcourt-Smith was leading a dissolute, unsettled, and possibly hard-pressed life, having left his Ormonde Gate house in 1925, and Bacon's parents likely "bought" or subsidized the trip. The Major would never have handed over a significant sum to Francis. He would have instead delivered the funds to the older and more responsible Harcourt-Smith, leading Francis to feel that he was sold. The more important implication of "sold" was unmistakable—a father selling his son for the sexual use of another man. There could hardly be a more cold-blooded transaction.

The prospect of the trip thrilled Francis. He left England "with the feeling that something would happen," said Diana Watson. In the spring of

1927, Harcourt-Smith and Bacon traveled to Berlin, intending to stay for several weeks. The rampant inflation that had afflicted the Weimar Republic earlier in the decade was easing. The political and economic unrest continued, but did not then seem dangerous to visitors. The Weimar period, which began in 1918 and ended when Hitler became chancellor in 1933, was a time of "almost continuous political upheaval, of brave efforts at stability undermined by economic ups and downs—mostly downs," wrote Peter Gay in *Weimar Culture: The Outsider as Insider*. What visitors saw firsthand was what Gay described as "a breathless era of cultural flowering that drew the world's attention to German dance, German architecture, German filmmaking, German fiction, German theater, German art and music. The republic provided clusters of excitement way out of proportion to the mere fourteen years of its life." Berlin particularly attracted sexual adventurers. They included many writers and poets, among them Stephen Spender and Christopher Isherwood. Spender, born the same year as Bacon, went to Berlin three years after Bacon did. "The Germany of the late 1920s and early 1930s," he wrote, "seemed, with its new architecture, its sexy air of sun and sea and nakedness, its accessible modernism, to represent what Auden called in an early poem: 'New styles of architecture, a change of heart.'" Or as John Russell mordantly observed, "Bacon knew a Berlin that was laid out on its back and asked only to be pleasured over and over again."

What might have intrigued Bacon in London—as its collar loosened after the war—was on full display in unbuttoned Berlin. The city appeared to be the most modern in Europe, or to put it differently, Berlin was leaving the Old World behind with the most conviction. For a homosexual of Bacon's disposition, Berlin represented another kind of home—a modern stage where the new truth was unmasked. "By way of education," he later said, "I found myself in the atmosphere of *The Blue Angel*"—the great Josef von Sternberg film—"in one of the great decadent years of Berlin." Until the founding of the Weimar Republic in 1918, Germany had been as reactionary as England, but the defeat and horror of the war seemed momentarily to silence that earnest Germany. Thomas Mann's *The Magic Mountain* was published in 1924. Bertolt Brecht and Kurt Weill soon launched their serrated satire *The Threepenny Opera*. Otto Dix painted a society that appeared irredeemably corrupt: his massive *Metropolis* triptych depicted a Berlin in which the moneyed café society of the city—presented in the central panel—was flanked by scenes of cripples and prostitutes. It was a nightmarish juxtaposition of the oblivious rich with a sordid underclass.

At the age of seventeen, Bacon would not have regarded the city in analytical or abstract terms. But Berlin permeated his sensibility, providing a perspective that seemed to him more or less right. Berlin began with the grand hotel where he and Harcourt-Smith booked a room. The Hotel Adlon was a palatial Old World fantasy located on Unter den Linden, in the heart of the city and close to a favorite palace of Emperor Wilhelm I. It had opened in 1907 and cost twenty million marks to build, an unimaginable amount to spend on a hotel. Heads of state and movie stars routinely stayed there, along with Rockefellers, Fords, and Vanderbilts. A huge Tiepolo painting dominated one room; another contained murals in the style of Raphael. In the Goethe garden was a bust of the German master. And in the cellar were 250,000 bottles of wine. The Hotel Adlon exuded Teutonic grandeur, as did its neighborhood, where one colonnaded building followed another down grand boulevards.

Bacon had already observed the display of huge fortunes and exquisite service in the big houses of Ireland during his childhood and adolescence. In the early 1920s, for example, when he was living with Granny Supple at Straffan Lodge, the family at the nearby Straffan House still employed footmen. "I was too young to go to these things," Bacon said about the formal dinners. "But I always remember my mother telling me they had eleven courses. They carried on the kind of Edwardian tradition of these very long, long meals . . . and in between to revive themselves they had sorbets. Just to keep them going for the next [course]." Bacon himself never returned to live in this extravagant, class-bound world, always insisting upon living in a room or two. But he sometimes loved outlandish fantasies and pleasure, made possible by money. He cherished, for example, the arrival of breakfast at the Hotel Adlon. "I always remember the wheeling [of] the breakfast in the morning with these wonderful trolleys, with enormous swan's necks coming out of the four corners of the thing." He loved reaching through the hangings on the sumptuous four-poster bed to draw the tray to him.

The contrast between opulence and squalor fascinated Bacon. He embodied it himself with rare intensity over the years. "Gilded squalor," he called it. Just outside the Adlon, Harcourt-Smith and Bacon encountered the numerous beggars, prostitutes, and disfigured veterans on crutches. The erupting underworld of Berlin also existed not far from the formal façade of the hotel. The unrivaled sexual scene that accompanied the artistic and intellectual ferment of Berlin in the late twenties was expressed in many ways, from Otto Dix's and Christian Schad's paintings to the famous Institute of Sexology. Dr. Magnus Hirschfeld's institute,

which opened in 1919, emphasized the farthest shores: in Christopher Isherwood's words, "whips and chains and torture instruments designed for the practitioners of pleasure-pain; high-heeled, intricate, decorated boots for the fetishists." There were more than five hundred erotic establishments in Berlin. The best known was probably the Eldorado club, which attracted homosexuals, transvestites, socialites, and gawkers. Drag queens were popular in Berlin, and if homosexuality remained technically illegal, the police did not enforce the law. "Even the Rome of Suetonius had not known orgies like the Berlin transvestite balls," wrote the Austrian writer Stefan Zweig, "where hundreds of men in women's clothes and women in men's clothes danced under the benevolent eyes of the police." Marlene Dietrich, who had grown up in an area of Berlin near the Eldorado, sang there.

Not only homosexuality flourished: so, too, did prostitution, pornography, organized crime, and drugs. Bacon was impressed by the open solicitation, he told the art historian Hugh Davies, with barkers standing in front of the various sexual establishments miming the perverse delights offered inside. Bacon was also struck by the city's violence. Berlin was far more raw, he said, than the "Cambridge gentleman's view" conveyed by many English writers who visited there in the late 1920s. By "raw" Bacon meant both the sexual violence on display and the willingness to violate any and all conventions—something that did not attract most of the "Cambridge gentlemen" who came to Berlin on a sexual lark. In Ireland,

The Eldorado drag club in Berlin, at the height of the sexually decadent Weimar Republic

Bacon was aware of the stealthy political violence of the IRA, who hid in the hedgerows and bogs, and he had observed the ritualized violence of the hunt. But the violence in Berlin had an anarchic, nihilistic edge. "Perhaps it was violent to me," Bacon said, "because I'd come from Ireland, which was violent in the military sense but not violent in the emotional sense, in the way Berlin was."

Still young and inexperienced, Bacon had not yet developed an interest in tough working-class lovers. Unlike W. H. Auden, Christopher Isherwood, and other young English homosexuals of limited means, Bacon did not frequent the poorer parts of the city, such as the Kreuzberg Hallesches Tor and the "boy bars" along the canals, in search of blond working-class sex. Instead, Harcourt-Smith mostly took him to the Kurfürstendamm area, the ritzy center of nightlife in the "New West" part of the city beyond the Hotel Adlon. But Bacon and Harcourt-Smith also trolled through some harder-core areas where sex was a cheap commodity edged with violence. Years later, Bacon and Spender became convinced that they had been in Berlin at the same time. But you wouldn't have seen me, Bacon said: I was "in the clubs all the time." "So was I," said Spender. But there were too many underground clubs, sinkholes, and erotic dives for them to have met up with any certainty, even if they had been in Berlin at the same time.

Bacon did not often mention his days in Berlin. And by "Berlin" he meant the city's night. He was not yet an active artist, and Harcourt-Smith was likely not interested in anything but the finer points of sexual outrage. Even so, they were inevitably awake during part of the day— Bacon, after all, remembered breakfast—and like cultivated tourists of the era spent some time on the new kinds of art, which were also part of Berlin's edgy outrage. At an early age Bacon became keenly interested in avant-garde film, plentiful in Berlin during the 1920s. The movies were a favorite German pastime, and Berlin was then the center of international filmmaking outside of Hollywood. Berlin was "an incomparable seat of creative experimentation," wrote Ulrich Gregor, a historian of German film. Perhaps the most famous film of the period was Robert Wiene's *The Cabinet of Dr. Caligari,* shot in 1919 and released in 1920, in which Dr. Caligari, a showman accused of murder, turns out to be the director of an insane asylum in which the inmates were telling the story. One critic said the story "takes place entirely within the dark depths of the soul." It became a living symbol of the period, as did Fritz Lang's *Metropolis,* a science-fiction fantasy filled with eerie robotic workers set in a future dystopia, which was released in 1927, the year that Bacon and Harcourt-Smith were in Berlin.

Both films likely interested Bacon. As the decade wore on, increasing numbers of films were also addressing the misery of the working-class population. Bacon cared little for overtly political or didactic films but was captivated by Sergei Eisenstein's revolutionary *Battleship Potemkin*, a masterpiece disguised as propaganda that he may have first seen in Berlin. The story of a mutiny against the tsarist regime, the film was initially banned by Germany's censorship board owing to its leftist politics and moments of extreme violence. In April of 1926, however, a shortened version released in Berlin became a sensation: there were probably numerous showings of the movie while Bacon was in the city. The indelible image of the nurse caught in the massacre on the Odessa steps—her pince-nez bloodily shattering as she opens her mouth in a scream—would haunt him for the rest of his life. *Battleship Potemkin,* without question, helped spark Bacon into life as an artist.

Bacon later spoke of visiting the Pergamon Museum and its renowned antiquities. Harcourt-Smith would not have been able to face his own family—his father had been the director, after all, of the Victoria and Albert Museum—if he could not at least discuss the Pergamon after his trip. Bacon later claimed he "wasn't the slightest bit interested in art until around 1930," but he also acknowledged seeing German expressionist and postexpressionist painting while in Berlin. It probably made an impact: in Paris after his two months in Berlin, he was soon visiting museums and art galleries. Bacon and Harcourt-Smith, like any sophisticated Englishmen at the Hotel Adlon, would also have known, heard about, and visited the popular—then sensationally popular—*New Objectivity* show on display at the Galerie Neumann-Nierendorf in Berlin. The *Neue Sachlichkeit* show—the original title had been *Postexpressionism*—had opened in Mannheim and then traveled to Chemnitz and Dresden before Karl Nierendorf, the director of the Berlin gallery, mounted his own version. It became a must-see cultural event, and it was open during precisely the period when Bacon was in Berlin—April and May of 1927. It contained the paintings of seven leading artists of the time, among them Otto Dix, George Grosz, and Georg Schrimpf.

Bacon would flatly deny later that he was ever influenced by twentieth-century German art. His paintings never looked much like German art, and he disliked the overt moralizing of many artists working in the German tradition. "It always had too much of a story to tell," he said. "And I really hate that kind of painting, that has a story to tell." In Christian Schad's glassy portrait *Count St. Genois d'Anneaucourt* (1927), for example, he depicted the aristocrat dressed in a tuxedo gazing directly at the viewer. On his left was a towering transvestite, on his right his companion Bar-

oness Glaser. Each wore a transparent dress that revealed the life underneath. But German art had one quality that Bacon would also develop in his own way. The Germans aspired not to violence itself but to a truth so difficult it felt like violence. They insisted upon the life underneath and behind—the concealed truth behind the mask—and they emphasized the tension between the two by focusing upon "gilded squalor."

German design also appealed to Bacon, particularly the cool functionalism of the Bauhaus. He liked the idea of designing away the past. That was no surprise, given his own history. Founded and run by Walter Gropius from 1919 to 1928, who was eventually succeeded by Ludwig Mies van der Rohe, the Bauhaus hoped to fundamentally redesign the way people lived. The bringing together of all the visual arts—architecture, design, sculpture, painting—could create, it was believed, a new environment in which a new society could flourish. Buildings and furniture were to be rational. Craftsmanship, from cabinetry to weaving to typography, was prized for making the useful simply beautiful. Bacon may well have seen one of Marcel Breuer's famous chairs of tubular steel and leather, or any of a number of related designs, in one of the elegant and supremely modern shops near the Hotel Adlon.

In 1930 *The Studio*, an influential English magazine of fine and decorative arts, published an article entitled "A Modern Utopia? Berlin—the New Germany—the New Movement." In it W. Gaunt wrote: "If the new movement in the arts is going to produce a Utopia, that Utopia will be found in Germany and the centre of it in Berlin. All the forward-looking ideas, ideals, enthusiasm, and tendencies of the century have found a home there." Bacon did not share the utopian aspirations of the postwar Bauhaus, but the Bauhaus visionaries—like the German painters—may have also strengthened a quality developing within his sensibility. The Germans disliked decoration. They sought something fundamental. All that mattered could be found, they implied, in an elemental room. For Bacon, the idea of "room" would always be essential: he had spent much of his life trapped inside rooms, without room enough to breathe. The fresh air of the Bauhaus promised to replace the wheeze of Victorian plush.

And yet Berlin might have remained just another place visited—offering the young Bacon nothing more than an eye-opening snapshot—were it not for his companion. Harcourt-Smith transformed the eruptions of German art and society, which might otherwise have appeared foreign and abstract, into something personal, immediate, and true. Harcourt-Smith and Bacon appeared in public to be wealthy, well-dressed gentle-

men. In private, however, Harcourt-Smith destroyed all manners, becoming a kind of sexual monster. Even Bacon could never quite bring himself to describe the details of what happened, but he left no doubt about its violent character. Later in life Bacon often mixed pain and pleasure. It therefore meant something when he judged Harcourt-Smith, of all the men he had known, the most "vicious." John Richardson called him "a real ultra-sadistic sadist. And he took Francis to Berlin where it was kinky heaven, and used to thrash Francis and sort of broke him in." Harcourt-Smith did not appear homosexual, a quality Bacon found attractive. In fact, he was bisexual. He was "a brute," Bacon said, who "fucked absolutely anything." A picture of Bacon taken in Berlin attests to his almost feminine beauty, an allure so delicate that the radical German photographer Helmar Lerski actually stopped him on the street to ask if the seventeen-year-old might sit for him. Bacon was initially concerned that Lerski was proposing an assignation, but finally agreed.

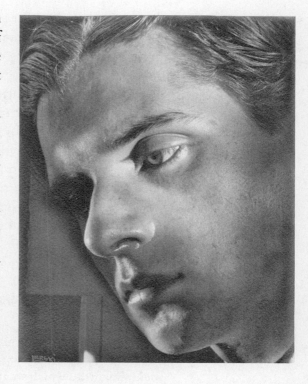

Lerski's dramatic lighting—influenced by his work in films—gave his portraits an unearthly glow. (He had worked as a special-effects photographer on Lang's *Metropolis*.) In Lerski's photograph, Bacon's face is presented in profile, looking down, with eyes and mouth highlighted. It was no doubt the tender boy beauty that Harcourt-Smith wanted to rape. The experience shocked Bacon; but his later words on the subject were less those of complaint than of bemused observation. Bacon found in the pulled-back curtain and animal eruption a paradoxical appeal. From neither Berlin nor Harcourt-Smith would there be flowery talk (unless calculated to seduce). Bacon wryly observed: "He soon got tired of me, naturally."

Toward the end of May, their second month in Berlin, Harcourt-Smith met a woman whom he liked. He moved on, having had his fill of Francis. He did not, however, leave behind a deflowered virgin fainting on the couch. In Berlin, the young Bacon had a glimpse of what artists can do—and men can become. He did not want to return to London. He must have had some remaining money—or perhaps he wired his mother—as

A dramatically lit photo of Bacon during his stay in Berlin in 1927, taken by the experimental photographer Helmar Lerski

he now departed for Paris, the other great destination city in Europe for those in search of the avant-garde. It was natural that his thoughts should turn to Paris. It was the city he fled to when he briefly ran away from home at sixteen. He had even once told his father that he wanted to learn French, to which the Major—a soldier of the Empire—replied, "Forget it. You speak English and that's good enough for everywhere."

Although Bacon in 1927 was still young and alone, with little if any French, he could survive in the modern city. He was more knowing, freshly toughened by a cynical world. He spent his early days in disheveled Parisian hotels, too shy to make friends. Without French, he could not even buy things in shops. But he was pretty, and he knew it. "I didn't keep myself to myself all that long, thank God!" he told Michael Peppiatt. "I started going round with a male prostitute, and we went to places like the Select in Montparnasse, which was one of the big homosexual cafés at the time, and to the bars behind the Lido." At an exhibition, as he struggled to understand the French of a tour guide, a French woman stepped in to help him.

Yvonne Bocquentin was an amateur musician and dedicated follower of the arts who lived in a charming house in the hamlet of Saint-Maximin, near Chantilly, which was not far from Paris. Once a week Madame Bocquentin went into the city to visit galleries and attend various cultural events. She knew English said Anne-Marie Crété de Chambine, her daughter, which is why she helped the pretty English boy. She then took him under her wing, inviting him to live with her family in Chantilly. It was a bold move; but then, Yvonne was as "headstrong," said her daughter, as she was "cultivated." Anne-Marie vividly recalled Bacon's first evening at their house: "I was then six—I went into the study and discovered to my surprise a tall, calm young man with . . . a round face and big eyes: He was hunched over books that my mother was giving him and saying words I couldn't understand. My mother smiled and gave me a kiss: 'This is Francis, my darling!' she announced. 'He comes from England and we are speaking English, his language. He is very nice, you must be welcoming and teach him to speak French.'"

Marvelous Women

BACON WAS KNOWN mostly for the men in his life, but there were also a number of extraordinary women. Madame Bocquentin was the first outside his family. Bacon paid her only a nominal rent; their transaction was not financial. Charm was the medium of exchange: words, glances, smiles, a lift of the glass. Living in a French household was the best way to learn French—and to begin a lifelong love affair with France. Bacon had the great advantage of daily conversation with a spirited young woman eager to discuss art, religion, fashion, and the startling this-and-that of life as it passes—including, of course, anything delightfully wicked or funny.

The Bocquentins resembled the Bacon family in certain respects. They lived in a small hamlet, much as the Bacons did in Naas, near a great estate (the château of Baron Robert de Rothschild). Their house was not far from the famous racecourse in Chantilly. It was a region where horses, estates, and titles mattered. Pierre Bocquentin managed several large properties and circulated among the local landowners. The family, said Anne-Marie, was "very very bourgeois—very upper-class." On her father's side, they came from a "great family" in the South of France. The elegantly mannered young Bacon would instinctively understand, of course, how to live in an *haute bourgeois* household. A photograph of the Bocquentin family shows the couple and their daughter posed in the greenery in front of their house. Madame Bocquentin wears a stylish drop-waisted dress and swinging coat. She has a bemused, slightly coquettish smile. Monsieur Bocquentin is big, square, and tweedy: Eddy Bacon would have liked his soldierly manner.

Bacon never found reason during his life to mention Monsieur Bocquentin, which suggests that the man of the house cared no more than the Major did for the arts or, indeed, for any of the subjects that enlivened the world for Bacon and for Yvonne Bocquentin. In contrast to

Yvonne Bocquentin, the art lover who took Bacon in and taught him French during his early months in Paris in 1927, with her husband and daughter

Major Bacon, however, Monsieur Bocquentin obviously did not mind the constant chatter between his wife and the charming young Englishman. He would otherwise have thrown him out of the house. Like other Frenchmen of his class—and unlike the foxhunters in Ireland—he probably had a more open understanding of relationships and sexual preference than the Anglo-Irish did. He knew Francis to be an effeminate boy who posed no sexual threat and who might even make his own life easier by providing his wife with an amusing companion. Bourgeois French women could become bored in the countryside, particularly those like his wife who enjoyed the bright lights of Paris.

As a child and adolescent, Bacon spoke mainly to women and girls, who made all the difference for him. Madame Bocquentin was no less sympathetic than Granny or Diana Watson or the girls in the big houses; but she was also more sophisticated. She introduced Bacon to the art of conversation, critically important to him as an adult. He had never before engaged in quite this kind of lively sustained talk—a form of play for imaginative people—that could touch upon anything from trivial gossip to serious matters of the heart. Sunday lunches were especially important in the Bocquentin household and an occasion for Bacon to polish his French. "My mother would conduct the conversation, asking Francis questions about his cultural visits that week and gathering his various impressions," said Anne-Marie. "Numerous comments sparked intense discussions that I couldn't understand."

Like Harcourt-Smith, Madame Bocquentin was about ten years older than Bacon—the beauty to Harcourt-Smith's beast—which made their relationship pleasingly ambiguous, touched with the varied accents of mother, sister, and lover. They would retreat to the drawing room, said Anne-Marie, surrounded by books. Francis and her mother would become remarkably animated, often bursting into laughter together: "My mother told me that he was very clever and that he learned French very easily." That the young Englishman had "ideas" and was slightly flirtatious in his attentions particularly appealed to Madame Bocquentin. "He was so talented. And when they spoke together, they were happy with each

other. They talked about everything—painting, religion." (So charming did Bacon prove that Madame Bocquentin's sister, who had married an Englishman, sometimes competed for his attention.) The young Bacon's round face and "big enormous eyes" reminded Anne-Marie of an angel. He was—"'in the moon' very often, as we say in French, *à la lune*." Often he looked startled, as if just coming out of a reverie. He dressed extremely well. "I saw him always in a cravat, in the clothes of an English gentleman." With Madame Bocquentin, the shy Francis learned to focus intently on the person he was speaking to, a quality his later friends often admired, and he won over one older person after another during his late adolescence and early adulthood. Madame Bocquentin was the first—and perhaps the only—woman in Bacon's life cast in the role of what her daughter described as an *amitié amoureuse*. Bacon, still so young himself, also charmed the little girl, playing leapfrog and ball games with her in the garden.

Madame Bocquentin probably first brought to Bacon, in a way he respected, the sensual joy that could be found in life apart from sex: what the French called *jouissance*. It would be surprising if a woman of her station did not set a fine table in Chantilly or, when she went out with her companion, did not take him to places where life had a stylish allure. At Chantilly, he was simultaneously educating himself in other ways. He continued to be a determined reader, and—owing to his lack of a traditional education—traveled the world of literature freely and without a guide. He could discover (and ignore) things in his own way. He did not forget the darker, beastlier parts of life while in Chantilly. Quite the opposite. He was increasingly obsessed with images that challenged or upset the settled face of the world. He was drawn to representations of maimed or distorted figures; to powerful renderings of animal life; to depictions of phenomena that were ordinarily concealed or invisible.

In Berlin or Paris, Bacon probably bought several German books (later found in his studio) on eroticism and sexuality. Two were by Eduard Fuchs—*Geschichte der erotischen Kunst: Das Individuelle Problem* (The History of Erotic Art: The Individual Problem), which was published in 1923, and *Illustrierte Sittengeschichte vom Mittelalter bis zur Gegenwart* (Illustrated History of Morals and Customs from the Middle Ages to the Present), published in 1910. Fuchs's *Erotic Art* was filled with phallic and erotic images culled from art history. Male homosexuality was not illustrated or addressed, but there was a section on "lesbian love," no doubt because men often took an interest in that subject. Other topics in the table of contents included "autoeroticism," "anal erotics," and "sadism in art." Before the

Weimar period, the sale of the book in Germany was banned for all but "scholars, collectors, and libraries" (as a note from the Munich-based publisher reads). Had Bacon found German books on homosexuality, he would doubtless have purchased them, though such books hardly existed at the time. He would later purchase, in 1938, an issue of *Crapouillot*, a satirical and socially adventurous French journal that published a special issue on deviant sexuality, *Le Crime et les perversions instinctives*.

In Paris, Bacon found that the booksellers along the Seine offered many intriguing oddities, such as collections of documentary or quasi-scientific photographs of the human figure that were distorted in some way through maiming, unconventional sexual desire, or physical malady. Although the dates when he bought individual books can rarely be determined with precision, he began to build his eccentric library in Paris. (In the end, it numbered more than 1,200 books, quite a few of them in French.) He often spoke of a book on diseases of the mouth that he purchased in Paris during his early time there, Ludwig Grünwald's *Atlas-Manuel des maladies de la bouche, du pharynx, et des fosses nasales*, which was published in Paris in 1903. It may also have been during this period that Bacon began to collect books containing images of animals, especially big game animals, an interest he maintained for much of his life. He owned A. Radclyffe Dugmore's *Camera Adventures in the African Wilds*, which was published in 1910, and Marius Maxwell's *Stalking Big Game with a Camera in Equatorial Africa*, published in 1925.

Images that purported to show emanations from the body, especially of mediums summoning spirits—a subject of enduring interest to many Europeans since the late nineteenth century—fascinated Bacon. *Phenomena of Materialisation*, for example, first published in English in 1920 by Kegan Paul publishers, was the work of a psychiatrist and psychic researcher named Baron Albert von Schrenck-Notzing, who had also written in the 1880s on deviant sexuality (which is possibly how Bacon learned of him). *Phenomena of Materialisation* captured the "ectoplasmic" shapes—allegedly of the dead—summoned by mediums during séances, then hugely popular in Europe and America. In his book, Schrenck-Notzing photographed and attempted to analyze the "ectoplasm" of the medium Eva Carrière. (Later evidence demonstrated that Carrière was a fraud.) It was probably less the spiritual aspect of such things that interested Bacon than the way boundaries were breached: the true "figure" contains more than what people ordinarily see. Many figures in his later work would leak or spill shadows, and fluid shapes streamed like mercury from the flesh.

Even at seventeen, Bacon's hunger for images was omnivorous. He did not particularly distinguish among photos, paintings, films, newspapers, and the kaleidoscopic flux of the street, but he was becoming more and more aware of painting. It was probably Madame Bocquentin who took him to the Musée Condé, filled with French and Italian art and located in the vast and ornate Château de Chantilly near her house. Bacon found Poussin's *Massacre of the Innocents* (1629) revelatory. A mother flings up her arms to prevent one of King Herod's soldiers from putting her squirming son to the sword. Her mouth is torn open in a scream—placed in the center of the painting—that becomes particularly shocking given the formal face of the composition. Perhaps Madame Bocquentin also accompanied Bacon to see *Battleship Potemkin*. In his late teens, then, Bacon was already engrossed in two of the greatest representations of inhumanity in art— two different women screaming over the fate of infants.

What could someone his age possibly do with such pictures? Bacon knew only that they mattered to him. What could be more intense—or less ironic—than the furious let-go of such a scream? The mouth was a door flung wide open. And what could be more embarrassing or shameful or create a greater feeling of vulnerability than the light shone by a doctor onto the leaking diseases of one's body? Bacon was interested in both warm- and cold-blooded—formal and informal—depictions of the mouth. The Poussin scream not only was a *cri de coeur*, for example, but was also informed by the painter's classical conscience and elaborately determined composition. The brilliant step-by-step syncopation of the famous scene in *Battleship Potemkin* placed the scream within a carefully designed montage. The clinical photographs of the mouth were dedicated to fact, not art. But all the different screams had one thing in common: they were silent. You could look at but not hear them. It was another form of muffling or dramatic suffocation.

Madame Bocquentin was a talented pianist who played duets with her friends in the drawing room at Chantilly. She also carefully followed the evolution of modern art. She liked nothing better than her cultural excursions into Paris. It was pleasant to show off the well-dressed young Englishman at her elbow. Madame Bocquentin not only was introducing Bacon to the French art of conversation, as he mastered the language, but was also providing him with a window into the larger world of Parisian culture. For the first time, Bacon observed people closely involved in the arts, and he began to sense the artistic excitement in the city. The odd expressions of surrealism were certain to intrigue any curious adolescent. What fantastic show would artists come up with next? André Breton, the

combative spokesman of the group, generated talk. So did the work of such figures as Giorgio de Chirico, Max Ernst, André Masson, and Man Ray. In the summer of 1927, Bacon might easily have seen the di Chirico exhibition then on view in Paris.

Steeped in the disruptive tradition of Dada and avant-garde writing, artists were taking up subjects and images that were deliberately surprising and sometimes bizarre, an echo of Bacon's own developing interest in mouths. *Documents*, for example, a surrealist art magazine launched by Georges Bataille in 1929 (after Bacon moved back to London) would become known for its disturbing photographs, which included screaming mouths and dead animals in the abattoirs of Paris. Bataille's vision of suffering was analogous in many ways to that of the mature Bacon. The critic Dawn Adès later noted: "Some of the most central of the texts in *Documents* are those by Bataille, which set up a series of paradoxes between noble and ignoble, and human and animal which, as it were, turned things around so that in the end man, Bataille suggests, is at his most human when he is also revealing the animal side of his nature."

Madame Bocquentin "knew about all the different schools of painters," said her daughter, which "would have been very helpful for a student of his age." During the time he lived in Paris, Bacon did not see the Picasso pictures that would particularly inspire him, the so-called Dinard series, in which figures on the beach were dramatically abstracted. (Picasso began that series only in the summer of 1928 and did not exhibit the paintings until after Bacon returned to London, though Bacon would continue to make regular trips back to Paris.) But during this period Bacon could see a great deal of Picasso's other work at Galerie Paul Rosenberg. *Cent Dessins* (100 Drawings) opened in the early summer of 1927 and contained more than a hundred neoclassical ink and sepia drawings, watercolors of harlequins, theatrical scenes, and seashore nudes. Another major show at the Galerie Paul Rosenberg opened just before *Cent Dessins*—in May and June of 1927—that included important recent Picassos together with work by his contemporaries Georges Braque, André Derain, Marie Laurencin, Fernand Léger, and Henri Matisse. "The Galerie Rosenberg used the broad stairwell leading to its upper rooms to juxtapose large-scale canvases representative of the artists it promoted," wrote Anne Baldassari in *Bacon, Picasso: The Life of Images*. "Picasso's pictures were hung in pride of place, as can be ascertained from the surviving photographs, and monumental works, such as *Open Window* of 1919, were probably visible at the very moment the young Francis Bacon entered Rosenberg's for the first time."

Meanwhile, Picasso's *Studio (Atelier)* series of drawings were being

reproduced in the art magazine *Cahiers d'Art*. Founded by the art critic Christian Zervos in 1926, the year before Bacon arrived in Paris, *Cahiers d'Art* became the most important art journal of the period. It both defended and spoke for modernism. Entire issues of *Cahiers d'Art* were devoted to certain artists, among them Matisse, Léger, Braque, and Gris. Artists on both sides of the Atlantic eagerly read the magazine to keep up with the Parisian art world. But its main focus remained Picasso. The last issue of 1927, for example—which Bacon could now read in French—published twelve Picasso works from that year with an accompanying article by Zervos. In 1929, *Cahiers d'Art* published a folio of reproductions from the Dinard series, which would eventually prove so important to Bacon's life as a painter.

Perhaps the impact of Picasso was immediate—an epiphany—when Bacon first stepped onto the staircase of the Galerie Rosenberg. Perhaps it took somewhat longer. The result was the same: Picasso, Bacon said, left him "stunned." The shock of liberation—of seeing a new figure bursting free, arms flung out from nineteenth-century closets—changed his understanding of the world. This new figure did not live in a plush, old-fashioned room. Bacon underwent a "second innocence," he said, as if the world had been made new or newly ancient, and he passed through "profound experiences to a neo-paganism." He was still too young and inexperienced to know what to do with such experiences. But the desire to tell the truth can become, for certain young people, a kind of addiction—or an infection that can be treated but not cured.

Bacon later denied having attended art classes in Paris, but Anne-Marie Crété de Chambine reported that he studied drawing while he lived in Chantilly, commuting in and out of Paris several times a week for his course. Bacon would return home to Chantilly, Anne-Marie said, with a "sheaf" of drawings. (His sister Ianthe also recalled that he attended some form of academy in Paris to study draftsmanship.) There were a number of readily available options for a young foreigner like Bacon who might want to take art classes. Two in particular attracted foreigners, especially English-speaking students: the Académie Colarossi and the Académie Julian. Their tuition was relatively inexpensive, and at the Académie Colarossi one could take life-drawing classes without being enrolled: it was only necessary to purchase a book of tickets. (Henry Moore had done that.) Among those who made their way to the academies was the eminent Anglo-Irish designer and architect Eileen Gray (1878–1976), who, like Bacon, came from a privileged background in Ireland. Gray attended both of the schools, first the Colarossi and then the Julian.

So crowded with foreigners and English-speaking students were the

two academies that they became in their way rather provincial: there was not much contact between them and the vivid world of French artists and culture not far from their doors. "We were so hedged in," said Gray, "it seems unbelievable that all this artistic life went on under our noses and we knew nothing about it." At the same time, these schools bustling with English speakers—many of them dabblers and daubers—did not threaten a beginner and were excellent places to meet people. Bacon's initial work seemed to vary in style. Anne-Marie Crété de Chambine recalled drawings and watercolors that looked cubist in inspiration, suggesting that Bacon had little patience for the kind of studious academic drawing taught in life class. Ianthe remembered a different style. During a brief visit home, Francis presented their mother with drawings that belonged more to the world of fashion than to art. "Ladies with long cigarette holders and cloche hats," Ianthe said. "Just the heads. I don't know what my mother did with those. They were very realistic. Very art deco. Very sharp noses. Very refined things. There was some color in them. I would say watercolor. Not a lot of color. I seem to think that these cloche hats were light brownish . . . it was the fashion really in the twenties. They could have been fashion illustrations."

As he mastered French and became familiar with Paris, Bacon grew more confident of his taste. He brought home playful gifts for Madame Bocquentin, such as an evening bag or a piece of elaborate costume jewelry, and he once gave her an enormous ostrich-feather fan dyed yellow that became a family heirloom. He took pleasure in the florid, theatrical, and outlandish. He would send similar gifts home to Ireland for his mother and sisters, including a jade-green ostrich fan for his sister Winifred and a red one for Ianthe. Ianthe loved her fan. Bacon likely accompanied Madame Bocquentin to the fashionable shops of Paris. She was not a bohemian—though she took an interest in bohemian life—and he could enjoy with her the elegant arrondissements of the Right Bank. Montparnasse was the district, however, where imaginative people of every kind (and those attracted to them) congregated in the cafés and shabby side streets. There were many Englishmen and Americans in Paris—not a few drawn to art and literature—with whom he could talk at the cafés. Sharing a language or country while in a foreign place made introductions simpler, of course.

After nine months or so in Chantilly, Bacon decided to move to Montparnasse, probably after first visiting his family in Ireland. Madame Bocquentin understood: Francis was a young man with his life ahead of him. Montparnasse, concentrated between the boulevard du Montparnasse

and the boulevard Raspail, had become the excitable heart of Parisian artistic life toward the end of the nineteenth century. Paul Gauguin and August Strindberg met in its cafés; the young American Gertrude Stein and the young Spaniard Pablo Picasso walked its streets. By 1920 it was attracting many English-speaking writers, among them James Joyce, Ezra Pound, and Ernest Hemingway. Bacon had spent time there in his initial weeks in Paris, and he now took a room in the Hôtel Delambre, on the rue Delambre, then a narrow and rather dirty street with some small hotels. In 1891, Gauguin had stayed at the Hôtel Delambre, and Breton also once had a room there. Isadora Duncan and Man Ray both lived on the rue Delambre, and Joyce, Henry Miller, and Tristan Tzara at various points lived at the Hôtel Lenox, just down the street from Bacon's hotel. The Dingo Bar, where Ernest Hemingway met Scott Fitzgerald in 1925 and writers often congregated, was also on the rue Delambre.

At the head of the street, on the boulevard du Montparnasse, was At the Sign of the Black Manikin, an English language bookstore and an important gathering place for English and American writers. Its American owner, Edward Titus—married to the cosmetics queen Helena Rubinstein—published a literary review and had his own book imprint. Bacon, continuing to read avidly, enjoyed *transition*, the experimental literary journal that was launched in 1927 by the poet Eugene Jolas and published Joyce's *Finnegans Wake* as a work in progress. (Bacon also discovered, read, and liked Djuna Barnes in *transition*.) The journal was distributed primarily at Shakespeare and Company, the bookstore on the Left Bank famously frequented by expatriates, but could have been seen by Bacon at the nearby Black Manikin.

Café life flourished in Montparnasse. One could take a journal or book from At the Sign of the Black Manikin and read it all afternoon next door at Le Dôme. Not far down the boulevard were La Coupole and the Café de la Rotonde. Le Select, where Bacon noted the homosexual crowd, was across the street. One of the representative figures of the era, often seen around, was the celebrated model and artist Kiki de Montparnasse, usually described as Man Ray's lover and muse but also a significant figure in her own right. "Kiki's Paris was the open society of Montparnasse, which offered individuals the opportunity to be themselves artistically, intellectually, politically, and sexually," wrote Kiki's biographers, Billy Kluver and Julie Martin, in *Kiki's Paris: Artists and Lovers 1900–1930*. Bacon himself may have had an affair with a homosexual artist; his cousin Diana alluded to one. "It was this atmosphere of liberation, freedom, and equality that attracted the whole world to Montparnasse during the 1920s," wrote

Kluver and Martin. Hemingway, with comic hyperbole, declared that Kiki "dominated that era of Montparnasse more than Queen Victoria ever dominated the Victorian era."

Bacon, now settled into Montparnasse, remained grateful to Madame Bocquentin for the rest of his life. He kept in touch with the family when he went to Paris in later years. "All of his life he telephoned and asked us to come to him," said Anne-Marie. "We would have dinner, my family, at L'Escargot with him and maybe some friend of his. And he would be interested in each of us, my husband, my thirteen-year-old son, my daughters, my mother. She was getting older. But he was always attentive. He listened to people." In a chatty letter to his own mother in 1966 Bacon mentioned that Madame Bocquentin was visiting her sister, Mrs. Luntley, who had moved with her English husband to Deal in Kent, on the coast of England. (He would give Mrs. Luntley, also a favorite of his, a work by Henri Michaux.) When the elderly Madame Bocquentin became ill many years later, Bacon made certain that his *amitié amoureuse* wanted for nothing. "He asked me, 'Manu'—he used to call me Manu—'tell me if you need anything for your mother. Money or anything else.'" They did not need anything, she replied. "But he thought about that. You see how he was?"

How remarkable it would have seemed—to a later English audience—that Francis Bacon, at the age of eighteen, lived in one of the most stimulating and storied neighborhoods of the twentieth century. An endless number of books would eventually commemorate those Parisian blocks in Montparnasse: every last Picasso sighting; the madcap surrealists; James Joyce sipping white wine; Kiki swanning down the boulevard; Hemingway haunts. Surely Bacon remembered Picasso in a café? Or Breton pronouncing? But Bacon hardly ever mentioned Montparnasse. As the painters in Montparnasse remade modern art, he began to design rugs and chairs.

It was a perfectly reasonable decision. Bacon was not yet prepared, at the age of eighteen, to be an artist in the tradition of Picasso or the surrealists. He lacked the training for the first and the confidence for the second. He was only beginning to discover where his particular interests and talents lay, and he probably learned during the brief period when he took lessons that he was not one of those natural draftsmen who, even in childhood, can capture a likeness with a line. If the Dinard series by Picasso that Bacon saw a year or two later gave him hope that he might

become a painter, it was partly because—like many surrealist-touched pictures—they were not bound to literal representation or obvious academic training. The *Cent Dessins* exhibit of Picasso that Bacon saw at the Galerie Paul Rosenberg soon after he arrived in Paris might well have delivered precisely the opposite message. That exhibit was replete with miraculous fluency and old-masterly skill. The most talented of students, after seeing such an exhibit, might break his pencil. And even if Bacon took lessons, how was he to become an artist in Paris? How would he make a living? How would he go on to *paint*?

In Paris, the vibrant world of decorating and design also dazzled—and beckoned. Design throughout Europe was continuing to change in radically new and exciting ways, led by the utopian visionaries of the Bauhaus in Germany, the Wiener Werkstätte in Vienna, and De Stijl in the Netherlands. The opulence and orientalism of art nouveau had given way in Paris during the 1920s to the more streamlined look of art deco. (The Exposition Internationale des Arts Décoratifs et Industriels Modernes in Paris in 1925 had been particularly influential.) Art deco itself was now yielding to a look that was more stark, modern, and sculptural. Eileen Gray—who remained in France after her student years in Paris—was a leader in this shift of taste. In the teens and early twenties, she had become known for her exceptional work in lacquer, which brilliantly complemented the exotic looks favored by art deco. An apartment she created for the designer Jacques Doucet was filled with opulent touches such as zebra rugs, lacquered screens, and a scrolling "serpent" chair. But her later commissions developed a more angular line, while her furniture assumed the stripped-down look of De Stijl, Breuer, and the Bauhaus.

The boundaries between fashion and art—and between the artists in Montparnasse and the interior designers in the Faubourg Saint-Honoré—were loose, permeable, and vague. Coco Chanel knew Picasso, and Elsa Schiaparelli worked with Dalí, Cocteau, and Man Ray. The painter Marie Laurencin, then celebrated for her tastefully colored cubist paintings, was also known for textile design and costumes. Designers, then as now, carefully studied the shifting inflections of art. They frequented the arty cafés of Montparnasse, where the young Bacon would hear ideas and meet people concerned not only with painting and literature but also with every facet of design and fashion in the modern world. If Picasso seemed too intimidating to the young Anglo-Irish artist, his fellow expatriate Eileen Gray appeared more accessible.

Inevitably, Bacon came upon Gray's startling storefront on the rue de Faubourg Saint-Honoré. The Galerie Jean Désert was set like a stark

Jean Désert, the shop of
Anglo-Irish designer Eileen
Gray and a mecca of
modern design in Paris in
the 1920s

jewel in a typical Parisian building that, above street level, displayed a
conventional row of vaguely classical and heraldic carvings. Underneath
was Gray's modern face. Peter Adam, a biographer of Eileen Gray, called
it "a new face, entirely in black and white. The windows were enlarged
and the black doors became three white lacquer panels. Above, in shiny
lettering, [Gray] placed the name of the gallery Jean Désert in a plain
modern font.... Inside, she ripped out the moldings and fittings and
painted the walls all white. She installed a new staircase to the basement."
The gallery's name invoked the desert, the landscape to which Gray was
most drawn. She created a spare interior: a striped abstract rug lay on
an open wood floor, and sculptural furniture stood out like forms in the
desert.

The interior of Jean Désert delivered, in 1928, a tremendous shock.
Suddenly, the known world of rooms looked undone and emptied out,
replaced by light, a few simple forms, and exhilarating open spaces. For
an asthmatic who grew up in damp and airless Irish rooms, Jean Désert
contained a promise of renewal and escape. Bacon probably never met
Gray. By the time he arrived in Paris, Gray—whose love for the warm,
dry climate of southern France and the desert surely owed something
to her youth in rainy Ireland—was living on the Riviera and building
her dream house. She was now focused on architecture rather than fur-
niture and interior design. But her beguiling showroom at Jean Désert,

run by her collaborator Evelyn Wyld, remained very much a going concern in Paris. Bacon would naturally be intrigued that this radical female designer and architect should have emerged from their shared and conservative Anglo-Irish society. Although he took pains not to mention it in later years, Bacon also probably had a personal connection to Jean Désert through a woman named Madge Garland, an English whirlwind of fashion and design who was certainly important to him after his return to London but likely first met him in Paris.

Garland was a second remarkable woman who, like Madame Bocquentin, could take Bacon in hand. She knew almost all the major figures in the design, fashion, and literary worlds of the period. Her influence spread across New York, London, and Paris. She had a distinguished career as a fashion writer and editor and then, later, as the first professor of fashion at the Royal College of Art in London. (Only recently has she begun to re-emerge from obscurity.) Born in 1896 in Melbourne—a fact she concealed, given the prejudice against Australians—Garland was raised in London. Like Bacon, she suffered from serious childhood illnesses, in her case a curvature of the spine that led to her being strapped, at times, to a board. She also suffered from allergies so debilitating that she was often kept in darkened rooms. After she abandoned a degree course at Bedford College, a pioneering institution for women at the University of London, her father, a prosperous businessman, did everything he could to prevent her from working as a journalist on rowdy Fleet Street. She persevered. She found a job at British *Vogue* and then, in 1922, left her short-lived marriage to Captain Ewart Garland, a pilot in World War I, to move in with British *Vogue*'s new homosexual editor, Dorothy Todd.

In the London of the 1920s, lesbians were not uncommonly found in the rarefied worlds of art and fashion. But they generally remained circumspect. Todd and Garland flaunted their homosexuality, entertaining at their flat in Chelsea at 71 Royal Hospital Road—where Bacon himself would live for a time in the 1930s—and seamlessly weaving together parties of people from the art, fashion, photography, and dance worlds. Cecil Beaton, then eager to become a photographer for *Vogue*, recalled a party in December of 1926 at which he watched "transfixed" as Frederick Ashton, who would become the leading English choreographer of his generation, "carried out a series of impersonations of various ballet dancers and an uncannily accurate imitation of Queen Alexandra," according to Ashton's biographer Julie Kavanagh. Madge Garland helped to dress Virginia Woolf, who sometimes came to lunch at the flat. (Bacon later mentioned a luncheon with Woolf, probably hosted by Garland, at which he found

the writer honking and disagreeable.) Woolf herself described the willowy Garland as "pearl hung and silken" and the stocky Todd as "buxom as a badger." Beaton, more waspish than Woolf, said that Todd had a face "like a sea-lion."

The parties at 71 Royal Hospital Road added some modern sparkle to conservative, inward-looking London. Todd and Garland—demanding a more stylish capital—insisted upon importing French flair from across the Channel. Upon becoming editor of British *Vogue* in 1922, Todd, with Garland as her fashion editor, transformed the magazine from a publication that sprinkled English gossip onto an essentially American fashion template into a passionate advocate for the modern eye. Side by side in the same pages the magazine published articles on art, literature, fashion, and design. The novelist Rebecca West wrote admiringly that the new *Vogue* "helped [the influential Bloomsbury art critic] Roger Fry in firmly planting the Post-Impressionists in English soil." Paris figured—prominently and essentially—in the new British *Vogue*. Garland loved all things French and spent her years at the magazine, from 1922 to 1926, moving continually between Paris and London searching out what was new. She herself liked to wear striking deco clothing designed by Nicole Groult, a leading French designer of the time and one of Garland's inside sources for news about French art and fashion. Groult not only was the sister of the celebrated couturier Paul Poiret: she was also married to the artist-decorator André Groult and was the intimate friend of the painter and decorator Marie Laurencin, who painted Garland's portrait.

Madge Garland loved Galerie Jean Désert. "In the 1920s, walking into Jean Désert . . . Madge fell in love with the rich simplicity of Gray's work and the stark geometry of Wyld's work, and she became close to both women," wrote Lisa Cohen, Garland's biographer, in *All We Know: Three Lives.* In London, Garland began to champion Gray, who embodied what Garland wanted from every English designer: that they, too, become spirited contributors to the modern arts. Just before Bacon came to Paris, however, Garland suffered a serious setback in her drive to awaken London. Dorothy Todd was fired from British *Vogue* in 1926 for not sufficiently emphasizing fashion—that is, for being too daring and probably too lesbian. Garland was dismissed a few days later. In 1927 and 1928, when Bacon was in Paris, Garland was at loose ends and therefore often living in Paris, where, said John Richardson, she had "a lot of friends" and knew almost everyone in the expatriate community. One such friend was, of course, Evelyn Wyld. Bacon may have met the Scottish-born Wyld before he met Garland, but to meet one was to know the other.

"Madge was the sort of woman who would move in next door to you," said Richardson, "if she thought that you'd be a help to her." Garland was, as Lisa Cohen described her, "a connector. She was like an agency. She just wanted to bring people together."

Bacon would only have to display an interest—and a woman like Garland or Wyld would welcome the charming young man into the fold. The design world still valued the tradition of apprenticeship. Its masters were often generous and willing to teach. And this new modern world of design did not necessarily require the same long apprenticeships that were once common. Bacon was not only promising and bright, but he had also now developed some skills in making fashion sketches (as Ianthe noted) and cubist-looking drawings (as the Bocquentins noted). He could apply those skills to design without worrying about Picasso's overweening power as an artist. It must have surprised Bacon, accustomed to regarding himself as useless, to see a possible career now open up before him. He might even make money, which would surely astonish the Major, who was forever complaining about money and who himself had failed to sustain a career after he left the army.

In Paris, Bacon could study, close at hand, the different fields of design. He became interested, for example, in designing rugs. In a narrow street on the Left Bank, at 17, rue Visconti—the same house where, a century before, Balzac attempted to start a modern printing business—Wyld was concentrating on the design and weaving of modernist rugs. Wyld's current personal, business, and design partner at Jean Désert was a young American named Elizabeth Eyre de Lanux, loosely married to a French diplomat and writer named Pierre de Lanux. (Wyld's letters to Eyre de Lanux in later years attested to their passionate relationship.) Their work together flourished in the late twenties and early thirties, thanks in part to the enthusiastic backing of Garland, who brought them to the attention of London galleries and ensured that their work was written up in magazines. Eyre de Lanux herself had studied with Constantin Brancusi before becoming a designer and illustrator. Bacon may well have worked on and off with both Wyld and Eyre de Lanux. The drawings that he brought to Ireland of the deco-sharp women in cloche hats may have even owed a debt to those of Eyre de Lanux, who also did fashion illustrations in precisely that style.

Although Wyld and Eyre de Lanux at Jean Désert were keenly interested in rugs, the Parisian designer whom Bacon seemed to favor most in that field was Ivan da Silva Bruhns. Born in Paris in 1881 to a Brazilian mother and French father, da Silva Bruhns designed rugs that owed

little to the traditional, highly decorative patterns of the past but instead adopted a more angular modernist style. He was influenced by the geometric designs and darker colors of Berber rugs, displayed in Paris during exhibitions from 1917 to 1919, and he also incorporated pre-Columbian and African motifs into his work (much as Picasso and other modernist painters borrowed from African art). In the 1920s, increasingly successful as a designer of art deco rugs, he opened his own gallery at 9, rue de l'Odéon in Paris, and he collaborated with other like-minded designers, among them Jules Leleu, who with Émile-Jacques Ruhlmann came to epitomize the rich art deco interior.

In contrast to well-known art deco designers who favored brilliant colors, such as Jean Lurçat, da Silva Bruhns preferred his strong geometric forms to be woven in more subdued colors. In 1928, Bacon made designs for rugs that were almost identical to those of da Silva Bruhns. Bacon may even have spent some time in da Silva Bruhns's workshop. Two early Bacon rugs, both signed in the square prominent letters that Bacon used in 1930, were essentially copies of a rug first executed by da Silva Bruhns. Some of da Silva Bruhns's more cubistic rugs also closely resembled those that Bacon designed once he returned to London.

As he studied the field, Bacon also became interested in furniture design, especially that of Eileen Gray. Like Marcel Breuer, who designed his first, revolutionary tubular chair in 1925, Gray was a pioneer in the use of chrome metal. Many of her signature chairs, such as the semicircular Bibendum chair—its molded triple tier of plump, curved cushions sitting atop a rounded chrome base—dated from 1926 to 1928, around the time when Bacon was in Paris. "There seems to have been an instant recognition among architects and designers that bent tubular steel was the ideal material for modern furniture," wrote J. Stewart Johnson in the introduction to a book on Marcel Breuer's furniture and interiors published by the Museum of Modern Art in New York. "The cool austerity, the sleek gleam of metal were exactly what had been needed to bring the modernist interior to life."

The same cubist inclination that brought Bacon to da Silva Bruhns led him to the designer who, in addition to Eileen Gray, also influenced his developing eye for furniture. Robert Mallet-Stevens (1886–1945), a celebrated figure in Paris during the 1920s before he dropped from sight, was known mainly for avant-garde architectural designs. As part of his commissions, however, he also designed furniture that looked blockier and more squared-off than Eileen Gray's, qualities that Bacon adopted in his own furniture designs. Mallet-Stevens favored tubular metal con-

struction, chairs with dramatic wooden armrests, and rooms marked by built-in elements, such as beds, shelves, and cabinets, all ideas to which Bacon was attracted. But Bacon, characteristically, would not give up an echo of past luxury, either—not even as a young man. He spoke with rare passion later in life about the furniture of Ruhlmann, who made pieces so resplendently beautiful they might have been created for a modern monarch. Ruhlmann, who opened his own gallery in 1919 to sell his furniture, was celebrated in his day as a latter-day successor to the great French cabinetmakers of the eighteenth century, when, as the critic David Netto noted, "furniture-making was king of the decorative arts, a field then viewed as the equal to painting or architecture." Ruhlmann used only the finest materials—exquisite fabrics and the rarest woods. His marquetry was unequalled. The curve of a chair's line seemed a perfect caress.

Many of the most interesting designers, such as Gray and Mallet-Stevens, wanted to perfect a room. That unifying idea probably captivated the young Bacon, who was always interested in a powerful room and wanted to find a new place for himself in the world. Perhaps one day, in a room of his own, he might design the rugs, create the furniture and fittings, and even paint the pictures. Some evidence exists that Bacon secured a commission or two in Paris. An early résumé at one of his future galleries has an entry for the years 1927–28: "Travels to Berlin, stays for two months only, then on to Paris where he occasionally secured commissions for interior decorating." (Such résumé tidbits were later withdrawn.) For an eighteen-year-old Englishman to fabricate and sell his designs in Paris was, however, nearly impossible. Toward the end of 1928, Bacon decided to bring home what he learned on the Continent.

In London, he would face little competition in the modern field. The design and decorating worlds there remained old-fashioned, and the experimental spirit that existed before World War I had receded somewhat. But Madge Garland would certainly support his career and help him find commissions. He was just what she was looking for: a young English modernist fluent in the Parisian styles. Bacon could meanwhile follow Garland's example and travel back and forth to Paris—a city he now knew better than London—picking up fresh ideas and further developing his own. He also knew of weavers in Ireland where prototype rugs might be created. Workshops that made hand-knotted rugs existed in both Abbeyleix and Naas, the location of his two earliest homes, and there was a famous weaving concern in Killybegs, Donegal.

Bacon lived for a year and a half in Chantilly and Paris, more than twice the time he spent in London after leaving home. He arrived in

Paris alone at the age of seventeen, not speaking French and with neither an education nor a vocation. By the time he left, he not only spoke the language but was a committed young designer with good connections and a promising future. But later résumés referred to his time on the Continent as "visiting" Berlin and Paris. He told David Sylvester, "I went to Paris then for a short time," and admitted to little more than seeing a Picasso exhibit at the Galerie Paul Rosenberg and learning French from a family in Chantilly. Bacon's time in Paris would become one of two pivotal periods in his life that he all but erased from the public record. (The other, about two years long, occurred during World War II.) The simplest explanation for this first erasure was that Bacon did not want to be identified with commercial art. Many artists have been reluctant to discuss the commercial art they created early in their careers in order to make ends meet, but Bacon appeared particularly touchy, probably because there was a moment when his design work was not an unpleasant chore but a chosen career.

The more significant reason for this erasure, however, was Bacon's later desire to control his public image and story. He had learned as a child and adolescent, as many homosexuals must, to present a carefully composed face to the world. In the future, he would not want to discuss the ordinary missteps and slog that afflict almost all artists. And he would not want to admit to having worked hard to attain success (one of his aristocratic predispositions) but would instead present his early years as a muddled disaster, a time of dissipation made possible by family money during which he gained almost no experience or training in art. He could then emerge miraculously as an artist, as if sprung fully formed from the head of Zeus. This was not untrue by his lights; he was simply emphasizing the emotional truth concealed by the deceptive facts. He would often later describe how at the easel, chance effects suddenly brought the figure to life. The same must also hold true for his life as an artist: suddenly, mysteriously, he jelled in the 1940s.

Bacon left Paris a designer, but his extended stay would also help his art. He would never have to catch up to either Picasso or Paris, and, already, any authority he recognized was vested not in the conservative British art establishment but in the freewheeling world across the Channel. It made a difference, not having formally studied in London. And it made a difference to have lived abroad as English society looked inward. He could now more easily establish himself as an outsider with an idiosyncratic vision and, during the afternoons and nights, enjoy a free-spirited sensuality of the kind he found in Montparnasse. Shortly before leaving

for London, he attended the twentieth birthday party of the celebrated Dutch-Javanese model Toto Koopman, one of the favorite subjects of the fashion photographer George Hoyningen-Huene. (The invitation may have come through Madge Garland, although Bacon later claimed to have crashed the event.) At the party, Toto did not notice the reserved Bacon. After World War II, as Bacon shocked the art world with his paintings, he would happen upon her again. She had become a war hero and fallen in love with yet another of the remarkable women who marked Bacon's life, the German art dealer Erica Brausen.

Gallant Men

Eric Allden, the first full-time companion of the young Francis Bacon, in his later apartment in South Kensington

O N JULY 15, 1929, Eric Allden, an upstanding member of the Tory establishment with some years in government service, met a beguiling young man while crossing the Channel. "He told me he was starting a shop in London for ultra-modern furniture and was going to Paris to purchase samples," Allden wrote in his diary. "His name was Francis Bacon and he had big childish pale blue eyes." Two weeks later Allden, now back in London, called upon the young man at his flat at 6 Relton Mews, Knightsbridge. "He is very young, only 19," wrote Allden, "and has a most original mind, intensely modern and futurist in art. He designs very odd-looking furniture and rugs and has just furnished somebody's yacht."

A sensitive and observant diarist, Allden was particularly impressed by the young man's ambition. Not only did Bacon appear determined to establish himself as a successful designer; he was also making modern paintings on the side. He appeared intellectually voracious. He loved ideas. He read the most difficult books. Bacon himself would never confess in the future to such behavior. When his amanuensis, the critic David Sylvester, asked him, "When did you start reading seriously?" Bacon's answer was: "Oh, not till years after I tried to start to paint. I am fairly self-educated because I wanted to enjoy myself. When you are young you want to enjoy yourself, and reading was not one of my enjoyments then." Asked if he ever went to the theater, where Allden regularly took him, Bacon replied, "I drifted from bar to bar."

At that moment Bacon was not mainly thinking about bars and love affairs. In 1929, he was intent upon establishing a business, an absorb-

ing and difficult challenge. Although his mews flat was modest, he was not just living anywhere. He lived near Harrods and Belgravia, just off the Brompton Road—a fashionable address. He had located a place that could produce rugs based on his designs, Wilton Royal Carpet Factory. (Many of Madge Garland's friends also brought their rug designs to Wilton.) And he was not simply designing furniture but also beginning to fabricate certain pieces. Allden described going with him to Euston Square, "where a wholesale firm named Eward is going to upholster [Bacon's] modern metal furniture. The man in charge of this work was a typical Londoner, quick as lightning, friendly, humorous, self-assured. He motored us in his old car, exchanging banter with several chauffeurs on the way, to another wholesale place off New Oxford Street where we examined calf skin and sheep skin leather which is going to be used to cover some of Francis' things."

Bacon was keeping an eye on Paris as well—maintaining his connections, watching developments in design, and returning home with samples. A shipment of glassware arrived from Paris while Allden was getting to know Bacon, for example, and Bacon may have considered selling imported French goods along with his own if he was starting a shop. He would also want samples from Paris to show customers who hired him as an interior decorator. The man who asked him to furnish his yacht (a commission about which nothing is known) might well have expected, for example, a set of exquisitely modern martini glasses. Well aware of the importance of design in Germany, Bacon, having mastered French, was now taking lessons in German with his cousin Diana Watson at the Berlitz School in Harrington Road, South Kensington. Madge Garland, as she probably promised, was beginning to direct small commissions his way. She was more likely than Bacon to know a yachtsman. Even so, it would be no easy matter for Bacon to establish a modern design business in London. The best design was expensive. And how was he to exhibit his creations? How was he to open, as Allden put it, a "shop"?

Bacon did not really mean a "shop." Not unless Galerie Jean Désert was a shop. Bacon's dream as he returned to London was likely a showroom as remarkable as Eileen Gray's. Perhaps he could become the Eileen Gray of London. He hoped to sell his own designs in his showroom (and perhaps those by other designers he admired). But he also wanted to recreate the intoxicating environment of Jean Désert, with its *frisson* of walking into a new and different world. Bacon did not have the money, however, to create such a showroom. His mother was almost certainly providing him with ongoing support during these years, but she could

go only so far, given the Major's views about money and his effeminate son. Winnie herself did not understand Francis's rugs and furniture. She could only imagine what her husband would think of them, let alone how he would respond to a request from Francis to finance a shop to sell such frippery.

Some part of Bacon relished life's hustle, especially when the emotional vibrations intimated something important about the world. He won over Granny Supple, Madame Bocquentin, Madge Garland, and many others. He did not do so as a cold, manipulative narcissist. He liked being charming—charm brought light into the dark world—and he enjoyed those he charmed. For a homosexual with Bacon's past, succeeding in a difficult world naturally required mixed motives. He enjoyed attracting older men. So much could happen during a fling with an older man. Elements of power, weakness, revenge, crime, subterfuge, shame, and love all came into play. The pretty conventions were often a lie papering over the animal transaction, of course, but it was equally true that powerful and poignant feelings existed within suppressed men that sometimes erupted during the sexual act.

Bacon was curious about the practices of various homosexual subcultures: he was becoming familiar with codes, conventions, and locations. Anonymous sexual contact was not what ordinarily interested him. His particular métier was the glance across the room when, amidst the smoke and confusion, eyes suddenly met and held for a moment too long. He had other preferences apart from being attracted to older men. He wanted his lovers to seem heterosexual and, ideally, be handsome and powerful. Not surprisingly, Bacon was catnip for the closeted. He was someone a thwarted older man would also want to advise and guide. (They could pretend the sex was just some naughtiness on the side.) During his early years in London Bacon found that such men were often pleased to supplement his mother's allowance with ambiguous gifts.

Eric Allden was different. He was not a man to be hustled for a day or a week, and Bacon did not do so. No record exists of the exact relationship between Allden, then forty-two years old, and the nineteen-year-old Bacon. Allden never confided in his diary any deeply personal details about the close friendship that developed between the two. There are men who would not wish to embarrass a diary. And Bacon, in later years, never named Allden as an important figure in his life. Like Madge Garland, he would disappear from the record of Bacon's earliest years. Allden was a key figure in Bacon's life during the late 1920s, however, the kind of man who would befriend not only Francis but also his mother,

remaining friends with Mrs. Bacon long after he and Francis parted. He did not appear to others as obviously homosexual and he was, besides, a devout Roman Catholic. Allden had a private income and took a gentlemanly interest in the arts, keeping an open mind even about modern art. His own life had not unfolded as he might have liked, but he wanted the best for this brilliant boy—as their glance met on the boat—with the "big childish pale blue eyes."

Several months later, the couple moved into the first of the flats that they shared over the next two years, at 54 Vincent Square, near Westminster Cathedral.

Eric Allden grew up in Southampton and London. His father, John Horatio Allden, was a member of the Royal College of Surgeons and the Alldens were well-to-do. (Later, Eric's father and Peruvian-born mother, Francisca Maria Stubbs, would move into Northgate House, a fine example of an eighteenth-century Palladian house in Beccles, Suffolk, in the southeast coast of England.) The family albums were filled with photographs of horses and riders—both of Eric's parents rode with the local Hursley hounds—and Allden went to Charterhouse School, one of England's best public schools. In 1904, he matriculated at one of the most distinguished of the Cambridge colleges, Trinity.

Like many other graduates of Oxford and Cambridge, Allden entered government service, working during World War I on the War Refugees Committee and then as an intelligence officer. He was briefly the private secretary to Sir Laming Worthington-Evans, the Conservative Party's Secretary of State for War in 1921–22, but lost his job when the coalition government fell apart. His name was put forward for the 1922 Honours List, however, and he was awarded a CBE, or Commander of the British Empire. Letters indicate that he then tried but failed to find a suitable new position. He became the kind of self-conscious gentleman who concludes over time that worldly success was for the vulgar and striving. Since he had a private income and no profession, he began to travel the world. He bought a steamer ticket to India and went to cities as far-flung as Buenos Aires and Manila. He spent several years in China, staying in Shanghai for a time and working without pay for Sir Ronald Macleay, the British minister in Peking.

On his return to London, Allden filled his days with friendship, books, religion, and the arts. He took periodic trips to the Continent. He particularly enjoyed the theater. He was gently and inoffensively snobbish, a

man attracted to titles and the aristocracy who belonged to the conservative Carlton Club, which stood high in the pecking order of clubs located in and around St. James's. He was not just a practicing Roman Catholic but a deeply conservative one who favored the incense and velvet of the Brompton Oratory in South Kensington. In a period photograph, Allden wears a double-breasted pinstriped suit. On his head is a bowler hat. He carries a rolled umbrella. He is dapper, almost dandyish, and fairly handsome in a conventional way—a Tory gentleman who knows how to fold a handkerchief with flair. He smiles at the camera, but rather wryly, as if wondering what foolishness might follow. About him generally there was a sweet and melancholy air, like the incense at the Oratory.

Allden probably did not approve of homosexuality. Initially, he found Bacon not manly enough, arching an eyebrow after their second meeting: "I like this boy, who is extremely intelligent, but he has the complexion of a girl, with big blue eyes and long lashes. He is really too pretty for a boy, and his ways are rather effeminate." A photograph of Bacon bears him out. Taken around 1933 by the photographer Francis Julian Gutmann, it is a close-up of Bacon's head and shoulders, lit from the side. He does not look directly at the camera but appears lost in reverie, his eyes dreamy and distant. It is hard to imagine a more melting depiction of a young man. Soon enough, Allden put aside his reservations about Bacon's "too pretty" looks and was dropping regularly into Relton Mews, where Nanny Lightfoot was now established along with Francis. (Having left the main Bacon family, Nanny now lived with Francis, or close by, for the rest of her life.) Allden would instinctively appreciate where Bacon chose to live, between Harrods (worldly goods for the upper classes) and the Brompton Oratory (soulful sustenance for the higher spirits). He would appreciate Bacon's nanny-in-residence, his conservative Anglo-Irish background, and his family's easy familiarity with the great houses of Ireland. He would have been reassured by the company Bacon kept. On an early visit to Relton Mews, for example, Allden found Bacon "giving an oldish man tea." The man was Guy Brunton, an eminent Egyptologist who, despite being thirty years older than Bacon and married, was probably no less taken with the precocious Bacon than was Allden. Only two or three weeks after meeting Bacon, Allden observed that, despite having hardly been to school, Bacon "has an astonishingly cultivated taste in reading."

During his first summer in London after Paris, Bacon came under increasing pressure. He was living alone and trying to design and fabricate pieces for a modern showroom that would impress both cities. He had not yet found, let alone designed, a "shop" or showroom. He

was sleeping poorly. He had digestion problems. He had no money to speak of. His asthma bothered him less than it once had, but there were always flare-ups. His mother was helping him financially, which probably increased her problems with her husband, and she may have engineered Nanny's move to London to take care of Francis. The irascible Major groused that the penniless Francis somehow managed to wear handmade shirts which, said Ianthe, "disgusted my father terribly." His mother was herself under considerable personal strain after the recent deaths of both her son Harley in Africa and her seemingly indestructible mother, who died while visiting her son Peter in the United States. (Decades later some people in Ireland still remembered that Granny was about to be married a fourth time after returning from what proved instead to be her fatal trip.) The death of his eldest son the previous spring, like the earlier death of Edward, also made the Major disconsolate. Bacon's mother, now forty-five, was left with two daughters, a peculiar son, and a glowering husband.

Winnie was a sociable being. September 1929 was the first anniversary of her mother's death, and Straffan Lodge, where she was living with her family, was also Granny's house. She looked forward to a momentary escape in September to the west of Ireland, where the family traditionally went to fish and hunt grouse. Not surprisingly—given her mourning, loneliness, and boredom—Winnie wanted her one surviving son to join her. For Bacon, however, spending September in the west of Ireland with his family was more like hell than a vacation. It would also distract him at a critical moment from his design work. In later years, his friend and fellow Anglo-Irishman Caroline Blackwood observed that Bacon always seemed to fall ill or find a reason not to revisit Ireland. He had now done his duty there, he would have felt, having returned to see his family several times since leaving for Europe in the spring of 1927.

During that summer of 1929, however, how could he say no? How could he ask his grieving mother for *more* money—and he would surely require more money to establish a showroom—if he refused to take the trouble to visit her? And so he agreed to spend September in rural Ireland. Just not alone with his family. He asked Allden, whom he had known for only a few days, if he would like to accompany him on the visit. "He wants me to remain all the time he is there and is quite ecstatic about it," the flattered Allden wrote. "As a matter of fact I think it will be delightful." Winnie rented a cottage in Galway for Bacon and his friend for a month, about six miles from the house that she and the Major took. "The cottage has two bedrooms and a sitting room," wrote Allden, "and

she has hired an old woman to do for him and cook. It is understood that I am to accompany him and stay there."

Not long before the trip, however, Bacon broke down. He entered a clinic at 106 Cromwell Road, South Kensington, run by Dr. Robert Fielding-Ould. (It would be the first of many such withdrawals, often triggered by a buildup of nerves.) The doctor came from a distinguished line of physicians in Ireland; Bacon or his family may have known of him through Irish connections. Bacon's ailments, sleeping badly and stomach problems, were imprecise, but typical of what nineteenth-century doctors often diagnosed as nervous exhaustion—a kind of fatigue suffused with ennui. A modern doctor might call it "acute stress." Dr. Fielding-Ould probably regarded the symptoms as partly mental or spiritual in origin. In addition to being a medical doctor, he was also the vice president of the London Spiritualist Alliance. (Arthur Conan Doyle served as the president.) The Alliance supported research into mediums and spiritualism. It was yet another time in Bacon's life when he drew close to spiritualism without endorsing it, probably taking an interest in its visual properties and odd rituals.

Fielding-Ould's diagnosis was that Bacon was "very run down, rather anaemic, poison in his system," as Eric Allden noted. The cure was complete rest and no food—a common prescription of the time—presumably to cleanse the body of toxins. It was not unlike the cleansing practice of earlier physicians, when they bled patients to rid them of evil humors. Allden, a kind man, became a solicitous visitor. "I found him looking rather feeble," he wrote after his first visit, "but over the worst of the cure, as the first 36 hours of starvation are the most trying." On subsequent days, Bacon was "allowed to dress and sit out in the garden at the back." Allden would be served dinner and wine, but "the poor boy of course had nothing at all." Bacon was probably comforted and touched by these visits, so different from the ministrations of his father.

Once recovered, Bacon packed for Ireland as if he would never see civilization again. Not only did he bring a human companion, ensuring that he would have company apart from his family; he marshaled additional defenses, including a formidable collection of books. Foremost among them was Oswald Spengler's *Decline of the West*, not usually considered vacation reading but then almost obligatory for the intelligentsia. ("In the 1920s and 1930s the idea that Western civilization was coming to an end seemed something given—a *donnée*," as Stephen Spender later wrote. "The title of . . . *The Decline of the West* conveys this.") For lighter fare, Bacon brought along Carl Jung's *Psychological Studies*, Plato's *Sympo-*

sium, Wyndham Lewis's novel *Tarr,* and the current best seller *All Quiet on the Western Front* by Erich Maria Remarque. The inclusion of Donald Clive Stuart's *The Development of Dramatic Art* suggested a growing interest in theater. Bacon intended to paint when not reading. He packed brushes, a palette, and a box of paints: he wanted to keep trying his hand as an artist. He could not forget Picasso.

And if not reading or working, Bacon would listen to music. Allden was astonished to discover that Bacon planned to lug a heavy and cumbersome gramophone to Ireland, probably accompanied by a set of jazz records. (No doubt Bacon was already prone to flapper-style parties with martinis and dancing.) The machine would delight his sisters, fill the silent spaces, and offset nature's autumnal gloom. It was also a way to bring London with him. Bacon and Allden took the train to Holyhead in Wales and then crossed the Irish Sea by boat, the same trip Bacon had made numerous times before between England and Ireland. They were concerned that customs officials would look askance at the gramophone, but, wrote Allden, "the customs examination on the quay was a muddle and actually quite perfunctory."

Allden regarded the English as the injured party, of course, after the recent Troubles in Ireland. "The Kingstown Yacht Club [Royal Irish Yacht Club] is just by the quay and from its flagstaff floated the red ensign," he wrote, "a welcome sight in a land where English people have been relegated as far as possible to the background." Bacon gave Allden a tour of Dublin's Georgian squares, built during the high summer of Anglo-Irish rule, and Allden—a natural tourist—delighted in the details. "He took me through Merrion Square past the railings of the Museum, then along the railings of Trinity College to its main entrance, facing the curved front of the Bank of Ireland." They then took the train to Galway and Connemara, where Mrs. Bacon—a dutiful mother and hostess—picked them up and drove them down stony roads to their cottage. On the way to their cottage they passed the "blackened walls" of what was formerly a great manor house: it had been "burned down in the 'bad times,'" wrote Allden, "as the days before the Free State came into being are referred to."

On the sides of Killary Bay, the scrabbly mountains rose up, austere but delicate in the way of mountain stone when the light brings up the grays and the soft mossy colors. The famine during the 1840s had killed or driven away many of the inhabitants of Connemara, who left behind them as melancholy monuments small stony cottages now open to the weather. The rural cottage rented for Bacon and Allden was "by the sea with only a few peasants' huts near," wrote Allden. "There is nothing

between it and America." By London standards, the cottage was exceedingly primitive. They would have to light a smoky peat fire, for example, in order to offset the September chill. Allden admired the autumn hedges of red fuchsia and the scenery—"really lovely, not so grand perhaps as Scotland, but infinitely beautiful in its soft charm." From a window in the sitting room, Allden reported, "there is a beautiful view seawards, across the sloping fields to the shore of Killary Bay, ½ mile away."

The first night went poorly. The mattresses, sheets, and blankets had been newly washed but not properly dried, leaving Bacon and Allden to sit up late warming themselves before a peat fire in the sitting room. Around one a.m., Allden retired to his bed and lay down in his overcoat. An hour later Bacon opened the door of Allden's room—disturbed like a child by noises in the dark. The sound of a stream running by the house, together with the general air of loneliness, troubled him: "'Can I sleep on the chair in your room, Eric,' he asked. 'I simply can't stay alone in the other room.'" Allden was not unsympathetic. He agreed with Francis that the cottage had a "strange eerie feeling. There were noises outside, as if people were prowling about the house, and up in the roof things kept rustling. However I persuaded him to go to his room and do as I had done, and eventually we both got some hours sleep. This morning Mrs. Grady [the woman hired to help with the washing and cooking] asked me if Mr. Bacon had been ill in the night."

Bacon set up a studio in the room beside the bathroom. He mostly remained inside working. He told his mother that Mrs. Grady was not ideally suited to help two English bachelors. Instead, he proposed that Nanny Lightfoot come to Ireland to look after them. Nanny had seen Francis through many a dark Irish night during his childhood. Why not a few more? His mother, of course, would pay Nanny's way.

On most days, Winnie picked up the two gentlemen in her automobile. The Major was out shooting as Bacon and Allden whiled away the day with Mrs. Bacon and Ianthe, who was ten, and Winifred, then eight. They strolled on the beach, went on picnics, and visited the local Anglo-Irish gentry. The grandees of the area, Dr. Oliver St. John Gogarty and his wife, had acquired Renvyle House in 1917, which had subsequently been burned in 1922 during the "bad times." Dr. Gogarty, an on-and-off friend of James Joyce, was an influential Irish doctor, writer, and politician and the model for Buck Mulligan in *Ulysses*. He was now building a hotel on the site of the former big house, while his family lived in a newly built one beside a lake on the property. One week into Francis and Allden's vacation, on a Sunday just as Allden was returning from Mass,

"a lady and her daughter appeared at the front door. I went to earth in my bedroom and Nanny hauled Francis out of the room by the bathroom. . . . He went to the door palette in hand and received an invitation 'for him and his friend' from the lady, Mrs. Gogarty, to fish tomorrow in their lake." The two men subsequently called upon Mrs. Gogarty. "Our arrival caused some confusion as one or two young men of the party were indulging in a sun bath and had removed their shirts."

Bacon fulfilled his familial duties as best he could. Allden's impression of Mrs. Bacon was favorable. She, in turn, thought highly of him. "Mrs. Bacon, nee Watson, is an attractive woman with light blue eyes and a pretty smile. She hunts with the Kildare during the winter, and the rest of the time is entirely devoted to husband, children and household. But she is intelligent and interested in things of all kinds, whether she understands them or not." The "whether she understands them or not" was a deft touch. Allden and Mrs. Bacon found they could talk about most anything, with knowledge no bar to pleasure. Like many women married to a stiff upper lip, Winnie was thirsty for lively talk. They were, besides, only two years apart in age. Allden observed her deep devotion to her son: she was "anxious to understand him and sympathises with him in his aims and achievements." What Allden simply could not fathom was how Francis Bacon ever emerged from this particular family. "I cannot see that any of his characteristics," he said, "come from either of them."

Especially, of course, from the Major. Bacon prepared Allden for his father, but even so Allden found him worse than he anticipated. "He is as selfish as it is possible to conceive; thinks of nothing but his own pleasure in sport of various kinds; never gives Francis a penny, yet, although eternally grumbling about being hard up, can always find what money he needs for his own entertainment." Winnie's only fault—and Allden found it understandable—was in not standing up to her husband; "but she was married at 17 [in fact, nineteen] to her husband and has been overshadowed by him." Both Francis and his older brother, reported Allden, ran away from home at different times because of their father: "The elder boy could not live at home, and work was found for him in South Africa, where last spring [six months before] he died of tetanus, a great shock to his family. Francis says that his father has been better tempered since the boy's death, having been much affected by it."

During the trip Bacon and Allden settled in together comfortably. They found that they could live in the same house without getting on each other's nerves. They then made plans to share a flat once they were back in London. Nanny would of course join them, making it a house-

hold. "I have been here three weeks and enjoyed it very much," Allden wrote on the 24th of September. "I know Francis much better now than I did, and he has stood the test well. He is a delightful companion and has as keen an intellect as anyone I know. It is extraordinary that at his age he should have such a vivid interest in such intricate and abstruse studies." Bacon also proved himself unexpectedly capable in the real world. Before Nanny arrived, for example, he presided over the kitchen. "He can cook admirably. Francis cooked both our meals yesterday and did them remarkably well. We had cold lobster with mayonnaise for lunch." Bacon was even a skillful driver, something that would have astonished friends who knew him in his drinking days.

Allden left Ireland a week or so before Bacon, intending to look for a flat in London. He noted cheerfully on October 6 that "Francis has sent a brace of grouse," likely shot by the Major. Left alone in the cottage—perhaps Nanny was still there—Bacon now found the situation in the countryside more difficult. The melancholy of Connemara weighed upon him. He had grown up in claustrophobic rooms. The forces outside, especially during the "bad times," had never meant well. The distant sounds, the limitless spaces, the beams of light with no message: the world outside his room made him anxious. Its features came alive to him, but as menacing rather than comforting spirits. "Last night I walked down to the sea: it was so calm and beautiful," Bacon wrote to Allden, adding, "I cannot stay in the big room here as the twilight falls. The hills seem to press down into the room to fill it with some primeval despair. Trees grow lecherously into the walls and the sea creeps slowly across the floor. . . ." He was grateful for the fall of night, which closed out the world like a drawn shade: ". . . and then night comes down, the mountains are drawn and once again my mind becomes normal. Eric, there is a strange melancholy about the twilight—you too, I'm sure have felt it, the time when the sinister Dionysian side of nature predominates most." Bacon liked Dionysus, but in his city guise.

Allden found a small but suitable flat in Victoria, at 54 Vincent Square, where they could stay for a few months—until, that is, Bacon could design a showroom where they might also live. (In Ireland, Bacon likely secured a promise from his mother to defray the cost of creating such a showroom.) The new neighborhood was favored by foreigners with distinguished pedigrees but not much money. "My room is on the first floor, a big room with two windows, and as I lay in bed this morning I saw the light gradually come into the sky," wrote Allden in a poetic mood in late October. "Francis has the back room on the same floor. Above live

Mrs. Campbell-Johnson [another tenant] and her son. On the ground floor, our sitting room looks out on the square, with nanny's room behind it, and our bathroom. Below in the basement is our dining room, kitchen and lavatory."

The day Bacon and Allden moved into their flat—October 29—was the last of the fateful six days that began the Wall Street Stock Market crash of 1929. Almost thirteen million shares of stock were sold on the first day of the crash, triple the usual amount, and values began to plummet. It was the start of what would become the worst stock market crash in U.S. history and would lead to the Great Depression, which lasted for the next decade. Bacon's career as a designer would have seemed particularly vulnerable to a worldwide financial panic—yet Bacon and Allden hardly seemed to notice. There were no references in Allden's diary to economic ruin. To a remarkable degree, the well-off in Britain were buffered from the turmoil even as unemployment reached staggering levels in parts of northern England, Scotland, Wales, and Northern Ireland. In 1929, for Eric Allden and his young friend, life continued as usual, with nights spent at restaurants or the theater and servants tending to any need.

Allden enjoyed indulging his "dear boy" with haircuts at Harrods and finely tailored clothing. He knew a number of actors and theater folk, and he often took Bacon to see the latest plays being performed in London—Chekhov's *Seagull* and *Three Sisters*; Shaw's *The Apple Cart*. The couple went to see a work called *Maya*, probably at Bacon's urging. It was a play that could particularly interest closeted homosexuals. (Many believed it should be censored.) It described a French prostitute who could not live as she wanted: her life required her to embody, and play out, the expectations and fantasies of others. Allden considered it "a sordid, crude, dull tale," but did not report Francis's reaction. Having made a friend of Bacon's mother, Allden now did the same with his cousin Diana Watson, who came to tea at Vincent Square in October. "She is quite young, very intelligent, with a type of mind similar to Francis. Apparently she reads all sorts of books girls shouldn't, and there can be few mysteries for her."

Not surprisingly, Bacon and Allden often went to museums. Allden did not record Bacon paying much attention to the decorative arts. In October, Bacon wanted to show Allden "certain pictures in the Tate Gallery." They looked at the "long gallery filled with the French impressionists," but Bacon drew Allden's particular attention to two figurative paintings by the English eccentric Stanley Spencer (1891–1959), *Christ Carrying the Cross* (1920) and *The Resurrection, Cookham* (1924–27). Allden wrote of them:

Both are most strange in conception. The *Christ* picture is soft in tone & attractive in colour. It is all in dull pale shades of blue & green & pink. The figure of Christ is practically hidden by other figures, all of which are in everyday clothes. Behind a sunny modern house of red brick shows windows, from each of which a pair of spectators lean, the window curtains blowing out rhythmically. *The Resurrection* is still more startling, and at the same time extremely funny. The dead, clothed & naked, black & white, rise from a medley of tombs, such as one may see in any country churchyard, some enclosed with railings, some ivy covered. Two women in neighbouring graves are reading & comparing their funeral notices, another woman coyly sniffs at a daisy as she glances over it at a man rising from another tomb.

A few days later, Bacon brought Allden to the Leicester Galleries "to see the exhibition of the work of a much different painter named John Armstrong, some of which was good," Allden wrote. "He is obviously influenced by Chirico in his use of Greco-Roman forms." Spencer, Armstrong, and de Chirico were each developing a theatrical and visionary space in their painting, and Allden noticed that Bacon—when he had time during the weekend—painted a picture of "three horses jumping in a circus with a big curtain down one side, rather in the style of John Armstrong." At the time, Bacon was drawing and painting "in his own peculiar modern style," as Allden described it. His earliest works to survive, thanks to Allden, who purchased them, date to 1929: they might have been painted in Ireland. *Watercolour* was quite small, only a bit over eight by five inches. It was a mélange of cubistic elements and influences, as Ronald Alley, the author of the first catalogue raisonné on Bacon pointed out: Léger for the leaves and late-cubist forms, de Chirico for other pictorial elements. A second work, this one slightly larger at approximately fourteen by nine inches, also contained a medley of influences and elements. The leaf form may have come from Léger; the column resembled those of de Chirico; a brown, vaguely violin-like shape evoked early cubism generally. And in the center was a highly stylized diver who owed a debt to art deco.

Still, most of Bacon's energy in 1929 was directed toward his career. That October, he received a shipment of finished rugs from the Wilton Royal Carpet Factory. "They have made them up beautifully," wrote Allden. "One, called 'Formal Design,' in black and grey with a touch of white and scarlet, he is letting me have at cost price as a birthday present." Bacon meanwhile worked to develop and maintain useful connections.

Allden's diary recorded a lunch with Bacon and "a fellow named Tom Arundell-Brown, who has a business in very modern decoration." On their first day in the Vincent Square flat, Bacon brought home "a metal and glass stand for cocktail glasses, which he wanted there and then to fasten up on the wall 'to see how it looked.' I managed to restrain him, because it would have meant huge holes in Miss Green's [the landlady's] immaculate walls, and as we've only got the place for 10 weeks, we must be careful what we do to it." Allden's qualms led to a quarrel with Francis. "This put him in a mood," Allden observed sympathetically, as if he were describing a child, "which in spite of all his efforts, lasted till bed time. He is a dear boy and very seldom gets into such moods."

Bacon was understandably tense, as he worked toward finding and opening a showroom. He wanted to be in South Kensington, which was not known for its artists, but was congenial to both men—to Bacon, given his roots in the colonial and Anglo-Irish world, and to Allden with his background in the civil service. "South Kensington was enormously respectable," said John Richardson. "It was where you'd find retired ambassadors. People without a huge amount of money. In Onslow Gardens the houses were *huge*. And they still belonged to one family." The writer and broadcaster Daniel Farson (known universally as Dan), a drinking companion of Bacon in the 1950s, thought Bacon's commitment to South Kensington was significant. "South Kens was known as a final resting place for generals and their lady wives, governors and top civil servants after their service in India or the Far East," wrote Farson. "Significantly, [Bacon] told me, South Kens was the place where he found it easiest to paint." Bacon understood such an environment, even if he rejected the social world of his parents. The point was made by the art historian and critic Richard Shone in *The Burlington Magazine*, in an article on Bacon's early design career:

That Bacon chose South Kensington in which to begin his career is an interesting indication of how he perceived himself. It was not a district known for its artists or for an art-world community, although Chelsea, which was, seeped into it at its southern border. The districts associated at that time with more progressive or avant-garde artists were either in the area of Fitzroy and Charlotte Streets and Fitzroy Square or in Hampstead, already nursing its "gentle nest of artists" in Mall Studios.

Bacon settled on 17 Queensberry Mews for his showroom, a building then being used as an automobile garage. It was one of the small mews

houses built directly behind the grand, five-story town houses lining Queen's Gate. Originally, the grooms who worked for the owners of the town houses on Queen's Gate lived in these mews, above the horse stalls and carriages. In 1930, many of these houses still retained ties to transportation, having been converted into garages or showrooms for cars and accessories. Number 17 Queensberry Mews was the last house in the row and abutted a much taller ecclesiastical hall, its high stained-glass windows lending a faintly liturgical glow to the small enclosed world of the mews. Although his dwelling was small, its two stories were ideal for Bacon's purposes. One side of the house may already have been turned into a double-height space so that automobiles could more easily be placed on a hydraulic lift for repairs. That may have given Bacon the idea to keep the house divided vertically, with a second-floor entrance leading down into a double-height showroom. Bacon, Allden, and Nanny could use the remaining space on the other side of the mews house for their living quarters.

Visiting Bacon's showroom meant walking toward the ecclesiastical hall at the end of the small, narrow mews. A steep outside staircase led upwards to the entrance of number 17. The visitor then entered a kind of surprise—the radiantly open space below, two clean stories of air and light, which was not what one would expect in the higgledy-piggledy of a typical London mews or, indeed, a London still crowded with Victorian furniture and decoration. (The showroom was not unlike the open loft spaces in former factories that became fashionable after World War II.) The space could be used privately, to invite friends for tea or perhaps a well-made martini: the cocktail shelf awaited placement. Its main purpose, however, was to exhibit and publicize Bacon's furniture and rugs—and to inspire others with how modern people might choose to live in London, especially as small mews houses were beginning to come into vogue among stylish Londoners.

In creating his space, Bacon owed a debt to many important designers. One major source, as Bacon told Michael Peppiatt, was *New Dimensions: The Decorative Arts of Today in Words & Pictures,* by Paul T. Frankl: it became a guide to many in the field when it was published in 1928. Dedicated to Frank Lloyd Wright, *New Dimensions* was a textbook of design that contained advice such as this: "Our ceiling above should be as plain and simple as possible. The days for plaster scroll work and painted angels is past." And this: "Decoration is mainly a process of eliminating." Frankl reserved his highest praise for the design community Bacon knew best, the French artist-decorators: "The chief characteristics of [their] work

are simple lines, graceful shapes, with a slight elegance, and a restraint in applied decoration."

Above all, Bacon looked to Galerie Jean Désert. Both Eileen Gray's showroom and Queensberry Mews were painted white, and their high-rising walls contained no molding. In each, the most dramatic feature was an angular interior staircase. At Jean Désert, the staircase (which led to the basement) was a solid molded form that appeared thick enough for a person to sit upon. A similarly modern effect was achieved in Bacon's showroom where the thick, rectilinear walls of the staircase connected the narrow landing at the top of the stairs with the ground floor—and may well have been fabricated from poured concrete. Each studio was sparsely furnished. The dark wooden floors were mostly bare. A striped abstract rug was carefully placed near the stairs at Jean Désert, while in Bacon's showroom several rugs with a cubist look were positioned on the floor.

Apart from constructing the showroom itself, Bacon was making designs for furniture, having the pieces made up, and then planning where to place them. His glass-topped circular tables in particular resembled Eileen Gray's rounded chrome-and-glass tables of the period. One of them—seen in a photograph of the showroom taken in 1930—was supported by three slender tubular legs that connected to a tubular base that was itself a partial circle beneath the glass top. Bacon sent his mother a photograph of the showroom that also included a curved wooden bench, its two solid sides flowing upwards and leaving a molded seat in the center. It was an almost exact copy, in miniature, of a longer bench designed by Gray between 1920 and 1922. Another armchair had very thick wooden armrests and rectilinear cushions: it resembled pieces designed by Robert Mallet-Stevens for one of his commissioned houses, the Villa Cavrois in Croix. A large cabinet composed of a series of open and closed rectangular boxes was an airier version of Mallet-Stevens's designs.

As he struggled to get things right, Bacon was his own most important critic. The other critic, almost as important, was Madge Garland.

Stage Sets

The Studio magazine's "The 1930 Look in British Decoration," which included a spread on a young designer named Francis Bacon

READERS OF *The Studio*, an elegant English monthly with an international outlook, knew what they wanted: the latest trends in design; an overview of the current art shows; an indication of who was up and who was down in the world of decorating; and anything that might constitute "the new look." Founded in London in 1893, *The Studio* was the sort of insider magazine that helped make or break reputations, and like

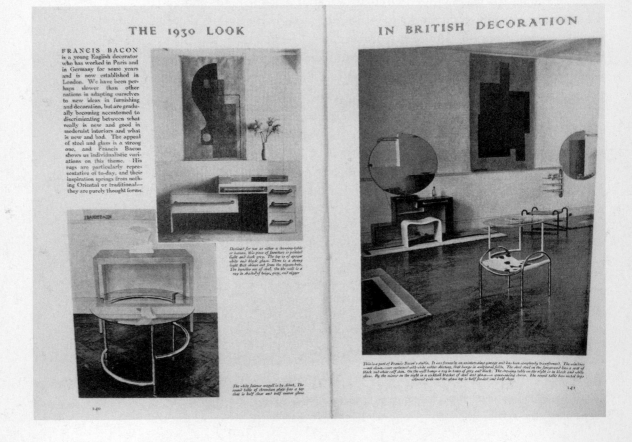

THE 1930 LOOK
IN BRITISH DECORATION

FRANCIS BACON is a young English decorator who has worked in Paris and in Germany for some years and is now established in London. We have been perhaps slower than other nations in adapting ourselves to new ideas in furnishing and decoration, but are gradually becoming accustomed to discriminating between what really is new and good in modernist interiors and what is new and bad. The appeal of steel and glass is a strong one, and Francis Bacon shows us individualistic variations on this theme. His rugs are particularly representative of to-day, and their inspiration springs from nothing Oriental or traditional—they are purely thought forms.

Madge Garland's and Dorothy Todd's British *Vogue* of a few years before, it had a strong modernist slant, though its purview was wide. Articles were devoted to such topics as mosaics, folk art, and "Modern Electric Light Fittings." It might also run a letter on art written by Picasso. The magazine regularly covered events in both France and England ("The Trend of Decorative Art: The Salon d'Automne," "The Spring Salon of the Artistes Decorateurs").

The six-page spread that appeared in the August 1930 issue—under the headline "The 1930 Look in British Decoration"—would typically have showcased the work of leading designers of the day. And it did so in part. Its second feature focused on an ornate room decorated for Lady Gerald Wellesley by the Bloomsbury lights Duncan Grant and Vanessa Bell; the room contained six life-sized murals (painted by Grant), wall sconces, and cane-backed chairs. The third feature celebrated the strong masculine aesthetic of the influential designer Serge Chermayeff: woodwork in English walnut, solid rectilinear furniture, and a functional sliding partition to separate the dining and living rooms. But the surprise of the package was the opening feature, which was entirely devoted to the spare, stripped-down work of a complete unknown whose name was Francis Bacon. Only the feature on Grant and Bell contained a byline— Madge Garland—but the writing in all three was consistent. Garland was the author.

Garland was a cat with nine lives. Her affair with Dorothy Todd had long since concluded. Her sacking by British *Vogue* was ancient history, at least according to the fashion clock. After her extended stays in France, she took a job in 1929 editing the women's section of *Britannia and Eve* magazine, an English general-interest monthly for women. It was not a position her highbrow Bloomsbury friends respected. "Rebecca West told her she could not possibly be associated with such a lowbrow publication, especially one with a name as absurd as *Britannia and Eve*," wrote Lisa Cohen in *All We Know.* But for the practical Garland it provided a salary during an economically perilous period. And she could find other ways to maintain her Bloomsbury connections and her presence in the design world.

Garland regularly championed her friends in *The Studio.* One signed article by Garland from 1930 focused on Eyre de Lanux, her good friend in Paris and the designer who collaborated with Evelyn Wyld at Jean Désert after Eileen Gray left for the South of France. Garland never acknowledged that she was writing about friends or that she herself, for example, organized the exhibit of Eyre de Lanux's interiors at the Curtis Moffat

gallery in London to which her own piece referred. Her tone remained one of impartial observation. Two other favorites of Garland's were the Bloomsbury-connected designers E. McKnight Kauffer and Marion Dorn. Kauffer, an American born in Montana, was a colleague of Graham Sutherland's who revolutionized British graphic art with his use of cubist geometry in—among other celebrated instances—posters for the Shell Oil Company. Garland was in love, not so secretly, with Kauffer's partner Marion Dorn, an important designer in her own right who, like Bacon, had her rugs made at Wilton's. While the couple's work was exhibited at the Moffat gallery, Garland published an unsigned piece in *The Studio* called "New Designs for Wilton Rugs by E. McKnight Kauffer and Marion V. Dorn: A Conversation with a *Studio* Representative."

It was a measure of Garland's extraordinary esteem and personal regard for Bacon that she chose to open her spread, "The 1930 Look in British Decoration," with the work of the unknown twenty-year-old. No other young artists or designers were featured in the magazine during those years. It was so unprecedented that Garland took pains to enhance Bacon's résumé: "Francis Bacon is a young English designer who has worked in Paris and in Germany for some years and is now established in London." Apart from wanting to help Bacon, Garland was also looking—as always—to advance the cause of modernism in provincial London. "We have been perhaps slower than other nations in adapting ourselves to new ideas in furnishing and decorating," she wrote, "but are gradually becoming accustomed to discriminating between what really is new and good in modernist interiors and what is new and bad." She named Bacon an example of the former: "The appeal of steel and glass is a strong one, and Francis Bacon shows us individualistic variations on this theme."

The spread included a large-scale photo of Bacon's showroom and alluded to the earlier purpose of the space as an "uninteresting" garage. No doubt Garland herself had observed the metamorphosis. She singled out the unorthodox window treatment: "The windows—not shown—are curtained with white rubber sheeting, that hangs in sculptural folds." These same curtains, surgically isolating the room from the outside world, would be part of Bacon's makeover of several fashionable rooms, including one designed for Garland herself. She also mentioned the "cocktail bracket of steel and glass—a space-saving device" that earlier provoked the quarrel at Vincent Square between Bacon and Allden. Two smaller photos highlighted individual pieces—one of a dressing table "in black and white glass" and one of another of Bacon's signature round tables: "The round table has metal legs coloured pink and the glass top is half frosted and half clear."

Perhaps most interesting of all was Garland's description of Bacon's rugs. "His rugs are particularly representative of today, and their inspiration springs from nothing Oriental or traditional—they are purely thought forms." Four decades later, recalling the era in her 1968 book *The Indecisive Decade: The World of Fashion and Entertainment in the Thirties*, Garland took some pride in her early patronage of Bacon—and used some of the same language she used in the 1930s to describe his work. The inclusion of Bacon in her book seemed to emerge out of nowhere, with no context, unless one knew about her *Studio* piece and the room she personally commissioned Bacon to design. "Francis Bacon, today internationally famous as a painter, was himself responsible for a 'constructivist' room," she wrote. "In this room long shelves were built against white walls, neutral-coloured rugs were woven in 'thought forms,' curtains were made of white surgical rubber sheeting and low glass tables, like the wall-mirrors, were circular in shape."

The *Studio* feature—everything Bacon could hope for—capped what must have been a frantic three or four months as the designer struggled to transform 17 Queensberry Mews into his version of the Galerie Jean Désert. It was not simple to turn an oily garage into a modernist dream. And he faced an unforgiving deadline. The showroom would have to be photographed well in advance if the article were to be published in the summer. Bacon—who relied on deadlines all his life to complete work—renovated the space in time. The *Studio* photographer who came to Queensberry Mews found a stark white room that, when compared to the frumpiness outside, represented an alternative world, like a stage set made for a science-fiction film about the future—a beguiling mix of radiant white, gleaming steel, mirrored glass, boxy chairs, animal skins, and mysterious geometries.

Exotic animal skins and patterns played an important part in art deco, but Bacon probably had additional reasons for making use of them. They reflected his ongoing fascination, since his teenage years, with big-game animals and Africa and also served as a robust, earthy foil to a pared-down aesthetic with which he was probably not entirely comfortable. The month of the photo shoot for the *Studio* article, Bacon wrote an upbeat letter to "Dearest Mummie" and enclosed some photographs. He took a moment to describe, in his free-form writing style, what she should particularly notice:

The staircase leads up into the rooms above. They are all rugs hanging on the walls The screen behind the glass table which lights up is not finished but I have done another panel since the photograph

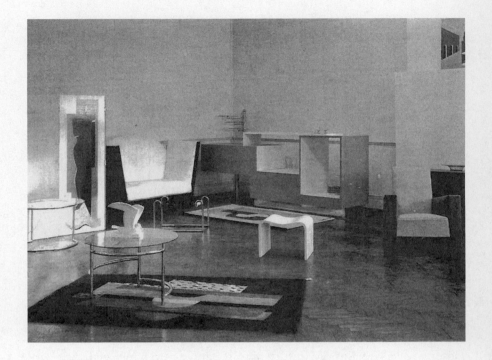

was taken I do so hope you will like them Do let me know. The little snap I also took. Do you like the rug above the calfskin pouff. It is my favorite, it has a brilliant yellow background The design is in dark brown, white, green, lavender and black. The table with the beads on [it] is of pale finish enamel and in the mirror is a black dressing table I will send you one of the desk as soon as I get it.

Bacon also sent photographs to his mother of individual pieces, writing descriptions of them on the back of the images. One photograph displayed a square table of "silver oak with a black glass top" on top of which rested a "seagull by [Jacques] Adnet"—a fashionable art deco designer. Bacon ended the letter with "All my love to you and Daddie for Easter. I am sending the children Easter eggs today love Francis." Bacon's mother would support her son in whatever he endeavored to do, but she was clearly bewildered by his interest in modern design. (She would have been dumbfounded by Paul Frankl's proscription in his book *New Dimensions* against the classical Oriental rugs favored by the British ruling class: "There is little excuse for the use of Oriental rugs except that one has them around and one has grown up with the impression that they are of immense value and therefore must be held quite sacred. Some people are either born with or inherit a flock of Oriental rugs; others marry into a

family of them. There are some, however, who set out deliberately to buy them and for such there is little hope or excuse.") Two years later, Bacon gave his mother a mirrored glass table, a rug, and a stool with a zebra-skin cover. Winnie placed the pieces in her bathroom, where no one else would see them.

After the showroom was completed and photographed, but before the article appeared, Allden proposed an Easter getaway: his young friend surely deserved a respite after all his work. Bacon sent the Easter eggs to his sisters, then traveled with Allden to Cologne and Munich to attend the Passion Play at Oberammergau, famously performed once a decade at Easter time by the inhabitants of the Bavarian village. The play presented the story of Christ from his entry into Jerusalem until his Crucifixion and Resurrection. No doubt the devout Allden, who also loved the theater, enjoyed the seven-hour-long Passion Play. Bacon was less appreciative. He disliked the Bavarian Alps, but found certain parts of the performance impressive, notably when the cross was lifted at twilight. He was growing interested in various depictions of the Crucifixion. He was too closely involved in his projects to stay on the Continent for long, however. Outside 17 Queensberry Mews, next to the stairs that led up to the door on the second floor, Bacon now hung a sign: FRANCIS BACON, DESIGNER. He was open for business. The artist H. M. Sutton, passing by that summer, happened to see the sign. "I was hawking my portfolio of art work, hopefully, to prospective buyers," he wrote to Bacon years later. "Intrigued by the sign I walked up the steps. At the top the door being open I walked in on to a narrow landing. Below was a pristine studio its walls hung with one, or two, rugs in simple colours and geometric design signed Francis Bacon. You looked up from the centre of the studio and kindly invited me down. We checked over *my* work." Bacon also prepared a business card that included a logo rather like the one Eileen Gray had created for Jean Désert. "Francis Bacon" appeared in a modern, geometric sans-serif font, set against a triangle and a series of narrow parallel lines that ran horizontally from the top toward the bottom of the logo. His address appeared just below his name, and below that was "Modern Decoration, Furniture in Metal, Glass and Wood/Rugs and Lights."

Once the *Studio* feature appeared, Bacon could look forward to more business. But he also faced a new challenge. How should he capitalize on the feature and his dramatic new space? He could aggressively seek commissions, of course, and operate a high-end furniture showroom with regular hours. That was what he should do to advance his reputation. But he also had more time now to paint. During the summer of 1930,

Bacon met a serious and well-regarded Australian painter named Roy de Maistre, another somewhat older gentleman—there was a fifteen-year age difference between them—who took a keen interest in the young designer, his showroom, and his painting. De Maistre gave Bacon an idea.

Of the artists whom Bacon befriended during his early years in London, Roy de Maistre was the most important. Like Bacon, de Maistre was a "sort of outsider" in London—his family was Australian—and his father was a horse breeder. Unlike Bacon's "failed horse trainer" of a father, however, de Maistre's was successful and owned an extensive farm. His family was devoutly Catholic. Born in New South Wales in 1894, the ninth child and sixth son in a large household, de Maistre was named Leroy Livingston de Mestre. Like Bacon, he became the family misfit and weakling. And, like Bacon, he was an asthmatic homosexual who preferred music and art to horses. He was remembered, in one account, "as a prissy little boy who always wore a bow-tie at play and wheeled his pram of dolls through the paddocks."

De Maistre grew up to become "a short stubby man without much hair . . . always correct in his manner . . . always neatly dressed in a grey flannel pinstripe suit, which he wore when he painted and never made dirty." He left his family early—at age eighteen or nineteen—to study art and music in Sydney, then emigrated to Europe in 1930. He seemed to live by unknown means, dressing like an Edwardian aristocrat. He liked to imply that he had noble blood, sometimes intimating that the mysterious limousine that regularly parked discreetly in his London neighborhood belonged to a member of the royal family. (It belonged to a wealthy homosexual patron.) De Maistre served dinner on fine china, secretly on loan from his cousin, indulged in fresh flowers daily, and spent ninety-eight pounds to line his dressing gown with fur when he came into a little extra money. He doted over a possible family link to the eighteenth-century French philosopher Count Joseph de Maistre. His Australian family was unfortunately named de Mestre, however, so he eventually changed his surname to "de Maistre," and his given names to Leroy Leveson Laurent Joseph. Around the time he met Bacon, he was still de Mestre but had already shortened "Leroy" to "Roi"—French for "king." In the end, he found that too obviously pretentious. The artist known in the late 1920s as Roi de Mestre eventually became Roy de Maistre.

De Maistre was a serious artist. He studied color relationships with the intensity, dreaminess, and putative scientific authority that was typical

of the era. Like Wassily Kandinsky, de Maistre regarded color as visual music, and before he left Australia for Europe, he was already known for comparing music and color. (He originally studied violin and viola at the New South Wales State Conservatorium of Music and, at the same time, learned painting at the Royal Art Society.) Eventually, de Maistre created a color chart in the shape of a wheel that corresponded to musical notes. He used his color chart as the basis for the "color music" pictures that he painted throughout the 1920s, in which colors were chosen to harmonize as they would in a musical scale. His paintings had titles like *The Boat Sheds, in Violet Red Key*. His most famous painting, completed in 1919, was called *Rhythmic Composition in Yellow Green Minor* and was regarded as the first example of abstract art in Australia. The *Colour in Art* show of the same year that introduced his work to Sydney was both controversial and a huge draw: some seven hundred people attended the opening.

De Maistre was a more experimental artist in Australia than he became in London. At the time he met Bacon, however, he was regarded as modern, established, and sophisticated—even about interior decoration. De Maistre had also done some serious design work as a young man, a fact that no doubt drew him to Bacon, in whom he probably saw something of his younger self. One of the purposes of his Colour Harmonizing Disc was to help interior decorators use colors knowledgeably, leading to the creation of an ideal modern room. De Maistre remained deeply interested, as was Bacon then, in the invention of a room of his own. The atmosphere of de Maistre's later studio, dating from the mid-1930s, was arguably one of his greatest creations.

De Maistre's reputation preceded him to London. No sooner did he arrive than an exhibit of his work was held, in July 1930, at the Beaux Arts Gallery, then one of the few galleries in London showing contemporary art. The gallery had been founded in 1923 by the sculptor Frederick Lessore and was later run by his wife, Helen, a painter with a particularly discerning eye. (Bacon would say that he had not known a better eye than that of Helen Lessore.) Bacon met de Maistre soon after the Australian's arrival in London. The connection was almost certainly through Gladys MacDermot, a wealthy Irish patron of art and artists who knew Bacon and had met de Maistre during the period from 1925 to 1929, when she lived in Australia and was part of the theater and art circles in Sydney. De Maistre, then part of the decorating world, had designed a room for her house, and he would naturally have wanted to see the room splashed across the pages of *The Studio* and created by this boy who possessed such charm.

Whatever his affectations, de Maistre, like Allden, was a kind and paternal man who enjoyed helping younger people. He became enamored of Bacon, though their relationship was almost certainly never sexual. (De Maistre's one passionate affair in the 1930s, a well-known one, was with an important art dealer named Robert Wellington.) Effeminate queens did not, in any case, sexually attract Bacon. But that suggested nothing, of course, about the potential for friendship. De Maistre liked spending time with Francis. At a certain point, he asked if he might possibly paint a picture of Bacon's showroom at 17 Queensberry Mews and if, perhaps, Bacon himself would sit for a portrait.

That summer or autumn de Maistre painted two pictures of the showroom and also a portrait of Bacon. It was probably then that Bacon and de Maistre came up with the idea that paintings could also be exhibited in this white modern room. De Maistre knew that the young designer was struggling to paint—as he himself had once done while engaged in decorating work—and he thought that Bacon might be intrigued by the idea of de Maistre's portrait of a designer hanging in the designer's own showroom. De Maistre had just exhibited at an established gallery, but was no less pleased to show his work in this young designer's singular space. The boy was young, talented, and untrained. Perhaps de Maistre could even help him with some technical tips about oil painting, and they could both exhibit their paintings in the space.

It would have been odd, however, to exhibit only two painters in Bacon's showroom—the one well-known, the other the nameless owner. It would have looked as if Bacon were reaching too boldly for a reputation he did not possess. And so Bacon thought of a third artist with whom to exhibit, but not one as well-known as de Maistre. Jean Shepeard, a remarkable actress and artist in her mid-twenties then making her way in London, had also grown up around horses, just not the kind raised by the Bacon and de Mestre families. Her parents were Jewish immigrants from Romania. When she was a child, her stepfather—an itinerant tinker—moved the family to Ireland, where they traveled in a horse-drawn covered wagon from fairground to fairground selling and mending saucepans. Despite her unconventional background, Shepeard was educated at a foundation school and managed to enter the Slade School of Fine Art in London, after which she won a scholarship to the Royal Academy of Dramatic Art. She seemed talented at everything—and liked by everyone. She knew painters and painted well, just as she knew actors and was a gifted actress. She was popular in Bloomsbury. She was a real force, said her niece Doreen Kern, "very domineering—an organizer."

Like de Maistre, Shepeard was more established in 1929 than Bacon. She had been included in a Summer Salon show at the Redfern Gallery along with Augustus John, Duncan Grant, and Roger Fry. She also exhibited at the Picture Lending Society on Bloomsbury Street with Fry, Vanessa Bell, and Ben Nicholson. A critic in 1931 wrote that Shepeard "has urgently something to say and at her best draws with great nervous vigour and amazing emotional power. Her work is alive, sensitive, and stimulating." Shepeard was never without her sketchbook, and many writers, actors, and artists of the day sat for her. Vanessa Bell, Virginia Woolf, Edith Sitwell, Noel Coward, George Bernard Shaw, Aldous Huxley, and T. S. Eliot all were captured in her line drawings. For four years she roomed with the actress Peggy Ashcroft on Gordon Square, a part of Bloomsbury, and she performed regularly on the London stage. She once toured with John Gielgud (who remembered her well years later). Eventually, she founded and ran her own theater company.

Shepeard may have met Bacon through her lover of the time, the Irish landscape painter Ronald Ossory Dunlop. Dunlop's background would have interested Bacon. His father was one of Yeats's best friends, and his parents were key figures in the Irish literary renaissance. Or, possibly, Shepeard and Bacon met through theater connections, such as the actor Ernest Thesiger, who was also a friend of Eric Allden. (Allden's friends in the theater world included Noël Coward as well.) In her biography of Ivy Compton-Burnett, a close friend of Thesiger's, Hilary Spurling memorably captured Thesiger's manner: "He had enlisted as a private in 1915 and baffled his command officer by taking his needlework with him," she wrote. "Ernest Thesiger was the man who said, or is supposed to have said, when asked for a first-hand impression of Ypres, 'My dear, *the noise!!* and *the people!!*'" Thesiger was a noted presence in so many different London worlds that he himself probably lost count. But the most likely connector, once again, was Madge Garland. Both Garland and Shepeard were woven into the world of Bloomsbury. Garland would have appreciated Shepeard's quick line, which was as deft (and sometimes caricatural) as a fashion illustrator's, though with a more serious intent. It was not uncommon then for artists and designers to exhibit together. Not only did few galleries of the time sell contemporary art, but many thoughtful people found the distinction between the decorative and fine arts artificial: the mix of genres in *The Studio* was proof of that. The Omega Workshops (1913–19), a Bloomsbury enterprise overseen by Roger Fry, had famously sought to erase or modulate such distinctions and made the argument that artists themselves should exhibit their own work.

The three artists agreed to exhibit in Bacon's design showroom.

WESTERN 1244

FRANCIS BACON
17 QUEENSBERRY MEWS WEST
QUEENSBERRY PLACE LONDON SW7

MODERN
DECORATION
FURNITURE IN
METAL GLASS
AND WOOD
RUGS AND
LIGHTS

The honour of your company is requested
at the opening of an exhibition on
Tuesday November 4th at 11 a.m. of recent
Paintings by Roi de Mestre
Drawings and pastels by Jean Shepeard
Paintings and rugs by Francis Bacon
Daily from 10-6

Invitation card for the 1930
show at Queensberry
Mews of the work of
Bacon, Roy de Maistre, and
Jean Shepeard—Bacon's
first public appearance

Shepeard provided eight pastels and twenty-two drawings, including portrait drawings of her two collaborators. De Maistre contributed seven paintings, among them an early *Portrait of Francis Bacon* that has been lost. (A few years later, he would paint a sensitive portrait of Bacon that did survive.) De Maistre's painting titled *Francis Bacon's Queensbury* [sic] *Mews Studio* highlighted Bacon's stark, soaring staircase to maximum effect. Bacon himself exhibited four paintings and a print called *Dark Child*. Just one Bacon picture from the show, *Trees by the Sea*, survived his destruction of his early work, probably because Eric Allden purchased it. It was later retitled *Painting* (1929–30) and may be the first oil Bacon completed. It was substantially larger, at three feet by two feet, than his small gouaches. Blocky forms represented tree trunks. Their branches, shorn of leaves, protruded skyward. A stylized beach was seen in the distance. The painting resembled the work of the French painter Jean Lurçat (as Ronald Alley indicated in the first catalogue raisonné of Bacon's art), in particular a 1926 Lurcat oil entitled *Paysage à Smyrne, l'arbre mort*. Bacon might have been partly drawn to Lurcat because of his work in tapestry, which had an obvious connection to artful rugs.

Bacon also exhibited his own furniture and rugs. Some rugs were hung on the walls like tapestries or cubist paintings. Bacon's folding screen was arguably the most striking work on view. Each of the three panels was six feet tall by two feet wide and contained stylized figures with tiny heads placed in a mysterious and theatrical space reminiscent of, among others, de Chirico. (Eric Allden also bought this screen, which he kept with him for the rest of his life.) Before the opening, Bacon printed a handsome invitation card in "fashionable eau-de-nil and black," as the art critic and historian Richard Shone described it in a piece in *The Burlington Magazine* devoted to the early show. He also made up a small catalog/leaflet to give to visitors that listed the works on display. It contained the dates of the show—November 4–22—and the times—"daily from 10 to 6"—it was open to the public. The pricing was ambitious. For his paintings, Bacon asked between twenty-five to forty-five guineas, very high for an unknown artist. (Guineas were considered a "gentlemanly" payment suitable for artists; craftsmen were paid in pounds.) The pictures of the

better-known de Maistre—or de Mestre, as he was still known—were priced at twenty to forty guineas. Jean Shepeard asked four or five guineas for her pastels and two guineas for her drawings. Bacon was in business.

At least one reviewer covered the show, as a clipping kept by Jean Shepeard attested. It was unsigned and undated; the publication was unknown. The reviewer praised Shepeard's work for being "of great sensibility and beauty of line . . . full of vigour and character." But the critic was mainly interested in the design elements of the show, treating the paintings as part of the larger environment. The headline on the piece was "Pictures for Interior Decoration":

> Transported into different and less congenial surroundings, these paintings might lose some of their interest, their main raison d'être being the decorative purpose which they serve in a general scheme of interior decoration. Not that Mr. Bacon and Mr. de Mestre are not gifted painters, but their individual eye seems to express itself chiefly in their sense of the fitness of their pictorial efforts to the ambient style of the room in which they hang. The pictures continue on the dead-white walls the shapes and designs of the metal furniture and the rugs.

The critic noted and praised the curious effect created by the two de Maistre painstings that depicted the very same interior in which they were exhibited, "a fact which in the present surroundings makes them appear like mirrors reflecting the room in different angles." Bacon and de Maistre would also note this beguiling mirror-within-a-mirror quality, of course, but it was doubtful that Bacon privately responded with equanimity. For the young designer it would have been an odd experience—perhaps disturbing in a stimulating way—to have the gifted older painter bring his witches' brew of brushes and paints into Bacon's pristine showroom and then, in the resulting composition, claim the room as a subject for his brush.

The juxtaposition between art and design was provocative. De Maistre depicted a very different room from the one illustrated in *The Studio*.

Painting of Bacon's Queensberry Mews studio by Roy de Maistre, the first artist-mentor in Bacon's life

The light in his paintings was subdued and melancholy, with nothing of the cheeky white élan suggested by *The Studio* photographs or noted by reviewers. In one picture, de Maistre emphasized the bars in the small windows at the far corner of the studio, some distance away from the dramatic stairway. In the other—a painting of the main studio space—he transformed the room into subtle relationships among planes and angles; the two glass-and-chrome tables provided the only curves in a space dominated by the angular stairway, the blocky desk at the foot of the staircase, and two rectangular rugs on the floor. In neither painting did the art deco sculpture have a fashionable gleam.

Serious paintings can burn holes in a fashionable room, and Bacon would have felt their lively intrusion in his decorated space. The de Maistres returned his gaze in a way the calfskin pouffe did not. Did his own paintings simply fit, as the critic said, into "the ambient style of the room in which they hang"? Did his cubist rugs, which he hung on the wall as almost-paintings, hold the eye as actual cubist paintings did? Could his large oil painting of a tree, which de Maistre may have encouraged Bacon to paint, inhabit the same world as his pouffe? Bacon's own sensibility as a designer was still not wholly clear. Although he was attracted to Eileen Gray's emptied spaces and elegant minimal aesthetic, he also liked Mallet-Stevens's robust, comfortable furniture. Where was his room? Which was his stage?

As he walked about his showroom, Bacon would also have paused before the two portraits to look into his own refracted face, as presented by Shepeard and de Maistre. The room did not just display his furniture. It presented *him*. Shepeard ordinarily depicted her subjects as open-eyed individuals charged with feeling. Her drawing of de Maistre, for example, described a balding, affable-looking person, his head resting against one hand, who appeared to be listening intently to someone just outside the frame. The actress personally knew Bacon as a charming young man with a bright laugh and big blue eyes, but she obviously saw something else too, which was reflected in her portrait. She portrayed him as a young man sealed off, his eyes sewn almost shut. He was not looking from the wall into his own room. In the middle of each closed eye she drew twisty vertical lines, like the loose threads around a knot.

Following this small splash in London—just four months after he had been featured in a trend-setting magazine and appeared in an exhibition—Bacon fell silent. No more shows; no more reviews. He was not a natu-

ral businessman. He did not appear able in a systematic way to cultivate the wealthy, study the market, keep appropriate records, and hire useful employees. The most important reason for Bacon's sudden silence, however, was probably the obvious one: he was losing interest in the field of design.

Or, more likely, the desire to be an artist finally possessed him. The young Bacon continued to dream of a Picasso-like eruption, liberating the dark forces suppressed within the conventional figure. How was he to do that? He lacked technical training, and he did not know what his art should look like. He was twenty-one years old. He had a further difficulty. Although he was drawn to explosive art, he was also strongly attracted to a more restrained style, one that focused on nuance and the quiet way a sensual passage of paint could come alive. He sometimes seemed pulled in opposite directions. Explosive or restrained; bestial or civilized; masked or revealed; raw or cooked. In fact, these contraries could form—over time—a sensibility locked in natural tension. A shy homosexual boy beset by illness might want to hide in a closet, growing there to love the shadowy thoughts and melancholy pleasures of the concealed life. That did not mean the same boy might not also dream of delirious release. In the months after his November 1930 exhibit of painting and design in Queensberry Mews, Bacon talked of going to pagan Greece, and he was already reading Nietzsche, who longed to transcend the Western room.

In 1931, as Bacon took up the life of a committed artist, he became captivated by two novels, one particularly English, the other exceptionally French. *Wuthering Heights* was a novel of suffocation and release. It moved between the boundless moors of Yorkshire (where the young Bacon traditionally visited his Watson relatives) and the close rooms of polite society. It was steeped in suppressed family secrets and explosive revelations. Over the entrance to Wuthering Heights were grotesque carvings, and the stormy Heathcliff—a man from nowhere who performed different social roles while remaining forever an outsider—was a sexually charged violator of boundaries. The visceral energy of Emily Brontë's novel, sometimes regarded as coarse by refined tastes, could nourish and inspire a young artist like Bacon, just then emerging largely unschooled from adolescence. *Les Enfants terribles*, which Jean Cocteau published in 1929 and Bacon probably read in French, came out the following year in England as *The Holy Terrors*. Like the Brontë novel, it was a theatrical story full of secrets and revelations. Its action took place mostly in a claustro-

Drawing of Bacon by Jean Shepeard, a gifted portraitist who drew many of Bloomsbury's most famous figures, and who showed with Bacon and de Maistre at Queensberry Mews

phobic sickroom occupied by two adolescents, an isolated brother named Paul and his sister Elisabeth, who engage in incestuously suffused games that eventually explode in a shattering release. Bacon was particularly taken with its opening scene, an ecstatic snowball fight among schoolboys during which Paul is hurt by a rock buried inside a snowball thrown by a beautiful, brutish boy whom Paul loves. Bacon even wrote a "scenario" for a film that resembled something from Cocteau. Perhaps he might become a filmmaker. . . .

In June 1931, Bacon saw *Thirty Years of Picasso* at the Alex Reid & Lefevre gallery in London. It included an important painting from the artist's Dinard series, *Baigneuse* (1929), and *Abstraction (Figure)* painted in 1930. Bacon had already seen Picasso's abstracted figural shapes—which suggested new ways of capturing the emotional truth of the figure—but probably only in the art magazines. Not only would Bacon's work in the following years often reflect the Dinard series, but the Reid & Lefevre exhibit demonstrated that in London itself there was also a small group of artists, collectors, and critics who supported Picasso; that is, an audience. In 1931, Bacon visited his cousin Diana in Bishopthorpe, Yorkshire, probably during the same summer the Picasso show opened. Diana had purchased some of Bacon's design work, including a table and a rug. In Yorkshire, Diana found her cousin full of moody thoughts, the kind that keep young Heathcliffs awake at night, including "suicide, insanity and lust."

It was likely the expiration of a two-year lease at Queensberry Mews that formally ended the period during which Bacon and Allden shared a flat. In December of 1931, they were still together when Bacon wrote a chatty letter to his mother at Straffan Lodge: "We would simply adore a turkey and plum pudding as I shall be here for Christmas." In the new year, however, the two went their separate ways. No doubt Eric Allden always knew that the young man with the big blue childish eyes would not live with him for very long. The pattern of Allden's later life, and also of his life before Bacon, was to offer help to one promising young man after another. And there was always another young man of promise. Their separation was probably not especially difficult. Allden did not care for messes. Just a certain passing melancholy; fond memories; and then tea or an occasional drink with the dear boy.

Neither man turned his back on the other. They remained cordial for years. Allden eventually moved into a flat at 73 Egerton Gardens in Knightsbridge, almost directly across the street from the Brompton Oratory and a brief stroll from Harrods. He loyally placed his collec-

tion of works by Francis Bacon among his more traditional furniture—
the watercolor of 1929; the gouache from the same year; the Lurcat-like
painting of the tree by the sea that was included in the 1930 Queensberry
Mews show. He also owned a Bacon rug and the three-paneled screen. In
one carefully composed photograph of Allden, taken later in his life, he
poses directly in front of the Bacon screen. In another, while seated on a
couch above the Bacon rug, he wears a striped suit, a polka-dot tie, and a
pocket handkerchief.

Starting Over

S UDDENLY BACON WAS FREE. No Allden, no showroom, no job. Why not share a flat in Paris with Diana Watson? The weather would be dreadful—in January 1932—but Paris was still Paris. (Diana, whose family was wealthy, could help defray the cost.) Practical problems arose. What was Francis to do, for example, with the rugs and furniture from Queensberry Mews? And how was he to make money? Before going to Paris, he must put his affairs in order.

Roy de Maistre helped out with the furniture. During the early 1930s de Maistre was making extended trips to France and, while abroad, leased a space in Chelsea—at Carlyle Studios, 296 King's Road—where he could store his paintings and belongings. Bacon now moved many of his own possessions into the same space. A recent émigré named Thérèse Veder once stayed in what she called Bacon and Roy de Maistre's studio at Carlyle Studios, and photographs taken either by Thérèse or by her future husband, Eric Megaw, depicted a large room filled with Bacon's furniture—including a rug, a mirror, a large squarish chair, and a famously uncomfortable high-backed sofa that de Maistre would later keep in his studio. Neither Bacon nor de Maistre probably lived or worked in the space, though Bacon may have spent a night or two there when he had nowhere else to go. He could even bring a customer to Carlyle Studios, should a customer wish to look at his design work. As for money and a place to sleep, Bacon retained a certain class-based confidence. Money and a bed would occur. He could move from room to room. His mother probably continued to provide him with an allowance, and she could always help out *in extremis*.

Bacon could also fall back upon a circle of friends in Chelsea centered around the designer Arundell Clarke. By the time of his Queensberry Mews show in 1930, or possibly shortly afterward, Bacon had begun doing occasional freelance work for Clarke. Not surprisingly—in the small world of modern design—Clarke was a good friend of Madge Garland.

During the late 1920s, he maintained a studio and showroom at 71 Royal Hospital Road, the same town house in Chelsea occupied by Garland and Dorothy Todd during their heyday at British *Vogue*. Clarke enjoyed being a mentor. Two other young designers were also working with him, each about Bacon's age. One was Misha Black, who later founded the influential Design Research Unit in London. (His work included the street sign for Carnaby Street.) The second was Richard Levin, who occasionally put Bacon up at his flat in Notting Hill. Levin would become, from 1953 to 1971, the head of design for BBC Television. His daughter, the artist Gill Levin, said a rug Bacon gave her parents remained in the family until it was threadbare.

In addition to doing occasional work for Clarke, Bacon made some money from older men. It was probably during this period that he began to hustle wealthy targets more systematically, looking for work as a gentleman's companion in the personals advertisements of *The Times*. The hustle, for Bacon, was rarely about just the money. It was still important to *steal* from the older men. The weak could nick the powerful even if they must surrender their bodies, the payment in coin if not love. All his life Bacon sympathized with petty criminals, isolated by the world, trying to find a way to get by. He later told the literary editor and writer Miriam Gross, "I can't say that when I was young I was at all honest. I used to steal money from my father whenever I could and I was always taking rooms in London and then disappearing—not paying the rent, not being able to."

Getting by was now, however, just a distraction. In 1932, having left Queensberry Mews, Bacon was swept up in a solitary dream of art. He displayed little patience for either chores or people. An exception was Diana Watson, who provided her cousin with a comforting presence when, as she observed, he felt "the need of someone to talk to" or was "starved for want of sympathy." They would meet several times a week, at tea or for an inexpensive meal, where the lonely painter described his evolving life as an artist. "He seems to be without any link with the outside world," she wrote, "except for the Nurse and myself." Diana knew how to listen to others. After her father's death in 1917, the prospect that she most feared had almost come to pass: being trapped in a lonely house in Yorkshire with a widowed mother. Mrs. Watson, said her daughter Diana, "thought that hubris, Greek tragedy, must inevitably be standing beside us."

If Diana herself could not bear to live year-round in Yorkshire, her

Diana Watson, Bacon's cousin and confidante in the 1930s and beyond

mother may have felt the same way, for the two women spent much of the late 1920s in London. As Francis set out in 1929 to become a modern designer, Diana and her mother moved into a house at 4 Thurloe Place in South Kensington, not far from Queensberry Mews. Diana had always found Francis to be "an oasis in the middle of a desert," a boy of "good temper" and "gay, serene disposition," a figure who "stood out in relief against the negative life in Yorkshire." In London, they renewed their intimate friendship, though Diana sometimes worried about her cousin's passion for painting and his tumultuous inner life. He had not always been like that. In a diary she kept at the time, Diana affectionately used the hyperbolic *mad* to describe him; he seemed to coil inward, barricading himself within art, while also flying outward to explore worlds traditionally ignored by families like the Bacons and the Watsons.

Francis was now "separated from a certain life," by which Diana meant their upper-crust background, but she may also have been thinking of Bacon's retreat from the wealthy modernist milieu of Madge Garland and Arundell Clarke. "The painting was more serious," she observed. "He never spoke of doing anything else." The two "went to music halls, circuses, down squalid streets—the paraphernalia of common life from which," she wrote, "I was completely shut off." Francis informed her that "things were more interesting in a place like Hoxton"—a working-class district in the East End also noted for its music halls and circus performers—"than in St. James Street." Her cousin was being led into "infinite worlds," Diana wrote in her diary, and she "marveled at his tormenting himself for such a passion." The young artist's mood was often heightened, but he did not drink much. "Everything was done without spending any money. I did not drink and [Francis] had no money. He drank cups of tea through the hours."

Sometimes, they went to a Lyons teashop in South Kensington where, said Diana, "a passable meal was had for one shilling and sixpence." The chain of J. Lyons & Co. teashops, spread throughout London, was both reassuringly cozy and prototypically modern. Many kinds of Londoners mixed and met there. On special occasions, middle-class families might visit one of the company's flagship Lyons Corner Houses—vast, multi-storied emporiums in the West End whose uniformed waitresses were called "Nippies"—where one could enjoy, in addition to restaurants, various shops and forms of entertainment. (At the Corner House in Coventry Street, homosexuals staked out an area that became known as "the Lily Pond.") In a "darkened empty teashop," the cousins would talk of "Byron & the romantic period.... These places were delightful to me,"

said Diana. "Rumour and legend are potent aphrodisiacs." She noted that her cousin's "freedom was very much greater than mine." He took an interest in the strangers who passed in and out of a teashop. Francis "always had contacts by accident. On decks of ships, waiting-rooms of aerodromes, restaurants, back-stage, Lyons . . ."

At this early age, Bacon's mature sensibility was already remarkably present—if still molten. He had the words but not yet the art. He was already insisting upon great themes and difficult facts. "His mind seldom moved from the facts of love, death, massacre and madness," Diana wrote, "in whatever form he could seize upon them." Most fine ideas were a wan coverup, concealing the underlying power of sex, illness, cruelty. He loved the visceral physics of the body and talked about "the beauty of blood." The arm holding the brush, he said, moved to the beat of his heart. The head was not something distinct from the body. A thick neck was "an advantage for the intellect, because it enables the blood to get to the head more easily." He wondered what the refined symbolists must have thought, at the outbreak of the great war, when the soldiers in boots tramped past. During the late 1920s, certain intellectuals in Paris were challenging the mental doodling of the surrealists: Georges Bataille insisted, for example, upon the brutal primacy of the abattoir. Bacon agreed. He would look for models in slaughterhouses, he told Diana. He hoped to find inspiration "inside of an operating theatre."

The ordinary surface of the world, expressed in art by "literal representation," now aroused in Bacon nothing but "disgust." No longer did he despair over the lessons he never learned in an art school, such as "the problems of perspective and arbitrary form." That form of control, in the modern world, was a lie. "A thing has to arrive at a stage of deformity," he told Diana, "before I can find it beautiful." Rather than well-laid plans, he believed in serendipity, chance, and accident. Once, after the camera slipped when he was taking a picture, he admired the unexpected result. "But it's a lovely effect, look how it's arranged itself. Do you think because it's an accident it can't be good?" He took Diana to see acrobats—performing at the Lyons Corner House in Tottenham Road—whose contortions thrilled him: the "position of their bodies, seen from underneath, from above, hanging, suspended, jumping." (He would especially like, twenty years later, the unexpected poses found in the photographs of Eadweard Muybridge.) He admired the legendary Barbette, a high-wire performer who was also a female impersonator, which was another form of contortion. Barbette, said Bacon, was a "real artist."

To provide the brutal facts with a theatrical foil, Bacon was already

inclined toward gold frames. And he often spoke with theatrical effervescence. "Everything is given in a confident narrative," Diana said, "clear and full of power." He appeared oddly upbeat, despite the darkness of his worldview. "He always had a feeling that miracles did happen. He was so accustomed to being carried along by chance." That was a seductive aspect of his character, that he should appear filled with both lights and darks. He was also funny and—despite the chiaroscuro of his conversation—enjoyed the gray tones of irony. (He once became angry with a friend, probably Eric Allden, "who could not let him enjoy his tragedy in peace.") In 1932, Diana watched as "flaming forms and screaming backgrounds" appeared and disappeared in his painting. He saved almost nothing, though he might for a time be "cheered" by a picture. But "his passions are immediate and violent," she wrote, and she regularly observed the "sudden dislike that settles on his mind about a finished work."

By 1932, Bacon had found his essential subject: the Crucifixion. It gave him a point of concentration, a kind of clarifying lens, as his work began to form. "At tea," wrote Diana some years later, Francis "said he could not get away from the Crucifixion idea—that he never really wanted to do anything else." She called it his "frightful Crucifixion complex" and saw him depict "a bandaged Christ lying on a table." Almost all of Bacon's subsequent art could be regarded as part of a broader Crucifixion-like scene in which the central event was rarely presented while all around and to every side—in innumerable smaller scenes, like Stations of the Cross—pictures emerged that were related to the central theme. It was not the Christian sacrifice per se that excited Bacon. He was looking for the displaced modern Cross, the one shorn of religion, and he already sought inspiration in the pagan authority of the ancient world. One Christ figure he painted had "Semitic" rather than European features.

On his studio wall, Bacon—sometimes working through the night—hung a diagram of the human nervous system. Scattered near his easel were "innumerable white china plates," dripping and stained with colors. Occasionally, he worked without brushes so nothing would come between him and the figure. He often rubbed the paint into life with his hands and used his fingers or a bit of filthy rag to elicit details on the canvas. He added—experimentally, but with increasing knowledge over time—whatever amounts of oil, water, and probably dust he thought might awaken the flesh or help generate a powerful image. If the picture became a mess, he might take a rag and wipe the canvas with his eyes shut to see what happened, an approach inspired by the surrealists. He sought power not finery, wanting to enter "the vital parts," Diana said, "without any lights or shades."

Early in the summer of 1932, Francis and Diana finally made the trip to Paris proposed six months earlier. More than two hundred Picassos were on display at the Galeries Georges Petit—Picasso's first large retrospective in Paris. No doubt Bacon saw the show, though Picasso was not what most interested Diana, who did not mention the Galeries Georges Petit or the Louvre in her diary—or, indeed, any of the sites in Paris that a well-brought-up girl might visit with, for example, her mother. Her cousin "liked" Montparnasse, where she noted the "gold domes & dirty streets—the squalor of the Place d'Alésia on a hot summer night." They walked through "the glare of a June afternoon" and, later, saw the avenue du Maine streaming "away under a smooth yellow sky at ten o'clock." A pianist was "playing an old song over & over again" in a basement. Francis lingered in bookshops ("their counters piled high with treatises") along the Seine and in Montparnasse, as he did when he lived there, looking for offbeat images. They took photographs of each other. Some were ordinary tourist snaps. In others, Bacon positioned himself or Diana in a pose that might prove useful to a figurative painter. He was finally a working artist in Montparnasse.

In 1932, Arundell Clarke moved from his flat in Chelsea—at 71 Royal Hospital Road—to Bruton Street in Mayfair, a tonier address for an ambitious English designer. The following year, his friend Madge Garland also moved to Bruton Street. (The famous couturier Norman Hartnell lived next door to Garland.) Clarke had the flair for business that Bacon lacked. If he was looking toward Mayfair while he was in Chelsea, he now began to focus on New York. During the Depression, Clarke's kind of modernism—luxurious, if seemingly "severe"—fared better in America than in London. In October 1933, *The New York Times* noted that "Arundell Clarke, Ltd., designer and maker of modern English furniture and pottery," was renting two shops in the elegant British Empire Building in Rockefeller Center. The New York showroom prospered. By 1947, "former English designer Arundell Clarke" was launching a new textile division for Knoll Associates, the leading American manufacturer of modern furniture, and in his five-story headquarters on Madison Avenue, he showcased handcrafted objects and promoted the work of architects and designers, among them the young Philip Johnson.

Clarke was fond of Bacon in the early 1930s, not only providing him with freelance work but also hiring Nanny Lightfoot to cook for him in Bruton Street. When Clarke's elderly father—who had been living with Clarke at 71 Royal Hospital Road—died in June 1932, Clarke, now in

Bruton Street, had no more need for his flat in Chelsea. He knew that Bacon dreamed of becoming a painter and could use a studio and a bed. By the autumn of 1932, Bacon was living in Clarke's former residence at 71 Royal Hospital Road, probably with Nanny. He now had a proper studio in which to paint, solidifying his position as an artist. Chelsea was a place where artists congregated, moreover, unlike South Kensington or Mayfair. A later friend of Bacon, Michael Wishart, described Chelsea then:

> Chelsea in those pre-war days had almost nothing in common with the district as it is today. It was something like a tranquil market town: a real artist's quarter, and more romantic than the rest of London. The King's Road was a quiet residential street.... Family grocers and a few small inexpensive restaurants all added to the homely domestic atmosphere of an untroubled lifestyle which exists nowhere today.

Some wealthy people also lived in Chelsea. Bankers and businessmen with slightly unconventional tastes enjoyed Chelsea and inhabited the larger houses by the Thames or near Sloane Square. Margaret Lygon Fenton, the daughter of an alderman whose family moved to a substantial town house at 3 Embankment Gardens during this period, found the mixture of worlds a central feature of the district's character. "Artists really were here," she said. "But a lot of city people [bankers and financiers] were too. It was a wonderful thing—so relaxed. When you went to Belgravia you really had to tidy up." At the time, wrote Richard Shone, Chelsea remained "socially smarter" than the other areas of London that attracted artists, such as Hampstead or the Charlotte Street area near Bloomsbury. One could be bohemian, but also "above the salt."

A cliché of London life during the 1930s was, in fact, that anyone who lived in Chelsea was an artist. In his memoirs, the flamboyantly homosexual Quentin Crisp half-joked that this kept him from harm: "Later, when I lived in Chelsea (which was proof positive that I was not of this world), this deference to art often saved my skin. As I stood pressed against the railings of some dim London square with a stranger's hand at my throat or my crotch or both, another member of the gang would whisper, 'But he's an artist. I seen him in Chelsea.' Immediately the grip on my person would loosen and, in a shaken voice, my aggressor would say, 'I didn't know.'" The Chelsea of the artists was found on the narrower streets and in the older houses of what had once been a hamlet. "It was," said Fenton,

"very much a village." Oscar Wilde and the American expatriate paint-
ers John Singer Sargent and James McNeill Whistler once lived on Tite
Street, almost around the corner from Bacon on Royal Hospital Road.
The writer Radclyffe Hall, whose *The Well of Loneliness* introduced many
young Englishwomen (including Bacon's sister Ianthe) to the subject of
lesbianism, also lived on Tite Street. Chelsea's reputation for arty naugh-
tiness lingered well into the 1950s. When a well-known Chelsea house
came on the market in 2011, for example, the *Evening Standard* noted that
"When Mr. Fenwick Owen bought the lodge [in 1958], Chelsea was seen
as bohemian and rather risqué and his mother was concerned no one
would venture from Mayfair to visit him."

Bacon enjoyed juxtaposition and pointed coincidence. It was pleasing
that Sargent and Wilde had lived around the corner. Carlyle Studios,
where he stored his furniture, was a short walk away. Arundell Clarke's
house, where he now lived, was also once Madge Garland's house. Two
blocks away was 26 Ormonde Gate—the house his sadistic cousin Cecil
Harcourt-Smith occupied before his divorce. Next door, at 27 Ormonde
Gate, lived a man named Geoffrey Gilbey, a well-known racetrack cor-
respondent whom Bacon soon met. Chelsea was small, neighborly, and
uncrowded, its houses often occupied by a single family. New arrivals soon
came to know, at least on a nodding basis, their neighbors—especially if,
like Bacon, you were handsome and inclined to hold a passing eye. Geof-
frey Gilbey was a neighbor in his early forties, with a wife and two young
daughters. He was a member of the wealthy family that owned Gilbey's
Gin. After founding a wine importing company, his grandfather Alfred
and his great-uncles, Walter and Henry Parr, began in 1872 to distill Gil-
bey's gin, which became the basis of one of the significant fortunes of the
day.

Geoffrey himself possessed a rare combination of qualities. He some-
times wrote pieces about religion (*Pass It On: Religious Essays*) or books of
light comedy (*She's and Skis* and *Not Really Rude*). But his presiding passion
was horse racing. He was the author of *Horse Racing for Beginners* and *How
to Bet and Win*. And he was well-known as the racing correspondent of
the *Daily* and *Sunday Express*. He kept a stable of racing ponies. Like many
public school men of his background—Gilbey went to Eton and then
Christchurch, Oxford—he engaged in some gentlemanly naughtiness.
He had an affair with Terence Rattigan in 1927 while the future play-
wright was still at Harrow and Gilbey was the racing correspondent for
the *Daily Express*. Their affair was exposed after Rattigan leaked a story
to Gilbey about student opposition to compulsory military training at

Harrow. ("Rattigan was probably not expelled," noted the author of *A History of Harrow*, "because of his useful combination of academic ability and promise as a batsman.") Geoffrey's first cousin was Monsignor Alfred Gilbey, who, after retiring as the Roman Catholic chaplain at Cambridge, became a picturesque adversary of all things modern. When he was "robed in the sanctuary," it was "watered-silk purple soutane, tasseled cape and purple pompon to biretta."

There were few charming young homosexual artists who could discuss horse racing with Geoffrey Gilbey. Bacon would enjoy telling him about running bets to the bookies for the Major. The racecourse at Cheltenham would interest Gilbey, of course, as would those in Ireland. Bacon's old friend from Dean Close, A. L. Jayne, called Gilbey not only a "fine writer and truly Christian man" but a person "who may have tried to help Francis as he did me in those early years." In what sounds like a highly fanciful position, Gilbey hired Bacon to be his "racing secretary," a title Bacon surely relished. (It would have amused the young Bacon to inform his father that he had finally found a job that the Major could not possibly disparage—working for a figure in the horse world who was actually successful.) In 1933, the cultivated Gilbey probably visited Bacon's studio a few minutes away on Royal Hospital Road in order to see what "modern art"—then often a cause of bemusement—the amiable young man was making.

Gilbey's next-door neighbor for a time was an ambitious London politician named Eric Hall, who had moved with his family into 26 Ormonde Gate, the house where Cecil Harcourt-Smith had once lived. At the time of his divorce, Harcourt-Smith had likely put out the word that his house was available. It often happened that houses and flats passed among friends when private circumstances changed. Hall and Harcourt-Smith were both men from "good families" who probably knew each other. Married and with two children, Eric Hall was eminently respectable. But he was also a quiet epicurean who—like Gilbey and like Harcourt-Smith—was a serious gambler who loved horse racing. Bacon could easily have met Hall through either Harcourt-Smith or Gilbey; or, he might have met Hall at the Bath Club, where Hall was a member and where Bacon had an odd job at one point. (It was thought that P. G. Wodehouse modeled the swimming pool of his fictional Drones Club, where Bertie Wooster took an unexpected dip, on the pool at the Bath Club.). It was the most natural thing in the world, in any case, for Eric Hall to drop by his friend and former neighbor's house to discuss with Gilbey upcoming races of mutual interest. *Eric, have you met my . . . racing secretary? He also makes modern art.*

Like most of the men in Bacon's life during the 1930s, Eric Hall was old enough to have known the world and experience its regrets—yet young enough to want something more. He was different from Eric Allden in an important respect. Whereas Allden was now a somewhat effete observer who had set aside his ambitions, Hall remained a determined player in the larger world. After Francis left Allden to become an artist, he found in Hall a powerful older lover.

Born in 1890, Hall was a well-connected Tory. His father, a surveyor who made a fortune as a developer, sent his son to Malvern College, a public school founded in 1865 in Worcestershire. Like Wellington, the school that Bacon's father attended, Malvern maintained connections to the military, sending its boys both to Oxford and into the officer corps. In the fall of 1909, when Bacon was born, Hall matriculated at Trinity College, Oxford. He chose to pursue a classics degree, a highly respected decision at Oxford and one that suggested that he was a good student interested in the humanities. But Hall struggled during his first year, failing to pass the Part I exam until the final term. He changed his course to history, where he did little better, leaving Oxford without an honors degree in 1912. It was unlikely that his results indicated a lack of intelligence or academic skill. Instead, he probably enjoyed Oxford too much, like many boys liberated from public school. "To modern eyes this would seem a shocking academic failure, and the pass degree (as opposed to Honours) is no longer an option," according to the Oxford archivist Clare Hopkins. "However, in the Edwardian period such a result was far more common, and certainly no bar to a successful career!"

Particularly, it would seem, if followed by military service. In September 1914, one month after England entered the war, Hall enlisted in the Middlesex Regiment, known as the "Duke of Cambridge's Own." He joined the 16th battalion, informally called the "Public Schools battalion," where he was commissioned a lieutenant and sent to the front. Like Bacon's father, Hall succeeded in the military and, in January 1916, was promoted to the rank of captain. Hall fought in the Battle of La Bassée early in the war and then at the Battle of the Somme in 1916, where he was part of the disastrous first day's attack in which the British army suffered fifty-eight thousand casualties (one-third killed in action). Hall described his experience in classically restrained, stiff-upper-lip terms. "On the morning of July 1st 1916 I was in command of A Company 16th Middlesex Regiment, 29th Division. We were to attack the trenches in

front of the village of Beaumont Hamel [on the Somme] at 7:30 a.m. My company was timed to leave the trenches about 7:34 a.m. On mounting the parapet we were received with intense rifle and machine gun fire just as the battalion of the 2nd Royal Fusiliers and C Company of our battalion had been in front of us." Those in Hall's company not killed immediately as they went over the top would have seen, splayed out brazenly before them, dozens of slaughtered and wounded soldiers, many crying out and grotesquely tangled in barbed wire.

"I got to within a few yards of the enemy's trench," Hall wrote, "when I was severely wounded in the knee." The Germans repulsed the British offensive or, as Hall diplomatically put it: "The whole attack was held up and there was no further attack during the day." Then, for almost ten hours, Hall lay bleeding in no-man's-land. The Germans hoisted the Red Cross flag in the late afternoon in order to collect the dead and wounded. They did not initially notice Hall on the field. Once he was found, no stretcher was available. Four German soldiers dragged him into their trenches and sent him to a dressing station. His family heard only that he was missing in action. Hall spent the next half-year in prison camps and hospitals in western Germany, his wound described as "very severe." He could not easily walk: a bone broken behind his left knee left him with a permanent disability. He was sent in December 1916 to Berne, Switzerland, to undergo an operation and then interned for eight or nine months in Mürren, an alpine village in southern Switzerland. The operation left his damaged leg an inch too short. For the rest of his life he wore a shoe with a built-up heel and had a discernible limp. In September 1917, he was repatriated to England. Four months later, though deemed unfit for active duty, he served as an adjutant helping to establish a Royal Air Force facility in Epping.

Hall married in December 1917, soon after his return home. Barbara Preston, five years his junior, was seventeen during Hall's final year at Oxford—and, possibly, still a student at Bedales, a progressive but socially prominent school that she attended in Hampshire. In a wedding photograph, Hall looks dapper in his army uniform and hat, his trousers tucked into high boots. He has a mustache and a sword by his side. His expression is confident. His round-cheeked and cheerful bride poses with him under the arch of the church; she is arrayed in a cascade of lace and carries a spray of lilies. Hall appeared set to become the sort of man who forms the backbone of the community—successful, prosperous, useful, perhaps a little dull. After he left the army in 1919, Hall became (possibly after a period of banking) the Establishment Director at Peter Jones, an upscale

department store in London. Peter Jones was founded in 1877 and located on Sloane Square, the commercial center of Chelsea and not far from Ormonde Gate. Hall administered the day-to-day operation of the store but also began to take an interest in politics, becoming a member of the local borough council. He would spend over three decades in London politics, with a particular focus on schools and recreation.

Hall possessed a natural air of authority. In vacation photographs taken at the beach with his young family—his daughter Pamela was born in 1919 and his son Ivan in 1921—he appears young, bronzed, and healthy. On a sand dune, wearing what looks like a swimming cap, he darts a glance at the photographer as if suddenly aware of the intrusion and not pleased. Another picture shows him standing erect against a striped cabana, virile and at ease. Hall appreciated elegant clothing, the best restaurants, and days at the racecourse. He liked his gentlemen's club. The wife of one of Hall's friends, who remembered him as "very suave," called him "self-assured and comfortable and worldly."

In the 1920s, Hall inherited a fortune from his mother. No longer obliged to work for a living, he gave himself over to politics, philanthropy, and life's passing pleasures. He served as a county alderman on the London County Council from 1931 to 1937, a period when he spent much time with Bacon. In addition to local education, he took a great interest in the humanities and the arts, as his early decision to pursue a classics degree might suggest. He sought ways to help museums, musical groups, and arts organizations. He was the kind of man invited to serve on boards; he would eventually become chairman of one of London's symphony orchestras. Having experienced firsthand the horrors of World War I, Hall could perhaps understand more easily than most the disruptions of modern art—especially when they were created by Gilbey's charming young racing secretary.

After he met Bacon, Hall asked to visit his studio. "One day he came to find me," said Bacon. "He was very interested in my painting and from that moment on he began to help me without ever letting me down." *Without ever letting me down.* Francis Bacon could pay no higher compliment. Eric Hall was not the first man in English politics to have a secret life, but it seemed possible that if he had not met Bacon, Hall might have lived a conventional existence seasoned by a few forgivable vices. The Englishman who marched into barbed wire at the Somme was not ordinarily subject to disruptive feelings, but he now proved willing to

Eric Hall, the alderman who came into Bacon's life in the early 1930s, with his two children, Ivan and Pamela. He fell "completely and insanely" in love with Bacon.

risk everything—his political career, his marriage, his family, and his fortune—for the young artist. In the beginning, Hall's friends and family tried to avert their eyes, though the pretty Chelsea artist was not easily overlooked. Sometimes, Bacon even wore makeup: a touch of powder on the cheek, a glistening of red on the lips. Certainly not someone an officer would have found useful at the Somme.

Hall's steady world began slowly to upend, but in the quiet way of a Tory gentleman. Francis always appeared to have free time, of course; he lived just around the corner. It was not difficult for Hall to steal the hours. He had no regular job—just certain official appointments and responsibilities that were flexible—and in the evenings he could often be at his club. Eric Hall, said John Richardson, "fell completely and insanely in love with Francis." If Hall's friends could not fathom his interest in the boy, Bacon's friends felt much the same way about Hall. What did Francis see in a middle-aged Tory with a gimpy leg? John Richardson acknowledged that he was "prosperous looking" but found him "very conventional. He was pompous and stuffy." The young Australian novelist Patrick White, a friend of Roy de Maistre who came to know Bacon later in the 1930s, tersely noted: "As lover there was an alderman." Eric Allden and Roy de Maistre, then becoming friends owing in part to their shared interest in Francis, regularly tut-tutted over the older man's evil influence on the boy. They may have been a touch jealous. In September 1933, after de Maistre returned more or less permanently from France, Allden wrote, "We talked of Francis, who he [de Maistre] thinks is beginning to get restless. He fears that he is deteriorating in his habits and way of living. Poor little boy. Francis is one of those people who always arouses my protective instincts. He is like a child and needs to be cared for like a child." Some months later, Allden and de Maistre repeated the conversation. "We talked of Francis and both regretted the influence Hall continues to exercise over him. Poor little Francis!"

For a young man to be loved by someone like Hall had immeasurable value. Money was not the only important element, though Hall was much wealthier than Allden, able to gamble and lose. Hall began to educate Bacon in the pleasures of London, which extended further than Eric Allden's tea, theater, and visits to the museum. Hall had no qualms about betting big on the ponies or ordering the best bottle in order to improve Bacon's palate. He took the superficial pleasures of the world seriously, as one who almost died on the battlefield may. Hall recalled with nostalgia "the feeling of great leisure & peace" from before the war, and he would have sympathized with one of Nietzsche's observations about the Greeks:

Oh, those Greeks! They knew how to live: for that purpose it is necessary to keep bravely to the surface, the fold and the skin; to worship appearance, to believe in forms, tones, and words, in the whole Olympus of appearance! Those Greeks were superficial—from profundity!

It may have particularly mattered to Bacon that Eric Hall was a powerful man of the world—as straight as any officer at attention—who could yet love and respect him. Hall cared about his opinions. Hall wanted him to be a successful artist. Hall enjoyed teaching him the ways of the world. (It did not hurt that Hall displayed not the slightest interest in fox hunting.) Even so, Bacon was never a kept man. In the bedroom he might be sexually submissive, but he would not accept any great imbalance of power or authority. Hall's financial assistance likely gave him more time in the studio, helping him find his way as a painter, but he continued to earn money of his own through freelance design commissions. It was probably Bacon's idea in the mid-1930s to spread some of Hall's munificence to his other mentor, Roy de Maistre, who had also once made the move from designer to artist. Although he took pains to appear manor-born, friends knew that de Maistre struggled financially. Why not help him with a commission?

At mid-decade, de Maistre painted a portrait of Hall. Well aware of his secret life with Francis, de Maistre—whose art could be psychologically provocative—depicted the middle-aged lover wearing a well-cut suit, starched shirt, and perfectly knotted tie. The handkerchief in his pocket was impeccably pointed. Hall appeared to be a contained man who kept his thoughts to himself. His strong hands were as carefully clasped as his tie; his balding head reflected the light. And yet, de Maistre found a way to suggest the extraordinary interior world of his subject. Hall's shadow fell across a luminous crimson wall of flocked velvet wallpaper, glowing with fanciful curlicues and arabesques. Hall was a masculine man with a baroque inner life.

Around the time that de Maistre painted Hall's portrait, he also made one of Bacon. If Hall was a well-composed man with a florid inner

Roy de Maistre's revealing painting (c. 1936) of Eric Hall, whose proper exterior belied a baroque inner life

life, Bacon resembled—as de Maistre once described him—a "rather dubious choir boy." His tie was not perfectly knotted, but slithered like a snake down his shirt. He appeared both shy and theatrical. His face was powdery with makeup, his eyebrows thickly penciled, his eyes defined by heavy shadow. The lipstick was bordello-bright. The background was again important. (Bacon once observed to Diana—in a squalid pub lodging house—"what a psychic feeling the wall-paper gives.") Just as with Hall's portrait, de Maistre chose a reddish backdrop for Bacon's. If Hall's world was filled with dreamy but precise arabesques, Bacon's appeared hot, formless, and shimmering. The portraits deserved to hang together. They made an unusual couple, Eric Hall and Francis Bacon.

Not a single Bacon painting from 1931 and 1932 has survived, despite Diana Watson's description of her cousin working with such excitement. There was no compelling reason for their survival, no more than there was for the school work of most twenty-two-year-old art students. And that was what Bacon was then—a student—though his professor was mainly himself. Bacon during the early 1930s was rigorously schooling himself both in matters of sensibility and, more practically, in matters of painterly technique. How was he to put what where? His approach, as Diana Watson's diary suggested, was not one of cool appraisal. It was helter-skelter. Try things and then more things. Eric Hall, while an inspiration in certain respects, could not help Bacon become a modern artist. In the London of 1932, few could provide such assistance.

Bacon nonetheless found occasional instruction, both at hand and from afar. In 1931, Amédée Ozenfant (1886–1966), the French painter and writer, published the English edition of his influential *The Foundations of Modern Art*, which first appeared in France in 1928 while Bacon was in Paris. During a period when few substantial books on modernist art were available and information did not easily cross the Channel or between studios, *The Foundations of Modern Art* served as a kind of quirky, brilliant, and learned schoolroom—a sourcebook of images and ideas. It helped Bacon, who owned the 1931 edition, become fluent in the language, tactics, and controversies of modernism.

Ozenfant did not respect ornamental effects. He was best known as the founder, with Le Corbusier, of a movement that criticized the decorative character of synthetic cubism. "Purism"—also the name of a book they published in 1918—emphasized the fundamental building blocks of form, proposing an art that could give modernity the orderly spine of classical art. Bacon's own earliest surviving paintings included aspects of both synthetic cubism and purism. Ozenfant's work in the mid- to late-1920s contained "purer" forms than Bacon's did, but the young artist's visual vocabulary included classical columns, the inevitable guitar shape, and—particularly in his *Watercolour*—the use of wavy lines that could have been borrowed from Ozenfant. The relation was also close in the three dramatically elongated figures found in Bacon's "painted screen" from 1930, which the Picasso scholar Anne Baldassari has called "painting 'disguised' as 'décor,'" where each body was topped by a tiny head and wore robes reminiscent of the ancients.

Cézanne was the modern catalyst, according to Ozenfant, setting up the cubists who followed: "It was only after Cézanne's death that the Cubists, with no uncertain finger, pointed nature to the door." It was an idea that appealed to Bacon, then recoiling from the deceiving appearance of the world. Ozenfant gave credit to Dada as a "nihilistic protest against art" and also to surrealism: "The turn of thought of the Surrealists of 1927 is melancholy: but it forces us to think, and that is much. Their preoccupations mean something." Ozenfant delighted in upending apple carts, even those filled by modernists. The Old Masters could also be modern in their way, for example—another idea that appealed to Bacon—and their old-fashioned elements could be renewed or remade:

> At certain of my lectures on modern art I successively projected different masterpieces on the screen without any attempt at order, and without attributing either date, or school, or artist's name to them: as, for instance, Seurat, the Egyptians, the Cubists, the Greeks, Cezanne, negro Art, Michael Angelo, the incised carvings of prehistoric caves. A few specialists realized what I was doing, but the majority of my audiences thought it was all modern art. It is quite natural and most reassuring. Masterpieces are always modern.

Ozenfant found beauty in forms others overlooked, mixing into his book images drawn from every aspect of modern life. Not only did art imitate life; life also imitated art in the forms assumed by modern machines, unfurling buds, wave structures, or even "a diatom seen under the Micro-

scope." An interest in photographs, machines, and the mechanical—which Ozenfant and other modernists considered essential—was already shared by Bacon. Ozenfant's book contained an image of the instrument panel on Charles Lindbergh's airplane, and a photograph called "Temple or Machine? The First Sulzer Compressor." Although Bacon and Ozenfant would finally differ on what mattered most, they were companions on the elusive modern quest for the fundamental. Both looked well beyond the parochial concerns of the contemporary art world to find what they wanted.

As a mature artist, Bacon often sounded rather like Ozenfant. He would say that "observing" the world—not just art—was "his life": "I observe all the time, even when I'm almost drunk." The example set by certain artists that Ozenfant admired may have helped strengthen Bacon's determination—at a time when many of his contemporaries insisted upon abstraction—to concentrate on the modern figure. Ozenfant hailed Rodin, for example, as an essential innovator rather than an interesting throwback. "It is somewhat surprising that Rodin the revolutionary should almost systematically be ignored in works dealing with modern art," Ozenfant wrote. "The freedom with which Rodin treated nature and the human form, was added to that of Cezanne liberating himself from the subject. Fauves, Cubists, and all succeeding schools are indebted to these two masters."

From de Maistre, in the early 1930s, Bacon took other lessons. To begin with, de Maistre provided a model. He was a homosexual modern artist, powerful but not intimidating, who was succeeding in the world. To a casual acquaintance, de Maistre—fastidious and effete—might have resembled Eric Allden. But he was remarkably strong-minded. The novelist Patrick White, who knew de Maistre well in the 1930s, acknowledged him as an "intellectual and esthetic mentor," which was high praise from a graduate of Cambridge who would go on to win the Nobel Prize. John Rothenstein, the director of the Tate Gallery from 1938 to 1964, described de Maistre as "a small upright figure, a miniature Roman emperor, dignified, discreetly dandified, courteous in an old-fashioned style, unyielding in his principles, exacting in his standards of behavior, to his friends boundlessly benevolent." His affectations were easily mocked, but the world de Maistre fashioned for himself was not pathetic. To enter his studio at 13 Ecclestone Street, reported White, was to embark "on a voyage of discovery. The narrow, white boarding of the studio walls

together with white curtains did in fact suggest an actual ship. Through the great windows along one side, a sooty, fog-bound yard became in my eyes a mystic garden." To Rothenstein, the "theatre of Roy's actions was his home, his studio, the place where he preferred to see his friends, and which he was forever embellishing":

> Roy's studio was a work of art . . . The Roman Missal and the opera hat reposing on a small table inside the front door, miscellaneous chairs and pieces of porcelain, of fine design and inherited from remote French ancestors, a screen painting by Francis (one of his earliest surviving works), and an art nouveau settee also of his design; paintings of Roy's own from his early Australian years to work in progress, characteristic gifts from generations of his friends. All these miscellaneous objects, arranged with the art that conceals art, created an environment of tenebrous beauty . . . as was an element of fantasy by the palettes placed on a high shelf showing as black silhouettes against the sky.

De Maistre conjured his illusory royal lineage with panache. "Friends reported dinner parties at his studio," wrote his great-niece Heather Johnson, "where the serving was done, by virtue of his royal connections, by waiters lent from Buckingham Palace." It was all make-believe. De Maistre's friend Geoffrey Houghton-Brown—a gentleman who bought and renovated decrepit mansions—once noted that "Roy wanted to go to two smart weddings near Reading so I hired a smart car, dressed

The artist Roy de Maistre in his studio, which many described as a work of art in itself

as a smart chauffeur and took him to both." De Maistre's friends and patrons included, among others, Sydney Courtauld Butler, the daughter of Samuel Courtauld, the textile magnate and art collector who, in 1932, founded the Courtauld Institute in London. Her husband, R. A. Butler—known familiarly as "Rab"—was a leading Conservative politician. Bacon himself would never have wanted to play de Maistre's particular role, but his example assured Bacon of something critical: You can present yourself on a stage of your own making. You can bet your life, and save your life, on your performance. You can assume power as if you inherited it.

De Maistre was also a man on a quest, like Ozenfant an artist in search of something fundamental. Eventually, in 1949, he converted to Roman Catholicism. "I believe his faith was a genuine one," wrote Patrick White, "though it had a worldly tinge; he would have favoured a priest in watered silk rather than a peasant in a grubby cassock." In the early 1930s, de Maistre became attracted to Dimitrije Mitrinović, a visionary born in Herzegovina who lived in London. Mitrinović, a charismatic man with a small but passionate following, was by turns a philosopher, art historian, political analyst, and utopian dreamer. "There is no record of de Maistre's ever becoming an ardent follower," wrote Johnson, "but the idea of 'an organic, harmonious world order,' based on a combination of Eastern and Christian theology, beliefs developed from theosophy and Rudolf Steiner's anthroposophy . . . were ideas de Maistre, although not officially espousing, was sympathetic to." Bacon derided religion, but also sought the overarching sensation of truth—his reading list in Ireland did not lie—and de Maistre's ambition, if nothing else, would encourage him not to settle for the small insight or pretty effect.

During 1932, de Maistre—while often abroad—came occasionally to London. One day he walked to 71 Royal Hospital Road and climbed the old staircase up to Bacon's studio. A formal studio visit, especially by another artist, is seldom a casual matter. The wrong word can end a friendship; the right one sustain a lifetime of work. De Maistre had noted something in Bacon's painting—something more, perhaps, than he first saw at Queensberry Mews. The boy might be an artist. He was so determined and impossibly ambitious. That de Maistre was intrigued became clear over the next months, as he spent significant amounts of time thinking about Bacon's studio. The largely untrained Bacon was beginning to make surprisingly well-done pictures, at once stylish and sensually painted, in addition to his more explosive art. They were influenced by Picasso, as was de Maistre himself, but Bacon was also struggling

with the big and difficult in a way that interested the older man, who had himself tried to strike a grander chord.

It would become essential to Bacon, later, that he appear sui generis—self-taught and untouched by any but a few distant masters. Some technical instruction in oils could certainly have helped him, however, since he did not seek the "naïve" look found in folk or outsider art. Bacon later said that he could not recall much about his early years with de Maistre, though the two remained friends until de Maistre's death. When de Maistre was asked if he had instructed Bacon, the older painter was invariably modest, although he did recall questions about painting not long after they met that were quite elementary. With someone who was not going to write an article, however, Bacon was more forthcoming. Thirty years later, a young man working as a chauffeur and handyman at the Marlborough Gallery—Terry Danziger Miles, later an art dealer himself—dropped off a book at Bacon's studio, and the painter offered him a coffee. "We got talking . . . and he said that he had a friend called Roy de Maistre who was an Australian painter who basically taught him how to lay paint onto a canvas. Not how to paint paint, but how to actually control the paint [on] the canvas." In short, de Maistre helped Bacon with technical matters rather than with a style, subject, or vision. He did not provide the words or the sentences—just some of the letters.

De Maistre brought Bacon one other element a master gives an apprentice: day-to-day gossip and chat about developments in art. Bacon could never remain quiet when another person was in his studio, and the same was probably true of the sociable and well-mannered de Maistre. During the 1920s and 30s, those few who looked across the Channel with interest at cubism and surrealism, including Bacon and de Maistre, discussed *Cahiers d'Art* with the intensity of medieval exegetes poring over a text by Aquinas. "Each of its huge issues . . . unlocked and lavishly exhibited secret gardens of world art," wrote the poet Geoffrey Grigson. "*Cahiers d'Art* was the great eye-opener; it was divine visual food for those on a starvation diet." Picasso's Dinard series was a continuing influence upon both de Maistre and Bacon, but while de Maistre simply added the style to his array of modernist devices, Bacon was now trying to use the Dinard series to uncage his "something big." Bacon himself emphasized the impact of the series on his development—what he called Picasso's "surrealistic women." He relished the playful female forms, tiny heads atop immense bodies with free-flowing arms and legs and breasts, finding them deeply suggestive of a truth that could not be conveyed by superficial realism:

Pablo Picasso, *Bathers at the Beach Hut*, 1929, part of the Dinard series that strongly influenced Bacon in his early years as a painter

The figures in the Dinard series were the "real realism, because it conveys a whole sensation of what it's like to be on the beach," said Bacon. "They're endlessly evocative, quite beyond their being extraordinary formal inventions. They're like the bullfights. Once you've seen them they remain in the mind."

Picasso's images were "profoundly unillustrative but profoundly real about figures."

Bacon's imagination in the early 1930s was also captured by certain other Picasso images. He and de Maistre would have discussed the figures in *Three Dancers* (1925), which Bacon probably saw in person at the Galeries Georges Petit retrospective in 1932, in which a naked dancer has raised her arms, preparing to pirouette. Her two partners have linked arms behind her. A mysterious element of danger underlay the performance in *Three Dancers*. The dancers' arms were pinioned to the top of the image: the dance was a kind of crucifixion that acknowledged death no less than life. In Bacon's *After Picasso, "La Danse"* of 1933—a direct homage—that element of danger was reinforced. The Bacon picture depicted three figures tremulously hovering somewhere between bodies in motion and bodies nailed to a cross. The figure in the lower right seemed to wear a long, flowing gown; but just above her arms was the unmistakable horizontal thrust of the cross. Her upflung arms could almost be nailed down. The other two figures appeared to be bending forward, also as if nailed to an imaginary cross. Long striated lines ran from the top to the bottom, distancing the viewer from the ghostly dance of death.

In 1932, de Maistre asked to paint Bacon's studio. Both artists would understand the implications of the request. Two years before, in 1930, de Maistre had painted Bacon's design showroom at Queensberry Mews. Bacon had not altogether left the design world, but this new request differed from the first one. De Maistre was now depicting an *artist's* studio. And Bacon, in his new studio, could now observe an older artist studiously prepare his canvas; adjust his paints; select this and that brush;

make the cut with the knife; wipe some-
thing down with his rag; pull off dead paint.
Bacon, in his own studio, could observe de
Maistre's observation of his studio as they
gossiped about the world. It was a kind of
teaching concealed as a social occasion.
Technical instruction mattered but was,
of course, the least of it. That a serious
artist should choose to paint a picture of
his studio possessed a value, to a young
painter, that could hardly be overstated.
It was a laying on of hands and a friendly
shove.

Over the coming months, de Maistre
painted several pictures of Bacon's studio,
each with strong allegorical overtones.
Up to a point, de Maistre depicted what
he saw, but he also adjusted the image to
intensify its meanings. The early studio
of Bacon, according to friends, was messy.
De Maistre instead presented a clarified

stage. In his first picture, titled *Francis Bacon's Studio*, he emphasized the
finely chaotic angles of the (probably) attic ceiling. Bacon's thoughts may
have been strong but were still unordered. The open door to the studio
gave onto a dark passageway, the door's edge running vertically down the
center of the image. To the right of the door, de Maistre depicted several
stacked paintings—only one of which can be seen—that blocked the exit
from the studio. (The artist would not easily escape from the light of art
into the darkness of the world.) The one visible painting in the stack
contained an image of a creature that resembled a feathered version of
the Dinard figures. On the opposite side of the door—against the far
wall of the studio—was a single painting that depicted what seemed like
some strange mythical creature. With its long and craning neck, it fore-
shadowed the nightmarish figures in Bacon's best-known work, painted
more than a decade later, *Three Studies for Figures at the Base of a Crucifixion*.

In 1933, de Maistre painted another version of Bacon's studio, this
one even more abstract and allegorical. The door again opened onto
his studio, the way again blocked by a painting. The mythical creatures
were now replaced by geometric forms. Bacon's circle mirror—one of
his designs—hung on the far wall. It reflected sharply diagonal shapes.

Francis Bacon's Studio
(1932) by Roy de Maistre.
The long-necked
creatures anticipate the
fearsome ones in Bacon's
breakthrough work, *Three
Studies for Figures at the
Base of a Crucifixion*, 1944.

Leaning against the mirror was an unfinished painting of a headless figure. Next to this painting was an abstract-seeming cone. De Maistre's painting also contained a surprise. In the dark passageway leading to the studio, he limned the outline of a dreamy, ghostlike figure that has not assumed flesh-and-blood form. The painting was titled *New Atlantis* and was probably made for Mitrinović, who bought a number of de Maistre's paintings and used the phrase New Atlantis to convey his own utopian aspirations. (The ghostly figure in the painting could represent to Mitrinović an ideal figure still Platonic in form, and the geometry his new formula for mankind.) But the figure could equally represent an incomplete artist standing before a room of possibility. De Maistre took an interest in genealogy. He would know that Bacon's celebrated ancestor, the original Francis Bacon, wrote an unfinished utopian novel called *New Atlantis*.

Early Success

IN 1932, FEW CONVERSATIONS about modern art took place in Depression-bit London. The Tate Gallery did not purchase its first Picasso until 1933; and it was a pleasing picture from 1901 of a vase of flowers. Kenneth Clark, the art historian and longtime head of the National Gallery, said of the 1920s: "In England the people who had seen a Cézanne or a Renoir, even in reproduction, were few, and for the most part hostile." If some foreign modern art appeared in a gallery, it was typically regarded as a bizarre curiosity, like a headdress from the South Seas brought to England by Captain Cook. At its best, modern English painting was tasteful in the Bloomsbury way. There might be a wild card or two in the pack, such as Walter Sickert or Stanley Spencer, who all would agree were *interesting*. A market for contemporary art hardly existed. Collectors desiring a conversation piece crossed the Channel to make a purchase.

Nothing in the London art world resembled what later periods called a "scene." In 1925, when Rab Butler was courting Sydney Courtauld, he felt duty bound to learn about art, given her family's legendary collection of impressionists. "About very modern [French] art I'm rather ignorant," Sydney explained to him, but then named Charles Dufresne—a fauvist/cubist painter, sculptor, and decorator now largely forgotten—as "the most modern man in Paris." Picasso's importance stemmed mainly from theater design, she wrote, and he was "much better known for his decorative work," specifically his collaboration with Sergei Diaghilev and the Ballets Russes, which often performed in London. Her perspective was not unusual. A nationalist spirit in post–World War I Britain led many painters to resist Continental influences.

But there was one brilliant outlier in London, little known to the general public, that championed modern art from the Continent; and in the early 1930s Bacon found his way there. It was one of those mysterious

bookstores with a soul. Located at 78 Charing Cross Road, Zwemmer's was founded in 1924 by Anton Zwemmer, a "tall, elegant, at times formidable and austere Dutchman" who was interested in Continental modernism. His bookstore soon became invaluable, helping to keep alive in London the barely flickering modern spirit. In the period between the two World Wars, art historians and artists and "those interested in the applied arts" frequented Zwemmer's—then the only major art bookshop in London—and found what could not be located elsewhere, particularly books and magazines from abroad. The aging wooden shelves and display cases were so crowded with books that customers hardly had a place to sit or stand.

Zwemmer's was close to Shaftesbury Avenue and the theater district, and writers and actors also liked to stop in for a browse. T. S. Eliot located obscure books from the Continent on its shelves; and the rare English collectors of modern art, such as Sir Michael Sadler, regularly stopped by. Kenneth Clark was an admirer of the shop. Clark, who had become director of the National Gallery at the strikingly early age of thirty-one, would often have his latest personal purchases—not usually of modern art—framed at Zwemmer's, which maintained a lucrative sideline in that business. Zwemmer himself usually had lunch at the Ivy restaurant near Covent Garden, then a favorite of writers, artists, and actors.

Long before any English museum exhibited cubist and surrealist painters, their work was on display at Mr. Zwemmer's bookstore. Clark later recalled that color reproductions of van Gogh's paintings did not exist, "and when they first appeared in Mr. Zwemmer's windows they were almost deliriously exciting. The same is true of Picasso and Matisse." If Francis Bacon during the 1920s and '30s wanted to look at a large collection of modern art, he went to Zwemmer's, where the reproductions could be found in books and magazines (in particular the essential *Cahiers d'Art*). When Zwemmer went to Paris to acquire art books, journals, and modern rarities, he would also meet with important artists, among them Dalí, Miró, Matisse, and Picasso. In Montparnasse, Le Dôme was his café.

In 1929, Zwemmer decided to open a small art gallery around the corner from his bookstore. At first, he intended to use the storefront—at 26 Litchfield Street—to sell high-quality reproductions of art from Skira, a firm in Lausanne that specialized in art books. Soon, however, he began to exhibit actual works of art. To manage the gallery, Zwemmer hired a young man named Robert Wellington, who was as well-connected in the English art world as Zwemmer was in Continental circles. Wellington was a creator of sparks who, like Madge Garland, knew how to stage art.

He became an early master of the opening event. The son of Hubert Wellington, a lecturer at the Royal College of Art and a painter of note, he seemed to know everyone. "Robert Wellington's meticulously noted and retained appointment diaries read like a who's who list of artists, patrons and exhibitions of 1930s London," wrote de Maistre's biographer, Heather Johnson. "In 1932, for instance, Wellington had meetings with Robert Medley, Paul Nash, Ivon Hitchens, Ben Nicholson, Graham Bell, Mark Gertler, Charles Ginner, Victor Pasmore, and Stephen Spender—most several times." In 1933, his entries expanded to include Henry Moore. In that year he also met Roy de Maistre. The two almost immediately began an affair.

Wellington knew two other Bacon friends, Arundell Clarke and Madge Garland. In 1932, the year Bacon moved into Clarke's flat in Royal Hospital Road, Wellington included Clarke in a group show along with such other acquaintances of Bacon—

and Madge Garland favorites—as Curtis Moffat, Marion Dorn, and McKnight Kauffer. He mounted the first one-man show in London of Dalí, the surrealist always sure to gather a crowd, and organized an exhibit around the book *Laughing Torso*, the autobiography of the Welsh artist and art world personality Nina Hamnett, an artist close to Bloomsbury who was also a showy bisexual who relished the high life of the Montparnasse cafés. Wellington opened that exhibit with a cocktail party, something then unheard-of, which attracted the gossip columnists. Art met the martini glass: attending the opening were the composer and conductor Constant Lambert; Lady Rothenstein, the former actress; the socialite Lady Juliet Duff; the distinguished artist Augustus John; and the director of the Tate Gallery, J. B. Manson.

There was one other brash spirit in the London of the early 1930s who soon joined Wellington in challenging the fusty art world of the time. The young art dealer Fred Mayor (known to all as "Freddy") sought to carry the modern spark directly into fashionable monied London. Like Wellington, he was exceptionally well-connected and, now thirty years old, delighted in pushing social boundaries. "He was the most charming man," said Lindy Dufferin, the Marchioness of Dufferin and Ava and an artist. "He was in with Bloomsbury. Freddy was very much in that set. He was short, ebullient, a little bit pudgy. He exuded charm and confidence."

Freddy Mayor, the charming owner of the Mayor Gallery, which included Bacon in its debut show in 1933—with his wife, Pamela, in Mayfair

Mayor had grown up in France, where his father had moved after his wife was disinherited for marrying an artist. In the 1920s, he became one of the Bright Young Things of the era. He enjoyed the titled world. "He knew all these young peers who he'd get to buy a little Degas print or something," said John Richardson. "He was a racing guy. He'd go to races on the weekend. And lord so-and-so would have won some money on a rank outsider who came in 40 to 1. 'OK,' Freddy would say. 'I've got just the painting for you. Put the money in a painting.' He was that kind of dealer. And he was a nice man." Mayor certainly knew Gilbey—everyone in racing knew Gilbey—and no doubt met the handsome young "racing secretary" then setting up a studio in his friend Arundell Clarke's flat in Royal Hospital Road.

Freddy's first eponymous gallery, on Sackville Street, was known during its brief tenure—in 1925 and 1926—for exhibiting contemporary European art. When that gallery folded, Mayor served as secretary of the London Artists Association, a Bloomsbury group headed by, among others, Maynard Keynes. Adrift in 1930, he ran a small space inside the interior design gallery of Curtis Moffat, the American photographer and designer, at 4 Fitzroy Square where he exhibited mainly Bloomsbury artists and friends of Moffat's, such as Duncan Grant and Vanessa Bell. He had also exhibited Picasso, Matisse, and Modigliani in a forward-looking show called *Since Cézanne*.

Without the money to open a splashy gallery on his own, especially in Mayfair, Freddy brought in partners. The most significant was Douglas Cooper, who became the gallery's curator. Cooper, who would later befriend Picasso and become his main English champion, had not yet assembled his great collection of cubist art. But he was decidedly ambitious, with an exceptional eye for talent and a trust fund of 100,000 pounds. Very bright, very loud, and exceedingly quarrelsome, Cooper was the great-grandson of Sir Daniel Cooper of Woollahra, who had made a fortune in Australia and been knighted. Douglas himself was often mistakenly assumed to be Australian, one of the many and varied things to which he took offense. The backwardness of English taste, in particular, affronted him. Both Cooper and Mayor knew the French modernist world well. Cooper had studied at the Sorbonne and had met Daniel-Henry Kahnweiler and Pierre Loeb, two leading dealers of avant-garde art in Paris. He had already begun to collect Picasso and Braque. Mayor, raised in France, knew "hundreds of living artists," as one newspaper account put it, and traveled back and forth to Paris frequently. Mayor and Cooper were, in short, about as French as one could be in the London art

world of the early 1930s. The *Daily Express* dubbed Mayor the "Maecenas of the extreme Left in art" and reported that he "hasn't spent a week-end in London for seven years. Drives annually to burgundy district. Likes old burgundy."

To stand out in Mayfair, Mayor and Cooper decided that they must have a modern space for modern art. Mayor and Cooper selected Brian O'Rorke, a young, prizewinning architect known as a modernist, to design a gallery on Cork Street. Arundell Clarke also played a role. The result was a starkly modern interior with a white-and-orange exterior that contrasted sharply with its surroundings. The *Daily Mail* observed that "The white and orange-vermilion frontage of the premises cannot fail to attract attention and stimulate joviality in the visitor before he crosses the doorstep." The *Daily Mail*'s critic P. G. Konody noted that "The very interior, with a ceiling on different levels, rustless steel furniture, hidden lighting and severe simplicity, has the effect of a Cubist picture." The inaugural exhibition had an anodyne title—*Recent Paintings by English, French and German Artists*—but placed English artists first, an implicit declaration that English modernists could now hold their own with those across the Channel, including Braque, Picasso, Masson, and Ernst.

The inaugural exhibit opened on April 20, 1933. Hanging beside the French and German works were three paintings by Edward Wadsworth, two by Ben Nicholson, and one each by John Armstrong, John Bigge, and Tristram Hillier. Affixed to the Hillier was a cage containing a live white dove, which generated just the sort of hooting derisory commentary—the headline in *The Daily Sketch* was "Too, too Symbolic"—to attract attention. Henry Moore was represented by four sculptures. And then there was *Woman in the Sunlight* by the twenty-three-year-old Francis Bacon.

Why would an obscure young painter—described by Diana Watson as "isolated"—receive an invitation to this rarefied party? Not only was Bacon sharing a room with Picasso and Braque; he was also much younger than any of the other English artists, each of whom exhibited regularly. The explanation was not talent alone. Personal connections played their part. Like Madge Garland, who was willing to feature an obscure boy-designer in her 1930 feature for *The Studio*, Roy de Maistre would be willing to speak to Freddy Mayor on Bacon's behalf. So would Robert Wellington, Arundell Clarke, and Madge Garland. The most important link may well have been Douglas Cooper, who was probably distantly

related to Eric Allden. Bacon and Cooper likely met through Allden while Bacon was a designer. Cooper even commissioned a desk from Bacon, "a massive, Bauhausy piece painted battleship grey"—perfect for a fighting critic. In the summer of 1932, during Bacon's trip to Paris with Diana Watson, Bacon spent some time with Cooper, there to see the Picasso retrospective at Galeries Georges Petits.

Bacon "wanted success very badly" during this period, said Diana—while adding the qualification that he "did not like lion-hunting parties and wearing evening clothes so much." But Bacon knew how to hunt lions in his own way. (In 1931, Diana observed, "He seems to be getting on. Perhaps it is the writers he sees.") For a young artist in an economically desperate time, he appeared to lead a charmed life. The inaugural show at the Mayor Gallery was fairly well-received. More than thirty reviews and short feature pieces were published about it. The critic for *The Times* wrote, "It should help to destroy the silly notion that the new picture is being produced out of perversity." Some argued that the English artists could not sustain comparison to their French peers. But Mayor was nonetheless filling a "want," as Edward Crankshaw wrote in *The Week End Review*, by offering a "continuous display of the newest international art."

Bacon's *Woman in the Sunlight*, which he subsequently destroyed, was not well-received. *Time and Tide* reported that "*The Lady*, by Francis Bacon . . . has a tiny piece of red mouse-cheese on the end of a stick for a head." *The Observer* thought "works shown by Max Ernst, Francis Bacon, and Paul Klee . . . can but be taken as practical jokes." (It was enough to be mentioned, however, between Ernst and Klee.) *Harper's Bazaar* described Bacon's painting as "a tiny ray of [sunlight] falling through cosmic darkness on a glass of champagne which denotes a woman"—which sounded nothing whatsoever like the "flaming" Crucifixions Diana observed in his studio. Bacon's art dealers and probably the artist himself, as he tried different approaches in the studio, no doubt chose one of his more sedate pictures for the exhibit, one that would have suited the showroom of the young designer at Queensberry Mews. It did not seem too far in spirit from the cocktail shelf and the deco seagull.

The cultivation of worldly success did not make Bacon hypocritical or lead him to become less "isolated" in his work. It was natural for him sometimes to work in a restrained style, and he retained a serious interest in the more pleasing forms of modernism. The following year, for example, he would create the most "painterly painting" of his early career—*Interior of a Room* (c. 1934), a mix of lovely greens, shimmering purples, and brightly patterned wallpaper (with a dog on a rug before an implied

hearth). Various elements of the painting may have been inspired by the softer and more sensual side of Picasso, who seemed to offer Bacon help in whichever direction he turned. The wallpaper in the painting, for example, evoked decorative patterns in Picasso's work. Bacon was also attracted to eccentric colorists, especially Bonnard, who could capture extraordinarily subtle and complex moods through unexpected relationships of color. And yet, the first recognition Bacon received from the art world was leading him where he did not always want to go.

He was probably more interested in the disturbing, long-necked figures that anticipated *Three Studies for Figures at the Base of a Crucifixion* (1944). So was de Maistre, whose *Figure by Bath* of 1934 depicted a bulbous creature craning its head over a claw-footed tub. The two artists possessed some sort of stuffed animal, perhaps a children's toy with a long neck, that they were using as a kind of surrealist model. Picasso's Dinard series was the main inspiration. (There was no reason not to keep stealing from the master-thief of modernism.) Bacon in 1934 also made turbulent pen, ink, and wash drawings that stemmed from Picasso's studio drawings of the early 1930s, and was especially drawn to the way Picasso treated the Crucifixion. Throughout the late 1920s and in 1930, *Cahiers d'Art* reproduced Picasso's drawings of the Crucifixion, which alternated with images of bathers. Bacon studied them: "There are some beautiful drawings around the Crucifixion," he later said. Picasso's drawings culminated in a small oil, *The Crucifixion* of 1930; the convulsing bodies and gaping mouths anticipated *Guernica*. The first series of drawings was followed by another in 1932. This one—the so-called Boisgeloup suite of thirteen drawings—was inspired by Matthias Grünewald's shocking Altarpiece in Isenheim. The raised arms of this Christ were cross-nailed and his fingers curled upward in pain. Six different Picasso drawings on the theme appeared in *Minotaure* early in 1933. Later that year, Eric Allden reported that Bacon "is mad about Grünewald's paintings and the German primitive school, and Michelangelo, whom I remember he rather despised at one time."

Perhaps Bacon could reimagine the crucified body. He liked Picasso's contrast of white figures and black backgrounds—and also, surely, the visceral immediacy that Grünewald transmitted to Picasso. As he focused in 1933 on this subject, Bacon also found inspiration outside of art. He owned a book called *The Wonder Book of Electricity*, for example, that contained modern images of electrical patterns that could almost be an arterial map or an excited nervous system. The patterns suggested a lit-up agitation, a crackling in which every nerve fires at once. Bacon was always

dreaming of passing through the body's surface in order to reach its essential wiring. The emerging technology of the X-ray naturally appealed to him. The X-ray machine was a source of fascination for the public—some shoe stores possessed X-ray machines in which a customer could place his foot in order to admire his bones—and X-ray imagery (like the Dinard figures, electrical wires, nerves, or the diaphanous spirits summoned by a medium) evoked the hidden parts of human life.

In 1933, Bacon painted a small black-and-white Crucifixion. It owed a debt to Picasso, yet was not like anything else in art. The Christ figure was a ghostly emanation; any lingering sensation of flesh came from the earth tones of the vague cross and background. Yet the figure was physically vivid, almost more so than human flesh. The religious-minded might have supposed, but only for a moment, that the Holy Spirit was escaping the body. In fact, the ghostly ectoplasm was nailed down, and three white brushstrokes—like ribs stripped of flesh—held the body in place.

Not long after their well-reviewed debut show, Mayor and Cooper began to cast about for other provocative ideas. Following *Recent Paintings by English, French, and German Artists*, the gallery had exhibited the paintings, gouaches, and collages of Max Ernst. It was a worthy show—Ernst's work was hardly known in England—but aroused little talk. Mayor and Cooper heard that a writer named Herbert Read was intending to publish, in late 1933, a book called *Art Now*. The title expressed Mayor's own ambition: London must stop thinking of *art then* and consider *art now*. Why not borrow Read's provocative title? Why not organize an exhibition around the publication of his book?

Read readily agreed. An energetic young man eager to make his mark, Read had been raised on a farm in Yorkshire and early on moved into the literary and art worlds. (His first book, a volume of poems, was published in 1919.) In the late 1920s, he supported himself by working in the ceramics department of the Victoria and Albert Museum, but he left in 1931 to take up a position as professor of fine art at the University of Edinburgh. That position lasted only two years: he wanted to be in London. Read was phenomenally prolific, publishing fifty-four articles in 1930 alone and becoming the editor of *The Burlington Magazine*. In 1933, with *Art Now*, Read hoped to capture the character of contemporary art. In the foreword he wrote for the catalog to the Mayor show he anticipated, not without a measure of hope, a "storm of criticism." "A book on the art of the past can always securely anchor its pages to works in public

museums and galleries; the reader can refer to the originals and compare criticism with facts," he wrote. "But a book on modern art must venture into unknown seas. . . ."

Read began to discuss, with Mayor and Cooper, what pictures to include in the exhibition and book. Since Bacon had been part of the gallery's inaugural show, Read naturally looked into what Bacon was doing. The young artist's *Crucifixion* was unusually restrained for a Bacon, its black-and-white tone more whisper than shout, but it was also unforgettable. Read made a remarkable decision. He decided to publish a reproduction of the Bacon painting in his book and place the image directly across from Picasso's *Female Bather with Raised Arms* of 1929, in which the figure was similarly positioned. For an unknown twenty-three-year-old, it was both a striking act of recognition and an illustration of his debt to Picasso. No other English modernist his age (not that there were many) had attained comparable recognition. Bacon had every reason to believe that he was a rising star of English painting.

The *Art Now* show opened at the Mayor Gallery in October of 1933. It included the work of forty-one artists, among them many of the best-known modernists on the Continent. Fewer English artists were included this time—only ten, among them Bacon and Roy de Maistre. (Some of the less obvious choices from abroad were Kandinsky, Ozenfant, Giacometti, and Sophie Taeuber-Arp.) The styles presented ranged from complete abstraction to decorative cubism to surrealism. What held the show together was not any particular aesthetic, but the desire of the organizers to present the range of contemporary modernism. Read's book was taxonomic in outlook, with chapters titled "Metaphysical Aesthetics," "Psychology of Art," and "Science to Symbolism." It named few actual artists, instead including their work as illustrations of his modern themes. But readers looked at and remembered the images.

The exhibit met with some skepticism, if not the "storm of criticism" Read expected. "London's Strangest Art Show," read the headline in the *News Chronicle*, whose art critic began by saying, "The unanimous question of people who see the latest exhibition of ultra-modern art at the Mayor Gallery, Cork Street, will surely be, 'What are these artists driving at?'" The critic of *The Sunday Times* went farther, calling the show "A Hold-Up in Cork Street" and alluding to the "Shock Tactics" of some of the artists. But the amount of coverage remained impressive. The Mayor Gallery was continuing to draw attention. Several critics praised Read. Geoffrey Grigson wrote in *The Bookman* that *Art Now* was "a book which no one dare avoid," and said of the show that viewers would see "not only a cross-

section of the best contemporary art in Europe, but delightful evidence that there are English artists not stunted by insularity, not reactionary in the best manner of our most 'advanced' official institutions, but sharing, as we have not shared for a long time, in the general art-consciousness of Europe."

No critic singled out Bacon for comment, but *Crucifixion* soon developed a wide reputation among those who followed art. The stretched-out limbs and tiny head of the Christ figure evoked the Dinard series, but the X-ray ghostliness was something new. Eric Allden was impressed. "Lunched at the Carlton and afterwards went to see the exhibition of modern painters at Douglas Cooper's gallery, the Mayor in Cork Street," he wrote on October 25, 1933. "There I saw Francis' picture.... It is called *Crucifixion* and has a quite remarkable quality. It suggests a spidery emaciated cruciform shape, with a bent figure clasping it, white on gray-ish black. It is far and away the most significant picture there and marks an enormous advance in his work." The small reproduction of *Crucifixion* in Read's *Art Now*, wrote John Richardson, "made such an impression on me and so many others of my generation." Fifteen years later, before he came to know Bacon personally, Richardson recalled noticing the man on the street who made *that* painting:

> On the way home, I passed a youngish man with a luminous face, who was often to be seen prancing about the neighborhood— evidently a painter. As usual, he was lugging canvases in or out of the house opposite ours [where Bacon's cousin Diana Watson lived with her mother]. His paintings, of which I had only the brief-est, most tantalizing glimpse, intrigued me. They looked as if they might be by a mysterious artist whose work I knew only from a single, unforgettable reproduction of a *Crucifixion*, painted fifteen years earlier—an orgasmic gush of white paint—in Herbert Read's *Art Now*, an artist called Francis Bacon.

It was triumph enough to be included in the book. And then: Sir Michael Sadler purchased the painting. A passionate advocate for secondary education, Sadler was also a renowned collector of modern and contemporary art. From 1911 to 1923, he had been the vice-chancellor of Leeds University, where he became a force at the left-leaning Leeds Arts Club and an early collector of Kandinsky, among other modern artists. At the time of the Mayor Gallery show, Sadler, then seventy-two, was the master of University College, Oxford. He could not afford to buy art

on the same scale as Samuel Courtauld, but he reached far and wide—from Rouault and Modigliani to emerging British artists, among them Henry Moore. He liked to buy work from artists in whom he believed, not just "collect" per se. Writing in *The Spectator* about a posthumous show of Sadler's collection, the artist and critic John Piper recalled that Sadler "bought the right pictures at the right time, not waiting for the critics' verdict."

Sadler purchased Bacon's *Crucifixion* sight unseen, by telegram, on the strength of the reproduction in Read's book. He also acquired Bacon's other *Crucifixion* from 1933—the chalk, pencil, and gouache that later became *After Picasso, "La Danse."* Sadler, a witty and good-humored man, then decided to commission a further painting from the young artist that might amuse the dons at his Oxford college. He wanted a sort of portrait, he informed Bacon—*one based on an X-ray of his own skull*. "I've discovered a new painter," he told Kenneth Clark. "He's called Francis Bacon. I've commissioned him to paint my portrait for Hall [the dining room of his Oxford college that probably contained traditional portraits of earlier masters]. It will be like an X-ray photograph of my nut." Eric Allden noted in his diary on October 19, 1933: "I went round to the Blue Dog for dinner and on the way ran into Diana Watson [whom Allden continued to see regularly], who told me that Sir Michael Sadler, who has a collection of modern pictures, has bought one of Francis' for 20 pounds and has commissioned him to paint a picture of his skull from an x-ray photo for 30 pounds! Francis is rather sniffy about doing the commissioned one!" It was, Allden noted, "so like him, with his supreme contempt for filthy lucre!"

Bacon executed the painting for Sadler, but probably not as Sadler wanted. On November 28, five weeks after hearing about the commission, Allden "looked into the Mayor Gallery and saw Douglas Cooper, who showed me the new picture Francis has painted for Sir Michael Sadler, a strange powerful figure against lurid yellow, and a skull below." It was an example of Bacon's more challenging style—and not as easy to like as *Crucifixion*. Instead of an image reminiscent of an X-ray, revealing the mysterious interior of an Oxford don's "nut," the central figure's upflung arms were nailed to an unseen cross, and the body could almost be a side of beef. Several ribs were limned in broad strokes of white, further adding to the effect of an aged, mottled carcass. The disproportionately small head of the figure—painted red—peered downward. To the left rested the "X-ray portrait" of a skull. It had a pair of bulging, pink, fleshy lips. The painting proved unsuitable for Hall, but, even so, Bacon appeared

well on his way. "For Bacon to engage the interest of Read, Mayor, and Sadler," John Russell later wrote, "represented about as much as could be achieved in so short a time in the England of the early 1930s: Read was the critic most alive to new art, Mayor had a long record of discernment in his choice of exhibitors, and Sadler was a collector of quite outstanding accomplishments who had visited Kandinsky when hardly anyone in England had ever heard of him and had seen the point of Henry Moore when Moore was an unknown student just out of the army."

Then, suddenly, the Mayor Gallery dropped Bacon. Or perhaps Bacon dropped the Mayor gallery. There may have been an argument, probably fierce and likely provoked by Bacon's eruptive style. Having gained confidence after exhibiting twice at the Mayor Gallery, Bacon now wanted to show his difficult Crucifixion-centered works, like those Diana Watson regularly saw in his studio. In particular, he was excited by a new idea about how to get at the "core" of the Crucifixion. He wanted to push past the distracting details of cross and story, in order to concentrate upon the all-important fact—the *wound*. This Crucifixion would not have the scientific detachment of an X-ray. It would have the toe-curling immediacy of Grünewald, shimmering with reds and capturing the sensation of pierced flesh.

Mayor and Cooper may have already disliked the Sadler commission. More likely, they paid a visit to Bacon's studio, where he showed them his most difficult pictures. Cooper was not one to hold his tongue. And it is the rare artist (or his lover) who can accept criticism from an art dealer or critic with equanimity. The professional quickly becomes personal. Eric Hall and Douglas Cooper began to feud. The intensity of the feud was astonishing. Cooper would find infuriating even the hint of disapproval from a man like Eric Hall, a distinguished English gentleman with strong views of his own. Hall in turn was revolted by this florid, arrogant, and impolite young man—about the same age as Francis! Cooper enjoyed baiting his enemies, and he would have known exactly how to provoke Hall, dismissing Francis's art with casual condescension, for example, or gleefully spreading rumors about Hall's sexuality. He began to refer to Hall, politician, war hero, and family man, as "the alderwoman." Making matters worse, no doubt, was Bacon's refusal either to criticize Hall or to court and flatter Cooper, a man who required such attentions. In April of 1934, Eric Allden stopped into the Mayor Gallery to see Cooper, who "talked of Francis, whom he is not allowed to see because Hall dislikes him so."

Cooper's own association with the Mayor Gallery did not end well. "He was an absolute monster," said James Mayor, the son of Freddy.

"He was gratuitously mean and unpleasant." The feud with Bacon, once begun, never ended: Cooper would not surrender a grudge. Later in 1934, he made a point of not inviting Bacon to a housewarming party and stopped using the desk he commissioned from Bacon. After he moved to France, he placed it in a guest room and invariably told houseguests, "Oh, my dear, you don't want to be in the room with that dreadful man's desk." He spread it around that Bacon had abused an elderly relative of his who had bought the artist's early paintings and helped him in his decorating career—no doubt Eric Allden, but with about twenty years added to his age. (Allden himself never bore a grudge against Bacon.) Bacon always appeared mystified by this undying enmity. Bacon could be quarrelsome, too, but his quarrels were typically passing squalls followed by sunny reconciliations, and a lifelong spat with Cooper hardly seemed worth the energy. To outsiders, Bacon explained that he and Douglas "were not exactly each other's cup of tea." But to his homosexual friends, he described Cooper as a dreadful she-monster. He had "known that treacherous woman. She's even more loathsome than she looks."

The break with the Mayor Gallery was a shock for Bacon. He wanted to exhibit his unknown work. He would not take no for an answer. No doubt with Hall's encouragement, Bacon now decided to exhibit his paintings himself—a remarkably bold act. His own private Salon des Refusés, uncluttered by the work of other artists. His career as a designer began with a private showroom. Why not do the same with his paintings? In early 1934, Bacon and Hall leased a basement room in Sunderland House, Mayfair, one of the best addresses in London. Located on Curzon Street just a few minutes' walk from the Mayor Gallery, Sunderland House—built at the turn of the twentieth century by the Duke and Duchess of Marlborough with money from the duchess's father, William Vanderbilt—was an imposing mansion whose ballroom contained eleven soaring stained-glass windows and extended the full 110-foot length of the house. The duke and duchess once employed fifty servants, many fitted out in ducal livery. During the Depression, Sunderland House was broken up and put to new uses. In December of 1930, *The New York Times*—which, like many American newspapers, enjoyed London gossip—reported that Sunderland House "is to be occupied by a famous dressmaking firm," probably that of the couturier-to-the-queen Norman Hartnell. Arundell Clarke, a close friend of Hartnell's, also rented space there for a showroom, which was near his new flat on Bruton Street and close to the houses on Park Lane and in Mayfair that he was stripping and modernizing. Clarke, in turn, probably leased the space in the basement to his friend Francis, or perhaps told him that space was available.

Bacon and Hall took the room for six months. They intended to mount a series of exhibitions of Bacon's work

Bacon transformed the space into a gallery. He was torn between painting the room "grey like a battleship" or having it "hung with red velvet." Either, he believed, suited his pictures. Money was no object. He spent £150 on the space, probably helped by Eric Hall. In the end, he chose dull red walls and velvet curtains, a marked contrast to the white modernist environment of Queensberry Mews. The somewhat fusty and constrained environment set off his explosive painting, much like a murder in a Victorian drawing room. (He painted no pictures of women who resembled champagne flutes.) He named the new space Transition Gallery in recognition, perhaps, of the Parisian journal *transition* and the changes occurring in his art. He included seven large paintings and two drawings in the show.

Diana Watson immediately bought the two best-behaved—and small—works on paper, which had been completed the year before. Their titles were abstract, and they remained safely within Picasso's orbit. One was *Composition (Figure)* of 1933; the other, *Composition (Figures)*, was a related gouache of long-limbed, long-necked figures seemingly in motion. The larger paintings in the exhibit—obviously too much even for the devoted Diana—seriously disturbed Bacon's friends. The most important was called *Wound for a Crucifixion*. Another was named *Head in Ecstasy*. The painting of the wound was likely Bacon's most ambitious work to date, anticipating many of his keynote later paintings. John Russell later wrote that it was "set in a hospital ward, or corridor, with the wall painted dark green to waist-height and cream above, with a long narrow, horizontal black line in between. On a sculptor's armature was a large section of human flesh: a specimen wound, and a 'very beautiful wound' according to Bacon's recollection." The wound opened a gash not only in the flesh but also, by poetic implication, in the red velvety room.

The exhibit seemed to Diana Watson an "event" and "extraordinary," even for Francis, with "pictures that suggested a lurking madness—a sensibility disconnected." One painting she described as "a stream of blood falling down a yellow background." Like many people during Bacon's life, she struggled to "place" her cousin in a familiar English context, asking him at one point "to do me a painting with the feeling of Blake—and a blood-stained floor." The blood-stained floor was doubtless a nod to her cousin's strange modern ways, but "the feeling of Blake" was a way to make him part of an English visionary tradition. (Blake, for all his wild imagery, was a rather cozy eccentric.) A friend, probably Allden, said of

the Transition show: "This is altogether too morbid, eccentric and peculiar. There is no beauty in it, though I know he hates the word beauty." Allden was disappointed that Diana beat him to the two small drawings and reluctantly purchased *Head in Ecstasy*.

Bacon was unusually proud of his painting of a "wound." He said, "I may never be able to get it again." The exhibit opened on February 14, 1934: Ash Wednesday, the first day of Lent, and a day when Christians reflect upon the Crucifixion.

Early Failure

N<small>O ONE CAME TO HIS SHOW</small>. Just friends. A couple of critics. The *Daily Mail* dismissed Bacon's paintings as "exotic monstrosities." The critic from *The Times* began: "The difficulty with Mr. Francis Bacon is to know how far his paintings and drawings—at the new Transition Gallery, in the basement of Sunderland House, Curzon Street—may be regarded as artistic expression and how far as the mere unloading on canvas and paper of what used to be called the subconscious mind." Bacon was just an unloader, the critic concluded. "As the latter they are not of much consequence—except by way of release to the artist." He might be "an interesting colorist," the critic granted, but "colour is a natural gift" and not enough to support a painting:

> Does it, as a matter of cold fact, require a high degree of artistic talent to give the impression of a wound in pigment? Certainly most of the seven paintings are too large for anything they have to say. Confidence in Mr. Bacon is not increased by the information that it is proposed to hold a series of exhibitions of his work at this gallery.

A week after the opening, Eric Allden visited the show accompanied by John Skeaping, a sculptor who in the 1920s was married to Barbara Hepworth. Skeaping was well-established: he won the British Prix de Rome to study in Italy in 1924. Allden reported that Skeaping "liked [Bacon's] drawings very much"—the ones bought by Diana Watson—but Allden did not mention what he said about the paintings. Allden could not get accustomed to his own purchase, *Head in Ecstasy*, which he found "not recognizable as a head." It was "pleasing in colour and drawing, though it has a strangeness, which makes me slightly uncomfortable. Francis has genius undoubtedly, but he is too introspective." Eventually, Allden asked Francis if he could return the painting. "I felt it didn't go in my room, and I am to have another when I see one I like better." Bacon

was gracious about the return. Then Allden could not find anything he wanted in the studio. "I cannot wait till the present phase of Francis' work is past," he wrote. "I can't say that I care about the rather gruesome distortions of heads, bodies etc. in which he seems to find his only self-expression at the moment."

It was a devastating defeat. Once, during the course of the show, Bacon—standing in the middle of the gallery surrounded by his paintings—described his future as "so hopeless." After the show closed, he walked away from the gallery and never showed anything there again. He destroyed all his large unsold paintings; and also *Head in Ecstasy* once Allden returned it. He did not even spare his favorite child, *Wound for a Crucifixion*. (He regretted its loss all his life.) Bacon—who could find beauty in a justly painted wound—always took a certain pleasure in sacrificing his own work. A pleasure seasoned with pain. It would not be easy, however, to put behind him the implicit message delivered by the Transition exhibit: he had publicly succeeded only when he remained close to Père Picasso—when, that is, his art looked like other art—but failed when he dared to be himself and develop his own challenging eye and "I." He was not even granted, at his first solo show, the dimly reassuring words *interesting* or *promise*.

In the next years, Bacon continued to move restlessly among styles. It would be almost a decade, however, before he again dared to exhibit his more challenging work. Fewer than a dozen Bacon oils have survived from the 1930s, usually because they represent the more sober (but still important) aspects of his sensibility that his supporters preferred. They cannot even begin to represent the radical play of the young artist's imagination, however, given the loss of the work closest to his heart at the Transition Gallery. Once the show came down, Bacon did not abandon his eruptive style. Diana reported "flaming forms" in March of 1934, with "a blood-stained look that I had not seen before." She did not immediately notice any obvious loss of confidence in her cousin, but Bacon now "agreed that he was perhaps very limited," confined to "the facts of love, death, massacre and madness, in whatever form he could seize upon them."

In 1934, the year of the Transition show, Bacon suffered—perhaps with fresh intensity—from significant stress, depression, and isolation. He was now taking drugs "to calm his nerves," Diana noted. The drug was likely a barbiturate; phenobarbital was becoming a popular sedative. His relationship with Eric Hall was difficult. Now past the first bloom of their love affair, Hall was finding that a relationship with the proud, touchy Francis came with quarrels. (Bacon mentioned to Diana "the back-stairs squabbling that goes on.") They probably saw less of each other after the

Transition debacle. Hall remained a married man who lived with his family, a busy politician with a position to maintain, and he accused Francis of being a "super-egotist." Money problems further increased Bacon's stress. He could not give up his expensive tastes or live entirely on handouts. He had never entirely abandoned design work, though he regarded himself after leaving Queensberry Mews as a painter who only occasionally took up projects. Now he edged back, a little, into the design world.

In the early 1930s, he had designed an "ultra-modern" room in Bruton Street for his mentor Madge Garland, a room that she praised years later in *The Indecisive Decade*. And in late 1932 or early 1933, just before the inaugural show at the Mayor Gallery, Gladys MacDermot—the Irish patron and friend of de Maistre—gave Bacon a substantial commission. He designed for her a dining table and chairs, plus a sideboard, desk, and several coffee tables. After the failed Transition show in 1934, de Maistre, eager to help his protégé, encouraged his wealthy and stylish friends Rab Butler and his wife Sydney Courtauld to give Bacon a lucrative commission. The Butlers were redecorating their house at 3 Smith Square, near Westminster Abbey, and Sydney wanted a house that was conventionally fashionable—the socialite and designer Sybil Colefax probably had a hand in the decoration—but with some added modern panache to suggest that the Butlers were not just like every other well-connected couple. A friend wrote Sydney a letter in July 1934 that included the gossipy observation: "I do very heartily agree with you that a little of Lady Colefax—both in taste and person—goes a very LONG way!!!!!!"

Bacon designed a showpiece dining room that would have turned Lady Colefax pale. A visual record of the room exists in an article that Bacon sent to his mother. The writer—probably Madge Garland again—wrote: "It is not often that you find painters turning into decorators, but a talented young painter, Francis Bacon, has done this with marked success. One of the latest rooms he has designed is a very remarkably modern dining-room. The walls and ceiling are painted white and against this background have been placed a metal and glass table and curved shaped stools, instead of chairs, painted a light turquoise blue-green colour. And the curtains in this room are made of white rubber—yet another new fabric to be used for curtains." It was no doubt distressing for Bacon to read the phrase *painters turning into decorators*. And he would wonder what his paintings—notably *Wound for a Crucifixion*—would look like in Sydney and Rab's white dining room, near the surgical curtains, as politicians discussed the Depression.

In the autumn of 1934, Bacon faced a new problem. Not only had he

been cast out from one of the best clubs in the art world—the Mayor Gallery—but he must also leave the studio in Royal Hospital Road where he began his life as a painter. Arundell Clarke, having moved to Mayfair and New York, had no reason to retain his Chelsea flat for longer than the life of his father—or the terms of his lease—required. The kindly Clarke had been remarkably generous, but Bacon would, alas, have to find somewhere else to live and work. Where would he go? London no longer appeared to welcome him as an artist. Even his best friends had not, after all, supported the direction of his work at the Transition Gallery. Was there a room for him in London?

Bacon now sometimes spoke of escaping to "Arabia." The idea of disappearing into "the Orient"—Bacon mentioned both Turkey and Persia—continued to beguile many demoralized Europeans. He also took an interest in the upsurge of fascism in Germany. As early as December 1933, he and Diana were discussing the "political marches" described in newspapers. The massive Nazi rallies in Nuremberg—a new kind of spectacle—astonished many people in Europe. In the spring of 1934, Bacon "talked of the return to nationalism and vitality apparent lately" and, according to Diana, Herman Göring "obsessed" her cousin. "When a person feels as strongly as that," Bacon told her, "they cease to be a dilettante." The powerful and gaudily beribboned Göring—who collected art and loved beautiful uniforms—kept lion cubs as pets.

Why not Berlin again? Bacon could leave behind the Freddy Mayors and Douglas Coopers and Eric Halls. Perhaps it had been a mistake to settle in Paris. Perhaps he should always have focused on Berlin. If Paris was the more tasteful city, Berlin was the more truly modern. Berlin was where to find the brutality of modern truth. Bacon had wondered before about this untaken road; he had studied German with Diana in 1929. Now, with the rise of the Nazis, Berlin continued to be an essential, if disturbing, part of the modern stage. (It would be "awful" to end like Rudyard Kipling, Bacon observed, and outlive one's time.) Bacon probably was not enamored of fascism, but maintained a clinical fascination with its demonic force: the mighty theater in which it presented unlimited power, for example, or the way in which it brought out the animal in the uniformed man. "Amid the clatter of Hitlerism," he told Diana, you saw "shadows in the process of becoming substantial."

At the end of October, 1934, Bacon moved out of his studio on Royal Hospital Road, informing only Diana of his new address because, she supposed, he was eluding creditors. Then, early in November, he left for Berlin. He planned to "stay indefinitely." He had "really found," he told

Diana, "his spiritual home." It was not long, however, before he was back in London. Berlin might be interesting to think about, but under the Nazis it was no place for a homosexual to live. His enthusiastic departure (and early return) became a characteristic pattern in his life. Bacon loved to flee London, looking for another shore; and then return to his inescapable home. In London, with no settled address, he moved intermittently from room to room. In March 1935, he lived at 102 Fulham Road, across from a small Jewish cemetery, and then went to 10 St. Barnabas Street, Pimlico—Nanny's address. Five years before, he had brought her to Queensberry Mews, near his elegant showroom. Two years after that, she was looking after him in Royal Hospital Road, Chelsea, where he had a studio. Now, she found him a spare room in her boarding house.

It requires talent to live in a feral way, which Bacon possessed. There were periods during his life when he did not want to live too far from the street. He was never entirely down-and-out (there were always people looking out for him), but he appreciated life on the edge and he seemed to find something truthful in desperate circumstances. And Nanny Lightfoot could be a rather naughty Nanny, who understood life's underbelly. She had her moods. She was sometimes "in a temper." It made quite a picture: Francis and his Nanny sitting in the parlor of her boarding house in Pimlico poring over the adverts, searching for wealthy men who wanted a little something on the side. *Well, Francis, look here. . . .*

Such a life exacted a price. In April 1935, for example, Bacon suffered from chronic nausea. The nervous tension knotted up his stomach. Often, he could not sleep. He was tossed about by dreams after he drifted off, and he sometimes awoke "feeling faint." His medical problems were similar to the ones that led to his rest cure in 1929, when he retired into Dr. Fielding Ould's clinic and Eric Allden proved to be so sympathetic. Now, reported Diana, Francis "ate salads to cool the blood," which sounded like a treatment for neurasthenic Victorians. He also sought professional treatment and probably drugs. It was during 1935 that Bacon became a regular patient of Dr. Stanley Brass, who would look after Bacon until the early 1960s, when Brass's son Paul assumed responsibility, caring for him until the end of Bacon's life.

Diana Watson observed subtle changes in Bacon's perspective. She had first known him as a child and adolescent when, his charm unalloyed, he created "an oasis" for her. Then, when he determined to be an artist, the "madness of genius" found him. Now, she sometimes worried that he would darken rather than brighten her life. "I had become convinced that he was an evil spirit," she wrote in 1933, "and that I was in the process of

becoming the same. In spite of the gaiety of life, everything he touched turned to disorder for all others but me." Over time, she began to notice a shift in his approach to sexual and personal relationships. She possessed a photograph of Francis taken at the age of nineteen—probably by Eric Allden—when she thought he looked open and innocent. "He hadn't got at that time the sensual, compelled look he has now, the sidling, flowering abandon." By 1935, Bacon was telling her "that now everything was possible, the only thing that seemed impossible were intimate personal relationships." He may have been referring to the rocky period with Eric Hall after the Transition show. She added that he "has a Hawaiian living with him now."

Diana herself wanted to be modern, but likely knew little about masochism or the theatrical character of sexual submissives who, while subservient in the bedroom, can be powerful figures beyond its door. No doubt Francis regaled her with astonishing stories and, while Diana (like Eric Allden) would not embarrass her diary with such details, she recorded her opinion that Francis and "the old Victorian women" were "the most extreme victims of lust I know." In 1935, she was concerned that Bacon was a sexual plaything: jaded, embittered, derisive. In fact, he never quite became a cynic—not altogether. He said something revealing to Diana in 1934 when they were discussing what she called "the dialogue with a worm" in Blake's "poems on the physical passions." The worm looked "awful," she said, until "the voice comes through." Bacon responded, "That is the soul, I suppose," adding that he himself "could not be satisfied with purely physical love." Diana confided: "I have doubts of this."

That is the soul, I suppose was a telling phrase. Bacon was typically less wistful in later formal interviews when he jauntily mocked words like soul or love. But he did not entirely deny their substance, as his actions if not his pronouncements regularly proved. During the 1930s, Bacon began, conversationally, to imprison "love" or "soul" inside implicit quotation marks. Or, he used an aggressive modifier before the word, as in "*What's called* love . . ." It was a stagy kind of unmasking, stripping "love" of its power and revealing it to be a fraudulent coverup for the animal passions. And yet, there remained the rueful hedge, that *I suppose*.

During the 1930s, Bacon once met a Greek man for an assignation. The Greek lived on Dover Street, in Mayfair, an indication of his wealth. When he disappeared into the bathroom, Bacon rifled through his pockets. It was the way of the world. It was the truth of the street. It was also an act of weakness. The man spotted him, probably in the bathroom mir-

ror, and asked: "What are you doing, Francis?" Bacon told him, and the man did not erupt into anger. "You don't have to do that. Just ask." Then he took Bacon to a bank and withdrew a hundred pounds, a significant sum, and gave it to his hustler. "It was," said Bacon to Michael Peppiatt, "a marvelous way to behave." Bacon never forgot the gesture, which was generous, morally elegant—and powerful.

By the autumn of 1935, Bacon—at loose ends for almost a year—still had no settled address. Eric Hall decided that, whatever the state of their relationship, this could not continue: his artist-lover must have a bed and studio. An efficient man who got things done (if Francis let him), Hall shared the pain of the Transition failure. He wanted Francis to succeed. He worried about him. The year before, after returning from Berlin, Bacon told Diana that Eric was "very sentimental & I just can't be." Now, Hall deepened his commitment to Francis. In fact, he wanted to live close by—almost next door.

Earlier in the decade, Hall and his family moved from Ormonde Gate to 4 Tennyson Mansions, Lordship Place, just off Cheyne Row in Chelsea. It was probably late in 1935 (or, at the latest, early in 1936) that Bacon moved into 1 Glebe Place, part of a row of modest houses just off the King's Road. The building was on "one of the less impressive Victorian streets" of Chelsea, according to Mollie Craven, who lived there and became friendly with Bacon. But Glebe Place was also just one long curving block from Tennyson Mansions. At any time during the day, Hall could walk to the King's Road, stop for the papers at a news agent—to read, perhaps, what Gilbey was writing about the upcoming races—and drop in to see Francis.

Hall probably arranged for Bacon to sign a long lease at Glebe Place. Either Hall or Bacon's mother, perhaps both, likely helped with the cost, since Bacon had very little money. It now became Bacon's duty to collect the rent from his tenants, "rent collector" being the most unlikely position Bacon ever held, surpassing even "racing secretary." Offered the chance to lease the flat below Francis, Diana Watson demurred: she liked being close to Francis, but not next door, which would have placed her on permanent call and perhaps led to her seeing things she did not want to see. (Diana continued to live with her mother.) Francis, now entering his late twenties, occupied the two rooms on the top floor. The smaller was his bedroom, the larger his studio. There was not space for Nanny, but she lived nearby and could look after him.

Diana said Francis lived "rather like an Arab." In other words, his life in the "back bed-sitting room" appeared to her mysterious, veiled and exotic. He cooked "curious" meals. He worked strange hours, often late into the night. In early October 1935—probably soon after he moved into his new studio—Diana saw "a painting in a mulberry-coloured frame. There was a bucket in the middle of the room, filled with wet, gleaming colour. Crimson was everywhere. He was stirring the slimy mass. Monstrous shapes on the canvas." Francis was interested in the idea of a treeless waste and figures set before a curtain. He imagined "a party of lunatics walking across some very waste land." He even quoted Nietzsche's "The genius raids," perhaps referring to his ongoing experiments with different styles, for his neighbor Mollie Craven observed less monstrous imagery than Diana did. Mollie saw many "river-and-leaves" paintings with vivid colors and a general air of sunniness. She thought Bacon was more like a post-impressionist than a surrealist. Craven also vividly remembered Bacon making charcoal sketches on heavy, expensive paper—a great many drawings, one after another—all of which he would gather together once a week and then discard. In later years, Bacon insisted that he never made drawings—though he exhibited two works on paper at the Transition Gallery—beyond a note or a sketchy outline. His denial, while literally incorrect, was also true. The charcoal drawings were experiments rather than finished works of art. Bacon was still learning by doing, coming slowly to the realization that he preferred fleshy paint to the drawn line, even the lush line of charcoal on rich paper.

If Bacon found the future hopeless after the Transition show, he did not give up all hope of exhibiting his work. In 1934, a group of modernists in London began to think of taking the future into their own hands with a series of group shows that they—and not the art dealers—would organize and exhibit. Well-meaning supporters of the arts had long struggled over how such a scheme might work. In 1925, at the suggestion of Roger Fry, patrons such as Samuel Courtauld and John Maynard Keynes developed a scheme that they called the London Artists' Association in which a mix of established artists and young unknowns would exhibit together in galleries and spaces found by the association and then charge only enough in commissions to cover costs. If an individual artist's sales did not reach a certain fixed amount in any given year, he or she was guaranteed a steady income of from three to five pounds a week. The London Artists' Association lasted an impressive eight years, ending not long after Freddy

Mayor—who oversaw the association in its early years—launched his own gallery to great fanfare.

In 1934, Roy de Maistre and Robert Wellington—having begun their two-year affair after meeting at Zwemmer's in the late fall of 1933—considered resuming something like the London Artists' Association. They initiated a year of intensive meetings with a core group of artists, among them Francis Bacon, which also included the more successful Henry Moore, Victor Pasmore, and Graham Sutherland. Bacon and de Maistre were among the first nine proposed member artists. The organizers kept detailed records of current earnings. In 1935, Ben Nicholson realized 460 pounds in sales; Paul Nash 300; Henry Moore 325 pounds; and Graham Sutherland 85. Bacon had still less: 65 pounds in sales. Wellington and de Maistre began looking for backers. They had lunch, for example, with Maynard Keynes at Rab and Sydney Butler's house at 3 Smith Square, Westminster (perhaps in the dining room with Bacon's rubber curtains). Wellington and de Maistre also met with Kenneth Clark and Lord Balniel (later the 28th Earl of Crawford and the 11th Earl of Balcarres), a newly appointed trustee at the National Gallery. In the end, money was difficult to find, and the ringleaders began to quarrel in 1935 during a summer vacation in France. Wellington could not finally tolerate de Maistre's affectations, among them his insistence upon signing visitors' books in a way that indicated he was "a royalist and a catholic." The art scheme collapsed along with their relationship.

In 1936, another opportunity arose for Bacon to exhibit. What had once been treated as a marginal movement even in Paris—surrealism—was now attracting serious worldwide interest. Francis Bacon's dark dreams fit comfortably into the huge surrealist extravaganza being organized in London for the summer of 1936. Important surrealist shows that year were also planned for Paris and New York, where Alfred Barr was organizing *Fantastic Art, Dada and Surrealism* for the Museum of Modern Art. The show in London, called simply *International Surrealist Exhibition*, would be staged at the New Burlington Galleries from June 11 to July 4. London's embrace of surrealism was unexpected. Not many exhibits showcasing the style were mounted in the 1920s and 1930s, and British critics tended to dislike hallucinatory paintings. The idea for a London show originated with two English expatriates. One was the painter and collector Roland Penrose, who had lived in Paris for thirteen years and befriended most of its leading artists and writers, among them the young English poet David Gascoyne. According to Penrose, Gascoyne remarked one day, "This is extraordinary. Why do people in London know nothing about the marvelous things going on here?"

Penrose and Gascoyne joined Herbert Read—the writer whose finger was in every pie—to begin organizing a show. They were remarkably ambitious. In Paris, Breton, Paul Éluard, and Man Ray agreed to help them. Then, in the winter of 1935–36, Herbert Read and Roland Penrose began to tour English studios, including Bacon's, like a pair of inquisitors come to determine if an artist possessed the true surrealist faith. Bacon knew Read, who helped organize the famous *Art Now* show at the Mayor Gallery and included Bacon's *Crucifixion* in his celebrated book. Bacon showed Read and Penrose "three or four large canvases including one with a grandfather clock." The inquisitors were not very strict, in the end, about what constituted the surrealist faith. Eventually, they selected about four hundred works by seventy-one artists—in what for the period was an enormous show. All the core surreal-

ists were well represented, and many attended the opening in London. Picasso (the surrealist flirt) contributed eleven works. Breton wrote the preface to the catalog and Read an introduction and note on "the English Contribution," in which he argued that England, usually regarded as a nation of skeptics, was in reality a surrealist hothouse: "A nation which has produced two such superrealists as William Blake and Lewis Carroll is to the manner born." The exhibit in Mayfair drew an astounding thirty thousand or so visitors during its three-week run. On opening day, the crush of cars brought traffic in Piccadilly to a standstill. Dalí gave a talk on July 1 while wearing a deep-sea-diving suit. As the day was exceptionally hot, Dalí began to overheat: David Gascoyne was on hand with a wrench to pry the helmet off him.

Bacon was not selected for the exhibit. Penrose found his work "insufficiently surreal to be included in the show" and, in a remark that still rankled Bacon decades later, said: "Mr. Bacon, don't you realize a lot has happened to painting since the Impressionists?" Bacon's exclusion was not inexplicable. He remained largely unknown, and his kind of nightmare did not resemble the finely painted dreamscapes of Paul Nash or John Armstrong. And if Penrose saw some of the paintings that Mollie likened to post-impressionism, he may have had good reason to doubt

Bacon, *Abstraction from the Human Form*, c. 1936, destroyed. His work was deemed "insufficiently surreal" to be included in the giant London exhibition of surrealist art of 1936.

Bacon's interest in surrealism. But Penrose also saw pictures with a decided surrealist spirit. He described one as a "grandfather clock," probably *Abstraction from the Human Form*, in which a tripod-shaped body was topped by a gaping mouth with prominent teeth. Below its mouth hung a pendulum, reminiscent of the one that keeps time in a clock. He may also have seen Bacon's *Abstraction* from the same period (which, like *Abstraction from the Human Form*, now exists only in black-and-white reproductions). That painting depicted a long-necked creature with two legs and a tethering rope that could represent a third leg. Bacon may even have painted these two pictures, which date from mid-decade, especially for the show. Time and timepieces were a favorite surrealist subject, one certain to appeal to Penrose, and a painting like the "grandfather clock" seemed more prototypically surreal than many other Bacons of the time. Penrose later explained "almost apologetically" to the art historian Hugh Davies that Bacon had "become more surreal in his later work."

Bacon informed friends that he turned down the surrealist show, telling Mollie Craven, "No way would I accept." Eric Hall knew the truth. Disturbed by the ongoing rejections experienced by Francis, he again stepped in to help. There was still merit in the Wellington and de Maistre scheme, Hall believed, and he decided to resurrect their idea for a cooperative gallery. At a time when several million British men were on the dole, Hall was wealthy enough to put money behind his ideas and, of course, the alderman had extensive connections. One was to the art dealer Geoffrey Agnew of Thomas Agnew & Sons, the venerable Old Master gallery founded in 1817. Located on Old Bond Street in a purpose-built Victorian space, the gallery maintained an atmosphere of hushed opulence designed to reassure collectors—the perfect old-school setting, Hall thought, for an organization of young artists looking to expand their market.

Agnew's occasionally organized shows of contemporary British art, but usually of Bloomsbury favorites like Duncan Grant and Vanessa Bell or the well-known Walter Sickert. The Wellington–de Maistre group would not be business as usual for Agnew's. Hall nonetheless managed to persuade his friend to loan him the gallery, probably by offering him a deal in which he could not lose money. All expenses would be paid by Hall, who also underwrote the printing of five hundred catalogs and posters. Hall marshalled influential backers in the art world to ensure that the show would not be lightly dismissed. The distinguished lineup included Kenneth Clark, who approached Agnew's directly to indicate his support for the show. Hall also brought in Professor W. G. Constable, the director of

the Courtauld Institute, and Sir Trenchard Cox, the assistant keeper of the Wallace Collection. Herbert Read participated, of course. And Miss Thelma Cazalet, a well-known member of Parliament. Bacon and Hall then visited the studios of eleven artists and selected thirty-six pictures, which were hung on the plush red velvet of the gallery's walls. Eric Hall also printed—in an accompanying handout—a description of the cooperative scheme that he now wished to advance, which included salaries for the artists and a regular space where their work could be exhibited.

The show opened the second week of January 1937. Of the eleven artists five had also been part of the earlier Wellington and de Maistre scheme—Bacon, de Maistre, Graham Sutherland, Robert Medley, and Ivon Hitchens. Among the new artists were Victor Pasmore and John Piper, who later became a friend of Bacon's. Predictably, the illustrious backers attracted considerable press notice for the exhibit. But not even Eric Hall's string-pulling could guarantee a hit. On the favorable side, at least three reviewers were sympathetic. The *New English Review* critic wrote that "some of the best contemporary English work . . . is to be seen here this week." But other critics used the show as a pretext to attack modern art. Under the headline "Nonsense Art Invades London," Pierre Jeannerat of the *Daily Mail* wrote, "The more we see of such absurdities the more we shall realise their emptiness and ugliness." Far more damaging than these populist blasts, which were expected, was the measured skepticism of Frank Rutter in the respectable *Sunday Times*. He began, "Time was when the House of Agnew was regarded as the citadel of conservatism in British art, but then much to the dismay of conservative collectors came a show by Sickert and then one by 'the Arch-Anarch, Cézanne himself.' "

Far more revolutionary, however, than any previous exhibition at Agnew's is the collection now on view at 43, Old Bond Street, and, despite the tendency of history to repeat itself, it is difficult to believe that in another thirty-three years the abstract paintings of Francis Bacon, John Piper, Julian Trevelyan, etc. will appear as normal and easy to understand as do now the paintings of John, Steer and Sickert.

The lapse was not Agnew's fault, Rutter said. "In fairness . . . it must be pointed out that this special exhibition has not been organized by the firm: the galleries have been generously lent to a group of unorthodox painters, whose exhibition has been organized for a purpose by Mr.

Eric Hall." On the invitation itself, Hall had written—in consultation, perhaps, with the former designer Francis Bacon—that the diverse work was united by "qualities more penetrating than the merely fashionable or decorative." Rutter chided Hall for this observation like an Oxford don shaking his head at a foolish student. "Is it not a great pity, when so much information is given on the back of the invitation card, that we are not told what these mysterious qualities are?"

Rutter's review infuriated Hall. It was bad enough that Rutters criticized the attempt to unite the artists under some comprehensible aesthetic. It was worse that the critic also specifically singled out Bacon, who exhibited four pictures, for attack: "And is it certain that all the exhibitors make use of a 'new' idiom? Mr. Francis Bacon's 'Abstraction' (20)—with a complete set of false teeth—and his more powerful and better coloured 'Abstraction from the Human Form' (26)—are not these entirely in the later idiom of M. Picasso?" So vexing did Hall find Rutter's condescension that he wrote a letter to the editor of *The Sunday Times*, which was published the following week. What was new about the show, Hall argued, should have been clear to the critic—"methods of approach to painting which are, for the most part, in the early stages of development, and with which the public are not yet familiar." Hall went on to defend Francis. "As I cannot go through the whole list of painters I will take two paintings by Mr. Francis Bacon. First, No. 26, 'Abstraction from the Human Form,' where the very developed formal qualities and the beauty of the colour should, I feel, have offered no difficulties to Mr. Rutter. Secondly, No. 13, 'Figures in a Garden,' to which the same qualities are applicable."

It was odd that Rutter chose to attack Bacon, in particular, who was decidedly not exhibiting examples of his most difficult work. Bacon's picture with the "complete set of false teeth," while not to everyone's taste, was a well-managed example of surrealism—a style now respected by many. *Figures in a Garden* (c. 1935), a reasonably restrained and well-bred painting, was also one of the young Bacon's most ambitious works. It was purchased by Diana Watson, and Bacon himself took some pride in the picture. He wrote Watson: "I am doing a painting of a figure in a garden which has I think come very well." The painting reflected not just Picasso but also work by Gauguin and Toulouse-Lautrec, as Martin Harrison noted in the *Francis Bacon Catalogue Raisonné*. A rich yellowish shade of green defined a lawn in the foreground, while another band of green across the top evoked foliage. In the center, a menacing figure—part human, part machine, part plant—had a massive torso covered with a bark-like surface that suggested a sort of human trunk. It had a great

gash of a mouth with a row of glittering teeth and, on the side, a prominent ear. (At one point the painting was called *Göring and His Lion Cub*; Bacon may well have drawn a connection between his menacing figure and the bull-necked Nazi.) In the foreground stood an anxious-looking creature with one paw raised. The disquieting scene would have looked at home in the International Surrealist Exhibition.

Every critic who disliked the Agnew's exhibit singled out Bacon for attack. Even his more restrained work, it now appeared, would never be accepted in London. A mocking review appeared in *The Referee*. The caption under an illustration of his work was "The titles of these three pictures, reading from left to right are 'Abstraction from the Human Form', 'Abstraction', and 'The Sculptor'. But, as this is Nonsense art, you might just as well read from right to left." The ridicule might have been easier to accept had any of the more positive reviews of the show praised Bacon. But they did not. After a month, the exhibition closed with little to show for the hard work. Only two of the thirty-five paintings sold, one by de Maistre and one by Ivon Hitchens. The buyer of the de Maistre was his close friend Rab Butler. Yet again, the idea for an artists' cooperative foundered. Bacon may have sensed that the show would not go well. At the private view, Diana found him talking once again about escape, this time to the South of France. He would have a cottage near Avignon and Nîmes. "He knew a lot about prices and food, standing in the middle of Agnew's gallery—the walls red all round."

Almost any young artist, even one as tough-minded as Bacon, required a few approving eyes in the face of constant rejection. Hall provided them. So did Diana Watson, who, with Eric Allden, helped support Bacon by purchasing his earliest work. Hall became the reliable family that Bacon could fall back upon (even during his feral periods), but it was a strange sort of family, of course, as Hall occupied a position somewhere between a lover and a father, and he continued to maintain his own regular family in Chelsea. Did Bacon confide his inner anxieties and fears to the paternal Hall? Bacon may have sometimes dropped the mask, but perhaps not; or not altogether. Hall himself was not a demonstrative Englishman, though he regarded Francis "sentimentally." Their relationship may well have been mostly allusive, expressed in the knowing glance, the wry aside, or the momentary revelation of the bedroom.

No doubt friends in the art world regarded them as a sexual couple. But Eric Hall's wife and children probably still did not, at least not in

the 1930s. The family was instead confused. They knew that something was wrong. The head of the family was away far more than was customary. The situation was especially difficult for Hall's son Ivan, who could not help but wonder why his father appeared more devoted to a strange young man than he did to his own son. The head of the household was being led astray not by love, it was assumed or hoped, but by an eccentric and dissolute crowd. Hall's weakness for gambling was well known: there was even some danger, should matters deteriorate further, to the family fortune. As for Hall's passionate interest in the arts, especially music and modern art, that was an acceptable diversion but was getting out of hand. Hall was altogether too concerned with the absurdities of modern art, spending far too much time and money on the peculiar artist with an illustrious name who painted disagreeable pictures—mouths and things.

Hall did not conceal Bacon. To do so would have suggested something illicit. But he concealed the truth of the relationship. In public, Hall treated Francis as a close friend in whom he took an avuncular interest. He was well-known to be a kindly mentor. He would even bring Bacon to family events, as if Bacon were also a friend of his wife and children. One time in the mid-to-late 1930s, when his wife could not attend a visiting day at Eton for their son, Hall instead brought Bacon. He intended nothing provocative. He wanted the life-as-usual world to grow accustomed to Francis, to regard him as almost an honorary member of the family. Hall's political life appeared to be unaffected. Throughout the 1930s and well into the 1940s, he was elected to the London County Council from the districts of Paddington North and St. Marylebone, and he even served in 1943–44 as deputy chairman of the Council. He was also a Justice of the Peace.

After the Agnew's disappointment in early 1937—a personal affront to Hall no less than to Bacon—the couple began to live more extravagantly. Bacon even hosted private gambling parties, no doubt with the alderman's careful and guarded advice, as gaming was then illegal. Hall would know of gentlemen who enjoyed such parties, in which they could drink, make merry, and misbehave outside the public eye. The easiest game to stage was roulette. Gambling parties were a reliable way to make money and, in Nanny Lightfoot, Francis found a delightful co-conspirator who kept an eye on each penny. It must have been deeply rewarding for Bacon to have been loved as a child by Jessie Lightfoot and then, with a complicit smile, loved and acknowledged by her as a mischievous adult.

In the mid-1930s, as his painting failed in the galleries, Bacon may have painted himself more often in the mirror, brightening his face with

pancake makeup and lipstick. Always keenly aware of his social setting, he was never a man who, unable to control himself, must wear makeup or dress in women's clothes. He did not present as a girl. The mask was more ambiguous than that, and in the shadowy light an observer might not notice anything untoward or might simply wonder *Is that really lipstick?* Roy de Maistre captured that painted ambiguity in his portrait of Bacon. Only in certain circumstances and lights would Bacon really stand out. As a child, Caroline de Mestre Walker, visiting her cousin Roy in his studio, met Bacon and grew anxious, "wondering whether she should point out to him that he must have sucked his paint brush and had red paint all over his mouth."

Bacon continued to write to his mother and visit his family, revealing little about himself. No one in his family—except Diana Watson—acknowledged either his aspirations or his failures as an artist, let alone his sexual nature. Not all families then maintained a "don't ask, don't tell" perspective. Most members of de Maistre's large family knew of his sexual inclination, for example, and judged him harshly for it: only one sister kept up with him. The Bacons resembled the family of Eric Hall, sensing something awkward and embarrassing and choosing not to know. Bacon did not conceal Eric Hall from his family, just as he made no such effort with Allden when he came to Ireland. Both Erics were men whom the Bacon family could respect. Allden was a comfortable bachelor from a good family. Hall was a war hero, a married man with children, and an important figure in London. "Eric Hall was fashionable," said Bacon's sister Ianthe, who saw him "a few times" in London. "He was always immaculately dressed in a suit and a tie. He acted like an alderman, you know? He was nice, actually."

In 1932, the Bacon family moved permanently to England. Enough was finally enough, the Major decided, when Eamon de Valera, a leader of the independence struggle in Ireland, won the most seats in a parliamentary election and was named President of the Executive Council. "I remember de Valera came in and he was a Communist," said Ianthe. "And I remember my father saying, 'I'm not bringing up my daughters in a Communist country.'" The deed for Straffan Lodge, where the family had lived on and off since 1921, records that Winnie and her brother Leslie sold the house on February 26, 1932. The house was entailed to Francis and one of his cousins. (Granny Supple had placed the house in trust for Winnie and her brother Leslie Firth to use during their lifetimes.) Granny also left her shares in Shell Oil and Imperial Tobacco to Francis. Bacon himself did not record whether or not he received any of these proceeds. The

Major and Winnie now purchased their final house, called the Old Rectory, at Bradford Peverell in Dorset. "A friend of my mother's" lived in Dorset, said Ianthe, "and she persuaded them to live in Dorset. So then we bought the Old Rectory."

Bradford Peverell was 130 miles southwest of London. "When we went back to England, to Dorset, we certainly did see more of [Francis]," said Ianthe, "because it was easier and we were older then, too." When Bacon came, the family "sat around in the garden . . . just visited," said Ianthe. "My memory of him was that he was always very quiet, very well-behaved, I'm sure." The Old Rectory, later placed on the list of English Heritage houses, was built in the early nineteenth century and later greatly expanded with a third story, an ironwork verandah, and a rear kitchen wing. Its expansive lawn sloped down to the River Frome. The Major now spent his time puttering. "He was very, very keen on gardening," said Ianthe. "He had a greenhouse. And he was keen on fishing. But I also think he was probably bored. You see, in Ireland there was a farm and there was a dairy and all that kind of thing. And horses. And he had these dogs. But when we went to Dorset really there was just the garden. Nothing more than that."

Bacon's mother regularly sent Francis fruit and game from the countryside—Mollie Craven remembered "constant deliveries" to Glebe Place—and Winnie sometimes visited London herself. On December 10, 1933, for example, Eric Allden recorded having lunch with both Francis and his mother at the well-known (and sumptuous) Criterion Restaurant in Piccadilly Circus, then popular with ladies who came to town to shop in the West End. On her visits to London, Winnie was sometimes accompanied by one or both of her daughters. Once or twice a year the Major, generally alone, traveled to London but he did not see his son. Ianthe believed that the Major gave himself a week or two each year in which to misbehave and divert himself with prostitutes.

Bacon's family made no effort to see his exhibits. After they moved permanently to England in 1932, they did not come to either the Mayor or the Transition show: Eric Allden would have noted their presence. A couple of years after the Transition Gallery closed, about the time Bacon was rejected from the surrealist exhibition, Ianthe and her mother visited him at his studio on Glebe Place. Ianthe remembered tramping up the stairs, up and endlessly up—"to the very top" of the modest house. Well-born relations did not ordinarily live at the top of the stairs. It was the first time she realized, Ianthe said, that her own brother was actually an *artist* living in what she considered a *garret*. "We came up from Dorset for some reason and went and had lunch with Francis. I was amazed."

The furniture was nothing more than "a table, a sofa of sorts, and an easel." The tiny kitchen was concealed by a curtain. "He had a little stove, just one of those little electric stoves." The table was sloppy with art supplies. "It didn't look very comfortable or smart," said Ianthe. "I think my mother thought, 'Oh, really, Francis.'" Bacon prepared an elegant meal. (His mother would remember cooking with her son in Ireland.) "We had a lovely lunch," said Ianthe. "He did oysters in some way. Oysters wrapped in something, I think. That he'd done himself." A painting was turned against the wall. Bacon eventually let them see it. They were taken aback: it was a Cyclops. "He had a painting there of a man's head and the eye was [right in the middle]. It wasn't frightening. It was very straightforward but only had the one eye." Their mother "didn't like it of course. She probably said, 'Oh, Francis, my dear,' or something like that."

Winnie and Ianthe were visiting Francis around the time Ianthe made her debut. Perhaps they were shopping in London for the party. Eric Allden happened to visit the Bacons in Bradford Peverell in April 1936 shortly after the debut. He was staying nearby in Weymouth with Peter Land, a German photographer who was his latest promising young man. "Mrs. Bacon drove us all the way home afterwards," Allden wrote in his diary. "She had a house full of young people as Ianthe had just come out to the Wilts. & Dorset Hunt Ball." For her daughter, then, big houses and balls and tennis on the lawn. For her son, a Cyclops turned to the wall. How was Winnie to make heads or tails of such a situation? Bacon chafed at his mother's indifference to his work, later observing that she became enthusiastic only when she realized that he could make some money. Their mother, Ianthe said, "didn't take much notice of his art or anything."

Bacon later claimed to have all but given up painting in the late 1930s. The evidence left by his contemporaries suggested otherwise. His neighbor Mollie Craven recalled him working hard during the late 1930s in his Glebe Place studio. And Eric Allden recorded that Bacon, in May 1939, was "painting a lot but not showing anything." Visitors to Glebe Place remained in the main room, which also served as the studio. Bacon's mother and sisters never saw his bedroom. Once, when Bacon was ill, Mollie Craven walked into the bedroom to see how he was feeling. She was shocked by what she saw. The walls and the ceiling were painted a dark and brooding blue, nothing like the rooms he designed for others. "Across the opposite wall" from the door she saw a "vast mural of a crucified arm." She recalled the arm in detail: "just a hint of torso and an enormous arm with nails in it pointing towards the window." Bacon kept most of his life to himself.

Breakdowns

As BACON NEARED THE AGE OF THIRTY, he withdrew from the conventional art world. He continued to work hard but made no recorded effort to exhibit his painting or win favor with the powerful. Young artists in Bacon's position, if rejected by dealers, critics, and collectors, often look to other artists for support. But Bacon did not cultivate friendships with other painters his age, and his older friend and mentor Roy de Maistre did not approve of his current direction. Bacon turned his pictures to the wall, both figuratively and literally; or, as with his mother and sister, granted visitors just a glimpse. The public rejections he suffered may help explain this withdrawal, but there was likely another reason as well. Bacon now preferred to work unseen and alone until—and if—he was confident of the results.

There was one small but significant exception to his isolation. In the mid-to-late 1930s, Bacon briefly befriended the young Australian writer Patrick White, who, after earning his degree at King's College, Cambridge in 1935, chose to remain in England. Family friends introduced White to his fellow Australian Roy de Maistre. "Roy's relationships with either sex began as courtships, of which he was often unconscious," White wrote in his memoir, *Flaws in the Glass: A Self-Portrait*. "I fell in love very quickly." To White's regret, he and de Maistre did not become lovers: at most, they had a dalliance. (De Maistre had not yet recovered from his breakup with Robert Wellington.) But a "fruitful, lasting friendship" developed between the two men. Not long after they met, White's father died and left him a substantial inheritance. No longer pressed for money, he moved from his bedsit in Ebury Street to a larger flat in the building on Eccleston Street where de Maistre maintained a new studio. Soon de Maistre introduced him to Bacon.

White came from a background remarkably similar to Bacon's. The Whites, like the Bacons, chose to live outside England but in the English-speaking world. His mother was English and his father a wealthy Anglo-

Australian. White developed serious asthma at the age of four, with attacks so severe that sometimes, like Francis, he could hardly breathe and could not participate in the rough-and-tumble of other boys. He became withdrawn and shy, left on the sidelines of childhood. And, like Francis, he realized early that he was homosexual. He adored his nanny and called her his "real mother." He disliked his father and found in Roy de Maistre something of a substitute. For White, his mother was extremely important but, in the end, unable to understand him. White's mother was in many ways another Winnie Bacon, maintaining a lively interest in society and a hopeful but bewildered view of her son. She regarded the arts as nothing more than hobbies.

Bacon had few friends his own age. White was an exception, just three years younger than Francis, and each found much to like in the other apart from their similar backgrounds. Each was naturally shy. Each was struggling with his work. White's growing friendship with Bacon coincided with the Agnew's failure, and White himself suffered from the usual insecurities that afflict a young writer. (He could never have imagined that one day he would win the Nobel Prize for Literature.) In the prewar period, de Maistre had developed his carefully designed studio into a salon for the art world. Literary figures also dropped by, including Stephen Spender. Douglas Cooper, said White, would "start off genial and generous, then turn against those he had taken up," and White "did not dare" exchange a word with either Henry Moore or Graham Sutherland, who appeared older and distinguished. Although Sutherland in the late 1930s had yet to enjoy the same success as Moore, he was remarkably self-assured, with years of teaching experience and a network of prominent friends. He was marked for a brilliant career. By contrast White found Bacon approachable.

The two went on excursions together. Bacon "opened my eyes to a thing or two," among them the strange charm of abstract graffiti scrawled across the wood of a temporary footbridge. "I like to remember his beautiful pansy-shaped face," wrote White, "sometimes with too much lipstick on it." It was no doubt comforting for Bacon to have a friend who was not part of the art world take an interest in his work. White, like some critics of the time, noted Bacon's use of false teeth as a subject and was interested that he did so "obsessively" before destroying the images. False teeth must have appeared to White a strange subject. They reflected Bacon's interest in the human maw, of course, and they united power and powerlessness. (Teeth could rip the world apart, but a man with false teeth was just another toothless man putting up a false front.) Flush with money from his father and with his own life's work before

him, White would probably have bought a difficult Bacon painting if one were available. But the withdrawn painter no longer had anything for sale in the galleries. So White did something marvelously kind: he commissioned Bacon, then as always struggling with his own feelings of power and powerlessness, to design a writing desk for him.

White had probably heard about the desk Bacon made for Douglas Cooper. He would certainly have known about Bacon's falling out with the critic. Commissioning a desk from Bacon would be financially helpful to his friend and useful to White himself, of course, but Bacon was also likely touched by the tribute and vote of confidence—that a young writer just starting out should want something made by another young artist, almost as a talisman, to use in the intimate workshop of his imagination. Calling it "the best desk I have ever owned," White described it as "very large, with long narrow drawers to the left, ending about 18 inches from the floor, and narrow, deep drawers to the right, all the way to the ground. The top was in white rubber, and the woodwork spray-painted a kind of stone colour. Handles were chromium tubular." White sold all of his furniture when he returned to Australia after the war, which included the Bacon dining table and chairs bought from the Butlers when they broke up their London home. White never regretted the loss of the dining table and chairs. (The heavy glass top had cracked, anyway, during a bombing raid.) But he always regretted the loss of his desk. Later, he would design one "*after* the Bacon desk, but *lacking* its grace."

In de Maistre's studio salon at 13 Eccleston Street—in Belgravia, not too far from his "relatives" in Buckingham Palace—the growing Nazi threat was typically left at the door with the coats. "In his dedication to painting," wrote White, "de Maistre may have wanted to avoid topics which impinged on it." Even in de Maistre's studio, however, politics began to intrude upon art. Among intellectuals, by mid-decade, "art talk and sex talk were out and political talk was in," wrote Ronald Blythe in *The Age of Illusion*. "It absorbed every stratum of society." The Spanish Civil War particularly captivated London: "government and the press could no longer largely ignore what was happening," wrote Stephen Spender. White found Spender himself anything but warlike—"his gawky, school-girl stance, right hand grasping left elbow behind his back"—but in 1937 Spender nonetheless joined the International Brigades being formed to fight alongside Republican forces in Spain. Auden, George Orwell, and many other writers also went to Spain to join the struggle.

The rise of a warlike dictator, rearming Germany and stockpiling arms, horrified many who remembered the earlier war. Spender later wrote of the "kind of anguish" many felt in the 1930s, "of being in London and

reading day after day *The Times*, which contained but the briefest news items about horrors that were taking place in Germany, in accordance with the newspaper's then policy of publishing nothing that might conceivably cause annoyance to Herr Hitler." The Spanish Civil War was widely regarded as the harbinger of the wider European war to come. Hitler was providing substantial military assistance to Franco, turning the Spanish strongman into the proxy for a fascist Europe. In April 1937, as part of Franco's campaign against Republican forces, German and Italian bombers destroyed the Basque town of Guernica. The bombing immediately became a symbol not only of the war's horror but also of what could happen to European cities. The horror might come from the heavens, not the trenches.

Picasso captured the moment with his painting *Guernica*, completed in June of 1937 not long after the annihilation of the town. Horrified as both a man and a Spaniard, Picasso filled the painting—eleven feet high and twenty-five feet across—with fierce images of death and destruction: wailing women, dead children, broken bodies, a screaming horse. His use of black, white, and gray made the scene appear disturbingly contemporary. Modern life and art were bleeding into the abstract palette of newsprint. The completed painting—a powerful piece of propaganda as well as a masterpiece—went on exhibit at the Spanish Pavilion during that summer's Paris Exposition, or world's fair, at which time the Nazis had already begun their campaign against "decadent" modern art. (The German-language guide to the Paris Exposition called *Guernica* the vision of a madman.) After Paris, in a carefully calibrated tour designed to maximize publicity, the painting and related sketches set off for exhibitions in Scandinavia, Britain, and the United States.

Guernica arrived in London as Neville Chamberlain prepared to cede the Sudetenland to Germany and "Chamberlain Must Go" rallies were erupting in Hyde Park. The huge exhibition *'Guernica' with 67 Preparatory Paintings, Sketches and Studies* opened in early October of 1938 at the New Burlington Galleries, the same venue that two years before housed the surrealist extravaganza. The principal organizer of the *Guernica* show was again Roland Penrose. Two years before, Herbert Read presciently titled a piece in *The Listener* "The Triumph of Picasso." *Guernica* now underscored the triumph. Not surprisingly, interest in Picasso was increasing exponentially: besides the *Guernica* exhibit, three other shows of his work were mounted in England between 1936 and 1938. It was the second showing of *Guernica* in London, however, at the East End's Whitechapel Gallery, that drew astonishing crowds—more than fifteen thousand in the first week alone, many of them workers who donated boots to the

Spanish cause. The painting created a surge of publicity about the atrocities being committed. It was "a reminder of the threat to civilization that Nazism posed," as Gijs van Hensbergen wrote in *Guernica: The Biography of a Twentieth-Century Icon.*

Guernica and the glowering threat of war from abroad—and the discussion of almost nothing else in the late 1930s—provoked Bacon in deep but subtle ways. It had been his great achievement to beat back illness and escape from the rejection of a tyrannical father and, briefly, make a success of himself. Then he had faced another implacable rejection by the authorities of the art world who had once taken him up. And now yet again, in different forms, he faced other kinds of crushing power. There was the prospect of war itself, the preserve of military men. An attack from the air from unseen people reflected certain of his personal preoccupations. He recalled the zeppelins over London during the first war, when the Major moved his family to London, and the ominous but strangely abstract power of the unknown fighters in the Irish night. You did not know where they were or when they might strike. The same was true of bombs from the air.

But Picasso himself was also a great power, a kind of father with whom many artists struggled during the twentieth century. Bacon would later become a critic of *Guernica.* "Well, *Guernica* is just a long story, isn't it?" he said. "It's just an illustration. . . . It's not one of Picasso's good paintings." It seems unlikely, however, that in 1938 Bacon dismissed the picture so lightly. *Guernica* was not just a didactic illustration of the horrors of war. It had the visceral pungency—and classical tremor—that Bacon himself sought in art. It exposed the flesh beset by an invisible and incalculable evil, and it made other pictures look small and decorative by comparison. At a time when painting appeared irrelevant, Picasso linked art to the terrifying modern world—and seemed to master both. Bacon was failing in a world at peace. How would he succeed in a world at war?

In March of 1939, the Nazis, having won the Sudetenland through negotiation, seized the rest of Czechoslovakia by force of arms. Then, on September 1st, 1939, Germany invaded Poland. Chamberlain and his allies in France still hesitated, considering further acts of appeasement in order to avoid a Europe-wide war. Chamberlain's cabinet overruled him. On September 3rd, Chamberlain went on the BBC to inform the country that Britain was now at war with Germany. Twenty minutes later, the first air raid sirens—a false alarm—sounded over London. The Battle of Britain, fought mainly between British and German pilots, was still ten months

away. But the English knew, on the first day of the war in 1939, that the Germans would soon send bombers. London, anticipating bombs and poison gas, prepared to defend itself.

Military conscription began immediately. By order of the National Service (Armed Forces) Act, passed on September 3, men between eighteen and forty-one were deemed eligible for military service and required to register with the government. Eric Hall, as an alderman who had bravely served in the first war, played a critical role in London's defense, becoming a leader of the Air Raid Precautions program (ARP) in Chelsea and an important figure in the Red Cross. Although at the age of twenty-nine Bacon was eligible to serve, owing to his asthma he was never likely to be sent to the front lines. To ensure that the officials did not overlook his asthma, Bacon, the night before his appointment with the military board, allegedly rented an Alsatian (German shepherd) from the kennels beneath Harrods. After spending the night with a big, hairy dog, he was in fit condition to successfully fail his physical. He later reported that "I was asthmatic and because of that I was turned down and was put into the rescue service in Chelsea."

Bacon served honorably, though he shrugged off his wartime service with the shaggy dog story. For a young Englishman from a storied military family whose older lover once charged the German machine guns at the Somme, the outbreak of war could not be a simple matter. Bacon never indicated any interest in left-wing pacifism, and he did not choose to become a conscientious objector—as did the artists Keith Vaughan and John Minton, among others. Bacon, however much he despised his father, would not have wanted to be regarded by either the Major or Eric Hall as a shirker and coward. If Bacon had wished to avoid all service, he could easily have asked Hall to help him gain a medical deferment. Or he might have applied to become a "wartime artist," joining the program that Kenneth Clark developed, in which artists were commissioned to make an artistic record of the war. Graham Sutherland and Henry Moore were among those chosen and were not only kept from the ranks but also paid handsomely in six-month contracts. Sutherland had multiple assignments, for example, with one six-month contract running from January 1, 1941, and paying him a very significant 325 pounds.

Instead, during the early weeks of what came to be called the "Phoney War"—the year of anxious waiting in Britain before Hitler's massive air attack finally came—Bacon began working in London's preparedness campaign. He first served in the Red Cross and then at some point was assigned to the rescue service of the Chelsea ARP, a local unit of the program overseen by Eric Hall and designed to protect civilians from

air raids. He certainly served in the ARP later in the war. On September 8, 1939, Eric Allden recorded that just five days after the declaration of war, Bacon was already "working 12 hours a day at first aid." That Bacon was working for the Red Cross so early suggests that he volunteered or was a willing conscript.

A young man was an especially welcome recruit on the home front. A photograph exists from later in the war of Bacon's ARP stretcher unit in Chelsea. The men wore dark jackets, white shirts, and ties; the straps of their satchels ran diagonally across their chests. (After May 1941, dark-blue serge uniforms were issued to most ARP workers.) On their heads members of the unit wore regulation metal helmets, similar to the bowl-shaped hard hats worn on the front lines. Bacon, with his distinctive round face, was positioned in the middle row of the photograph. Most of the ARP workers stared directly ahead. Bacon, looking down, appeared much younger than the others in the group.

Many artists and writers in London had similar jobs. Stephen Spender was a fireman, and Sonia Orwell, a friend of Bacon's after the war, served with a mobile first aid unit. Diana Watson joined an ambulance unit once women began to be recruited for more jobs on the home front. Roy de Maistre served in the Red Cross. Some who could escape the city did. Early on, a million children and two hundred thousand mothers were evacuated from London. Many people of means fled to the country. Many others with means enough chose to stay in the city, among them the writer Theodora FitzGibbon and the painter and photographer Peter Rose Pulham, her boyfriend, who were close friends of the poet Dylan Thomas and later in the war would also become friends of Bacon. FitzGibbon and Pulham, who left France as the Nazis advanced across Europe, leased an inexpensive flat in Chelsea not far from where Bacon lived. "Rents had dropped considerably owing to the evacuation of many people to the country," FitzGibbon wrote in her memoir *With Love*, "so for the 'mansion' flat [a capacious four rooms] we paid two pounds a week." Bacon's new friend Patrick White, who was in the United States when war was declared, quickly returned to London. "Back in London,"

Bacon with his Chelsea Air Raid Precautions team in 1943, after he returned to London

he wrote, "everything had to some extent changed. Evacuation had begun. There were gas masks. There was an increase in cynicism, fornication, jokiness at the war's expense, not yet the shortages, anyway for the rich. There were the same old faces, changed, but not all that much. . . ."

Bacon's world began to upend well before bombs fell. Like many tightly wound people, he depended upon settled routines. He could break those routines when he liked, as they belonged to him, but it was a different matter when outsiders took them away. By the late 1930s, he had already developed his lifelong habit of hard studio work. Now, the world removed him from his studio and ordinary habits. He had never before worked at a regular job for a large organization, but now must appear at a certain time and place and sign out at a certain time and place. Bacon could no longer predictably see Eric Hall. England was at war. Hall was busy and probably saw more of his wife, who was an important nurse on the home front. His conversation and time with Bacon, another part of Bacon's routine, were disrupted.

Bacon's own family began to disperse, never to reassemble. Ianthe, at war's outbreak, joined the Voluntary Aid Detachment service as a nurse. She was initially stationed at the naval hospital on the Isle of Portland, not far from the Bacon home in Bradford Peverell. But in 1942, after her boyfriend was killed in action, she sailed to South Africa to serve and married Benjamin Knott, a South African, the year after. Her younger sister Winifred, then only eighteen years old, also joined the armed services, in her case the Auxiliary Territorial Service (ATS) of the army. Bacon's friends scattered, too. Their wartime duties made them difficult to find and their schedules difficult to know. Some left England altogether. Patrick White joined the Royal Air Force and, assigned to intelligence, was posted to the Middle East and did not see de Maistre or Bacon until after the war—and then only briefly before he returned to Australia to live.

London was growing surreal, ominously so, especially at night. No street lamps were lit. Vehicles used only their side lights. Thickly drawn curtains closed off all the pubs, restaurants, and houses. As the writer William Sansom described the central city, "By moonlight the great buildings assumed a remote and classic magnificence, cold, ancient lunar palaces carved in bone from the moon." Overhead, searchlights randomly crisscrossed, wrote J. B. Priestley, "many-coloured flares blazing like sudden comets." All road signs and road directions vanished. The hours were ritually divided as if London were, after all, an ancient culture ruled by the sun. By day people thronged the streets; by night they huddled inside. Time lost its usual rhythm. "Waiting, always waiting," wrote Theodora

FitzGibbon. "Waiting for news, for buses, for trains, the stations teeming with evacuees going out and coming back. . . . It became known as the Great Bore War."

In this trying period, Bacon's father began to fail. The Major suffered from anemia and an enlarged spleen, a common consequence of malaria, which he had contracted in Burma. Over time, the loss of red blood cells was probably making it increasingly difficult for him to breathe and placing pressure on his heart and other organs. In the fall of 1939, the family realized that his condition was becoming grave. The naval hospital in Portland, where Ianthe was stationed, was only seventeen or so miles from Bradford Peverell, but she had trouble securing time for a leave. "I did go home and saw my father and realized he was very ill," she said. "But I was only home for a few days." Bacon was now obliged to look after his mother, as best he could, and assume the role of dutiful son. He had witnessed his father's will in January of 1937, and he visited him during his decline, though there was no rapprochement.

As his father failed Bacon himself became ill. Winters in smoky, foggy London were not easy for an asthmatic under the best of circumstances, and his long hours of labor among people he did not know—in a city becoming strangely different—only increased the pressure on him. He may have undergone surgery on his sinuses. Exactly what ailed Bacon was not recorded, but it was likely a combination of asthma attacks and heightened stress brought on by his father's illness, caring for his mother, exhaustion, unfamiliar work, and a developing emotional collapse. He had suffered breakdowns before, but his situation during the winter of 1939–40 appeared unusually dire. His friends became alarmed. Eric Hall probably feared for Bacon's life, as there was no other explanation for the extraordinary lengths to which he now went—despite his manifold responsibilities in wartime London—to put Bacon in the best possible position to recover. It was not enough, given Bacon's condition, to place him on leave and send him somewhere quiet in the English countryside. No, Bacon must also escape in wartime from the cold, wet English climate. His clotted lungs must have dry, clean air. His mind must have peace. He must sit in the sun. And so, as desperate, clamorous refugees from France and the Low Countries streamed into England to escape the Nazi advance, Bacon went in the other direction. He traveled to the French Riviera.

Eric Hall made the arrangements in April of 1940. Through a bank in Paris he sent eight thousand francs to support Bacon in the South of France. Diana Watson, also alarmed by her cousin's health, loaned Bacon additional money. "I hope you are not going to be short of money for

the rest of the time," she wrote after he departed, before asking, "Do you think you will stay another month?" Watson mentioned that she hoped the climate was "doing you some good," an indication that Bacon's asthma was indeed part of the problem. She also made oblique references to his state of mind, urging him in so many words to take it easy in the sun. The deteriorating political situation naturally concerned her. The Germans began their invasion of the Low Countries and France on May 10, and she feared that Bacon would be trapped in France. "I hope you won't have any difficulties," she wrote, "but if there should be send me a telegram as some of our Belgian friends have gone to the south of France and we could probably get hold of them if you found yourself stranded out there." She also returned to her concern about his health. "I should take everything as calmly as you can whilst out there and try to get really well again."

In the end, Bacon stayed in France only a few weeks. He received a report that his father was dying, and returned to England. He could not abandon his mother under such circumstances. Both Ianthe and Winifred were part of the war effort, and his mother would want her son. At the bedside, Bacon found his mother worn down by her husband's slow decline. The approach of death had not softened the Major's mood or inclined him toward last-gasp wisdom. Bacon told Michael Peppiatt: "About a day before he died, he said to the nurse, 'For God's sake keep that woman out of my room—tittering-tottering all over the place in those high heels!'" Bacon's mother implored the doctor, "Can't you help him out? Can't you just help him out?" Although the Major thought his wife wanted the doctor to push matters along in order to get on with her own life, Winnie probably wanted to relieve her husband's pain and suffering. Perhaps both motives played their part, as they often do under such circumstances. Ianthe, who spent only a few days with her mother toward the end, also thought Winnie longed to be free. "You know, there was thirteen years' difference between them in age," she said with characteristic understatement. "And that makes quite a difference too."

On June 1, 1940, Eddy Bacon died of splenic anemia. His daughters were not present at his death. Bacon did not report whether or not he himself was at the deathbed, but he was at the funeral, which the Major stipulated should be private and simple. Accordingly, A. E. M. Bacon was cremated and "his ashes were scattered at Weymouth," said Ianthe. "Francis was part of that." No one would have remembered, except the Major, that Weymouth was also where his grandfather General Anthony Bacon—wounded at Waterloo—first met Lady Charlotte while sailing in his yacht the *Hussar*. Francis Bacon was his father's executor and sole

trustee, there being no other sons alive. The Major's estate amounted to 344 pounds. At the end, as at the beginning, it was Winnie who had all the money.

During the Battle of Dunkirk, as Major Bacon lay dying, Allied forces were pinned against the English Channel, though about 250,000 British and 50,000 French troops were rescued by boat. Britain stood precariously alone. On June 14, German soldiers marched through the Arc de Triomphe in Paris—erected by Napoleon to honor the French military— and down the Champs-Elysées. Three days later, Marshal Pétain ordered the surrender of French forces and assumed control of the government. The fall of France was, among many other more important things, devastating to artists. Paris was not just the City of Light. It was the incubator of modern art.

London's art world began to close up shop. Faculty members at art schools joined the armed forces, forcing the schools to shut down. The leading galleries began to lock up. At the Mayor Gallery, the last show was an exhibit of Georges Rouault paintings in July of 1939. The final hurrah at Zwemmer's came on June 12, 1940, with a show of English surrealist art. Using their "characteristic shock tactics and self-publicizing," wrote Nigel Vaux Halliday in *More Than a Bookshop*, Zwemmer's splashed the word "surrealism" in huge letters across the window and presented an artwork that a reporter for the *Daily Sketch* described in detail: "a miniature bed, its rumpled sheets transfixed by a dagger. Near it was a full-size chair, upholstered in the shape of a fat negro mammy. Her wide lap formed the seat, white-cuffed hands made the arms. Her grinning head surmounted the back." The war made such things appear absurd by comparison, though crowds peered in the window. *The Times* observed: "Surrealism, in fact, intensifies the practical disadvantage of realism in art, because nothing that you can do on canvas will stand up to what is going on in the world."

As Bacon returned to London, his studio in Glebe Place appeared ghostly with undone work. Soon the bombs would start to fall around the studio. Was he healthy enough to return to duty after his convalescence? For an asthmatic like Bacon who also suffered from hay fever, summer could be difficult. But the wet chill of autumn could be even worse. Once again, it would not have been difficult for Hall to obtain a medical exemption for Bacon, given his asthma and his recent collapse. Instead, Bacon chose to return to service. It was a notable decision. Perhaps he did not want to offend his father's memory. Perhaps he sought

Eric Hall's respect. Perhaps he even felt a twinge of obligation. Bacon would never have admitted to such motives, certainly not later in his life, but no others explained his rather brave and foolhardy decision. Bacon rejoined the home forces and waited, with the rest of London, for the German bombers.

On the afternoon of September 7, 1940, they came—348 German bombers and 617 Messerschmitt fighters, sweeping across the Channel from France toward London. Hermann Göring, commander-in-chief of the Luftwaffe, "stood and looked at England 22 miles away across the channel. Over his head roared wave after wave of bombers, on their way to London," wrote Leonard Mosley in *Backs to the Wall: London under Fire 1939–45*. The attack formation, twenty miles wide and filling eight hundred square miles of sky, was mounted on a busy Saturday afternoon on a warm and beautiful autumn day. Thousands were in the streets as the wall of planes appeared with little warning and began to disgorge bombs. Their primary target was the great sprawl of wharves and docks along the Thames, but the conflagration soon spread from the docks to the old houses and narrow streets off the river where the East Enders lived. The blaze confounded London's firemen, four-fifths of whom were volunteers with little firefighting experience. About 430 Cockneys died on the first day of the Blitz; another 1,600 were wounded.

For Bacon, September 7th was also a trial by fire. Heavy bombs fell in Chelsea and Victoria. At 8:35 p.m. a massive bomb exploded near Sloane Square in the heart of Chelsea. The bomb was an almost direct hit on the Cadogan House community shelter where people were huddling for protection. One resident of Chelsea wrote in her diary three days later, "Official number for the Cadogan House Shelter is 57. Some crushed beyond recognition and in pulp. Heaven help us all!" It was the rescue service and the Red Cross that dealt with the injured and retrieved the bodies crushed beyond recognition. They would move into the rubble, with fires burning and knowing a gas pipe might explode, to search through the damaged buildings for bodies and survivors. Bacon was a driver, having applied for a driver's license immediately after the Blitz began. It was granted two days later, on September 9th, 1940, probably on a rush basis. (The license was issued by the London County Council, on which Eric Hall served.) As a driver, Bacon did not dig through the rubble, but presumably helped workers reach a bombing scene as quickly as possible and transport survivors to the hospital.

The raids continued relentlessly, often at night. Each typically began with incendiary bombs designed to start fires that could provide light for the incoming bombers bearing high-explosive bombs. They were fol-

lowed by planes dropping so-called land mines—eight feet long, two feet wide, and packed with explosives. A direct hit by one of these could devastate an area half a mile in diameter and cause massive civilian casualties. In a television interview late in his life, Bacon—who avoided talking much about the war—alluded specifically to the carnage he witnessed during his time in the rescue service. "I mean, one's lived through a time of chaos, in a sense, and I think that . . . does affect one's way of feeling about things." He had seen people, he said, "in an appalling state." Noise, fires, smoke, dust, sleeplessness, carnage: these were part of the daily life of those serving on the home front. In *Digging for Mrs. Miller*, his detailed account of one ARP warden's wartime experiences, John Strachey described the job of tunneling through mountains of debris as "nightmarish"—the "raw, brutal smell" of houses reduced to rubble; the voices calling for help but growing fainter as rescuers desperately burrowed downwards; the horrifying discovery of a dismembered or crushed body.

Life in London became both deadly and, paradoxically, intensely alive. For certain artists and writers the Blitz produced—as the monstrous sometimes will—a surprising joy: a feeling of never before having experienced something so immediate and powerful. "London became a city of restless dreams and hallucinogenic madness; a place in which fear itself could transmute into addictive euphoria," wrote Lara Feigel in *The Lovecharm of Bombs: Restless Lives in the Second World War*. "To stay in London was to gamble nightly with death." That gambling high was something Bacon understood. He found the visual drama of the nighttime sky perversely picturesque, calling the klieg lights "beautiful when the bombs were falling." Evelyn Waugh wrote: "The searchlights clustered and hovered, then swept apart; here and there pitchy clouds drifted and billowed; now and then a huge flash momentarily froze the serene fireside glow."

But Bacon began—once again—to suffocate. Memoir after memoir of the Blitz emphasized the great clouds of dust that, after each attack, settled over London like a shroud. "It was like running into a pea-soup fog," said one air-raid warden of the brick dust that followed each blast. He also noted the "acute irritation of the nasal passages from the powdered rubble of dissolved houses." In the aftermath of an attack on Piccadilly Circus, John Rothenstein, the head of the Tate Gallery during the war, found everything "was covered in light grey dust; the trees looked like full-size clay models of trees." After a few days of bombing it became obvious that Bacon could not serve in the dust. It would be difficult, if not impossible, to treat his asthma effectively with London's doctors and hospitals overwhelmed by casualties from the ongoing bombing. Fif-

teen months before, he had suffered a breakdown so significant that Eric Hall sent him to the Riviera as the Germans prepared to invade France. With bombs now exploding daily in London and winter approaching, he would not survive for long on the domestic front line. He must escape the dust—and find a place out of the city in which to paint. About two weeks into the Blitz, Bacon was probably granted an extended leave from duty. No doubt Eric Hall facilitated the leave.

There remained the question of where Bacon would go. There had been an exodus to the countryside once the Blitz began, particularly to the relatively remote West Country of Devon and Cornwall. Hall envisioned a retreat closer at hand where he could continue to look after Bacon. He found what he was looking for through a schoolteacher friend. Hall first came to know Ken Keast, then teaching at the Strand School in London, while serving on the Education Committee of the London City Council: the two often discussed school issues. Keast was now the assistant headmaster of Bedales, the school that Hall's wife once attended. Bedales was in the village of Steep, near Petersfield, Hampshire, and about sixty miles from London. Perhaps anticipating a need to evacuate either Bacon or his family to the area around Bedales, Hall had made a determined effort to keep up with Keast. In January of 1940, during the calm of the "Phoney War," Hall invited Keast to a "grand supper," as he described it to his fiancée, at Café Royal in London, the celebrated restaurant just off Piccadilly Circus where people often went to mark an occasion. Nine months later, shortly after the Blitz began, Hall heard that a "wonderfully remote" cottage on the extensive rural grounds of the school was about to become vacant. The science teacher who lived at the Lodge, as it was called, was leaving.

Bacon went to see the cottage two weeks later and arranged with the headmaster at Bedales to lease it. The headmaster was happy to help the young friend of Eric Hall. Unfortunately, the headmaster could promise Bacon the cottage for only three months at a time, as it was eventually intended for others—but that prospect did not appear imminent. Bacon agreed to lease the cottage at the ongoing rate of fifty-three pounds a year, undertaking any necessary "inside decoration" himself, which may have included setting up a studio, and also to maintain the garden "in good order." He appeared eager to make the move. "I am sure you will understand that as things are so very unpleasant in London and it is quite impossible to work that I should like to take the cottage as soon as possible," wrote Bacon with characteristic British understatement. He moved his belongings to Steep on Friday, October 4, 1940.

Wilderness

THE COTTAGE WAS SET APART in a grove of trees on the 120-acre estate of the school. Its parlor was so small that there was room for only two chairs by the fire, where a couple could warm themselves, with another two chairs for visitors. The rest of the Lodge rambled, its rooms having been added as the need arose over the years. In the end, Bacon lived there by himself for about two years, probably looked after by Nanny Lightfoot. Eric Hall visited when he could, usually on the weekend.

On one such visit toward the middle of 1941, more than six months into Bacon's life in Steep, Eric Hall invited Ken Keast and his fiancée, Diana, to drop by the cottage for a drink after dinner. "Francis joined us a bit later," said Diana, "as though he'd been busy in the studio." She had never met Bacon before, and she was struck by the markedly dif-

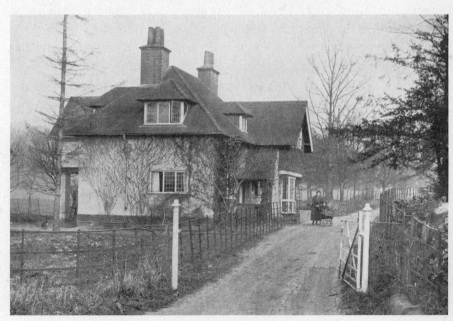

The Lodge on Bedales's bucolic campus, where Bacon, whose lungs were severely compromised by the dust from the bombing, retreated in October 1940

ferent bearing of the two men. Hall impressed her as "worldly" and in command, a "good manager of life," hospitable, alert, suave, and well-dressed—"sort of 'country suit.'" He would discuss "an important topic" without becoming dull. (He could also always locate an excellent bottle of sherry.) Francis, by contrast, "sidled" into the room, she said, pleasant enough and "very observant," but "he was very much sort of a soft-shoed man. Rather large and shambly. Very gentle. Very, very nice. But rather remote." She found herself "not at all attracted to him in any way." He appeared "sallow and podgy" with a "rather sort of ashen complexion. Perhaps rather unhealthy . . . I don't know if he went to bed late or didn't eat properly or whatever."

Bacon may have been recovering, on that evening, from an asthma attack or other physical ailments. More likely he no longer felt obliged to perform for guests. It was exceedingly odd that Diana Keast should have felt none of the charm to which both men and women responded so strongly before the war. Her "sallow and podgy" Bacon—passive and "shambly," with an "ashen complexion"—was not the man whom John Richardson recalled "prancing" down the street. Nothing like the "beautiful pansy-shaped face sometimes with too much lipstick on it" that Patrick White observed or "the dear boy" of Eric Allden. Neither Ken nor Diana Keast considered Hall and Bacon a homosexual couple. They knew Hall to be a successful politician and married man inclined to lend younger people a helping hand. "He was extremely kind to my husband. You know, as an impoverished assistant headmaster. I'm sure he must have been like that with so many people." They supposed Hall was similarly helping Bacon, setting him up "so he could paint." Although Diana did not see a studio in the house, she thought there could easily have been one among the ramble of little rooms. Eric Hall never stayed long in Steep. His wartime duties at the London County Council were pressing. He would become, in 1943 and 1944, the Council's deputy chairman. Goodbyes would be said, doors closed shut.

Silence can be a great surprise. Day after day of silence. No ordinary city sounds in Steep, but also no *thump-thump-thump* of antiaircraft guns. No clattering crash of a nearby explosion. No wailing chorus of sirens, no choking clouds of dust, no corpses pulled from the rubble. Even school life in Steep was more than usually subdued: Bedales, like many schools with children from prosperous families, had lost students to Canada and other safe havens. It was twelve years since Bacon had been in the country on his own without a friend—his brief period alone in Galway after Eric Allden returned to London—and he had not enjoyed the country

solitude then, growing lonely, isolated, and melancholy. In Steep, he did not have a car and there was probably no phone. He or Nanny could walk several hundred yards to the village shop for incidental supplies, and the market town of Petersfield was a couple of miles farther down the road. The coast was less than twenty miles away, and Portsmouth was an important Allied staging center. A bomber might fly overhead or a military vehicle rumble past. The peaceful stillness of English country life could seem like a pleasant mask.

Throughout his life, Bacon inevitably joked about what mattered most to him. He could not abide the "dawn chorus" at the cottage, he later declared, and hoped never again to suffer through the mad cacophony of birdsong. It was his way of alluding to the Steep silence.

The critical moments in an artist's life, which rarely occur in public, usually consist of internal reckonings. Often, a period of soul-racking pressure—of loss and failure—yields a clearer view of art and, possibly, a transformation of spirits. Bacon hardly ever spoke of Steep, much as he rarely spoke of the year and a half he spent in Paris or his years of struggle in the 1930s. His silence was eloquent. In Steep, Bacon was left alone with his thoughts for weeks on end, interrupted only by a rare excursion to London or a visit from Hall. (Perhaps the domestic chatter of Nanny Lightfoot sometimes rescued him from the dawn chorus.) It was likely that during the two years in Steep the "shambly" Bacon took stock, recasting himself as the powerful figure the world would come to know.

When he left for the country, Bacon could neither take pride in his past nor, as he settled into Steep, look forward to his future. He was more than thirty years old, an often sickly asthmatic given to nervous disorders who was constitutionally weaker than his father and two brothers had been, all of whom were now dead. It would take no more than the ignoble dust of war, not German bullets, to kill him (another reason, perhaps, why he was reluctant to discuss Steep). He depended on Eric Hall's charity. He had failed at two "careers." He was no longer a designer; he could barely call himself a painter. No gallery wanted to represent him. He had never obtained any serious schooling as an artist—no real schooling, period. He could hardly draw yet wished to make figurative paintings. How was an artist without much skill as a draftsman to portray the figure? What thirty-year-old painted bizarre pictures on his bedroom walls?

Eric Hall continued to believe in Bacon, encouraging him to paint. But perhaps Hall was just being kind, as Bacon might easily suspect: one often

saw wobbly convalescents, sitting outside, dabbing at a canvas. With war now exploding across the globe, no one was paying attention to art. The only visible contemporary art was the official "war art" commissioned by Kenneth Clark and the other rulers of the art world. Otherwise, art was now little more—if one was realistic in 1941—than a way to interest or amuse oneself. Or, to put it differently, the desperate circumstances were ideal for Bacon. There was no pressure for success because there was no such thing as success. No distractions, either, no diverting parties or bright lights. Later, Bacon said he might never have continued as an artist were it not for the asthma that now sealed him, alone, in Steep.

During the silent days, Bacon filled his hours with books. He owned many himself, which Hall could bring to him on visits. Once the bombing decreased in the late spring of 1941, Bacon himself probably went to London more often and could bring back what he wanted to Steep. The library at Bedales was a magnificent arts-and-crafts building with a good collection. Bacon was already well-read in Nietzsche—he owned much-thumbed copies of the Nietzsche canon—and the modern poets, but he now read them with new intensity during this time of war. He was not alone in his enthusiasm for the German philosopher. "In his fondness for Nietzsche, Bacon was . . . representative of his generation," Martin Hammer wrote in *Francis Bacon and Nazi Propaganda.* "Nietzsche was an enormously influential figure in Britain, in the wake of the appearance of translations of his work in the early part of the twentieth century."

World War II appeared to confirm Nietzsche's dark view of Western civilization. The first war could no longer be dismissed as a ghastly parenthesis, one not to be repeated in the progress of the West. Christianity, in particular, had failed to prevent a collapse into savagery. It was a religion merely of pity, weakness, and irrational longing, offering only illusions to distract the weak-minded from the brutal struggle for power. Compared to the sickliness of Christianity, the robust pagan civilizations of the classical world at least respected powerful instincts and the great play of power. Modern men were mostly befuddled weaklings: only the Übermensch (or "superior man" or "above-man"), who did not yield to social weakness, possessed a powerful independence. The German philosopher's reputation in England was beginning to decline during the war, of course, as many Nazis simplified or distorted his work. Some treated certain themes, such as the will to power or the development of an Übermensch, as a harbinger of German fascism and anti-Semitism. There was also an understandable recoil from Nietzsche's contempt for Western civilization. England and its allies—nations filled with coura-

geous men and women—were engaged in a crusade to save the West from fascism in general and Adolf Hitler in particular, and they rallied to the famous Churchillian cadences. "We shall fight on the beaches, we shall fight on the landing grounds, we shall fight in the fields and in the streets, we shall fight in the hills. . . ."

Bacon could not forget that the Nazis were also human. It was human to be inhuman. He could not lose himself in the mesmerizing cadences of Churchill's rallying cry "We shall fight"; or the deeply English love for compromise, small improvements, and a "meliorist" perspective—precious to many during a war against extremists. His favorite poets confirmed his instincts. They, too, despaired of modern civilization (not just the German enemy) and, like Nietzsche, often found relief in the ancients. Yeats was an admirer of Nietzsche. In "The Second Coming," his image of the "rough beast" slouching toward Bethlehem inspired Bacon, who first read the poem before it became well-known. The poem had been published shortly after World War I, when "the best lack all conviction, while the worst/Are full of passionate intensity." Bacon considered it "prophetic."

T. S. Eliot also had a bleak, end-of-the-world perspective and, like many writers of the time, made frequent use of the ancient world. Bacon admired Eliot's play *The Family Reunion* (first staged in 1939), with its overtones of Greek tragedy. *The Family Reunion* included the avenging Furies, soon to play an important part in Bacon's own art; and it would have been impossible for Bacon not to have been affected by *The Waste Land*, widely regarded as the defining masterpiece of the age. Stephen Spender wrote that his generation elevated the poem "into apocalyptic vision in the Wagnerian sense of *Das Ende* ["the end"]." In the poem, "the whole past of Western civilization is seen as fragmented within the present and in an irreversible state of decline. *The Waste Land* is supremely unpolitical. There is no indication in it that any kind of social action can save the fragmented civilization from its fall. . . ."

But Bacon also had differences with Eliot. In 1941, he may have been shambly, but he shared with Nietzsche and Yeats a fire-in-the-belly appetite for the world and its struggles. The impact of Nietzsche on Bacon was profound. (It could simply not be overemphasized, said Lucian Freud, after the war.) Bacon took Nietzsche personally. Nietzsche was attacking the same society that alienated Bacon, and Nietzsche's assertions about power and weakness not only reflected Bacon's larger view of the world but also spoke to his private history as a powerless asthmatic homosexual. Nietzsche's emphasis on the Dionysian aspects of classical culture offered

an implicit defense of outsiders who could not conform to more Apollonian standards of behavior.

The most unexpected of Nietzsche's gifts was that he offered hope. His writings were illuminated by a kind of displaced resurrection: an individual could transform his life and "rise" above the weak-minded crowd. Perhaps Bacon did not always have to curry favor, but could instead assert himself forcefully, becoming a solitary power or Übermensch. The upendings, reversals, and inversions of power in Nietzsche opened a space in which Bacon could breathe. Nietzsche himself had also been sickly; unlucky in love; bedeviled by professional problems. But Nietzsche refused to be pitied, followed his own way, and permitted no one to control his work. His attacks often seemed inspired, his aphoristic and poetic style exciting. In tiny Steep, as Nanny fussed in the kitchen, Bacon could dream of his own will to power. What was there to lose? Nietzsche "told us it's all so meaningless," Bacon would later say, that "you might as well be extraordinary."

Bacon began to make Nietzsche's uncompromising spirit his own. In the silence of Steep, his mind aroused by books, Bacon set up a studio that was not for others to see, much like his bedroom in Glebe Place. He probably did not expect much of himself during the war but "found, against all expectation, that painting had become an obsession." He did only what he wanted to do, destroying, as usual, most of what he created. What little survived from the Steep period made clear that, to begin with, he still loved the physical paint. He had never altogether abandoned his sensual touch, but during the later 1930s he had sometimes made work that resembled the more abstract and diagrammatic art favored by some surrealists. Now, inside the messy oil, he began trying to unlock a new and more satisfactory figure. During 1941 and 1942, when Bacon was mostly in Steep, Eric Hall was also bringing him images of the war. Bacon was particularly excited by news photography, most specifically that published in the photograph-driven magazine *Picture Post*.

In the late 1930s, two newsmagazines that stressed photography were launched—the *Picture Post* in England and *Life* in the United States, which had been bought by Henry Luce in 1936 and changed from a general-interest to a news publication. The *Picture Post* published memorable visual reports of the war, though it also included "lifestyle" stories and shots of pretty girls and cute animals. Photographs stimulated Bacon in the studio. "Photographs are not only points of reference; they're often triggers of ideas," Bacon later said. "I think it's the slight remove from fact, which returns me onto the fact more violently. Through the photographic image

PICTURE POST

IS HE HITLER'S SUCCESSOR?
Goering with Hitler at a Nazi Celebration.

HULTON'S NATIONAL WEEKLY

In this issue:
THE LIFE OF GOERING 3d
DECEMBER 16, 1939 Vol. 5. No. 11

Picture Post magazine, launched in 1938, proved a constant visual inspiration for Bacon during the war.

I find myself beginning to wander into the image and unlock what I think of as its reality more than I can by looking at it." News photos could be torn from a newspaper or magazine and cropped and manipulated, using the bottom rather than the top portion, for example, or folding over images to create new perspectives. Bacon had always been strongly attracted to photographs, beginning with the compilations he bought from booksellers along the Seine, but they were now entering his art in powerful new ways. (Even before the war, Patrick White noted the almost obsessive interest of Bacon and Roy de Maistre in news photography.) Bacon could go to the neighboring market town of Petersfield weekly to purchase the latest *Picture Post* or wait for Hall to bring him one.

The sensations stimulated in Bacon by war photographs were highly charged. Before the arrival of television, they presented the war's horror with vivid immediacy, but in a way that also felt displaced. They needed the life of paint. It was unsettling to live in the peaceful countryside and stare at black-and-white images of anger, devastation, and merciless power. Bacon and Nanny may also have listened to a wireless in the cottage or elsewhere; the urgent, static-filled voices would interrupt the rural silence much as the blurred and grainy photographs did. During this period, the war photographs that particularly interested Bacon depicted the power rituals of fascism and the bestial character of certain Nazi leaders, whom photo editors often presented with snarling mouths. Bacon did not have to invent monsters and crucifixions all by himself. They came to him in photographs. Bacon was well prepared by Nietzsche to unmask the animal within. "Man is a rope between beast and beyond-man," wrote Nietzsche, "a rope over an abyss." It may have increased Bacon's confidence to know that, already in 1933 and 1934, he had confronted the underlying ferocity of Nazism. Perhaps, in short, he was not just a backroom eccentric who made pictures too disturbing for even his friends to like. Perhaps the world was now catching up with him and, in his art, might finally recognize its own shadow.

Bacon probably worked very hard in Steep, despite his later refusal to discuss the period. Painting was critical for his spirits, not least because it helped an extraordinarily tense and preoccupied young man fill and

regulate the hours. "I think the only thing that really keeps me going on," he would say many years later, "is that I want to work—but work, I may say, for no reason. I just work; it still excites me to work." He had worked hard for most of the 1930s, as Diana Watson and other friends attested. What else was he to do during almost two years in the country except work and rework images?

The four pictures that survived from the period—all of them later revisited before being abandoned—were oil on fiberboard (canvas being scarce during the war). Their imagery reflected Bacon's turn toward a more gestural form of figurative painting. The most finished of the figural paintings, *Man in a Cap*, was inscribed "F. Bacon/Petersfield" and depicted a sinister man in a military cap with no visible eyes, only a mouth with two savage rows of teeth opening in a scream. He appeared to be standing at a railing or podium: his left arm, all that existed of the central part of his body, angled downward while his hand appeared to clutch the top of the podium. Behind his mouth and cap, the world exploded toward the viewer. The background—a flaming orange—suggested a bombing underway, and a shape resembling a plane stretched across the canvas. (A mass of black lines raining down could be flying shrapnel.) Plumes of thick black paint rose just behind the man's cap, possibly from bombs. Here, perhaps for the first time, Bacon used the shocking orange that would distinguish many of his later paintings.

The genesis of the image was relatively straightforward. In the summer of 1940, the *Picture Post* published a photograph of the Nazi leaders Heinrich Himmler and Joseph Goebbels in uniform. Goebbels was open-mouthed—captured in mid-snarl—and wearing the military cap seen in Bacon's painting. In the same issue there was an even more repellent photograph of Hermann Göring in uniform: his mouth opened grotesquely, and his right arm was raised in the Nazi salute. Other unfinished paintings from the Steep period attested to Bacon's exploration of animal power and chaos emerging from within the figure. *Man Standing* was almost a direct borrowing from a photograph of Hitler, published in 1938, looking down over the city of Prague from a casement window. Bacon depicted Hitler's pose, hair, and even the way the sunlight splashed across the bottom of the window in the photograph.

Bacon did not regard such pictures as successful, but they were not unimportant. In certain respects they were among the most significant of his life, privately conveying to him that he might yet find his way as a painter. He was developing—or recovering—concerns that excited him: a brushy human form rather than a surrealist stick figure; something ani-

mal bursting forth; the presence of overweening power. He was begin-
ning to see that his love for control and the sensual subtlety of paint did
not necessarily contradict his more raw, eruptive impulses; perhaps, as he
put it later, he could come upon a "deeply ordered chaos." The news pho-
tographs gave his work additional immediacy, though he was not, even in
these early days, isolating Germany for blame. (He might begin with an
image of a Nazi, but the pictures eventually left most identifying markers
behind, becoming more Everyman than Aryan man.) Most of all, he was
developing a feeling for metaphysical scale. The war itself had heightened
the cultural conversation generally to one of the "clash of civilizations."
The great questions now seemed to matter, even as people lived out their
day-to-day lives.

Another element, foreign to the village coziness of Steep, began to
excite Bacon—a passion for stage, spectacle, and dramatic props. In his
most accomplished painting of the time, begun in Steep and reworked
in 1945, Bacon made the grandiose theater of fascism developed by the
architect Albert Speer and filmmaker Leni Riefenstahl into a private
stage. *Landscape with Colonnade* began with a photograph of Hitler at the
head of a party rally in Nuremberg. In Bacon's painting, the road along
which Hitler was being driven became a vast diagonal stage bordered on
the one side by the monumental colonnade Speer designed for the annual
rallies of the Nazi Party and, on the other and in the foreground, by an
intimately worked and luminous earthy surface. Patches of reddish light
bled from the windows of the dark colonnade. The stage set evoked but
did not celebrate war. And it was emptied of Hitler. This stage awaited a
new kind of tragic theater in which Bacon could play out the underlying
truths of power and weakness.

A moment came in the summer of 1941 when the head of Bedales
School, Frederic Meier, told Bacon that he would probably have to leave
the Lodge. He was very apologetic. "You and Mr. Hall have been such
delightful tenants," he wrote. (Bacon had made certain, not long after
moving in, to invite Meier and his wife to tea.) But then what was the
"bare possibility" of a reprieve did occur. The new tenant did not need
to move in right away. All through 1941 and 1942, then, Bacon chose
to remain in Steep, paying the school every three months, even though
London was becoming livable again. Toward the end of 1942, however,
he began to spend significantly more time in the city. The Germans were
now attacking only sporadically: the dust became manageable for an asth-

matic. But there were likely other reasons, too, for his visits. He appeared mentally ready to return to London as an artist. In early February of 1943, he posted one of the most important letters of his life. At the top he wrote out his country address: "Bedales Lodge, Steep, Petersfield." "Dear Graham," he began:

> I have been meaning to write to you for ages to know how you and Kathleen are. If you are ever in London now will you both come and have some dinner with me one night. I would love to see you again or if Kathleen can't manage it perhaps you will come. I am more often in London than here now so will you write to me at 1 Glebe Place and make your own date. I still know one or two places where the food is not too bad. I hope you are working a lot. I must tell you how much I like some of your paintings in the National Gallery. I do hope I shall see you both.

"Graham" was Graham Sutherland. He was thirty-nine years old, only six years older than Bacon, but immeasurably more consequential—Bacon's natural "elder." Bacon knew Sutherland through de Maistre from before the war, and they had exhibited together in the ill-fated Agnew's Gallery group show six years earlier. Following that failure, however, Bacon vanished as Sutherland went on to be acclaimed the most important living British artist, after Henry Moore, of his generation. And yet, Bacon wrote to Sutherland as an easy equal, with an air of familiarity and confidence, able to like "some" of Sutherland's paintings very much and others presumably less. He was the gourmet who knew his way around, prepared to lead Sutherland to a meal that was "not too bad."

No one can fully master the mysterious formula by which a charming, reserved, but sallow young man who retired in 1940 to a country village could emerge two years later as a confident English artist able to brush off the difficulties that life presented—anxiety, illness, homosexuality, and failure—as annoyances worthy of a joke. It was probably less a fundamental change of character than a recasting of elements already present. Future friends considered Bacon powerfully "male," despite his obvious homosexuality. Perhaps he felt confident enough now to assert his power. No doubt he found encouragement in Nietzsche. Most of his confidence, however, probably stemmed from results in the studio—from an inkling that, finally, he was starting to find the right images.

During this period a slim volume came into Bacon's hands that provided him with a model and added a special fire to his convictions. Perhaps

it was Eric Hall, who read classics at Oxford, who gave Bacon *Aeschylus in His Style: A Study in Language and Personality*. Or perhaps Bacon read about the book in the literary press. Its author, W. B. Stanford, Regius Professor of Greek at Trinity College, Dublin, was thirty-two years old—Bacon's age—when the book came out in 1942. The son of an Anglo-Irish clergyman who may have known Bacon's classically trained tutor at Straffan, the rector Lionel Fletcher, Stanford had already published two books on Greek literature, the first when he was only twenty-six. He was a very unusual professor of classics. He was also a poet fluent in current literary issues, and in his new book he cited many contemporary figures, from Virginia Woolf to Bertrand Russell. He was not a scholar who holed up in the past, developing a protective erudition with which to look askance at the present.

Instead, this highly cultivated scholar made the rough-hewn Aeschylus his proxy in the modern world. *Aeschylus in His Style* was the defense of a writer who, like Bacon, did not believe in classical restraint. From the opening sentence of the book—"Aeschylus's style was not of the unobtrusive, subtly modulated kind that escapes criticism"—Stanford might almost have been writing about the mature Bacon rather than the Greek playwright. Throughout the book, Stanford argued the merits of Aeschylus's language (and sensibility) over that of the later, more polished playwrights Sophocles and Euripides. Like Bacon, Aeschylus was not "technically accomplished" in a schooled way, and he would often be dismissed by the lesser lights who made a tea party of art. His "untutored genius" owed little to an inherited tradition. He had instead "an inner compulsion, the force of his own genius, his emotions, his thoughts, his sensations, his imaginings."

If Aeschylus was sometimes crude, in short, Stanford would not have him more refined. To reach meanings that technical skill alone could not capture, he was willing to be vulgar and obscure rather than lucid and intelligent, and harsh rather than mellifluous. He sought "transport" not persuasion. His imagery was unconstrained. "At best," wrote Stanford, "an Aeschylean passage is sumptuous, exotic, dignified, pregnant, arresting, grandiloquent and imaginative; at worst, bombastic, semi-barbarous, enigmatical, uncouth and metaphorically confused. No other Greek poet had such extremes." Stanford quoted Aristotle's famous observation, in *Poetics*, that "poets are either men of fine natural endowments or else men possessed. In general, ancient critics preferred the former type, whose supreme exemplar was Sophocles, and this was the pattern of classicism in European literature till hardly more than a century ago."

Stanford, Bacon later said, "wrote a book which had a great influence on me," adding that "some of the images are so startlingly beautiful in there and so exciting I go on reading it over and over again. He both, I think, is very drawn by particular metaphors and particular images, which might inspire painting, and he's also drawn to moments of suffering, moments of expectation, moments of . . . of fear, of premonition, a half open door opening onto blackness." Like Aeschylus, Bacon was interested in pushing beyond conventional ways of seeing in order to find images of violence and inhumanity that few other artists were willing to confront, even amidst the horrors of World War II. Stanford's perspective was immensely reassuring. Bacon could stop worrying about school and create imagery that went too far. Perhaps he could push painting to the breaking point, as Stanford argued that Aeschylus pushed language. "One is reminded of the strained, distorted, almost grotesque figures of a painting by El Greco," wrote Stanford. "And the reason for both of these Greeks' extraordinary style is similar—the tension between an original and forcible mind and a conventional and highly formalized mode of expression." Bacon could dream of becoming an artist like Aeschylus, a mentor who was all the greater for representing a tradition of one.

Bacon was less lonely now and more proud. He was tiring of silence, and he missed London's conversation. It would be easier to see someone like Graham Sutherland—who was invariably gracious, and responded favorably to the letter from the confident young artist—while living in the capital. But where exactly was one to live? Surely not in cramped rooms at the top of the staircase at 1 Glebe Place. He was no longer a man who could be kept in a nearby flat.

Good Boys and Bad

SEVEN CROMWELL PLACE had an illustrious pedigree. A terraced town house in South Kensington, minutes from the Victoria and Albert Museum on Cromwell Road, it was once the stately home of John Everett Millais, the Pre-Raphaelite painter, who lived there in some splendor from 1862 to 1877, when he was much sought after. E. O. Hoppé, a stylish portrait photographer in London, occupied the house from 1912 to 1936 and turned it into a kind of shrine to Millais. (Cecil Beaton called 7 Cromwell Place "the holy of holies.") Another fashionable photographer, Gordon Anthony, followed; his sister, the ballerina Ninette de Valois, founded the Vic-Wells Ballet company, progenitor of today's Royal Ballet. The building suffered some bomb damage to its upper floors during the Blitz, which may have somewhat reduced the cost of living there.

In 1943, Bacon leased the ground-floor flat, which included both the basement and a spectacular space, once a billiard room, that extended from the building back toward the mews behind it. It had long since been converted into a studio with a skylight. (On the floor above was the now-bomb-damaged studio once used by Millais for "artificial light work.") The front of the flat remained formal in tone and included a large dressing room, used by Millais and the photographers who followed him as a place where subjects could change their clothes or costume. There was also a bedroom, where Bacon slept. Nanny Lightfoot each night turned the small kitchen into a makeshift bedroom. Margaret Fenton, who met Bacon around 1950, remembered "a huge, huge place. You went up the steps and there was a passageway. On the left was a big bedroom overlooking Cromwell Place. Then you went on down the passage and there was a bathroom and kitchen. And then this huge, huge studio. There was

a roaring stove fire, which was very beautiful, and a skylight. It was very dark, very dim."

Bacon was still nominally a member of the ARP. Having recovered his health in Steep and returned to the capital, he had no reason not to return to service. Messerschmitt and Focke-Wulf bombers, flying below the radar, still occasionally dropped bombs on the city. With the Blitz over, however, his services were not often necessary and he could concentrate on his studio. Furnishing 7 Cromwell Place presented no problems. After the death of the Major in 1940, Bacon's mother remained for a time at the Old Rectory in Bradford Peverell with her second daughter, Winifred. But the house became too much for her and later in the war she moved to London with Winnie, now married with two children, taking a flat at 12 Granville Place in Marylebone, just north of Mayfair and not far from Westbourne Crescent where the family spent the first war. "Winnie at the age of 18 married a barman," wrote Eric Allden disapprovingly. "And one could have said that butter wouldn't melt in her mouth." Bacon's mother shipped many of her belongings to Francis at Cromwell Place. "When we left Dorset, you know, during the war, she gave everything to Francis," said Ianthe. "All the china, all the beautiful Waterford crystal, a lovely chandelier."

A shipment of family silver once arrived when a new Bacon friend, Janetta Woolley (eventually, Janetta Parladé) was visiting Cromwell Place. Bacon told her that he was getting rid of the silver and she could take whatever she wanted. (She took one embossed fruit spoon.) He was also prepared to sell all the furniture to friends but had little success, ruefully noting that fashion had turned against the overstuffed look of the Edwardian era. The young artist Michael Wishart, who befriended Bacon after the war, called the flat "massive" and remembered—especially in the studio—pieces of large and antiquated furniture. "The dowdy chintz and velvet sofas and divans with which the cavernous room was sparsely furnished gave it an air of diminished grandeur," he wrote, "a certain forlorn sense of Edwardian splendor in retreat." Two large Waterford chandeliers "produced the mysterious illumination of the room." Graham Sutherland told Cecil Beaton, who met Bacon a few years later, that the studio possessed "a strong individuality," describing Bacon's penchant for Turkish carpets and huge pieces of mahogany furniture, "the antithesis of all that the painter had once created in the days when he was a designer and decorator of furniture." In this artist-haunted house in South Kensington, in a grand but now shabby game room that resembled a stage set, Bacon settled down to work. "Upon a dais in the shadows," said Wishart, "stood an enormous easel."

Eric Hall lived with Bacon in Cromwell Place, for the most part, and probably paid the associated costs. Hall's personal situation was difficult. He and his wife were now almost certainly separated, though they both attended the marriage of their daughter, Pamela, in March of 1942. Hall was much too conscientious, upstanding, and generous not to be concerned over the pain that he was causing his wife and children. No doubt there was some gossip about Hall's personal situation. The deputy chairman of the council with some louche artist in Millais's studio in South Kensington? The issue of homosexuality was still not directly addressed. Hall's wife wrote Bacon threatening letters during the war, but her anger was pointed less at the personal relationship between Hall and Bacon than at their extravagance—especially the gambling—which she chose to blame on Bacon. She was, of course, right to be concerned. Bacon could be as free with Hall's money as with his own, and it would naturally upset a wife to see a husband run through their children's inheritance. But it would have been unusual if she did not also suffer from feelings of rejection, that her husband should love this *boy* more than he loved her.

During the war, Hall became a man of secret indulgences, picking through the rubble of the pleasure-starved city, with Francis, for the best wine and food. The deputy chairman was even willing to skirt the law during wartime, gambling with both his reputation and his money. Shrewdly cashing in on the dearth of gambling venues in London, Bacon began to organize illicit roulette evenings in the new studio, much as he had done earlier. The former billiard room became a smoky gambling den, its focus a roulette wheel rather than an easel. (Bacon might have joked that there was no difference between the two.) The cars would begin massing in Cromwell Place after hours, which threatened to attract the attention of the police. As a result, Bacon "had scaffolding put up and bogus window-cleaners as lookout men, because it was illegal, quite an elaborate thing," said Lucian Freud, who met Bacon in the mid-1940s. "Not hole in corner. He took a lot of trouble." Nanny Lightfoot served as the doorman to the den—she might also talk away an inquisitive bobby—and charged customers to use the toilet.

It was at 7 Cromwell Place, as Bacon settled into his studio, that his relationship with Graham Sutherland—initiated by Bacon's letter early in 1943—began to flourish. Although the Sutherlands lived in Kent, they came fairly often to London, and by 1945 they were dining with Bacon almost weekly. Sutherland told Cecil Beaton with amusement that "the salad bowl was likely to have paint on it and painting to have salad dressing." Sutherland noted Bacon's "very special sense of luxury. When

you go to him for a meal, it is unlike anyone else's. It is all very casual and vague; there is no timetable; but the food is wonderful. He produces an enormous slab of the best possible Gruyère cheese covered with dewdrops, and then a vast bunch of grapes appears." On one occasion, Bacon procured a rare bottle of gin, as a second letter to Sutherland in 1943 attested. "Dear Graham," it read, "Here is the gin at last. I am so sorry not to have sent it but I could not get a box to put it in and I thought it would get broken if I sent it in paper. . . ." If Roy de Maistre was important to Bacon in the 1930s, Sutherland began to play a similar part as friend and mentor in the middle-to-late 1940s.

It was Sutherland's art that then mattered the most to Bacon, though he also enjoyed his conversation. In the 1940s, Sutherland was working with lush, painterly effects, which reflected Bacon's longstanding but still developing taste for a fleshy brushstroke. More important, Sutherland was developing a kind of figure that was less a recognizable form than a kind of creaturely excitement in the paint. And he imbued his paintings with a sensation of menace that, while a response to the horrors of the war, did not merely describe, illustrate, or comment. Sutherland's landscapes became filled with spiky briars and brambles—all electric with a kind of kinetic energy—in which the soft and fleshy could survive only perilously. Often, he isolated his threatening-looking images boldly in the center of the canvas, and he painted them against strongly colored backgrounds, giving them a drama that Bacon could not fail to appreciate.

Bacon and Sutherland made an unlikely good boy/bad boy pair. Sutherland had a "thoroughly conventional upbringing," wrote Roger Berthoud in his biography of the artist, with a middle-class lawyer for a father. Graham "liked to work office hours and within a supportive context of loving wife, patrons, friends and sympathetic dealers." In contrast to Bacon, who was largely self-taught, Sutherland studied at Goldsmiths, University of London, for five years and became a master etcher. While Bacon went to Berlin and Paris in the late 1920s, Sutherland cultivated his art at home, not traveling to the Continent until an assignment in 1944 took him to newly liberated France. In fact, like many contemporary

The charming Graham Sutherland in the 1940s, then being acclaimed, with Henry Moore, as one of the two most important British artists of their generation

British artists in the 1920s and '30s, Sutherland deliberately distanced himself from French modernism even as Bacon embraced it. "British art had long been torn between the dominance of Paris and a hankering after a national tradition," wrote Berthoud. "The end of the Great War set the clock back. It was not until the 1930s that the spirit of discovery and adventure returned. Graham was typical of his generation in being suspicious of Continental influences."

Bacon was an avowed atheist, Sutherland a devout Catholic. If Bacon was an open homosexual who ran a pickup gambling den, Sutherland was a model of decorum, with a wife, Kathleen—known as Kathy—who was very concerned with their social standing. She dressed in chic suits, and she and Graham mixed easily with the rich and titled. "His wife was ambitious," said Anne Dunn, who met Bacon around 1948 but knew the Sutherlands before. "It's hard to say in those situations who is pushing whom. I think men let women do it for them. But I think it was Kathy who was ambitious and much more snobby, in a social-class way." If Bacon could procure the gin and delicacies, Sutherland knew how to find art supplies during the latter part of the war. "Please do not send a cheque for the gin or anything foolish like that," Bacon wrote in his note, "it is a present and in any case I owe you such a lot for colours." Neither artist in the early 1940s painted on canvas—all but impossible to find during the war—but instead used Sundeala, a lightweight fiberboard. Martin Hammer observed, in *Bacon and Sutherland*, that it was not just ordinary supplies like canvas and the wood for stretchers that were impossible to find. "Sutherland's correspondence with the WAAC [War Arts Advisory Committee] indicates that official permission was required to obtain virtually any materials. . . ."

Of course, Bacon also mattered to Sutherland, who first became intrigued by him after he saw the *Crucifixion* of ten years earlier. "In Graham's battered, paint-spattered copy of Read's book which did not mention Sutherland—the illustration of the *Crucifixion* was the most heavily thumbed page," wrote Berthoud. "He rapidly became one of Bacon's most enthusiastic admirers." More important, Sutherland was now trying to find a way past "neo-romanticism," and the provocative Bacon implicitly challenged him to develop the ambition and reasoning to move in a new direction. Not surprisingly, neo-romanticism focused upon the English landscape. It often had a surrealist inflection and venerated, in addition to John Constable, visionaries like William Blake and Samuel Palmer. Its practitioners tended to look past Picasso to such painters as Pavel Tchelitchew (in whom Bacon was also sometimes interested in the 1930s).

In *A Paradise Lost: The Neo-Romantic Imagination in Britain, 1935–55*, David Mellor wrote: "Neo-Romantic art of the 1940s fixed its gaze beyond Surrealism to the future, but it was often a future written in the British past. This was a projected past which found its myth of origins in the land of Britain itself. . . . Here was an organic myth of rocks, hills and Arcadia; a myth of origins to be drawn out by artists such as Graham Sutherland and John Craxton, all through the high years of Neo-Romanticism in the 1940s . . ."

By the early 1940s, Sutherland, Moore, and John Piper were widely regarded as the leaders of the neo-romantic movement. All maintained some links to Continental modernism yet emphasized peculiarly English qualities. In the case of Sutherland, the fierce Welsh countryside of Pembrokeshire had provided him with a way to root some modernist ideas within the English tradition. As Berthoud described Sutherland's cathartic visit to Pembrokeshire in 1933: "Its impact was also a matter of timing. Graham had (belatedly) become increasingly conscious of the work of Picasso, Matisse, Miró and other Paris-based artists, through the magazines *Cahiers d'Art* and *Minotaure*. He was looking for a way of using what he had learnt without abandoning his individuality. In the contours and details of that landscape, he found it." For all three artists, success became intertwined with the war. Each was chosen to be part of the British War Advisory Scheme. Their vivid renderings of the bombing and widespread destruction, exhibited in a touring war artists' exhibition in 1941, were widely celebrated. In an introduction to one booklet on war art published by Oxford University Press in 1943, *War Pictures by British Artists, Second Series: Air Raids*, Stephen Spender wrote:

> There is an unearthly glory about Graham Sutherland's study for *Devastation in An East End Street*; and his pictures of twisted girders have something in them of twisted humanity. John Piper makes us more directly aware of a great architectural tradition burning up with a sunset fire which our civilization has neglected. Henry Moore's figures of people sleeping in the Underground shelters have acquired something of the quality of stone buildings. We feel that these people are the guardians and even the foundations of the streets above them.

Sutherland played effortlessly to powerful English patrons. Kenneth Clark, the young director of the National Gallery who was the leading reputation maker in the English art world, all but adopted both Suther-

land and Moore: Sutherland's career could be separated into BC—Before Clark—and AC—After Clark. The two had become close friends immediately upon meeting. Each had a silken, drawing-room charm. The charm was what people often first noticed about Sutherland—a "blend of wonderful manners," wrote Berthoud, "an extraordinarily attractive, light, very clear speaking voice, good looks—when young, rather those of the *jeune poète*, later of the 'distinguished' variety—a flattering capacity to focus on one entirely, and a considerable sense of fun and feeling for words." Clark purchased his first Sutherland painting soon after they met. He introduced Sutherland to Colin Anderson, the shipping magnate and collector, who would soon acquire several Sutherlands. While visiting Paris in February of 1938, Clark talked up Sutherland to the legendary art dealer Paul Rosenberg, who represented not only Picasso but also Braque and Matisse. The dealer had branched out to London: his brother-in-law Jacques Helft opened the Rosenberg and Helft Gallery on Bond Street in 1935. Clark not only persuaded Rosenberg to give Sutherland a London show; he also set its date—October 1938—writing to Sutherland that "I made it that month as it allowed you a summer holiday to prepare in. . . ." Sutherland's response was an exclamation: "What really staggering news! And a complete surprise to me, since the idea seemed so far beyond the bounds of possibility. Thank you a thousand times."

Sutherland met his deadline. No artist could have hoped for a more successful debut: he rose to the top of the forward-looking art world in London. Seven of his paintings sold to an influential group of buyers, ranging from the private collectors Lord Sandwich and Colin Anderson to the Tate Gallery and the Contemporary Art Society, which had been founded in 1910 to buy and present modern British art to institutions and galleries. Promoting his protégés, Clark included Sutherland and Moore among those selected to represent the nation at the New York World's Fair in 1939. When war was declared, Clark and his wife volunteered to house Graham and Kathy at their estate in Gloucestershire. In May 1940, toward the end of the Phoney War, Sutherland was the subject of a second one-man show, this time at the well-regarded Leicester Galleries, and it was an even greater success than the first. In the *New Statesman*, Raymond Mortimer described "a cumulative effect of certainty and power that I have never had from an English contemporary."

A new generation of British artists, looking toward the English landscape, venerated Sutherland. "Graham's exhibitions of 1938 and 1940," wrote Berthoud, "and the voyaging of his war drawings . . . had made him an inspiration to younger British artists of a 'romantic' bent, such

Painted Screen, c. 1930.
Oil on plywood,
each panel 72 x 24"
An early painted work
made during Bacon's time
as a designer

Crucifixion, 1933. Oil on
canvas, 24¾ x 19"
Bacon's new take on the
ancient theme reflected
his interest in X-rays,
spiritualist phenomena,
and the concealed life.

LEFT AND OPPOSITE, TOP *Three Studies for Figures at the Base of a Crucifixion*, 1944. Oil and pastel on fiberboard, each panel approx. 37 x 29"
The triptych shocked the London art world as England emerged from World War II. It led one critic to declare that there was English art "before" and English art "after" Bacon.

Figure Study I, 1945-46. Oil on canvas, 48½ x 41½"
A figure painting without the figure

Interior of a Room, c. 1934. Oil on canvas, 44 x 34"
Bacon's friends and collectors preferred his exercises in tasteful French modernism to his wild and disturbing early work, almost all of which he destroyed.

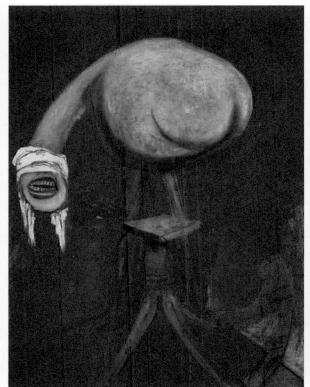

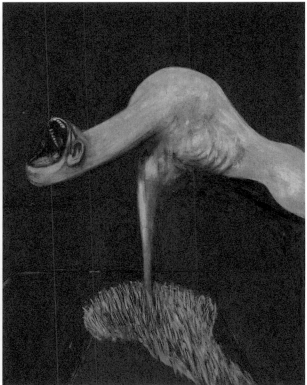

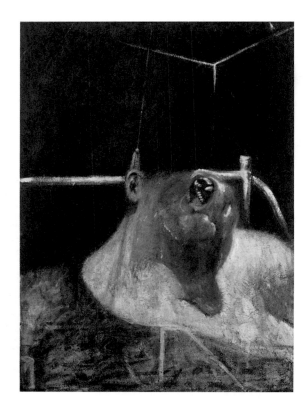

Head I, 1948. Oil and tempera on hardboard,
approx. 40½ x 29½"
The Mr. Hyde of English art

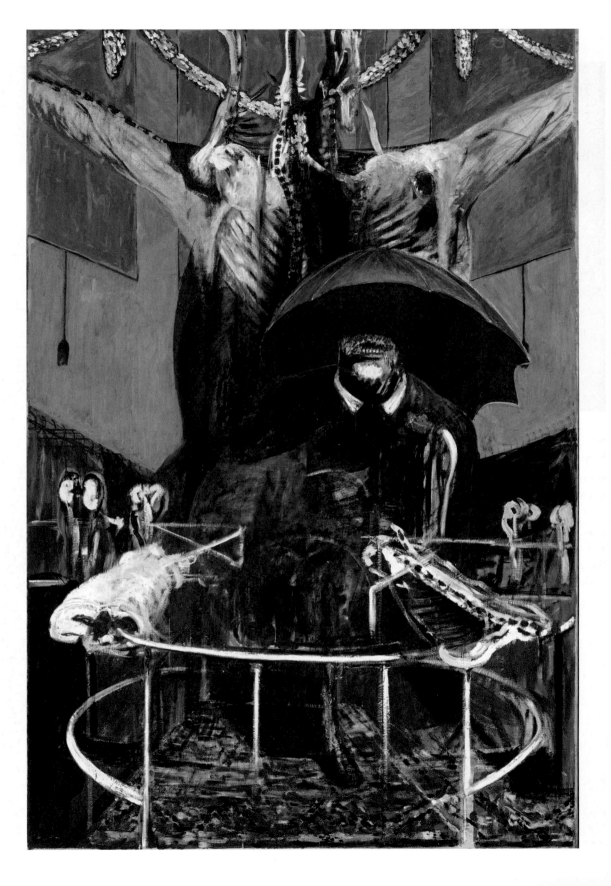

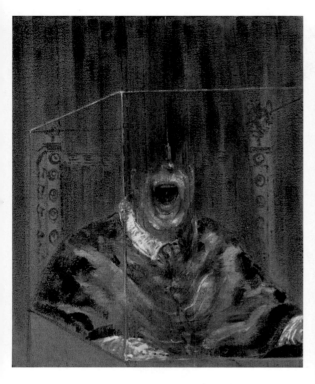

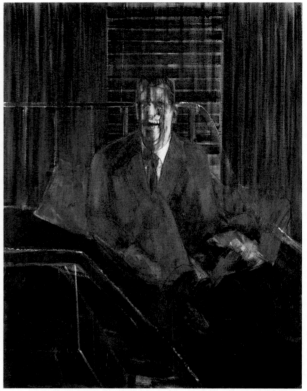

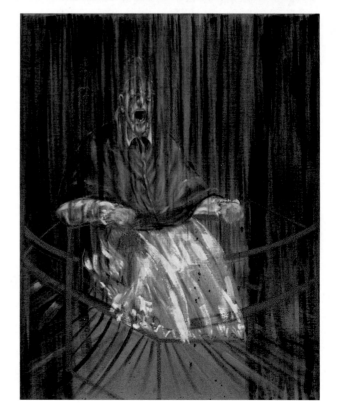

TOP, LEFT *Head VI*, 1949. Oil on canvas, 36¾ x 30¼″
Bacon's first screaming pope

TOP, RIGHT *Study for a Portrait*, 1953. Oil on canvas,
60 x 46½″
The first of Bacon's shadow-trapped businessmen

RIGHT *Study after Velázquez's Portrait of Pope Innocent X*,
1953. Oil on canvas, 60¼ x 46½″
Bacon liked to strip away the mask of pomp and circumstance to
reach the surprisingly clear animal scream.

OPPOSITE *Painting 1946*. Oil and pastel on canvas, 77⅞ x 52″
The picture, purchased by Alfred Barr for the Museum of Modern
Art, brought the Crucifixion into the modern slaughterhouse.

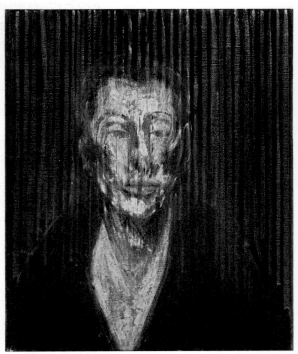

TOP, LEFT *Study of Figure in a Landscape*, 1952. Oil on canvas, 78 x 54″
The human animal emerges from the sharp African grass

TOP, RIGHT *Sketch for a Portrait of Lisa*, 1955. Oil on canvas, 24 x 20″
A pharaonic image of Bacon's patron, Lisa Sainsbury

Dog, 1952. Oil and sand on canvas, 78 x 54″
The dog of despair, circling in the sun

Two Figures, 1953. Oil on canvas,
60 x 45⅞"
An iconic image of homosexual passion
that Bacon's art dealer considered his
greatest work—but also a painting whose
subject meant it could not be sold

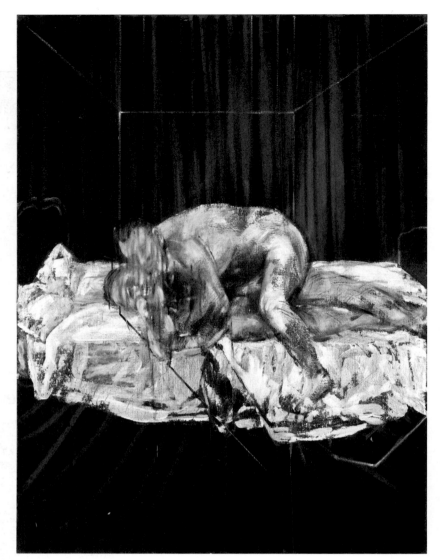

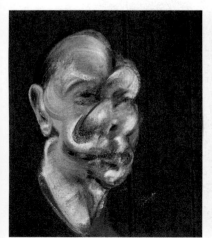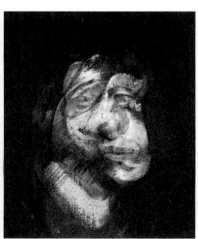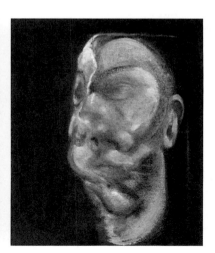

Study for Three Heads, 1962. Oil on canvas, each panel 14 x 12"
After Peter Lacy's death, Bacon pictured himself, his face suffused with grief, between two robust portraits of his lover.

Study for Portrait of Van Gogh II, 1957. Oil on canvas, 78 x 56″ Bacon's color began to erupt in the van Gogh series.

as Michael Ayrton, John Minton, Robert MacBryde, Robert Colquhoun, Keith Vaughan and John Craxton . . ." His "Welsh Sketch Book," which had been published in *Horizon* magazine in 1942 and described why Pembrokeshire meant so much to him, helped inspire a surging return to the land. But Sutherland also feared becoming provincial. He wanted to join the bigger and wider modern world represented by the France of Picasso, to "broaden his range and open his style to the influence of the great modern masters." As early as 1939–40, he began to produce paintings, such as *Association of Oaks,* that were more somber than his earlier work and not an obvious lyrical celebration of England. The next few years saw him diverge farther from the neo-romantic movement, wrote Berthoud, shifting "away from Wales and towards France, both spiritually and in actual fact." Fellow artist, and critic, John Piper, reviewing a group show in 1940 that included Sutherland's work, observed that his paintings were "vigorous and dangerous as painting in 1940 should be, and seldom is."

Bacon's wartime work celebrated neither England nor its countryside, which perhaps strengthened Sutherland's resolve to explore a more unalloyed darkness. No doubt Bacon's talk also helped. His bad-boy mockery of patriotic platitudes was astringent. With Bacon, Sutherland could discuss Aeschylus, Eliot, Yeats, and Picasso—each a major artist and each unsentimental. Bacon's huge, shadowy studio gave his dark paintings, filled with snarling mouths and headless figures, the glowing power of the cave. Together, Sutherland and Bacon developed a shared interest in an indecorous and shocking orange that had nothing to do with either the Union Jack or "England's green and pleasant land." And yet, Sutherland—however amused and intrigued by his bad-boy friend— remained closer than ever to Kenneth Clark. He always kept one foot in the drawing room.

Through Sutherland, Bacon met the younger neo-romantic painters of his generation. "I want you to meet this fantastic painter, Francis Bacon," Sutherland would kindly say. He would describe Bacon as "like a cross between Vuillard and Picasso." He may also have introduced Bacon to Peter Watson, a new star of artistic, literary, and intellectual life in wartime London. The second son of a wealthy baronet, Watson, a cultivated man undistracted by work, lived an enviable life in Paris during much of the 1930s. He collected, among others, Picasso, Miró, de Chirico, and Klee. In the late 1930s, the approaching war forced him back to London. His eye then turned to English artists. Watson bought his first Suther-

land, *Damp Tree Roots*, in 1939, followed shortly by *Entrance to a Lane* and *Gorse on Sea Wall,* whose craggy, indeterminate forms appeared primordial. The amiable Watson encouraged, befriended—and became the forgiving banker to—many indigent young artists, among them Lucian Freud, John Craxton, and the two Roberts from Glasgow, Colquhoun and MacBryde. Just as important, he financed the founding of the literary magazine *Horizon*. The first issue appeared in January of 1940. It was initially coedited by Stephen Spender—at least through 1941—and the writer and literary critic Cyril Connolly, though it was particularly associated with Connolly. Watson became a sort of arts editor, and Sonia Brownell (later Sonia Orwell) played a key editorial role. *Horizon* went on to publish most of the leading writers of the day. It also encouraged criticism by, and of, artists such as Moore, Piper, and Sutherland. It reproduced artworks, including a very early drawing of Lucian Freud's, provided by his friend Spender.

Horizon soon became a vital and encouraging center—as the bombs fell—of ongoing modernist thought in London. Watson was determined to "sustain, against all the odds, a European-based Modernist culture inside wartime Britain," wrote David Mellor in *A Paradise Lost.* The magazine also provided a social focus for what literary life was left in London. Those Cyril Connolly did not know, Stephen Spender did. Spender was then well established as a poet and leftist critic and was a close friend of Auden's and Isherwood's. Sonia Brownell—blond, glamorous, imperious—would become a figure of note first in literary London and then on the Left Bank in Paris after the war. (She would also marry George Orwell three months before his death in 1949.) And then there was Watson himself. "Where Cyril was short and podgy, Peter was slender, willowy and elegant," wrote Hilary Spurling in *The Girl from the Fiction Department,* her biography of Sonia Orwell. "Where Cyril's wit flashed and crackled, Peter was quiet, slow-spoken, self-effacing. He was by all accounts irresistible to both sexes, with a string of boyfriends as striking as Cyril's girls." Over time, Bacon became friendly enough with those around *Horizon*, and he would now and then visit the hangouts of the younger neo-romantics. The two Roberts, for example—the homosexual Scottish couple patronized by Watson—lived at 77 Bedford Gardens in 1943 with the independently wealthy John Minton. Bacon probably went sometimes to the famous Sunday gatherings of the two Roberts at the Windsor Castle pub in Camden Hill, where "Lucian Freud, Dylan Thomas and the poet W. S. Graham were among the crush," wrote Frances Spalding in *Dance Till the Stars Come Down,* her biography of John Minton. Watson arranged for the homeless Lucian Freud to room with John

Craxton, a young, neo-romantic artist who idolized Graham Sutherland. "Sutherland," he said, "was my hero."

But more important than his occasional connection to these intersecting circles of art, conversation, and power was the distance Bacon maintained from it all. Bacon could be as charming as Graham Sutherland and as festive as the two Roberts. He could easily have joined the small group in the cultural throne room. But he did not finally want to. Part of his reluctance probably stemmed from his underlying tension and unease, now largely concealed by his new air of public confidence. Bacon lacked the education of the literary figures at *Horizon*—since he had matriculated at neither Oxford nor Cambridge—and also the practical know-how of the many schooled neo-romantics. He also disliked Cyril Connolly intensely. But Bacon's anxiety was not the main reason for his reluctance to join the up-and-comers. He wanted to be Aeschylus, not Sophocles. Bacon was a "Dionysian," as Stanford said about Aeschylus, in "Nietzsche's sense." Bacon now found himself drawn toward the shadowy street rather than to the *Horizon* crowd. He was beginning to establish the pattern of his mature life: hard work in the morning followed by sometimes feral nocturnal wanderings.

In the war's last years, Soho did not possess the dirty glamour it would soon develop. In 1943, Soho—and its neighbor Fitzrovia to the north, where the pubs closed half an hour earlier—were desolate. Once a home, in the seventeenth and eighteenth centuries, to the rich and titled, Soho developed during the nineteenth century into a neighborhood of often poor immigrants. This was the period of "sepia Soho," as the writer Keith Waterhouse described the immigrant era, when the area seemed drawn from a yellowing Old World photograph. Soho developed a reputation as the place in London where you could find anything from anywhere. In the 1940s, there remained a few tailor shops, and some European artisans still mingled with Italian grocers. But the area was now better known for prostitutes and cruising homosexuals. The bombing had reduced parts of Soho to rubble, which only added to its air of desolation.

A few pubs continued to draw crowds, notably the York Minster and its Belgian proprietor, Victor Berlemont. It was so popular with the Free French forces in London that it came to be called "the French House" or simply "the French." "We fought our way in, pushing through the crowd of sailors, whores, airmen, negroes and French sailors," wrote the young artist and writer Denton Welch, describing its wartime character. "Close to my ear people whispered to each other earnestly, ecclesiastically. The thimblefuls of golden whisky spilt on dark cloth when elbows were jogged.

Someone said playfully, 'I'm feeling hysterical.'" Soho was swallowed by the darkness once the pubs closed—except not quite. In basements and behind ragged curtains lay a smoky kind of light. It was not easy to find this "Soho after dark" in blacked-out and rubble-strewn London, but the pleasures could be peculiarly intense. On a night in February, as the chill of London stiffened bones, a walker might come upon an old off-kilter door that opened into a sudden enveloping warmth. Soho had small one-room basement cafés and restaurants, such as the Horseshoe and the Mandrake, that offered ample food, plenty to drink, and sometimes jazz until the small hours. Not too far from Soho was Café Royal, the celebrated restaurant near Piccadilly Circus where Eric Hall had recently taken Ken Keast and where Cyril Connolly and the writer James Pope-Hennessy were often found. Bacon himself retained a restaurant like Café Royal as a social option, but preferred the less glamorous French House. Grit interested him more than glamour. "In North Soho, during the war years, a true bohemia had flourished and, in a measure, a true anarchy prevailed," wrote Anthony Cronin in *Dead as Doornails*, his look at Soho culture during its heyday. As Cronin described the atmosphere of Soho in the 1940s:

> The sort of artist who emerged from it was apt to be a higher type than the success-oriented younger poets or painters of the fifties, but he was also apt to be a more than usually highly developed misfit. . . . There were old Soho hands who were still about to be overtaken by the success machine, such as Francis Bacon, but in his case, as in others, overtaken is almost literally the word, and the success would be the result of a defiance of the world and its fashions rather than a cultivation of them.

In the mid-forties, the poet Dylan Thomas became a drinking companion of Bacon's. Another was the artist and photographer Peter Rose Pulham, the partner of the writer Theodora FitzGibbon, who described Pulham as "a large man with a beautifully shaped head . . . a well-trimmed long, silky moustache, a well-shaped full mouth, and the most extraordinary eyes." Bacon often found the couple with Thomas and his wife, Caitlin, in the pubs and late-night clubs of Soho and Fitzrovia. Of all their wartime friends and "as yet little-known painters," FitzGibbon singled out Bacon: "Peter always thought Francis looked like me and was delighted to find that we had both been brought up in the same part of Ireland. Francis was always my favorite, a brilliant painter working under great difficulties, yet he was, and still is, totally without malice. His face,

to the world, was one of gay equanimity; his troubles were not brought out for drinks."

Like Bacon, Pulham disliked the close-knit provincialism of British art, and he shared with Bacon a passion for France. After Oxford, he established himself as a fashion photographer in the 1930s, shooting glamorous pictures for *Harper's Bazaar* in London and Paris. He did a famous series of photographs of Picasso in 1938 and also photographed Graham Sutherland. (One sign of Sutherland's success was that he was photographed by three of the leading photographers of the day, Lee Miller, Cecil Beaton, and Pulham.) By the late 1930s, however, Pulham had grown weary of fashion. He moved to Paris where he became close to Man Ray, who may have edged him toward a more surreal approach in both photography and painting. Forced to return to London because of the war, Pulham remained linked to France in a way that Bacon envied. The connection between Bacon and Pulham—who died in 1956—was close throughout the 1940s. Pulham was far more cultivated and Continental than most young English artists of the time, not only a "passionate surrealist," as FitzGibbon said, but an intellectual who resembled many of Bacon's later French friends in the 1960s and '70s. He shared with Bacon a love of Buñuel and Eisenstein and the avant-garde cinema. Most of all, Pulham believed, like Bacon, in pushing the boundaries of his medium. Cecil Beaton described Pulham's later photographs, before he abandoned photography for painting, as looking like they were "developed in a particularly virulent poison, probably violet or viridian coloured; his prints have a mysterious, pernicious and enigmatic quality. . . ."

Bacon usually saw the two Roberts, Colquhoun and MacBryde, in down-and-dirty circumstances. By far the wildest of Watson's protégés, Colquhoun and MacBryde came from poor working-class backgrounds in Scotland and originally met at the Glasgow School of Art when they were still in their teens. In 1938, as German aggression intensified, they won fellowships to study on the Continent and were in Paris when Great Britain and France declared war on Germany. After fleeing France, they initially returned to Scotland, where they serendipitously met Peter Watson, who helped them move to London in 1941. They "lived on the margins, doing Civil Defense work, scrounging and stealing," wrote David Mellor in *A Paradise Lost.* Not long after reaching London, however, the two Roberts abandoned the elegant world of restaurants, clubs, and cocktail parties of their patron Watson in favor of "strange little pubs . . . in strange little quarters," as Colquhoun described them. In those "strange little pubs" they came to know Bacon.

No one who first met the two Roberts during the dark days of the

war forgot them. They moved through the subculture of the forties like two clan chieftains, wrote Mellor, with their "kilts, Highland reels and denunciation of fellow Scots whom they deemed collaborators with the English and with metropolitanism." The roistering Roberts—Colquhoun tall and "roughly handsome," MacBryde "small, and constantly in deft movement"—were known for drinking and brawling but were beloved by many as a bright-burning light in a desperate time. Bacon admired them for holding nothing back: they were not artful politicians. It was probably with Pulham, Dylan Thomas, and the two Roberts that Bacon first began to drink heavily, and regularly, at after-hours clubs.

It was also now that Bacon began to frequent the underground homosexual world of Soho, called by Dan Farson the "sexual gymnasium of the city." With the exception of an exciting moment of freedom during the 1920s, a lively homosexual scene did not exist in London before the war. It was simply too dangerous. But the war brought a measure of sexual liberation. Anti-homosexual laws remained on the books, but the police rarely enforced them. That—combined with the heady sense of living on the edge in the presence of so many men in uniform—created a surreal erotic paradise in the darkened city. "I met several guardsmen during that strange period when the bombing had not yet started and the black-out heightened the sense of adventure as one slipped into pub after pub," wrote the poet John Lehmann in his autobiographical novel *In the Purely Pagan Sense.* "My sexual hunger was avid as it was with so many others at a time when death seemed to tease us with forebodings of liquidation in terrors still undeclared." During the day the basement cafés on Charlotte Street in Fitzrovia were all but hidden from view, and at night they were difficult to find during a blackout. But for the knowing, they were sexual meccas. A guide first pointed the way to Quentin Crisp. "If it had not been for this casual invitation, a whole world might forever have remained closed to me," he wrote. "By night, when these places came most vividly to life, no one who had not a pathfinder's badge could have reached them."

The homosexual trade that surrounded the Queen's Guard and cavalry—the contingents of highly dressed soldiers who, ramrod straight, guarded the royal palaces in London—was an open secret. For many young soldiers, casual homosexual sex almost amounted to a regular night job. "There were goings-on in high society, in the household cavalry or the Guards," said Grey Gowrie. "If you were married to a duchess or something, and you wanted a chap, you would ring up your old regimental sergeant major and he gets you a guardsman who's saving up for his house

and marriage. A lot of that went on. And people knew about it." Soho was the best place for such minglings. "The French Pub was filled during the war with a lot of drunken soldiers and artists and hookers," said John Richardson. "Where we all went. The French Pub was headquarters— you could pick up everything you wanted." There were also less reputable forms of the disreputable to be found: "male whores" in Piccadilly and people "cottaging," or engaging in anonymous sex in the public toilets.

Bacon's primary relationship remained with Eric Hall, but his confidence, as he returned to London to live in a handsome flat with a magnificent studio, conveyed to everyone around him that he was Hall's equal. Bacon was not interested in cottaging or routine prostitution. He wanted the more powerful personal undertones that can accompany sex, even if the sex itself was casual, anonymous, or rough. Sex at its best could be a kind of revelatory theater. During the latter part of the war, Bacon— far from being a young ingenue—could even become the "older man" to certain young soldiers, or chance upon a man his own age. The older closeted homosexuals with whom Bacon spent his younger years—Allden, de Maistre, Hall—would certainly have understood if he sometimes took exercise at the "sexual gym." But they were not themselves attracted to rough trade or heavy drinking. "Most of them were well-brought-up— upper-middle-class or higher," said Heather Johnson. Such behavior was "something they didn't want to be associated with." They were too respectable, and respectability did not interest Bacon any more than it did Aeschylus.

Sewer Boots

GRAHAM SUTHERLAND recommended Bacon to the tastemakers. One of the first was John Rothenstein, who became director of the Tate in 1938 at the age of thirty-seven after serving as the director of museums in Leeds and Sheffield. Just three months after Bacon first wrote to Sutherland, Rothenstein happened upon Sutherland and de Maistre at an exhibition and, said Rothenstein, the two artists "spoke to me with enthusiasm of the work of a strange but gifted painter, Francis Bacon." Sutherland also talked Bacon up to important collectors, among them Colin Anderson, who would eventually purchase two Bacon paintings and become, in the early 1950s, a patron of the artist.

In 1944 or early 1945, Sutherland even persuaded Kenneth Clark to visit Bacon's studio. Clark walked into 7 Cromwell Place "with his tightly rolled umbrella" and appeared importantly busy, said one witness, "very much the Director of the National Gallery." He "gave Bacon's work a swift appraisal, and said, 'Interesting, yes. What extraordinary times we live in.'" Then he walked out. Earlier, Sutherland, who was present during the visit, advised Bacon to cultivate figures like Clark: "One could not work in a vacuum." Once the door closed behind the director, however, Bacon turned to Sutherland and said, "You see, you're surrounded by cretins." Bacon's work would always be, for Clark, too outlandish; Sutherland's brambly forms, derived from nature, provided for him the right mix of traditional and modern, despair and finesse. But Clark did not, in fact, dismiss Bacon's art. That same night at dinner Clark said to Sutherland: "You and I may be in a minority of two, but we may still be right in thinking that Francis Bacon has genius."

Early in 1945, Duncan Macdonald, a director of the Lefevre Gallery, sensed a stirring in the English art world. The war was nearing its end,

and Londoners were eager to reclaim their city. Although the gallery traditionally focused on established French and Continental art, it also sometimes exhibited modern English artists, among them Walter Sickert. A spring show of England's wartime art, thought Macdonald, might give Lefevre a head start in the competition to represent artists in the postwar period. The show would ideally include the three best-known British artists of the time: Graham Sutherland, Henry Moore, and Ben Nicholson. Each was in his prime. Each could be presented as a contemporary master.

Macdonald was particularly interested in Sutherland, who was known to be finicky about exhibiting with other artists. Macdonald therefore discussed his ideas for the show with Sutherland and eventually decided to add two modernists from an earlier generation, Frances Hodgkins (a New Zealander living in London) and the widely admired Matthew Smith. It was a shrewd decision. Smith and Hodgkins, as éminences grises from the prewar period, could create an atmosphere of historical continuity while Moore, Nicholson, and Sutherland could represent the vigorous present and future. English art, it would seem to a weary public, was moving ahead. Then Nicholson decided not to participate. Macdonald considered replacing him with John Piper, also a well-known artist during the war, but Sutherland preferred not to exhibit with him. Instead, Sutherland suggested that Macdonald add a wild card to his hand—the almost completely unknown Francis Bacon. Sutherland wrote:

> I should really prefer Francis Bacon for whose work you know I have a really profound admiration. It is true that he has shown very little, but nowadays with every Tom, Dick and Harry showing yards of painting without much selection or standard this is refreshing, & his recent things, while being quite uncompromising, have a grandeur & brilliance which is rarely seen in English art.

The inclusion of an unknown would have the additional benefit of making the show more exploratory and less top-heavy with reputation. Sutherland regarded Bacon as, if not a protégé, then one for whom he had served as a mentor, and he would not have failed to notice a few flattering reflections of his own art in Bacon's painting. In February 1945, Macdonald asked Bacon if he would submit four or five pictures to the exhibition, fewer than half the number requested from the more established figures. The invitation "may have seemed rather intimidating but it also presented Bacon with a challenge," wrote Martin Hammer in *Bacon*

and Sutherland, "and a real opportunity to make an impact. His response was to devise as large, powerful and hard-hitting a work as he could contrive, at a time when most current work was rather modest in scale and ambition, reflecting economic realities."

It was probably less the company that excited Bacon than the pressure to finish a painting. He had not exhibited in eight years. His enforced withdrawal had freed him to revise, dither, recoil, experiment, and destroy. A deadline interrupted this cycle, like the music stopping during a game of musical chairs or the roulette ball dropping into place. It therefore had its uses. The pressure to find a lasting image required a momentary clarity: it focused his energy. He might take a radical chance or make the desperate bet. Two and a half weeks before the show was scheduled to open, Macdonald asked Bacon to telephone him. Could they possibly discuss which pictures to exhibit? The call was likely prompted by a concern that Bacon was still working and revising, having not himself decided what, if anything, he was prepared to exhibit.

Before the exhibit, Bacon procured some hard-to-find canvas, probably through the resourceful Sutherland. He may have hoped to paint all his pictures for the show on canvas; he preferred it to fiberboard, the only option available during the war. On the precious new surface he now completed his largest recorded painting to date, *Figure in a Landscape* (1945), a lushly painted scene of a man—whose head cannot be seen—sitting inside a cavelike ring of darkness. The painting was in Bacon's more restrained style but was filled with foreboding. The waiting figure could be too shy to emerge—or perhaps was the troll under the bridge.

Bacon required more than one image: Macdonald had asked for four or five. There was unfinished work on fiberboard in his studio (all his pictures then were "unfinished") including studies for a ghoulish crucifixion scene—far more challenging than *Figure in a Landscape*—that he may have begun in Steep and continued to develop in London. (In 1944, Graham Sutherland saw some Crucifixion imagery in Bacon's studio.) Bacon's presiding theme, in 1945, continued to be the Crucifixion. Many other artists, determined to capture the agony undergone by Western society in two world wars, were also interested in creating one. When Bacon made his *Crucifixion* of 1933—a beautiful but not especially difficult image—he had been absorbed in surrealism and the elongated figures of Picasso's Dinard series. It was not surprising that his new work, an echo of the traditional subject of mourners at the foot of the cross, also retained some surrealist and Dinard-like forms. Otherwise, these new studies bore little resemblance to the ghostly painting of 1933. They were

joltingly raw, with a crude and visceral surface: there was plenty of spit in the paint. The "mourners" themselves were long-necked, gloating creatures probably inspired by the gruesome Furies of Aeschylus. If Kenneth Clark saw a version of these pictures when he visited Bacon in Cromwell Place, he could be forgiven for leaving promptly and observing correctly, "What extraordinary times we live in."

After eight long years Bacon did not want to hide or deny his wounding images, which were the culmination of hundreds of earlier efforts that he had concealed and destroyed: Diana Watson's "flaming forms." Still, it would take courage to exhibit them. He would not have forgotten the humiliating failure of his "wound" painting at the Transition gallery. But he was now more confident and experienced at the easel. "If you are going to decide to be a painter," he would say later, "you have got to decide that you are not going to be afraid of making a fool of yourself." And besides, *Figure in a Landscape* offered him some protection. It was a fine picture that no decent critic could dismiss out of hand. But it was not enough, not after a war.

"Flinging a pot of paint in the public's face," as Ruskin famously put it, would become—in the decades following World War II—a conventional aspiration. It takes some imagination, then, to understand the boldness required of Bacon to exhibit *Three Studies* in 1945. Denton Welch published, in 1942, a kind of parable in *Horizon* that brilliantly captured the suffocating social pressure faced by any English artist who wanted to step outside the English drawing room. The putative subject of his "Sickert at St. Peter's" was a visit Welch made in the mid-1930s to his idol, Walter Sickert, not long after the aging painter moved to a village near Broadstairs. Its real subject, however, was the exquisitely painful contrast Welch drew between himself and the eccentric and powerful Sickert (one of the few English artists whom Bacon respected). Having cajoled an invitation to tea, Welch—then an earnest, well-educated art student—knocked on the door of the rather grand but run-down house. He experienced a "slight shock" at seeing, as Sickert's wife opened the door, "a glistening white 'W.C.'" directly in front of him. He found the floor of the room where they were to have their tea "quite bare." He looked at "two glittering monstrances" from a Russian church. "They were fascinatingly gaudy and I coveted them." "The tea cups," he noted, "did not match." He checked the hallmarks on the "flimsy and old" spoons. "I felt that at last I was seeing Bohemian life."

Welch happened to be looking at a Sickert painting of a miner—just emerging from the pit and fiercely kissing his wife—when Sickert himself came into the room. "Huge and bearded, he was dressed in rough clothes and from his toes to his thighs reached what I can only describe as sewer-boots." (They were probably rubber work boots.) Sickert exclaimed: "That picture gives you the right feeling, doesn't it? You'd kiss your wife like that if you'd just come up from the pit, wouldn't you?" Welch found himself "appalled by the dreadful heartiness of the question." He blushed and "hated him for making me do so." Later, he was astonished when the painter began "to dance on the hearth in his great sewer-boots. He lifted his cup and, waving it to and fro, burst into a German drinking song. There was an amazingly theatrical and roguish look on his broad face." Sickert—who, like Bacon, worked from photographs—asked Welch what he thought of a small "carte-de-visite" photograph of a woman. Welch found its subject "quite hideous with a costive, pouchy look about the eyes and mouth," but felt himself in a "difficult position." He observed that the photo was so tiny he could not see the subject's features well but loved the clothes of the period.

> Sickert snatched the photograph from me. "Tiny! What do you mean by tiny?" he roared. He held the picture up and pointed to it, as if he were demonstrating something on a blackboard; then he shouted out in ringing tones for the whole room to hear: "Do you realize that I could paint a picture as big as this (he stretched out his arms like an angler in a comic paper) from this 'tiny' photograph as you call it?" Horribly embarrassed and overcome by this outburst, I smiled weakly and cast my eyes down so that they rested on his enormous boots. . . .

Sickert said, "Ah, I see that you're staring at my boots! Do you know why I wear them? Well, I'll tell you. Lord Beaverbrook asked me to a party and I was late, so I jumped into a taxi and said: Drive as fast as you can! Of course, we had an accident and I was thrown on to my knees and my legs were badly knocked about; so now I wear these as protection." It had become dark when Sickert helped the young artist and his other teatime visitors with their coats—"as if he were dressing sacks of turnips." Welch once more noticed the indiscreet "flush-closet" by the front door. Sickert, still dancing and singing, led his visitors to "the creaking stable yard door and stood there with his hand on the latch. . . . 'Good-bye, good-bye!' he shouted after us in great good humour. 'Come again when

you can't stop quite so long!'" At those words, wrote Welch, "a strange pang went through me, for it was what my father had always said as he closed the book, when I had finished my bread and butter and milk, and it was time for me to go to bed."

In April 1945, the week before the opening at Lefevre, Bacon made his decision about what to exhibit: the three studies of figures at a Crucifixion and his big new painting on canvas. Perhaps he enjoyed the prospect of juxtaposing the muted landscape with the ghoulish creatures at the Crucifixion. The figure in the landscape, half-concealed in the dark, could almost be their waiting audience. He knew that many would find the Furies offensive. He also knew that the finely painted canvas *Figure in a Landscape* was likely to arouse praise. He did not care much either way. Bacon was now himself, like Sickert, in possession of his "I" and "eye"— prepared, if necessary, to wear sewer boots.

THREE STUDIES FOR FIGURES AT THE BASE OF A CRUCIFIXION (1944)

Like Aeschylus, Bacon hoped to capture the inexpressible—to locate, by going too far, powerful inchoate feelings that lay behind words or the well-trained eye. He might then touch some deeper, more visceral nerve. (He often chose not to depict the eyes of a figure.) Bacon relished Stanford's actual translations of lines in Aeschylus because, in his rendering, the playwright awkwardly twisted and displaced language into newly raw meaning. One phrase particularly pleased Bacon: "The reek of human blood smiles out at me." *Three Studies* have that smell—and that smile. The figures may have placed themselves at the foot of a cross, but they conveyed nothing dolorous, mournful, or tragic. Instead, they appeared delighted at "the reek of human blood."

The central figure, who "smiles out" at the viewer, carried a special charge. On either side of him, the creatures could be the fanciful inventions of a diseased imagination, like those found in Hieronymus Bosch or the Grand Guignol, and then dismissed as mere monsters. But the central figure, in the position usually occupied by Christ in a triptych, appeared grotesquely familiar, grinning and big-toothed, like the disagreeable relative at a family reunion. The bandage was the brilliant touch. The bandage was a sign of sacrifice in a war. It stanched the blood and closed the wound. It represented healing and heroism. Whose heart had not leapt with sympathy upon seeing a photograph in *Picture Post* of a maimed soldier or a wounded civilian? Here, the bandage covered the eyes, increas-

ing the focus on the other senses, notably the huge gloating mouth. The bandage became a blindfold that could cover the eyes but not the maw.

On the central figure's left was a cronelike creature that resembled a bird. She was hunkered down and looking away from the viewer as if she were hiding something. She had heart-shaped shoulders and little bone-twigs for arms that resembled a chicken wing plucked of feather and flesh. She could be hovering over an egg or protecting a piece of bloody meat. On the central figure's right was a baying creature who, it appeared, stood planted on a small piece of spiky grass. His head was almost entirely mouth, and the mouth was turned upward like a cup, the better to receive some dreadful nourishment from the sky. All the senses were stimulated by these creatures. The viewer could almost smell the musk, hear the baying, feel the coarse flesh. All three had elongated necks, connecting their heads to repulsively plump bodies, and it was not hard to imagine food or blood pulsing down their gullets. In *Three Studies*, Bacon—from childhood both fascinated by and fearful of the animal world—found the animal in the man and the man in the animal.

The three figures inhabited a strangely bare environment. Two occupied a space that contained scraps of what could be old furniture—what was left, perhaps, of the European drawing room. The third stood outside the room, but on a piece of grass that was no more welcoming than the room or the furniture; not much remained outside the drawing room either. Behind the figures were bits of melting geometric line that, by failing to define anything specific, evoked a fateful space around the figures that could not be read or brought to order. The space was filled with an extraordinary burnt-orange light, which glowed eerily but did not illuminate. It was a color to shock wan, gray, war-weary London, where for years there had not been any intense light apart from the bomb flashes and subsequent fires. John Russell would later call these images that Bacon was about to exhibit a key marker: there was English art before, and English art after, *Three Studies for Figures at the Base of a Crucifixion*.

Iconoclast

Francis Bacon in his studio at Overstrand Mansions in Battersea, where he lived with the flamboyant
Paul Danquah and his partner, Peter Pollock. Cecil Beaton called it a "Dostoevsky shambles of
discarded paints, rags, newspapers, and every sort of rubbish."

"I began"

IN APRIL OF 1945, not much art was on view in London. The museum collections had not returned from the countryside, and few galleries were mounting exhibits. Great swaths of the city lay in ruins. News of the death camps flickered across the newsreels. Allied forces were liberating Bergen-Belsen, Buchenwald, and Dachau: Auschwitz's liberation had come three months earlier. The skies over London were now clear of the unmanned rockets nicknamed "doodlebugs" that tormented the city in a second wave of terror from June 1944 to March 1945. The Red Army was driving toward Berlin. Soon, England began to realize, the Nazis would surrender.

Half-forgetting, putting aside, getting back to business: the survivors of the war began to think of trying to move on. At the Lefevre Gallery, *Recent Paintings by Francis Bacon, Frances Hodgkins, Henry Moore, Matthew Smith, Graham Sutherland* included a surprisingly large number of works—fifty altogether, among them eleven Sutherlands and fifteen Moores—and attracted big crowds eager to recover some of the savor of prewar life. Almost everything sold. If people came to admire the bright lights of English art, however, they left shocked by the orange darkness of Francis Bacon. It was instantly sensed, as John Russell noted, that something important in art was occurring. "Visitors tempted into that gallery by the already familiar name of Graham Sutherland were brought up short by images so unrelievedly awful that the mind shut with a snap at the sight of them," wrote Russell. The figures in the paintings "were equipped to probe, bite, and suck, but their functioning in other respects was mysterious. Ears and mouths they had, but two at least of them were sightless. One was unpleasantly bandaged."

The first response of many critics, including Russell, was to try to tame the paintings. Russell fretted about "the furthest reach of anatomical Guignol." Raymond Mortimer appreciated Bacon's "uncommon gifts,"

but considered the paintings "symbols of outrage rather than art." Macdonald, the curator of the show, chose to emphasize their formal qualities. Some people might find their subject "frightening," he observed, but he considered them "very well designed and painted." The painter and critic Michael Ayrton, a strong supporter of the neo-romantic movement, believed that Bacon had done nothing more than raid Picasso's pantry: "These are large studies for a Crucifixion which, unless he is the victim of a remarkable coincidence, are completely under the influence of one of Picasso's epochs; the so-called 'Bone' period of 1932, when with spectacular cynicism Picasso reduced the gigantic achievement of Grünewald's Isenheim Crucifixion to a series of French loaves, putty and damp cloth."

The critics, painters, and sophisticated viewers who were taken aback by *Three Studies* were not inexperienced in the tricky ways of modern art. They knew about the impressionists being attacked before they were praised. They had heard the sad story of the great Vincent. They were prepared for bulls in china shops. They recoiled nonetheless because Bacon challenged current modern attitudes held by thoughtful people. The blasphemous attack upon Christianity—while unsettling—was not the worst of it. Christianity was easily mocked, pilloried, and abandoned after two wars. Loss of faith was a familiar subject. But even sacrilege was governed, in 1945, by certain implicit understandings. God might be dead, but one still doffed the hat before the mourning, suffering, and tears, and it remained possible to believe in secular forms of redemption. In his spectral *Shelter Drawings*, Henry Moore depicted ordinary Londoners taking shelter from the Blitz deep in the tunnels of the Underground, driven like animals into a hole. And yet they did not become Bacon "animals." They created some order in their hole and formed a community of the under-the-ground. The stoic heroism of the present contained a promise for the future: the buried would rise into the light. Moore became especially important in the postwar period, when, as Russell put it, he began "manifesting a robust confidence in the continuity of normal life" and was "at one with most English people."

Even *Guernica*, for all its newsprint modernity, was suffused with a feeling of old-masterish authority and classical high tragedy. The ancient symbols—the gored horse, the bellowing bull, the grieving mother—gave a timeless aura to the bombing of the Basque town, and the scream to the heavens appeared cathartic. Bacon would also become interested in catharsis and the timeless element of Greek tragedy, but in 1945 he sought the smiling "reek of blood." He wanted nothing high or reassuring or

escapist, only the truth of two bestial wars. Many in the crowd at Lefevre would have been reminded, as they looked at this cackling caricature of the great religious triptychs, of all that they once loved about art.

Most disturbing of all, Bacon did not distinguish between good and evil. The war represented a struggle for Western civilization, it was widely believed, in which people fought and died for a reason—to protect decency but also, among many other things, to preserve civilization. It was not *we* who had behaved badly, the visitors to Lefevre believed; it was the other lot. The Fascists. *Three Studies* suggested that the fault lay "in ourselves"—that is, cocooned within humanity—and not "in our stars" or in certain Germans. It was not the Hobbesian message that people in April of 1945 wanted to hear. "All over the country," said Russell, "the phrase 'After the war' was being taken down from the shelf and dusted off. Something of the magnanimity of Winston Churchill had been passed on to the nation which he had so often had to take into his confidence. Nobody wanted to believe that there was in human nature an element that was irreducibly evil."

Who was this new monster maker? A past was wanted, but Bacon seemed to take no interest in revealing any details. "I began," Bacon later announced, with *Three Studies for Figures at the Base of a Crucifixion*. He treated his new success with beguiling indifference. He did not preen or seek out well-known people; he appeared more interested in opening oysters than doors. In fact, he could not really claim to be all that successful. Even though his work was the talk of the exhibit, no outsider actually stepped up to buy one of his pictures. *Three Studies* went to Eric Hall, who purchased it before the show opened, perhaps understanding before Bacon himself did the importance of keeping the three pictures together. His cousin Diana Watson bought Bacon's other work on view, *Figure in a Landscape*, after the show came down. Bacon's mother never seemed to consider buying a painting by Francis or hanging one in her home. Like Patrick White's mother, she would have preferred that Francis—if he should choose to become a painter—compose pleasing landscapes and nice portraits, especially of horses. Bacon's sister Ianthe recalled her asking, "Why does he have to paint pictures like that?"

The truth was that Bacon's "beginning" was far from over. *Three Studies* represented a confident public attack upon conventions, but Bacon himself was less certain than he might appear. The question was how he could follow *Three Studies*, especially since the less shocking but more painterly *Figure in a Landscape,* also included in the show, represented the direction that he was mostly pursuing in 1944 and '45. The critic David Sylvester

loved *Figure* and called it "an inexplicably awesome and threatening scene made still more disturbing by its joyous lyrical harmony of blue sky and ecru land."

Seven months after the Lefevre exhibit, London honored Bacon's first master. *Picasso and Matisse* opened at the Victoria and Albert Museum, a ten-minute walk from Bacon's flat in Cromwell Place. Postwar London was in a celebratory mood, though rationing and rubble remained. Over five weeks, an astounding 160,000 people viewed the thirty Matisses and twenty-five Picassos. No doubt the barren culture of the war contributed to this success, but many in England also believed that the best modern art by definition came from abroad. Picasso's prewar exhibition of *Guernica* had been extraordinarily well attended.

The new exhibition was oddly reassuring. All the familiar prewar arguments about the dueling masters, Picasso and Matisse, were once again rehearsed in the press, although the exhibit focused on work made during the war. Then as now, critics generally regarded the period as a weak one for both artists. Picasso was criticized for not creating more paintings in the tradition of *Guernica* (to which Picasso replied, "I am not the kind of painter who goes out like a photographer for something to depict"). Matisse's paintings of "gorgeous girls lounging on cushioned divans in transparent tops and filmy harem pants," wrote Hilary Spurling, were regarded as the "epitome of bourgeois conventionality." But even the weaker work of these two masters was more interesting, many observers then believed, than the best London could offer. The critic for *The Sunday Times* called Picasso's misshapen figures and stolid everyday objects (*The Enamel Saucepan*) "a blast of searing air from a furnace."

Younger artists, eager for news from across the Channel, did not regard the Picassos as a tailing off. His latest paintings had "a galvanizing effect on a generation of young British artists," among them the neo-romantic painters—John Minton, the two Roberts (Colquhoun and MacBryde), Keith Vaughan, and John Craxton—many of whom Bacon had first met in the underground clubs of Soho and Fitzrovia during the war. In Picasso's latest work, they admired what neo-romanticism typically lacked and what the public at large tended to dislike: a commonplace realism, rough and unsweetened. Vaughan thought Picasso had found a way to depict bodies and objects that was appropriate to postwar life. Others admired the way he could bring a sense of brash largeness to whatever he depicted. In her biography of Minton, Frances Spalding wrote:

A change of direction became imperative after the *Picasso and Matisse* exhibition opened at the Victoria and Albert Museum in London in the winter of 1945–6. . . . It included *Night Fishing at Antibes* which, in its scale alone, was impressive, the exhibition as a whole effectively terminating the introspective melancholy and nostalgia of neo-romanticism, encouraging in its place the production of large, strident, forceful pictures.

In January of 1946, Bacon ran into Eric Allden on Brompton Road. What did Francis think of the show at the V&A, Allden asked, which everyone in the London art world was now chattering about? Bacon found it "anything but interesting." A lesser artist than Bacon, determined to maintain momentum, would have continued to work safely within the Picasso tradition. (Bacon acknowledged that his *Three Studies* was inspired by the Picasso "biomorphs on beaches turning keys in the doors of their bathing cabins.") Instead, just when he had finally attained some recognition in his late thirties, he began to turn away from both *Three Studies* and Picasso. The success of the controversial triptych did not change his mind about the direction in which he now wanted to take his art. Bacon may have "begun" with *Three Studies*, but it would become in his oeuvre a startling if essential outlier: more ghoulish, caricatural, and linear than much of his work.

What claimed Bacon's interest at mid-decade was the sensual intoxication of paint. If he relished the brushy fleshiness of oils, however, he still seemed reluctant to address human flesh itself and focused on clothes, flowers, and fabulous shapes. He was reducing his emphasis on line and becoming more painterly and "Venetian." He lacked both Picasso's training and his genius as a draftsman: he admitted as much. It was not lack of skills alone, however, that led him to reduce the importance of drawing. It was also a matter of conviction. The prospect of "line" containing form and color and paint—controlling and directing the scene—made him uneasy. If human beings did not possess any true power over themselves, within themselves or in the world at large, why pretend otherwise in art? A reliance on line led too often to an illusion of mastery, a fatherly sort of domination of the picture—what Bacon later dismissed as merely "illustrative" or "decorative" effects. He preferred the painterly nuance of Rembrandt or the late Monet, in which recognizable forms emerged—vividly, mysteriously, without the presumption of line—in a way that seemed unknowable. Sorcery of a kind.

Initially, Bacon created hybrid works that straddled the eruptive world

of *Three Studies* and his more restrained painterly interests. He may have briefly considered turning *Three Studies* into an ongoing signature style. Variations on the famous creatures were in the studio, perhaps painted at about the same time. A picture called *Fury* was an almost exact copy of the figure in the right-hand panel of *Three Studies*—also painted on fiberboard and displaying the same striking oil-and-pastel orange background. This time, a spray of flowers issued from the creature's gaping mouth. (David Sylvester called it "a beautiful variant of the right-hand panel.") A second, somewhat later variation—this time painted on canvas, so it probably came later than *Three Studies*—was of the left-hand panel. The figure was bending over to sniff a bouquet of red tulips placed upon a decorative table. The lustrous blackness of the figure's cape, the carefully painted shock of reddish-brown hair, the striated paint strokes in the background that evoke curtains: all attested to Bacon's tactile interest in paint. These two Furies appeared tamed, brought back into the drawing room, as in Eliot's play. But Bacon, dissatisfied, released neither from the studio.

The two paintings that Bacon did release in 1946—the same size as *Figure in a Landscape* (a bit over four by four-and-a-half feet)—were significantly larger than the panels of the triptych. They were works of opulent melancholy. One was a study of an emptiness full to overflowing; the other was a crying-out that seemed unheard. In the first, *Figure Study I*, Bacon painted someone who was not there, turning the image into a kind of still life or memento mori of the human figure. The man was sensed through what he wore, such as a fedora and a magnificently rendered tweed overcoat full of painterly touch. Red and blue flowers painted with symbolist pungency—an air of deathly rich rot and perfume—filled the space where the head would otherwise be. In *Figure Study II*, Bacon created an image that evoked, as he acknowledged at the time, the lamentation of Mary Magdalene before the cross. (Graham Sutherland also painted a *Weeping Magdalene* around the same time as Bacon's *Figure Study II*, and her screaming mouth and arched body resembled the creature in the right-hand panel of Bacon's triptych.) In Bacon's picture, the figure was positioned beneath a black umbrella, likened by one critic to bat wings, and beside spiky palm fronds. All that could be seen of her head was the mouth, opened in a cry of desperation. A tweedy fabric—luxuriously detailed and tactile—covered the figure's lower body, whose sculptural solidity seemed more like a tomb than human flesh.

Both of these "figure studies" contained overt echoes of *Three Studies*, though not as obviously as in the works Bacon did not release from the studio. But neither was monstrous: both were steeped in sensations of

mourning and loss. For the first time, in *Figure Study II*, Bacon created a figure that appeared more human than animal: the open *o* of the mouth was that of a person, not some howling beast. In each of the pictures, the figure was poignantly conveyed, and the painterly touch expressed a rapturous love for the world's richness. (In *Three Studies*, there was no love to be lost.) Hoping to consolidate Bacon's reputation after his success in the first show, Macdonald asked Bacon to include these two pictures in a second group show at Lefevre scheduled for early in 1946. This time, Graham Sutherland and Ben Nicholson were the show's headliners, while six less established but well-regarded artists—Bacon, the two Roberts, John Craxton, Lucian Freud, and Julian Trevelyan—would serve as the younger chorus.

Macdonald was hoping for more than two pictures from Bacon, but a month before the private view Bacon wrote him an apologetic note confessing that he could not contribute any more. He had earlier sold a picture privately (probably to Peter Watson) that, he informed Macdonald, could not be included because he had not yet found an adequate frame. Frames certainly mattered to Bacon, but this excuse must have struck both Macdonald and Bacon as preposterous. It was almost certain that Bacon simply wanted to revise the picture, which he did eventually take back and then destroy on the easel. There might be one other painting available, Bacon hinted, but the "new one you saw," he informed Macdonald, "I am not satisfied with yet." In the end, he contributed only the pair of figure studies. They persuaded certain critics, however, that Bacon was not just another china-shop bull. He possessed a bravura touch that could be surpassingly subtle. "Roger Marvell"—the pseudonym of the well-known writer and authority on film Roger Manvell—wrote an extraordinary rave about the artist's work:

> There is nobody in England who can paint better, and only two or three who can paint anything like as well. Look at the grey material and the blue flowers, the handling is consummate. I should suggest an affinity with Velázquez's, if I did not know that somebody would at once attribute to me the view that Mr. Bacon is as great a painter as the Spaniard. I don't cotton on to his symbolism and—far more serious—I find his compositions hard to grasp. But what excitement to find in a young English painter such staggering virtuosity.

The institutional powers of the English art world took note: not virtuosity alone, but *staggering* virtuosity.

It was probably Graham Sutherland who first recommended Bacon to the immensely wealthy Colin Anderson, an art collector whose fortune stemmed from his family's Orient shipping line. Anderson "radiated good looks and charm," wrote Roger Berthoud in his biography of Sutherland, and he had an eye for modern design as well as art. (He admired the Bauhaus and decorated his firm's new ocean liners in a version of that advanced style.) Since Anderson was also a patron with a sense of duty, who believed that collectors should help educate the public about modern art and offer support to struggling young artists, he joined the organizing committee of the Contemporary Art Society, which had been founded in 1910 to buy modern works of art to donate to public galleries and museums, usually outside London. Another member of the organizing committee was John Russell, the young critic of *The Sunday Times*, who had a highly attuned instinct for both art and that part of society that gathers around art. Russell probably seconded Sutherland's interest in Bacon. Anderson and Russell induced the society to purchase *Figure Study II*. It was an English institution, then—not a collector—that made the first significant purchase of a Bacon painting apart from friends and family (and Bacon's early admirer, Michael Sadler). The "wild man" was not unconnected. And yet no English museum was willing to accept the freely offered painting. The problem was likely the figure's disturbing mouth. Six years would pass before the society finally persuaded a small institution—the Bagshaw Museum in Batley, West Yorkshire—to accept the painting.

Artists, of course, also took note. Not long before the first show at Lefevre, Lucian Freud, at Sutherland's suggestion, visited Bacon at 7 Cromwell Place. There he saw *Three Studies* already set in the heavy gold frames that Bacon preferred. Francis Bacon, Freud would later say, was the "wildest and wisest" person he had ever met. The young Irish artist Louis le Brocquy, who had moved to London not long before Bacon's first show at Lefevre and had heard of him through the grapevine, visited his studio just before the second exhibition at Lefevre. There, in the flickering light of the gas stove, he saw *Figure Study I*. It must have looked even more dramatic in Bacon's vast studio than it did on the gallery walls. Le Brocquy was "staggered"—that word again—"by its sheer presence." It "reflected the person who wasn't in it." A figure without the figure?

Macdonald considered Bacon an up-and-comer. Even the New York art world, thanks to Macdonald, would soon hear about this new painter of monsters. Having spent much of the war in New York, at the Bignou Gallery, Macdonald had made friends in Manhattan's art world, among them James Thrall Soby of the Museum of Modern Art in New York.

In 1935, Soby published a kind of primer on modern art called *After Picasso*, outlining his theories of modern art following the heyday of cubism. Like Herbert Read's *Art Now,* published two years before it, *After Picasso* had a pronounced impact upon artists in both America and England, especially those who wanted to continue to work with the figure. "For art students raised on the theories of Roger Fry and Clive Bell," wrote Frances Spalding, "it offered a wholly new sense of direction." Macdonald began sending photographs of Bacon's work to Soby, an important figure at the Modern, in the hope that the critically influential museum would purchase a painting.

The promotion started to work. MoMA discussed including a reproduction of a Bacon painting in a book that Soby was then writing, to be titled *Contemporary Painters.* In 1946, Graham Sutherland also urged a remarkable woman, Erica Brausen, to visit Bacon's studio. She was a war refugee from Germany, a shy, highly sensitive, and rather mannish lesbian who could appear brusque. She had recently joined the Redfern Gallery, one of the very few in London to remain open during the war, which exhibited works by, among others, Augustus John, Paul Nash, and Eileen Agar. Like everyone else in the postwar art world, she came to know Sutherland, and in 1946 she proposed an exhibit of his landscape studies. Her first visit to Bacon's studio, at Sutherland's urging, was probably awkward. But her air of "difference" as a German lesbian appealed to Bacon, who knew what it meant to be a homosexual from another place, let alone Germany. Brausen was raised in an upper-class milieu much like Bacon's. Her father, with whom she had a difficult relationship, was a master of the local hunt. (A friend recalled seeing a photograph of Brausen at the age of six, dressed for duck hunting with a gun resting on her shoulder.) She and Bacon could expertly discuss together "the unspeakable chasing the uneatable," Oscar Wilde's famous definition of fox hunting, and the other monstrosities of country life.

Brausen, who was just slightly older than Bacon, left Germany for Paris when she was only twenty-one, settling into the bohemian world of Montparnasse around the time Bacon lived there. Five years later, she followed Joan Miró, whom she admired, to his native Catalonia and ran a bar in Mallorca that attracted writers and artists. During the Spanish Civil War, her strong opposition to fascism—the main reason she left Germany—led her to help many Jewish and Socialist friends escape from the Franco regime aboard ships and submarines. When World War II began, Brausen, penniless, herself escaped on a fishing boat to London.

Initially, she worked in London's fashion industry, but—given her knowledge of the French art world—Brausen also organized exhibits in

artists' studios before joining first the Storran and then the St. George's Gallery. To become a citizen, she also entered into a marriage of convenience with a young homosexual artist named Clem Haizelden. In the mid-1940s, she went to work for the Redfern Gallery. The main figure at Redfern was a collector and homosexual named Rex Nan Kivell, whose hoard of art, manuscripts, and artifacts was so extensive that it was stored in different places around London. Nan Kivell owned a sumptuous house in Tangier called El Farah that he trusted would live up to its name—Paradise—and he had no problem with Brausen's personal or artistic tastes. Like Nan Kivell, who helped establish the reputations of Chaim Soutine and Max Ernst in London, Brausen preferred art from the Continent and found English neo-romanticism insipid. She nonetheless hoped—encouraged by Nan Kivell—to represent English artists, especially younger ones.

It was a propitious moment to meet Bacon. Not long after his 1946 exhibit at Lefevre, he completed the largest painting of his life to date. *Painting 1946*—almost six and a half feet high—concluded the lush series that began with *Figure in a Landscape*. But it had several important new qualities. The previous figurative paintings in the series, while somewhat disturbing, did not have the animal edge of *Three Studies*. This new painting contained both the nuanced brushwork and the eruptive edge. At its top, well above the head of most viewers, the legs of a beef carcass were splayed out and upflung like Christ's arms sagging on the cross under the weight of his dying body. Where a head would ordinarily go, lolling sideways in death, the carcass presented a confusion of viscera. Below, a black umbrella shielded an open-mouthed man with half a face and no eyes. This was Bacon's first substantial male figure, one that appeared as stiff and upright as a banker in the City. Was this the figure Bacon sought? The secular crucifix he might have earlier desired?

Brausen entered the studio and was dumbfounded. *Painting 1946* lacked the careful, modest, and well-crafted spirit of most English art. It seemed closer to the raw—if elegant—power of some great German painting, especially Grünewald's. It had a merciless energy, as if Bacon wanted to push painfully into the body's quick. On the spot, Brausen offered Bacon two hundred pounds, more than he received for his two previous paintings together. Bacon accepted, and Brausen went directly to her bank. She returned to Cromwell Place with 40 five-pound notes.

The private studio sale of a major work could not have pleased Macdonald. But he had no contractual relationship with Bacon, and he knew that

the artist—always in need of money—sometimes sold work privately. In any case, Macdonald continued to promote Bacon, who enjoyed their connection. It was businesslike. A businesslike relationship was simpler than other relationships because, with his fine manners, Bacon could always just be an English gentleman. He could not treat a woman like Brausen the same way. "She was a powerful person, very impressive," said Louis le Brocquy. "Through her convictions. With an extremely keen eye for art." In the summer of 1946, the Redfern Gallery suddenly became a significant competitor for Bacon's work. It exhibited not only Brausen's purchase, *Painting 1946*, but also imaginatively juxtaposed it with Bacon's *Crucifixion* painted in 1933—the one Herbert Read published in *Art Now*. Its original owner, the prescient collector Sir Michael Sadler, had recently died. Brausen now sold the early picture to Colin Anderson.

Brausen's juxtaposition of the two Crucifixions was deft. Both owed an important debt to Rembrandt, especially to the Louvre's small *Carcass of Beef* (1657), where the splayed carcass hanging from a wooden beam recalled the Crucifixion. It was not the subject alone, however, that connected Bacon to Rembrandt. The master's brush was both meaty and mysterious, a quality Bacon particularly loved. Bacon's small *Crucifixion* was tenebrous—an X-ray of the dance between life and death—but also robust. And this large new Crucifixion painting, while visceral, was also cryptic and steeped in shadow. One critic observed, "Some people have said, though not in print, that these latest works of Francis Bacon's are comments of the first importance on the times." The aftershocks from *Three Studies* and *Painting 1946* were ongoing. They could make other works of art appear too tidy, tame, and genteel. Drawing-room theater, drawing-room music, drawing-room novels: these, too, felt Bacon's shadow. Balance and discernment remained important, but what was lost in the ruthless strip-down of *Three Studies* and *Painting 1946* could not be easily recovered. London could be rebuilt, but it would prove more difficult after the war to reconstitute many of the ideas, intuitions, and conventions that once sustained art.

During the next two decades, Bacon continued his assault on convention. His attack was never mounted abstractly from the outside, as a deduction from an a priori position or ideology, but seemed to emerge from deep within the physical body as a welling-up of rage and despair over the fraudulent constructs of civilized life. The visceral images were disturbing—no idea could finally escape the body—but there was also, for a homosexual who disliked closets, a tigerish, paradoxical, and sometimes comic joy to be found in tearing off masks, shattering norms, and breaking constraints. It would have made sense for Bacon, building on

four separate shows in little more than a year, to solidify his reputation in London's circles of power and taste. But the 40 five-pound notes said otherwise. (The average annual English wage in 1946 was about 250 pounds.) He was rich by his lights. And "rich" to Bacon meant nothing more, and nothing less, than the freedom to live as he liked. After the war, having completed a Crucifixion, Bacon not only "began" as an artist. He also began to remake his life. He looked south.

PAINTING 1946

A beef carcass—its legs outflung and with no head—assumes the traditional position of Christ on the cross. The only head in the painting is half a head and belongs to a man in a suit who sits under an umbrella shielding him from the crucified flesh, bones, and viscera behind him. However, he is not wholly removed from the scene. He sits at an elegant modernist table—of the kind Bacon once designed for fashionable rooms—on which he may be peddling two slabs of meat. The painting is shockingly physical, its atmosphere vaporous with the reds, dimmed reds, violets, and pinks of watery blood. The chunkiness in some of the paint resembles fat, bone, nerve, and meat. *Painting 1946* stripped Christian metaphysics from the Crucifixion scene. The sacrificed flesh is nothing more than meat in a godless modern world. Nothing of divinity or redemption remains. God is dead. And so on.

But Bacon was an artist more than a statement maker, and *Painting 1946* is not entirely secular—if by "secular" is meant a perspective that excludes everything mysterious and sacred. The painting is not only intensely physical; it also appears filled with enough enigmatic symbols to keep a medievalist happy. And while none can be "read" or interpreted with certainty, they invite speculation. What do the violet shades represent? Are they closing off the world, or can they be let up? Is the top of the man's head gone because the modern mind has been lost? That disturbing little ridge of ragged red where his head divides suggests that he himself is meat and that his mouth may be opening in a bellow. The modern tubular table, an early example of Bacon's love of a curved theatrical space, is becoming a stage or sacrificial arena. What will be enacted? The inky black above the eyeless man's half-head and below his umbrella—where his mind would ordinarily be—is especially provocative. It is more opaque—locked—than the other blacks in the painting. It suggests a space that the mind's eye cannot finally penetrate.

Bacon had a slyly subversive sense of humor that sometimes slips into his art. That umbrella, for example: Perhaps, in 1946, England had had enough of the sky. Enough of the rain, enough of the bombs, enough of the metaphysics. Perhaps the man is half-smiling. He is wearing a yellow boutonniere. One must dress for a formal affair like a Crucifixion.

The Road South

Cyril connolly called postwar London "the largest, saddest and dirtiest of great cities," its people suffering from "undernourishment, dearth of vitamins and sunshine, lack of hope, energy, leisure and spirit." Desperate for sun and diversion, many in London with the means went to France as soon as possible. Stephen Spender announced in the July 1945 issue of *Horizon* that the three weeks he recently spent touring France "were among the happiest in my life." The cultural atmosphere of France was no less appealing than its food and wine. "There is no way now of telling how powerful a dream France was then," wrote Doris Lessing. "It is hard to remember how people yearned for France, as for civilization itself."

For Peter Watson, who lived in Paris before the war, the city had symbolic power. Paris, he believed, could help English artists become less provincial. Hilary Spurling described his view:

Peter believed, like Cyril, that England should look outwards, to Europe and America, after the war, rather than retreat into introspection and nostalgia. In the first years of peace it was Peter who commissioned *Horizon* articles in Paris on artists barely known in Britain, like Balthus and Morandi. It was Peter who persuaded Picasso's dealer, Daniel Kahnweiler, to report on the contemporary art market, and Peter who coaxed Michel Leiris to write about his friend, Alberto Giacometti, whose elegant, elongated sculpture seemed unimaginably strange to unaccustomed eyes in those days.

A fashionable English scene developed in the cafés. By the summer of 1946, Sonia Brownell was "turning heads among the existentialists on the Left Bank," wrote Spurling in her biography of the woman who would become Sonia Orwell. They were "dazzled by her pale, blonde English

beauty and frankly incredulous to discover that a girl in her twenties with the looks of a Hollywood film star" had some say over a publication like *Horizon*. Connolly was "feted as though he were Voltaire returned," said Diana Cooper, the wife of the British ambassador to France, Duff Cooper. So many English writers, artists, and tastemakers gathered in the cafés that the best way to get ahead in London was probably to live in Paris. You could meet Picasso. You could sit at the Café de Flore with Giacometti and at Les Deux Magots with Jean-Paul Sartre. But Paris was not then Bacon's particular dream of France. He had no desire to see English writers or sit with the artist whose influence he wanted to escape. He would never finally meet Picasso.

In 1940, during his brief convalescence on the Riviera, Bacon glimpsed something else in France. It would be an exaggeration to call it an intimation of paradise. Bacon was fiercely unsentimental, and he had no patience for the Edenic art of Matisse (whom he also never met). It was always a mistake, however, to underestimate Bacon's capacity for pleasure and joy. He would, of course, later become indelibly associated with gritty London. But light-filled people sometimes best capture darkness. Bacon relished the senses. He "adored life." There was something shuttered in England that the sun and curves of the Côte d'Azur promised to release. He would breathe more freely in the south, and of course the casino always beckoned.

Bacon decided to move south without even another visit. Eric Hall and Nanny Lightfoot went with him. Hall now lived more or less openly with Bacon. He could come and go to London as his duties on the London City Council demanded: he would not retire until the end of the 1940s. France beckoned to Hall no less than to Bacon. He had been Bacon's mentor, after all, in the cultivation of the senses. Nanny Lightfoot might complain about the French, but she would, of course, go anywhere with Francis. Bacon intended to live in Monte Carlo for most of 1946, making occasional trips to Paris and London—more to Paris than to London—in order to see shows and friends. Early in July, he and Nanny received their Monegasque identity cards, required of foreigners who planned an indefinite stay in the Principality. Bacon composed himself for the photo. He appeared to be a serious, round-cheeked Englishman, noticeably youthful-looking for a man of thirty-six. He wore a proper coat and tie.

The small group moved onto the second floor of the Hôtel Ré, at 3, avenue Saint-Charles, which had a modest view over the downward sloping town and was one of the many small, Belle Époque pensions traditionally frequented by foreigners without the money to live in splendor

at the Metropole or the Hôtel de Paris. It was four stories high, with a tiled roof; room and board were probably provided. As at Cromwell Place, Bacon envisioned carving out a studio within the living quarters. His friends wondered why he chose to live in Monte Carlo rather than just make a visit. The Riviera was not yet a celebrated draw for artists. (In 1946, Picasso was just beginning his move to the area.) Nor was Monte Carlo the seductive town it had once been. Before the war Monaco depended upon the tourists and gamblers who visited its casino. After the war, the number of visitors had fallen by 75 percent. Jobs were scarce, the buildings in disrepair, the stucco peeling. The remaining croupiers were surly: the big tips were scarce. Monte Carlo looked as melancholy as a threadbare ball gown. But Bacon always appreciated what one friend called "weary glamour." And he did not mind the crime-soiled alleyways—a shadowy counterpoint to the bougainvillea and the sea—or the men who gathered near the cafés or hung about the corners waiting for what would never arrive.

Besides, Bacon was almost wealthy in these surroundings. The exchange rate was miraculous—480 francs to the pound—and he was a painter making a living with more paychecks to come. He now set up his version of the good life, one focused upon the studio and casino but permeated by the pleasures of the Côte d'Azur. For a time, his sensibility almost softened. He did not dismiss out of hand Balthus's aspiration "to get the tenderness which we would all love to get for a change," and he referred without irony to the light and the lovely blues and pinks of the region. He loved being on "this coast," he told Colin Anderson, saying that "with this light one always seems to be on the edge of the real mystery." He even mentioned Renoir: "Sometimes the colour is wonderful with a gorgeous pink haze over things that Renoir tried to catch." He continued to scoff at artists who tried to illustrate such effects, remarking upon "the extraordinary lesbian affairs [artists] concoct out of the landscape and the bougainvilleas which have to be seen to be believed but perhaps their ignorance is not greater than the knowing ones at home."

His quarrel, in any case, was less with ends than means. Qualities such as "tenderness"—or the way the bougainvillea hugged the stone on the Côte d'Azur—were not necessarily unsuitable subjects. But they "[could] only come," he wrote Sutherland, "as a technical thing and not as illustration," by which he meant something like the vivid painterly researches undertaken by the elderly Monet at Giverny. Monet did not simply describe the water lilies. He seemed more intensely involved than that, as if he were painting *within* the lilies and not about them. "The thing I

was very shocked by," wrote Bacon when criticizing a group show of the period ". . . was the boring lack of reality, the lack of immediacy which we have so often talked about. I think it is also why so many Picassos are beginning to look so jaded now. It is the terrible decoration we are all contaminated by."

Bacon found Monte Carlo "very good for pictures falling ready made into the mind," writing, "I paint dozens every week here." But he did not seem to complete any, as he searched for some new "technical" approach. Mornings were spent in his makeshift studio. Afternoons included a long Mediterranean lunch. Evenings, like mornings, were given to luck and intuition: the casino was just a walk down the hill from the Hôtel Ré. Bacon, who always appreciated a memorable room, enjoyed the opulence of the casino. Designed in the late nineteenth century in high wedding-cake style, the casino was a fanciful stage set of riches. It was playful, delicious, and delightfully vulgar. Its atrium was paved in marble, with twenty-eight Ionic columns made of onyx. It contained a small opera house—designed by Charles Garnier, the architect of the Paris Opéra— that served as a fig leaf for the real purpose of the building. Dazzling reds and golds, sparkly chandeliers, coffered ceilings, pink nymphs, stained glass, allegorical paintings unburdened by any moral: and within it all the casino's finely made roulette chips lay heavy in the hand, almost like golden coins. During the war, the casino was almost untouched. It had

A period postcard of the Monte Carlo Casino, designed in high wedding-cake style, which Bacon found irresistible

seen better days, of course. The "Place du Casino looked rather like a derelict papier-mâché film set," said one writer, "abandoned after some weeks of shooting."

The capital of roulette, if there could be said to be a capital, was Monte Carlo. Its casino helped make the game fashionable in the nineteenth century. It offered the French version of roulette, which differed slightly from the European and American variations. For one thing, the odds were better for the players: the French game had one rather than two zeros on the wheel. For another, the pace was slower and more formal. In the French game, the wheel was placed in the center of the table, not at its head, and the players fanned out around the wheel, facing one another, and also standing at both ends. It was a handsome, intimate, and fluid design. The casino also left ample space around each table. You could hear the lengthening roll of the ball. You could play at more than one table at once, since the French game was slow, and make bets on all sides in between sips of champagne.

The systems many roulette players obsessively devise to improve their odds held no interest for Bacon. It was unfettered chance that he valued. The ball rolled in the opposite direction from the wheel and then suddenly dropped. Bacon loved to win. He also loved to lose, especially everything. Bacon's friend Michael Wishart, who once gambled with him in Monte Carlo, said Bacon displayed "the committed masochism of Dostoevsky, who claimed that the real thrill of involvement only began when he had pawned his wife's jewels and was staking the proceeds. Francis failed to convince me that there was a deep satisfaction in being completely 'cleaned out.' " But losing cleaned out illusions, sweeping away the fog of hope (especially if you pawned the family jewels). The cold reality of loss was bracing and nervy, as good art should be, forcing an acknowledgment that fate cared nothing for petty bets and small wantings.

The universe of roulette was fundamentally dark, but you could occasionally imagine a better world. Your own character, amid the winning and losing, came into focus. Would you risk everything on a single number? Or shrink back to smaller bets? Roulette for Bacon was amusing living theater, but also a distillation of his instincts about the world. Wishart recalled him "wild-eyed with enthusiasm" as he gleefully staked his all on the spinning wheel: "Francis, between spins, would stagger towards us and drop another bottle of champagne into our ice-bucket."

But even the casino's charm had its limits. Only a month into his new life on the Riviera, Bacon became restless. Staying in Monte Carlo through the coming winter without a break began to seem unappealing.

He wrote to Sutherland as summer waned to let him know that he might spend the fall in Paris. Would Sutherland perhaps like to share a studio there? "I thought I would look around for a large room or studio that I could go to from here for some weeks at a time perhaps," Bacon wrote. "If you still think of part of the year in Paris perhaps we could find something we could use alternately." Bacon had not given up on his dream of Monte Carlo, but he had not anticipated how much he would miss certain kinds of night talk deep in the hideaways of Soho. He required the right pub, bar, joint, dive, hole in the wall, and the conversation must be edgy, funny, foul, and high-spirited—anything but dull. Three months after settling into the Hôtel Ré, Bacon wrote to Macdonald: "I do not feel I could stay here permanently, not because of work, because as long as it is fairly quiet I can work anywhere, but I do not care for its sort of village life after a time." Sitting in a café surrounded by men wearing berets and wondering who the tourist in the corner might be—"village life" in the back streets of Monte Carlo—did not meet Bacon's expectations.

Bacon also felt the loss of a second kind of conversation: the way artists talk to one another. "Nobody here is at all interested in ART," he reported to Sutherland, which he acknowledged as "perhaps a comfort." But his letters made clear that he did miss talking to artists, especially to Sutherland. Not surprisingly, Bacon tried to entice the Sutherlands to visit him in Monte Carlo, though he was not sure whether or not the sociable couple would find enough diversion there. He also took pains that autumn to congratulate Sutherland on a painting he had not even seen—what would become Sutherland's best-known work, a huge *Crucifixion* for St. Matthew's Church, Northampton, which owed a debt to Bacon. (The influence was no longer in one direction.) "The strung man sounds very exciting. I feel it is very much your subject."

In Monte Carlo, Bacon had an inkling—nothing more—that finishing paintings in paradise might also prove more difficult than he anticipated. He told everyone that he was doing well, but emphasized practical difficulties. Initially, he had trouble locating canvas, even on the black market, but found that he could use coarse linen sheets. Stretchers were not easy to find in August when stores closed for the holidays. He made the best of it: his problems might lead serendipitously to something new. But he felt the pressure to produce something, especially since his reputation was growing during his absence from London. Although Erica Brausen had still not sold *Painting 1946*, the picture was being lent that autumn to a large international exhibition of painting organized in Paris by UNESCO, the cultural arm of the United Nations. Before the painting left London,

Sutherland, at Bacon's request, stopped by the Redfern Gallery to apply fixatives to the pastels Bacon used to depict the magenta blinds: pastels were easily damaged in transit. Sutherland was still working, at the time, on his *Crucifixion* for Northampton. Putting a hand on another artist's painting was an intimate act, and it was not surprising that *Painting 1946* should then have had some impact on Sutherland's own art.

It was the size of *Painting 1946* that, Macdonald believed, kept it from selling. Where would one put it? Artists were not yet ordinarily painting with the museum in mind. Bacon nonetheless continued working on canvases, he wrote to Macdonald, that were "still very large & it is unfortunate for me financially but there is nothing to be done at the moment." To his credit, Macdonald repeated Bacon's words back to him. "If you do not feel like shrinking your sizes, I fear there is nothing to be done about it." Like Sutherland, Bacon remained interested in painting a large modern Crucifixion. But he also now began to play with the related idea of making a painting that looked into two great wells of meaning in Western culture, Catholicism and the old master tradition. Unable to find the way to a modern Crucifixion—the central figure eluded him—Bacon considered another singular figure of authority: the pope. He greatly admired Velázquez's *Portrait of Innocent X*, in which the pope simmered inside his robes.

But first, Paris. Bacon arrived in early November 1946. It was not an auspicious time of year. The café life of the summer had retreated indoors, and not much sparkled or seduced as the days shortened and grew colder. Except for its landmarks, Paris resembled any other dark, down-at-the-heels city in northern Europe. The stone façades were smoke-blackened and in disrepair. Many Parisians were trying to find jobs and food rather than whiling away the evenings in the local cafés. Food rationing remained in effect. Instead of staying on the Left Bank, as he would do later in his life, Bacon chose the Hôtel Saint-Romain on rue Saint-Roch, an inexpensive place long favored by English travelers.

Bacon knew the area from his work in interior design: Jean Désert had been located nearby. The hotel, just north of the Tuileries Garden, was also within easy walking distance of the Louvre and many art galleries. One reason Bacon went to Paris was to see *Painting 1946* at the UNESCO exhibit, then on view at the Musée d'Art Moderne. The exhibit was a sprawling example of worthless do-goodery, more than 650 paintings representing fifty countries. The British section included sixty works by

twenty-eight artists, among them Bacon, Sutherland, Stanley Spencer, and Roy de Maistre. Always concerned by the company he kept, Sutherland had been ambivalent about exhibiting among lesser artists. Bacon had few qualms. "As I have sold the picture to the Redfern they can do what they like with it and I do not really mind," Bacon wrote, a perspective Sutherland did not share.

Bacon judged the UNESCO exhibit "awful." The English part was somewhat better than the rest, he told Sutherland—perhaps hoping to reassure his friend—but mainly because it was presented in the best location. The "Picassos were very bad and the Braque awful in the French section." Worse still were the lesser French lights, among them Édouard Pignon, Maurice Estève, and Pierre Tal-Coat, all of whose work Bacon regarded as "a new low in clever ideas and bright color." Bacon reserved higher hopes for the Balthus exhibition, then at the Wildenstein gallery. Balthus was Bacon's age and, like Bacon, determined to keep the figure in modern art. He was fashioning a mysterious, aloof, and aristocratic persona—becoming known for not being known, except to those in the know—that would interest Bacon, who was himself interested in self-invention and could enjoy the performance of others. (Before his 1968 retrospective at the Tate Gallery, Balthus proved so elusive that John Russell introduced the exhibit by saying: "Balthus is a painter of whom nothing is known. Now let us look at the pictures.") The exhibit disappointed Bacon: Balthus could illustrate, but not directly transmit, a value like tenderness or erotic desire.

Bacon made no effort while in Paris to join café society. There were no artist sightings. And he did not drink with English writers, most of whom had returned home for the winter. But he did find the talk he wanted and companions to go out with. Peter Rose Pulham, his Soho friend during the war, had moved back to France. He and his wife, Mary, lived in a small village north of Paris, Valmondois, where Daumier had spent his last years. Pulham often visited Paris and was a sociable and popular figure there who could easily have introduced his friend to important writers and artists had Bacon wanted that. Perhaps more important, Pulham was a passionate epicurean, at least where matters of the table were concerned, and he had an expatriate's gusto for France that went well beyond what is suggested by the word "gourmet."

One of Pulham's closest friends, Isabel Rawsthorne, joined them. She was then Isabel Delmer, but would become best known by the name of her last husband, the English composer Alan Rawsthorne. Then thirty-four years old, Isabel was three years younger than Bacon. She had grown

up in Liverpool, the daughter of a master mariner, and from an early age knew that she wanted to be an artist—and escape into the world of artists. She earned a scholarship to the Royal Academy in London, where she supported herself by modeling. She was a mesmerizing young woman with pharaonic cheekbones. James Lord, the biographer of Giacometti, found in her the "agility of a feline predator. Something exotic, suggesting obscure origins, was visible in her full mouth, high cheekbones, and heavy-lidded, slanting eyes from which shone forth a gaze of exceptional, though remote intensity."

Isabel became the assistant, model, and probably lover of the English sculptor Jacob Epstein, who made a celebrated bronze, a half-length portrait-bust, of her bare-breasted. The nakedness of the young woman— who stared straight ahead, unflinching, like a ship's figurehead come to life—had none of the sugary sentiment usually displayed by middle-aged artists when they admire a bare-breasted young woman. She wore only an exotic pair of spiral earrings. She was not girly. She was young, startlingly sexual, and unafraid. Rawsthorne left for Paris at the age of twenty-two, where she took life classes at the Académie de la Grande Chaumière in Montparnasse and began to model for André Derain. They became lovers and Derain painted her portrait. She quickly became a familiar figure at the Left Bank cafés. At Le Dôme, Sefton Delmer—then the Paris bureau chief for the *Daily Express*, and soon to become her husband— suddenly realized with astonishment that the beautiful girl he noticed at a table nearby was the model for the Epstein bust he admired. "Have you ever fallen in love," he wrote, "with a character from a novel? I have many times. In 1934 however the latest passion of my imagination was not out of a novel. It was the bronze bust by Jacob Epstein of Isabel, a long-necked girl with thick hair falling to her shoulders, a pouting almost Negroid mouth, high cheekbones, and those slanting Nefertiti eyes."

Her impact upon Parisian artists was in some cases revelatory. Not long after her marriage to Delmer, Rawsthorne met Giacometti at Le Dôme, and they began to see each other daily. She became the model not only for many of the sculpted heads that Giacometti made in 1936 but also for the series of small, naked women on solid bases that preceded his celebrated, etiolated statues. "I had an English girl friend," Giacometti said, "and the sculpture I wanted to make of this woman was exactly the vision I had had of her when I saw her in the street, some way off. So I tended to make her the size that she had seemed at a distance." Through Giacometti, Rawsthorne became friends—in some cases, lifelong friends—with many writers and artists of her generation or slightly

older, among them Jean-Paul Sartre, Georges Bataille, and Michel Leiris. Leiris would later become the French friend, writer, and intellectual whom Bacon most admired. She was also a close friend of Balthus, who first introduced her to Picasso. In 1936, Rawsthorne reported, Picasso fixed his stare upon her: "I was living with Alberto. He always worked all night, but at five every day we used to go and drink at Lipp. Picasso used to sit at the table opposite, and one day, after staring at me particularly hard he jumped up and said to Alberto, 'Now I know how to do it.' Then he dashed back to his studio and started my portrait right away."

The war forced Isabel and Sefton Delmer back to England, where both worked at Bletchley Park as part of the English effort to break the German codes. In 1945, after parting with her husband, she returned to Giacometti and Paris, where their long affair ended. Isabel was rarely alone, however. She had a dalliance with the philosopher A. J. Ayer, the logical positivist. (Between chiseled essays, "Freddie"—by his own admission a small and ugly man—gave himself up to a pursuit of women that his friends, agog, found neither logical nor positive.) When she met Bacon in Paris she had just concluded a liaison with the Polish-born French composer and conductor René Leibowitz—an important champion of serial music—and had met her soon-to-be second husband, another composer and conductor, Constant Lambert. Bacon and Rawsthorne immediately became fast friends, as intimate as lovers—perhaps more so, as sex did not confuse their relationship, though Bacon claimed after her death that he had once made love to her. Rawsthorne's connection to Giacometti intrigued Bacon, who disparaged the work of most French artists but greatly admired Giacometti, and her looks naturally charmed him. How could they not? Bacon loved ancient Egypt, and her ancient-seeming freshness was intoxicating.

But Rawsthorne possessed something rarer, in fact, than exotic looks or impressive connections. She appeared free—unusually and adventurously free. She slept with whom she liked, stayed out all night with the boys, and did not—like many beautiful girls—play the coquette. She loved Giacometti for being mysterious and febrile, not because he was handsome or an expert lover. (He suffered from impotence.) She delighted in big ideas, but also in gossip, which can be the bread of life. And so, Rawsthorne offered Bacon just what he needed at the moment, a companionable escape from the "village life" down south.

Even with food rationing, Pulham knew all the best restaurants, many of them in Les Halles, and he and Rawsthorne appreciated their every moment in restaurants and cafés. The intensity with which they

approached table and glass—a trait they shared with Bacon—went well beyond the ordinary and suggested the kind of starvation of the senses that robust spirits underwent from the Depression era through the crushing deprivation of the war. For many years, Rawsthorne was an epistolary companion of Pulham's, their subject often being a joyous recounting of menus planned and feasts undertaken, some of which occurred over several days. Not long after marrying Constant Lambert in 1947, for example, and moving back to England, Isabel wrote Pulham:

> Depressing situation. We long to put channel between ourselves and creditors, telephone, beer, BBC, English newspapers, English Sundays, Cockney speech, housekeeping, other peoples worries, and soppy Puritanism of whole place . . . Made a prawn omelette last night—v. good. Also dinner for Balanchine consisting of oeuf dur mayonnaise with prawns, fennel salad, radishes, cos lettuce. Followed by Roast Turkey (sherry in gravy. Sausage and [indecipherable] Stuffing), plain new potatoes, sweet corn from tin with egg yolks—quite good.

In Paris, Bacon made an indispensable friend. He would eventually paint her, but in November 1946 she gave him something else: she recalled the joyful, unsparing life. He returned to Monte Carlo refreshed.

In December, Bacon wrote his longest and most cheerful letter to Sutherland, beginning with "Dearest Graham" rather than his usual "My dear Graham." Eric Hall had arrived in Monte Carlo for the holidays, and while they were "so disappointed" that the Sutherlands had decided not to come south for the season, they were still holding out hope for future visits. The weather was "lovely." Monte Carlo was once again attracting visitors. "I feel you would like it too as it is beginning to get people of all nationalities passing through and as it is very small it seems concentrated in that way." English visitors, too, now came and went. Kenneth Clark (now Sir Kenneth) and his wife; Peter Watson; John Piper and Julian Trevelyan. "It would be so lovely if you and Kathy felt like working here," Bacon wrote, "and I always feel with a little clever manipulation the Casino would buy our pictures."

Despite his bright tone, Bacon made two pointed observations to Sutherland. The English art world was "too artificial for me to live in," and while Monte Carlo was recovering from the war, it remained "com-

pletely insulated against modern art and interesting people which is really very pleasant." Apart from Kenneth Clark and Henry Moore, however, no important artist or writer in England inhabited the "artificial" English art world with more comfort than Sutherland did. He was the very model of the establishment insider who had no wish to be "insulated" from either "modern art" or "interesting people." If Bacon was warning Sutherland not to expect too much from Monte Carlo, he was still and again upholding—asserting, even—a different view about how to live as an artist, one that could not appeal to his older friend. He also told Sutherland about his dream of a Velázquez painting:

> I don't know how the copy of the Velasquez will turn out. I have practically finished one I think and am going to start on a portrait I want to do, but it is thrilling to paint from a picture which really excites you. I am sick to death of everything I've ever done in the past but continue to think like a child or a fool that I'm on the edge of doing a good painting.

Although Bacon liked to say that he was being productive, he rarely spoke with enthusiasm about work underway in the studio. That would be pompous, and hubris invited retribution. To use the word "thrilling"— that it was "*thrilling* to paint from a picture which really excites you" and to conclude that this might result in "a good painting"—suggested that, whatever his output in Monte Carlo, Bacon was not wasting his time. "Thrilling" was not a word that came naturally to Bacon. If he felt thrilled, it hardly mattered that he finished nothing. He was not an artist like Sutherland who took some pride in a history of achievement.

Velázquez was the most masterly of the old masters. No artist in the canon possessed greater authority; none could make a painter feel more like a child or a fool. Velázquez was also a master adept at the alchemical arts that Bacon most admired, able to turn paint into flesh without appearing merely to draw, copy, contain, or illustrate the figure. As if that were not intimidating enough, the Velázquez that fascinated Bacon was one of the greatest of all portraits, *Portrait of Pope Innocent X* (c. 1650). It was a powerful image of a powerful man—an authoritative vision of an authoritarian. The Holy Father sat in judgment on all his guilty sons. He had an intense, almost sulfurous physical presence, an old-man-ness that could not be escaped. His glare—shrewd, suspicious, baleful—would follow anyone out of the room. And yet, the pope also appeared trapped inside his body, and there was a cagey fear in his expression, that of a cor-

nered animal who might make an unexpected move. He did not appear homosexual—though his dress could please a queen—but seemed closeted and buttoned up, if not sexually, then in some elusive but essential way.

The impact of *Portrait of Pope Innocent X* on Bacon was not the formal and iconographic kind usually described in art history (such as the effect of Picasso's Dinard series on Bacon's forms). Instead, *Innocent X* was an invitation to a staged confrontation: an intensely personal conflict with authority that was also an existential drama. Bacon could not have picked a more formidable symbol of authority, of course, than this pope painted by that artist. But that was where the thrill lay. It was not an easy stage to perform upon. In Bacon's struggle with the pope there was naturally much "fathers and sons": that was inevitably the primal struggle. But the Holy Father also represented the authority of religion, and Velázquez the authority of the old-master tradition. Bacon himself was personally ambivalent about both power and weakness. How was he to get this ambivalence into a picture? How was he to use a Velázquez painting as a subject? (It would be many years before late modernists and postmodernists made the ironic painting of other paintings routine. Picasso began painting his variations on *Las Meninas* in 1957.)

The decisions to be made, instinctively or not, appeared endless. So far, he had painted mostly concealed or half-faced people. Should he paint a full face? He loved the whisper of a certain kind of tonal painting and spoke regularly of blue-violet. Would that have drama enough? Of the three sketches of the Velázquez *Portrait of Pope Innocent X* that Bacon reported he was working on in 1946, only one survived from this exploratory period, a version that he abandoned. He placed some props behind the seated figure, including Fascist colonnades, an extension of his earlier practice of sometimes referring directly to the war or evoking the collapse of civilization. The pope's face appeared uncertain. It may have been this painting that Bacon told Sutherland was "practically finished." In fact, his struggle with the Holy Father was ongoing, with no conclusion in sight.

Mr. Hyde

BACON'S TRIP TO PARIS was reassuring. Friends and conversation were only a long train ride away. And in Monte Carlo he had found a subject, the Velázquez pope, to excite him. But certain toads now began to appear in his French garden, one familiar, and the others unexpected.

Money was the tiresome old toad. Bacon was broke—or put differently, no longer free. Eric Hall did not have a limitless fortune, though he doubtless helped Bacon. Hall, a gambler himself, knew that giving Francis money outright only enriched the casino. Gamblers can be hard on other gamblers. Hall likely kept his support to living expenses and art materials. An early hint of Bacon's money problems came in late January 1947 when he wrote to Kathy Sutherland. The Sutherlands were planning a trip to Paris and wondered if Bacon might join them there. "About Paris," Bacon replied, "I would have simply loved to have met you there but there are two things—for the first time for ages I feel like doing lots of work and secondly at the moment until another allowance I am rather short of money to go to Paris." He added wistfully: "If I make some money in the Casino which is always possible, I will wire you and come to Paris for a few days."

Instead, Bacon went briefly to London in February of 1947. Coal shortages were then forcing the government to turn off the electricity for five hours a day, and the city was ashen and gloomy. Bacon did not come to deliver paintings to an art dealer. He did not even visit Duncan Macdonald. He had no reason to visit London in February except, perhaps, to treat Nanny's eyes—she was developing cataracts—and to look for money. His lease at the Hôtel Ré in Monte Carlo was ending in March, and he wanted to move. (He had a better idea, after his months there, of the real-estate market in Monte Carlo.) He was beginning to wonder if he should sell his lease to 7 Cromwell Place, but the flat was also Eric Hall's place, which limited Bacon's options. By the mid-

to-late 1940s, Hall's life with Bacon was a continuing source of strain for the older man's wife and for his son, Ivan, if not for his daughter, Pamela. Through her wartime job, Hall's daughter, Pamela, met a man in the French Resistance and married him in 1942. After the war, the two moved to France, where her father and Bacon occasionally visited them. They would also meet on the Riviera, where Hall gave his son-in-law money with which to gamble. "He was amazingly warm and generous," said Pamela's daughter, Béatrice Mitchell, of her grandfather. Pamela led her own life, in short. But Ivan was single and very much around, as was Hall's estranged wife. Ivan was, said Mitchell, "clearly hurt" because of his father's homosexuality. He would later bitterly inform Bacon—to Bacon's surprise and remorse—that Francis's intrusion into their family ruined his life.

Bacon probably asked his mother for an "advance" on the allowance that he mentioned in his letter to Kathy Sutherland. He was likely successful because once he was back in Monte Carlo, he lived for several months without complaint until once again he was forced to go begging. Not surprisingly, Bacon was an artful beggar, offering up touching excuses that rarely included gambling. He may have felt a gentlemanly twinge about his behavior, but it was likely no more than a twinge. He had an aristocratic disdain for money—when he had it he often gave it away—and, more important, would not grant moral authority to a social system he regarded with contempt. The system was rigged. The house stacked the odds. *Sauve qui peut*.

Bacon did make time to see Sutherland during his few days in London. They had lunch at the White Tower restaurant on Charlotte Street, much loved in the 1930s by the students from the nearby Euston Road School of Drawing and Painting and still favored by artists. Afterward, they went to an exhibit of Spanish painting at the National Gallery—of particular interest to Bacon given his engagement with Velázquez—and then to Cromwell Place for tea and drinks. They had much to discuss, including a reproduction in *Picture Post* of Sutherland's *Crucifixion* for St. Matthew's Church in Northampton—the painting that owed a debt to Bacon, specifically to *Painting 1946*. Sutherland's positioning of the Christ figure, the rounded railing below the body (an incongruously stylish note), and the background forms all suggested two closely linked artists. But with one fundamental difference: the *Crucifixion* by the older artist, a practicing Roman Catholic, was traditional enough for a church; the younger artist's was not.

It would have bolstered the confidence of any painter, even one as

independent as Bacon, to know that he had helped to shape the work of the best-known British painter of his day, one who seemed to be rising inexorably in public esteem. In May 1948, Sutherland even joined Henry Moore as a trustee of the Tate Gallery. He continued all the while to promote Bacon. In November 1948, for example, as Robert Melville prepared a monograph on Sutherland, the painter wrote to him: "Francis B. has done two remarkable canvases—depressing & attenuated—but his painting I think *real* & containing the germ of recovery & the possibility of a post-Picasso development—at all events, to me, he makes nearly all the others look whimsy or folksy or schematic or just simply dead." While Bacon in person still conveyed the excitability of a young artist, Sutherland, only six years older, now appeared to come from a different generation. After seeing them together during Bacon's visit in February 1947, Benedict Nicolson, the editor of *The Burlington Magazine*, observed that Bacon "talks a lot, condemns everything with sweeping gestures—but I think there is something burning and alive there." He was, said Nicolson, "hopelessly young and dogmatic—in contrast to Sutherland, who has reached the boring profundity of middle-age."

On his return to Monte Carlo, Bacon prepared to move out of the Hôtel Ré. Perhaps a change of studios would lead to a more productive period. Bacon never cared much where he slept, but his studio must somehow feel mysteriously right. Bacon and Nanny Lightfoot now moved into the Villa Minerve, at 2, avenue de la Costa, a larger and more ornate place than the Hôtel Ré. It was decorated with elaborate parapets and arches, giving it a slightly ridiculous air, like a grand dame with too much jewellry. It stood on a steep hill near Port Hercule, close to the splendid, Anglicized Hôtel Balmoral (where Bacon would sometimes stay in later years). It was even closer to the casino than the Hôtel Ré: it would not prove easy for Bacon to avoid that distraction. And then there was suddenly another diversion. The Sutherlands, in the spring of 1947, finally visited Monte Carlo.

Bacon's recent visit to London may have helped persuade them to

Villa Minerve, the second of Bacon's three homes in Monte Carlo, a building heavily embellished with parapets and arches

make the trip. Others had urged them to do the same. As Roger Berthoud, Sutherland's biographer, wrote:

> Bacon's had not been the only siren voice luring them to the South of France, with his descriptions of the gorgeous, pearly haze which Renoir had tried to catch. There was also Roderick Cameron, whom they had met in London during the war through the Clarks and whose mother, Lady Kenmare, owned La Fiorentina, a villa on the peninsula jutting out from Cap Ferrat. Graham later inscribed a book: "For Rory, whose description of this region—so true, so felicitous—first fired me with the idea to work here...."

The magnificent villas and the social merry-go-round of the recovering Riviera enticed the Sutherlands. Graham was making a handsome enough living and, having finished his celebrated *Crucifixion*, could afford to relax. In early April, joined by the wealthy collector and dealer Eardley Knollys, the Sutherlands set off on a trip through France in a newly purchased Standard Motors Tourer, stopping at Dover, Paris, Avallon, Tournus, and Aix-en-Provence. As lovely as Burgundy could be in the spring, it was the Midi that enthralled Sutherland. He enjoyed the contrast between the pleasure-loving coast and, just inland, the ancient olive groves and sunbaked hills, which intoxicated many light-starved Londoners. Berthoud wrote:

> The sound of the cicadas, the subtle light of the avenues and squares of peeling plane trees, the red of the soil, the dark, slim verticals of the cypresses, the singing greens of the bushy-topped pines against the often flawless blue of the sky, the first sight of the Mont Ste-Victoire: coming from the north, the thrill is infinitely renewable, and for Graham it was a different world....

The Sutherlands stayed in Villefranche, then a modest fishing village nine miles from Monte Carlo that clung to a plunging hillside, its steep passageways connecting the old port with the newer developments above. Their rooms were in the Welcome Hotel, which Eardley Knollys recalled fondly from the late 1920s. Although the hotel faced the village harbor on a street of open-air cafés, no casinos or noisy nightlife disturbed the evening quiet. An easy road along the spectacular coastline linked the village to Monte Carlo. The Sutherlands could enjoy the best of both worlds—the serenity of a village and the nightlife of a resort. On their first night,

the Sutherlands and Knollys joined Bacon and Eric Hall in Monte Carlo. No doubt they dined well before strolling to the casino where Bacon, aglow with champagne, played the charming host. He could explain the rules and finer points of roulette to the Sutherlands, who were not gamblers, and he always took particular pleasure in defending gambling to the sober-minded and socially responsible. That night the Sutherlands lost a significant amount, five hundred old francs—the equivalent of sixty-three pounds (about two thousand pounds today). That did not discourage Sutherland, however, perhaps because Bacon did not allow discouragement. "It was Graham's introduction to roulette," wrote Berthoud, "to which he and Kathleen became mildly addicted in the next five years."

At least twice a week the Sutherlands met with Bacon and Hall. They occasionally made a day trip together to Tourrettes-sur-Loup, for example, a walled medieval village near Vence, set on a hill overlooking wild gorges. The Sutherlands also developed their other interests. They were given an introduction to Somerset Maugham, then the most celebrated English expatriate on the Côte d'Azur. Maugham was almost synonymous with the region. He had remained there so long after war was declared that he, along with some fifteen hundred fellow holdouts, had to be evacuated by two old British coal ships—and he had returned as soon as he possibly could after the war. The Sutherlands began to visit him regularly at Villa La Mauresque, a Moorish fantasy overlooking Cap Ferrat. They also met Lord and Lady Bearsted, whose Upton House in Warwickshire was one of the great houses of Britain. Bacon probably did not join them. Then, for ten days, the Sutherlands stayed in ducal splendor at La Fiorentina. (In 2014, the villa was placed on the market for a rumored asking price of $525 million.) It was far grander than Maugham's estate. In his book *The Golden Riviera*, Cameron celebrated the villa's "red-tiled floors, white marble stairs and pinkish-ochre walls—set in a spectacular garden, with shallow grass steps lined with cypresses leading down to the sea."

After their stay at La Fiorentina, the Sutherlands returned to the Welcome Hotel and then left for Paris on May 20th. If Bacon was sorry to see them go, his pocketbook was not. He refused to scrimp, especially with friends, but the five weeks with the Sutherlands had placed him in a new financial bind; it did not help that the casino, immediately at hand, was always whispering that one good night would make him right. In May, after the Sutherlands left, Bacon wrote the first of a number of pleading letters to Macdonald. "If I sent you over two or three pictures at the end of June, do you think you could do anything with them?" he wrote, adding, "I am getting nearly completely broke." A sign of how seri-

ous his problems were becoming was the urgent letter he wrote to Colin Anderson a month later. Bacon did not know the shipping magnate well and owed the connection to Sutherland. Nevertheless, Bacon wrote to Anderson in June asking for a loan of three hundred pounds "until October." To persuade Anderson that the loan would advance English art and not just pay off gambling debts—and aware that Anderson had already purchased his 1933 *Crucifixion*—Bacon revealed that he was hard at work on a "large crucifixion group": "I am so anxious to finish them in this light but I am quite broke now."

Anderson agreed to the loan. The money did not, however, fully cover Bacon's debts. That same month Bacon also went to Macdonald for money, telling the art dealer about the Crucifixion group he was finishing, a group of paintings that "want to be hung together in a series as they are a sort of Crucifixion." The "sort of" before the word "Crucifixion" suggested that they did not directly refer to the Crucifixion. Perhaps Bacon was thinking of his Velázquez pope. He mentioned "an intense blue violet," the coloring of his abandoned pope painting of 1946. Bacon asked when the art dealer might exhibit them, "as I really need the money desperately." He proposed a price of 750 pounds for the three pictures, high for the time and more per painting than Brausen had paid for *Painting 1946*. Bacon went on to say that the price was "not a quarter of what it has cost me with gambling etc; if you think you can get more, it would be tremendously welcome. Or perhaps your gallery would speculate in buying them directly. . . ." If Bacon was not exaggerating, he may have owed creditors about three thousand pounds, a frightening amount in the threadbare world of 1947.

Like many destitute gamblers, Bacon often responded to a dire situation with fantasies and desperate measures. He continued to think about selling both his furniture and the lease to his house. "I have a certain number of quite valuable pieces of furniture in the flat at Cromwell Place," he told Colin Anderson, "which I will sell and I can repay you then." It was a pathetic remark, as if the wealthy patron would want a poor artist to sell his furniture just to pay him back. Bacon reported to Macdonald that he might even "try and go" to America, still a place where Englishmen sometimes went in the hope of making a pot of money or escaping from creditors. Bacon's friend from the design world Arundell Clarke had had a great success in the States. If Bacon failed to dazzle the provincials, as Wilde and Dickens had during their lecture tours, he might at least appeal to them in other ways. "I will get a job as a valet or cook," he joked to Macdonald. "I can do both well, so if you have any rich friends who want a good English slave, do let me know. . . ."

In September, Bacon and Nanny Lightfoot briefly went to London. They likely returned in order to say goodbye to Bacon's mother, who intended to move to South Africa the following month. Ianthe and her husband Ben were there. But Bacon's mother was also emigrating to marry a Dr. William "Joss" Montgomery, whom she may well have met during a recent extended visit with Ianthe and her family. Eric Allden, who remained friendly with Mrs. Bacon, was invited to a sherry party two days before her departure. "She leaves for South Africa on Oct. 10," he wrote, "via Marseilles in a Greek steamer of only 1400 tons." Nanny may also have required continued medical treatment for her cataracts. Bacon did not, however, bring any "crucifixion group" with him to London; nor did he personally call on Anderson. He did finally speak to estate agents about selling his lease at Cromwell Place. It would be painful to make the sale, leaving Nanny, Hall, and himself without a home base in London. Upon his return to Monte Carlo during the first week of October—the date by which he had promised to repay Anderson—Bacon wrote to his benefactor:

> I have put Cromwell Place into the hands of the agents to sell the lease and the contents for me as I am in desperate straits as usual for money and as soon as it is through I will let you have the 300 pounds you so kindly lent me. If by any chance you happen to know of any one who wants a studio like that would you tell them of it it consists of the studio you know also a large room in the front and a bedroom, bathroom and kitchenette it has some good furniture in it although large and an enormous carpet for the studio which is in store now there is everything including bedding and linen . . .

It was another oddly pitiful note, designed to make a wealthy man feel that collecting his debt would throw a poor artist onto the street. Bacon could not possibly have imagined that the shipping magnate would be interested in a real estate transaction "including bedding and linen." Later that same day, Bacon wrote to Anderson yet again, not to ask for more time to repay his earlier loan but to beg for another. This time he wrote of health issues and medical costs:

> I am so terribly sorry to ask you again but I am in one of those troughs of misfortunes at the moment as my old Nurse has had an operation for cataract done which has not been a success and I have to have another operation for sinus trouble as I have been running a temperature at nights for some weeks, I had it done about six years

ago and it cleared up then for the time. It is not serious but like all those things awfully expensive.

Bacon undoubtedly had sinus issues, as he told Anderson. He certainly suffered from hay fever, or allergic rhinitis. But as always throughout his life, when things went wrong, he began to have anxiety issues and a build-up of nerves, which then affected his overall health. He did not tell Anderson about that. But on a visit to London during this period he went to see Dr. Brass, who noted heart palpitations. Unexpected bills only added to his stress. Bacon implored Anderson for another 300 pounds.

Anderson again obliged. And Bacon again changed studios. His regular moves while in Monte Carlo suggested that he was unable to find a place where he could work successfully. (Only two studios in his life truly pleased him: one was 7 Cromwell Place.) As his debts increased, he may also have sought out less expensive lodgings. The Villa Souka-Hati—Bacon and Nanny's third residence in Monte Carlo, after only six months at the Villa Minerve—differed in both location and feel from the earlier flats. The Hôtel Ré and the Villa Minerve possessed the sunny atmosphere of the Belle Époque. Part of their appeal for Bacon may have been their cozy familiarity, as Majid Boustany, the founder of the Francis Bacon MB Art Foundation in Monte Carlo, has speculated: English families like Bacon's traditionally stayed at such places. The Villa Souka-Hati—a severe, turreted building on a hill overlooking the sea—had views but little charm. There was no reason for Bacon to move there except to save money or because it offered an appealing studio space. Perhaps its severe appearance suited his mood. He had still not completed a single painting in Monte Carlo.

Just as Bacon set up his third studio, the Sutherlands reappeared. The couple now intended to spend the entire autumn on the Riviera: Graham was "keen to launch out." It would be another serious expense—and distraction—for Bacon. The Sutherlands had always been impressed with Bacon's ability, during the war, to divine where an excellent meal could be found. He was now obliged over the coming weeks to join them in dinners and visits to the casino, where the Sutherlands could indulge their "mild" addiction to roulette, to them no more than a naughty diversion. Bacon doubtless sometimes paid the bill at the restaurant: he would become known in the 1950s for restaurant debts that he could not hope to pay. Bacon would not of course reveal the difficulties the Sutherlands' visit caused him, but he also sensed that there was developing in Monte Carlo something new, appreciated by the Sutherlands, that fundamen-

tally did not suit him—a picturesque group of writers, artists, tastemak-
ers, and moneyed gadabouts, now beginning to repopulate the Riviera
after the war. It was another kind of "village."

Six months earlier Bacon happened upon Rory Cameron in the casino
but did not bother to say hello. "I did not like to go and speak to him,"
he wrote to Sutherland, "as there were lots of jewels and white shirts
and ties and Lady K[enmare] in a crinoline." High social rank and great
houses still held no appeal for him. Nor did the reminder of the society
of his youth. There was no record of Bacon ever visiting La Fiorentina,
even for curiosity's sake. It would have been simple to get an invitation
to arguably the most beautiful house on the Riviera. Sutherland, during
his ten-day stay, could have asked Rory Cameron if Bacon might visit one
evening. Bacon also made no effort to meet Somerset Maugham or any of
the English grandees in the region, let alone Picasso and Matisse. (Picasso
was now working at the pottery factory in Vallauris.) The Sutherlands,
during their autumn stay, visited both Picasso and Matisse through the
auspices of an old friend, Tom Driberg, who was staying at the Welcome
Hotel and writing a series on the celebrated writers and painters on the
Riviera.

It was becoming fairly common for people to note, waspishly, the social
aspirations of the Sutherlands. They blamed Kathy more than Graham.
Roy Strong, a curator and art historian who, as a young man in his thir-
ties, would head the National Portrait Gallery and then the Victoria and
Albert Museum, found her frightening. Sutherland, he thought, was "a
thoroughly nice man with a twinkle in his eye and such a pleasure to
talk to, that is away from his wife Cathy [sic]—hard as nails with her
tight-pressed lips and her little Chanel suit, exuding the warmth of a
tiger about to claw . . . And yet the marriage works. She is his keeper, his
defender, his protagonist." Graham himself had a weakness for titles. The
artist Anne Dunn, who became a good friend of both Sutherland's and
Bacon's in the late forties, described Sutherland this way: "Graham was
incredibly kind and gentle and charming. A real gentleman. . . . I think
he thought more about his art but he had a sense of glamour and certain
names meant a great deal to him. Sort of romantic in the way that his
early work was romantic. He felt very romantic about the Italian aristoc-
racy, for instance. And he loved beautiful clothes."

Bacon woke every day to the bright Mediterranean sun rather than
to the filmy London grays. He ate lunch in a pleasant open-air café and
passed the evening in a glittering casino filled with shiny riffraff rather
than in a smoky pub overflowing with artists, con men, and queers. He

did not lack for English company. Nanny was there, and Eric Hall frequently so. Friends passed through. But there are many ways of being alone; most include other people. Bacon, in Monte Carlo, was increasingly alone.

During his autumn on the Riviera, Sutherland set up a studio and completed painting after painting. The landscape delighted him. He had always been drawn to the natural forms of the countryside, enjoying rugged Pembrokeshire, and he now responded to both the brilliant colors and lush vegetation of the coast and the wild, gnarly forms inland. He filled many sketchbooks with drawings. The spiky shapes of his *Thorn Tree* of 1945–46 were replaced by images of vines and palms; *Vine Pergola* and *Palm Leaves* were completed in 1947, followed by such paintings as *Palm on Wall* and *Pink Vine Pergola* of 1948. The Riviera was becoming for Sutherland what Bacon had hoped it would be for him—a healthy place in the sun where he could both work and play. Eventually, the Sutherlands would move permanently to the South of France.

Sutherland was working toward a series of scheduled shows. In 1948 alone, he was included in group exhibitions in Paris and Brussels and had one-man shows in London and New York. The group shows were organized by the British Council. Inclusion in an official British Council show abroad (or an Arts Council show at home) led to both attention and financial returns. "It was a misfortune for an artist," wrote Berthoud in his biography of Sutherland, "not to be admired by Mrs. Lilian Somerville, director of the British Council's art department for more than twenty years, or by Philip James, her almost equally durable Arts Council equivalent, and their respective selection committees." Bacon had not been asked to join the shows in Paris and Brussels. He didn't know Mrs. Somerville or Philip James. He could only observe Sutherland with astonishment as a man of the world who knew everyone but also met deadlines while living in the sun. In mid-December of 1947, the Sutherlands, having spent more than two months in France, returned to Kent. Bacon remained in Monte Carlo over Christmas, most likely joined by Eric Hall. Now too poor to purchase canvas, he began to flip around failed paintings in order to work on the unprimed canvas on the back. What began as a necessity became a preference: he liked how the rough burr of the canvas caught the pigment and provided texture. Art, and life too, was best unprimed.

Early in 1948, Bacon sent another letter of distress to Macdonald.

The appeal was shopworn. He again attempted to entice the dealer, this time with the prospect of a "set of three paintings," probably intended to remind Macdonald of the success of *Three Studies*. Did Macdonald plan, Bacon asked, any group shows in which they might be included? Aware that Macdonald might question their existence, he offered him not proof but testament. "A friend of mine, Eric Hall, is coming in to see you, and could give you some idea of them, as he is coming back here, perhaps you could tell him if there is any chance of showing them." Then came the pitch: "There is another thing. Is it possible to make me a small advance? I am quite broke, and canvas and paints are terribly expensive. Would it be possible to advance me 150 pounds. You can speak to Eric Hall about this."

Bacon's appeal failed, even with Hall's imprimatur. Macdonald had always been accommodating, even once suggesting that if Bacon remained in Monte Carlo "between us we might devise a scheme for putting British Painting (via Francis Bacon) on the map, dans le Midi." But Macdonald would wait only so long. Bacon now turned to Erica Brausen. Yes, she replied, he could join a group show at the Redfern Gallery in June—but she herself was moving to a new gallery. Having established that he could exhibit at least one painting, he wrote to Colin Anderson to ask again for money. "I am so sorry not to have repaid you the loan [of six hundred pounds] . . . I have not yet got rid of the studio . . ." But, he informed Anderson, he would be "showing some things at the Redfern in June," and promised him a particular treat—a "painting for you of Monte Carlo." Bacon was now uncertain, he told Anderson, where to live. "I do not know if I shall come back [to Monte Carlo]. I long to go to America to work for a bit." He also expressed reservations about moving: "I think the nostalgia for everything I love might be so strong." For the moment, he said, he had decided to return to London "at the end of April." His decision to return a month before the Redfern opening, his first significant trip to London in almost two years, suggested that he had come to a critical realization: working in London against a deadline was how he could finish paintings. In April, under great financial and professional pressure, he went back to England, bringing with him several unfinished canvases.

If Macdonald had lost patience, Erica Brausen was willing to wait. She might even have intended, at one point, to open her new gallery with a show of Bacon's work. Some months earlier, she had had a falling-out

Erica Brausen, Bacon's first real dealer, a "formidable, razor-sharp German" lesbian

with Rex Nan Kivell at the Redfern and had left to open the new Hanover Gallery, named for its location off Hanover Square in Mayfair. She managed to persuade Arthur Jeffress, a wealthy art collector, to back her. She also brought in a friend and artist named Elsa Barker-Mill, whose husband was the wealthy patron Peter Barker-Mill. Peter had gone to school at Harrow—where Jeffress was a classmate—and to Sandhurst but was now an aspiring artist. It seemed less difficult to a couple like the Barker-Mills to start a gallery than find one. The improbable financial partnership at the Hanover Gallery lasted only a few years, but it gave the penniless Brausen her start.

Jeffress had an adventurous eye, despite some distaste for Bacon. He owned a Picasso portrait of Dora Maar and works by de Chirico, Soutine, Modigliani, Balthus, and Vuillard. (He also had important connections to the American art world.) Brausen's new business, at 32A St. George's Street, consisted of a handsome ground-floor exhibition space connected by an exposed stairway to an upstairs gallery. It was well-positioned to attract wealthy collectors. Since Bacon had so few paintings available, Brausen opened her new gallery with a show of Graham Sutherland's work. It was a tribute to her force of character that she could persuade him to exhibit with her. Sutherland could have exhibited anywhere, although he was probably looking for new representation: the Lefevre Gallery was becoming less adventurous and would soon revert to showing leading European art, not up-and-comers. The forward-looking Macdonald would die the next year.

Sutherland proved to be a Mediterranean fountain. He had twenty-five oil paintings and a dozen drawings ready to exhibit. He was, wrote Berthoud, "still reveling in the exotic subject matter of the South of France, and many of the pictures showed insects like the praying mantis or the grasshopper, or banana leaves, gourds and hanging maize cobs." The response to Sutherland's "Mediterranean mode" was all Brausen

could have hoped for. Critics were effusive; crowds came. Sales were brisk, too. The *Tribune* critic judged that it "may well be that Graham Sutherland is the most important painter working in England today. . . . Whatever he paints Sutherland endows with a strange flickering vitality which exposes the ends of the spectator's nerves." The chatty column "What's On in London" called the opening "one of the most brilliantly crowded first views London has seen for many a day." The Sutherland exhibit gave the Hanover Gallery a reputation for being at once edgy and established. That suited the evolving art world in postwar London, which remained conservative yet aware that the world was changing. At her openings, Brausen was always elegantly, even somewhat forbiddingly, dressed.

Her partner added to the exotic allure. The legendary Toto Koopman, born in Indonesia of mixed Javanese and Dutch descent, was, like Brausen, a war hero. She served as a spy for the Allies throughout the war and was imprisoned several times, the last at the notorious Ravensbrück concentration camp. She recuperated in Switzerland and then moved to Florence, where she met Brausen in November 1946. Not only was she a war hero: in the 1930s, she had had an affair with press baron Lord Beaverbrook. Even more exciting for gossips was Koopman's simultaneous affair with Beaverbrook's son, which resulted in Beaverbrook running stories denigrating her in his *Daily Express*. She was, in short, a beautiful woman with an exciting past and an impressive list of well-connected friends, many drawn from the aristocratic world.

The Redfern group show at Brausen's old gallery opened around the same time as the Sutherland exhibit. Bacon contributed only one work, *Head I* (1948). It was painted on hardboard, which suggests that Bacon began work on it in Monte Carlo, where—unable to afford canvas—he sought out less expensive surfaces. But he probably finished it in London. *Head I* appeared strangely untouched by pleasure-loving Monte Carlo. During the spring of 1948, Bacon had still been struggling to create a "crucifixion group." He had been thinking about Pontius Pilate's presentation of Christ to the people. Bacon probably intended to depict a group

Toto Koopman, the celebrated Indonesian-born beauty and model who in 1946 became Brausen's lifelong partner

of heads from the mob that mocked Christ, one of which became *Head I*. He was finding that he could concentrate in one image his interest in both whisperlike painterly effects and the eruptive animal.

Embarrassed by his debt, Bacon wrote Anderson to offer him the picture that he was then working on—a study for this larger work, he said, on the subject of "Christ shown to the people." The picture was, as Martin Harrison has suggested in his Bacon catalogue raisonné, almost certainly *Head I*, his one finished painting at that time. Bacon doubted the Andersons would want to own it. He was right. The figure could have emerged from the darkest alleys of Victorian London. Erica Brausen probably first saw *Head I* at Cromwell Place, where she had earlier purchased *Painting 1946*. Brausen loved the extraordinary new painting. She and Toto purchased it from her previous gallery. A dealer with a marvelous eye still supported Bacon passionately even as she exhibited many Sutherlands to great acclaim.

After the summer exhibitions, Bacon and Nanny returned to Monte Carlo, but no longer as determined expatriates. London was once again a critically important place to live and work. Before he left London, Bacon promised Erica a show at her new Hanover Gallery. The promise was not forgotten by either Erica or Arthur Jeffress, who now advanced him two hundred pounds against the upcoming show's earnings. Soon, from Monte Carlo, Bacon began sending to London the same vague promises that he once had made to Macdonald. The painting was going well, he said: "I am at the moment working on some heads which I like better than any I have done before." It would also be most helpful, he suggested, if the date of the show were extended out as far as possible. Jeffress, who already entertained suspicions about Bacon, insisted—unlike Macdonald—upon a firm date. At the end of September, Bacon wrote him: "Thank you very much for your letter. I would like the 12th of June to the 7th of July [1949] as all the stuff will be new it will give you a bit more time. I expect to be over about the middle of November and will leave some of it with you then. It is terribly quiet and deserted here which I quite like and lovely weather."

Bacon promised to move back to London in dreary November—in other words, to help ensure that he would complete enough work for a show at Hanover seven months later. His work in Monte Carlo, despite his report to Jeffress, was going poorly. (He did, however, complete a second painting, *Head II*, a picture no less disturbing than *Head I* and one that also contained few Mediterranean notes.) Before he left for London, Bacon destroyed the work in his Monte Carlo studio, which probably

included ambitious but incomplete pictures, some of which may have reflected his Mediterranean surroundings. He would come and go from the Riviera for the rest of his life but would never again regard it as his primary residence. A gambler walks away from a bad bet.

HEAD I (1948)

Head I is one of the most disturbing paintings in British art. It seems to begin as an ordinary old-master portrait. The ear is correctly positioned for such a painting. But something extraordinary has also happened to this particular head. A taut, tasseled line pulls upon the ear, as a schoolteacher might draw back the ear of a misbehaving student, and the exquisite tension of the line seems to release the face from the head, which then no longer appears to be an altogether human face. It lolls grotesquely to one side, its open mouth in a chimpanzee's grimace. The head is losing the mask of the face, revealing the creature within.

 Head I is the Mr. Hyde of English art, emerging from the Dr. Jekyll of the well-mannered portrait. It has a startling, revelatory suddenness, like the figure revealed when the shade snaps up. This particular Mr. Hyde, however, is a complicated sort of monster. He is frightening in the way that monsters can be, and his teeth—especially the prominent canines—are unnerving. But his mouth also seems to be crying out, and the scramble of teeth appears powerless before the assured geometry above. The absurdist comedy of the Victorian tassel, reminiscent of a fusty propriety, only deepens the animal pathos. More intimate than Bacon's earlier pictures, *Head I* presents the head as isolated, exposed, and pared back, without much overlay of other elements. It is a suffering head, alone in a dark and stripped-down room. Human control, vested in settled human features, is an old-master illusion. The only power that matters is invisible, affixed to the other end of that cruel but luminous line, arguably the most abstract line in English art.

Soho Nights

BACON BEGAN TO REDISCOVER Soho's edgy streets, old staircases, and inward-looking rooms. One could tire of fresh air and sunshine. He needed a confined London room in which to work and then, at night, the laughter of the pub and the smell of stale smoke.

It was not a simple matter to take up life in London again. His circumstances had changed. So had London's. Bacon was no longer the young artist who, during the war, caroused with the two Roberts in Soho basements. He had made successful paintings with three different "looks"—from *Three Studies* to *Painting 1946* to *Head I*—and the future seemed to await his next move. He was talked about. He could not always go to Soho without being noticed, and the old places—as London slowly recovered from the war—were no longer concealed in the shadows. The small, hidden-away clubs still existed, but the life of Soho had also begun to move upstairs. New clubs were opening. Old pubs took on new life. Bacon's generation, home from the war, was starting to assert itself.

Bacon's new position began to change his relationship with Eric Hall. Bacon was now almost forty years old, a powerful man in his own right, no longer an almost-son and companion to a London politician. Eric Hall seemed from "before the war." In 1949, as he turned sixty, Hall retired from the London County Council. The aging Tory did not always feel at ease playing second fiddle to Bacon at a postwar private view. Nor did he wish to stay out late in smoky pubs with the edgy young people—writers, artists, actors, musicians—who were trying to make new images in a new world. There was no angry break between Bacon and Hall, however, as the younger man began to create a new life for himself in postwar London. A sociable being, subject to the demons of loneliness and despair, Bacon required lively company at night. Now and then he went out with establishment figures, but it was far more important to him to develop a kind of eccentric family life in Soho—his version of another man's armchair

and newspaper—where he could relax in familiar circumstances surrounded by noisy, amusing, and sometimes quarrelsome "children." He would even find a club where there was a mother, of sorts, to keep order.

Each morning, Bacon struggled dutifully in the studio over his *Heads*. Then, around midday, he would begin his night early, moving out into broader London. He emerged from the Underground at Piccadilly to have a drink at a pub and then fell into the natural rhythm of Soho life, which began late in the morning and lasted into the small hours. Bacon's Soho days often began at his "family" restaurants, one of which was the York Minster, or French House, on Dean Street.

During the war, the "French" and its Belgian proprietor, Victor Berlemont—whose handlebar mustache was worthy of a villain in a silent movie—created a paradoxical sort of feeling. It was at once a cozy family restaurant for the Free French forces (and many others) and a pickup joint, filled with all possible kinds of talk, where anything seemed possible. Regulars could charge meals and drinks. The French, now run by Victor's son Gaston, easily adapted to postwar Soho. It opened at eleven a.m., "dispensing Pastis to settle uneasy stomachs," as one chronicler of the scene said. Bacon, after a first drink, might head upstairs to the restaurant above the pub or go with friends to Wheeler's, his other family restaurant a few steps away. Wheeler's was run by Bernard Walsh, who had opened the oyster bar and seafood restaurant in Old Compton Street in 1929. Like Victor Berlemont, Walsh learned that Bacon—who almost always picked up the bill—cared nothing for money. As a result, Walsh was never difficult about the bill because he knew that the same disdain for money that emptied Bacon's pockets would, as the pockets filled again, lead Bacon to shower the restaurant with tips, business, and the sort of wit and gusto that drew in other patrons. (In 1966, Bacon, making good on all bills, gave Bernard Walsh a portrait of Lucian Freud.) Informal but expensive, the restaurant seemed conventionally

Gaston Berlemont, the more-French-than-the-French Belgian proprietor of the York Minster, aka the French House or simply the "French," in the mid-1950s

French with a "plush cocktail bar with red velvet banquettes and stools" at the back, an oyster bar to one side, and a serious restaurant up front. The tables were bare, with checked napkins. The pictures had a dull nautical theme. The staff knew the regulars, and the regulars knew the staff.

When Bacon came in over the years, the longtime barman John Normile said, spirits inevitably soared. "He would say to everyone, 'Have a drink, have a drink, have a drink.' He was very generous." The man behind the bar could open, it was said, four hundred oysters an hour. And Bacon could eat that many, it sometimes seemed. Few people enjoyed an oyster more than Francis Bacon did. It was probably not the taste alone that appealed to him. The gnarled shell was also a tight, beautiful mask, and the oyster itself, once the knife stripped back its shell, appeared vulnerable and liquidly alive, cut to the quick. Its sacrifice was nicely acknowledged with champagne or a fine Chablis. Well-nourished by oysters and wine, Bacon often became a carefree performer, delighting the restaurant audience with outrageous remarks. Jeffrey Bernard, another connoisseur of Soho, described two moments at Wheeler's that, though they occurred later, were also typical of Bacon's early years. Once, during one of those strange moments in a restaurant when suddenly the room falls silent, Bacon loudly asked Bernard: "Now that you've lost your looks what are you going to do?" The "entire place," said Bernard, broke up. Another time, said Bernard, Bacon was sitting near a table of matronly American tourists. During a natural lull in the lunchtime clatter his voice rose into the air.

> "Which woman do you most fancy in the entire world?" he asked me. "I don't know. What am I supposed to say? Ava Gardner? Cyd Charisse? What a daft question! Anyway, who do you most fancy in the entire world?"
>
> He replied with a languid yet loud tone: "D'yer know, I think I'd really like to be fucked by Colonel Qaddafi." Exit the Americans.

Under the licensing laws of the time, pubs were required to close each afternoon from three to five p.m. and then again at eleven. This left too many hours untended. Members-only "social clubs" formed to fill the hole in the afternoon and that time after dinner when one might want a last drink before heading home. In December of 1948, Brian Howard—a dissolute poet and the model for Anthony Blanche in Evelyn Waugh's *Brideshead Revisited*—took Bacon to a new club then just opening. The

Colony Room was on Dean Street, near Wheeler's and the French, and it was well-named. It attracted a crowd washed up from a far shore. It consisted of one big room with a bar and a piano (there was even a piano player on some evenings) up a narrow flight of stairs in a worn-out town house. The Colony was a little dingier than most such places, with walls a "bilious green" that eventually became so celebrated and stylish the color might have been marketed as a paint chip. Its more official "colonial" theme of bamboo and palm trees was rarely noted. Bacon, who came from a family that often lived in the colonies, liked to check his hair in the big mirror over the fireplace.

What distinguished the Colony was the woman at the door, a plain-faced, caustic lesbian named Muriel Belcher. She was the same age as Bacon and presided over the Colony from her stool by the door, ostensibly to receive members and their guests while keeping out riffraff (though any rules at the Colony were made to be bent). Her presence was so strong—a kind of musk—that the Colony was not ordinarily called the Colony: it was called "Muriel's." Bacon and Muriel soon became fast friends. When he walked into the room, Muriel—her voice rising a little higher than usual—would sing out, "Hallo, *Daughter*." Belcher offered Bacon a weekly stipend and unlimited champagne in exchange for introducing his friends to the club. "I don't know, perhaps she thought I knew a lot of rich people, which was untrue," Bacon later said. "But she knew I hadn't got much money, and she said, 'I'll give you 10 pounds a week and you can drink absolutely free here and don't think of it as a salary but just bring people in.'" It was a successful arrangement. When Bacon was pen-

Muriel Belcher, the tart-tongued owner and a queen among the queens at the Colony Room, Bacon's favorite after-hours hangout for decades

niless in the 1950s, Muriel let him run up bills, and meanwhile, younger artists began to frequent the Colony. Often Bacon himself was the lure, as Muriel Belcher had shrewdly fore-seen. Lucian Freud, Anne Dunn, Dylan Thomas: all crowded into the confined, smoky room of the Colony, reaching toward the small bar.

Belcher was a queen among the Colony queens. "Muriel's girl Car-mel [Stuart] was Jamaican," said Isabel Rawsthorne. "They made a truly extraordinary pair. Carmel, if she liked you, was fond of raising her

skirt to show her streak of thick long hair that went in a band from navel to pubis." Muriel greeted gentlemen with "Hallo, Mary" and ladies with "Hello, Cunty." She had been a proprietor at two previous London clubs—first the Sphinx and then the Music Box, which had originally attracted the Bright Young Things. But the Colony seemed made for Belcher, and she for the club. Isabel Rawsthorne was one of Muriel's favorites. The "success of the club was due to [Muriel]," said Rawsthorne. "She was witty, extremely efficient, also perceptive. An excellent judge of the people who came to her club . . . I went there knowing that I was likely to meet Francis Bacon and other friends . . . She was genuinely pleased when any of her members had any success."

The writer Geoffrey Wheatcroft described Belcher's "machine-gun chatter: sarcastic, witty, scabrously obscene." John Moynihan, son of the artists Rodrigo Moynihan and Elinor Bellingham-Smith, wrote:

> Once again Muriel's voice boomed out as she ejected another cowering non-member: "MEMBERS ONLY, DEARIE—AND GET A FACE LIFT ON YOUR WAY." Muriel's imperious status often transformed her. Her determination not to take prisoners at all costs both alerted and alarmed some of the most powerful and rhino-hided of her customers, and even a swaying Francis Bacon was known to twitch momentarily at her verbal blasts.

The seeming emphasis upon "membership" was also comic, of course, as this was a club for people who—to paraphrase Groucho Marx—would refuse to join any club that would have them. (Even the famous members of the Colony liked to imagine themselves as outsiders.) The club sometimes had a childish quality, as if Peter Pan and the Lost Boys had grown up to be cynical drunks in Neverland, with Muriel herself a fairy fucking godmother to lost boys and girls. She would lend her fox fur to a friend for an opening. She maintained a significant charity for children. "They'd throw a benefit every year, just before Christmas, in a children's home," said Emelia Thorold, whose mother, Marilyn, was a Colony regular. Women who came at off-hours would find a cozy, comforting Muriel—someone who talked about how hard it was to find good cleaners.

But the Colony was also serious the way "home" can be serious. Muriel defended an invisible line between worlds. The outer world and its conventions were hostile. Inside Muriel's room, however, those conventions became playthings to be teased apart and reversed. Calling someone a cunt in the outside world was one of the worst possible insults, but at

Muriel's it could mean almost anything, depending entirely upon the context, and often served as a term of endearment. At Muriel's, masculine power and its sanctimonies were mercilessly and vengefully ridiculed. Most he's were called "she." "She was a brave little woman in the Somme," she liked to say of Leonard Blackett, one of the Colony pianists who was universally known as "Granny Blackett." Homosexuals gave the club its élan—a heterosexual guest would be toasted with "Champagne for the norm!"—but many straight men and women who recoiled from the world also found relief in its unapologetic drinking and irreverent banter.

The freedom inside the bilious green room, while naughty, funny, and subversive, also included the darker liberties. You could wound and be wounded. You could choose to drink yourself to death. Veneers were stripped; masks were picked up in pieces. Sloppy drunks often fell down the narrow staircase. By the next day the performances were forgiven or forgotten—or perhaps not. (It was never easy to know what people remembered from the night before.) Not infrequently, after a night of drinking, Bacon wrote a letter of apology. In the 1950s, there were many characters at the Colony, and many others who hoped to become characters—especially later, in the 1960s, when the club became celebrated and began to attract cultural tourists. The people who mattered most to Bacon, however, were the ones who had slipped on the vomit on the stairs, lost five years to an interminable war, and played for keeps.

If there was one figure who stood out among the Lost Boys—who represented the unhedged life and all the Colony could be—it was the photographer John Deakin, who often photographed Bacon and his subjects over the years. It was hard to know if Soho saved or destroyed Deakin. Probably both. No one at the Colony seemed to like Deakin very much. He was a small, disheveled man, so homely people looked twice. The journalist Daniel Farson, the Colony character who would one day write *The Gilded Gutter Life of Francis Bacon*, first noticed Deakin in a pub in the early 1950s:

> He looked as if he'd been rescued from a wreckage at sea and fitted out by the generous crew. He wore paint-stained jeans and a polo-necked sweater that was grey with age and flecked with blood from the cut above his ear. And then a British warm overcoat which he clutched like a Mandarin. A coat he must have loved as it was a sort of nostalgic coat of cigarette burns and wine stains as if he'd often fallen in the street with it, which it turned out he had.

John Deakin, a small, disheveled man and sharp-toothed gossip whose photos for Bacon inspired many of the artist's portraits in the 1960s

When Deakin noticed that Farson was staring at him, he gave Farson "this hideous grimace with his discolored teeth and a tongue the colour of aubergine and I was entranced." Deakin was a witty, sharp-toothed gossip who could be shockingly rude—"the second-nastiest little man I ever met," someone once said. "If he hadn't been a little wizened like a dwarf or a jockey, I mean he would have been murdered." He once insulted Belcher, for example, by suggesting that she fiddled with the Colony books, to her an infuriating accusation that transformed her momentarily into a Victorian lady with feelings of propriety. He had very large eyes in his small body, with a "marvelous sort of Mickey Mouse face" that also had the aspect of a sad clown. Lucian Freud said Deakin seemed to be both Cinderella and her evil sisters in one.

During the day—first in the late 1940s and then in the early 1950s—Deakin was improbably a photographer for *Vogue*. The editors tolerated him because he was so gifted. (They fired him twice, once in 1948 and once and for all in 1954.) Although fashion seemed an unlikely field for Deakin, he was able to capture the shiny airs, poses, and masks that sustained the industry. But he was even better at displacing them. Deakin was a natural "night" photographer, a master of the three a.m. world who skunked around Soho and became a great portraitist. Farson said that when he first went to Deakin's studio he was stunned because "I'd never seen such brutal photography before." The "brutality" was in no way coarse, cruel, or heartless. It often revealed something tender, much as Bacon's "brutality of fact" did.

The brutality lay in Deakin's determination to expose the cover-up, to pick at the scab of the world. Deakin loved unforgiving close-ups, which broke the settled planes of the face, and his obnoxious manner (he would often erupt into spitting bitch-fits with *Vogue* models) also forced his subjects into new aspects and poses. Deakin was able to take one of the best portraits of Picasso—an artist who typically dominated photographers by assuming his various "genius" looks—through being disagreeable. Picasso, who was himself very small, could not bear spending time with this very

small and repulsive Englishman. Deakin weaseled into him and revealed the artist's shrewd, rather cold appraisal of others. The portrait, as Bruce Bernard observed, was "not done on Picasso's terms."

Artists usually require a few kindred spirits, and Deakin became one of Bacon's, though they were not intimates. Bacon felt comfortable with Deakin despite and because of the prickly awkwardness. Asked why he went to Muriel's day after day, Bacon replied, "Because it's different from anywhere else. After all, that's what we all want, isn't it? A place to go where one feels free and easy."

If Muriel's was Bacon's everyday home—and Wheeler's and the French Pub his home cooking—the Gargoyle Club (also on Dean Street) became a way to "go out at night." The Gargoyle, as its name suggests, was meant to be agreeably naughty and posh. Soho had long provided diversion for prominent people. If, for example, you lived at Albany—the gentlemanly eighteenth-century flats on Piccadilly well-known in the aristocractic world—you could be minutes away from both elegant St. James's, where you could lunch at White's or Boodle's, and from Soho (out the back of Albany), where you could make mischief.

Before the war, the Gargoyle's membership skewed toward Blooms-bury, aristocrats, and those who could talk easily with its owner, David Tennant, and his brother Stephen, who came from the socially pow-erful Tennant family. It was not intended for nameless young people, unless they were particularly beautiful or brilliant, and its early members included such luminaries as Virginia Woolf, Noël Coward, and Nancy Cunard. (The precocious Lucian Freud, drawn early on by the club's social allure, was an exception: he seduced Tennant's eighteen-year-old daughter, Pauline, in 1945.) The Gargoyle became a different club after the war. It retained elements of high style, but it now hosted the next generation of writers, artists, and musicians, who did not observe the Edwardian or Bloomsbury proprieties. The Gargoyle became scruffy Soho's palace. Freud and Bacon were both members, as were the two Roberts, John Craxton, and Isabel Rawsthorne, newly returned from Paris. Other women and friends of Bacon's who were members included Erica Brausen, Anne Dunn, and Caroline Blackwood.

Like the Colony, the Gargoyle was another kind of stage set, one that seemed made for personal theater. It was an excellent place, for example, to make an entrance. After dinner elsewhere, its members would creak up to the top floor in a tiny "mouse-trap lift," as Michael Luke described it

in his *David Tennant and the Gargoyle Years,* which then opened to a paneled reception room. From there they would move down a long mahogany bar "with an amazing variety of bottles" and pass by a relic from the building's past, "a rather fusty country-house sitting-room" that was known as the Tudor Room. At last, they arrived at the architectural pièce de résistance: a mirror-lined staircase that swept dramatically down to the main ballroom below. Bacon loved the effect. (For his showroom at Queensberry Mews he had also designed a staircase that swept down into a high, open space.) Most people would arrive "quite late" and "generally half drunk," Bacon said. But they "looked for a moment like birds of paradise coming down this beautiful gold and silver staircase into what the multiplicity of small mirrors made into a very beautiful room."

The ornately coffered ceiling of the ballroom, enlivened by gold leaf and intended to evoke nothing less than the Alhambra, was David Tennant's idea. But the Gargoyle's main architect was, surprisingly, Henri Matisse. The French master appreciated a fine setting; ideally, place and painting should come together, making for a more marvelous union. Tennant had a personal connection to Matisse—a friend married the artist's daughter. (Tennant, in the 1920s, purchased from the artist himself one of his greatest works, *The Red Studio* of 1911, which hung at the Gargoyle until it was sold in 1948 to the Museum of Modern Art.) It was Matisse who thought of the mirrors. Michael Luke described Matisse in his account of the Gargoyle's glittering years:

> [He] made the suggestion that was to lift the décor of the Club's main room hors de categorie and give the place such a unique flavor. He knew of an eighteenth-century chateau whose contents were about to be sold. Included were some immensely tall looking-glasses. Doubtless these could be bought very cheaply. When cut into thousands of small squares and set into the walls, these tiles of subtly imperfect glass would produce un effet éclatant.

The ballroom, where a live band entertained the crowds, became a bewitching space. The faceted mirrors broke the reflections of the members into glittering pieces as they swirled about the dance floor wobbly with drink. The painter John Minton was particularly attracted to the Gargoyle. He introduced many artists to the club, including Bacon. Before Bacon arrived from Monte Carlo, Minton was already one of Soho's leading men. He seemed to know everyone and to have taught everywhere—at the Camberwell School of Arts and Crafts (with Victor

Pasmore and William Coldstream), at the Central School of Art and Design, and, in the 1950s, at the Royal College of Art, where Rodrigo Moynihan was considered the leading artist. Minton was a homosexual who went to Soho almost nightly, often with sailors in hand, and he burned painfully bright. He danced, caroused, and laughed as fast and hard as he could. His group of followers from his Camberwell days were known as "Johnny's circus." He had money, having inherited a small fortune from his maternal grandfather, the managing director of the department store D H Evans, and he liked to drive by the store at night in a taxi full of friends and yell, "We're spending your money, darlings!"

Minton was also a deeply ambitious, often despairing artist with a "dagger-like, down from the brow" face, as John Moynihan described his sharply etched nose and brooding eyes. (In contrast, Moynihan wrote, Bacon's cheeks "looked wholesome, puffy and slightly florid, suggesting good nights in company with croupiers.") Minton was one of those whom the Soho nights might destroy. He "played the extrovert, bringing to his performance a fast, sophisticated and exhilarating intelligence which could not, however, remove his inner melancholy and discontent," wrote his biographer, Frances Spalding. "His heightened sense of the absurd was related to his grasp of the significant, in art and life, for his constant clowning veiled a fundamental seriousness and dedication." At the time, Minton was a more established artist than either Bacon or Freud. He had first begun showing in the mid-forties. In 1944, he was part of a group exhibition at the Lefevre Gallery with the two Roberts. The next year he was the subject of two one-man exhibitions, both of which sold well, one of them at Lefevre.

Both Bacon and Minton liked a dramatic gesture, and neither was averse to rows. At the Gargoyle, owing to the mirrors, everything seemed magnified, including the quarrels that naturally arose in a heady environment after staggering intakes of alcohol. Bacon thought the club "was really made for rows. I've seen greater scenes than I've ever seen in my life in the Gargoyle—except for one's personal rows. They were nightly. They went on not only for hours, they went on for days. It was like one of those installments where it says tomorrow you'll get such and such. . . . Well, you certainly did in the Gargoyle. It was great fun, really, in spite of the rows." One night in 1950 or '51, for example, the young Margaret Fenton came to the Gargoyle for the first time and was sitting goggle-eyed at a table along the dance floor. She was with a group of artists, among them Robert Buhler, and Rodrigo Moynihan and his wife, Elinor Bellingham-Smith. She was about twenty years old. "Suddenly there was

an explosion and who should come in but Francis, on top of the world, at the head of a fairly rough rabble of sailors . . . I don't know who. This train following him. All came downstairs, and of course he knew Rodrigo and came across to our table with his followers and they all sat down around us."

Fenton found herself seated next to a sailor, "a nice boy," and they were talking to each other in a casual but innocent way and "getting on rather well" when Bacon began to glare at them. "The sailor was telling me where his boat had been. Suddenly there was a mask on Francis's face: his face changed and he was absolutely furious. I think he thought that I was trying to walk off with his boyfriend. And he said something very, very savage, which I don't remember, mercifully. I rather admired him and suddenly to have this savage thing . . ." A week later Fenton was back at the Gargoyle sitting in a corner with the same company of friends. "Suddenly the waiter came over with this magnum of champagne which he placed in front of me." She became confused and glanced at Rodrigo Moynihan, who said, "It's yours." She was still confused. "I'd never had a magnum of champagne." "'Look over there,' someone said. There was Francis in another corner, who got up and kissed his hand. He was making up. I thought that was such a nice thing to do. For a young person . . . it still makes me want to cry."

Sex was readily available in postwar Soho, just as it had been during the war, when Bacon first began his nocturnal prowls. He did not especially look for sex at a place like Muriel's, where he knew most of the members. Nor did he seek out men at the pickup spots favored by the furtive and closeted—around the public toilets, for example, or the Piccadilly Underground station. But he was attracted to the "rough trade" homosexual bars in London that appealed both to gentlemen and to young toughs. A one-night stand with a sailor could be meaningless in a meaningful way: despairing, cruel, cathartic. Bacon was at loose ends. He could find a moment's clarity in the sometimes violent serendipity of the night.

Together with Nanny Lightfoot, Eric Hall had been, for two decades, the great constant during the upheavals of Bacon's life. To be with Francis, Hall had sacrificed his family life and even run off to the Riviera. He had been with Francis when the blue-eyed boy was still designing furniture. He had assiduously promoted his career as a painter. He took pride in Bacon's success. Anne Dunn remembered Bacon referring to Hall in the late 1940s in a conversation with her, but as if Bacon were describing not a lover but someone in his family, "rather affectionate. Rather uncley." Hall would be disappointed, but not surprised, when his powerful wild

child slipped away into this new and strangely youthful postwar world. Hall moved to the Bath Club. In his last years, he often traveled the world by ship—Barbados, Mozambique, Peru, Australia—which was a good way to remember the past and fill the present. He died in 1959, a wealthy man (with an estate of forty-eight thousand pounds) until the end. Decades later, Bacon still referred to him fondly.

Brothers and Lovers

Francis Bacon and Lucian Freud c. 1952. The two were inseparable for years.

IN THE LATE 1940s, Bacon began two intense friend-ships that lasted for decades. The first was with Lucian Freud, whom he now began to see not only at social gatherings—at a Wheeler's lunch or in the crowd at the Gargoyle—but almost daily. Their relationship flour-ished throughout the 1950s and '60s, but it was in the late 1940s, when Freud was absorbed in his first marriage to Kitty Epstein and a new affair with the painter Anne Dunn, that they became regular companions. Freud, thir-teen years Bacon's junior, looked up to the older painter. For Bacon, still struggling in the studio, there was no more valuable admirer and, sometimes, adviser.

If Bacon was a relatively new arrival in London's larger art scene—given his prolonged absence in Monte Carlo—Lucian Freud, as Michael Luke wrote, was already a "comet of astonishing brilliance." Even as a teenager, Freud had established a reputation as someone equally enig-matic and seductive, at once a mysterious émigré and a social lion. Born in Berlin, he arrived in England with his family in 1933. But with a name like his he was, of course, no ordinary immigrant: Sigmund Freud was his grandfather. Nor would he submit to an English public-school sys-tem designed to produce the next generation of leaders. By the winter of 1939, when the future artist, writer, and curator Lawrence Gowing met him, Freud had already been expelled from Bryanston, a progressive but posh public school, for dropping his trousers on a street in the resort town of Bournemouth, not far away.

Freud then returned to London, where his family lived—and where, more importantly, England's artistic and literary worlds were centered—and enrolled at the Central School of Arts and Crafts in January of 1939. He soon left. It was "too much like school," wrote his biographer William

Feaver. Freud had heard about an offbeat alternative, the East Anglian School of Painting and Drawing in Essex. Originally located in Dedham, Essex, the school, which was also a kind of rustic art commune, was founded in 1937 by Cedric Morris (later Sir Cedric Morris) and his partner, Arthur Lett-Haines. After a fire in 1939 destroyed the original building—Freud was there at the time—Morris moved the school to a rambling house in Hadleigh, Essex, called Benton End. It was a draw for those also interested in botany, as Morris was, or who liked the outdoors and horses. Freud was a gifted horseman.

But Freud also returned to London on weekends; he could never settle in the country for long. He liked making connections. He seemed to mix in many worlds and became a precocious presence in nighttime Soho. Freud was "already spoken of as a boy wonder," said Gowing, and Freud himself said that he felt "curiously privileged and in a terrific position to experience things. I was excited by life." Freud also seemed to know instinctively how to play the political game in the arts. One of his earliest "conquests" was Stephen Spender. Not for nothing had a drawing of Freud's appeared in the third issue of *Horizon* while Spender was one of the editors. (The editorial secretary there, Sonia Brownell, would become one of Freud's early sexual conquests.) Spender found Freud "totally alive" in those early days—"like something not entirely human, a leprechaun, a changeling child, or if there is a male opposite, a witch." Graham Sutherland also felt Freud's magnetism: the two met in 1942 through *Horizon*. By then Freud had briefly served as an ordinary seaman on the SS *Baltrover*, part of an Atlantic convoy: "I liked the idea of adventure—the Ancient Mariner—but I was soon pretty desperate." He had also briefly returned to Benton End. But Morris now seemed part of the past and Graham Sutherland, then in his ascendancy, representative of the future. Both Freud and his friend John Craxton looked to Sutherland for guidance. They attended Goldsmiths College in London at his suggestion. (Peter Watson said, "Lucian must learn how to draw a hand before he distorts one.") They also joined the Sutherlands in August of 1944 on their annual holiday to Pembrokeshire, on a trip that mixed art and pleasure.

Many people remarked upon Freud's interest in aristocrats. Bacon himself embodied a certain aristocratic spirit that Freud prized: He did not appear to be governed by the concerns that motivated most people. Bacon would not make money, but spend it. He would live as he liked and say what he would, indifferent to the consequences. He liked rogues and those who stood apart from the conventional middle class—he could

climb both up and down socially—and was sexually unafraid at a time when homosexuals caught in the act could still be imprisoned. Freud's way with the world would likely have been much the same had he not known Bacon, but the example set by Bacon helped the younger man develop and strengthen his own perspective.

Freud certainly appreciated Bacon's art. He bought his first Bacon in the summer of 1951—*Head* (1951)—and would eventually possess nine Bacon paintings, including one of his greatest, *Two Figures* (1953), which Freud placed over his bed. But the younger man's respect for Bacon's art—then so free-seeming when compared with his own lyrical but tightly drawn work—was probably not what helped Bacon himself the most. It was more personal than that. Freud, with his uncanny intuition, surely sensed Bacon's anxiety, loneliness, and feelings of weakness behind the fearless façade. (The shy Bacon was a touch too eager for the company of a friend when he was out in public.) Freud knew how important Nietzsche was, of all writers, to Bacon's internal evolution. Freud, also an outsider in English society, appreciated the powerful face Bacon turned to the world. Freud could be a cruel critic—which Bacon knew, since they were often cruel together—but regarded Bacon's performance with unreserved admiration.

Although Isabel Rawsthorne considered Freud's art "not my cup at all"—a feeling she extended to Freud himself—others could not resist him. He gave an erotic edge to almost everything. He loved animals particularly—horses most of all—and, like Bacon, seemed to look for the animal in the man or woman. He could be aloof yet had an astonishing gift for intimacy. (One of his later lovers recalled that, unlike any other man she had known, he would hold her in his arms for the entire night.) He could be cruel to his lovers but also surpassingly kind. He was not large but appeared alert, fine-boned, and well plumed, like a small bird of prey. There was something beautifully careless about his dress; the better sort of dandy never, of course, revealed effort. There would be a fraying, a paint stain, or a scarf just coming undone. Sometimes a surprise: tartan trousers? Freud had no money, but enough for an old Bentley.

While drawn to aristocrats, Freud also kept somewhat apart. He was Jewish in a world that was casually (but no less cuttingly) anti-Semitic. And he was German; he retained a bit of an accent. But he did not appear needy as many social climbers do. The socialites sometimes wanted him more than he wanted them. He excited them. He broke rules. He held a woman's eye a little longer than was appropriate. Or he might suddenly appear abstracted, as if he had more important things in mind.

He was a great friend of "Debo," for example—the former Deborah Mitford, now the Duchess of Devonshire—and was her first house guest after she moved into Chatsworth, the seat of the duke. "Being driven in London by Lucian was hazardous; Marble Arch was terrifying, Hyde Park Corner even worse," she later wrote in *Wait for Me!*, her memoir. "He was Mr. Toad, scarf and all, in his old but powerful car. When I shouted, 'Slower. STOP. PLEASE,' he said, 'It's all right. They've all got brakes.'" No one quite smirked about Freud's climbing as they did about Sutherland's. Freud seemed more accomplished than aristocrats at the aristocratic pleasures. And more dangerous. He was a player in some private game and very intelligent. Like Bacon, he never displayed weakness, whatever the private torments of love, but rather conveyed a superiority that drew others close.

If Graham Sutherland was six years older than Bacon, yet seemed much older, Freud seemed almost Bacon's contemporary. Sutherland, essential to the early formation of Bacon's sensibility, had little more to say in the late 1940s and the '50s to a Bacon who had now "begun." With Freud, however, Bacon could talk about anything—art, love, boredom—and find some telling rhyme in Freud's sensibility. During her brief marriage to Freud in the early 1950s, Caroline Blackwood said that they had lunch or dinner with Bacon almost every day. Of course, the relationship between the two artists was erotically edged. Like all great seducers, Freud could make the object of his desire feel what she or he longed to feel: beautiful, perhaps, or gifted, or unique. He could make his relationship with a homosexual deliberately vague—or even overtly sexual. "Lucian was very attracted to homosexuals and was very happy to cock-tease, if I can put it like that," said Stephen Spender's son, Matthew. Freud admitted, for example, to a sexual encounter with W. H. Auden. It probably mattered little to Freud, except for his interest in the conquest. Freud might do something just because he would not submit to the voice that says no. Auden, however, seemed to hold a grudge. At a dinner party at Stephen and Natasha Spender's in 1955, which Bacon attended, Auden maintained that Freud was a "crook" about money. Bacon insisted that he wasn't. "It was really one of those strangely unsatisfactory controversies between the prigs and the anti-prigs," wrote Spender, "in which both sides are both in the right and in the wrong, one through being very moralistic, the other amoralistic."

Over the years, gossips wondered if Bacon and Freud had a sexual relationship. Anne Dunn, a close friend of both at the time, said no. But it hardly mattered. Both Bacon and Freud were highly sexual beings,

but neither was remotely the other's preferred partner. They may have had sex to get it out of the way. In 1951, Freud made three drawings of Bacon in which both the shirt and the top of Bacon's trousers have been peeled back, revealing the top line of the undergarment. The drawings themselves resembled a "Do you dare?" tease. (As he undid his fly, Bacon said to Freud, "I think you ought to do this, because I think that's rather important.") But the excitement of the actual drawings came less from any genital promise than from Bacon's open chest, a beautiful empty plain except for the dot of nipple and navel.

Anne Dunn, who liked each man individually, found them intolerable together. They were annoyingly superior, like young lovers who believe they alone know the secret. Neither respected conventional hours. Freud liked to breakfast with friends, which was not one of Bacon's habits. Bacon welcomed those mornings when, still ragged from the night, he made his way to the easel. But he made an exception for Freud, who, very early in the morning, would drive to Bacon's flat. They'd go somewhere to eat, often a small workingman's café at the sprawling Smithfield Market. In the larger world—outside the province of art—the physical body that Freud and Bacon insisted upon in their work was becoming increasingly distant. News, fashion, and commercial photography conveyed a cool immediacy, but not the slow pungency of the flesh. Both Bacon and Freud were devoted to an animal warmth. Each understood fleshly melancholy, its sensations of power and powerlessness. In their friend John Deakin's fashion work, the bodies lay glassily smooth on the silken page; in Deakin's portraits, however, he seemed to break the glass, releasing the squirrely flesh. Bacon habitually fingered, cracked, smeared and distressed photographs, as if they needed to be gnawed at like an old bone or broken in like a glove before the image could hold. In the 1950s Freud fastened on detail as if it were life itself; he must own, as Isabel Rawsthorne noted, the half-moon on the fingernail. His tightened bodies, even so, did not quite suppress the flesh. His line never wholly trapped the form, and the eyes of his figures appeared disturbingly wet from some upwelling that was not tears. In Freud's portrait of John Minton, the painter melts from the eyes.

Denis Wirth-Miller was Bacon's intimate brother. He was a promising artist but also needy and determined to steal any show—a brother less powerful and focused than Freud. But Bacon revealed more of himself to Wirth-Miller than he did to anyone else.

In 1948, the two Roberts, Colquhoun and Mac-Bryde, having heard that Wirth-Miller did not know Bacon—which seemed "crazy" to them—set up a meeting at a pub on Rathbone Place, possibly the Marquis of Granby, which appealed equally to poets and prostitutes. Wirth-Miller and Bacon "immediately started a very intense and fascinating conversation." As the night wore on, the party (including Wirth-Miller's partner, Richard Chopping) drifted away, leaving Bacon and Wirth-Miller alone and still talking. After the last call they went home to Cromwell Place, where they talked until dawn. Wirth-Miller had seen Bacon's *Crucifixion* (1933) in Herbert Read's *Art Now*. He had also been following Bacon's work at the Lefevre Gallery, where Wirth-Miller had also exhibited in a group show.

Over the next days, the two became inseparable. Wirth-Miller, said Chopping, was "obsessed" with Bacon. They had sex together, but neither enjoyed it much. They were too alike: what Bacon called "bread on bread." They continued to talk intently about the art and the people around them. They confided in each other: there would be times during their lives when they spoke daily. And they quarreled, if not in the beginning, then incessantly over the years. Each felt free to say what he liked. Each knew precisely how to wound the other. They had much material to be anxiously quarrelsome about, and drunken squalls could become flamboyantly theatrical. Wine-glasses broke, doors slammed. The tension was increased because Bacon was the unstable third element in the life of a settled couple, a satellite to the inseparable pairing everyone called (as if they were a vaudeville act) "Dicky and Denis." Bacon and Wirth-Miller quarreled messily, then tidily made up.

Six years younger than Bacon, Wirth-Miller—like Freud and Erica Brausen—was an outsider with German roots. His father was a German who kept a hotel in Folkestone, which Wirth-Miller proudly broadcast whenever he sensed anti-German prejudice. But Wirth-Miller grew up with his mother in Bamburgh, Northumberland, the part of northern England that Bacon's maternal family was from and where Bacon's wealthy great-aunt Eliza Mitchell had taken her relatives to the hulking Bamburgh Castle for a family holiday. (Bacon would have enjoyed

Young Denis Wirth-Miller and Richard Chopping in their early years together. They would remain a lifelong couple, despite the overwhelming presence of Bacon in their lives.

describing his castle days to Wirth-Miller.) Having left school at the age of sixteen, Wirth-Miller worked as a commercial artist, becoming a designer at Tootal Broadhurst Lee, a textile manufacturer in Manchester. But he was not a young man to be long kept from London. When he was twenty-one, Wirth-Miller—pretty, soulful, and already flamboyantly homosexual—leased a studio in Camden once occupied by Walter Sickert, near the locks of London's "Little Venice." He soon met the gifted illustrator and writer Richard Chopping, either at a posh charity garden party in Regent's Park (Chopping's version) or at a well-known pickup spot, the elegant Café Royal (Wirth-Miller's).

Chopping came from a prominent family, "about as upper-class as one can get in Colchester short of nobility," said Dan Chapman, Chopping's friend and an executor and beneficiary of his and Wirth-Miller's estate. Chopping's father served as the mayor of Colchester, Essex, where the family occupied a Victorian mansion. He went to Gresham's School in Norfolk, where the composer Benjamin Britten was a good friend and fellow student. Tall, elegant, and reserved, Chopping was marvelously droll. "I'd like you to meet Richard Chopping," a friend might say, and Chopping would add "or *Chopin*." As an illustrator, he had a fine, spidery line. Insects were his passion. He also gave time to plants. He would become the respected author and illustrator of *Butterflies in Britain* (1943) and the lesser-known *Some of Britain's Moths*. The work in which he probably took greatest pride, however, was a mordant novel called *The Fly* (1965), in which a house fly buzzes around observing the grotesque antics of the human beasts. (For the dust jacket, Chopping drew an enormous close-up of a fly sipping from the pupil of an eyeball.) His publisher described Chopping as "a most fastidious person with flaring nostrils and an apparently hairless body, revolted by the detritus, the muckiness of everyday life, hence presumably his preference for plants." Chopping would become celebrated in the 1950s for the macabre covers he designed for Ian Fleming's James Bond novels. His most famous one was for *Goldfinger,* published in 1959, in which a large skull—with a succulent rose between its teeth—took up most of the cover.

Soon after they met, Chopping moved in with Wirth-Miller. Once war was declared, the two relocated to a poetic cottage in Chopping's home county of Essex. Chopping was briefly conscripted, but the army released him as "unsuitable," a rank accorded many homosexuals. The couple worked at odd jobs; for a time, they were gardeners to nuns. In 1941 and much of 1942 they were students (but also housekeepers and bookkeepers) at the East Anglian School of Painting and Drawing where

Freud was also a student. Set among
four acres of orchards and gardens,
Benton End—a sixteenth-century
farmhouse—was well suited to a
man like Chopping who was fasci-
nated by plants and insects. Dicky
and Denis "were maid and cook in
exchange for tuition," said Freud.
"It didn't work out very well as
Denis made some remark about old
people and Cedric was very touchy."

Dicky and Denis were sociable.
Denis, the shorter and more flam-
boyant of the two, was excitable and
prone to queening. Dicky craned
above him and, one friend dryly

observed, "would appear to be a lot quieter." During the war, the couple
sometimes went to London, where they would visit the two Roberts and
John Minton at the house the three shared at 77 Bedford Gardens. On a
visit to Bedford Gardens Denis tried to pick up a man on a nearby street
and was arrested for "gross indecency." He spent nine weeks in Worm-
wood Scrubs Prison. In 1944, shortly before Denis was imprisoned, the
couple purchased a house in Wivenhoe, a small river town near the North
Sea that was a short distance from Dicky's hometown of Colchester. On
the quay along the River Colne, their new house, known locally as the
Storehouse, had most recently been used to build a private yacht. Its large
double doors gave onto the quay and river. Dicky and Denis were in the
middle of fixing up their house when the two Roberts set up the evening
with Bacon.

On an early visit to Wivenhoe, Denis took photographs of Bacon
bare-chested and wearing paisley briefs. In some he was standing and
in others lying down. The pictures were not those of a studio photogra-
pher, but they were also not amateurish snaps. Both the lighting and the
figural poses and reflections were carefully considered. The images had a
slightly titillating and erotic tone, like the drawings Freud made of Bacon
at about the same time. Denis and Francis might just have been on a
lark or trying out a new camera, but the pictures were probably intended
for a practical purpose. Bacon liked to work from photographs, and over
the years he became fascinated by photos of himself, especially those he
arranged. (He would shoot himself in the photo booths in the Under-

Experimenting with light
and mirrors: a photo of
Bacon taken by Denis
Wirth-Miller

ground and would paint many self-portraits.) In the late 1940s and the '50s, Bacon was trying to develop a new kind of figure, one not created with the techniques taught in school. How was he to paint, position, and pose the human body and its many shadows? Bacon was now in his forties. He would also be looking for incipient signs of decay, for the peeling back of beauty.

The same restlessness that drove Bacon to Monte Carlo also increasingly led him to leave London for weekends in Wivenhoe with Dicky and Denis—and, farther afield, on numerous road trips with them over the years, some of which ended in quarrels. Their house in Wivenhoe became a second home to Bacon, with Dicky and Denis his eccentric relatives. He had his own bedroom, dubbed the Igloo because it was so cold in winter. On weekends Chopping and Wirth-Miller often hosted parties. Friends would come from London or their country places nearby. As the years went by, illustrious new friends often arrived in a chauffeured car. "Sometimes Dicky and Denis had really posh luncheons," said their neighbor and friend, the artist Pam Dan. "These very upmarket people came in elegant cars. Rolls-Royces. They [did] the parties brilliantly. They knew all the smartest people."

From the beginning, of course, Chopping was the odd man out. Denis's devotion to Francis was not easy for him to tolerate, and he often bitterly resented the intrusion as Jon Lys Turner, a friend, co-executor, and beneficiary of the couple wrote in *The Visitor's Book,* his biography of the couple. One Wivenhoe neighbor, Jan Richardson, recalled how furious Dicky became when Denis phoned Bacon in London, which he did constantly: "He was very angry. This was his love partner. There was a triangle—this other person in this lifelong relationship." But Chopping would not stand in the high-spirited Denis's way. The granting of emotional freedom, for homosexuals who grew up painfully constrained, was the most important value of all. When the duo became a trio, and Denis and Francis were squabbling, Dicky was often the adult who managed the details of daily life. Bacon rarely acknowledged his forbearance. Bacon was, said Chopping, "a selfish shit—with the best manners in the world."

Friendship was one thing. But love? It was a point of pride for Bacon that he was "immune" to romantic love. Yet there would sometimes be, in the passing parade, moments of unusual intensity. In 1948, for example, Michael Wishart—then a student at the Académie Julian in Paris—returned home for a period. Across the room in a Soho pub he felt the

eyes of a man. He was "a striking young man, resembling strongly David's self-portrait in the Louvre, or pictures of the youthful Beethoven . . . I was struck by the intensity of his gaze: it was as though he had X-ray eyes," said Wishart. The David-in-the-pub then bought him a drink, and Wishart "succumbed at once to his romantic charm." The phrase "romantic charm" was not inaccurate. Bacon liked seduction, of which romance was a part, and Wishart was not a casual pickup. A socially adept bisexual adventurer, he had already developed lively connections to the art world and elegant society. He was a Gargoyle regular and a great friend of David Tennant's daughter, Pauline; Graham Sutherland was his godfather. Wishart, born in 1928, was nineteen years younger than Bacon (who was himself nineteen years younger than Eric Hall) and the son of Lorna Wishart, with whom Lucian Freud had his first passionate affair. He was only six years younger than Freud.

Wishart was a wickedly amusing companion who relished the social pantomime. He would later become a gleeful eccentric—a reasonable response to his early life—who "loved to make an entrance." At one wedding he wore, in his own description, a "Bonnie Prince Charlie kilt a lot of ecru lace & half my grandmother's pearls and rubies." Bacon's affair with Wishart was brief. The sexual interest did not outlast the seduction. On such occasions, however, the happy result could be friendship. Bacon would make Wishart dizzy, at Cromwell Place, with "enormous dry Martinis in brimful Waterford tumblers." Perhaps because they were both so theatrical, Bacon—during their affair—would allow Wishart into his dressing room as he put on a face for the Soho night:

Seated on the edge of his bath I enjoyed watching Francis make up his face. He applied the basic foundation with lightning dexterity born of long practice. He was more careful, even sparing, with the rouge. For his hair he had a selection of Kiwi boot polishes in various browns. He blended these on the back of his hand, selecting a tone appropriate for the particular evening, and brushed them through his abundant hair with a shoe brush. He polished his teeth with Vim. He looked remarkably young even before this alchemy.

Another passing, but not inconsequential, affair in the late 1940s happened completely by chance, when a painter named Rosalie de Meric visited Bacon with her husband, the poet Thomas Blackburn. She had met Francis on one of his visits to his parents' home in Bradford Peverell, and now that he was in London she wanted to see him again. She was discon-

certed to find that while she was the painter, Bacon preferred the poet. Not only was her husband a handsome heterosexual man; he also conveyed a certain half-suppressed vulnerability. Then in his mid-thirties, Blackburn was engrossed by the idea of the monstrous and unknowable. In her astonishing account of growing up in the painfully dysfunctional Blackburn household, Julia Blackburn quoted the beginning of a poem that her father wrote in 1944:

> Come carrion birds of an appalling menace,
> Violence in coils of claws, thick ropes and knives,
> Sinews of strangled grief and nets of scream,
> Stormy cold filling him who is all beast . . .

Not surprisingly, the author of those lines felt a kinship with the Bacon of *Three Studies*, painted at the same time the poem was written, and believed that they possessed "a shared blackness." By day, Blackburn was a thoughtful and sensitive man who taught literature at a boys' school in order to support his higher calling. He had a long, handsome face and a winsome smile. His hair flew about, and he dressed in the pleasingly rumpled and ash-strewn style of a man whose mind is somewhere else. But Blackburn was also a prodigious drinker and addicted to barbiturates. He could fly into alcohol-spiked rages, and had once been institutionalized for a nervous breakdown. He and his wife sometimes screamed through the night. Both Blackburns were undergoing analysis and, like many artists and intellectuals of the period, were Freud-addled. She would profess concern about her "inner penis." He blamed his alcoholism on, among other things, his mother's "septic tit." Believing that sexual restraint would harm his art, Thomas's analyst encouraged him to have affairs.

At their first meeting, Bacon teasingly changed Blackburn's name, christening him "Tony" because he did not look like a Thomas. The two men then spent days together at Bacon's studio, which Blackburn found "full of newspaper photographs of the mysterious and terrible, tubes of paint, paint-stained plates . . ." The two men collaborated on making a scrapbook that included, in the words of his daughter:

> . . . a photograph of a child in Bergen-Belsen, walking past a line of emaciated corpses, laid out very regularly along the side of a wooden lane. Then came Sugar Ray Robinson, punching Joe Louis on the jaw, and you could see the long tentacle of spit floating in the air and the punched jaw had gone all soft and Sugar Ray had a swollen

eye. And there were hippos in a drought and they were all stuck in the mud . . .

It was likely Blackburn's idea to make the scrapbook: Bacon was not ordinarily a collaborator. It was no doubt stimulating for both to sit and stand together, closely examining and juxtaposing the images. Each had much to say about the bizarre and outrageous. Blackburn's childhood was gothic, easily the match of anything Bacon could recount. His father, a clergyman who abhorred masturbation, once sent his adolescent son a metal contraption to clip over his penis at night so that "if you had an erection . . . your expanding penis pressed into the sharp teeth of the firm outer clip. You were woken up and an ejaculation was avoided."

For a time, Bacon was drawn into the strange, interior world of the Blackburns. Rosalie wanted to experiment with automatic writing—a sometimes cultish practice of the time, with links to the surrealists—in which the hand is left to move without conscious intent. Participants thought automatic writing might bring to the surface unconscious thoughts and desires; for lovers of the occult it was a way for the spirits of the dead to communicate with the living. Although it was difficult to imagine Bacon not dismissing much of this as nonsense, he did believe firmly in giving chance a central role, and he continued to be interested throughout his life in images of the spectral and "ectoplasmic."

Blackburn was not a friend of Bacon's like Wirth-Miller or Freud. Nor was he a sexual fling. Blackburn represented an early example of something new. Bacon was growing more interested in a serious relationship with a man his own age—not, like Eric Hall, much older or, like Wishart, much younger. Blackburn wrote in his notebook: "We had long hours of conversation and although I am a heterosexual, I fell in love with him and there were kisses in taxis; my love trying in vain to ignore the repulsion of bristles on his face." Bacon still retained reservations about the idea of love, but during a trip back to Monte Carlo, he wrote Blackburn an extraordinary confessional letter and signed it "All my love, Francis":

Do you manage to defeat the terrible boredom? Love, or whatever you like to call it, and work, seem to be the only things that do at all for me—even the gambling has lost its potency and the love thing seems to start off with so many complications, especially the homosexual side now that everyone knows as much and are afraid of everything. How wonderful if we could live the gay and magic idea, all at once.

By "gay" Bacon did not, of course, mean homosexual; the word was not yet applied in that way. He was instead calling to mind the dream of a simple, lighthearted, and unkinked love. It was the most poignant of dreams, one shared with most people in the world. Bacon sometimes professed a deep weariness with homosexuality and the sexual merry-go-round. Without question he sought, as Blackburn said, "the sudden moment of truth when the mask disintegrates and the raw animal appears." But he also wanted there to be "love in the act." In his notebooks, Blackburn wrote: "One night, drunk and disintegrated, I briskly sodomised him. He divined there was no love in the act, only infinite revulsion, and our relationship terminated."

Wilde Man

IN THE SPRING OF 1949, the stylish wife of the press lord Esmond Cecil Harmsworth, 2nd Viscount Rothermere, gave a sumptuous ball that conceded nothing to the austerity of postwar London. The men came in white tie; the women wore the family jewels; the Queen Mother was there. So was the Royal of the moment, Princess Margaret, who smoked cigarettes and palled around with friends the tabloids called the "Smarties." The ball promised to end with a flourish when the princess, giddy with champagne and urged on by the Smarties, took the mike from Noël Coward. "All the guests who had been waltzing under the vast chandeliers instantly stopped dancing," said one partygoer. "They stood like Buckingham Palace sentries called to attention in order to watch the royal performance." The princess began to sing, wobbling off-key. She could not deliver quite the right slink despite some wriggling. But the fawning guests nonetheless "shouted and they roared, and they asked for more." The pleased princess was just settling into "Let's Do It" when there welled up from the belly of the crowd a ghastly hiss, a jeer, "a prolonged and thunderous booing." The band sawed to a stop. The princess reddened and rushed from the room, with several flustered ladies-in-waiting following.

It was that appalling Francis Bacon, some guests muttered, standing with the no less appalling Lucian Freud. Some dismissed Bacon as a drunk—and he was, indeed, drunk. Others, said Freud, became "extraordinarily angry." But there were a few who found the artist's music-hall boos thrilling—a rush of night air into England's stuffy room. One who was especially thrilled was Caroline Blackwood, a debutante of the year (and soon to be Freud's second wife). Blackwood—the daughter of a marriage between two of Anglo-Ireland's great families, the Blackwoods and the Guinnesses—was a golden-haired "Alice-in-Wonderland" beauty, as her third husband, the poet Robert Lowell, described her. But Guin-

ness already had a well-developed rebellious streak, and she detested the debutante season that had been thrust upon her, with all of its attendant balls. She was enthralled with Bacon's thumbing of the nose:

"Who did that?" I asked the nearest white-tied and black-tailed man who happened to be standing next to me. His face was already red but rage made it look apoplectic. "It was that dreadful man, Francis Bacon," he said. "He calls himself a painter but he does the most frightful paintings. I just don't understand how a creature like him was allowed to get in here. It's really quite disgraceful."

Bacon had actually been invited, as it turned out, not by Lady Rothermere herself but by Freud, who was part of her circle. Lady Rothermere, who would later marry Ian Fleming and, as Ann Fleming, continue as one of the reigning hostesses of London, liked to season the parties she threw at Warwick House, the Rothermeres' London mansion, with writers and artists. Politicians often had no conversation apart from politics, she found, and the well-born could be dull as dust. Lady Rothermere found Bacon's behavior shocking but also delightfully wicked. "She had the money, the style and the energy to brighten the drabness that had descended on London, and set about doing so," wrote Mark Amory, long-time literary editor of *The Spectator*. And a bad boy or two was always useful: a good party generated gossip. Although he was already known to the London art world, Bacon, at this party, began to break into the larger English conversation of the postwar period. He was not just a figurative painter—he was a figure.

Bacon expected, soon after his scene-stealing performance, to deliver an art shock at his inaugural exhibit at the Hanover Gallery, which was scheduled for June 1949. He wanted his art to be no less surprising—and even revelatory—than his performance at the ball. But he did not have enough completed pictures for the show, which had to be postponed. He had nonetheless been working steadily and hard since completing *Head I*. Isabel Rawsthorne saw him regularly in Soho but, aware of his struggle in the studio, was reluctant to interrupt him. "Haven't seen Francis lately," she reported, "as I know he is working, so have not telephoned . . ." Bacon was continuing to paint heads, few of which met his standards (four abandoned or unfinished heads would turn up some years later) and also working on larger paintings of the figure. Some did not resemble his thick, darkened heads and contained a more radiant light; perhaps, having failed to complete a Mediterranean picture in Monte Carlo, he could

make one in London. "I went to see Francis two days ago in his Millais room," Rawsthorne wrote to Peter Rose Pulham in March. "One large landscape with headless figures impressed me. Lovely color, open air, etc. Really most mature in every way." In August, she wrote: "I gather from Francis he is working on the same kind of subject (well—I mean nude in open air) & using the brightest colours also . . . Powdered cerulean etc." No such pictures survive.

Bacon's struggles stemmed from his ongoing attempt to develop a new kind of figure. He had hardly exhibited an image of a complete human head, face, or body. Parts of the face were usually missing, bodies largely concealed. There were expressive reasons for missing pieces, of course, but Bacon had probably also not found a way to make a full body or face that visually satisfied him. It was far from obvious how to position the head or figure on the canvas or how to fill the "negative" space around the figure. His lack of training increased the difficulty. It also stimulated Bacon's originality, of course: he would have to find the figure in his own eccentric toolbox. (One aid was a T-square used in his designer days, which remained in his studio for the rest of his life.) Bacon's native gift was to charge the paint with energy. By playing with the paint and welcoming chance, he might find a way to evoke an open mouth or fleshy chin. But how was he to convey the eyes? That sublime jelly? And what of the closed oval of the head?

Bacon instinctively recoiled from a tightly drawn or fully closed form like a head. There must always be air to breathe and room to move. (The trapped form must at least be allowed to writhe.) He was still experimenting with, and musing about, heads and bodies. He continued to look at and collect great numbers of photographs, mostly because they gave him literal ideas about position, pose, and form. He would rip from newspapers and magazines photographs of animals and people in some way damaged or disfigured. He himself would increase the disfigurement of the photos, cutting and tearing them and letting them lie around on the floor, stepped on and paint-splashed. Photographs were not only documents but also mysterious objects or talismans, at once distant and full of touch. He considered them "profoundly suggestive." In paint, he felt the palpable flesh. But, like most people in the twentieth century, he also knew the figure through photographs and the flickering of movies.

Bacon remained interested in the photography of Baron Albert von Schrenck-Notzing, with its mediums and ectoplasmic spirits. A leaking shadow, stealing out from the settled mask of the face or body, would often appear and reappear in Bacon's paintings during the following decades.

The séances he attended with his friends Rosalie and Thomas Blackburn in the late 1940s were doubtless part of Bacon's interest in spiritualist effects as well. "They would sit round the heavy rosewood table in my mother's studio," said Julia Blackburn, "and the two men asked the questions to the ghosts of the departed, while my mother's hand wrote faster and faster in a wild script that was nothing like her own."

Bacon was also taken by the spectral imagery in K. C. Clark's *Positioning in Radiography*, published in 1942. Bacon cited it as a vital source, and, as David Sylvester speculated, it may have contributed to the grayish, see-through, X-ray quality of some late-1940s paintings. *Positioning in Radiography* remained at the forefront of Bacon's photographic borrowings for decades. He continued to collect books on maladies. One other new discovery now fascinated Bacon as well. In 1949, Denis Wirth-Miller told him of the rich collection of Eadweard Muybridge's work at the Victoria and Albert Museum, just down the road from his studio. Muybridge, born in England in 1830, had perfected the use of multiple cameras to record sequences of animals and humans in motion. During one period in the 1880s, while he was at the University of Pennsylvania, he shot over one hundred thousand pictures. Bacon had seen Muybridge photographs before, but he now began to study them intensively; he also purchased the photographer's best-known work, *The Human Figure in Motion*.

Muybridge created what Bacon termed a "dictionary" of images that helped the painter develop his own kind of "figure," providing him with body shapes and positions that looked fresh. He did not want the traditional or classical poses, preferring a figure that was more awkwardly factual: less "figure," that is, than body. Muybridge also created a sensation of movement, something that already interested Bacon in the 1930s, when he was attracted to the wavy forms of Picasso's Dinard series. Although celebrated for their clinical depiction of motion, the bodies in Muybridge did not, of course, move as bodies did in film. They remained stills, but stuttering stills. Both individually and as part of a series, they had a flickering stop/start effect that affected Bacon, whose own work often seemed to interrupt a body moving under the impulse of feeling. They put time on pause.

Although Freud and Wirth-Miller were becoming his closest friends, Bacon sometimes saw certain other artists during the day. Graham Sutherland was no longer often in London, though he and Bacon still spent time together when he was in town. The older artist, highly disciplined, was heading into the most public years of his life. He would

be the marquee name at the British Pavilion in the Venice Biennale of 1952, and that same year he became the first living British painter ever accorded a show at the Musée d'Art Moderne in Paris: a retrospective at the Tate followed the next year. Although he had no taste for the Soho merry-go-round, Sutherland admired Bacon's latest work and continued to promote him.

Bacon often saw Isabel Rawsthorne, whose letters to Peter Rose Pulham portrayed a Bacon very different from the one celebrated in later, more myth-fired accounts. Her Bacon assiduously looked after his

Photo montage of wrestlers by Eadweard Muybridge, whose sequences of figures in motion deeply influenced Bacon

Isabel Rawsthorne in the Colony Room— a close friend of Bacon's and the subject of one of his greatest paintings, *Portrait of Isabel Rawsthorne Standing in a Street in Soho*

friends and consistently helped them exhibit. He introduced Sutherland to Wirth-Miller, hoping that the famous artist could help him find a gallery. He even brought Sutherland to see Dicky and Denis in Wivenhoe. (Bacon passed on an encouraging compliment: "Thank you and Dicky both so much for having me to stay I enjoyed it so much in spite of my bitchiness—had a very good journey with Graham who is a great admirer of you both. . . .") In the end, Sutherland did assist Wirth-Miller, persuading the framer Alfred Hecht, who provided the frames for both his and Bacon's paintings, to include Denis in one of the small exhibitions he regularly curated in his shop. It was Bacon's esteem for Rawsthorne—and her connection to Giacometti—that led Erica Brausen to offer her a show at the Hanover Gallery.

Bacon and Rawsthorne each loved to cook, eat, and drink and would sometimes while away a day in sensual abandon, despite Isabel's concern about interrupting his work. She wrote of one meal Bacon had prepared: "As usual admirably cooked and served. Grilled red-mullet with delicious slightly sharp thin mayonnaise. Plain boiled potatoes, salad, cheese, Beaune." Bacon felt more comfortable discussing art with Rawsthorne than with many other painters. She was a woman in a man's world, and not particularly successful. She also had pointed views that she was not afraid to express, which the bitchier side of Bacon probably appreciated during a time when he could not finish a painting. "Am told that Lucian has sold all his pictures before the show starts," she wrote to Pulham. "How does he do it? Oh well, we know how, but how does ONE do it?" Like many others, she attributed much of the interest in Freud's work to his social connections, which included both Sutherland and Kenneth Clark. "Very *Germanic*. Great detail . . . Carefully done . . . but oh, what a poverty-stricken view. Both flat, personal, rigid—clever." In July of 1949, she wrote a letter to Pulham that described Bacon's thinking at the time, including his belief that "all the difficulties" of art "reach their summit in the human form" and noting a particular obsession she shared with him: "And one of the most immediate questions to solve for me is how to situ-

ate a human figure, so that it partakes of its surroundings (in sculpture this problem does not arise) and yet paint only IT."

To Rawsthorne and Bacon, the human form was more powerful than "all other living forms." That made it, she said, "appear over life size, or better to say, [increased] the space around it." Modern figurative artists failed to address the relationship between the figure and this hugely expanding space: "This is what is so LACKING in the vast majority of representations . . ." Giacometti, Isabel's former lover, was also interested in this problem; his figures mysteriously suggested an infinite surrounding space. Bacon also wanted both to convey that expansive sensation of space around the figure and equally to focus inward on the figure with extraordinary pressure. He later said, "I cut down the scale of the canvas by drawing in these rectangles which concentrate the image down. Just to see it better." Those transparent rectangles, perhaps drawn with the old T-square, did not only "concentrate" however: they also opened out. It was during this period that Bacon began experimenting with transparent rectangles—in paintings such as *Head I*—and the sensations created by glasslike walls and boxes. (They were also reminiscent, critics noted, of those used in the Nuremberg trials.) It was not only Bacon who was using what David Sylvester later called "the spaceframe." It was also common in the work of Giacometti and Moore.

Bacon tried to hold the figure in an expanding space, wrote Rawsthorne, by emphasizing the tactile. "Largely a matter of texture—skin as opposed to fur, feathers or scales. Proportion of head too. Francis understands this—tho' wishes to arrive at it by devious means." Bacon himself said in 1949 that "One of the problems is to paint like Velázquez but with the texture of a hippopotamus skin." But he was no less interested, it seemed, in making pictures—and the figure—filmy and evanescent. In *Head I*, the paint alternated between thickly clotted and barely there. "You are quite right to say that [Francis] is most exercised by this question of surface," Rawsthorne told Pulham. "ONLY—he has such a particular view, and such a different one from myself, that it is difficult to quote him on the subject. He is obsessed with the photographic delineation of form—wishes, as far as I can see, to seize such a quality in paint."

In their discussion about how to situate the figure, Bacon and Rawsthorne also discussed how to frame the paintings themselves and "present" the figure inside to the outside world. Framing was already a concern of Bacon's in 1934, at the time of his self-staged show at the Transition Gallery, when his glazing and heavy gold frames first appeared. In 1949, the issue had a certain poignancy, as he had so little to frame. But he knew

what he wanted. He was trying to push the image forward from the frame, to give it more physical force, an interest he passed on to Rawsthorne. At the approach of her show with Erica Brausen in February of 1949, she put his ideas into practice. "His suggestion for framing my paintings is an interesting one. . . . Idea being that the pictures be projected forward, rather than be thrown back as in ordinary framing." She attached a sketch to demonstrate what Bacon imagined. A simple mahogany outer frame was separated from an interior mahogany rectangle by some gray material. The image did not then sink behind the wood of the outer frame but instead appeared highlighted by the inner frame.

When Rawsthorne's exhibit opened, the unconventional frames stole the show. "And the frames!!!—Erica nearly fainted when first saw them— still, I think, doesn't like them," Rawsthorne wrote to Pulham. "On the other hand Francis does (wants to get one copied), . . . I think they are not really right—but being so very different from the usual chic light-colored, or gilt, or antique, they do give a surprise. They also allow an approach to the paintings—the paintings are projected." The reviews of the show were lukewarm. "No one, among all my old friends who might have gone there, has telephoned or otherwise conveyed any message whatsoever, so I do not know what they think," she wrote. But Francis Bacon "turned up at 10 am, telephoned to me at 10:30—saying I ought to feel very pleased as it was an achievement. (Always full marks for manners.)"

By the autumn of 1949, Bacon had reached the point when he could no longer keep experimenting. He must momentarily put aside the grand dream. He must produce a show. If he concentrated on smaller pictures, he could complete enough work. He may have done the same for his inaugural Lefevre show, setting aside a larger, ambitious treatment of the Crucifixion in order to exhibit *Three Studies*. Now, he may have turned away from an ambitious version of a Presentation of Christ to the People (which may have included Velázquez-inspired popes) and also the brightly colored pictures Rawsthorne observed in the studio. He had successfully completed *Head I* and *Head II*; they may have begun as depictions of people at a Presentation of Christ but could also be shown on their own. He could paint more. By now, Bacon moved naturally along a continuum between "restrained" and "eruptive." A picture could have elements of both. Melancholy musing—when one was closeted within oneself—mattered to him. So did the explosive outburst.

With the spectral *Head III*, Bacon attempted for the first time (as a

mature artist) to depict human eyes. He placed the eyes behind a pince-nez and, as Martin Harrison suggests, may have been alluding for the first time to the shattered pince-nez of the screaming nurse in Eisenstein's *Battleship Potemkin*. In *Head IV (Man with a Monkey)* he depicted a man's head and shoulders from the back. The man, who wore a suit, was pressed against a monkey who faced the viewer; the separation between man and beast appeared to be little more than a matter of clothing. *Head V* had a sulfurous aura; two safety pins seemed to keep the head and the draperies from coming apart. All five heads emerged from a prevailing murk, like black-and-white photographs forming in a darkroom solution, their impastoed white highlights glimmering eerily against darker backgrounds.

Crowning the series was an altogether different head, *Head VI*—a masterpiece loosely based on another masterpiece, Velázquez's *Portrait of Innocent X*. Bacon's painting depicted a lushly caparisoned pope, splendid in purple, screaming within the confines of a transparent rectangular box in which floats a ghostly gold filigree. Lawrence Gowing later wrote of the painting:

> It was an outrage, a disloyalty to the existential principle, a mimic capitulation to tradition, a profane pietism, like invented intellectual snobbery, a surrender also to tonal painting, which earnestly progressive painters have never forgiven. It was everything unpardonable. The paradoxical appearance at once of pastiche and iconoclasm was indeed one of Bacon's most original strokes.

The show also included two larger paintings, recently completed, that foreshadowed future work. Each was 4'10" x 4'3", or roughly twice the size of the heads. *Study from the Human Body*—also a masterpiece—was Bacon's first full-figured body and his first nude. It depicted a figure from behind, his muscular back and legs disappearing into thinly painted vertical strips that suggested a curtain or drapery. The painting was rich, the figure plain, the mundane pose made mysterious by the painterly effects and the haunting sensations aroused by the curtain. Bacon would paint many pictures that included curtainlike forms, which could both symbolize and convey the revealed and the hidden. Curtains, in Bacon's hands, were a kind of half-open closet.

The other larger work, *Study for Portrait*, anticipated Bacon's fascination with the men in suits who—silent, suffocating, alone—would enter his painting in the early 1950s. Brausen filled out the show with two earlier

works—Bacon's large *Figure in a Landscape* from 1946 and the triptych that began it all, *Three Studies.* The earthy power of the Bacons in the downstairs gallery was increased by their contrast with the confection upstairs, a show by Robin Ironside, a sort of rococo surrealist who made dreamlike paintings to which he gave names like *The Nativity on a Lace Collar* and *The Gondolas of Venice.*

Brausen took private views very seriously. In his memoir of the London art scene, *Restless Lives,* John Moynihan described her, on such occasions, as "a formidable, razor-sharp German . . . who dressed impeccably and was very different from some of the more harassed gallery owners of the time. She turned out on gallery match-days dressed as if she were about to launch the *Queen Mary.*" At the private view on November 8, 1949, many in the crowd recoiled from the Bacons, just as they had in 1945 before *Three Studies.* A friend of Toto Koopman said the sight of the howling heads "was incredibly shocking for the Londoners present. They had never seen such violence. Some of them were shaken and livid. Bacon was there, delighted, and Toto and Erica went from one group to the next, as if nothing had happened. The contrast was rather comical." After the viewing, Bacon went out to dinner with friends. Rawsthorne sent Pulham a report, along with two reviews of the show. "Spent evening with Francis," she wrote, "oysters, champagne, brandy, negro night club." Bacon, she added, refused to be treated.

The reviews—more than a dozen—were enticingly purple: "a mutilated corpse . . . some act of frightful violence and cruelty being committed out of sight," "a tardily evolved creature which had slithered out from below a large stone that had been in a noisome cellar for a century or two." But even the critic who saw Bacon's creatures as slithery monsters acknowledged: "Make no mistake about it however, Francis Bacon is an artist." In *The Sunday Times,* Eric Newton wrote: "I do find them horrifying and 'nightmare' is the precise word for the kind of horror they induce in me. It is like the unexplained scream in the night or the touch of a slimy hand or an atmosphere that is too damp and stagnant to breathe." At the same time, he called Bacon a visionary and, foreshadowing how many people would react to Bacon over the years, wrote: "Nothing would induce me to buy one of his paintings, but a representative collection that did not contain one would lack one of the most definite and articulate statements made by contemporary art."

A particularly perceptive response came from Wyndham Lewis, who wrote a tantalizing and poetic piece for *The Listener* shortly before the show opened. "Bacon is a Grand Guignol artist: the mouths in his heads

are unpleasant places, evil passions make a glittering white mess of the lips." Lewis, himself a careful painter, was impressed by Bacon's formal prowess and illustrated his main review of the show with Bacon's *Study from the Human Body*, in which the male figure disappeared through the draperies. Lewis declared the show "of exceptional importance":

> Of the younger painters, none actually paints so beautifully as Francis Bacon. I have seen paintings of his that reminded me of Velasquez and like that master he is fond of blacks. Liquid whitish accents are delicately dropped upon the sable ground . . . or else there is the cold white glitter of an eyeball, or of an eye distended with despairing insult behind a shouting mouth, distended also to hurl insults. . . . I must not attempt to describe these amazing pictures—the shouting creatures in glass cases, these dissolving ganglia the size of a small fist in which one can always discern the shouting mouth, the wild distended eye. . . . Bacon is one of the most powerful artists in Europe today and he is perfectly in tune with his time. Not like his namesake "the brightest, wisest of mankind," he is, on the other hand, one of the darkest and most possessed.

The colorful reviews attracted the public. Why miss the chance to see, in fashionable Mayfair, what gave critics nightmares? Art that was "slimy" and "tardily evolved"? Institutional tastemakers—on the higher perches—remained wary but open-minded. It would have been irresponsible to appear otherwise; they were custodians of the Western tradition. John Rothenstein, the director of the Tate, could not yet bring himself to write in his own diary about what he thought of the extraordinary Bacon show. Instead, he commented on the safe Ironside exhibit upstairs. (The Tate had bought an Ironside, *The Somnambulist*, in 1943.) Still, Rothenstein had been "impressed" by one of Bacon's *Figure Studies* he saw at the Lefevre Gallery in 1946.

Isabel Rawsthorne looked at the work the way artists typically do—more interested in the hows than the whats or whys. But she sensed the wider public interest. "Show is most impressive really," she reported. "Especially large male nude walking through curtain. Quite unlike anything else. They gain from being seen together. Appear highly colored. Gallery full from morning 'till night, Erica happy." In a gossipy piece from *The Observer*, which appeared just after the opening, the writer noted Bacon's high prices, 150 to 250 pounds a picture, which he deemed "remarkable." Another gossipy item, in the *Daily Herald*, noted Bacon's

newfound popularity among literary figures: his pictures "were being inspected by Somerset Maugham when I was there." (Perhaps Sutherland, now a good friend of Maugham's on the Riviera, urged him to see the show.) The writer from *The Observer* also linked Bacon's growing notoriety to "the enthusiasm his work has aroused amongst the literary intelligentsia. . . . I have not seen so many writers at an exhibition of painting for a long time. Turning their backs firmly on the pictures, famous men of letters could be heard discussing the more subtle points of their craft—the iniquities of publishers, the size of royalties, and the heartening failure of their closest rivals."

Some of the literary interest stemmed from *Horizon*. Its critic Robert Melville—after the war an important and fresh voice—liked to place works of art in a wider cultural context, both literary and philosophical. Art could express, no less than a book could, what it meant to be alive after World War II. The piece that Melville wrote on Bacon, timed to coincide with the Hanover show, was arguably the first major assessment of his work. The article was detailed and perceptive:

> Every activity in these paintings of men going in and out of curtains, or imprisoned in transparent boxes, has an air of extreme hazard, and this powerful overtone obscures the modernity of Bacon's formal resources. He is probably the only important painter of our time who is exclusively preoccupied with man, and his innate tendency to comment upon and expose the state of the human soul— which relates him to Goya, Daumier and Toulouse-Lautrec—is the incalculable factor in his readjustment of cubist seeing.

Bacon's show attracted intellectuals who, after the war, took an existential interest in outsiders and criminals. Existentialism was very much in the air, particularly among those who looked to France. The critic Neville Wallis made the connection directly. Bacon's work, he wrote in his *Observer* review, "is the most profoundly disquieting manifestation I have yet seen of that malaise which, since the last war, has inspired the philosophy of Sartre and the drama of frustration of Tennessee Williams." At the time of the Hanover show, Frances Partridge, a member of the Bloomsbury set and a good friend of Dicky Chopping's and Denis Wirth-Miller's, came into London from the countryside to do some Christmas shopping. As she noted in her diary:

> I felt stifled and hurried away to a very different atmosphere, an exhibition of paintings by Francis Bacon, a friend of Richard and

Denis's whom I met briefly last summer. The paintings were impressive, completely original and absolutely terrifying. They reminded me of the thoughts and images aroused by the books Ralph [her husband, Ralph Partridge] and I read all the time now about the Criminally Mad.

Partridge added, "The artist is said to live alone with his nanny. I couldn't help wondering what she thought of them."

In fact, Nanny Lightfoot would be most interested in successful sales for Francis. (Bacon sent the positive reviews to his mother.) Brausen, who loved the work, was also naturally interested in sales. She was concerned that her gallery might not last despite the backing of Arthur Jeffress. "I think Erica is worried about the whole set-up," Rawsthorne had reported to Pulham earlier that year. "Losing money etc. Feels that none of *us* will sell for ages." But buyers did step up to buy the Bacons, rewarding Brausen's faith. Earlier, led by Bacon's patron Colin Anderson, the Contemporary Art Society—which was created to take chances—had purchased *Figure Study II*. Now, before the opening at Erica's gallery, the CAS bought *Head II*, sending a helpful signal to private collectors. *Head III*, *Head IV*, *Head V*, and *Head VI* all sold. The National Gallery of Victoria in Melbourne soon purchased *Study from the Human Body*.

One indication that Bacon's reputation was breaking out came when the American magazine *Time* decided to publish a short profile on him. Its tone was breezy, knowing, and tongue-in-cheek—as if to say, "Let's see what those crazy modern artists are going to do next." "One of England's most original painters," it began, "is a baby-faced 39-year-old named Francis Bacon, and one of the most original things about him is that he has destroyed some 700 canvases to date." It was the sort of exaggeration for which Bacon, over the decades, would become famous. But who cared? It was all in the interests of an amusing story—and an amusing persona. In less than a year, then, Bacon had stolen the scene from a princess, created a Grand Guignol revue of monstrous heads, and appeared in *Time* as a baby-faced canvas slasher. (It was famous gangsters who, in America, were usually called baby-faced.) But Bacon, once again ignoring what might be best for his career, immediately left for Monte Carlo before his first show at his new gallery even closed.

Bacon spent whole days in the casino, arriving at ten in the morning and not leaving until well past midnight, usually when the doors shut at four a.m. The long hours at the tables sometimes put him in an otherworldly mood, not unlike the séances with the Blackburns. He thought he was picking up mysterious messages. "I used to think that I heard

the croupier calling out the winning numbers at roulette . . . the winning number, before the ball had fallen into the socket . . . and I used to go from table to table. . . ." One afternoon, when he was playing on three different tables, "I heard these echoes and I was playing rather small stakes but at the end of that afternoon chance had been very much on my side and I ended up with about £1,600," he said. "Well, I immediately took a villa and stocked it with drink and all the food that I could buy in. . . ." Isabel Rawsthorne reported: "Rumour has it that Francis has won at the tables," adding that he has "taken a house for 3 months."

Bacon and Nanny Lightfoot had lived in a succession of modest quarters during their previous periods in Monte Carlo. Now, gambler-rich, Bacon floated up the craggy Riviera mountainside and settled into La Frontalière, a villa with a spectacular setting in the highest quarter of Monte Carlo. The hillside plunged just below the villa, and the views were picture-postcard: the Mediterranean in the distance, Monte Carlo below, Mont Agel to one side, and the neighboring villages of Beausoleil and Cap-d'Ail close at hand. For his studio, the lord of the manor, fresh off his success in London, picked a commanding room at the top of the house. It had windows on all sides and "far more sensational views," he wrote, "than the chateau de Madrid." (Wealthy English travelers enjoyed dining at the Château de Madrid, which clung romantically to the cliff face above Villefranche.) Nanny, old and rheumy-eyed, surely enjoyed the change of circumstances. No need to make up the kitchen table into a bed during the London winter. She had a room of her own, with Francis just up the stairs.

Bacon wrote to Sonia Brownell, one of his newer friends (and recently married to George Orwell) that, "I have a wonderful room to work in with sensational panoramic views—The weather has been wonderful hot and trembling like summer. . . ." Bryan Robertson, the future director of the Whitechapel Gallery, later rented La Frontalière on Bacon's recommendation and described the villa as "delightful, secluded and spacious." He was amused "to find that the furnishings included the most comprehensive library of literature on sexual perversion imaginable, which added a certain zing to hot afternoon siestas." Brausen was the person most distressed about Bacon leaving for the Riviera. To help consolidate his reputation, she was pressing for a second show soon. Four and a half years had passed between Bacon's inaugural exhibition of *Three Studies* at the Lefevre Gallery and his first full exhibition at Hanover. Before he left, Brausen won from him a promise that he would complete enough new work for an exhibit in September of 1950, nine months away.

Bacon shared Brausen's desire for another show. But he was in a mood to enjoy himself. For an artist, the second act can be a formidable test. Was the first success an anomaly? Was anything left in the well? Bacon was now momentarily free of the doubt that he could generate another exhibit. He spent the next months living well and making extravagant gestures. He tried to mollify Brausen, as he had Duncan Macdonald, with reports of his painting. He made certain to let her also know about his studio's more practical aspects. "I feel I should be able to work rapidly and a lot," he said. He also invited her to visit him in Monte Carlo. "There are plenty of rooms and bathrooms so do come and stay if you feel like it any time."

Not long after Bacon's private view, the Sutherlands also left London to spend the winter at La Mignonelle, a villa they rented in the area. They were joined by Elsbeth and Hans Juda. Elsbeth was a fashion photographer who had fled Nazi Germany with her husband; both worked on *The Ambassador*, a journal of textiles and fashion that helped bring the British textile industry back to life after the war. Their flat in South Kensington attracted modernists. Their specialty, British design, would have naturally interested Bacon. The Sutherlands and their party "made a killing" at the casino and, on Christmas Eve, had a convivial dinner with Bacon. The next day the Sutherlands—now without Bacon—joined Somerset Maugham for Christmas dinner at Villa Mauresque. Earlier that year, Sutherland had painted Maugham's portrait, which the writer disliked at first but then pronounced "magnificent" to *Time* magazine, which ran a reproduction.

Maugham soon fell out with his portrait again. But the portrait led to a succession of further high-profile commissions for Sutherland, including a portrait of Winston Churchill, who enjoyed the results no more than Maugham did. The portraits—lauded at the time—were polite attempts to be both modern and old-masterly by reasonably splitting the difference. In Sutherland, *Time* found an artist whose portraits might live comfortably on its cover while Bacon, who showed no interest in either Maugham or his portrait, remained for *Time* the artist who "destroyed some 700 canvases." Graham Sutherland continued to be much better-known than Bacon at mid-century, but the spotlight directed at Sutherland was made from a fading light. Sutherland himself sensed the difference. The two artists were still friendly, but Sutherland—after Bacon's show at the Hanover Gallery—now began to add more "buts" to his compliments, telling John Rothenstein, for one, that Bacon had "a certain originality and power but his works [were] too large and empty and less dynamic

than earlier ones." When Bacon and Sutherland dined together some days after the opening of the Hanover show, the subject of Bacon's work then on view came up only at the end of the evening, when Sutherland told Bacon, "I think that the dimensions are interesting."

Perhaps Sutherland was hurt. Bacon probably did not compliment him on *his* recent work, and Sutherland was certainly no longer Bacon's mentor. Bacon did not now attend to Colin Anderson or Kenneth Clark or any of the others who once held the cards that mattered. They belonged to the war and immediate postwar years. Bacon, as *Time* sensed, was beginning to play a part in some new and larger contemporary drama that extended beyond the traditional art world. Bacon made a brief trip to London in April of 1950, then moved back to the city in July—essentially for good. Duty was one reason: he had promised Erica that show in September. But pleasure was another. He had a party to give.

HEAD VI (1949)

The Holy Father, in Velázquez's portrait of Innocent X, is a frightening figure. His mouth appears firmly sealed, though he could drop a cutting remark at any time. He simmers with power, condescension, and annoyance. He is everything a father should not be to a son.

Bacon was attacking, during this period, many kinds of paternal authority. If *Head VI* (1949) opens a discussion about Western religious, artistic, social, and familial authority, it is only because the image itself visually unmans the Holy Father with such verve. Something must really be done—says Bacon's brush—about Innocent's arrogant mouth: Bacon uses a modernist lever to pry it open, borrowing the scream from the woman in the Odessa steps sequence of Eisenstein's *Battleship Potemkin*. The silent scream opens the gate to the body. The father is now no longer frightening, but frightened. Bacon teases apart the accoutrements of power in the most subtle and beautiful way. The pope's purple robe is brilliantly evoked, for example, yet is also coming apart in the brushstrokes. The pope's august throne, in turn, is just a soft whisper of gold filigree in the air. Bacon takes away the pope's eyes and dangles a tassel on a cord in front of his nose. A tassel is sometimes a symbol of a penis, as Martin Harrison has pointed out, but the mockery amounts to more than sexual derision. It is poignant. If the pope could see—and if he had hands—he could at least pull the cord to see what happens. The secret he can't see or grasp dangles in front of his nose.

The final unmanning matters the most. The Holy Father may lay claim to divine authority, but he appears powerless inside a transparent box. Nothing about him—not his flesh, not his clothes, not his throne, not his scream—can escape from this indifferent geometry. Powerful and dark vertical lines of unknowable energy rain down both outside and inside the box. They convey the real power. A bleak perspective? Of course. But the picture is painted with such sensual joy that despair becomes a pleasure.

Follies

I F LADY ROTHERMERE'S BALL was Bacon's first act on the larger stage of London, the wedding celebration he threw at his studio the following summer was a brilliant second act. It was still remembered decades later as "one of the bohemian parties of all time." Some months earlier Bacon, playing matchmaker, had chosen a roundabout way to introduce his friends Michael Wishart and Anne Dunn. Would Wishart do him a small favor and take Anne the money from a loan that Bacon had arranged for her? The first thing Wishart noticed when Dunn answered the door at her flat in St. John's Wood was a tightly bandaged wrist. "I fell in love with the bandage on sight," he wrote, "and very soon afterwards with the wearer, when we were dancing at the Gargoyle." They were engaged within days; the wedding followed not long after. They made an odd couple—Wishart the bisexual bohemian, Dunn an artist-heiress.

The daughter of Sir James Dunn, a banker, industrialist, and socialite, and his second wife, Irene, the former Marchioness of Queensberry, onetime actress, and celebrated beauty, Dunn had grown up partly in Canada—where the family fortune was centered and where Dunn relished the backwoods—and partly in England, where her father founded the banking firm of Dunn, Fischer & Co. "The English bit of life you know was rather grandiose and formal," she reported. After unhappy years at finishing schools, she made a prominent debut. But she preferred the artist's life. "Anne's background was quintessentially international café society," wrote Wishart, "from which she was pleased to escape." The flamboyant Wishart—the scion of a publishing family with some titles of its own—had questioned his sexuality from a young age. He consulted a psychiatrist as a teenager because his "inability to decide whether I preferred boys or girls sexually was making a havoc of my emotional development."

The soft-spoken Dunn had a somewhat complicated love life as well.

She had been having an on-and-off affair, since 1948, with Lucian Freud, whom she met in a London nightclub not long after she returned to England from a Swiss finishing school. Only a month after Kitty Freud gave birth to their first daughter, Annie, Freud left on a romantic trip to Ireland with Dunn. Freud and Dunn's relationship, which was woven around Freud's affairs with other women, continued for several years. "My father was spectacularly unfaithful," said Annie Freud. "My mother was pretty unfaithful, too. But although unfaithfulness had a part in destroying their marriage, it really involved my father's aspirations to want to be with the top echelons of society that my mother found intolerable." Dunn was top echelon but not dull, which pleased Freud. Given their eccentric histories, Wishart and Dunn became a kind of Rubik's cube of gossip, their emotional and sexual genealogies presenting an irresistible puzzle. Did Anne marry Michael to keep Lucian in her life? Was *Michael* interested in Lucian? Why was everyone always talking about Lucian? And so on.

In fact, Wishart and Dunn unscrambled each other in a pleasing way. They became a devoted couple and decided to marry—but not in a splendid church overflowing with flowers and ladies' hats. Instead, on July 17, 1950, they were married at the Marylebone Register Office "in an uninspiring little ceremony," as Wishart said. The true ceremony followed at 7 Cromwell Place. Francis Bacon considered it only right that, as the matchmaker, he should host the wedding reception. Turning his paintings to the wall, Bacon scraped out the agglutinating clutter and opened up the vast space of his studio. He painted his two magnificent Waterford crystal chandeliers—inherited after the breakup of the family home at Bradford Peverell—an extraordinary hue that in some addled memories was brilliant pink and in others crimson. The room appeared incarnadine, a worthy stage for pagan revelry. Wishart brought one hundred gold chairs into the room. And a piano. One of the pianists was the painter Ruskin Spear. The other was "Granny" Blackett, who played regularly at the Colony. Expecting two hundred guests, the couple ordered two hundred bottles of Bollinger champagne. Almost immediately, they had to send out for more. The crowds were thick and pushing through the door. And then more people came. And more.

It was not simply that Wishart and Dunn were people of wide acquaintance. Bacon was now himself an alluring figure in different London worlds. No one had qualms about crashing the party: this was not a reception with a guest list at the door. The aristocratic David Tennant came with many of the Gargoyle Club regulars ("his clientele," Wishart

called them). Muriel Belcher arrived "with the entire staff and member-ship of her newly founded Colony Room." The writer John Richardson remembered "a great many well-known painters, a great many sort of Cockney thugs—I mean East Enders—gay people, straight people, gate crashers—I mean, you name it, they were all there. And it was all slightly presided over by the nanny, the blind nanny, who would be in the rocking chair in the back of the studio." The party continued through the night. At dawn, as the light scraped over tired eyes, many guests did not go home. They called for more champagne to greet the morning.

No one seemed sure where Wishart and Dunn spent their wedding night. Perhaps they themselves were uncertain. The mystery was part of the charm. A popular piece of gossip was that the bride spent the night with her mother-in-law, Lorna Wishart, while the groom spent the night with Lucian Freud, the lover of both his mother and his wife. Freud did not go to the party, but he might well have been part of the sex later on. The party continued all day and into the second night. It carried through that night, too, and did not end with the morning. More champagne and more champagne. There was not much food. Sometimes the piano music continued. "My mother had a house around the corner," said Richardson, "so I used to come and go at the party. I would stay for eight hours, then go home and collapse and sleep it off and then rejoin the party."

Richardson found the goings-on "absolutely astonishing." Wishart credited his wedding reception with bringing about "an alteration in the marital arrangements of a surprising number of our guests." David Tennant, a stylish master of party hounds, was gracious. He told Wishart that the "prolonged ruby-lit nuptial bacchanal was the first real party since the war." The party continued through the third night—"It was terrifying," said Anne Dunn, "people wandering in and out"—and in the morning, yet again, some guests would not leave. How does a party end that dreams of going on forever? Sometimes, when parties refuse to die in place they move like a bee swarm somewhere else. On the morning of the third day, taxis were summoned to Cromwell Place and the revelers, now somewhat diminished, ended up in the town of Wivenhoe, where Dicky and Denis provided wine, food, and the salty nostrum of walking it off near the sea. Even so, the revelry continued. Wishart wrote: "After five nights of non-stop celebration, we left, exhausted, for Paris."

No one at Lady Rothermere's ball forgot that evening: the same was true of Bacon's bacchanal. At neither party had Bacon set out to create a memorable spectacle. He followed his instincts. Although he himself disliked drawing a moral, each party became, under the pressure he brought

to bear, something more than itself—an outrageous declaration of sorts in the postwar period. At Lady Rothermere's, Bacon's boos symbolically shattered sentimental social conventions. The pagan party at Cromwell Place was, in turn, a kind of boo (and laugh) at inherited morals and platitudes—at old-fashioned marriage, at sobriety, at the sensible long-term perspective. It was irreverent, too, about the sacred space of an artist's studio.

Bacon's art and life seemed to outsiders mysteriously intertwined. At the mid-century mark, he was helping create a new cultural and social light that would mark the postwar period. People began to speak of the Bacon "aura." The art dealer Helen Lessore, who would bail Bacon out in the 1950s when Erica Brausen failed to advance him money, thought that he was "not the same shape as any other human being. . . . There was the sense of an aura about him—something radiant." In Soho, the other drinkers at the Colony and the French leaned closer in. Henrietta Moraes, whom Bacon would famously paint in the 1950s, arrived on the scene around the same time as the bacchanal. "If there is a force-field around people, his was ten times as strong," she said. "I always knew he was going to be very famous."

As a wedding present, Bacon gave Dunn and Wishart the family collection of Waterford crystal. He kept only the incarnadine chandeliers, which he soon sold when he needed cash.

It pained Erica Brausen to see revelers milling around Bacon's place of work, the face of each painting turned to the wall. She knew that Bacon must live his own way to live at all, but the distractions were maddening. It was not merely carousing and trips abroad. Other diversions presented themselves as Bacon became better-known as an artist and a flamboyant figure in London's nightlife. The previous fall he had received an offer to design a social club in the City. He had not designed a room in years, and ordinarily he did not like to be reminded of his past as a designer. But he seriously considered the commission. In her diary, Frances Partridge reported that Denis Wirth-Miller told her Bacon "has a project for decorating a luxurious drinking-club in the City for big businessmen to meet in." From La Frontalière, Bacon had written to Erica that "at the last minute they decided they wanted me to do the club. I don't know how good the terms will be." What the City financiers could possibly have been thinking when they considered Bacon for the job remained a mystery. The commission never materialized.

Two months before the September 1950 show promised to Brausen, Bacon had not resolved any of the paintings turned to the wall during the wedding bacchanal. His subject was challenging. He dreamed of an elaboration of *Head VI*, the painting after Velázquez from the year before. He now planned three grand paintings based on his ongoing fascination with *Portrait of Innocent X*, each life-size, almost twice as large as *Head VI*. In a darkly Nietzschean vein, he could continue his confrontation with the masculine authority of Western culture, represented by the Holy Fathers of religion and art. The three pictures differed in an important respect from *Three Studies*, where the creatures were related but separate beings. Now, inspired partly by Muybridge, Bacon hoped to depict a single figure that changed from image to image; the shifts would be of mind and mood rather than of physical motion. Bacon imagined an ever-heightening hysteria. In one, the pope was close-mouthed; in the other two, screaming. (In *Three Studies,* two figures were open-mouthed and one turned away.) Vertical lines that resembled flowing ribbons—what the critic Robert Melville called an "iron-grey" curtain—were painted on, in, and around the figures. The pope was to appear increasingly entwined, like a fish snagged in a net by one of its gills.

Bacon had heretofore exhibited only one painting of similar size, roughly six and a half feet tall by four and a half feet wide—his spectacular *Painting 1946*, that combination of man, monster, and butcher shop. He may have found it difficult to situate the pope in a space so large, the problem Rawsthorne earlier described. He placed the pope in the dead center of the rectangle, as if planted on the canvas, in two of the images. In the third, he situated the figure to one side, much as Velázquez did in *Portrait of Innocent X*. The "negative space" around the figures, sometimes a compositional problem for Bacon, appeared slapdash, perhaps as much from necessity as from conviction. The first pope to be completed—the first full-faced portrait that Bacon ever finished—astonished visitors to the studio. Melville, who visited Bacon shortly before the opening in September, saw the painting while it was still drying and before it was framed. He judged it a "masterpiece":

Bacon's figure was tense, and clutched at the arm-rests in fear; and instead of that extraordinary look of ferrety penetration on the greasy red face of the [Velázquez] Pope, this face—exquisitely painted in mauves and greens—was torn open by a scream. The Velázquez figure is complacent in worldly knowledge; in Bacon's version it looked as if it had suddenly been confronted by all the horrors of damnation.

Beneath the pope lay an extraordinary red that seemed to make impossible the geometry above: the pope sat above a chaotic cauldron. In his essay, Melville admired Bacon's formal innovations:

But the mysterious, the wholly inexplicable thing about Bacon's painting was the fact that the figure and the chair were not in front of the curtain, or behind it, but had somehow materialized within it. Technically, it was a masterly solution of a problem that haunted the Cubists—the problem of describing solid forms without destroying the two-dimensional integrity of the canvas surface. It was a different solution, baroque in spirit, and as phantasmal in appearance as the miraculous apparition of the Christ of the Sorrows on Saint Veronica's kerchief.

This particular formal innovation reflected Bacon's deepest convictions. The curtain of power (like the homosexual closet) could not finally protect the man. Some part of Bacon surely enjoyed stripping down this figure of patriarchal authority, but the mood of the painting—despite the fiery scream—was also steeped in sensations of loss, emptiness, and melancholy. Isabel Rawsthorne, who also saw it at 7 Cromwell Place, called it "really very impressive":

It is far and away the best thing he has done I think—much less peculiar and the painting of the head is quite extraordinary (hell!) brilliant. A most beautiful pearly color, and like Velasquez. He has made a great leap forward—it is very large about the size of the man through the curtain. The background is the same grey curtain, with a suggestion of the folds in front of the head—"dissolving" is Francis' own expression for this kind of double vision . . . The modeling, and it is really the only word to use in this case, of the head is quite remarkable. The whole thing has a beautiful texture.

Years later, David Sylvester, who would become Bacon's most influential critic, regarded it as a painting "which Bacon never, perhaps, surpassed":

The figure is at once monumental and evanescent. Its majesty is frayed at the edges by the astringency of the surrounding atmosphere. But the controlling force is the immensity of the mouth. It seems a silent mouth, open in a snarl, a realization of the desire that Bacon was constantly avowing at the time "to make the animal

thing come through the human." But it is more than that: it has a cosmic dimension, as if it were a Mouth of Hell. It seems to suck in and expel every particle of energy in the air.

Melville did not see the other two pope paintings when he visited the studio. The second was then at the framer's; the third was probably still incomplete. As the opening approached, Brausen insisted upon a list of pictures. Bacon included the three pope paintings, which Brausen coaxed from his hands and then prepared a catalog. The first two pope paintings were not only framed but also photographed; their inclusion in the exhibit seemed inevitable. Bacon was not pleased, however, when the second came back from the framer. The first painting, the one that Melville and Rawsthorne admired, was powerful enough to exhibit. But this second painting, a frontal portrait of an almost close-mouthed pope staring at the viewer, appeared insipid by contrast. Bacon would always find a closed mouth difficult to depict unless the eyes were also turned away. How could one look directly into another face and—with just a line of lip—seal off the immensities within?

But there was another problem with the second pope. In the first pope painting, Bacon repaid his debt to Velázquez by creating a work that was itself of great originality. The second painting was not only insipid but could not remotely sustain the comparison to Velázquez. The standard set by Velázquez was of course impossibly high. During a later stay in Rome in 1954, Bacon never visited the Palazzo Doria-Pamphilj to see, in person, *Portrait of Innocent X*. The reason, he said, "was probably a fear of seeing the reality of Velásquez after my tampering with it." Velázquez's unmasking of the Holy Father—the ungodly humours rising strong and acrid into the chamber of power—could inspire Bacon to do something related in his own day, but he could not hope to succeed by paraphrasing *Innocent X* on anything close to the Spaniard's terms. The first pope was different enough. The second, compared to the fiercely intelligent Innocent, resembled an anxious sheep.

Bacon's third painting in the series, in which the pope became a more contemporary figure—a businessman, perhaps—was more successful. But he was not happy with the group as a whole. Shortly before the opening, he took all three back to his studio. He destroyed the second, insipid picture. He then asked Brausen to delay his show until November: he might yet complete the series, given another few weeks to work. Brausen refused. No doubt she urged him to exhibit the first and third paintings, but there was now a further problem. The relationships among the three

mattered to Bacon, and the first and third did not work especially well together. Not only were the figures differently situated, but the form of the curtains and the rendering of the dais in the two remaining paintings bore little effective relationship to each other. At the last minute, Bacon pulled both from the show.

Bacon clearly still liked the first pope that Melville and Rawsthorne admired: he would continue to show it privately to friends during the next few weeks. At the end of August 1950, not long before the opening, Isabel Rawsthorne reported that "Francis [is] supposed to have 4 or 5 pictures ready by Sept. 14 for Erika [sic]—hasn't got one yet." The pressure on both Brausen and Bacon now became enormous. Brausen had only three new Bacons to exhibit. She added some earlier ones, including *Three Studies*, and filled out the exhibit with posters by Picasso, Matisse, and other French artists and an arrangement called "Hilly Paintings."

Of the new Bacons, one was important. In *Fragment of a Crucifixion*, the Riviera, which Bacon had yet to incorporate into an exhibited painting, appears as the backdrop for a singularly profane version of a Crucifixion or deposition. A distant and banal promenade of loosely rendered figures, automobiles, and a bit of blue coastline serves as a foil for a shocking interior that contains a thick, T-shaped cross that could also be a window frame—a mocking reference, perhaps, to the many artists of the Midi who painted pleasing views out the window. On the cross is a winged creature, squat and doglike, with a mouth full of razor-sharp teeth. The limp body of a dead dog—further underscoring the idea of an ignoble death—is draped above the creature. The juxtaposition of harpy and holiday was jarring, as was the use of raw canvas. Bacon may have intended to leave much of the canvas alone; or perhaps, lacking the time to finish the picture before the opening, he made a virtue of necessity. Rawsthorne singled out *Fragment of a Crucifixion* as the high point of a very limited show.

After the actual opening, Bacon brought into the gallery a fourth new picture, called *Painting* (1950). It was a brilliant outlier in his oeuvre, very large—the size of his seminal *Painting 1946* and the abandoned popes—and vivid. Against a colorful striped curtain, Bacon posed a figure and what could also be the figure's shadow, twin, ghost, or after-image. The double exposure was suggestive of the moment-to-moment photography of Muybridge as well as the ectoplasmic materializations of form seen in the drapery during a séance. At first glance, the brightly lit and well-muscled figure—seemingly carefree in the shower—conveys a handsome, posed, somewhat arty look. But a heavy shadow also appears to be

slipping downwards, like an intimation of mortality or something worse, from the wonderfully fine and unknowing flesh.

Only a few papers reviewed the small, episodic show. The critic for *The Times*, however, wrote a plaintive piece that perfectly captured the continuing desire of many English observers to tame Bacon by "placing" him. Bacon was not working within any set of conventions, this critic observed, that could ultimately make him a natural or useful part of the community. He was living, that is, outside the English house:

> . . . The pictures are so large and disquieting that in spite of the impressive powers that have evidently gone to their planning and execution one is forced to ask what purpose they can have; they would be impossible in any living room; there is no building of today in which they could fulfill the function of a painting of Hell in a medieval church; museums can and sometimes do take them, but there is something unsatisfactory, and much as if teapots were being made for the British Museum, about a picture that can find no other abode.

Not surprisingly, the exhibit's lack of focus—and the paucity of works on view—resulted in a lack of sales. Once again, Bacon faced serious money problems. He kept an eye out for patrons. He might even have reverted for a time to some version of his earlier practice of cultivating wealthy older men. In an undated letter probably from this time, Rawsthorne reported—she must have smiled when she wrote the capital letters—"Francis is trying to tie up the man who owns TIDE (the soap I mean). I hope he does." Then, unexpectedly, Bacon was thrown an actual lifeline. He received a job offer that could help solve his financial problems. It was a temporary teaching position at the Royal College of Art, then an emerging force in the world of mid-century British art.

The painter John Minton—the same artist who lit up the Gargoyle—wanted to take a long lovers' holiday in the West Indies with his new boyfriend, Ricky Stride, whose name was worthy of a camp classic. Stride, wrote Minton's biographer, Frances Spalding, was "not long out of the navy, training as a body builder, doing carpentry, and also working on the door at clubs." Minton was head over heels: why else jeopardize his standing at the Royal College of Art? Minton had always been the most conscientious of teachers, as serious about his teaching as about his art. It seemed absurd to propose Bacon, who had never taught before and did not respect art schools, as a replacement. The two men did not even

get along well. Temperamentally, they seemed to be opposites. The constantly clowning Minton was a pessimist just beneath the surface, while Bacon—the seeming nihilist—was, as he liked to say, "a desperate optimist . . . because I live from day to day as if I am never going to die." They were also naturally competitive. In public, Bacon effortlessly commanded attention. Minton, by dint of both his fortune and his frenetic ebullience, also liked to be the star of any show. At the Gargoyle, Minton and Bacon would both order champagne in copious amounts and stake out different sides of the room in which to hold court.

Bacon was surely not Minton's first or second choice as a substitute. But their differences could be set aside in the best interests of both. It was difficult to find an acceptable substitute on short notice. Bacon had a reputation that would interest students, and Minton's colleagues at the RCA would enjoy his company. Under the school's ambitious and vigorous new director, Robin Darwin—the great-grandson of Charles Darwin—the RCA was beginning to flourish. Darwin, appointed director two years before, was determined to bring the stodgy institution into the modern era. It had been in a slow decline since the 1920s, when Henry Moore and Barbara Hepworth were students. One of Darwin's first moves was to fire its professor of painting, Gilbert Spencer—the younger brother of the great eccentric Stanley Spencer—who painted conservative landscapes and portraits. Spencer had famously advised his students not to bother seeing the Picasso/Matisse show at the Victoria and Albert Museum in 1945, even though the RCA was only several blocks away.

Darwin appointed Rodrigo Moynihan to the distinguished position. Moynihan was a gifted and well-schooled painter who was also forward-looking and excellent company. He and his wife, the painter Elinor Bellingham-Smith, entertained smartly at their house on Old Church Street in Chelsea. Moynihan became the guiding spirit at the college in the early 1950s. His own representational painting, while hardly radical, reflected his study of modern developments in art. He commemorated the Royal College's faculty in a huge, eleven-by-seven-foot showpiece of a painting titled *Portrait Group (The Teaching Staff of the Painting School, Royal College of Art, 1949–50)*. Among those portrayed were John Minton, Ruskin Spear (one of the pianists at Bacon's wedding party for Michael Wishart and Anne Dunn), and Moynihan himself. The painting was, among other things, an homage to the school and its aspirations. The individual portraits were nuanced, the allusions to art history respectful. It had a certain solemnity.

Along with appointing new faculty, Robin Darwin created a senior

common room at the college's new location on Cromwell Road—not far from Bacon's Cromwell Place studio—that was modelled on those of Oxford and Cambridge. It quickly became a social and intellectual hub at lunchtime for those who wished to be modern and yet not abandon figurative painting. The food was good but inexpensive, the company convivial. The senior common room was actually two rooms and contained marble and gilded columns and fireplaces from the eighteenth century. "Extraordinary members," drawn from the arts and business, were invited to patronize the common room. The young critic David Sylvester, also committed to figurative painting, was a frequent guest.

If Moynihan was the guiding spirit of the RCA, Minton was its heart and soul. Darwin hired him not only because he was a celebrated teacher, but also because Minton brought such energy and life to his surroundings. "Outwardly, Minton personified success," wrote Spalding. "He was one of the best-known living artists in England, as yet uneclipsed by Pasmore, Bacon or Freud." In June 1950 the *Daily Express* described him as "at 32 the Royal College of Art's youngest teacher, a brilliant exhibitioner in London and New York, and one of our most sought-after magazine illustrators.'" His neo-romantic paintings had a burnished, moody look: he admired Samuel Palmer. Minton also looked to the Continent more than many other neo-romantic painters. He had gone to Paris to paint in 1938, studying mostly on his own but also absorbing some Parisian notes. Darwin hoped, with his hire of Minton, to mix things up a bit. "They have inaugurated a drive to bring [the RCA] in line with what they call Contemporary Trends," Minton wrote to a friend, adding, tongue-in-cheek, "I think they have got me in as comic Relief." Minton was not, in short, an easy man to replace, even for a semester. Bacon did not try, accepting the position "less as a tutor than as an honorary visitor," as Spalding put it, and because he liked the income (a portion of Minton's 425 pounds per year) and the conviviality of the senior common room. Bacon did no conventional teaching at all: some students were already more technically knowledgeable than the largely self-taught Bacon. Yet his carefree stint at RCA in the fall of 1950 did have an impact. Not only was he liked, enlivening the lunch and cocktail hours: he would also be invited back the following year, when his impact on the school would be substantial.

Most of Bacon's energy that autumn went toward trying to produce paintings for a proposed show at the Knoedler Gallery in New York: America continued to interest him. "Have seen Francis once only in last three weeks," reported Isabel Rawsthorne. "He is trying to get 12 pictures

finished by end of December for America." The show never material-
ized. Brausen also encouraged him to produce a painting for an enormous
exhibit planned for the following summer called the Festival of Britain,
which was intended to celebrate the spirit of the nation after the war. The
festival, an exercise in cultural uplift supported by politicians and art-
world grandees—among them Kenneth Clark—would take place on the
South Bank of the Thames, where the war damage remained extensive.
It would include new buildings in the modern style and a series of wide-
ranging exhibits on history, the sciences, and the arts, some of which
would travel around the nation. As part of the festival, the Arts Council
invited sixty painters to participate in a show called *60 Paintings for '51* and
also commissioned work from twelve sculptors.

Many well-known English artists of the day participated, among them
Henry Moore, Ben Nicholson, John Piper, and Barbara Hepworth. Brau-
sen thought Bacon should join the club. He could paint a big pope paint-
ing, if nothing else. Bacon was still uncertain about his popes, however,
and his failure to complete the series for his recent exhibit naturally led
him to wonder whether or not the pope was, after all, the right subject
for him. Bacon was instead talking to friends about making large-scale
portraits of living people, which were certain to challenge the more tra-
ditional portraiture of Sutherland and Freud. And what better subject
than Lucian Freud himself? Bacon could paint Lucian on one of the big
canvases earlier intended for a pope. Instead of a Freudian pope, the fes-
tival could have a popish Freud. Bacon drily told Rawsthorne, "They're
bound to look at it *if* it's Lucian—even Kenneth Clark." And then, once
again, the opportunity arose for a lark, and Bacon put art and financial
worries aside.

In the late 1940s, Bacon was sometimes a guest at Faringdon House, an
idyllic estate near Oxford owned by Gerald Hugh Tyrwhitt-Wilson, 14th
Baron Berners. Born in 1883, Lord Berners was a talented painter, nov-
elist, and composer. (Balanchine choreographed a ballet to one of his
scores, *The Triumph of Neptune*.) But he mattered especially as an eccentric,
living in a fanciful world located somewhere between a P. G. Wodehouse
and a Ronald Firbank novel. He wrote witty musical pieces that he played
on a small clavichord in his Rolls-Royce; it could be stored under the
front seat. He kept a pet giraffe. His dogs wore pearls. On Easter Sundays
he dyed the estate's pigeons pastel colors and then released them—to the
delight of weekend walkers in the countryside. He once asked his friend

Lord Berners, an eccentic
in the grand manner who
thought nothing of inviting
a horse to tea

Penelope Betjeman if he might paint a portrait of her white mare, Moti, and then invited Moti into the drawing room to pose. (The horse also joined them for tea.) His house was redolent of flowers from the estate hothouses, and his table was well served by a kitchen garden. Cyril Connolly once observed that "if every sort of luxury had been forever banned in England, Lord Berners would somehow have managed to maintain a secret melon house."

At Faringdon, Berners staged parties where the only sin was a failure to amuse. Artists, musicians, and writers often went there. Igor Stravinsky was a friend, as were Salvador Dalí, H. G. Wells, and Osbert Sitwell. Evelyn Waugh studied him closely. Lord Merlin in Nancy Mitford's *Love in a Cold Climate* was modeled on him. In the early 1930s, Lord Berners fell in love with a handsome man thirty years his junior. The young man, Robert Heber-Percy, hoped only to be charmingly trivial, and he took an interest in riding, shooting, and drinking. His nickname was "Mad Boy." Berners adored him and built—in his phallic honor, it was said—a 140-foot tower called "the Faringdon Folly," the last great folly ever constructed on an English estate.

Heber-Percy, who lived with Berners, also took an occasional interest in women, and he could sometimes be cruel and confounding. In 1942,

he married a socialite named Jennifer Fry and, while the marriage lasted only a few years, the couple had a daughter. Faringdon House then became an unstable mix of dueling relationships, with Heber-Percy in the middle. But the partying continued. One of Lord Berners's close friends was Constant Lambert, the well-regarded English composer who was married to Isabel Rawsthorne. It was probably Rawsthorne who first brought Bacon to the estate and introduced him to Berners and Mad Boy. "Social notes too long to go into now—notably a weekend at Faringdon with Francis," she wrote to Peter Rose Pulham. Or it could have been Toto Koopman who effected the introduction. Or any one of a number of others. Mad Boy was widely known.

In the spring of 1950, Berners died, leaving his estate to Mad Boy. The party lights flickered out, and Heber-Percy appeared inconsolable for a time, writing to Osbert Sitwell, "I never made any decision without either mentally or actually considering [Berners's] reaction. I feel quite lost." By that autumn, however, Mad Boy was rallying. Guests visited Faringdon again. Male lovers came and went. One day at the Ritz bar, while Bacon was teaching at the RCA, he happened upon Heber-Percy, who told him that he was planning a trip to South Africa with a group of friends. "How lucky you are," Bacon told him, to which Heber-Percy responded, "Well, why don't you come with me?"

Bacon liked the idea of visiting his family in South Africa. But he was also tempted—at least a little—by Heber-Percy. Mad Boy was his age and had endless amounts of money. He enjoyed food and wine. He was sexually dominant. He sometimes appeared almost straight, enjoying the manly diversions prized by Bacon's father: he rode horses and shot birds. "He, Francis, has gone to N. Africa with a group headed by the MAD-BOY!! R. Heber-Percy," wrote Isabel Rawsthorne to Peter Rose Pulham on January 10, 1951. Isabel was certainly thinking about the future of Faringdon and a possible role for Bacon on the great estate. "Perhaps Faringdon yet?" she wondered. "Two months they are supposed to be away. I wonder. Thebes at the end."

Homeless

THE MAIL BOATS of the Union-Castle steamship line left Southamp-
ton every Thursday afternoon at four p.m. like clockwork, bound
for Cape Town, South Africa. At precisely the same time, a second ship
would depart from Cape Town, making the return trip. The Union-
Castle ships were impressive, many of them over six hundred feet long,
with hulls painted a distinctive lavender and tall red smokestacks topped
with a black band. Bacon and Heber-Percy and his group of friends were
on the boat that sailed from Southampton on Thursday, January 4, 1951.

The trip did not begin well. Heber-Percy booked himself a first-class
cabin with spacious accommodations. But he skimped on Bacon, putting
him in tourist class. (His wealthier friends probably paid for first-class
cabins of their own.) Tourist-class passengers were mostly "immigrants,
students and budget tourists," as Union-Castle described them. It was a
slight that Bacon, who believed in outsized acts of generosity, could not
forget. Bacon exaggerated his plight, complaining later that he had had a
berth in "steerage." But tourist class was indeed tight; brochures indicated
that the cabins typically had three berths with a small shared washstand
and chest. The common areas were agreeable enough, but Bacon surely
found the idea of sharing space with strangers and being segregated from
the upper decks offensive. The voyage to Cape Town took fourteen or
fifteen days. The only port of call was either Madeira, off the coast of
Portugal, or Las Palmas, in the Canary Islands, about ninety-three miles
from Morocco, where the ship paused for just a few hours. Then came
eleven uninterrupted days at sea.

No doubt many passengers enjoyed, as the Union-Castle advertised,
the "sociable atmosphere," the "varied deck games," "swimming in the
ship's bathing pool," the "dances and concerts," and the "splendid oppor-
tunity for recuperation in the invigorating sea air and sunshine." But
Bacon was not that kind of passenger. Ships are famous hothouses, of

course, and Bacon and Mad Boy were ostensibly a couple at the end of the voyage. Bacon then flew from Cape Town to Johannesburg, where he were met by Bacon's sister Ianthe and her South African husband, Benjamin Knott. All of Bacon's immediate family were living in South Africa. Ianthe and her husband Ben Knott were farmers in the eastern Transvaal, the northeast region of South Africa, now called Mpumalanga, when Bacon visited. Three years later, they would purchase a substantial farm across the border in the southernmost part of Southern Rhodesia, now Zimbabwe. Bacon's mother was living with her new husband not too far from the Knotts, in a tiny settlement named Munich. Bacon's youngest sister, Winnie Stephenson, had also joined her mother and Ianthe along with her two children. The younger Winnie's marriage unraveled by the late 1940s, and with nothing to keep her in England, she too moved, to Durban, South Africa. Ianthe felt "tremendous excitement" at the prospect of seeing her brother. Bacon was the family's prodigal son—always extravagant and doing unimaginable things: written about in the newspapers, famous for painting monsters—and a perfect gentleman to his mother and sisters.

Ianthe and her husband thought nothing of driving eight hours to Johannesburg, mainly on unpaved roads, to meet Francis. The three spent the night in Johannesburg. The next day they set out on a leisurely trip to their mother's house in Munich. Winnie had asked Ianthe and her husband to give Francis and Heber-Percy a tour along the way, in order to see something of the eastern Transvaal and Limpopo province, which was named after the river that served as a border between South Africa and Southern Rhodesia to the north. The spectacular countryside was cut by gorges and a grand canyon that rivaled the one in the United States. The famous gold-mining town of Pilgrim's Rest remained, in 1951, a picturesque frontier settlement. (It would eventually be sold to the government and proclaimed a heritage site.) Like most visitors, Bacon mainly wanted to see the big game in Kruger National Park and in the many private game preserves that dotted the province near the western border of the park. The Bacon party meandered east on ever smaller roads before looping up into the southwestern portion of Kruger Park and then turning west toward Pilgrim's Rest.

"I don't think we saw lions or leopards," said Ianthe, "but certainly game, big game." It was not the animals alone that attracted her brother, she noticed, but also the immense and grassy plains enveloping them. The grass constantly moved with the wind. Within the grass one sometimes glimpsed mysterious intensities, perhaps caused by animals. Or was

it simply a concealed rock? It was impossible to be certain at a distance what disturbance was masked by the brush. The veldt offered Bacon a new perspective on several of his presiding themes, including concealment, revelation, and the animal hiding inside the man. It would soon make itself felt in his art. *Landscape* (1952), for example, combined elements from both the Riviera and Africa, depicting sharp and edgy grasses that looked, Bacon said, "violent."

Not until a later, second trip to Africa, however, did the region fully enter Bacon's painting. Part of the reason was Bacon's need for solitude, particularly after a long voyage with Heber-Percy. Mad Boy directed all attention to himself. But a lengthy stay with family could also prove wearying. The tiny town of Munich, in the middle of nowhere, offered few escapes from family. Bacon remained with his mother for about ten days, but home—even home in Africa—soon left him restless. He had survived only by putting home behind him, a proud exile from domesticity. Ianthe noticed that her brother always made a point, when he visited them in the future, of having already booked passage home. "He never stayed terribly long," she said, "but long enough for us all to enjoy it."

After the ten days in Munich, Bacon rejoined Heber-Percy in Johannesburg. The days and nights spent there probably differed little from those in London or Faringdon. Then the two headed north toward Salisbury, stopping to visit the Great Zimbabwe ruins. The fortified city had been built between the eleventh and fifteenth centuries by a cattle-herding, sub-Saharan people who, as traders, established routes that stretched as far as Persia and India. Their skills extended to metalworking and building. The towering walls of the Great Enclosure, the heart of the site, were constructed of almost a million granite blocks. Bacon wrote that he had stayed nearby, probably in the small town of Masvingo thirty minutes from the ruins and on the main north-south road. He found the ruins "incredible," and he was beguiled by the countryside. "Too marvelous," he said. "It is like a continuous Renoir landscape."

He did not mention Mad Boy's response to the site. During the trip, Bacon came to an important conclusion: he was not suited to Mad Boy or the Faringdon way of life. Bacon, when he wished, could flawlessly speak the idiosyncratic Faringdon language. He might even have become a star in the Faringdon firmament. He painted frightening pictures in which literary people took an interest, and he possessed wit and sexual allure. Would such a version of the "kept" life have been so different from his earlier ones? But Bacon was now too powerful in his own right to be kept. He could enjoy Faringdon—and the Colony and the

Gargoyle—but they were only part of his world. They left out his mornings, when he confronted the brutal reality that Mad Boy ignored or kept at a remove through his outrageous life. Anne Dunn did not consider Bacon decadent, for example, and she was very familiar with those who were (or dreamed of becoming) decadent. He worked too hard, suffered too much, and behaved too well. He was "not remotely decadent in the way that Aubrey Beardsley might be a decadent character," she said. "His manners were too good. He was too conventional in a certain sense. He would have thought that being decadent was really corny. Which is the one thing he never wanted to be."

Bacon initially planned to return home with Heber-Percy by way of Egypt. He was eager to see Thebes, the greatest of the ancient Egyptian cities, but now found intolerable the idea of viewing superb examples of ancient art with someone like Mad Boy. Heber-Percy was finally just too trivial and too rich—too bored and in turn boring. At the Great Zimbabwe ruins, Mad Boy and Bacon parted. "Robert Heber-Percy has left and will be back in London soon," Bacon wrote Erica Brausen, sounding delighted that he had "got rid of Robert," as he put it. He could now spend his time as he liked. He still intended to go to Egypt but, he wrote, had "met someone who has a farm near Zimbabwe." He was "going back there." Just whom he visited he never said. Bacon was amused by the colonial mixture of entitled white expatriates and handsome black natives that he found in Southern Rhodesia, though he would later criticize the arrogance and indolence of the British abroad. He wrote: "The men are too marvelous drinking lazing overfed—and rich. Champagne starts at 11 o'clock in the morning." Erica must tell Arthur Jeffress, Bacon told her, that "the Rhodesian Police are completely him—too sexy for words starched shorts and highly polished leggings." He concluded his breezy report by saying that he "felt 20 years younger" and that "we are mad to stay in England."

Bacon provided such news mainly, of course, to disguise a plea for financial assistance. When Mad Boy left, so did his money. All that Bacon had left, he informed Brausen, was an air ticket that Heber-Percy had earlier purchased for him from Johannesburg to Cape Town, where he could board a ship for London. He could cash in the ticket to raise some money, but could she also send him fifty pounds against his next show so that he could buy some paint and canvas? He claimed to be working in Africa, with plans to do a set of three paintings "quickly." "Everyone is so terribly nice here," he wrote. "I don't like sponging on them all the time and paints and canvas are very expensive." Bacon may have had vague

plans to paint a picture, but more likely he wanted the money for his upcoming trip to Egypt. Rather than board a ship in Cape Town, fifteen hundred miles to the southwest, he could catch a Union-Castle liner at Beira in Mozambique on the eastern coast of Africa, only three hundred miles by train from Salisbury. He could then steam north through the Indian Ocean to the Red Sea. He proposed "to get off at Port Sudan and go to Thebes and rejoin the boat again at Alexandria to Marseilles." As requested, Brausen wired fifty pounds to Thomas Cook in Salisbury and Bacon, freshly moneyed, boarded the ship at Beira on the 18th of March. He would return to England, he promised Erica, "about the end of April." He probably stopped briefly in Mombasa, a Union-Castle port of call, then disembarked as planned at Port Sudan.

From there, visitors to Thebes typically traveled by rail to Wadi Halfa on the border with Egypt and then took the ferry down the Nile to Luxor, the modern Egyptian city located near Thebes. Two temple complexes remained from what Homer called "hundred-gated Thebes"—Luxor and Karnak—each filled with colossal statues of gods and pharaohs, immense carved columns, and powerful frescoes of Egyptian warriors. Most impressive of all, to many visitors, was the fifty-thousand-square-foot Great Hypostyle Hall. It contained 134 thick columns ranging from thirty to seventy feet high. A ceremonial boulevard lined with sphinxes connected the two complexes, and on the opposite side of the Nile, near the mountains, were the Valley of the Kings and the Valley of the Queens, with tombs of pharaohs and nobles carved into the cliffs.

Bacon often spoke of the influence of the Greek tragedians, but he was also marked by the work of the ancient Egyptians. The celebrated sphinxes at the Temple of Karnak—part animal, part man, in a proportion that suited Bacon—would soon make their way into his painting. But the impact of Egypt upon Bacon transcended passing quotations. He found there an ancient fellowship, an affirmation of his instincts. The art of the ancient Egyptians was magnificently physical; even after death the body persisted. Bacon told Helen Lessore that Egyptian art was "the greatest that has been produced so far." (The "so far" was a characteristically witty touch.) "I always find medieval art so boring," he told David Sylvester in the 1970s. "I hate the men's long hair because you can't see their skulls." He enjoyed, he said, "Egyptian things not only for their extraordinary quality but I like their short hair and I like the short hair of certain Greek things too." Researchers after Bacon's death found many torn and smudged images of Egyptian art in his studio, including a close-up of an Egyptian noble depicted in the book *The Sculpture of Ancient*

Egypt. The face was lean and angular, the hair closely cropped. Flesh followed bone.

Bacon did not comment on Alexandria, his final stop in Africa. It was a famous destination for luxury-loving Europeans owing to its long beaches and English and French gardens. But after his experience at Thebes, Bacon was probably eager to make his way home. He had been away for three and a half months. "One characteristic letter from Francis," Isabel wrote Peter Rose Pulham in April. "What a handwriting! Only a person who knows him well could possibly decipher it." And: "Shall be very glad to see him. He is missed by a lot of people." Bacon could not, of course, steam insensibly past the casinos. He arrived in Marseille around the 22nd of April and went directly to Nice, where he was delighted to find his old friends Michael Wishart and Anne Dunn. After the bacchanal, Dunn and Wishart lived briefly in Paris, St. Tropez, and Ireland. Now they were settled in Nice. The couple named their new son Francis in honor of their two favorite Francises—Francis Bacon (Wishart) and Francis Wyndham (Dunn).

Bacon was seeing friends, gambling, and anticipating a return to the studio when, like a stirring on the veldt, a telegram arrived. Nanny Lightfoot was gravely ill—heart failure and arrhythmia. Bacon, frantic, left immediately for London. "Francis," said Wishart, "looked as if he wanted to die." By chance the couple, also returning to London, found him on the platform at Lyon, "in a terrible state." On April 30, 1951, Nanny Lightfoot died at Cromwell Place, where she and Bacon had lived since 1943. She was eighty years old. Bacon arrived shortly before her death. He did not record whether or not she was conscious. A close friend of Nanny's, who had looked after her when her health began to fail, probably arranged for the telegram to be sent to Bacon. Every week, for many years—until she herself died—Bacon paid a visit to Nanny's elderly friend.

Nanny had known Francis as a shy and sickly boy, a baby-faced seducer of older men, an extravagant gambler, and a serious artist. Nanny was the mother who never nannied, the mother with no rules who never left him. And she had mischief in her heart. She was the "advisor," said John Richardson, who "ran his life." She steadied the day. And she loved him, of course. Bacon regarded death unsentimentally but lacked the gift of forgetting, and he was not coldhearted. He would chastise himself for spending time with Mad Boy while Nanny's heart gave out. Near the end of his own life, Bacon told a friend that he considered himself unlucky

because "a lot of my friends have died . . . not only more recently but before that . . ."

Nanny Lightfoot's death came after Bacon had waved goodbye to his mother eight thousand miles away in South Africa and after he had grown apart from the adopted "uncles"—Eric Allden and Eric Hall—who once helped stabilize his life. Along with Nanny, they provided him with an extended family that not only allowed him to live like a gentleman of means—without the means—but gave him the time necessary to develop a very slowly maturing sensibility. Diana Watson remained close at hand, but no other family that mattered was nearby. His morning's work, without Nanny about, was newly solitary. It was different to push the key into the lock. Death changes a house. "He was heartbroken," said Richardson.

Bacon sold his Cromwell Place lease to the painter Robert Buhler, whom he knew from the Gargoyle and the Royal College of Art. He had often spoken of selling the lease in order to pay his debts. Nanny Lightfoot's death cut a last string. He probably could not imagine living in Cromwell Place without her. Bacon now radically pared down his circumstances, in a way that was almost punishing. He made himself all but homeless. No house, no studio. In the midst of his mourning, as these changes pressed upon him, Erica badgered him to select a painting for the Festival of Britain exhibit, which would open that summer. While Bacon had been away and unreachable, the festival organizers had requested a painting to put in the catalog. Brausen dared not give them an image. She could not be certain what Bacon would want; that must await his return. She therefore gave them only a title with the dimensions of his recent larger paintings. She could not go too far wrong, she reasoned, if she named the still-to-be-selected picture *Painting*.

Bacon himself took no interest in the festival. He was not attracted to patriotic occasions presided over by plummy masters of the Establishment—especially not, it would seem, in the weeks after Nanny's death. He told Erica he would not submit a painting. When he moved out of Cromwell Place, he left behind in the basement a number of unfinished canvases, assuming that Robert Buhler would discard or paint over them. (Buhler later sold the unfinished works, many of which wound up in Italy.) He sent the two popes to an artists' suppliers in Chelsea, where he no doubt requested that the frames be salvaged and new canvas be put on the stretchers. Over the next few years the two popes were all but forgotten. Bacon later assumed they had been destroyed, which he said he regretted. Both were found after his death still rolled up at the art supply store.

In the summer of 1951, Bacon could stay for a while with friends or

rent a room. But where was he to paint? Brausen scheduled a show for December, and neither she nor Bacon wanted to repeat the experience of the previous year, when he had produced almost no new work in time for his show. Meanwhile, Bacon continued to spend freely and came under increasing financial pressure. He owed money to, among others, the Hanover Gallery and his tailor on Jermyn Street. His friends at the RCA, aware of his desperate circumstances, became concerned. He was almost one of the RCA's own, after having filled in for John Minton in the fall of 1950, and he was widely liked and often in the senior common room, talking with faculty and other drop-ins, like David Sylvester—arousing, as always, edgy and laughter-filled conversation. Even the conservative sculptor of animals, John Skeaping, told Lucian Freud, "I don't think I quite understand his work but I'd back him on character alone." It was Skeaping who had admired Bacon's draftsmanship at his long-ago Transition Gallery show in 1934.

Robert Buhler, who had recently painted Bacon's portrait—a casual rendering of him in jacket and open shirt and in a relaxed posture— probably felt especially uneasy about Bacon's predicament. How could he live comfortably in Bacon's former home and studio while Bacon was living hand-to-mouth? Buhler was dashingly handsome, well liked, and generous-minded. He might well have discussed Bacon's plight with his great friend Rodrigo Moynihan—who now offered to lend Bacon his own official studio at the college. Moynihan himself preferred to paint more privately at Carlyle Studios, his "hideaway" in the King's Road. (It was there, wrote John Moynihan, that his father "painted a succession of attractive women, who arrived parading spikey eyelashes, and left without them, having mislaid them somewhere in the battered wasteland of disrupted sheets and blankets on a large mattress-crowned bed.") Moynihan's offer—a generous sign of personal and professional regard—sent a signal to the students and faculty that Bacon was someone to respect. Bacon meanwhile also found temporary lodging at the same Carlyle Studios where Moynihan painted (and where Bacon had stored his furniture in 1932). Perhaps this, too, came by way of Rodrigo. There he could sleep and put his few belongings. About a month before the opening of his December 1951 show, Bacon went to Monte Carlo, hoping to solve his financial problems. He soon returned, having lost all his remaining money.

In his new college studio, facing the forbidding deadline, Bacon took up his unfinished business with the Holy Father. He intended, once again, to paint three large pope paintings. He did not think of them as a triptych, or not formally so, but they were again to be related: an ever-

intensifying scream passing across the three paintings. This time, however, Bacon made the project somewhat easier for himself. He put more distance between his work and the powerful Velázquez. The old master's *Portrait of Innocent X* remained a presence, to be sure, but not the only or even the crucial one. The camera now mattered more. Bacon fastened upon a news photo of the bespectacled Pope Pius XII (1876–1958) being paraded through the Vatican on the *sedia gestatoria*, a throne borne on the shoulders of twelve footmen. The photograph was not a penetrating psychological study, but instead the depiction of an outlandish spectacle of power—a folly—whose origins lay in the distant past. That helped change the dynamics of the painting: Bacon did not have to confront Velázquez's particular insight into Innocent but could contrast the man with the spectacle, confronting the pope and the old masters as a modern director might—theatrically, almost hysterically. Spectacle, as Leni Riefenstahl understood, was often the masked face of power.

Bacon now began to use photography's look, its visual savor, to help differentiate his work from the old masters. Many great modernists had made use of photography, of course, especially as a compositional inspiration. But Bacon also looked for other qualities, such as the blurriness of the photos of the period, especially in the newspapers, and their very loose or casual crops. Color, still rare in the medium, bled and spilled across forms. Negatives appeared spectral and unearthly but not divine. If Bacon brought such elements into painting, he would obviously be competing less directly with Velázquez and also bring something newly crude and unartful into contemporary painting. He could also draw upon the movies. Bacon admired the use of montage in early filmmaking. Perhaps his art could become one of broken pieces, reassembled theatrically— a kind of montage that, for example, combined old-masterly touches with more modern elements.

In his three new pope paintings, Bacon followed the same general scheme as before, beginning with what he was most comfortable with—an open-mouthed pope. Only then did he attempt a close-mouthed version, which he now depicted in a studiously naïve manner, almost like a cartoon or the drawing of a conscientious child. None of the figures was now centered, and the "negative" space was different. In 1950, Bacon had placed a transparent cube, like an abstract dais, under the curtain-trapped pope. Now he stripped away the curtain and surrounded the figure with vague and fantastic geometries. They suggested certain elements from the original photograph—the fan vaulting, the throne—but not in a literal way. Unlike the modernist grid, which gave order to much mod-

ern painting, Bacon's geometry was disorienting. The pope inhabited a baroque jail of infinite space ordered by an unknowable logic.

In the third painting of the series, the scream did not come only from the pope's gaping mouth. Curved over the pope's head was a flabellum, a large fan of white feathers traditionally used in papal processions. The flabellum resembled a visual scream, an early example of Bacon's use of synesthesia; its rhythm also suggested the pulsing of a modern radio wave. More mysteriously, the flabellum seemed to emerge—as a chorus might in a Greek tragedy—from an unreachable space beyond the pope. It cupped the figure's head in an implacable crown. With this three-act work, Bacon edged closer than ever before to the theater. The old masters remained important, a palpable presence able to suggest majesty and damnation. But they spoke from the wings. They were felt in matters of scale and in passages of painterly fluency, but could not claim the whole. Bacon's space was now filled with broken visual and metaphysical pieces. He could not abandon the past, but it could not provide him with a room or resting place. Nor was he comfortable with "make-it-new" modernism, with its presumption that the past could be ignored or escaped. He liked to be both inside and outside his time, making art from the edgy in-betweens.

Critics understood from the beginning that the patrimony of the old masters remained disturbingly alive in Bacon's "phantasmal" art. Melville called his pictures "subtle wrecks of masterpieces." In 1950, Eric Newton of *The Sunday Times* referred to Bacon's invocation of the "Grand Manner." And in 1952, Lawrence Alloway wrote:

> To Bacon, the Grand Manner is indispensable, as a frame against which to work, eroding and subverting it, but not removing it. He needs both the symbol of order, of which the Grand Manner provides an ample and long-lived example, and its opposite, intimate and unanticipated images. The two elements interlock, one giving body, one giving mystery, to the other.

There was another element Bacon brought to his relationship with the old masters: a queen's mischief. The Grand Manner had a royal quality, conveyed in the 1950s through the taste of Kenneth Clark. After two world wars and the transformations of modernity, wasn't Kenneth Clark—despite his many undeniable virtues—also engaged in a kind of impressive dress-up? The opulent glazing and heavy gold frames that Bacon continued to employ were, among many other things, a kind of sartirical costume—the old masters in drag. The stagy air of performance

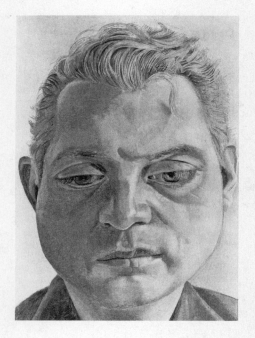

they gave his art was not disrespectful, for no one loves the original more than the drag queen does.

In addition to the three popes, Bacon included two other large works in his 1951 Hanover show, which opened on December 11th. One was the full-length portrait of Freud standing in a doorway, which he had once thought of contributing to the Festival of Britain. (The next year, Freud painted a masterful portrait of Bacon.) The other was a burly nude who—hunched over and monkeylike—emerges from (but is also part of) a curtain. A smaller picture, *Figure with Monkey* (1951), was based on a zoo photograph and showed a man whose face the viewer cannot see reaching up to touch a monkey's face through the cage. His upraised arm could be a fascist salute or a poignant supplication. The show, focused around the dramatic popes, was a great success: Brausen extended its run into February. A critic from Glasgow now placed Bacon at the center of London's "fashionable taste," observing that his "six huge canvases confront a steady procession of visitors, who look about them with a kind of interested bewilderment; nobody is quite sure what to make of them, but everybody has much enjoyed talking about them."

The Contemporary Art Society purchased the least alarming of the popes—the tight-lipped *Pope I*. It was their third acquisition of a Bacon. The two screaming popes went to Brenda Bomford, who, together with her husband, H. J. P. Bomford, was forming an astonishing collection of both modern and ancient art. "Jimmy" Bomford had made a fortune after World War I in the London stock market. He retired in the 1930s to a farm near the rural village of Aldbourne in Wiltshire, where he became known for modern agricultural practices. He enjoyed parties and fast cars, and he and Brenda became possibly the most independent—and, indeed, pioneering—English collectors of the period. Not only did they gather the big names in French modernism: they also bought the work of modern English artists, some before they became well-known. They filled their substantial house with art and stored the overflow in farm buildings. Beginning with *Figure Study I* of 1946, the Bomfords bought a remarkable nineteen Bacons between 1946 and 1958. Very few people wanted to buy Bacon paintings in the late 1940s and early '50s, however much they enjoyed "talking about them." Bacon still depended for sales mostly upon friends, relatives, and institutional supporters. Even

Lucian Freud's intimate portrait of Bacon, painted in 1952 and stolen from a museum show in Berlin in 1988

some institutional supporters could not quite bring themselves to display his work. *Figure with Monkey*, for example, was purchased by the brilliant Cambridge statistician F. J. Anscombe, a man with a curious and far-ranging turn of mind, who generously gave it to the Fitzwilliam Museum in Cambridge. But the Fitzwilliam found the painting too difficult to exhibit and returned it to Anscombe, who later sold it to pay for his children's education.

It was ever so slowly that "official" England—in addition to the Contemporary Art Society—was taking notice of Bacon. John Rothenstein, the director of the Tate and a specialist on English art, had been exceedingly hesitant to collect the great Continental modernists. But he was reasonably open-minded about which modern English artists could join the canon. A small, proper man and a devout Catholic convert who was knighted in 1952, Rothenstein had been appointed director in 1938. His views were shaped by Bernard Berenson, the Renaissance scholar and tastemaker enthroned at I Tatti in Florence, and Kenneth Clark, the head of the National Gallery—the first of whom detested most modern art and the second of whom, while far more liberal, often described the modern world in words tinged with a mandarin's regret. Rothenstein, after a lunch with Clark in 1950, reported, "We agreed that compared with the '90s ours was a decadent age, lacking sense of *importance* of things."

In 1951, Rothenstein "hardly knew" Bacon personally, as he noted in his memoir *Brave Day Hideous Night*, but he had been intrigued by Graham Sutherland's endorsement six years earlier. And of course the Contemporary Art Society had purchased three Bacons. That meant something in the world of museum directors and collectors. Kenneth Clark had also told Benedict Nicolson—a distinguished art historian himself—as early as 1947 that he thought Bacon was "first rate." The Tate itself, in 1950, acquired Bacon's *Figure in Landscape* of 1945. One night in August of 1951, several months before Bacon's show, Rothenstein invited the painter Matthew Smith to dinner at his private club, the Athenaeum, where people concerned with literature, the arts, and science liked to dine and quietly celebrate their success. At the time, Smith, who had studied with Matisse, was a distinguished "elder statesman" entering the final decade of his career. (In 1953, he would have a valedictory retrospective at the Tate engineered in large part by Rothenstein.) After dinner, the two men walked through Soho, wrote Rothenstein, "lamenting the drabness of cafés, bars and of public places of amusement generally." Along the way, they spotted Bacon in a pub and went in to see him. Ever the genial entertainer, Bacon then took them on a personal tour of the Colony and

the Gargoyle. It proved a revelation to the prim Rothenstein—"a most 'twentyish' evening, charged with smart repartee, excessive drinking and so forth—an amusing 'period' occasion." Bacon, he noted in his diary, was an "amusing and generous" host. He was "about to settle for the time being in Monte Carlo, where he intends to paint and gamble."

During the next four years, Bacon would have no settled address. He would move at least ten times and often depended upon friends for temporary quarters. He was chronically broke. There was no safety in his art: perhaps there should be none in his life. His situation in 1951 was nomadic, chancy, and vulnerable. He was living an almost feral life when he first fell in love.

Love and Power

Bacon met peter lacy in the churning Soho night, perhaps at Careless Talk, where Lacy played the piano. Or perhaps it was at another of Lacy's favorite hangouts, the Music Box, considered "less squalid" than most Soho places. Fair, lanky, and fine-boned without being delicate, Lacy did not appear homosexual. He resembled in some respects the sporty men of Bacon's childhood who religiously jumped horses over stone walls in pursuit of a fox. He was genial but reserved.

Peter Lacy, the love of Bacon's life, whose upbringing, like Bacon's, was constricted by his conservative—and in his case, Catholic—family.

He dressed smartly and spoke with "a slight, endearing stammer." He had an "extraordinary physique," said Bacon, with plenty of manly English starch. Behind the elegant clothes and "pleasant, nervous expression" keen observers sensed a restrained tension. Something within lay powerfully coiled.

Lacy had been a pilot during the war—a heroic fighter pilot, everyone said. The more prosaic truth was that he worked in aircraft production and then joined the RAF in June of 1941, well after the conclusion of the Battle of Britain, during a period when Britain desperately needed to replenish its ranks. He did not fly Spitfires or engage in combat missions but was instead a mechanic and test pilot for Wellingtons, the British twin-engine bombers then becoming outmoded. (The Lancasters, heavier and more technically advanced, were the mainstay of the European campaign.) But the embellishment had its own truth. Lacy looked the part.

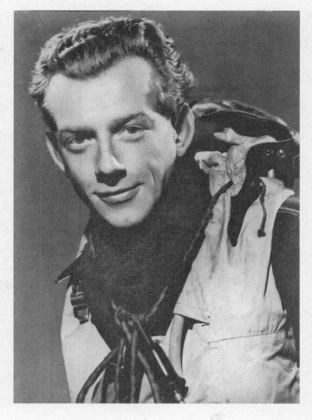

A romantic director could easily have cast him as one of the golden boys lost to the century's wars, a Rupert Brooke who has seen too much too young or a fair-faced pilot who runs, donning his leather jacket, toward the Spitfire across the green.

Bacon fell passionately, and desperately, in love. Lacy was thirty-six years old—to Bacon's forty-two—and slightly weathered in appearance. He had lived abroad, most recently in Barbados, a Caribbean playground of many wealthy Englishmen, and did not feel entirely at home in London. Some of Bacon's friends considered him just another gin-and-tonic Englishman; one called him "too desiccated to be described as handsome, with the bleached appearance of someone left out in the tropical sun." But the wearing of a handsome face, and its wearing down, can also be beautiful. John Richardson met Lacy at the Music Box around the same time that Bacon fell in love. "I remember he came up to me and we had a drink and he said, 'Come on,' and I was about to say yes when my friend James Bailey [a renowned costume and set designer] arrived and said 'John, what are you doing here? Fuck off.' And off he went with Peter Lacy. He had that sort of RAF pilot all over him. Very trim, very correct, very controlled, but with . . . You felt a demon. You felt a force there. I think he was very attractive."

It was more than improbable—it was shocking—that Bacon should put himself into this position of weakness. Bacon, who put "love" in quotation marks? Who called love a dreadful illness? But Bacon now appeared entirely undone. He was meek and smitten as a schoolgirl, concerned that he loved Peter more than Peter loved him. "Even his calves," Bacon said, "were beautiful." Bacon had never before fallen passionately in love with someone as close to his own age and from a similar social background. He would never do so again.

Much about Lacy reminded Bacon of the world he left behind. Both men came from wealthy Midlands families with Irish connections and storied names. During the Norman Conquest a de Lassy had crossed the Channel: a John de Lacy signed the Magna Carta. The Lassys had vast estates in the west of England. After the Anglo-Norman invasion of Ireland, members of the family also gained extensive lands in the former Irish Kingdom of Meath, which Cromwell later stripped from the resolutely Catholic family when his army of Ironsides invaded Ireland. (Another ancestor, Count Peter de Lacy, became a mercenary in the service of Peter the Great after fighting Cromwell and fleeing Ireland.) During the potato famine of the 1850s several Lacys crossed the Irish Sea and settled in Birmingham, where they traded Irish livestock and joined in

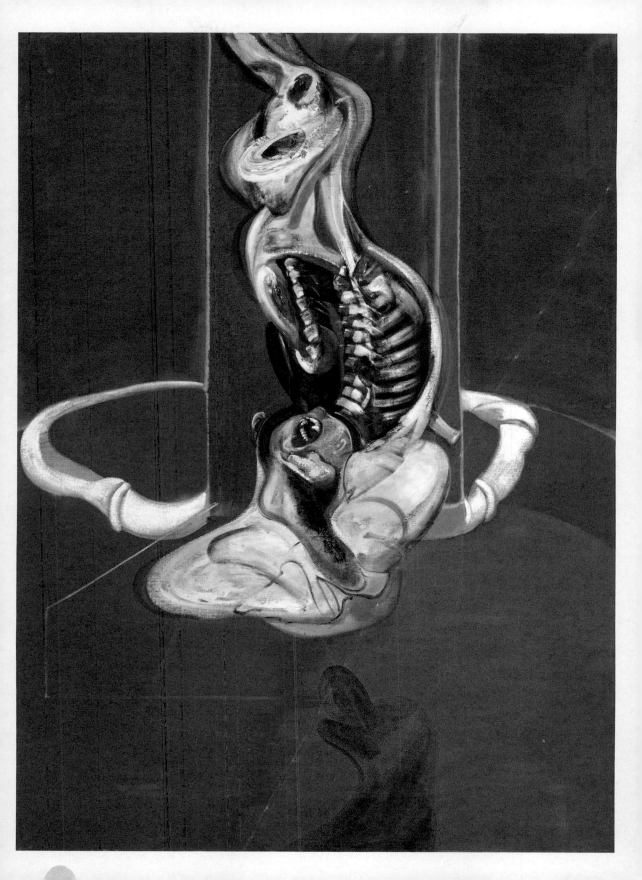

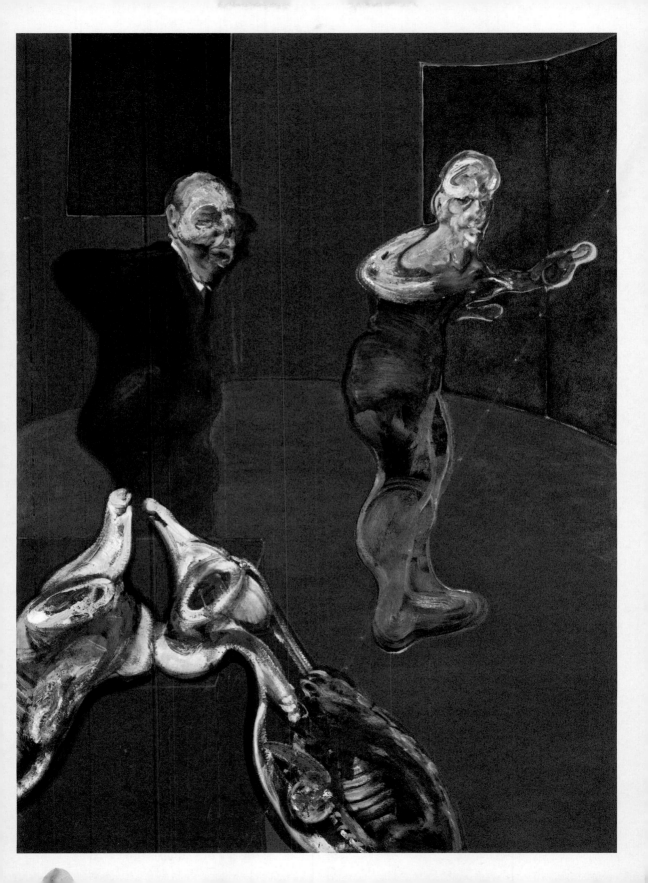

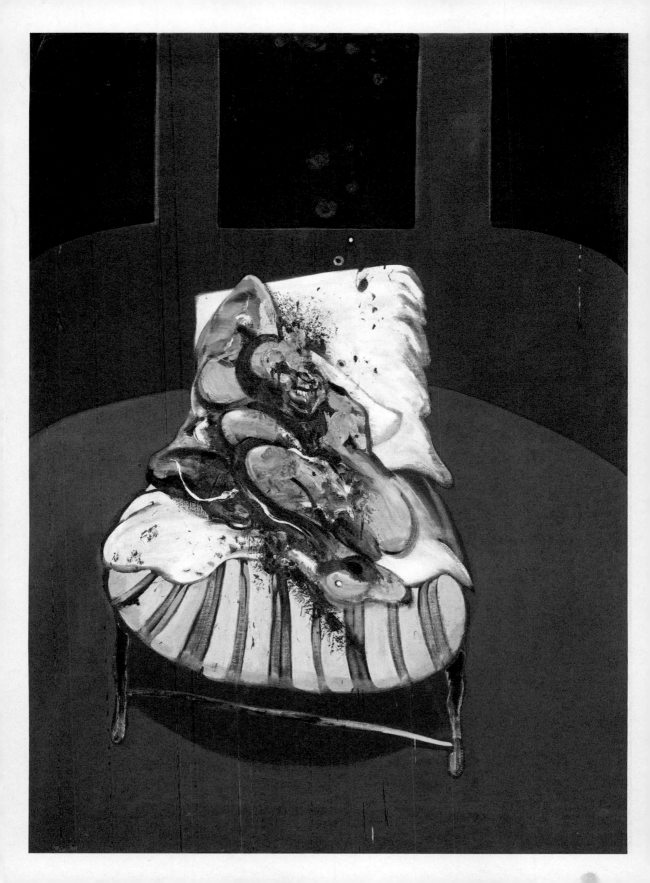

the industrialization of the Midlands. In 1864, John Pierce Lacy formed a business with Joseph Ash—Ash & Lacy—to galvanize metal used by railroads and heavy industry. He also acquired and invested in other industrial enterprises and speculated in stocks. The next generation, which included Peter's father, James Stanislaus Lacy, lived mainly on inherited money. Peter's father was a stockbroker and "never got his fingers dirty." Peter's uncle Pierce was an illustrious money man. He was head of the Birmingham Stock Exchange, and in 1921 he was made a baron. He lived on a five-thousand-acre estate in Sussex.

Peter was born in 1916 in Leamington Spa, a pretty enclave with some fine Georgian buildings situated just outside the factory cities of Birmingham and Coventry. He was raised in a strict Catholic household—yet another Catholic in Bacon's life. His father served as chairman of the Southwark Catholic Rescue Society, which helped orphans and poor children. Peter, the youngest of three, was not particularly close to his brother, Anthony, who was five years his senior. Bacon also had a significantly older brother. But Peter and his sister Joan became devoted to each other. Each loved the piano. Each excelled at tennis. Peter was talented at arithmetic and adept at figuring out how things worked. He relished automobiles and motors, which, given his grandfather's predilection for engineering and the mechanical world, would have pleased his family. Peter's youth was entirely ordinary until he reached adolescence.

Then something broke. He attended a preparatory school from 1928 to 1930 but did not subsequently follow his brother, Anthony, to the Oratory School—founded by Cardinal John Henry Newman and sometimes called "the Catholic Eton" of England—until 1934. Members of his family recalled that he left school owing to an "illness" and that, unlike his older and more conventional brother, he lived at home until he was eighteen. No one in the family ever identified his illness, but it was unlikely to have been primarily physical. Diseases that struck adolescents rarely lasted four years; when they did, they were named and remembered. Lacy was robust, athletic, and healthy enough to become a pilot. What members of his family recalled was that he appeared "thwarted." He continued to be interested in the piano, at an age when most boys give it up, and he developed an interest in theater and jazz, an unconventional and even scandalous form of music in the England of the 1930s. His family—Victorian in outlook, and rooted in Midlands society—could not accept such interests as anything more than irrelevant hobbies. "Doing and making things was considered a far more valuable contribution," said Peter's nephew Gerald Towell. There was "a conflict between work and play. . . . The Catholic

Church was [also] very much against the theater. Music was allowed. But the idea of acting and playing and dressing up was . . . *trivial.*"

No mention was ever made of Peter's sexual nature, though that was likely the source of his "illness." His parents may have caught him in a homosexual act, as Bacon's father may have caught Bacon, but they may also never have discerned his leanings. Peter himself may have been sexually uncertain as an adolescent. He was not girly. He gave no signals, or none a conservative Catholic household would divine, of a homosexual inclination. What Peter knew was that his Catholic parents would regard his sexual desire for boys not only as disgusting but also as morally and spiritually damning. Almost inevitably a boy like Lacy would become tied up in powerful knots of suppressed feeling—a tangle of adolescent love, despair, rage, and intense dreams of escape into the theater. Or, as the family put it, "thwarted." It did not help that, like many others in his family, Peter had a quick Irish temper. By the age of eighteen he had finally mastered himself, at least enough to begin attending the Oratory School. He was old for a schoolboy (his contemporaries were moving on to university). But he stayed at the school for two years, from 1934 to 1936, then went up to Hertford College, Oxford. He dropped out after a year.

Peter's family pressed him to complete his studies. Or become a stockbroker like others in the family; or perhaps read law. He was probably investing his own money. But he took little interest in any profession. He spent most of his time dreaming at the keyboard. (Bacon had done the same as an adolescent and also fantasized about becoming an actor.) In the summer of 1938, Lacy likely heard the masterful American jazz pianist Fats Waller, then on a celebrated tour of Europe. Fats became his favorite musician. Fats was nothing like Peter—nothing, indeed, like any fair-haired Englishman. Fats was big and black and funny and entirely at home with himself and music: a natural all around, with qualities that Peter—closeted around his family—could not hope to possess.

Unable to do what he wanted, even if he could determine what that was, Lacy aspired to do nothing rather well. Life could then pass smoothly by. He could have diverting affairs and wear fine clothes and, if asked, play the piano at a friend's get-together or in an entertaining dive. In a photograph taken when he was in his early twenties, about the time that Fats was touring Europe, Lacy is seen wearing a suit, striped tie, and boutonnière. The handkerchief in his breast pocket is casually placed, but casually in a "just so" way. According to his nephew Father David Lacy, "He always had a lovely car."

It would have taken a rare sort of courage, once the war broke out, to

continue doing nothing rather well. In 1939 Peter took a job as a senior clerk at Armstrong Siddeley, whose headquarters were in Coventry, a short drive from the family home. Best known for its luxury motor-cars, Armstrong Siddeley was also an engineering firm that made air-craft engines and military equipment. It was a good fit for a man with Peter's interest in motors. According to Gerald Towell, "He drifted into something during the war because it was required." He also moved into a boardinghouse with others connected with aircraft production. Then, in April of 1941, as England replenished its air force after the Battle of Britain, Peter enlisted in the RAF. That would also have seemed a logi-cal move for a young man already employed in the aircraft industry. He joined the ranks and specialized in aircraft maintenance. Soon he began to train as a pilot and, after a year and a half, was commissioned first as a flying officer and then, in April of 1943, as a pilot officer, a rank roughly equivalent to that of lieutenant.

Peter's family was proud of him at last. He delivered Wellingtons to the distant theaters of the war in Africa and the Middle East, flying them or accompanying their parts by ship around the Horn of Africa to reach Mombasa and the RAF base in Aden, where he would test and maintain the planes. At various times, he was based in Southern Rhodesia, South Africa, Aden, and Cairo. During the longueurs of the war, he had time to wander through cities and landscapes fantastically different from those in England. He would not be the first English homosexual to find, in the shadowy heat of the Arab alley, something like liberation, escaping from both the squinting eyes of the military and from the distant reproach of his parents. Cairo and Alexandria had long been celebrated, depending on one's perspective, as dens of iniquity or delight. In an hour, one could pass from a club filled with alcohol-soaked Europeans to an Arab brothel filled with doe-eyed boys. Everyone knew, and no one was the wiser.

After the war, Peter's family hoped he would remain in the military. But he demobbed as soon as possible and resumed his earlier life. "For a while [after the war] he had an old Bentley," said his nephew David, ". . . and a Citroën with a long bonnet. With wings over the wheel. Six cyl-inder. Very few of this particular model were made with a right-handed wheel, so he had quite a rare Citroën." During brief visits to the upright households of his siblings, Peter played the part of favorite uncle. He would arrive in his splendid car. He was dashingly handsome. He was a pilot in the war. "I think Peter was a sort of heroic figure for us as a child," said David Lacy. Peter would toss off the occasional wry aside and brought with him music that was not like tedious piano lessons. The

music was mischievous and naughty and composed by larger-than-life figures like Fats Waller, who played songs with names like "Ain't Misbehavin'"and "Your Feet's Too Big." Once, seemingly without a thought, Lacy gave each of his sister's three sons twenty pounds, then a magnificent sum to a child. It was a gift to put scrimping to shame. (The boys' mother tucked the money into a drawer.) On another occasion, he was asked to help transport the extended family to a vacation house in what his nephew David recalled as a huge and unwieldy holiday camper or caravan. He drove "superbly," but "the moment we arrived on the cliff in Cornwall, he said, 'Well, I'm off.'"

Lacy soon went to London: the city naturally beckoned to a homosexual interested in jazz. There he could be almost free. Even so, Lacy did not live an openly homosexual life, though the people in the Soho clubs he frequented would know his predilections. He first settled, in June of 1946, at 26 Sackville Street in Mayfair and then, the next year, on Wimpole Street in Marylebone, an area with lovely old squares just north of Mayfair and Oxford Street. He considered living abroad. He was thirty years old, an age at which many young men begin to feel less young and decide the time has come to make a responsible decision. He dabbled at being a stockbroker. And stockbrokers dabbled at him: he was a man who would inherit money. He continued to play the piano. Then, in 1948, his father, who had Parkinson's disease, died and left an estate of eighty thousand pounds to his children. It was a significant fortune.

Not long afterward, Lacy left for the Caribbean, most likely after the settling of his father's estate. "He might have gone abroad for tax reasons," said Gerald Towell. "Death duties were ruinous." He adopted the life of a gentleman in the colonies, purchasing or leasing a vaguely Moorish house in Barbados with a lovely interior courtyard and views over the sea. In July of 1950, returning to Barbados from a trip back to England—he may have gone to visit his favorite sister—he described his profession on the ship's log as "nil." Only six months later, however, he returned to London for good. He was too restless for paradise. Daniel Farson recalled visiting him at "a gentleman's ground-floor flat at the top of Sloane Street, a suitably genteel and impersonal residence."

In Soho, Lacy picked up piano craft. The Music Box—the second of two London clubs that Muriel Belcher began, with her friend Dolly Myers, before she opened the Colony—attracted those employed by the nearby theaters. They admired its pianist, Hugh Wade, whom Lacy befriended. Wade, a songwriter and man of the theater, played jazz and show tunes on a flashy white piano. Lacy sometimes filled in for him. When not at the

keyboard, Lacy could appear quite reserved, though he had no difficulty picking up men. Certain women underestimated him. Frances Partridge, the marvelously acerbic friend of Chopping's and Wirth-Miller's, met Lacy at the Gargoyle in February of 1952 not long after he and Bacon began their relationship. Partridge, in a letter to Chopping, found Bacon "most amusing and charming." He "stood everyone" to champagne "in a reckless way." Of Lacy she wrote: "The boyfriend was as light as an owl and blinked unceasingly. I can hardly imagine that even when sober he could have been other than repulsive." Partridge did not appear in the mood for any man, however, apart from Bacon. She also found Lucian Freud wanting—"so deadly grave & self-conscious looking; no irony, no light touch. . . . I can't think how he gets so many rich girls to adore him—for he's no oil painting either."

Unlike Partridge, most homosexual men found Lacy not only physically appealing but also quietly witty. Bacon told Michael Peppiatt that Lacy came up "with one amusing remark after another unlike those dreadful bores who plan from morning to night what they're going to say." Wit in a quiet man can be seductive, and reserve fetching. Bacon found Lacy's diffident charm poignant. It was simpler, of course, to talk about his "extraordinary physique": even his calves. But the best bodies will grow dull without some drama in the man himself, such as that knot of reserve, despair, and thwartedness that lay inside the handsomely worn Lacy. Bacon was excited, but also moved, by Lacy.

Lacy's arrival changed the rhythm of the day for Bacon, who might still hold court at the Gargoyle but often wanted Lacy to himself. On Dan Farson's second day in Soho, Farson—soon to be a Soho regular—noticed Bacon at the Gargoyle engaged in "an angry though quiet argument with his friend Peter Lacy." It was obvious, he thought, that "they wished to be alone." Being alone in Soho was not that easy, however, with friends around. Why not make a romantic second trip to South Africa, this time with Peter? Both had reasons, apart from each other, to make the trip. Lacy was an Englishman who, like Bacon's sisters, seemed happier in the colonies. He had served in Africa and likely made friends in South Africa. Not a few British servicemen, shipped to the far corners of the world during the war, eventually settled outside England. Bacon, in addition to seeing his family, could hope to focus on what interested him in Africa without the trivial distraction of Mad Boy.

Not long after the ship left Southampton, Bacon and Lacy began to argue. An ocean liner easily becomes a private theater, and Bacon had a taste for farce and the absurd. Perhaps Lacy did, too. Bacon had brought

along "all these suits and things" (he loved dressing up, especially when in love), and in a drunken rage Lacy "pushed the lot out of the porthole." The only clothing available for onboard purchase was shorts. The stewards, mostly homosexual, put together a working wardrobe for Bacon. The story was rather amusing to tell—Frances Partridge would have enjoyed it—but the slapstick contained dark undertones. Drinking unburdened Lacy, enabling him to let go, and he was "dead drunk" for the entire voyage, Bacon said, with other passengers noticing how menacing he could appear. Bacon liked rough sex and letting go, of course, but even he was impressed by the lengths to which Lacy went. Bacon could not pretend that it was all just "very amusing." "People came up to me and said, 'Who is that awful man you're with?' and, of course I had to say, 'Well, I don't really know.'"

Ianthe had only vague memories, many years later, of Francis's second trip to South Africa, although she recalled that he brought someone with him and that they had taken the famed Blue Train to Johannesburg. Most likely Lacy, after the bruising quarrels onboard, spent the first part of the trip with friends while Bacon stayed with his family, where he had the time to look at and think about Africa. The couple probably spent the latter part of the trip together in Johannesburg and Cape Town. Details were scarce. Bacon rarely had much to say about his family, and Lacy did not keep a diary. In the middle of May 1952, the couple boarded the *Carnarvon Castle* for the two-week return trip to Southampton. Sealed on the ship once more, with no escape possible, they had little to do but drink, make love, and perhaps quarrel. It was probably on board the ships that Bacon and Lacy firmly established the pattern of their days and nights together.

In 1952, Bacon found not only a lover but a champion. The critic David Sylvester, then in his late twenties, had been ruminating over Bacon's work. Sylvester enjoyed the common room at the RCA, and he had noted Bacon's impact on students in the fall of 1950. He knew that it was usually young artists, not art critics, who first recognized an original. Although Sylvester respected abstract art, he was longing for—and he was a man of many longings—an artist who could make "the figure" new in the ways that the twentieth century was new. (It helped if the artist himself also seemed somehow new.) He found English realism wanting. It was often nostalgic, and when it wasn't, it seemed modern in an obvious, updated, and dreary way. Sylvester especially disliked social realism. In 1954, he

invented the term "kitchen-sink school" to describe the paintings about drab everyday existence that he disliked. (The term was later used to describe the "kitchen-sink" plays of John Osborne and others.) The art was as lackluster, he believed, as the scenes depicted.

Sylvester was prepared to assert—after Bacon's third Hanover show in December of 1951—that Bacon was the major English artist of his time. He was eager for the fight. The son of a Russian-Jewish antiques dealer, Sylvester was a man of gusto who, like Bacon, was largely self-taught. When he was not quite sixteen, he was asked to leave his school—University College School in London, which he did not like. His formal education ended there. He rapidly became a cultural adventurer, developing many and varied passions, among them cricket, jazz, and the cultivation of a rich and soulful melancholy. He regarded himself as an outsider. "I don't have a drop of English blood," he would tell Americans who found him very English. But he also knew how to get inside the door. He was only twenty years old when the *Tribune* accepted a trial piece that he had written, and his three happy years of regular reviewing—with George Orwell, the *Tribune*'s editor, as his mentor—ended only when he complained about being poorly paid for an article he wrote on Henry Moore. (The arts editor, Aneurin Bevan, also considered his style "too heavy with Latinisms.") Henry Moore liked Sylvester's piece enough to hire the young man as a part-time secretary. No record exists of secretarial work performed; instead, Sylvester argued with Moore about art. The job ended within a few months.

Sylvester hoped to support his poorly paid work by gambling, as did Bacon and Freud. But unlike Bacon—who never wanted to defeat chance—Sylvester was attracted to betting systems. He loved the idea of scoring, working an edge, beating the house. He was sometimes entrepreneurial. He even dealt in Oriental rugs. Sylvester would always rather win a living than make one, but there was no doubt that his presiding passion was art. And he knew that the way to power, of the small kind available to critics, was to identify—and to be identified with—an essential emerging artist of his time. Despite his unusual academic background, Sylvester's precocious gifts were enough to earn him an offer—after the war—of a scholarship at Trinity Hall, Cambridge. That was a ticket to conventional success. He turned it down. Instead, in 1947, he joined the wave of British artists and intellectuals leaving London for Paris.

His mission was different from most. He wanted to seek out the great artists of his time. Where art was concerned, Sylvester was a romantic, even though he could become absorbed by the period's despair. He was

David Sylvester, Bacon's great champion, who helped Bacon hone his ideas into epigrammatic form

not afraid of words like "great" or even "genius," and he had little patience for the small success or the careful irony. His eye was discriminating; and yet, said one person close to him, he was also inclined toward hero worship. In Paris, the principal altar then raised was to Picasso. But Sylvester— who acknowledged Picasso's preeminence in twentieth-century art—was never particularly drawn to either the man or his work. Perhaps Picasso was too old and famous; perhaps Picasso was also too fluent. In Paris, Sylvester found a hero in Giacometti. (The young critic discerned in him "the saintly knight without armour who had come to redeem art from facility and commercialism.") But Sylvester also sought an English artist, and he kept one eye on the artist across the Channel who—no less engrossed than Giacometti by the ancient and monumental—appeared intent upon creating a new kind of figure.

Sylvester's early response to Bacon was respectful but, as his gambling friends would say, not "all in." The almost-aborted Bacon show of September 1950 did not present a rich occasion for a piece. But the 1951 Bacon exhibit of popes gave Sylvester enough material. That his rival John Berger—who then disliked Bacon's art—intended to review the same show for *The New Statesman and Nation* probably goaded Sylvester into issuing a declaration meant to rebut the arguments of such critics. Berger was even younger than Sylvester but no less ambitious. The two would often clash. (Years later Sylvester attacked Berger in an interview for "promoting lousy artists instead of good ones" and called him "too prejudiced, too bigoted, too puritanical.") Like Sylvester, Berger was fascinated by the development of modern figurative art, but his taste differed from Sylvester's. It was Berger's conviction that artists must confront without compromise the corruption of their society. He was a champion of the same kitchen-sink school Sylvester detested. Berger particularly objected to artists who, while praised for being avant-garde, were complicit with the ruling culture and indulged in merely personal expression, and he disdained the dissolute drinking and carrying-on of cosmopolitan London, the milieu inhabited by Bacon and many other artists and intellectuals. Although Sylvester had no problem with left-wing views, he found

Berger loath to acknowledge that bad art could be made with the best intentions, as great art could emerge from an impure heart.

Sylvester published his piece in *The Listener* the first week of January 1952. Berger's piece came out the same week in *The New Statesman and Nation.* It was unlikely that Sylvester read his rival before he wrote, but it almost seemed that he had. The arguments Berger advanced against Bacon were precisely those that Sylvester answered. Berger was a formidable adversary who, when he wrote about art, took care not to appear as just another social critic. The ideology did not overwhelm the sensibility; and in addition to a marvelous conscience, Berger also possessed a feeling for tradition and an eye for form. He liked visual analysis. He was a subtle killer, too. Aware in 1952 of the widespread interest in Bacon, he began by complimenting him, much as one fattens the calf. Compared to the ephemeral quality of most recent art, which "like overheard conversations" depended upon the context of the moment, the "paintings by Bacon do exist in their own right," Berger acknowledged, "and indeed have a uniquely convincing presence which their startling, unlikely subject matter somehow makes even more convincing. One watches them, hypnotized as an agnostic might be hypnotized by some ectoplasmic manifestation at a séance. . . ."

And yet, while "very remarkable," Berger concluded, Bacon was "not, finally, an important painter." He worked "outside the main tradition of painting"—it was sly for a left-wing critic to pay respect to "the main tradition of painting"—and he was not visually inventive enough to be more than a "stage manager" of arrangements, effects, and dramatic content (that is, a set designer or that special bogeyman of English art criticism, an illustrator). "No new meaning," Berger wrote—assuming the mandarin manner of a connoisseur of significant form—"is added in the actual process of painting them." The objection that English painters were often merely literary was the lash frequently applied to the back of English art, owing in part to the emphasis on visual analysis by the modernist critics Roger Fry and Clive Bell. Bacon was often attacked on those grounds, as was the kitchen-sink school. By emphasizing his own formal interests, Berger could attack Bacon aesthetically—in addition to morally—and implicitly defend the kitchen-sink school. At the end of his piece, Berger returned to criticism of Bacon's "unlikely" content, changing his analogy from a séance to the lurid melodrama of the Grand Guignol. (A dismissive comparison to Grand Guignol was the most common criticism of Bacon's work.) Bacon's painting, Berger wrote, was too private and "egocentric" to address the true horrors of the day in a socially aware

manner. He ended with a moral flourish: "If Bacon's paintings began to deal with any of the real tragedy of our time, they would shriek less, they would be less jealous of their horror, and they would never hypnotize us, because we, with all conscience stirred, would be too much involved to afford that luxury."

Sylvester was a slow writer, a bleeder who revised to revise again. He found it difficult to describe what happened once he immersed himself in a work of art. He would feel intimations, he said, of both sex and prayer, an experience at once intensely spiritual and physical. The tone he sought was intimate but consequential. And clear, always clear. He hated the fog of art writing. Arriving at clarity was especially difficult because Sylvester did not maintain or desire a settled perspective on art to ease the toil of judgment. (A settled perspective required only that the critic drop the pigeon in the hole.) There was also the complex business of addressing what others thought. Sylvester had an ear as well as eye for art, and as a Jewish Englishman not raised in a wealthy household, he was wary of the established tone of opinion. Berger's "main tradition of painting" could become, for example, a clubby way for critics on both the left and the right to exclude Bacon. Clubs as a rule did not approve of eccentric homosexual screamers. Nor did they welcome those without proper schooling or a respect for others. In his *Listener* piece, Sylvester immediately addressed the issue of Berger's "tradition" by treating it as beside the point.

Bacon did not *want* to belong to the usual clubs, Sylvester argued, but was initiating a new tradition—starting his own club. It was therefore not necessary to discuss his relation to the formal evolution of modernist painting or to engage in the usual "this begat that" of art history. Picasso, in Sylvester's piece, was absent. Bacon's "point of departure" was not painting per se but a response to photography that, in painterly terms, required new formal approaches. Less discerning critics might withhold from Bacon the club tie of modernism, regarding him as a stage manager of flashy effects, but they were blinded by the conventions of their own club. Sylvester presented the many ways in which Bacon used photography. His surfaces had a "matt haziness" rich in smudgy grays and blacks. His figures were casually placed. He chose not to emphasize the flatness of the picture plane, a modernist obsession, but instead led the eye into vague photographic depths. None of this, Sylvester argued, suggested that Bacon was an inferior painter. He simply belonged to a different club, now arguably more advanced than the old one. From late Rembrandt, Sylvester wrote, Bacon had learned how—it was clever to mention Rem-

brandt but not Picasso—to create paintings "akin" to the photography of the modern era. It was late Rembrandt who helped Bacon use a limited palette, work behind and through the picture plane, and dissolve forms in space with "extreme precision."

Only after attending to these broader questions of Bacon's formal skills and their relation to modernist tradition did Sylvester address Bacon's content. But he did so mainly through a further discussion of Bacon's formal gifts in order to emphasize, *pace* Berger, that Bacon did not finally depend upon extravagant imagery. Sylvester hardly bothered to mention the dramatic popes, which dominated the show, just as he ignored Picasso as an influence. He intended a manifesto about Bacon's originality, not a conventional review of an exhibit. He chose to focus instead on a painting from two years before that was not in the most recent show—the early masterpiece *Head I*. "One of his pictures shows the lower half of a human face with the mouth open in a scream," Sylvester wrote, "which is provoked by the fact that one ear is attached to a cord drawn out taut from the ceiling of a room." It was Bacon's visual mastery, Sylvester wrote, that created the excruciating impact of this image. "What makes this image so overwhelmingly moving—at the level of tragedy, not of Grand Guignol—is how vividly we are made to realize the tightness of the cord."

Sylvester also made certain to distinguish Bacon's work from photography. His paint handling could convey, Sylvester wrote, tactile sensations that no photographer could hope to attain. He could use "deliberate and controlled distortion"—something not available to the rigid "mechanical eye"—to create a sense of reality and flux that was truer than a photograph could be to the actual experience of life. Above all, Bacon's subject—despite its "guise" of the "casual" and "everyday"—transcended journalism. His subject was finally nothing less than "a mythology of terror" developed through three kinds of imagery—Crucifixions of various kinds, images of a man bounded and dominated by a curtain, and portraits of figures whose mouths open in a scream:

When these horrifying phantasms are presented to us, as they are, in the same form as the film star getting into her aeroplane, and the goalkeeper failing to make a save, they become all the more disquieting, because all the more to be taken for granted. And it is this, I believe, that gives Bacon's work its value: that he has distilled the essence of human agony and presented it in a perfectly matter-of-fact way. Like Kafka, indeed. And as with Kafka, it only seems to be a matter-of-fact way.

Toward the end of his piece, Sylvester offered one qualification. It was possible that Bacon owed too much to the "peculiarities" of the period, such as the murk in newspaper photography. That might eventually date his work. "But I do know that for me," he continued, as if to challenge Berger on his own ground, "he is today the most important living painter—by which I do not mean the greatest—because no other has expressed as he has our particular attitude to human suffering." Refuting Berger's dismissal of Bacon's art as an indulgent "shriek," Sylvester wrote that Bacon had little in common with the attitude toward suffering displayed by the expressionists—"who frenziedly inflict their personal torment upon the objects presented." Instead, Bacon was a later historical figure, one no longer personally shocked or surprised by suffering. Yet he also had little in common with the cool analytical approach to suffering displayed by the surrealists, who were characterized by "a desperate attempt to exorcise one's fears by looking at them with the cold unblinking stare of the dead. Bacon is as free of this morbidity," wrote Sylvester, "as he is free of the hysteria and self-dramatization of the Expressionists." Sylvester ended by calling for generational solidarity, quoting the fashionable Jean-Paul Sartre:

[Bacon's] paintings embody the attitude which is essentially that of our generation, a generation which has had to learn to go beyond despair: the attitude expressed in the closing words of *Huis Clos*, when Garcin, having recognized that there is no way out and that frustration is endless, says, "Eh bien, continuons." The attitude that life is hell and we had better get used to the idea.

In 1952, Sylvester and Berger together laid out the gist of the arguments that would continue to divide critics over the next half century. Yet they disagreed with each other less than they might then have supposed. Over time, they came to admire and fault Bacon for similar reasons. Sylvester was never an unreserved champion of the popes, especially the later ones, and disliked many of them for the reasons that Berger advanced. (Bacon also had doubts about many of his popes.) Late in his life, Berger became an ardent admirer of Bacon, demonstrating that he was one of those rare critics with courage enough to change his mind in a significant way. Bacon was not a vulgar showman interested only in shock for shock's sake, Berger came to believe, but an artist who presented a world "more pitiless than any painted before," capturing its modern character through a devastating crack-up of Old World meanings. In a 2004

review in *The Guardian,* "Prophet of a Pitiless World," he wrote that "the Renaissance idealization of the naked human body, the church's promise of redemption, the Classical notion of heroism, or Van Gogh's ardent 19th-century belief in democracy—these are revealed within his vision to be in tatters, powerless before the pitilessness. Bacon picks up the shreds and uses them as swabs. This is what I had not taken in before. Here was the revelation."

Berger still disliked Bacon's milieu: the "melodrama of his provincial bohemian circle, within which nobody gave a fuck about what was happening elsewhere." And yet "the pitiless world Bacon conjured up and tried to exorcise has turned out to be prophetic. It can happen that the personal drama of an artist reflects within half a century the crisis of an entire civilization. How? Mysteriously."

A month after Sylvester's and Berger's dueling reviews, Bacon wrote yet another letter to Colin Anderson to beg for money. His creditors were beginning to swarm. "I am in a desperate state," he wrote. . . . Could Anderson lend him four hundred pounds?:

> I am being sued and made bankrupt which starts the most awful complications—The work is going really well and I feel at last I have got through the nonsense and will really be able to paint—I am starting on the autobiographical pictures which I want to do and believe with them I can really get on to the nerve—I have not forgotten what I already owe you and as soon as I have some more paintings in a few weeks I want you to choose any you like—If you could help me I should be so terribly grateful as I am in such a desperate state—All my love Francis.

Anderson was no longer an easy mark. He informed Bacon that he did not want to encourage his gambling. They then agreed that, rather than giving money directly to him, Anderson would pay some of the more pressing debts. Bacon mentioned "two accounts that I simply have to pay." One was to Chelsea Art Stores for paint and supplies. The other was "to the Tailors who are suing me." Bacon also mentioned his personal debt to Muriel Belcher: he owed her 182 pounds. Anderson probably knew all about Muriel and the Colony drinking club. He would have smiled, or perhaps scoffed, to read in Bacon's letter, "She has been terribly kind and lent me this over a long period for day to day living expenses."

"Day to day living expenses"? Anderson was not a fool. "I must say painting is a mugs game when it comes to making money," Bacon confessed to him. "I seem to have spent so much on materials. . . ." "Materials"? Bacon could not bring himself to end the letter without some small defense of gambling. "I would like to explain to you the vice of gambling one day it is for me intimately linked with painting."

Erica Brausen could not solve Bacon's financial problems. She had difficulties of her own. She had no family fortune, and her gallery depended upon quixotic patrons like Arthur Jeffress, who had little sympathy for Bacon's art and none for his extravagant habits. Brausen herself was not a natural businesswoman: her gift was a passionate eye. She often complained that she would have to shut down the gallery. She paid Bacon a monthly allowance and made loans to him, but she could never provide enough to satisfy his wants. In one letter, for example, Bacon asked her if she could please send him an extra fifteen pounds because he had spent his allowance on a suit. Bacon began to consider, in 1952, another way to make some quick money—sell some small pictures privately. It was not that he wanted to deny Erica her due. But he did not want her gallery to then apply most of his earnings toward his debt. That would not give him enough cash in hand. He still dreamt of large, ambitious paintings for Erica, but he had not forgotten Macdonald's observation that small ones were easier to market. He often spoke of painting small portraits or heads. Lucian Freud did well with such portraits; Graham Sutherland was painting them. The Royal College was full of portraitists, among them Rodrigo Moynihan, Robert Buhler, Ruskin Spear, and John Minton. And sometimes, from a failed larger work, Bacon cut out the head—beheading the figure to save the painting. In 1952, he painted some small head studies in what probably began as a way to raise money but became, in the years ahead, an enduring interest. On the question of where—and whether—to sell the small heads, Bacon listened to the advice of David Sylvester and Lucian Freud. Both were devout gamblers who, like Bacon, were more interested in spending than in saving.

Sylvester himself dealt occasionally in art. He could help in that way. Freud, in turn, urged Bacon not to concern himself with Erica's feelings: An artist should do as he liked with his pictures. Freud was also angry with Erica Brausen. In May of 1952, on the eve of his second show at the Hanover Gallery, Freud fell into a mortal quarrel with her. In early February of that year, during a visit to Freud's studio, John Rothenstein had admired two of Freud's best paintings of the period, the brilliant small portrait of Bacon and the early masterpiece *Girl with a White Dog*

(1951–52). On February 20th, Freud and his wife Kitty brought these two paintings to Rothenstein so that he could present them the next day to the trustees of the Tate as a possible purchase. Although Henry Moore and the chairman of the trustees, William Jowitt, remained skeptical, Rothenstein succeeded—with the help of John Piper and William Coldstream—in persuading the board to buy them. Then, when Freud brought his work to the Hanover Gallery for the May exhibition, he informed Brausen of this prior sale of his two best pictures. She was furious. Her commission on the remaining works paled before what she would have earned on the two pictures already sold. Stung, astonished, humiliated, Brausen told Freud: "Get out of here. You don't need to come back."

Freud would not hesitate to tell Bacon, with cutting contempt, his thoughts about Brausen. Bacon was not as ruthless as Freud, but it happened that—in addition to his financial difficulties with the Hanover Gallery—Bacon was also rather annoyed by Brausen's partner, Toto Koopman. Bacon was attracted to close couples, like Dicky and Denis or Erica and Toto, and sometimes jealous of their domestic intimacy, easily feeling excluded or like a third wheel. Bacon knew that both Denis and Erica remained devoted to him, but each possibly loved his or her partner *more*. For his part, David Sylvester, while he admired Brausen, always reserved his first sympathies for a needy artist or critic. Sylvester was a good friend of Helen Lessore, the director of the Beaux Arts Gallery. He knew that Lessore would buy Bacons if given the chance and suggested Bacon drop by her gallery.

Lessore was no less discriminating than Brausen. She was also a well-schooled painter, and a writer with a keen eye. She was even related through marriage to Walter Sickert. Bacon held her in very high regard. Lessore supported representational painting but believed that artists—while educating their eye through a disciplined study of the old masters—must also be part of their time. Artists from the kitchen-sink school favored her gallery, but her taste was not limited by those ideological constraints. She recognized the originality in Bacon. She even wrote about him in *A Partial Testament: Essays on Some Moderns in the Great Tradition*:

> Whatever name one gives it, there is a power which cannot be explained which Goethe called "the daemonic," and which he recognized not only in himself but, for instance, in Napoleon and Mozart; Picasso had it; and it is surely this daemonic element which lifts Bacon high above all the other painters of the present time—

this, and the fact, which goes with it, that he is able to handle, as very few can today, the great themes.

During 1952 and 1953, both Bacon and Sylvester sold paintings to Lessore. Bacon also peddled a head to the Leicester Galleries. (Sylvester was also friendly with that gallery and sold several other Bacon paintings there.) When Brausen closed her gallery for the summer in 1953, leaving Bacon practically penniless, Lessore bought enough of his work to stage her own small Bacon show at the Beaux Arts Gallery the following December. Brausen was furious when she returned and discovered the sales, even demanding that Lessore sell the pictures back to her, which Lessore refused to do. Still, Brausen respected Bacon too much to confront him directly. She was not wealthy enough to support him and realized that he could not live within his means. Even so, the gentleman in Bacon surely felt the shabbiness of selling pictures behind her back. He could reassure himself with the indisputable fact, however, that he reserved most of his major works for Erica—even if they were not yet painted.

Shortly before the trip to South Africa with Lacy, Bacon painted two important pictures, both of which he sold through the Hanover Gallery, in which his love affair probably played a part. They appeared premonitory. One, *Landscape* of 1952, depicted the South African grasslands. The image contained a mysterious tightening in the grass, as if something was ominously forming. Wirth-Miller reportedly helped Bacon develop a way to depict grassiness—with quick strokes and striated forms—that Denis himself used in his landscapes. Never one to remain quiet, especially about something as interesting as helping Francis paint a picture, Wirth-Miller later implied that he placed a few brushstrokes directly onto the Bacon canvas. Wirth-Miller's influence was certainly present in the other painting Bacon produced early in 1952, this time of a dog (a subject traditionally important to the cozy side of English painting). Wirth-Miller took a great interest in dogs as a subject. In October of 1954, he would exhibit fourteen dog paintings at the Beaux Arts Gallery. Bacon had stored some of his possessions from Cromwell Place, including his roulette wheel, in the small building that stood behind the main house in Wivenhoe that Dicky and Denis used for their studios. Dicky's studio upstairs was filled with pleasant furniture. Denis's studio was scrappier, and he invited Bacon to work there whenever he liked—and sometimes Bacon did. His *Dog* was probably painted there. The pose came from a Muybridge series of a dog that influenced both Bacon and Wirth-Miller.

Bacon's painting was large, six and a half feet by four and a half feet, with much of the space on the unprimed canvas left open. An abstract-seeming line defined an empty horizon. On a distant road a few moving cars were passing a single palm tree. A touch of blue suggested the Mediterranean. The bland surroundings recalled *Fragment of a Crucifixion* (1950), where a remote nothingness contrasted with a frightening deposition in the foreground. The same eerie contrast between a furiously erupting foreground and an infinite blandness (and infinite indifference) occurred in the new dog painting. The currish dog appeared trapped—except for a bit of trailing leg—within a green circle inspired by a photograph of the 1936 Nuremberg Rally. He appeared to be circling, tongue dripping, as dogs do when they try to lie down. He could not find peace. Bacon's youth was filled with dogs that his parents—and the society around him—loved with the physical easiness they rarely displayed around their children. Bacon found something deeply human in doggish despair, whatever the growls.

The Violence of Grass

IN JUNE OF 1951—six months or so before meeting Bacon—Peter Lacy bought Long Cottage in the village of Hurst, an hour's drive from London and seven miles from the fashionable town of Henley-on-Thames. His sister Joan lived half an hour away in Newbury. Peter could dip in and out of London, alternating between Long Cottage and a flat in town. Wealthy Londoners began regularly visiting Henley in the eighteenth century—five hours by horse-drawn coach on a good road—and built many fine houses there. The town's élan continued into the modern era with the celebrated Henley regattas. After the war, many Londoners, attracted by green and rolling hills, bought weekend places near Henley. Lacy could have joined Henley society, of course, but he had few traditional social ambitions. He preferred Fats Waller. He was not especially concerned with decorating his cottage, situated on a pleasant country road, though he did lay out his collection of miniature bottles. And he had a grand piano. Outside, he parked his old Bentley and the six-cylinder, right-wheeled Citroën that invariably drew admiring comment. He could drive to London in less than an hour. Henley was minutes away.

In London, Bacon continued to move around. Early in 1952, he lived at 30 Sumner Place in South Kensington, only a few blocks from his previous Cromwell Place studio. By May—after he and Lacy returned from South Africa—he was at 6 Beaufort Gardens off the Brompton Road. But he now began to spend most of his time at Long Cottage with Lacy. They would sometimes drink at the Jolly Farmer, not far down the road in Cookham Dean, or drop into Henley, which attracted writers and artists, among them John Piper and the cartoonist and architectural historian Osbert Lancaster. Lacy had no interest in the literary or art world. He did not conceal his dislike for Bacon's paintings. In fact, his indifference constituted for Bacon part of Lacy's standoffish appeal.

In Henley, their quarreling intensified. Bacon remained an exquisite

needler, especially when drinking, with a preternatural instinct for where the tender parts lay. The rows were painful, but not entirely unwanted. They fought, aware of the consequences and emotional patterns. Bacon would provoke Lacy into a rage. And Lacy—losing control or icing up—would beat and assault Bacon. It was not a choreographed S&M session with clear boundaries, safe words, and delicately colored bruising. The beatings were furious. And yet they stayed together. It can become important in certain lives to lose control. "You can leave your painting and come and live with me," said Lacy, inviting Bacon to Long Cottage.

"What does living with you mean?"

"Well," said Lacy, "you could live in a corner of my cottage on straw. You could sleep and shit there."

Lacy "wanted to have me chained to the wall," Bacon later told Michael Peppiatt, describing Lacy as kinky "in all sorts of ways." Bacon's public comments about the relationship invariably possessed an ironic, mocking tone, aghast but not really. He used heightened words—"disaster," "frightful," "awful"—to suggest that the relationship was utterly mad, as if a curse had been cast upon them by the gods. The disaster was hardly worth rational discussion, then, only a flippant joke or an eye-rolling story. Of course, that particular form of indirection—common at the time—protected one from appearing vulnerable to the charge of emotion or an embarrassingly meaningful moment. Peter himself was an almost silent witness, leaving Bacon's words to define the affair. Over the years, the nature of the relationship—spreading from Bacon's ironic milieu into the larger pop culture—developed the lurid quality of a movie poster. "Peter, a Sadistic Fighter Pilot . . . Francis, a Painter of Nightmares . . . in a Relationship Neither Could Escape!"

In fact, the relationship was complex, serious, and meaningful, the most important in each man's life. It lasted many years. It was never broken off once and for all. Even the story of the straw in the corner was not as simple, or grotesque, as it might at first sound. Both Bacon and Lacy were theatrical and amusing, and Lacy's remark about spreading straw in the corner was a barbed piece of hyperbole typical of his dryly mordant humor. What was one to do with this annoying little bitch queen, after all, but chain her to the wall in a corner of the cottage like a kept beast or pet troll, where she could shit and make her nasty noises without causing too much bother to the men in the family? Not everyone would have enjoyed this form of drollery, of course, but Bacon did. And, like the best black humor, it touched on the truth. Bacon was searching for the primitive animal in the man; his paintings after the trip to Africa began to fill

with actual animals. Lacy's image of a man living on straw like an animal chained in a corner recalled existential theater and anticipated the dark unmasking that—in a cultural atmosphere Bacon helped create—would absorb many English playwrights during the 1950s and '60s. Lacy's image was one of power and powerlessness, of great interest to both men.

Sexual violence was not healthy, of course, but "healthy" was not the point for Bacon and Lacy, two homosexuals who grew up in difficult closeted homes. Bacon and Lacy were releasing demons. Stripping the finely reserved Lacy and provoking tormented rage—and bare-knuckled love—moved a man with Bacon's history. Such a moment would be no less moving to the thwarted Lacy, a man with a handsome surface who, before meeting Bacon, probably engaged in a bit of rough stuff without letting it amount to much. Bacon forced Lacy to open up, insisting upon the painful life concealed within.

One day not long after they began their affair, Lacy gave Bacon a black-and-white photograph of his house in Barbados, an image of the comfortable life he had given up to return to England. Would Bacon make a painting of the house depicted in the photograph, Lacy asked, "copying it as closely as possible?" Lacy could then hang the painting in Long Cottage. Perhaps Lacy really did want such a painting. Given his wry and teasing tone, however, he probably also enjoyed asking Francis to become a Sunday painter who tarts up a photograph by "copying it as closely as possible." That was not the way, Lacy would know, Francis liked to use photographs. It would have pleased Lacy to be the Philistine demanding a "realistic" painting of a place Francis had never seen, one now all but destroyed for Lacy by Bacon and Soho. It was not unlike asking a killer to paint a nice picture of his victim.

Rather than an exterior view of a free-standing house, the photograph was an enfilade shot of a succession of rooms opening finally to the distant sea. Probably completed in the summer or fall of 1952, *House in Barbados* was a small painting unique in Bacon's oeuvre for its apparent faithfulness to a documentary photograph. But Bacon did subtly add and subtract elements—and brought an extraordinary color to bear. He removed most of the exterior wall of the house in order to emphasize two grand doors that led, first, to a space of darkness and shade, but one aroused by some angled light on the floor. This darkness gave way to an illuminated courtyard enlivened by wild sprigs of green and a shimmering mosaic color. This courtyard yielded, in turn, to a room of impenetrable darkness. Then, in the distance, there was a strict rectangle or final door that framed two astonishing blues, one of the sea and another

of the sky. They were melancholy blues, dreamlike blues, that did not describe the actual world. In the center, between the viewer and the sea, Bacon painted what looked less like a vase with flowers than a small and distant idol, arms upheld in supplication.

In later years, Bacon claimed to hate the painting and said that he had made Lacy's house "look as awful as I could so that he would like it." Though more academic than anything else he painted, the picture was certainly not "awful." The obvious care with which Bacon undertook its painting suggested that it was a gift that Bacon did indeed hope Lacy would like, one that even reflected certain important aspects of their relationship. Bacon's affair with Lacy, stretching over most of the 1950s, was not fashioned merely of pain and rage. Much too embarrassing to be discussed were the sweeter moments of intimacy and reconciliation, perhaps even tears, that typically frame episodes of rage and passion in unstable but devoted couples.

Although he played the submissive role, Bacon dominated the relationship. He also considered himself the one more in love. He would push and push and push until, typically, both he and Peter seemed to collapse with exhaustion. It was usually Peter who withdrew from Bacon, for a time, slapping him away to London or Wivenhoe. Bacon still maintained his studio at the Royal College of Art, and in the late autumn of 1952 he faced another show—his fourth—at the Hanover Gallery. Even so, he could not keep away from Lacy for long. Sometime during the period just before the show, Lacy, during a furious row at Long Cottage, hurled Bacon through a window. Bacon hit the ground ten or fifteen feet below. Isabel Rawsthorne breezily reported: Bacon "being drunk survived without much damage." (Freud never forgave Lacy for the violence.) Rawsthorne was no less impressed that Bacon began painting for this next exhibit—scheduled to open on December 9th—only a month before the private view.

No one at the Royal College of Art, that autumn of 1952, would have been surprised by Peter Lacy's image of Bacon living on straw and chained in a corner like an animal. Bacon was becoming their madwoman in the attic, the almost-human creature who occupied the once handsome official studio of their professor of painting, Rodrigo Moynihan. It was in that same studio that Moynihan had been working until recently on the enormous *Portrait Group (The Teaching Staff of the Painting School, Royal College of Art, 1949–50)*. It was that same open, tidy, and utilitarian space—which

contained a handsome old wood file cabinet for storing drawings and works on paper, that Bacon now transformed into an astonishing spectacle of paint, brushes, and important-seeming litter, a cave from which the resident art monster came and went.

Bacon appeared perfectly genial. Some ignored him, but others he significantly affected, though he played no official role in the life of the college. He could force certain artists—as he did more personally with Lacy—to reexamine themselves in ways that were both enriching and disturbing. It was another kind of education. By 1952, the students (and their faculty) could not easily ignore the insistent questioning of what it meant to be a contemporary artist at the midpoint of the twentieth century. The senior common room at the RCA was becoming a center of conversation about new directions in art. It escaped no one there that critics, dealers, and artists were increasingly interested in abstract art. Far from being a passing fad or narrowly focused, abstract art was attracting strong artists of varied sensibility in both Europe and the United States, where the abstract expressionists were beginning a star turn. By contrast, the giant Festival of Britain in 1951, with its sixty painters and twelve sculptors, seemed a poorly focused potpourri—a bit of everything and not much of anything. During the festival, another show stood out. Gimpel Fils, a gallery founded after the war by two Parisian brothers with a philosophical commitment to abstraction, mounted a concurrent exhibit called *British Abstract Art* that included, among others, Ben Nicholson, Barbara Hepworth, and Victor Pasmore. It had precisely the sharp, forward-looking focus that the festival lacked.

At the RCA, where many worked in the traditions of English realism, some teachers and students were understandably concerned. Moynihan himself—an assured artist—appeared free from the conventional anxieties. But the dimming reputation of certain key neo-romantics worried other representational painters. During the war and for a few years afterward, for example, the two Roberts—Colquhoun and MacBryde—went from success to success. John Minton also met with success in the mid-to-late-1940s. *The Studio* magazine featured all three, for example, along with such other neo-romantic artists as Michael Ayrton, John Craxton, and Keith Vaughan, in its March 1946 issue. By 1950, however, David Sylvester—who had lived in Paris and followed the work of the great modernists—was expressing doubts about British painting even as he enjoyed the senior common room at the Royal College. MacBryde was now sometimes dismissed as MacBraque. Although *Vogue* photographed the two Roberts in 1952, their friends were watching the couple enter a

downward spiral of drink, poverty, and despair about the prospects for their work. And while Sutherland continued to claim fame and international attention, the reviews of his 1953 retrospective at the Tate were much more mixed than in the past. Meanwhile, John Minton watched uneasily from the wings.

It was at just this moment of anxiety that Bacon, with Moynihan's blessing, moved into the professor's studio. His studio was now getting, Moynihan wryly observed, "a good rinsing with paint." The teachers and students could not help staring. The studio door was usually ajar. Certain students would steal inside when Bacon was at the college lunches, which were invariably long and wine-soaked, to examine the visceral pictures that were appearing one day only to disappear the next. Traditionally, teachers and students treated the figure as something to be observed, studied, painted, and framed. There was no such distance found in Bacon's pictures. "I first saw him," said one student, "in the students' washroom, stripped to the waist, washing oil paint off his shoulders." The paint also left his easel to claim the walls and floors of the studio. "At one stage he filled a bucket with black house paint and with a broom from the corridor splashed it over the canvas," said the student. "It also went over the walls and ceiling." One artist in thrall to Bacon—though not then a student at the college—remarked with astonishment, "He sees people as mountains of flesh. He is obsessed by this extraordinary capacity for flesh to breathe, walk, talk."

Even when he was in another room, people always knew when Bacon was close. His distinctive voice carried, fluty and funny. He appeared neither fustily professorial nor artily dandified. His suits, those at the college observed, were remarkably fine. "He looked smart and well-turned-out, with spotted ties, elegant dark suits, and if he was to wear a shirt, it looked as if it had been purchased at Harvie and Hudson," recalled John Moynihan in *Restless Lives*. It was no wonder that Bacon's tailor bills were high or that his tailors were suing him. But even as he appeared so physically present, Bacon was also strangely apparitional, like those X-rays and ectoplasmic photographic effects he would sometimes talk about. One day he was there, the next gone. To Africa *twice*. Or to the Riviera—where, rumor had it, he lost fortunes at roulette even though he had no money. He had no fixed address. He moved like a transient from room to room. Did he sometimes sleep on the messy floor of the studio?

Even the most radical teachers at the college were required to show up for class. But Bacon had no classroom duties and followed no discernible rules except to work religiously in the morning. Sometimes, it was

said, he visited a fighter pilot outside Henley who beat him up. He might appear in the common room with bruises, but also joking, convivial, and delighted to pop the cork at noon. Like many others he drank away the afternoons and nights—a conventional enough practice at the time—but his world also purportedly spread well beyond Soho. He drove around in a Bentley with the peculiar Lucian Freud, and he was invited to dinner with Ann Fleming, the former Lady Rothermere, or Stephen Spender. He remained committed to "the figure," which might ordinarily have reassured many at the Royal College, but he did not mollify their fears about either abstraction or weak-tea figuration. There was no rallying of artists in his studio. Bacon was sui generis, a party of one, a leader who refused followers. There was no possible way to "teach" Bacon. He was indifferent to what the college offered—instruction and craft—leaving young artists nothing to depend upon, if they could not count upon the professional secrets of the great traditions. It would actually have been simpler for students if the world were a contest between abstract and figurative art. But Bacon did not even deign to discuss abstract art and appeared to like contemporary figurative art no better, though he was invariably affable about such views. If he shrugged at Henry Moore or Graham Sutherland, the artists around him could only imagine what he thought of their own work.

Bacon was not unsympathetic to the difficulty of becoming an artist. The painter Michael Andrews remembered one student who, impatient with the bandying about of theory and argument, plaintively asked—as so many artists in the modern world have asked—"Why does there have to be all this talk? Why can't we just go out and paint?" Bacon actually softened and became, Andrews said, compassionate, funny, and understanding: "My dear, if only we could!" Bacon's implicit message, however, was disconcerting. If talent, craft, and intelligence could carry you only so far, then the challenge lay not in how to paint but in how to *be*. It was perfectly true that without skill no artist would amount to much. It was equally true that without a powerful sensibility even the greatest natural gift would not catch a spark. Bacon did not put it this way, but he was telling students to find their own Nietzsche.

Robert Buhler, the faculty member who purchased Bacon's Cromwell Place lease, once persuaded him to give students at the college a "critique," a conventional practice at art schools in which a teacher publicly discusses and analyzes the ongoing work of students. One student, Herbert Allen, described Bacon's critique: "He paced up and down in a bouncy way in his thick crepe soles smiling amiably and said, 'I am afraid that I just can't think of anything to say about these paintings. I am told

that I should give three prizes but as they all appear equally dull I can't do that.'" Bacon then began to walk away. Buhler called him back. "Perhaps you could answer some questions, Francis?"

"So he stood smiling confidently at us, rather like an actor," Allen said, "apparently unaware that he now had a hostile audience, most of whom did not value him as an artist much anyway." One student asked why he found the paintings dull. "Because," he answered, "they are all based on someone else's painting." A student countered, "Mr. Bacon, in your last show all the paintings were based on Velázquez. How do you answer that?" And then: "Why are you painting the pope?" The annoying logic flustered Bacon, who, Allen said, "began to justify his work with impulsive, sometimes absurd explanations that he seemed to be making up under the stress of the questions." Bacon replied, for example, that he painted the pope because he wanted to use purple paint—it was as if there were an aspect of his work he was anxious not to reveal or else he really did not know consciously what he was doing. The students could not explain Bacon, and he could not explain himself—at least not yet. Allen considered this exchange between Bacon and the students the most significant lesson he learned during his entire time at the RCA. "Every other artist or teacher had spoken of painting as if it was a craft which one went about in a rational controlled way—Francis was demonstrating that this was not so."

Certain artists naturally worried about Bacon's impact. They did not deny his power but tried to isolate him as eccentric, someone who should not, therefore, affect the normal course of art. In the fall of 1952, the neo-romantic painter Michael Ayrton told John Rothenstein that Bacon's "nihilism" was having "a very bad influence at RCA." Bacon was "one of few people who really did not care for consequences." Ayrton dismissed Bacon as "not a painter, but a *Fuseli*," referring to the late-eighteenth- and early-nineteenth-century artist who attracted attention less for his painterly gifts than for his emotionally wrought subject matter. The painter Matthew Smith, whom Bacon admired, isolated him in a gentler way. In contrasting Bacon with Freud, Smith distinguished between the "respect" he felt for Freud and "the quality of *interest*" he found in Bacon. Freud, that is, was an artist deserving respect for his traditional accomplishments, whereas Bacon was something exotically different, like a specimen an eighteenth-century naturalist might bring back to London from the tropics.

The painter most troubled by Bacon was John Minton, whose sabbatical led to Bacon's original appointment for the one teaching term in 1950. It was the ambitious but uncertain artists who found Bacon most

disquieting, and Minton was both. By the early 1950s, Minton knew that the excitement in art had moved away from the neo-romanticism with which he was identified. He knew that other artists in his circle at the Gargoyle, especially Bacon, were overtaking the leaders of the 1940s. He knew that the art world was becoming, as John Moynihan put it, "increasingly pressurized, snobbish and cruel." Minton's demons, as early as 1951, were there for all to see. In Moynihan's *Portrait Group* of that year, Minton sat apart, a book open on his lap, with his "sullen Modigliani" face (as one friend described it) downcast as the others gathered collegially together.

Everything about Bacon conspired to make Minton look like the good boy who does not quite carry on to the end of the road. Minton was conscientious and talented, troubled by Bacon even as Bacon was untroubled by him. In her biography of the artist, Frances Spalding quoted an account from one of Minton's friends:

> I was once at Johnny's house in Allen Street when he came back in a terrible state with his hair all wet. He'd come out of a taxi as black as thunder. He charged down the stairs. He was abusive to me and told me to get out and Rick was to get out and all sorts of things—we hadn't done anything . . .
> It seems that Francis had bought a bottle of champagne, poured it over Minton's head, massaged it into his hair and said, "Champagne for my sham friends and real pain for my real friends." It sent him absolutely wild with despair.

In his diaries, Keith Vaughan described the impact that Bacon had upon one young representational painter who, while not a student at the RCA, was part of the London art world in the late 1940s and '50s. Denis Williams (1923–98) was an artist from Guyana who studied at the Camberwell School of Art and met Bacon as his affair with Lacy intensified and Bacon moved from room to room in London. (At one point, Williams shared a flat with him.) Williams idolized Bacon. He wanted to help him. "There was nothing I could do," Williams said. "He would lie in bed in the morning, purple in the face, looking ill—terrible—unable to move until he had taken enough pills, but talking all the time about the paintings he had dreamed of. If I offered him a cup of tea he wouldn't drink it. He just didn't see me. I could have been anyone else and he wouldn't have noticed." A story that Williams told Vaughan could be an allegory:

I was in his studio one day and he came in with a suit which had just come from the cleaners. He laid it down on a large table in the middle of the room which was thick with paint, cotton wool, bits of dirty paper and said he had to go out for a moment. As the suit had just come from the cleaners I picked it up and put it on a hanger and hung it out of the way by the wall. My only reason for doing this was that I thought it would be helpful—a small thing—but something he was incapable of doing for himself. Directly he came back into the room, without saying a word, he went over to the wall, took the suit down and laid it again in the paint on the table. I felt absolutely shattered, as though my personality had been wiped out.

Bacon worked with unusual efficiency during the month he gave himself to paint his next show, scheduled for December of 1952. For some artists, love does not distract from the ongoing work: love instead sharpens the focus. Bacon painted two more large dog pictures. He also painted four more grassland paintings. Three of the grassland pictures were big—at six and a half by four and a half feet, the same size as the dog paintings—and depicted ominous, mysterious forms half-concealed in the grass. In one picture, a darkened figure rose into view. In another, two figures were coupled together in clotted shadow. In a third, a naked man was possibly copulating in the grass. Although the human animal became clearer in these pictures, the forms remained dark and shadowy: the atmosphere of the grassland paintings suggested vibrations, echoes, and intimations. He also included a dusky painting with an altogether different spirit—an elephant, seen in the distance, moved across a river into darkness, its majestic form dwarfed by the massive wall of trees beyond it. A tusk gleamed. It was a rare moment of serenity in Bacon's work—a painting touched, perhaps, by love and longing.

In early December, many of the teachers and students at the RCA attended Bacon's overflow private view at the Hanover Gallery. It was suddenly obvious that, at the end of 1952, Bacon was a public figure. His earlier exhibits had been "something of an insider's event," as John Moynihan described them; but now Moynihan found that their "feeling" resembled a competition—"very much like a prize fight, without the punches on this occasion, with Francis up there in the ring, leaving many envious painters and fastidious critics to brood, some highly confused, about his talents from the ringside seats." The observers were not unaware of the English love for dogs, of course, and had grown up with Edwin Henry Landseer's portraits of man's noble friend. (Landseer

had also designed the bronze lions guarding Trafalgar Square and the National Gallery of Art.) But the Bacon dog was the dog of obsession and anger, a cur restlessly circling and circling. Bacon's dogs were "mangy, leering, hungry, shy, malevolent, greasy, crawly," Moynihan thought. They were unable to find a place by the English hearth. In the taxi on the way to Bacon's private view, Minton became irritable. "It's all about Bacon dogs," he said. "Dogs, shitty South African dogs, with foul breath."

For Bacon's supporters, the show and the attendant excitement made for a "particularly satisfying afternoon." David Sylvester appeared to bask in Bacon's reflections. Not only had he championed Bacon in his well-read piece in *The Listener* earlier that year: during the same month in which it appeared—January—he had chaired a panel discussion on Bacon's art at the Institute of Contemporary Art. Sylvester was now understood to be part of the Bacon phenomenon. The critic John Russell, once concerned about Grand Guignol in Bacon's art, was another convert. Like other reviewers, he was impressed by the sudden infusion of Africa into Bacon's imagination and work:

> Mr. Bacon has turned to new subjects for this wonderfully unseasonable display. The most unexpected of these is an imagined Africa: as mythical as Shakespeare's Italy, this somehow contrives to supplant reality. When the crippled rhino founders in the desert, or the elephant comes down to drink in the shadow of the blue forest, what Mr. Bacon gives us is Africa-and-something-else—that "something else" being, of course, the haunting power of private emotion.

Bacon was, Russell concluded in his *Sunday Times* review, "the most interesting painter now practicing in this country."

Bacon usually left London after an opening. And he liked the South of France at Christmas. This year he did not leave but, distraught, instead shadowed Lacy, moving between London and Henley. His friends were struck by the contrast between the powerful London artist and the whipped dog hanging around Peter Lacy's ankles. In addition to drinking heavily, Bacon was now regularly taking amphetamines—as the young artist Denis Williams noticed—then an easy form of self-medication that took the edge off hangovers, fatigue, and depression. Few people in the early 1950s—even doctors—were concerned about the impact of amphetamines on a user's health. It is likely that Dr. Stanley Brass, who

saw Bacon quite regularly from 1948 until his retirement in 1963, felt no qualms about Bacon taking them. Brass may have prescribed the drug much earlier, when Bacon began to see him in the 1930s. It was then that Benzedrine inhalers—advertised as a nasal and bronchial decongestant— became popular and were thought to help asthmatics. Users observed that Benzedrine also created feelings of alertness and euphoria. They opened the inhalers in order to swallow the paper strip inside that was suffused with the amphetamine. "Bennies" were often taken by people in the arts, who thought they improved focus and kindled the imagination. Friends saw Bacon take handfuls of pills. Whether or not they were Drinamyl, the widely used amphetamine of the day, is unknown, but they were certainly amphetamines—very helpful after a painful night with Lacy.

No doubt fortified by the amphetamines, Bacon worked well early in 1953, though he still destroyed most of his pictures. He continued to depend upon that collection of ever-shifting rooms that always seem available by chance to artists moving around in a world of flux. Someone would leave; a couple would break up; a bed was available. Bacon often saw David Sylvester, who liked to live among artists. The artists sometimes joked that "Sylvie" took their ideas and turned them into art criticism a week later in *The Listener;* Minton, who especially disliked Sylvester because of his closeness to Bacon, called the process "pre-Sylvestration." Later in 1953, Sylvester and Bacon even roomed in the same small house, at 9 Apollo Place, just off the Thames. Minton would buy the house the next year. Sylvester began to observe closely what Bacon did in the studio from day to day.

Two important paintings survived from this period. The first was a large screaming pope from February of 1953. It was one of Bacon's strongest popes, which he delivered to Helen Lessore at the Beaux Arts Gallery. As in Bacon's pope paintings of 1951, the pope sat on a gilded chair modeled on the *sedia gestatoria*, or ceremonial throne, on which popes were once carried through adoring crowds. There was no sanctity or dignity about this pope. He appeared open-mouthed with horror, as if he has seen not the Heavenly Father but the devil himself.

Then came something fresh from Bacon: an austere, blue-black image of a man instead of a pope. The man wore a suit and appeared to be sitting on a bed, with the shuttered Venetian blinds behind him letting in some light. His mouth was half-open, and he had powerful teeth. But his form could not quite hold in the blurry murk around him. Bacon liked to intermingle shadows and curtains with flesh, as if the question were not the either/or of hiding or emerging; the closet was the man. Since Sylves-

ter was often visiting Bacon's studio, he was probably the first outsider to see the painting. Like Brausen when she first saw *Painting 1946*, Sylvester bought *Study for a Portrait* (1953) on the spot, recognizing a possible new direction in Bacon's art. The painting was still on the easel when Sylvester arrived to pick it up. Bacon was further darkening its atmosphere, changing the metal tubing of the bed frame from pink to blue and seeking out a rich and velvety darkness. Two years later, Sylvester sold it to Erica Brausen rather than to the Beaux Arts Gallery. Brausen may have persuaded him that new turns in Bacon's art should come first to her.

In June, Bacon went to Monte Carlo looking for a jackpot. This time Muriel Belcher and Ian Board, who helped run the Colony, went with him. They stayed at the Hôtel Victoria, because, said Board, "he preferred ordinary little places." Bacon and Board, who never got along very well—they were rivals for Muriel's affection—had established an amicable truce. The group lost everything in the casino and, in search of funds to keep going, concocted, said Board, a "little burglary." Their target was Norman Fowler, the well-to-do American lover of Peter Watson. As Board told Dan Farson:

> Francis shinned up the drainpipe—he had tremendous strength and vitality. He copped 300 pounds, worth a lot in those days, and went straight back to the casino while we sat in the bar drinking champagne. Francis had a real winning streak, going from one table to another, which was the way he liked to play. . . . Anyhow, Francis won so much that the first thing he did was climb up the drainpipe again and put the money back.

Before Bacon left for the Riviera, Erica arranged a substantial show for October at Durlacher Brothers, a gallery in New York that she knew well. The gallery was founded in London in the 1840s, specializing for decades in high-end furniture and decorative objects. (Sir Richard Wallace of the Wallace Collection was a long-term client.) A New York branch of the gallery opened in the 1920s. Both Brausen and Bacon were eager to exhibit his painting in New York, now a taste-making city with important and wealthy collectors. Alfred Barr, the curator and presiding spirit of the Museum of Modern Art, had purchased *Painting 1946* from Brausen for MoMA and continued to regard Bacon highly. (Not long after Bacon returned from Monte Carlo, MoMA purchased one of his 1952 dog paintings.) By 1957, Barr was proclaiming Bacon "England's most interesting painter."

With his first New York show approaching, Bacon worked irregularly, as usual. He painted eight new popes over two weeks, one seemingly leading to the next. They were not small: each was around five feet by just under four feet. The face of the pope, who sits on a gold throne against a pervasive blackness, was calm in the first painting but became more and more contorted over the course of the series, ending in a "state of convulsive hysteria," as Ronald Alley wrote in the first Bacon catalogue raisonné. It was Bacon's longest series to date and, as Alley noted, seemed like a sequence of film stills. Although nothing Bacon did during this period lacked interest, the new popes were sketchy and did not have the beautifully worked surfaces and enveloping aura of his best work. They were arguably the first "cranked-out" Bacons, somewhat formulaic and created for the market. Yet the series would develop over the decades a strangely postmodern aura, a foreshadowing of the faux luxury and slap-dash pastiche that would later become popular in art.

It was an old tradition among some European painters, of course, to send lesser or studio work to the colonies. Six other new paintings completed the American show. Two were a continuation of Bacon's African paintings, including a powerful image of a baboon sitting in the fork of a tree howling or snarling upward. One other new figure painting depicted an athletic male nude doubled over and crouching on a Baconesque railing. (Railings would become a particularly important theatrical element in Bacon's later work.) He also sent to New York an image of a sphinx, one of two that he painted at the time, set in a grand hexagonal field inspired by the stadium Albert Speer designed for the Nuremberg rallies. The critical reaction to Bacon's first New York show was generally respectful—better than Brausen or Bacon might have expected, given his hasty production. The *Art News* critic noted the unfinished look of the fourteen paintings but found them "audacious enough to explain why Bacon has acquired both influence and imitators in his native Britain." In *Art and Architecture*, James Fitzsimmons praised Bacon's "powerful talent" and his "mastery of means—of line and of a highly sophisticated, atmospheric kind of color." But he also believed, like many other critics, that Bacon's "Grand Guignol" imagery worked against his undeniable talent. "My quarrel is with his taste," Fitzsimmons wrote, "for I do not see how a reasonably adult mind can be expected to take this Grand Guignolism, this romantic fascination with the macabre very seriously."

The strongest review came from the young critic Sam Hunter, who had written a highly original piece the year before about influences on Bacon. He based the piece on an interview with Bacon and on the pho-

tographs he found and photographed in Bacon's studio. Hunter, as if to debate with Fitzsimmons the way Sylvester debated with Berger, argued that Bacon's imagery was "extravagantly unpleasant" for good reason:

> In the most potent images imaginable, Bacon has stated the case for post-war European despair with a vehemence and original-ity that should earn him a permanent place among contemporary Cassandras—those artists and writers who have made esthetic capital of the violent aftermath of the war. . . . Horrific as they are, [Bacon's paintings] have something important to say about our period. They bear the same relation to contemporary experience as Goya's grotesques did to his troubled and dislocated epoch.

A montage of images, many of them dating back to the war years, photographed in Bacon's studio by the American art critic and historian Sam Hunter in 1952

James Thrall Soby, a friend of Barr's who also worked at MoMA—and a man with an adventurous eye—bought the baboon howling at the sky for his own collection, and would eventually donate *Study of a Baboon* to the museum. Barr always claimed, with some justification, that it was

MoMA and not any museum in Britain that first became an institutional champion for Bacon.

In England, the drama of Bacon and Lacy continued throughout 1953. When Bacon found that he could not, finally, live with Lacy in his cottage, he tried the next best thing: he rented a house next door later in the summer. Nothing better conveyed Bacon's passion for Lacy than his willingness to sentence himself to a term in a quaint English village. He loathed the countryside and did not own a car. (He stopped driving after the war.) But the decision probably helped his work. He would have completed nothing inside Long Cottage. Next door, he could be near the man he loved—with a room of his own.

In England, homosexual acts remained illegal even in private between consenting adults. The government began regular crackdowns in the early 1950s. "The homosexual world, invisible to almost all who do not live in it, was still as extensive as it had been immediately after the war," wrote the journalist Peter Wildeblood, who served a jail sentence for homosexual offenses in the 1950s. "In London, there were still a great many men, outwardly 'respectable,' who were in immediate danger of imprisonment because they had chosen to live with another man." The most celebrated victim of the time was Alan Turing, the scientist who contributed so much to the war effort. He was arrested in 1952 and subjected to chemical castration. He was only three years older than Bacon.

Bacon never publicly concealed his homosexuality. He took a chance when he picked up men but was not at great risk since most such arrests occurred either through bad luck—as in Turing's case—or in roundups of men found loitering around public toilets. In any case, Bacon's fastidious nature—and Edwardian manners—generally precluded overt displays of affection. Bacon did not flaunt his homosexuality in his painting, either, though he made no deliberate effort to conceal it. Homosexuality per se was rarely his subject. Certain experiences—such as social masking and unmasking—were, of course, essential to Bacon and to many other homosexuals. But they were also important to many heterosexuals. By 1953, the anti-homosexuality sentiment of the early 1950s was becoming even more frenzied. The home secretary decided to mount a drive against "male vice," and the Metropolitan Police commissioner, Sir John Nott-Bower, reportedly promised to "rip the covers off all London's ilth spots." About one thousand homosexuals were then being imprisoned every year. The attack stemmed in part from a Cold War panic:

such English homosexuals as Anthony Blunt and Donald Maclean could be blackmailed by the Soviets. The situation worsened after the arrest of Lord Montagu of Beaulieu and his conviction in 1954 for indecencies with an RAF serviceman. Peter Wildeblood was one of two others sentenced, with Lord Montagu, to serve a prison term of one year. The arrests eventually led to a backlash, however, the result of which was an easing of laws against homosexuality. But in 1953 the situation for homosexuals was worsening.

At the peak of the hysteria in 1953, Bacon painted a picture of two copulating men. *Two Figures* of 1953—which many people came, in time, to consider his greatest work—was a subtle, beautifully shadowed, but also fierce image. There could be few doubts about what was happening, though some referred to the figures as "wrestlers" (not altogether incorrectly, if by that was meant emotional struggle). A Muybridge photograph of two wrestlers influenced the pose. Those close to Bacon instantly recognized the painting as a masterpiece. Bacon painted the picture in a furnished room at 19 Cromwell Road during one of his periods in London. Also living at 19 Cromwell Road was David Sylvester. Lucian Freud and his new wife, Caroline Blackwood, frequently visited Bacon there as well. Both Freud and Sylvester saw the painting soon after Bacon completed it. Sylvester, acting in his capacity as an occasional agent for Bacon, immediately bought it and then resold it to the Mayor Gallery. (Brausen and Lessore probably knew that their galleries could not exhibit the picture without attracting police attention.) Freud then purchased the painting for himself; he placed it over his bed. Approached once by a potential buyer, Erica Brausen wrote, "You and I realize that it is [the] best painting he ever painted, but it is not a picture easily to be sold. So I wish you good luck."

Freud and Blackwood were naturally concerned about Bacon's health. They knew that he took too many pills. He had both high blood pressure and asthma. He drank to excess. His liver was a mess. His lover threw him out the window. During a dinner at Wheeler's, Bacon informed the table that his doctor, whom he had been to see, had just told him that his heart was "in tatters." As Bacon told it, "Not a ventricle was functioning," said Blackwood. "His doctor had rarely seen such a hopeless and diseased organ. Francis had been warned that if he had one more drink or even allowed himself to become excited, his useless heart would fail and he would die." Bacon ordered a bottle of champagne, and once that was finished he ordered several more. He appeared "ebullient." Blackwood and Freud went home thinking they might never see him again. "We were convinced he was going to die, aged forty."

TWO FIGURES (1953)

No one would call Lucian Freud homosexual, yet he hung *Two Figures* over his bed for more than a half-century. That is because the painting, while important to any discussion of homosexuality in art, is much more than a homosexual picture of two men coupling. It may be the most sensitive, even tender, depiction of the animal-in-the-man to be found in twentieth-century art. No doubt Freud admired the masterful way Bacon painted the lively sheets—so much rough-and-tumble white in a perfect disorder—and his vivid evocation of fleshiness. In *Two Figures*, the bodies are not muscular or sculpted or described in a literal way, and Bacon does not sensationalize the coupling. Instead, he captures something plain, rough, and flat about male flesh. He adds just the right amount of blur to keep the bodies from stopping.

The figures bear some resemblance to Lacy and Bacon, though not enough to become distracting or voyeuristic, and the monochromatic palette allows Bacon to train a kind of spotlight on the coupling figures, as if they were onstage or (as often in Bacon) participating in a sacrifice. Even what David Sylvester called "space-frames"—the geometric lines around the figures in a Bacon painting—have a sensual gleam. A triangular corner in the upper left glows mysteriously, rhyming with the triangle in the bedsheet. The painting is as notable for whispers as for shouts.

This was a radical work that in 1953 could not be exhibited. Even without puritans, squeamishness, and repressive laws, presenting the sexual act between any couple (gay or straight) is rarely successful in art. It is too difficult to capture at once the many elements, physical and emotional, that are part of the experience. Most attempts appear sentimental, pornographic, or simple-minded. The complexity of mood in *Two Figures* makes the picture extraordinary. Its focus is the unforgettable expression on the submissive man's face, a crying out of inseparable joy and pain. The two men are lovers in a rut, cheek to cheek.

Shades of Blue

The Imperial Hotel in Henley, whose anonymous traveling businessmen inspired Bacon's "men in suits" series in the 1950s

Bacon huddled up for weeks on end next to Long Cottage. Living beside Lacy proved as difficult, however, as living with him. Bacon regularly went to London to paint and get away even though he had no settled address. But he could never remain apart from Lacy for long, and so he began to take the train to Henley and stay in local hotels. In March of 1954 he decided to move into the town itself. He and Peter would then be living a few minutes apart. Restaurants and pubs were within easy walking distance. The painter John Piper probably helped Bacon with practical advice. Six years older than Bacon, Piper was both admired and respected in the art world; he and his wife, Myfanwy, had been well established in the Henley area since the 1930s. Piper may have suggested that Bacon stay at the Imperial Hotel until he could find a proper room and studio, though any traveler by rail to Henley would also know the hotel, which stood near the railway station.

The Imperial represented what was most modern about Henley—the railroad that reached the town in 1857 and stimulated the area's modernization. The hotel was built at the turn of the century in the Old English style, generally a fussy Victorian pastiche steeped in nostalgia. It was four stories high and heavily ornamented with mosaics, friezes, and decorative timber work. Nostalgia was, of course, an essential modern trait, and while the hotel presented itself as quaint, it also stood somewhat apart. It looked toward the railway station, not the town (until

the station moved in 1987) and, by implication, to the abstract world of commercial London. It was where a traveling salesman or businessman stayed if he did not know anyone in the area and must catch an early train.

With money scarce for renovations in the early 1950s, the Imperial was becoming threadbare, as was the empire it commemorated. Financially pressed writers, actors, and eccentrics sometimes boarded there. Its Victorian mask still signaled "propriety," but the Imperial also harbored secrets. It was becoming a place to take a mistress or to engage in anonymous or illegal sex. The Imperial had a modern edge, in short, rarely found elsewhere in Henley. The bar was immediately to the right as a traveler entered, at some distance from the front desk. It was fitted out to look luxurious—in the way mahogany suggests "first-class"—which distinguished it from the old-fashioned pubs of Henley, usually homey places where regulars bought rounds for friends.

In Henley, Bacon felt the contrast between the anonymous strangers at the Imperial and the genteel, sometimes violent world of Lacy. He observed the lonely parade of pinstripes, always coming and going, good for a few drinks and maybe a quick go upstairs before the return to the wife and children. Bacon began painting businessmen before he settled into the Imperial in the spring of 1954, but the hotel certainly provided him with a marvelous view of native habitat. Bacon's businessmen looked like they had spent weary hours over a cigarette and a drink in the bar at the Imperial Hotel. They would have reminded Bacon of the closeted and conservative men he knew from his past. They might sometimes have even reminded him of the combustible Peter, who had almost become a stockbroker.

Bacon persuaded one of the anonymous men in suits whom he met at the hotel to sit for him, and he asked the management to let him work in a shed—"a little medieval prefab," as Freud described it. The nameless man became a model that Bacon drew upon for a series of businessmen. Sylvester called the paintings Bacon's blue period. The pictures appeared blue in both palette and mood. In contrast to the pope paintings, where some vivid color could suggest the panoply of an old-world office, these pictures were usually an almost monochromatic blue-black. There would be only a glint of light or color, like a random memory, to serve as a visual foil for the darkness. The businessmen lived in the modern shadows, enveloped in a blue closet of their own making.

The power of these men, like that of the popes, could not hold. There seemed to be no authority in their lines or their lives, not even in the easy symmetry of pinstripes; any hope for control appeared lost to the mys-

terious asymmetries around them. Bacon addressed the businessmen, as he had the popes, for personal reasons. But Bacon's "personal" now had a way of becoming uncannily public. Both the popes and the businessmen were symbols of masculine power and authority that also gave form to a widespread loss of confidence in Western moral and spiritual authority. His alienated businessmen, possibly but not necessarily closeted homosexuals, embodied the tormented Everyman of postwar corporate culture. Bacon made most of these paintings in 1953 and 1954. Arthur Miller's iconic play *Death of a Salesman* was first staged in 1949. *The Lonely Crowd* was published in 1950. *The Man in the Gray Flannel Suit* appeared in 1956.

John Piper was good friends with the Stonor family, the local "gentry" whose estate dated to the twelfth century. Piper brought Bacon's plight to the attention of Sherman Stonor, 6th Baron Camoys, the chairman of the local district council. A room was found for Bacon on Market Street along with a studio in a disused firehouse. Bacon continued to see Lacy regularly, both in Henley and at Long Cottage. He also made friends in the area, in particular a young Dutch-English composer named Gerard Schurmann, then around thirty years old. Schurmann was a protégé of the English composer Alan Rawsthorne, who had recently married Bacon's friend Isabel following Constant Lambert's unexpected death in 1951. (How nice that you two found each other, Isabel told Schurmann, once she learned of the friendship.) For a time, Schurmann—who lived in Henley with his wife—saw Bacon almost daily. No doubt he sensed the difficulty in Bacon's relationship with Lacy, whom he called Bacon's "most intimate friend," but Bacon and Lacy did not fight in public, and Schurmann also saw other sides of their relationship. Lacy "sometimes assisted Francis by giving him money," and he would also tease Bacon, edgily, in a way that they both enjoyed, by playing the straight man to Bacon's reprobate. Lacy was "apt to suggest," said Schurmann, that Bacon "should stop painting and do another job!"

Bacon's friendship with Schurmann was gentle and convivial, nothing like his *Sturm und Drang* with Lacy. He was fifteen years older than Schurmann, a kind of big brother who was sympathetic to Schurmann's situation as a young artist from abroad hoping to survive in a difficult field. It probably helped that Schurmann was a musician and not a painter. It also did not hurt that he was appealingly young and handsome, though not homosexual. (He had the eyes and dreamy look of a poet.) Schurmann felt "flattered" by Bacon's "articulate companionship," and Bacon assisted the younger man in whatever ways he could. "I loved him dearly as a close friend," said Schurmann. "I trusted him in all things, especially his loyalty

and discretion." Bacon even kept a watchful, rather parental eye on the younger man, said Schurmann. He "protected me from many pitfalls and meeting people whom he considered undesirable." He did not permit his young friend to join him in taking drugs.

In Henley, Bacon went in and out of roles and worlds, as ever a man of parts. There can be little doubt, however, of his private despair. He was a solitary Londoner in a quiet English market town, tormented that he could not successfully live with Lacy. Meanwhile, the outside world of exhibits, money, and reputation weighed upon him. After Bacon's renegade show in December 1953 at Helen Lessore's Beaux Arts Gallery, Brausen—eager to reassert her prior claim to Bacon—pressed him for a show in June of 1954. She wanted this show to coincide with the 27th Venice Biennale that same month. Bacon had been selected, along with Ben Nicholson and Lucian Freud, to exhibit in the British Pavilion, which could extend his reputation in both Europe and America. But Bacon, given his situation with Peter, did not want the pressure of a London show, even of older, unsold work. He wrote Brausen:

> I am not able to finish any paintings at the moment so will you please put off the exhibition . . . I will let you have the paintings I owe you as soon as I possibly can but please do not have a show of the things you have got in the gallery of mine /I think it would be a great mistake to show them both for you and for me . . . I am desperate and completely broke and am going to try and get a job for a time—I am terribly sorry about this but will let you have the pictures as soon as possible I hope before the end of the year. Please forgive me but I cannot finish them at the moment /best love, Francis.

Bacon was not serious about getting a regular job, but perhaps Lacy had made the joke often enough. In the end, Bacon yielded to Brausen and managed to paint, quickly, a new series of *Man in Blue* paintings for the exhibit at Hanover that June. The Biennale, in turn, included a collection of nine works, beginning with *Three Studies* and including popes, heads, and a sphinx, which were intended to be representative. David Sylvester contributed a statement: "In these claustrophobic curtained settings, there loom up before us beings whose shadowy, ambiguous, unexpected presence takes command of any setting they survey, making real beings seem like shadows. They are appalling as they are compelling, for these are creatures faced with their tragic destiny."

Despite the attention, Bacon himself was now hardly to be found. He

did not go to the Biennale in Venice but remained mostly holed up in Henley. His condition worsened. A girl of thirteen, a devout Catholic whose family was friendly with John Piper's, made a visit to Bacon's studio one day with her father and Piper. They found Bacon sleeping on the floor in some bedding provided by the Pipers, looking not unlike Lacy's animal chained to a wall. He was "out of his mind with drink, pee on the floor, hadn't changed for days." She was shocked. Just as memorable to her was the extraordinary way he rallied. He "had a beautiful voice," she said. The three polite visitors pretended not to notice his condition or surroundings, but she remembered "a long conversation about good and evil and Bacon saying you could make a choice between the two"—which the young Catholic found helpful and exciting.

Bacon and Lacy concluded that Henley would not work for them. They had failed to live together in the same house or next door; now, they had failed to live together a few miles apart. It was remarkable that they did not give up, instead deciding to try somewhere else entirely. By 1954, Lacy was beginning to regret his decision to leave the Caribbean and move back to England, where he had made a name for himself as neither a stockbroker nor a pianist. Dan Farson also believed that Lacy, by the mid-1950s, had lost most of his fortune through a failed investment in a music group. Bacon and Lacy both loved the south, where it was possible to live reasonably. Perhaps they would be happier in a less claustrophobic place than England, warmed by the sun and not cooped up in small wintry rooms.

Bacon thought first of Monte Carlo or Nice, of course. He and Lacy probably made a trial run to the Riviera late in the summer of 1954. Isabel Rawsthorne, who tracked Bacon's movements in the early 1950s, wrote to Peter Rose Pulham that Bacon "might call in on you on his way south. He's being driven there I think by Peter Lacy. It would be towards the end of August." Whether or not Bacon saw Pulham as they drove down through France is unknown, but a series of black-and-white photos of Lacy and Bacon on the rocky Mediterranean coast likely commemorated this trip. There are snaps of Bacon with a group

Bacon—who said that he "loathed" beaches—relaxing on one, probably in the South of France

of other homosexual young men on a two-masted schooner, itself the star of several photos. Like the other men, Bacon wears shorts and is sometimes shirtless. His face—the beautiful pansy shape Patrick White described—still appears untouched by age, even though he was in his mid-forties. His body is trim. Lacy appears older than Bacon. He is lean and silver-haired, shirtless, and wearing dark glasses. He could be a famous character actor.

The intimacy of the photographs is striking. Bacon, who detested "beach" vacations, is shown stretched out on a towel reading intently. The camera hovers lovingly, taking in his elongated figure in bathing trunks and also his widespread thighs. Two mats are placed cozily together on the sand, one obviously for Bacon, the other for Lacy, who was likely taking the photograph. In another shot, Lacy floats on his back off the schooner. And in still another, this one a dramatically lit indoor shot, Lacy lies silhouetted against the darkness, his eyes closed and his body bathed in a golden light. The camera pays special attention to Lacy's white trunks. It is almost a pinup shot: the romance is palpable, as is the pleasure taken in the body.

Despite the charms of the Côte d'Azur, Bacon and Lacy decided to spend the winter in Rome. Peter would not want Francis to be in the casinos all day and night, losing what was left of Lacy's money after he lost his own. Bacon probably agreed. In early November, they packed up Lacy's Bentley again and headed to Italy, where they planned to spend at least two months, though Bacon told Isabel Rawsthorne they hoped to stay until April. At first they settled in Rome. (For his postal address Bacon chose the Hotel d'Inghilterra in Rome, which was long favored by elegant English travelers.) But the "American invasion," as Bacon wrote Erica, made the city too expensive. So Bacon and Lacy retreated west, to a furnished flat with a terrace in Ostia, the Roman resort town on the beach next to Ostia Antica.

In the off-season, Bacon reported, "masses of apartments" were available for next to nothing. Bacon and Lacy would often spend the evening in Rome and then drive home. Their flat was modest, inoffensively modern in design, and looked west over the water. Ostia had some charm, but not the monied allure or architectural panache of the Côte d'Azur. And now, in late fall, it appeared lonely and echoing, as resorts will in the off-

Peter Lacy lying silhouetted on a bed, his body bathed in a golden light, in what is almost a pinup shot

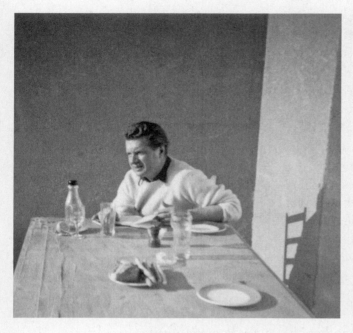

season. Its spaces probably reminded Bacon of de Chirico, who emptied the classical world into a modern stage set. The photographs the couple took of their flat look oddly staged: each man photographed the other alone since no third person was there to photograph them together. One shot of their terrace depicts, with no human presence, two place settings on the otherwise bare table. Another lovingly frames the Bentley parked below their terrace. It is the only car on the otherwise deserted street.

In November, not long after they arrived, Bacon wrote David Sylvester: "I find I can work terribly easily and I think well here—I am very excited about the new series I am doing—it is about dreams and life in hotel bedrooms. . . ." In a letter to Erica he told her, "I have finished 2 large ones." One that survived was *Two Americans*—two anonymous men placed in the same sort of darkness as the figures in the *Man in Blue* series. The darkness was broken only by the tiniest glint of gold tubular framing behind the two men, whose faces were blurred beyond recognition. After the previous June's Biennale, in which Bacon's work was granted pride of place in the main gallery of the British Pavilion (Ben Nicholson and Lucian Freud were accorded a lesser positioning), the Roman art world naturally took some interest in Bacon. Eager for sales abroad, Brausen alerted colleagues in Rome to his arrival. Perhaps Gaspero del Corso and his wife, Irene Brin, who ran L'Obelisco, the main contemporary gallery in Rome, would want to exhibit his work. Bacon went to a few parties, but Roman society bored him: "I love Rome not the social life the little I have seen but the Town." To Erica he reported that del Corso would not want to pay her much commission if he ever mounted a Bacon show, and besides, the gallery space was too cramped for his current pictures. Bacon also made a trip to Naples, perhaps with Lacy. Bacon preferred it to Rome, as he wrote Erica. The Bay of Naples not only reminded him of the Riviera, but Naples itself was redolent of the ancient world. Bacon could relish its great museums and the often histrionic character of Neapolitan culture—which sometimes had a touch of Grand Guignol.

Bacon on the lonely terrace of their flat in Ostia, near Rome, where he and Lacy retreated after their disastrous efforts to live together in Henley

At one point during his stay in Italy, Sonia Orwell wrote Bacon that someone wanted to do a book about his art, in which quotations from reviews would accompany his paintings and Bacon would comment as well. George Weidenfeld had hired Orwell in 1951, first as a reader and then an editor at his Weidenfeld & Nicolson publishing house: she was proving her worth as an acquisitions editor. Bacon's response was both oblique and imaginative. He could imagine composing a kind of auto-biography, he told Orwell, but not anything straightforward. He could evoke his life in a book that combined paintings and public or newsy pho-tographs, creating "a sort of life story which ran underneath the events of the last 40 years so that you would not know whether it was imagina-tion or fact." He could "distort" the photographs into "a personal private meaning." By so doing, he might create something more true, he wrote, than the recorded facts.

Eventually, Bacon and Lacy had a devastating fight. Lacy returned to England, leaving Bacon bereft. The problem might not lie in their sur-roundings, he was now forced to acknowledge, but in themselves. It was probably Bacon who precipitated many of the problems. He was highly wrought; he could not live without intensity. But most relationships could not survive too much truth. Lacy wanted sometimes to be left to himself or to pass the time just enjoying life. Toward the end of his time alone, Bacon was often in Rome. He was "extremely unhappy emotion-ally." He claimed to "loathe" churches, but spent much of his time in St. Peter's "just wandering around." He did not mention any other places in Rome. Although he often visited this church of the popes, he did not go to see the Velázquez painting that had inspired him, *Pope Innocent X*, at the Villa Doria Pamphili, not far from the Vatican. He never said with precision why not. (Besides, he now considered his pope paintings unsuc-cessful.) Perhaps he did not want to meet Velázquez for the same reason he avoided Picasso.

In January of 1955, Bacon—cutting short his Italian stay—returned to the English winter. Earlier, on December 27, he had written to Erica more or less telling her that his relationship with Lacy was over. "I am leaving Henley and am going to try and find a place in London where I can really settle for a change and perhaps let when I go away / I am so sick of never having a permanent place." On January 24, not long after his return, Bacon served as a witness in Henley to a deed of sale for Long Cottage. His own address was listed as 9 Market Place in Henley and his occupation as "gentleman." Lacy now intended to move to another southern place, Tangier, this time without Bacon. Serving as a witness

to the deed of sale would have been an extraordinarily painful moment. Bacon could no longer maintain the illusion that they would ever live together. Lacy, Bacon said, had fallen for someone else.

Four days before the sale of Long Cottage, with all its attendant sadness and pain, the first retrospective of Bacon's career opened at the Institute of Contemporary Arts on Dover Street in Mayfair. A so-called collective that had been founded after the war by, among others, Peter Watson and Herbert Read, the ICA was—in Read's words—a "daring" enterprise meant to showcase important contemporary art. The Bacon retrospective, composed of thirteen paintings, included the recently painted *Man in Blue I, Sphinx* from 1953, and *Figure with Meat*. Painted in Henley the previous year, *Figure with Meat* was a conflation of Bacon's popes and *Painting 1946*. Here the pope was squeezed to the very bottom of the canvas, while two hanging carcasses of meat overwhelmed him from above. Lucian Freud bought the painting.

More shocking for many was *Two Figures in the Grass*, which was painted in 1954. It was a companion piece to *Two Figures*, the painting of two coupling men, with the difference that now the two figures were depicted outdoors in a grassy field that could almost be a black-box theater: there were railings around an enclosure. At the back were the striated black forms common to Bacon's paintings at the time, which also resembled curtains in a theater. The flesh on the two bodies was lovingly highlighted, and the lower figure seemed to radiate carnal pleasure. Two women who went to the show were so appalled by the image that they reported it to the police—who came, looked, and pronounced the painter innocent.

In his review of the show, the *Daily Mail* critic wrote of the dark shadow that Bacon cast over contemporary art: "In London art schools Francis Bacon is a force to be reckoned with. He has to bear part of the responsibility for the mass of depressingly drab and nightmarish work that students are producing just now in hundreds." If any further proof were needed that Bacon was becoming a dominant figure in contemporary British art, however, the reviewer also noted what he called Bacon's influence over Graham Sutherland. "Among the first to realise the strength and newness of Bacon was Graham Sutherland," he wrote. "Bacon has increasingly of late cast his 'Svengali' spell over Sutherland. Clear evidence of Bacon's spell-binding comes to the fore in Sutherland's much-discussed portrait of Winston Churchill." (The official portrait, which both Churchill and Lady Churchill detested, was in the end rejected.) The *Times* critic had reached much the same conclusion one year earlier when reviewing Sutherland's Tate retrospective. He thought that Suther-

land, in several recent works, was "drawing uncommonly near in style and sentiment to Francis Bacon." No doubt the Sutherlands recoiled from such reviews, which cast Sutherland as Salieri and Bacon as Mozart.

The miserable artist paid little attention to the show. He visited Dr. Stanley Brass at his surgery, who found him worse off than usual. "My father frequently commented in his records that Francis was overweight, overwrought, stressed out, suffered heart palpitations and was most often in a state of nervous tension," said Paul Brass. Bacon needed more than his usual mix of anti-anxiety drugs and depressants, Dr. Brass Sr. decided. It was probably at this visit that he prescribed Largactil for Bacon, the first of the so-called psychotropic drugs, which were used to treat severe depression, among other things. The two Brasses would continue to prescribe high doses of Largactil to Bacon over the years as needed when his nervous anxiety became pronounced.

On the day of the private view, Bacon had lunch with Janetta Parladé at her house in Montpelier Square. Parladé was a celebrated beauty who seemed to know everyone: she had worked at *Horizon* briefly and was a great friend of Frances Partridge and the Bloomsbury world. After lunch, Bacon announced that he would skip the opening. "Oh no, Francis, you shouldn't," Parladé told him. "Francis was protesting a lot. In the end I persuaded him to go if I drove there." When they arrived, they were almost turned away for being too casually dressed for the occasion. Finally, "somebody came from behind and recognized us," said Parladé. "I was wearing a tweed coat and skirt—countrified." Not long after the opening, Lacy telephoned Bacon to inform him that he was leaving for Tangier, telling him that he never wanted to see him again. From now on, he said, Bacon should consider him "as dead."

Around this time Bacon's young friend Gerard Schurmann, who was working on a musical piece called *Nine Poems of William Blake*, asked Bacon if he might be interested in contributing an image of Blake for the cover of the song cycle. Schurmann took Bacon to see the Blake life mask at the National Portrait Gallery in London. Bacon did not respect Blake's visual art, and while he could not dismiss the distinctive poetry—he would probably admire "The Tyger"—the poet who wrote the line "Little Lamb God bless thee" was not going to be his cup of tea. But the life mask captivated Bacon, though he found most of the other portraits in the gallery dreadful. Later, he was given a plaster cast of the mask, which he kept until the end of his life.

In his makeshift studio at the firehouse, as he prepared to return to London full-time, Bacon made three small paintings of the mask.

Blake's wife had not liked the mask when it was cast in 1823, as it did not convey the poet's characteristically light and playful expression. The face looked sealed, like that of a man steeling himself to get through some unpleasant business, as indeed Blake was doing while the mask was made: he was left to breathe through two straws placed in his nostrils as the plaster hardened. No doubt Bacon loved the visceral physicality and simultaneous ghostliness of the mask. Each of his three initial versions was different. The first was strongly featured, inward-looking, and otherworldly—a face barricaded against the dark. The mouth was down-turned in the second in an exaggerated way, almost like a sad-sack clown. Still, the power in the face could not be penetrated. Bacon striated the third with shadows; creating an evanescent head that appeared lost in a meditation from which it would not awaken.

Bacon's friends welcomed him home to London. "Nobody wanted to talk to anyone else," Sylvester observed, "when he was around." With more time, Bacon began to see old acquaintances, having lunches and dinners with Janetta Parladé, Stephen Spender, Cecil Beaton, and Lucian Freud. It was also friends who helped him find a room and, in March, a studio at 28 Mallord Street, Chelsea, which had been purpose-built in 1913–14 for Augustus John. (Among those who sat for John at Mallord Street were Thomas Hardy, George Bernard Shaw, T. E. Lawrence, and W. B. Yeats.) Bacon resumed his Soho life. He entertained lavishly. John Rothenstein was amused to hear that Bacon had given a luxurious dinner at Wheeler's for a big group of friends after having told Bernard Walsh that, as he was so broke, he would have to stay away from the restaurant for a while.

It was during this period that Bacon became friendlier with Rothenstein—a friendship that would have important consequences in the future. Rothenstein had just survived the worst crisis of his career. At the time, "the Tate affair," a bitter and much-publicized controversy over the direction of the museum, was still the talk of the art world. Rothenstein's main detractor in the Tate fight was Bacon's nemesis Douglas Cooper, the champion of Continental modernism in general and Picasso in particular. Cooper, a red-meat critic, had attacked Rothenstein for halfheartedly collecting the great modernists across the Channel while overvaluing provincial English work. Partly goaded by Cooper, Graham Sutherland, once friendly with Rothenstein, then resigned from the Tate board in protest. The controversy reached a climax during the private view of a Diaghilev exhibition, when Cooper loudly remarked that Rothenstein would soon be out of a job. Rothenstein—diminutive, tidy,

bespectacled—then punched Cooper—large, slovenly, loud—in the nose. It created one of the better teapot tempests of the time. "The Tiger of the Tate," as the small Rothenstein was subsequently nicknamed, kept his job, and the controversy slowly faded away.

Bacon did not take sides during the Tate dispute. The stuffy but well-meaning Rothenstein was pleased that Bacon, the most radical and difficult English artist of the period, remained friendly with him and retained an interest in English art. Rothenstein enjoyed Bacon's conversation and gentlemanly manners. The director was even beginning to think about writing a short book on Bacon. That would then confirm, ipso facto, his interest in difficult modern art. ("Francis Bacon agreed to cooperate in a volume on his work, seemingly with great warmth," Rothenstein wrote in his diary in 1956.) And he welcomed the odd night out with Bacon, whose tour of the Colony and the Gargoyle a few years before had proved so revelatory. At the Colony, Rothenstein now reported, were "Johnny Minton, Rodrigo Moynihan and more, but FB King in that world."

The person who confirmed Rothenstein's regard for Bacon during the 1950s, however, was Roy de Maistre, with whom Rothenstein developed a close friendship that lasted until de Maistre's death in 1968. Rothenstein often discussed Bacon with de Maistre. The two gents enjoyed clucking affectionately over Bacon's naughty adventures and dissolute habits. Rothenstein found de Maistre's stories about Bacon as amusing as he found Bacon himself, writing that he enjoyed Bacon's company "immensely." Besides, Bacon had done Rothenstein a favor: when asked to write the foreword to the catalog of Matthew Smith's 1953 retrospective at the Tate, Bacon agreed. In the end, because he was desperately behind in preparing for a show of his own, Bacon produced only a "note." But it was an important note, a tribute from a younger artist to an older one. (Smith was thirty years older than Bacon and a favorite of Rothenstein's.) Bacon praised Smith for achieving "a complete interlocking of image and paint," so that "the brush-stroke creates the form and does not merely fill it in." Bacon was of course projecting his own ambition onto Smith.

Soon enough, Bacon also had a new patron: Robert Sainsbury, then fifty years old and the co-manager with his brother, Alan, of the family's vast grocery business. Sainsbury was an unconventional collector. He bought mainly tribal art—then called "primitive art"—which was not fashionable in London. He mainly liked powerful sculpture, and in painting he preferred artists like Giacometti who had a sculptural feeling for the body. His wife, Lisa, had a gentler and more lyrical eye, but she was no

less resolute than her husband in defense of difficult art. ("Most people know," she said, "that I'm extremely direct.") She had recently purchased Bacon's small masterpiece *Study of a Nude* (1952–53), in which a minuscule standing diver—naked and seen from the back, arms upraised—appears ready to dive into the unknown. She then decided that Francis Bacon must paint a portrait of her husband. He would prove an ideal sitter for Bacon's first commissioned portrait. He admired Bacon's art, and he did not expect to be flattered.

In March of 1955, Sainsbury occasionally sat for Bacon in the morning. Neither man found the Mallord Street studio—which Michael Astor, a Conservative politician with an interest in art, had lent to Bacon—a congenial place to work. The glass skylights did not keep out the wintry drafts, and the light was always changing. Sainsbury would wear his overcoat inside the studio and bring sandwiches to keep them going. The finished work, *Portrait of R. J. Sainsbury* (1955), fit naturally into the series Bacon made of businessmen, but was more conventionally "realistic" than the others. Perhaps, for this patron, Bacon held back a little. The awkward situation of artist and subject, or artist and friend, made Bacon uncomfortable. He felt obliged to amuse his guest. He also considered all portraits "dual"—that is, they reflected both the artist and the subject— and it seemed to him indelicate to impose himself on another. Those few people who did sit for Bacon said that he invariably turned the event into a delightful social occasion.

In the resulting portrait of Sainsbury, the magnate's expression, accented by his glasses, was pleasingly quizzical, as if he were squinting at eternity. It led to further commissions, notably a series of pictures of his wife. (She sat for Bacon at his next studio in Battersea.) Lisa found the sittings, always in the morning, great fun. She would settle into a chair in the middle of the room. Bacon would constantly dry his hands on the curtains as he worked. He encouraged her to move around as much as she liked as they talked and gossiped. Only rarely would he fall silent with concentration. She grew "particularly fond of" Bacon. "He had an enormous impact on our lives," she later said. "Because he was so interested in everything." She was once asked, "Did you talk about other painters with him?" She replied, "Oh yes, and he destroyed them with great pleasure."

Lisa found him even more dismissive of his own work: "I don't think I've known anybody more self-critical than Francis." He would never let her see the image on his easel, and he would regularly destroy what he painted, telephoning her to say, "It's gone." He told her so often that "it's gone," or "it went" that she and her husband were surprised that anything

at all survived. Once, while they were having drinks with Bacon in Soho, he told them, uncharacteristically, that he was pleased with the work he had done that morning on a pope painting. He invited them back to his studio where, suddenly, he found that he actually disliked the painting. He intended to destroy it. The Sainsburys protested. They particularly admired the head of the pope. Bacon then scissored out the head from the wet canvas and gave it to the Sainsburys, who drove it home on the top of their car so that it would not stain the seats.

Bacon completed eight portraits of Lisa Sainsbury, together with the one of her husband, and destroyed many others. A second painting of Robert Sainsbury developed into *Chimpanzee* of 1955. Bacon reported that Sainsbury was not offended: "Oh no. I've already told him." *Sketch for a Portrait of Lisa* (1955) was his first surviving painting of a woman and one of his finest portraits. Lisa Sainsbury saw little of herself in the picture but did not mind: "I never felt they were quite me but I think they're marvelous." (One probably apocryphal story made the rounds about Lisa's portrait. "What a terrific portrait of your father," someone said to one of the Sainsbury sons, who dryly replied, "Yes, but it's of my mother.") There was a royal aspect to the elongated body of the middle-aged woman who looks out from the painting. She appears to be at once modern and classical, an ancient Egyptian living in mid-century London. The shadowy bands or serrations that Bacon pulled through her form gave her flesh, otherwise vividly present, an otherworldly timelessness.

Although the Sainsburys did not consider Bacon's work expensive— "It cost about a thousand pounds for the whole lot," said Lisa later—they were disciplined collectors who kept to an annual budget for art. But they were too generous and mindful of the responsibility of the patron not to help Bacon. Robert Sainsbury guaranteed payment of Bacon's overdrafts. And no doubt they found some way to press coin into Bacon's palm. (In September, Bacon took one of his regular trips to the South of France, perhaps supporting the casinos with some of their grocery money.) David Sylvester and other friends knew that Bacon disliked the Mallord Street studio, and so the word went out: Bacon soon had another patron, Peter Pollock, the homosexual heir of a Midlands light steel company.

Then in his mid-thirties, Pollock was a sometime gentleman-farmer in Hertfordshire, where he had once been the lover of the Russian spy Guy Burgess. He liked artists, writers, and imaginative people, much as Peter Watson did, and was often in London where he owned a substantial flat in Battersea. His lifelong partner, Paul Danquah—who was then studying law—lived full-time in Battersea. The flamboyant Danquah had been

born in London to an English mother and a prominent Ghanaian politician who settled in London to escape political difficulties. They made a striking couple. Pollock was blond and boyish "in the Rupert Brooke tradition," as Dan Farson described him. Danquah was black, and both were extremely handsome. (Danquah, then thirty years old, began acting while studying law; he became a barrister and eventually a consultant at the World Bank.) They often drank at the Colony. Danquah recalled Muriel Belcher asking him if they might have a spare room for Francis. The couple already knew and liked Bacon. In an act of remarkable generosity, they invited him to join them in Battersea. Money was not mentioned.

Bringing Bacon into their flat was not like letting a relative use an extra bedroom. Not only did Bacon sleep there, using a servant's room that had space only for a bed, a wardrobe, and two chairs; he also took over an entire room next to Pollock and Danquah's sitting room which he transformed into his studio. He could control the light from windows that looked north over Battersea Park. The neighborhood suited him. Just across the bridge from Chelsea, Battersea was then, as Danquah put it, "a respectable part of unfashionable London" (although a much seedier area existed just south of it). Quite a few homosexuals lived near Battersea, and some mild cruising occurred in its large park. Pollock and Danquah's flat, up three flights, was part of an elegant Victorian development called Overstrand Mansions. It was built along a curving road—Prince of Wales Drive—that ran along the park.

Pollock and Danquah had a monied, bohemian outlook and an open relationship. They knew exactly how to treat Bacon: they were accustomed to a life almost as freewheeling as Bacon's own. Danquah had previously lived, for two years, with John Minton, and their cruising and queeny behavior had almost led to trouble several times. Danquah was as capable of outrageous acts as either Denis Wirth-Miller or Minton. "Danquah was very warm and friendly to one and all," said Christopher Gibbs. "You couldn't stop him taking his clothes off and dancing on the table wherever he was, being very saucy indeed, outsaucing Francis." The pair also had a third roommate, John Hutton, whom Gibbs recalled as "always hurrying, rushing up and down the stairs, always being sent out on errands of one kind or the other." Danquah nicknamed him "Breathless Johnny Hutton."

Pollock and Danquah did not bother Bacon. Nor did they tiptoe around him. They tolerated his eccentricities. Sometimes, he would bring home "boyfriends who were bad news," usually from rough pubs in the East End.

But that was less often than some might imagine. Bacon preferred regular boyfriends. He often gambled, sometimes at the racetrack—betting on dogs or horses with Sylvester or Freud—but more often at a club after a night of drinking at Muriel's. (Casinos were not yet legal.) Occasionally, he returned with fistfuls of fivers, which he scattered about to help pay for his lodgings. But he could not put Lacy behind him. He was often tense, and once erupted at Thomas Blackburn at the Colony, perhaps dousing him with champagne as he had Minton. Blackburn's offense was probably nothing more than being a heterosexual man with whom Bacon had once been emotionally close, reminding him of another straight-seeming man whom he still loved.

Bacon was now entering a long period when the completion of paintings became more difficult than ever. To raise immediate cash, he continued to sell occasional work out of the studio. He sold directly to, among others, Helen Lessore at the Beaux Arts Gallery and Kenneth John Hewett, a distinguished dealer of ethnographic art and antiquities. Hewett was probably acting as the agent for the collectors who had by far the largest holding of Bacon's art, Jimmy and Brenda Bomford in Aldbourne. Hewett delivered five more Bacons to them in 1955 and 1956. He also worked closely with the Sainsburys, who may also have encouraged him to buy from Bacon's studio.

In January of 1956, a large show of American painting—*Modern Art in the United States: A Selection from the Collection of the Museum of Modern Art, New York*—opened at the Tate Gallery. The mid-decade show, which traveled across Europe like a Stars and Stripes caravan, made stops in Paris, Zurich, Barcelona, Frankfurt, The Hague, Vienna, Linz, and Belgrade. Its impact was considerable. It would eventually be regarded by many as an expression of the Cold War, a symbolic assertion of Western freedom in the face of Soviet totalitarianism. (One sponsor, it was later suggested, was the CIA.) Not all the Americans included in the show painted abstractions, but the airy freedom of the abstract expressionists registered with European artists. The wide-open scale and untrammeled color in American painting could seem intoxicating, making Soviet realism look dreary and European art appear by contrast small, fussy, and—in the case of neoromantic painting—old-fashioned and provincial. Jackson Pollock was hurling paint across the floor, invoking some primitive life force. Willem de Kooning was turning canvases into "activated fields." Europeans tidily prepared the palette. So went the cliché.

Bacon took in the expansive scale, the propulsive brushwork, and the striking patches of flattened color. None of the hallmarks of American

abstract art appeared immediately in his work, but they were no doubt considered by the interior eye that every painter possesses and would, soon enough, subtly affect his art. In the meantime, Bacon continued to look for what to do next. He had made a series of popes. He had made a series of businessmen. Now, he was quietly selling this and that out of his own studio. Early in 1956, he painted his first so-called van Gogh painting, *Study for Portrait of van Gogh I*. It was based on van Gogh's *The Painter on the Road to Tarascon* (1888), a self-portrait of the artist walking to work carrying his paints and easel, which was destroyed during the bombing of Dresden. Bacon's picture appeared, in certain respects, to be a rejection of free-flowing American art. It was representational, and the background tightened into a stygian darkness that contrasted starkly with the free American light. But the extremely thick brushstrokes that Bacon used for the figure of van Gogh were a departure from what had come before in his painting, and the image possessed a kind of clotted power.

Van Gogh's own painting was a self-portrait of a man going to work. The Bacon painting was also a self-portrait, symbolically if not literally, and its differences with the original were telling. In Bacon's work, the artist was not walking along a clearly-defined path but stood poised between "the violence of the grass" and a downward sloping road. His dark shadow linked him to the road. He was staring directly at the viewer, his thoughts not on the work ahead, and the picture around him was seemingly falling to pieces. His face had character but was almost featureless and the stare almost eyeless. Like most painters, Bacon revered van Gogh's letters, and he genuinely loved his paintings. But why paint van Gogh? Perhaps Bacon was responding to the image of an artist in a southern landscape. And the idea of an artist caught in midstep along the road of his art could naturally move a middle-aged artist. Perhaps the painting's destruction in the bombing also interested him.

It was strangely prescient, however, that Bacon should choose to paint van Gogh. It was another example of his instinct for what was stimulating Western culture, an instance of his knack for turning private demons into public revelations. Implicit in the American show then touring the Continent was a romantic celebration of the artist as a moral figure: the artist, while often misunderstood and abused, might yet represent and embody the values of Western society when nothing else was left. (The Nietzschean in Bacon would not have agreed with this romance.) In the popular imagination, Vincent van Gogh was not just walking the southern road. He was walking the Western road. At mid-century, van Gogh was becoming a pop standard bearer for the moral glorification of the

artist. Both his art and his sad, sacrificial end—when society all but abandoned him—helped make this possible. Irving Stone's biographical novel *Lust for Life*, published in 1934, began the apotheosis. Just a few months after Bacon painted his first van Gogh painting, MGM released, to great fanfare, Vincente Minnelli's movie version of *Lust for Life*, which starred Kirk Douglas as Vincent and Anthony Quinn as his friend Paul Gauguin. The art pot was beginning to boil. Bacon probably sensed that he might make further paintings on the theme, but did not do so immediately. His first van Gogh painting attracted no immediate interest. He sent the picture to the Hanover Gallery, and Erica sold it to the Sainsburys two months later.

On those days when Lisa Sainsbury came to sit for Bacon, they would sometimes talk about gambling, and Bacon discussed with her his interest in fate. He did not really believe in such a thing, yet both were intrigued by the way some chance encounter or moment in life can suddenly change everything. In the late spring of 1956, Bacon had such a moment. He received an unexpected telegram from Peter Lacy. Would Francis like to join him in Tangier? The telegram shocked Bacon. Did Peter still love him, more than a year after their terrible parting? Bacon immediately became so desperate to leave for Tangier that he all but ignored his friends—for which he later apologized, but explained that "I was really a bit mental." He begged Robert Sainsbury for a loan to make the trip. The timing could not have been worse: Sainbury's father had just committed suicide. Bacon, ordinarily sensitive about such matters, asked anyway—a measure of how much he wanted to see Peter. He did not tell Sainsbury the reason for his trip, but instead emphasized his painful struggles with art:

> I hope you will forgive me for bothering you at this time—but I have been in a bad way mentally and physically for the last few months and I simply cannot work and I feel the only hope is to try and get away for a few months—and perhaps if I get away I shall be able to start working again. . . . I have not told Erica I have written to you. She is very annoyed with me as I do not produce any pictures for her but I simply cannot. If you could possibly manage this it would be a godsend to me.

Bacon asked for 450 pounds, a considerable sum. Sainsbury obliged. Bacon used 150 pounds to settle his most pressing debts and saved the rest for his trip. To reach Tangier as quickly as possible, he traveled by

plane—wags called it "the queens' flight"—carrying on board with him a number of "huge canvases." He hoped to stay awhile. He might yet revive his love affair—and perhaps renew his art.

STUDY FOR A PORTRAIT (1953)

Bacon loved to expose secrets. The hysteria in many of his screaming popes is often visually high-pitched—the eruptive part of his temperament—with dramatic purples and golds set among bright swirling forms. But with *Study for a Portrait* he moved into the shade, tamping down the hysteria in a claustrophobic room. His restrained subject became a man in a business suit rather than a pope in a cape. The Everyman role of "the businessman" in the 1950s was no less spiritually fraught than that of pope. Instead of asking whether or not God was dead, critics were asking what meaning a salesman found in modern society.

In *Study for a Portrait*, Bacon extends the conventional questions put to "the businessman." His subject is not simply despair in modern Western society, but the despair of a life passed in shadows. His businessman could be a closeted homosexual, but also anyone with a secret life—emotional, criminal, sexual—who cannot emerge into the light. The room tightens with vertical and horizontal bars, and it is full of enfolding shadows. Ribbons of darkness, softly striated, pass down through the man's face, and his blue suit is melting into shadow. Just his left collar and cheek—and his crooked teeth, which seem only for show—can hold much light. (The bit of golden glitter to his right is out of reach.) In the murk, even his shape seems to contain a secret. His upper body appears formally straight, as if for public presentation, but his legs are awkwardly drawn up on a daybed, like puppet legs on a string. He could be laughing or screaming, to himself alone.

Tangier

Tangier was a lady with a reputation. She historically attracted not only invaders who valued the strategic location of the port—just across the strait from Gibraltar—but also smugglers, exiles, and travelers with an eye for the exotic. The adventurous hoped to find, in a port poised between Europe and Africa, whatever was missing at home, which was often sexual adventures that could only be dreamt of elsewhere. The English maintained a naval base at Gibraltar in order to protect their Mediterranean trade routes, but they also took an avid interest in Tangier, which was briefly an English colony in the seventeenth century, and between periods of Moroccan rule, it was dominated by the Western colonial powers. In 1923, England, Spain, and France agreed to turn Tangier into an "international zone." "This 'international' status reinforced the conviction," wrote one historian, "that Tangier was a city apart from the world, on the edge of a continent, overlooking two oceans, caught between Africa and Europe, between Islam, Judaism, and Christianity. . . ."

Tangier became a city without a country, one in which authority was left intentionally unclear. The police had little to no power over Westerners, who made up almost half the population. Not surprisingly, Tangier then attracted eccentrics, exiles, and nonconformists—often more exotic themselves than anything "the Orient" offered. Homosexuals, eager to live freely, found Tangier especially congenial. The English expatriate community in Tangier maintained its own newspaper, church, and clubs; Gibraltar, a ferry ride away, was within lunching distance. Some expatriates lived in elegant villas on what was optimistically called "the Mountain," a hill on the Bay of Tangier. Others lived well enough—better than they could in Europe—in dodgier parts of the city. The low cost of living probably appealed to Peter Lacy, who still wanted to live well but needed to watch his money. "Everything cost nothing," said the Moroccan author

and artist Mohammed Mrabet, who knew the expatriate community well. "You could rent the best house here and pay 1500 pesetas per month, that's to say nothing at all." Inside Tangier there flourished a gossipy English village, but one with a campy, farcical edge, more Mapp and Lucia—the writer E. F. Benson once lived on the Mountain—than Jane Austen or George Eliot. Everyone had a secret, usually shared.

During the 1950s the "uncrowned queen" of the Mountain was David Herbert, the second son of the Earl of Pembroke and a close friend of Cecil Beaton and Brian Howard. A brilliant dabbler and enthusiast—a typical entry in the local English paper read, "The Hon. David Herbert is just back in town after his 'wild plant gathering trip' in Morocco"—Herbert hosted the most elegant parties in Tangier at his ornate pink villa on the Mountain. Tangier also took particular pride in another kind of queen, Barbara Hutton, the American Woolworth heiress who married a succession of Europeans with obscure titles. She had also been the wife of Cary Grant. (The couple was nicknamed "Cash and Cary.") Hutton would occasionally arrive at her Kasbah palace and throw wildly opulent parties designed, it seemed, to impress a sultan.

Flocks of young Spanish and Moroccan men filled the streets. The soft-eyed charm of young Mediterranean men was as alluring, for European homosexuals, as the Grand Tour itself. Few homosexual travelers then considered sex with adolescent boys wrong, and among Arab men who had little money or access to women before marriage—which often did not occur until they reached their late twenties—a youthful period

Socco Chico, in the heart of the Kasbah, the old town of Tangier

of same-sex recreation was not necessarily regarded as sexually definitive or perverse. "There were thousands of Spanish boys and also Moroccan boys and everybody did whatever they wanted, no problem," said Mohammed Mrabet. Expatriates typically hired one or more houseboys, who might provide additional services, and pickups were easily found in the streets and bars of the old town, especially around the Café Central, or at the beach cafés and the public baths. Narcotics were as easy to come by as sex. One often fueled the other.

Bacon dropped easily into the English community. The *Tangier Gazette* announced his arrival, on June 29, 1956, in typical village style:

> In Tangier for a holiday is the young English painter Francis Bacon, whose work is considered by experts to be England's most outstanding contribution to the arts since the end of the war.
>
> Bacon, whom we met the other evening, is quite unlike the conventional idea of the artist, but then most genuine artists are. We found him reluctant to talk about himself or his work, and it was from his friends and admirers that we learnt how highly he is regarded and that he represented England at the last Venice Biennale.

Bacon had been the subject of a short profile in *The Sunday Times* before he got on the plane, which the *Tangier Gazette* writer probably read. The profile announced Bacon's emergence as a person of interest outside the narrow art and literary worlds of London. The breathy feature had spoken of Bacon's frightening imagery—"a demonology more appropriate to *The Revenger's Tragedy* than to the *Essayes* of his first-Elizabethan namesake"—and linked Bacon to Nietzsche, who "has always fired his imagination." Clearly impressed with Bacon's family connections, the *Times* feature writer also spoke admiringly of Bacon's "aristocratic disdain" for success: "If I have another ten years, I might get to be good." Flattered to have a celebrated painter in their midst, the expatriates in Tangier helped Bacon find a place to put the large canvases he carried with him on the plane. The director of the local museum lent him a room at his institution, which was up some winding streets at the very top of the old quarter, to use as a studio.

It was telling that Lacy, after the never-again break with Bacon and the retreat to Tangier, would invite him back. Perhaps, having once lived

Peter Lacy in Tangier. He never lost his weathered good looks despite his epic drinking

with a man like Bacon, he now found the days without him emotionally flat, like a world without the theater. He may have grown bored with Tangier. It was becoming clear that Lacy, never able to find what he was looking for, was also incurably restless. He could not settle down in Barbados, London, Henley, or Italy. But the likeliest reason for the invitation was also the simplest: he missed Bacon. The artist found Lacy somewhat changed after a year, a little softer and more wistful, age and alcohol having dimmed some of the fire. Bacon appreciated an air of beautiful futility. Lacy still kept up appearances, the very model of the well-made Englishman—sun-shot and with drink in hand—who put passion in parenthesis and listed toward the diverting shade of the Arab alleyways.

The writer Robert "Robin" Cook—a sometime member of the Tangier expat community known for his British noir mystery writing under the pen name Derek Raymond—described Lacy in Tangier as "wearing a pristine lightweight suit and bow tie. His white shirt was spotless, and he had the pale, elegant fingers of people whose admirers say, 'You should have been a pianist,' with the difference that he was one." Tangier enabled Lacy to become what, at heart, he probably always wanted to be—the piano man at the bar, at home like Fats or, in *Casablanca*, the character Sam, who serenades the world-weary Rick. Any larger worldly ambition no longer held any interest for him, but he might yet drink Scotch, play the piano, and dabble with local men.

Lacy played the piano around town, but mostly at Dean's. In a city full of bars and clubs—the Bar Paradis, the Bar Marchica, L'Escargot, Le Coeur de Tanger, all open from eight p.m. to six a.m., if not around the clock—Dean's did not seem flashy, but it was showy all the same. It shared certain traits with the Colony. It was small, cramped, and ugly, and its owner was a castaway for whom running a bar was a calling, not just a job. Joseph Dean was a dapper black man who conveyed the impression that he knew where all the bodies were buried. No one was sure where he was from: it was said he once had a bar in Goa. Bacon found him "charming." An old photograph shows Dean and Bacon posing together outside the bar. Bacon looks at least ten years younger than his real age, the late forties. His curly shock of hair does not seem touched by time, and his body appears youthful. Bacon's arm circles Dean and his hand rests lightly on Dean's shoulder. Everything looks bleached in the hot glare of the Moroccan sun. Behind the two men, the sign over the door in Arabic seems suitably strange.

Dean had been the bartender at El Minzah, the grand hotel—originally a palatial house—near the old quarter frequented by the British and

other higher-end tourists. It was whispered that Dean had underworld connections, dealt drugs, and knew smugglers—that, for a price, he could get anything done. Like the Colony, Dean's was mostly a homosexual bar for serious drinkers, but it was also visited by curious sippers, among them Errol Flynn and Ava Gardner. Few Moroccans went to Dean's, and the regulars would have disliked the idea of any "décor," so Dean's had no Oriental touches for the tourists—though for a time there were dancing boys in a back room. The grandees sometimes descended from the Mountain with their guests and went to Dean's in order to give them a look at life below the belt.

Dean's was gossipy, quarrelsome, and unsentimental, except, perhaps, for a certain washed-up-on-a-far-shore melancholy. The talk was mostly of travel and pretty boys, said Mohammed Mrabet. Ian Fleming, now married to the former Lady Rothermere—at whose ball Bacon had mercilessly booed Princess Margaret—went to Tangier to work on a James Bond novel during this period. He wrote to his wife:

> My life has revolved around a place called Dean's Bar, a sort of mixture between Wilton's and the porter's lodge at White's. There's nothing but pansies and I have been fresh meat for them. David [Herbert] is a sort of Queen Mum. He calls himself Lord Herbert and has that in the telephone book. Says he can't get them to change it as they don't understand "honourable." He's been very sweet to me but I'm fed up with buggers. They all do absolutely nothing all day long but complain about each other and arrange flowers ... Francis Bacon is due next week to live with his pansy pianist friend who plays at a bogus Russian restaurant.

Bacon and Lacy had grown shrewder about their relationship. They might have preferred to live together in the same house or flat, but their best long-term arrangement was to live apart while remaining a couple. Bacon stayed initially with Lacy at the Hotel Cecil and then they took time off for another trip to the South of France in Lacy's Bentley.

Bacon and the mysterious Joseph Dean in front of Dean's Bar, a mostly homosexual hangout for serious drinkers

Upon their return, Bacon moved first to the respectable Rembrandt Hotel on boulevard Pasteur, one of the main streets in Tangier, and then to the far more offbeat Villa Muniria, a peeling rooming house on the water run by a Vietnamese woman who, people said, had once been a madam in Saigon. (It was always helpful in Tangier to have a past.) The Muniria was a favorite of American writers, among them William Burroughs and Allen Ginsberg, whom Bacon would meet the following year.

For Bacon and Lacy, Tangier offered more diversions—and less time, therefore, to quarrel—than Ostia or Henley, which were small places that isolated them in small rooms. Bacon moved fluently among intersecting social circles, much as he did in London, including the high end. He might attend a dinner party at David Herbert's villa or that of the aristocratic Louise de Meuron, scion of a wildly eccentric and fabulously rich Swiss family, who also lived on the Mountain. Or he might meet friends for drinks at the Café de Paris, steps from El Minzah and across the street from the French consulate. The Café de Paris was the center of upscale society in Tangier during the day and a well-known Western meeting place. But it was not prudish. Nothing in Tangier was prudish. It was the only rule. The playwright Joe Orton once tried to chase away some straitlaced tourists from the Café de Paris, telling them they had "no right to be occupying chairs reserved for decent sex perverts."

Not surprisingly, Bacon favored Tangier's version of Soho, the more down-market old town, or Kasbah, centered upon the square called the Socco Chico (or Petit Socco in French). At the celebrated Café Central, which stayed open all night, the young men would momentarily meet your eye. There were Arab places, Spanish places, and French places. There were filthy all-night waterfront dives where Bacon might happen upon someone he'd seen the night before at David Herbert's. He was impressed by the physical beauty of the local men, whom he called—sounding like his father discussing a horse—"superb looking a great mixture but with predominantly Berber strains." Gambling could be found, of course, since everything could be found in Tangier; but without the casinos of Cannes and Monaco Bacon could go broke more slowly. And then there was Dean's, where Robin Cook met Bacon one afternoon. "He was broad-shouldered, rubicund and definitely looked like an Englishman," wrote Cook of Bacon, "except that I thought his eyes probed a little too far, further, in fact, than was good for them. He had a bottle of champagne beside him and was covered in splashes of paint."

Bacon typically appeared at Dean's in "rolled-up shirtsleeves," said Cook, and "leaned carelessly on the counter with his back to the bottles,

his crossed legs adorned with a pair of green wellington boots." Cook's description of Bacon's probing eyes was apt. He was easily bored. He required tension. The young Moroccans and Spaniards might be fetching, but he was more interested in difficult, emotionally intense sex than in pleasant diversions with a pretty boy. Aberrant sex wasn't really aberrant in Tangier—it was ordinary. And Tangier should have been more French, to please Bacon. Educated conversation was rare. As for the beach—Bacon knew about the beach, he had lain on the beach, but the beach confounded him. "I have learnt to swim a bit," he wrote to Denis Wirth-Miller, "but apart from the wonderful looks of the people it is a dead town. The Europeans are terrible. Peter seems to like it and seems to want to live here—but after a year I don't believe he could stand it."

Then, unexpectedly, Bacon found a more serious vein in Tangier. It wouldn't have to be an English village, after all. The impact of two wars had led some intellectuals to dream of an escape from a morally ruinous West. Modernists with an existential edge—preeminently, the American writers Paul and Jane Bowles, but also Jean Genet, William Burroughs, Tennessee Williams, and many others—thought living in Tangier might represent more than a desire for the exotic, or sensual pleasure. It could instead symbolize a sometimes dangerous passage toward self-discovery. Drugs and sex might transform and not just titillate. On this existential stage set wanderers from the West might discover what had been lost. Tangier could become a revelation.

Bacon soon came to know Paul and Jane Bowles, the reigning literary couple in the city. Paul Bowles first visited Tangier in 1931 on the advice of Gertrude Stein and Alice B. Toklas, and he moved there full-time in 1947. His highly regarded novel *The Sheltering Sky*, published in 1949, was set in North Africa. Jane was also a novelist and a playwright of note. Of the two, Bacon preferred the "very amusing" Jane. "Paul was very kind, but I don't feel I was ever able to make much contact with him," Bacon said. "He liked marijuana and I liked alcohol, and they create very different worlds." Bowles, for his part, thought Bacon seemed like a man "about to burst from internal pressure." But the Bowleses were undeniably stimulating to the bored artist: Bacon now wrote Erica Brausen that he found Tangier "in lots of ways very exciting." Paul, a musician and folklorist as well as writer—he studied with Aaron Copland—was a mandarin with a fastidious, dandified, and rather scholarly mien. He took a serious interest in Asian and Islamic cultures. He was fluent in Arabic. His high-mindedness and a certain timidity sometimes annoyed Bacon. Bowles disliked the idea of being publicly called a homosexual. (He and Jane

Bacon with his Moroccan protégé, the artist Ahmed Yacoubi, who came from an ancient line of storytellers and mystic healers

were both bisexual.) Friends nicknamed *Without Stopping*, his autobiography, "Without Telling." Even so, Bowles's outlook held some appeal for Bacon during a period when he wanted to renew his art.

When Bacon first arrived in Tangier, Bowles was spellbound by a handsome and astonishingly fit young Arab protégé who, for Bowles at least, embodied everything missing from the West. Ahmed ben Driss el Yacoubi—Ahmed Yacoubi for short—had been born into a family of storytellers in the primeval city of Fez. He appeared to be steeped in ancient secrets and lost arts, including a mystical healing practice known as *f'qíh*, and traced his family to Mohammed. He was robust, good-humored, and beguilingly free, responding sexually to both men and women. He seemed preternaturally gifted in the arts. He was a maker of images—he had initially worked in leather and decorative pottery—in addition to being a storyteller. When Bacon first met him, Yacoubi was making ink drawings, and his Western friends had arranged shows for him in Tangier and were urging Brausen to exhibit his art. Always interested in fostering his protégé's career, Bowles thought that Bacon, in addition to talking to Brausen on Yacoubi's behalf, could offer him technical tips. Ambitious young artists, in the mid-1950s, did not just do small line drawings. Could Bacon perhaps—Paul wondered—teach Yacoubi how to use oil paint? The prospect had slightly comic overtones that Bacon, never far from a laugh, surely appreciated: the self-taught teaching the unschooled.

Uncharacteristically, Bacon decided to let Yacoubi observe him working with oils in his new studio in the Kasbah. Bacon also let Yacoubi use his Winsor & Newton paints. They communicated well enough with scraps of French and Spanish, but agreed to remain mostly silent in the studio, where Yacoubi sat "watching him like a cat." In a letter of the time, Bacon referred to Yacoubi with passing admiration. How seriously he regarded him as an artist was unknown—probably not very. Bacon admired few living artists, and he did not share Bowles's optimistic view of non-Western societies, which remained somewhat colored by the "exotic East" sentiments of the colonial period. The cynic in Bacon also

likely noted that Yacoubi, in addition to his artistic gifts and impressive lineage, was adept at using his charm to advance his own interests. Bacon told Erica that he thought a Yacoubi show would do well in London, "especially if he came over too." Yet Bacon, who loved the ancient world, may also have felt moved by Yacoubi.

In the summer of 1956, Yacoubi completed a number of oil paintings for a show in Madrid that fall. Not long before the opening, a writer for the *Tangier Gazette* went to Paul Bowles's house for a preview of Yacoubi's latest work. He or she was astonished to see—in place of Yacoubi's previous "precise, jewel-like" pen-and-wash drawings—"mighty swirls and splotches of vivid color which hit the viewer like a blow on the head." Amid all the high drama, "as you look a face appears menacingly from the confusion." Bacon had some impact, whatever the language barrier between the two. Bowles professed himself amazed. He was unable, he said, to "imagine for myself exactly what happened as [Bacon] painted."

As usual when he lived in the sun, Bacon promised to be productive. He wrote Robert Sainsbury that he was excited by a painting of camels. He made a brief trip to Paris during the summer, probably to firm up plans for a show that Erica arranged for the following spring at the Galerie Rive Droite. Even as Bacon was committing to Tangier, the prospect of Moroccan independence began to suppress, slightly, the traditional gaiety of the city. Morocco declared its independence from France in 1956, and its government tried to assert its sovereignty over Tangier. Under the headline "Doomed Town? Boom Town," the local English paper declared, "Considering the halcyon days of yore, when Tangier waxed fat on economic liberty and financial freedom, the prospect of a sudden eclipse, a return to normalcy with currency control and a protectionist tariff system, looms darkly. . . ."

In September, Bacon, pressed for money and the prospect of his approaching shows—including his first one-man exhibit in Paris—wrote to Denis: "I must come back and work. I have not been able to finish anything here and feel I never will." In Tangier, he worked out plans for about twenty pictures to complete in London, though such plans were "as you know only a shadow." He was "dreading Battersea and the debts" and hoped that he could sneak into London with no one knowing. "I want just to work and I am afraid they will all be down on me with the awful debts." Late that month, Bacon left for his Battersea studio, parting from Lacy on good terms. He intended to return as soon as possible to

Tangier. He had little to show Brausen after his months abroad, but she understood his ways. It was promising that he was back in London. The pressure on her was mounting as ambitious abstract art from New York continued to create talk—and prices began to increase. Brausen wanted to arrange further exhibits for Bacon abroad, and she planned to bring a revised version of the show in Paris to the Hanover Gallery. About two and a half months before the Paris opening, Bacon, having completed little work, probably left London to spend Christmas with Peter in Cannes. They both loved spending the holidays on the Riviera, a pattern that continued over the next few years.

After Cannes, Bacon returned to Battersea. The pressure was unnerving, but the situation Bacon faced in the winter of 1956–57 was not unfamiliar, and it was one of his own making. Something in Bacon welcomed the tension. It deepened the internal tremors that sustained his art, giving him the devil-may-care courage to try something new. In the past, pressed by a deadline, he had learned to make a series based upon a successful work. His painting of van Gogh's *The Painter on the Road to Tarascon*, exhibited in the last show, could obviously be extended into a series. But he did not immediately take up the idea. Perhaps he did not want the world to think that he was "commenting" on the van Gogh phenomenon following Vincente Minnelli's much-discussed movie.

As his Paris deadline drew close Bacon tried pictures of animals—owls, a chimp, a gorilla skull. There was a scream (a powerful image of the woman with cracked spectacles from *Battleship Potemkin* set upon a naked female body). He made a painting of a Muslim man carrying a child, an unusually gentle idea—a father in a maternal role—that he did not pursue further. He worked up another picture based on Pope Innocent X. He painted a series of five melancholy pictures of Peter Lacy that lacked the power of his earlier series of businessmen. He might well have destroyed many of these paintings had he not needed to fill the walls. But Bacon did produce one remarkable work that winter that looked past the uninspired recasting of old ideas. *Figure in Mountain Landscape*, painted in November of 1956, was unique in Bacon's work, a painting so bold and brushy that it verged on abstraction. It was hard not to see some influence from the American painting show earlier that year. The "space-frame" that Bacon often used to establish order and structure almost disappeared in this painting, absorbed into the sea of paint strokes. The "figure" in the title was also almost lost to the all-over pattern of the landscape. Only the blue sky at the top, and the dark shadows of several deep ravines, remained to orient the viewer. It seemed to be the antithesis of the "tonal

painting"—subtle gradations of color used to create images—that characterized much of Bacon's previous work.

In the end, Brausen sent twenty paintings to Paris. To fill out the show, she was forced to reach quite far back. She included two popes from Bacon's series done in the summer of 1953, plus a dog painting from 1954. Bacon himself regarded his Paris show as feeble, just a recycling of earlier work. He stayed away from the opening, even though he was in Paris at the time, writing Erica an excuse on the back of one of the gallery notices: "everything went wrong and I *couldn't* get along." No doubt he had had an attack of nerves. Paris mattered to him. In the same note, he told Erica that he hoped "the show will go well. I hope to have some *good* [his emphasis] paintings for the show in London."

The French response to his show was warmer than Bacon's own. Bacon, determined to do better, uncharacteristically continued to struggle in his Battersea studio during the course of the Paris show. It was then that he unexpectedly took up the van Gogh theme from the year before—perhaps because everything seemed a disaster, so the risk was less. The Sainsburys had purchased the original painting, so he could see it again. In a frenzied burst, he then made several paintings, in just a few days, on the theme of van Gogh's *The Painter on the Road to Tarascon.* So absorbed did he become that when he went out he did not wash as carefully as usual. The artist Frank Auerbach, who was friendly with Bacon, was surprised to notice for the first and only time some Prussian blue under Bacon's fingernails. Three new paintings were ready for the opening—but just barely. The paint was still wet. The remaining two were added, also still wet, during the course of the Hanover exhibition.

All five were an emphatic departure from what came before, though the breakthrough *Figure in Mountain Landscape* indicated the way. That first homage to van Gogh remained in keeping with Bacon's light-against-dark work of the earlier 1950s, with van Gogh's figure picked out against the prevailing darkness of the background. Now Bacon brought in the sun. Gone was the dark, monochromatic palette. Gone, too, was the subtle tonal brushwork. The paintings were suffused with hot Mediterranean colors—brilliant blues, sizzling reds, fierce yellows—and the gestural brushworks resembled the bravura spirit of the abstract expressionists. Martin Harrison, in the catalogue raisonné, wrote that Bacon seemed to have "taken up the challenge of European and American expressive painterliness."

On the day of the opening, Bacon had lunch in Soho with John Moynihan. He was helping nurse Moynihan through his parents' mari-

tal upheavals (and eventual divorce). Nothing indicated to Moynihan that it was a day unlike any other or that Bacon's opening was just hours away. At some point during the lunch, however, "Francis's round jowls snapped sideways, his hawkish eyes boring into me," wrote Moynihan. "Do you know those marvelous Van Gogh paintings of his daily walks to work in Arles, *The Painter on the Road to Tarascon?* Sheer torture for the old dear. I've rather followed them up. You must come and see them at the Hanover." After a "reasonable time," Moynihan said, they took a taxi to the gallery where Erica Brausen was in more than her usual flap about an opening. The lights were blazing. The smell of fresh paint permeated the space. Brausen was concerned that viewers would brush up against the wet canvases and get paint on their clothes—which Moynihan did: "The shoulder of my Harrods 'young man' suit brushed against one of the pulpy red-yellow raging oils on canvas, leaving a smear, which made Francis chuckle: 'I only finished it this morning!'"

Brausen was annoyed, but Bacon could not have cared less, and told her how to remove any paint stains: "Just soak them in champagne, Erica dear." The private viewing was mobbed. John Rothenstein found himself offended by the "sinister" crowd: "drunk, tough students, car-salesman types." At one point during the private view, a picture hook suddenly gave way, badly cutting a man's head. Bacon "leapt forward to staunch the wound." There was, wrote Moynihan "eulogistic back-slapping and buying." John Golding in *The New Statesman and Nation* wrote: "The gallery is crowded from morning to night," while "the pictures, some with the paint still wet on them, are selling like hot cakes." Something "new and important" seemed to be happening. "For better or worse," he concluded, "Bacon has become the most controversial and influential living English painter."

Alfred Barr of the Museum of Modern Art admired the van Gogh series, but some other serious eyes expressed reservations or offered faint praise. Henry Moore found the series "remarkable" and the technique "increasingly skillful," but also called it (in perhaps an oblique reference to *Lust for Life*) "excessively influenced by ephemeral things: films, photographs in press etc etc." Bacon's "melodrama," said Moore, "would quickly look flat," though he found him "with all his defects, a better painter than Graham Sutherland." Two ardent champions, David Sylvester and John Russell, also could not warm to the series. Sylvester found most of Bacon's recent work wanting, in fact, and during this period fell out with him over what was likely a pretext. Bacon described Braque's late work as "mere decoration." Sylvester, an admirer of Braque who sometimes

wearied of Bacon's narrow view of what mattered, became annoyed. No doubt he thought Bacon could sometimes have used Braque's pictorial intelligence.

Bacon himself remained uneasy. The public's obsession with van Gogh was disorienting. He would naturally worry that his paintings were riding a fashionable wave or did not represent a serious enough response to the Dutch master. Bacon considered van Gogh, who died at the age of thirty-seven, to be "one of the very greatest painters who have ever lived," saying that "what I admire is his ability to put across a tremendously complex sensation in such a simple way." Was Bacon's link to van Gogh even more presumptuous than that to Velázquez? And what of those who suggested that his new work was influenced by the brash Americans? Bacon scoffed at the idea of such influence, but that did not mean he was unconcerned. The art world was rapidly changing. New money was coming in; international art galleries were forming; New York appeared more powerful than ever. David Sylvester was rumbling. Erica Brausen was grumbling. She wanted more paintings to sell.

In January of 1957, the month before Bacon's show in Paris, John Minton committed suicide. He was thirty-nine. On his easel rested a painting of James Dean, like van Gogh a pop icon, who had died at the age of twenty-four. The causes of Minton's suicide were varied and complex, but one important element was the fading of his kind of figurative easel painting. It had lost its place. Bacon, eight years older than Minton, was a new sort of figurative painter with a better claim on the postwar world. But he was finally no more certain than Minton of his place.

STUDY FOR PORTRAIT OF VAN GOGH II (1957)

"On the road" is an eternal theme, of course, beginning at the beginning, when Adam and Eve were sent on their way. It was an idea of particular interest to many American writers and artists. Bacon himself was always wanting to "set out," especially to the more blissful south, and never more so than when he was frustrated. Despairing over his life and work, he now figuratively put his art "on the road," searching for a change of atmosphere. He was aware of the new expansive scale and color in the art being made in New York, and while he may not have been directly influenced by American art, he probably also felt its make-it-new spirit. The first van Gogh painting, from the previous year, remained quite dark. In the convulsive period in which he painted the

van Gogh series, however, Bacon seems to have put aside qualms and just let go.

Study for Portrait of van Gogh II is one of the eruptive paintings in which Bacon's art is pushed to an extreme point, as if to see where resistance finally lies. The paint is not just heavy, but so heavy it seems to stream down the road. The impasto on van Gogh's face buries his features like a mud slide. The colors are starkly dramatic. Some look right out of the tube. The picture is nonetheless darker in spirit than most of van Gogh's art. Not only is the artist trudging downwards "on the road," but shade remains very important among the brightening colors. In *The Painter on the Road to Tarascon*, van Gogh gave himself a black shadow, naturally placed. In Bacon's version, the artist seems to be following his own shadow down the road. The van Gogh series was not widely admired. Bacon himself considered it a dead end. That did not mean it was unimportant. A dead end on the road can also spin an artist around in new directions.

Limbo

BACON DID NOT KNOW, in 1957, if he lived in London or Tangier. He did not know if he lived with Peter Lacy. He did not even know if his painting was alive: the van Gogh series could be a dead end. What he did know was that he must finally do something about his debt. His friends were growing increasingly concerned. In 1957, his debt approached five thousand pounds. He could not ignore such a number. Five thousand pounds could then buy a house in Chelsea. Bacon looked to banks for relief, and Brausen probably helped him secure a loan, though she did not know the extent of his indebtedness. At Christmastime in 1956, Bacon gave a bank manager one of the five studies he had recently made after the life mask of William Blake.

What Bacon most wanted, of course, was to escape debt altogether. There was little Brausen could do. He was not a reliable earner for the gallery, whose financial backing was never very secure. (Brausen's wealthy partner, Arthur Jeffress, left in 1954 to open his own eponymous gallery.) Bacon rarely produced paintings on time, especially when he was living abroad; and he was now spending most of his time in Tangier and the South of France. In 1957, the market for contemporary art in London—upon which Brausen depended—was still not as strong as it would become in the future. It did not help that the gallery had already advanced Bacon more than a thousand pounds.

Lucian Freud knew of Bacon's difficulties. In the mid- to late 1950s the two continued to have breakfast, lunch, or dinner together when Bacon was in town. Freud was a good friend of David Somerset, a genial young aristocrat who was one of the owners of Marlborough Fine Art. Freud had recently been taken on by the gallery; his first Marlborough show was in April of 1956. Freud continued to dislike Brausen—he did not easily give up a grudge—and had of course earlier encouraged Bacon to sell privately behind her back. Freud suggested that the Marlborough gallery

might find a way to settle Bacon's debt. He also told Bacon that Erica was underpaying him. "He'd done a painting of birds, two owls, very nice," said Freud. "Erica had paid him 37 pounds 10 shillings and Ann [Fleming] said, 'Do you think that it'll be very expensive?' and I thought 60–70 pounds, and Ann went the next day and it was 120–140 pounds, which she thought a little much. And Francis was furious."

That March, the same month as Bacon's show at the Hanover Gallery, David Somerset invited him to lunch. Somerset did not discuss any business details: his role was to prepare the ground. Somerset and Bacon, along with Freud, enjoyed a lively lunch together, at which was conveyed, in so many words, that Marlborough would naturally be proud to represent the man it considered one of the greatest English painters of his time. After the lunch, another owner of the gallery, Harry Fischer, immediately wrote a courting letter to Bacon in which he referred to the recent lunch and complimented him on his exhibit at the Hanover Gallery. Bacon, now one step ahead of a lawsuit, wondered if a new gallery could be the solution to his problems.

Founded in 1946 by two Austrian Jewish émigrés, Frank Lloyd and Harry Fischer, Marlborough had become in little more than a decade one of the most powerful galleries in London. Lloyd—born Franz Kurt Levai—was a talented man with the numbers, but the gallery did not owe its success only to his financial gifts: he understood that style sold art. During the war, he had changed his name in order to protect family members who had fled Germany and were living in France. The name Lloyd also evoked the financial sturdiness of Lloyd's of London, a firm that dated back to the mid–eighteenth century. For his fledgling business he borrowed, in turn, one of the great family names of England, Marlborough, whose rolled *r*'s and lazily drawn syllables conveyed aristocratic ease and gave the new gallery a patina of age and power.

Lloyd's greatest coup in this gathering of names was Somerset. Tall and fine-boned, David Somerset, who joined the gallery in 1948 and later became the Duke of Beaufort, was an all-but-perfect representative of a certain breed, the affable, well-tailored English gentleman. He knew how to enjoy himself—he had an easy and winning sense of humor—and maintained a wide acquaintance. (His best friend for many years was the Fiat magnate Gianni Agnelli.) As a young man, Somerset did not have much money, and he had no idea what to do with himself. He readily agreed when Lloyd asked him to join the gallery. Somerset enjoyed the role of charming Philistine and liked to suggest, in a pleasingly offhand manner, that he knew nothing much about anything, and certainly

nothing about something as important as art. But Somerset knew how to open the door to the great houses in England and put their residents at ease. In many such houses hung old, yellowing paintings whose owners—struggling financially after the Depression and the Second World War—were pleased to market them quietly to one of their own.

In its early years, Marlborough flourished in the secondary market for old and modern masters. It fortified its financial reserves, stocked its back room, and developed relationships with collectors from around the world. It mounted popular exhibitions, especially of the impressionists and post-impressionists, who appealed to collectors who wanted something modern but nice. Lloyd and Fischer also aspired to represent established living English artists. Fischer was the gallery's main "eye." He was adventurous. In prewar Vienna, where Lloyd's family were prominent antiques dealers, Fischer—mainly a seller of fine and rare books—would mount small exhibitions of advanced artists, among them Paul Klee. He retained a passion for the more difficult German and Austrian artists. It was not surprising that an art dealer who revered Egon Schiele would be powerfully drawn to the work of Francis Bacon.

"Fischer really liked art," said Somerset, who also admired his "wonderful eye," whereas "Lloyd was more like someone selling cabbages: he knew what cabbages people wanted. . . . I was a complete Philistine." Lloyd did not initially like Bacon's work, correctly supposing that it would be difficult to sell, but Fischer was determined. Somerset described Fischer as "an excitable Viennese intellectual" who, even as a man of business, could not quite pull himself together. His shirttail was hanging out, or a button was missing, or a shoelace was untied. At a restaurant he "inevitably spilled something or sort of spat in someone's face, you know." While he wanted to make money, Fischer also wanted to bring the more challenging forms of modernism to the public's attention. At Marlborough in the late 1950s he organized shows of German expressionist art. If Lloyd was inclined to regard such art as difficult to sell, particularly to conservative English collectors, Fischer believed in developing new markets and then waiting for results. Lloyd could be persuaded. It had not escaped his attention that Sidney Janis, in New York, was not only selling established European modernists such as Picasso and Mondrian but also marketing the challenging work of young Americans like Willem de Kooning. Something feverish, born of the mixture of art, money, and fashion, was beginning to heat up the American market. The talk generated by contemporary art could bring useful attention to the gallery and give it a public edge—possibly a gilded edge.

Bacon's lunch with Somerset and Freud in March 1957 deepened the unease he was feeling more generally. Never mind his financial debts: he felt an intense personal debt to Erica Brausen. He was not just grateful for her early help and support. He admired her rare and decisive Nietzschean spirit. She would regard his departure for a larger and more impersonal institution—just for the money—as a personal betrayal. Bacon often concealed his conscience, but he had one nonetheless, and it was neither small nor tame. He stayed in touch with Marlborough, but also began to imagine problems and raise obstacles to any arrangement. It was essential that he remain free to deliver only paintings he found acceptable and allowed to turn down exhibits, for example, and he did not want to produce a set number of paintings a year.

Nor did he want to sign a contract granting Marlborough complete exclusivity. Although he knew that Erica would never agree to share him with Marlborough, he worried about the financial situation of another of his early supporters, Helen Lessore, and informed Marlborough that she must be allowed to sell a certain number of his works. He also expressed concern about losing a forthcoming exhibit that the Hanover Gallery planned for him at the Durlacher Bros. gallery in New York. Bacon was well aware of the growing power of the New York art world. Even as he hesitated, Marlborough moved forward, but not too quickly. Bacon met and liked Fischer, who clearly loved difficult artists and was another rather brave and bumbling foreigner in London. Bacon must have wondered why it was that awkward people with German accents particularly wanted to represent him. In any case, Marlborough appeared willing to grant Bacon almost any request. He half agreed. Early in May 1957, Fischer wrote him:

> I will tell Lloyd and Somerset and I am sure both will be very happy to know that you will give us the opportunity of becoming your Dealers, without a written agreement to begin with, and that at the end of September you will fly over with your pictures [from Tangier] and give us the first opportunity of buying them from you. I will also tell them that you have a moral obligation to Mme. Lessore, who is to have approximately three pictures a year at cost price, and who will sell them at the same price as we do.

Two days after Fischer sent this letter, Bacon departed for Tangier for what would prove his longest stay there—fourteen months, interrupted

by several visits to London and the South of France of shorter or longer duration. Perhaps because he now planned to live mostly in Tangier, Bacon drove there with his Battersea roommates, Peter Pollock and Paul Danquah. He could bring with him much more in the way of art supplies than he could on a plane. Danquah was studying for the bar, and the spring term had probably ended; Pollock could afford to be indolent. It would be a lark to accompany their roommate to Tangier. They stopped in Paris, then drove south through France and Spain. They traveled in style in Pollock's white Rolls-Royce, a car even more striking (and finicky) than Lacy's Bentley. Bacon was "marvelous" to travel with, Pollock later told Daniel Farson: "When the Rolls broke down and we were stranded in Spain for four days he turned it into fun." Bacon, who often seemed to know these things, suggested that they stay in a "lovely hotel" in Algeciras named the Reina Cristina.

Once in Tangier, Bacon briefly settled into the Hotel Cecil, a once-grand establishment that had come down in the world. Located on a bluff overlooking the harbor, it had recently been renovated by two entrepreneurial English drifters, Dickie Fester and Roy Rutherford. Like Joseph Dean, Rutherford claimed to have once run a bar in Goa. In its piece on the renovation, the *Tangier Gazette* focused, as usual, on matters of consequence to the English village: "The new bar is downstairs and has been opened into what was originally merely a light well. With the aid of gay striped awnings and pots of flowers this has now been transformed into a miniature courtyard, with tables and chairs, where those who do not want to prop up the bar can sit out in the open air."

Peter Lacy hosted a luncheon at the Cecil on May 17 in honor of Bacon's return. Bacon told the local newspaper that he planned to "spend some time in Tangier." In fact, he was still hoping to settle there, except for the occasional trip to London. Once again, he tried to live in the same rooms with Peter after leaving the hotel. Bacon wrote Wirth-Miller: "I am staying with Peter in a flat everything is disastrous as you can imagine." In July, Bacon rented a fifth-floor flat on the avenue d'Espagne, in the "new town" of Tangier, a good walk or brief taxi ride from the Socco Chico. It contained a studio and a separate room where guests could stay. Lacy joined him there only briefly. Bacon lived at the flat for the next year, receiving his mail at the Cecil, where the post was more reliable. The new quarters were spacious, but the building itself was shabby—so dilapidated, Paul Bowles later said, that the "matchwood lift" finally plummeted five floors, killing a baby and crippling its mother. (Bacon told Bowles about the deadly building "with some relish.") But Bacon required the space and

privacy. Bacon was "so pleased to feel I can work here now," as he wrote to Wirth-Miller sometime after the move, adding that "either or both you and Dickie are welcome to come here when you like as there will be a spare room now." At some point, probably after Christmas, Wirth-Miller did visit, joining Bacon in his almost daily drinking at Dean's.

In late June, six weeks after Bacon arrived, the expat community experienced a great shock. The police arrested Ahmed Yacoubi—the painter and protégé of Paul Bowles—on a morals charge. The parents of a German boy accused him of seducing their teenage son. The shadow at the Tangier picnic began to lengthen. The Moroccan government, having assumed sovereignty over Tangier the year before, was divided over whether or not to tolerate its traditional homosexual culture. At first it appeared that the Moroccans would be lenient. But then came a crackdown. The government chose to make an example of native Moroccans like Yacoubi who consorted with Westerners. He was soon released, but the arrest disturbed the English village. It was whispered that Yacoubi's Western friends were now being watched, Paul Bowles among them. Jane Bowles had recently suffered a stroke and, as Bacon wrote to Sonia Orwell in London, was "in a very agitated state," concerned about both Yacoubi's fate and her own health. She frequently visited Yacoubi in prison, and she suffered a further seizure in July. The Bowleses appeared constantly anxious and preoccupied.

The shadowy tone extended to Bacon's life. Lacy was beginning to darken in a new way. He had always been a heavy drinker but functioned well enough. He was now losing control. His situation differed from that of Bacon, who abstained while he worked in the mornings and then kept to red wine and champagne. Lacy would drink a fifth of Scotch a day—perhaps more. For Lacy, who still played the piano in the evenings, the side effects probably included hand tremors, which would make playing difficult unless just the right amount of alcohol was consumed. The two men's evening interests also diverged. Lacy still had no interest in the writers, artists, and oddballs with whom Bacon sometimes liked to spend time, and Bacon himself was too restless to spend many nights just watching Lacy play at Dean's. Bacon and Lacy were absorbed in each other but not in a shared social life, which left Bacon to wander alone through the Tangier night.

One singular bright note marked the summer. Bacon met, through Paul Bowles, the American writer William S. Burroughs, a leading figure in the Beat generation who first came to Tangier in the early 1950s looking for an alternative world. He and Paul Bowles did not get along initially. "The one time I met Paul Bowles he evinced no cordiality," Burroughs

wrote to the writer Jack Kerouac in August of 1954. Over the next two years, however, Bowles revised his opinion about his fellow American. Burroughs could be irresistible. He "proved to be vital and engaging and funny," wrote Michelle Green in *The Dream at the End of the World*, her portrait of Paul Bowles and the Beat generation in Tangier. "An inspired storyteller, he had a buzzsaw drawl that lent irony to every phrase. He could talk for hours about lemurs or yage or telepathy. . . ."

During the spring of '57 Bowles and Burroughs became closer. Not only was Burroughs in town: so were the poet Allen Ginsberg and a circle of writers and hangers-on who surrounded Burroughs at the Villa Muniria. (It was known to the group as the "Villa Delirium.") Burroughs was trying to finish, with Ginsberg's help, what would become his best-known novel, *Naked Lunch*. Before moving to the Muniria and later the Tanger Inn, Burroughs lived mainly at "Dutch Tony's" a boardinghouse and bordello down an alley near the Café Central in the Socco Chico. It was owned by Anthony Reithorst, locally famous for poodles and pimping. But Dutch Tony was also a target of the moralizing Moroccan nationalists of the mid-1950s, which led Burroughs to move to the Villa Muniria. He first lived on the top floor, where he and his friend David Woolman gave cocktail parties on the balcony—during which, the local newspaper reported, "everyone was in a hilarious condition."

By the time he met Bacon, Burroughs—now living on the ground floor—was more interested in drugs than in alcohol, and Bacon's asthma kept him from the many forms of marijuana and hashish available in Tangier. (They also made his face "blow up like a balloon.") But the nihilistic, anything-goes spirit of Burroughs and Ginsberg impressed him. He was naturally curious about the Americans. He had never been to America but was, of course, aware of the growing reputation of its artists and writers. He wanted his next show in New York to be especially strong, he had told Erica, and now here in Tangier he found two Americans who regarded the illusions of Western culture with the same contempt that he did. Burroughs particularly attracted him. Just as Bacon was trying to settle down, and perhaps change the tenor of his art, he observed in action (and inaction) arguably the most uncompromising sensibility of the period—a man who could make Bacon look pious by comparison.

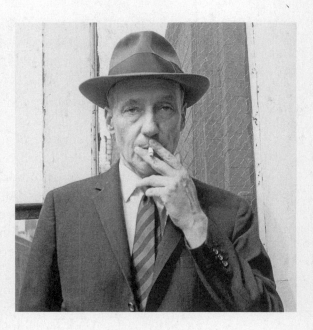

William S. Burroughs, the American writer whose radical indifference to social norms and sentiments impressed Bacon

Rarely, if ever, would Bacon happen upon someone as radically indifferent to social norms and sentiment (of both the Left and the Right) as this strangely deadpan American. Burroughs sometimes behaved like a secret agent from another planet, one camouflaged in an accountant's suit, and he said things without a change of inflection that sounded—his deadpan was as good as Andy Warhol's—at once ordinary and mad. He had views about control and exploitation that seemed tinged by science fiction and, like a sorcerer, dabbled in areas of arcane knowledge. He appeared to subsist on drugs and boys. Guns interested him almost as much as drugs and sex did, and everyone knew that he had killed his wife while trying to shoot an apple off her head like William Tell. There was an almost criminal freedom to Burroughs, and an almost criminal joy.

Burroughs and Ginsberg were delighted with Bacon. Ginsberg called him "the most interesting person here" and reported that Bacon promised to paint a "big pornographic picture of me and Peter [Orlovsky]." Bacon sometimes spent evenings at the Villa Muniria and invited them to his flat. They once found him at the Bowles house at three a.m. as Paul played tapes of Indian music, rolled "huge bombers" (marijuana joints), and discussed medicine with Burroughs. Ginsberg described Bacon:

> . . . a great English painter . . . who looks like an overgrown seventeen year old schoolboy, born in Dublin, started painting late at thirty and now he's forty-seven and wears sneakers and tight dungarees and black silk shirts and always looks like going to tennis, like[s] to be whipped and paints mad gorillas in grey hotel rooms drest in evening dress with deathly black umbrellas . . . He's like Burroughs a little—painting a sideline, gambles at Monte Carlo and wins and loses all his painting money, says he can always be [a] cook or [in] trade if he fucks painting.

The druggy atmosphere did not attract Bacon, however, even apart from his difficulty with the smoke. It often seemed filthy as well. Fastidious by nature, except where painting or sex were concerned, he was repulsed one evening at the Muniria when a friend of Ginsberg's poured him a drink from a dirty tin can fished from the trash. ("I was only afraid," Bacon later said, "of getting typhoid.") Once, when Yacoubi brought some majoun—a jamlike confection of honey, fruits, and cannabis—to Bacon's, Burroughs went around "with a great spoon and the [majoun] in an old-fashioned jam jar, growling 'Now have some of this'"—and Bacon demurred. It was their inexhaustible conversation, not the drugs, that

attracted him to Burroughs and Ginsberg. Except with close friends like Freud or Wirth-Miller, Bacon rarely discussed art in a serious way; he kept to quips and one-liners. But with these unbuttoned (if not slightly unhinged) strangers from another country, he talked freely and intensively about his views on modern art. "He said so much of it is nothing, it's decoration, it's not painting," Burroughs said, "and as to what painting actually is, his views were hard to understand but very interesting to hear."

It was with Ginsberg that Bacon clarified one of his preoccupations—how to end a painting. How could an artist know when a work of art is complete, sufficient in and of itself? The discussion was important to both the poet and the painter. Bacon was finishing next to nothing in Tangier. Ginsberg, in turn, was struggling to help Burroughs organize the scattered pieces of *Naked Lunch* into a readable novel. How could one complete a novel that seemingly had neither beginning nor end? Bacon, ever the gambler, put his chips on chance. A painting ended, he told Ginsberg, when a chance brush stroke "locked in the magic." The idea helped Ginsberg put aside preconceptions about how *Naked Lunch* should work as a novel and, instead, look for the chance strokes that awakened the words.

Both Burroughs and Bacon were drawn to the underworld in Tangier. The ancient port teemed with hustlers, touts, thieves, and smugglers—as ageless in their way as the prostitute in the door—who moved money and contraband throughout the Mediterranean. To Bacon they were more interesting than the grandees on the Mountain whose pedigree was less ancient. A surprising number of the local outlaws—or "villains," as they were called in London's East End—were actually English. They enjoyed the sun and made money in the shadows. "This was before dope," said a gentlemanly-looking English-Irish smuggler of the period named Bobby McKew. "We thought we were wicked. It was nothing. Nylons, cigarettes, booze." In wide-open Tangier, subcultures mingled. The nightlife "is an interesting mixture of Debrett's *Peerage* and the *Police Gazette*" wrote Kenneth Allsop in a *Daily Mail* special report.

In Tangier Bacon became friendly with Ronnie Kray, one of the famous Kray twins who dominated organized crime in London. Ronnie, a homosexual who visited Tangier less for the business than for the sex, behaved well enough in public. "We were all having dinner once," said McKew, "and I said, 'Oh, for fuck's sake.' And Ronnie said, 'I don't like you using language like that.' He might kill you—he was a psychopath—but he was a gentleman." Kray liked to stay at the homes of people he knew. "He wouldn't buy just a bunch of flowers," said McKew. "There were flowers

everywhere. A cartload of flowers." Bacon became so friendly with Kray that one drunken evening he offered to give Kray a painting, or perhaps paint his portrait, but Kray refused, telling McKew: "I wouldn't have one of those fucking things."

Bacon shared the widespread fascination of the time with tough cockneys and criminal outsiders who rejected the bromides of Western society. Sometimes, he drank heavily with underworld figures and, while enjoying the spectacle, made a spectacle of himself. Outside Scott's, an upscale bar in the new town known for its murals of Moroccan boys in kilts, Bacon once collapsed in the gutter. "I stepped over him coming in," said McKew. "Anna [his wife] said, 'Oh, pick him up.' Just to stop her nagging I pulled him in. Not long afterwards a big lorry came along that would have crushed him." Bacon's interest in the outrageously rough could become mannered, almost absurdly so. He had a brief relationship with a legless Moroccan who pushed himself around on a board with wheels. He was growing unsteady without the discipline of the studio. In late September, after four months in Tangier, he reported to Denis that he had "not done any actual work," adding that "I feel on the edge of it now." To try and make some money, he planned a trip in October to Aix-en-Provence that also included the casinos on the coast, where he could look for the rainbow jackpot that would solve his problems. Then he intended to go to London. "I don't want to stay long in England if I can help it but I shall have to do a few paintings to get some money."

While in Tangier, Bacon continued to worry about his gallery representation. At the end of May, he wrote Brausen to ask for help: "I hear . . . that Toto is coming out here. I would be so grateful if you could send the 100 pounds you owe me by her. . . ." The tone of the letter, while friendly, was more reserved than was typical of his letters to her, which often began "Dearest Erica" and ended with "All my love," "Best love," and the like. (This letter ended with "All best wishes.") The request for the 100 pounds "you owe me" had a slightly testy edge, given the debt he was carrying at the gallery. Then, in early June, Fischer wrote Bacon to tell him that Knoedler's, an eminent New York gallery, had agreed to exhibit Bacon's work in the autumn of 1958—the date that Bacon now preferred for a New York show since he had completed so little work. Not only had Marlborough solved the problem of his representation in New York, but Knoedler was better known than Durlacher Bros. Brausen also wrote to Bacon in early June:

Dearest Francis,

We have sent the 100 pounds with Toto—I hope it will reach you safely.

George Dix came in today; we talked about your show [at Dur-lacher] and he thinks that as you have had so much success lately it would be a good idea to have your American exhibition in the not too distant future. He would like to arrange it for April 1958. . . .

The bank has been paid—in fact everything is going well.

With all my love . . .

Brausen was almost family. She sent him money when he asked. She never complained about his mercurial behavior or lack of production. She didn't push him to sign a contract. How could he leave her? What would he say to Toto, who was now coming to Tangier? Bacon answered Brausen promptly on June 12th—one sign of how his gallery troubles claimed his mind—asking her to postpone his New York show until the autumn of 1958, the same time proposed by Fischer for a Knoedler show. He signed this letter "love Francis." He then wrote to Marlborough to tell them that he was no longer interested in a change of galleries. Fischer immedi-ately responded on June 19th, conveying Marlborough's disappointment. Aware of Bacon's qualms, Fischer set up dueling morals, pointedly men-tioning that Bacon had given the gallery his word.

We considered that we had made a "Gentleman's Agreement" with you, on the basis of which we have already arranged at Exhibition for you in NY on a very big scale, as you wanted us to do.

Personally, I have a very great consideration for your feelings towards the Hanover Gallery, but you will see from the careers of many other painters that they have gained considerable rewards by changing their dealer.

During the next few months, however, Bacon put Marlborough's "rewards" out of his mind. In the autumn of 1957, he returned to London still undecided. He asked Denis to tell no one that he was coming but did little to conceal his presence. He visited the Tate, where John Rothen-stein found him looking "brown and well." He went on his old Soho rounds. And he tried to work in his Battersea studio. He painted what would prove to be his final version of van Gogh going to work and then turned, yet again, to the pope—this one a portrait of an effete pope with limp wrists. He also produced, probably as a commission, an uninspired portrait of the French cabaret singer Suzy Solidor. Another painting in

the abstract vein of *Figure in Mountain Landscape* was brushy and vibrant, but the painting did not inspire Bacon to do more of that kind. No doubt he saw Harry Fischer while in London and provided his usual apologies to Erica. Two weeks or so before Christmas, he left London for Cannes, where he was meeting Lacy.

Once the couple found themselves isolated together in Cannes—in Tangier they had lived apart—the tension increased. Bacon reported to Denis Wirth-Miller that he had some luck at the tables while Lacy did poorly. It had traditionally been Lacy who had money to spend, but he was now under some financial pressure himself. "We had a lovely week," Bacon wrote, "but now the rows have started." Bacon sympathized with Lacy even if he could not finally comfort him. Lacy's losses at the table symbolized a series of larger defeats. "It is terrible I suppose to be frustrated as Peter is in so many directions," Bacon wrote. "I wish he could get a break even in the casino." Lacy, as usual, threatened to leave. "Peter packed his bag last night, but I don't know what is going to happen—there is lots of bag packing here. It is a place made for rows . . ." Perhaps the ongoing misery reinforced Bacon's desire to cut free in other ways. That January, he wrote to Fischer from Cannes that, after all, he would be prepared to consign pictures to Marlborough by the middle of March.

Before he left to join Peter on the Riviera, Bacon had completed two paintings of him. One depicted Peter in a large rounded chair staring directly at the viewer. A triangular framing shape focused and isolated Lacy at the center of the painting. The more powerful painting was *Study for Portrait of P.L.* The twisted figure, lying in a fetal position on an ominous black banquette, might have been made by a sculptor pressing his fingers into wet clay. It had some of the worm (and squirm) of the great Cimabue Crucifixion, and the pose was revealing. The RAF pilot with perfect calves was becoming a man-child curled in upon himself, his beautifully delineated flesh infinitely vulnerable. It was perhaps at the end of 1957—when he painted this fetal Lacy—that Bacon realized that Lacy was weakening and that Bacon could not let him go. It may also have been about then that Peter Pollock received a letter one day for Bacon. It was from Lacy. Bacon opened it eagerly—and his face fell. "He received a card which wasn't as warm as it should be," said Pollock. "He looked so sad that I realized he was very much in love with Lacy." He had "a need for that kind of affair," said Danquah. "It was obsessional."

In early February 1958, Bacon and Lacy returned to Tangier. They found the port even more shadowed by the crackdown on "vice" than during the previous autumn, when the new government determined to clean out undesirable elements once and for all. The English-speaking community had felt somewhat protected before, at least if certain implicit rules were followed. Burroughs wrote at one point: "So long as I go with Spanish boys, it is like having a girl in the U.S. I mean you feel yourself at one with the society. No one disapproves or says anything. Whereas to walk about town with an Arab boy would be unthinkable at this point . . . You dig no one cares what the unbelievers do among themselves." As part of their assertion of control, the Moroccan government had announced in November, while Bacon was back in London, that British citizens entering from Gibraltar would henceforth require a visa—a shot across the bow for the expatriates. More important, they again decided to make an example of well-known figures, in particular Ahmed Yacoubi, who had a show at the Hanover Gallery in October. Upon his return to Tangier from London, the police arrested him for a second time. He languished in jail for five months, during which time his teeth were knocked out.

The second arrest of Yacoubi terrified Paul and Jane Bowles, who had proudly accompanied their protégé to London for his exhibit. (Jane had also spent time in a psychiatric clinic in Northampton.) They had accompanied Yacoubi home to Tangier afterward. Yacoubi, everyone knew, was Paul's lover. Would the police now publicly brand the finicky writer a homosexual and also throw him into a filthy Moroccan prison? The Bowleses hired a lawyer. Yacoubi by now had a team of lawyers working on his case—to no avail, said Paul. The Bowleses were concerned that powerful people in London would blame them for Yacoubi's arrest. (There had been talk that Yacoubi should remain in London until the situation in Tangier calmed down.) Late in January, the worst appeared imminent: Bowles was called in for questioning in connection with Yacoubi, and his lawyer told Jane that she would be next. Concerned about being arrested for espionage, Paul and Jane fled from Tangier not long after Bacon returned in February. They happened to run into Bacon the same day they left. Bacon was also deeply worried about the crackdown, said Bowles, and about who might be arrested. Expatriates who feared financial loss or a morals charge (such as Dutch Tony) were leaving the port in significant numbers. Burroughs left in January, flying to Paris. As he famously wrote to Ginsberg, "Tanger [sic] is finished. The Arab dogs are upon us. Many a queen has been dragged shrieking from the Parade [a bar], the Socco Chico."

It was well-known that Bacon was a good friend of Yacoubi's. But during the developing panic, Bacon refused to shun him. Nor did he try to hide the friendship from the authorities. In February he went to London, as he had written Harry Fischer that he would, but made no effort to see Fischer and soon returned to Tangier. In early April, the Bowleses reported that they had heard, by way of Paris, that Bacon himself was in serious trouble with the police. At one point, Bacon even wrote a cloak-and-dagger letter to Bowles, telling him that he should be very cautious about returning and instructing him not to write his return address on the back of the envelope of any letter he sent Bacon. Bowles wrote to Sonia Orwell that Bacon had left for Gibraltar. Perhaps the trigger was the jailing of Nicolas Brusilowski, an artist whom Bacon knew. Eventually, Bacon would sell the lease to his studio to Brusilowski.

It was unlikely that Bacon was as panicky as the Bowleses assumed. He soon returned to Tangier. It was true that some Europeans were being arrested, but the Moroccans were also treating well-known Europeans very carefully. Bacon was a famous Englishman, the subject of multiple stories in the press, and he had not been an actual lover of Yacoubi's. Bacon did what he could for Yacoubi, sending canvases to the prison with the Bowleses' driver so that he could continue to work. A certain stubborn inertia seemed to keep Bacon in Tangier as others left and the once lively city faded. The Café Central in the Socco Chico was perhaps the starkest example of life before and after. The dark, boozy bar, where the Spanish owner, Don Felipe Cacarella, had served wine and tapas for half a century, became a generic Arab tea room with linoleum tables, fluorescent lighting, and sweet tea. All the young men were gone.

And then, suddenly, the crackdown ended. There was no official explanation, but the implication was clear. The government did not want to lose the revenue or the tourists: the money was worth the disreputable sex. The new authorities even built a Municipal Casino that was closed to Moroccans—who, of course, could not drink alcohol—but was wide open and enticing to Westerners. Bacon became a patron of the roulette tables there. Yacoubi was released and, in June, exhibited in Tangier. On the surface, life had returned to normal. The *Tangier Gazette* reported on June 27th that Dean's was "packed full the evening I went there. Dean was in very good form and told me he was getting plenty of visitors morning and evening." Peter Lacy was still playing the piano at the bar. He had just returned from Madrid, reported the *Gazette*, a trip on which Bacon may well have accompanied him. Some snapshots showed the two of them together in Madrid, taking turns posing in front of the Prado.

During the spring troubles, Erica wrote Bacon to congratulate him on the success of a small exhibition she had arranged for him in Italy. It had opened in Turin in January and toured to Milan and Rome. "We are in a terrible stew here," she wrote, "as we have almost completely sold out your paintings in Italy (of all places!). . . ." For a full year, Bacon had sent her nothing new, but she trusted him enough to plan and schedule exhibits for him in England, America, Germany, and Mexico. Bacon expressed surprise that his pictures had sold in Italy—"I only wish they had been better ones"—and promised that he was hard at work:

I am working a lot here. I have finished 4 I think. 2 are the best things I have done. I am doing two series one of the Pope with owls quite different from the others and a serial portrait of a person in a room. I am very excited about it. I hope to come back with about 20 to 25 pictures early in October. Do you think we could delay arranging exhibitions a bit so that I can for once work in peace. I would like to have one next time of things I especially like in America . . .

Fischer, of course, was also waiting for news of Bacon paintings. He must have wondered what happened to the series that Bacon promised him in January for a March delivery. In early May, a reporter for the local paper interviewed Bacon in his flat on the avenue d'Espagne—now newly renamed the boulevard Mohammed V—and wrote breathlessly: "Tangier will have added luster now that Mr. Bacon has chosen this Moroccan City in sight of the classical Pillars of Hercules to work in. With fabulous success in Rome, Milan and Mexico City to say nothing of New York and London, a world conqueror in paint is on our doorstep."

In late May, growing desperate, Erica asked Bacon to send her some of his new pictures by air. She wanted to have something to show George Dix, who was planning the Durlacher Bros. show in New York. (The show in Mexico City at the Galería Antonio Souza, which Brausen had promoted and Bacon had mentioned to the reporter never materialized: Brausen had to explain to the gallery that she had nothing to send to them.) In response to Brausen's pleas, Bacon said he wanted "to keep the pictures here until September or October as I am right in the middle of a lot of things which bear on one another." He hoped to have "at least 20 by the middle or end of September. I find I can work very well here now." At the same time, he asked her to advance him three hundred pounds: "I am getting very short as I have to buy a lot of paint."

Bacon asked Erica to transfer the money into the bank account of a Gibraltar firm with a name so bland—"Auto Gears and Spare Parts Co."—that it could have been a cover for a nest of smugglers. It was probably just a firm with a relationship to Englishmen who appreciated a fine motorcar, as Peter Lacy did. Sometime later, Bacon sent an impatient telegram to Erica. The money had still not arrived. She responded affectionately—he should shortly receive his three hundred pounds—but with some questions of her own. Would he like a show in London the following spring? "I am trying to arrange the exhibitions for 1959, and you know that, apart from my sculpture shows, you are the one I love best." Would he please send just a picture or two to London so that she could show something to the Americans?

By mid-July, Bacon's output—after more than a year in Tangier, and despite his talk of bringing back "about 20 or 25 pictures" to London—amounted to a series of paintings all of which he had rejected except for *Pope with Owls*. The expatriates around Bacon celebrated the return of freedom, but Tangier was no longer alive in the same way, like a creature that does not yet know that it has sustained a mortal wound. (The *Tangier Gazette* would soon become the *Moroccan Mail*.) On July 18, the paper reported that Bacon had left for England by way of Marseille. He was headed home to paint. But he did not give up his flat—Peter still lived in Tangier.

Bets

O N OCTOBER 16, 1958, eighteen months after he first met with David Somerset, Bacon signed a ten-year contract with Marlborough Fine Art. He received £2,500, enabling him to settle his most pressing debts. He gave the gallery the exclusive right to sell his paintings; no allowance was made for Erica Brausen or Helen Lessore. He agreed to supply £3,600 worth of paintings annually. For each large (78 x 65 inches) or midsized (40 x 46 inches) painting, Marlborough would pay him £420; for each smaller picture (24 x 20 inches), it would pay him £165. The following day Bacon, visibly upset, went to the Hanover Gallery and asked to see Erica. She was in Paris. He could have waited until her return to convey the news in person, but instead handed a check to Brausen's assistant, Michael Greenwood, for £1,240—his outstanding debt to the gallery—and explained that his financial affairs were in such disarray that he had no choice but to sign a contract with Marlborough. He would not have done so without first consulting Erica, he told Greenwood, but he knew that she could not possibly cover his debts (which he suggested were as high as £5,000) and chose therefore not to raise the matter with her. "He knows that you will be distressed, as he is himself," Greenwood wrote Brausen, "but he says that his position was desperate and that he had no alternative."

Brausen was more than "distressed." She felt privately betrayed and publicly humiliated. Like the wife who waits on tables to put her husband through university, only to be divorced as her husband succeeds and she becomes less pretty and useful, Brausen had spent almost fifteen hard years helping make Francis Bacon's reputation. And now she was to be shunted aside. Even so, she blamed Marlborough more than the artist she loved and admired. She also blamed Freud, who she correctly suspected still held a grudge against her. Bacon was a great artist, she believed, who deserved financial peace of mind. She knew that he would not have lightly

abandoned her and was ashamed. What galled Brausen was that neither Lloyd nor Fischer—like Brausen, German-speaking refugees from the war who settled in London—took the trouble to call, write, or visit her. She was a lesbian with a German accent who—in London, in a man's world, under difficult circumstances—developed arguably the most forward-looking English gallery of the postwar period. She deserved a word, she felt. And so she directed her despairing rage into a hopeless legal action. She sought what amounted to a cease-and-desist order against Marlborough, which had far greater resources to fight a legal battle than she did. In December, a writ was issued. Marlborough's solicitors were confident they would prevail. Fischer wrote Bacon in December, "We are going ahead and please do not worry about this silly Hanover case; there is no doubt that she will either withdraw or we'll win." Before Marlborough mounted its first exhibition of Bacon's work, Brausen assembled a show of her own, in June of 1959, drawn mainly from her back room. It was an exercise in masochism. It could only pain her to see Bacon's work on the walls. Bacon himself did not attend. Critics alluded to the "back-story" behind the show and "internal quarrels." Brausen eventually reconciled herself to the inevitable, and her lawsuit faded away.

Only desperate circumstances, both financial and psychological, would have persuaded Bacon to leave Erica. He could not bear to hurt someone close to him, not for long. (Spats and dueling wounds were another matter.) Money was the main reason for his departure, but there were also others. He was drained by indecision and tired of a cast-about life. He was weary of his own ceaseless supplications, as he badgered Erica for cash and she begged him for pictures; weary, too, of begging rich men for help. Everything about Erica was exhaustingly personal. Marlborough promised a more businesslike relationship, less emotionally taxing. And Bacon could call upon all the usual justifications. Other artists did the same. The change was necessary *for the work*.

One bold move sometimes leads to another. Shouldn't he resolve his other difficult relationship and break once and for all with Lacy? That might also help his work. The rows were tiresome, and no one wants to take care of a sloppy drunk. Bacon sounded cold-blooded when he discussed the relationship with friends, continuing to describe it as a kind of madness, but he did not completely hide his warmer feelings for Lacy. At a dinner party a month after he left Erica, he told Freud, Cecil Beaton, and John Rothenstein, "I need Lacy, but if he died I wouldn't miss him." His work was going very poorly. In the end, the van Gogh series did not satisfy him. Perhaps he felt that the pictures owed too much debt

to other painters. In Tangier, Bacon had not taken up the van Gogh idea but instead tried painting more popes—some with owls, some not—and crouching figures. He painted a colorful version of his earlier businessmen. He painted one astonishing outlier—a figure in a darkened and mysterious seascape, surrounded by whitecaps and set against a stormy, blue-black sky. It resembled nothing else in his work but seemed another dead end. (It was abandoned and found after his death.) After signing with Marlborough, Bacon made four paintings of Lacy, the subject that then seemed to inspire him the most. The first two were small, head-size portraits. One resembled a photograph of Lacy taken by John Deakin in the Smithfield meat market. The two *Heads* of 1958 were the final pictures Bacon delivered to the Hanover Gallery not long before he signed with Marlborough.

Two larger pictures—images of Lacy's full body—were the first he delivered to the Marlborough gallery, in November of 1958. Freud called *Lying Figure,* 1958—the companion piece to Bacon's painting of a nude and recumbent Lacy from the year before—"extraordinarily tender." Bacon chose to spend that Christmas, yet again, with Peter in Cannes. He could at least be assured of pleasure at the table—both at the casino and the restaurant—now that Marlborough had put fresh money in his pocket. Bacon and Lacy booked outside Cannes, at the Loge Duclos Garibondy in La Bocca Cannes, and they planned to stay through February. Fischer, still unfamiliar with Bacon's ways, probably hoped the slight remove from Cannes indicated a desire for peace and quiet, as if Bacon—like the other artists in the region—intended to set up a serious studio. And Bacon, as always, did plan to work. Just before he left, he visited Dicky and Denis in Wivenhoe and carefully washed and packed his brushes for the trip. But he forgot them "in my rush."

Bacon encouraged Fischer's hopes from afar—of course—plying him with extravagant promises and writing in the middle of December: "I expect to bring back about 10 paintings at the end of February—They are going really well now." Fischer began to plan future exhibits on the strength of these reports. He focused on Bacon's international reputation. He wanted twelve paintings from Bacon for the British Council, which was organizing England's contribution to the 1959 São Paulo Biennial in Brazil; three paintings for the upcoming Documenta in Kassel, Germany; and several new works for the New York show intended for Knoedler. He also began stocking the back room with older Bacons, buying every Bacon he could find.

It was strange that Bacon and Lacy chose to spend not just Christmas,

but also January and February living together in Cannes. They had tried to live together many times before without success. Their most peaceful arrangement had been to live apart—in a large town like Tangier—while seeing each other frequently. And yet they kept trying. Not long after they arrived in La Bocca Cannes, they began to quarrel and Bacon wrote Dicky and Denis one of the most despairing letters of his life. "I am afraid things are going just as badly as they ever have," he told them. "It is so depressing—I know now once and forever not to go on ever trying again to go on living together." Still, Bacon refused to cut loose from Lacy, or from the Tangier where Lacy still lived, even though Tangier itself now held little appeal for him. And Lacy would not cut loose from Bacon. In a second letter to Wivenhoe, in which Bacon congratulated Wirth-Miller on joining the Lefevre Gallery, he reported that he would return to England in the spring but planned to go to Tangier "early in April" and offered them the extra room at his studio to work in. "It is lovely there at that time of the year."

On his return to London in late February of 1959, Bacon avoided Fischer, no doubt from feelings of guilt. Fischer was obliged to use the post to inform Bacon that the Knoedler exhibit in New York was now confirmed for later that year. Pained that he had not been invited to the Battersea studio, Fischer added: "Lucian [Freud] told me that you have nearly finished fifteen paintings and so I think with the three we have in America, we have plenty." The confirmation of the show in New York did not, however, ensure the survival of the "nearly finished." It may have had the opposite effect. Bacon, a competitive man, wanted only his best work for New York.

A few months earlier, the Whitechapel Gallery had mounted a Jackson Pollock exhibit. After Bacon returned from Cannes, the Tate opened *New American Painting*, which was the second major show in three years devoted to contemporary art in the United States. It focused primarily on the latest developments of the so-called New York school and included eighty works by seventeen of the best-known abstract American painters. It was hugely popular. The Museum of Modern Art was not shy about making claims for the art, asserting in a press release that it was "acknowledged that in America a totally 'new'—a unique and indigenous—kind of painting has appeared."

In this new world order, Bacon, in the parlor game of reputation, was London's champion—the English version of Pollock or de Kooning. He

was regarded as someone who, while still part of the figurative tradition, was unafraid to push the boundaries. Henry Moore was now a silver grandee. People sometimes forgot altogether about Graham Sutherland. But the Americans themselves often spoke of Bacon with condescension. During the *New American Painting* exhibition, Grace Hartigan—the only woman included—called Bacon "a weak painter and a psychological case." Neither Clement Greenberg nor Harold Rosenberg, the most influential American critics of the period, gave Bacon more than a glance. Bacon was interested in meeting the Dutch-born Willem de Kooning, who also maintained a connection to the figure and whom Bacon called "the great man in the United States, for bursting through the abstract and planting an image on the canvas." He was prepared to drink and argue with de Kooning during his visit to London at the time of the show, but found him unforthcoming.

In early spring of 1959, as Fischer pestered him about the upcoming Knoedler show in New York, Bacon was trying yet again to reinvent the figure—something that seemed all the more important now that he would be exhibiting in New York—but without success. He had completed six paintings in 1958, the most interesting being the two larger portraits of Lacy that had a new kind of color—the contrasting blues of the one, the bright orange and green of the other. The van Gogh series had also brought new color into his work. Perhaps it was not just the figure itself, or its pose, that could open a new direction. Perhaps color was the key. The new palette marked a change—and may well have been a response, in part, to seeing the vibrant colors used by the American artists. The American art historian Hugh Davies, who wrote extensively about Bacon in the 1970s, noted that it seemed in 1959 "as if floodlights had been turned on in Bacon's previously murky interior settings and the intensity of palette originating in the van Gogh series had moved indoors." But Bacon still had not arrived at a confident new sense of color and the figure. After returning from Cannes early in 1959, he painted five more figure paintings and one head—Fischer was desperate for product—but then finished almost nothing for several months. Fischer was forced to cancel the New York exhibition.

Under enormous personal and professional pressure, Bacon, in the spring of 1959, was hospitalized for what was most likely a gastrointestinal problem. In a letter that made mention of this hospital stay, Bacon wrote that he was "hoping that my trouble will heal without an operation." (He would eventually have his gallbladder removed in 1974.) It may well have been that his symptoms were exacerbated—or brought on—by

the mental and physical exhaustion created by his block in the studio and his ongoing troubles with Lacy. That Bacon went into the hospital suggests that his health problems, in the spring of 1959, were more serious than usual. Ordinarily, he refused to be hospitalized unless there was absolutely no choice. The following year, for example, he fell down some steep stairs after dining (and drinking) with his framer, Alfred Hecht. (Hecht, who lived above his ground-floor shop on the King's Road, "collected both paintings and people at his premise . . ." wrote Roger Berthoud. "There, over dinner, he mixed a series of intriguing human cocktails. . . .") Bacon was knocked unconscious. Hecht called Paul Brass, who had newly completed his medical studies and was covering for his own father, and asked him to come urgently. It was after midnight. Brass threw a coat hastily over his pajamas and rushed over. With Hecht, he moved the drunk and unconscious Bacon into a spare bed—over which, as Brass recalled, Edvard Munch's *The Scream* was hanging during a period when Hecht was reframing it. "He obviously had had an injury to his skull and I said I wanted him to go to hospital straight away," said Dr. Brass, but Bacon replied that he would under no circumstances go to the hospital. Brass arranged for an X-ray "there and then and in the home." Bacon had fractured his skull. "I said, 'Look you've got to go to hospital, this is ridiculous, I can't keep you here with a fractured skull.' But he wouldn't go. And so I used to go and visit him twice a day every day and after about a week he said, 'Look, I'm not lying here anymore.' He was concussed. 'I'm getting up and going.' And off he went."

Bacon's illness led him to decide, in the summer of 1959, to reduce the length of his stay in Tangier. Fischer would have preferred, of course, that Bacon not make any trips that summer. But Fischer could not initially complain too much, given Bacon's recent illness. Perhaps rest in a dry climate was medically necessary. But soon enough Fischer lost patience. On July 22, he wrote to Bacon in Tangier to inquire about his health—and chide him for not returning and settling down to work. People were visiting the gallery and wanting to see a Bacon, he reported, but he had only three pictures to show them. "It is difficult for us to keep your flag flying when we cannot show your friends a few paintings." Fischer was no doubt heartened when he heard that Bacon had finally sold the lease of his flat in Tangier to the Russian painter Nicolas Brusilowski. But Lacy was deeply wounded by this sale. Lacy himself came and went, of course, and Bacon lived in Tangier only intermittently, but Bacon's readiness to own a place in Tangier was a symbol of his commitment to Lacy. Much of their life together involved houses charged with feeling. Bacon's willing-

ness to paint a picture of the house in Barbados that Peter had left, to say nothing of his willingness to submit to Peter in his country cottage in Hurst, had been signs of love. The flat in Tangier was the same.

There was worse to come. While in Tangier, Bacon was dreaming of "a really handsome east-end thug" whom he had recently met—who liked "giving the whip." Bacon almost certainly did not keep such news from Lacy. Champagne would bring out the truth about this handsome young thug with the curiously gentle mien who appeared straight but could erupt into homosexual violence. Lacy probably did not mind the sexual adventures. If their relationship was open sexually, however, it was not so emotionally. Was Francis leaving him? Lacy was usually the one who would leave, opening his suitcase on the bed in dramatic fashion, but he never left forever. And Bacon, "the one more in love," then waited for the telegram. But this time the edges between love and lust appeared less clear.

Ron Belton was a "smudge," underworld slang for a disreputable photographer. The word originated on Fleet Street, where a poorly shot or developed photograph was sometimes called a smudge. Belton would cockney-charm the gullible tourists in Trafalgar Square with a camera dangling around his neck, snapping their pictures before they could say no. They would not want him to waste his expensive film, since he was twenty and handsome and spoke with that accent. He would painstakingly write down their home addresses and, for a small fee, he promised to post them the prints. The prints never arrived. There was no film in the camera.

Like many working-class boys in the game, Belton—who also went with women—was not averse to making money off the poofs. He liked to deliver a good "thrashing," which many public school boys grew used to in school and continued to want as adults, and he had the further advantage, in the eyes of some homosexuals, of being remarkably well-endowed. ("Ron was very big in that particular department," said Paul Danquah, "and Francis liked that.") The underworld pubs that Belton frequented in Soho attracted writers, artists, and musicians who were out slumming. Belton had also been the occasional boyfriend of Dan Farson. Beginning with the grooms in Ireland, Bacon was attracted to working-class men, a common enough predilection. It was not unusual for a middle-aged man to take up with a younger lover—Bacon turned fifty in 1959—and Belton had more than his physical attributes to recommend him.

"He was very sweet and charming in his rough-and-ready way, not boring," said Christopher Gibbs, who knew him from around Soho. "And very beautiful skin. I was his age. He used to say, 'You're still steamer bait, mate.' A steamer is a sort of old queen who goes around and tries to pick up attractive young men. It was all chat and charm, to be a smudge."

In London, what struck Bacon's friends—and probably Lacy—was that Belton appeared to be more than a passing sexual fancy. Bacon enjoyed dressing him up in fine suits and, increasingly, Belton accompanied him when he went out. They became an "almost couple." Bacon had never before developed a sustained relationship with a working-class lover, and when he first returned to London in August of 1959, he was loath to introduce Belton to his elegant friends. That made them more eager to meet him. The month of his return, Ann Fleming reported:

Last London evening a grouse celebration with Beaton, Bacon and [Frederick] Ashton—Francis was restless for he had a date with a Ted [the Teddy Boy culture of the 1950s] at Piccadilly Circus, I persuaded him to collect the Ted, though warned by Cecil that he was known to be equipped with bicycle chains and razor blades and though worshipped by masochistic Francis was a danger to normal mortals; it was therefore an anti-climax when Francis returned with an undergrown youth with most amateur sideburns and drainpipes—he was named "Ron," blushed when spoken to, a refined cockney accent and a lamblike disposition—I was most disappointed and refilled his glass assiduously hoping to promote rage, but it failed to perturb his most gentle disposition.

Bacon's interest in the East End was more than sexual. He had long relished and taken comfort in people (above all Nanny) who cared nothing for his persona or fancy preoccupations. He loved the hard-as-nails insolence and conversational slang of those who claimed to know what's what behind the pretty mask. It helped if they had the courage of their convictions—that is, if they were a little crooked, pinching the silver or the occasional watch. "He would go along to Ann Fleming's," said Gibbs, "but lowlife was much more sympathetic to him, rackety life, trouble, and he quite liked being the sort of star of that world." Lacy taxed him as only the love of one's life can, whereas the tough boys from the other side were diverting. And when they were not—during the fights or those moments when the violence crossed a line—they could not finally touch him. The quarrels remained theater even when there was real blood.

Bacon soon discovered the streak of violence beneath the "lamblike" Belton. "He had a sort of latent violence that bubbled up quite quickly with a drink, spoiling for a fight," said Gibbs. "Bacon would have seen the possibility of winding up the smoldering violence. It was the possibility of violence he always found attractive." But Bacon also took a paternal interest in Ron, calling him a "remarkable boy" as—complaining—he paid Ron's bills. The "really handsome east-end thug" helped confirm Bacon's uncertain conviction, as he struggled over his feelings for Lacy, that love itself was finally just a smudge or cover-up for sexual obsession. Bacon did not generally bring a boy like Ron into the rooms so kindly lent to him in Battersea by Peter Pollock and Paul Danquah, who had become good friends. Danquah, who was usually in the flat, disliked Belton. "Francis rather liked that sort of thing, and the Kray Twin lot."

Fischer increased the pressure on Bacon in the late summer of 1959. He was too diplomatic to mention their contract, but Bacon knew perfectly well that he was already failing, in his first year, to meet its terms. How was Bacon to love—and paint—with abandon? He found an unlikely solution. He decided to move away from London for some months, not to marvelous France or pleasure-loving Tangier, but to the isolated artists' colony in St. Ives, Cornwall, on the westernmost tip of England. It was an unlikely match of man and place. A 250-mile drive from London, St. Ives was known for abstract art and picturesque charm, neither of which appealed to Bacon. Scenery, to Bacon, was the view framed by the train window. It was true that he liked seaports—St. Ives had a beautiful harbor—but only if they had dirty dives and naughty sailors. Bacon nonetheless decided, like a man entering debtors' prison, to lock himself up in St. Ives during the deadest part of the year.

Dicky and Denis probably encouraged the retreat to St. Ives. Bacon kept nothing from Denis, who knew of his desperation over both work and Lacy. Wirth-Miller and Chopping had themselves lived briefly in St. Ives after the war; and their own village of Wivenhoe also attracted artists. Bacon had done well enough in Wivenhoe, even sharing a studio with Denis, and during his visits seemed to enjoy the hours away from London. In the waning months of 1959, Bacon might have preferred Wivenhoe, but his friends there would be a constant distraction and temptation. If Bacon was looking for a village like Wivenhoe that wasn't Wivenhoe, then St. Ives made sense.

St. Ives first began to attract artists earlier in the century when the potter Bernard Leach settled there. In the 1920s and '30s, as the fishing industry declined, painters and sculptors—drawn by the brilliant sea light

and the rolling countryside—moved into a former fishery by Porthmeor beach, and carved out studios from lofts that once housed netting. Among them were Ben Nicholson and his then-wife, the sculptor Barbara Hepworth, who would become two of England's best-known abstract artists. Some strong-minded artists who worked the seam between abstract and figurative art, such as Patrick Heron and Peter Lanyon, also lived in St. Ives. The village was becoming so well-known in the art world—it was almost a "school" of art, almost a "scene"—that Robert Motherwell, Helen Frankenthaler, and Mark Rothko, abstract artists from America, considered spending time there. Studios were easy to find in the fall and winter, when Bacon proposed to go.

At the Sloop Inn, an ancient pub on the harbor, Bacon happened upon the painter and sculptor William Redgrave, whom he knew. Did Redgrave know of an available room and studio? Redgrave ran an art school in the summer with Peter Lanyon called St. Peter's Loft. Redgrave offered Bacon studio no. 3. It was vacant during the off-season, and Bacon, unlike many others, could afford the rent. Only a few doors down from Bacon was Patrick Heron's studio no. 5, until recently occupied by Ben Nicholson. Redgrave, a figurative artist who felt somewhat isolated in St. Ives, enjoyed the prospect of dropping England's best-known figurative painter into the social mix. It might provide amusement. So in September Bacon rented the "spacious, Edwardian" studio no. 3 for six months at a cost of thirty-eight pounds. He also rented a flat in Seagull House, which overlooked the harbor and was a short walk from the studio. And who better to share this prison with than a petty criminal—one who liked to beat the inmates? Ron Belton was happy to make the trip to St. Ives with Bacon.

They moved to St. Ives in October. "My dear Fischer," Bacon wrote to his dealer. "This is my address. I have been lucky enough to find a wonderful studio for six months." Bacon lived much as he did in London, working hard in the morning and drinking at night. Bacon, as Redgrave hoped, diverted the abstract artists. Relations were friendly enough: the argument between abstract and figurative art, rehearsed so many times over the decade, was now so familiar it caused little stress. And so the edgy public jousting in the pubs was more playful than not, just a means to keep boredom at bay. When Bacon bumped into Patrick Heron for the first time, he told him that he had had to get away from London but pretended that he had known nothing of St. Ives's reputation. "I had no idea *you* were all here, *dear,*" Bacon told him. For his part, Heron said in astonishment: "Good God! Francis! What on earth are you doing here?"

In his journal, Redgrave described Bacon as a Wildean figure who loved to use his wits and his makeup brush: his liberal use of cosmetics drew stares and scowls at the local Three Tuns pub. On one occasion, for example, Bacon was talking to Roger Hilton, an abstract painter who had been a student of the legendary Henry Tonks (1862–1937). Tonks, a surgeon who became the most formidable studio teacher of his day, was known for exposing with medical precision the technical shortcomings of his students. With Tonkian dryness, Hilton informed Bacon, "You are the only non-abstract painter worth consideration, although of course you are not a painter—you don't know the first thing about painting." Yes, Bacon agreed, his own work was "perfectly horrible." "Now we can get together," he told Hilton. "You teach me how to paint and I'll lend you my genius." The story was surely improved in the telling. It sounded much too Wildean: Bacon rarely talked about "genius," especially where he himself was concerned. But it suggested both his impatience with the academically minded and his frustration with the lack of fire that he found around him—and possibly in himself, too.

Bacon continued to search for a figurative image in St. Ives to assert against the prevailing fashions of the time. To develop such a style he studied abstract art more than he would admit, as if its preoccupations might help him transform figurative art. He would have been the first to appreciate the irony if abstract ideas should lead, in the end, to a successful modern figurative style. The large blocks of color, both vertical and horizontal, that formed the simplified backgrounds of several paintings that Bacon made in St. Ives may well have owed something, as Martin Harrison has pointed out, to Patrick Heron's *Horizontal Stripe Painting: November 1957–January 1958*. Bacon was laboring over both portraits and larger figurative paintings. Sometimes, he chopped up a canvas when he wanted to salvage a lively figurative bit from its dead surroundings. The negative space around the figure could still be a confounding problem for him. He experimented with the "flatness of the picture plane," then an issue of obsessional concern to modernists (though the flatness of the picture plane was something good painters had always worked with). In *Reclining Figure* (1959), the figure seemed squeezed and flattened into a very narrow space, as if pressed between a slide and its coverslip. Belton recalled that Bacon made six versions of the pose, even ordering more canvas from the Chelsea Art Stores for the purpose.

But Bacon had small interest in most abstract conventions—or in most figurative conventions, for that matter. During a studio visit, Redgrave concluded that in Bacon's paintings, "all the canons retreat like school-

marms from a lunatic asylum." Bacon himself preferred the asylum to the canons of St. Ives. "This is a stronghold of really dreary abstract stuff," he wrote to Wirth-Miller after a month or so there, "and they are all fanatical about it. I can't tell you how bad it all is." Bacon soon began to long for London and friends. "It is terribly isolated here . . . I could never live down here and long just to finish the work and leave. I often feel so lonely and unhappy." So desperate did he become for a visit from Dicky and Denis—a visit from family—that he resorted to telling them, unpersuasively, that "if you have a car it is the most wonderful country around this part." In December, he confessed, "I have really learnt my lesson this time never to move from a large town. I can't wait to leave this dump."

Bacon worked quite hard in St. Ives, however, much harder than he had in Tangier. He began dozens of paintings while—in his usual way—completing few. Many were in the brilliant vermilion green that he took up while there. In mid-November he thought he had finished three pictures. To keep the pressure up, Fischer told him there would be a show the following spring. Stephen Spender, Fischer informed him, would be delighted to write the preface. Bacon dreaded the trip that Fischer promised to make to St. Ives to see how he was doing. When the art dealer unexpectedly canceled, Bacon seemed as relieved as a schoolboy who gets more time to finish a required essay. "I doubt if I shall ever get the pictures done for the show—Fischer could not come down thank God as he had to go to Germany but is coming now on the 15th of January. I hope some miracle will happen that I can do the work."

Bacon's money problems returned. One year after abandoning his close friend Erica in order to escape from his financial burden, Bacon felt no less insecure than before. "I am in the most ghastly financial state," he wrote Wirth-Miller in November. "I feel now I shall never get straight." The switch to Marlborough had not been a liberation, perhaps, just a stay of execution. Bacon's fundamental problem in St. Ives was probably not abstract art, productivity, money, or Fischer. It was probably Peter Lacy. Bacon in St. Ives was overcome with feelings of guilt, failure, and remorse. Erica Brausen was a good friend, but she could take care of herself. Peter was irreplaceable and suffering. Bacon had hoped to put their relationship behind him, renewing his life with Belton, but he was already tiring of the "remarkable boy." Belton was not wearing well in St. Ives, either with Bacon or with the locals. Initially, he had made a good impression, just as he had with Ann Fleming. Giles Auty, the art critic of *The Spectator,* met him on a visit to St. Ives and found him fresh-faced "and expensively dressed (by Francis)." Auty also noticed Belton's main appeal.

When Auty and Bacon fell deep into a discussion of Bonnard, a painter whose color was then much on Bacon's mind, Belton came over and "fingered his belt and inquired, 'Are you ready for a thrashin' yet, Francis?'"

But Lacy could also wield a whip. And Belton was not Lacy. Belton just drank and fought in the pubs. During a fight outside a pub that Bacon was probably trying to break up (or observe), Belton knocked out one of Bacon's teeth. Halfway through their stay in St. Ives, Bacon sounded like a cranky father, writing to Denis: "I long to be free of Ron—I really wish he would get a job." What was becoming clear to Bacon in St. Ives was that Belton was an amusement who was not always amusing, while Lacy remained at the center of his life. What was also becoming clear was that he had wounded Lacy in a way that was more serious than one of their traditional rows.

Lacy considered Bacon's ongoing relationship with Belton, together with the sale of the Tangier flat, a devastating betrayal. Lacy now considered moving to Mallorca. He wrote Bacon "terribly unhappy letters." At one point in the autumn Lacy wanted to see Bacon, and Bacon hoped they might reconcile. But Lacy wrote again to break off contact. On a trip to London during the time when Bacon was in St. Ives, Lacy struck back by hawking around the painting of the house in Barbados that Bacon had painted for him in 1952—a painting he had promised Bacon he would never sell. But if Bacon had now sold his studio in Tangier—and bought into a boy like Belton—then Lacy felt free to sell his house in Barbados. None other than Erica Brausen bought it, another person who felt betrayed. Bacon, of course, understood what both the sale and the purchase meant. Bacon struggled to get news of Lacy, who had told friends that he might be leaving Tangier. "If Dennis dear you go to the Colony— would you try and find out from Leonard where Peter has gone," begged Bacon, "if it is back to Mallorca or not and any news of him you can get."

In mid-December, Bacon's misery peaked. He would remember how he had passed the last few Christmas seasons—gambling with Peter on the Riviera. Now he was trapped in cold St. Ives with Ron Belton. Fischer's rescheduled visit was coming soon and Bacon could not tolerate the idea of seeing Fischer in his St. Ives studio. He had finished six pictures with which he was not particularly pleased. They did not constitute a show. London must be, as always, where a show came together at the last minute. Patrick Heron kindly invited Bacon and Belton to Christmas dinner at his marvelous house, Eagle's Nest, which was set on the cliffs five miles from St. Ives. The abstract painter later did a deft impersonation "of Bacon volunteering to light the pudding": "He swayed to his feet

and sloshed most of a bottle of brandy over it with the words, 'I'm very good at starting conflagrations!'" In early January, leaving Belton behind to clean up the studio and cut any remaining, half-completed canvases off their stretchers. Bacon returned to London two months earlier than he had intended. "This," he had earlier written to Wirth-Miller, "has been quite the worst year of my life."

In London, over the course of the next few months, Bacon painted or completed more than a dozen pictures as he elaborated the ideas he had been exploring in the last year into a series of paintings. Two of those ideas were particularly important. The first was presenting the figure (usually in backward-leaning recline) in a simplified abstract space, as he had in *Lying Figure* (1959), and in the bright color that newly interested him. The second was presenting small heads and portraiture with a kind of free, brushy panache, often against the vermilion green backgrounds that he had taken up while in St. Ives. Three portraits were of Mary Redgrave, William Redgrave's wife, whom Bacon found sympathetic. Two were of Belton, with an additional two seemingly inspired by him as well. One pope also appeared against the vermilion green. Fischer was relieved. Marlborough intended a major exhibit, opening in late March, with some thirty paintings and a catalog that was lavish for the times.

It was during this period leading up to the show that Bacon painted a portrait of Cecil Beaton. They had been casual friends for years. Both were at Lucian Freud's wedding to Caroline Blackwood in 1953; both were invited to dinner parties where the rich and social mingled with artists and writers; both were often in Tangier, where Beaton stayed with David Herbert, the queen of the Mountain. Beaton had initially asked Bacon to paint his portrait two years before. His motives were not complicated. The American artists were the talk of the town and his friend Francis was their principal rival. "He is acclaimed by the younger generation," Beaton wrote, "which, it seems, considers Picasso to be old-fashioned." Beaton wanted to be portrayed by the major new painter. He could also portray Bacon, of course, in a sort of reciprocal artistic arrangement.

Beaton was vain in a way that charmed away all objection. He assumed as a matter of course that the most-talked-about painter in England should paint the most-talked-about portrait photographer. No one could deny, he would have thought, that Bacon and Beaton made a brilliant match: the best painting the best. "It was pointless," Beaton said, "to sit to the usual portrait-painter." The Royal Academy now brimmed with old-

fashioned hacks. Beaton had last had his portrait painted twenty years before by the French artist, fashion illustrator, and designer Christian (Bébé) Bérard. The result flattered him: "It is as I would always like to be." A Bacon portrait would be different, he understood, but surely no less pleasing in a more important way. He had seen Bacon's portraits of the Sainsburys and pictured himself "as a sort of Sainsbury floating in stygian gloom."

Bacon initially appeared delighted with the project. The challenge might lead somewhere, though he must have wondered why a man like Beaton would risk the portrayal. "Francis started to work with great zest," said Beaton of their initial sittings, which were themselves a pleasure. Beaton found Bacon to be "one of the most interesting, refreshing and utterly beguiling people. He is wise and effervescent and an inspired conversationalist." With Francis, Beaton said, "the air is mountain fresh." But Beaton had gone to America and somehow the sessions had not resumed. Finally, after Bacon's return from St. Ives, Beaton caught up to him. "Francis, bubbling with amusement, smiled and with his usual marvelous manners said nothing would give him greater pleasure than to finish the picture that he'd long had of me in his mind." Bacon began anew, this time working with the green background of his St. Ives works. (Cornwall had been a disaster, Bacon told Beaton—"such terrible quarrels and he got behind-hand with his work.") Beaton sat for several more sessions. The two hardly stopped talking.

Often, Bacon left the easel to search around for—and usually fail to find in the "Dostoevsky shambles of discarded paints, rags, newspapers and every sort of rubbish" that covered the studio floor—something to illustrate a point. He longed to visit Aswan in Egypt, he told Beaton, "to see the carvings before they are flooded . . . Those early heads are *amazing*, but, of course, it's because of the sun that they're so beautiful." Once, he successfully fished out a Bonnard reproduction from *Paris Match* that was stuck onto a piece of cardboard. Together they admired the "oranges, reds, red-browns, brilliant blues, enough colours," Beaton observed, "for three pictures." It was after they admired the Bonnard that Bacon informed Beaton that his portrait was almost done. "Next time you're here," Bacon told him, "I'll show it to you because it doesn't need much more work on it. When they go well, they go very quickly." During the next visit Beaton, at Bacon's suggestion, did not immediately look at his new portrait. He took time to savor the moment, then approached the "degutted chair in the corner" and "turned round square and sat to get the full effect":

It was as well I was sitting, otherwise I might have fallen backwards. In front of me was an enormous, coloured-strip cartoon of a completely bald, dreadfully aged—nay, senile—businessman. The face was hardly recognizable as a face for it was disintegrating before your eyes, suffering from a severe case of elephantiasis: a swollen mass of raw meat and fatty tissues. The nose spread in many directions like a polyp but sagged finally over one cheek. The mouth looked like a painful boil about to burst. He wore a very sketchily dabbed-in suit of lavender blue. The hands were clasped and consisted of emerald-green scratches that resembled claws. The dry painting of the body and hands was completely different from that of the wet, soggy head. The white background was thickly painted with a house painter's brush. It was dragged round the outer surfaces without any intention of cleaning up the shapes. The head and shoulders were outlined in a streaky wet slime.

Bacon, noting Beaton's shock, told him to please not worry: Marlborough could have the portrait if Beaton did not want it. There would be no fee, and the gallery was "screaming at him" for more pictures. Then Bacon amiably changed the subject. "Oh, I unearthed these beautiful Egyptian figures for you to see. Look, here they are! How beautiful they are! They're only three feet tall, but the way the faces are painted . . ." In the end, Beaton felt honor-bound to purchase the painting but asked Bacon if he could sell it. Bacon said of course. Beaton went home "crushed, staggered." Not long afterwards, Bacon rang him at his country house and told him, "in an ecstatic voice, 'This is Francis, and I've just destroyed your portrait.'" Beaton asked, "But why? You said you liked it. You thought it such a good work, and that's all that matters!" Bacon answered: "No—I don't like my friends to have something of mine they don't like. And I often destroy my work in any case; in fact, I've destroyed most of the pictures for the Marlborough. Only I just wanted to let you know so that you needn't pay me." Beaton was astonished at how little Bacon minded "wasting" all the work in the studio. "He seemed jubilant at not getting paid, at *not* finishing a picture." Not surprisingly, Beaton did produce *his* Bacon. It was a superbly flattering portrait of the artist in a casual sweater—with just enough texture to lend interest—and appearing as "extraordinarily healthy and cherubic" as Beaton had described him. He also photographed Bacon at a remove, contrasting the man with the clutter in his Battersea studio.

Just before the opening, Bacon destroyed another three works that

he considered not good enough. It was a characteristic gesture, akin to a ritual sacrifice. In the end, Fischer, who had considered asking Stephen Spender to write the catalog essay for the show, instead decided to reprint a 1959 essay on Bacon by Robert Melville, one of Bacon's most sympathetic critics. Melville likely spoke to Bacon at length before he wrote (as he had on earlier occasions when reviewing Bacon). His piece almost seemed designed to fortify Bacon during a difficult period. Melville began:

> Francis Bacon is essentially a metropolitan artist. He is at home in the complicated night life of big cities, interested in the exhibitionism and instability of the people he chooses to mix with and absorbed by extreme situations. Highly gifted and satanically influential, he discovers in the art of painting the felicities of the death warrant.

Bacon would, of course, enjoy being associated with "the complicated night life of big cities." Instability, exhibitionism, and extreme situations—Melville's words—were also an indirect acknowledgment of his homosexual world and an appreciation of the vivid, discordant energy of the modern city. After the condescension directed at him by the carefully schooled artists in St. Ives, Bacon would like being judged "highly gifted" and would relish being called "satanically influential." Could an abstract artist in St. Ives ever descend into the hellfire or rise to the "satanic" heights? Melville stated Bacon's own view of abstraction, then condescended to the condescenders in a way that would have pleased Bacon:

> He has for many years taken it for granted that the last phases in the art of Turner and Monet, in which the autonomy of the brushstrokes is pushed to the ultimate limits commensurate with a perceptual image, was the natural point of departure for 20th century painting: but it was also clear to him that the abstract, focusless activation of a surface was so logically and obviously the next step to be taken that it hardly seemed to be worth taking.

Melville identified, probably through his conversations with the artist, what was likely Bacon's own view of what he was trying to do. Pressed by abstraction yet determined to assert the figure, Bacon let the struggle between abstract and figurative art come to symbolize something greater:

the existential struggle of humanity to survive in a cruelly abstract world. Bacon "replaced the perceptual image [the literal appearance of a human figure] with a conceptual one," Melville wrote, "and has taken openly sadistic pleasure in forcing it to struggle for survival in the quicklime of his paint."

Melville did one further service for Bacon: he defended him from the charge that his art was fundamentally old-fashioned. "He has been able to concern himself almost exclusively with the human presence—seemingly against the general tendencies of his time—because the evidence on his canvases has not been gathered from the artist-and-model relationship but arises from a highly selective predilection for the moment of revelation." Melville cited Bacon's modernist use of "found images," then concluded with an important point he had made before, which evoked Bacon's relationship to—and difference from—the old masters:

> Francis Bacon has a refined and mocking flair for grandeur, and his paintings sometimes provide a remote and bitter aftertaste of Venetian sumptuousness: but what he always, inexplicably, achieves is an eerily erotic collusion between the substance he manipulates and the psychic content of the image it tries to deface.

At the private view, a reporter for the *Evening Standard* wryly observed that Bacon's "complicated night life," to which Melville had alluded, "was much in evidence." Bacon's friends from his different circles came together on such occasions in a strangely turning social kaleidoscope. The prominent—more so than in the past—were present, among them Beaton, Antonia Fraser, and Stephen Spender. But the reporter also observed, as the guests sipped dry and medium-dry sherry, that a "young man in gym shoes padded past Sir John Rothenstein, director of the Tate, who was in white tie and tails. Writer Frank Norman said surprisingly: 'I feel tired.'" (Norman, a former thief, Soho miscreant, and master of the cockney dialect, had been taken up by Stephen Spender and the literary world after writing a prison memoir, *Bang to Rights*.) Afterward, a party was thrown not by a socially important Londoner but by a young Sudanese painter named Hussein Shariffe, who came from a prominent family in Africa and had a couple of shows at Gallery One, an outpost for young artists in the late 1950s. "Taxis throbbed out to South Edwardes Square for Mr. Shariffe's party," wrote the reporter. "Pianist Mike McKenzie [one of the keyboard regulars at the Colony Club] thumped the ivories in a studio groaning with frames. Floorboards creaked ominously but cham-

pagne corks popped encouragingly." The one person whom Bacon would have most wanted there, Peter Lacy, was of course absent. On the eve of the show Bacon painted *Seated Figure*, a full-figure depiction of Lacy turning restlessly in a chair, which arrived at the gallery—no doubt still wet—too late to be photographed for the catalog.

The Fig Tree

AFTER THE MARLBOROUGH SHOW, Bacon's affairs improved. Fischer and Lloyd, when they drew up the contract, did not know Bacon well. They had every reason to fear, a few months later, that they had thrown their money away. It had taken a year and a half to mount their first Bacon exhibition. But they better understood his studio practice now. The reviews were also reassuring. In his *Observer* piece, Stephen Spender emphasized the dark, Beckett-like humor in Bacon and dispensed with doubts and doubters. He wrote:

> The impact of these figures is so immediate . . . so devastating in the light-flooded underground tank of the Marlborough Gallery, that to say that these pictures tell us something about the modern world seems almost an evasion.
>
> A good many people will find in these paintings nothing but nausea, loathing and disgust for the world. Perhaps these are present, but I think that to see only them is to miss something else—the quality of an immensely tragic joke, the pleasure in the absurdity of the truths which surround us but which everyone avoids.

Not everyone agreed with Spender's assessment, though the caustic tone adopted by skeptics was growing more muted. Marlborough did its best to present Bacon favorably: the critic Lawrence Alloway pointed out that the "bibliography . . . leaves out all items about Bacon except those by Melville and David Sylvester . . . [which] means there is no opposition recorded to Melville's creedy reading." The most offbeat review came from the American-born painter R. B. Kitaj, who echoed Melville in a slangy style:

> Bacon's paintings always were nightmares, but now the bad dreams are over and dawn breaks in the nuthouse. Bacon stains each canvas

with some eerie color, after which an event (he believes in re-creating events) is staged with some mighty fine brush work. Imagine Lon Chaney Sr., made up for one of his ghoulish roles, let loose in a plush Park Lane flat in nothing but his undershirt—crawling all over the carpet, up on the couch, crouching, gesturing, mimicking. In a word, Bedlam in Baconland.

Collectors were becoming more interested in the artist who created bedlam. The *Evening Standard*'s reviewer noted the "red stars" on Bacon's paintings that telegraphed sales. "Buy Bacon—It's chic to be sick," he wrote. And the buyers were, indeed, beginning to arrive (though Marlborough did not find Bacon easy to sell until many years later). Joseph Hirshhorn, the eccentric American tycoon who liked to buy art in bulk, had purchased five Bacons by 1962; the New York dealer Martha Jackson at least one. For all his professed hatred of Bacon, even Douglas Cooper bought his work in the early 1960s. Fischer and Lloyd now set out to promote the art while managing the man. Adjustments must be made to forestall the difficulties of the last year. Never again would they leave Bacon entirely alone. Someone must tend him, weighing his need for money and assistance while arranging what could be done for him without interfering in a way to cause consternation or offense. Bacon began wryly to refer to Lloyd and Fischer as his "uncles."

The uncles knew how to sell art on the secondary market and were determined builders of inventory. In his quest to stock the larder, Fischer looked first to the Bomfords, the collectors from Wiltshire who bought so much modern art. At times, Jimmy Bomford—the former stockbroker—would sell off works in his collection in order to buy others. Bomford was "a very nice man," said David Somerset. "He had a beard. He used to come into the gallery all the time—that's how we knew him. He said, 'Come down to my place.' We used to buy other paintings from him. He had sort of Renoirs, things like that. Fischer was the one who somehow made friends with Bomford." Fischer thought it made sense to visit the collector again, so he and Somerset drove to Wiltshire. "I was just the driver," Somerset said—but few galleries, of course, had a future duke as a chauffeur. The Bomfords now sold twelve of their nineteen Bacons to Marlborough. "We brought them all back in the car," Somerset said.

Buying Bacon in bulk was not regarded, Somerset said, as necessarily prescient. "You couldn't sell them." But they were also inexpensive, and Fischer and Lloyd, as they built their inventory, used a technique perfected by art dealers in New York to develop a market for contemporary

art. They created an aura of "modern masters." The idea was that a living artist—such as an abstract expressionist, for example, with whom a collector could still have a drink—eventually would graduate into an old master whose art hung on museum walls. No one much wanted a Bacon *now*. But in the future? Think van Gogh! Around contemporary artists, dealers tried to generate a paradoxical sense of both fashionable frisson and intellectual gravitas. The *gravitas* was attained, whether deservedly or not, when an artist became the subject of a scholarly show at a prestigious museum. Serious books on an artist, even when unreadable—perhaps especially when unreadable—also helped burnish a reputation. The frisson came from parties, fawning profiles in the press, and openings around the world. In an increasingly prosperous and confident postwar society, collectors could use art to present themselves as both exciting and safe—and unquestionably rich.

In 1960, London's art world was not as fashionable or freshly moneyed as New York's. But Fischer and Lloyd (and also Brausen, though she lacked the resources) understood the new rules of the game. Fischer sought to position Bacon as a major artist through museum exhibitions. He wanted a big traveling show of the kind later known as a "mid-career retrospective." Since no important museum had yet offered to organize such an exhibition—and, given the difficult character of Bacon's work, none was likely to do so in the immediate future—Fischer began to prepare one on his own. He floated the idea of a Bacon retrospective to museums around Europe and worked to bolster Bacon's scholarly reputation, planning a mid-career catalogue raisonné that Marlborough itself would publish. Fischer also planned to commission high-minded writers such as Spender to compose essays on Bacon.

The critical museums, for Fischer's purpose, were the Tate and the Museum of Modern Art. John Rothenstein, at the Tate, remained bemused by Bacon's "naughtiness." Bacon knew just how far onto the dark side he could take the conservative director. He had recently brought Rothenstein to the Rockingham, for example, a homosexual club that Christopher Gibbs described this way: "You went down the stairs and there were two rooms. Each had a bar and a personable young barman, and everyone was dressed up in suits and ties and shiny shoes, and it was a real mix. Full of people who wanted to look as if they'd just come out of White's club or Brooks's club or the Garrick or something—and some actually had. And then quite different sorts of people, full-time gay folk as well." Rothenstein had become more comfortable with Bacon's art as more people endorsed him. The book on Bacon that Rothenstein

had proposed four years earlier—which Bacon initially endorsed, only to conclude that the idea "repelled" him—still remained in the back of Rothenstein's mind. But a book by the director of the Tate without an accompanying exhibition would not have seemed reasonable to Fischer. The Tate had mounted retrospectives of Henry Moore, Matthew Smith, and Graham Sutherland. Why not follow with Bacon?

Bacon and his Marlborough uncles had no such close connection to MoMA. Even so, Fischer proposed that MoMA publish a book on Bacon with the leading London art publisher Lund Humphries, who worked with the museum in New York. The idea took hold. Just before Bacon left London for St. Ives in the fall of 1959, Fischer received a book proposal from James Thrall Soby, who not only remained a powerful figure at the Museum of Modern Art but had a lengthy relationship with Bacon's work. A close personal friend of Alfred Barr, the founder and guiding spirit of MoMA, Soby had been a pioneering early supporter of the museum, serving as a trustee and important advisor. On occasion, he had temporarily assumed administrative posts, among them director of painting from 1943 to 1945. He was a prolific writer, producing a monthly column for years for *The Saturday Review of Literature* and writing short books intended to introduce modern art to a popular audience. His private collection included two paintings by Bacon, the powerful *Study of a Baboon* of 1953 and one of Bacon's paintings of the life mask of William Blake.

The prospect of such a book thrilled Marlborough. MoMA was the St. Peter's of modernism, its curators a clerisy determined to distinguish the truly modern from the historically false, backward, or mediocre. They could be dogmatic, emphasizing formal values and the move toward abstraction, and they generally believed that New York had replaced Paris as the capital of modernism after World War II. It was no small matter, then, that they should take an interest in a figurative English painter who loathed abstraction. Soby's book on Bacon could also strengthen Fischer's position with other museums, including the Tate, and it raised the tantalizing possibility that MoMA itself would organize a Bacon exhibition. In December 1959, Fischer wrote Soby that Bacon "would be very happy if you would undertake this task" and suggested that Robert Melville assist in the selection of illustrations.

A small problem arose immediately. To gather background material, Soby sent the gallery several outsized pieces of paper that resembled an enormous examination booklet or job application in which a series of questions was put to Bacon. What led him to become a painter? What

were his main influences? A space was left underneath each question for a two-or-three-hundred-word answer. Soby, it was clear, was a conscientious author. His intent was reasonable. Readers of an introductory book on a difficult artist like Bacon would want to know a few personal details and hear what he had to say about his life and work. But Soby's questions were so painfully earnest and solemn, like something a schoolboy might write to an eminence, that Bacon—Fischer knew—would respond only with eye-rolling hilarity and a raised glass. Some answers would nevertheless have to be sent to the earnest American. How to do so presented a problem. Bacon was an unabashed homosexual who did not live a settled life. He had hardly gone to school. His influences, about which he could be touchy, were all over the place. And he never liked to discuss his past.

Fischer and Melville determined that, much as doctors once gave soldiers whiskey before surgery, they must get Bacon drunk in order to open him up. In January of 1960, they took him to the Reform Club on Pall Mall for a long, wine-soaked meal. The results of the operation were mediocre, though Fischer wrote Soby that "Bacon became rather talkative as time went on":

> He made many references to his father which I think it wiser to leave out, but one thing he said which you could use (though in a more sober mood he might not like it) was that . . . all his life he had been looking for some help to find a "Theoretical Background" for his painting. Once in life he hoped Graham Sutherland might provide him with it.

Fischer reported that Bacon "found it was not possible to give direct answers to some of the questions." Fischer instead provided Soby with a highly misleading "summary of remarks" that represented Bacon's first significant effort to devise a public mask for a mass audience. Bacon did not begin to paint until he was "nearly thirty" (a version of his life that Bacon preferred to the facts). Before that he did nothing, as there was family money "which enabled him to lead a life of leisure." He had had "no art training." He had been to Africa "about 20 times." (Fischer did not specify that Tangier was a frequent destination.) He had "traveled from one end to the other [of Africa] but apart from that has made no significant voyages" (which left out his many trips to Italy, Spain, Paris, and the South of France). About his sources, Bacon was more helpful. "He is interested in specific painting(s) more than painters. 'Certain

painters,' he says, 'have created images which have had a hypnotic effect on me,' and he instances Cimabue (*Crucifixion*) [what is ordinarily called *Crucifix*]; certain works by Velásquez and Rubens; the late self-portraits of Rembrandt." Bacon also mentioned Zurbarán, El Greco (*View of Toledo*), Daumier, Seurat's oil sketches, late Monet, early Matisse, Picasso, and Soutine—and, Fischer reported, said he "hates the paintings of Fuseli and William Blake." Bacon always took pains to deny any parallels between the early, eccentric English visionaries and himself.

Soby could not have been pleased with Fischer's summary, though he wrote back amiably, "I roar with laughter when I think of Bacon saying that not only did he not know what decided him to become a painter but that he wishes he'd never started." If Bacon did not himself provide a "theoretical background," however, Soby could not be expected to devise one. He was neither a bold nor an original thinker. None of the information flowing from London to New York helped Soby understand why Bacon mattered. He wanted to put a tag on Bacon, place him under an "ism." When Soby ventured to Fischer the idea that Bacon was "the purest surrealist," Fischer responded with "Bacon himself says that he does not consider himself as such but adds 'I don't mind what anyone calls me.'" Soby concluded that the only solution to his problems was to interview Bacon personally. Fischer could not promise to deliver such an interview. After telling Soby in May of 1960 of the "tumultuous success" of Bacon's first Marlborough show, he added, "It is a problem to contact Bacon. He disappeared, as usual, after the last picture was delivered."

If Bacon's career appeared more settled in 1960, he continued to be under tremendous stress emotionally. The feelings of guilt and remorse that he had felt about Peter Lacy while in St. Ives continued. One day in June of 1960 John Rothenstein happened to see Bacon at the Whitechapel Gallery, where the abstract artist Ceri Richards was exhibiting. "FB said going into hospital for, apparently, a psychologico-physical ailment," Rothenstein noted in his diary. Bacon made light of it, as he usually did of his ailments. The best defense, he well knew, was deflection. The reason for the treatment, he said, was "because I want to live long enough to paint better." He "*looked* very well indeed," Rothenstein noted. To the world at large, Bacon conveyed inner strength. He would say to a friend as if it were nothing at all: "You mustn't look at my mouth. I'm just recovering from having a tooth knocked out. My face was in

an appalling mess." Most nights, he still went out, treating everyone to drinks. He spontaneously gave the painter Frank Auerbach 100 pounds when the painter was hard up. Only with his closest friends did he sometimes confess to moments of intense melancholy and despair. Anne Dunn noted a "fragility" that he had to "protect." His letters to Denis Wirth-Miller were an ongoing stream of anxiety and vulnerability. Even the Largactil that Dr. Brass routinely prescribed did not appear to be working.

Even so, Bacon took Ron Belton with him to Tangier that summer; he obviously still found his thuggish charm appealing. They booked on the *Kenya Castle*, a liner that regularly circled Africa on the eastward route from London; its first port of call was Gibraltar, across the straits from Tangier. Denis Wirth-Miller, who also fancied Belton, saw the couple off at Waterloo Station, where the train left for the Southampton docks. They arrived early at the station and stopped for a drink. Wirth-Miller, always prepared to overturn an apple cart, wanted to keep drinking until the last moment. That angered Bacon, who, like an elderly lady, always left himself enormous amounts of time to reach a station or airport. In a spirited letter written onboard, Bacon chided his friend for trying to steal his boy prize:

> I am sorry I was annoyed with you at the station but I knew if you went to the other bar Ron would miss the train and have to take a taxi to the docks. You will be able to say I am an old governess but if I had made the same head on dash to seduce a friend of yours by trying to be outrageous you would not feel so good about it. But as you know it will make no difference as I shall always love you.

The *Kenya Castle* was a good but dangerous place to engage in a shipboard romance, as Bacon knew from his earlier voyages with Heber-Percy and Lacy. Bacon brought along fishnet stockings for the occasion. "The crew are so handsome and charming and sweet on the boat," Bacon wrote Wirth-Miller. "They think we are a honeymoon couple, isn't it camp . . . The boy who waits on us is so sweet and camp Ron has quite fallen for him." Alas, the seas proved rough and Belton mostly stayed in the cabin, seasick. At Bacon's table for dinner were "an old queen who has a physical training school in Nairobi" and a "charming johnny man and his wife going out to Uganda." With Belton in bed, Bacon drank with the young johnny, who "confessed how he hated married life. He said he hates homos but gave me some luscious kisses in the cabin. Will let you know how things go."

"How things go" meant both how things went with Belton (and the charming johnny) and—much more importantly—how things went with Lacy. It would have been kinder not to bring along Belton; kinder, in fact, not to visit Tangier at all. Bacon remained desperately worried about Lacy, as his letters from St. Ives proved. But Bacon must always go to the center of the emotional knot, always force the revelation. Or, at least not avoid it. Like the Greek playwrights he admired, he would not hide from fate or avoid consequences. And so he went to Tangier with his handsome young thug to see what would happen.

Few details survive from his meeting with Lacy. There was an evocative mention—almost farcical—of Lacy and Belton joining forces at one point in a shared taxicab and *both* setting upon Bacon. But in the end Lacy simply avoided Bacon, who, flush from his successful show, spent much of his time gambling at the new municipal casino in Tangier. Bacon and Belton then went on to the tables of Monaco, another place steeped in memory for Bacon—of Lacy, of course, but also of Nanny and Eric Hall. Bacon wrote a letter asking Denis to visit them in Monaco and to please remember to bring along fifty pounds in five-pound notes. Only then did he report his anxiety about Lacy:

> I am terribly upset over Peter. He looks so ill and is in such a state and won't speak to me. I cannot bear to see someone suffer because of me . . . [Ron] sometimes is so violent I am afraid of him. Please don't mention to him I told you. I think Peter is going back to Mallorca. I am afraid he will never forgive me and it is dreadful to see him looking so ill. I feel desperate sometimes and feel I have done something terrible.

Back in London, Bacon's anxiety persisted. The elder Dr. Brass became concerned. He noted, on August 8, 1960, that Bacon arrived in his office feeling far more perturbed than usual. He had lost all of his money gambling in Tangier, Bacon informed his doctor, using his financial loss rather than his private worries over Lacy to explain his agitation. (Personal relationships and sexual matters were only glancingly referred to by Bacon in his dealings with Stanley Brass.) No doubt there was also truth in what Bacon said: the gambling losses made a bad situation worse. Bacon told his doctor that he felt he was losing control of his life, "living at the edge of a volcano." Dr. Brass then gave him intravenously a high dosage of Equanil, a tranquilizer used to treat symptoms of nervousness and anxiety.

The unsettled nature of Bacon's life, as he floated between Pollock and

Danquah's flat in Battersea and Tangier and the South of France did not help him complete paintings. Fischer and Lloyd, unaware of Bacon's state of mind, were only too aware of his living arrangements. It must have struck Fischer and Lloyd as absurd that Bacon did not have a place of his own. A modern master painting in a room in someone else's Battersea flat? Bacon himself wanted to move: he had presumed for too long on the generosity of Pollock and Danquah, and he disliked bringing Belton there. With the help of his "uncles" he began a focused search for a studio. At the end of November 1960, Fischer and Bacon found a place that deserved a second look. Fischer hoped it was "free from damp."

By Christmas, Fischer was negotiating with Robert Savage, a frame maker, restorer, and occasional art dealer with a shop at 65 Old Brompton Road. Over the years, Savage had employed many poor young artists, among them Yves Klein, to help him build frames and restore paintings. On a mews off Old Brompton Road Savage maintained a small house—7 Reece Mews—where he kept an automobile and probably supplies for his workshop. The garage was on the ground floor. On the first floor, up a steep and narrow staircase (with an old knotted rope for a railing), was one larger room, a second space with no doors that could serve as a bedroom, and a narrow kitchen that included a bathtub. Nothing slicked up. Bacon liked it. The larger room could be his studio, and the kitchen and second room were serviceable. Soho was close—a few stops on the tube from South Kensington Station.

Savage was ambivalent. He dillydallied through the winter and into spring. In May, with Bacon at "the end of his tether," Fischer delivered an ultimatum. Savage then agreed to a lease of about twenty pounds a month, beginning in June 1961, with the understanding that he could continue to use the garage. Fischer was not surprised—now that he knew the artist better—that Bacon took his time making the move. It was troublesome. Summer was at hand. But Fischer had put in place a keystone—to help hold together the artist's scattered life. Peter Pollock and Paul Danquah, the latter in particular, were sorry that he was leaving Battersea. Danquah enjoyed attending fancy dinners and art-world events with Bacon. During the period when Bacon lived with Pollock and Danquah, he went from being a painter best known for his Soho exploits to an artist with a small but growing international reputation. As Danquah put it, "Towards the end of his time with us, the whole world began to realize his importance."

Fischer continued to try and "center" Bacon's reputation in the library and the museum—elevating him, to some extent, above the hurly-burly

of the press and the "raging around Soho" stories. It seemed increasingly unlikely that Soby would finish his book, yet Fischer was willing to be patient in 1960 and well into 1961. In the fall of 1960, he had delicately pressed Soby: "We have heard nothing lately about your plans for a Bacon book. Has it materialized yet?" MoMA was a prize worth the exasperation, in short, and Fischer continued to hope that good relations with Soby would lead to a retrospective at the museum. In fact, Soby was himself urging MoMA to organize a Bacon show. Early in 1961, the influential poet and curator Frank O'Hara, a close friend of many of the American abstract expressionists, agreed to begin work with Soby on a Francis Bacon exhibition. They continued to develop plans for a show through the rest of that year. Fischer, who was not informed of their work, maintained his gentle pressure on Soby. Fischer wrote Soby in May 1961: "I have just spoken to Bacon and he would be very pleased to see you when you come to London this summer." He emphasized that "It is of the greatest importance that the book is ready in February [1962] as Bacon's first continental exhibition will be held in Zurich in April [of that year]. It will be a retrospective exhibition with seventy-five paintings in the show."

By talking up a ready-to-go exhibit for museums abroad, Fischer, as Bacon's reputation grew, shrewdly put pressure on the Tate. How could the English museum let a foreign institution mount the first retrospective of an artist who, some thought, was England's foremost living painter? Were the English *really* so visually illiterate? Rothenstein was susceptible to this pressure. He had been relentlessly criticized for failing to collect the best European art of his time. Whatever his failures as a collector or limitations as a critic, he was not simply a reactionary. He was a perceptive admirer of both Moore and Stanley Spencer, and he had enjoyed the exhibit of Jackson Pollock's painting at the Whitechapel Gallery in 1958, writing, "How good *originators* are." And his great friend Roy de Maistre liked Bacon. Fischer found reason to bring up Bacon whenever Rothenstein visited the Marlborough gallery. He might mention that book by the American at the Museum of Modern Art in New York. He could refer to negotiations with European institutions—including one in Paris—which were going well. The French found so much to admire in Bacon's art. And so on.

Still, Rothenstein remained cautious. In June of 1961, he happened upon Bacon at the opening of an exhibit of Daumier's paintings at the Tate. He asked him a second time if he might write a short book on him: a short book might develop, of course, into a catalog essay for an exhibition.

This time Bacon "liked" the idea. It was Bacon's response to Daumier, however, that most impressed the director, who had "never known him so moved by anything." Ordinarily Bacon did not appear moved by an exhibit. But there were exceptions. Bacon was probably not overly familiar with Daumier's paintings; then as now, he was best known as a caricaturist. As a painter—and it was as a painter that Daumier moved Bacon—he was a different artist. There were some beautiful lines in his painting, but Daumier did not rely upon draftsmanship or illustration to describe, capture, or fix appearances. Instead, as in Bacon's work, the figures came mysteriously to life through a kind of push-around in the paint: they were highly specific, but not literal. The mood was melancholy and the lighting theatrical, the forms picked out against an indistinct, powerful, and enveloping darkness. No doubt Bacon enjoyed those connections to his own work. But he may have felt a personal connection, too, as Daumier was largely self-taught and rejected the interests of the fashionable artists around him. His work looked awkward and raw to his contemporaries, who, like many abstract painters in Bacon's day, had a finely polished ideology. And he had such a darkness, softer than Bacon's but no less pervasive. Bacon could talk fluently about art, and he probably talked to Rothenstein about Daumier. Rothenstein was not stupid. If Daumier's paintings could hang in a museum, so might Bacon's.

Not long before seeing Rothenstein, Bacon got a surprise—a telegram from Peter Lacy asking him to come to Tangier. It was as unexpected as the telegram from Lacy five years before, when Bacon immediately scrambled to Tangier at his summons. Only now the chances of restoring any happiness between them seemed as remote as a miracle. Lacy had kept apart on the last visit when Bacon appeared in Tangier with Ron Belton. And he had sold Bacon's painting of the house in Barbados after Bacon sold his flat in Tangier. Bacon knew it was "all over" between them, as he later told Michael Peppiatt, but "like a fool" he went anyway, intending to stay for two months. He could not avoid such an invitation. Besides, he and Ron Belton were drifting apart. The smudge was not only excessively violent but too interested in crime. In 1964, he would marry a fashion model. Six months later they were charged with receiving stolen goods when police found thirty thousand pounds' worth of "hot" jewelry in the boot of the model's car.

If Bacon hoped for a miracle in Tangier, he instead became part of a parable. No one was home when Bacon—fate's fool—arrived at Lacy's house. "But there was this Arab boy, well it sounds mad, but he was sitting up in a fig tree in the courtyard and he asked me whether he could pick

the figs . . . And in the end he climbed through the window and, well, he was terribly good-looking."

The forbidden fruit must be picked.

"Peter came back just then, I'm afraid, and found us both in bed and he got so absolutely mad, he went round and broke everything in the place."

Peter's rages were once powerful. Now, after years of drowning in alcohol, he could only rage impotently on his sunny heath, smashing everything. What kind of man was Francis? "Even though there was nothing between us anymore," Bacon said. "He broke everything." Except, of course, Bacon. "In the end, I had to go out and try and spend the night on the beach."

Once again he and Lacy had tried to come together. For the rest of the visit, Bacon stayed at the El Djenina Hotel. He found some old friends in town, notably Ahmed Yacoubi. The two briefly shared a work space on the terrace of the Hotel Mimosa, where the actor and costume designer Larbi Yacoubi prepared meals for them. But Bacon did not stay the two months he intended; he left, the local newspaper reported, in a hurry after only a month, heading on the morning of August 12 "to France and England to finish off some work urgently awaiting his attention." The night before Bacon left, Cecil Beaton arrived in time for one of Barbara Hutton's legendary parties—170 guests at her house in the Kasbah—with "two over-life-sized negroes entirely made of flowers" decorating the terrace and "an entire Moorish cabaret complete with belly dancers, Mexican singers and gentlemen with guitars." The last guests, said the *Morocco Mail,* didn't leave until seven a.m. Tangier continued, but for Bacon, the city was no longer "the dream at the end of the world." He would never again spend much time there.

"Such Ardour"

I N THE AUTUMN OF 1961, Rothenstein began intensive discussions with Fischer about a Bacon retrospective at the Tate. It was not certain that the trustees of the museum would agree to the show. They were fairly conservative and included the traditional figurative painter William Coldstream, then the Slade Professor of Fine Art, University College, London. Old-fashioned views were not, however, Rothenstein's main problem. The trustees noted that Marlborough was the principal architect of the exhibit and were concerned that it would be regarded as a marketing enterprise. Fischer did everything he could to minimize the gallery's contribution. Rothenstein was flattered by Fischer's close attention to the "many points I made," and Fischer invited him to write introductions to both the retrospective and the upcoming catalogue raisonné. Rothenstein assured the trustees that he himself intended to control the content of the exhibition, which would include "almost all" of Bacon's art.

Coldstream called Rothenstein's bluff in December, asking for a list of the pictures to be exhibited. That led the trustees to postpone their decision about whether or not to proceed. In January 1962, John Witt, an important English collector, strongly objected to the show "on principle" because of "dealer" contribution. Rothenstein foresaw "endless discussion and delay." But he also had strong supporters. The chairman of the board of trustees, Colin Anderson, continued to maintain a personal relationship with the artist. On January 15, Anderson and Rothenstein had a "long talk," presumably on the subject of how to support the show financially and morally. The next day, when the Arts Council informed the museum that it could not provide "substantial help," it no longer mattered, because Robert Sainsbury decided to offer support. He sent a letter to the Tate's director in favor of the show, which Anderson then authorized.

Rothenstein immediately went to Marlborough to tell Fischer. He also

informed Erica Brausen, whose help he considered critical. The following week he visited Bacon in his new studio in Reece Mews:

> A largish, secluded place: room partitioned by unpainted wooden boards: picture mags. scattered; paint v. untidy + only one pic. there, an unsuccessful nude on settee. He quite touchingly appreciative of what I have done to bring abt. T.G. exn. Have never before known him int. in anything affecting his reputation; evidently deeply moved by this proj . . . Am v. fond of FB.

In the early 1960s, it was not impossible to plan and execute an exhibit in a matter of months. Rothenstein now took charge of the London venue, scheduling the Bacon exhibit to open that same May. Meanwhile, Fischer worked on Zurich and the foreign itinerary. Once he received approval for the exhibit, Rothenstein had only four months to publish a catalog and assemble the pictures. He persuaded a somewhat reluctant Erica Brausen—still smarting over Marlborough's behavior—to help with archival information. Whatever her lingering anger, Brausen felt an obligation to Bacon's art. She arrived for a working lunch with Rothenstein and Ronald Alley—drafted to oversee the Bacon catalogue raisonné in place of Robert Melville—armed, Rothenstein wrote, with "her invaluable F. Bacon records." She worked long hours to provide the right facts and chronology, such as dates, provenance, photographs of paintings, and so on. Bacon himself helped with the catalog entries. As Rothenstein prepared to write the introduction, he discussed the artist at length with Roy de Maistre and David Sylvester. And in the hope of obtaining some personal information, he invited Lucian Freud to dinner at the Athenaeum: Freud would know things no one else did. But Bacon—"wishing perhaps to exercise some supervision," as Rothenstein put it, "over the interrogation of an intimate friend"—invited himself along. "I had only a moment alone with Lucian in which he barely had time to say, 'Don't overlook the influence of Nietzsche on Francis' before Francis himself arrived."

In early February, Rothenstein spent an afternoon with Bacon alone at Reece Mews, questioning him about his work and life and writing down his observations in a notebook. Bacon treated him with unfailing courtesy while admitting him into what must have seemed, to a man like Rothenstein, an unimaginable world. As a devout Catholic, Rothenstein wanted to discuss soulful meanings, repeatedly bringing up the Crucifixion. The subject had long fascinated Bacon, of course, but he invariably denied that religious feeling entered his work. Instead, he hoped to recover the

sensation of physical agony on the cross that religious conviction only attenuated. But Rothenstein liked to ponder great questions, such as the decline of religious art in a secular world; and discussing the implications of the Crucifixion in the modern era was irresistible to him. He loved pressing the charming atheist on the matter so that they might eventually agree to disagree. It was unlikely that Bacon took what Rothenstein said seriously. He had heard the Crucifixion talk before. But even a throwaway moment can suddenly become unexpectedly important to an artist, especially one like Bacon who depended upon chance. After talking to Rothenstein, Bacon, who had been trying for years to reinvigorate his art, was seized with the desire to paint a Crucifixion. A summary sort of Crucifixion.

Mid-career retrospectives, however flattering, disturb many artists. A thoughtful artist sees, on the cold institutional wall, not just success but failure. And not just the life of art but also the approach of death. Bacon, always secretly anxious about his health, never felt far from death. His lungs were compromised by asthma, his blood pressure was dangerously high, he existed in a state of constant tension, and he was fifty-two years old. The chances were good that he would not live to see another retrospective. For the last few years he had been floundering, failing to locate that powerful internal tremor that sustains major art. Was he willing to conclude the exhibit with the van Gogh paintings or some of the wan, melancholy figures from his last Marlborough show? Where was the tigerish energy? The scream from the throat?

To end with the whimper and not the bang offended Bacon's sense of occasion. And so he set to work on a Crucifixion—a large triptych to serve as a bookend to the original *Three Studies* that launched his career. Perhaps he might recover something of his early rawness, locate again the spirit of Aeschylus. He was rereading Nietzsche, itself an act of recovery. And he had never abandoned his Nietzschean admiration for the sacrificial power of the ancients. It was not easy, however, to find an image. He was in a new studio. He began to drink while he worked, something he rarely did at the easel, in order to become "a bit freer." Sometimes, he suffered from a hangover so punishing that he could hardly stand. (He had a "massively distended liver from at least 1961 until his death," according to Sophie Pretorius in her study of Bacon's medical records.) He kept an expensive electric radiator running at all hours. He had traditionally worked at a feverish pace before gallery shows, of course, but over this period of two to three weeks he appeared to be half killing himself. At one point, Rothenstein was shocked to see Bacon out and about in "such cold

weather" without an overcoat, describing him as "suffering fr breathing trouble (asthma) + not at best."

Three Studies for a Crucifixion (1962), intended to cap the retrospective, would become one of Bacon's greatest works. It would also become a touchstone for the artist. In the years to come, he would increasingly use the triptych form in his most ambitious work. He relished the chance to present a rich spread of meaning in a three-act drama. Bacon twice pulled the large triptych back into the studio before the opening, however, which frightened one and all. He might easily have turned it into a muddy ruin. That he did not was perhaps a sign of its strength: even Bacon could not find fault enough to destroy it. Meanwhile Rothenstein, who felt the "extraordinary intensity" of Bacon's triptych when he first saw it at Reece Mews, now feared that he himself was not up to the task of writing the introduction to the show. He wrote:

> For a long time I gazed at this extraordinary painting with a fascination touched with horror. "You know, of course," Francis eventually announced, "where all this comes from—it's inspired by you." I must have made a gesture of incredulity. "When you were here last week," he replied, "you spoke about artists as conveyors of religious truth . . ."

Six weeks before the May opening—uncharacteristically late for him—Rothenstein began writing the introduction. He finished in two weeks. He took it to Bacon's studio with trepidation early one morning. Rothenstein read it out loud as Bacon made breakfast. Bacon was moved to tears, Rothenstein confided to his diary, telling the director "it was by far the best thing ever written on him, [the] only one to treat his art in a matter-of-fact way, etc." Rothenstein felt "touched and relieved." (Just how much of Bacon's response was calculated is an interesting question. Bacon was a master of manipulation when he wanted to be, and Rothenstein was willing to be manipulated.) The introduction was very careful, its "matter-of-fact" tone taking the edge off the arguments that surrounded Bacon. Rothenstein, the tradition-minded director of a national institution, did not assert Bacon's importance in relation to other artists, which would have aroused debate and made enemies. Instead, he wrote, "Perhaps the present exhibition . . . will bring about some consensus of informed opinion . . . but I should not be surprised if it served only to intensify the division and to deepen critical confusion."

Rothenstein could safely insist upon Bacon's contemporary relevance,

however, whatever the judgment of the future. Not only did Bacon reflect the horrors of the century: he also made use of photographic imagery, which had created "a language which, more than any other factor, has formed our way of seeing." Rothenstein tried to keep Bacon in the realm of good taste by downplaying the frequent criticism that his art was melodramatic:

> The element of Grand Guignol—which plays in any case a diminishing part in Bacon's art—is not the agent that chills the blood. On the contrary there is something reassuring about, for instance, his vapourizing heads, for we know that heads do not vapourize and that what we are looking at is a work of macabre fantasy. Fantasy can only chill the blood for a moment, but it is otherwise with the contemplation of certain aspects of reality. "Human kind," as T. S. Eliot truly observed, "cannot bear very much reality." It is the reality, not the fantasy, in the art of Bacon that horrifies.

The show filled five large galleries and featured most of Bacon's strongest paintings—from the 1933 *Crucifixion* to the screaming popes and shadowed businessmen of the late 1940s and early '50s; to three of the van Gogh paintings; to a careful selection of more recent work and, underscoring it all, the new triptych. Bacon came to the press preview the morning of May 23, which no one expected, and spoke "amiably" to the critics. He was carefully dressed in an informal way, wearing blue jeans, a black-and-white checked shirt, and a black leather jacket. (Black leather would increasingly become Bacon's signature look.) The three owners of Marlborough—Lloyd, Fischer, and Somerset—gave a small luncheon for Bacon and the Tate curators at Prunier in St. James's Street, a London satellite of the legendary Parisian restaurant known for its seafood and caviar. The group then returned to the Tate for the private view. Earlier, Bacon had asked the Tate if he might arrange his own party to follow the private view, where he might entertain a more marginal crowd. The trustees turned him down; they preferred to keep the party at the museum. Bacon, noted Rothenstein, was "most understanding."

Although the evening was a "very formal occasion," it was already obvious in the early 1960s that the social life of art, especially among the young, was changing. Worlds once kept apart were mixing and colliding, and it was becoming fashionable not to follow formal conventions of dress and behavior. Bacon, as a theatrical man, understood that. He always presented himself carefully. He was not the showier sort of dandy,

but he loved clothes. "He'd see something in a shop in Soho and buy it," said Paul Danquah. "I think he consciously put on slightly extravagant things sometimes." When Rothenstein returned to the Tate for the party that evening—for a crowd of five hundred to six hundred people—he noted that Bacon was still wearing his blue jeans and his checked shirt. Rothenstein went on to observe that "instead of wearing his black leather coat he swung it about as a toreador his cloak":

At a few paces distant he was followed by a few youths similarly dressed. He was very drunk, but his condition did not in the least diminish his dignity or the charm he so powerfully exerts. When he left he again thanked me for my part in the exhibition, embraced me, and kissed me on both cheeks, making me feel like a French officer receiving a decoration.

The reviews were celebratory. "Such ardour," the curators at the Tate noted, suddenly expressed by the typically reserved *Times*. The paper's unsigned piece, which appeared the day after the private view, called the retrospective "the most stunning exhibition by a living British painter there has been since the war." To come upon Bacon's work, the critic wrote, resembled "one's first encounter with the late paintings of Goya in the Prado":

The emotional shock is extraordinary, because it is so instantaneous and at the same time complex and contradictory. This is the black night of the twentieth-century soul, images of man which are terri-fying, violent and at times bestial. Yet they are royal, and proud, and silent. No other painter of our day—and for once the phrase can be left as it stands, without worrying about the word "British"—could make these five large galleries look so nearly like an exhibition by an old master, yet leave one in no doubt that here, flashed on the canvas like one of the startling news-photos or cinematic images from which the paintings so often derive, is the cry of agony of our own age, an age which has lost its faith.

David Sylvester's review no doubt pleased Bacon the most, despite Sylvester's reservations about his recent work. The critic had been pain-fully silent of late. He regarded Bacon's art since the mid-1950s as at best transitional and at worst marked by a serious decline. Writing in *The New Statesman* a few weeks after the opening, Sylvester admired the

many passages of brilliant intensity, almost always in the way Bacon rendered the actual figure—"the paint that composes a head or a figure is marvelously alive: it seems to be generating form under our eyes." But the intensity was not always sustained throughout the canvas. Figure and ground did not always work well together: the artist failed to create a "coherent pictorial structure." The earlier "smoky, tonal paintings," while diffuse, remained marvelous, "with that quality of late Titian which Iris Murdoch has exactly evoked: 'full of great melancholy shattered forms.'" In the later paintings, however, where the colors were vivid and the forms more linear, Sylvester wrote, "the masses still don't link up with the surrounding space: they look now like silhouettes cut out and stuck to the canvas. . . . And the backgrounds, still detaching themselves, look too resolutely designed."

Sylvester was a courageous critic—that is, an honest critic. It was not easy to question his friend's work of the late 1950s. Indeed, it had led to an estrangement. Although Sylvester's formal analysis was acute, and what he wrote was often true, he left out one important element in what he considered the compositional weakness between figure and ground. He did not allow for the oddly expressive quality of Bacon's awkwardness. It might seem absurd to call such a weakness a strength, but in certain pictures it was true nevertheless. Bacon, always astride weakness and strength as both a man and an artist, could make that tension come to life. It was this formal breakage, in many paintings, that led the *Times* critic to feel as if he were in a room full of Old Masters—but, importantly, was not.

Sylvester loved Bacon's summary work—the Crucifixion triptych—and he no longer worried about decline. He was back together with his friend. "This triptych is probably Bacon's most remarkable achievement to date, and it has shown me what this superbly ambitious artist was talking about when he said, seven or eight years ago: 'What I've always wanted to do is to make things that are very formal yet coming to bits.'"

On May 24, the official opening day of the exhibition, Bacon sent Lacy a telegram in Tangier with news of the show's success. The answering telegram shattered him: Lacy was dead.

Lacy died on the day of the triumphant private view. His "pancreas exploded," Bacon later told Michael Peppiatt, since he was drinking three bottles of whiskey a day, "which nobody can take." Bacon suspected that the doctors neglected to tell Lacy not to drink after he underwent

treatment for his alcoholism. Lacy's estate, valued at £3,205, went to an insurance company in London for administration. He was buried in Tangier.

In the weeks after the opening, Bacon did not publicly exhibit signs of grief. No doubt he felt a measure of guilt. He was always troubled by the way he treated Lacy. He was always concerned about his health. The decision to send Lacy a telegram the day of the opening may have been yet another effort to establish some kind of reconciliation. Impeccably mannered as always, Bacon, after Lacy's death, took Lacy's beloved sister Joan and her husband to lunch in London. On a trip to Tangier two years later, he visited Lacy's grave before heading to the Riviera, also so full of memories of Lacy. In the early months, he let only his old friends see his sadness. He "spoke movingly" to Stephen Spender of his feelings for Lacy. "Dined with Francis Bacon. Francis looked sad and talked about his friend who had died." Spender asked Bacon why he did not express such feelings in his painting. Bacon replied that he was not able to. "Certain friends," he said, "were far too beautiful for him to distort—and he had always distorted." Before he died, Bacon said, he hoped "to do something really beautiful and not ugly as all my paintings are."

After Lacy's death, Bacon achieved what he told Spender he found impossible to do: he successfully captured the "too beautiful" part of the man he loved. In a small triptych called *Study for Three Heads*, Bacon, continuing to use what he described to Spender as a "distorting" idiom, made two portraits of Lacy that he placed on either side of a central self-portrait. On the left, Lacy appeared to be a composed man, his decisively painted face settled into lines of thought and determination. (He could be standing on the bridge of a ship contemplating the horizon line.) On the right, he was powerfully fleshy, with some marvelous acreage of nose and a kind of Easter Island monumentality. Both Lacy portraits were painted in a roughly three-quarter view and looked in toward the central portrait, which was of Bacon. Bacon's full, flat face appeared, in contrast to Lacy's, a slop pail of grief. He seemed to be melting apart, the eyes sodden with tears, the cheeks swollen. In many self-portraits, Bacon presented himself as undone by melancholy or the subversions of an implacable world, but he had never before portrayed himself in such terms—and would never do so again. He was pathetically, and ineffably, sad.

Landscape Near Malabata, Tangier (1963), was a different response to Lacy's death. It was one of only two Bacon paintings that directly evoked North Africa (the other being *Man Carrying a Child*, 1956). It was very nearly abstract, and it commemorated in musically visual ways the rela-

tionship with Lacy. Malabata was a rocky cape just outside Tangier where Bacon and Lacy may well have had some important emotional and sexual history. (Bacon visited Malabata on his trip to Tangier following Lacy's death.) Within an unfathomably dark surround, Bacon depicted what might be a spinning disc or stage on which two ghostly figures swirled. He included a tree and some suggestion of the same African landscape in which he once painted two figures coupling in the grass. The two ghostly forms could both be emanations of Lacy, or they could represent a couple. One of the forms, as Martin Harrison has suggested, calls to mind a greyhound racing around the track chasing the mechanical rabbit. (Freud bet on the dogs, and Bacon sometimes accompanied him to the track.) The image of the circling greyhound, or the hamster spinning uselessly on the wheel, could symbolize an unending cycle of erotic obsession and failure. The figure at the center of the disc, whom Bacon may have regarded as Lacy, is a churning blur of movement, his arms outspread like a man being crucified as the world revolves around him. The relationship evoked in the painting was dark but not pathetic. It resembled a passionate, if joyfully doomed, dance.

Thirty-five years later, a blind American writer named Sidney Bigman wrote to the Tate Gallery with a story he thought worth preserving. Early in 1961, the year before Bacon's retrospective at the Tate, Bigman was staying in the Termino Hotel near the port of Algeciras, Spain, just across the border from Gibraltar, waiting for his family to arrive. Peter Lacy was also staying at the Termino, waiting to pick up a car. One morning around 9 a.m., as Bigman drank his coffee, Lacy entered the hotel bar. "We were the only people there and we chatted while he drank his first and then second gin tonic." Over the next few days, they saw each other several more times, their conversations remaining "rational" during Lacy's first two drinks. Bigman, before he lost his sight, had also been a pilot, and once briefly met Bacon. But soon, Lacy "could only talk (or mumble) about Bacon and how wonderful he was, how talented, how beautiful, what an extraordinary love they shared."

On the day his car was ready, Lacy met Bigman for coffee in the bar. He was sober, very serious, and "also very shaky." He told Bigman that he had reached a decision: he would "put his life with Francis away in a drawer of his mind and leave it there." Then he handed the writer a couple of pages from a family album, "the only material thing he'd kept from their time together." It seemed to matter, to Lacy, that the blind writer could not see the pages, which included pasted-in photographs of himself and Bacon, together with some watercolors and "scratchings" made by Lacy.

Then he "watched me put them at the bottom of my suitcase." The next morning, Lacy picked up his car and ran off the road on the Spanish side of the border, "smashing the car up rather badly." He abandoned the car before the police arrived, walking back to Gibraltar, to take the first ferry to Tangier. "I came to realize," wrote Bigman, "that I had never met anyone more in love than Peter Lacey [sic] or more destroyed by the breakup of that love."

THREE STUDIES FOR A CRUCIFIXION (1962)

Bacon understood the importance of the final act. As his Tate retrospective approached in 1962, he was not pleased with the quiet way his chronological retrospective would end. In a feverish period of about two weeks, he painted *Three Studies for a Crucifixion*, a work that reprised his past and looked toward his future, when many triptychs would include dreamy, half-graspable narratives and bodies that cannot retain their form on the fierce modern stage.

Bacon pressed himself extraordinarily hard in this triptych—much as he had during the van Gogh series—hoping to break through into original work. The triptych was large; each panel seventy-eight by fifty-seven inches. The central panel is the most difficult image in the Bacon oeuvre. Some people refuse to look at it, which is understandable. It presents a blood-spattered human figure, perhaps once a kind of odalisque, horrifically killed, butchered, stabbed, and carved up with a knife. (The figure's teeth are the easiest way to locate its head.) The most disturbing aspect of the carnage is the frenzied brilliance of the killing brush; Bacon's painterly freedom echoes the hysterical letting-go of slaughter and blood lust. On either side are more restrained but also disturbing panels. The panel on the left shows two contemporary figures who could be having a conversation about what to do. From one of the figures, a pair of enormous butchered leg bones flares out. The panel on the right depicts a Crucifixion scene in which the eviscerated figure has been hung upside down. The image is partly inspired by Cimabue's *Crucifix*, which Bacon once likened to a "worm crawling down a cross."

Not surprisingly, critics have been reluctant to address what Bacon meant. As usual in his large, iconographically complex works, the details probably contain some personal references that cannot be known. But Bacon certainly also wanted viewers to move among the images, wondering and making connections. Bacon's broad intent is fairly clear. If he

"began" in 1945 with *Three Studies for Figures at the Base of a Crucifixion*—part of an attempt to paint a modern Crucifixion scene—he would now conclude his 1962 retrospective with studies of a more contemporary killing ground. His placement of the panels was essential. In the old Western world, the central image of suffering was the Crucifixion, always in the center. In a world unredeemed by Christianity, however, the central image of suffering—after the wars and horror of the twentieth century—is simple butchery.

The traditional Crucifixion—Christ on the cross—has now moved to the right panel and become a gruesome, upside-down dream that, while troubling, is more nightmare than fact. The Crucifixion and the Old Master tradition were earlier ways of making sense of the world. They were no longer paramount; Bacon's old-style Crucifixion even has a kind of absurdist shadow, like the outlines of a cartoon character. The left panel shows living people who may think they are making modern sense. But they are also complicit in the slaughter (as the leg bones make clear) and they cannot control or stop what is occurring next door. Neither side show is as disturbing as the hot facts in the middle.

Settling In

Nearly 100,000 people saw *Francis Bacon* at the Tate. Many thousands more saw the retrospective in Germany, Italy, Switzerland, and Holland. Even Picasso admired the catalog—or so he told Harry Fischer. Bacon was pleased by the success, but probably also found the honors disquieting. His retrospective had gained a shadow, of course. Peter Lacy dead as if on cue. The weeks following the opening, when fate seemed to toy with him and public acclaim fused with private despair, may have made the prospect of a more regular life appealing. The peculiarly feral atmosphere that surrounded him during the 1950s began to lift.

Already by the late 1950s, Bacon was bringing some order into his affairs. Ron Belton did not become, as Peter Lacy had been, a romantic obsession—he was just another sexy lad—and Bacon's ties to Marlborough lacked the roiling intensity of his relationship with Erica Brausen. The gallery's money eased his life, and its cultural muscle served him in the larger world. It was doubtful that the Tate would have offered Bacon a retrospective as early as 1962 had Fischer not relentlessly pressed the case. As Fischer hoped, Bacon slowly took to 7 Reece Mews. He made few structural changes apart from removing a low ceiling and placing a square skylight in the roof of both the bedroom and the studio. The light from the studio windows on the street was blocked by canvases. A more perfect studio, its north light evenly defining the space, would have paralyzed Bacon.

The exterior of 7 Reece Mews, Bacon's legendarily cavelike studio just off Old Brompton Road in South Kensington

In November of 1961, five months after the lease was signed and six months before his retrospective, Bacon moved into Reece Mews. The delay conveyed his ambivalence. Did he really want a room of his own? And what kind of room would that be? As a young designer, he had assertively claimed a room of his own: emptying it, cleaning it, whitening it, filling it with his own designs. But he had lost his faith in the power of the perfected space. The environment Bacon eventually created at Reece Mews, however, once the distraction of his retrospective was behind him, was as carefully calculated (in a paradoxical way) as the showroom at Queensberry Mews had been thirty years before. The internal calculus began with the location itself. Friends wondered why Bacon chose South Kensington over more "artistic" districts like Hampstead. South Kensington was handsome but stuffy. The Major and Mrs. Bacon might have purchased a house there. Which was likely the point: Bacon wanted to live close to his tribe but at one remove. In South Kensington, he could live in a mews once inhabited by the servants, above what had once been the stables on a street whose cobblestones once rang with the hooves of horses. Besides, he was a short walk from the South Kensington tube, which in a moment could whisk him to Soho.

Nanny Lightfoot once had a natural claim to any Bacon residence. But Bacon had learned that he could not finally live with anyone else. He might briefly share rooms, as he did, unhappily, with Belton in St. Ives, but that was only outside London. He soon made his intentions clear: 7 Reece Mews would be the home of a solitary. The larger room that faced Reece Mews, to the right of the stairs, would be his studio. It quickly became so messy and "bombed out" that there appeared to be hardly space for anyone else. The bedroom became Bacon's all-purpose living quarters, which he crowded with heavy-looking furniture—whales from the past, beached on an unfamiliar shore. Incongruous velvet curtains hung at the windows.

Perhaps the most distinctive feature of Bacon's bedroom was "a bedside table piled high with books," wrote John Rothenstein in 1962. "Aeschylus and other Greek dramatists (in translation), Pascal, Shakespeare, Montaigne, Baudelaire, Nietzsche, Dostoyevsky, Van Gogh's letters, *The Golden Bough*." Otherwise, it was long and narrow, and "there was hardly any space to move in," said the artist Alice Weldon. It was odd that there were no doors to the bedroom. The narrow kitchen looked out over Manson Place, the street behind the mews. Bacon liked to cook for a friend or a lover spending a night or two, and he made a proper cup of tea, taking care to warm the pot to the right temperature.

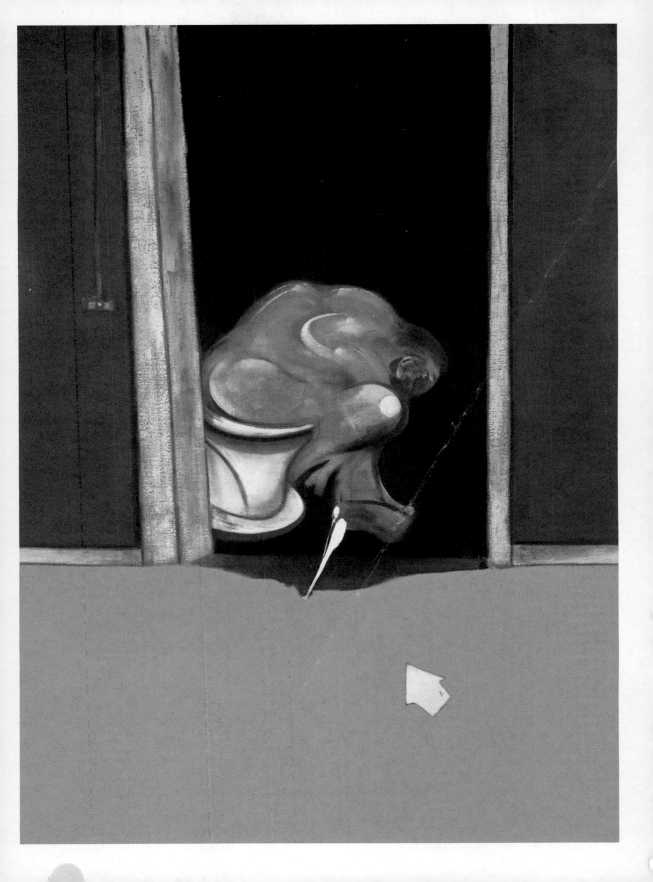

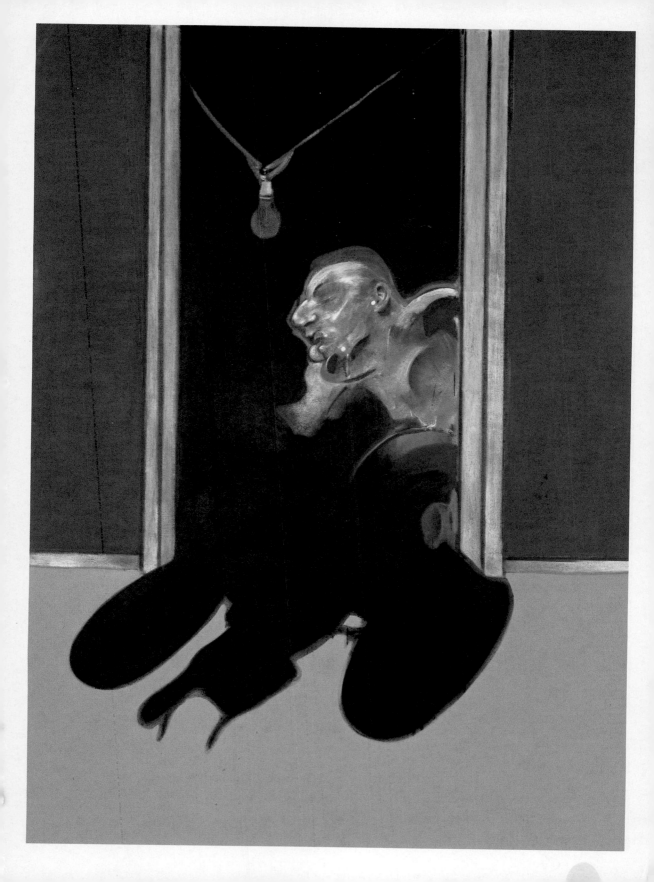

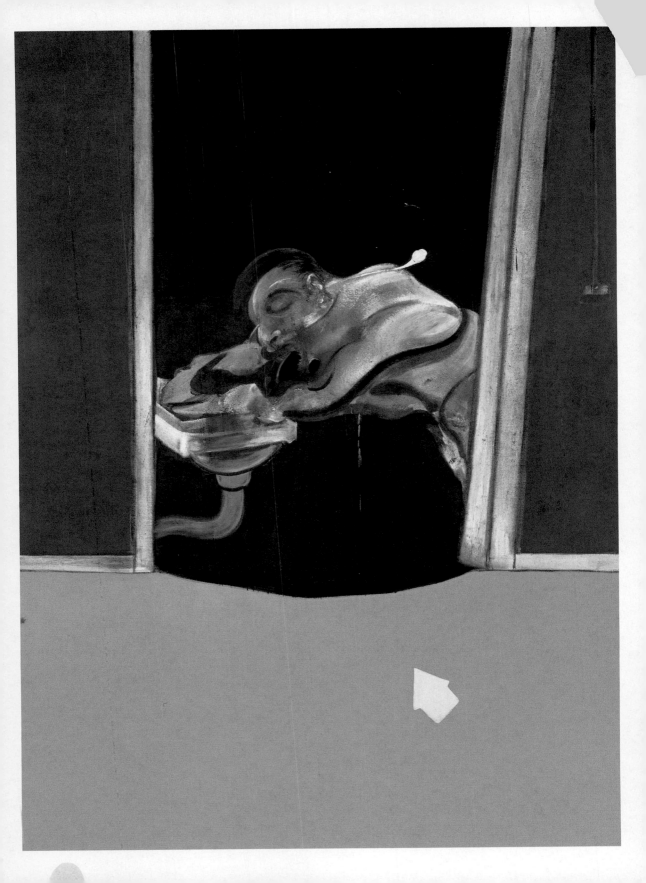

But the galley kitchen also included a bathtub, and there was no easy place to linger over dinner: he would clear a space at the table in the bedroom. For Bacon's purposes, however, Reece Mews was as focused as a pared-down modernist room. It was for sleep, work, sustenance. His social life he directed outward into the flux at the other end of the tube.

Yet power must, as ever, play its part. What kind of power could he claim over these rooms? He could not imagine Reece Mews as a comfortable retreat. Reece Mews was where he did his work. The rooms must tell the truth. And so Bacon chose not to fix, design, mask, soften, or doll up his house. Instead, he paid respect to the two great powers, time and chance, and let them have their way as much as possible. He maintained a small but essential difference between his studio and the rooms where he cooked and slept. His studio he allowed to clog with dog-eared books, yellowing newsprint, torn images, beat-up boxes, empty cans. A mirror hung on the wall behind the easel, in which he would sometimes glimpse himself as he worked. He flung scabby paint, scraped dead from the easel, onto the floor and walls. He rubbed dust from the studio into his paint to create texture and modulate tone, as if the studio itself were a partner in his efforts. The mess became a kind of mulch, nourishing his imagination, with the art on the easel the only possible and momentary point of order. But he kept the living quarters very clean. "When I went to the studio I always noticed how incredibly tidy the kitchen was," said Gilbert Lloyd, Frank Lloyd's son, "like an operating theater in a hospital, absolutely spotless."

Bacon himself was invariably scrubbed and well dressed in public. Before he went out, he would clean the paint from under his fingernails (and, often, apply makeup). No such enhancements existed in his living quarters which, while clean, resembled the stage set of a play by Beckett or Pinter. Bare bulbs shone on dull walls. In the outside world, Bacon often enjoyed a finely appointed room and the soft caress of luxury. But he was never going to suggest that his home should be comfortable. The only cozy touches he permitted were in the kitchen where, along with a

Bacon's open bedroom at 7 Reece Mews was bare and functional, but stuffed with books.

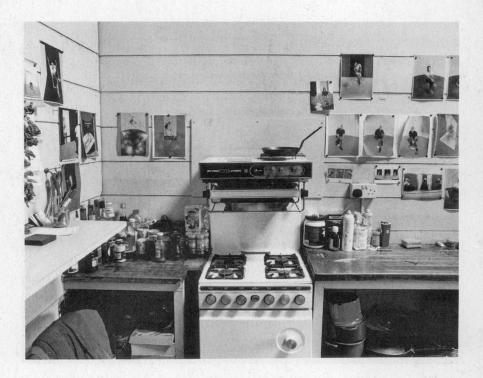

few cookbooks, the artist-chef kept certain English staples such as Tiptree
"Tiny Tip" Raspberry Preserve and Broadland Pudding and Dumpling
mix. Later, he placed photographs of the lovers most important to him
during his life on a cupboard near his bed, an incongruously sentimental
note. Visitors typically regarded Reece Mews as bizarre or outlandish.
It was, more importantly, the expression of a simple and well-regulated
system. At Reece Mews, Bacon—the devout atheist—recast (to a degree)
the life of the reclusive monk living in a cave.

Curiosity about Bacon increased after the retrospective. Marlborough
could address Bacon's art, hiring distinguished critics, poets, and academ-
ics to write essays. But they could not provide the voice of the eccen-
tric in the cave who was now expected to speak with beyond-the-pale
authority—not just about art but also about lofty themes like existential-
ism and postwar society and "Is God dead?" It was a fairly new problem
for Bacon, this demand for a public voice. He already had a number of
personal voices, of course, none of which were simple to develop. Dr. Paul
Brass heard a very particular Bacon when the painter visited his fam-
ily for a home-cooked meal. Muriel heard a different, no less particular,
Bacon. Ann Fleming, a third. A carefully crafted reply to all future ques-
tions about his life and art would make things simpler. In fact, a public

face and voice intelligently conceived was the best way to remain private. Like an actor, he could then deliver his lines in a way that, night after night, appeared spontaneous.

In the months after the retrospective, Bacon—pleased that Sylvester admired his newest work—resumed his friendship with the critic. They made an odd but appealing pair. The round, oracular Sylvester liked to stand in front of a single painting and ruminate for what, to Bacon, seemed an eternity, whereas the high-strung Bacon preferred to drink in a picture like an oyster and move on to the next. Each found the other's views on art stimulating, if not always persuasive. Each suffered from interminable romantic problems. Each enjoyed gossip but neither, importantly, took quick or permanent offense. Sylvester understood that Bacon—extraordinarily tense, frequently bored—must sometimes bedevil a relationship. The critic had recently spent time in New York, where he befriended a number of its ambitious painters and witnessed at first hand the intensifying star system in American culture. Its alluring mixture of money, fashion, and art was creating a seductive scene that extended beyond the traditional boundaries of the art world. In 1960, when he was in New York, Sylvester interviewed six leading American artists, including Franz Kline and Willem de Kooning: the interviews were then broadcast on the BBC later that year. Why should he not do the same for a great English artist?

And so he thought of Bacon. Sylvester could become the sharpening stone for Bacon, clarifying what remained shadowy and helping the artist develop answers to the expected questions. And if Bacon was indeed one of the great artists of the century, then it would be an honor to be his amanuensis. Sylvester was not like the American from MoMA with his earnest questions. Nor did he resemble the careful Sir John Rothenstein, who was too fusty an establishment figure to grasp Bacon's world. With Sylvester, Bacon could develop a new voice, and he knew that this particular critic and friend would not betray him, quoting him in ways that he did not approve. Bacon had long been looking for what he called, when answering Soby's questions, a "theoretical construct." Now, Sylvester could help him craft one.

Sylvester proposed a radio interview to the BBC similar to the ones he had conducted with the Americans. BBC radio remained a cultural touchstone in Britain—a way for the nation to listen in on itself—and there would surely be an audience since the Bacon retrospective attracted crowds. In October of 1962, Sylvester taped the interview, which was not aired until the following July. In the years to come, Sylvester would

conduct many more interviews with the artist, which culminated in the famous best-seller *Interviews with Francis Bacon*. The later interviews were elaborations upon what Bacon now set out, in this formal interview with Sylvester, with tailored concision. The critic asked brief questions, occasionally following up. Bacon answered in clear, often simple sentences. Parts of the interview sounded prepared, others more spontaneous. The critic and the artist certainly rehearsed, to some degree, the questions and answers. Bacon may even have read certain passages; a careful listener will occasionally hear a splice in the audio tape.

Bacon understood the BBC stage. He had no intention of sounding anything like a monster who painted gruesome pictures. Speaking in a precise and clipped voice, enunciating each word as if to give it a chance, he used phrasing that suggested a subtle mind attuned to fine distinctions. "Well, I never thought of it that way," he confessed when Sylvester proposed a connection between the popes and the romantic longing in Western culture for the tragic hero, "but when you suggest it to me I think it may be so." In half an hour, he efficiently distilled his approach. He discussed the role of accident in his art; why he disliked illustration and story lines; what impact he hoped his pictures would have upon the viewer; how his love for Velázquez and Rembrandt could be explained; whether the religious undertones in certain paintings mattered; why he chose such idiosyncratic frames and glazing. There was even some barstool Bacon. "One of course always loves the story . . ." he told Sylvester, "to be cut down to its most elemental state." Then he added: "That's how one longs for one's friends to be, isn't it?" Sylvester laughed, and Bacon observed, "One can do so much without the padding."

In July of 1963, when Sylvester's BBC interview was published in *The Sunday Times Colour Supplement*, John Russell was working on a slight volume on Bacon. In contrast to Sylvester, Russell was a well-schooled insider. He was educated at St. Paul's School and Magdalen College, Oxford. His slight stammer suggested intelligence, as if he were searching for the right word rather than just any word. He was also at home with the silky connoisseurship of Kenneth Clark. And yet, Russell also developed a passion for the unruly artists of his time. *Francis Bacon*, published in 1964, was only fifty pages long, the sort of primer Soby probably intended to write and one that any local English library would want for its more adventurous readers. It presented Bacon as one of the major artists of the day. Although not as close to Bacon as Sylvester was, Russell had become a friend as well as an admirer. Like Sylvester, he would certainly consult the painter about the book and not publish anything to discom-

fit Bacon. Certain ways of discussing his art that annoyed Bacon, such as ascribing to him a Grand Guignol freakishness or a vision so warped and nightmarish that it seemed merely a private obsession, Russell now directly confronted and dismissed. Russell was also proud of his attention to formal and visual values, and he took pains to defend Bacon from the charge that he did not paint expertly enough.

The new Russell and Sylvester writings, added to the Rothenstein retrospective, gave Bacon a quasi-official status in English culture. He would soon have renewed attention in America as well. In the fall of 1963, a year after the Tate exhibition, a similar retrospective opened at the Guggenheim Museum in New York. Bacon did not come to the opening, but David Sylvester was on hand with a piece in *The New York Times Magazine* titled "Enter Bacon, with the Bacon Scream." The Marlborough Gallery would have preferred a show at the Museum of Modern Art, heralding Bacon as vital to the evolution of modern art in the twentieth century, but the exhibit planned by Soby and Frank O'Hara never gained momentum. The Guggenheim was now more receptive than MoMA to contemporary European art and—with its traditional commitment to surrealism—more tolerant of difficult imagery. It was the Guggenheim and not the Modern that, much to James Thrall Soby's regret, purchased the extraordinarily difficult *Three Studies for a Crucifixion* (1962). MoMA could not figure out how, in the end, to approach the elderly lady on its acquisitions committee who would have been asked to fund the purchase.

Bacon's work looked nothing like either abstract expressionism or pop art, the two styles that most concerned the New York art world. The title of Brian O'Doherty's review in *The New York Times* was "On the Strange Case of Francis Bacon." Irving Sandler, in the *New York Post,* was full of praise: "The din which Bacon makes the *eye* hear is shattering." Still, Sandler could not resist a wisecrack. "There is so much flayed flesh on display that on opening night one artist quipped that the invitation should have specified butcher's apron instead of black tie." Many Americans resisted Bacon's evident homosexuality. There was little if any tolerance for homosexuality in the New York art world, whose outlook at the time was often a strange admixture of abstruse theorizing and macho posturing. The photographer and art critic Max Kozloff wrote to David Sylvester in November of 1963 about the response:

You may be curious about attitudes towards Bacon here. The opening was quite fine and most of the press notices, naturally, were

favorable. But feelings were very mixed. There were a number of older artists who had a sometimes uneasy respect for the show. But there are hordes of younger artists who couldn't stomach it one bit . . . A goodly number weren't convinced that Bacon is a painter, that he knows how to wield a brush. Also, there's a strong anti-homosexual feeling.

The Marlborough gallery was aware, of course, of the larger reason for Bacon skepticism in New York—figurative art was unfashionable in America in the early 1960s. Most followers of the scene thought New York had supplanted Paris, let alone London, as the center of the art world. Bacon's art dealers agreed with the assessment. Fischer told John Rothenstein in 1962, "Paris, after all, it doesn't matter." In 1963, the year of the Guggenheim retrospective, Marlborough opened the Marlborough-Gerson Gallery in New York, where Bacon's work did not prove especially popular. During the 1960s and '70s, Frank Lloyd's son Gilbert would regularly go on the road in America carrying color trans-parencies, "and I'd get to some private residence in Dallas, Texas, and finish with my Vuillards and Picassos—I'm exaggerating slightly—and the lady of the house would say, 'Well, haven't you got any really exciting living artists?' and I'd say, 'We have this artist Francis Bacon,' and I'd get out the transparency of two men screwing in the field, and this was difficult to handle in the Bible Belt."

Still, the attention given the Guggenheim exhibition reassured the gallery that Bacon was an artist with potential international appeal. He was simply an undervalued asset in an anti-figurative period. According to Gilbert Lloyd, employees at the gallery—even in London after the Tate exhibit—celebrated on the rare occasion a Bacon sold for a few hundred pounds. The elder Lloyd and Fischer patiently bet that stockpiling paintings and increasing Bacon's production would ultimately pay off. They had now succeeded in placing the wayward artist into a flat and studio where he was more likely to complete work (and less likely to be found dead in a Soho gutter). But it still remained difficult to manage him or prevent him from destroying picture after picture. He was cordial to everyone at the gallery and tolerated shoptalk—Lloyd regularly took him to lunch at Wiltons on Jermyn Street—but he would not be nannied and became prickly if pressed.

Marlborough then happened upon a piece of luck: Bacon appeared remarkably at ease with a painstakingly guarded employee named Valerie Beston, then in her early forties and unmarried. Beston's role at the gallery was to mind the store. She ensured that the bills were paid, supplies

ordered, queries answered, schedules established. Employees tended to come to her with problems. She was far from the most powerful person at Marlborough—she did not often sell pictures or develop strategy—but she had become, in a mysterious, catlike way, the spirit of the house. The reserved "Miss Beston," as she preferred to be called, began to dote upon Bacon. They developed into—no other phrase does it justice—"a kind of couple."

This highly respectable woman, who never discussed her past, had been born into a colorful, even racy family that appeared, at different times, rich and poor, scandalous and upstanding. According to Harriet Lane, who wrote a piece about Beston in *The Guardian*, her father Ernest was "a prosperous bookmaker, and her mother Daisy Mary, known as Dulcie, had been on the stage. Both had been married to other people when they began their affair and, though they passed themselves off as husband and wife . . . were never actually married." Dulcie was an Irish Catholic. Her common-law husband was flashy. He collected Rolls-Royces, the family legend being "that he owned 13, his lucky number; there were also 13 peacocks in his garden." Valerie was the fourth of five daughters, a quiet and intelligent girl. In the late 1920s, when she was six or seven, her family moved to Belgium, probably because her father had developed tax problems. He and Dulcie then boarded their daughters in a convent, where Valerie became fluent in French, which the Francophile Francis Bacon always appreciated.

The family soon moved back to England, and not long afterward, in 1933, Valerie's father died. He split his estate between Dulcie and his legal wife. With no husband and five daughters, Dulcie struggled financially but tried to keep up appearances. Lane wrote:

Inheriting a quantity of furniture but no cash to speak of, Dulcie found herself on her uppers. She bought short-lease properties in Surrey and later on the south coast, around Folkestone and Hythe, so she and the girls could live in some style, but the leases were forever running out, obliging them to move on. . . . Dulcie seems to have concentrated her mothering efforts on her first two daughters. To Joy and Shirley, she was generous and painstaking, scraping together enough money in the mid-Thirties to send them to finishing school in Germany, and making ballgowns which she dispatched after them "so they could go to all the parties." Sylvia, Valerie and Betty experienced a different sort of mother: strict, austere, rather hard. Perhaps, by the time it came to them, she had run out of patience and ideas, as well as money.

There would be no easy choice for Valerie Beston: she must make a life of her own. She took a secretarial course, then one of the few options open to career-minded women, and during the war—still not twenty years old—volunteered for the army with one of her sisters. They were sent to work at Bletchley Park, where, as Lane wrote, the "uniform of discretion, efficiency and anonymity suited [Valerie] very well." In fact, Beston would have made an ideal spy. She could appear colorless; she was secretive; she never spoke of herself; she had a talent for administration and detail. (She later became a fan of the novels of John Le Carré.) Her mother, Dulcie, took in boarders during the war. One was an odd, erudite, and rather messy refugee from Vienna—the bookseller Harry Fischer. "At Dulcie Beston's tea table," wrote Lane, "Fischer hatched a plan with his friend Frank Lloyd to start a picture gallery in London 'when all this is over.'" Family lore had Dulcie pushing Valerie towards the pair, asking them to give her a job as a typist when the time came. As Marlborough Fine Art established itself, Beston made herself indispensable.

She was not quite a spinster knitting by the fire. In her twenties, it was whispered, she had an affair with Frank Lloyd. It was rumored that she also maintained a long relationship with an older art and antiques dealer from Oslo that ended or broke off during the 1960s. "I think I can say without overstepping the mark," said Gilbert Lloyd, "that she was very unhappy in love." Not given to self-pity, Beston put the different pieces of her life into discrete boxes whose contents did not mix. Her family knew little of her work at Marlborough. Her colleagues knew less of her family life. She did not invite them to tea. Her personal feelings about anything important she kept to herself. Over the years, she became a familiar type: the no-nonsense, rather old-fashioned—but friendly enough—Englishwoman who is more competent than those around her, especially the men. But Miss Beston also had a kind heart, if one had the wit to see it. She would go out of her way to purchase something from a poorly reviewed painter or be unexpectedly generous to a lowly staff member at the gallery. She made regular presents of cash and expensive paints to indigent artists. Invariably, she concealed her generosity.

Miss Beston's relationship with Bacon began starchily enough. A January 1963 note had a schoolmarmish tone. "Dear Mr. Bacon," she began: "Mr. Fischer tells me that you complain that we bother you on the telephone so I am writing today to tell you that we are filling in the form for the Salon de Mai 1963 and I need to know the approximate format of the oil painting you propose sending and, if possible, a title." Soon enough, however, Miss Beston appeared transformed around Bacon.

"On a normal day she would go straight into her office and it had a sliding door and she would be busy," said Terry Danziger Miles, the gallery's driver at the time. "But if Francis was due in five minutes, she was down there waiting, 'Can we get you tea?' etc. She seemed radiant around him. Kind of besotted." Frank Auerbach was also a great favorite of Valerie Beston's, but Miles considered that relationship more "motherly." Soon, Miss Beston became the go-between not just for Bacon and Marlborough but, rather often, for Bacon and the larger world. He felt free to telephone her at any hour of the day or night: Dreadfully sorry, but could she send a taxi to a pub in the East End?—he'd lost his watch and all his money. Or might Terry drive over a tube of Prussian blue—and five hundred pounds? She was always pleased to take his call. She dealt with the paperwork and the people who wanted to see him. She organized his household. She did not go to Reece Mews to wash his socks, though people said she did, but she would arrange for the right housekeeper to be hired, one informed in no uncertain terms not to touch the studio.

Miss Beston did not discuss Bacon's art—any more than she discussed his romantic life—beyond making a polite observation about a fine color or a deft passage. Anything odd about the messy studio she did not appear to notice. "If you wanted to be on the right side of her," said Miles, "you made sure you didn't mention anything about Francis. You couldn't say 'That's a funny-looking picture, miss,' because she'd be down your throat like nobody's business." And yet, Beston was far too intelligent to be nothing more than a subservient woman infatuated by a man. A shy and thoughtful child, just as Bacon had been, she had also grown up around gambling. Her parents misunderstood and mistreated her. She was "unhappy in love." And like Bacon, in order to survive, she had developed a powerful public persona. No one was going to remove the mask called "Miss Beston." There were moments when he spoke rudely to her. She expected nothing less. He never failed to apologize, of course.

Bacon could not have granted a man such authority. It was only somewhat easier with a woman. He chafed under Valerie Beston's ministrations, however grateful he was for them. He gave her a nickname that sounded like a lovely piece of cockney slang. "Valerie from the Gallery" was the woman who could provide a man with anything he could possibly want, apart from sex, while never interfering and always remaining safely at the office. She may have guessed that Bacon missed the uncritical and enduring womanly attention that Nanny Lightfoot once gave him. Miss Beston could not replace Nanny but she could help center his life and protected him as best she could. "Sometimes he would bring Valerie

Beston" to Wheeler's, said John Normile, the longtime barman there. "She was a nice woman. She was very quiet—very hard to get to know. She didn't get to know me until she found out that I was married" and therefore not coming on to Bacon. She understood the subtle English codes, the inflections and indirections, bred into the gentlemanly Bacon. She could wordlessly understand—as a Granny Supple or a Diana Watson or a Madge Garland could—what Bacon meant or sought in most circumstances. "It was as if by stumbling upon Francis," wrote Lane, "she had found the personality capable of filling the silence."

At night Miss Beston was mostly alone. Very occasionally she would join Bacon for dinner with friends. Otherwise, she typically remained at the office until seven thirty or eight. Then she would cross Piccadilly to Jermyn Street. A few doors from Wiltons, the celebrated restaurant favored by Bacon and Frank Lloyd, was a modest Italian mom-and-pop called Frank's. Most evenings she dined there by herself. (It later morphed into a fancy Italian restaurant called Franco's.) Then she would take a taxi to her small flat in Harley Street. Not infrequently, on a Sunday when she found herself with nothing much to do, Bacon found himself in similar circumstances. His companions were spending their Sunday sleeping off Saturday while Bacon had worked as usual through the morning and then . . . a phone call to Miss Beston. Would she have time, perhaps, for lunch or a movie? On several occasions Bacon made Sunday lunch for Valerie at Reece Mews: "smoked salmon and scrambled eggs and bacon," she recorded in her diary, "with Petrus Pomerol 1961."

Miss Beston treasured Sunday with Francis, two solitaries together at the movies. She was always more talkative the next morning, telling everyone in the office about the new, or old, film the two went together to see. (Bacon regularly returned to the Buñuel classics.) No fuss was ever made over their relationship. She needed to give what he needed to get. Miss Beston's greatest value to her employer was that she heard, sensed, or knew when a painting was momentarily complete, and before Bacon could take a second look, Valerie from the Gallery would appear at Reece Mews to distract him with tea and talk until the van pulled away.

In late 1963, Bacon heard a tremendous smash and scrabbling about. A cat burglar had fallen through the skylight and crash-landed on the floor of the studio. Bacon did not miss his cue. He rushed into the studio and confronted the burglar: they must have sex then and there. Otherwise, he would report him to the police.

Or so the story went. The melodramatic introduction of George Dyer into Bacon's life was a piece of theater whose stage directions sounded like an existential romance: *Thief crashes through skylight . . . Sex to follow*. During the postwar period, the erotic imagination of many writers had been aroused by criminals, with Jean Genet famously making a gritty outsider's romance of homosexuality and crime. Homosexuals were well positioned to sympathize with criminals who lived outside convention, and an aura of violence appealed to highly refined people with either a personal or a symbolic predilection for bondage and discipline. Breaking through a skylight into a private studio was a revelatory symbol of sex, including rape, but also suggested another theatrical staple—the pratfall—that would characterize Bacon's years with George Dyer. The relationship with Lacy was long, desperate, and sharply lit, with tragic overtones. The one with George was more often absurdist: loving, bumbling, melancholy.

There would never be an agreed-upon account of the break-in. All that's certain is that a cat burglar broke into Bacon's studio a year earlier, just before the opening of the Tate retrospective. John Rothenstein, then in almost constant contact with Bacon, later wrote, "Francis had been up gambling the previous night, he told me, and during his absence somebody—he suspected an acquaintance just out of prison—had broken into the studio through a skylight and stolen two paintings." It was possible, if unlikely, that George Dyer was the cat burglar who stole the paintings in 1962 and that he and Bacon came to know each other better the following year. George was indeed an occasional cat burglar, a nimble "second-story man" who knew his way around the drainpipes of London.

George's relatives termed the story false, however, and Lucian Freud gave a more prosaic, if touching, account of the beginning of the relationship. Bacon and Dyer met at a club, Freud said, and went to Reece Mews to have sex. Traditionally, Bacon expected a casual pickup to steal his expensive watch. (Bacon even lost a few watches that he hid from potential thieves and then, like a squirrel burying nuts, could not locate again.) In an unexpected gesture, Dyer did just the opposite. "Francis was terribly pleased," Freud said, "as George gave him an enormous gold watch which he'd stolen the night before."

Dyer was an East Ender, though his family did not consider themselves High Church cockney. "We all lived in the Borough, in Redcross Way," said George's half-brother, Ronnie Dryden, referring to southeast London, south of the Thames near London Bridge. The district where George was born in 1932 differed little from true cockney London on the north side of the river. In that period, in fact, it bore more resemblance

to the East End of the nineteenth century than it did to any London neighborhood of the later twentieth century. George's mother, Mag, had her first child, Ronnie, out of wedlock, then married and had five more children, four boys and a girl. The last, Leonard (Lee), was the result of a wartime affair. "My father wasn't the father," said George's sister, Rita Isaacs, "so my mother was a bit of a girl, evidently." Living space was tight. Several people ordinarily shared a room, and children moved about, often staying with a grandmother or an aunt. Relationships were fluid. Work was scarce.

The Dyer boys worked odd jobs. Pilfering and petty crime were a common, almost acceptable way to get by for those without jobs or a regular address. The eldest boy, Ronnie Dryden, was a sometime bookie and a friend of the Kray twins, who began their operation in the East End and then moved into the fashionable West End. (In the early sixties their swanky Mayfair gambling joint, Esmeralda's Barn, became the rage.) Ronnie Dryden was tough and often in trouble with the police. He never avoided a fight, and he looked out for his four brothers and sister. Ronnie was especially fond of the little brother the family called "Georgie," a name more likely to be given a girl than a gangster. Georgie, the quietest member of the family, had a sweet disposition. "He was just a lovable rogue, really," said Terry Miles. "He was an East End London boy that was just that bit cut above the normal. There was just a natural nicety about him. But of course, you know, catch him on the wrong day and you could be in serious trouble."

Lucian Freud, who could be famously difficult himself, found Dyer appealing: "All sorts of people liked George." Dyer had a pronounced stammer and an even more pronounced cockney accent, which often made it difficult to understand him. "And when he was drunk his speech got worse," said John Normile, the Wheeler's barman and friend of Bacon. George also found it difficult to meet another person's eye, often turning slightly away in conversation. Ianthe Knott, Bacon's sister, could hardly get a word out of him. His strangled efforts at small talk could be painful. George fancied a good suit, as did the Kray twins—George was their age—and he wore slick suspenders. "He was a gentleman, George," said his youngest brother, Lee Dyer. "He was an absolute gentleman. Always in a collar and tie." When others at a pub ordered an unstylish pint, George often asked for whiskey instead—almost always Haig Dimple, a showy Scotch noted mainly for the shape of its bottle.

George was not tall, but well-muscled and compact, with features more striking than handsome. He had a magnificent (if broken) nose—a splendid beak that lent Roman distinction to his profile—and pronounced

eyebrows under which, his brother Lee said, "George's eyes just tilted a little bit." He was part of an East End gang—the Richardsons, Freud thought—but he was not a gifted criminal. Bacon later called him "useless" and couldn't believe he was good at stealing. George had few talents to help him get along in the world, in short, and during the 1950s, at loose ends with no place to sleep, would shimmy up a pipe to the third-floor flat of his aunt and then, smelling of drink, bed down with his relatives. His aunt was not pleased; but, "You know Georgie." Lee Dyer said, "How he got up there we'll never know, but he used to climb up from the landing up the pipework onto a small verandah and into the house. This was regular."

His brothers refused ever to confirm that George was a thief. He just took occasional advantage. But George himself was happy to say that it was his calling. The artist Michael Andrews once wanted to buy George a drink in the Colony, but George said no: "I have more money than you do—you're a painter." "And what do *you* do?" Andrews asked. "I'm a thief." George mostly drank away his days and nights in the clubs. A favorite was the Jack of Clubs on Brewer Street, Soho, where there was live music and the crowd was a typical Soho mix of shady and bright. (It was at the Jack of Clubs, in 1964, that David Bowie—as Davie Jones—gave his first live performance with the King Bees.) George was certainly not a hardened criminal. In school, he caused little trouble. As he began to spend more time in the clubs, however, he sometimes stumbled into a fight. Once, he was badly beaten up, and the doctors had to wire his jaw. Ronnie was usually around to help him. A friend of the Krays once insulted Georgie at an underworld club, for example, and Ronnie quickly came to his defense:

> One of them give Georgie a slap and I went over there, I was going in there with a couple of friends of mine as well and all of a sudden it was off and bang bang wallop, you know, and it was a big fight in Wardour Street between us and them. We won! And then I went to see Ronnie and Reggie [the Kray brothers] in the club and I said to them, "Look, what's happened in there, he took a liberty with my brother Georgie" and they said, "We didn't know it was your brother . . . [We've spoken to them] and the row you've had with them it's all finished now, it's all over," and that was that.

Once, George even took a swing at his big brother. To teach him a lesson, Ronnie then pulled out a knife and opened a long gash on George's arm. The wound required several stitches and left an impressive scar to

show friends. When Ronnie was not around, he asked the bouncer at the Jack of Clubs, Nosher Powell, to look after George. Nosher was a former boxer and movie stuntman with "connections"—important in the underground world of East London. He served as a bodyguard for, among others, Frank Sinatra Jr. and Sammy Davis Jr. Nosher kept an eye on George when he was drunk. George was rarely violent, and then only when he was provoked by insults.

One day in 1963, when he was supposed to meet Ronnie for a drink, he failed to appear. George had been living at his mother's, who reported him missing. "I found out that he was drinking in that pub up in Knightsbridge," said Ronnie, "up past Harrods in the little pub on the corner." Ronnie was surprised: George did not usually drink in elegant Knightsbridge establishments. Ronnie then found him with Bacon and a circle of Bacon's friends. "I had a drink with them—they wasn't my friends, they were his friends. He was doing what he was doing. I didn't know what he was doing. I found out later what was up. But I left them there and they went to a club, some club up the road—one of them gay clubs I think it was. But I didn't go. I went somewhere else." Dyer wasn't obviously homosexual, but he could be accommodating: Cockneys famously lived by their wits. Terry Miles thought George's homosexuality "came about by being in prison and having the usual."

Few in Bacon's circle supposed, at first, that the relationship would last. The two might find each other amusing, but what would keep the odd couple together? Then for both men, the relationship became serious. Each opened a world to the other. Bacon began introducing George into his way of life. He loved the stroppy cockney spirit that sometimes emerged when Dyer was drinking. The art critic Giles Auty once happened upon George and Francis in the restaurant car of an English train. "In days when Britain was less affluent," he recalled, "I suspect many users of restaurant cars seldom dined out other than when traveling. There was a subdued hush in the dining-room broken only by the tinkle of cutlery and whispered discussions between long-married couples as to whether to order a half-bottle of beaujolais." The waiter serendipitously directed Auty to a chair beside Francis and George. "If you wouldn't mind joining the other gentlemen, sir." "Almost as I did so, Mr. Bacon's new companion, sporting a bright ginger crew-cut, complained very loudly of the heat: 'Cor, Francis, it ain't alf-fuckin' 'ot in 'ere.' Throwing off his coat, he revealed a short-sleeved shirt, impressive musculature and brilliant braces. Several delicately poised fish knives clattered to the floor."

Like Miss Beston, George brought a measure of stability into Bacon's life. He was not going to move into Reece Mews, but Bacon did not want him too far away. In fact, there was news of a flat in Lurline Gardens, across the river in Battersea, that might suit George. No doubt Miss Beston helped with the details.

Younger Crowds

GEORGE COULD SIT FOR HOURS. He was making good money for nothing: sixty quid a month. He just moved this way and that, depending upon what Bacon wanted, or remained perfectly still. He did not complain, and sometimes they worked for the entire morning. Bacon might even finish a painting in one go. It remained true that Bacon did not ordinarily like to paint from life—he felt too obliged to entertain

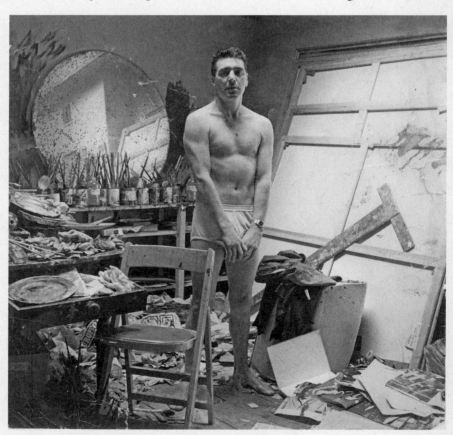

George Dyer could pose for hours: a John Deakin photo of George, whom Bacon painted again and again in the 1960s

his sitters, almost always his friends, and he could not then properly concentrate—but George was not Cecil Beaton or Lisa Sainsbury. Bacon did not have to amuse George or worry about his opinions.

The same was true on other occasions. In the back of a cab—or, for that matter, in bed—Bacon did not have to talk to George, not as he had with Eric Hall and Peter Lacy. He may have shied away, after Lacy, from a lover of his own age and background. It was too painful. George was naturally quiet—so was Ron Belton—but sometimes prattled along cheerfully in a way that did not tax Bacon. And Bacon never tired of looking at him. He was beautifully, but also naturally, formed. His muscles were not gym-made but came from years of manual work, and perhaps some schoolboy boxing. And that proud nose: a commanding prow under retiring eyes. Since Bacon could not always find George when he wanted him to model, he commissioned John Deakin to take some photographs of George stripped to his pants, which revealed his musculature. George found the pictures embarrassing, a bit like dirty postcards.

Perhaps it was George's marvelous physical features that inspired Bacon to focus more on portraiture, which became his presiding passion during the 1960s. He had painted portraits before, most memorably of Peter Lacy, but after the van Gogh series he appeared mainly interested in a recumbent figure placed at odd angles. Now, he began to paint every possible kind of portrait—large, small, triptychs, heads, full bodies, profiles, close-ups, even, in one whimsical moment, a *Portrait of George Dyer Riding a Bicycle*. The portraits were typically of people he knew intimately. In many cases, he asked Deakin to photograph his subjects for him, providing a reference or starting point. He found making portraits very difficult. "You simply can't bring off a portrait today," he said. "You're asking chance to fall your way *all the time.* The paint has to slide into appearance at every level, the accidents have to be all in your favor."

Bacon wanted to capture an individual's "look," never of course in an "illustrational" way. He was equally after the "sense" of the person. That did not mean depicting definable elements of an inner life or psychology, but instead conveying the mysterious aura of feeling-shaped flesh—present, for example, in later Rembrandt. The portrait almost had to paint itself, with Bacon serving as a kind of medium, as the "chance" found the man. In addition to George, Bacon often painted Isabel Rawsthorne (fifteen times) and Lucian Freud (eleven). Rawsthorne, whom Bacon continued to admire and often saw in Soho, emerged with rare strength on his canvas. There were not many strong unsentimental portraits of women painted during the twentieth century—Picasso's paint-

ing of Gertrude Stein set the standard—but Bacon's portraits of Lisa Sainsbury and Rawsthorne were an exception. John Russell praised an "energy, intensity of perception, depth of feeling, bodily magnificence and an undiminished vitality" that went beyond other portraits. Muriel Belcher appeared in a Bacon portrait, as did Richard Chopping (named) and Denis Wirth-Miller (unnamed). Bacon made a series of a man wearing glasses, the subject never identified with certainty, in which the head was viewed from different angles—but not as a cubist might divide a head into different-facing facets. The flesh instead became a kind of twisting putty, as if all the lines had been yanked from a cubist grid. David Sylvester believed Bacon was extending the tradition of English portraiture: "In a way they're sort of country house portraits by Reynolds which are sort of mouldering."

Bacon's portraits emphasized movement, but not of the overtly physical kind found in Muybridge photographs. The twisting in the paint evoked a sudden turn or jolt of feeling. The triptych form itself conveyed movement—presenting three different views of a person. But the changing play of expression in a Bacon triptych was never of the seamless kind found in the movies but instead became a kind of rhythmic stop-start or freeze-frame that emphasized different heightened moments. His portraits rarely depicted people in happier moments, of course, but his range on the darker side was remarkable. His art could shift from gentle melancholy to black despair to falling-apart agony—each rendered with energy.

George was his favorite subject. Bacon made more than twenty paintings of him over the decade. Soon after they met, he painted a triptych portrait in which George, while not idealized, was placed against a black background in richly luminous colors; the earthy internal glow has the radiance that may accompany the early stages of love. But Bacon also depicted George in many other guises. In the triptych *Three Figures in a Room* (1964), for example, Bacon presented a much more Rabelaisian view of love's body, also no doubt inspired by his relationship with George. Its central image depicted a contemplative figure (perhaps a combined portrait of Bacon and George) on a blue piece of furniture that looked like a cross between a chaise longue and a philosopher's throne. In the left panel, George sits enthroned on a toilet, his back to the viewer. In the right, he reclines on what looks like a revolving seat, his elbow absurdly cocked behind his head in the classically seductive pose of love.

The triptych was partly a sardonic echo of Rodin's *Thinker*. Bacon admired Rodin, but likely found *The Thinker* preposterously elevated in feeling. The rendering of George's back on the toilet recalled the pro-

nounced spine and slanted shoulders of *The Thinker*'s back (and also owed a strong formal debt to the Degas pastel *After the Bath, Woman Drying Herself* in the National Gallery in London). And each of the three figures in the Bacon triptych appeared lost in elbow-bending thought. Whereas Rodin's thinker was engaged in a profound meditation, however, the thinker in Bacon's central panel is positioned between a throne of *merde* and a stool of love. George was always immediately recognizable in a Bacon painting, partly because of his jaunty nose and partly for more mysterious reasons. Bacon captured the way George filled his space. John Russell believed that in George, Bacon created an unforgettable cockney type. While some portraits of him revealed a "private despair," wrote Russell, others seemed to echo "his wild humour, his sense of life as a gamble and

the alarm system that had been bred into him from boyhood." George Dyer, Russell added, "will live forever in the iconography of the English face."

During the early 1960s, when Bacon and George went out, they made an impression. Bacon often replaced the jacket and skinny tie—the uniform of many English artists and writers in the 1950s—with more casual but no less studied dress. At a private view he might wear a turtleneck and jacket. George fancied suspenders, waistcoats, and Edwardian suits. He began every night with perfectly combed hair. Bacon no longer looked young but still appeared boyish, giving him a mysterious betwixt-and-between air. He might attend a certain kind of dinner party on his own—a woman like Ann Fleming found George Dyer less amusing the second or third time around—but otherwise George was at his side. Bacon, always intensely aware of himself in public, never outgrew his reluctance to enter a crowded room alone.

Bacon remained an artist of settled habits. He invariably rose early,

During the early 1960s, when Bacon and Dyer went out, they made an impression—Bacon carefully casual, Dyer in Edwardian-looking suits.

sometimes having breakfast with Lucian Freud or making scrambled eggs for a friend. He worked hard all morning. In the afternoon, he immediately sought diversion. He liked sex best in the afternoon when he was stimulated by work but not yet overcome by food and wine. He took the tube to Soho for a quick drink and lunch at Wheeler's or the French with a pickup crowd of friends. In the evening, after dinner, Bacon and his friends would often break in different directions—some to Muriel's, of course, but Bacon himself often to a casino. In 1960, Parliament passed the Betting and Gaming Act, which led the following year to the opening of casinos in London. Bacon no longer had to travel to the Riviera or find an illegal London den. He liked Crockfords in Mayfair, which could be as quiet as velvet, and Charlie Chesters in Soho, which was filled with raucous sounds of laughter, drink, and ringing coin. Roulette remained his game. He played two tables simultaneously when he could. (He would probably have liked a triptych of tables, if that were possible.) "He thought the patterns repeated themselves" in the casino, said his friend Anne Dunn. "It was terribly exhausting. He was running from table to table. He said that he could hear the numbers coming up. On the spin of the balls happening at one table and then another table. It was almost mystical between two tables, and he thought he had an instinct about it."

Bacon's friends remembered Ron Belton, and now there was George. His friends explained the relationship in the conventional way. Bacon was one of those Englishmen trolling the East End for rough trade. It was well known that certain gentlemanly queens romanticized love's escape across class lines, supposing that a relationship with an earthy East Ender living outside middle-class norms might release them from the sexual and spiritual fetters that ordinarily restrained a gentleman. But Bacon was much too unsentimental to submit—at least wholeheartedly—to that dream. He knew about the one-offs with the Dilly boys (who took their name from hanging about in the corners and shadows around Piccadilly Circus), and he had spent several months with a smudge. George meant much more than that. It was the innocence, Bacon would say, that captivated him. He was moved by the yearning he saw behind the good looks.

Despite their obvious differences, George shared certain qualities with Peter Lacy. Each was a handsome man who longed for the good life. For Peter, it was a purring motor, a career in the theater, and a devil-may-care insouciance found in a performer like Fats Waller. For George, it was a happy wallet, one that paid for round after round at the pub; and then a posh pillow for the head that ached in the morning. Both George and Peter were reserved men with a slight speech impediment—Bacon, of

course, had his own tic—who drank heavily not just for the pleasure of it but because drinking can release a reserved man. George and Peter shared one further trait. Each was thwarted. Thwarted men were often angry men, in whom drink released not only tension but also the dark angels of disappointment and despair. Neither George nor Peter appeared homosexual, and neither developed a successful public face. Each remained partly in the closet, uncertain of his place and unable to realize his ambitions. Until late in his life Bacon was attracted to beautiful but suppressed men in whom there lay—somewhere between weakness and power—a seductive but dangerous line that he could test. It was not surprising that frustration and bitterness led such men into tempestuous, sometimes violent rages. Still, most of the time George was more hapless than frightening, and Bacon seemed determined to give his "inept thief" whatever he dreamed of having.

More than twenty years older than George, Bacon became both a lover and an indulgent father—and, strangely, a Pygmalion, who was both an all-powerful creator and a man powerless before love. Dyer, said Terry Danziger Miles, was "a very rough diamond." It became a joint endeavor, between Bacon and Dyer, to polish this diamond. Bacon's doctor, Paul Brass, said George "would wear the most beautiful suits and a waistcoat, beautiful shirts and ties. . . . His hair was immaculate, always, always in place." Some believed that George, insecure in the elevated milieu of artists, hoped that elegant clothing would make him appear more at home. He had always dressed up, but now he spent a fortune on clothes. The effort appeared too earnest, of course, which turned his clothing into a poignant cover-up rather than a confident statement. He remained stylistically uneasy, even with every hair in place, and seemed all at once a little Edwardian, a little Kray, a little Marlborough, even a little Mod, the sixties style just becoming fashionable. Bacon, absorbed in masking and unmasking, found such behavior touching, though it also made George a target for his needling. The more George reinvented himself, the more he stood revealed. George was painfully sincere in his desire to "better" himself. He began to take elocution lessons. One of George's brothers, after not seeing him for a number of years, used a slang expression for a smug upper-class man putting on airs to describe the changes in his brother. "He did come across to me as rather blasé," said Lee Dyer, "was a bit 'Okay, yah Hooray Henry,' you know, to me."

To his family, George—like Peter Lacy—remained closeted. Men who fancied men were well-known in the East End, but no one talked to Ronnie Kray about being "homosexual." His tastes were just differ-

ent. George's family did not want to think of their Georgie in that way. George himself, said his brothers, could not bring himself to tell his mother how he met Bacon—in a homosexual club, Lee Dyer said, and not through the skylight—and as a result invented the story about the burglary gone wrong. Better thief than poof. His older brother Ronnie Dryden also guffawed at the idea George would ever break into Bacon's studio. "I said, 'Broke into his house?' I said, 'He wouldn't break into a lollipop.'" Still, George's brothers noted the obvious, even if they did not quite acknowledge it. George and Francis, not long after they met, stopped into a betting shop on Great Suffolk Street where Ronnie happened to be working. "I'm marking up the board and he walks in with Bacon, both of them drunk." Bacon asked Ronnie if he would pose for him at Reece Mews. "Wanted to paint me, if you don't mind! I said a lot of police officers want to paint me!" They were "slurring and everything else," Ronnie said, "being pissed they were, but he said, 'I'd like to do you,' I thought, 'Would you!'" George's sister Rita was as naïve about such matters as Bacon's sister Ianthe and did not learn that George was homosexual until after his death.

The family officially chose to take a positive view of the relationship: look at the money Georgie was making! And he spread the money around. They would always stress that George was *working* for Bacon as a model and handyman, and it was not easy work, either, with some crazy artist, never mind that the money was good. Bacon regularly accompanied George on fortnightly Sunday visits to his mum, charming Mag with flowers, elegant manners, and an air of unsnobbish élan. You'd hardly know he was famous, let alone queer.

In 1962, Robert Fraser—a wealthy Etonian rebel who refused to go to Oxford or Cambridge—opened a hip new art gallery in Mayfair. The Robert Fraser Gallery made Marlborough look prim by contrast. Fraser loved "sharp suits and pink shirts," said one of his artists, Clive Barker, adding that "then, pink was extraordinary." A few years later, Fraser was sometimes called "Groovy Bob," and the visitors to his gallery—and to his flat on Mount Street, which became known as the best "pad" in London—included the Beatles and the Rolling Stones. Fraser was part of a profound change of tone and style in London. In Chelsea, Mary Quant was selling miniskirts—the signature look of the sixties—and, in 1963, the nightclub Annabel's opened in a basement off Berkeley Square. Soon the Beatles and everyone else vied to spend the night in its dark red rooms.

Even Soho appeared to be aging. Carnaby Street, only a few blocks west of Soho, looked like tomorrow. Suddenly, there always seemed something new to talk about: music, clothing, politics, art. Novel kinds of drug-induced oblivion, too. "That period after the war was a tough time," said Clive Barker. "Everything was gray. All of a sudden it all burst open . . . these girls in their bright colors and short skirts." London, twenty years after the war, was recovering its animal spirits.

Bacon probably enjoyed the change in tone for a while. He sometimes paused before the windows of the new clothing boutiques opening in and around Carnaby Street to buy a brightly colored or striped shirt. Now and then George took him to the new music and homosexual clubs. (The people in the rock bands sometimes sounded rather like George.) Soon enough, however, the decade began to wear on Bacon. He might be a well-known and articulate artist, with a Tate retrospective behind him and a powerful gallery to promote him. He might have a house, a boy-friend, and money enough. But in ways large and small he was continu-ally reminded that, in essential respects, he was an artist of the past, not the present. He could not sustain, to begin with, much interest in trendy "youth culture." Neither rock music nor fashionable drugs attracted him. His asthma ruled out marijuana. Psychedelic drugs did not tempt him. Neither did political movements or utopian writers. To the extent that he maintained political views they were acerbically conservative. The Old Left he found annoying: they wanted to steal his gambling money. The New Left he considered absurdly naïve. He apologized to Sonia Orwell after abruptly leaving one contentious dinner in the 1960s at Alfred Hecht's house: "I have a deep suspicion of the people who back the help-less in their search for power without really knowing what the powerless want, and [think that] if they were to gain power they would . . . impose a greater tyranny than we have already." He added, "I am only echoing Nietzsche when I say this."

Bacon was not attracted to what young journalists called "scenes," such as the rock scene, the gallery scene, the literary scene. He was himself a theatrical man, but the play around him was changing. He was accus-tomed to modernist rooms, to conventional rooms, to piss-poor rooms with low light and a single bulb. But the taste of someone like the brilliant designer and antiques dealer Christopher Gibbs represented a form of radical connoisseurship that was new to Bacon. Gibbs was adept at com-bining the styles, objects, and varying patinas of the past—he loved faded glories, oddities, and a "distressed bohemian style"—and he helped create a new look for old things. Sometimes credited with inventing the term

"the swinging sixties," Gibbs knew everyone daring in London. Gibbs and Bacon were affectionate, teasing friends, no matter that Bacon was two decades older than Gibbs or that his territory was Chelsea and Bacon's resolutely Soho. Bacon's head would "swivel," said Gibbs, when he and Robert Fraser entered the Colony. "Let's get out of this place," Bacon would pipe up. "Here come the Belgravia fairies." Gibbs and Bacon shared an interest in reconstituting what was lost. If Bacon was haunted by history, Gibbs—who anticipated aspects of postmodernism—was playfully at ease with its remains. And they both found cockneys bracing.

All around him, Bacon observed the rise of a generation of younger artists with tastes unrelated to his own. He was in his fifties. Many of these artists—Richard Hamilton, Clive Barker, Andy Warhol, Bridget Riley—were in their twenties and thirties. Many became art world celebrities. "The thing was, we became [sort of stars]," said Barker. "The magazines would ring us up and ask us what we were wearing. They were doing to us what they did to models." Bacon became friends with both Hamilton and Barker, but it was not easy for him, in this new "art scene," to appear at the door with George and push into a crowd of smiling young faces at the private view of a twenty-eight-year-old pop artist, especially when the art on the wall did not interest him. The atmosphere in this younger art world was so different: the music, the dress, the pace. "Everybody came to the openings," said Barker of the Fraser Gallery. "Bacon sometimes. You'd have film stars, all the rock-'n'-roll boys." The younger artists might respect Bacon enormously—while regarding him as . . . *from before*. Was anything more old-fashioned than painting portraits? Portraiture was thought, said John Russell, to have "all its old hazards"—especially the need to pander to the sitter—"without any of its old prestige."

That sensation of standing apart was highlighted in 1963 when John Deakin took what may be his most famous photograph: a group portrait of the so-called London school of painters. The small group gathered around a table at Wheeler's consisted of Timothy Behrens, Lucian Freud, Francis Bacon, Frank Auerbach, and Michael Andrews. All were more or less figurative painters during the pop period. *The Sunday Times* magazine editor, journalist, and literary writer Francis Wyndham, who thought there might be some sort of story in the older Soho painters who ran a tab at Wheeler's, asked Deakin to pose the group as if they were having a jolly lunch together. The idea was to present an alternative or counter "scene" and celebrate their independent "otherness." But everything about the photograph was staged. It wasn't a real lunch, Auerbach said, only a "photo op." And Wyndham's story was for *Queen*, a "glossy maga-

zine favoured by younger members of the British Establishment, known as the 'Chelsea Set,'" wrote Martin Gayford in *Modernists and Mavericks: Bacon, Freud, Hockney and the London Painters*. They would not care what the Soho artists were doing, only what Richard Hamilton and Clive Barker were wearing.

They convened at Wheeler's at eleven a.m., said Auerbach, all "rather bad-tempered." Deakin hopped up on the bar and snapped away at the faux "lunch." In the center of the photograph, Bacon raises a glass convivially as he turns to Freud on his right. On his left, Auerbach and Andrews seem to be sharing a private joke, while on the far left the much younger Behrens stares down at his plate. In front of them, crisp checked napkins are folded upright on the placemats, and a bottle of Moët champagne sits in an elaborate ice bucket, as if the cork will be popped any second now. At the end, Behrens—thinking it might become a real party—"suggested that a bottle should be opened," said Auerbach. "Rather grudgingly, because he realized he'd be paying for it—not that he would usually have minded that—Francis agreed. Then we all went away before lunch." Deakin's group portrait later became the branding photograph for the "school of London"—the figurative band that had putatively challenged abstraction, pop, and the following isms. A number of shows would one day honor the stubborn artists, each continuing to paint in what Auerbach described as a sort of "Robinson Crusoe" isolation. But Bacon—its apparent leader—always denied its existence. He found no common aims among its artists; and, besides, he would not belong to any "school," even one he led.

Although the sixties were a politically fiery decade, its art rapidly cooled as abstract expressionism yielded to the ironies of pop, minimalist, and conceptual art. There was no longer talk of directly "reaching the nervous system." Artists focused on the eye and the mind. To many in the art world, especially in America, Bacon seemed an old-fashioned figurative painter from Europe with a bizarrely overwrought sensibility. Not surprisingly, the coolly stated art of the 1960s—so abstractly thoughtful and also indifferent, usually, to human flesh—had little direct influence upon his work, though he may have brought some sixties color and scale into his painting. But the decade could have marked him indirectly, arousing in him a spirit of resistance. He continued to think about ambitious triptychs, but as celebrity culture spread through the media, Bacon drew inward, looking close at hand, to portraits, old friends, and familiar places.

Muriel's was little changed, and Soho—despite the new clubs and the

flashes of fresh color—remained reassuringly squalid, with its curtained sex shops, shabby pubs, and walkups where women advertised "French lessons." Freud and Bacon still often headed off to an early breakfast or were seen arm-in-arm after a fancy dinner going out for an evening of drinking and gambling. In 1967, they traveled to Paris together to see the Ingres centennial retrospective. At the Colony, Bacon became friendly with some of the younger regulars, notably Henrietta Moraes, another in the line of adventurous women whom Bacon instinctively liked.

Moraes, a sometime artists' model, first came to Soho in the early fifties with Michael Law, a documentary filmmaker whom she would eventually marry. "Soho was alive and kicking," wrote Moraes in her memoir, "full of people and credit was easy." Moraes was immediately drawn to Bacon and Freud. "Lucian's hypnotic eyes and Francis's ebullience and charming habit of buying bottles of champagne proved irresistible." She had a fling with Freud and fell into an easy friendship with Bacon. Upon meeting her for the first time, Dan Farson found her "wildly attractive, fussing over her cigarette, with an arrogant upturned nose which I later learned had earned her the title of 'The Lady Brett of Soho.'"

Early in 1963, Bacon approached Moraes in the French Pub and told her that he was thinking of painting some of his friends, but that he only really worked from photographs. Would it be all right, he asked sheepishly, if John Deakin came round to her house and photographed her in the nude? At the time, Bacon had in mind a variation on the reclining figures that he had been painting. Moraes later told her daughter that Bacon admired her "herculean body," both curvy and muscular. But Bacon may also have seen in Moraes a bohemian who, while claiming the new freedoms and pleasures of the decade, remained vulnerable to its risks. (She would eventually become addicted to heroin and spend years caravaning around England and Wales.) Bacon developed the idea for an unusually literal painting, one depicting the underbelly of drug use during the sixties, in which a female nude lies on a bed with a syringe in her arm—the victim, perhaps, of an overdose.

One of John Deakin's photographs of a naked Henrietta Moraes, which inspired many Bacon paintings of her in the 1960s

Moraes did not feel she could say no to a man she regarded as a great artist. But she was not pleased with the choice of Deakin to photograph her. She knew him from the Colony as that biting little gossip in the rumpled raincoat cadging a drink—not the sort of man before whom a woman wants to undress. The first session went poorly. Deakin seemed to molest Moraes with his lens, setting up angles that seemed pornographic and making her feel deeply uncomfortable, as if she were a Soho whore in a squalid walkup. The more Moraes held back, the more Deakin badgered her. "Open up your arms and legs wide. Come on." Moraes protested that Bacon would not want "hundreds of shots of these most private parts in close-up." Deakin insisted otherwise.

Moraes was correct. Bacon found the images useless. He did not want sexually charged shots, but a disheveled nude (however beautiful) that captured some mysterious twisting or writhing of the flesh. He asked Deakin to try again. Sensing Henrietta's reluctance, he bought Deakin and Moraes a drink in the Colony and approached the subject obliquely:

Francis said, "Look here, Henrietta, this blithering nitwit has reversed every single shot of you that I wanted." "Ho," I said. "You amaze and astonish me." "Well, look here, Henrietta"—Francis shot his cuffs, displaying enormously strong-looking wrists—"would you mind letting him do the whole thing all over again, but the other way up this time?"

Henrietta recalled the many times she dined with him at Wheeler's or went to the Gargoyle, when "the air brightened, groups of people were animated, electricity hummed and buzzed and bottles of champagne appeared." She submitted to a second shoot. This time, Deakin provided images that worked, and Bacon made a stark painting of a nude, lying on a rounded bed, with a hypodermic syringe standing upright in her arm. The nude was not recognizable as Moraes, but Bacon was so taken by the photographs that he went on to make fifteen more paintings of her over the decade, sometimes naming her directly. The first named portrait was a small triptych that he painted in November of 1963. It was steeped in lush reds and earth tones and captured her forceful beauty. One of the last would be the equally bold *Three Studies of Henrietta Moraes*, painted in 1969, in which her powerful features were set against a vibrant yellow background. Bacon called it "one of the best sets of 3 heads I have done."

Not long after the first photo shoot, Moraes happened upon Deakin at "a really low little afternoon drinking club" full of sailors and drunks.

Deakin "was furtively flitting about with bits of paper, and so I went over and had a look and they were all these photographs of me with no clothes on that he was selling to sailors, ten bob at a time. I was absolutely furious. And yet I couldn't be really very angry because it was so funny."

Living with George proved more difficult than loving him. Reece Mews was not intended for a couple, but inhabiting separate flats proved almost as challenging, not because Bacon missed George but because George (as retiring as he could be) still found ways to exasperate Bacon. He would arrive at Reece Mews unexpectedly and at all hours, sometimes waking Bacon "wanting to talk." He chain-smoked, which the asthmatic Bacon couldn't bear. He seemed unable to stop doing anything he was enjoying. He had a bottomless mouthy hunger, like those chicks in the nest who never close their beaks. Smoke, drink, eat. Smoke, drink, eat. Bacon drank heavily, but even when bumping into furniture maintained a wobbly air of dignity and authority, however illusory, and kept himself to his morning work schedule.

Whenever Bacon found George annoying, he carped and needled. That led to occasional rows. Not long into their relationship, Bacon—while remaining devoted to George—began looking for ways to spend more time alone. What if they found a country place outside London? With a studio where he might be able to get away? In July of 1964, with Marlborough's assistance, Bacon purchased 2 Horsemoor Studio, Chieveley, in the Berkshire Downs, about sixty miles from London and easily reached by train. The seller was James Page-Roberts, an artist and set designer who a few years earlier bought a "medieval wreck" with a thatched roof and then torched it. ("I telephoned the Newbury fire brigade, told them not to come out, and put a match to the downwind corner.") Page-Roberts then constructed the studio and one-bedroom house that he sold to Bacon. The house was near the Newbury Racecourse, which was probably not a coincidence. Although Bacon preferred other forms of gambling, George may have liked Chieveley since his family had connections to bookies and racecourses. Fourteen months later, Bacon declared himself "bored to death with his country house" and gave it to George.

He also hoped to escape domestic difficulties by taking George on the road: Bacon remained unfailingly optimistic about getaways. In April 1964, they not only traveled to Malta, Sicily, and Naples, but also went to Monte Carlo, this time with Lucian Freud, where they lost all

of their money gambling and were stuck—
"idling at the hotel," as Freud put it—until
Marlborough wired money. But Bacon
and George were soon bringing their
quarrels on their trips. In May of 1965,
Bacon planned what seemed a journey
to paradise. He and George would take
the legendary Orient Express to Athens,
then visit Crete and its great ancient site,
Knossos. Athens was the home of Aeschy-
lus. Athens was where sculptors worked
on the male form with such intensity.
It would also amuse Bacon, of course,
to insert his cockney King George into
this rarified place. The rocking passage
over the tracks—Paris, Belgrade, Athens—
would provide a steady counterpoint to
the couplings of love.

Bacon unexpectedly invited John Deakin on the trip, just as he had
Freud the year before, since George alone was too much George. Deakin
himself genuinely loved the shady places of the Mediterranean, having
made some memorable photos of the region in his younger years, and he
understood the conjunction of the sublime and the seedy. On the Orient
Express, Deakin took some snaps of Bacon and George in the restaurant
car. The pictures had an offhand, slightly tilted look—suggesting the roll
and shake of the train—and captured the dreamy expectations of the trip.
Bacon was sitting there as Yugoslavia slipped past, drinking bottles of red
with a man who wore a slick pair of sunglasses and looked a bit like one of
those boys on motorbikes you saw hanging around the nameless railroad
stations. A more unstable threesome, however, could scarcely be imag-
ined: two prickly queens and a combustible East Ender all in their cups.
Perhaps Bacon had in mind Agatha Christie's *Murder on the Orient Express*.

The group spent some time in Athens and then took the overnight
ferry to Crete, likely an old vessel that did not offer a smooth ride. Bacon,
who feared the water, spent the night near the lifeboats. No reports sur-
vived of any powerful moment on the Acropolis or at Knossos. Only
reports of quarreling. All that George and Bacon did, according to Dea-
kin, was carry on with endless rows. George did not know how to quarrel
like Denis, who was a match for Bacon. George took the insults too much
to heart, especially when he was drinking. When Bacon needled him,

The romance of the
road: Bacon and Dyer
photographed by John
Deakin on their way to
Greece in 1965

saying, "She's not feeling very well today, is she, the poor dear?" George would rise predictably to the bait. Deakin, in turn, was no peacemaker. Not only was he himself a heavy drinker given to argument; he was also a sly and observant man fascinated by couples. Deakin was unlikely to interrupt the Francis-and-George peep show.

In London, desperate to put some space between himself and Dyer, Bacon proposed that Freud paint George's portrait. Freud took weeks, sometimes months, to complete a picture. He demanded hours a day from a sitter. Freud agreed. He told his biographer William Feaver that George was "really sympathetic. He wasn't tough." Dyer was actually quite fussy. He had "a hand-washing mania," said Freud, "and a tidiness and cleaning-up mania: never so shocked as when he went into Isabel [Rawsthorne's] flat," which the artist did not often bother to clean. He also had a good heart. "George was the sort of person who would be protective if someone was in a bad way. He was incredibly brave and had been knocked about by the police. He was completely unvenal and had proper feelings." While posing for Freud, Dyer discovered art books for the first time. "His face absolutely lit up."

Freud began the portrait, titled *Man in a Blue Shirt*, in London. In late October of 1965, he and George went to Drummond Castle in Scotland, the estate of Jane Willoughby. She was the 28th Baroness Willoughby de Eresby—with a partial claim to the hereditary title Lord Great Chamberlain—and a lover and close companion of Lucian Freud. She was also a friend of Bacon. The trip was principally an exercise in drying George out: there were many such attempts during the 1960s. In Glenartney, the shooting lodge of Willoughby's estate, Freud continued to paint Dyer "in an upstairs room at the end of a long corridor hung with antlers." What the East Ender thought of his castle surroundings was not reported, but the estate must have looked to him like something inside a movie-house newsreel, except in color. From Scotland, George wrote a letter to Francis that was both loving and slightly bewildered, beginning with an indirect acknowledgment that their rows disturbed Bacon's work. "I do hope you are feeling OK and have been able to start your work as I know you have wanted to so much." He went on to say that he was posing for Freud and promised that he was doing well enough getting sober:

I like it here very much and have had nothing to drink but tea and water. I've not taken the pills [likely Antabuse, which sickens alcoholics who drink] as the cook puts wine in a lot of the food. I think

the first day I was quite sick but I did not tell anybody and hope you will not do so. I do miss you very much indeed and long to see you. It seems as if we will be staying here for at least two more weeks. The country here is very lovely. Jane has a full-sized billiard table and it's very good fun playing with Lucian. This house is very big and I have my own bathroom which is as big as the bedroom. . . . Today Lucian and I went for a long walk and saw a lot of deer. They were very nice. I did write you a letter yesterday but tore it up after you phoned me.

George had the time—now that he was not in a pub—to report that Willoughby was going to London and then flying back, and that Sonia Orwell would also be visiting. He also had time to worry about the condition of his new property in the Berkshire Downs, asking Bacon to make sure that a Mrs. Rampling paid the bills and turned on the underfloor heating:

We get very good food. Tonight, for instance, we had grouse. I try so hard not to think of you, as it makes me unhappy not to be with you. I do hope you can stay away from Soho just for me, as it always seems to lead to disaster, perhaps more me than you. It is rather cold here at the moment, but I suppose this is to be expected. Well my dear Francis, I do hope you are happy and well. Write soon and thank you very much for ringing me. All my love. As Oscar Wilde said, please believe me. Yours, George.

From Wilde or Bacon, the valediction would be ironically edged. From George it was earnest—the more so followed by the wooden "Yours, George." But the sweetly plaintive tone suggests that between George and Francis there were many private moments of intimacy and love that, being good news, were not often recorded.

Bacon continued to regard trips as helpful. The couple went to Tangier in the summer of 1966. George especially liked France, and he wanted to learn the language. He realized the difficulties involved, however, asking Francis, "How can I learn French when I can't speak English?" Bacon himself would go to France on any pretext. They traveled to the Midi in 1967 and visited Bacon's old friends Anne Dunn and Rodrigo Moynihan, now married and living at their estate near Lambesc, Provence. (Dunn and Michael Wishart, for whom Bacon had given the legendary wedding party in 1950, amicably separated and divorced in the late 1950s.)

Moynihan and Dunn, both serious painters, now spent much of their time in France. "George was so sweet," said Dunn. "Sort of an innocent character." She recalled him kicking a football around the garden with her young son. What she particularly remembered was how old-fashioned Bacon could be. One evening, George and Francis began to quarrel and then took their argument upstairs to bed, where George became so noisy that the nanny felt obliged to take Dunn's son Danny, who was seven or eight, "away and hide." The enraged George, Dunn believed, was "starting one of their S&M things upstairs," but Bacon would not allow it. Rodrigo was not prudish but maintained a certain reserve that Bacon did not want to violate. And so Bacon continually admonished George: "Not in Rodrigo's house!"

More and more often, Bacon retreated to the Storehouse, the house of Dicky and Denis in Wivenhoe, sometimes with George and sometimes alone. Bacon first took Dyer to Wivenhoe only a month or so after they had met, with disastrous results: Dicky and Denis's house caught on fire, and the two remained convinced that George had started the blaze with a careless cigarette. Bacon found in Wirth-Miller's company everything that was lacking in his relationship with George. In Bacon's two previous important affairs, with Eric Hall and Peter Lacy, the situation had been different. Hall and Lacy understood Bacon, at least somewhat. George could no more fathom Bacon than run the London mob from the back of a pub. Only Denis Wirth-Miller, and perhaps Freud, could now see into Bacon, who otherwise remained sealed.

Bacon's favorite retreat—the Storehouse (painted white) in Wivenhoe, the home of his friends Dicky Chopping and Denis Wirth-Miller

Dicky and Denis liked to concoct weekend parties. Friends would drive to the Storehouse from London or, if they had a weekend place nearby, drop in. A walk along the river could be taken when air was needed. Wivenhoe's many pubs seemed just a barstool away. The house frequently filled with a colorful array of people, quite a few well-known— Kingsley Amis, Benjamin Britten, David Douglas, 12th Marquess of Queensberry, Terence Conran—but the party was never pretentious or posh. People came to eat, drink, laugh—and to appreciate the high-strung Denis and the droll, rather disapproving Dicky. Denis was a brilliant chef. Even the celebrity chef Robert Carrier was his admirer, particularly praising his chicken with avocado in aspic. The talk around the table, often interrupted by Denis, could have taken place at the Colony. It was baroque and outrageous. "I remember once Peregrine Worsthorne"—a well-known journalist and Roman Catholic—"and his wife were there," said a young friend and aspiring journalist, David Wallace, "along with Queensberry and a few others, and Denis turns and says, 'Oh, I know her, her cunt smells like lavender.' And Worsthorne turned and said, 'Oh, what are you talking about, Denis. Cunt smells like rotten fish.' And the conversation went round like this for five or ten minutes."

Sometimes, Bacon holed up for days at his friends' house in his regular bedroom, or he might stay at a local hotel. He still sometimes painted in Denis's studio. Denis helped steady him during the celebrity-charged 1960s, paradoxically helping to keep him "sober"—unintoxicated by the fame game. Denis was from "before," and he never treated Bacon as important. To others, when Bacon was not around, Denis was unstinting in his praise, love, and admiration for Bacon; he even kept a book of Bacon's "sayings." But when Bacon was present, Wirth-Miller—excitable when sober and a spinning top when drunk—verbally slapped Francis around. The words became almost physical in their intensity, and Denis had a way of grabbing an arm when he was talking and squeezing a little too tightly. Francis treated Denis the same way. Their conversation resembled "flyting," an old English and Scottish word that suggested both "fight" and "flights of fancy." In the sixteenth century, flyting was a kind of verbal dueling in ritualized form—a back-and-forth of outrageous invective and delirious insult. The insults could wound, of course, but were not intended to be mortal.

In London, Bacon began to look for a second studio. Perhaps with two places he could always get away from George when necessary. Perhaps, in fact, he and George could sometimes live together at Reece Mews if there was another place Bacon could go every morning to work.

In the late fall of 1965, Marlborough arranged the purchase of a very large and high-ceilinged studio flat at 43-45 Roland Gardens, South Kensington. The price was £7,500. Originally designed and purpose-built for artists in 1891–92, the building offered north-facing, floor-to-ceiling windows. Bacon's particular flat, 45C, was on the second floor and had several skylights. With Miss Beston's assistance, Bacon undertook three months of extensive renovation. The results would have delighted many artists, but Bacon failed to work there successfully. The studio, Bacon told Sylvester, was too grand: "I was absolutely castrated in the place."

But the studio proved just right for an Edwardian gentleman. Bacon soon signed over the flat to George, just as he had the country place in the Berkshire Downs. The East Ender and petty criminal who spent his youth moving from room to room, often crawling up a pipe to sleep in a corner of his aunt's flat, now had a room of his own in London. In fact, he now had a flat and a country house. The flat had high ceilings and looked—for a single room—exceedingly large. A small flight of stairs led to a sleeping balcony, and the kitchen was concealed behind interior blinds. George grew up in a world of tired furniture. He now ordered an oval divan with a headboard that appeared wildly modern and very sixties, certainly not like anything in the East End, and a round velvet bed so expansive (and probably expensive) that workmen could not shoulder it up the stairs. A crane came to lower the bed through one of the skylights in the roof. Bacon, once a designer of furniture, probably regarded the bed and the divan as grotesque, amusing, and—like much else about George—poignant.

George loved precious things, and he became house proud. Not long after moving into the flat, he happened upon his brother Lee, whom he had not seen for years. (Lee was ten years younger.) They spent the evening at a pub in the Boltons, and at closing time George insisted that they continue drinking at his place in Roland Gardens. They brought home a bottle of Haig Dimple. When Lee finally said, "I need to get some sleep now," and prepared to lie down on the pillows of the sofa George told him, like a girl protecting her dolls, "Oh, you can't sleep on those!" His head might soil the pillows. "Anyway," said Lee, "I managed to find a bit of comfort on the floor."

PORTRAIT OF ISABEL RAWSTHORNE STANDING IN A STREET IN SOHO (1967)

Strong, handsome women delighted Bacon. Granny Supple in Ireland, who rode to hounds, set the standard. In his *Portrait of Isabel Rawsthorne*

Standing in a Street in Soho, he presented Rawsthorne as a commanding Soho duchess, dominating her world like an eighteenth-century English aristocrat standing in front of his great house and deer park.

Bacon painted many portraits of Rawsthorne. He enjoyed the sculptural planes of her face, always alive and shifting, and the high arch of her forehead, which yielded a great mane of hair. In the Soho portrait, lines of energy flow from her head with such electric intensity that the background seems to crack, becoming what looks like pieces of her personal puzzle. Bacon's Soho was changing in the 1960s. New colors and syncopations surround Rawsthorne. The speed is picking up. The classical power of a bull—trapped in a mirrorlike reflection—is now meeting the automotive wheel of the modern age. The bull's horn is also a stylish wheel cover.

Bacon made other pictures of commanding women. Lisa Sainsbury, in a painting from 1955, displays the confident reserve of a queen. Bacon's women do not finally escape—any more than his men do—the pressure of the great questions and unknowable answers. (Rawsthorne may rule Soho, but she remains largely confined within a "space-frame.") But they elude what later critics would call "the male gaze." Rawsthorne is not dainty, submissive, or fashion bound. She is not young—fifty-five years old at the time of the painting—and does not curry favor with a sexy pose. She is not only a duchess but a matador in the ring, with the bull under control and an admiring crowd in the distance.

Ancient Rhymes

Lᴏɴᴅᴏɴ ᴡᴀꜱ ʙᴀᴄᴏɴ's ʜᴏᴍᴇ, but he often thought of Paris. During the 1960s, as the hot glare of fame picked out the next generation of artists, his feelings for Paris intensified. The way in which London and New York chased after the new and newer annoyed him, especially since he disliked most contemporary art; and he had not done that well in New York. The styles originating in the English-speaking world had less impact in Paris, and de Gaulle was sharpening France's profile, declaring a measure of independence from both a uniting Europe and the Anglo-American alliance. The writer André Malraux—de Gaulle's minister of cultural affairs—was a French triumphalist who proudly asserted the achievement of France.

Many French intellectuals wrote about art from a somewhat different perspective than the English and American critics did. The French retained a strong interest in figurative and surrealist styles. Picasso was both the most modern and the most ancient of artists—his "brutality of fact" sometimes could have the pungency of the sacrificial stone—and Giacometti's totems had an ancient aura. (The "London school of painters," otherwise so diverse, revered both.) Few French intellectuals took warmly to the idea that New York had replaced Paris. Important figures from the prewar and early postwar period remained alive and vigorous, among them Jean-Paul Sartre, Samuel Beckett, Claude Lévi-Strauss, Jacques Lacan, and Alain Robbe-Grillet. Giacometti lived until 1966, Picasso until 1973. Artists were treated with a reverence that appeared more serious than the celebrity game in London and New York. Malraux promoted a Picasso exhibition of pharaonic scale at the Grand Palais. *Hommage à Pablo Picasso*, scheduled to open in October 1966, would be a modern apotheosis—and, by extension, a celebration of Paris. The show would include eight hundred works, among them seven hundred from Picasso's own collection.

Bacon had a history in Paris, of course, not just an affinity. He came to know the city during two magical moments—the late 1920s and the years just after World War II. Paris was where Bacon first dreamed of becoming an artist and where he first discovered Picasso's gift. Paris, though not part of the ancient world, had certain ancient-seeming notes that appealed to him. Paris could be a place of origins and first principles, an Athens of modern art, with its philosophical spirit and sensual sweetness. In 1966, Marlborough planned a show for Bacon at Galerie Maeght, scheduled to open a month after the Picasso exhibition at the Grand Palais. Marlborough hoped to develop the Continental market for Bacon's art, but it was likely Bacon himself who pressed for an exhibit in Paris.

In 1965, when a retrospective of Giacometti's art opened at the Tate—the curator was David Sylvester, long an ardent champion of the Swiss sculptor—Bacon spent several memorable days in Giacometti's company. They first met when Giacometti came to London on a planning trip for the retrospective and then again around the opening, when the amiable Giacometti took time to slip away and visit Marlborough to see Bacon's recent work. The two spent one epic evening together. Bacon first took Giacometti to the Colony and then to a dinner party hosted by Isabel Rawsthorne for the artist and his wife, Annette. At dinner Bacon fell into a wine-soaked and "meandering monologue about life and death," as Dan Farson described it, with Giacometti listening patiently and occasionally adding a Gallic shrug. Finally Bacon—"probably aware that he was boring the man he considered 'the most marvelous of human beings'"—began silently raising his edge of the table higher and higher. All the plates, glasses, and silverware cascaded onto the floor. Giacometti "shouted with glee," reported Farson, at "that kind of answer to the riddle of the universe."

Giacometti's gift to Bacon was Michel Leiris. Bacon had previously met Leiris in Paris, but only in passing; Giacometti now brought them together during his show. It was the beginning of what would prove to be an enduring friendship. In the 1920s, Leiris was a respected surrealist and a friend of André Breton's until the inevitable falling out, which happened with most of Breton's friends. He had also been a contributor to, and staff member of, *Documents*, a journal founded by Georges Bataille that was a kind of *Wunderkammer* of modern marvels and astonishments. In 1931, he joined an official, year-and-a-half ethnographic expedition to French Africa whose purpose was to collect art and artifacts from native African cultures and also to document something of the myths, language, and worldview of its diverse peoples. He was the mission's "secretary-

archivist" and kept an explorer's journal that became the basis for his celebrated book *L'Afrique fantôme* (1934), an inward-coiling meditation upon the mission that included many personal, dreamlike, and erotically charged details. Not surprisingly, Leiris took a dim view of colonialism, but not in a conventional leftist manner. According to Kwame Anthony Appiah, who reviewed the English-language edition of the book: "The most consistent attitude of the book, though, is not really anticolonialism but a kind of general misanthropy. If the administrators are stupid, the locals are dishonest, manipulative, duplicitous—as, of course, are the members [of the mission]; as, of course, is Leiris."

Leiris had a morbid fascination with the body. He had once studied to be a chemist and retained a rather clinical view of the flesh. He would certainly have understood Bacon's passion for books that documented the body and its many ills. (The issue of *Documents* presenting photographs of slaughterhouses was well-known both to Bacon and to Leiris, who, while they might have found the abattoir horrifying, would never have thought to turn their eyes away.) After his mission to Africa, Leiris became an ethnographer at the Musée de l'Homme, writing scholarly papers while publishing many volumes of confessional literature. Leiris, like Bacon, had no patience with a conventional autobiography or surface "realism." How could you hope to reveal something as complex as the "I"? Leiris instead discovered pieces of the elusive self in a shifting phantasmagoria of art and dreams—and in his case, in the mystical visions of tribal cultures. It was a perspective Bacon found sympathetic. The scholar James Clifford called Leiris's massive *L'Afrique fantôme* "ethnographic surrealism," a phrase that made sense in Paris (and to a man like Bacon) but sounded odd in more empirically minded London. In Paris, you could be at once a scientist and a dreamer, a freethinker and an academician. The American poet John Ashbery, who saw Leiris often in the 1960s, said, "He was sort of forbidding. Well, more anguished, maybe, than forbidding." Bacon and Leiris were natural soul mates—had either believed in the soul.

A lofty French intellectual ordinarily would have made Bacon anxious. The two men appeared comfortable with each other, however, their relationship fortified by Sonia Orwell, who organized dinner parties that brought them together. The evenings she hosted set the tone of the relationship to come—at once intimate and formal, with observations and compliments well delivered and graciously accepted. Six months after the Giacometti show, in January of 1966, Bacon was writing to Leiris as one would to an old friend. On the occasion of Giacometti's death that month, Bacon, casually mixing French and English, wrote in French, "I

know that the death of Giacometti has shattered his friends as well as people he barely knew. I wanted to write to Annette but I did not know what to say. When you see Annette would you give her"—shifting to English—"my best wishes and love, just as Michel I send them to you and Zette [Leiris's wife]." The letter was signed "Fondest Love." Few things were more flattering to Bacon than the regard of a Left Bank mandarin. Of what consequence was Grub Street when Leiris sat with you at Flore?

Leiris wrote only about the artists he admired, and he could provide Bacon with a different kind of history. He would no longer be just an eccentric English painter with a famously messy studio in South Kensington getting older among the throng of younger artists. He could instead be rooted in the Paris of Picasso and the surrealists. Leiris had another important quality: he was a genuine power in the French art world. His influence stemmed not just from his literary eminence but through his marriage to Louise "Zette" Leiris, the stepdaughter of D. H. Kahnweiler (1884–1979). Kahnweiler was modernist royalty, an art dealer present at the creation. The cubists were personal friends whom he wrote about. He was the champion of cubism generally and Picasso particularly. Since he had failed to apply for French citizenship before World War I—he was a German Jew—the French government auctioned off his collection as war bounty. As he reconstituted his gallery between the wars, his stepdaughter became his essential partner. During World War II, Kahnweiler passed the business to her—now renamed the Galerie Louise Leiris—and went into hiding. The Nazis did not seize the gallery, as Zette was not a Jew, and the gallery flourished after the war (often exhibiting Picasso). Leiris and his wife, not surprisingly, developed an extraordinary art collection and were often with Picasso in intimate settings. In 1944, for example, they held a reading in their flat of Picasso's surrealist play *Desire Caught by the Tail*, whose main character was named Big Foot. Albert Camus directed, and the cast included Raymond Queneau, Sartre, Simone de Beauvoir, Valentine Hugo, and Picasso.

As a friend of Leiris, Bacon was brought into the inner sanctum, which included the Galerie Maeght, with which Marlborough had a relationship. It was an ideal venue for an exhibition of his work. Maeght exhibited prominent modernists, as did the Galerie Louise Leiris, but Maeght additionally published an influential art magazine, *Derrière le miroir*, which typically focused on one artist in each issue, usually the artist the gallery was then exhibiting. In the year before Bacon's exhibit, for example, *DLM*—as it was generally known—published issues on Alexander Calder, Saul Steinberg, and Jean-Paul Riopelle. To mark Bacon's show, in

November 1966, *DLM* published Leiris's first essay on his work, together with an interview by David Sylvester. Bacon professed himself delighted with the Leiris essay. "Michel," he wrote in French, "I do not know how to thank you, it is the first time that someone has explained what I intend to do, even when I fail to do it. And also, thanks for having said that I am not an expressionist."

For Bacon, the weeks around his upcoming exhibit at Galerie Maeght became quietly portentous, as if he were reprising his life. First, he went to gamble in Nice, staying at the Hôtel Ruhl on the Promenade des Anglais, an opulent Belle Époque confection near the casino. Then he traveled to Paris, where he likely stayed at the Hôtel Pas de Calais on the rue des Saints-Pères. It could not have been more different from Hôtel Ruhl, but had the style Bacon expected in Paris: small, elegant enough, and perfectly situated on the Left Bank. It was a block from the Café de Flore, the Brasserie Lipp, and Les Deux Magots. Bacon brought George Dyer with him on the trip—and then to Paris. The young American novelist David Plante, who went to the Maeght opening, noted the evening's strange intensity. Sonia Orwell and Isabel Rawsthorne were there to toast Bacon's new prominence in the city they loved, with Rawsthorne "laughing a wide, wet, red laugh" and "tearing open congratulatory telegrams and reading them and then letting them drop to the floor." Dyer, overshadowed, tugged Plante from the crowd around Bacon:

> George took my hand and led me around the exhibition to tell me, in nasal Cockney, which pictures were of him, and to ask if I recognized him. One was of him, very mutilated, sitting on a toilet. He put his arm around me and was affectionate. He wore a suit, and a tie knotted so tightly that his sharp-edged collar cut into his neck, and his face and carefully combed-back hair seemed to form a wedge.

The writer was traveling with his friend Stephen Spender. They planned to spend a couple of days in Paris, then plant some trees at the house that Spender and his wife, Natasha, owned in Provence. The day after the opening, they met Bacon, George, and Sonia for lunch, and Spender impulsively asked Bacon and Dyer if they would like to visit him in Provence. Bacon agreed. Two or three days later, Bacon and George went to Provence, staying at a hotel in Maussane not far from the Spender house. Over dinner, Bacon—having been to the Grand Palais to see the Picasso show—expressed unreserved enthusiasm for the artist: "I

can't admire the man enough." It was high praise from one who, as Plante noted, dismissed most art: "Henry Moore's drawings were knitting, Graham Sutherland's portraits were no more than *Time* magazine covers."

The following day, the group drove to the Musée Granet in Aix-en-Provence to see its late Rembrandt self-portrait, in which the artist's inward-looking gaze was conveyed mysteriously, but precisely, in the play of the paint. Bacon was himself increasingly interested in self-portraits as well as portraits of others. (He would paint five self-portraits in the 1960s.) On their way home along a Provençal road, the group suddenly happened upon another kind of power that Rembrandt explored: the slaughterhouse. A "van had smashed into a tree," wrote Plante, "and, all about the van, fallen from the van, were dead, bloody pigs. Francis asked Stephen to stop the car so he could look." At dinner that night Bacon and George drank heavily. "George simply looked around. Francis focused with a frown on what Stephen and I were saying, as if waiting for a reason to be angry." Bacon found his reason when the conversation touched upon Christianity. When Spender observed that while he himself "certainly wouldn't give everything he had to the poor," he still "felt he should." Bacon erupted. "*Rubbish!*" The anger triggered by Spender's ordinary sentiment shocked Plante. Nothing, for Bacon, changed the cruel facts. The game was fixed. Bacon intoned, "*Rubbish, rubbish, rubbish.*"

Only on the issue of homosexuality, Plante recalled, did Bacon express social concern. The crackdowns on homosexuality in the later forties and early fifties, which led to the death of the scientist and code-breaker Alan Turing and the trials of Peter Wildeblood and Lord Montagu of Beaulieu, had created a backlash, leading the Conservative government in 1954 to establish a departmental committee—chaired by Sir John Wolfenden—to examine the issues of prostitution and homosexuality. (They were thought related, both being a matter of morals.) An indication of how touchy the subject remained came when it was decided that, in deference to the ladies on the committee, the words "homosexual" and "prostitute" would not be used in conversation. Homosexuals would instead be referred to as "Huntleys" and prostitutes as "Palmers" (after the famous English biscuit maker Huntley & Palmers). After reading the Wolfenden report, Mollie Butler, the second wife of the Conservative politician Rab Butler—an early supporter, with his first wife, Sydney, of Bacon's design business—told Roy de Maistre: "I don't know what I'd do if one of my boys turned out to be homo sapiens."

At the time of the Spender dinner in Provence, the Wolfenden report—which had been published in 1957—was still a topic of intense

debate among British homosexuals. The report recommended that homosexuality be decriminalized, but Bacon still spoke "bitterly," Plante said, about the situation of homosexuals. His concern was not the particular rules and regulations addressed by the committee. What enraged Bacon was the social rejection of homosexual children and adolescents. It was not "unorthodox emotion" that imbalanced them, he said, but rather the emotional "deprivation" they suffered. He was obviously describing not only his own experience, but also that of a man like Peter Lacy. (Many years later, Plante persuaded Bacon to sign the only political letter of his life, when Margaret Thatcher was in power and homosexual rights were coming under attack.) Spender later advised his young friend that Bacon's darkness was just something one must accept as part of life. Bacon also had life-affirming qualities, Spender said, among them his love for George. Spender was being sensible, but it is doubtful Bacon wanted to be "sensible." He transformed the period around his show at Galerie Maeght into a private set piece on power, weakness, and sentiment.

In the 1960s, Winnie Bacon's health began to fail. Always a dutiful, if wayward, son, Bacon made three trips to South Africa to see his mother, in 1967, 1968, and 1969. His mother's first serious illness occurred in 1962, but Bacon did not make a trip then, explaining that work for upcoming shows precluded his going. He felt guilty at the time: "I know you feel I have been very neglectful," he told Ianthe. In 1967, Bacon wrote to his mother asking how to get to her house in the town of Louis Trichardt, then an eight-hour trip from Johannesburg. Her response was not recorded, but his solution became part of the family lore. "He landed at the airport and went up to a taxi and said, 'I want to go to Louis Trichardt," said Bacon's nephew, Harley Knott: "And the guy said, 'Well, you know it's a long way.' And Francis said, 'I've got the money to pay.' So the guy went home and got some clothes and he dropped Uncle Francis off at my grandma's house and [Bacon] was obviously not in a very good state. He had stopped at every pub along the way."

Bacon with his mother and sister Ianthe in South Africa in 1967, the first of three trips he took to Africa as his mother's health failed

A family photo—probably from this first trip—shows Bacon and his sister standing on the lawn next to their seated mother, whom Bacon had not seen for a decade and a half. Another shows a family reunion, probably occasioned by Bacon's visit, that included Ianthe and her husband, Ben Knott, Bacon's sister Winnie and her daughter, Jane Stephenson, and Bacon and his mother. By then, Winnie had outlived the Major; her second husband, Dr. Montgomery; and a third husband, James Mavor, who died in 1960. In the photograph, Bacon looks tanned and healthy. Mother and son remained, as ever, affectionate. Winnie could never talk to her son seriously about his adult life and work, but she was a well-meaning mother and proud of her son's inexplicable success in London. She remained a link to his childhood. After losing two sons and three husbands she had and ended up, as she might have put it, "in Africa, of all places." It was a late gift to find her delicate son thriving and chatty. No conversation would have meant more to her, as her body failed, than one with Francis about how, say, they cooked a brace of grouse together that time in the west of Ireland, or a "Do you remember?" story about Granny Supple. It would have also meant something to her how very English Francis appeared in rough and ready Africa, a reminder to her of her own privileged youth in England and Ireland. He possessed not only a sense of occasion but a keen awareness of the unspoken feelings playing out behind another's eyes.

Bacon returned not by plane but—as a treat—by ship. "I enjoyed the few days so much with you and Michel and Zette," Bacon wrote Sonia Orwell during the voyage. "As you can imagine the people on this ship are incredibly boring—but it is a marvelous relaxation—and already I feel so much better . . . We cross the equator early tomorrow morning so it has suddenly got very hot." His latest show at Marlborough had opened the month before and the Leirises came to London to mark the moment. Leiris had written an essay, "What Francis Bacon's Paintings Mean to Me," for the catalog, which obviously delighted Bacon. The show itself did not please everyone. After attending the opening, the waspish Frances Partridge—who admired Bacon—wrote in her diary that "there isn't much 'newness' about it except his increased popularity." ("In the narrow gut of the gallery, turds were slowly circulating," she wrote. "I stepped close and hoped I was 'appreciating the quality of the paint,' but it gave me no pang, thrill or lift. Nor did I get the electric shock his first shows produced.")

Two more trips to South Africa came in quick succession—one in 1968, when Bacon rushed to his mother's bedside after receiving a cable from

Ianthe, and the last a year later. He began to help out his family financially. He gave Ianthe's sons Harley and Keith and her daughter Mary a bequest and brought Ianthe herself a rolled-up painting of Henrietta Moraes in a bag, telling customs that oh, it was nothing, he was just a Sunday painter. (Ianthe told him he had no reason to worry: they were just looking for the nudes in *Playboy*.) Ianthe and her husband, Ben, visited London in 1970, her first trip to England since the war, and she henceforth attended many of her brother's shows. Ianthe and her sister, Winnie, appreciated their brother's concern for their mother. They knew that they had little in common with him, apart from family, and that he did not have to make the effort. But there he was, rather restless, strangely tense, charming and funny—eager, perhaps, to leave, but there nevertheless.

On his trips to Africa, Bacon liked to spend a few days with Ianthe and Ben on their farm in Rhodesia (now Zimbabwe). Ben Knott—a cheerful, robust man who managed the farm well—was the sort of conservative but open-faced Englishman living in the Empire who would have known how to talk easily to Bacon's father. But he was also the sort of man who, as a father, would have made all the difference to Bacon. Knott was not snobbish in the least, and he displayed no prejudice toward homosexuals. As a good host, he "drove around in the Land Rover a lot" to show Bacon sights that might interest him. On a hunting expedition, for example, he killed an eland. Bacon helped cut up the meat to make jerky. "He enjoyed that," said Ianthe. "The skinning. The Africans do the skinning. So he would have seen all that and actually [her son] Keith was the one who said he was absolutely fascinated with the color."

As Bacon's mother failed, George also struggled. He was noticeably absent from Bacon's trips to South Africa. Bacon did not want to worry about George drinking too much in front of his family or explain to his mother why he was traveling with an East Ender. George's drying-out trip to Scotland did not work. Nor did subsequent efforts. Miss Beston and Bacon sent him on vacations outside London. Bacon tried to persuade him to move to Brighton, the seaside resort George liked, with the promise of a lump-sum payment. To no avail. George spent some time at the Hotel Metropole in Brighton but always returned too soon. He went to medical clinics that treated alcoholics, but always relapsed. "Of course he came out and said, 'I can't touch the spirits,'" said his sister, Rita Isaacs, "'but I can have a glass of wine.' He was back on it again."

Bacon and Freud both believed that George lost his self-respect when he gave up his profession as a burglar. He had everything but something to do. Morning was for sleeping off the night. Afternoon was for getting

ready. George began to drift apart from his family. In their view, he lived with Francis now and, like many drunks, was becoming more trouble than he was worth. He saw his mother less often on Sunday. During a visit to Rita, he went to the local with her husband—who brought him home when he became too drunk. She put him to bed. "He laid on the settee in my lounge and actually wet all the way through it," Rita said. "We had to throw it out afterwards." She told George not to come back. Bacon never abandoned George, continuing to look after and support him, but he could no more resist taunting him when he made a fool of himself than George could turn down another drink. The strange seesaw of power between them bewildered George. Although he was "the man" in the relationship—the muscle—outside the bedroom he was anything but dominant. He was the consort of a powerful queen, more "Georgie" than ever. If Bacon felt isolated within the relationship—with George unable to understand him in a serious way—so too was George isolated. He was losing his family; he was a stranger in the world of art; and now Bacon was tiring of him. Freud told William Feaver:

> It was awfully tragic, really: Francis stopped fancying him and George was in love with him. Francis got him these marvelous— horrible—grand flats, but [George] wanted to be with him. Francis hoped he'd get off with someone, but, Francis said, under drink he was impotent and so people took him home and in the morning didn't want him any more. He had DT's.

George became increasingly subject to a self-destructive, intensifying hysteria that was by turns comic and pathetic. He once hurled an ashtray at Francis but missed, cracking the floor-to-ceiling mirror in the bedroom at Reece Mews. Bacon—who used the mirror to dress and examine himself—refused ever to repair it. One evening, George went to Reece Mews and, finding Bacon out, began furiously throwing pieces of furniture down the narrow staircase, where they crashed and piled up against the front door. Bacon, when he came home, could not enter the house and, worried about his paintings, called Terry Danziger Miles of Marlborough for help. Miles drove the tall gallery van to Reece Mews, set it against the side of the house, and climbed onto the van's top. He began tapping on the upstairs window. "And of course George came to the window and it was like, 'What the fuck you want, what you doing here,' and the window came open and I probably said, 'Hi, George, Francis phoned me, he needs to get in, apparently you've thrown all the furniture

down the staircase and I need to get in. I'm doing my job, George, you know.'"

The last phrase did the trick. Terry was on a job, and George knew when a bloke needed help. "He said, 'Yeah, yeah, yeah, come in and I'll give you a hand.'" George had toppled a couple of chairs and the French chest of drawers down the staircase, probably after emptying the contents into the kitchen bathtub. Miles squirmed under the chest, wrenched it around, and then, with George's assistance, hauled it back up the stairs step by banging step. "By which time," said Miles, "it had all simmered down." Bacon could open the door and get inside. Then "the two of them went out together, went wherever they were going."

George also began attacking Bacon in more underhanded ways. One day Bacon came home and found that someone had broken in and stolen a portrait. About a week later, as he was walking down Duke Street in Mayfair, he noticed the portrait in a gallery window. "Funny that you say that this painting was stolen," the dealer told him. "Someone came in who said he knew you and where you lived." Together, they arranged to meet the thief when he returned to the gallery. When the thief saw Bacon, he ran for the door, shouting, 'I'll get you, Francis.'" Soon afterwards, a mysterious man telephoned Bacon and told him, "Don't do anything about that painting." A few days later, Bacon found Reggie Kray on his doorstep with a bottle of champagne. The thief was apparently an acquaintance of the Krays and probably of George. Later, when a friend asked Bacon what he did about the theft, he replied, "Well, nothing. I didn't want to wake up one morning with both hands cut off."

Bacon behaved as dutifully toward George, when sober, as he did toward his mother. No matter the quarrels, they continued to appear together at parties and private views. On important occasions it would have been simpler to leave George behind lest he become an embarrassment. But Bacon found it difficult to do so. One such occasion came in November 1968, when the Marlborough gallery scheduled a Bacon show in New York at its sister gallery, Marlborough-Gerson. The London gallery was determined to open the American market for Bacon. Not only did the show in New York include an unusually large number of pictures—nineteen—compared with the twelve recently at Maeght; but among them were two triptychs and Bacon's impressive, full-size *Portrait of Isabel Rawsthorne Standing in a Street in Soho*. Lawrence Gowing, an influential curator, writer, and painter in London who frequently came to America, wrote an essay for the catalog. Bacon was not only a great painter, argued Gowing; he would also rattle your cage and change your life:

In London this year I have felt a distracting reverberation in the air. It is generated by the knowledge that a mile down the street, too close for comfort, Francis Bacon is in tremendous form, painting continuously and surely disturbing something that one would sooner leave settled. . . . Waiting for a new group of [Bacon] pictures I tremble a little, lose track of my thoughts, wake in the night. Every time the image that emerges can be counted on to strike directly at a vital and vulnerable sense. One has no way of preparing or protecting oneself . . . For some unknown reason, one's private view of oneself is at stake.

It was a first trip to America for both Bacon and George. Miss Beston, aware of the hotels that Bacon preferred in Paris, booked them into the Algonquin, a small, old-fashioned hotel in Midtown that was favored by writers at *The New Yorker*. Bacon found New York forbiddingly foreign. Its scale was not European, and there was no circle of old friends to ease his mind in unfamiliar surroundings. George was no less anxious. It was on trips away, when Francis became King Francis, that George felt his secondary status most acutely. But both men, once they began drinking to ease the tension, became unpredictable. Bacon could slip into his more dramatic self, for example, acting bitchy, funny, and outlandish. At a luncheon in his honor, when he was introduced to Jason McCoy, a handsome young man (and art dealer) in New York, Bacon asked an English friend about him. Informed that McCoy was the nephew of Jackson Pollock, Bacon replied, "You mean, she's the niece of the old lace maker?"

The show was not a failure, but neither was it a success. The gallery was hoping that Bacon would become fashionable; that seemed to be the way to a strong market. But it was not obvious, in 1968, how to gain that status for Bacon in America. His imagery was not necessarily a problem. Many collectors prided themselves on liking difficult art. But few were courageous enough to buy work that was not championed by critics, curators, and other collectors. And the critics, curators, and collectors in 1968 had other things on their mind besides Bacon. The work then fashionable tended toward the cool, ironic, and abstruse. Meanwhile, America was erupting in racial riots and demonstrations against the Vietnam War. In the spring of 1968, both Martin Luther King Jr. and Robert Kennedy were assassinated. The English artist Francis Bacon might receive a respectful nod of the head, but he was not part of the American conversation.

The critic for *The New York Times* was Hilton Kramer, a bright man

dismayed by what he regarded as the decline of high culture. He loathed fashion and the middle-brow appreciation of art, reserving a particular contempt for the mandarin celebrants of the pop and minimalist styles. A critic more noted for what he hated than for what he loved, Kramer was drawn to art with a lofty, aestheticized tone, including some figurative painting. In 1968, Kramer still retained some of his youthful enthusiasm for art, but the culture warrior in his makeup—who had a sharp puritanical voice—was growing more pronounced. There would seem to be much for Kramer to admire in an English figurative painter who adored the old masters and bored the fans of pop art. But Kramer was concerned. He sensed postmodern qualities in the later Bacon, though the word postmodern was not yet current, and he seemed worried about getting conned. Too fierce to hem and haw with faint praise—a habit of mind that disables many critics—Kramer chose to damn with high praise in a review titled "The Problem of Francis Bacon."

Kramer saluted Bacon's "unerring pictorial intelligence," "virtuoso performances," "dazzling" pictorial effects, and "incomparable cleverness and facility." But he used those phrases to pump air into a bubble he intended to pop. After the strong initial impact of a Bacon painting, Kramer wrote, "we are left, not with a penetrating insight into the agony of the species, but with a mannered and deftly turned style." The art was "clever rather than profound—brilliant rather than authentic." It was "not a cry of pain, after all, but a well-composed aria." And he could not resist reminding London of its secondary status. The catalog introduction by "Professor Lawrence Gowing," wrote Kramer, represented the "established judgment—established, at least, in London—of Mr. Bacon's work." The review was bad news for Marlborough's sales if even a critic open to figurative art disliked Bacon.

George and Francis saw each other both too little and too much during the trip to otherworldly New York. George was sometimes shooed away and expected to amuse himself, and Miss Beston was not there to think up diversions for him. A night or so after the opening of the show, Bacon and Dyer joined John Richardson and Anne Dunn—old friends both in town—at a pleasantly sketchy bar at Ninety-Second Street and Lexington Avenue. It was "sort of half black half white half gay half straight half whores, sort of rough bar on the border of Harlem but had a certain kind of charm," said Richardson. Bacon began to needle Dyer relentlessly:

George said, cockney voice, "Wat you want to drink," and I said beer or something, and Francis, queeny voice, "Don't listen to her, she

hasn't got a penny in the world. Do shut up, George, for God's sake stop asking people what they want to drink." George said, "Well, listen, I brought my traveler's checks with me—they've given me lots of drinks and I want to pay people back." Francis said, "She doesn't know what she's talking about," and they had this little fight and George left and went back to the Algonquin.

Like many alcoholics, George could become weepy and self-pitying, something that Bacon could not abide. Also like many alcoholics, he would sometimes threaten to kill himself, which annoyed Bacon no less. After a night of drinking, Bacon was inclined to tell George—baying about ending it all—to just bloody well get on with it. Bacon carried strong sleeping pills and blood-pressure pills with him as well as Librium, a sedative that he had begun taking the year before. An overdose could be dangerous. But he always hid his pills, Freud recalled, out of concern that Dyer would find them and overdose. "If I don't hide them I know George would eat them all and I just can't let him," Bacon told Freud, adding—lest he appear too sympathetic—"I've often thought of forgetting to hide them." That night, Dyer found the pills and swallowed too many. After his stomach was pumped, the couple returned to London, and Bacon began another painting of him, as if nothing had happened. Miss Beston wrote cheery letters about their time in New York.

George developed the desolate anger of a man who has realized his dreams and found them wanting. Sometime after their return to London, in a blind rage, he savagely attacked Bacon's studio and his paintings. It was far worse than throwing the furniture down the stairs. Now George was attacking Bacon's art. He ripped up canvases, threw them in the bathtub, and poured wine over them. Most disturbing of all, he set fire to the studio, probably causing more damage than he intended. It was an old "villain" trick: to make your point, you would bundle up newspapers and other trash in a pile outside the door, soak it in gasoline, and set it on fire.

Bacon and Marlborough, fearful that Dyer might hurt Bacon, moved quickly to find him a temporary studio. With the help of Dicky Chopping, who was still on the faculty at the Royal College of Art, Bacon began working again in a borrowed studio there. He was so grateful that he promised the college a painting in exchange for rent. In July of 1969, as Bacon continued to paint at the Royal College, the gallery began advertising for a "large artist's studio . . . with good north light, with or without living accommodation, to rent or buy, Kensington, Chelsea or Fulham area." But the restless Bacon also began looking for another place on his

own. It would be helpful to have a more welcoming flat than Reece Mews (which he did not own) close at hand, where his family or the Leirises could stay, for example, when they came to London or where he could greet the people who wished to interview or meet him.

In September of 1969, Bacon purchased a house in the East End, at 80 Narrow Street in Limehouse, a worn-down neighborhood on the Thames. It was a long London trip from Roland Gardens: Bacon was moving east as George moved west. He could live there among the "villains" of the East End, and he bragged that his new neighborhood might be dangerous. "I have bought," he said with a flourish, "the house in which I shall be murdered." Although much of Limehouse was destroyed during the war, the bombs directed at docks and warehouses missed a small strand of early Georgian houses along the Thames. They stood derelict until the mid-1960s, when a band of young intellectuals, recognizing a bargain, began to buy up and renovate them. The center of the neighborhood was an ancient pub (once enjoyed by Charles Dickens) called the Grapes, which was two doors down from the house Bacon purchased.

Bacon renovated the house in a modern style. The large, spacious main room on the ground floor opened onto views of the river through floor-to-ceiling windows at the far end, and steeply angled stairs reminiscent of 7 Reece Mews—this one with an elegant, burnished-steel handrail—led to the upper floor bedroom. But Bacon once again found it difficult to adapt to a new space. Through the large windows the great river beamed a lovely and ever-changing light into his house—a fine spectacle, no doubt, but distracting and not Bacon's sort of light. Bacon rarely went there. "He did one or two small paintings maybe but it was like a kind of glory hole, with the river and all that," said Terry Miles. "If he had, say, Leiris over to discuss an exhibition, they would do it there." Bacon also loaned the flat to Miss Beston. "I think she spent nearly every weekend there that he wasn't. Just cleaning it, being there, being around it, because for her it would have been a luxury. With a pub right next door and the river going by." The ongoing gentrification of the area—of which he himself was a part—also disappointed Bacon. Not long after he moved into his house, the well-known MP David Owen moved in next door. That was perhaps, as John Russell wrote, "the last straw." Narrow Street was changing from a slightly seedy and raffish backwater into "one of the best-protected and most carefully guarded streets in London," a place where one could not reasonably hope to be murdered.

During this period, George—stewing inside and often dreaming of revenge—became a police informant. Knowing nothing more of him

than that he was an alcoholic with a record who lived on the fringes of the underworld, the police thought he might be useful. A young woman named Carol Bristow, one of the first female detective sergeants in England, began to keep an eye on him. They would hallo and chat occasionally in Chelsea. Then George telephoned her "out of the blue" and asked for a meeting. Perhaps, Detective Sergeant Bristow thought, he wanted to "grass" on a crime or two. The two met over coffee in a homosexual bar in the King's Road, where George told her that his rich homosexual employer was handing out cannabis to young men like "sweeties."

George did not tell her that Francis Bacon was a famous painter. It was a deft, even brilliant strike at Francis. Suddenly, it would be Francis who was the criminal and George who pulled the strings. George kept a stash of cannabis for his own use at Reece Mews, which he concealed in a hollow statue that the Krays had given him. All that was necessary was to plant the drugs around the studio. Bristow, after obtaining a search warrant, organized a group of uniformed officers and sniffer dogs and led them in September of 1970 to the address in Reece Mews that George gave her. Be sure to watch the back of the mews house, she warned the uniformed officers, in case the suspect tried to jump out a window. Then she banged on the door and shouted in best movie form, "Open up! This is the police!" Bristow described the scene in her memoir, *Central 822*:

There was silence inside for a moment, and then I heard shuffling, as someone wearing slippers ambled down the stairs. A bolt was slid across and the door opened a few inches. Wedging my foot into the gap, I showed the disheveled-looking occupant the warrant for drugs, and he stood there blinking at me. "Just who do you think you are?" he suddenly asked me in an indignant but impeccable Anglo-Irish accent.

Bristow forced open the door. She "brushed past him, up the stairs and into his little flat, followed closely by the team of dogs, pulling on their leads." Bacon, in pajamas and a brightly colored paisley silk dressing gown, appeared "bemused." He dropped an important name, asking her if he might call Lord Goodman, the personal solicitor of the prime minister, Harold Wilson. A power broker who served on what sometimes seemed every important board and committee in the nation—and was chairman of the Arts Council of Britain—Arnold Abraham Goodman, Baron Goodman, was well-rounded in every way. (The satirical weekly *Private Eye* called him Lord "Two Dinners" Goodman.) He was "infinitely

human," said the museum director Roy Strong, and "infinitely devious." He was a formidable opponent, in short; and he would not want a living national treasure inconvenienced.

The stalwart young detective sergeant, who had never heard of the painter Francis Bacon, stood her ground as the dogs continued to snuffle through the rooms. Bacon repeatedly asked her what they were looking for. When she finally told him "cannabis," he "snorted" and "laughed out loud." He was an asthmatic, for heaven's sake! It was just then that the dogs found the stash:

> I walked into what looked like an artist's studio, covered in canvases and easels, and watched as the dogs' tails wagged furiously by some paint-boxes on the floor. Sure enough, in the bottom of one of them, we uncovered some cannabis wrapped in silver paper. A few minutes later, a twelve-inch pipe stem was found hidden among some clean underwear in a tallboy in another bedroom. Despite the suspect's protestations, I arrested him and took him back to Chelsea nick, well pleased with my morning's work.

Lord Goodman soon arrived at the station with a powerful entourage. "They treated me," said Bristow, "like something they had picked up on the underside of their shoe." The case then dragged on for nine months. Bacon first attempted to have it thrown out, arguing that friends from the arts must have left the cannabis there, but the effort failed. During the jury trial at the Inner London Crown Court, Bacon was represented by Basil Wigoder, a famous defense lawyer, who placed the blame on George "as an alcoholic ex-con who had worked for Bacon for years, but kept falling out with him." The prosecution placed Bacon in an unflattering light, claiming that during one of George's suicide attempts Bacon told him to ask the doctor to write him another prescription "so he can do the job properly." Bristow wrote:

> Bacon told the court that George was a sick man who had only gone to the police out of spite. The pair had undoubtedly had a very turbulent relationship. "When he is drunk he feels I don't pay him enough. Sometimes he has broken down my front door and forced his way into my flat. I pay him a regular wage but that doesn't suffice because of his drinking."

Bacon was acquitted. The detective sergeant did not enjoy the sight of the powerful asserting themselves. "I watched him climb into a taxi with

some of the most influential people in the land," Bristow said, "and it occurred to me that it wasn't what you knew that mattered, but who you knew. I made a mental note never to tangle with the likes of them again if I could help it." Bacon's sister Ianthe also learned something of her brother. In the run-up to the trial, Ianthe and Ben coincidentally were visiting London after the long-expected death of Ianthe's and Francis's mother in April of 1971. It was Ben's first time in the city. Bacon had arranged for them to stay with Sonia Orwell, and Ianthe looked forward to dinners out and nights at the opera. They were astonished to find once they arrived that her brother had been charged with drug possession. "He told us he was having a drama," Ianthe said. "He still had to go to court. And then of course Sonia filled us in a bit more when we got there."

For the first time, Ianthe observed her brother in his natural surroundings, where drunken cockneys accused him of drug abuse; Lord Goodman called him "Francis"; waiters treated him like a movie star; and a literary eminence like Sonia Orwell revered him. And he was, besides, this peculiar thing called a homosexual. (Her husband now told her those particular facts of life.) Bacon himself found his situation no less strange than his sister did. Outside, a world gone popping mad. Inside, poor pathetic George. But Paris was not far away.

Hommage à Bacon

Early in 1969, four months after his New York show, Bacon received a letter from the French curator Blaise Gautier. Would Bacon be interested in a retrospective in Paris? It had been a pleasant surprise when the French government purchased his difficult triptych from the Maeght exhibit, *Three Figures in a Room* (1966), in which George sat enthroned on the toilet in the left panel. Bacon was "hardly known in France" not long before that, said Jacques Dupin, the poet, art critic, and director of publications for Galerie Maeght, "and not at all liked." (The Musée des Arts Décoratifs turned down his 1962 Tate retrospective.) It was a shock now to be offered a retrospective. Only Graham Sutherland among twentieth-century British artists had been honored by a retrospective in Paris during his lifetime, at the Musée National d'Art Moderne in 1952. Leiris was a willing advocate behind the scenes. He would write the catalog essay.

In July of 1969, Gautier came to London. He spent two days with Bacon making an initial selection of paintings. Bacon found him "charming," he told Leiris. The exhibition venue remained in question. A new minister of cultural affairs—a lofty position in France—would soon succeed André Malraux. Bacon told Leiris he preferred the Grand Palais "because of the size of my paintings." No doubt the idea of being honored by the French in the same space where Picasso had been celebrated also appealed to him. That same summer Bacon painted the first of three bullfight paintings with a deep yellow background. The impetus probably came from Leiris, who loved bullfights and in 1966 sent Bacon a copy of his book *Miroir de la tauromachie* (Mirror of Bullfighting). Bacon was still working in his borrowed studio at the Royal College of Art, where he painted several works with the yellow background, including a large triptych, *Three Studies of Lucian Freud* (1969), which captured the taut energy of his friend. Bacon's bullfight paintings—steeped in Mediterranean light—

possessed the formal air of ritual typically seen in the bullring. *Study for Bullfight No. 1* would become the image on the poster advertising Bacon's retrospective in Paris.

During the negotiations over the venue, Bacon quietly orchestrated efforts to secure the Grand Palais. He made his desires clear to Leiris and other friends who could put in a word. He hosted a large dinner for Jacques Dupin and his wife at the White Tower restaurant in London, for example, which included David Sylvester, Sonia Orwell, and Isabel and Alan Rawsthorne, a well-connected group knowledgeable about the French art world. He also invited Isabel to a meeting with Blaise Gautier, who would enjoy seeing the former lover of Giacometti. The government granted Bacon his wish—the Grand Palais in the autumn of 1971. The deputy curators on the museum's staff were already visiting him in London in December of 1969. He treated them with his habitual good manners, but did not conceal from them the other aspects of his life. He asked Ann Fleming if he could bring a visitor from the museum to one of her dinner parties and Fleming was surprised—or perhaps not—when the evening collapsed into furious arguments. Calming things down, she said, was "like taking a bone from mad Alsatians [German shepherds]." Among the onlookers was a "French lady, unknown to me and imported by Francis; she is organising a retrospective exhibition of his paintings at the Grand Palais; he is the first English painter to have such an honour bestowed upon him, tho' I should think the occasion is in some jeopardy now."

The Grand Palais was a bragging sort of building, originally built as the massive exhibition hall for the Exposition Universelle of 1900. In style, it was mainly Beaux-Arts, but contained some elegant touches of art nouveau and possessed the largest steel-and-glass domed roof in Europe. Above the grand staircase of the Entrée Clemenceau, where visitors would enter Bacon's exhibition, was a quadriga by Georges Récipon (1860–1920): the female charioteer, Immortality, commanding four powerful horses, is seen springing forth into the air above the entrance, exulting in her victory over time. Over the years, the Grand Palais had housed exhibits of all kinds, from fashion to motorcars. It was where the fauves were first called fauves and where the French honored Matisse after his death. And, of course, where Picasso ascended.

Bacon rapidly created twenty-five new works for the retrospective, including four triptychs. George was not an important part of this surge. Bacon and Dyer remained friendly, even after the drug bust and George's slash-and-burn attack on the studio, but Bacon distanced himself some-

what from Dyer. He did not abandon George altogether as a subject; but in 1970, for example, he painted only one picture that included George's features. Instead, he painted Henrietta, Isabel, Denis, Dicky, the composer Gerard Schurmann—Bacon's Henley friend—and numerous self-portraits. In his *Triptych* of 1970, Bacon painted another man in whom he took an interest, which distressed George. In the late spring of 1971, with the show only weeks away, George entered a treatment program at the Priory Hospital in Roehampton and was sedated for ten days. Nonetheless, he asked Bacon if he could attend the opening, and Bacon did not say no.

Among the 134 works selected for the Grand Palais—almost forty more than at Bacon's 1962 Tate retrospective—were ten large triptychs painted since the first retrospective. It was not unusual in 1971 to come upon large abstract paintings in a museum, but figurative art seemed to have retired to the drawing room. The ambitious Bacon triptychs approached the scale of the history paintings in the Louvre. The catalog essay by Leiris thrilled Bacon, who immediately cabled the writer: "THANK YOU MORE THAN I CAN EVER SAY FOR YOUR MARVELLOUS TEXT." Uneasy about the installation, Bacon went early to Paris to help the curators. He might have stayed at the Ritz or the George V, but instead he shared a small suite with George at the Hôtel des Saints-Pères on the Left Bank, which he liked and which was popular with many people in his circle. ("We all went to that hotel at that time," said Janetta Parladé.) It was impressive, in its own way, that he should stay there. Bacon was not the more obvious sort of celebrity.

The Hôtel des Saints-Pères had three floors of rooms, a creaky staircase, and an interior courtyard. Bacon's family reserved rooms at the same hotel, together with Valerie Beston and Terry Danziger Miles, who were assigned by Marlborough to assist Bacon and his family. Fearing that he would be unable to sleep—he had trouble at the best of times—Bacon asked his doctor, Paul Brass, for an additional supply of Tuinal, the barbiturate he used as a sleeping pill. Soon every last person Bacon knew appeared in Paris, or so it seemed. He did not have enough time in a day to go around, and the social pressure was intense. French president Georges Pompidou—himself a collector of modern art—planned to open the exhibition in person. His wife was hosting a reception two days before. The British ambassador would attend, of course. Bacon was naturally concerned about George, who could be difficult at openings. But he had interviews to give and details to sort out. Bacon also worried about his family. Who would look after Ianthe and her teenage daugh-

ter, Mary, neither of whom knew much about the art world? The day before the opening, Bacon asked Miles, an attractive young man, to entertain his niece, who clearly wanted to see some of the city's famous nightlife. "She was fifteen or sixteen," said Miles, "and Francis asked me to do him a favor and take her on a Bateau-Mouche and he'd pay for it all."

The day before the formal opening and the press view, Bacon had a long lunch with Dicky and Denis. As they passed the Grand Palais on their walk back to the hotel, they saw an honor guard drilling on the steps in preparation for the opening: the ceremonial red carpet was being laid. Bacon was initially taken aback, but also honored. France herself was rolling out the red carpet. He returned to his room to find something far less welcome—George drunk and incoherent with an Arab rent boy. The room stank. Bacon became incensed. Neither Bacon nor George held back when they had been drinking, and they had what Valerie Beston called "a terrific row." Bacon left for a reception that evening, and afterwards he stayed out late gambling with Denis. When

he returned to the hotel, the room still stank. It was too much: he could not spend the night before his opening sleeping in such a room. Between one and two a.m. Terry Miles, whose room was on the ground floor, heard a knock at his door. "I thought, 'Bloody girl.'" Instead he found Francis at the door, asking if he could sleep in the second bed. "George has brought home this filthy Arab whose feet stink," he said. "Do you mind?"

Early the next morning, Bacon asked Miles if he would check upstairs to see "if George has got rid of that bloody Arab." On his way up, he ran into Miss Beston, on her way down to breakfast. They nodded a good morning on the stairs, and she asked him where he was going. He explained his errand. Together, they then climbed the stairs and knocked on the door to the suite. There was no answer. They edged it open, with Miss Beston pausing at the door. "The bed was all in a kerfuffle," said Miles, "and there was no George, and I opened the bathroom door to check and see if he was in there and he was on the loo." George sat leaning forward. Miles stared for a few moments. "For all intents and purposes he was dead." He then turned around to tell Miss Beston, still pausing at the door, and "she says 'You're joking' and I said 'No, no, it's like he's got all

Valerie Beston—Bacon's minder and devoted friend at the Marlborough gallery—with Bacon at the opening of his 1971 retrospective at the Grand Palais in Paris

his color under his skin, as if his veins are all blown up and everything.'" Miss Beston said, "Oh God, close the door."

They went downstairs and told Bacon. There was "no crying or anything," Miles said. "He was a tough guy. He didn't show too much emotion. It would have been more about 'What are we going to do?'" Miss Beston, however, saw the "devastation" in his eyes. She accompanied Bacon up the stairs: he must see for himself. The official state opening and press view were scheduled for that afternoon, to be followed by the larger private view—a festive social occasion for the Parisian art world. Afterwards, a grand dinner was planned at the legendary restaurant Le Train Bleu, hosted by the Leirises and Sonia Orwell, who also planned an afterparty. "They called the [hotel] manager," said Miles, "and explained what happened." Would it be possible, they asked, to postpone George's death until the following morning? His death would otherwise dominate news of the opening. The manager, like any good hotelier, was discreet. Illicit sex and unexpected death were part of the job. He understood the difficulties the situation presented. Yes, George could wait until the morning after the formal opening. The manager went upstairs to lock the room where George sat on the loo.

Nadine Haim rode with Bacon to the opening. Haim, the sister of the powerful French dealer Claude Bernard, was a new friend. Bacon looked distraught, she said; but when the car door opened onto the red carpet he walked confidently up the stairs, lined on either side by the honor guard, to meet the waiting dignitaries. A large sign proclaimed—just below the *Immortality* quadriga—"Francis Bacon, 26 Octobre 1971–5 Janvier 1972." Bacon, wearing a suit and a tie, became what he unfailingly became at such events: smiling, polite, effervescent. Inside, people pressed forward to congratulate *le maître*. Soon enough, the first faint whispers began. "Where is George?" He could usually be found pointing himself out in a picture. The few close friends who knew of George's death, including Sonia Orwell, Isabel Rawsthorne, Nadine Haim, and the Leirises, were too shocked to keep the news completely to themselves.

Bacon himself, however, appeared at ease. He smiled, turned, and walked about in the vast galleries, the gilt frames of his paintings reflecting the grandeur of the space. He spoke French to the French, English to the English, either language to the bilingual. Would he say hello to Miró and Masson? Here was Michel Leiris. There was Salvador Dalí making a surrealist spectacle of himself with a statuesque blonde. Bacon was photographed and tugged at. His friends emerged for a moment, coming in and out of focus—Isabel! Muriel!—between the strangers being introduced.

Beyond the revolving kaleidoscope, Bacon sometimes caught glimpses of paintings, including ones of George, staring back at their maker. Bacon surely heard the cruel rhyme now beginning to sound. Peter Lacy, dead at the opening of his Tate retrospective. George Dyer, dead at the opening of his Grand Palais exhibition. He would sense not only the tragic tolling, but also, probably, the ironic absurdity of the moment. In the corner of his eye, past the heads of friends and strangers, was the left panel of *Three Figures in a Room*, depicting George slumped over the loo. President Pompidou made a show of stopping in front of this very triptych, purchased by the French state.

Bacon talked his way through the opening and listened to toasts at Le Train Bleu. The Leirises had offered to cancel the dinner, but Bacon insisted that it go forward. He had often been to Le Train Bleu, located in the Gare de Lyon, on his way to the South of France, including with George when they traveled to Provence to visit Stephen Spender in 1966. By now, most people at the long tables had heard the news, and as they looked at Bacon, he possessed for them a strange new fascination: his art no longer seemed an exaggeration. It was the truth, imperfectly con-

Bacon performing at a glittering dinner the night of his private view in Paris— just after George died from an overdose of drugs and alcohol

cealed by a party. The figures in his paintings might almost have jumped into the room. At the end of the evening, Bacon briefly stood to thank the Leirises and Orwell for hosting the dinner and everyone else for coming. He passed through Sonia's afterparty. He spent the night—as he had the night before—in the hotel room booked for Terry Miles. As he lay down, George still sat upstairs.

The Times called the success of the Bacon show "astonishing," running the headline "Francis Bacon Paintings Boost Britain." "Long articles on him appeared in every newspaper with any artistic pretensions," wrote its correspondent. "A film about his work appeared on television . . ." To many in England, it was a source of pride that Paris, widely acknowledged as London's superior in the visual arts, should celebrate an English painter. Andrew Causey, in *The Illustrated London News*, wrote that Bacon's retrospective "marks one of the rare successes of British painters in capturing the attention of a European public."

Bacon was becoming a national figure, not just a modern artist. The exhibit also marked a success for the figurative tradition in Britain, a point that Bacon's friend Louis le Brocquy—himself committed to representational art—stressed in a letter to Bacon about the "sweep of his achievement":

Perhaps you yourself have reservations, but to me it is here in the Grand Palais—in the great circumstance of Paris—that your gesture is seen finally to assume and assert its universality. . . . That you have sometimes been regarded as an outsider on the contemporary scene is perhaps the measure of the recent general indifference to this particular painterly tradition. That in spite of this you are progressively regarded as central to your time and pre-eminent in it is surely due to the overwhelming force of your vision.

Pockets of resistance remained, especially in Britain itself. The critic John Berger, still many years away from changing his opinion, compared the paintings to the work of Walt Disney. If the cartoonist made human behavior look "funny and sentimental," Berger wrote, Bacon imagined "the worst possible having already happened"—and yet Francis and Walt shared formal qualities and were equally interested in distorting reality. But most of the English art world had come around on Bacon. The first substantial book on the artist, which John Russell completed in 1971

to coincide with the show at the Grand Palais, was widely praised. The Continental Europeans were even more enthusiastic than the English. French reviews were largely favorable. After Paris, the show traveled to the Kunsthalle in Dusseldorf, where it was also well received.

Even before the Grand Palais show, French artists and critics, asked which artist they would like to see exhibited in Paris, overwhelmingly chose Bacon, and he polled well when *Connaissance des Arts* asked one hundred prominent people to name the ten most important living artists. The French novelist Marguerite Duras, now one of Bacon's friends in Paris, conducted an interview for *La Quinzaine Littéraire* in which Bacon sounded very much like a Frenchman on the Left Bank. "To work I must be absolutely alone. Nobody in the house," he told her. "My instinct fails when others are there." He confessed to anxiety in the studio, recalling that Ingres wept for hours before he began a painting. And in an interview the day after George's death with Jean Clair—the nom de plume of the art historian and essayist Gérard Régnier—he declared that for him love was "an obsession."

The Italian director Bernardo Bertolucci, after seeing the show at the Grand Palais, decided to use images from Bacon in the opening credits of *Last Tango in Paris*, a film that soon became a sensation. He brought his leading man, Marlon Brando, to the show because "I wanted him to respond to and reflect Bacon's characters. . . . I wanted Paul [Brando's character] to be like Lucian Freud and the other characters that returned obsessively in Bacon's work: faces eaten up by something that comes from within." Bacon himself found *Last Tango in Paris* dreadful, telling friends that Brando droned on endlessly, and platitudinously, about the futility of life. But the appeal of Bacon's work to a smart, glamorous director like Bertolucci conveyed how stylish the artist was becoming—an attraction that only increased with the death of George, a lover "eaten up by something that comes from within."

Bacon was attracting attention as a social performer as well. His face was almost as memorable, and as calculated, as Andy Warhol's. He could even fit into *Vogue*. He appeared to be a radical sexual showman, even if he was not, and his persona was that of a public man with fascinatingly dark secrets. He was a teller of mysterious stories—though he disliked "narrative" in art—set in grandiose frames. To some, he appeared to be a modernist searching for the dark and cathartic truth, with the death of George a sign of authenticity. To others, he seemed more and more to be a performer playing the role of tormented artist on the canvas. There was an intriguing tension developing in his paintings between up close

and far away, reserve and revelation. The glazing and the frames created, among other things, a stage set. The iconoclast might even be an icon—an increasingly popular word in Western cultural discourse—especially if you placed "icon" in quotation marks.

The American critic Paul Richard, who admired Bacon's art, once wryly captured the tension after watching Bacon at a press lunch:

> "Life is wholly futile," said English painter Francis Bacon. He ate another oyster. "Wholly futile," he repeated. "Yet I have this eternal optimism about the day, the hour, an optimism about nothing, really." He took another sip of wine. . . . Bacon's conversation often seems a construct previously prepared. "How can one remake the image without merely illustrating?" Bacon asks the question and Bacon knows the answer. "Some paint speaks directly on the nervous system; it does not merely tell a story."

The critic's eyebrow was nicely arched, but the answer to his implicit question about authenticity was not difficult. No one enjoys an oyster and a glass of wine more than a man intensely aware of death. As for the charge that Bacon was a performer reciting his lines . . . *Well, of course!* Sometimes there was that, too. Bacon could represent contrary things at once.

"Icon"

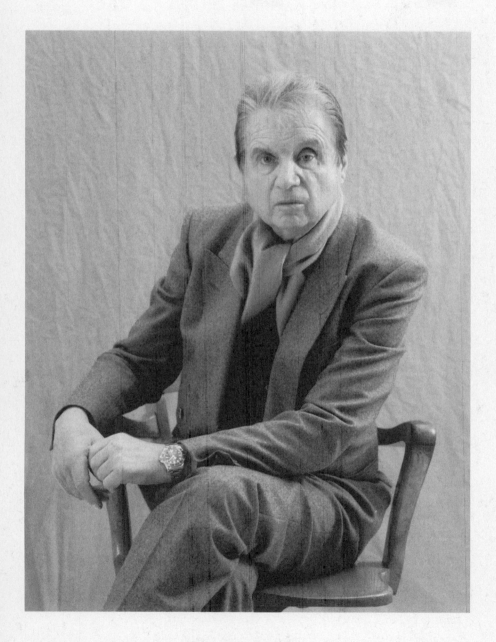

Bacon was a "natty dandy," said the influential English designer Christopher Gibbs. "I think it was quite subtle when subtle was in order and quite trollopy when trollopy was in order."

A Toast to Death

IT WAS HARD TO BURY GEORGE. The authorities were eventually notified, and Miss Beston, who spoke perfect French—and knew the French—handled the situation upstairs with aplomb. The officials did not want to disturb the great man, but there would have to be an autopsy. Delays began to develop. The note of poignant farce, never far removed from George's life, persisted after his death as Ronnie Dryden, George's older step-brother and the family leader, lost patience and threatened to come to Paris himself to bring his little brother home. Francis Chappell & Sons—the undertakers who, as Ronnie put it, "had a lot of business all over the world"—finally succeeded in shipping the body back to London, but the airport workers at Heathrow were on strike, so the coffin was diverted to Luton, north of London. "He had to go up to Manchester or somewhere," said Lee Dyer, "and come back down through all the villages. It cost a fortune." Bacon, who paid for everything, knew the family blamed him for George's death. And he did not disagree. He was shuttered in with guilt.

It was probably Bacon who informed Mag of her son's death. He responded on such occasions to the call of duty. Bacon always got along well with Mag, visiting her, said Lee Dyer, with "the usual 'Hello, mum,' and he was only a few years older than my mother." Bacon purchased a plot large enough to hold George's parents and all his siblings, in the City of London Cemetery in East London. ("George was the first one there," said Ronnie, years later. "Now the mother's there, the father's there, the brothers are there.") Before the funeral, at an open-casket viewing, George's sister, Rita Isaacs, did not want to look at the body. A relative told her, "'You've got to look,' and I was shocked when I seen him because all his hair had gone gray and evidently he used to touch it up with man's hair dye, Grecian 2000."

The funeral took place on the 8th of November, two and a half weeks

after George's death. Rita Isaacs called it "massive." Bacon arrived in a limousine with Miss Beston. Quite a few of the mourners were friends of Bacon's. They did not attend simply to satisfy their curiosity or to support a friend. They valued the rare sweetness of George's nature—he remained an innocent, behind the drink and the petty thievery. "The little church was packed with very, very large men who were undoubtedly on day-to-day terms with what Bacon called 'the brutality of fact,'" wrote John Russell. "As the service proceeded, those men broke down, one after another in floods of uncontrollable tears." But, wrote Russell, "neither then nor at the graveside did Bacon give away anything of his feelings." He behaved with "a stoicism for which even Homer might have been hard put to find words."

At the gravesite, Bacon and Miss Beston stood some distance apart. They did not want to intrude upon the family, but were also concerned about trouble from Ronnie Dryden, who was upset: "We was close, me and him, but he drifted away," said Ronnie. "When he met that crowd what he got involved with, with Bacon and all them, he started getting drunk and that was his downfall. George, he changed into a different person. He was getting out of hand, he was getting drunk, he was getting abusive to people. It wasn't Georgie." Ronnie wanted to discuss the matter further with Bacon. "I was going to give him a clump, to be honest. It wasn't Bacon's fault, but in my mind it was. And the other brothers—Bobby and Terry and Patsy—were all there, and Lenny (Lee) and they said, 'Oh, don't,' and my mother said, 'Look, don't you start.' And I said, 'Oh, all right then,' and that was it and I let it go by."

Miss Beston worked assiduously to defuse any difficulties with the family. When Rita walked up to Bacon at the funeral, she could hardly say her name before Miss Beston was giving her a telephone number and telling her to call anytime if she or the family should need anything. Not long after the funeral, Bacon gave the family the flat at Roland Gardens. "Bacon paid £8,010 for Roland Gardens," said Lee Dyer. "And when George died I went to Roland Gardens with my mother, and Bacon said to my mother, 'Don't let this go, Mrs. Dyer, for under £12,000.' He said, 'I paid eight grand for this.' And the property was then put in the hands of the estate agents and his furniture was put in I believe into Christie's or Sotheby's, I'm not sure." In the end, said Rita, the flat sold for £14,000, and the furniture fetched a good sum. The proceeds "kept my mother and father until they died."

Bacon was inconsolable, his grief sharpened by remorse. "He was shattered by George's death," said Anne Dunn. "He felt tremendously

responsible—that he hadn't realized that George was in the state that he was in." Bacon's friends closed protectively around him, in particular Sonia Orwell, who specialized in moments of emotional crisis. Not long after George's death, David Plante saw Sonia at a party standing in front of the fireplace with Bacon, her face "drawn as with the fatigue of her seriousness" and "too occupied with [Bacon] to take me in." Later, after Bacon left and Orwell was emboldened by drink, she went on a tirade about George's death and Bacon's acute feelings of guilt. "You don't understand," she shouted. "None of you understands what desperation is. You won't help. I could kill, kill, kill, kill, kill, kill you all for your lack of sensitivity. He is suffering. Does any one of you care? Do you ring him up? Fuck all if you do." Sonia wrote to Michel Leiris about Bacon: "We talked about George and guilt for a very long time."

The death of a lover before each of his two retrospectives looked very much, Bacon acknowledged, "like a Greek tragedy." Or, to skeptics, like Grand Guignol. In any case, George's death was much more vivid than Lacy's had been in distant Tangier. The punishing gods, demanding a sacrifice, were edging closer. Most people assumed George committed suicide. His death seemed too well timed and positioned to be otherwise: George dead on the loo, in a fit of existential pique, on the occasion of his lover's apotheosis. They wondered: was this an act of revenge? Some people close to the situation doubted that he was serious about suicide. Drink made him hot-tempered and capricious, and he had taken more or less serious overdoses in New York and London. But a constitution already gravely weakened by years of heavy drinking and smoking—the autopsy indicated liver damage—might also not tolerate an innocent ingestion of alcohol and barbiturates. Sonia Orwell, who read the coroner's report, resolutely maintained that George's death was an accident. And Paul Brass, the doctor who treated both George and Bacon in London, reported that George rarely took sleeping pills and was not aware of the power of Tuinal. Brass believed that George—upset by a row, woozy with drink, and desiring sleep—mistakenly gulped a few too many pills, which, combined with the elevated amounts of alcohol in his weakened system, killed him. In the end, no one could be certain what happened. It may well have been just another drunken muddle.

At first, Bacon publicly rejected the idea of suicide. Suicide was too painful a rebuke, with its implicit suggestion that Bacon failed to look after his younger (and weaker) lover. George's family also wanted to believe that George, only thirty-seven years old, died of natural causes. The autopsy determined that he died of a heart attack, the family was

informed, with additional signs of cirrhosis. When *The New Statesman* published a piece the day after Dyer's funeral alluding to suicide, Bacon took legal action, forcing the reporter to print a retraction that read: "The death of Francis Bacon's friend George Dyer has been certified as due to heart failure, and I am profoundly sorry to have made the totally mistaken assumption in my article last week that he took his own life." Bacon was determined to protect George after his death.

Privately, Bacon did not shirk responsibility. Michael Peppiatt, who met him for lunch at Wheeler's a few weeks after George's death, thought he looked dreadful—not just pale but "almost translucent, with a strange bluish hue as if he were deathly cold." He would stare into the middle distance and then circle back again and again to the ways in which he might have prevented George's death had he been more observant. More than ever, Bacon turned to Dr. Brass for help during this crisis. Along with Librium and the high blood pressure medication that he regularly prescribed for Bacon, the doctor now added two powerful new drugs. Drinamyl was an antidepressant—extremely habit-forming—that also led to weight loss. (It was discontinued in 1983.) Bacon, who usually struggled to keep his weight down, now lost so many pounds that he looked almost anorexic. The second drug, Surmontil, was both an antidepressant and a sedative. Not surprisingly, Bacon also drank. One night, he became blindingly drunk in the Caves de France, a bar in the building next door to the Colony that was once described as possessing "an atmosphere almost solid with failure." When he tried to move on to the Colony, "he slipped on the stairs and one of the metal strips hit the right side of his eye and put it half out," remembered a fellow drinker. "Francis forced it back in and went to a hospital." It was this fall that inspired Bacon's 1972 *Self-Portrait with Injured Eye* and several more portraits in which dark patches ate into his cheek.

To exorcise George's ghost—or perhaps welcome it—Bacon began in 1972 to return regularly to the Hôtel des Saints-Pères where, said Françoise Salmon, who was hired at the hotel in the early 1970s, he usually asked for the suite in which George died. He sometimes booked for two weeks. He would walk through the same hotel lobby, strangers passing him by, where George and the rest of the Bacon party once walked. He would sit on the loo where George died, sleep in the bed where George lay with the rent boy with smelly feet. Bacon, always a poor sleeper, left himself open, during this private ritual of expiation, to the night thoughts most people would do anything to avoid, enclosing himself in the ghostly room with only the vague hotel sounds to keep him company. Bacon appeared to Salmon "never a very, very happy person," but she understood his need

to return. She had joined the staff not long after George's death and knew the situation. "I think it's something that made Mr. Bacon want to come back to this hotel," she said. "People kept it quiet, but we knew. . . . An accident that happens in a hotel where there are other people, it's something we'd try to hush up a bit. . . . It was a link that bound Mr. Bacon to the hotel and the management, let's say. Perhaps he liked the way the management handled it at the time. It was a rather shocking event, rather striking."

It may have been during this disorienting time that Bacon was suddenly overcome by a religious experience in the South of France. He told Wirth-Miller what happened, but swore him to secrecy. Many years later, Denis let the fact slip to a friend named David Wallace, an appealing young man and aspiring journalist in Wivenhoe who, while not homosexual, was befriended by Dicky and Denis. Sometimes, Denis asked Wallace to go to dinner with Francis when he and Dicky were not there and Bacon was alone. The religious experience happened, Wirth-Miller told Wallace, during the 1960s or early 1970s. "Denis never told me what [Bacon's] religious experience was, other than he indicated it happened somewhere in southern France. I got a feeling it might have been relating to a building, maybe a church, a cathedral, something like that, but Francis definitely had a massive religious experience. . . . I think there was a loss of control. I don't know whether Denis was present, or Francis told Denis. Denis indicated to me that I shouldn't mention it [to Bacon]. But I did."

Wallace brought up the subject one evening when he was having dinner with Bacon in Le Talbooth in Dedham, not far from Wivenhoe. "He was very comfortable talking about film," said Wallace, who took a great interest in the movies. "In particular, he wanted to talk about Eisenstein. He did say to me that there was a sort of point where he could have done something different in his career. He might have talked about maybe wanting to have been a filmmaker." It was during easygoing talk of this kind that Wallace alluded to Bacon's religious experience "in the most oblique way. Honestly, I was very circumspect." But Bacon, said Wallace, was "on to it instantly. It was like a spider's web. I touched it on the outermost perimeter, but he instantly knew where this was going." Bacon stared furiously at Wallace, not saying a word. "It was one of the most powerful things that ever happened to me in my life," Wallace said. "I didn't know how he could be so angry, how he could put me in such fear, but there was just the way he looked at you, I can remember being . . . I was very scared: I've never been terrified like that before. You can meet people who are pretty scary, but this was the scariest. A small man, he wasn't a big bloke, suddenly being able to create that kind of anger and

fear in you is quite astonishing. Denis couldn't make me feel scared like that. But this guy . . . with his little leather jacket sitting there . . . Yes, a darkness . . . I got the feeling that the genie came out of the bottle for a moment and then was rammed back. So any attempt to fiddle around with the stopper was not welcome."

Bacon remained an avowed atheist, but the religious moment he experienced indicated just how troubled he could become about his years with George. It also suggested that he was instinctively susceptible to religious and spiritual feeling: that, indeed, his rage at Christianity was more that of an enraged or rejected lover than of an indifferent skeptic. Helen Lessore, an astute friend of Bacon's, once wrote: "For the truth is that Bacon's works are great religious paintings. The very agony of his unbelief becomes so acute that, by the intensity of its involvement with final questions, the negative becomes as religious as the positive."

With time, Bacon resumed his regular life, but he could not easily shake two shadows. One, of course, was George. The other was the image of himself as a celebrity, the hard-living artist whose East End lover killed himself on the loo. Some people now looked at Bacon with gossip in their eyes, titillated by the dark and salacious. Eventually, Bacon also referred to George's death as a suicide. He was not yielding to the celebrity gossip, however, but demonstrating his willingness to face the most brutal kind of fact and story. In the immediate aftermath of George's death, he sought escape and spoke of moving elsewhere—and not only to Paris—as if he might actually recast his life. In 1972, he visited his old friend Janetta, who now lived in a fine house in Marbella, Spain, with her new husband, Jaime Parladé, a noted decorator and Andalusian grandee (the 3rd Marques of Apezteguia). During this period, Bacon also mused about moving to Athens. "Francis said he was fed-up with living in London and was thinking of moving to Greece, to live in Athens," recalled the Australian artist Jeffrey Smart, after a lunch with Bacon. "I warned him that my American and English friends there had complained that they became depressed with the life there—too much promiscuity and heavy drinking. Francis replied that was just his ideal sort of life and he added, 'And you know, *I never get depressed.*'"

George's death led to important work. In under two years, Bacon painted four triptychs on the subject—a modern meditation on death. The first was *Triptych—In Memory of George Dyer* (1971), painted so soon after Bacon's return home from the retrospective that he was still writing

thank-you notes to friends. The triptych contained elements of illustration and narrative that Bacon ordinarily disparaged. In the central panel, he depicted the staircase of the Hôtel des Saints-Pères, not only capturing the lovely, musty feeling of a staircase in an old Left Bank hotel but also endowing the passageway with a haunting allegorical power. The steps rise, but toward a bare bulb. At the door to his hotel room George stood looking up the stairs. Death was already claiming him, his body filling with shadow except for one heroically muscled arm about to turn the key in the lock. In the left panel, Bacon painted George cast on his side, another image of wrestling, but here George was tangled up in death, a shadow spilling from his body and his face the pulpy color that Terry Miles noticed. In the right panel, Bacon depicted George as melting or dissolving—in a kind of draining away—from what could be a painting (or mirrored image) of himself. The melting George appeared more vivid —and alive—than the static standing image.

Many of the details probably had a personal significance for Bacon. To a viewer knowing nothing of the circumstances, such details could nonetheless provoke a contemplative walkabout in the neighborhood of death. Two scraps of newsprint lay under George's feet, for example, partly concealed by the deathly darkness emanating from him. This newsprint could equally suggest the attention generated by the Grand Palais show, the fading of fame, and the corruption of matter. Between the two scraps of newsprint Bacon left (or painted) a seemingly accidental drip of white paint. Why? It visually awakened the floor of the landing, which would otherwise be too dark, but it also evoked an accident, mistake, or forgotten detail. Wasn't death often a kind of unexpected leak? Bacon's focus on the key at the door unlocked many allusions, of course, notably to Picasso's Dinard period, where the key that opened the bath hut also provided entry into the hidden recesses of love. George, who once entered Bacon's "hut" through the skylight—or so the story went—and found a forbidden love was now unlocking the other great, dark, and mysterious door. The key may also have been suggested by two poems of T. S. Eliot. A figure climbs a staircase in *Ash Wednesday* all the while "struggling with the devil of the stairs who wears / The deceitful face of hope and of despair." And in *The Waste Land*:

> I have heard the key
> Turn in the door once and turn once only
> We think of the key, each in his prison
> Thinking of the key, each confirms a prison . . .

While the first triptych—painted when Bacon was wracked by "if onlys"—recalled the moment when the turn of the key might have been stopped, the second, *Triptych August 1972*, was stripped of such illustration and narrative detail. It was instead an otherworldly dream of formal grandeur in which death appears as spare, austere, and desolate. In the side panels, George sat bare-chested on a bentwood chair, placed on what resembled a stage, in front of a large, cold rectangle of darkness that starkly contrasts with his still-living body. In these two panels, George leaked a pinkish shadow, full of visual incident, that formed a lively shape; a diagonal black space sealed him off, as a stage might, from the viewer. In the central panel, however, there was no such separation. The stage pitched toward the viewer. George's body had fallen from the chair and was now a dead tangle of dissolving form. Although the body in each of the three panels leaked a shadow, the shadow in this central panel appeared shockingly still. It contained no visual incident and, instead of pink, was a cold and declarative opaque violet. There have been many images of death in the history of art, but none like Bacon's violet.

The third triptych commemorating George, *Three Portraits—Posthumous Portrait of George Dyer; Self-Portrait; Portrait of Lucian Freud* (1973), was a dispassionate contemplation of love and friendship during a time of death. Bacon painted himself in the center, looking straight ahead, flanked by George (on the left) and Freud (on the right). Freud and Bacon were casually dressed while the dead Dyer appeared in his briefs, as if about to pose for Bacon. Each figure was draining a black shadow; each was illuminated by a bare bulb. In the George panel, an image of Bacon was pinned to the wall. In the Freud panel, an image of George was similarly pinned to the wall. Why? Bacon would have his private reasons, of course, and viewers contemplating the picture could as usual answer the question in different ways, never conclusively, which was an apt description of the emotional complexities of love and friendship. It was only in the fourth and final triptych, *Triptych May–June 1973*, that Bacon—who so often hoped to touch the deepest nerve—finally forced himself to face the brute fact of sink and toilet. In the central panel, however, he also pulled from the scene (like a medium) an extraordinary death shadow. Bacon later told the art historian Hugh Davies he "regretted the sensational nature" of his George triptychs but felt compelled to do them to confront his guilt, as if he were continuing to play his fated part in this personal tragedy.

· · ·

Bacon drew closer to his family. He complained of the intrusion upon his time when they visited from South Africa, but he also seemed pleased to see them. Besides, they were well-mannered and understood that he required time alone. Wendy Knott, the wife of Ianthe's son Keith, called Francis "welcoming, but you mustn't stay too long." Bacon would always make an effort to meet family members at Heathrow, and he would book lunches and dinners. "But you could see that after a couple of days . . . he would become a little bit abrupt." He might even announce: "Got to go and paint." Unconcerned about the gentrification of Narrow Street, Bacon's family liked to stay in the impeccable house with the perfect river view. Bacon took pride that the house was more to his sister's taste than "my dump in Reece Mews." With Sonia Orwell's help, he sometimes organized a picnic on the jetty or took them to the Grapes.

In 1973, Ianthe's son Harley Knott—a young man on his first trip to London—knocked on the door to Reece Mews with two friends. "He told us to come up for a quick drink." Then Bacon spent the next few days showing Harley the sights. Perhaps he was reliving, in part, his own early days in London. He remained always aware of what a young man might enjoy. "He took me to the V&A Museum. He took me to Greenwich to see the *Cutty Sark*. We went to Madame Tussauds. He was looking at somebody [real] and said, 'Is that a person or is that wax?' He had a wonderful sense of humor. We also went to the planetarium together. He was just fascinated by all this stuff." Bacon was probably not all that fascinated, in fact, but he could join in another's pleasure. Bacon did not insulate Harley from his drinking or his less reputable haunts, which would naturally be of great interest to many young men. "The first place he took me to was the York Minster [the French] and the Colony Room." They also went to Crockfords, the elegant casino. Bacon judged Charlie Chester's, located near the Colony, a bit rough-and-ready for a young man from Rhodesia. According to Harley, Bacon "got this funny look on his face when he gambled—this glassy-eyed look. He used to walk along with these great wads of notes. He used to just peel them off, as if they were lettuce leaves. He would throw the money on the table. He'd be totally focused on it. Then afterwards he said, 'My failure was *greed. Greed* was my failure.'"

Harley also observed the practiced survival instincts of an experienced drinker. "He knew exactly what he was doing. He used to get drunk and he would say, 'I'm really hungry now.' We'd had a meal but he was really hungry. He ordered himself bacon and eggs." He tolerated no assistance when he couldn't get the door open at Reece Mews. "I tried to take the

keys away from him and he slapped me. He said, 'Don't worry about me. I'm all right.' And he went lumbering up the stairs." Bacon included Harley in dinners and lunches with friends, but also sensed that his nephew might prefer people his own age and, like a conscientious parent, took the trouble to arrange meetings and gatherings. Harley considered his uncle "such a kind man," who "looked you straight in the face as if you were the most important person in the world to him. And he did so much good. When I used to arrive he'd give me a thousand pounds. I mean, a thousand pounds for a poor kid from Rhodesia, where money was very tight."

The highlight of Harley's first trip to London was Christmas Day. He joined his uncle, Muriel Belcher, Muriel's Jamaican girlfriend, Carmel, and Ian Board—the barman at the Colony—for a Christmas feast at a cheerfully decorated hotel near St. James's Park. Bacon almost invariably left London during the holidays, both to avoid invitations from people who might feel obliged to take him in and also to shield himself from family treacle. Perhaps, this time, he felt obliged to look after Harley. After the feast, Bacon took the group to Narrow Street. "It was cold," said Harley, "and everyone was confined and we had wonderful conversations. He was a fantastic conversationalist. He knew everything about everything. We used to speak about Kierkegaard and existentialism and the ambivalence of Nietzsche. He thought that Nietzsche was absolutely fantastic."

After George's death, Bacon often saw his "brothers" Denis and Lucian. He mixed his real and adopted families, taking both Ianthe and Harley to Wivenhoe on separate occasions, and he playfully taught his nephew some manners. "We had a magnificent roast beef at Denis's," said Harley. "The port was going around the table. The port came to me and I put it down on the table. And Uncle Francis said, 'You never put the port down on the table. You hand it around until the butler takes it.'" Ianthe twice accompanied Bacon to Wivenhoe. "We went over to the boats and walked around and talked—and *drank*. There was always a joke. Francis had painted a dog and I think Denis had painted a dog, hadn't he? There was a joke about who had the better dog." Ianthe probably did not note the edge in their joking. Bacon and Denis remained close friends after George's death, each the confidant of the other, and Bacon willingly helped Denis with galleries. They still sometimes worked together in the studio behind the Storehouse while, next door, Dicky craned over his spidery drawings. But Bacon could not quite pretend to admire Denis's landscapes—not the way Denis admired the work of the artist who exhibited at the Grand Palais.

Dicky and Denis were "family" with whom Bacon was comfortable enough to be on his worst behavior, and the roaring pub life of the little town provided a perfect place to discharge tension. (If Bacon went to Wivenhoe to recover from London, he also went to London to recover from Wivenhoe.) "We had the most extraordinary pub culture [in Wivenhoe]," said Pam Dan. "In those days there were lots of quite good artists in my age group. There was a post-Chelsea feel to the pubs. We had such a very exciting variety of people coming to the pubs because of the university [the University of Essex, which was nearby and had been founded in 1963]. . . . The artists were here, the sculptors and writers and music people were here." There was even a Wivenhoe Arts Club, run by the editor of *The Spectator*, George Gale. "Half of Fleet Street used to come down," said Dan. "Kingsley Amis would be playing the piano. And Peregrine [Worsthorne, then deputy editor of *The Sunday Telegraph*] and Francis and everyone were all very civil to each other."

Still, the unstable family triangle of Dicky, Denis, and Francis often cracked open, according to Dan and to Celia Hirst, a blues and jazz singer who moved to Wivenhoe in 1975. "Three men each with a different and incredibly strong personality," said Dan. "Francis, Denis—and Dicky was trying to sort it all out." If Dicky was sometimes bitchy, she said, Denis could be "downright rude." Dicky had a "quirky sense of humor, a little bit surrealistic." Denis in turn was wholly unpredictable. "You never knew what Denis would come out with. . . . He could be very nice . . . or else blow your head off with words." According to Hurst, Dicky would sometimes retreat to the house of the local doctor, Edward Palmer, where his wife, Hally, "would say, 'Come in, Dicky. Now what's wrong?' And Dicky would say, 'I can't stand that man [Denis] anymore. I can't bear to go back.'" Dicky would sometimes hole up inside the Scheregate Hotel in Colchester, a haven of provincial gentility, in order to dry out and decompress. During the scenes between Dicky and Denis, or Francis and Denis, or among Francis, Denis, and Dicky, Bacon was "gentlemanly in this funny sort of way," said Dan. "It would be Denis doing most of the shouting. And annoying people." Only rarely was Bacon as rude as Wirth-Miller— but then "ruder, actually," said Hurst. "He would begin to act important. He would wonder why he was trapped with these people."

Sometimes, when Bacon wanted to escape London on a weekend, he would ask Terry Danziger Miles from Marlborough to drive him to Hintlesham Hall, in Suffolk, not far from Dicky and Denis's house in Wivenhoe. The chef Robert Carrier had opened a restaurant and hotel there in the summer of 1972, on a lovely Georgian estate that he painstakingly renovated. Carrier was "what is now known as a celebrity chef,"

said Miles. "And Hintlesham Hall was a big baronial mansion that Robert had turned into a fantastic restaurant and sort of guest house. It was the first of the sort of Michelin-star restaurants in that area. And he lived on the upper floors." Carrier was also a Colony member who got along well with Bacon and Muriel's other favorites. "Our company had this big shooting brake," said Miles. It was a Vauxhall estate vehicle "that had lift-up seats in the back so you had six standard—two and the driver in the front on the bench seat and three on the next bench seat—and then you had these two lift-up seats in the back." In London, seven people would get into the vehicle. "It would start with me picking up Francis, going round to Muriel's flat, where she would have an entourage there, already having champagne or whatever, and this would be seven in the morning. Then after drinks everyone would pile into the car."

The drive was nightmarish, almost four hours, "because going out east," said Miles, there were "no decent roadways." They would therefore stop at a pub, or the house of a friend, or a place in Suffolk they called Auntie Mary's. Auntie was a homosexual man who in good weather maintained a weekend open house. "You would never know who you would get there, and maybe it would be artists in the region or just local people, anybody could go," said Miles. "He opened the doors at ten in the morning and closed whenever everybody went. And it had a pool, and in the summer people would be in and out of the pool." Auntie Mary's was not far from Wivenhoe, and Dicky and Denis often met up with the entourage there. "It was always a big palaver when Denis arrived," said Miles, "coming in and starting in on Francis about this that or the other." The group might then continue to Hintlesham Hall, where for Bacon the draw was less Robert Carrier and his restaurant than the British-American jazz singer Annie Ross, a regular at the Colony whom Bacon particularly liked. (She would sometimes sing for free at Muriel's.) Ross also liked Bacon. He seemed "slight" to her; she sensed, as some women did, his vulnerability. "He was always gentle to me. He was sensitive. And charming. He could charm the birds off the trees, and funny." Whenever Ross was performing for a day or two at Hintlesham Hall, said Miles, "Francis with his loyalty would want to go see her."

Ross often performed during a lunch prepared for people who bought tickets. Then the real party began. "[Bacon] had the most impeccable taste," said Ross. "We would do a show [for the public] and then afterwards a sumptuous private meal and sit around and drink brandy." Usually, it was about twenty or twenty-five people at the private party, friends of Annie's or Carrier's or Bacon's, "all played by ear by Carrier," said Ross,

"about when there should be food and when drink. One of those English afternoons when lunch merges into dinner and the party just keeps going." At the Colony, Bacon once approached Ross just to tell her how much he loved her music: "I think I told a story and [Bacon] liked that." Terry Miles was never excluded from these private parties. "The minute you drop in you're no longer a driver," he said. "You were, 'Terry, come on' and off you went."

Bacon would also bring his family to see Lucian Freud. The two artists remained so comfortable together, in the early 1970s, that each seemed to invite the other into his work. One day Freud came to Reece Mews, said Harley, and began "speaking to [Bacon] about one of his paintings. About how he thought that he should [paint] something there." Later, they went to dinner at Freud's place, and Freud, as if drawing back a curtain, "showed me that picture [*Two Figures* (1953), sometimes called *The Wrestlers*]." If Bacon happened to be queening at the Colony, he would immediately drop the theatrical play of voices and affectation whenever Freud arrived. The two men would instead retire to a corner to catch up and discuss art. One time, the painter Timothy Behrens was at the Colony with Bacon and "a group of his hangers-on" when one of them said, "What's the matter, Francis? You're not your usual brilliant self":

At this point Lucian came in, but Francis had his back to him so didn't see him. Francis said to the man in his most mannered style, "If you must know, duckie, I've got the curse." Lucian, who was embarrassed by that side of Francis, pretended not to have heard, but he must have done because the Colony was such a small space. Then Francis turned round and saw Lucian standing there. He dropped the gang like a stone and retreated into a corner with Lucian. A bit later I joined them there. They were talking as usual about Velázquez, Giacometti, risk, danger and so on, as if the awkward little incident had never happened.

Annie Freud believed a powerful chemistry existed between the two men. "Theirs was a deep love." They had eyes only for each other when they were together, she said, and the relationship appeared almost physical. "I'll tell you something that Dad said about Francis that was so lovely," she said. "He said he had the most sensuous forearms. That is lover-like, isn't it?" In the 1970s, she would occasionally join her father and Bacon at Wheeler's. At one dinner,

Francis was there, and Dad was there and he was telling a story about being in Paris, when he hung out with Giacometti and Picasso and all these different people. And they were all talking about all the kinds of girls they liked. And one of them said that he didn't like girls who really really liked him; he preferred girls who didn't like him all that much because it was so difficult when somebody really liked you and he preferred girls that didn't like him very much and apparently Giacometti's younger brother, Diego, said, "*Moi, je préfère la chèvre. Me, I prefer the goat.*" And that's the sort of conversation they had. It was flashy, it was like being at the theater. It was like a kind of public verbal love-making—telling stories, and being absolutely scandalous and looking fantastic, and attracting attention and showing off. They were together a lot. Dinner after dinner after dinner after dinner.

Earlier in their relationship, Freud had been known for meticulously made paintings, often likened to the art of the Northern Renaissance. A small but dedicated circle of collectors admired the delicate melancholy of his art and draftsmanship. But his reputation languished during the 1960s. His style then began to change—under the influence, many believed, of Bacon, and perhaps of Frank Auerbach. Although he remained as meticulous as ever, studying his models for hours on end, Freud developed a more visceral feeling for the body. His paint became tumid; he presented his models in sometimes grotesque or vulnerable poses. Anne Dunn believed that Freud—however assertive his social performance—remained artistically timid during the 1950s and sought the approval of the keepers of taste, such as Kenneth Clark. Bacon's brave example and fleshy art, she said, helped him develop a more confrontational style. She considered Freud's 1963–64 portrait of John Deakin—a man of rumpled flesh and indelicate line—a key indicator of the change.

Initially, Freud's shifting style attracted little interest. His sales were even worse than Bacon's. His obsessive womanizing also bothered some people in the society he frequented. According to James Kirkman, who worked at the Marlborough gallery from 1962 until the early 1970s, the early shows of Freud were "very unprofitable, and Marlborough liked to look at the bottom line. Lucian liked to borrow back the work he'd done in the previous five years, so there wasn't much at the gallery, and he didn't paint very much in those days, so it wasn't very profitable, and nobody cared a hoot about him, I can tell you that. He was pretty much

disliked by everyone on a personal and on a painting level." Bacon did not agree. In 1972, he sent Freud a cable—Freud maintained no street address or telephone, and even his children communicated with him by telegram—to congratulate him on his recent Marlborough exhibit. "Your show looks marvelous stop Can you come to lunch at Wheelers at one o'clock tomorrow and see Warhol film afterwards stop Francis."

Freud left Marlborough for the gallery of Anthony d'Offay, one of the critical art dealers of the next generation, in 1972. The move suggested a refreshed determination on Freud's part to succeed not only in the studio but also in the larger world. D'Offay, working with Kirkman, began to increase Freud's profile. Two years later, in April of 1974, came Freud's exhibition at the Hayward Gallery, a museum founded in 1968 as part of the Southbank Centre. The show aroused a great deal of attention. It traveled to Bristol, Birmingham, and Leeds. Freud had been viewed as "Francis Bacon's sort of pet," said d'Offay. "And then with the show at the Hayward, it really opened up, and he was seen for the first time as a painter in his own right." Freud's changing fortunes had no perceptible impact on his friendship with Bacon, but their relationship—like that between Bacon and Wirth-Miller—developed some edges. Lucian a widely admired artist? Bacon had never thought of him like that. Francis a Parisian divinity? Lucian did not think of him in those terms.

Freud and Bacon, like any couple, maintained certain traditions and unvoiced understandings that time, age, and fortune could affect. The weaknesses each discerned in the other, once perhaps easily set aside, slowly became more annoying. The sycophants who gathered around Bacon exasperated Freud (and also Wirth-Miller), and neither Bacon nor Freud easily tolerated the other's sexual obsessions. Freud was disconcerted by Bacon's interest in rough trade and Bacon bewildered by Freud's obsession with the high-born and dull. Why this endless pursuit of young but needy aristocratic girls? Why this taste for cockney boys? Christopher Gibbs, with his sharp eye for the society of his time, contrasted the two: Bacon was "not a social mountaineer like Lucian—Lucian climbing to the last gasp."

Bacon also found Freud's refusal to acknowledge any kind of "duty" annoying. Freud "shunned dutifulness," said Freud's close, longtime friend the artist Alice Weldon; and while his values might be "very good in some respects and better than those of other people," he had no scruples about trying to seduce women in committed relationships, even among his friends. Nor did he feel obliged to honor certain other implicit understandings. It dismayed Bacon that Freud would not loan *Two Figures* to a

later exhibit of Bacon's work. When Valerie Beston wrote Freud—yet again—requesting the loan of the painting, Freud wrote a charming reply:

Dear VB, Thank you for your letter. There has never been a show of any great painters work without at least one masterpiece missing. Painters through the ages have been affected and inspired by reproductions. Francis, in all the time he spent at Ostia never once went to look at the Velasquez Pope the source of many of his works preferring to rely on photographs. I really love "the wrestlers" and need it here to enrich my privacy. Love Lucian.

No doubt Bacon also recognized the compliment embedded in the refusal. Freud hung the painting where a chaste man might hang a crucifix. The painting was steeped in art, love, and flesh. It had the muscle of sexual obsession. The mouth of the submissive "wrestler" was opened in a smile that with uncanny precision described the space between pain and pleasure. For Freud the picture was a magical touchstone, more difficult to let go of than a lover. When Alice Weldon asked why he did not loan the painting, he replied, "It wouldn't be the same when it came back."

After the show at the Grand Palais, the atmosphere at the Colony changed. Muriel did not usually acknowledge reputation, but by the early 1970s when "Daughter" arrived she would drily announce, "Oh, royalty's arrived." "Most of the time when [Bacon] was in London, he did come here often," said David Marrion, who worked with Ian Board behind the bar. "He would go out for lunch or whatever. There would always be a buzz around at the time if he was in the area, or 'the Village,' as it's called. People would say 'Francis is around.'" The old-timers, "Muriel's boys," were now beginning to fade, and a new wave, including many younger artists, were coming into the club. Bacon paid for drinks less often than he once did. "He would say hello to everyone, but he didn't want to get in a conversation with everyone," said Marrion. "He'd never stay by the bar on his own, 'cause he didn't want to attract people around him. He didn't want people sort of coming up to talk to him—'Oh, thank you for the drink.' He liked the people he wanted to talk to and he would choose what people." Bacon, lonely after George's death, increasingly arrived with the entourage Lucian and Denis detested. When Denis told him he "only had sycophants for friends," Bacon replied: "I wonder Dicky doesn't cut your throat."

Bacon's own sense of mortality was underscored in January of 1974

when he developed gallbladder colic, which, said Dr. Brass, was "known to be terribly painful." The year before, Bacon had some gallstones removed but that had not ended his troubles. He tried to conceal the subsequent operation from his friends. The prospect of death did not especially frighten him, and he was not squeamish about blood or pain, but he had a dread of hospitals. The enclosed atmosphere of the sickroom recalled his childhood—the smell of illness, the hush of voices, the administering of medicine. A few months after George's death, John Deakin contracted lung cancer. After he underwent a successful operation, Bacon bought him a trip to Brighton to convalesce. Deakin was an essential piece of Bacon's world—and not just because he provided photographs of Isabel, Henrietta, and George. He came from "before," and he was a master, as was Bacon, of what Hugh Davies called "the unrehearsed face." He did not seek fame and stored his negatives under his bed. Ninety-nine percent of people never become themselves, Bacon liked to say, remaining passive creatures who wait to be entertained. Bacon later corrected himself. It was 99.99 percent. And Deakin was among the .01 percent.

In Brighton, the incorrigible Deakin went out drinking, which precipitated a massive heart attack. Before he died, Deakin informed the hospital—in a final stroke of black humor—that Bacon was his next of kin. It was the "last dirty trick," Bacon told his friends in Soho, "he played on me." Bacon was working on the paintings triggered by George's death when, in May of 1972, he heard the news about Deakin. He traveled to the Brighton morgue to identify the body. Later, at the Colony, the photographer Jeffrey Bernard asked him: "Was it alarming to see someone you've known for years dead? How did you feel?" The question annoyed Bacon, as questions about feelings often did. Such questions implied that he was vulnerable—that he must be predictably horrified, moved, sad, poignant, overwhelmed, teary. In a full and flutey register, Bacon sang out, "It was the first time I've ever seen him with his mouth closed."

One death may inform another. Bacon was the last left alive of the three travelers who once set out together for Greece. His young lover George was dead. His old Colony comrade was now dead. And Deakin was three years his junior. Bacon began complaining, only partly in jest, that everyone seemed to be dying—that the reason he painted self-portraits was because no one was left alive to paint. Not long after George's death, Thomas Blackburn—the intense poet with whom Bacon had a brief affair in the late 1940s and early '50s—staged a reunion with Bacon at the Colony. They had not seen each other for years. Blackburn brought his daughter, Julia, who described the meeting in *The Three of Us: A Family Story*. Her father arrived first, waiting nervously at the bar for the

celebrated painter. "Then Francis entered the room," she wrote, "four or five young men dancing attendance, like a flurry of courtiers around their king." Bacon, upon seeing "Tony," abandoned his entourage and became himself. " 'My god, Tony!' he said, 'you look awful! You used to be so beautiful!' 'You look pretty horrible yourself,' said my father hopefully, bobbing up and down like a courting bird, his head bent slightly forward and his mouth pulled into a tight grin. Francis was dressed in a black leather biker's jacket and black leather trousers, while my father had put on his best white linen suit, which was by now far too tight for him so that his arms, his chest and his legs seemed to be trying to burst out from the confines of the cloth." Blackburn tried to introduce his daughter, but Bacon replied—continuing to use his intimate nickname for Blackburn—"It's you I am interested in, Tony. Only you! Drink up your champagne, there's a dear, and let's dance!" Then they "curled into each other's arms, the man in white and the man in black, and they began a slow waltz, each holding an almost empty glass of champagne over the other's shoulder. They were ironic in their manner, yet they were also tender."

"Champagne!" cried Bacon. "Champagne to celebrate the death of love!"

TRIPTYCH, MAY-JUNE 1973

Bacon made four large triptychs after the death of George Dyer. It was only in the fourth and last that he confronted the gruesome details of the overdose, which included vomiting into the bathroom sink and dying on the toilet. The central panel depicts the moment of death, with a batlike shadow flaring out from George's body. The side panels are provocatively placed. After confronting the central panel, viewers instinctively "read" from left to right, expecting some narrative line culminating in death. Instead, they begin on the left with an image of George after his death, the least disturbing of the three panels. He is hunched over, his face not visible, in a calm abstract shape. But the right panel—where a "reading" ordinarily concludes—portrays George actively vomiting toward the central image of death. Bacon forces the viewer back into the brutal scene, with the stage-prop arrows also encouraging a right-to-left reading.

The batlike shadow emerging from George's body is one of the strangest—and possibly bravest—moments in Bacon's art. He usually gleefully declared that dead means dead, as in meat on the floor. Why add an outlandish bat shadow? Bacon did not believe in spirits leaving

the body (even on their way to hell), and the shadow also looks goofy, like a melodramatic spook in a horror movie. Bacon's detractors might be reminded, as usual, of Grand Guignol or ectoplasmic spiritualism. Perhaps Bacon created the shadow because George's death did, in fact, have some tabloid or Grand Guignol elements. Perhaps he was acknowledging that death is haunting to atheists no less than to believers, sometimes crazily haunting and in bad taste, and that the moment when life leaves the body remains absurdly mysterious. Bacon did not like to let the flesh go.

An Englishman Abroad

As BACON WEARIED OF LONDON, Paris beckoned. "Parisian art-lovers were unanimous in considering Francis Bacon the most important painter in the world," said the English sculptor Raymond Mason. "This, despite the existence of two Frenchmen called Balthus and Dubuffet." Some younger people in Paris began to treat Bacon with the reverence accorded the fathers of twentieth-century art. During the summer of 1973, he was often seen in the boulevard Saint-Germain "somewhat inebriated," according to the younger English artist Mark Lancaster, with people staring at him from a distance. "I once saw Francis walk straight into the traffic. I rushed over and grabbed him and put him on the traffic island. He said, 'Oh, it's you, dear boy. What are you doing here?' We would have dinner at La Coupole. I'd bump into him at the Flore, and he always picked up the tab."

Now that Bacon was spending more time in Paris, he became an object of particular interest to the flamboyant art dealer Claude Bernard Haim. In the late 1960s and early '70s, Bernard, having noted Bacon's success at Maeght in 1966 and his triumphal show at the Grand Palais in 1971, began to court the emerging English master. The eponymous Galerie Claude Bernard was situated on the Left Bank, a reflection of its owner's desire to develop a hipper reputation than a storied old shop like the Galerie Maeght on the Right Bank. His gallery in the 1960s mainly exhibited sculpture and works on paper, but Bernard now intended to enter the flashier and also more lucrative market for contemporary painting. During the 1970s, said Mason, Claude Bernard "was attracting as much attention on the Left Bank as Maeght was on the Right."

In his effort to woo Bacon, Claude Bernard had a secret weapon—his sister, Nadine Haim. She was short, wiry, and bronzed from years of Mediterranean sun. She was also unusually independent, a lesbian who became another of the strong-minded women to whom Bacon was drawn.

Nadine was adept, like Bacon, at mixing worlds. By day, she worked at the gallery. By night, she was a bright light in the homosexual demimonde. In the period before the show at the Grand Palais, she became a good friend of Bacon's and their relationship strengthened during the 1970s. "We went out a lot together in Paris, to restaurants, bars," she said. "We nearly always went out just the two of us. Sometimes we went to dinner with Michel Leiris and his wife. We saw each other all the time." During this same period, Claude Bernard was also assiduously courting Balthus, then admired both as a painter and as the director of the French Academy in Rome, a post once held by Jean-Auguste-Dominique Ingres.

In 1971, around the time of Bacon's Grand Palais exhibition, Balthus agreed to a show at Claude Bernard. The art dealer decided it might be useful to cultivate a friendship between Balthus and Bacon. Neither liked the other's work; yet neither could easily dismiss the other. If one could be persuaded to exhibit regularly at Claude Bernard, perhaps the other one would agree to the same. Sometime around the Grand Palais show, he invited both painters to dinner. It was not a successful evening. Bernard organized a second meeting. This time he included his sister, hoping she could relax Bacon. The group was supposed to meet for drinks at Nadine's flat above the gallery. Bacon appeared on time, but Balthus did not. The situation became awkward. Bacon allowed Nadine's son, an adolescent enthralled by photography, to take his portrait. "I asked him if he minded if I took pictures of him," said Michel Soskine. "I took him to my room and I was very nervous. There was a little chair there and a light on his face."

Once Balthus arrived, the silences lingered painfully. Neither painter was typically reserved. In fact, Raymond Mason, who knew each of the three artists whom Alfred Barr called the "mavericks" of modern art—Balthus, Bacon, and Giacometti—considered both Bacon and Balthus remarkably sociable and witty. Balthus was appreciated for his "mordant irony," and Bacon enjoyed quips. When a deeply tanned man in a navy-blue blazer once walked into a party at Claude Bernard's gallery, for example, Mason told Bacon that the man was very rich and lived year-round on his yacht in the Mediterranean. "'Ah, a skipper,' said Francis in a drawl. Then, looking a second time at the man's tan, added: 'Looks more like a kipper.'" But Bacon "didn't say a word" as they were having drinks, reported Soskine, who had been allowed to sit on the floor and quietly take pictures—until Balthus irritably snapped at him to stop.

And still Bernard persisted. In February of 1973, he invited Bacon to join him on a trip to Rome, where he arranged for Balthus to take

Bacon on a tour through the grounds of the Villa Medici. Perhaps now at last, in this classical setting, they might come to a meeting of the minds, and Bacon would follow Balthus into his gallery. Balthus had spent years exquisitely restoring the gardens and Renaissance palace on the Pincian Hill, and there was much to admire, even in February: eighteen acres of considered greenery with splendid views. Bacon was not ordinarily interested in green unless it came from a tube, but the tour of the garden did give him the opportunity to employ one of the best and subtlest forms of insult: misdirected praise. With such lavish generosity did Bacon compliment Balthus on the garden that Balthus could only take umbrage: *Not a word, from this dreadful Englishman, about my art?*

Bacon had last visited Rome in 1954, during his tormented months in Ostia with Lacy. Although he was now visiting the city as an important man—and consorting with the elegant Balthus—he did not put on airs. When a limousine pulled up to the flat that the artist Jeffrey Smart shared with his boyfriend, Ian Bent, in Trastevere, "the first person we saw coming up the steps was Francis Bacon," said Smart, "followed by Sandro Manzo of the Il Gabbiano gallery in Rome. Then comes someone from the Maeght Foundation and finally Claude Bernard himself." Bacon kept apart, but in a simple way. "Francis and I had a drink by the fire while the three gallery people talked to Ian down in his studio. I found Francis agreeable and extremely intelligent." Lunch followed at a local restaurant. Bacon, genial and relaxed, displayed his authority in indirect ways, such as pleasantly mocking his own work. His paintings came to him relatively easily, he said, now that he rolled on the backgrounds in acrylic like any idiot. All that was necessary was to add "his gestural images, some of them from Eadweard Muybridge, some culled from medical books on plastic surgery . . ." At the end of the meal, despite the deep-pocketed men at the table, Bacon picked up the bill.

In London, Bacon's prominence brought new friends and changed opportunities. If Bacon was now a modern master, reasoned David Sylvester, shouldn't his views be widely disseminated? Their occasional interviews in the press could be reformulated into a "once-and-for-all" expression of Bacon's views in book form. In the early 1970s, such books were rare: artist interviews were mostly published in small journals, art magazines, and the academic press. It testified to Bacon's hold on the European imagination—and the interest people took in him beyond the small art world—that Sylvester found a publisher. Sylvester had already helped Bacon hone his ideas into epigrammatic form. Now, in 1975, the interviews would become canonic, the quotations repeated until the

"Bacon line" appeared set in stone. (Sarah Whit-
field, Sylvester's companion later in his life, said
Bacon would often telephone Sylvester to ask his
advice about how to answer interviewers' questions.)
Interviews with Francis Bacon continued to sell over the
years, helping consolidate Bacon's reputation and
develop his prophetic voice, particularly among
rebellious young people. Together with James Lord's
A Giacometti Portrait (1965), in which Lord recounted
Giacometti's struggle to paint Lord's portrait, *Con-
versations with Francis Bacon* came to define for many
people the existential quest to find a truthful image
of the modern figure.

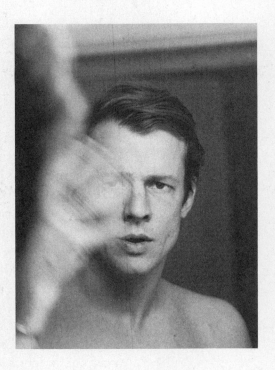

Scholars were also beginning to take an interest.
It was not common for graduate students in the con-
servative field of art history to study contemporary
artists. However, one of Bacon's earliest admirers in
America, Sam Hunter, was a professor at Princeton
who, as early as 1952, wrote an influential piece about
him. In March of 1973, Hugh Davies, a graduate student at Princeton and
protégé of Hunter, decided to write his dissertation on the first twenty-
five years of Bacon's art. Without George to keep him company, Bacon
welcomed the presence of the knowledgeable and appealing young man.
What followed was a series of detailed interviews, among the lengthiest
Bacon had done, that stretched from early March through early August.
Bacon, as usual, allowed no impediment of profession, age, role, or station
to develop between them. Davies became the friend who, after work, sat
around with Bacon and the visiting William Burroughs in Narrow Street;
or had dinner at Sonia's with Bacon and Erica Brausen. (It was impossible
for the art dealer to hold a grudge against her favorite artist.) There was
even one memorably dreadful dinner in Wivenhoe when Denis Wirth-
Miller exploded in a rage because Bacon brought along Davies, whom
Wirth-Miller at first mistook for yet another good-looking sycophant.

One other younger admirer from America—the photographer Peter
Beard—also became important to Bacon in the period after George's
death. Then in his mid-thirties, Beard possessed star power of his own.
He was tall, athletic, and slightly otherworldly, with an outlook that
Bacon once termed under different circumstances "exhilarated despair."
Beard was also—there was no other way to put it—impossibly good look-
ing. He had been born in 1938 into an old WASP family and, like many

The American
photographer/socialite/
animal rights activist Peter
Beard, whose chiseled
features inspired nine major
Bacon portraits

of that time and with that background, cast himself as a Hemingway-esque adventurer. Instead of shooting animals in Africa, however, he photographed them, although usually when they were dead. His powerful images of dead elephants, collapsed within their skins, impressed Bacon. Beard was welcome in every celebrity bar. He knew Mick Jagger, Truman Capote, and Andy Warhol. He was also heterosexual. His first marriage had been to the Newport, Rhode Island debutante Minnie Cushing—her name defined her milieu—whose family owned a grand "summer cottage" there. Beard's lovers included Lee Radziwell, the sister of Jacqueline Kennedy Onassis. In 1981 he would marry Cheryl Tiegs, the American "supermodel."

Beard and Bacon first met at Bacon's 1965 Marlborough show and went to lunch together. Later that year, Bacon attended a party for Beard at the Clermont Club in Mayfair, which attracted high-end gamblers. The occasion was the launch of Beard's book *The End of the Game*, a photographic testament to the rape and pillage of Africa by foreigners. Beard believed that "the deeper the white man went into Africa, the faster the life flowed out of it, off the plains and out of the bush . . . vanishing in acres of trophies and hides and carcasses." Bacon shared Beard's fascination with the terrible slaughter of animals in Africa and still leafed through his well-worn copies of A. Radclyffe Dugmore's *Camera Adventures in the African Wilds* (1910) and Marius Maxwell's *Stalking Big Game with a Camera in Equatorial Africa* (1925).

Bacon also admired Beard's restless existence. One day he was photographing Mick Jagger in Europe, the next living at Hog Ranch, his place overlooking the Ngong Hills of Kenya—a region first made famous by the writer Karen Blixen (Isak Dinesen). Beard photographed Bacon on the rooftop of his Narrow Street house in 1972, and in late March of that year, Bacon noted two words in a work diary: "Peter Beard." Bacon was beginning a first, unrealized portrait of him. In the end, he would paint three triptychs of Beard as well as individual portraits. Their long-distance friendship was nurtured by the many idiosyncratic postcards that Beard sent Bacon, embellished with photos, drawings, and bits of writing. He once sent Bacon a view of the Montauk cliffs on the eastern end of Long Island, for example, where he had a house that doubled as a retreat for the "beautiful people" of the sixties and seventies. "It's the last house on Long Island," he wrote. Beard often dropped into London between photo assignments and visits to Hog Ranch. "Peter was a lovely man," said Wheeler's barman John Normile. "He would come in in sandals, and the manager would look at him a bit funny. And he had big hands. You'd

think he was a bush ranger or worked on the land." Terry Danziger Miles also noted the attraction: "I'm not sure [Bacon] didn't have a thing with Peter Beard. Not maybe gay, but Francis had a fancy. There was quite a lot of Peter around. He did love his photography."

Marlborough wanted to capitalize on Bacon's growing reputation and, as ever, hoped to crack the American market. Interest from an American museum would help, but it was not obvious how a museum exhibit—in New York or elsewhere—could equal or surpass the one organized by the Grand Palais. MoMA had by now moved on entirely from Bacon. The problem was no longer James Thrall Soby's misbegotten effort to write a book. MoMA was becoming High Church in spirit, asserting a kind of pontifical power—assumed by the curator William Rubin—over what constituted or advanced the essential modernist dogmas. MoMA was not opposed to the English painter Francis Bacon, but he was now regarded as an outlier irrelevant to the development of important new art. The Guggenheim had also moved on: it had already exhibited Bacon in 1963. The only possibility left was the Metropolitan Museum of Art, the ency- clopedic museum that had recently begun to exhibit and collect modern art. It was not a bad venue for Bacon, who revered ancient art and gave modern painting a sumptuous, old masterly feel.

It happened that the Met also wanted to exhibit Bacon. In June of 1971, before the opening at the Grand Palais, the Met's curator of modern art, Henry Geldzahler, approached Frank Lloyd at the Marlborough gallery in London with the idea of an exhibition. At heart a playful curator who did not share the earnest outlook of MoMA, Geldzahler was also intel- lectually and institutionally adroit. To counter an argument that he might not be as serious as the curators at MoMA, Geldzahler, in 1970, had orga- nized *New York Painting and Sculpture: 1940–1970*, a triumphalist show that reflected the establishment view of recent art. (His controversial exclu- sion of the sculptor Louise Nevelson signaled his adherence to conven- tional modernist dogma.) With his bona fides established, Geldzahler could now roam more freely in modern art. Given his close friendship with the English figurative artist David Hockney, he could never quite treat figurative work as irrelevant, and he knew more about English art than most American curators did. Bacon and Hockney did not get along. But Geldzahler did not let that stand in the way. Bacon could draw a crowd, attracting people from the art and other worlds—including many homosexuals—interested in his tormented imagery.

Bacon was thrilled at the prospect of a show at the Met and wrote Geldzahler to thank him. Unwilling to repeat the Grand Palais exhibition, Geldzahler hoped to concentrate on recent work, highlighted by the great triptychs painted after George's death. Geldzahler had strong support for the show within the museum. The Grand Palais exhibit had deeply impressed both the museum's director, Thomas Hoving, and its curator-in-chief, Theodore Rousseau. "We were both overwhelmed by the works of this 'painterly' painter of great sensitivity," wrote Hoving, "and then and there started the 'plot' to have an exhibition here at the Metropolitan." There was a problem, however, and a serious one: Bacon, despite his friendly letter to Geldzahler, wanted nothing to do with him personally. Not only had Geldzahler made his name showing art Bacon disliked—abstract art and pop—but he was a flamboyant social figure who cultivated fame and power. Hilton Kramer, the senior art critic for *The New York Times*, called Geldzahler "the Diaghilev—or was it . . . the Barnum?—of Pop art." Worse, in Bacon's view, was Geldzahler's friendship with Hockney. "I don't want my show hung by Hockney," he told Pierre Levai of the Marlborough Gallery in New York, only half joking.

A persistent myth about Bacon was that he was too distracted by art to focus on the presentation of his work. In fact, he concentrated on exhibits with the same intensity that he brought to everything else. He had always respected Harry Fischer's ability to promote his work, but in 1971 Fischer left Marlborough to found Fischer Fine Art. Bacon himself now felt obliged to step into the discussions with the Met. He was polite to Geldzahler and exchanged a number of letters with him, but did everything possible behind the scenes to replace him. Theodore Rousseau requested a meeting with Bacon during a visit to London in June of 1972, and Bacon, sensing an opportunity to press his case, obliged. When Rousseau afterwards wrote to thank him "for your delightful hospitality," Bacon wrote back to repeat a pitch he probably made in person. "I did so much hope you were going to arrange the exhibition. Between ourselves, I do not have much confidence in Geldzahler's taste." He added a significant P.S.: "Can you and I make the choice of what is to be shown?"

Rousseau responded with a firm no. "I shall, of course, be here and will certainly keep an eye on everything," Rousseau wrote back, but Geldzahler must be the one to "make a first selection with you." Geldzahler initially envisioned only a show of "twelve to fifteen paintings, many of which should be diptychs and triptychs," but then increased the number to about thirty-five. Bacon pressed for even more. Altogether, he wrote, he expected to be able to exhibit "between 60 and 70 canvases or more done in the last 5 years." (The final count was 36 paintings, including eight

large triptychs.) Bacon also made a bold bid for the grandest exhibition galleries in the museum: "I have one query as to the space—is this the same space, which Mr. Lloyd described to me, as that given to the Lipchitz exhibition?" Bacon hoped to achieve in one swoop at the Met what he had failed to do over the previous twenty years: win over New York.

Despite Bacon's reservations, Geldzahler was a tireless advocate. He had originally hoped to open the show in March of 1972, but timing problems pushed the date to the autumn; then to November of 1974; and finally to March of 1975. Bacon also became closely involved with the catalog. Unwilling to put much money behind a difficult modernist, the museum refused to underwrite a catalog with a good color reproduction of each painting. Bacon told Geldzahler he was willing "to contribute whatever is necessary to have the catalog in full color. I understand the Museum has about 10,000 to spend. You can charge me with the difference." In the end, Bacon would pay $50,000 for what remained a rather modest catalog with color reproductions, an interview, and a ten-page introduction by Geldzahler.

It was probably around Christmas 1974 when an idea arose seemingly from nowhere. The text of the catalog could include an extensive interview, suitably revised, that Peter Beard had conducted with Bacon in March 1972; Beard called their collaboration the "Dead Elephant Interviews." Beard had spent that Christmas with Bacon, Dicky and Denis, and probably several others at Narrow Street, and it was the sort of idea that emerged from a day of drinking, cooking, and fanciful talk. David Sylvester, who regarded himself as Bacon's interviewer-in-chief, no doubt did not approve. Fischer's strategy was always to bolster Bacon's reputation with essays from writers who would impress the gatekeepers of art. Beard was not a Leiris, a Spender, a Gowing, or a Sylvester. Beard was instead glamorous.

But Bacon himself loved the idea of continuing his collaboration with the handsome American—two artists confronting subjects of mutual interest—and he was now mostly paying for the catalog himself. Bacon and Beard also discussed collaborating on a book to be called *Nor Dread Nor Hope Attend*, a title (borrowed from Yeats), which sounded like Hemingway after too many martinis at Harry's Bar. It would include an introduction by R. D. Laing and confront, wrote *The Village Voice*, "such things as stress, death, and a lugubrious future in ways that one can hardly predict, but the elephant motif gives an indication of its tone. This may be the project that finally defines Beard's vision."

Nor Dread went nowhere. The interview with Bacon proved productive, however, in ways that Marlborough would not have anticipated.

Beard made Bacon more fashionable, much as Leiris made him more serious. To many stylish and well-connected people of the period, Beard was a figure of great fascination; nothing was more intriguing than a man who loved elephants, except possibly a Tibetan monk. Beard was also socially nimble. He was friends with both Jackie Onassis and Andy Warhol, who was Beard's neighbor in Montauk and often partied at Beard's house with stars from the 1960s and 1970s. Beard approached the Met interview the way a magazine editor might compose a celebrity shoot on a light board. On the back of a contact sheet that already contained thirty-two images of Mick, Bianca, and the Rolling Stones beside their private jet, Beard scrawled a message in orange grease pencil. "I have enlisted some professional help (an ex-ace reporter for *Newsweek*—Mrs. Now Karen Lerner) to add style & genius (she is very good at this) to my reassembling—EDITING of our 'interview,'" he wrote. "Believe me it will be GREAT, eventually, after CUTTING, reworking & later elaborating." In the final version of the interview, Bacon sometimes sounded like Beard. "Dead elephants are more beautiful because they trigger off more ideas to me than living ones."

In March of 1975, a few days before the opening, Bacon flew to New York to begin the requisite lunches, teas, dinners, and interviews. Terry Miles preceded him to unpack the crates—a separate crate for each canvas, each

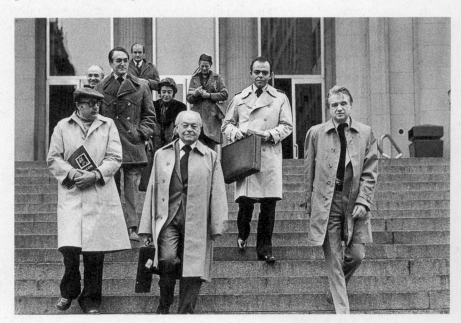

Bacon with Frank and Gilbert Lloyd of London's Marlborough gallery, at his 1975 show in New York at the august Metropolitan Museum

glass, and each frame. On his first night at the Carlyle Hotel, Bacon, who had been told he would not have much say in how the paintings were hung, told Miles, "I want my paintings where I want them." The next morning, according to Miles, "We all fronted up at the Metropolitan and Geldzahler was there and the director at the time, and Geldzahler was all blahdiblahdiblah, showed him around. In theory we placed them all and then they were hung. Then Francis went out for lunch to meet dignitaries." But Bacon was unhappy with the hanging. "Francis phoned me that evening and said, 'Look, are you doing anything?' and I said no, and he said, 'Look, we need to go back to the Metropolitan—they're going to let us in specially at night.' So we went back and walked around and he said, 'You know, I don't like that one there, that doesn't work.' So with Geldzahler's help we were allowed to move them around, even though they were hung. In the end, we moved two. And a third we moved and put back."

Bacon and Terry Miles were unusual friends—the one a homosexual artist whose work shocked many people, the other a heterosexual handyman with a family and ambitions in the art world—whose relationship many people would not understand. Both took a personal dislike to Geldzahler, who was just too free and easy. He offended their sense of propriety. At one point Geldzahler, assuming that Bacon surrounded himself with decadent young homosexuals, stuck his hand down the front of Miles's trousers. Miles was stunned. "I told him in no uncertain terms to *fuck off*." Geldzahler then smiled conspiratorially at Bacon and said, "'God, he's touchy,' or whatever an American might say in those circumstances," and Bacon snapped back: "Serves you right." Bacon was on his best behavior with the press and seemed, thought Gilbert Lloyd, unusually articulate. It was no wonder: he was often repeating lines from *Interviews with Francis Bacon.* In London, the week of the opening, *The Sunday Times* magazine came out with seven pages of excerpts from the book. His social schedule was full, thanks in part to Peter Beard's participation. Lee Radziwill gave a luncheon where Bacon met Andy Warhol, who arranged to give him a tour of the Factory. John Russell—a great admirer of Bacon—was now an art critic for *The New York Times* and gave a party for him with his third wife, Rosamond Bernier, a popular lecturer on modern art. Geldzahler arranged oyster-and-champagne lunches with critics. Amei Wallach of *Newsday* reported: "The Metropolitan's phone began ringing incessantly with requests from photographers like Richard Avedon and Duane Michals. They'd go anywhere, anytime, do anything for a chance to photograph Bacon."

Francis Bacon: Recent Paintings, 1968–1974 opened on March 19, 1975. About four hundred people in formal dress, freshly hatched from limousines, walked up the museum steps to the lavish party. Willem de Kooning greeted Bacon warmly. Several prominent younger artists came, among them James Rosenquist, Jim Dine, and Larry Rivers. Andy Warhol wore black tie and blue jeans. It was fortunate that the Americans did not know how Bacon regarded their work. He maintained a grudging respect for de Kooning, but Pollock remained "the old lace maker," and he could not abide the work of Larry Rivers, who was an admirer of Bacon's. Christopher Gibbs recalled a cork-popping lunch in London at La Popote, a restaurant favored by "screaming queens" in the late 1960s and early '70s, where "Francis had it in for Larry Rivers. He said, 'She's simply not a deep-end girl like myself, dear, she's minnying along the sidewalk of life.'"

During the opening, according to Wallach, "Guests rose from the little pink tables with tulips on them to besiege him for autographs. 'I've never seen anything like it,' one onlooker said. 'You'd think these people would know better.'" Some friends came from London, among them Dicky and Denis and Helen Lessore, for whom Bacon continued to feel both gratitude (for helping him out in the 1950s) and respect (for what he considered her acute eye). The Met opening naturally aroused disturbing memories of his last two important museum openings, each overshadowed by the death of his lover. Nothing so dramatic happened at the Met. After the opening, a cocktail party was planned at the Algonquin, where George had taken an overdose seven years earlier, to be followed by dinner at Sardi's, the celebrated theater restaurant. But Bacon disappeared, taking refuge in the bar of the Stanhope Hotel across Fifth Avenue from the Metropolitan Museum, where he asked the bar to stay open after closing.

Bacon was well served by the relative smallness of the show: the eye often loses focus if too many highly-keyed paintings are hung together. Gilbert Lloyd said, "Geldzahler put on one of the best shows I ever saw." Not only was the selection deft, but Geldzahler hung the work with flair. He filled most of the first two rooms with large, brightly colored images and a smattering of smaller portraits and triptychs. Thirteen self-portraits—three of them small triptychs—stimulated the public's fascination with the artist's face, personal life, and star power.

Geldzahler crowned the show in the last room with three of the four

triptychs made after George's death—the first, *In Memory of George Dyer* (1971), was missing—including the graphic *Triptych May–June 1973*, with George dead on the toilet. Five other large triptychs were also on the walls. Some writers now referred to the George paintings as "the black triptychs," invoking the example of Goya's great "black paintings." There was some advertising huff-and-puff in that signage, but the impact of the pictures on many people was undeniable. Norman Canedy wrote in *The Burlington Magazine*:

> . . . In the climactic final gallery of the exhibition one is not prepared for the impact of the triptychs, an impact, one soon realizes, that depends initially on the palette. Whatever one ultimately comes to feel about the works to which the viewer is introduced first in the exhibition, the initial impression of highly sophisticated, decorator-coloured surfaces remains. The works in the last gallery, however, are realized with a palette seemingly comprised of black, white, red, and yellow. . . . The resultant effect is one of dramatic gravity, so at odds with the gaily-painted settings of the pieces which introduced the period.

In his introduction, Geldzahler shrewdly deflected criticism of Bacon as a figurative painter and "master of the macabre." He began: "It is a tribute to Francis Bacon that his work can still elicit adulation from some and be dismissed thoroughly by others":

> He has been a major figurative painter since the mid-forties, yet his work can stir as much debate as that of a debutant. Bacon himself says that his work is hated in America. This is both true and untrue. The audience that admires his work is large; the audience that dislikes it is smaller but more vociferous, made up of artists and critics committed to the idea that we live in an era when the human figure has simply defied being portrayed explicitly . . .

Geldzahler emphasized how contemporary Bacon's figures were. They introduced a fresh kind of movement, different from that of the futurists, into the "'static' art of painting": the "image of speed, the contorted body which can hold its position only for the moment it is pictured, or, most characteristically, the head in violent motion, sliding between attitudes. . . ." The New York critics, most of whose views on Bacon were known, were just as grudging as Geldzahler expected. Hilton Kramer

at *The New York Times* dismissed Bacon as a painter who "certainly left no discernible trace on American painting," as if that were the purpose of an English painter, and would not "make the final cut." Two leading proponents of abstract expressionism, Thomas Hess and Harold Rosenberg, were no more enthusiastic. Rosenberg reported that Bacon is generally regarded as a "'horror' artist" and dismissed his "self-conscious aestheticism." Hess's review in *New York* magazine—"Blood, Sweat and Smears"—found the recent work more theatrical and less powerful than earlier paintings. Although "superficially, everything looks better," he wrote, Bacon was now "a virtuoso of his own eccentric manners."

No doubt Bacon's painting did not suit these critics, but a certain cultural touchiness also emerged. Proud that a once-provincial culture was now producing important art, American writers did not want to overpraise a figurative artist from Europe. They allowed for no influence from abroad and appeared eager to claim the cultural high ground from middle-class Philistines. "In the past few weeks, the *New York Times*, the *Washington Post* and other establishment resonators," wrote Hess, "have thrilled their readerships with the glittering, tawdry, glamorous, fusty anecdotes that have become this artist's peculiar litany." This litany he attributed mostly to Bacon's being English. He exhibited a condescension toward postwar European art second only to Bacon's toward postwar American art:

> The British always love a local lion; see how well they've done for such comparatively modest big cats as Benjamin Britten, Graham Sutherland, Christopher Fry, Henry Moore. The best writers introduce them . . . and the lions themselves are piquant, cultivated, above all interviewable. They expound beautifully about aims and means. How pleasant it must be to be English, able to express yourself accurately, with charm, and not to be tongue-tied like the Americans, impenetrable like the Germans, irrelevant like the French.

As if to confirm the darkest suspicions of such critics, the Bacon exhibition pleased the masses. One month into its run, Geldzahler gleefully reported 90,000 visitors. The show was extended through the popular July 4 weekend and drew nearly 200,000 people altogether. Not all American critics were grudging. The writer Susan Sontag—almost French when she wanted to be—cut sharply against the grain. She argued that the obsessional quality of Bacon's art was a virtue, not a fault, and she regarded the period of work after the Grand Palais show as "one of

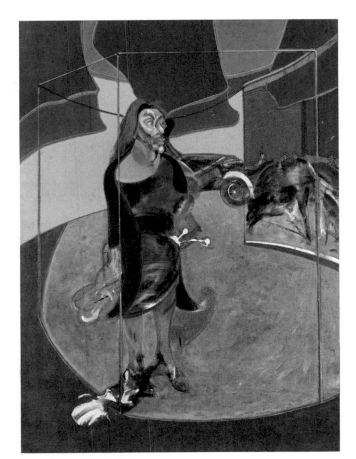

*Portrait of Isabel Rawsthorne
Standing in a Street in Soho*,
1967.
Oil on canvas, 78 x 57¾"
A bohemian duchess surveying
her domain

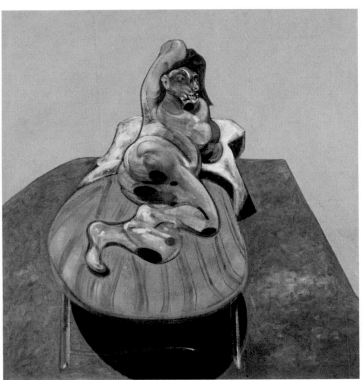

Henrietta Moraes, 1966.
Oil on canvas, 59⅞ x 57⅞"
Moraes was a friend of
Bacon's who, when asked to
pose naked, felt obliged to
help out.

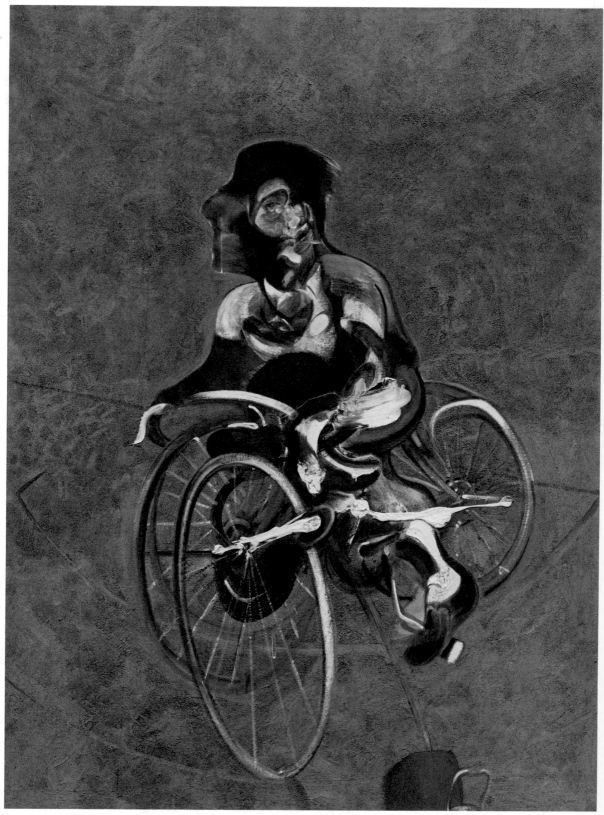

Portrait of George Dyer Riding a Bicycle, 1966. Oil and sand on canvas, 78 x 58″ An English "everyman"

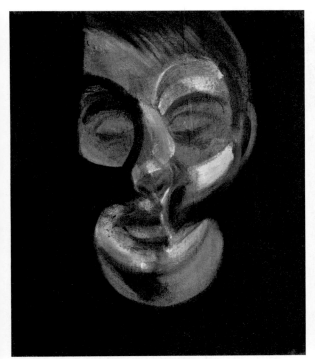

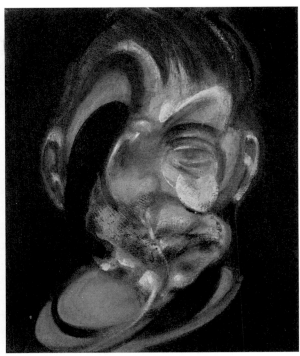

Self-Portrait, 1972. Oil on canvas, 14 x 12"
A face losing itself in thought

Self-Portrait, 1973. Oil on canvas, 14 x 12"
The solitary eye

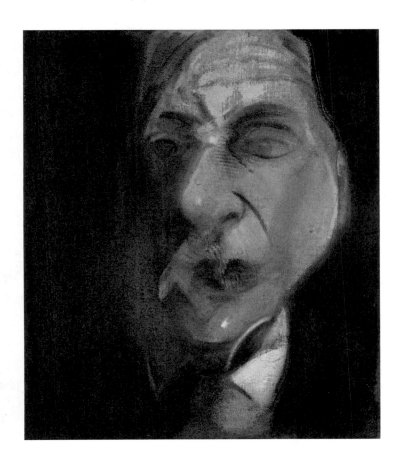

Study for Self-Portrait, 1979. Oil on canvas, 14 x 12"
An aging Queen

RIGHT, THIS PAGE AND OPPOSITE *Three Studies of Lucian Freud*, 1969.
Oil on canvas, each panel 77⅞ x 58⅛"
The intimate friendship between Bacon and Freud led each artist to
paint the other. Bacon believed that he could only successfully paint
people whom he knew well.

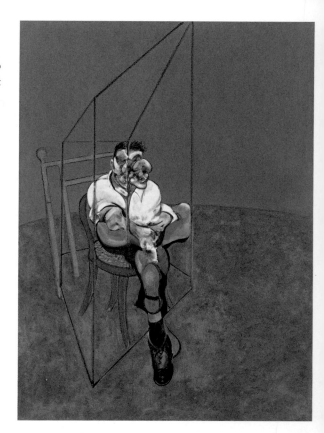

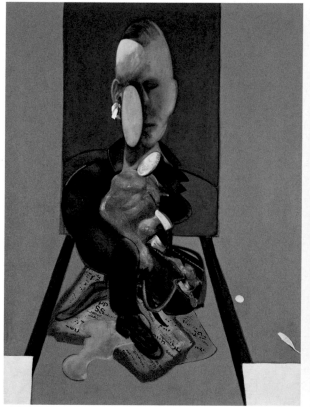

LEFT, THIS PAGE AND OPPOSITE *Triptych, 1976*. Oil, pastel, and dry-transfer lettering on canvas, each panel 78 x 58″
A mysterious work that could almost be a dark altarpiece from a forgotten religion

Figure in Movement, 1978.
Oil and pastel on canvas,
78 x 58″
The existential ballet: figure,
shadow, reflection

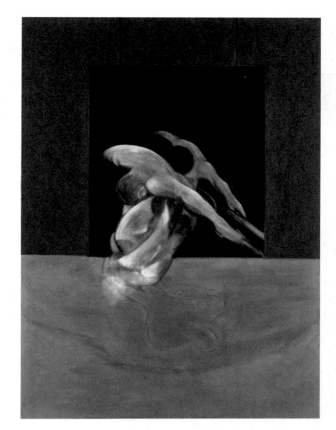

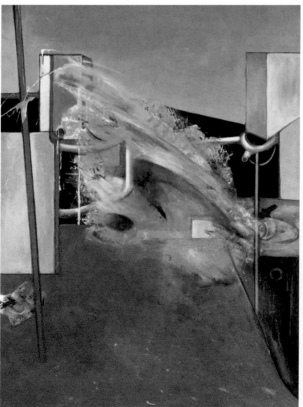

Jet of Water, 1979.
Oil and dry transfer lettering
on canvas, 78 x 58″
An eruption, not a fountain

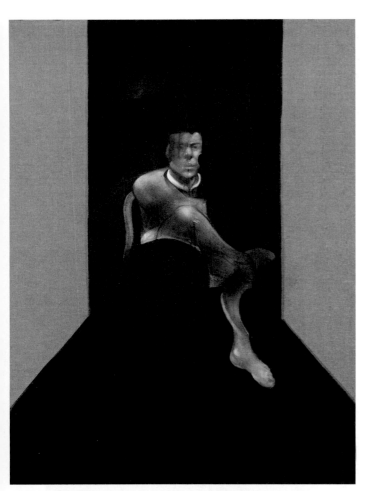

LEFT *Study for a Portrait of John Edwards*, 1988.
Oil and aerosol paint on canvas, 78 x 58″
A Cockney aristocrat, with barely a chair

BOTTOM, LEFT *Portrait of Michel Leiris*, 1976.
Oil on canvas, 13⅜ x 11⅜″
The French mandarin became one of Bacon's most
esteemed friends.

BOTTOM, RIGHT *Study for Portrait (Peter Beard)*, 1975.
Oil on canvas, 14 x 12″
The handsome American photographer, admired for
his pictures of dead elephants in Africa, fascinated the
aging Bacon.

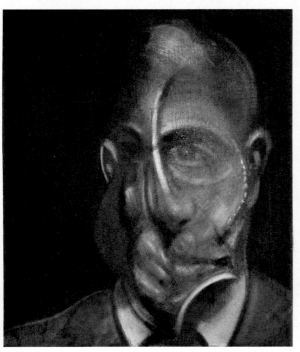

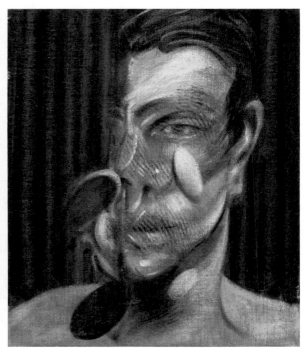

Second Version of Triptych 1944, 1988.
Oil and aerosol paint on canvas, each panel 78 x 58"
The images that once shocked London—reimagined decades later
in the postmodern era

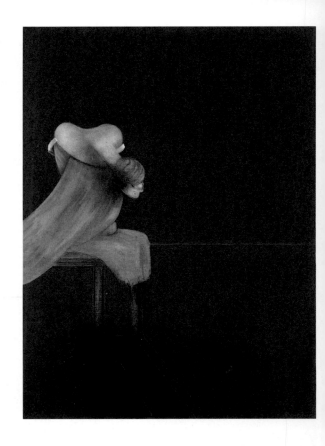

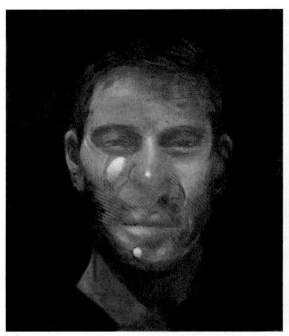

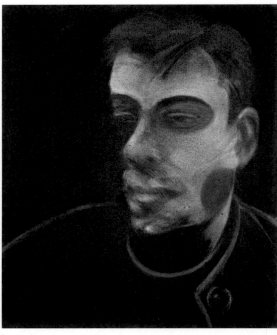

Two Studies for a Portrait, 1990. Oil and aerosol paint on canvas, each panel 14 x 12"
Bacon's elegant friend and last love, José Capelo

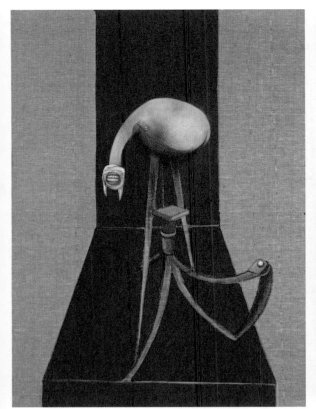

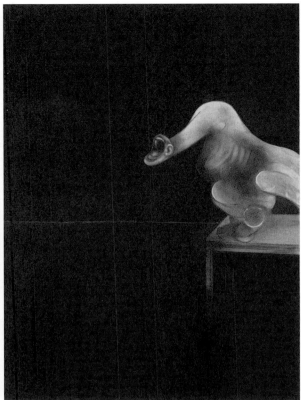

Blood on Pavement, 1984. Oil on canvas, 78 x 58″
The human stain

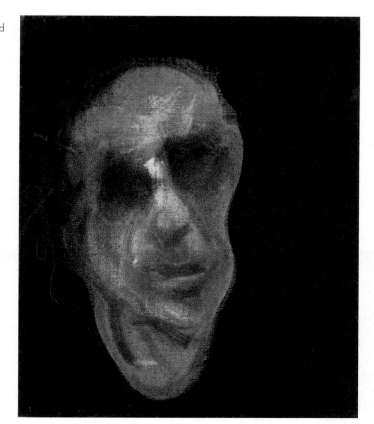

Self-Portrait, 1990. Oil and pastel on canvas, 14 x 12″ Bacon's final self-portrait evoked the masks used in Greek theater.

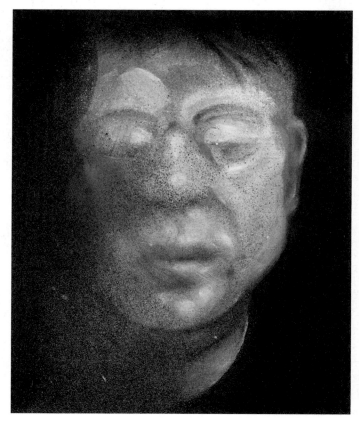

Self-Portrait, 1987. Oil and aerosol paint on canvas, 14 x 12″ The soft bruising of melancholy

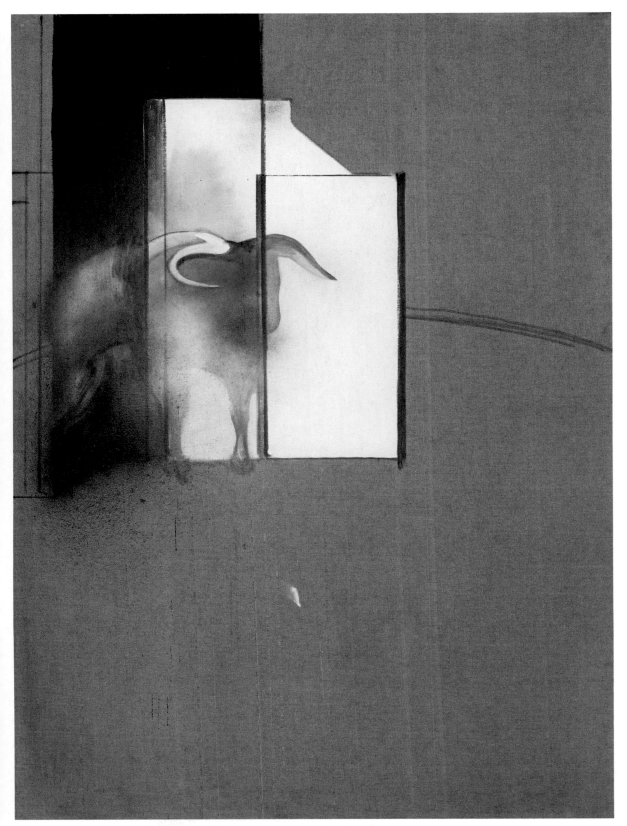

Study of a Bull, 1991. Oil, aerosol paint and dust on canvas, 78 x 58″ A farewell to the ring

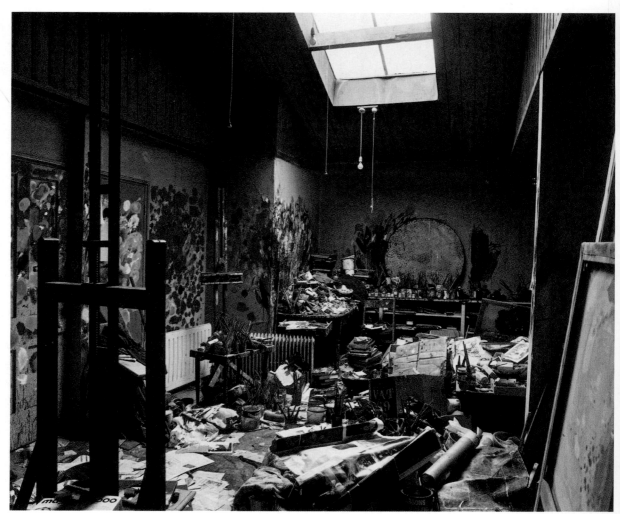

Bacon's legendarily messy studio cave at 7 Reece Mews

bold development." Years before other critics, she deftly situated Bacon in contemporary art:

Bacon is one of the least provincial of important modern paint-ers. It is almost startling to remember that he is English—and not just because one has stopped expecting truly major, ambitious, full-blooded work in any of the arts to come out of England. Bacon seems particular—supra-national, almost ideally European. He is probably lucky not to have been born either French or American, and thereby to have been burdened with that load of chauvinist self-consciousness that has gone with the self-definitions of Paris (before World War II) and now New York as The World Capital of Art.

Sontag praised Bacon's painterly isolation. It was a sign of his unique and inimitable position that "many lesser talents" should have more influence over contemporary painting than he did, and the echo from the old masters was not in her view a mannered weakness but a source of strength. "Bacon's work seems so centered, so personal, so idiosyncratic, so powerful," she wrote, "it is as if he were already a classic. As the last of the traditional painters, Bacon is both absolutely central to contemporary painting (by virtue of the quality and integrity of his work) and marginal to it (by virtue of the work's authority, its completeness, its assuredness, its inwardness, its commitment to despair)."

Bacon spent a further five days in New York. He visited Andy Warhol at the Factory, then at its third location, 860 Broadway on the north side of Union Square. The waspish Dicky gave his impression:

Big scruffy building. Bullet proof door. Stuffed Great Dane in reception. Young man offered us champagne and magazines. Andy Warhol and Francis arrived. AW very frail, paint be-spattered. . . . Strange atmosphere of dereliction. "My pictures are so fresh they stick together" Warhol. Art deco desk of brass and black marble. Moose head given by John Richardson. Huge black kitchen under construction. Furniture arranged like movie lots so that the whole place had the appearance of being lived in by absent people. All rather sad and a "has-been" feeling.

Warhol was nevertheless an American artist whom Bacon found inter-esting. He admired the *Car Crash* and *Electric Chair* paintings made in the

sixties. "I also think he did a thing which was perhaps different in that he made a serialization of those things," Bacon told Sylvester, perhaps thinking of Eadweard Muybridge. "Being a serial production also made them interesting in a way." Warhol also admired Bacon—and not just with the customary deadpan "Wow." Warhol cheerfully confessed at the Met opening that he copied Bacon's color—"and his skills." Warhol had noticed something rarely remarked about Bacon's art—namely, his provocative use of keyed-up color.

Not surprisingly, Bacon, growing weary of the unfamiliar social pressure in New York, enjoyed himself more at less formal occasions. Before the opening, Terry Miles had met an art restorer named Barney Brown who worked at Marlborough in New York and also sometimes looked after the Rothko studio for the gallery. "He was a tiny little guy, lovely man, as gay as gay could be," said Miles. Barney was attracted to Miles but unfailingly polite and not the least bit forward sexually. Socially, it was a different matter. Barney wanted to introduce Bacon to his friends, but Miles doubted it would be possible, telling Barney: "Henry Geldzahler is one of those grabby-grabby people who will want to take him here there and everywhere." Barney replied, "Well, he must have a night off in which case I'd like to give a party for him." On Bacon's first night after arriving in New York, Miles told him about Barney's wish. " 'I don't think he's your type, Francis. He's really a fairy-godmother type.' And Francis said, 'No, no, I'd love to meet him, he sounds wonderful.' "

In the end, Barney Brown had his night. All his friends came to his modest apartment on Lexington Avenue to have a party with Francis Bacon. And, said Miles, "it was great for Francis." Another friend told Miles that Bacon, as a celebrated homosexual, would enjoy seeing the intense downtown gay scene, in particular the Eagle's Nest, a famous leather bar located at Eleventh Avenue and Twenty-first Street. Bacon should also know about the anonymous sex available in the long, empty trucks (or lorry trailers) left parked overnight in the West Village near the Hudson River. "You'd go in one end," said Miles, "and it would be all dark, and then come out the other end, and they'd done whatever they'd done." Miles could wait in a regular bar close to the Eagle's Nest, the friend suggested, while Francis explored the scene. "And I said, 'You don't know Francis—Francis would go in there [and] he'll be there all night, and I'll get chucked out in the middle of the night, and it's not a safe area, is it?" No, the friend said, it's definitely not safe.

In the taxi they took downtown, Miles told Bacon about the long trailer trucks. Bacon was not enthusiastic. "I don't like the idea of it being

all black so you don't know who you're with. It could be some really ugly duckling." Instead, they went to a regular bar near the Eagle's Nest to discuss the matter. The bar was lonely and not fashionable—something like Edward Hopper's *Nighthawks*, but shuttered and serving rumpled alcoholics. "There were two or three guys, normal kind of old drinkers, all crowded around one end, and then there was a woman three quarters of the way along the bar, sort of an oldish woman, and again obviously a big drinker." Miles and Bacon sat at the bar, and after a while Bacon turned and said hello to the woman. They began talking. Miles paid no attention, because "it was their conversation." Not surprisingly, as Bacon grew more comfortable, he began to act the way he did at the Colony, another rundown place for serious drinkers. But this bar was not the Colony. Suddenly, from under the bar, "this handbag comes up and smacked Francis straight in the head. I mean, really badly." The men at the bar leapt up. "I thought, 'Oh shit,' so I said to Francis, 'Come on, got to go,' and I shoved him out and then luck of the draw there was a cab dropping somebody off and I pushed him in and away we went." Terry asked what on earth had happened. "He said, 'I have no idea, the bitch just smacked me.' And I said, 'Well, you must have said something.' And he said, 'Well, I can't remember what I said. I might have said she was an ugly old bitch or something like that.'" Getting smacked by a handbag, Miles believed, was Bacon's favorite moment in New York.

Echoes

Bacon always wanted to be elsewhere. His restlessness only increased with age and success. Monte Carlo and Tangier were no longer places he could live—too much history—and Narrow Street was no longer a refreshing alternative to Reece Mews. Why not sell the Narrow Street flat and, once more tossing his life into the air—move to Paris? In 1974, as he worked toward his Met show in New York, Bacon asked a younger friend who lived mostly in Paris, Michael Peppiatt, to help him find a studio. Peppiatt found two possibilities, a small but smart flat in the Marais on the rue de Birague and a grander residence where Puvis de Chavannes once kept a studio.

Bacon chose the rue de Birague flat. He liked the Marais, then mostly a working-class area with an air of faded splendor. Workmen bellied up at bars near the magnificent place des Vosges. Gentrification was beginning. By the early 1970s, a rehabilitation project had renovated some of the hôtels particuliers in the neighborhood, and Bacon's flat was part of a large house with several interior courtyard entrances. "The apartment was on the second floor at the back of the courtyard, a place that was set a bit deep," said the young Serbian expatriate and artist Vladimir Veličković, who lived with his wife at a different entrance of the building. It contained one large, high-ceilinged room, which could serve as Bacon's bedroom and studio; a staircase led down to a kitchen and bathroom. Two tall windows faced north. "The size and light were perfect and, equally important, the compact flat was off the street, on the second floor overlooking a cobblestoned courtyard," wrote Peppiatt. "It was as close to a mews as one might find in Paris."

In September of 1974, shortly after the purchase—but months before he moved in—Bacon invited Peppiatt and his girlfriend, Alice Bellony-Rewald, along with Sonia Orwell and Nadine Haim, to a housewarming. Many glasses of Cristal champagne later, they began to rip off the

black-and-gold-flocked wallpaper encrusting the walls. (The architect who had recently renovated the flat was in the building. He stood "transfixed," wrote Peppiatt, "watching his flock fall.") Instead of Reece Mews, Bacon wanted something more like the pared elegance of Narrow Street or even, as a very distant echo, his modernist interiors of forty years before. The art dealer Claude Bernard, still wooing Bacon, assigned Michel Cosperec, a young man who helped around the gallery, to oversee the remodeling. Using traditional craftsmen, Cosperec transformed the flat—replacing the windows, putting in a parquet floor, building floor-to-ceiling bookshelves. Nadine Haim and Sonia Orwell added homey touches. "I arranged it a little, but I didn't decorate it, because it wasn't the kind of place you would decorate," said Haim. "I helped him a little bit for silly things," including what kind of bed to buy.

The result was airy and "really beautiful," said Terry Danziger Miles, who made many trips to Paris to bring Bacon art supplies and furniture. "It was more like an apartment than a studio. And there were lovely wooden stairs going up." Bacon liked the renovator as much as the renovation. Michel Cosperec played a role at Galerie Claude Bernard rather like Miles at Marlborough. Bacon made a friend of Cosperec, who was not homosexual, taking him to well-known places such as La Palette, an art deco café on the Left Bank. The two sometimes drank together. "He was exceptional," said Cosperec. "His generosity was boundless." So boundless that Bacon gave him a portrait. "This caused consternation at the Galerie Claude Bernard," reported Raymond Mason, "where they dreamed every day of selling such a work." Cosperec eventually sold the painting to raise money for a new roof on his suburban house. "When he saw Francis again a few months later, he confessed the thing to him with a mortified air. 'You did the right thing, Michel,' said Francis, patting him on the shoulder. 'I'll give you another one.'"

Bacon did not think of his new flat as a getaway. It was to become, he told Dicky and Denis, his new "centre." Without the company of George—as difficult as that company could be—Bacon had been left to watch his "family" at the Colony slowly dying and drifting away; and the troupe of sycophants, however noisy, could not make up for the loss. He was becoming more peevish in London. He felt older there than he did in Paris. He still depended on old friends. In 1975, for example, Rodrigo Moynihan began painting a portrait of Bacon, and the daytime sittings were always jolly. "He came round every day and he'd stay for lunch," said the writer and artist Danny Moynihan, the son of Rodrigo and Anne Dunn. "And then Francis would go off to the Playboy Club on Curzon

Street." His evenings there could be festive, too, said John Normile, who sometimes accompanied Bacon. Once, when the gambling went poorly, a Playboy bunny asked Bacon to please refrain from using bad language. "Bunny girls," muttered Bacon, shaking his head. "What they need is more buck rabbits." But Bacon also too often let slip an ugly word or did something thoughtless. One morning, after writing Rodrigo a typical note of apology for behavior the previous night, Bacon added the world-weary words: "You see why I have no friends—I have tried all morning to telephone you without success."

Dicky and Denis did not believe Bacon would leave London for good but began to change their minds when he sold his flat in Narrow Street, in October of 1975 and then, early in the summer of 1976, began organizing for a major move. "Francis *really* intends to make Paris his centre now," wrote Dicky, who was not sorry to see Francis go. It had not always been easy for Denis to watch as his friend became the talk of Paris and New York and, once deprived of Bacon's "stimulation," Dicky believed, Denis might finally make his own way as an artist. During a goodbye visit in Wivenhoe, Dicky and Denis toasted Bacon in the barber shop Bacon frequented in nearby Colchester. (He "liked it a certain way," said the barber, and would sometimes come from London and leave the taxi "running outside.") Denis no doubt found the valedictory scene amusing: the painter preparing his entry into Paris . . . from a barber shop in Colchester. "So they bought champagne from the supermarket," said the barber, "and opened it in the barber shop, spraying it everywhere and plying all the customers with it."

In the middle of June 1976, a big black truck—filled with furniture, canvases, and painting supplies—appeared in the courtyard of the house on the rue de Birague. The truck also probably contained the sea chest and round marble table that soon became focal points of the Parisian studio (along with a mirror on one wall, as at Reece Mews). A long table held his brushes and paints. Several canvas director's chairs stood about. By July, Bacon was living in Paris. He appeared to be delighted with his new studio—and with Paris itself. Raymond Mason was astonished both that Bacon had made the move and that he used the word "beauty," which—like "love"—usually required quotation marks:

This surprised me, since to me Francis was the quintessential Londoner, as at home in the little patch of clubs and restaurants around Soho and Mayfair as William Hogarth, Henry Fielding and their friends had been in the eighteenth century. No, no, he insisted, he

loved French cuisine, but above all he loved Paris. From the point of view of beauty, he added. I would never have imagined that this familiar of the underworld, with its vice and its criminals, liked to stroll about with his nose in the air, admiring the architectural beauty of Paris.

No sooner had he arrived in Paris, however, than Bacon looked back at Wivenhoe, surprising everyone by buying a small house there. Dicky Chopping was not pleased. He had dared hope that he was finally free of Francis—and now Francis was purchasing a house in the neighborhood. "F and D off to see Cameron's cottage, F and D returned, F having made the decision to buy the place," recorded Chopping in his diary. "I have very mixed feelings but at least I have done nothing to prevent either doing what they want." The purchase, in August of 1975, was followed by a champagne lunch at Robert Carrier's restaurant at Hintlesham Hall and then hours more at a pub with "D and Francis spending lavishly." The cost of the Wivenhoe house presented no problems for Bacon. In 1975, the year of the Met show and his move to Paris, he sold Marlborough £75,000 worth of paintings and, in October of that year, he sold the Narrow Street lease for £27,000.

One in a row of attached redbrick terrace houses on a working-class street in Wivenhoe, 68 Queens Road was a small, two-story Victorian. It was neither wide nor deep. It had two small rooms on each floor. The *Daily Express*, not inclined to understate, struggled to find something exciting to say. "Francis Bacon, whose pictures sell for anything up to £100,000, has just bought a new home . . . a surprisingly modest, £6,500 terraced house in Wivenhoe, Essex, not far from Constable country." The newspaper could only explain such behavior as another example of a celebrity desiring peace and quiet. "The great man is being equally modest with his neighbours. Few have managed the opportunity even to exchange greetings." Bacon ordered the floor removed between the front rooms of the house, in order to create a two-story, light-filled studio. Not long after the purchase, during lunch with Dicky and Denis, Bacon did something remarkably intimate—and perhaps damaging. Although Denis had recently painted a landscape that somewhat restored his confidence, Bacon offered to help him with his work. "To my amazement he let him," wrote Dicky, "adding quite a lot of thick paint."

The purchase of the house in Wivenhoe—mystifying to Bacon's friends—had a certain logic. Bacon could maintain the relationship with Dicky and Denis, at whose house he traditionally stayed, but with a dif-

ference. He seemed both closer and more distant with a house of his own. In general, Bacon could now move among the people and places he enjoyed—or so he might suppose—while remaining unconfined by any of them. He was a Londoner not wholly claimed by London, and a Parisian not wholly claimed by Paris. There were no final claims.

Still, Bacon promptly returned to Paris. Four years after George's death and now nearing seventy, Baocn remained as committed as ever to his radical perspective. But he now sought in Paris a simpler, less edgy life. During his first months on the rue de Birague, he recreated much of his life in London, but as a kind of echo. He was already attuned to echoes, both in his art—which was filled with reflections, leaks, shadows, and emanations—and to people and places. Peter Beard, for example, was an echo of Peter Lacy. Both Peters were tall, blondish, and handsome. Both were well-born, well-educated, and loved Africa. But Beard was an American and not homosexual. After the death of George, Bacon now told friends, he never expected to have another serious relationship.

Paris itself was full of echoes from his past. It was his "other" city. Paris beguiled in ways that London did not. It still echoed with Picasso, another artist from elsewhere—dead only two years—and the one Bacon called "the genius of the century." Bacon liked to live with French art as a backdrop. He was "almost the only important artist of his generation anywhere," said David Sylvester, "who behaved as if Paris were still the center of the art world." John Russell wrote at the time of the Grand Palais show that "Paris is the place where the great things were done—or, if not done, nurtured—over the last hundred and fifty years. . . . [Bacon] loves the prodigality of imagination which has been shown by the best French painters, the vaulting ambition, the total seriousness, the readiness to dare anything, the instinctive knowledge of how to pace a career."

Bacon also loved the aura of French letters. He was largely self-taught in English literature, and—while he relished Shakespeare, T. S. Eliot, and Yeats—could not claim his own literary inheritance as comfortably as his more educated contemporaries could. Apart from Stephen Spender, he did not often befriend English writers. But he felt free to assume and adopt the French intellectual tradition, which he knew better than most literary Englishmen. "The thing about the French, of course, is that they have a study, and they spend time studying in the study," he once told the young artist Michael Clark. Bacon read Racine, Baudelaire, and Balzac in French, and the Duc de Saint-Simon and Madame de Sévigné in En-

glish. Proust was of bedside importance. He admired Roland Barthes and Georges Bataille. And, of course, he esteemed Leiris. How Bacon found the time to read was a mystery to his friends, given the rival claims to his attention of paint and champagne, but he did read fairly extensively, probably because he only appeared to go out every night. He was often sleepless. Television did not occur to him, or only rarely.

Bacon enjoyed French conversation, at once playful and merciless, as much as French food—preferring it, said John Russell, "to almost any kind of formal entertainment." And he paid close attention to dress. A fine turn of phrase went well with a well-turned collar. In Paris, depending upon the occasion, he wore the English bespoke suits that he rarely took from his closet in London. Bacon also liked some "vague flummery bits," said Emelia Thorold, who sometimes went to the Colony with her mother. Christopher Gibbs admired the way Bacon dressed. "You know, he's an artist, so a certain attention to detail. I think it was quite subtle when subtle was in order, and quite trollopy when trollopy was in order. Mrs. Vreeland [Diana Vreeland, the longtime editor of *Vogue*] was always going on about the things a girl could do with a scarf. Well, Francis had thought about all of those long before she had, I'm sure. Tried them out. Seen what worked."

Bacon's extensive reading, along with his command of art history, prepared him well for the conversation at French dinner parties, where—said Leiris's close friend Jacques Dupin—he strongly expressed his likes and dislikes:

> He talked about painters like Velázquez or artists like Rembrandt or Goya, about, you could say, traditional painters of the seventeenth, eighteenth centuries because he thought that it was these painters who tackled the truth about man and the body and which was, on the other hand, in counterpoint to the painting of the 19th and 20th centuries which, for him, had abandoned the true stakes [in favor of] esthetic, decorative, agreeable art. And that was something he completely refused.

It was Michel Leiris, above all, who united Bacon's artistic and social worlds. They would have lunch together at Le Récamier, a restaurant favored by intellectuals. Leiris was not a man who easily smiled, laughed, or lifted the glass, and Bacon took the trouble to prepare himself for their meetings, thinking up topics to discuss. Their intimacy sometimes seemed almost official, their friendship a stage set. Leiris also created

echoes. He was now Bacon's unfailing critical champion—not, in some respects, unlike David Sylvester—but he additionally possessed the august presence of a great academician. Bacon would sometimes take Michel and Zette to dinner at Le Grand Véfour, for example, a choice that reflected the degree of deference Bacon felt was owed to Leiris. Le Grand Véfour, which opened in the early 1800s, was an Old World establishment housed in one of the colonnaded buildings adjacent to the gardens of the Palais Royal. Every inch of its interior seemed to be covered in mirrors, painted panels, and red velvet. It placed diners on a stage where they felt assured of their consequence.

To friends in London, Bacon acknowledged the slightly absurd aspect of the radical mandarins on the Left Bank. He was amused that the rich and well-dressed Leiris, for example, whose grand dwelling looked out over the Seine, should also be a Communist. "I really can't see how he manages to be both a communist and a millionaire," he told Peppiatt. "He says how marvelous life seems to be under Mao, but of course if he lived under Mao he'd never have been allowed to do all the books and things that he has done." But Bacon also savored the courtly air around Leiris. He did not have courtly admirers in London. Leiris could be an echo of Sir Kenneth Clark, in French.

Bacon did not give up his nights, in Paris, but their character softened. He liked to have—as he usually did in London—someone by his side. His main companion in Paris continued to be Nadine Haim. Bacon enjoyed, said Haim, "the more chic bars on the rue Sainte-Anne," then the city's main homosexual cruising scene. Its centerpiece was the nightclub Le Sept, which had a restaurant on the ground floor and a throbbing disco in the basement. It was run by the impresario Fabrice Emaer, a master of the see-and-be-seen. The particular brilliance of Le Sept, said the deejay Guy Cuevas, was that it was not simply a homosexual club. "You didn't have to be rich, you didn't have to be famous," he said. "You had to be beautiful." The worlds of art, money, fashion, and celebrity mingled: Karl Lagerfeld, Rudolf Nureyev, Francis Bacon, Mick and Bianca Jagger. So well-known did Bacon become at Le Sept—and so comfortable—that sometimes he went alone to relax at the bar. In London, Bacon rarely participated in see-and-be-seen, usually avoiding the glamorous places that developed during the 1960s. But he seemed more willing in Paris to dabble in those reflections.

On quieter evenings, Bacon and Haim sometimes went to a fine restaurant and then trolled the homosexual bars or just lingered in a café. "He really loved eating; he was very, very refined," she said. "But he also

liked just having a drink at La Palette," the old standby on the Left Bank. Sonia Orwell often seemed to be arriving in Paris, where she would take up with French friends (Haim, Jacques Lacan, Marguerite Duras, the Leirises). She always included Bacon. Bacon's old friend Louis le Brocquy and his wife Anne Madden, also a painter, enjoyed going with him to Le Duc in Montparnasse, a great seafood restaurant whose interior suggested a fine wooden boat. The staff was supremely attentive, said Madden, as Bacon waved "five-hundred-franc notes behind his back," causing the waiters to begin "circling like sharks."

Bacon also developed a warm village relationship with the Veličkovićs, the couple in his building. Maristella Veličković looked after him sometimes. She could be playful but also maternal. She respected—but did not fear—the paradoxes in his temperament. She considered him one of "the most intelligent" people she knew, but also childish: "For example, Bacon would say, like a little boy, 'Me, I don't know how to draw.'" And like a little boy he could be "very cruel and very thoughtful at the same time." He would attack well-known artists with a fervor disproportionate to their crimes against art. Dubuffet's art was interesting in the 1920s, he told the Veličkovićs, but Bacon now detested his new "graffiti" art—and resented Dubuffet's desire to befriend him with almost daily invitations to visit his studio. And yet, Madame Veličković appreciated Bacon's kindness and manners. Whenever he saw her, he would ask about not only her husband but also her sons. He once left thirty roses at her door to apologize for some apparent slight she had forgotten. Almost always, she saw only the "kind and nice" side of him.

Friends regularly took it upon themselves, as they did in London, to introduce him to other well-known figures. It rarely worked. The Veličkovićs, for example, invited him to dinner with Peter Brook, who had moved to Paris to found the International Centre for Theatre Research. Bacon remained fundamentally shy, and he would often drink too much before an introduction. A rare success came when the Veličkovićs brought the surrealist poet and art critic Alain Jouffroy to meet Bacon at their flat. The dinner lasted until three a.m.—despite an asthma attack that Bacon suffered in the middle of the meal—and they discussed politics, communism, and the misery and poverty of India. Bacon did not try to dominate the talk, said Madame Veličković, but would often ask a rhetorical question ("Isn't it strange that . . . ?") or toss out a bristling negative ("Don't you think he was boring?") to excite the table. "He would let the other person speak," she said. "He would listen to everything with a characteristic, mocking smile on his face, jumping in when he had the opportunity

or found something interesting." He would lean forward with one arm
crossed over his body and his hand beneath his chin, a studied pose in
which he appeared at once relaxed and engaged.

Soon after Bacon's move, the Veličkovićs told one of their friends—a
young art historian named Eddy Batache—that the English artist Francis
Bacon was moving into the neighborhood. Batache, who lived around
the corner on the place du Marché-Sainte-Catherine, considered Bacon's
exhibition at the Grand Palais "a revelation." He wanted to meet the art-
ist. Perhaps Bacon would like to see his collection of drawings by Brett
Whiteley, an Australian artist Batache knew to be a casual friend of
Bacon's. It might be pretext enough. Batache soon chanced upon Bacon
in the neighborhood. He was wearing, said Batache, "a leather jacket with
rolled-up sleeves, and such tight trousers that it was a wonder he had
managed to get into them." Bacon liked to roll up his sleeves because he
was proud of his meaty forearms. His manner was even more distinctive.
"He came up to me with his round face, his eyes wide, like those of a child
discovering the world, and his distinctive gait resembling a poorly exe-
cuted dance step." Batache asked him if he would like to see his Whiteley
drawings.

Bacon, delighted at the approach of a charming young stranger, readily
agreed. Perhaps too readily. Batache quickly brought into the conversa-
tion the name of his partner, Reinhard Hassert, with whom he'd been liv-
ing for more than thirteen years. Bacon politely responded that he would

also like to meet Reinhard. "We agreed then and there to meet for dinner at Bofinger the following evening." They gathered first in Bacon's flat, where Batache and Hassert found its order and cleanliness notable—"the total opposite to the picturesque disorder of his studio in Reece Mews." Then they walked to Bofinger, the Belle Époque brasserie almost around the corner, which soon became one of Bacon's favorite neighborhood restaurants. In the coming weeks and months, Bacon discovered that the couple were also eager travelers in Paris and France generally and—an echo of Dicky and Denis—they invited their restless companion on their trips. Bacon was delighted, as always, to pay the bills.

A charming couple in their mid-thirties, Batache and Hassert (an independent art dealer) were intellectually adventurous. "Francis was a man who read an enormous amount," said Batache. "He enjoyed discussing anything and everything with us: literature, painting, facts and even politics, although the latter more rarely." Bacon took an immediate interest in a book that Batache was then writing, a study of the handsome young surrealist writer René Crevel, who was forced out of the movement by André Breton owing to his "corrupt" homosexual leanings. Crevel was also a man closely shadowed by death: both he and his father committed suicide.

The three soon became good friends. Bacon—no less generous with introductions than with money—brought them into his circle. Although Eddy and Reinhard never fully joined the extended Bacon world, they became friendly with Claude Bernard, Sonia Orwell, and—said Batache—"above all Michel Leiris." The couple endeared themselves to Bacon by a willingness to drop everything when he came to Paris in order to keep him company. "Francis was one of those persons who, if you knew him and you were fond of him, the minute he was there, all your agenda and timetable would change because of his presence," said Batache. "And he considered it as due somehow." Bacon loved taking the train to Paris. The young couple would meet him at the station, where, like a child eager for what was ahead, he was always first off the train. He also loved to take the "Night Ferry" back to London. After dinner at the Gare du Nord's delightful brasserie, he boarded a sleeping car and woke in London the next morning.

To an outsider, the relationship among the three might well have appeared odd. It was no wonder that Eddy and Reinhard would enjoy befriending a celebrated older artist, but wasn't Bacon already busy and surrounded by distinguished company—Michel Leiris and his friends; Nadine Haim and Sonia Orwell and their friends? And all those passing

through Paris? And the paintings, of course, needed attention. In fact, the young couple intrigued Bacon. Like most of Bacon's close friends, Eddy and Reinhard were also outsiders forced to find their own way in an often forbidding world. Eddy was a Lebanese disinherited by his father for being homosexual. Reinhard was born behind the Iron Curtain in East Germany. The young men met when they were not even twenty, becoming inseparable and making a life for themselves far from Lebanon and Germany. They moved to Australia in 1964, where Batache then taught at the University of Sydney while Hassert managed the city's well-known Holdsworth Gallery before becoming an independent art dealer. After establishing themselves in Australia, the couple divided their time between Sydney and Paris, staying on the move in a way Bacon instinctively appreciated. They were also interesting to look at, one very different from the other. Eddy was dark-haired and handsome in a Mediterranean way, with a playful expression in his eyes. Reinhard, slender and fair-haired, could be a bespectacled German schoolboy with an amusing and slightly waspish manner.

Bacon hated growing old. The couple noticed (and Bacon noticed their noticing) how the five flights of stairs to their flat left him gasping. His asthma was reasserting itself again in the 1970s, and, after years of only moderate trouble, he was feeling the effects. On a Parisian bus he would stare at someone very old and then look at his young friends. Eddy and Reinhard were rejuvenating. They treated him as a friend and fellow adventurer, not as a celebrity, which he appreciated. Eddy and Reinhard were invariably cheerful, and they presented him with something that, in art and life, always engrossed him: they were a *couple*—two in one, a coupling couple, a *homosexual* couple who, however much they wrestled, did not break apart. Bacon often edged close to couples. He traveled with couples. He was envious of couples. Sometimes, he tried to break up couples. "He believed there was no such thing as real love, only sexual desire," said Eddy. "He couldn't accept that two people could have a lasting, loving relationship, sharing their lives every day, willingly making sacrifices for each other, out of pure love." Eddy and Reinhard flummoxed and fascinated him. "Francis tried to break up our relationship out of possessiveness," said Reinhard, "as he also tried to break up the long partnership of his oldest friends in England, Denis Wirth-Miller and Dicky Chopping. But he failed. He'd say in exasperation, 'I cannot understand you two!'"

Bacon filled many hours when he would otherwise be alone exploring the city with Eddy and Reinhard. They noted that Bacon—who in London never mentioned a park—admired the Bagatelle and the Lux-

embourg and Tuileries gardens. The three went to the many museums of Paris, looking at Bacon's favorite painters, but "also those he detested." At the Musée Nationale Gustave Moreau, Bacon intensively studied the work of the symbolist painter and, asked what he thought, responded, "I want to vomit." He liked to say, "You learn as much from a bad painting as from a masterpiece." At the Louvre, Bacon's close looking extended across many fields, from the French Middle Ages to the rooms of Egyptian and Mesopotamian art. He did his other kind of looking, Batache said, during long afternoons at Parisian cafés:

What he loved above all was observing people; hence his partiality for cafés and bars where he could spend hours looking at the customers. As one glass succeeded another, the subjects of his interest would be revealed as they really were: the facades imposed on them by hypocrisy, or modesty were stripped away. Everything that touched on the human comedy fascinated and inspired him.

The young Eddy and Reinhard echoed the older Dicky and Denis in certain physical respects. One was tall, the other short; one fair, the other dark; one outgoing, the other reserved. (Similar contrasts were found in Peter Pollock and Paul Danquah, another favorite couple of Bacon's.) But there was also an essential difference. Eddy and Reinhard refused to become involved in quarrels. Sometimes, if his work was going poorly, Bacon would seize contemptuously upon a remark one of them made, but the fuse once lit did not lead to an explosion. If Bacon did feel that he had misbehaved, he would gasp up the five flights first thing the next morning in order to apologize. The atmosphere in Paris was lighter than in London, and he rarely had to make amends.

Claude Bernard still dreamed of exhibiting Bacon. It did not discourage him that his long campaign had not succeeded. He had boundless faith in his powers of persuasion. Raymond Mason once stopped by his gallery on a Saturday morning and saw Bernard beaming by his door, enjoying the contrast between his crowded gallery and the empty galleries down the street. "What do you put this down to?" Bernard asked Mason. The appeal of his artists, answered Mason. "His astonishment confirmed what I had suspected for quite some time," wrote Mason. "Claude sincerely believed that the public came for him, attracted by his aura, eager to catch a glimpse of him . . ."

In fact, Claude Bernard *was* something of a draw. A flamboyant impresario who helped marry society and the art world, he attracted attention by spending a fortune on two personal properties, both of them a kind of living fantasy. One was a "palatial residence" in a grand building that overlooked the Arc de Triomphe where he sometimes gave seated dinner parties for a hundred people at a time. The party might include an organ recital or a performance by a pianist as admired as Sviatoslav Richter. (Bernard himself was an amateur musician.) At his country estate, La Besnardière, northeast of Tours, the main living room was Nordic in design, "with a huge fireplace—plus organs of course—and bearskins that were not only spread over the floor," wrote Mason, "but also hung in front of the windows as curtains." He built a barn as a venue for concerts. An enclosed courtyard, seemingly lifted from *The Arabian Nights*, was decorated with sumptuous cushions, rugs, lamps, and mosaics made by the artisans who worked for the king of Morocco.

Bernard was another important Parisian echo. He resembled the individual art dealers Bacon admired in London (such as Erica Brausen and Helen Lessore) more than he did the more corporate-seeming Marlborough. But there was something else, too, about Bernard. He was a florid self-inventor—more like Lord Berners than a conventional art dealer—for whom Bacon maintained a kind of instinctive sympathy. Bacon respected the performance; he understood the masks. He also probably enjoyed being courted by Bernard. In London, Bacon was respected by most of the trendy young art dealers, but they focused mainly on the art that was emerging in the sixties and seventies. Bernard had the stylish buzz of a Robert Fraser, but he also very much wanted Francis Bacon.

It was probably not long after he moved into his flat that Bacon informally agreed to exhibit with Bernard a year or two later. He also consigned some smaller works to the gallery. An exhibit of Bacon's recent art was now scheduled for the summer of 1976 at the Musée Cantini in Marseille, a city whose gangster charm Bacon found irresistible: gun in pocket, Gauloise on lip, in the shady Mediterranean. There was nothing Marlborough could do about Bacon's passion for France and the Mediterranean, especially after the success at the Grand Palais, and there was nothing wrong with exhibiting in Marseille. But Bacon was probably not forthcoming with Marlborough about his relationship with Bernard, which they viewed with increasing alarm.

Meanwhile, Bacon settled down at his new easel. The first question raised by any Bacon studio was, Could he work there? He found that he could work in Paris, up to a point; though the city often drew him away

from the easel. "I love Paris so much that when I had a studio there," he later confessed, "I couldn't work as much as I should have because I went out all the time, just to look at the town." But with pressing deadlines, Bacon began to work hard on the rue de Birague. The big table next to his easel sprouted unruly brushes and Winsor & Newton paint tubes. Socks caked with paint were strewn among smudgy photos and open books. He acquired a frying pan as a palette, an idea borrowed from Reece Mews, and it soon curdled with brightly colored goo. But he did not splash paint on the walls, and he did not, as at Reece Mews, let the room become a free-for-all. In London, he was a clean man with a messy studio who slept, ate, and worked in separate rooms. In Paris, he had only the one large room.

Bacon began with mostly smaller portraits and self-portraits, less messy in the making than larger works. His main subject was Peter Beard, or, more precisely, a particular black-and-white photograph of Beard. It was one of many such self-portraits that Beard gave to Bacon, and it depicted a man staring directly into the camera. His lips were puckered as if he were about to speak. His thick hair was swept to one side, his neck and shoulders muscularly defined. Bacon was painting a portrait of a self-portrait. After the high drama of the Grand Palais, however, he did not want to exhibit merely a few small portraits in his upcoming French shows. The operatic Bernard would certainly want a show-stopping trip-tych, and Bacon himself possessed a strong feeling of occasion.

Bacon now tried, with varying success, to make larger pictures using his preferred 78″ x 58″ canvas. Two were particularly poignant. In *Studies from the Human Body* (1975), a kind of triptych-within-a-painting, a naked man writhed on his back on a hard bench. To his right, a bare-breasted woman impassively gazed toward him, and to his left her reflec-tion telegraphed unconcern. The image suggested both a ritual sacrifice and a man-child torn apart by a raging tantrum, both occurring as his indifferent mother withholds the breast. His other larger painting also addressed a small, isolated person. Bacon cast the picture as a kind of diptych-within-a-painting. A dwarf was seated at the far right, and on the far left, enclosed in a kind of floating vitrine, two grappling figures coiled so tightly together that they appeared lost in themselves. Bacon struggled with this painting, perhaps because the figure called to mind the great Velázquez images of dwarves (particularly *A Dwarf Sitting on the Floor*). Reinhard Hassert convinced him that the image of the dwarf was worth saving. "Francis came round to his opinion," said Batache, "and decided to get his London gallery to destroy two thirds of the picture and save only the right part." In the end, two paintings survived in odd

dimensions, the 78″ x 58″ canvas becoming *Two Figures*, 1975 (at 78″ x 28″) and *Portrait of a Dwarf* (1975) (at 62½″ x 23″).

In November of 1975, Ianthe and Ben Knott visited Bacon, who took time from his studio to wine and dine them through Paris. Ben and Francis always "got on famously," said their son Keith. The Knotts then traveled to London, where, on November 27th, Ben suffered a fatal heart attack in their hotel room. It was a "terrible shock" to Ianthe and the entire family. Bacon rushed to London to help his sister through the formalities that attend death. (He paid £362 for Ben's cremation.) Led by necessity to spend time at Reece Mews, he painted the accomplished *Three Figures and Portrait* (1975) and was forced to acknowledge the obvious yet again: he worked best in London, even as a Parisian. Once back in Paris, he was unable to complete any large paintings or triptychs. In March of 1976, pressured by the deadline of the Marseille show that summer and an exhibit he hoped to have with Bernard in January of 1977, he returned to the studio at Reece Mews.

Bacon began working on a large triptych in April 1976 in which, as he told Leiris in a letter, "the accidents were based on *The Oresteia* of Aeschylus and *Heart of Darkness* by Conrad." He added the flattering observation that *Frêle bruit* (the fourth volume of Leiris's *La Règle du jeu*, which had just been published) "comes in as well, all the time." Bacon probably sensed that what was becoming *Triptych* (1976) could crown either upcoming show. Bacon's paintings often resembled existential stage-sets, increasingly so in the 1960s and 1970s. His audience looked onto a platform—or sacrificial arena—and he regularly used certain stylized props or symbols, such as a naked hanging bulb, a pointing arrow, or some time-worn newsprint. It was not just the desire of a showman, however, that led Bacon to begin painting *Triptych* rather than a more modest work. A solitary image, large or small, could not capture the way moments develop, evolve, and change. It could not convey a moment's larger cultural context. But *three* was a great and mysterious number. *Three* also had a supreme formal solidity, like a pyramid, the Trinity, or the acts in a play. The painter who loved Aeschylus liked to think in acts, and his triptychs often sought the paradoxical distance and immediacy of theater.

The Musée Cantini, where Bacon's next show would be, possessed one of the largest collections of twentieth-century art in France, including not just works by Picasso, Léger, and the surrealists but modernist paintings done outside France. It was housed in the kind of elegant space Bacon favored. The building was constructed in the seventeenth century as the headquarters of a company that specialized in coral fishing off Tunisia,

and it had a walled entrance courtyard and sweeping galleries. Bacon liked the long-time mayor of Marseille, Gaston Defferre, less because he was a leading Socialist and presidential candidate than because he plainly knew all about workingmen, criminals, and the mob. Before the show, Bacon invited Defferre and his wife, Marie-Antoinette, to dinner at his Paris studio. In France, writers and artists were so respected that a politician like Defferre treated the invitation as an honor. The dinner was prepared by "chef" Denis Wirth-Miller, who, with Dicky, arrived in Paris several days before the Marseille show in their touring van. "Dicky and Denis had a van that they converted [for such trips]," said the art dealer James Birch, a family friend of the two who had known them since he was a child. "It had a mattress in the back, with a fishnet for their clothes. They got it to go gambling. . . . They would stay with people along the way." And, if necessary, cook for Gaston and Francis.

A surprising number of Bacon's friends came from London to see their newly Parisian friend exhibit in Marseille, among them Rodrigo Moynihan and Lucian Freud. The Marlborough gallery was represented by Pierre Levai. Only three of the large images on display were new—*Three Figures and Portrait, Figure in Movement*, and *Portrait of a Dwarf*—although several small self-portraits and two small triptychs of Peter Beard, all recently painted, were included. More important, however, each of the so-called "black triptychs" created after George Dyer's death came to Marseille, including the first in the series (with its enigmatic stairway), which had been missing from the exhibit at the Met. Lucian Freud hosted a bouillabaisse lunch for Bacon. After the opening, Bacon "went to a bar with prostitutes and tarts," said Pierre Levai. "It was near La Canebière [the old quarter of Marseille]. Bacon arrived with a famous French lesbian "and he bought the most expensive champagne for the whole bar." The casinos were not far away.

TRIPTYCH (1976)

"History painting," it was once thought, clarified Western ideals. Artists made large paintings intended to embody a key moment—often elevated in feeling—found in Western history, myth, and religion. That would not ordinarily seem Bacon's cup of tea. But Bacon felt the appeal of Western conventions even as he attacked them, and he often used and adapted old-masterly elements in a slyly subversive manner. *Triptych* is a kind of modern history painting, dramatic and high-flown, that conveys an

important modern moral. David Sylvester wrote that the triptych had "an unmistakable feel of an organized spectacle, not a spontaneous event but a scene that has been staged, whether in an opera house or a cathedral." Or, given the presiding spirit of Aeschylus in Bacon's life, the amphitheaters of ancient Greece.

The central panel marks the decisive moment—one like the culmination of an ancient tragic myth. A birdlike creature has swept down from above to drive its beak into the head of a human figure. The body cavity lights up with the strike. Nearby, two birds pick at flesh. Each side panel is dominated by a huge and intimidating—but modern—image of a man's head and shoulders. (The image might be resting on an easel.) These heads are connected to what appear to be twisted jumbles of genuine flesh. Like many history paintings, *Triptych* also contained a scattering of emblems, attributes, and symbols—such as a goblet of wine (or blood) and scraps of mysterious writing that could be ancient runes or modern newsprint—that further amplify and illuminate the story.

But what is the story? The ancient myths surrounding Prometheus—the most grisly of which features an eagle sent daily by Zeus to feast on Prometheus's liver—contributed details. (Bacon could hardly be more gruesome than the ancient myth makers, and he lived in no less barbarous times.) Joseph Conrad's *Heart of Darkness*, Michel Leiris's *Frêle bruit*, and images sent to Bacon by Peter Beard also added details. There were even distant echoes of the Christian Crucifixion. Bacon once said he preferred "elliptical form," by which he meant form that suggests rather than defines. He felt the same way about stories. Interesting hours could be spent puzzling over the triptych's iconographic pieces, arranging them this way and that to see what messages they yield. But the full story or meaning of *Triptych* cannot finally be put together. The triptych, said a friend of Bacon's, looks like the "lost secrets of an ancient religion."

That is, of course, the modern moral. The immediate jolt to the "nerves" as the bird drives its beak into the figure can still be experienced. The pulse of a story, created by Bacon's rhythmically curving shapes, can easily be felt. And the redolent fume of sacrifice, generated through Bacon's brilliant use of complementary colors (on the one hand a gangrenous green; on the other, reddish flesh tones) can be drawn deep into the lungs. But you cannot, like a Christian looking at a complex altarpiece, be moved by the central human sacrifice and then place the event into the settled context of the life of Christ. You cannot study familiar scenes and symbols knowing you will have an explanation. Bacon not only confines many of his painted figures within an unknowable geometry: he also puts an implicit space-frame around you.

Spectacle

O NE AFTERNOON IN 1976, when he was back in London, Bacon quit for the day and went to the Colony. Suddenly, a young man with dark curly hair was all over him. "So you're the fucker who I got champagne in for then didn't turn up to drink it. What kind of bloke are you?" The young man spoke with a thick cockney accent. He did not stop. Bacon was only dimly aware of what he was talking about. Sometime before, Muriel Belcher had promised her friend Joan Littlewood,

who directed the Theatre Royal in Stratford, east London, that she and Bacon would visit the theater. To make the trip an adventure rather than an obligation, Muriel asked another friend—David Edwards, a publican in Stratford who sometimes dropped into the Colony—to stock some champagne at The Swan, his pub near the theater. But "Daughter" had not yet made the trip, sticking Edwards with the champagne, which was not a cockney drink of choice.

Bacon loved being braced by this handsome cockney. John Edwards, then twenty-six or twenty-seven years old, worked at The Swan with his brother. Some thought John staged the confrontation at the Colony. "I do think that it wasn't Francis who met John; it was John who made Francis meet him," said Bacon's doctor, Paul Brass. "He knew. . . . his weaknesses and proclivities

John Edwards and Bacon in 1980: Bacon "fell for John in a minute."

and thought that maybe he could get in on the act when George was no longer around. I think that's a possibility." Bacon would not entirely mind, of course, being John Edwards's mark. That could remain ambiguous, just another of love's concealed knots. Bacon invited John to dinner at Wheeler's. "Francis fell for John in a minute," said the artist Brian Clarke, one of Edwards' close friends and later the executor of his estate. "He was breathtakingly handsome. John's demeanor . . . he exuded strength. He was very reliable, like a rock. Very strong." David Marrion, a barman at the Colony and a friend of Edwards's, described him as having "an aura about him. Charisma. And he was fun."

Bacon found "something terribly depressing about old people in love." Old people in lust was worse. But there Bacon stood, as Ian Board put it, "riddled with love." As usual, he fell for a man who did not appear homosexual, or not obviously so. And as usual, Bacon believed he was the one more in love. John Edwards reminded many people of George Dyer, of course, another East Ender looking for an angle; but John differed from George much as Eddy and Reinhard did from Dicky and Denis. He was a safer "echo." He was not a hopeless alcoholic, for one thing, and while he had a temper, he was not subject to tantrumlike rages. He typically refused to react to Bacon's needling—shrugging him off with a "You silly old queen"—and he did not flatter or kowtow. "I think he felt very free with me because I was a bit different from most people he knew," Edwards said. "Most people around Francis looked up to him and he didn't like that. I asked him once, 'What do you see in me?' and he laughed and said, 'You're not boring like most people.'" In a world where most people praised Bacon, Edwards's roguish charm and independence were a relief. "John," said his friend Brian Clarke, "didn't have it in him to be deferential."

Edwards was born and raised on Cable Street in Stepney, in the docklands area north of the Thames, where his father was a docker who also boxed successfully and had earned a medal for bravery as a seaman in World War II. His mother, Beatrice, known as Beatty, was an East Ender who worked in a retail shop in Stepney before having a large family. John was the next-to-last of six siblings. He had three older brothers—Leonard, David, and Michael—and one older sister, Patricia. The last child was his younger sister, Colleen. The family was "very close, a very tight East End family," said Philip Mordue, John's closest friend. Born in 1949, Edwards was dyslexic, a condition not then well understood that often led schools to label otherwise normal children as slow-witted. "He could read certain things and recognize word formations," said Brian Clarke. "He would sit

with the newspaper in front of him for a long time enjoying it. But if he were trying to leave a note for someone he might begin the word 'bottle' with a *t* and then couldn't move on. If he wanted to sign a note 'Love to David,' say, someone would need to write it first and then he would copy it." Edwards was also left-handed when that was considered a physical handicap: a "lefty" often had the left hand tied behind his back to force him to write with the right hand.

John "bunked off" a lot from the local Church of England school he attended because he felt constantly humiliated. At fourteen, he dropped out and "bounced from pillar to post," said Clarke, taking one odd job after another. "He was incapable of academic learning, but he was highly intelligent: many dyslexics are." His older brothers Leonard and David managed a number of pubs in the East End—the Black Horse, the White Horse, the Salmon and Ball, the Plough and Harrow, and by the mid-1970s, The Swan in Stratford. John began working at The Swan off and on from about the age of sixteen. John loved automobiles, often a symbol of escape, freedom, and wealth for young men with few prospects. He was arrested three times and fined a thousand pounds for drunk driving. At the third offense, he lost his license for seven years. The fourth time he was caught he was sentenced to six months in jail.

Edwards's most lucrative job was that of "kept man and companion," a profession Bacon also once practiced in his way. "John had very few jobs in his whole life," said Clarke. "Between leaving school and arriving on the radar John formed a friendship with a man of a similar age and resources to Francis." The role of "kept man," in which a good-looking young man developed a relationship with a much older, rich queen, was usually more business than pleasure. Edwards himself was attracted to younger men and romantically committed, in particular, to Philip Mordue, whom Edwards met when Edwards was around twenty-two. Despite the complicated dynamics, Bacon became very possessive, wanting always to be with Edwards—to the point, said David Marrion, that it "might have been a bit trying for John." Edwards "was a young man; he still wanted to see old friends." Bacon took pride in taking care of his young companion, much as he once did with George, Marrion recalled:

It was like, you know, *My Fair Lady* in reverse, someone he could sort of groom, teach to dress, take out eating . . . John and I, our best food was pie and mash. But you know, I was a bit more sophisticated and I'd been out much more, but after awhile it was John that was

going out and becoming a bit more sophisticated. Better groomed. Knew about wine. I think that Francis enjoyed seeing him blossom. He loved it.

In the beginning, the relationship between Bacon and Edwards was sexual, but Edwards—four decades younger than Bacon—was not sexually interested in him. That did nothing to cool the ardor of the older man, who wanted Edwards to become his public partner. The relationship was soon well-known at the Colony and among Edwards's friends, but John at first refused to enter the wider circles of Bacon's world. Valerie Beston, Sonia Orwell, and David Sylvester knew nothing of him for a long time. It would remain, said Clarke, "a nighttime acquaintance" until Bacon and Edwards sorted out their relationship between themselves.

In the late summer and fall of 1976, Bacon—having completed his big theatrical triptych and now working toward his January 1977 show at Galerie Claude Bernard in Paris—made a number of portraits and self-portraits, the most notable of which was *Portrait of Michel Leiris* (1976). Bacon did not intend this painting for the show, but as a gift for Leiris. Its power seemed to come from Leiris's mind, which animated his face. He appeared as a man of ample thought and questioning, telegraphed in a series of tics and grimaces. Leiris's left eye, somewhat enlarged by the magnifying Baconian disc, stared intently at the viewer while his doubled mouth appeared poised to speak. His nose sliced downwards with the force of the last word in an argument. The likeness was less exact than that found in a portrait Bacon made two years later, which conveyed "precisely the upward crinkling of the forehead," wrote John Russell, "with which Leiris would prepare to address any topic that moved him deeply." But Bacon preferred the first. "It is less literally like him but in fact more poignantly like him."

Not surprisingly, the directors of Marlborough were growing annoyed. They had the exclusive right to sell Bacon's paintings and, while they could arrange with another gallery to exhibit his art, that also put another hand in the financial pot. Bacon insisted upon the Bernard show in Paris. And so, Marlborough sold Bernard three Bacon paintings for his exhibition, which also exasperated them, since Marlborough, like other galleries of the time, preferred to sell pictures from its own venues outside England—such as Zurich and New York—in order to avoid English taxes. Selling directly to a dealer in Paris could limit their many options. Even

worse, Bacon had already sold works directly to Claude Bernard—and not just small ones. "They [Bernard and Bacon] were great friends, but not through us," said David Somerset. "I remember Lloyd being irritated because he rather liked to think [the Marlborough's deal with Bacon] was an exclusive."

Claude Bernard knew how to promote a show. The international edition of *Newsweek* planned a cover story on Bacon timed to coincide with the January opening, an indication that Bacon's mystique now extended well beyond the art world. It was not the art that captivated *Newsweek* but the aura:

> For weeks the Parisian art world has been gearing up for the great day. French Minister of Culture Françoise Giroud will be there in company with other prominent government officials. So will the cream of le tout Paris and a legion of Europe's top art critics. (One group of Italian critics and gallery owners plans to arrive in a chartered jet.) To make sure things don't get out of hand, the section of the narrow rue des Beaux Arts that runs in front of the Galerie Claude Bernard may well have to be closed to traffic—an understandable precaution in view of the fact that the staff of the fashionable gallery is braced for an onslaught of as many as 5,000 people within a matter of a few hours.

Newsweek was very interested in money and controversy:

> Bacon's grisly visions have outraged scores of critics—and made devoted disciples of many others. And the furious controversy that has swirled around him and his paintings has helped make Bacon one of the world's highest-priced and most courted artists. One work by Bacon that sold in 1953 for a mere $85 is now valued at $171,000, and among the paintings on display in the Claude Bernard show will be a massive three-panel work priced at $500,000. (A painting by Jasper Johns that sold for $240,000 in 1973 holds the price record at Sotheby Parke Bernet for a living American artist.)

Newsweek published its cover story before the private view. It would otherwise have described one of the most feverish art scenes of the 1970s. The night of the opening, Michel Soskine was working at his uncle's gallery. "The whole neighborhood was closed by the police," he said. That would happen occasionally before big shows, with employees at the door "busy

driving people back," but this time the excitement verged on hysteria. Three rooms were given over to the show and, said Soskine, there were "crowds and crowds and crowds of people. People sitting on the floor... queues waiting outside." Inside, visitors saw (when they could see) three of the large George Dyer triptychs and Bacon's recent *Triptych*. Eight additional large paintings were on view and six new small triptychs and single portraits that Bacon painted after the show at the Musée Cantini. The three rooms provided less space than at Maeght a decade before. Now, the concentration was "incredibly powerful," with no escape from either the paintings or the monstrous crowd.

Floating in the mob was Francis Bacon, wearing a glistening leather trench coat, tightly belted and with shoulder tabs. He looked like a glamorous—if world-weary—French detective investigating a murder on the Left Bank. A French minister told him, "You are the Marilyn Monroe of modern art," a compliment Bacon did not appreciate, but he otherwise enjoyed the fuss. His French always became remarkably good in public after a glass or two of champagne. A "contingent of heavy drinkers from England" eventually arrived at the gallery. By the end of the evening, according to Raymond Mason, they "could be found on all fours or lying on their backs under the influence of alcohol." And then *les punks* arrived. For the punks, the more Grand the Guignol, the better. They strode barbarously into Claude Bernard's gallery in Mohawk haircuts, spiky dog collars, and clinking chains. *Paris Match* estimated that eight thousand people came to the private view: "Never has a living artist had so frantic a private viewing." Its reporter called Bacon the "most expensive artist in the world."

Some of Bacon's friends disliked him in the role of movie star. Not only did Reinhard Hassert refuse to attend the opening, for example, but he also especially disliked the centerpiece, *Triptych* (1976). Bacon noticed: he always referred to the triptych around Reinhard as "that painting you don't like." But Bacon respected the challenge. Bernard capped the event at ten p.m. with an enormous dinner party. He commandeered "an old grain market house, the Bourse de Commerce," said Soskine, an historic building and home to the commodities exchange. It had a mural-lined rotunda and an imposing dome. At the dinner, Bacon, who spent his time at the gallery mostly greeting visitors and signing catalogs and posters, circled continuously through the vast space, visiting each table to chat and individually greet the hundreds of guests. Two days later, he went to the gallery with the Veličkovićs to see his exhibit under quieter circumstances. "The best exhibition I've ever had was in 1977 at the Galerie

Claude Bernard, in Paris," he would later declare, "where the spaces are all small and the paintings looked more intense." The critics did not as a rule hold back. "Powerful like Rembrandt, tragic like van Gogh," read the announcement in the *Quotidien de Paris*. "He is our grand painter."

Bacon was successful in London, of course, but the streets were never barricaded, and Miss Beston was never forced to beat back mobs at the door. The spectacle in Paris could hardly have pleased Marlborough, whose directors now felt—as Erica Brausen once did—that they had done all the hard work over the years only to see someone else grab the glory. Had Bacon forgotten about their exclusive contract? Why did he consign some pictures directly to Bernard? He was not particularly productive, moreover, after the Bernard show. He completed fifteen pictures in 1976—including the imposing *Triptych* that he consigned to Claude Bernard—but only eight the following year. Meanwhile, he spent as freely as ever, traveling between London and his new studios in Paris and Wivenhoe.

In January of 1978, after a year of small production, Marlborough asked Bacon to take a pay cut. Bacon wrote Somerset—one of the most genial men in the London art world—an icy letter in response:

> I have been thinking over Frank['s] and your proposal to reduce what you pay me by 10 or 15 percent. I have decided I cannot do this for paints and canvases have [*the page is torn: the missing word was probably "risen" or "increased"*] by about treble will you please let Frank know that I cannot do this reduction.
>
> Yours very sincerely, Francis Bacon

The note contained a subtle insult and, in its way, a declaration of principle. Bacon knew perfectly well, as did Lloyd and Somerset, that art supplies were not the issue. But Bacon refused ever to discuss—not with holders of the purse—serious matters like oysters, champagne, and roulette. Extravagance was a principle. To a serious nihilist, a virtue. Contracts and ordinary commerce meant nothing to Bacon, and he cared little if Lloyd and Somerset took advantage of him if they honored the only agreement that mattered, which was an implicit gentleman's agreement. They could have his paintings. He must live without a bridle. Bacon's reference to the cost of "paints and canvases"—and mention of the penny-pinching "10 or 15 percent"—were a way to make Somerset

and Lloyd feel like grubby tradesmen who could not possibly understand the life of a committed artist.

Bacon was so angry that when a friend proposed that he leave Marlborough for the Pace Gallery, he agreed to meet the founder of Pace, Arnold "Arne" Glimcher, who was then turning his gallery into one of the most important in New York. Glimcher brought a kind of museum luster to his exhibits of contemporary American artists by publishing serious (and seriously lavish) catalogs. Among the artists he represented were a number of older "modern masters," among them Jean Dubuffet, Louise Nevelson, and Agnes Martin. They gave to his younger artists an air of gravitas. Glimcher's own combination of boyish charm and business smarts appealed not only to collectors but also, sometimes, to lonely (and elderly) artists. He possessed the enthusiasm of a fan and the reverence of an acolyte. He was also a serious student of art. Bacon was a prize.

At the time, Marlborough appeared wounded, its reputation damaged by the Rothko trial, in which the children of the painter Mark Rothko (after his suicide in 1970) sued the gallery and the executors of their father's estate for "waste and fraud"—in effect claiming that the gallery cheated them out of millions of dollars in sales. In 1975, the court found for the children, excoriating the gallery and its executors. In 1977, Frank Lloyd was indicted in New York for tampering with evidence presented during the trial and though the case still had several years to run, celebrated artists were beginning to leave the gallery. Bacon looked ripe for the picking. Glimcher flew to London, meeting Bacon for tea at Claridge's. Bacon came wearing a coat and tie, said Glimcher, and "beautifully turned out. We had such a long talk. He knew the gallery. He was very complimentary. . . . He had just told me that he sold his paintings to Marlborough for fifty thousand [pounds] each and then they asked for whatever they wanted. . . . He said he would sell the paintings to me at a very good price and I said that would be very nice, but I wouldn't do that, we have a commission and when we make money you make money. And he said, 'Well, I've been going on like this with Marlborough, fifty K a painting, for years now.' I said, 'How could you get yourself into a situation like that?' Bacon said, 'Because sometimes I prefer the company of thieves.' I absolutely loved that. So we laughed. I said, 'Are we going to do this?' He said, 'Absolutely.' "

On the flight home, Glimcher wrote Bacon, "I'm drafting this letter on the Concorde which spiritually seems an unnecessary form of transportation as I am so elated by our new association." Once Bacon informed Marlborough, Glimcher intended to announce the move in the art jour-

nals and schedule an exhibition of between six and eight paintings "with a suitably important catalogue" in April–May or November of 1979. "I am not suggesting that you rush to produce works—whenever your works are ready I am at your service." The association with Pace, Glimcher assured Bacon, would improve the market in his paintings. Soon after, Bacon wrote back to ask Glimcher to hold off the announcement. "He was very nervous about telling Lloyd," said Glimcher, who returned to London once more before finally learning that Bacon would, after all, remain with Marlborough.

Years later, Glimcher attributed Bacon's decision to remain with Marlborough to his complicated tax and financial position. In the 1960s and '70s, taxation rose to an all-time high in the UK, with a top rate of 83 percent. In 1980, the records of Marlborough Fine Art show that seventy thousand pounds were set aside from Bacon's profits as a provision for income tax. Many high earners in the UK simply left—David Bowie to Switzerland, the Rolling Stones to the South of France. Even after the Labour Party was ousted in 1979, the top rate of income tax stood at 60 percent. As a result, tax games—generally legal—were common. Peter Beard alluded to Bacon's "Swiss bank account" in his 1980s letters to "Fran," and of course Marlborough maintained a presence in Switzerland and Liechtenstein. Over the years, Bacon often made short trips to Switzerland. He was not known as a skier or mountain climber. He was likely picking up cash before proceeding to the Mediterranean casinos, or working out estate planning for Ianthe and her children. He had reason to fear that if he left for the Pace Gallery, he would not have access to his foreign accounts.

Martin Summers, for thirty-five years the managing director of the Lefevre Gallery, where Bacon exhibited in the 1940s, described how galleries could move money around to escape taxes: "You see, there was Marlborough London and Marlborough International. Marlborough International would sell the picture and give London a commission and give Francis a commission in Geneva or Zurich. So it would go into there . . . There would be no record in London that Francis was being paid [abroad]. . . . Whether Miss Beston had the key to the safe in Switzerland I don't know, but there was a lot of money there." Bacon himself often mentioned such arrangements. Andrew Graham-Dixon reported in a profile in *The Independent* in 1988: "A friend remembers meeting him in Soho just after VAT [Value-Added Tax] was introduced. Bacon looked very cheerful. 'The Marlborough gets me out of VAT,'" he said. Grey Gowrie, Margaret Thatcher's minister for the arts and later the first

chairman of the Arts Council, believed that an "offshore" tax arrangement probably complicated—but also solidified—Bacon's relationship with Marlborough. Any such arrangements would have "made Bacon apprehensive," said Gowrie. "This is what I suspect may have happened, but I have no knowledge whether or not it was the case." But Bacon resented paying huge sums in taxes, and he detested remittance laws that limited the amount of pounds sterling he could take outside the country. The limit was set too low for a high-stakes gambler: he would hide money in his belt when he left for Paris.

It was not surprising, then, that Bacon and Marlborough repaired their relationship. Each maintained significant leverage over the other. Marlborough did not want to lose its best-known English artist as the Rothko trial threatened its reputation. At the same time, Bacon became aware that disentangling himself from Marlborough would be both daunting and worrisome. And he was, besides, a homebody. A restless homebody, but one with settled habits, accustomed to being taken care of by the priceless Miss Beston. New York was an ocean away. How could he start, at almost seventy years of age, afresh with the Americans?

That spring of 1978, after the momentary uproar, Miss Beston took particular care of Bacon. His studio and living quarters at Reece Mews were in sorry need of care; no maintenance had been carried out since 1961 (apart from a spruce-up after the fire in 1968). The year before, in August of 1977, she had asked John Lelliott Ltd. contractors to take a look. The firm proposed stripping the ceilings, walls, and woodwork—with the exception of the sacrosanct studio—and rewiring the space. Varnishing the floors could follow. Bacon initially resisted the idea of a renovation, but finally allowed the workmen to enter. He could hardly bear the thought of daytime strangers, not to be confused with the strangers of the night, wandering through the careful disarray of his rooms, especially the studio. Not long after the renovation began, in April of 1978, his fears were realized. He caught some workers in flagrante: they were putting their dirty hands on his dirty magazines on his dirty floor. He retreated to his studio in Wivenhoe, and Miss Beston fired off a stern letter that was a small and comic set piece on the sacred and profane. Her letter foreshadowed the reverential removal to Ireland many years later of his relic-filled studio—lock, stock, and dust:

Although Mr. Bacon has cleared away as much as possible of his personal possessions, he has left his studio exactly as it was. As you know, the floor is littered with apparent rubbish and old magazines

etc. . . . but to the artist it is a very private place for his work (even I who consider myself one of his closest friends never ventures in there). Nothing whatsoever must be moved or even touched. . . .

"Apparent rubbish" and "even touched" had such a lofty ring, given the piles of old newspapers, books, and boxes that littered the studio floor, that the blokes at John Lelliott Ltd.—putting in a day's work—might well have imagined they now had no choice but to get on their knees in penance at the National Gallery. One stole a seemingly rejected or unfinished painting of a bullfight left in the "apparent rubbish." Bacon did not notice its absence for months, then reported the loss to the police. He was reminded of the painting stolen a decade earlier by an associate of the Kray twins, and in July of 1979, he made two comic-tinged pictures of gangsters. Valerie Beston nicknamed the two pictures, originally part of a triptych, the "Mafia triptych," which sounded too important to capture the pleasure Bacon took in caricaturing his own dream of bad boys. In the first painting, a gangster in a dark suit leered at the viewer, his wolflike teeth exaggerated and his eyes hidden. He looked like a laughing but dangerous hyena, yet very dapper, too. ("I think the most attractive man I've ever met," Bacon once said, "is Ronnie Kray.") In the second picture, two figures in dark suits and fedoras sat at ease, leaning toward each other as if engaged in private bad-guy stuff. They looked ominously still. Bacon liked to be in places where there could be, said his friend Clive Barker, "some very undesirable people." Lucian Freud, no less enamored of gangsters than Bacon, told a story about a party where Francis met a man whom he fancied, but who was already with a boyfriend. One of the Kray twins, to be helpful, offered to do away with the boyfriend. You could never quite be sure if the Krays were joking. Bacon liked that feeling, too. (By the late 1970s, the Krays were serving life sentences.)

Working with the police, Bacon set a trap for the thief, offering a reward for the return of the unfinished bullfight. The thief fell into the trap, receiving £2,500 for the stolen work, and was arrested: he was subsequently put on probation for two years. Once Bacon recovered the painting, he gleefully picked up a knife. There was sometimes no greater joy—or solace—than murdering a bad piece of art. It was another way of laughing off a failed bet.

Friends and Rivals

AFTER THREE DECADES, two of Bacon's intimate friends—Lucian Freud and Denis Wirth-Miller—began to wonder if he was worth the trouble. They came to different conclusions. The less important cause of strain, in each instance, was Bacon's new relationship with John Edwards. It was never easy to bring a much younger person into a settled environment of old friends, of course, and Bacon's infatuation perplexed some people. It was also annoying to deal not only with John but also with his friends, brothers, and the roving bands of who-are-these-people? that surrounded Bacon. Most of Bacon's friends did their best to ignore his fame. They resembled actors in a theatrical troupe who try to set aside hierarchies; outsiders might pick out a star, but backstage the actors become a communal group making a play. That spirit continued among the artists and lost boys of the Colony, but it was more difficult to maintain.

Much more important, to Freud and Wirth-Miller, was Bacon's impact on their artistic lives. The difficulty for Wirth-Miller was not one of "influence," or not the kind usually described by art historians. Denis arguably lent Francis more than he borrowed. The problem lay in Denis's lighter sensibility. He was gentler than Bacon, despite the Sturm und Drang. He was absorbed in the grasses and the subtle hues of the marshy land around Wivenhoe. There was some prick, cut, and slash in his brushwork—some turmoil in the grass—but he could reconcile himself to nature, and he had a feeling for the small or fine effect. Into this reasonably quiet place, Bacon figuratively brought spooks, a brass band, boxing gloves, and an otherworldly chorus.

Over time, Wirth-Miller—always tussling with Bacon in a playful but ambiguous way—began to wear down. So little success had come his way. In 1977, after the second apotheosis of Bacon in Paris, Wirth-Miller completed enough work for an exhibit at the Wivenhoe Arts Club. They

were good paintings. Even Bacon, who disliked Wirth-Miller's recent figurative art, expressed admiration for his landscapes. Sometime before the opening, Denis badly injured a finger. Bacon then went to Wivenhoe to nurse his friend while Dicky was abroad. Francis "was terribly kind," Denis wrote Dicky, "and slept in your bed in case I needed anything." As both an old friend and a famous artist, Bacon was especially welcome at the private view for Wirth-Miller's show at the Wivenhoe Arts Club. Denis walked outside to greet Bacon, "who was already drunk and unsteady on his feet," wrote Jon Lys Turner in *The Visitors' Book*, his biography of the Wivenhoe couple. In front of the paintings, Bacon

began to rock back and forth. The guests waited respectfully to hear his opinion. Bacon stopped rocking on his heels and started laughing. For the next ten minutes, he went around the exhibition, stopping to laugh, gesticulate and insult various works—even though he was acutely familiar with the psychological crisis his friend had endured in relation to his work. Wirth-Miller's friends and neighbours looked on in shock.

The cruelty was unconscionable. Artists did not murder artists; that was left to critics. Friends did not devastate friends; the world took care of that. Alcohol was only partly to blame for Bacon's behavior. Intense anxiety before a social occasion often led him to drink, of course, and attending any private view, particularly a friend's, could make him edgy. He hated to lie but did not want to offend. And the private view of his best friend? The pressure was only that much worse. The same courage that enabled Bacon to throw off convention in both his art and his life—to leave the closet, boo Princess Margaret, and paint *Three Studies*—sometimes led him to tell the truth when he should not have. He could not bear watching everyone politely murmuring about the nice small paintings. Why didn't Denis strike back at the world in his art? And so, with elation, the drunken Bacon erupted in wounding laughter.

The friendship between Francis and Denis rested on a paradox familiar to many homosexuals of the time: the unforgivable must be forgiven. It was a principle to which the acerbic but kindly Dicky, for one, pledged regular allegiance. Denis understood that Bacon must sometimes attack him. Denis must also sometimes attack Bacon. But Denis lacked Bacon's appetite for the larger existential fight and his willingness to risk the mortal wound. It was enough simply to quarrel with his old friend. Dicky often told Denis that he must choose between Francis and art: the obses-

sion with Bacon made his life in the studio impossible. Wirth-Miller now faced the choice again. He must give up Francis or his art.

He kept Francis. He gave up his art. He destroyed most of the paintings exhibited at the Wivenhoe Arts Club and took up other pursuits. He decided to master French, a language in which Francis was fluent. He blamed problems with his eyes for not working in the studio, but artists with bad eyes rarely stop painting. He tried to maintain his friendship with Bacon, but it was not easy for several years. It would have been unnatural if the decision to stop painting did not leave behind some curdling resentments. In December of 1978, Wirth-Miller and Bacon flew to Nice (without Chopping) and went to Monaco where they were joined by Bacon's cousin Diana Watson. A Christmas feast of roast turkey highlighted the holidays, with fireworks over Monaco's royal palace. But Bacon and Wirth-Miller appeared edgy. Denis wrote to Dicky about Bacon's heavy gambling losses. "I tried to deter him but he eventually got 24,000 francs off me—the same old song—'when I think of what I've done for you' and so on. Parted virtually no speak." Fewer than six weeks later, however, Bacon visited Wirth-Miller in Villefranche, where he was studying French. He arrived with Eddy Batache and Reinhard Hassert.

In 1978, after the Wivenhoe debacle, Bacon painted the mysterious *Landscape* (1978). It might almost have been called *In Memory of Denis*. Inside one of his transparent boxes, Bacon created a flurry of the grasslike marks that Denis used in his landscapes. Bacon would also sometimes employ this kind of mark, particularly in his early landscapes; perhaps the two artists together devised this form as they worked side by side in Denis's studio during the 1950s. In contrast to Denis's art, however, which conveyed the appearance of the landscape around him, Bacon sought something else. "I wanted it to be a landscape and look unlike a landscape," he told David Sylvester. "And so I whittled it down and down until in the end there was just a little stretch of grass left which I enclosed in the box." Bacon was hoping to attain what he called "the artificial," by which he did not mean the false or abstract. In 1981, he explained to Leiris that "realism" was always subjective when it is most profoundly expressed. "When I look at grass, sometimes I feel like pulling out a clump and transplanting it inside a frame."

In *Landscape*, he depicted only the bare rudiments of landscape. Large planes of featureless cobalt blue could signify the distant ocean and the sky; the color around the grasslike forms could evoke sand dunes; a strange scumbled violence above the grass could suggest moonlight or a brief atmospheric disturbance. There was also a large swath of vacant

black—the nothingness that often appeared in Bacon—and two red arrows implied an unknowable narrative. In contrast to the remote stillness of most of the forms and colors, the grassy marks seemed windtorn and furiously alive, like an animal trapped inside a transparent cage. There was certainly something oddly human about the grass—a gathering implication, as if the whirling dervish of shape might attain human form. Bacon was now treating landscape the way he did the popes, placing the living part of nature on a stage and exposing it inside a transparent box that traps and constrains even as it provides the illusion of freedom. Nature may suppose that, like a pope, she has a godly authority. But just beyond lies the indifferent blue. *Landscape* (1978) is nature's suppressed scream.

It was odd that Bacon painted only one—unnamed—portrait of Denis. The argument could be made (but only as a guess) that *Landscape* was among much else a concealed portrait of Denis Wirth-Miller. The picture was the first of ten artificial landscapes that do not contain a figure, though each was haunted by figural feeling, that Bacon went on to paint toward the end of his life. In spirit, they descended partly from *Landscape Near Malabata*, the desolate picture he painted in 1963 to commemorate the death of Peter Lacy. But they were also the aging artist's way of speaking simply. Taken together, wrote Sylvester, the ten paintings constituted "most of the finest paintings of Bacon's last years."

Bacon's power nourished Freud, even as it paralyzed Wirth-Miller. Freud admired, as Bacon did, those strong enough to ignore convention—aristocrats especially, but also gangsters, outsiders, or anyone able to be himself. It was not surprising that the young Freud was drawn to Bacon, who appeared so flamboyantly free. Bacon's only weakness appeared to be love, a weakness with which Freud could sympathize, but even in lovetorn moments Bacon presented an imperious confidence: he refused to conceal his homosexuality or explain the beatings.

Unlike Freud, Bacon owed nothing to traditional art schools, curried no favors, laughed off Kenneth Clark, and made pictures that resembled nothing else. And he made the touch of the flesh—so important to Freud—newly alive. Bacon's feeling for the body was always a kind of beckoning invitation to Freud, pushing him to drop the porcelain protections that represented both the charm and the weakness of his early style. Bacon seemed to get inside the paint. Others, notably Chaim Soutine and Frank Auerbach, also emphasized a fleshy physicality (as

the world around them drained into etiolated abstractions), but Bacon got so close to the body that it was no wonder Freud kept Bacon's *Two Figures* above his bed. Attracted by Bacon's power and presence, Freud rarely challenged him, as Wirth-Miller invariably did. Instead Freud joined him and became part of an unassailable rather than a quarreling couple.

The success Freud experienced at the Hayward Gallery in 1974—his first retrospective—probably initiated the strain in their friendship. Freud was now a powerful painter in his own right. And he was not shy about his power. Like two strong horses in one stall, Francis and Lucian began to stamp and kick. "When each one got very famous," said David Somerset, "they got rather protective about their own bit." Freud later said that when his work started selling, "Francis became bitter and bitchy." James Kirkman, a dealer who represented Freud after he left Marlborough, first at the Anthony d'Offay Gallery and then on his own, said that Bacon could be highly supportive of other artists—so long as the other artists weren't selling. "I remember his complaining about Frank Auerbach's work, whereas earlier on he'd been quite keen. As soon as Frank got a bit successful, 'Oh, those fucking muddy things!'" An insult intended to remain private easily spread, of course. "Lucian took the view that Francis's late paintings were frightfully bad," said Somerset. "Bacon was saying the same about Lucian. 'Such a pity he doesn't go on doing his little things.'"

Bacon was gifted at insults—and so was Freud. Freud criticized Bacon's skill as a draftsman and disliked the way, in his later work, he often evenly filled in the background behind his forms rather than animating the negative space. He told the art critic Martin Gayford, "Having a plain-coloured background and putting the subject matter as such on it is, one can really say, a recipe for illustration. Of course, the best things, when Francis worked on the whole canvas and livened it up, are very different. But when he simply put, as he did later more and more and more frequently, something onto the . . . canvas without it relating in *any* way, well of course the result was illustration." And he complained that Bacon was repeating himself. Bacon could be no less cutting, taking every opportunity, said the art critic and Freud biographer William Feaver, "to say waspish things about Lucian." Bacon called the Hayward show—a turning point in Freud's career—"far too expressionist for my liking." To Kirkman, Bacon shrugged off one of Freud's strongest paintings— *Large Interior W11 (after Watteau)* (1981–83)—by saying, "Congratulations, James. Lucian has really reached the peak of the Euston Road School"—a

reference to the group of painters who, before World War II, sought to make realistic paintings of modern everyday life in a rather dutiful left-wing way. As with all good but unfair insults, there was a small measure of truth in Bacon's charge—a note of drab depression enfolded the figures—but the true cut lay in the suggestion that Freud's instincts were proletarian rather than aristocratic; backward-, not forward-looking; and small-time rather than big-stage.

In the early 1980s, said David Russell, the new driver for the Marlborough gallery, Freud would still occasionally show up at Reece Mews around dawn, and the two would head off to Smithfield Market for breakfast in Freud's Bentley, just as they had in the old days. But their relations gradually became so strained that other friends sometimes tried to bring them back together. John Edwards once set up a conciliatory lunch with Freud, who arrived for drinks at the Connaught with Baron Thyssen-Bornemisza, the great art collector, whose portrait Freud had recently completed. Bacon came with Edwards and the Leventises, a couple whom he met and befriended in 1980 after the couple sent him a bottle of champagne in a Soho restaurant. "He was my iconic figure," said Michael Leventis. Michael, who was Greek, was a painter; Geraldine launched a successful restaurant in Maida Vale. Thyssen left after drinks, and the remaining party then went to lunch at the Dorchester. Freud was in a terrible mood. He had been with Baron Thyssen. Now, he was trapped with a cockney and some couple with a restaurant in Maida Vale?

Bacon and Freud remained friends until the 1970s, but rivalry gradually got in the way.

"Lucian made no effort at pleasantness," said Geraldine Leventis. He was particularly unpleasant to her. "'You're in the restaurant business,' he kept saying. 'Why didn't you taste the wine?'"

Graham Greene famously referred to the "splinter of ice in the heart of a writer." Neither saintly nor sentimental, a writer will do what is best for his or her own work, which can mean ending friendships that are no longer helpful. Although Bacon and Freud were occasionally sighted together, they did not pick up their dropped thread.

Bacon's most relaxed moments in the late 1970s and early 1980s came with Eddy Batache and Reinhard Hassert. Not only did they take him on trips, as Dicky and Denis did for decades, stealing him from the difficulties of the moment: they also did not arouse new anxieties. It probably helped that they were not French, but—like Bacon—people who loved France. Bacon was more comfortable speaking English than French with Eddy and Reinhard, but he liked to show off his French to other Englishmen, who had often not mastered the language. At a restaurant once, the three friends noticed the English actor Rex Harrison sitting nearby, who also noticed Francis Bacon. No acknowledgment of any kind was made except that Eddy and Reinhard observed that Francis suddenly spoke only French.

In July 1978, they drove with Bacon through the Burgundy region to Colmar, in Alsace, to see Matthias Grünewald's altarpiece in Isenheim, which had influenced Bacon as a young man. The Crucifixion scene was one of the most powerful renderings of physical suffering in art: sores pucker the body of Christ, and his nailed palms almost cry out in pain. The three travelers stayed at the Chateau d'Isenbourg, just to the south, which was a grand house surrounded by vineyards. It was a perfect day for Bacon, and one in which he would find no contradiction. Suffering acknowledged, pleasure indulged: the trip set the pattern for subsequent travels. There would often be a museum or particular painting to see, but—as Batache put it—"art was far from being the only lure in our wanderings: gastronomy and fine wine, landscapes and architecture all helped to intensify his *joie de vivre.* He would exclaim with a radiant smile: *'Isn't it wonderful to be alive?'*"

The following year, they traveled in February to Castres, in the French Pyrenees, on their winding way to Nice. Castres had a lovely small museum—the Musée Goya—with one of the most important collections of Spanish art in France. Bacon wanted to see Goya's *L'Assemblée de la Com-*

pagnie royale des Philippines (1815), which conveyed a peculiarly palpable sensation of a large and shadowy interior, one illuminated by the shafts of light that streamed down from one imposingly tall window. The echoes were almost seen, the light almost heard. "Some friends of Francis told him, 'It's quite outstanding, you have to see it,'" said Batache. "So we went there to look at it." Bacon's reaction, he said, was characteristic. "He thought it was a very good painting," said Batache. "But, you know, he was never really impressed by anything. He would be enthusiastic about one thing and then the next day he'd say, 'Yes, well, that wasn't much.'" It was only once that Batache and Hassert saw Bacon truly overcome with admiration. "It was in Amsterdam, with the Rembrandts and van Goghs, that we were able to see him in the grip of genuine jubilation."

Paris was a convenient base for trips. The three could drive to Brittany or Normandy in a few hours, though Bacon's favorite destination

Bacon and Reinhard Hassert in front of the Monte Carlo Casino, where Bacon returned again and again over the decades

remained the Riviera. Bacon usually went to Nice or Monte Carlo once or twice a year, sometimes with Wirth-Miller, sometimes with Batache and Hassert. Occasionally, Dicky made the trip. In time, Bacon came to know Eddy and Reinhard well enough to want to paint their portraits. (He granted Batache permission to use reproductions of his paintings in two of his books.) Painting their portraits was not something, as Batache understood, that Bacon undertook lightly. "His models can be counted on the fingers of both hands." He would only paint faces and features that he found "sufficiently interesting," and "he also had to have known you for a long time, because what fascinated him beyond appearances, and what he needed to fuel his creativity, was your inner self." Bacon even asked Batache to shave his beard, saying that he must see the shape of the face and head before he could paint the portrait. And so he shaved it off—only to have Bacon murmur, "Oh no! You were better with it."

It took Bacon three weeks to finish the pair of portraits, said Batache, and "we weren't allowed in to see it till it was finished." The result was a pairing of intimate, pastel-colored images that stand apart from the other portraits of the period. Instead of the more typical dark background found in many small head paintings of the 1970s, Bacon used a pale blue. Hassert's and Batache's cheeks and chin were painted in a purplish and pink tint. The small diptych paired Hassert on the left—one eye obscured and the other magnified and gazing out directly at the viewer—with Batache on the right, also staring intently at the viewer and with a sketched-in beard. In the portraits of his young friends there was something both sprightly and intimate, a sign of his affection for them. The color in the portraits owed a debt to the pastel coloring in Chardin's self-portraits, which the three friends had recently examined together; Chardin's way of painting round spectacles on a nose fascinated Bacon. When he showed the couple their portraits, said Reinhard, he appeared "shy."

The year before, Bacon had painted a similar portrait of his friend Clive Barker, who had been one of the stars of Robert Fraser's trendy gallery in the 1960s. Born in 1940, Barker was a year younger than Batache and a year older than Reinhard. Bacon and Barker maintained an easy friendship over the years. In 1978, Bacon admired a sculpture Barker made for one of Bacon's favorite restaurants, MR CHOW, that depicted three Peking ducks hanging down on a rail. Bacon told Barker: "That's what I want to do. A figure on a rail that I can move around." Bacon painted several works with the idea in mind, seemingly drawn to the image of a sculptural male body in motion. Then, when Bacon proposed painting a portrait of Barker, the younger artist suggested a portrait idea of his own—specifically, a series of life masks of Bacon. "He had been looking at a show—it might have been at the British Museum," said Barker. "Of gold Aztec masks. He thought it was so marvelous."

The process of making a life mask was intimidating, particularly for an asthmatic. Bacon would have to lie perfectly still for almost an hour, breathing through a straw while the liquid mask hardened (no longer made of plaster, said Barker, but a "new rubbery Swiss material. You boiled it and then let it cool"). In the end, Bacon could not resist the challenge, the discomfort, or the historical example. Not only had William Blake agreed to have a life mask made, but Bacon owned one of the Blake life masks. And so, Bacon "lay on the couch," said Barker. "I told him, 'Francis, there's going to be no way to communicate. So I'm going to hold your hand. Squeeze my hand if it gets to be too much.'" Barker painted on the rubber as Bacon sucked on the straw, then added a layer of plaster. Bacon proved an ideal subject, although he later called the

process "right difficult." The idea of a life mask naturally appealed to an aging artist who spent his life disrupting faces and contemplating death.

One day not long afterward, Bacon telephoned Barker to tell him that he had completed a small triptych of him from Polaroid photographs taken by Barker's wife. "He did them in Paris," said Barker, but shipped them to Reece Mews. He asked Barker over for a look. "I remember standing looking at them in his studio. He was sitting there having a cup of tea. 'You know, I don't think that looks anything like me,' I said of one of them. 'It's a strange one.'" The next time Barker visited the studio, the "strange" panel was out of its frame "and the other two were now framed as two." Bacon gave the diptych to Barker.

In Paris, Batache and Hassert had a hand—serendipitously—in helping Bacon complete, at the end of the decade, another of his new "landscape" paintings. As early as December of 1977, on a visit to Monte Carlo over Christmas, Bacon was talking about painting a wave of water. "He was in the Hotel Westminster," said Louis le Brocquy, "and looking at the sea because he wanted to paint a wave." He did not have in mind a wave mildly lapping on the seashore. He was imagining, said le Brocquy, "*jeux d'eau* [water games] in the bathroom of the mind. That's what is extraordinary." The idea of painting some kind of wave continued well after Bacon completed *Landscape* (1978), and into March of 1979, when, now struggling to paint the idea, he talked at length to his neighbor Madame Veličković about his efforts. It seemed impossible to paint a wave. He doubted he would succeed.

At one point, Bacon invited Batache and Hassert to his studio to examine the painting, which he was not certain was completed. "He would sometimes share his doubts with us when a work was finished," said Batache, "and even asked our opinion on occasion." What they saw was an erupting arc of water in a disembodied landscape. The spurting jet, at the center of the image, was framed by pipes and rectilinear pink structures. "The only possibility of doing it," Bacon said to David Sylvester while working out his ideas, "will be to put the beach and the wave on a kind of . . . artificial structure." Bacon told Batache and Reinhard, "It's finished; but I'm not happy with it. I have a feeling there's something missing but I don't know what." At that moment, the phone rang. Bacon left them looking at the painting. Batache pointed out what he considered a problem to Reinhard—an empty space on the canvas:

I did not realize that Francis had not taken his eyes off us while he was on the phone. He was back very soon: "I saw what you were pointing at, Eddy. You're right. That's exactly where something

needs to be done. I know just what to do." He quickly pulled on his gloves and, with all his strength, hurled a pellet of white paint at the canvas, which stuck by chance in the desired area. After that, it only took him a few minutes to blend the paint into the canvas.

Batache and Hassert felt "shaken" by the risk Bacon took. What if the pellet of white paint had missed and the painting had been ruined? They recognized that *Jet of Water* (1979) was an unusual picture. It would be another of the small late group that lacked a figure. It was certainly more evocative (and provocative) than a term like "wave" or "artificial structure" could suggest. The painting depicted an explosive release of tension that the rational geometry of pipes and plumbing could not suppress. It could be a burst pipe, an erupting fountain, a ruptured manhole. It could be the overpowering wave of male sexual orgasm. All settled form was momentarily destroyed by the explosive "jet." It was not possible to say whether the release was angry or joyful, destructive or cathartic. It simply appeared necessary.

If the wave sounded, the sky was silent. Under the calm and careless sky the glorious eruption would fall back soon enough, of course, becoming just another puddle. Perhaps, in *Jet of Water*, Bacon was also thinking of the pressure of time.

Illness and death now regularly interrupted Bacon. In August of 1977, the younger of his sisters, Winifred, suffering from multiple sclerosis in Rhodesia, came to London for treatment and was admitted to the Royal Hospital and Home for Incurables. The name itself, to a man like Bacon, must have aroused a feeling of Victorian dread. Bacon never had much to say to Winnie, but he remained loyal. "Eventually Winnie couldn't cope at all," said his sister Ianthe. "Then Francis offered to look after her." Not only did Bacon arrange for her transport; he also wrote, in a letter of July 22, 1977, to the Royal Hospital, that he had now "undertaken to be responsible for all payments." Winnie had money in Rhodesia that could be tapped, he wrote, "but should there be any delay in arranging this, I will in the meantime make any payments that become due." Bacon made certain she had a color television set.

Muriel Belcher began to have medical problems in the mid-1970s. She may have had a minor stroke in late 1974 and subsequently fell and broke her thighbone. She became increasingly frail later in the decade. It seemed a crime against the natural order, Muriel's frailty: she must

remain forever the half mother, half dragon, guarding the door. Bacon paid her medical bills, too. And something was going wrong with Sonia Orwell. In the spring of 1977, she impulsively moved to Paris, leaving her two-story house on Gloucester Road. Her friends were shocked. She was a Londoner who was also a Parisian, not a Parisian who was also a Londoner. She did not move like Bacon into an elegant space near the place des Vosges. "She rented a single damp furnished room, on the ground floor of a block on the rue d'Assas, with a basement kitchen that smelt of escaping gas," wrote Hilary Spurling in *The Girl from the Fiction Department*. "She had no oven and no bath. People who visited her in Paris were bewildered."

In 1979, at the Colony, Muriel fell again and knocked out her two front teeth. Only Robert Carrier, among the drinkers that day, rushed to her assistance. Soon, she was bedridden in her flat in Wellington Court, in the West End theater district. In early August, Bacon took Muriel's partner, Carmel, to dinner at Wheeler's. Valerie Beston was also there—and noted in her diary, for the first time, the presence of John Edwards. Bacon, she wrote, was "very depressed." Eventually, Belcher moved into Athlone House, a convalescent facility connected to Middlesex Hospital. "When Ian [Board] told Francis how ill Muriel was, he wept," said the artist and Colony regular Michael Clark. "That was the only time I saw [Bacon] cry." Bacon regularly visited Muriel, who shared a room with a rather starchy, old-fashioned lady. At each visit, Muriel greeted Bacon with a cheery, "Hello, daughter!" Eventually, the lady in the neighboring bed asked Bacon, "Are you a woman?" Bacon thought about it. "Sometimes."

In one memorably difficult week, Bacon visited Muriel at Athlone House in Hampstead and, two days later, his sister at the Royal Hospital and Home for Incurables in Putney. He continued to visit Muriel periodically until her death on Halloween in 1979. (She was cremated on Guy Fawkes Day, November 5.) Before she died, Bacon—with Muriel's blessing—arranged for John Edwards to assume the lease on her flat. "In order to transfer the flat to John, at the suggestion of Francis," said Brian Clarke, "John changed his name to John Belcher Edwards." That way it would stay in the "family."

In 1980, Sonia Orwell returned to London, now suffering from a brain tumor that would eventually cause her to hallucinate—and penniless after a bitter copyright battle over George Orwell's writing. "Sonia came back to England to spend the final months of her life camping out in hotels, friends' spare bedrooms, and eventually public hospital wards,"

wrote Spurling. Flowers, cards, letters, and phone calls arrived from friends attempting to track her down. The Spenders invited her to stay. "Mary McCarthy sent a long, fond, gossipy letter, begging her to come to Maine for the summer. Francis Bacon's French dealer, Claude Bernard, offered his house and staff." In the end, Orwell spent her last days at Blakes, a small luxury hotel in Roland Gardens not far from the studio that Bacon once purchased and then gave to George. It was Bacon who brought Sonia from the hospital to Blakes. Valerie Beston ordered lavish bouquets of flowers. Bacon did not visit her while she was actually in the hospital. "He used to have to go see his sister at the Hospital for Incurable Diseases," said Paul Brass, who also tended to Sonia. "And he told me that the days before he knew he was going, he felt absolutely sickened ill." But Bacon visited and served Sonia attentively at Blakes, where he paid the bills. One night in December she died after being rushed to St. Stephen's, an acute-care hospital in Chelsea. Bacon's closest French friends—Michel and Zette Leiris and Nadine Haim—came to the funeral in London a week later.

His sister continued to fail. Not long after Belcher died, Winnie also broke her hip. Valerie Beston visited her more often than Bacon did, but when the hospital called one night in March of 1981 to report that Winnie had fallen ill with a chest infection then sweeping through the hospital, both of them went to her side. Her son John Stephenson arrived on March 23 from Tanzania, and four days later Winnie died. Bacon hosted a lunch for John and his wife, Susan. Bacon had always portrayed Winnie to his friends as someone unlucky in love and in life. They had nothing in common, but she was family, and Bacon would honor the connection.

Three people close to Bacon had now suffered slow, wasting deaths, the kind Bacon himself most feared. It was likely Muriel's death in 1979 that particularly troubled Bacon the most. She had provided the stage—for three decades—for so many days and nights. Her death marked the end of an era, which was also his era. In the months before her death, Bacon had been working on a large triptych based on the story of Oedipus and the Sphinx. He retained only the left panel—a depiction of the Great Sphinx of Giza—that began to assume the unmistakable features of Muriel. It was no longer a lion's paws but a woman's arms that, in *Sphinx—Portrait of Muriel Belcher* (1979), stretched catlike before the world. "Francis came into the club one afternoon and was in an elated mood," said Michael Clark. "He said, 'I've just finished this painting called *The Sphinx*. And the extraordinary thing is that it looks just like Muriel.'"

Bacon's sense of control slipped in the late 1970s. It was a loss when Lucian was no longer regularly there. It was a loss when Denis stopped painting, and Bacon could no longer be certain of their relationship. It was a loss when John Deakin died and then Sonia and Winnie too, all of them younger than Bacon. And Muriel was his age, or just a year older. The Colony could no longer be the same kind of home. In this situation, the relationship with John Edwards became all the more important to Bacon. John could provide focus. John could fill the hours. And yet, John was not quite yielding to him. He would not drop everything. In *Study for Self-Portrait* (1979) Bacon painted an image of crushing pathos, portraying himself as a ghostly old queen with blood-shot eyes, powdered cheeks, and pursed red lips. His haunted eyes stared to one side. The facial cake could not conceal the wounds of age. The mask might fall at any moment, it seemed, into a heap of dust, powder, and rouge.

Bacon resented anyone—not only Philip Mordue—who fancied John. "Francis was very, very jealous," said Michael Dillon, a former actor and Colony regular who eventually took over Gerry's, a neighboring club in Soho for actors, writers, and theater people. Once, when Edwards was paying attention to Dillon—a man about his own age—Bacon expostulated: "What are you two up to? I'm going home." Neither young man felt intimidated. Dillon told him, "Sit down." Edwards said, "You fucking silly old queen, behave yourself. Sit down." In her diary on February 28, 1980, Valerie Beston noted: "FB very depressed over JE. Feels he cannot paint ever again." Bacon regularly booked the train to Paris in order to escape and just as regularly came back to John. The aging Bacon was slowly beginning to acknowledge that in the struggle to possess John Edwards, Philip Mordue might have the stronger hand.

David Plante captured the uncertain dynamics of the relationship during this period when he and his partner, the poet and editor Nikos Stangos, dined with Edwards and Bacon in 1979 at MR CHOW in Knightsbridge. The dinner was ostensibly to discuss a book about Bacon's art. But Bacon brought John along and introduced him, inaccurately, with a jaunty "haven't known him long, six weeks or so." Bacon and Edwards began edgily bantering. "There was very little discussion about the book":

Francis said, "John doesn't like my paintings. Do you?"
"Fuckin' awful I think they are."

Francis laughed.

John said, "He can't even do a fuckin' drawin."

"It's true," Francis said, "I can't. I can't draw at all. I can't do anything."

"You fuckin' can't."

"Nikos and I got on very well with John," Plante wrote, shrewdly noting, "Francis less so, but maybe not getting on for them was getting on." Toward the end of the evening, Edwards "braced" Bacon for standing him up on a date the week before. "Francis, clasping John's hand, said over and over, 'I'm sorry. I had to see a Belgian dealer. I had to. You have no idea how hard it is to sell my paintings. No one wants them.' 'Fuckin' right,' John said." The evening appeared to end badly when John disappeared, as he was prone to do. Later, Bacon, Stangos, and Plante found him standing outside the pub next to Mr Chow. "John said, staring aggressively at Francis, 'You'll have a whiskey,'" wrote Plante. "'No,' said Francis. 'That's what you'll have,' John said, and he ordered a whiskey for Francis, who shrugged."

Among the drinkers in the pub were "two boys, one with dyed red, the other bleached hair, wearing what looked like public-school uniforms, their ties askew," wrote Plante. "They might have been Piccadilly boy whores." Earlier, Bacon had said, "John really likes boys. That's what he likes," while John was looking past Bacon at the boys with dyed hair. "That's my scene," Edwards said. When Plante offered to drive Edwards and Bacon home, John said, "No, just leave me here with Francis. We'll sort things out. Won't we, Francis?" "Anything you say," replied Francis, "with a bright, matter-of-fact voice." Bacon called the next morning to make sure that Plante and Stangos had arrived home safely. "He said John was there, getting dressed."

Love and Money

Early in his relationship with Bacon, John Edwards went to see Dr. Brass. After the examination he asked the doctor to "come outside, have a look at the car." Dr. Brass was impressed. "I mean it was one of these 120 mph things," he said, "but very small, a mini Renault. Within two days he'd had the most terrible accident in it and I think Philip [Mordue] was in there and broke his leg very badly and you know it was a disaster. And the next thing I knew . . . he was driving a much bigger car, much more luxurious car, and not a speedster." In fact, John was now driving a Bentley. He ordered a vanity plate: VIP Boy.

It was probably in late 1979 or early 1980 that Bacon's relationship with John began to settle down. John began to spend more time at Reece Mews, and he now accompanied Bacon openly to public events. John thought of himself as a son rather than a lover—Bacon's boy in a Bentley. Edwards, who did not conceal his homosexuality, repeatedly told others that his liaison with Francis was never sexual, which—while not literally so, at least early on—was true in one important respect. John did not give up his life with his romantic partner, Philip Mordue. Bacon had arrived, in short, at a remarkable concession: to have John he could not possess him. They probably never directly spoke of such matters. Neither Bacon nor a cockney like John would go on about "bloody feelings." In 1981, when Bacon finally gave Edwards the key to 7 Reece Mews, they both understood what it locked and did not lock.

In February of 1980, John Edwards became almost family, entering Bacon's art in the small triptych *Three Studies for a Portrait of John Edwards* (1980). Bacon had painted John before—the subject in *Study for a Portrait* (1979) looked like Edwards—but with his identity concealed. In this triptych, Bacon gave Edwards movie-star looks and set him against a gentle blue background. His features were hardly distorted. Bacon even reworked the center panel to remove a black circle that obscured

Edwards's mouth. Soon afterward, he painted a flattering triptych of Peter Beard—another handsome younger friend—and followed that with the astonishing *Three Studies for Self-Portrait, 1980* in which he presented himself as nothing like the haunted queen of the year before. Bacon took decades off his life and blended certain appealing features of Beard and Edwards into his own appearance. He set himself against the same gentle blue background that he used in the triptych of John. Not surprisingly, he still looked more melancholy than John or Peter did. And he trimmed the images on three sides with black, perhaps responding to the way Richard Avedon edged some portraits with the black border of a contact sheet. (Avedon photographed Bacon using that same conceit in April of 1979.) Compared with the previous self-portraits, however, the new one suggested both late love and the desire of an older man to recover his lost youth.

Now that John was "with" Francis, Valerie Beston's diary filled with reports of "JE" at dinner, "JE" gambling, "JE" traveling to Wivenhoe. Bacon paid all of John's living expenses and enjoyed teaching the younger man the finer facts of life. He bought his-and-her gifts. If Bacon was wearing a shockingly expensive Rolex GMT-Master II, he would give John a Rolex, too. Unlike George Dyer, however, Edwards never wanted to rise above his family, a cockney clan with a powerful and protective mother. The six children looked after one another and wanted to get ahead together. Just as Dyer's oldest brother, Ronnie, kept an eye out for George, so David Edwards watched over John. "They were a similar age, they were both gay and both liked to drink," according to Philip Mordue. After an early marriage, David became the partner of John Tanner, an interior designer and dressage rider in Suffolk. David, an entrepreneurial man, then began to find business opportunities in Suffolk.

The Edwards family was not pleased with the homosexuality of either David or John, but came to accept it. "Both my older brother and my father were champion amateur boxers, so it didn't go down too well to have two poofs in the family," said David. "If we had been gay and poor, it would have been a problem. Fortunately, we both made good money and with that came respectability." After being a successful publican in London, David—encouraged by his interior-decorator partner—began to deal antiques in Suffolk. It was a business that was growing during the 1970s as people bought second homes for renovation and the desire in America for anything old and English began to intensify. In 1976, David and John Tanner purchased a Georgian house in Long Melford, Suffolk, near the border of Essex (and close to Wivenhoe) that signified suc-

cess, especially in the postwar period when thousands of cockneys left the bombed-out East End to settle in the neighboring counties of Essex and Suffolk.

It was never possible to isolate John from his clan, and Bacon began to spend time at gatherings of friends and family at the Long Melford house. Bacon knew the Suffolk area. Not only did Dicky and Denis live in nearby Wivenhoe, but decades before his family would visit his uncle Lesley Firth, who left Ireland and its "Troubles" behind in 1922 to rent Cavendish Hall, a Regency estate in Suffolk with thirty parklike acres and many outbuildings. The area was prime horse country: the Newmarket Racecourse was nearby. (It was at Cavendish Hall that Bacon had dressed up as a flapper.) Cavendish Hall had recently come back to the Firth family, almost fifty years later, when the husband of Pamela Firth bought it for her in 1969, aware of its links to the family. Evenings with the Edwards family at Long Melford were convivial. Bacon's cockney nickname became "Eggs"—from "eggs and bacon"—and David's partner, John Tanner, answered to "Sixpence"—a "tanner" was slang for sixpence. Bacon liked to sing with the others around the piano. His favorite was "Maybe It's Because I'm a Londoner," which had a music-hall lilt. No doubt Bacon enjoyed such occasions, but he always preferred, when possible, to keep John to himself.

In the early 1980s, Edwards spent much of his time in London. What Bacon's next-door neighbor John Spero—who ran a car business at the head of the mews—remembered most about John and Francis was simply their "happiness." It was perhaps sentimental, but also a fact, that the dark, brooding, and world-renowned painter Francis Bacon gloried in Edwards's sunny smile. The open smile lit up Reece Mews. Spero called John a "really incredible" chap. "He was just a wonderful character. He was always having a laugh." Like everyone else, Spero did not pretend to understand their relationship. "You know, I never asked Francis, 'What's your relationship with John?'" he said. "Or I never asked John, 'What's your relationship with Francis?' They were just a very happy couple. They really were."

Wendy Knott, who was married to Bacon's nephew Keith, felt the same way. "I never really figured them out. There was no signal that they were a couple. I would say more a fatherly affection than anything else." John was "good-looking, not handsome," she thought, but with wonderfully engaging manners: "I knew he was gay but it wasn't obvious." Even though Bacon and Edwards "never really showed any emotion or affection towards each other," she said, "once he met John it was always John

there in the background. I think Francis liked him to be there [at family events]." Even the photos of Edwards taken at the time conveyed an informal easiness. In one picture from early in the relationship, John's hair curled like a beckoning finger and he seemed lazily at home in his pullover. He stared at the camera in a familiar, or familial, way.

Every now and then, John went missing. It was a long-standing habit of Edwards to disappear, dating from years before, but it was also a way to remind Francis of his independence. "I knew sometimes he'd go off to Scotland for a few days," said David Marrion. "He'd got this van there." His family always worried when he went missing: "They'd phone up and say, 'David, go and find our John.'" Bacon took these family worries to a new level. He feared that East End thugs would kidnap John, for example, and demand a ransom. "Francis was always frantic," said Marrion, ". . . that he had been kidnapped. And that it was too late to call John's mother, you know." But Edwards would not be monitored. He "had his own agenda," said Marrion. "'Not today.' And 'I'm going away for a week or two weeks' holiday.' And maybe Francis didn't like it. But then, that was it." In a typical diary entry (July 6, 1981), Valerie Beston noted: "Dinner at Mr Chow's. JE does not turn up. FB preoccupied with him."

Friends noted the contrasts between George and John, despite their similar backgrounds and good looks. George was clingy, paralyzingly shy, and sometimes could hardly speak, said Marrion. Edwards, by contrast, conveyed strength. Gilbert Lloyd, who observed Edwards in Bacon's company many times at the Marlborough gallery, thought "he had a very cockney personality: he was always very upbeat and quite good fun, and a very sort of streetwise guy by London standards. I could understand what Francis saw in him. He was not just a boy toy." Most of Bacon's friends readily accepted Edwards. "John was a good East End boy," said David Russell. "He talked a little bit hesitant. But East End. Cockney. I don't think he took advantage of Francis . . . I imagine if he really took the piss out of Francis, Francis would have dumped him." Michael Dillon also found Edwards "charming—no pretensions. I told him about [books on tape]. He said, 'Oh, my God.' The first one I gave him was *The Eagle Has Landed*." Stephen Spender, warmed by Edwards's boyish charm, complimented Bacon on finding someone like that. Spender assumed that since Edwards could hardly read or write, he could focus all his attention on Bacon now that, as Marrion put it, "it was just him."

But Bacon could not easily introduce John into some parts of his life. Edwards had no interest in Bacon's little house in Wivenhoe, for example, especially since his brother David lived not far away. And Denis Wirth-

Miller, after he gave up painting, could not stand to be around Edwards; or, perhaps more accurately, he could not tolerate Bacon's devotion to John. Perhaps he was still smarting (more than he would acknowledge) from Bacon's wounding words at his show in Wivenhoe. That rejection plus the Edwards infatuation finally proved too much. Toward the end of 1981, Bacon told Dicky and Denis, "It's no good. We can't get on. There it is." For a period of time, according to the Beston diaries, the three drifted apart. They had lunch in February of 1982 and then they managed a trip a year later that began in Chartres and progressed to Aix-en-Provence before returning to Wivenhoe by way of Brittany. For the next two years, however, there were no further references in Beston's diary to trips abroad with Dicky and Denis—or even of visits in Wivenhoe. In May of 1983, Denis called Bacon, which only underscored the painful rift between them. Chopping observed in his diary:

> [Denis] drunk telephoned FB. I spoke to him. [Denis] went out. Francis told me he realized that we had nothing in common and there was no use our having any relationship. Talked half an hour. I felt very sad. [Denis] back then he went to the pub. Back around 11 p.m., abuse until around 12:45. Violence. We both hit each other. He tried to kick me in the balls.

Not long afterwards, Bacon decided to sell the house in Wivenhoe after eight years of infrequent stays. "Francis didn't work here for very long at a time," said Pam Dan. "He would get fed up with the little house here. He'd spend three or four days at the most." Bacon and Edwards packed up the house in June and then Bacon sold it to Wirth-Miller, to whom he had promised the right of first refusal. That September, he wrote to thank Denis "for the 500 pounds towards the 5,000 pounds we verbally agreed on." He also asked if Denis would like Frank Auerbach to take a look at the house, with an eye to renting it. The tone of Bacon's letter was markedly different from the ones he sent Denis in the past, which were signed with "love" or "fondest love." This one ended, "With best wishes."

Bacon could not successfully introduce John to Paris. He tried, booking them into the Hôtel des Saints-Pères in April 1981, the same hotel where George had died ten years before. (Bacon's Paris studio was too small to hold them both.) But John took no interest in France—cultural or culinary—and there was no easy way to place him at a table in a great restaurant with a mandarin like Leiris. "It was very difficult for John,"

said Brian Clarke. "He didn't like Paris." English intellectuals and artists instinctively understood Bacon's interest in John, but it may have been harder for Leiris and his wife to accept. It was probably during this April trip—Bacon returned to London with Edwards only two weeks later—that he realized that his decision to live in Paris was a dream that could not be fulfilled. London was reality. And London was now John. He wrote Leiris that while in Paris he had felt "terribly sad and gloomy and absolutely listless. I was unable to work."

The most difficult part of John's life to integrate into Bacon's world was, not surprisingly, Philip Mordue, whose presence shadowed Bacon from the beginning. Bacon never stopped worrying about Mordue's love for John—or John's love for Mordue. Bacon expressed a dislike of Mordue's character. He feared him not only as a rival but also as someone who, he believed, continually skirted the law. He would lament to friends, "Why can't I get rid of Philip?" Both Edwards and Mordue, in playing the sexual field, were attracted to troubled adolescents. (They were themselves troubled adolescents not long before.) "I seem to recall Francis worrying about John because he was getting involved with underage," said Wendy Knott. "And I know he brought it up in my company."

Bacon sometimes became concerned that he was being hustled. Philip appeared to accept John's new familial relationship with Bacon but was also aware of how much money such a "son" could expect. No one understood better than Bacon did the shadowy space between money and love. Early in 1981, Mordue fell afoul of the law and was sentenced to serve nine months at Her Majesty's Prison in Coldingley, Surrey. Concerned that his position might interfere with Bacon's support of John, Mordue wrote Bacon a remarkable letter from prison. He suggested that his own love for Edwards should reassure Bacon that Mordue would not interfere in their relationship: "I think I owe you the promise and assurance of no aggro when I get out, you know what I mean don't you? I may as well try to explain; I do realize that by me acting the goat, I could put Johns future in jeopardy. If my love is true for him, I am not about to do that, am I? On that score I think I realize my responsibility." He ended his letter by saying, "Truly Francis I am a better person than I was and I do now have a conscience to guide me."

Philip's imprisonment sent John into a dangerous, unexpected tailspin. On March 6, 1981, when Dicky Chopping was in London and visited Reese Mews, he found Edwards with a broken foot and a bruised ear and eye. He'd been in a fight. A few months later, Bacon was having dinner with Nikos Stangos and David Plante when the waiter came and

whispered something to him. Edwards was outside, drunk. John joined the table and pulled out a photo of himself and Mordue, who had recently been given a three-day pass from prison. Then Edwards leaned across the table and whispered something to Bacon—at which point Bacon erupted angrily: "That's ridiculous and I'm not going to listen to it. That you want to kill yourself is ridiculous. I'm not going to listen to it." Nothing could be worse for Bacon, of course, than the prospect of another lover committing suicide. By the end of the year—as Valerie Beston reported after a call from Bacon—John was "getting blind drunk." The George story appeared to be playing out again. Bacon began to tell Miss Beston he would stop supporting John.

In March of 1982, Bacon became enraged when he discovered that John had sold a fragment of a painting out of his studio to Robert Fraser for a thousand pounds. No doubt the two were drunk when Edwards let Fraser into 7 Reece Mews with his key. Bacon was not home and felt violated—although Brian Clarke thought that Bacon also liked it when John "nicked" his paintings. (It happened so frequently, said Clarke, that stolen paintings became known as "John Edwards specials.") They were mostly paintings destined for the trash: John even cut out the heads in front of Bacon, leaving little room for doubt about what he planned to do. This time, however, seemed different. Bacon telephoned Valerie Beston at eleven-thirty at night to report the outrage. When Edwards assured Bacon the next day that he had not, in fact, let Fraser into the actual studio, the two made up. Bacon's inability to control Edwards, speculated David Marrion, added to John's appeal. "He wouldn't have wanted someone who was um, 'Yes, yes, yes, yes, yes,' you know," said Marrion. "He liked the challenge. It was a challenge to keep ahold of [Edwards] and it kept [Bacon] young as well."

The incident underscored John's unpredictability, however. Bacon began to look for a flat in the neighborhood where John could take a friend while still remaining close to Bacon. He was also growing somewhat concerned about his own situation at Reece Mews; there was gossip on the close-knit street that developers were eyeing the properties. In September of 1982, Bacon put down a deposit for a fine, airy flat at 21-22 Stanhope Gardens, a well-proportioned, six-story London town house with an impressive terrace and columned doorway two minutes from Reece Mews. His family could stay there; and, in extremis, he could use it as a temporary studio. "It was a lovely flat," said Ianthe. "I think there were only two rooms. It was about three floors up. There was a lift. It was a big sitting room with a little kitchen off of it. It had lovely big

windows." Edwards began to spend most of his time in London there. His brother David, the antiques dealer, also took an interest in the flat. It soon contained two Biedermeier sideboards, along with a new easel that Bacon never used.

The best way to stabilize John's life would be, Bacon thought, to buy him a pub in London. Not a pub to manage, since John could not keep to a schedule, but a pub whose license he owned. Early in 1982, Edwards began interviewing for the highly desirable license to a cozy pub in Knightsbridge named the Nags Head. A further interview was scheduled for April. John's mood improved. Philip Mordue wrote from prison: "I do hope everything comes good at the pub as John lacks the sparkle and bubble he had at the Swan." During this period, Bacon and Edwards were friendly with a pub manager named Kevin Moran, who had friends in both fashionable London and the East End. Moran was an ex-Guardsman (a group especially admired among many gay men) and a member of the Colony. He had "connections," as he liked to put it. After some colorful years in Soho, Moran worked on the King's Road as the manager of the Man in the Moon pub. Tom Baker, an actor known for playing Doctor Who in the 1970s BBC science fiction series and a Colony Club member, told Moran: "Get Francis to come to the Man in the Moon. It will inject excitement." Sometimes Bacon spent Sunday afternoons there with Ian Board. "I would close at two," said Moran, "and we'd go to the Hungry Horse," a restaurant that Bacon enjoyed on Fulham Road.

It was not surprising, then, that Edwards confided to Moran that he was applying for the Nags Head. "I got to know about this through John and Francis," said Moran. "They were going to turn it into a gay pub. To have a pub that's free of ties is rare. It's an achievement to get one. I went around them. I got it. . . ." The sneaky maneuver devastated Edwards and infuriated his family. "They were going to beat me up," said Moran. "From then on when I went in to the Colony I heard *zzzzz*." Running a pub would have suited Edwards, said Brian Clarke. "John really wanted to own a pub because it was something he knew. He would have been a very good host in a bar." To console John, Bacon gave him a trip to Las Vegas. Edwards liked pleasure-oriented places without any air of sniffy cultural importance: he later lived in Bokeelia, Florida—near Fort Myers—for a year after Bacon's death and then in 1993 moved with Mordue to Pattaya, Thailand, a beach town organized around cheap sex and cheaper beer.

It was difficult for Edwards to find a suitable job, one that also gave him

time to accompany Bacon. George had faced the same quandary. David Edwards, in 1982, encouraged John to sell antiques with him. On a visa application in 1982, John listed his profession as "self-employed antiques dealer." A typical Valerie Beston entry on August 9, 1982, noted that John Edwards was "busy antique-buying." John had a salesman's knack and "was a little entrepreneurish," said David Russell. "He was always buying and selling. He would go to an auction and buy a piano. Then he'd be on the phone selling it before he'd even bought it." Suddenly, however, there was more trouble. In August of 1982, the police stopped an intoxicated Edwards, who then broke a milk bottle and brandished it. The police arrested him. Bacon became concerned that John, given his previous record of arrests for driving while intoxicated, would end up in jail if he pleaded not guilty. In the end, he received no jail time, but the incident was not resolved until the summer of 1983 and underscored the dangers of his disorderly life.

John began to think of spending more time outside London. A few years after Muriel Belcher died—having bequeathed the lease on her Wellington Court flat to Edwards—a developer trying to remove tenants from the building paid him £25,000. He used the windfall to buy a house for £27,000 near where his brother David and John Tanner lived in Suffolk. The house was called the Old School House, soon shortened to "Schoolhouse," a name that must have amused Edwards given his history of school delinquency. It was a small redbrick Victorian located on the green in Sudbury, an eight-mile trip from David's house. John and Philip Mordue soon began to expand and renovate the Schoolhouse with Bacon's money. "Francis did all the decorating," said Brian Clarke drily. Throughout, Edwards remained Bacon's dutiful companion. In the spring of 1983, for example, he helped Bacon chop to pieces all the paintings stored on the left side of the studio at Reece Mews—to Bacon, a marvelous chore. It was lovely to watch a handsome young man destroy his art. Valerie Beston was naturally aghast ("5 sacks of cut up pieces") and rued the loss to history and pocketbook.

A young friend of Bacon's viewed John as "almost like a butler. He had his own independence, but in many ways he would sort Francis out"— something a son might do for an elderly father. And Bacon would sort out John, in turn, the way a mother brushes lint off a son's shoulder or a father opens his wallet. Whenever Edwards walked into the Colony, said the art dealer Paul Conran, Bacon gave him money—"like a son"— and reviewed his appearance. "He insisted that John be very well turned out—in very expensive Savile Row or bespoke suits. If Edwards came

in with his tie awry, Francis would attack, tell him he was unkempt, 'Fix your tie.'"

Edwards began to spend about half his time in London, said Clarke, and half in the country. When he was at Stanhope Gardens, he dropped in and out of Reece Mews. "They may have been out all night, but John never seemed to be there all night," said Bacon's neighbor John Spero. "He'd be back, back in the morning." In the evenings, said Spero, John always looked "terribly smart." So did Bacon: "He'd have these wonderful suits on when he was going to some particular thing in the West End or something like that." John would sometimes pick up Bacon in his VIP BOY Bentley. Even so, the mornings were probably their most important time together. John would visit "Eggs," usually with a smile, and Francis would scramble eggs for breakfast. And then Edwards would leave Bacon to his painting.

When Edwards was away, Bacon filled the time with new friends like the Leventises and old acquaintances living near his house in Reece Mews, such as John Spero and the composer Lionel Bart, his neighbors on either side. Often Bacon ate a late lunch at Pulcinella, a homey Italian restaurant at the entrance to the mews, where, said Felice Pollano, who worked there, he was sometimes accompanied by Bart or the photographer David Bailey or Jeremy Tree, a trainer of racehorses. Invariably, Bacon ordered his favorite Barolo wine, Pio Cesare. Pollano occasionally catered an intimate gambling party of three or four people at 7 Reece Mews; John Normile said that Bacon kept "a great big roulette table" at the top of the steep stairs. There was "never enough" gambling, said Pollano, for Francis Bacon.

If John was in the country and Bacon needed help with something he often called upon a young Canadian named Barry Joule. They met one morning in 1978, when Bacon leaned out his kitchen window after a big storm and asked a man whom he spotted in the street below if his TV aerial had blown over. The young man lived on Manson Place, the short street just behind Reece Mews. Joule was interested in music, art, photography, and especially ballet. He was often at the Royal Opera House (home of the Royal Ballet) and, like many balletomanes, lived for the backstage talk and gossip that surrounds theatrical troupes. He was always looking for a pound and an edge—a situation Bacon found poignant—and knew how to make himself useful. A friend of Joule "had the flower contract [at the Royal Opera House] and did special occa-

sions," said Joule. "When she wanted muscle, I would take her Land Rover, pick up trees, and decorate the stage. And she was well connected." The odd jobs opened other doors. Joule "would go to performances. The ushers would point out vacant seats." He "got to Maude Gosling. She was Nureyev's surrogate mother." Gosling invited Joule to a dinner party with the dancer. "Nureyev and I connected through kilim carpets, about which I knew quite a lot," said Joule. "I used to go shopping with him. Again, I was useful for my carpet knowledge. I broke through the steel wall around him. I became a friend in the same sense as with Bacon."

By the mid-1980s, with John around less often, Barry Joule was there to help Bacon screw in the right bulb, or, if necessary, with medical issues. Bacon not only had to use an inhaler on occasion but kept oxygen canisters at the ready. Joule also volunteered as Bacon's chauffeur. If Bacon wanted to go to Wivenhoe by way of Robert Carrier's Hintlesham Hall, for example, he thought to ring Joule to see if he was available. At one point in the early 1980s, Bacon and Edwards included Joule on several evenings out (as they did with other convivial neighbors, such as John Spero), but Joule did not enjoy the homosexual scene. "I went to West End clubs twice with Francis and John," he said. "John's there showing off really. Bacon was already a celebrity. Basically I was uncomfortable. I didn't like the scene, and that was obvious to them." But Bacon slowly became accustomed to having Joule nearby, just around the corner and never more than a phone call away.

Bacon could never quite count on John to be present on important occasions. At a Galerie Maeght-Lelong show in Paris in January 1984— the gallery had been renamed and reconfigured—Bacon arrived half an hour after the opening was scheduled to close. "Edwards had gone out and gotten lost," said Pierre Levai, "and he couldn't speak French. Bacon was out looking for him." Bacon remained a star in Paris in the 1980s, but no longer newly ascended. The show was "literally mobbed with groupie-like followers," wrote Michael Peppiatt, but the scene was not as memorable as the one at Galerie Claude Bernard seven years before. Bacon was returning to Maeght-Lelong. with which Marlborough was on good, businesslike terms. Nadine Haim, Claude's sister, maintained that Bacon had only exhibited at Galerie Claude Bernard as a favor to her and that Bacon, after his flirtation with the Pace Gallery in New York, did not want to get in Marlborough's way. Maeght was safe, with its own intellectual luster. Jacques Dupin, a close friend of Michel Leiris, continued to oversee its publications.

Four months later, Edwards—and Bacon's friends Michael and Ger-

Bacon with, from far left, his friend and helper Barry Joule, Dicky Chopping, and Denis Wirth-Miller on an excursion to Hintlesham Hall in 1979. © Barry Joule, courtesy of Joule

aldine Leventis—accompanied Bacon to a show at the Marlborough Gallery in New York. Bacon "loved seeing the curvature of the earth from the Concorde," he told Geraldine Leventis. He and John stayed for ten days, the Leventises for a week. There were the usual social occasions, but, as with the recent show in Paris, nothing like the feverish drama that attended the Metropolitan retrospective nine years before. What the Leventises most remembered was New York fashion—and the way Bacon enjoyed their enjoying. "We went to shops and he bought Geraldine two sets of shoes," said Michael Leventis—"a white splattered with paint and a red pair. He wanted to buy me a red bomber jacket so he bought it for himself." They observed how pleased Bacon became when young artists noticed him. "Francis loved students and art students coming up to him. He liked young people. At that time in New York the galleries were in Soho. As we were walking around some students saw him. It was like being with a pop star. He loved it." On the street in Soho, Bacon and the Leventises happened to pass Julian Schnabel, then the most touted of the young neo-expressionist artists attracting attention. "He came running back," said Michael Leventis. "He said, 'Francis, don't you know who I am?'"

In the London and New York of the 1980s, there was no escaping the pressure of money and celebrity, though Bacon tried to protect himself somewhat with friends like the Leventises, who led a more normal life. Between 1975 and 1980 the money Bacon earned at Marlborough doubled, and in 1981 the first of the triptychs Bacon painted after the death of George Dyer sold for $350,000 at Christie's in New York. It became the most expensive work by a living British artist sold at auction. By the end of the decade, one of his triptychs sold for $5.8 million at a Sotheby's auction. Museums around the world wanted an example of Bacon for their collections. Not only was Bacon now a postwar brand, but his recent work was somewhat less troubling than his earlier pictures had been. "Alfred Hecht had a person working day in and day out gilding Bacon's frames," said David Russell of Bacon's framer. By the early 1980s, the

triptychs were becoming so expensive that they were occasionally broken apart into single paintings by Marlborough, with Bacon's blessing, so that they could more easily find a buyer.

Bacon's relationship to money remained deeply eccentric. Money was theater. Money was pleasure. Bacon did not like money that hid itself away, saving itself in banks or assuming the bland mask of a check or credit card. Money should be as big and colorful as a French banknote. Money rescued widows. Money charmed waiters. Bacon never gave up the gangster's dream of the big score though he had not the faintest idea what he was worth. Valerie Beston was the fairy godmother of finance, the bills magically emerging from her drawer, filling his pockets with possibility. Sometimes, to keep him from losing everything at once, she would load different pockets of his coat with money. That way, with no chips left and nothing to pay the taxi driver, he would suddenly find—it was a miracle—a bill with a large number on it squirreled into a forgotten pocket.

Of course, money was also power. He must own the room, picking up every tab less because he wanted to dominate than because he did not want to owe anyone the debt of gratitude. He was not quite an innocent. He still grew angry if he felt Marlborough was taking advantage of him. He did not want to feel hoodwinked. In the mid-1980s, David Sylvester sold *Sleeping Figure* (1974), a picture that Bacon gave him. "When Francis heard, he wanted to know how much [David] got for it," said Michael Leventis. He was shocked and, probably recalling Arnold Glimcher's offer to take a commission rather than buy the paintings outright, "called Frank Lloyd and said, 'I want *x* amount from now on for my paintings.' He didn't realize what they were selling for. David bought a house in Oxford with the money." In 1985, Valerie Beston noted in her diary that Bacon was "in bad mood. Bitter about MFA [Marlborough Fine Art]."

But Bacon also understood that he could freely spend because, backing him up, lay the well-oiled financial institution. Once Bacon began doing well, said David Somerset, the gallery introduced him to Gilbert de Botton "to help him manage his money." Previously a key figure at the Rothschild Bank in Zurich, de Botton, erudite and powerful, moved to London in 1983 to found Global Asset Management. De Botton was a self-made man who appeared remarkably intelligent in a variety of fields. It was from no particular need or reason, de Botton's manner suggested, that he chose to manage money: he might as easily have been a scholar of Montaigne—which, in fact, he was. De Botton was known for displaying symbols of power, but not without humor. For example, he wooed clients

in an office that, *The Guardian* reported, resembled a James Bond movie set. When he pressed a button concealed in a drawer, an eighteenth-century mirror would withdraw in order to reveal a high-tech screen of the markets.

De Botton did not simply collect art. As befit a Renaissance man, he collected artists. Bacon often talked to de Botton, and also about de Botton, lecturing other artists about their responsibility to take care of their money. (It must have been an out-of-body experience to receive financial advice from Francis Bacon.) Bacon took pleasure in the aura of connoisseurship that de Botton cultivated during the financial boom of the 1980s. It suggested a shared community of the discerning. Eventually, as if to acknowledge de Botton's role in his life, Bacon painted a large portrait of him peering into a full-length mirror as he dressed for work, wearing fine trousers and a tailored white shirt, French cuffs carefully delineated. But his image also appeared trapped inside the mirror, and he fumbled awkwardly with the tie around his neck. This was not quite a desperate or suffocating man, but Bacon would not grant even de Botton—a deft presenter of himself—final power over his mask.

In the mid-1980s, Bacon was shaken by further rumors about Reece Mews. The developer was particularly interested, it appeared, in the side of the street that contained Bacon's house. It was becoming more common, during the financial boom, for owners to refuse to renew leases in order to renovate their properties or sell them to developers. The elegant backwater of South Kensington was becoming highly desirable, and most residents of Reece Mews, like Bacon, leased rather than owned their houses. Bacon was horrified. If he was a nihilist, he was one with settled habits. He loved the small shops on Old Brompton Road where he made his morning rounds. He enjoyed his neighbors, many there for years. It was an extremely cordial street, said John Spero. "Everybody knew everybody, you know. Nobody seemed to want to hide what they did or didn't do." For Bacon, losing Reece Mews would be devastating.

Marlborough watched carefully. The law firm Theodore Goddard had fired off a premonitory letter to the Royal Borough of Kensington and Chelsea as early as 1981, noting that any upward building next door to 7 Reece Mews would affect the light coming into Bacon's studio from the skylight. And any disruption of Bacon's studio would compromise his output: he had upcoming shows in Paris, London, and New York and talks were getting underway about a second retrospective at the Tate. In October 1983 a plan emerged that specifically outlined the conversion of nos. 5, 6, 7, and 8 Reece Mews. Not only would the developer trans-

form the row, but a new "2nd mansard floor" was proposed for number 8 next door to Bacon. One by one the residents around Bacon left as the developer bought or forced them out. "For a while, four or five of the places were just left empty by this developer," said Spero. Developers were also not averse to using complicated regulations in order to force tenants out. Next door to Bacon, for example, Lionel Bart lost his lease because, said Spero, "I think he was running that as a business there and that's how they got him away from there." Bacon was worried that he could be evicted for having a studio in his residence, which was also, in its way, a place of business.

In August 1984, as the borough considered the plans, Alan Bowness, the director of the Tate, and David Somerset, the chairman of Marlborough, wrote letters to the Borough Planning Office. It would be a disaster, said Bowness, if anything should bother Bacon before the "major retrospective exhibition" that had now been formally scheduled at the Tate for May 1985. "In fact his health and painting have already suffered due to the worry he has been caused." Bowness ended by declaring that it would be a "national scandal" if the studio "of such a great painter" were to be "violated." Somerset wrote a short and direct letter: Bacon was a "protected tenant," he argued, who had no wish to live anywhere else. His letter had the luster of a title to recommend it: Somerset that year succeeded to the title and estates of the Duke of Beaufort. A third letter, this one by Grey Gowrie—a Scottish hereditary peer, officially the 2nd Earl of Gowrie—was probably particularly effective. Gowrie, the minister for the arts in the new Tory government, had a personal tie to Bacon, having inherited a "big house" and the estate of Castlemartin in Kilcullen, County Kildare, Ireland, the part of Ireland where Bacon grew up. His great-uncle was the parson who instructed Bacon in Ireland.

Bacon was grateful for Gowrie's efforts. "In fact, he exaggerated the favor," said Gowrie. "It was fairly easy. I think I just made a call or two, but he associated me with saving him from being turned out of Reece Mews. I think I called up a property company which wanted to redevelop it and said, 'This is a major shrine in British art, and the guy's old and still living there . . .'" In the end, most of the mews houses were torn down and converted into ritzy three-story London residences. Patrick Kinmonth, who came to interview Bacon for *Vogue* in anticipation of the coming retrospective, commented on the noisy demolition on the street. "Next door to Francis Bacon is a heap of rubble," he wrote, adding that "audible bangs and crashes" punctuated the interview. Both Bacon's and John Spero's mews houses were saved, however, and the following year,

Bacon purchased his building. But the old Reece Mews, with its longtime neighbors, friendly atmosphere, and run-down air, was disappearing. The stylishly reconstituted street—faux mews buildings with mansard roofs—was not what Bacon liked. He was becoming aware, as many older people do, of time and the wrecking ball.

Performance Artist

WISDOM, RECONCILIATION, ACCEPTANCE: people growing older sometimes seek the burnished values. Bacon was not among them. If he no longer felt like himself, he would still play the part.

Only close friends knew of his deteriorating health as he reached the age of seventy. He confided to Michel Leiris in July 1982 that his asthma had proven so debilitating the previous year that he often could not work. From June of 1984 until the end of that year, noted Valerie Beston, Bacon was ill at least four times, with either bronchitis or asthma. On one occasion she wrote: "FB ill—bad asthma." On another: "Sounds miserable and depressed on phone. Not painting at the moment." A heavy cold in December led to such a serious attack of asthma that Dr. Brass admitted him to Cromwell, a private hospital in South Kensington. "FB hates it," wrote Beston. Two days later Bacon discharged himself, "still ill." A cold leading to a flare-up of asthma, followed by complications, was becoming a pattern. Bacon visited Dr. Brass more frequently now, and Brass prescribed Becloforte, an inhaled corticosteroid that worked directly on the lungs to reduce swelling. Becloforte and other steroid medications came with their own set of problems, however, including swelling of facial tissue and what doctors call "moon face." They also worked against Bacon's blood pressure medication, and contributed to his insomnia.

Bacon did not ordinarily discuss his health with John Edwards. It was the sunny smile that he wanted from John. In the early to mid-1980s, however, as age continued its beatdown, Bacon found a new, sympathetic young stranger with whom to discuss his depression and declining health. The flamboyant poet Jeremy Reed, whom *The Independent* called "British poetry's glam, spangly, shape-shifting answer to David Bowie," enjoyed hanging out with young punks and rent boys on Denman Street near Piccadilly Circus, where commuters looked for a bit of rough trade before dinner. At around six p.m., the empty hour between the Colony and a

restaurant, Bacon himself sometimes explored the "meat rack" under the arches near the Piccadilly tube station. He remained fascinated with the theater of dominance and submission, cold cash and hot love, release, revelation, and obsession—now played out against the haunting backdrop of melancholy and decline. At one point, he became entranced with a beautiful sixteen- or seventeen-year-old runaway even younger than Reed who perhaps reminded him of the Anglo-Irish almost-runaway who arrived in London decades before. Bacon favored the Regent Palace Hotel off Piccadilly, grown old and squalid with age, which rented out rooms by the hour.

Bacon and Reed met about once a month. Their relationship was not sexual. Typically, Bacon brought a fine bottle into some tawdry place near the Piccadilly tube station where he and Reed discussed everything from poetry to despair. For Bacon, said Reed, the meetings were almost "a kind of psychotherapy." Bacon would slip him envelopes containing five hundred pounds (and once a fat two thousand pounds) because poetry, he half-joked, must be supported. The painter presented himself as vulnerable and unmasked: old, tired, and jaded about the art world. He was always tired, he told Reed, but could not sleep. Barbiturates and tranquilizers—Bacon was taking Rohypnol—did not help. Nothing improved his mood—not sex, drugs, or champagne—though alcohol remained a friend. "He only got pleasure," said Reed, "from drink." The worst of age was sometimes the boredom and repetition, the daily tape loop of a waning life. (Beckett wrote: "The sun shone, having no alternative, on the nothing new.") What Anne Madden called the "demons of self-doubt" still tormented him, even after all his success, and he often referred to *The Waste Land*, admiring the poem's colors and existential dread. He loved, in certain poets, the fume of death. He brought up Genet and Baudelaire. "Death," he said to Reed, "destroys love or is bigger than love."

And yet with others, Bacon still appeared marvelously alive—appreciating each day. "Perhaps he had episodes of depression that he didn't show, but when he was with a friend he was absolutely the same, even at a fairly advanced age," said Jacques Dupin, who worked with Bacon in the 1980s on two exhibits in Paris. "Even at eighty he was still very much alive. You couldn't tell at all that he was old. He had such energy, such intensity in his behavior." Toward the end of a private view for Raymond Mason in 1982, Bacon, according to Mason, "held his arm out for his glass to be filled—then, misjudging the trajectory, threw the contents over his shoulder." Bacon shrugged and laughed: so what?

Then, as Mason and six friends looked for a taxi late that November night to take them to the restaurant Rules in Covent Garden, Bacon pushed into the traffic to capture one. "At the sight of all these people trying to pile into his vehicle," said Mason, "the cabby cried out no, that he had just been fined the day before. We climbed back out, and once again Francis disappeared with astonishing speed and came back with a second taxi."

At Rules, Bacon waved for champagne as he sat down, his wave resembling the opening flourish of a play. He turned the table into a kind of charmed circle. The world was filled with monsters beyond the table. But one must raise the glass with friends—and tilt at the monsters, who were everywhere. He informed the group at Rules that he had been assaulted on the tube that very day by a ghastly bore who gave him a tiresome lecture about the evils of propaganda. "Dead right you are," he told the man. "Just think of Christianity." The man vanished at the next stop. Once, when the art dealer James Birch was a child, his parents brought him to a dinner with Bacon. "I was sitting opposite him at dinner and thinking, 'What would this man be if not a painter?' He would be someone in the theatrical world." The art historian Sarah Whitfield, who met Bacon around 1979, called him "electrifying when he came into the room. He was a performer in that way. Some celebrated people want to hide. He didn't. He had an infectious laugh—a hoot. Just so genuine . . . David [Sylvester, her longtime partner] kept a Lord Snowdon photo of Bacon on his bedroom wall—not an original, I think, but a blown-up version. It showed Bacon with a glass in hand, happy."

Bacon was aware of every eye in an audience. If a waiter appeared indifferent, said Michael Peppiatt, "Francis would have twinkled at him, flirted with him, made him a player":

I remember once in Paris he ordered, as usual, a ridiculously expensive bottle of wine. The waiter poured it out with tremendous care, and Francis offered him a glass. 'Oh no, monsieur,' he said, looking over his shoulder, 'la direction!' But Francis wouldn't allow the management the right of veto. He gave the waiter a glass and told him to sneak into the kitchen with it and drink it later. After a while, the door from the kitchen opened, the waiter peeped out, raised the glass and toasted us.

Bacon liked to turn a table into a band of conspirators. He once said to Anne Madden with a naughty twinkle at lunch, "Now Anne. What about a glass of champagne?" And they ended up, she said, "in a night-

club at 4 a.m." An element of danger was sometimes necessary. Nothing was worse than a slow death by manners. Bacon was always playing with courtesy and rudeness. Sylvester referred to his "serrated-edge gaiety." The French art dealer Daniel Lelong considered him "*raffiné*," a man of *délicatesse*, who could become strange, sensual, eruptive, a one-man "deflagration." Bacon treated the lens of a camera like another eye. A German reporter described him at the opening of a show in the mid-1980s: "Surrounded by photographers gathering round him like insects, Bacon would interrupt his polite chat with an art lover and strike a pose, his mouth slightly open with his eyes looking both frightened and dreamy."

He tried to look well even when he felt desperately ill. Sometimes, he babied his face with makeup and Avon Pearls and Lace cream and used L'Oréal black hair "colourant" that he purchased at the nearby pharmacy on Old Brompton Road, occasionally supplemented by the boot polish that he traditionally brushed through his hair. In the early 1980s, he preferred Yves Saint Laurent clothing. A photograph taken by Edward Quinn in 1980 is a carefully composed presentation. Bacon is dressed in an elegant gray suit, with a navy cashmere sweater vest beneath the jacket, and appears much younger than he is. He confided to others: "I'm the most artificial person you'll ever meet." He said the same about his painting, of course, and probably meant that only by emphasizing artifice could he bring out the underlying truth; convention would otherwise steal the show.

Daniel Lelong called him "the last great dandy of the twentieth century," emphasizing that his use of the term had nothing to do with the way Bacon dressed. It referred instead to the way he lived life on a grand scale, indulging pleasure when he was not hard at work in the studio. Grey Gowrie said: "He was a terrific grandee, by which I mean that he had a very aristocratic indifference to what people thought. I've only seen that in very high grandees, who, while some can have very nice manners, very courteous, but one nevertheless feels they know who they are and that's that and they don't much care what people think of them. Francis was not short on empathy, but he had elements of aristocratic disdain, more psychological than concerned with his pedigree."

Bacon performed for writers no less than for photographers. He seemed to control the plotline, as most of the profiles were similar. He usually appeared as a man who remains sexually vibrant and miraculously young while living hard—and tormented by art, too. The Bacon persona was seductive, a dream of genius, celebrity, and the fountain of youth. In 1980 Geordie Greig wrote a profile for *Now!* that began:

In a back street behind Piccadilly you can sometimes see a local resident wearing brown leather boots, tight grey trousers, a blue polo-neck jersey and a fawn anorak with upturned collar. He has cropped hair, a round puffy face and he looks about 50. In fact, he is in his early seventies. His victory over advancing age gives him a slightly spooky Dorian Gray quality. He is that most remarkable and successful of modern British painters, Francis Bacon.

For *The Times* in 1983, Peter Lennon wrote a profile timed to coincide with the publication in English of Michel Leiris's new *Francis Bacon: Face et profil.* Lennon, a chronicler of Beckett in Paris, brought together the "high" of Leiris's meditations on Bacon with the "low" of a personality profile, an indication of the crossover appeal of Bacon, who would sometimes grant a journalist a day ticket to the imagined life of an artist. Michael Wojas, then the barman at the Colony, said that Bacon drank with journalists there "just to get the edge on them." Anthony Zych, a young artist whom Bacon befriended later in the eighties, noticed that he "got people drunk. That was his defense. Francis himself was often pretending to be drunk. He'd wander around the Colony and go into the loo and empty his glass." In his profile of Bacon, Lennon made himself part of the story. "I asked him what he thought of old age, which judging by his form he appeared to have pretty well tamed": "'It's a bloody nuisance,' he said, with a touch of melancholy. 'Well, you are nearer death. But so long as the brain goes on and one can move about!'" The writer then sacrificed himself—the public expected no less—to Bacon's bottle:

> After that there were only images, of endlessly, circulating bottles of champagne, dark, beaded with moisture, which drew out of the gloom what appeared to be hands with greedy mouths in their palms. And Bacon standing by the bar jaunty in old age. It was one of those evenings where you ask yourself next morning: "What the hell was that all about?"

Sometimes the mask slipped. The photographer Neil Libbert once stopped at the French House for a midday pint when Bacon walked in alone—in his long, belted leather jacket—and ordered a drink. He turned to lean his back against the bar. No one was watching. Libbert sneaked a shot. Bacon's chin was raised like a turtle straining to escape its shell. His eyes were hooded. His jowls flooded downward. The small spit curl of hair that he liked to arrange on his forehead was missing. Another

time, Libbert caught Bacon with a frank face at his Reece Mews door, an elderly man back from the morning errands, his arms filled with *The Daily Telegraph*, a bottle of Evian, and a loaf of Sunblest medium-sliced white bread. Drue Heinz, the patron and philanthropist, found his face "pudding-like, lacking structure." And yet, she said, "Ugly men are often so interesting."

Peter Conrad, who taught English literature at Christ Church, Oxford, once came upon Bacon at the Royal Opera House in what seemed full operatic attire:

He looked eruptive, like the popes who scream on their thrones in his early paintings. His face was a painting. Boot polish had been applied to his teased hair, with a quizzical wisp of a fringe fixed over his forehead; a thick application of make-up gave his cheeks a feverish heat. His eyes kept watch from inside asymmetrical craters, mementoes of drunken tumbles or of beatings administered by the East End bruisers with whom he consorted. His smile showed off teeth scoured with Vim, and inside his oddly circular mouth his tongue darted as if it were a lizard jabbing at its prey.

Now and then, Bacon disappeared into a health spa to reduce his weight, mend his nerves, and curb his drinking. The rumor would float through the Colony that he had plastic surgery to "tidy away" the jowls

and smooth out the moon. His hands, forearms, neck, and large head continued to appear burly and strong, but the proportions seemed increasingly odd—*such* a large head—and his seductive walk was less persuasive. He still pranced, but there was a wobble, too, like a woman insecure in heels. His opinions became more rigid. "He was marvelous company," said Anne Madden. "Trenchant, provocative, intelligent about other painters." But there was no longer any point in arguing with him, she said, as there was a dogma to be maintained. He must "put across his opinion."

Bacon remained ungenerous about most artists, even those whose star was dimming. It hurt the generous Graham Sutherland that Bacon publicly ignored the helping hand that he had once provided. Sutherland could accept the falling-away of the friendship, but not Bacon's way of erasing the past. He took to calling Bacon "Miss World." Bacon continued to mistrust any display of pity that he considered self-admiring. Before he sold his house in Wivenhoe, he was once at the Black Buoy during a lock-in after closing hours (which enabled the patrons to keep drinking) when Pam Dan and her friends began talking about some of the poor people who once lived in Wivenhoe. "There was this little boy," said Dan. "We always used to give him sixpence every Saturday to get chips for dinner." Bacon, drunk and belligerent, dismissed such talk as "a load of rubbish." He began, she said, to rant "about poor people," saying, "Well, if you're poor, die. Either make it in this life or just die." He did not say such things when sober. But deep in his cups the emotionally starved "little boy" from Ireland could still emerge as a pitiful caricature of the resentful self-made man who would deny others a helping hand. At around two in the morning, when the angry party walked home by taking a shortcut over the railroad tracks, Bacon tripped and "got caught in the railway line and was splattered there." Someone suggested just leaving him. Someone else pointed out that a train would shortly pass through. "So a couple of the lads got his foot out of the track and walked him to his house in Queens Road."

In 1982, Bacon's mordant friend William Burroughs, another nihilist who understood the seductive appeal of a persona, came to London to film a documentary. He and Bacon agreed to be filmed together in the fashionable fly-on-the-wall style while chatting at Reece Mews and walking about London. But Bacon and Burroughs could not be as they once were in Tangier. Bacon politely made tea for Burroughs, rather like an elderly aunt entertaining a relative from out of town, and they engaged in stilted small talk before the camera. On the street, he held the arm of his frail companion. Sometimes, friends worried that age

would embarrass Bacon. Paul Conran, the partner of James Birch in their Soho gallery, found the dyed hair troubling—"that orangish cast. Sometimes you would see it leaking down." And he wondered, "Doesn't he know that people see through the dye that he's using to disguise his gray hair?"

Bacon was too perceptive and self-aware not to know. He told Lucian Freud that he dyed his hair because he did not want people to think that he had given up. Bacon was indeed a great dandy; and no great dandy believes perfection is the goal. "Mirrors are the doors," Jean Cocteau wrote in *Orpheus*, "through which death comes and goes." Too well-prepared, Bacon would have seemed merely pathetic, pretending and trying too hard. As a dandy whose mask was slipping, he remained something to see.

The response of intellectuals to Bacon differed from that of journalists, but they also responded to him in ways that emphasized drama, masks, and performance. A second influential French intellectual, Gilles Deleuze, now joined Leiris in celebrating Bacon with his 1981 study titled *Francis Bacon: The Logic of Sensation*. To Deleuze, Bacon's portraits revealed the figure behind the "mask" more than the face itself. "As a portrait-ist, Bacon is a painter of heads, not faces, and there is a great difference between the two. The face is a structured, spatial organization that conceals the head, whereas the head is dependent upon the body, even if it is the point of the body, its culmination. . . . Bacon thus pursues a very peculiar project as a portrait painter: *to dismantle the face,* to rediscover the head or make it emerge from beneath the face." In a chapter titled "Painting Forces," he argued that Bacon's figures "seem to be one of the most marvelous responses in the history of painting to the question, how can one make invisible forces visible?" That, he argued, was the main purpose of both Bacon's heads and his figures:

> . . . The extraordinary agitation of these heads is derived not from a movement that the series [of heads and figures that Bacon painted in multiples] would supposedly reconstitute, but rather from the forces of pressure, dilation, contraction, flattening, and elongation that are exerted on the immobile head. They are like the forces of the cosmos confronting an intergalactic traveler immobile in his capsule. . . .

Bacon was flattered by the interest of Deleuze, but it was Leiris's new book, published in 1983, *Francis Bacon: Face et profil* (translated as *Francis*

Bacon: Full Face and in Profile), that naturally meant the most to him. Leiris, no minimalist, was not restrained in his appreciation. He began his book by likening his gambling friend to some of history's great performers:

> Orestes, only just released from persecution by the Eumenides; Hamlet reassembling his wits after the encounter with the Ghost; . . . a sort of Falstaff, now jovial now reflective . . . a lucky gambler, directly aware of every aspect of our contemporary upheavals, and whose elegantly modern silhouette we seem to glimpse at that precise moment, wholly outside clock-time, when he stakes his all on a throw of the dice, a hand of cards or the roulette wheel. . . .

Bacon's "clean-shaven face," wrote Leiris, was "at once chubby and tormented, and as roseate as that of some eighteenth-century English empirical philosopher discoursing over his brandy or his sherry." Bacon was the peer, he argued, of the great writers who confronted the darkness of their century. "Like Samuel Beckett whose apparently non-mysterious sentences are reminiscent of the discreet emanations from a smouldering peat fire, Francis Bacon . . . expresses the human condition as it truly and peculiarly is today. . . ." He ended with a grand flourish that tied Bacon directly to his Nietzschean roots:

> As an authentic expression of Western man in our time, Francis Bacon's work conveys, in the admirably Nietzschean formula he himself has coined to explain the sort of man and artist he is, an "exhilarated despair," and so—however resolutely it may avoid anything in the nature of sermonizing—it cannot but reflect the painful yet lyrical disturbance felt by all those who, living in these times of horror spangled with enchantment, can contemplate them with lucidity.

If Bacon often seemed to give "performances" in public, his paintings were also taking on a practiced air. Many critics who admired Bacon liked his later work less. They found it too "branded"—embalmed, stylized, mechanical, repetitive—and missed the sense of discovery in the earlier painting. In previous periods, Bacon emphasized an immediate visceral response to the paint. In the 1980s, he became more distanced, spotlighting starkly delineated figures against candy-bright and spray-painted backgrounds of the kind that bothered Freud. His painterly props—arrows, bare bulbs, plinths, newsprint—began to seem somewhat

repetitive, like a director using the same scenery for different shows. He liked to reprise celebrated aspects of his art. In 1979, he painted *Studies of the Human Body* with a flaming orange background. Twenty-six pictures followed in the '80s that included the "Bacon orange" (the unforgettable color in his breakthrough work, *Three Studies for Figures at the Base of a Crucifixion*). His surfaces grew flatter, and his figures did not deliquesce into ridges of paint. The figures still appeared contorted, but now often rested on plinths and pedestals or were isolated in solitary cages, their movement memorialized.

Some observers considered this distance "classical," as Bacon restated and clarified his traditional concerns. It was unexpected nonetheless when Bacon took up Ingres as an inspiration. A great draftsman and nineteenth-century representative of the classical tradition, Ingres did not appear to be a natural progenitor of Francis Bacon. To Eddy Batache, Bacon's neoclassicism was a reflection of his earlier annoyance at being called an expressionist. He did not like to be "linked with artists he detested, like Beckmann, or had rejected, such as Soutine":

> Wishing to show that his art had nothing to do with Expressionism, this dionysiac who worshipped Van Gogh moved closer to the champions of Classicism, to Seurat but also Ingres, whose *Oedipus and the Sphinx* and *The Turkish Bath* he used as inspiration for extremely controlled works. . . . Like Delacroix who, irritated by the excesses of Romanticism, asserted that he was a Classical painter, Bacon also wished to express himself in well-drawn, admirably controlled, clean compositions.

Although acclaimed as a classicist, Ingres also brought to art a powerful undertone of dreaminess and sensual kink. *The Turkish Bath*, for all its orderly structure, was a feast of the flesh. And Oedipus, as he stared jauntily into the eyes of the sphinx, did not suggest measure, stability, and reserve. That was the strangeness of Ingres: he drew lines that were boundaries but also suggested boundlessness. He combined austerity with sensual abandon. Bacon began to develop a similar perspective. While famously not a draftsman, Bacon could particularly enjoy the outline of a shape, which was a kind of drawing.

Bacon would also attempt at least seven paintings of what Martin Harrison called "imagined sculptures." "I would like, quite apart from the attempt to do sculpture, to make the painting itself very much more sculptural," Bacon told David Sylvester as early as 1974. Few of the "imag-

ined sculpture" paintings satisfied him. The best-known—*Study of the Human Body, 1981–82*—combined the brilliant cadmium orange palette with another Bacon obsession of the early 1980s: cricket. Only the lower part of the cricketer's naked torso, from the waist down, is visible above the cricket pads. The painting appears formal, stylized, highly colored, and static.

To Eddy Batache, the later paintings—owing to their high degree of control—"no longer corresponded with the dazzling richness of [Bacon's] earlier imagination." To Reinhard Hassert, they were flatter, lacking the rich "materiality" of the earlier work. Chance and its unexpected gifts were becoming less important. Raymond Mason thought that while Bacon's "handling was broad and sweeping and more than ever assured," he was creating "a standardized product, instantly recognizable." The late paintings were "a kind of ready-made, a Francis Bacon, a saleable object." By the 1970s, Bacon was destroying fewer paintings. He had become, he said, "much more technically wily. . . . I can manipulate the paint now in a way that I don't have to get into the kind of marshland which I [need to] extract myself from." Like Mason, Timothy Behrens—a friend of Bacon's in the 1960s—missed the marshland. He still believed that "Francis's own painting was way beyond what anyone else was doing," but considered him "better when he struggled more, before he learnt that incredible technical dexterity and confidence." Some early paintings "were (relatively) clumsy, even a bit of a mess," said Behrens, "as if he'd been genuinely unsure of what he was trying to do." They were, he wrote, "miles away from the later work, where you get the feeling that all he really wanted was to shock you in the most gorgeous way."

In fact, Bacon did develop an important late style, but not where he expected to. His most original late work lay in his occasional "artificial" landscapes—the pared-down pictures that Sylvester, for one, particularly admired. *Landscape* (1978) and *Jet of Water* (1979) were early examples. Bacon's first *Sand Dune*, painted in 1981, stood out among the stylized works of Bacon's last decade for the sheer physical beauty of its sand, whipped up by the air and swirling above concrete structures. In the *Sand Dune* of 1983, the sand leaks out of a structure that seems designed to contain it. The writer Colm Tóibín found "a restlessness here which we might also find in Beethoven's late chamber music—a feeling that Bacon might begin again, that he is searching for some way to make images that he knows will only be possible for artists in the future, if they are even possible at all . . ." The idea of a figureless figure painting always fascinated Bacon. One of his first mature paintings, *Figure Study I* (1945–46),

depicted an overcoat and a fedora suffused with the presence of an absent man. Bacon's images of water and sand sometimes concealed a possible figure, as did the tightening in certain images of grass. In the shifting of the sand, he was still searching for a new figure.

BLOOD ON PAVEMENT (1984)

Late one night, outside a pub known for rough trade, Bacon chanced upon blood on the pavement. He was pleased. An atmosphere of physical risk, in which the body might leak, break, or otherwise come undone, continued to attract him. It would have surprised no one if he had made a shocking image of this smear of blood. Instead, he did something rare, creating a contemplative painting, steeped in melancholy, in which he concentrated with power and luminous subtlety the obsessions of a long life.

Blood on Pavement was part of the group of paintings that Bacon made that suggest but do not contain a figure. They usually resemble abstract landscapes, which can include the human clay. This group has certain of the qualities often admired in a so-called late style—in which the elderly artist simplifies the work, taking much away but leaving nothing out. In this case, Blood on Pavement was also an echo of what was probably Bacon's first important painting, Wound for a Crucifixion, which he regretted destroying in 1934 after the failure of his show at the Transition Gallery.

In Blood on Pavement, the figure has left behind his essence or lifeblood. The blood itself resembles an open wound. The "wound" appears shockingly real, but can also symbolize the many wounds, always ending in death, suffered by humanity. Bacon does not announce this: death is always more interesting unannounced. He stacks three rectangles, placing all the drama in the lively middle rectangle, the smallest of the three, which envelops the wound. The wound itself looks as beautiful as a crushed ruby. The hard black rectangle at the top of the picture—opaque, blank, characterless—weighs upon the wound. Blood is pain, blood is revelation.

Blood on Pavement can appear very modern. It can evoke "blood in the streets" and the shocking violence of the twentieth century. It can also suggest a modern abstract painting—in particular, a Rothko. "Oh, Rothko," Bacon dismissively told friends. "It's all mooood." In Blood on Pavement, he leans his lance into Rothko's art, making abstraction bleed. He also calls upon the ancients and invokes ritual sacrifice. Blood on pavement is also blood on stone.

The Last Picture Show

DURING THE ORGANIZING OF HIS 1985 retrospective at the Tate, Bacon became as attentive as a pharaoh watching over the construction of his tomb. He found everyone wanting and nothing good enough. He shamed Edy de Wilde, the director of the Stedelijk Museum in Amsterdam, for not lending an important work: "I cannot believe you will not lend it to my LAST exhibition at the Tate gallery. I implore you to change your mind." Bacon did not usually "implore." He tried flattery with the Museum of Modern Art, in New York, complimenting the conservators on the restoration of *Painting 1946,* and noting that it had traveled to Paris for the Grand Palais show in 1971. "This," he said with a flourish, "will be the LAST retrospective in my lifetime." Of course, Freud refused to lend the seminal *Two Figures* (1953), but that was by now written into the stars.

Bacon was accustomed to working only with devoted admirers. The curator for the retrospective, Richard Francis, lacked a personal relationship with him. His view of Bacon's art was measured rather than adulatory. He "admired" the paintings but came to "like" them only after he had worked for some time on the show. Most artists have a nose for people with reservations; they rarely accept misgivings with equanimity. (No artist likes a review of his work, the American critic Tom Hess said, unless it begins, "Not since Michelangelo . . ."). Initially, Bacon was standoffish with Richard Francis. When they first met at Wheeler's, their discussion was "stilted but amiable," the curator reported. "He was a generous and sophisticated host in a diffident, upper class way, and we came away agreeing to meet and work again." But Bacon became elusive after their meeting, apart from helping with loans. "Nothing was explained and every question prompted evasion."

Richard Francis knew that Bacon required no introduction. It was his ambition, therefore, to create a scholarly exhibition that re-examined

Bacon's achievement. Through catalog entries he could provide fresh historical context for each painting, and he hoped Bacon himself would provide new information. But Bacon did not wish to be reinvented, especially by someone else. Nor did he like rummaging about in his history. The traditional presentation of his life and art, developed over the years into a finely wrought carapace, served him well enough. He was particularly touchy about "influence." He had long ago established his own origins. He acknowledged Picasso among the moderns (but only some of Picasso) and from the old masters paid homage to Velázquez, Rembrandt, and a few others. He tolerated no measurable debt to English art. He admired Turner and Sickert, but they were not his English relatives. He must remain sui generis, standing alone on the island between Ireland and France. It could not have pleased him that the Tate intended to present an introductory display of neo-romantic British art in the corridor that led to his show, placing him in the context of English artists at work in the 1930s and 1940s.

Once Bacon read several of the scholarly entries being prepared for the catalog—including one on *Painting 1946*—he was no longer standoffish. He was furious. He convened a summit meeting at Marlborough where, according to Francis, Nikos Stangos of Thames & Hudson "fought for the book." A highly respected poet and editor, Stangos and his partner, David Plante, were friends of Bacon's, but the artist was unyielding. He detested the entries. "If one entry could be said to have precipitated the collapse of our proposed catalog," Francis later wrote—he was astonished at the "brittle sensitivity" of Bacon—"it was the quotation from Sir Kenneth Clark's 1947 review of *Painting 1946* in *ARTnews*." Clark had compared the young Bacon and the slightly older, more established Edward Burra as neo-romantics and said: "They are both unusually skillful technicians, and this, combined with the sincerity of their disgust, gives value to what would otherwise be mere Grand Guignol."

Clark's condescension still stung forty years later. Only because he was a "skillful technician" aided by the "sincerity" of his "disgust" (he was also, apparently, an earnest Victorian) could Bacon be expected to escape the vulgarity of "mere" Grand Guignol and contribute some small "value." It did not help that Clark was also the champion of Graham Sutherland; or that he once pronounced Bacon's art "interesting," a word every artist knows to be a euphemism. Bacon told Richard Francis: "I always hated that cunt." Bacon "threatened to withhold copyright of the images," which forced the show's organizers to "capitulate": there would be no catalog entries in the catalog. To any question about his art, Bacon

was secretive to the point of rudeness. He would sometimes throw back his head, said Francis, "adopt a theatrical stance, and begin to project at a higher pitch with an emphatic intonation." His position in the afterlife, in short, must be set in stone.

Bacon took extraordinary care over the details of framing, glazing, and hanging the paintings. He approved of the essential grouping of the triptychs but stipulated that each must be approached head-on by the viewer and was to be hung exactly sixteen inches above the floor, the frames almost touching. Not long before the opening, David Sylvester saw the show, and either he expressed doubts or Bacon developed some of his own. Three days later, Dan Farson reported in the *Daily Mail* that Bacon did not like the hanging. "VB gets blame for bad hanging!!!" complained Valerie Beston in her diary, adding, "VB fed up." On the 16th and 17th, as the opening drew closer, Bacon was constantly at the Tate making adjustments.

The publicity began months before the opening. Michael Blackwood made a documentary called *The Brutality of Fact* for the BBC's *Arena* series. Richard Cork arranged a perceptive program, *A Man Without Illusions*, for BBC Radio. Bacon gave numerous newspaper and magazine interviews, carefully staging his appearance for photo shoots. He was "remarkably dressed," Patrick Kinmonth wrote in *Vogue*, in "a brown jacket of very soft leather, buttoned right up to the throat." The uniform was seen in photograph after photograph. At Wheeler's, the other diners seemed "rather more interested in Bacon than their own lunch," wrote Kinmonth, with the artist acknowledging attention "with occasional sharp stabbings with the eyes." His way of walking was noted. "His ageless, sharply focused gait, prone to sudden accelerations, gives an impression of going forwards and sideways simultaneously, a sort of walking cubism. The whole thing adds up to an effect about as incognito as Princess Di." Just before the exhibition opened, Bacon went to Colchester for a haircut with his favorite barber. John fetched him and they stayed overnight in Long Melford with John's brother, David.

The retrospective was very large: at 126 paintings about the same size as the Grand Palais show fourteen years before. The Tate's main exhibition spaces were given to the exhibit, with the usual twelve rooms, said Richard Francis, "reconfigured as a single room with freestanding walls." One big Bacon triptych followed another, each surrounded by constellations of large and small works from the period. The late work was heavily represented, many thought overly so. In *The Sunday Times Magazine*, Grey Gowrie, the minister for the arts, began: "Francis Bacon is the greatest

painter in the world and the best this country has produced since Turner." His piece was illustrated with an oversize photograph of Bacon in profile. (It would not have been surprising to find Bacon's profile on a coin.) Alan Bowness, the director of the Tate, wrote that "no other artist in our century has presented the human predicament with such insight and feeling." Not only that, but the "terrible beauty" of his canvases placed them "among the most memorable images in the entire history of art."

Two nights before the official opening, the Tate hosted a private dinner for five hundred people. Bacon invited almost all of his friends from his different social circles in England and France. He did not forget his longtime cleaning lady, Jean Ward, of the Aboyne estate in Tooting, or Ivan Hall, the troubled son of Eric Hall, who had spent time in a psychiatric facility after stabbing a woman and who continued to blame Bacon for breaking up his family. Before the dinner, Gilbert de Botton—whose firm sponsored the exhibition—mentioned to David Sylvester that he would like Bacon to make a speech. Sylvester was aghast, according to Sarah Whitfield, and told de Botton that artists don't like to speak at such events. De Botton appeared to understand Sylvester, but then at the dinner stood up, spoke briefly, and ended by saying, "And now I'm going to ask Francis Bacon to say a few words." It was less risky than many supposed. "And he did graciously say a few words," said Whitfield, "rather than taking offense."

The dinner was followed by an unscheduled private tour—in French—of the exhibition that was led by Bacon himself. He wanted to take some French friends through the show, including the sister of Yvonne Bocquentin, with whom he stayed in Chantilly in 1927. Bacon was "lovely and tender" with the elderly woman. Among those on the tour was José Capelo, an elegant young Spaniard with an interest in music and art who was fluent in French and knew some in the group trailing Bacon. During the tour, Bacon scoffed modestly at his own pictures, but was invariably hospitable, asking his guests about themselves or reliving time they had once spent together. Bacon learned, for example, that Capelo was a near-neighbor in South Kensington. After the informal tour, Bacon left for a private gathering at Wiltons that included special friends and collectors of note.

In his celebratory review in *Time*, the critic Robert Hughes wrote, "All of a sudden, in a rush, the English know what they have got." The more prosaic truth was that the English had long known what they had got. The praise for Bacon was much the same as it had been at earlier shows; so was the occasional voice of disapproval. The loudspeakers were just turned up

louder than before. "A genius? I say rotten," bellowed Bernard Levin in *The Times,* adding that "the puffing and booming of Francis Bacon seems to me one of the silliest aberrations even of our exceptionally silly time." The inflated rhetoric around the show gave the unconvinced the opportunity to declare—as many critics before and after would declare—that the emperor has no clothes. Few wrote in the balanced manner that Richard Francis was hoping to develop. Bacon was instead England's painter. Or, as the Japanese would have put it, a "living national treasure."

If the Tate show had included forty of Bacon's best works, created over four decades, the skeptics would have had a more difficult time. It would not have been easy to dismiss the best heads (no other painter in an age of photography made such distinctive portraits) or the most powerful triptychs (none addressed issues of life and death with greater force). In a carefully selected show, the skeptics would have found not repetition and bombast but a remarkable variety and subtlety of mood, and images like nothing else seen in the twentieth century. Even Bacon's great admirers seemed to agree that his late art had become more polished but less robust, more a refinement of the past than a discovery in the present. But even the late period, thoughtfully culled, contained powerful work—including the mysterious artificial landscapes that were indeed something new.

The most original response to the exhibit came from Emmanuel Cooper: he chose to address Bacon's homosexuality. Bacon was, of course, interested in muscled bodies, handsome faces, and intertwined couples, but the details of "of course" were rarely mentioned. In the *Tribune,* Cooper noted that homosexual subject matter was "largely ignored, politely skirted around as if it is not important." He considered that a mistake. "In a society in which there is still a great deal of stigma attached to being homosexual, such subject matter is highly significant." How to think about the homosexuality in Bacon's art was a richer, more complex subject than muscles could suggest, and Cooper himself did not venture more deeply into the issue. But he opened the closet door. If Bacon's aura of "performance" interested an increasingly postmodern culture, his homosexuality appealed to growing numbers of people who resisted the traditional stigma.

The crowds came—more than ten thousand people in the first ten days. The fascination with Bacon culminated with an interview by television personality Melvyn Bragg a few weeks after the opening. Bragg and Bacon pretended to be at lunch with no cameras around during an interview for *The South Bank Show*. They became nearly falling-down drunk.

Dales Farm, the country home of John Edwards and Philip Mordue. Bacon stayed in a barn "converted into a handsome black chalet."

"We ate nothing but we drank on," said Bragg. "We got very drunk. It showed. We slurred. Once or twice we all but stopped." Bragg probably intended for the drinking to get out of hand, having read print profiles of Bacon in which the reporter goes drinking with the artist. He certainly knew this would attract attention. The novelist Julian Barnes called it television at its best: the "painter's impish presence lit up the hour." It was an early example of reality television, and, if not quite an example of *in vino veritas,* a performance that captured the postmodern appeal of Bacon.

John came less often to breakfast. With Bacon's money, around the time of the retrospective, John purchased a second house in Suffolk. It required his time. The Schoolhouse in Sudbury was too small. He gave it to his mother, Beatty, so she could spend more time with her sons in Suffolk. John's new place, called Dales Farm, was in the village of Hartest about six miles north of his brother's house in Long Melford. It consisted of an ordinary farmhouse on just under two acres. For John Edwards and Philip Mordue—still decidedly together whatever the sexual diversion of the moment—Dales Farm was a dream house.

John and Philip resembled a married couple making excited plans. They must convert the barn. They would have a conservatory, shrubs with Latin names, and a pond with Japanese fish. A Wurlitzer organ? A snooker room? Around the property they erected a wall with signs such as GUARD DOGS—WARNING and soon built their conservatory for

about seven thousand pounds. A stone heron stood in a pond that glinted with Japanese koi. Massive plantings transformed the flat countryside. The small farmhouse rooms with low ceilings contained, said Brian Clarke, "a few big elaborate chairs," including one that resembled a round throne. Although John himself preferred modern furniture, he continued to work with his brother in the antiques business. Around the time of the retrospective he spoke of packing crates full of furniture bound for the States.

Parked in the driveway were John's prized VIP BOY Bentley, a Range Rover, and a trailer that could be towed around England. "If they got pissed," said James Birch, "they could sleep in the caravan." Dan Farson was impressed:

> I had been told that the house is beautiful but I was not prepared for the scale and splendor, with a barn converted into a handsome black chalet where Francis stayed, nor for the extent of the landscape gardening. Presumably the fields were flat and desolate before; now there are shades of Gatsby with young trees and banks of earth planted with exotic shrubs.

Hanging inside the house like an ancestral portrait was a large Bacon painting of John, who regularly gave parties of baronial abundance. (James Birch recalled, at one dinner, "a massive piece of beef.") The rooms regularly filled with family, artists, East Enders, Colony members, and anyone who liked a laugh. Sometimes, the Leventises drove Bacon to the parties; he liked their company and the sporty cars they drove. During these free-form parties, different dramas would play out in the different rooms of the house. In one room, for example, David Plante and Nikos Stangos once found Ian Board—Muriel's successor at the Colony—savaging Denis Wirth-Miller to his face with unrelenting ferocity: "You're a fake. A total fake. The only person who would ever buy one of your paintings is the Queen Mother":

> Denis, who at around seventy looked like a withered boy, just smiled. His friend Dick[y] Chopping was standing in the room, too, but turned away. I stood by Nikos and listened. As Ian continued to shout at Denis, Francis, wavering as he walked, his lips pressed together and his eyes staring, came into the room, and he, too, stood and listened, with his head lowered, looking like a priest listening to a confession. When Ian paused he raised his head and said calmly,

"It's absolutely true, Denis is a fake. That's what he is, a genuine fake." Denis went on smirking, his teeth showing. . . .

Shortly afterwards, alone again, Nikos said to Plante: "You shouldn't have left. In a strange way, those men were showing affection for one another."

At another moment, this time in the snooker room, Bacon approached Plante and seemed about to confide something. "Then the door opened and in came a group of East End friends of John's," wrote Plante, "and Francis jerked around to look at them and said, 'I loathe parties. I simply loathe them.'" When John approached him, "Francis, holding out both his hands to him, said, with a wide smile, 'What a lovely party, John. Such a lovely party.'" Bacon was not being two-faced, just playing with the party masks. Later, he walked Plante and Stangos to their car, where he tried to explain John's appeal. "He can't read or write," Francis said, "but, you know, there really is something very special about him. You see, John is an innocent." Bacon regarded both his "sons," George and John, as innocents—though he had an unusual view of innocence, since George was a petty thief and John was looking for an angle. But both aspired to the good life. Both thought "all that" finally mattered. Bacon himself was less lucky, but warmed himself in their innocence.

Like many sons, John did not always want his "father" to know he was in town. He also liked traveling with Mordue when they weren't at the farm. In 1985, John and Philip took a trip to California, their first to the States together; they returned for a month in 1987. They traveled to Kenya, Greece, and India and enjoyed cruises, including one on the Sun Line in 1988, after which a couple whom they met on board wrote them, "What fun it all was. Everyone still marvels at the amount of champagne you all bought." Valerie Beston's diaries in the late 1970s and early 1980s were filled with references to John, but by mid-decade he began to appear less often, and she noted whenever he happened to be in London. In 1984, Bacon spent New Year's Eve not with John but with the Leventises, eating a "delicious goose"—"just the three of us," said Geraldine. "John was in the country." In 1987, Beston's single and only note about John mentioned the trip to the States with Philip.

The previous year, John had accompanied Bacon to Berlin for the opening of the German version of the Tate retrospective—but with mixed results. Second only to the French in their appreciation of Bacon, the Germans could not easily accept the idea of "the fine arts," not after the romantic passions of nineteenth-century Germany had passed through the meat grinder of two wars, Nazism, and the Holocaust. In Bacon,

gilded memories of the past remained, but the crackup of art's finery represented—for many in Germany—the truth of experience. The version of the retrospective that went to Stuttgart and Berlin was reduced by about forty paintings, which the critic Hans-Joachim Müller in *Die Zeit* considered "more a gain than a loss. Missing were mainly the late works, which were over-proportionally represented in London—as Bacon had wished . . ." Bacon went to Berlin largely because he was eager to see the Pergamon Altar once more; he had seen it on his trip to Berlin with Cecil Harcourt-Smith many years before. Built in the second century BC for the acropolis of Pergamon, it was one of the greatest examples of classical Greek art in Europe. The altar was in East Berlin, on the far side of the Berlin Wall, and—for most of the Cold War—difficult for Westerners to see. The aging Bacon also wanted to visit the city that first helped open his eyes to the modern world.

In Berlin, Gilbert Lloyd warned Bacon that it might not be easy to see the Pergamon Altar. "You know, we'll have to go through Checkpoint Charlie," he told Bacon, warning him that guards often took a long time checking documents. Bacon did not care. The altar did not disappoint him. At lunch afterwards—in East Berlin—Edwards drank too much Hungarian wine. During the return to their hotel, said Lloyd, after we "got through Checkpoint Charlie," Edwards simply "jumped out of the car and ran away. Francis said, 'Oh, don't take any notice,' and we went back to the hotel." But he grew worried when John did not come back for dinner. "So I spoke to the porter," said Lloyd, "who gave me a list of all the gay nightclubs in Berlin, which I'd never been to, of course. And there must have been six or eight and no sign of John. He turned up not the next morning but the morning afterwards, looking really the worse for wear. And Francis was very gracious and pretended nothing had happened, that he'd just been for a five-minute walk."

Institutions now competed to give Bacon awards and honorary degrees. He turned all of them down, unwilling to become an old lion. The awards were like "being cordoned off from existence," he said, and besides, "they're so *aging*." He wanted "to die as I was born—with nothing." Two years before Bacon's retrospective at the Tate, Queen Elizabeth offered him the Order of Merit, the best of all possible awards, whose recipients constituted "the most exclusive club in the world." Established in 1902 by King Edward VII to honor "great achievement" in the sciences, education, literature, and the arts, the Order of Merit was restricted to no more than twenty-four living recipients at one time. "As I am sure you know, the Award is wholly in the gift of the Sovereign," wrote Sir Philip

Moore, the Queen's private secretary, "and is not dependent on Ministerial advice." In 1963, Henry Moore, having turned down a knighthood, yielded to the OM. So did Lucian Freud, who also had earlier refused a knighthood. "The only thing better," said Freud of the OM, "... is a dukedom and they don't make them anymore." Bacon sent regrets.

In the late 1970s, the National Gallery—determined to make its old masters newly relevant—began a series called "The Artist's Eye," in which a contemporary artist would select several favorite works from the gallery's collection and juxtapose them with his or her own art. Many well-known artists participated. The elderly Bacon was, of course, pressed to join the club. He refused. In the mid-1980s, however, David Sylvester took a walk through the National Gallery with Bacon, who became so excited by the art around him that he changed his mind—under two conditions: he would not include his own work and he would not explain his choices. His conditions were revealing. It was not that Bacon feared the juxtaposition, though he maintained that his work was not worthy of the context. But his relationship to the old masters was too complex to be satisfactorily explained by such a show. Bacon always liked a figure painting without a figure. Now, in 1985—the year of his retrospective—there would also be a Bacon exhibit without a Bacon.

The selection was mostly a dazzling celebration of Bacon's love for the flesh and its moods. From the Renaissance, he chose Masaccio's *The Virgin and Child*, in which the Christ child sticks two fingers into his mouth while plunging his other hand into some grapes intended to symbolize the blood and wine of the Eucharist (but are also no less significantly just juicy grapes a baby relishes); and Michelangelo's unfinished *The Entombment*, in which the body of the dead Christ looks as boneless as the filleted body in Bacon's *Three Studies for a Crucifixion*. He told Melvyn Bragg, "I think [Michelangelo] gave the greatest voluptuousness to the male body" of any artist. Ingres did the same for the female body—"No man ... who didn't love women's flesh would have been able to have painted something as beautiful as the *Bain Turc*." He selected Ingres's *Madame Moitessier Seated*. He brought in Velázquez's *Philip IV of Spain*; two paintings by Rembrandt and two by van Gogh; four Seurat paintings and Degas's *After the Bath, Woman Drying Herself*. Not least, he included Turner's richly atmospheric *Rain, Steam and Speed*.

It was not only institutions that wanted to exhibit Bacon. Some old friends also wanted to "present" Bacon to the world. Bacon liked the

idea no more than he liked the idea of catalog entries at the Tate retrospective. (To be placed historically was to be pinned down and framed under glass like a beautiful but dead butterfly.) The problem with most old friends was that they knew too much. They might even, like Richard Francis, maintain independent views. Lawrence Gowing was always wanting to get started on a comprehensive catalogue raisonné. Bacon was always putting him off. Michael Peppiatt wanted to write a biography. Bacon remarked that it would take a Proust. In 1982, Bacon gave Dan Farson money so that he would not write a book. Five years later, the photographer and writer Bruce Bernard—a friend for decades and a Colony stalwart—had almost completed an eccentric but insightful book on the artist that combined a critical narrative with Bernard's own personal commentary about Bacon's paintings. Bacon cooperated with him and the publisher for a long while—but suddenly, abruptly, withdrew his cooperation just as the book was about to go to press.

Most nights, after the heightened attention of friends and strangers, Bacon returned alone to Reece Mews. In the morning, he breakfasted by himself. It was difficult enough for a middle-aged artist to negotiate the letdown that often follows a retrospective. It was worse for an asthmatic nearing the age of eighty who lived alone. Bacon did not rebuke John for his inattention. He pretended to feel only the regret of a father who misses a son. John was so often away, however, that Bacon resumed— not surprisingly—his friendship with Denis Wirth-Miller. He found it almost impossible to abandon once and for all someone he felt especially close to—letting go was a small death—and soon he was drinking, quarreling, apologizing, and traveling with Dicky and Denis again. Bacon took a holiday to the Riviera in June of 1986. He spent two weeks there with the Leventises. John Edwards also came, and Dicky and Denis dropped by to visit him in Monte Carlo. Bacon gambled and visited Anne Dunn and Rodrigo Moynihan at their chateau. He went to Aix-en-Provence and Marseille, where he appreciated a restaurant known for bouillabaisse. Edwards and Geraldine Leventis went on a tour of a yellow submarine, which John "loved," and Bacon talked of buying a place in Monte Carlo. He visited "a block of flats, smallish and very expensive," said Michael Leventis, but did not especially like them.

Even so, Bacon remained sufficiently interested in the idea that he revisited the Riviera for two weeks early that October—this time with his sister Ianthe. "It was just Francis and myself," Ianthe said. "There was a balcony between our two rooms, where you could have some breakfast. For my benefit we did a lot of sightseeing. We went to see where Karl

Lagerfeld lived—he wasn't there, actually. I think Francis tried to phone him and he wasn't there. . . . Francis loved food and I love food and we always had something nice somewhere nice." At the gambling tables, she said, "I was quite lucky." Bacon, playing at a high-stakes table, was not. "Francis and I could always talk, actually. About Africa, family." Brother and sister had visited each other for years but had never before traveled together for pleasure. The trip to Nice became one of the highlights of Ianthe's life.

One evening as they sat in a restaurant that specialized in caviar, "a gorgeous-looking young man," said Ianthe, "came in and sat down near us." For one long *Death in Venice* moment, Bacon simply stared, an elderly artist lost in reverie before a beautiful young man. But then—"a girl arrived," said Ianthe, "and spoiled it all." In London, Bacon painted a portrait of the young man from memory, which Ianthe saw at Marlborough and called "stunning." Distracted by the details of her trip home, Ianthe neglected to tell her brother how much she liked it, but once home she wrote him a congratulatory letter, telling him, "If this young man only knew, he'd be so proud." Upon reading the letter, Bacon went to the gallery and destroyed the portrait. "Apparently," said Ianthe, "he thought John would be jealous."

Fresh Faces

O<small>N BASTILLE DAY IN</small> 1989, old Soho gathered to fête Gaston Ber-lemont at a retirement party on Dean Street. "The cordoned-off street was a swarm of bottle-swigging well-wishers, some kitted out in French Revolutionary costume," wrote Eve MacSweeney in *Harper's Bazaar*, "...and as the day wore on, Gaston appeared repeatedly at an upstairs window of the pub like the pope." Gaston had assumed control of The French House pub in 1951 after his father died. He was everyone's gruff but friendly French uncle (though the family was Belgian and he became quite English) and he often greeted Bacon at the door, as the barman popped the champagne cork, with some important news: the arrival, perhaps, of a particularly fine claret. Some who fêted Gaston on Dean Street had not raised a glass together for years, not since Gaston's mustache was a swashbuckling black. So many friends were dead and gone.

Margaret Fenton, then nearing sixty, came to pay her respects. She had kept up a distant but smiling relationship with Bacon over the years, occasionally sighting him near Harrods as he made his way toward lunch or the Colony. "We used to bow to each other across the street." At first, she did not see Bacon at Gaston's party. "There were crowds of people," she said. "And champagne." And then "I saw Francis look-ing very old, very old. Limping up the street. He had got off a bus or something. But he had also come to the farewell. All by him-

An aging, unhappy Bacon at the retirement in 1989 of Gaston Berlemont from the French Pub. Bacon wanted to deny age, not celebrate it.

Francis Bacon, a drawing from a series of Colony Room art works by Michael Clark, who discovered the club in 1977 and became a good friend of both Belcher and Bacon

self. I thought, 'Oh dear, that's Francis.'" He was wearing a light leather jacket, and his hooded eyes shot looks into the crowd. Duty and affection brought him to Dean Street, but he made it plain that he was not in a mood to celebrate the past with old friends. No raising of the glass with some jolly bag of bones. He was not habitually bitter or distant with friends, and he still enjoyed long nights out, but Soho was not what it was.

During the years after the Tate retrospective, Bacon wanted less and less of last shows or friends from the 1950s. He'd been old and revered enough. He now turned toward fresh faces and first picture shows—that is, toward the young. He had always liked being around young people. In Paris, Eddy and Reinhard, decades younger than Bacon, remained important to him. He enjoyed seeing Jeremy Reed and the lost young near Piccadilly. He had always taken an interest in young artists, especially ones who admired his work. He found beginnings poignant. He had befriended Michael Clark soon after his arrival at the Colony in 1977, and Clark drew and painted several portraits of Bacon in the 1980s. "How old are you, Michael?" Bacon once asked when Clark came to visit at Reece Mews. "I'm twenty-seven," Clark answered. "How marvelous," said Bacon. "You have your whole life ahead of you!"

In 1979, Bacon had seen the work of the young artist Clare Shenstone in a graduation exhibit at the Royal College of Art. She had just completed her master's degree. He admired the way that she did portraits on transparent cloth, which he found technically interesting. It was also a way, among other things, to bring physical intensity to the flesh. He left his number at the school and, when she called, asked to buy one of her portraits. Shenstone was thrilled and then "flabbergasted" when, two months or so later, Bacon asked her, "I wondered if you'd do my portrait." On her first visit to Reece Mews—she would sketch Bacon a number of times over the next months—she arrived nervously on her bicycle. She had no idea what to expect. Bacon stuck his head out the window above. He told her to come inside. She clambered up the steep stairs and found Bacon "dressed beautifully" in "a pale gray suit and very smart blue shirt." He also had on "a very thin gold necklace and his great big watch he always used to wear. And I thought, 'How absolutely lovely of him'"—all

of this for "just a student who he doesn't have to impress in any way." As she spent more time with him over the next four years, she found him open, honest, and a "little bit terrifying as well, because he could be quite cutting and quite ruthless when he wanted to be." Above all, she found him lonely.

Three or so years after the Tate retrospective, Anthony Zych, another young English artist eager to meet Bacon, asked Lawrence Gowing if he might effect the introduction. Gowing "said that he'd arrange it on the condition," said Zych, "that I was to try and talk Francis into letting him do the catalogue raisonné of his work. Francis would never agree. But I was to try and talk him into it." Gowing then called Bacon about Zych, no doubt informing him that Zych happened to be a handsome and muscular young artist who had enjoyed an astonishing success only two years after leaving the Slade. Zych had been given three one-man shows in the United States; and Charles Saatchi had purchased every painting from Zych's initial show in 1985 at the Bernard Jacobson gallery in London. (Saatchi would later buy paintings in bulk from Damien Hirst and the other so-called YBAs or "Young British Artists.") Zych had recently moved his studio to Limehouse, not far from Bacon's old house in Narrow Street. Bacon still liked the area, so he and Zych arranged to meet at a local pub that Bacon knew from the old days. "He was my idol," said Zych. "I could hardly believe this was happening."

Bacon enjoyed startling Zych with queening or outrageous behavior—performing, perhaps, for one of the new young actors in the postmodern art world. Equally beset by boredom and anxiety, he "tried to push the edge of the envelope," said Zych. "He could be really provocative and rude just to create a scene. He liked to provoke a situation that might become exciting." As they left the pub in Limehouse—which was not homosexual but filled with tough, masculine dockworkers and local drinkers—Bacon began to camp it up "outrageously" in the doorway. "Incredible. It was on the way out, to make an impression on the rough guys, the dockers. It was the typical East End types." Bacon was soon spending increasing amounts of time with Zych, ignoring altogether Gowing's desire to begin the catalogue raisonné.

Like Shenstone, Zych saw that he was lonely. "By 1987 and '88 [Edwards] had almost stopped going to Reece Mews," said Zych. "Francis was very upset. He said, 'I see so little of him.' John would only come to drop off his car in the garage at Reece Mews and then go to clubs. And that was it." Bacon made Zych part of his life in a way that echoed—but did not repeat in either time or intensity—the pattern earlier established

with John. They would meet once or twice a week and speak regularly on the phone. Zych moved his studio from Limehouse to Earl's Court, close to South Kensington: "One reason was to be nearer to Francis." It was pleasing to have a handsome young artist around who, unlike John Edwards, could intelligently discuss art and books. Bacon liked Zych's wry humor and probably found his early success puzzling in a provocative way. The art world was intensifying—shape-shifting under the pressure of celebrity and money. In the past, ambitious collectors would try to buy the best picture in a show. They did not, like Saatchi, achieve that end by buying the entire show.

In the evenings, Zych sometimes accompanied Bacon to dinner, often at neighborhood restaurants on Fulham Road and sometimes at fancier places, such as Langan's Brasserie in Mayfair. Bacon would even cook for Zych, an honor reserved for those with whom he felt particularly close. Bacon liked simple pastas—spaghetti with pesto or spaghetti with walnuts and olive oil—and he relished mussels. They would eat in the bedroom. "There was a dining-room table, a little one, in his bedsit," Zych said. "Two couches. Behind one was the huge, wall-to-ceiling mirror. And this smallish dining table. We'd eat and drink on that. And he had fantastic French furniture, this big bureau." Sometime after they met, Bacon asked Zych for photographs of himself. Zych appreciated the tacit compliment: Bacon only painted those whom he knew well. Zych also knew that it was not his face that especially interested Bacon: he "wanted photos of the body." Bacon was growing more interested, as his health declined, in muscle and youthful virility. Zych asked a friend, John Ginone, to take three-quarter shots "front and back," the result of which, Zych thought, might provide some useful muscle for Bacon's work.

Sometimes, Bacon befriended the grown children of old friends. In the late 1980s, he enjoyed seeing Tom Conran, whose father, Terence Conran, founded the eponymous chain that sold furniture and decorating ideas to the postwar generation. Bacon liked to go to the family's new restaurant in South Kensington, Bibendum, not far from Reece Mews. It occupied an art deco landmark that once housed the Michelin tire company. It had an oyster bar, a magnificent wine list, and an inspired young chef, Simon Hopkinson. Tom probably first saw Bacon on the artist's occasional visits to the family's country house in Suffolk. The elder Conran liked to describe one long country-house lunch while the children ran about. "A few bottles of wine were produced which vanished rather quickly and Francis was sitting there at the table and he went to sleep and one of my children walked down behind him. And Francis put his hand

in his pocket and took out a crumpled-up ten-pound note and gave it to the boy and said, 'There you are, there you are,' thinking he was a waiter."

Tom Conran became a handsome young man who lived with Katrine Boorman, the actress and the daughter of movie director John Boorman, best known for his 1972 movie, *Deliverance*. (She would later marry first Conran and then Danny Moynihan, the younger son of Rodrigo Moynihan and Anne Dunn.) "I had more in common with Francis" than Tom did, said Katrine. "Francis was fascinated by film. And he loved *Deliverance*." He would invite Tom and Katrine to Reece Mews for drinks before dinner, and Boorman—with a woman's eye for a house and an artist's eye for detail—missed very little. At drinks, she said, Bacon would make some small effort, but not much. "Little tidbits," she said. Olives, but with "loads" of champagne. "The kitchen was all messy and scuzzy. Very studentlike. The studio wasn't particularly big or bright. The skylight was dusty. There was a smell of paint and turp. He had oxygen canisters there [for his asthma]. There was a small one by the bed and then a big one."

A different kind of young friend was James Birch, who came from a well-known family close to Dicky and Denis. Bacon knew Birch as a child and, like Dicky and Denis, watched him grow into a handsome young man. His parents "had a place in Fingringhoe, opposite Wivenhoe," said Birch. "They met Francis through Dicky and Denis. In the early fifties Francis came round with two paintings, and he offered them for 150 pounds each. My parents didn't buy them, but they remained friends. My parents would give parties. They'd put Francis in a taxi. He'd get in on one side and get out the other and go back." As a young man, Birch became an art dealer in London with a taste for new and offbeat exhibits. He enjoyed nights out and could successfully keep pace drinking with Francis. Birch endeared himself to Bacon and Edwards when he managed to arrange a tour for them of the so-called Black Museum of London, also then known as the Crime Museum of Scotland Yard. Its particular treasure was a frightening and rarely exhibited trove of S&M tackle. "My father was the High Sheriff of London," said Birch. "He could get us in to the Black Museum, which had been put up to teach young recruits. This was right up Bacon's street. My father took John, Francis, and me to see it. They wandered round the exhibition. Afterward we had a lobster lunch at Wiltons."

The friendship led to an unexpected new development in Bacon's life. In March of 1985, Birch was invited to a party where he found himself talking with Robert Chenciner, an expert on the art, textiles, and carpets of the Dagestan region in the Soviet Union. During the cocktail chatter,

Birch told Chenciner that he hoped to mount a show of ten young artists in New York. Chenciner then asked Birch a provocative question. Why not in Russia? Relations between the Soviet Union and the West were then beginning to thaw. Not a bad idea, thought Birch. Mikhail Gorbachev, the new general secretary of the Communist Party in the Soviet Union and the de facto leader of the government, was a reformer who would soon restructure the Soviet economy and permit a more open press. Like many earlier Russian reformers, Gorbachev looked to the West for ideas.

Birch decided to pursue the idea of a show of Western artists in the Soviet Union. He first met in Paris with various Soviet officials—including Sergei Klokov of UNESCO—and eventually in Moscow with Mikhail Mikheyev, the minister of art promotion and propaganda for the Union of Artists. A problem arose: who would pay for such a show? Not, it turned out, the Soviet government. Perhaps, Birch thought, he could instead find funding for a show that highlighted an artist of international stature. Birch asked Mikheyev which artist the Russians would most want to exhibit. The answer was Andy Warhol first and Francis Bacon second. Since Western art was still regarded as decadent, Soviet officials—fearful of being embarrassed by a Western artist's work, behavior, or statements—wanted to "meet the artist beforehand." Birch asked a friend who knew Warhol if he would travel to the Soviet Union. The answer was no: Warhol disliked difficult travel.

At the time, Birch did not pursue the matter further. He was then establishing, with Paul Conran, a gallery on the ground floor beneath the Colony. When Gorbachev began talking about glasnost, however, Birch heard that the Soviets no longer needed to meet the artist before an exhibit could proceed. In fact, the Soviet Union actively wanted a show of work by an important Western artist. It was the "charming and committed" Sergei Klokov, as one critic called him, who tailored the arguments to reassure the Soviet bureaucrats that inviting Francis Bacon to exhibit in the Soviet Union was not a step too far. He persuaded them that glasnost embraced the truth much as Bacon stared down evil. His reasoning was marvelously contrived:

Why, I was asked, should we show this horrible painter, this creator of monsters and nightmares? I explained that Bacon's paintings are not negative, but actually very positive. I told them that to expose evil and to promote good is the same thing. I said that Bacon's paintings show the dark side, the void, and by doing so they

tell us to fill it. I explained this to the Soviet UNESCO Commission, to the Union of Artists, to the Ministry of Foreign Affairs. They accepted it.

At Birch and Conran's new gallery beneath the Colony, Bacon dropped by to see the work of his friend Richard Hamilton, one of the central figures in British pop. That led to drinks upstairs and then dinner. "Francis, what would you think," Birch asked Bacon, "about having an exhibit in Moscow?" The idea thrilled Bacon. This was not yet another last picture show, but something that might appeal to the new Soviet Union. He would represent change, as the first living Western artist to exhibit there. It did not hurt that Russia was also home to the prophetic Dostoevsky, who—born twenty years before Nietzsche—stripped away his period's masks and, in the nineteenth century, set the modern figure into stark existential relief.

In the meantime, alas, Bacon faced exhibits in New York and Paris, scheduled respectively for May and September of 1987. Only the show in Paris, at Galerie Lelong (formerly the Maeght-Lelong Gallery), concerned him. Paris remained an essential part of his life. As usual, he was dissatisfied with his recent work. He had completed only three new works in 1985, and in 1986 only five and a self-portrait triptych. A new "Russia" triptych painted at the beginning of 1987, when he was excited by the news of a Moscow show, was impressive, with an image of the desk where Trotsky was murdered. But he was also determined to create a new triptych specifically for Paris. Having twice failed in the past to complete a bullfight triptych (in 1969 and again in 1980), he began another attempt. His friend Michel Leiris, his health now failing, took a continued interest in the ritual. So had Picasso. But the bullfight's theatrical expression of death was its main personal appeal for the aging Bacon. A bullfight combined power and powerlessness. It was hot-blooded and cold-blooded. It proceeded through a series of woundings, carried out like scenes in a play or steps in a ritual, before the consummation of death. The artist-matador might himself die on the sacrificial stage.

Bacon himself expected, quite reasonably, to die at any moment. As a theatrical man, he would take trouble over stage exits and "last lines," especially in Paris. *Triptych* (1987) did not prove, in the end, to be his last important work, but Bacon probably regarded that as a possibility. According to Jacques Dupin, Bacon's subject was the death of the matador. Or the death of the artist. All his life, Bacon, like a matador, had been dancing with power, performing flourishes, suffering and delivering

Grand finale: Bacon's last gallery show in Paris in 1987, where it became so crowded that he couldn't breathe

wounds, and awaiting the final thrust. Bacon was inspired, said Dupin, by Federico García Lorca's "Lament for Ignacio Sánchez Mejías," an elegy for a glamorous matador who was gored and killed in 1934.

It was not easy to engage freshly with a well-worn subject like a bullfight. Bacon made several side panels, two of which eventually became independent works. In the end, he chose to address not the panoply of the bull-fight itself but only its tragic epilogue. In the central panel of *Triptych,* he highlighted—with a Baconian oval—the wound in the thigh where Sánchez was gored. The matador was naked; Bacon depicted only his torso and legs. While the body in the central panel still lived, the body in the left panel was laid on a table, the flesh greenish and dead. The paint itself seemed to smell of chemicals. (Sánchez died two days after the goring from gangrenous infection.) In the right panel, Bacon painted a shadowy bull with its head turned downwards and one of its horns bloody. Above the bull, in a kind of geometric cage, was a frighteningly vivid creature (or Fury) with a deadly vacant eye. The bull appeared weary rather than victorious, as if he too were tired of the game. Neither bull nor matador could, in short, finally escape the ring. Inside some vertical rectangular forms, Bacon also painted a cool blue sky color that, observed David Sylvester, contrasted sharply with a hot flat orange above—and, below, a soft, earthlike color mottled with bloodstains.

In September of 1987, Bacon went to the opening of his show in Paris, where the bullfight triptych was a centerpiece. Although he had finally given up his Parisian studio that June, shipping his furniture back to London, Bacon still anticipated spending more time in Paris—telling the Veličkovićs after he arrived that he hoped to buy something in Saint-Germain-des-Prés. He booked at the Pont Royal and began broadcast-ing the idea (despite the mountain of evidence otherwise) that only the French truly appreciated him. *Le Figaro* and *Le Matin* published long interviews. So did *Le Monde,* which placed its review on the front page— "unheard-of for an arts story," wrote Geordie Greig, who covered the show for *The Sunday Times:*

Paris has fallen completely under the hypnotic spell of Francis Bacon, whose new show opened at the Lelong gallery on Wednesday. For several days before the exhibition started, devotees gathered to stare at the paintings through the steel window shutters. All week France's newspapers and broadcasters focused on "le mythe Bacon."

Bacon's fourteen paintings were set off strikingly against white walls. Jacques Dupin's description of them as "like theater sets" was apt. On this occasion, Bacon did not question the hanging—a rarity, said Dupin—and he liked the dimensions of the gallery. He was a perfect gentleman to the entire staff of the gallery. "With the secretaries, with the staff who hung the paintings, he was very, very kind, very generous," said Dupin. "He would arrive with flowers, chocolates. He's the only artist I've seen behave in that way." On opening night, Bacon was particularly cheerful. He smiled and circulated through the crowds, telling people that he loved France so much that he was thinking of moving there even as, in fact, he retrenched to London. A long queue stood outside the gallery patiently waiting to enter. Ianthe was present with both of her daughters-in-law. English friends offered congratulations. Then, suddenly, Bacon's chest began to heave. He couldn't find a breath. He changed color. Moments before, the gallery was boisterous. Now no one said a word.

Bacon usually kept an inhaler in his pocket, making a point of buying new German inhalers when he traveled to Switzerland. Dr. Brass believed that the stress of public events, when the naturally shy Bacon was forced to perform, often precipitated an attack. This time he could not find an inhaler. A chair appeared. The crowd pulled back to open a space around him. Then, through the silence came a doctor, François Lachenal, who gave Bacon a Berodual inhaler. The drug helped regulate his breathing. Soon, he was standing. The noise began to pick up. Valerie Beston later wrote Dupin, "We all enjoyed the dinner at the École des Beaux-Arts which I think went extremely well, too."

Suddenly!

IN AUGUST OF 1987, Barry Joule—the young neighbor who occasionally helped out—began to organize a dinner party around Francis Bacon. He hoped to impress Bryony Brind, a principal dancer at the Royal Ballet on whom he had a crush. Sometimes mentioned as a successor to Margot Fonteyn, Brind was spindly, poetic, and coltish. Joule intended to use Bacon to lure other people to his table who would impress her. "I learnt very quickly that a whole host of people wanted to meet Francis Bacon," said Joule. "And couldn't." Bacon was by now grateful to Joule for more than practical help but, Joule said, "Francis seldom committed to anything in advance. He was my number-one choice. But much to my surprise he had finished a painting and was in a good mood and said yes. 'With Francis coming, the world is my oyster,' I thought."

One person eager to meet Bacon was Freddie Mercury, the magnetic singer of the rock group Queen. Joule had met Mercury while working "on the periphery of Live Aid," the 1985 rock megaconcert, and managed to get the star's phone number. "First I phoned Freddie Mercury. He said yes, he'd come. So now I have Bacon and Freddie Mercury. Nureyev was in New York. He said yes. Maude Gosling said yes. But she said, 'Well, if Francis is coming, Sir Frederick Ashton should come as well.'" Ashton, the leading English choreographer of the era, was now retired from the Royal Ballet but would impress Brind. No sooner had Joule arranged his big cats, however, than they started slipping away. Nureyev dropped out because "he had to do this and that in New York." Then Freddie Mercury rang at the last minute to say that he was ill. Now, Joule had only five people for his dinner party. Who, at the last minute, could make a sixth? Joule thought of José Capelo, a refined young Spanish businessman who lived in South Kensington and who, like Joule, was often at the Royal Opera House. José maintained an interest in the arts generally and was a good friend of Julia Ernst, who worked at the Saatchi collection

in London. José was a youthful thirty-one years old—handsome, well-traveled, sophisticated. He spoke several languages well. José Capelo, thought Joule, made an ideal sixth.

"For José, the draw was Francis," said Joule. "José really wanted to meet him." In fact, José had briefly met Bacon two years before at the artist's Tate retrospective. Julia Ernst had taken José to the opening celebration at which Bacon, after dinner, gave a tour to the elderly sister of Madame Bocquentin and José and others had followed along. It had been a memorable occasion for José, listening to a man whom he considered a great artist talk informally about his work. Afterwards, he wrote to Bacon to thank him, though Bacon—who did not connect the letter with the young man at the Tate—did not trouble to reply. Sub-

sequently, José sometimes saw Bacon and Joule in the neighborhood. On the evening of Joule's party, Bacon found he could easily talk to José, who was knowledgeable about the London art world. He could have happily spent the entire evening chatting with this charming young Spaniard.

Alas, another man at the party also found José charming.

"Freddie" Ashton was now eighty-two years old. His partner of many years had died two years before. He began to hold court at the table. He was a gifted gossip and raconteur who could make any table laugh. In the late 1950s and early '60s, Ashton and Bacon sometimes saw each other with Ann Fleming, who, bored by the bland political pooh-bahs of her era, enjoyed caviar lunches at Wiltons with a group whom her acerbic husband, Ian Fleming, called "her favourite coterie of 'Teds' [Teddy boys]: Freud, Bacon and little Cecil Beatnik." Ashton had long admired Bacon. "He was the master," Ashton said. "It was wonderful when he held forth, he had so much to say. Mostly though, our conversation was quite general, quite frivolous. We weren't on deep subjects by any means."

At the dinner party, Ashton—who was born in Ecuador—had an advantage because he spoke fluent Spanish. If he wished to make an observation fit only for the ears of José, he could speak in Spanish, leaving the rest of the table behind. Bacon was also accustomed to dominating a table, but this was a dance-world dinner and Ashton controlled the stage. Bacon brought with him three excellent bottles of white wine, all

José Capelo, the charming Spaniard who came into Bacon's life in 1987

quickly consumed, to accompany the Dover sole. "Ashton," said Joule, "had a full bottle of Johnnie Walker Black." For an outsider there was some comic charm in the situation—two ancient but incorrigible queens politely butting heads—but Bacon probably did not see the humor. Among his other failures that evening was that he had never heard of Bryony Brind. At a reasonable hour, Brind and Maude Gosling left for home while the four men continued at the table. And then . . . Johnnie Walker Black betrayed Sir Frederick. He began to deflate, while Bacon at four a.m. still felt fine. He was only seventy-seven to Ashton's eighty-two. José went home. Together, Bacon and Joule brought Ashton to his flat in South Kensington. "We managed to get him upstairs—his flat was on the first floor—and changed him into pink pajamas." Joule did not know until much later that the evening marked the beginning of Bacon's last great love affair.

Bacon immediately asked Janetta Parladé to find out more about the young man. Parladé maintained a flat in London, but lived mostly in Spain with her husband, Jaime Parladé. Francis "wanted an idea of his background," she said. "Where he came from." Her husband knew Spanish society intimately. The word came back that José was in business. "It was a desk life, with a very, very conventional father." Bacon was soon buying Spanish-language books and courses. "On his bedside table he had one of these recorders, a 'Teach Yourself Spanish' course on a recorder, and also a book of Spanish," said Dr. Brass, who made occasional visits to Reece Mews to check on Bacon's health.

José had been raised in a Spain still dominated by Franco. Although the oppression eased after the dictator's death in 1975, the country remained a Catholic society that did not easily countenance sexual freedom or eccentric behavior. José as a young man appeared set for a brilliant career. He was unusually intelligent, according to a Spanish friend, Cristina Pons, and had trained as an aeronautical engineer at the Polytechnic University of Madrid. Pons grew up playing the guitar and piano and studied English with José. "Sometimes," she said, the two of them "went to the opera." Pons regarded José as "very nice, very clever, very well-educated. Polite in all senses." José won a Guggenheim Fellowship, enabling him to study in the United States, where he earned an MBA from the Wharton School in Philadelphia. The terms of the fellowship did not permit José to seek immediate employment in the United States, which led him to find a job in London at Bain & Company, the American management consulting

firm. (Mitt Romney, who would run for president of the United States in 2012, hired him.) José's background in engineering and gift for languages soon made him a valued analyst. He moved into a flat in Cornwall Gardens, not far from Hyde Park.

In London, José began to change, subtly but undeniably. It had once been Pons who was particularly interested in music. Now, when she visited London, she discovered that José knew more about music (and also art) than she did. He introduced her to Julia Ernst from the Saatchi Gallery, whose sister was a musician. Pons described Ernst as "smiling, wore lots of color, very animated." At Bain & Company, José worked dutifully and successfully; in the evening, however, his imagination yielded to music and theater, where he could appreciate fresh kinds of light, color, story, and rhythm. He was especially drawn to opera, a form in which confined passions spill free, sometimes messily, but are nonetheless elevated into song. Unfailingly polite and fairly reserved, José was not the kind of man who would leave a sober home to shake a leg in the big city—"He owns himself," said Pons—but he made a critical choice in London about where he would direct his energy. He began to resemble a certain kind of European gentleman, less often found in the twentieth than in the nineteenth century, for whom life was not organized mainly around career and family but was focused instead upon music, art, and the cultivation of friendship. Money was necessary for such a life, of course, but it need not be spoken about, and certainly not often.

No friend of Bacon would have predicted the affair with José. Didn't Bacon prefer a bit of rough trade? But the relationship with José made sense when observed from a longer perspective. Before Bacon turned toward the East End—withdrawing from the emotional devastation of his years with Lacy—he was attracted to intelligent, well-educated people of means like Eric Allden and Eric Hall, who were men of the world committed to music and art. And the great love of Bacon's life, Peter Lacy, was a thwarted musician and man of the theater who came from a privileged background. None of the three was obviously homosexual. Each was deeply sensitive. Each maintained a complicated relationship to family, social expectations, and the homosexual closet. José came from social circumstances similar to those of Bacon; that he should be Spanish added a refreshing difference. After France, Spain was Bacon's favorite country, and his interest in the ancient ritual of the bullfight persisted.

Bacon and José began to go out frequently. José sometimes insisted upon paying the restaurant bill. It was a novel experience for Bacon, who had hardly let a dinner bill escape his hands for decades. But José did not

The Bavarian-style Bar
Cock in Madrid, favored
by Bacon and Capelo, who
usually drank three martinis
there before leaving for a
late dinner

want to be beholden. Bacon might typically respond by insisting that they then follow dinner with a trip to Annabel's, the chic basement nightclub in Berkeley Square, where Bacon would order (and pay for) unimaginably expensive caviar. Not long after the dinner party at Barry Joule's, Bacon and José flew to Madrid, where the traditional appeal for Bacon would have been the Prado and its collection of Velázquez.

José introduced him to other sides of the city, including its elegant restaurants and vibrant, evolving nightlife. It was the first of many trips to Spain. Bacon liked the celebrated Bar Cock, founded in 1921 by a man from the north of Spain who had purchased the entire interior of a bar from Czechoslovakia after the collapse of the Austro-Hungarian Empire. It had stained-glass windows, high ceilings with dark, timbered beams, and a decorative chimney. "We say 'Central European,'" said Patricia Ferrer, its third owner. "But it's very classic German." Bar Cock could have been the stage set for a German movie of the late 1920s rather than a real bar located off Madrid's Gran Vía. "Fifty percent of the charm," said Ferrer, "is the place itself."

After World War II, the area around the Gran Vía had fallen into seedy disrepair, but now once more was beginning to flourish. Bar Cock developed into a meeting place for sophisticated people in Madrid, both straight and homosexual; it was "*the* place to go among upper-class gays," said Maricruz Bilbao, an art dealer who had worked in New York and London and knew the international scene. "It's not a regular bar. It's very

loose. If a celebrity asked, 'Where do you go for a drink?' . . . Patricia [Ferrer] dresses in jeans. A little bit bohemian—but high-end bohemian." Bar Cock was more like the nightclubs Bacon frequented in Paris with Nadine Haim than a sketchy dive like the Colony. The cocktails were smart, the bar mirrored, the lighting dusky. Green leather banquettes and red leather club chairs—brass studs and wooden arms—provided a clubby familiarity. The art world liked it. So did the occasional royal looking for diversion.

Over time, Bar Cock, at 16 Calle de la Reina, became central to Bacon's life in Madrid. People there rarely bothered him, and Ferrer came to know his likes and dislikes. Bacon and José typically walked in around eight thirty or nine, always alone, and then often chose to sit at the bar itself, which they preferred because it afforded the most privacy. No one could then trap them in a booth; at the bar, one could always politely turn one's back to continue a conversation with one's friend. Even so, the couple also had a favorite table—"table number 9," said Ferrer. They would usually drink three dry martinis. Then they would leave for dinner at about ten thirty or eleven. "Sometimes," said Ferrer, "he'd order champagne for them both. He'd come Monday, Tuesday, Wednesday. Two or three times a week. Not on Friday or Saturday. And never after dinner." As usual, Bacon preferred fish restaurants. Other than a taste for lamb, which he may have developed as a child in Ireland, he rarely ate meat. In London, Wheeler's and Bibendum were excellent fish restaurants. In Madrid, he liked La Trainera, named after a small fishing boat.

Bacon usually wore "white linen with a closed shirt" in the Spanish heat. His skin was noticeable to a Spaniard, said Ferrer: he was that British pink with blue veins. He was "very much of a gentleman." During the day, Bacon took an interest in new (or newish) things. He was already friendly with some people in the Spanish art world, in particular Elvira González, who in 1977 had organized a Bacon/Picasso show with her then-husband at their gallery, called the Galería Theo. "Julián Gallego wrote the text of the catalog," said Elvira's daughter, Isabel Mignoni. "It's an invented dialogue between two painters. One is Francis Bacon, the other Pablo Picasso. Picasso says, 'I break the space.' And Bacon says, 'I do not break the space.'" Bacon was flattered by the show and—never one to forget a friend or a favor—made certain that Elvira was invited to all of his subsequent exhibits.

Bacon "liked flamenco," said González, whose mother was a classical flamenco dancer. "At that moment, in the late 1980s, Zambra was a very good place to go for good flamenco. It was near the Ritz Hotel." Bacon

and José also frequented another Madrileño dance form—the bullfight—but Bacon could enjoy it only up to a point. It was not that he preferred the metaphysics to the experience; the blood did not bother him. But the steeply raked steps in the arena brought on a touch of vertigo, and both the steps and the seats were difficult for an elderly man to negotiate. "The ring has stairs which are also where you sit," said Isabel Mignoni. "To make the steps you have to take a big step. It's not a nice place for old people . . . there are no backs on the seats. And they're either concrete or stone. Like a Roman Forum."

José rejuvenated Bacon, who still felt alone much of the time. Inside Bacon there remained, said Eddy Batache, a "deep well of loneliness," now sharpened by age and declining health. Earlier in his life, it had been a great comfort to have Nanny fussing about the flat. She aired out the loneliness of rooms. She was around at breakfast—that moment before he went into the studio. He wanted his lovers to provide, in addition to sexual excitement, that kind of company. Bacon was less attracted than in the past to the fraught world of emotional and sexual obsession. An educated companion like Eddy, Reinhard, or José—with whom he could freely talk, without drama, about any subject—appealed to him in a way that Peter, George, and John could not. And, as always, Bacon was delighted to appear in public with a handsome young man by his side. He felt desirable again. The elderly Bacon—observed one close friend—resembled those gallant French women from another era who refused to retire into widow's black: "French women are women until they die."

Bacon's friends noticed his changed outlook but were uncertain how to regard the relationship: Bacon and José did not make a point of being a couple. (They booked separate hotel rooms.) It was José who created this atmosphere of reserve. José did not think of himself as Bacon's "lover" any more than John Edwards did. Sex, he told friends, was "incidental." It was Bacon's world that fascinated José. Much as he once found himself drawn to the exotic life of opera, so José now came to know intimately—no longer as a member of the audience—the milieu of an important artist. He could witness the unflagging intensity of Bacon's inner life and, despite being a foreigner in London, enter his colorful English world: "I was never bored with him." José admired Bacon's distinguished friends, and he sensed the passing of an era. Stephen Spender was aging. Janetta Parladé seemed part of a more elegant time. José enjoyed the affectionate backstage irreverence with which Bacon would talk about these éminences grises. Bacon might say, with a twinkle, "She had this problem, Janetta's mother. She liked . . . *sailors*."

In deference to José, Bacon rarely spoke of the relationship—and then

only to old friends like Denis and Dicky. José himself remained silent. "He never opened up," said Joule. "Some guys do. José was reserved. He was a careful drinker, too." If Bacon mentioned to Joule that he had been to Madrid with José, José himself provided no details. José also strictly separated his business and personal worlds. He did not want to be discussed here and about as Bacon's lover. Nor did he want to assume, as John Edwards did, the family role of a "son." He did not conceal his connection to Bacon, but neither did he flaunt it. The relationship was in certain respects old-fashioned. His family and friends in Spain knew that José had an important painter friend in England. They might wonder at the relationship but would not push to know more.

Capelo recoiled, in particular, from tabloid gossip. The feverish inference around a May-December relationship involving a celebrity—*Did José set out to seduce Francis? Were John and José rivals? What did José want from the relationship?*—repulsed him. Bacon himself never seemed to mind when motives were questioned. Almost anyone close to Bacon was thought, by someone else close to Bacon, to be manipulating the old man for money and paintings. Bacon, if warned, would say, "I like being taken for a ride." Well-versed in the indirection and tangled complexity of love and motive—in that way, he was a Jamesian figure—José was affronted that his relationship should be reduced to coarse tabloid clichés. Was it not possible for a man who loved art also to cherish a master?

Problems arose with the Moscow show. Scheduled to open in September 1988, the Bacon exhibition naturally became a diplomatic occasion, which led to the involvement of the British Council. Gill Hedley, a member of the council's Visual Arts Department (and, later, the director of the Contemporary Art Society), was named the principal organizer—officially, the exhibition officer in charge. That displeased David Sylvester, who felt sidelined. He would expect to participate in a quasi-official show of this kind and also contribute to its catalog. The British Council would not underwrite the project, however, leaving open the question of who would pay for it. Eventually, at Bacon's request, Marlborough uneasily agreed to sponsor it. "Francis was worried that the Marlborough might pull out," said James Birch. "There was a meeting with Gilbert Lloyd, Miss Beston, the person from the British Council. I think Marlborough was enthusiastic because Bacon wanted it so badly. But the British Council wanted to control it."

In the end, as with the 1975 exhibit at the Metropolitan Museum in New York, Bacon personally put up much of the money. Then, as costs

rose, he began to lose his temper. In late June of 1988, Valerie Beston recorded in her diary, "FB explodes. Calls VB a liar over cost of Moscow Exhibition!!" It also proved difficult to get loans. "They had to persuade institutions and collectors to lend pictures to Russia, which was then still the enemy in Cold War terms," said Birch. Bacon was even trying to paint a second *Jet of Water* because the owner of the first refused to lend it. The Berlin Wall did not come down until 1989. "Francis could have pulled the plug at any time," said Birch, "because he could be as tricky as anything. It was amazing that the show could be put on in that period of history. It was a major coup."

In the months before the Moscow show, Bacon was also trying to create a spare and dramatically lit full-length portrait of John Edwards, which he would finally complete in February of 1988 in time to be included. *Study for a Portrait of John Edwards* (1988) was at once beautiful and serene, "serenity" being a word rarely associated with Bacon. The seated Edwards, his face instantly recognizable, stared outward with intense concentration, as if watching and waiting for something unknowable. His figure was positioned in front of a large black rectangle; a second black rectangle, suggesting a carpet, angled out from beneath the chair toward the viewer. The sense of stillness was heightened by Bacon's last-minute removal of much of the chair itself. Only a bit of the back curve was included and one tiny corner of the seat. The intense focus of watchful waiting held the figure visually in place.

No doubt the Russians selected that painting—which became the cover of the catalog—because it did not resemble Bacon's more disturbing images. They were especially concerned about any hints of homosexuality, then a crime in the Soviet Union. *Triptych August 1972* was originally intended for the exhibit, but its depiction of two intertwined male bodies proved too much for Moscow. Bacon wrote an official but also sly greeting for the catalog—"It is a great honour to be invited to have an exhibition of paintings in Moscow . . ."—that contained an acknowledgment of his debt to the Eisenstein films *Strike* and *Battleship Potemkin*. It ended with a remark from van Gogh that obliquely referred to the situation in the Soviet Union, then a society bedeviled by indirect or masked truths. "In one of van Gogh's letters," Bacon wrote, "he makes this statement 'How to achieve such anomalies such alterations and refashionings of sensibility that what comes out of it are lies if you like but lies that are more true than literal truth.'"

Bacon waffled about whether or not to attend. "Francis wanted to take the train from Moscow to Leningrad to see the Hermitage Museum," said

Birch. "John Edwards told me that he was listening to Russian on head-phones." But then David Sylvester began to worry Bacon, or so the gossipy Dan Farson told Birch, with talk of kidnappings: "They'll know who you are." But the main reason for Bacon's hesitation was, of course, medical. In April of 1988, Valerie Beston recorded that he was "ill with asthma" and taking cortisone. How could he go to Russia? He remembered all too well the German doctor in Paris who appeared from nowhere to rescue him. Then he had the idea of asking his doctor, Paul Brass, to accompany him. "He was terrified that the asthma would take over and he wouldn't be able to breathe," said Brass. "And he was terrified of being in Russia because he didn't want to go to hospital there." Once Brass agreed to the trip, Bacon calmed down. He did not want to miss the exhibit.

"The run-up to that exhibition was amazing because there was so much hype," said Brass. "And the greater the hype, the more anxious Francis was getting. We were all set to go when he rang me up one morning and said, 'You know, Paul, I'm not going to Russia. I don't want to go.' . . . He was getting himself into a real state, very tense, very worried, about going over there and not being able to speak the language, not being able to express himself properly." A little more than a month before the opening, Bacon informed the British Council that he would not attend the opening. Four days later, he wrote Sergei Klokov with the news. The Russians were upset. The exhibit was not just an art show; it was a symbol of glasnost, and the artist's personal presence had symbolic importance. Both Bacon and Brass believed, however, that the stress could precipitate an asthma attack, as it had in Paris. Bacon also disliked communism, said Brass: "Francis was not left-wing at all. In fact, he was really a conserva-tive at heart," and, according to Brass, found the very idea of visiting a Communist country distasteful. There may have been one last, unspoken reason to stay home. What if both John and José went to Moscow? They had been introduced to each other and seemed to get along well, but they had nothing in common except Bacon. What would an exhibit in Moscow be like with both of them there? Would they both be standing beside him? Would that create a problem of some kind? It was perhaps best not to tempt fate.

Bacon himself had sorted out his different relationships with John and José. In his mind, if not in that of many others, there existed no reason for conflict or rivalry. John was now his all-but-official son—not a particularly dutiful son, of course, but Francis himself had not been a perfect son and understood the desire of sons to escape a heavy hand. John was his heir, after provisions were made for other members of the

family, and José was the man he now loved romantically. The last thing he would want was for José also to become a son. And so he sent "family"— John Edwards—to represent him in Moscow. "Francis gave me a check for three thousand pounds to look after John," said Birch. "And beforehand John gave me three lithographs." Even then, Bacon hinted that he might still go at the last minute. The official press release issued by the British Council noted that he "hopes to attend" a press conference that would take place immediately before the opening of the show. On the morning of September 21, when Birch came to Reece Mews to take John to the airport, Bacon was still speaking wistfully of changing his mind. He cooked the travelers a breakfast of eggs and bacon, and Birch noticed that he had packed his bags: they stood there, ready to go.

The exhibition opened, without Francis Bacon, on the afternoon of September 22, 1988, at the Central House of the Union of Artists, across from Gorky Park. It was a "mini retrospective" of twenty-two paintings that included five triptychs. It began with the *Three Studies* of 1944 and ended with the two new paintings, the large silent portrait of John Edwards and the second version of *Jet of Water*. The ceremonies were "unlike anything one might expect to see at a Western exhibition," reported *Artnews*. There were lengthy "adulatory speeches" by Russian dignitaries, the British ambassador, and other officials. "The opening reception was unbelievable," said Birch. "The entire Politburo and Soviet dignitaries attended." The British press did not make life easy for the Soviet officials, asking unnerving questions about Bacon's homosexuality. Why was the Soviet Union showing the work of a homosexual artist when homosexuality was outlawed in the USSR? Was it true that several paintings had been removed because they had homosexual elements? The first secretary of the Union of Artists, Tair Salahov, noted that the government's laws criminalizing homosexuality were under review and that "perhaps some day we will have another exhibition [of Bacon's work] that will show other sides of his . . . creativity." It was, as Andrew Graham-Dixon noted in *The Independent*, "an impressive performance."

John Edwards was treated as a VIP. Wasn't that his portrait, after all, on the cover of the catalog? He flew first-class to Moscow and stayed at the Hotel National. John knew that caviar came from Russia, and so caviar was what he mostly wanted to eat. ("John can't read a menu," Bacon would say with admiration, "but he can order caviar.") "I'd go into the subway," said Birch, "and swap condoms for caviar." In the catalog, the Soviet critic Mikhail Sokolov allied Bacon's art to important Russian themes and precedents. "The present writer recalls an episode, long ago, when the postwoman who delivered a letter and catalogues sent by

Bacon, found that the reproductions of his cruel grotesques reminded her of Gogol's tragi-comic satire." Bacon's friend Grey Gowrie, who had contributed an essay to the catalog, suggested the Russians might have more in common with Bacon than his own countrymen did. "The British admire his eminence but do not know quite what to make of him: an elegant, wealthy, rather conservative gentleman who paints such scary pictures." The Russians possessed a certain focus that helped with the "scary" element. "The horrifying thing about [his paintings] is not the subject matter but the clarity of the gaze. In literature, this is the Russian characteristic. Perhaps it is why they take to him."

Some Soviet officials detested the exhibit. Andrew Graham-Dixon followed around one bemedaled general who could not pretend to neutrality. "'Mr. Bacon's paintings are evidence of a sick psyche,'" he said. The general would have found many in the West to agree with him. After years of looking at pictures of bronzed girls on tractors and statues of heroic men holding power tools, however, many less official Russians were of course eager for some sick psyche. Nine hours before the show opened to the public, a lengthy queue had already formed. Russian intellectuals treated Bacon as one of their own. Bacon, alone at Reece Mews, read the press clippings. In an interview with Geordie Greig three days after the opening, he referred "glumly" to his "great disappointment" at not attending the event. The writer underscored the "rare opportunity" Bacon had missed, calling the show "the pinnacle of an extraordinary career" and describing Bacon as the "perfect picture of health, happiness and bonhomie" in a striped shirt and leather bomber jacket, set off with black-and-white sneakers. "His whole body twists with a restless energy." It was probably less a missed opportunity that Bacon regretted, however, than a failure of nerve.

The exhibit was a success by any measure. Grey Gowrie, who was interviewed about Bacon on Soviet TV, was later told that the program was watched by more than one hundred million people. The print run of the catalog—five thousand copies—sold out. Bacon was so grateful to Klokov (and perhaps guilty for not attending the opening) that the following year he handed him a paper bag, inside which was *Study for Portrait of John Edwards*, painted in 1989. Klokov sold the painting to a Swiss collector, which was not something that would have bothered Bacon.

During the opening celebrations in Moscow, Zette Leiris died in Paris. And with her died part of Bacon's Parisian dream. Later that autumn, he watched in dismay the decline of his family favorite, Diana Watson,

who had been such a support to him in his early years. Always "a lady as Francis was a gentleman," said her friend Anthony Kelly, a young painter, she became overweight and untucked; she shuffled forward in lumpy shoes. Dirty plates piled up, and clothes went unwashed. "You realized that you were near her door," said Kelly, "because of the extreme smell." Bacon nonetheless continued to take her to lunch, refusing to acknowledge any smell, and pressed fifty-pound notes into the hands of waiters to ensure respectful treatment. In 1986, Diana still sometimes went to the Marlborough—"Diana totters in with friend from Philadelphia," wrote Valerie Beston in her diary. "Looks very rotten." By 1988 she rarely left her flat. She became concerned about money. Bacon told Valerie Beston that she wanted to sell the portrait he had made of her many years before for no less than a million pounds. The number was probably just a figure bandied about to reassure her. Meanwhile, Bacon took practical steps of his own, sending her money by post to cover all eventualities. She died on February 10, 1989.

Bacon often escaped from London with José, putting the grays of age behind him. José shared his passion for travel. In London, José also helped restore Bacon's relationships with certain colorful old friends and acquaintances from the literary and intellectual worlds of London and Paris. José took no special interest in either Bacon's queening or his drinking in Soho and the East End. Nor did he desire an invitation to society parties. But he enjoyed evenings with distinguished artists and writers, what Capelo called the "intellectual aristocracy." His enthusiasm offset Bacon's increasing inclination to withdraw. Once, the two went to a dinner in honor of the neurologist and writer Oliver Sacks. Stephen and Natasha Spender and Harold Pinter and his wife, Antonia Fraser, were also there. Such a dinner would normally have made Bacon uneasy, leading him either to decline the invitation or drink too much. But all went well because José was present and the evening was spent gossiping about Lucian Freud, himself a deft gossip, but one eccentric enough to interest Sacks. How could Lucian be so cruel? Why was he so devastatingly attractive? How many children did he really have? And so on. Bacon had a marvelous time.

It was rather disorienting, Robert Sainsbury observed, to find Bacon with such an entertaining companion. "He was really charming," Sainsbury said of José. "So unlike the other boyfriends that we weren't sure of their relationship." Jacques Dupin was also impressed. "Out of his friends, the one I knew the most was the Spaniard at the end, in the last years, because he was a very refined guy. He wasn't like Francis's other

friends . . . an engineer, but a very high-level engineer, the kind of engineer who advises industry, businesses, all over the world. He was . . . cultivated." There was nonetheless a tendency for old friends—even those with good manners—to look past or talk over someone in José's position. Although most of Bacon's friends were welcoming, José was particularly touched, he told friends, by David Sylvester's regard: Sylvester invariably treated José as a person of independent interest. Perhaps Sylvester's own history as an outsider, together with his rocky romantic history, helped give him this generous perspective.

José noticed the particular pleasure that Bacon took in fine rooms, admiring their proportions, scale, or thoughtful opulence. Unfamiliar rooms could also dismay Bacon, however. José was surprised to find that he himself—a reserved Spaniard—was often more socially at ease than the always tense Bacon. José once arranged for Bacon to visit the grand house of the Duchess of Alba, a legendary title in Spain. When they found themselves seated for a time in one of innumerable living rooms, Bacon became so nervous he could hardly sit still. José helped Bacon relax. Their days and nights were not ordinarily juiced with feverish social gatherings, partying, drinking, clubs, quarreling, or the pursuit of rough trade. What José most wanted, he told friends, was a normal life interspersed with moments of heightened interest. Sometimes, Bacon and Capelo would "dress up" for a night on the town. Bacon so admired one suit José wore—from Anderson & Sheppard, then in Savile Row, whose customers ranged from Noël Coward to Prince Charles—that he had one made for himself . . . and then never wore it. Sometimes, they went to Sunday lunch at Claridge's, where the Queen of Spain might be sitting nearby.

Capelo liked to imagine, as did Bacon, that something unexpected, provocative, or marvelous might happen any time. Just not every day. *Oeufs mayonnaise* at a café was sometimes better than dinner at the Crillon. Bacon once mentioned to Denis Wirth-Miller that "José brought some raw Spanish ham and membrilla [a quince paste much-loved in Spain] this evening on his way out to dinner." He told him, "At my age, it's very nice to find someone I can talk to." Bacon loved domesticity when it could be found. (He was probably never more at peace than when John came for breakfast.) The regular daily patterns established with José likely helped Bacon with his work, as age and asthma otherwise slowed him down. If nothing else, his improved morale fortified him in the studio. He was facing yet another "last picture show," this one organized by the Hirshhorn Museum in Washington, DC, which would travel to Los Angeles and to MoMA in New York.

The American retrospective was not nearly as momentous as the one in Moscow. But Bacon wanted—yet again—another "last" triptych to cap the exhibit and, potentially, his life. Why not end where he began? He had in mind a second version of the *Three Studies* triptych of 1944 that began his career as a mature artist. Such a reprise represented a greater challenge than might at first appear. It was true that Bacon would not have to invent wholly new forms. It was no less true that he risked being laughed off as an old man repeating stories and coasting on the early success of his brand. Bacon announced his intention—raising the stakes higher—to give the new triptych to the Tate, which already owned the first. The two triptychs would bookend his life's work at the same institution. Would their relationship be vivid and complex? Or pathetic, like an old man casting about?

Bacon completed *Second Version of Triptych 1944* in August 1988. Significantly larger than the first version—each panel measured seventy-eight by fifty-eight inches, versus thirty-seven by twenty-nine—the late triptych was suffused with luminous reds rather than the earlier, high-pitched orange. It followed Bacon's direction in the 1980s away from bold, turbulent canvases to more formal and hieratic ones, what Eddy Batache called his "extremely controlled" works. Bacon would have to wait to learn of its reception until the exhibit in Washington, more than a year away. In the interim, the triptych was exhibited serendipitously in Paris for one night only at an event dedicated to the composer and conductor Pierre Boulez, head of the IRCAM center for music and sound research in Paris. Bacon and Boulez had once been guests together at a long-ago dinner party given by Sonia Orwell. They liked each other but fell out of touch until Michel Archimbaud, a young editor at IRCAM's publication, *InHarmoniques*, wrote to Bacon, at Boulez's suggestion, to interview him about the connection between music and art.

Boulez's name immediately opened Reece Mews to Archimbaud. Not long after his initial meeting with Archimbaud, Bacon allowed *InHarmoniques* to produce a lithograph of his *Innocent X* painting of 1965. (It was to be used as a poster.) Now he agreed, several years later, to Archimbaud's request to dedicate a painting to Boulez, which would be part of a larger celebration of the composer's work by the editors of the journal. Bacon chose the second version of the 1944 triptych. For one night, then, the triptych was on display at the journal's space at 3, rue Séguier, on the Left Bank between the Pont Neuf and the Pont Saint-Michel. Boulez came to the event. So did the wife of French president François Mitterrand. Boulez displayed a manuscript version of his new orchestral piece and a

special publication, *Répons*, was published for the occasion. Bacon dedicated his triptych in French: "For Pierre Boulez, this new version of my *Triptych 1944*, in homage to his work, Francis Bacon." It was the beginning of a late-blooming friendship between Bacon and Boulez.

There was one other important moment as Bacon prepared for the Hirshhorn: John Edwards's final appearance in his art. In the fall of 1988 and the spring of 1989, Bacon painted three portraits of Edwards, one full-length and two small. Then, before the Hirshhorn opening in October of 1989, he painted a last portrait. Edwards sat casually on a deck chair in a deepening shadow, as if traveling or on vacation, dressed in shorts and with his legs crossed.

SELF-PORTRAIT (1987)

At the photo booths in the London Underground, on his way to and from Soho, Bacon sometimes slipped behind the curtain of the machine. After four bright flashes, a small strip of photographs would drop into the receptacle. Bacon liked the moment-to-moment feeling. Sometimes, when painting his self-portraits, he presented three together. But he did not require a series to convey his changing moods. Each Bacon self-portrait—and there are about forty of them, mostly made in the 1970s after the death of George Dyer—presents a different Bacon.

Self-Portrait is Bacon's next-to-last self-portrait. It is small, just fourteen by twelve inches, and finely painted. Bacon looks younger than his almost eighty years, but probably not because he is flattering himself. The self-portrait appears more timeless than some others, as if he were presenting an "essential" Bacon. He has sprayed some aerosol paint on the surface. The tiny hard red dots bring out the ruddy life in the flesh and also create a kind of scrim, making the face behind it appear gentler and more pliable. That face is full of beautifully bending lines—like the gentle curves of melancholy—and appears illuminated from within.

The Bacon missing from the self-portraits is the funny man who could laugh at his own dark vision. He was incorrigibly "a deep-end girl," as he confessed—not "minnying along the sidewalk of life"—and, besides, one does not often smile when alone. Bacon was offstage and solitary most mornings, whatever the power of his public persona or the drama of his imagery, and he never forgot that. In *Self-Portrait* he celebrated—modestly—the inward gaze.

Curtain Calls

The RETROSPECTIVE at the Hirshhorn Museum in Washington, the last in Bacon's lifetime, opened in October of 1989. Timed to coincide with his eightieth birthday, it was arguably his most powerful exhibit to date. Without Bacon's constant scrutiny and demands, James Demetrion, the director of the Hirshhorn, concentrated upon his best work. The gathering of fifty-nine pictures—a number of them triptychs—appeared neither overlarge nor distended. Nor did the selection overemphasize the later period. Visitors could see Bacon's range and changing focus over time far more clearly than usual, viewing in close juxtaposition singular examples of a screaming pope, an African landscape, two intertwined men (but not Lucian's picture), and a grand triptych.

The emphasis on his most accomplished work led to an unexpected critical reaction. In contrast to the reviewers of the Tate retrospective, some critics admired the polished late style and highlighted Bacon's formal gifts rather than his content. Bacon was becoming a *painter* rather than a postman delivering letters about the human condition. In *The Washington Post*, Paul Richard referred to "the unbelievable beauty" of the work. Alan Artner in the *Chicago Tribune* laid out the argument. The artist's earliest images, he wrote, conformed so closely to the prevailing existential philosophy that Bacon was naturally seen as having a "message." And yet, Artner argued, Bacon's own views were opposed to anything but art for art's sake: "I have nothing to express about the human condition" . . . "I believe that reality in art is something profoundly artificial." As time passed, Artner believed, Bacon's aesthetic interest in the paint itself—and his growing fluency—became only clearer: "But the fact that Bacon put esthetics before philosophy and was less involved with 'message' than with color and form has surprised people. And critics who saw his early paintings as existential illustrations later turned sour upon finding his newer works ever more concerned with the issues of art."

This formal about-face occurred for several reasons. It was partly the result of boredom with a traditional view of Bacon grown dull with time. It was also partly a response to the late pictures themselves, many of which contained fine painterly effects. And it owed something to the broader belief in Western culture—as the ideas of postmodernism and deconstruction took hold—that even a meaningful assertion of meaninglessness was a hollow illusion: all that now remained was the performance. Certain critics even took offense at Bacon's "beauty," given the subject matter. In *The Nation*, Arthur Danto felt misled, he wrote, by Bacon's aesthetic focus. The screams "seem to entitle us to some inference that they at least express an attitude of despair or outrage or condemnation." How "profoundly disillusioning," then, to "read the artist saying, in a famous interview he gave to David Sylvester . . . 'I've always hoped in a sense to be able to paint the mouth like Monet painted a sunset.'"

Many critics misunderstood Bacon's words. When Bacon stated that "I have nothing to express about the human condition," he was recoiling with annoyance from the weepy "human condition" moralizers who would reduce his art to obvious maxims. He was not, however, suggesting indifference to the human situation. When he said that "reality in art is something profoundly artificial," he was mounting an attack on the idea that realistic-looking art conveyed the human truth. The "reality" in which Bacon believed certainly did not represent a removal into a rarefied world of, to use Artner's phrase, "form and color." For Bacon, form was content, but form was also intended to embody—*in the paint*—the great questions of cruelty, despair, and meaninglessness that animated the ancient Greeks, Nietzsche, Leiris, and the existential philosophers. Bacon's intentionally provocative use of Monet—"I've always hoped in a sense to be able to paint the mouth like Monet painted a sunset"—was misread by Danto as a suggestion that, to Bacon, a human scream and a sunset were interchangeable motifs. In fact, Bacon hoped to bring Monet's mysterious power to render a sunset—without merely illustrating or describing it—to the rending despair of a scream.

But Danto's response touched upon something vital. Bacon never confused screams and sunsets, but it was now less clear than in his earlier works that he was getting "inside" the scream. Human beings do not scream form and color. Was Bacon's art too pretty, mannered, and expert now to capture the human howl? There was another way, however, to look at *Second Version of Triptych 1944* (1988). The loveliness created a filter, like the frames and glazing, distancing the viewer from the subject. That distance had its own particular and disturbing power, one different

from the immediate cathartic response Bacon earlier sought. Perhaps, finally, there was no true catharsis to be found, no violent impact on the nerves to be felt, no coin to be claimed at the bottom of the well. Perhaps the performance could not be cracked, and all the world really was a stage. *Second Version of Triptych 1944* was one of the fundamental works of postmodernism.

In London, Marlborough organized a party and a celebratory show of fifteen paintings for Bacon's birthday on October 28, 1989. "We expected him but he didn't turn up," Valerie Beston said. "He says he's just not up to it." Glum headlines appeared: "Bacon Reaches Eighty on a Low Note," "Francis Bacon Celebrates at 80 Without Pomp," "Francis Bacon Shrinks from Birthday Bash." Neither John Edwards nor José Capelo was in London for the birthday. Dan Farson, who always seemed to be around, called Bacon on his birthday. "I was startled when he suggested meeting for lunch," said Farson. "I had assumed that a gala lunch was being held in his honour somewhere, but that is not Bacon's style." Flowers began piling up at Reece Mews. "It's very nice, but I'm in a terrible mess . . ." said Bacon. "I haven't anything to put them in. I'm not the sort of person who has *vases.*"

Soon after his birthday, Bacon was diagnosed with kidney cancer. It was not the tap on the shoulder he expected. Bacon assumed high blood pressure and heart failure, aggravated by asthma, would cause his death. The ongoing asthma attacks were certainly increasing the pressure on his heart. "He was very worried that he'd get a stroke," said Dr. Brass, who had monitored Bacon's hypertension for more than two decades, "because, well, he would know that getting a stroke would mean the end of his career." In fact, a stroke would represent something far worse—a loss of control. And now, suddenly, a cancerous kidney? It must be removed, said Dr. Brass. A nephrectomy in the 1980s required opening up the abdomen and, often, cutting away a rib to reach the diseased organ. The doctor called a nephrectomy "probably one of the more painful operations."

Bacon did not expect to survive. He became increasingly agitated as his operation approached in December. He told only Valerie Beston and José Capelo—and not John Edwards—of his illness and upcoming surgery. But Bacon came through the operation well. Dr. Brass went to see him on the night of the surgery, at which he had assisted, and found Bacon "sitting up in bed having a drink and I said, 'Francis, aren't you in pain?' He said, 'No, no, no, I'm fine, thank you.'" Perhaps the best indication of

the operation's success was that Bacon promptly fell into a quarrel with Denis Wirth-Miller, who was offended that Bacon had not told him earlier, thereby denying him the opportunity to help.

An ordinary patient would have rested, but Bacon a few days later was pulling on the rope at Reece Mews, cranking himself up the staircase. José was back in town to provide company and assistance. Only three weeks after the operation, Bacon flew to Spain over New Year's to join Capelo in Seville. José particularly enjoyed Seville, long noted for its vibrant street life, pleasant weather, and magnificent Moorish architecture. He had many friends there to introduce to Bacon, who fondly remembered the time he once spent in Seville with Peter Pollock and Paul Danquah as they drove—in Peter's white Rolls—to Gibraltar and Tangier. He had long expressed a desire to return. It was a relief to leave behind the deadly air of the hospital, the penetrating cold of London, and the treacly despair of the holiday season.

The Sunday after his return to London, Valerie Beston visited Bacon for lunch at his studio, a ritual repeated over many years, where Bacon fixed her a meal of smoked salmon, scrambled eggs and bacon and Pétrus Pomerol. Miss Beston found him "fragile but content to be at home." He was cheered the next day by an unexpected visit from John Edwards. But Bacon did not resume old patterns after his operation. The trip to Seville began a period of feverish travel. He wanted the South. He wanted Paris. During the first nine months of 1990, Bacon warmed himself with at least eight substantial trips, usually with José, across the Channel—to Monte Carlo, to Madrid, to the Midi. After a successful term in London, José had been asked by Bain to open an office in Madrid. Employees at Bain worked long hours and were expected to drop everything to accommodate a client. The new responsibilities in Madrid would have increased José's workload and limited his freedom to travel, enjoy music—and see Bacon. He told friends that he did not want to commit to such a demanding job. He took a sabbatical, which left him free to accompany Bacon on even more trips. There were times when Bacon's asthma worsened, bringing on a serious attack of bronchitis, but then he would "go through phases of not suffering very badly"—and was traveling again.

Bacon was not trying to "outrun death." He meant to relish what would soon be lost. Anything and everything might be for the last time. He was "jolly ill at the end of his life," said Dr. Brass, "for about two years." Bacon could hardly imagine life without Paris or Monte Carlo; and so he must go again and again. The traveling was dangerous for a man in his condition, of course, but he returned from the trips in better

spirits. Two months after a trip to Paris in May 1990, he and Capelo went to Toulouse and Aix. In a letter of August 2, Miss Beston reported that Bacon was "just back from France and looking much better." No sooner had he arrived than he left again for Paris, claiming that his studio was too hot for working. There may have been another, less obvious reason—or a kind of soulful undertone—for making these trips. Bacon did not want to die in an English hospital or, probably, in Reece Mews. Every day now at Reece Mews he saw the oxygen tanks, standing at attention. He had already almost died of asthma in the frightening sickrooms of childhood, and it had always been one of his great joys to escape from confinements: from the sickroom, from Ireland, from his father, from his studio, from London. He loved to set out like van Gogh with his paints and wouldn't mind dying on the road.

Between trips and bouts of illness, Bacon managed to finish some work. Jack Lang, the minister of culture in France, had been commissioning eminent artists to paint portraits of leading Frenchmen and women. Not surprisingly, he sought out Bacon. Michel Leiris was the obvious choice, but Bacon had already painted his portrait twice. Bacon decided to portray Jacques Dupin, the poet, critic, and friend who had helped him with his shows in Paris for many years. Jack Lang, Dupin said, would have preferred someone better-known. "Francis said to them: 'I can only do people who are very close to me, who I like. I've already done Michel Leiris, now I can do Jacques Dupin. That's all. Don't ask me to do Nobel Prize winners or mathematicians.' So, without enthusiasm, they accepted." Bacon worked, as usual, from photographs. The photographs represented for Bacon nothing more, Dupin believed, than a rough mask of the facial features: Bacon's interest was to pass through the photographic mask. In *Portrait of Jacques Dupin*, the poet looked slightly to the left, his strong nose, left ear, and mouth faithfully reproduced. Bacon emphasized his luminous eye and questing intelligence. Dupin was the sort of man who made jokes at his own expense and liked to prick metaphysical balloons. "I thought that he would have done something more monstrous," said Dupin, who liked the picture, "and it's quite a proper portrait." In a way, Bacon captured not only a friend but also a kind of French thoughtfulness: glinting, irony-tinged, melancholic.

Sometimes, on his travels, Bacon was saying goodbye or making amends. A trip to Italy with José in the late summer of 1990, for example, was steeped in memories of the past. It concluded with a visit to the house of Erica Brausen and Toto Koopman on Panarea, the lovely Aeolian island off the coast of Sicily where the couple vacationed for many years.

It was astonishing that the ailing Bacon should trouble to make such a trip, crossing the water in a claustrophobic hydrofoil. Lovely islands were not, of course, his kind of paradise. Beaches bored him. Postcard views held no charm. And Panarea had no dissolute bars or taxis to whisk him somewhere else. Perhaps the most surprising fact of all was that Erica Brausen was not even there. Only Toto.

Over the years, Bacon had made his indifference to Toto clear. After Bacon left Brausen's gallery in 1959, he rarely saw either woman. But he was far more subject to conscience than many people supposed, and his guilt over Brausen, his great early champion, never left him. Barry Joule, who became a friend of Koopman's (but not of Brausen's) through a shared interest in photography, would talk to Bacon about Erica and Toto. He told Bacon of Toto's life as a spy during the war and her subsequent imprisonment (for almost four years) at the Ravensbrück concentration camp, a secret that Koopman rarely revealed. "Bacon became intrigued after I had access to their apartment and knew what the ladies were doing," Joule said. "This was around '86–'87, when I was flying to Panarea with Toto." One day in the late 1980s, Joule said, "Toto had called me and said, 'Erica is not well.' She couldn't go [to Panarea]. Francis got upset and demanded their phone number. Early the next morning the phone went and it was Toto. Francis had phoned at four a.m. and said he wanted to speak to Erica. He wanted to put a hundred thousand pounds in her account for medical expenses. He was trying to take care of her." His trip to Panarea was also a form of making amends.

In Paris, Bacon always made certain to see Eddy Batache and Reinhard Hassert. Together, they would recapture something of the old days. He also introduced Eddy and Reinhard, perhaps with some pride, to José. As always, Bacon enjoyed sitting in a Parisian café observing the passing parade. One evening, he took José to meet Michel Leiris at his magnificent flat on the Seine. His wife, Zette, had died two years before; Leiris himself, not long before Bacon's kidney operation, had suffered a heart attack. The two old friends had remained in touch, but inevitably drifted somewhat apart. Their friendship belonged more to the past, said one friend, than to the present. But the past still mattered. As always when he visited Leiris, Bacon dressed elegantly and Leiris was a thoughtful host. Leiris chose to sit in an armchair directly below Bacon's *Portrait of Michel Leiris* (1976) and, in deference to José, talked of Spain and bullfighting. At a certain moment, a Bateaux-Mouche passed by on the Seine, its lights sweeping through the apartment—and illuminating the portrait above Leiris. Everyone noticed. No one said a thing.

Bacon's sustained interest in José Capelo did not initially concern John Edwards. After missing Bacon's birthday in October 1989, however, he was taken aback to discover that Bacon told José but not him about the upcoming kidney-cancer operation. Dr. Brass, who possessed an old-fashioned sense of duty, thought that Edwards was not paying nearly enough attention to his paternal benefactor. "John did come occasionally," said Brass. "But he wasn't supportive of him in his illness." The Leventises, who were fond of John, took the trouble to warn him about neglecting Bacon. "We knew Francis was seeing José," said Michael Leventis, "and told John to be careful, that he could always change his will."

Not long after the operation, having returned from his trip to Seville, Bacon was pleasantly surprised to find John in London. Valerie Beston had taken note, recording in her datebook "Jan 8: John in London with Francis." Then, after Bacon and José went to Madrid in February, John accompanied Bacon to Monte Carlo the following month. Beston's datebook, which rarely referred to John in the late 1980s, now noted his presence more often in 1990. José also noticed John's increasing presence. He would have been less than human not to expect something from Bacon, who told him to take whatever he liked from the studio, but money and the disposition of Bacon's estate were not his main concerns. His financially secure parents had died, and he had done very well for himself at Bain. John's increasing presence around Bacon created other issues for José, who did not want to be perceived in the larger world as "angling" for anything. The idea of engaging in a squalid rivalry with John over an elderly man's estate was anathema to him. And he was concerned that Bacon was not doing what was best for his art. Bacon intended to settle his estate upon Edwards, having already made significant financial gifts to his family; but what of Bacon's pictures? It seemed irrational to José that Bacon's legacy should be left in limbo. Bacon should not just leave his work to be sold after his death. He should provide for its study and care. He should donate paintings to the institutions of his choice. At the very least, he should do *something*, not just leave the decisions about the disposition of his work to Marlborough and a genial cockney who knew nothing of art.

But Bacon recoiled from such discussions. He had grown accustomed to both Edwards and his family, and—Capelo told friends—the prospect of changing such relationships or his will made him deeply uneasy. John remained essential to Bacon; he was a foundation stone in Bacon's world.

Even while traveling abroad with José, Bacon would regularly write to John with nothing to say. In a letter from Naples in September of 1990, for example, he wrote: "I am in Naples for a few days tried to telephone you at the farm but no answer will be back at end of month. Love Francis." Bacon continued to express a baffling concern about John's future financial well-being. "I remember Francis having dinner alone with me and asking whether I thought he was generous enough to John," said Janetta Parladé. "He had already given him three million pounds." Although Capelo disliked seeing Bacon "conditioned" by Edwards, as he put it to friends, he would push Bacon only so far about the future. There was a risk of tiresome arguments, eruptive anger, and possibly a tabloid frenzy if people came to believe that Capelo was reshaping the estate.

And so, José distanced himself ever so slightly from Bacon—enough, however, to make clear that he was not trying to "claim" the elderly artist. José was still a young man, he was free of Bain, and he wanted to see the world. Bacon's feelings for him remained as strong as ever. The two men continued to see each other often, and frequently traveled together; but José also made clear during his sabbatical that, for example, he would take a trip to Italy alone. Bacon felt the fall of the shadow. José would now also have a life apart. Soon enough, José began to talk of a longer trip farther afield—to Asia—later in 1990. Like Dicky Chopping, Bacon maintained an absolute belief in freedom, however painful the results. He would make no specific demands of José. At the same time, he longed for his regular company. In August 1990, he wrote to Denis Wirth-Miller: "Trying to work—I think in October José is going to take one of the cheap tickets to go around the world—I don't see much of him as he is nearly always traveling. . . ."

Bacon was not very productive in the studio, given his traveling and his illnesses, but he managed to complete, in addition to the portrait of Dupin, some lesser work that reflected his ongoing (and now increasingly poignant) interest in virile, well-muscled men. But the principal male figure that absorbed Bacon, as he found himself increasingly alone, was José Capelo. Although the romantic figures in Bacon's life almost always entered his art, Bacon—three years after Barry Joule's dinner party—had yet to find a satisfactory way to portray José. It was not for lack of trying. Bacon made many small portraits of Capelo during 1990 and also possibly the year before, most of which remained unfinished. None was recorded by Marlborough. Bacon's difficulty in making identifiable portraits of José may have stemmed from José's desire for privacy. George and John did not care how Bacon depicted them, and neither had

a trained eye for art. By contrast, José would naturally focus intently upon any image made of him, and he did not appear eager to become a subject. That could be inhibiting to Bacon, who asked Capelo—as the younger man prepared to embark on his solo trip to Italy—if he might include his image in a large triptych. (He could at least keep José close at hand in the paint.) That Bacon asked for permission, which he would not have felt necessary with George or John, conveyed how sensitive he was to José's desire for privacy.

José agreed, and on June 2, just as he was leaving for an extended trip to Italy, Valerie Beston noted that Bacon was starting a "new, larger triptych." As he began, Bacon had a vague scheme in mind—a full-body image of Capelo in one side panel and of himself in the other side panel. What would fill the central panel was probably unclear at the outset. Although Bacon had often painted his lovers in the past, he had only rarely made a triptych that contained clear references to both himself and his lover. In two cases, these triptychs were painted after his lover's death. One was the 1962 *Study for Three Heads*, in which he painted himself flanked by two portraits of Peter Lacy. The second was *Three Portraits: Posthumous Portrait of George Dyer; Self-Portrait; Portrait of Lucian Freud* (1973), in which Bacon juxtaposed himself with his dead lover and close friend. It was telling that Bacon, who painted many self-portraits and never concealed his homosexuality, was not often drawn to the idea of pairing himself with a lover inside a triptych. Perhaps the living relationship eluded description.

What would become, many months later, Bacon's last triptych—*Triptych* (1991)—developed into an allusive evocation of a homosexual relationship. It would take him almost a year to complete, and it would represent (among other things) an elegy for his final years, at once a tribute to love and to love lost. From the start, Bacon struggled, finishing only one panel by early July of 1990. Subsequent trips to France and Italy with José further interrupted him. Then, after the September visit to Panarea, his health problems significantly worsened; at one point he went into acute heart failure. Dr. Brass persuaded him to go for an examination to the Royal Brompton Hospital, which specialized in heart and lung problems. Bacon saw a cardiologist whose judgment, said Brass, was that "there was nothing they could do for him more than he was doing at the moment." After that, Brass began to see Bacon weekly or biweekly. "And that was so unusual and he was so frightened . . . And he used to say to me, 'You know, Paul, I'm not scared of dying, and I don't know that I want to live like this. This isn't living.'"

Dr. Brass would often "get rid of all the fluid," a side effect partly caused by the cortisone that Bacon was taking. He prescribed an appetite sup-

pressant, which was also a helpful amphetamine, to reduce the bloat and weight gain. Bacon possessed an "armamentarium of different inhalers and steroid tablets and antibiotics," and when they failed him, he "would come and see me and we would change his inhalers." Other patients, said Brass, would have "just stayed indoors," but Bacon "loved his life." He resolutely refused to give up champagne. He stored the champagne crates at Reece Mews under a table on the landing outside the studio and sitting room, as the observant Brass noted.

During a period when Bacon was feeling better, Barry Joule drove him to see the exhibit *Francis Bacon: Paintings Since 1944* at Tate Liverpool. Bacon enjoyed riding in Joule's Porsche Targa, and so the pair decided to make a long weekend of the trip, first going to the National Museum of Photography, Film & Television in Bradford. They saw a movie on the big screen of an IMAX theater, the scale of which impressed Bacon. And they stayed at the Adelphi in Liverpool, the palatial hotel opposite the train station where once upon a time the fresh-faced young Bacon—leaving behind family and Ireland at the age of sixteen—spent the night before catching the train to London. Bacon also wanted to see the Liverpool docks where he had once disembarked. At Tate Liverpool, Bacon and Joule queued up with the other visitors. Inside, Bacon paused before *Triptych August 1972*, one of the "black triptychs" painted after George Dyer's death. Its central panel contained an image of two wrestlers—or lovers—engaged in the propulsive thrust of sex. Bacon told Joule, "I've always liked that one; it goes on having power . . . for me anyway." Then he added, perhaps with his unfinished triptych in mind, "Maybe I'll do another one day." Once back in London, Bacon asked the gallery to send the middle panel of his *Triptych* (1987) to Reece Mews, in which he had painted the bottom half of a figure—two heavily muscled legs and crotch without a torso. Two similar torso-less figures would eventually appear in the outer panels of his new triptych, now with heads included.

Capelo left on his Asian trip in the autumn of 1990. Bacon remained alone and unhappy in London. He had experienced before—with John Edwards—the slow, friendly, inexorable withdrawal of a man he loved. He became briefly infatuated with a Spanish waiter at Bar Escoba, a fashionable tapas place on Old Brompton Road, but failed to successfully chat him up. ("It wasn't a relationship," said a friend, "more an obsession.") It was probably in the late fall that Bacon completed his last self-portrait, a mysterious image that was indubitably Bacon but did not look much like him. The image called to mind an ancient Greek mask, the kind worn by actors in the plays of Aeschylus. The sensation of mask-making in the picture, of fingers pushing around wet material to capture a fleeting

likeness, was exceedingly strong: the eyes were thumb-punched sockets, the features a series of soft swirls. It was not difficult to imagine the man behind this mask grabbing his neck in order to remove his face.

All the while, Bacon eagerly awaited José's return. Valerie Beston noted in December that Capelo would be "back next Wednesday from Burma," a fact that she said made Bacon "chirpy," an adjective that had never before and would never again be used to describe Bacon. On December 12, Barry Joule and Bacon went to greet José in Sloane Square upon his return. José had cut his hair short, which Bacon liked. He always wanted to see the head behind the face. José went with Bacon to Marlborough to see the newly painted triptych. The two torso-less bodies of José and Bacon, echoing those of *Triptych* (1987) were in the side panels, while the center panel closely resembled the central image of the *Triptych August 1972*, which Bacon saw in Liverpool. The central panel appeared more schematic than the original did, and it was neither as richly nor as subtly painted. The sexual overtones, however, were hard to miss. Even so, José liked it overall, he told Bacon, with some reservations.

Capelo never conveyed what his reservations were to friends, but they likely concerned the juxtaposition of his figure with the sexually charged central panel. (Bacon, who had been working on small but faithful portraits of Capelo, may have begun with an equally recognizable portrait of him for this triptych.) Ordinarily, Bacon did not allow someone else to change the direction of a painting, but he would listen to the opinions of valued friends. Well aware of José's reticence, Bacon brought the triptych back to his studio. He would work on it some more. The last thing he wanted was to upset José. And he never really minded destroying a painting. By mid-December he had almost finished the reworking. He had meanwhile completed a small diptych of José called *Two Studies for a Portrait* (1990), which was among his most emotionally transparent works. He did not seriously mark or distort José's face. In the left panel, José's features—centered, eyes looking straight out, the expression forthright—were lightly blurred by the impressions of what appears to be a cloth pressed onto the surface to give the flesh some graininess. In a dreamier panel on the right, José's head was placed off-center and his eyes appeared lost in thought. A small part of his face seemed to have been sheared away, lost to the dark background, making his dreaminess appear all the more unreachable. The dark background was not ominous: it set off the youthful pinks and fleshy fullness of his lips. Bacon gave José the diptych for Christmas.

On Christmas Day itself, at five in the morning, Bacon called Barry Joule with exciting news: he had finally completed, after seven months,

the triptych of himself and José. It was Joule whom Bacon called because few others were available at five a.m. on Christmas. (At first Joule thought Bacon must have a medical issue.) Upon his arrival later that morning, Bacon uncorked a bottle of champagne. They then took Toto Koopman to Christmas lunch at the Onslow Court Hotel and afterwards retired to the Colony—on Christmas, perhaps more than any other day of the year, the preserve of lost souls—and ended by gambling away the night at Charlie Chester's. Alas, as often happened with Bacon, the painting may have appeared complete but was not yet finished. Only days later—perhaps because José still maintained reservations, perhaps because Bacon himself had changed his mind—the triptych was once again undergoing revision.

During that winter and spring what Bacon particularly feared became true: José's resolve to keep his distance appeared firm. David Sylvester once told José that the situation presented by a man like John Edwards—that of a lover having become a son—can create a paralyzing difficulty for an elderly man. There was simply not much that could be done. Bacon mournfully informed Dan Farson that, though his friendship with José remained, their physical connection had ended. Like a lover who cannot accept his loss, Bacon even showed Farson happy snapshots of José from the old days. He also lamented the change of circumstances to Wirth-Miller and Chopping. The loss of a sexual relationship was not for Bacon merely a portent of the loss of life itself. The sexual act was a drama that gave form and body to his most deeply held convictions about the world. It conveyed power and weakness; the animal and the human; the holding and the letting go; the love and the despair. As he did with Edwards, Bacon began to worry about José's future. He had enjoyed Capelo's career at Bain & Company; a businessman in a fine suit appealed to him. How would José pass the time, Bacon wondered, now that he no longer worked? Bacon himself could not imagine a life without work, and freedom from work had not always served John well. "He was clearly obsessed with José," said Joule, who believed Bacon was upset "that he had been dumped."

That was certainly not how Capelo saw their relationship. He would never "dump" a man like Bacon. They continued to see each other and travel together; and Bacon's passion for José did not flag. They went to Paris in January of 1991, for example, and thereafter to Madrid. In Paris, they were invited to the premiere at IRCAM of the first version of Pierre Boulez's seminal *Explosante-fixe* for flute, live electronics, and chamber orchestra. The piece, still a work in progress, was based on a phrase from André Breton's *L'Amour fou* that probably pleased Bacon: "Convulsive

beauty will be erotic-veiled, exploding-fixed, magical-circumstantial, or it will not be at all."

Over the next few months, Bacon's triptych came and went between studio and gallery. It was recorded arriving at Marlborough in March of 1991 and then again in May. By the summer, however, *Triptych* attained its final form. It had taken a year of work, chance, and accident—the same year during which Bacon's relationship with José shifted. The side panels, originally intended to represent Bacon and Capelo, probably underwent the most change. On top of each headless torso Bacon placed a rectangular masklike face that looked like a schematic painting of a black-and-white photograph—not like a painterly portrait. In the right panel, the photographic mask was obviously an image of Bacon. When an interviewer later observed that "it's a photograph of yourself," Bacon responded, "Taken many years ago." The interviewer added, "The young Francis Bacon," and Bacon laughed, "Well, it's younger." The mask in the left panel was less identifiable. It could be José, but it also resembled a photograph of the racecar driver Ayrton Senna, which Bacon had in his studio. The young man was possibly, not certainly, José.

The bodies in both side panels were visually discordant. They resembled ill-fitting and unlikely creatures, combining a black-and-white head with an animal-pink lower body. They lacked enough upper torso to connect top with bottom, and each was stepping, with one of its legs, outside a large black rectangle. Bacon's left leg was turned toward the other figure, whose right leg was not turned toward Bacon. The central panel, which contained the headless wrestlers-and-lovers, separated the two figures from each other despite their implied sexual union. The curiously ill-fitting figures, oddly reminiscent of centaurs, did not have to represent José and Francis. Nor did the two masks staring out from their rectangle-windows: the triptych contained many allusions to the difficulty of locating identity. Like the earlier triptychs in which Bacon pictured himself with a lover, the new one also commemorated a loss. It evoked love's conjoining but also its separations. Body and mind did not seamlessly connect, even within a single figure. The old dreamed of the young. The young dreamed of other things. Love's eruption could not finally displace the mask; and no living, breathing head could quite be found behind the mask of representation. The mood in this last triptych had some of the same distance as *Second Version of Triptych 1944*. The revelation was concealed. The closet was not easily escaped.

Borrowed Time

THE AGING BACON was often gallant. But he could also be querulous. He broke with the devoted Leventises in the late 1980s when they sold a painting that Michael bought, at the urging of Bacon, which he did not especially like. Barry Joule arranged a reconciliation a year or so later. He also broke with Anthony Zych when Zych, in an interview, mentioned his interest in Jackson Pollock. ("But everybody knows that you're the great influence on me," Zych told Bacon later.) Once, when Bacon took Ianthe and the Leventises to dinner, he suddenly whirled upon his mild sister, raging and raging at her, something not even a drunken Bacon would have done in the past. Ianthe did not like John, Bacon wrongly concluded, "and boy," said Ianthe, "did he lay into me. It was most peculiar. In front of the Greeks." The maître d' of L'Escargot, Elena Salvoni, a motherly figure much loved in Soho, stepped in: "He was very rude to her. I told him off. He said, 'Don't worry—it's the drink.'"

Often, Bacon was alone in the evening. David Sylvester remained a close friend; but others were dead or had drifted away. Caroline de Mestre Walker, Roy de Maistre's much younger cousin, lived not far from Bacon in the 1980s and '90s and remembered the youthful painter from her early visits, as a child, to her cousin in the 1930s. Now she would see his solitary figure at the post office and would say hello. He seemed, she said, very, very lonely. Sometimes Bacon ate at Bibendum or L'Escargot by himself, unimaginable even a few years before. Another breakdown of his manners occurred in November of 1990, at the funeral of Rodrigo Moynihan. Unlike many friends of Bacon's from the 1950s, the witty and outspoken Moynihan and his wife, Anne Dunn, always remained part of his life.

Moynihan was cremated at Mortlake, in Richmond, and the mourners afterwards returned to the Moynihans' house on Redcliffe Road in Chelsea for a half wake, half party, "where there was plentiful cham-

pagne, whiskey, and food, including delicious cake," said Richard Shone, who later became the editor of *The Burlington Magazine*. Bacon and Anne Dunn and one or two others then went to dinner at a Chinese restaurant on nearby Park Walk. Bacon called the Moynihans' younger son, Danny, from the restaurant and asked him to join the party. Shone and the painter Charles MacCarthy went along. "No one introduced anyone," wrote Shone, "and F.B. was already well on the way with the wine and Anne indulging too":

> F.B. in black leather zipper jacket; tawny to orange hair; those intense, staring eyes and two deeply furrowed lines between the eyebrows. "The epitome of the aging queen," Rodrigo once called him. They were talking about Lucian (of course) when we arrived and just carried on, as we three tried to settle into the swing of things. There seemed no particular reason for Lucian's and F.B.'s "quarrel"—they simply don't speak. "Lucian's portraits are the greatest portraits of our time," said F.B., "especially those of you [to Anne] and Caroline [Blackwood] and the head of me which was stolen."

Since Bacon brought up Freud, Shone felt free to ask him about other artists. "Some praise for Auerbach. Little for Kossoff: 'Not interesting.'" Bacon dismissed the Bloomsbury painters, notably Duncan Grant, with one word: "Awful." Shone mentioned Matthew Smith, for whom Bacon had written a small essay of praise many years before. Bacon pronounced Smith "not very good." When Shone objected that Bacon had once written admiringly about Smith, Bacon cut in with "'Yes' (curled lips). 'But they're not very good.'" Bacon snarled over the food, pronouncing the crisp prawn wafers "rubbish—just rubbish." The company was "rather stunned into submissive silence." By the end of the meal, Bacon was "far gone," said Shone, "but with a clutch on the conversation around him that was both impressive and pitiable." After dinner, the young Danny Moynihan suggested the group have an after-dinner drink at nearby Bar Escoba, the same Spanish tapas place where Bacon was rebuffed by the waiter. Bacon spat, "You're a shit if you go there." Then he continued to attack Danny, said Shone, "with a deadly straight, glowering look. Danny whitened visibly but, like an injection, it was over in a few seconds." The venom astonished Danny. Bacon's withering condescension implied, Danny said, that only "a certain type of person went to a tapas bar. A city boy. People raised like you. Bacon had an attack like a viper."

Such bitter, uncharacteristic actions were more the exception than the

rule, however. Friends noted, with admiration, that Bacon rarely complained about his health. He continued to be as dutiful as ever, particularly with his family, despite the embarrassing outburst with Ianthe. He looked forward to her visits. She was reliably and pleasantly old-fashioned in a comforting family way, and Bacon himself had never lost certain "very English qualities," José Capelo told friends, sometimes becoming reserved and diffident. (There were things he would not discuss in polite society, for example, including health issues.) Ianthe dressed like a lady, spoke with an accent from another era, and used expressions like "that sort of thing." She had the gift of seeing only what she chose to see, and she remained as averse as her brother was to using a word like "love." Peter Lacy was "the real tragedy" of Bacon's life, she once observed, because Francis "was very, very fond of him." A double "very" was about as effusive as Ianthe was prepared to be. And yet, Ianthe was winsome. She had a twinkle and a laugh that was not stuffy. She visited Bacon in November of 1991, and he felt saddened that he was not healthy enough to sustain the "jolly Uncle Francis" role that he played with Ianthe and her family.

He could still be consummately charming—and serious. On a trip to Madrid in 1991, he impetuously telephoned Manuela Mena, then the deputy director of the Prado, whom he did not know. An English voice came on the line. "Hello? Manuela Mena? I'm Francis Bacon." He asked if he might possibly come to the Prado on a Monday when the museum was closed to see the collection of Velázquez. He wanted to spend some time alone—at the end of his life—with this particular painter. The year before, during a visit to Madrid with José, he had failed to see to his satisfaction the great Velázquez loan show the Prado had organized: it was always mobbed, from early morning to late at night. Now was his chance. But it was not easy to arrange a private view. The Prado's guards were on strike. The next Monday, Mena told Bacon, go to the little-used door by the Botanical Gardens. "We opened that door for him at midday," she said. "The door opened and in with the sun came Francis Bacon."

The image enchanted her: art royalty slipping quietly, backlit and resplendent, into the silent museum by a little-used door. "I've never seen somebody so gentle . . . kind of a seventeenth-century king. He was not pretentious. He looked you straight in the eye. He wanted to see who you are. And he was open. He had an aristocratic bearing." Years later, when she took Lucian Freud on a similar private tour, she naturally compared the estranged friends. "Freud was very different. Very shy. Incredibly handsome. He had sparkling eyes, like cold fire. He would look at you in flashes. Not like the open look of Bacon, who had this kind of security

in himself." Bacon worried that the guards were being inconvenienced. Mena reassured him. For the hour and a half of his visit, she discreetly shadowed him. He would walk "within a few inches of the canvases" and then back up again, closing in and backing up. Bacon seldom lingered with a painting in a museum; he typically moved rapidly, as if to seize by surprise the essence of each picture. On that day, however, he lingered in front of *Mars Resting* (1640), the Velázquez painting of the Roman god of war. "I recall that he looked at it very close-up," said Mena. "The intensity of how he looked at Mars was very special." Velázquez had depicted Mars—usually a symbol of bold masculine power—with rare sobriety. The god was middle-aged now, lost in melancholic reflection. His warlike spirit was present mainly in a magnificent helmet and a swaggering moustache, a mask behind which the man himself—his face in shadow—contemplated the world. His aging flesh remained beautiful, but he did not possess the divine musculature of a Michelangelo figure. It was a more thoughtful kind of flesh.

Bacon was probably less secure than Mena imagined. After the visit, he sent her "the most beautiful flowers" that she had ever received. "But they came from a man increasingly worried about losing his powers. He wondered whether he could ever again meet the standard set by his "black triptychs" commemorating George's death, never mind approach the impossible standard set by Velázquez. He did not admire the later Picasso: perhaps he himself was just another artist trailing off. During his trip with José to Italy the year before, they visited the Titian retrospective in Venice, which commemorated the master's quincentenary. José reassured Bacon that an elderly artist could still create important work. There was no better example than Titian, who painted *The Flaying of Marsyas* (c. 1575)—one of the greatest works in the Western tradition—when he was in his eighties. In an August 1990 interview for *Kaleidoscope,* Bacon was asked whether the urge to paint was "just as strong now, in your life?" He answered, "Yes, stronger; the nearer to death I am, the stronger it gets."

Bacon would still walk alone, on occasion, to lunch at Bibendum. The Underground station at South Kensington, especially its long escalator, was becoming daunting: but he could take the number 14 bus to Soho. "On a good day, when glimpsed from the other side of the street," said John Russell, "he had even in his eighties the same lifelong spring-heeled walk." Russell recalled seeing him in "a pale grey silky raincoat, skirted and pulled fractionally tight. His huge, all-penetrating gaze had all its old

sharp focus. He still had the look of an English boulevardier for whom every chance meeting was matter for hilarity shared and reciprocated."

The Irish poet Paul Durcan witnessed a remarkable performance by the elderly Bacon during a healthy moment. Durcan had come to London in the mid-1960s and was introduced to Soho by the eccentric poet Paul Potts. "Francis in the Colony Room had the same effect on me as did Francis Bacon in the Tate Gallery," Durcan later wrote. "He was that rare bird of paradise: a creature of integrity in whom the work and the life are one." One day in 1990, Durcan noticed the eighty-year-old Bacon standing in a bus queue in Piccadilly. He wrote about it in a poem, "Putney Garage":

I fell into line.
We stood in silence
He lounging against the corner of the bus
shelter in a lounge suit,
Hands in trench-coat pockets . . .
Idly alert,
Courtly corner boy.

The bus arrived. Bacon was first in queue. He stood back to let "a young Asian gentleman" cut in front of him:

Then he, aged eighty years,
swung up the staircase like a gibbon
in the Dublin zoo.

Bacon turned down most requests to be photographed or interviewed. He feared a sudden asthma attack and did not want to be seen sucking pitifully on an inhaler. But he could be coaxed into conversation. Maricruz Bilbao, the Spanish art dealer then in the process of opening a Marlborough branch in Madrid, approached Bacon during this period for an interview on behalf of a good friend of hers, Juan Cruz, a talented writer for *El País*. "Oh, no way that he'll do it," she initially told Cruz. "*Fígaro* came yesterday and he said no." But Bacon said yes. Perhaps he enjoyed the prospect of José reading about him in the Spanish press. And so Cruz and Bilbao scrambled to London for the interview. "And the first thing we heard was that Bacon was not feeling well," she said. "He had had an asthma attack. He was going to come to say hello out of politeness because we had flown all that way." Bacon arrived at the Marlborough

gallery "ready to leave," she said, and remained standing. He even pulled out an inhaler. And then Juan Cruz also pulled out an inhaler: he, too, was asthmatic. And suddenly the two were discussing—like specialists at a conference—the subject of asthma.

Bilbao then brought up the Spanish old master Zurbarán, about whom she was passionate, further animating Bacon. He "started talking and talking about Zurbarán and the Prado and what Velázquez paintings he liked. He had been standing and he sat down. And then Juan started asking questions. So he stayed for about two hours. He was really very, very lovely." Like Manuela Mena at the Prado, Bilbao found him courtly. But she also enjoyed, as she watched Cruz conduct the interview, the play of expression in Bacon's face. "Suddenly he looked like an old man, then a young boy. Young, old, British elegant. I've never seen anybody going through so many changes so vividly." He resembled a fine old lady, she thought, as much as a fine old man. "He had this pinky skin. . . . There was something very tender and lovable about him. Everything about him seemed vulnerable. He was enormously likable." It was only the intrusive presence of the photographer, banging about the room with his equipment, that tired Bacon and led him to end an interview that had become a conversation.

In the fall of 1991, for a time, Bacon felt somewhat better—an Indian summer. True to form, he left London, traveling with José first to Madrid in late August and then to France, where they enjoyed the Seurat retrospective at the Grand Palais. Bacon had developed a deep admiration for Seurat, calling *Bathers at Asnières* (1884) in the National Gallery in London "magnificent." He was probably taken both by the classical stillness of the artist and his pointillist toolbox, which did not slavishly illustrate the world. Bacon and José also visited the Château Lafite Rothschild vineyard, where, Capelo later told friends, their "amazing" dinner was accompanied by great wines and, at the end, an unforgettable soufflé. The next day Bacon, as ever the passionate oenophile, tried to recall each wine. The neighboring vineyard of Château Mouton Rothschild, which each year asked a well-known artist to design a label for their wine, was still hoping against hope that the elderly Bacon might yet contribute a label.

That October, Michel Archimbaud proposed a series of interviews with Bacon. The two had remained in touch through Pierre Boulez. During the interviews, Archimbaud introduced Bacon to the French photographer Francis Giacobetti. Over the next months, from the fall of 1991 into early 1992, Bacon met Giacobetti eleven times for photo

shoots around London. Initially, Giacobetti did not use conventional lighting equipment, even though he thought of himself as "first of all a lighting technician." In a rental studio, he said, "I found a strip of neon and I shot a lot of portraits using just that." They usually went to lunch or dinner after a shoot. Bacon asked Archimbaud, "Why didn't you introduce me before?" It was an indication of Bacon's loneliness and inability to work—and also, perhaps, of his declining discernment—that he now gave Giacobetti more time than he previously granted some of the twentieth century's most celebrated photographers, among them John Deakin, Cecil Beaton, Lord Snowdon, and Richard Avedon. Giacobetti was for years the artistic director of *Lui* magazine, the French equivalent of *Playboy*, and he often worked with Prada. His feeling for the flashy—at once knowing and melodramatic—seemed designed to capture attention. He created self-conscious references to Bacon's art in his portraits. In one photographic triptych, drenched in reds, Bacon peered out from a hanging slab of beef.

In the end, Bacon did design a label for Château Mouton Rothschild. The label looked as lighthearted as champagne—a tease about himself, though he was serious about the joy of wine. He depicted a creature that resembled the ferocious Furies of *Three Studies*, except that this Fury, having seemingly left her day job, appears to have chosen the dance of life and not of death. Her elongated limbs sway gracefully, or perhaps tipsily, and the goblet she holds (which, in Bacon's *Triptych* 1976, overflowed with blood) glows with the rich reds of a fine claret. In another sly tease, Bacon used one of his traditional "stage props"—the chilly abstract circle he liked to press into a painting by drawing around the bottom of a glass or wastebasket—and turned it into nothing more (or less) than a glass of wine.

In late December of 1991, Bacon personally delivered the painted label to the Baroness de Rothschild, a formidable woman who had been an actress before inheriting the vineyard from her father, Philippe. Bacon brought the painting, the Baroness later said, in "of all things, a plastic bag." Bacon, if he lived long enough, could look forward to payment in kind—cases of fine wine from the vineyard. (In the best of all possible worlds, or at least in Bacon's version of it, that was how an artist should be

The final commission: the fanciful label for Château Mouton Rothschild wine that Bacon delivered, in a plastic bag, four months before his death

paid.) Valerie Beston enjoyed observing his pleasure. That same month, however, she told Maricruz Bilbao to "hurry up with the work of [opening] the gallery in Madrid because Francis is not well." And then, said Bilbao, "she started crying."

Around this time Bacon stepped onto a bus and saw his old friend and model Henrietta Moraes. He sat beside her making small talk about the *Mona Lisa*—whom he had visited not long ago in Paris—when suddenly he said, "I've got a problem. Do you know anything about funeral arrangements?" Moraes said she did not. "When I die," Bacon told her, "I don't want to have a funeral. How do I go about that?" She answered, "I suppose you go to your solicitor." "My solicitor," he said, "is away on holiday. I don't want anything, anything, anything." Also around this time, Bacon was briefly admitted to the London Clinic. Barry Joule picked him up, and the newly discharged Bacon declared that he must then and there eat a croissant. They went to a nearby restaurant and were settling into a table when suddenly Lucian Freud appeared with a "beautiful woman." Joule imagined a marvelous rapprochement. "Freud had a tray," said Joule, "and was moving in our direction. Francis said, 'Don't move. Let him come here.' Freud went right past us and went to the opposite end of the restaurant. Francis said, 'That's the way things are.'"

Sometimes, Bacon collapsed in public. Michel Archimbaud once saw him folding "in front of my eyes"—he had left Reece Mews without an inhaler. Anthony Zych, who then lived almost across from the Cromwell Hospital in South Kensington, recalled a moment at the hospital in the late summer of 1991 when Bacon "had virtually died and been revived." Bacon was suffering from pneumonia and incipient heart failure. He occasionally appeared rude without intending to be so: the loss of breath simply left him speechless. He could also be abstracted. When the painter Zoran Mušič found him sitting alone at a table in Paris and went up to say hello, Bacon barely spoke—not because he couldn't, said Music, but because it was "as if he weren't there any longer." Bacon's situation seemed dire even to observers not given to hyperbole. He was not living on "borrowed time," wrote John Russell, "but on time wrenched from the teeth and claws of death." Dr. Brass found Bacon "quite happy to die but he didn't want to be a respiratory cripple, which he became, he absolutely became. He couldn't walk across the room without being out of breath. So sad." Brass made regular house calls to Reece Mews. Rather than go downstairs to open the door, Bacon—like a lover—tossed him the keys from the upstairs window.

One day, a man Brass did not recognize answered Bacon's door. The doctor feared the worst. A break-in? "I have a sort of slight Victorian side to my character, and I saw this rather . . . long-haired fellow. He just didn't seem to be an appropriate person to be in Francis's flat. But then Francis said to me, 'Oh, this is Barry, he's getting me a few things.'" For thirteen years, Joule had been driving Bacon here and there, helping with odds and ends. Now he was managing most day-to-day matters—except for cleaning up, of course, a task performed by Jean Ward, the longtime and garrulous "char" for whom Bacon maintained an abiding affection. (Bacon's nephew Harley Knott once wondered how anything ever got cleaned at Reece Mews, since Ward and Bacon spent all their time chattering.) Bacon explained to Dr. Brass that Joule "always seemed to be available," and "you know, he's very useful because he comes and gets me things if I can't go out," even taking Bacon's clothes to the cleaner's. Nevertheless, Bacon still controlled his own time and movements. In late December of 1991, he was put in the hospital with a pneumonia scare. It seemed a cruel and fateful trick that one who so loved the breath of freedom should now begin slowly to suffocate, confined in a kind of airless space-frame. After emerging from the hospital, he decided to go to Paris. He often left London around Christmas, and he wanted to see a Giacometti show and visit his old friends Eddy and Reinhard.

Bacon packed a heavy bag and set off alone. At Charles de Gaulle Airport, the escalators were out of service. Bacon climbed down one long stationary escalator and then up another. He collapsed at the top. John Russell and his wife, Rosamund Bernier, were by chance traveling through the airport and spotted him "barely conscious," said Russell, "half leaning and half hanging on the hand-rail. Passengers were few, and those who passed him on the other side clearly took him for dead." Russell and Bernier helped him into a taxi bound for the city. The color began to return to his face, and he began to speak in his usual animated way. By the time they arrived at his favorite hotel of the time, the Pont Royal, "it was all that we could do to stop him carrying his bag up the steps."

An Errand

I MUST GO TO SPAIN," Bacon would say. "I want to go to Spain. I must go to Spain." Dr. Brass would always reply: "You are too ill. You might die if you get on a plane."

There were mornings, following his return from Paris, when Bacon went to work as usual at six a.m. Other days he spent chained to an oxygen canister. On January 18, 1992, he called Barry Joule from his kitchen phone and weakly asked, "Can you come right away?" Joule found him on the floor unable to reach the canister in his bedroom. Joule dragged the canister into the kitchen, turned on the oxygen, and pumped Bacon's chest. "I managed," he said, "to dial Paul Brass." The doctor rushed to Reece Mews and gave Bacon a shot of adrenaline, telling the ambulance dispatcher to send help quickly. "It's Francis Bacon." The attendants strapped him to a stretcher to get him down the stairs. "He started coming around in the hospital," said Joule. "He spent about a week there."

Bacon continued to go out with friends, though he could not walk far. He saw the Leventises. He reconciled with Anthony Zych in a restaurant on Old Brompton Road—though Zych himself, still smarting from the time Bacon attacked him for referring to Jackson Pollock, said things he later regretted about "old poofs and old queens." Afterwards, as Zych stepped into a taxi, Bacon "was looking at me in a valedictory way." Denis Wirth-Miller, in an effort to help Bacon, would bring cooked meals to Reece Mews. Bacon took the time to advise Gérard Regnier, the director of the Musée Picasso in Paris, about a future exhibit to be called *The Body on the Cross*, which would juxtapose the Crucifixions of Picasso and Bacon. He was probably both intrigued and amused by the topic of Regnier's essay—"That Wonderful Thing Called Sin"—published in the catalog under his nom de plume, Jean Clair. And he seemed to enjoy the ongoing interviews conducted by Michel Archimbaud. His shortness of breath sometimes made conversation difficult, but on the days he

could find air he seemed to talk all the more. No interview with Bacon remained formal for long. The previous year, he had become so animated during an interview with BBC Radio's *Kaleidoscope* that Richard Cork, the presenter, finally said, "The curious thing is I don't feel as if I'm talking to an eighty-year-old at all." Bacon demurred with pleasure. "Well, I'm very old . . ."—to which Cork replied, "I know, I mean you're old on paper, but to meet you and talk to you, it's quite uncanny." In addition to granting the interviews to Archimbaud, which continued through April of 1992, Bacon that spring agreed to be interviewed by the photographer Francis Giacobetti, with whom he had spent so much time.

In his late interviews, Bacon imparted little new information. But he described his art and life in less guarded terms than he might once have, with less philosophical éclat. As you get older, Bacon said, "You see fewer and fewer people, and people are less and less interested in you." He was also losing the companionship of work. He emphasized his lifelong paradox: he was a painter of darkness who remained a "desperate optimist" and awoke every morning thinking something marvelous might happen. He acknowledged that his art was indeed forcefully shaped by the century in which he grew up (which some of his defenders liked to downplay), and that Nietzsche and the existentialists helped him face the truth of the world. "During my childhood I lived through the revolutionary Irish movement, Sinn Fein, and the wars, Hiroshima, Hitler, the death camps, and daily violence that I've experienced all my life." The modern world might appear civilized on the outside, but "our very civilized century" had produced astounding new ways of destroying life. And still he loved the world with sensual intensity, saying, "Séduire, c'est tout." In his eighties, he would look at men "as if everything is still to play for, as if life could have a fresh start . . . and often when I go out in the evenings I flirt as if I was 50." Artists were fortunate that way, he said, feeling freer than most to flirt and play. "Passion," for artists, "lasts."

He could be remarkably forthright about himself: "I also think that I have a difficult character. I'm a pain. I say the truth even if it hurts. I have the excuse of liking wine, and when I'm drunk, I talk a lot of nonsense; but, as I have an excuse, I make the most of it." Not only that: "I believe in being selfish." By "selfish" he did not mean living without care for others—few took more trouble over friends than Bacon did— but that he "never made concessions. Not to fashion, not to constraints, not to anything." He had been fortunate not to have to compromise in order to survive. Even so, he found life inevitably became an endless series of entrapments. "We are all prisoners, we are all prisoners of love,

one's family, one's childhood, profession. Man's universe is the opposite of freedom, and the older we get, the more this becomes true." Freedom remained for Bacon, even in his eighties, a beckoning dream.

Dr. Brass noted that Bacon, at eighty-one, still did not "present" as an old man. He continued to wear tight-fitting trousers and jackets, refusing the tailor's request that he go up one size. His warmest wish, always, was to see José, who came to London episodically. José was impressed by how rigorously Bacon maintained his studio regimen during his last years, but the moment came when, on a trip to London, José finally noticed a pronounced change. Bacon's energy was failing, and, owing to the drugs he took, he could no longer enjoy meals. "This chicken has no taste," he complained. "I can't taste anymore." In late February, he planned to attend the opening performance, in Cardiff, of the Welsh National Opera's production of Debussy's *Pelléas et Mélisande*. It was an important event in the music world, with Pierre Boulez conducting and the German theater director Peter Stein in charge of the staging. "The first night, on Friday, attracted eighty critics from all over the United Kingdom and the Continent," wrote John Rockwell in *The New York Times*, "and counted as the most prestigious, intensely awaited event of the British operatic season." Michel Archimbaud hoped to accompany Bacon to the opening. But Bacon could not finally make the trip. Two weeks later, he suffered an attack of "acute shortness of breath," nonetheless waiting two days before reporting to Dr. Brass: "I can't breathe. I can't get any breath." Brass told him to come to his office immediately. "He was flushed when I saw him. He was short of breath lying down. His pulse was one hundred per minute: it was normally about sixty. He had a hugely fast heart rate. His liver was palpable. He was on prednisone and was really very ill."

Several weeks later, at the end of March, Bacon was admitted to the hospital, and, as usual, he discharged himself prematurely. Dr. Brass suspected that he suffered a small stroke around the first of April because he was beginning to lurch rather than walk with his distinctive rolling gait. The lack of balance became so pronounced that it seemed the result of medical issues. "Paul," Bacon reminded the doctor again and again, "I want to go to Spain. I must go to Spain." To which Dr. Brass replied, "You know you're really not well enough to fly with that chest. You'd have to go with oxygen and you'd have to probably have somebody with you." Talking on the telephone became difficult. He gasped at Michael Peppiatt: "I can't come out. I've been ill. *Really* ill." Any asthma attack could precipitate heart failure. "So he was getting massive swelling of his legs and breathlessness," said Dr. Brass. "And I agreed with him: his life really

wasn't worth living in that last year. He was a shadow of his old self. He couldn't paint. He wanted to paint. But he didn't have the strength in the last few months to do anything." In April, Dr. Brass went on vacation. Bacon booked a flight to Madrid.

Bacon spent some hours in his studio and in the garage below that he used for storage, sorting through dusty papers and pictures. The artist Michael Clark telephoned. He was working on a series of "wound" paintings influenced by Bacon and wanted to show him the series, *5 Wounds*, intended for Chichester Cathedral. "I didn't recognize the voice of the person who answered the phone," said Clark. "They said, 'Francis, it's for you.' Francis said he would love to see me and look at the paintings, but he was going away." Clark suggested they get together upon his return. There was a pause. "But the thing is, Michael, I'm working against time." On Easter Saturday, 1992—the 18th of April—Barry Joule came to Reece Mews at seven a.m. to drive Bacon to Heathrow. His flight was later in the day. "As usual Francis was dressed and ready and he makes breakfast." Bacon was functioning well enough, Joule noted, if "tired and tired-looking." (Joule also described him elsewhere as "agitated.") He took about an hour to prepare breakfast. "We were chatting about Madrid. Whether he was going to see Janetta and Jaime [Parladé]." Bacon intended to fly to Paris after some time in Madrid. He made arrangements with Joule to pick him up at the Pont Royal in Paris.

Before they left for the airport, Bacon brought Joule into the garage, where he had carefully arranged three large, waist-high piles of magazines, books, and bundled-up papers—"the sort of stuff," said Joule, "that he had lying around his studio." He asked Joule to put the three piles into his car. "Basically I was loading it all in the boot." Then, said Joule, Bacon brought him a stack of ten unframed and small early paintings. They bore little resemblance to Bacon's known work of the mid-1930s. The largest was *Studio Interior* of c. 1936, which was 9⅜″ x 13¾″; the others were smaller—sketch-size. Joule took them to be Bacon's work: exercises in surrealism, he speculated, during the period when he had hoped to participate in the International Surrealist Exhibition of 1936. Earlier, said Joule, Bacon had given him a cubist-looking portrait, in flaming reds, of a person with spiky hair—and then asked for it back. It did not look anything like a Bacon, either. Now, Bacon told Joule he could keep it, but asked him to destroy the rest. As for the piles in the boot—loosely sketched plans, old notes, and other discarded material—Bacon told Joule, "You know what to do with it." It was, said Joule, "a very strange experience for me, as if it were the final clear-out."

The Iberia flight was still some hours away. And so Joule took Bacon on a lengthy drive through his old haunts in South Kensington and Chelsea before heading to Heathrow. Bacon, carrying a canvas shoulder bag and a small suitcase, said goodbye.

José met him at the airport, and they made the usual rounds. A photo taken at Bar Cock showed Bacon seated at a round table with a martini in front of him, the olive proudly placed. He wore an open-necked white shirt that, even without a jacket, looked quite formal. The owner of Bar Cock, Patricia Ferrer, said: "Here he was, a perfect dandy, sitting with his back beautifully straight." In the photograph his face looked ruddy and glistening, and he appeared more abstracted than engaged. He made plans to see Janetta and Jaime Parladé in Marbella, and he was eager to visit the house of Ana Gamazo and Juan Abelló, well-known collectors who owned a Peter Beard triptych painted in 1975 that Bacon wanted to see again. "That's one I would love to have back," he had told them not long before in London, where they had met at the opening of an exhibit by Janetta's daughter, the artist Nicky Loutit. "I'd buy it from you."

Bacon soon tired and began to retain fluid. José took him to see his doctor, Luis Rodríguez, who had trained in London and spoke excellent English. Treatment was required for the buildup in fluid, Dr. Rodríguez informed Bacon, or his condition might rapidly worsen. He suggested treatment at the Clínica Ruber, a hospital where his health could be closely monitored, rather than outpatient visits to his office. The Clínica Ruber was the leading private hospital in the city, well-known among wealthy and upper-class Madrileños for both the quality of its care and its discretion. (Bedside check-in was available.) Bacon was placed in room 417, which employees called the "Royal Room." It was a well-furnished, capacious suite that members of the royal family might well have occupied. On the left of a large foyer was a sitting room with a television to help visitors while away time. There were two bathrooms, one for the patient and the other, in marble, for visitors. The large main room contained not only a hospital bed and medical equipment but also plush velvet love seats and a closet that concealed a large Murphy bed, should

The last martini in Madrid: Bacon at Bar Cock in the days just before he died

anyone wish to spend the night. The corner suite was filled with daylight, its rows of double windows looking out over Juan Bravo, the most expensive shopping street in Madrid, and the Calle General Pardiñas. Double curtains on the windows added a certain formality, but there was nothing grim about the Royal Room.

Bacon was not fond of hovering nuns. When he and William Burroughs were being interviewed together six years earlier, they discussed the death of their close friend in Tangier, Jane Bowles, with Bacon observing, "Died in a madhouse in Málaga. It must have been the worst thing in the world. Looked after by nuns. Can you imagine anything more horrible." But Bacon was not oppressed by the nuns at the Clínica Ruber, which was not a religious institution like its neighbor two minutes down the street, Our Lady of the Rosary Hospital. Some nuns worked at the Clínica Ruber, but only because nuns served in all Spanish hospitals. Sister Mercedes (her full name was Mercedes Moreno Martín) was the supervising nurse on the fourth floor of the hospital and oversaw Bacon's care. She worked with many secular nurses. In fact, the number of nuns at the Clínica Ruber was declining. The hospital catered to everyone, said Sister Mercedes. "Muslims, Jews, Protestants . . . We didn't speak about religion at all . . . And also he was here for a short time. If he had been here for longer, I would have said . . . but no." Bacon would not of course have found the idea of Heaven comforting. "All my friends," he liked to say, "are in Hell."

José visited Bacon at least once a day, usually after Sister Mercedes completed her morning rounds. He canceled his long-planned trip to Seville when Bacon's condition did not significantly improve. (Bacon intended to fly to Paris on the 26th of April, the day José planned to leave for Seville.) Bacon liked to get out of bed—gingerly, given his breathing difficulties—to sit on one of the love seats. His breathing was easier when he sat upright. His shortness of breath precluded much conversation, as did his lack of Spanish, but he amused himself with the English newspapers. "And by having all the windows open he could distract himself very well," said Sister Mercedes. "Because even from his own bed he could see all the streets. . . . Both streets cross and this [room] really does have quite a pretty and distracting view. So he wasn't enclosed. He wasn't locked in." Sometimes he telephoned friends. "In April, Francis rang me from his hospital bed in Madrid," said Eddy Batache. "He was worried about canceling his planned visit to Paris to see us, and I said he mustn't worry; we're always here for him."

Bacon improved somewhat after four days at the Clínica Ruber, said

The corner suite at the Clínica Ruber in Madrid, where Bacon was treated—and where he died

Dr. Rodríguez, who continued to see him after he was admitted to the clinic. Perhaps, the doctor said, he would be discharged soon. Bacon would ordinarily have been delighted with such news, but he remained subdued. He looked sad, José told friends. His shortness of breath made it difficult for him to eat and wash himself. The pharmaceutical regimen included pure oxygen, corticosteroids, bronchial dilators—"all the things," said Sister Mercedes, "you use for that kind of illness." He was beginning to suffer, she said, from slow suffocation. Mostly, he was calm, but he underwent some periods of agitation. "If you are breathless you have a relative calmness, you have moments when you are more calm. But if you can't breathe, you get anxious." On the morning of April 28, the night nurse reported to Sister Mercedes that Bacon had passed through a difficult night. "He couldn't really have his breakfast . . ." she said. "He didn't have enough strength. He needed oxygen constantly in high doses. We couldn't leave him alone." The nurses tried to sit him up, unsuccessfully, so that he might drink something. At around eight thirty a.m., his breathing worsened and suddenly stopped. The cardiac arrest unit, a flying phalanx of nurses and doctors, arrived at his bedside. "Many people came . . . because for an event like this a lot of people are required." Drugs were adminis-

tered. Doctors pressed and resuscitated and called out. He was piled onto a trolley. But his heart, in arrest, did not catch. Bacon was declared dead at nine a.m.

Sister Mercedes left to attend to other patients, and the body was taken to the hospital morgue. The hospital, with no record of Bacon's family members, tried to reach José, who learned of Bacon's death when he went to the Clínica Ruber later that day to visit him. The hospital also tried to reach Jaime Parladé. The news began to leak into the press. José telephoned Marlborough with the news. At first the gallery asked its representative in Madrid, Maricruz Bilbao, to send the body to London. Then they called back to report that Bacon had only wanted to be cremated. "And you don't have to do anything. He doesn't want a ceremony. He doesn't want anybody at the crematorium. He left very clear instructions." The British Consulate arranged for the cremation. Bilbao sent Lourdes Fernandez, who worked at the gallery, to collect Bacon's two pieces of luggage from the hospital. No one at the gallery wanted to open the bags. When they finally did, said Bilbao, she saw "exactly the same shirt that I had seen him in months before. A beautiful shirt with red and white stripes. Very elegant." The black leather jacket. "Scarves and a few books." The reading glasses.

Someone surreptitiously took a photograph of Bacon's body on a gurney. He looked lifeless in an ordinary way, with a tag bearing his name tied across his forehead. Eventually, the photograph surfaced in London, where the artist Catherine Shakespeare Lane, a member of the Colony, incorporated it into a collage called *Francis Bacon Homage*. (Valerie Beston bought the original.) On April 30, a small group of reporters gathered near the crematorium at Madrid's vast Almudena Cemetery, their number reduced by the news of a Basque terrorist bomb elsewhere in the city. They waited in the hot sun. The hearse appeared at around three p.m. and stopped outside the crematorium for several minutes. Two attendants in uniform—navy-blue suit, white shirt, black tie—wheeled the mahogany coffin inside. The casket bore a crucifix, which would have annoyed Bacon, but probably not greatly: this was Spain, and all would be dust soon enough. No mourners arrived, and the doors remained closed to reporters. There was a single floral arrangement, a bouquet of white and yellow roses with a card that read: "To Francis Bacon, with love. From Noel, Lesley and all the French House."

At first the headlines in London were quiet, like that moment when

the curtain first falls after a spellbinding performance. "No Friends, by Request, at Bacon's Farewell," announced *The Times*. "No Mourners at Artist's Funeral" reported *The Daily Telegraph*. Within hours of Bacon's death, however, the BBC set aside its regularly scheduled programming to rebroadcast the celebrated 1985 *South Bank Show* interview of the artist in which, over the long and bibulous lunch, Bacon seduced Melvyn Bragg into drinking past the professional limit. And then the great mass of remembrances and profiles and tributes flooded across the press—in the United Kingdom, of course, but also in France, the United States, and Spain. The obituaries, mostly bravos, emphasized the man as much as the art. The word "dandy" was rarely used nowadays, wrote John McEwen in *The Sunday Telegraph*, but Bacon's particular dandyism had flourished in the modern era. "Bacon as a man devoted to what Baudelaire defined as 'the cult of the self' was the real Regency McCoy. This Byronic aspect to his nature had something to do with a complete absence of sentimentality, a recklessness, a bleak rationality, an awareness that his lack of religious faith was in itself despair, and also an intense animalism." Bacon, while relentlessly modern, evoked a time "when being a gentleman meant something" and despite the preening, the rages, and the cockneys, he looked "made for an age of blades and beaux. His conversation was always conducted with courteous attention to whoever he was talking to. Since he knew he was the most splendid person in the room, there was no need for him to scan the crowd."

But Bacon was also, the critics inevitably recalled, a man of the flesh. Not far below the surface of the polished dandy lay the rough animal: McEwen was once with Bacon when an artist Bacon disliked entered the room. It was the only time in his life, McEwen said, that he saw the hairs on the back of a man's neck actually rise—like a dog bristling. Tom Lubbock in *The Independent*, who cared little for the grand statements about the human condition that swaddled Bacon's art, thought his gift was to make "extraordinarily vivid imitations or impersonations of the flesh," calling him "a great and original caricaturist of the body and like the best caricaturists he became a creative natural historian: after Bacon, there are now these strange kinds of creatures in the world which weren't there before." Among the obituaries were also some traditional boos, which made an impression: It was always surprising to come upon a writer who took "kicking a man while he's down" so literally. "Just a pile of paint and a nightmare of chic thrills" was the headline over Michael McNay's piece in *The Guardian's Weekend* magazine. Paul Johnson in *The Sunday Telegraph* turned the praise being lavished in other papers against the artist.

"The greatest British painter since Turner," "The heir to Velázquez," he wrote. "The mind reels. One looks again at his works and the mind reels further." Even the negative reviews seemed to find Bacon's awfulness somehow significant. The sensation of an era coming to a close was palpable. He was a marker.

Bacon gave the twentieth century one of its representative figures. It was not necessary to call Bacon the equal of Rembrandt—who gave the seventeenth century such a figure—to know that with his death the century was losing one of its defining pieces. The Bacon figure had two parts, one in the man himself, the other in the paintings. His creation of his dramatic *persona*—flamboyant, unafraid, free—extended the impact of another inventive Anglo-Irish dandy, Oscar Wilde, who died as the twentieth century began. The society that could not tolerate Wilde was the same society into which Bacon was born, but Bacon lived to see the position of homosexuals transformed. He bridged worlds. He gave body to change. The obituary writers knew there could not be another such performance. The tragic figures in the paint were no less essential to their century. The Bacon flesh was never just meat. Or if so, the meat was strangely alive, subject to moods ranging from terror to melancholy. In his earlier work, Bacon was a vivid modernist who stripped the Western mask to reveal a difficult interior truth. Later, he more closely resembled a postmodernist who found masks behind the mask.

The restless Bacon figure, far from sealing off questions with answers, gave form to the elusive, questing, and mercurial understanding of human identity that coursed through his dark century. By 1992, the animal musk of the Bacon figure had even developed a certain poignancy, as the digital world—advancing what the industrial revolution began—made the body seem ever more abstract. Sometimes, in Bacon's painting, the flesh seemed to shudder as if it had just been touched. Other times, the flesh appeared oddly trapped and dematerialized by glazing, stage props, and blank backgrounds. It was sometimes hard to know if the body, during the twentieth century, was being lost or found.

Bacon did not leave his own death entirely to chance. He liked control, especially the kind of control that left room for chance, and he was too experienced a director not to take advantage of his last scene. He culled his studio scraps before his death and, more importantly, did not die in either his studio or an English hospital. He wanted to die on the road south, in search of love and surprise. He also made certain his death would not contradict his art. The way his body simply vanished, cremated in a foreign country, evoked the empty spaces around many of his painted

figures. The absence of all ceremony left behind a sensation of blankness, incompletion, and erasure. He did not allow others to control his body by staging memorials or enfolding him inside their sentiments. He'd leave his dust outside, thank you. It would be wrong to suppose, however, that Bacon did not commemorate his death in his own way. He expected to die during the trip to Madrid, Dr. Brass believed, and in addition to editing his rooms at Reece Mews he likely prepared his studio—his private stage set—for his approaching death. John Edwards entered the house after the news from Spain arrived, however, and made some changes, with the result that the way Bacon left Reece Mews cannot be precisely determined.

Even so, Bacon's last two paintings were a meditation on his death. The first, which he left resting on his easel, was an unfinished head on a mostly empty canvas. It looked as likely to fail as to succeed as a work of art. It remained open to chance, to the Baconian bet that the paint might yet find a way to resurrect the flesh. It also left the impression that he died in the middle of work, his business unfinished; a memento mori forever awaiting his return. The second, *Study of a Bull* (1991), was Bacon's last finished painting, a monochromatic image of whites, blacks, and ashen grays set in a larger field of raw, earth-toned canvas. A simple curved band suggested the horizon line. On the left, against a deep black rectangle, a ghostly bull was emerging, his form partly blended into large white panels that resembled abstract doors. The bull was an ancient symbol of life and power—especially in the classical world that Bacon preferred—and the bullfight was a symbol of sacrifice.

Bacon created his last bull from whispering grays to which he added literal dust. He had sometimes used dust in his earlier paintings, but here it had special poignancy. It evoked not just the ceremonial words "Ashes to ashes, dust to dust" but also the clotting of Bacon's lungs. (He could almost have breathed this bull onto the canvas.) No other painting of Bacon's appeared so hushed; none had so little orange screech or bull bellow. There was no doubt of this bull's role. He was the messenger of death, an animal angel, bringing the news to the matador-artist. He was made mostly of gentle curves, with one sharp and glinting exception. His right horn was a sickle, the symbol of mortality. He has paused, before he reaps the life, to stare at Bacon and the viewer.

Bacon probably toasted the painting with champagne. The toast, a celebration of life in the presence of death, was very important. Every afternoon and evening for years, Bacon staged a kind of Irish wake for himself, creating moments of elevated intensity with food, drink, talk, argument,

rage, despair, and merriment. What else was one to do when there was always (for those who noticed) a pale corpse laid out in the drawing room? What else but put aside ordinary rules? Anything could be said at an Irish wake—and all forgiven. One evening in the late 1980s, when Bacon was already quite ill, he stayed up partying with young friends at the flat of Tom Conran and Katrine Boorman in Cleveland Square. At three in the morning a problem arose. How were the young people to get Bacon home? The elderly artist appeared unsteady, and there were six flights of stairs. The young people conferred. "We said, 'Goddammit, we'll carry you down.'" They placed Bacon in a nineteenth-century mahogany steamer chair, probably from an ocean liner, and hefted him onto their shoulders. Bacon delighted in the twisty and awkward progression of the chair down the staircase. He might have been a rajah on an elephant or a corpse in a box. On the landing above the entrance door, the weary party paused for a last glass of champagne. Outside, the first hailed cab refused to take Bacon home. Would he like to stay over? He shook his head. In the morning, work.

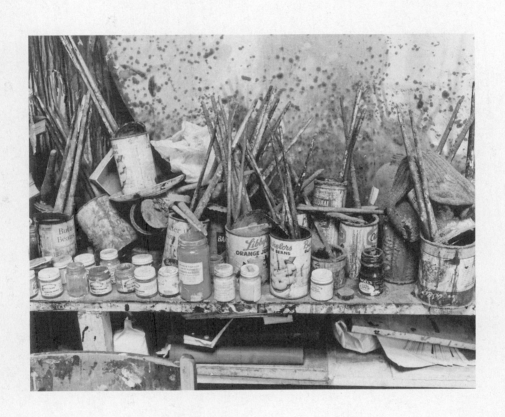

THE DARK CENTURY

3 "Nietzsche forecast": Bacon, quoted in "Francis Bacon: Remarks from an Interview with Peter Beard," *Francis Bacon's Recent Paintings 1968–1974* (New York: Metropolitan Museum of Art, 1975), 20.

3 The painter must be: John Russell, interview for Adam Low, director, *Francis Bacon*, *Arena* documentary, BBC Four archive, March 19, 2005.

3 The show was attracting: Martin Hammer, "Francis Bacon and the Lefevre Gallery," *The Burlington Magazine*, May 2010, 307–12.

3 They flinched: John Russell, *Francis Bacon* (New York: Thames and Hudson, 1985), 10.

3 So "shocked" was the writer: "Perspex" [Herbert Furst], "Current Shows and Comments on the Significance of a Word," *Apollo*, May, 1945, 107–08.

4 He had perfect manners: John Moynihan, *Restless Lives: The Bohemian World of Rodrigo and Elinor Moynihan* (Bristol: Sansom & Company, 2002), 117.

4 Four years after: Caroline Blackwood, "Francis Bacon, 1909–1992," *The New York Review of Books*, September 24, 1992.

5 As late as 1941: Diana Keast, interview for *Francis Bacon, Arena.*

5 The painter Lucian Freud: William Feaver, *The Lives of Lucian Freud: The Restless Years, 1922–1968* (New York: Knopf, 2019), 199.

5 Bacon would have agreed with Winston Churchill: Michael Richards, "Alcohol Abuser," International Churchill Society, winstonchurchill.org.

5 In the 1950s: Cecil Beaton, "Sitting for Two Portraits, 1960," in Richard Buckle, ed., *Self Portrait with Friends: The Selected Diaries of Cecil Beaton 1922–1974* (New York: The New York Times Book Company, 1982), 321–22.

5 "It was like looking into a light": James Moores, in conversation with Mark Stevens, October, 2014.

6 One friend found him: Grey Gowrie, interview with Mark Stevens, November 2011.

6 He moved on the balls: Chesterton's poem "The Aristocrat" begins "The devil is a gentleman."

6 About late Matisse: Christopher Gibbs, interview with the authors, October 12, 2013.

6 Bacon and Auden: Once, at a dinner party given for Auden by Stephen Spender and his wife, Bacon and Auden fell into an argument that neither would abandon. Spender later wrote that it "was really one of those strangely unsatisfactory controversies between the prigs and the anti-prigs, in which both sides are both in the right and in the wrong, one through being very moralistic, the other amoralistic— and both being so on principle." Stephen Spender, ed., *Journals 1939–1983*, ed. by John Goldsmith (London: Faber and Faber, 1985), 153.

7 Bacon put off more serious efforts: Daniel Farson published *The Gilded Gutter Life of Francis Bacon* (New York: Pantheon Books, 1993) the year after the artist's death in 1992. Michael Peppiatt's *Francis Bacon: Anatomy of an Enigma* (London: Weidenfeld & Nicholson, 1996), appeared four years after Bacon's death.

7 As early as 1932: Martin Harrison, "Diana Watson's Diaries," in *Inside Francis Bacon*, Francis Bacon Studio III (London: The Estate of Francis Bacon publishing, in association with Thames & Hudson, 2020), 69.

8 In fact, Lacy: Lacy's nephews Fr. David Lacy and Gerald Towell kindly provided the authors with documentation and details about not only Peter Lacy but also the family tree going back to the time of the Norman Conquest. Lacy and Towell, interview with the authors, February 16, 2009, and subsequent emails.

8 When his friend Roald: Roald Dahl collected Bacon paintings. He owned a portrait of Isabel Rawsthorne and a small triptych of George Dyer. Later, he and his wife Felicity Dahl collaborated on a cookbook that was partly a reminiscence, partly a collection of recipes, entitled *Roald Dahl's Cookbook* (London: Penguin Group, 1996). Dahl solicited recipes from friends for a chapter called "Hangman's Supper." Bacon wrote to Roald on December 19, 1989: "For my last supper—I would like 2 lightly salted boiled very fresh eggs and some bread and butter. Yours very sincerely, Francis Bacon." Felicity Dahl, interview with Annalyn Swan, April 2, 2008.

8 Bacon possessed: David Plante, "Bacon's Instinct," *The New Yorker*, November 1, 1993.

8 After his death: David Sylvester, "A Farewell to Bacon," short note in Paula Weideger, "Preaching Art," *The Independent*, May 11, 1992.

8 His friends sensed: The anecdote about Kitaj was told to Mark Stevens by Kitaj's son, Lem Dobbs.

1 BOY AT THE WINDOW

13 The house smelled of Potter's Asthma Cure: Ianthe Knott, interviews with Mark Stevens, March 5 and 6,

2008. Stramonium, a hallucinogenic ingredient in Potter's Asthma Cure, was often burned to help asthmatics breathe. Both Francis and Ianthe typically called their mother "Mummie," and Ianthe worried that her brother would die.

13 In early twentieth-century Ireland: Ireland continues to have one of the highest rates of asthma in the world. See www.asthma.ie.

13 Francis Bacon was Anglo-Irish: Elizabeth Bowen, quoted in Lara Feigel, *The Love-charm of Bombs: Restless Lives in the Second World War* (London: Bloomsbury Publishing, 2013), 104.

13 To know Francis Bacon: Caroline Blackwood, "Francis Bacon (1909–1992)," *New York Review of Books*, September 24, 1992.

14 "The Irish believe": Anne Dunn, interview with the authors, October 13, 2010.

14 His parents were proud: They were in residence in Ireland by late 1904, when Francis's older brother, Harley, was born in Dublin.

14 The Bacons were an old: Bacon's great-grandfather, Anthony Bacon, was the most illustrious military member of the family. See Alnod J. Boger, *The Story of General Bacon* (London: Methuen & Col, 1903). Anthony Bacon's son joined the 18th Hussars. Bacon's father was a career military man as well.

14 During the eighteenth century: For more on the history of the Anglo-Irish, see J. C. Beckett, *The Anglo-Irish Tradition* (Ithaka, New York: Cornell University, 1976).

14 It remained in Bacon's day: Brendan Lehan, *The Companion Guide to Ireland* (Suffolk: Boydell & Brewer Ltd., 2001), 16.

14 The Kildare Street Club: See R. B. McDowell, *Land and Learning: Two Irish Clubs* (Dublin: The Lilliput Press, 1993).

14 The Harley men: The original Earl of Oxford title—held by the de Vere family for centuries and the second-oldest title in England—became extinct in 1703 when there were no direct male heirs. The Harley family's title—Earl of Oxford and Earl Mortimer—was created in 1711 for the statesman Robert Harley.

15 The Major was born: *Australia, Birth Index 1788–1922*, ancestry.co.uk.

15 The General and Lady Charlotte: Boger, *The Story of General Bacon*. The following information on Brigadier General and Lady Charlotte Bacon's family comes primarily from this book.

15 In 1829 the General: For a corrective version of General Bacon's debts and schemes, see "Anthony Bacon (1796–1864)," *Australian Dictionary of Biography* (National Center of Biography, Australian National University, 1966).

16 A family history: a firsthand account written by a soldier named Tolmer, quoted in Boger, *The Story of General Bacon*.

16 She kept up appearances: George E. Loyau, *Notable South Australians; or, Colonists—Past and Present* (Adelaide: Carey, Page and Co, 1885), 216.

16 An earlier Anthony Bacon (1718–1786): Watkin William Price, "Bacon Family, Iron-Masters and Colliery Proprietors," *Dictionary of Welsh Biography*, biography. Wales.

16 Merthyr Tydfil, Wales became: Ibid.

16 His eldest son and main heir: David Nash Ford. "Anthony Bushby Bacon." Royal Berkshire History, www.berkshirehistory.com.

17 Eddy could also take pride: Information on Sir Nicholas Bacon, the Lord Keeper of the Great Seal to Queen Elizabeth I, and his celebrated son Francis Bacon, the philosopher and statesman, is available in all thorough encyclopedias and reference works. The Harley family was also illustrious. It dated back to the Norman conquest and had married into the de Vere family—the original Earls of Oxford.

17 The Bacon lineage even included: See www.tate.org.uk.

17 "I know Francis liked": Christopher Gibbs, interview with the authors, October 12, 2013.

17 Lady Charlotte's older sister: For background on Lady Charlotte's father's will and subsequent lawsuits, see *The Law Journal Reports XXVI*, no. 8 (May 31, 1873), 467–70. Also books.google.com.

17 But the Queen refused on the grounds: "Lady Charlotte Bacon: The Earldom of Oxford." *The Advertiser of Adelaide*, March 19, 1925, trove.nla.gov.au. The family lost the title but protested, some years later, when Prime Minister H. H. Asquith asked the Queen to grant him the title of the Earl of Oxford. The Bacon family claimed that too many relatives were still living who were connected to the title to bestow it elsewhere. Asquith was eventually given the title 1st Earl of Oxford and Asquith. The title of Earl of Oxford and Earl Mortimer is extinct.

17 Eddy nonetheless: Nicholas Kingsley, "Eywood," www.lostheritage.org.uk.

18 The family also possessed: *London, England City Directories, 1736–1943*, ancestry.co.uk.

18 His parents sent Eddy: The authors are indebted to James Norton for his research on Edward Bacon's school and military career.

18 His family purchased: Ibid.

18 There he rode: The authors are indebted to Harry McDowell, local genealogist and historian, Celbridge, County Kildare, Ireland, for much of their information on Edward Bacon's military career in Ireland.

18 In November of 1902: Military records compiled by James Norton.

19 Born in 1883: England and Wales, Civil Registration Birth Index, 1883, Q3 Jul-Aug-Sept. ancestry.co.uk.

19 He appeared reserved: Knott, interviews with Stevens.

19 On 8 July, 1903: *England and Wales, Civil Registration Marriage Index*, ancestry.co.uk.

19 Thomas Firth and Sons: For a history of the Firth family business, see "Thos. Firth & Sons, Norfolk Works—Sheffield, UK. Historical Review," www.wkfinetools.com.

20 Mark Firth, the family's most notable: Ibid.

20 Their fortune came: Obituary notice of Henry William Watson, Bacon's maternal grandfather, www.findagrave.com. He had inherited a stake in the St. Lawrence Colliery from his father, John Watson.

20 Born in 1859: "England: *Selection Births and Christenings, 1538–1975*," ancestry.co.uk.

20 Her first husband: John Loxley Firth's asthma was so bad that he had to spend winters in Italy, Bacon later said.

20 Michael Peppiatt, *Francis Bacon: Anatomy of an Enigma* (London: Constable & Robinson, 2008), 20. There are several editions of Peppiatt's biography, which was first published in 1996. The authors make use of this updated edition.

20 She soon married: Walter Loraine Bell's birth was recorded in the "*England and Wales, Civil Registration Birth Index, 1837–1915*. in the Jul-Aug-Sept. quarter of 1877," ancestry.co.uk.

20 Walter Bell lived: For more on the Bell estate and extensive grounds, see "Woolsington Hall," historicengland.org.uk. Bell also lived, with the elder Winifred and the young Winnie, in Hertfordshire prior to moving to Ireland. Genealogy records, ancestry.co.uk.

20 Eliza Highat Watson: Extensive documentation exists about the immense shipbuilding company. See "Armstrong, Mitchell and Co," *Grace's Guide to British Industrial History*, www.gracesguide.co.uk.

20 Yet another sister: Cecil Harcourt Smith was a fixture at the Victoria and Albert Museum for forty-five years, fifteen of them as head of the museum.

21 In the future, Francis Bacon would often: A number of interviews quote Bacon as saying that his father was a failure at his chosen profession. "He was a racehorse trainer, a failed trainer," said Bacon in one of the last interviews of his life. Francis Giacobetti, "Francis Bacon: The Last Interview," *The Independent Magazine*, June 14, 2003.

21 An early photo: The photo is in the collection of the Hugh Lane Gallery, Dublin.

21 Winnie enjoyed country life: Crabtree Meadow House and other details about the life of Winnie's family is mentioned in the obituary of John Loxley Firth, her father, that ran in the *Sheffield Morning Telegraph*, December 27, 1897.

21 She rode sidesaddle: Knott, interview with Stevens.

22 Granny and Walter Bell leased: Harry McDowell, local genealogist and historian.

22 The region's well-tended: "I was brought up for much of my childhood on the edge of very flat marshlands full of snipe and plover. That's the kind of country I find exciting,"

Bacon told John Russell. Russell, *Francis Bacon* (New York: Thames and Hudson, 1985), 74.

22 The huge headquarters: For the racetrack, see "The Curragh," www.irelandsancienteast.com. For the military headquarters, see "The Curragh Army Camp," www.history ireland.com.

22 The newly married couple's house: Most details of the house come from a personal visit by Annalyn Swan and interview with the present owner, Eugene McDermott, May 2008. Further details come from the Irish census of 1911.

23 The census of 1911: Ibid.

23 The hospital stood: John Russell, *Francis Bacon* (New York: Thames and Hudson, 1985), 12.

23 The Dickensian name: Deakin teased Bacon for inverted snobbery: "You don't fool me. I bet it was Upper Baggott Street." Daniel Farson, *The Gilded Gutter Life* (New York: Pantheon, 1993), 15.

23 Three months after his birth: Details of Bacon's baptism and of St. Patrick's Church come from St. Patrick's baptismal records, courtesy of Harry McDowell. The authors visited the church with McDowell.

23 It was the church: See Jim Brennan and Aileen Short, "The La Touche Legacy," September 1996, latouchelegacy .com.

23 St. Patrick's then became: Renagh Holohan, "An Irishwoman's Diary," *The Irish Times*, October 6, 2009. The authors are also indebted to Harry McDowell for details of the church's architectural history.

24 "We were taught": Knott, interview with Stevens.

24 In one, Winnie: The photograph is reproduced in Martin Harrison, ed., *Francis Bacon Catalogue Raisonné*, Vol. I (London: Estate of Francis Bacon, 2016), 75.

24 She was born: Hugh Lane Museum archive, Dublin, RM98F8:108 (Nanny Lightfoot identity card for her stay in France with Bacon). The first page reads: *Nom: Lightfoot Prenoms: Jessie Né le 28 Juin 1871 à Burlawn (Angleterre) de John ne a et de Jamy Chaltrouse ne á Professions: sans Nationalité: Anglaise Mode d'acquisition de cette nationalité: filiation. Situation de famille: célibataire*. The Irish census of 1911 falsely listed her age as thirty-four. It would have been thirty-nine or forty. ancestry .co.uk.

24 "She was very kind to us": Knott, interview with Stevens.

25 There was even an internal doorway: Annalyn Swan, visit to Cannycourt/Kennycourt. Swan is grateful to Eugene McDermott, the owner of Cannycourt, for providing a tour of the house. September 10, 2010.

25 The Major raised Irish Red Setters: Knott, interview with Stevens.

25 Not surprisingly: For the military maneuvers, see Hugh Davies, interview with Francis Bacon, April 3, 1973, for his book *Francis Bacon: The Early and Middle Years, 1928–1958*

(New York and London: Garland Publishing, Inc., 1978), 3. For the line of cavalry men, see Andrew Sinclair, *Francis Bacon: His Life and Violent Times* (London: Sinclair-Stevenson, 1993), 6.

26 It was believed: See Tori Rodriguez, "The Asthma, Mental Health Connection: Expert Clinicians Weigh In," *Pulmonary Advisor*, www.pulmonologyadvisor.com.

26 There is a photograph: See Harrison, ed., *Francis Bacon Catalogue Raisonné,* Vol. I, 77.

26 There was one house maid: Anthony Cronin, in *Francis Bacon in Dublin* (London: Thames and Hudson, published in association with the Hugh Lane Gallery, 2000), 25.

26 He also recalled: Bacon, interview with Richard Cork, presenter, *Kaleidescope* (BBC Radio), August 17, 1991.

27 "When I think": Francis Giacobetti, "Francis Bacon: The Last Interview," *The Independent Magazine*, June 14, 2003.

27 In a few years: Bacon later recalled posting his father's bets for him. David Sylvester, *Looking Back at Francis Bacon* (London: Thames & Hudson, 2000), 231.

27 "It was a candle": Phyllis Prior-Wandesforde, interviews with the authors, November 8–11, 2010.

27 "It was certainly marvelous": Bacon, quoted in Sophie Pretorius, "A Pathological Painter: Francis Bacon and the Control of Suffering," in *Inside Francis Bacon: Francis Bacon Studies III* (London: The Estate of Francis Bacon Publishing, in association with Thames & Hudson, 2020), 163–215.

2 WEAKLING

28 She gave birth: Edward Bacon was born in Naas, County Kildare, Ireland, on August 25, 1914. Martin Harrison, ed., *Francis Bacon Catalogue Raisonné*, Vol. I (London: Estate of Francis Bacon, 2016), 74.

28 "His wife's brother Leslie": "British Army WWI Medal Rolls Index Cards 1914–1920," ancestry.co.uk.

28 No jobs were forthcoming: Sinclair, *Francis Bacon: His Violent Life and Times* (London: Sinclair-Stevenson, 1993), 16.

28 Originally conceived: See "The Territorial Force," www.longlongtrail.co.uk.

28 "The Major's father": Alice Bacon is listed in the census of 1911 as living at 6 Westbourne Crescent in Paddington. She was still there in 1915. See also Harrison, ed., *Francis Bacon Catalogue Raisonné*, Vol. I, 74.

29 "I read almost nothing": Francis Bacon, quoted in John Rothenstein, introduction to the Tate Gallery catalog of Bacon's first retrospective, 1962.

29 During the war: Bacon later remembered these visits to the Norfolk area, even if some of the details do not match the facts. For example, his Great-Aunt Mitchell no longer lived at Jesmond Towers during World War I, as he mistakenly told John Russell. See Russell, *Francis Bacon* (New York: Thames and Hudson, 1993), 13. The property was sold in 1912 to the Filles de la Sagasse order of nuns for a school, La Sagasse School.

29 As a young man: The authors are indebted to James Norton for his research on the art of Charles Mitchell. Mitchell's accomplished painting *Hypatia*, in the high Pre-Raphaelite style, was his greatest public success. It was shown in 1885 at the Grosvenor Gallery, an art gallery in London devoted to the work of the Pre-Raphaelite movement in particular. In *The Times*, an unsigned review of June 1, 1886, noted that Mitchell had "astonished the world by his large and much-discussed picture of 'Hypatia'" when it was shown. And the critic of the *Pall Mall Gazette* praised Mitchell, in a review of April 9, 1885, as exemplifying "all the good and none of the bad qualities" of French painting. *Hypatia* is now in the collection of Newcastle's Laing Art Gallery. See also Marshall Hall, *The Artists of Northumbria: An Illustrated Dictionary* (Newcastle-upon-Tyne: Marshall Hall Associated, 2007), 122–3.

29 He then assembled: Ibid.

29 the young Francis: See "Jesmond Towers," newcastle photos.blogspot.com. Family ties to both Jesmond Towers and the nuns remained, however. Both Eliza Highat Mitchell and Bacon's step-grandfather, Kerry Supple, the second husband of Bacon's maternal grandmother, Winifred, returned to Jesmond Towers to be cared for by the nuns before they died.

29 Pallinsburn, whose great house: See "From the manor reborn," www.scotsman.com.

29 But they also stayed: Francis Bacon, interview with Hugh Davies, March 17, 1973, London, for Davies, *Francis Bacon: The Early and Middle Years, 1928–1958* (New York and London: Garland Publishing, 1978). Also John Russell, *Francis Bacon*, 13. For more on Bamburgh Castle, see www .bamburghcastle.com. Eliza Mitchell was both rich and eccentric: Bacon recalled how she redecorated her house in Mayfair using great quantities of black marble everywhere. Michael Peppiatt, *Francis Bacon: Anatomy of an Enigma* (London: Constable & Robinson, 2008), 15.

30 Before his death: See "Bamburgh Castle," willia-marmstrong.info.

30 Diana's family lived: See "Bishopthorpe Garth," historicengland.org.uk.

30 He would watch: Bacon, interview with Richard Cork, presenter, *Kaleidescope* (BBC Radio), August 17, 1991.

30 The first zeppelin raid: Information on the zeppelin raids comes mainly from Dan Vergano, "Fear of Floating," *Smithsonian Air & Space Magazine*, July 2009. www. airspacemag.com.

30 In the end, the zeppelins proved: Jordan Golson, "WWI Zeppelins: Not Too Deadly, but Scary as Hell," *Wired*, October 3, 2014. www.wired.com.

31 During the war years: Information on Bacon's grandmother's divorce comes primarily from Harry McDow-

ell, genealogist and historian, Celbridge, County Kildare, Ireland.

31 Francis, as a boy: Bacon, quoted in Peppiatt, *Francis Bacon: Anatomy of an Enigma*, 19.

31 At the outbreak: *British Army WWI Pension Records 1914–1920*, www.ancestry.com.

31 The separation proved: Harry McDowell, genealogist and historian.

31 Supple was a thin: Ibid.

31 She married Supple: Ibid.

32 Instead, she bought: Ibid. The authors visited Straffan Lodge with McDowell in November 2010.

32 "Farmleigh was a beautiful": Bacon in David Sylvester, *Interviews with Francis Bacon* (New York: Thames and Hudson, 1987),184.

32 The first of Francis's two: Ianthe Knott, interviews with Mark Stevens, South Africa, March 5 and 6, 2008.

32 At the age of fifty: Ibid.

32 Pamela Firth: Firth, quoted in Sinclair, 23.

32 There was no escaping: References to his flamboyant grandmother exist in multiple interviews throughout Bacon's life. See Peppiatt, *Francis Bacon*, 10. Also Ianthe Knott to Mark Stevens.

32 Ianthe described her: Knott, interviews with Stevens.

33 "She was a very clever": Ibid.

33 "I was quite a good cook": Bacon, in Sylvester, *Interviews with Francis Bacon*, 188.

33 He kept a copy: All of the books in Bacon's studio and bedsit were catalogued by the Hugh Lane Gallery, Dublin, when Bacon's 7 Reece Mews was transferred there.

33 "I can't remember him": Knott, interview with Stevens.

33 Without much else to do: Eddy Bacon was master of the local hunt in Abbeyleix. Harrison, ed., *Francis Bacon Catalogue Raisonné*, vol. I, 75. Walter Bell had been master before him.

33 Although the major's first-born: Information on Harley Bacon comes primarily from Harry McDowell, genealogist and historian. Other neighbors also recalled Harley living in the small gatehouse and training horses. For his departure, see Harrison, ed., *Francis Bacon Catalogue Raisonné*, vol. I, 75.

33 He later joined: Peppiatt, *Francis Bacon*, 12–13.

34 Local gossip had it: Harry McDowell, genealogist and local historian.

34 "I felt like I wasn't": Francis Giacobetti, "Francis Bacon: The Last Interview," *The Independent Magazine*, June 14, 2003.

35 One childhood friend: Quoted in Harrison, ed., *Francis Bacon, Catalogue Raisonné*, vol. I, 75.

35 Caroline Blackwood recalled a time: Blackwood, "A Big House in Ireland," review of David Thomson's *Woodbrook, The Listener*, December 12, 1974.

35 "Eighteenth-century Ireland": J. C. Beckett, *The Anglo-Irish Tradition* (Ithaka, New York: Cornell University, 1976), 81.

35 As the Roman Catholic majority: Ibid., 51.

35 Bacon's mother believed: Knott, interview with Stevens.

36 According to Marcus Decies: Marcus Beresford, 7th Baron Decies, interview with the authors, November 10, 2010.

36 Partisans killed: Ianthe Knott, interview for Adam Low, director, *Francis Bacon, Arena* documentary, BBC Four archive, March 19, 2005.

36 In her novel: Elizabeth Bowen, quoted in Lara Feigel, *The Love-charm of Bombs: Restless Lives in the Second World War* (London: Bloomsbury Publishing, 2013), 105.

36 He told his children: Bacon, quoted in an interview with Shusha Guppy, *Telegraph Sunday Magazine*, November 4, 1984. See also Hugh Davies, *Francis Bacon*, 5.

36 Watchers would appear: See *Triptych* (1976), among others.

36 Known as the Black and Tans: Hubert Butler, *The Independent Spirit* (New York: Farrar, Straus and Giroux, 2000), 40.

37 To protect the Supples: All of the information about Straffan Lodge and the IRA comes from Harry McDowell.

37 Granny had removed: Ibid.

37 For the rest of her life: Ianthe Knott, interview for *Francis Bacon, Arena*.

37 And once: Harry McDowell.

37 One night, as Inspector Supple: Francis Bacon, in Peppiatt, *Francis Bacon*, 18.

37 He felt he could also hear: Roy Miles, quoted in Daniel Farson, *The Gilded Gutter Life of Francis Bacon* (New York: Pantheon, 1994), 17.

38 Inspector Supple retired: All of the information about Kerry Supple's retirement, illness and death comes from Harry McDowell.

38 In December of 1920: House deeds, Marcus Decies, email to Annalyn Swan, July 2011.

38 "We vacillated very much": Francis Bacon in Sylvester, *Interviews with Francis Bacon*, 184.

38 The moves: Pamela Firth, quoted in Sinclair, *Francis Bacon*, 23.

38 At least 139 "big houses": Butler, *The Independent Spirit*, 78.

38 At one point the IRA: All information on Carnalway Lodge comes from Harry McDowell.

38 However, Winnie's brother and family fled: They rented Cavendish Hall, a stately home in Suffolk, where Bacon's family often visited over the next decade. Years later, Bacon would also visit his cousin Pamela Firth Matthews there; her second husband, the American editor and writer Tom Matthews, bought the house for her in 1969. Ibid.

39 In October of 1921: Marcus Decies, house deeds.

39 They initially settled: Bacon to Sylvester, *Interviews with Francis Bacon*, 186. Linton Hall is also listed in the school records of Edward Bacon, who attended Cheltenham College. The authors are indebted to Christine Leighton, archivist at Cheltenham College, for providing this information. Emails of February 14 and 23, 2011.

39 Francis recalled: Bacon to Sylvester, *Interviews with Francis Bacon*. The memory was deleted in the later published interviews. See Harrison, ed., *Francis Bacon Catalogue Raisonné*, vol. I, 75.

3 AROUSAL

40 In Naas: Ibid. Further details come from an interview by the authors with the then-owners of Straffan Lodge, Marcus and Edel Beresford, 7th Baron and Baroness Decies, November 10, 2010. The authors also visited Straffan Lodge and the surrounding countryside.

40 The rector, Lionel Fletcher, was appointed: Harry McDowell.

40 "I didn't know him": Grey Gowrie, interview with Mark Stevens, November 2011.

41 His sister noticed: Ianthe Knott, interviews with Mark Stevens, March 5 and 6, 2008.

41 "People like my father": Martin Harrison, "Diana Watson's Diary," in *Inside Francis Bacon: Francis Bacon Studies III* (London: The Estate of Francis Bacon Publishing, in association with Thames & Hudson, 2020), 76.

41 "When I was young": Michel Archimbaud, *Francis Bacon: In Conversation with Michel Archimbaud* (New York: Phaidon Press, 2004), 119–20.

42 "I suspect": Gowrie, interview with Stevens.

42 Bacon later said: Bacon, in David Sylvester, *Interviews with Francis Bacon* (New York: Thames and Hudson, 1987), 133. Bacon said that he remembered the moment "very, very clearly. I remember looking at a dog-shit on the pavement and I suddenly realized, there it is—this is what life is like." The fact that his loss of faith tormented him comes from the same interview.

42 Although Granny also spent: When Granny Supple died in 1929, she still lived, nominally, at Prescott House. *National Probate Calendar, 1929*. It was part of a grand estate in the small town of Gotherington, just outside Cheltenham. Built in Gothic Revival style, it has forty-two rooms and a fine stable block. But Bacon's parents also listed the house as their address in 1924, when Bacon enrolled at Dean Close School. David Jones, the owner of Prescott House (as of January 2012), confirmed, in a telephone conversation with Annalyn Swan, that both Winifred Supple and Eddy Bacon were still remembered as being associated with the house (and in Eddy's case, with the stables).

42 He admired her "marvelous ease": Bacon to Michael Peppiatt, *Francis Bacon: Anatomy of an Enigma* (London: Constable and Robinson, 2008), 10.

42 His sister Ianthe described her: Knott, interview with Stevens.

42 One of her canvases: Ianthe Knott, interview for Adam Low, director, *Francis Bacon*, *Arena* documentary, BBC Four archive, March 19, 2005.

43 She liked "having lots": Ibid.

43 She once invited: Peppiatt, *Francis Bacon*, 10.

43 Bacon later described: Ibid.

43 One friend remembered him: Bacon-Sylvester Correspondence, Tate Archive 200816. The Irish art critic Dorothy Walker sent Sylvester a piece she wrote on Bacon in 1977 for the Department of Foreign Affairs that included this reminiscence.

43 One tennis partner: Doreen Mills Moloney, Letter to Francis Bacon, The Estate of Francis Bacon archive.

43 Another close friend: Information on Billie Kennedy and her family comes from Harry McDowell.

43 The family seat, Bishopscourt: For a photograph and description of the house, see lordbelmontinnorthernireland.blogspot.com.

43 They "adored dressing up": Andrew Sinclair, *Francis Bacon: His Life and Violent Times* (London: Sinclair-Stevenson, 1993), 13.

44 During a visit: Ibid., 39–40.

44 One of the elder: Ibid.

44 At the outbreak: Tony Kearney, "Special Status for War Memorial to Arthur "Patch" Watson Who Lost His Life at Battle of Passchendaele," *Durham Times,* July 28, 2017.

44 He was killed: Ibid.

44 Visits from her bright cousin: Harrison, "Watson's Diary," 76.

44 "Its great fun": Letter dated September 5, 1924. Quoted in Martin Harrison, ed., *Francis Bacon Catalogue Raisonné*, vol. I (London: The Estate of Francis Bacon, 2016), 76.

44 After their move to England: School records for Edward Bacon, Cheltenham College. All subsequent information about Edward's school days comes from these records. The authors are indebted to Christine Leighton, archivist of Cheltenham College, for providing the information on Bacon's younger brother.

45 They later proposed: Ibid.

45 "There is no chance": Bacon, in Harrison, ed., *Francis Bacon Catalogue Raisonné*, vol. I, 76.

45 Dean Close was smaller: The authors are indebted to Charles Whitney, the school archivist of Dean Close, for the information about Dean Close School and Bacon's time there. See also Whitney's history of the school, *At Close Quarters: Dean Close School, 1884–2009* (Little Logaston: Logaston Press, 2009) which also proved particularly helpful.

45 Bacon later dismissed: Bacon in Sylvester, *Interviews with Francis Bacon*, 186.

46 The school hoped: Whitney, *At Close Quarters*, 5.

46 It offered "a particular discipline": Charles Whitney, interview with Annalyn Swan, June 17, 2010. The following information comes from this interview as well.

46 Students came mainly: Ibid.

46 Bacon remained remarkably touchy: In 1965, Bacon was once on a train with John Rothenstein, the long-time director of the Tate, heading west from London—the general direction of Cheltenham. Bacon looked out the window and told Rothenstein that "every one of those scenes was a nail in my cross." John Rothenstein, Rothenstein diary, July 22, 1965, in unpublished diaries, 1939–1990, Tate Archive, 8726/1.

46 "Of course what's called all conversation": Peppiatt, *Francis Bacon*, 23.

46 School records indicate: Charles Whitney, Dean Close School archivist.

47 Francis was placed: A. L. Jayne's reminiscence appeared in the annual Old Decanian House journal, *The Decanian News*, in 1993, a year after Bacon's death.

47 "He took little": Ibid.

47 Bacon was also not sporty: School records provided by Charles Whitney, archivist.

47 Perhaps most surprisingly: Instead of art, Bacon opted to study music. Dean Close School Archives Department.

47 (In 1934, for example): Records of the Mayor Gallery, London.

47 He later called Daintry: Rothenstein private diary, entry of July 22, 1965, Tate Gallery archive.

48 One of them described: Letter from fellow classmate E. S. Hoare, quoted in Peppiatt, *Francis Bacon*, 24.

48 A. L. Jayne: A. L. Jayne, *The Decanian News*, 1993.

48 Bacon himself acknowledged: Peppiatt, *Francis Bacon*, 23.

48 Bacon recalled one Persian: Ibid.

48 One time he got as far: Eric Hall, unpublished diaries, 1929. The researcher James Norton discovered the diaries while helping the authors research Bacon's early life. The diaries are now part of The Estate of Francis Bacon archive.

49 In 1926, compulsory education: The Fisher Education Act of 1918 made compulsory education mandatory through the age of fourteen. Later the leaving age was changed to fifteen, and then sixteen.

49 His father was "aggressive": Bacon to Francis Giacobetti, "Francis Bacon: The Last Interview," *The Independent Magazine*, June 14, 2003.

49 But he was never precise: Bacon in later years spoke of being raped by the grooms. Elsewhere he used different language, saying that he had been "seduced" by the grooms. Hugh Davies, *Francis Bacon: The Early and Middle Years, 1928–1958* (New York and London: Garland Publishing, 1978), 6.

But he also said that his first sexual experience had come in Berlin. David Plante, "Bacon's Instinct," *The New Yorker*, November 1, 1993.

49 "I don't like the smell": Giacobetti, "Last Interview."

50 "That's definitely why": Ibid.

50 Doreen Mills Moloney: Letter to Bacon. The Estate of Francis Bacon archive.

50 George V (1865–1936) captured: Ronald Blythe, *The Age of Illusion: England in the Twenties and Thirties* (Boston: Houghton Mifflin Company, 1964), 37–8.

50 Until 1861, the official penalty: "Gay Rights movement," www.britannica.com.

51 Lord Alfred Douglas: Sinclair, *Francis Bacon*, 37.

51 "Most upper-class Englishmen": Gowrie, interview with Stevens.

51 "I don't think": Knott, interview with Stevens.

51 Even Ianthe, who would move: Ibid.

51 Perhaps he should have told her: Quentin Crisp, *The Naked Civil Servant* (New York: Penguin Books, 1997), 18.

51 During the summer of 1926: The photograph was shown to the authors by Phyllis Prior-Wandseforde, Doreen Prior-Wandseforde's niece, in visit to Ireland, November 8–11, 2010.

51 According to Phyllis Prior-Wandseforde: Ibid.

52 He *loathed* it: Bacon, quoted by Caroline Blackwood in Nancy Schoenberger, *Dangerous Muse: A Life of Caroline Blackwood* (London: Widenfeld & Nichols, 2001), 90–1.

52 "Those hunting people are so cruel": Ibid.

52 He began to steal: Bacon, interview with Miriam Gross, "Bringing Home Bacon," *Observer Review*, November 30, 1980, 29, 31.

52 Although Ianthe agreed: Knott, interview with Stevens.

52 "I think Francis": Ibid.

52 Bacon's own letters: Letters from Bacon to his mother. The Estate of Francis Bacon archive. Also Ianthe Knott collection.

53 "I think artists": Bacon, quoted in Peppiatt, *Francis Bacon*, 3.

53 "He often used to say": Knott, interview with Stevens.

53 His mother provided him: Bacon in Sylvester, *Interviews with Francis Bacon*, 186.

4 THE QUEERNESS OF CITIES

54 Christopher Isherwood described: Andrew Sinclair, *Francis Bacon: His Life and Violent Times* (London: Sinclair-Stevenson, 1993), 45.

54 His great-aunt: Alice Harcourt Smith, née Watson, had been living in London since her marriage to Cecil Harcourt Smith in 1892. Bacon's grandmother remained close to her family. So did his own mother, who had taken her

children to Newcastle during the war on a number of occasions, further cementing the family connections. For Diana Watson and her mother, see Martin Harrison, "Diana Watson's Diary," in *Inside Francis Bacon: Francis Bacon Studies III* (London: The Estate of Francis Bacon Publishing, in association with Thames & Hudson, 2020), 64.

55 He later told: David Plante, "Bacon's Instinct," *The New Yorker*, November 1, 1993.

55 An early photograph: The photograph was taken by Francis Julian Gutmann in London and dated c. 1935.

55 His goal: Bacon, quoted in Michael Peppiatt, *Francis Bacon: Anatomy of an Enigma* (London: Constable and Robinson, 2008), 31.

55 Ronald Blythe wrote: Ronald Blythe, *The Age of Illusion: England in the Twenties and Thirties* (Boston: Houghton Mifflin Company, 1964), 155.

55 He became for a time: David Sylvester, *Interviews with Francis Bacon* (New York: Thames and Hudson, 1987), 188.

55 "I had to arrive": Ibid.

55 "I can't say": Ibid.

55 When he gave his employer notice: Ibid.

55 "I knew nothing": Daniel Farson, *The Gilded Gutter Life of Francis Bacon* (New York: Pantheon Books, 1993), 23.

55 He soon took a dislike: Ibid. Bacon told Farson that he was also sacked by a second "gentleman" whose house he looked after when said gentleman saw the young Bacon dining at the Ritz not far from him on his night off.

56 Soho then teemed: Keith Waterhouse, "My Soho," *The Evening Standard*, April 12, 2001.

56 Gentlemen from Mayfair: John Richardson, interview with the authors, June 28, 2012.

56 "We were children": Dennis Myers, personal reminiscence of the 1920s, Tate Archive, 968.6.2. The following quotations come from this reminiscence as well.

56 The Charleston arrived: Michael Luke, *David Tennant and the Gargoyle Years* (London: Weidenfeld and Nicolson, 1991), 1.

56 That was also the year: Ibid., 2.

56 Tennant himself was: Ibid.

56 A Police Commission: Ibid., 19.

56 The Gargoyle was: Christopher Gibbs, interview with the authors, October 12, 2013.

57 By the mid-1920s, wrote Ronald Blythe: Blythe, *Age of Illusion*, 19.

57 "Here they were": Quentin Crisp, *The Naked Civil Servant* (New York: Penguin Books, 1997), 20–1.

57 In *World Within World*: Stephen Spender, *World Within World: The Autobiography of Stephen Spender* (New York: The Modern Library, 2001), 370–9.

57 "Sex was a beastly invention": Blythe, *Age of Illusion*, 33–5.

57 On February 21, 1927: The date is carved on Edward's tombstone at the local Straffan Parish church near the family's home of the time, Straffan Lodge, in Straffan, County Kildare, Ireland. Visit by the authors to the church, November 8–11, 2010.

57 During the previous autumn: All of the information on Edward's school attendance and illness comes from school records, Cheltenham College, courtesy of archivist Christine Leighton. Email correspondence with Annalyn Swan, February 23, 2011.

58 Upon hearing the news: Ianthe Knott, interview for Adam Low, director, *Francis Bacon*, *Arena* documentary, BBC Four archive, March 19, 2005.

58 Bacon attended the funeral: David Sylvester, *Interviews with Francis Bacon*, 188.

58 "I remember the only time I ever saw my father": Ibid.

58 Tuberculosis, he told Michael Peppiatt: Peppiatt, *Francis Bacon*, 12.

58 But Cheltenham College records contained: Records, Cheltenham College, courtesy of Christine Leighton, archivist.

59 His doting grandmother: *England and Wales, National Probate Calendar, 1850–1995*. She was buried in Onondaga Valley Cemetery, New York. Ancestry.co.uk.

59 She ventured: Harry McDowell, genealogist and historian, Celbridge, County Kildare, Ireland.

59 Family stories had it: Ianthe Knott, interviews with Stevens, March 5 and 6, 2008. The rumors had also reached Ireland. Harry McDowell, genealogist and historian, Celbridge, County Kildare, Ireland. Another interesting fact is that her son "Peter" was originally named Edward, which suggests that he assumed a new identity when he reached the U.S.

59 And then, the year of Granny Supple's: Harrison, ed., *Francis Bacon Catalogue Raisonné*, vol. I, 77.

59 He had served: The authors are indebted to James Norton for his research at the National Archive into Harcourt Smith's family and military background.

59 Bacon would later identify: Bacon interview, in Pierre Koralnik, director, *Francis Bacon: Peintre Anglais*, Radio Television Suisse Romande, Geneva, July 2, 1964.

59 On January 31, 1921: *England and Wales, Civil Registration Marriage Index*. For her family, see ancestry.co.uk.

59 The newly married couple: Rate books, research conducted by James Norton.

60 Only one year later: National Archives, research of James Norton.

60 In 1924, she petitioned: Ibid.

60 "The two sons": John Richardson, interview with Mark Stevens, March 3, 2008.

60 As for his big brother: Ibid.

60 Bacon enjoyed observing: Multiple sources, including Alice Weldon, a close, longtime friend of Lucian Freud. Alice Weldon, interviews with Annalyn Swan, March 7 and 12, 2012, and February 15, 2020.

60 "You know, my father and my mother": Bacon, in *Francis Bacon: Peintre Anglais*.

60 He left England: Harrison, "Diana Watson's diary," 69.

61 The Weimar period: Peter Gay, *Weimar Culture: The Outsider as Insider* (New York: W. W. Norton & Company, 2001), v.

61 What visitors saw: Ibid.

61 "The Germany of the late 1920s": Stephen Spender, *World Within World: The Autobiography of Stephen Spender* (New York: The Modern Library, 2001), 370–9.

61 Or as John Russell: John Russell, *Francis Bacon* (London: Thames and Hudson, 1971), 15.

61 "By way of education": Francis Bacon, in Farson, *The Gilded Gutter Life*, 23.

62 The Hotel Adlon: All of the information on the hotel comes from Hedda Adlon, *Hotel Adlon: The Life and Death of a Great Hotel* (London: Barrie Books, 1958).

62 "I was too young": Bacon, in interview transcripts from Michael Blackwood, director, David Sylvester, interviewer, *The Brutality of Fact, Arena* documentary, BBC Television, November 16, 1964.

62 "But I always remember": Ibid.

62 He loved reaching through: Peppiatt, *Francis Bacon*, 36.

62 "Gilded squalor": Dan Farson riffed off the well-known phrase in the title of his book on Bacon—*The Gilded Gutter Life of Francis Bacon*.

62 Dr. Magnus Hirschfeld's: Christopher Isherwood, quoted in Peppiatt, *Francis Bacon*, 35.

63 There were more than five hundred: See Tony Perrottet, "Weimar Club-hopping," thesmartset.com. See also Mel Gordon, *Voluptuous Panic: The Erotic World of Weimar Berlin* (Port Townsend, Washington: Feral Publishings, 2008).

63 "Even the Rome": Stefan Zweig, *Die Welt von Gestern*, quoted in Gay, 129–30.

63 Marlene Dietrich: Rachel Doyle, "Looking for Christopher Isherwood's Berlin," *The New York Times*, April 12, 2013.

63 Bacon was impressed by the open: Bacon, in Hugh Davies, *Francis Bacon: The Early and Middle Years, 1928–1958* (New York and London: Garland Publishing, 1978), 7.

63 Berlin was far more raw: Bacon to Davies, interview of May 29, 1973, for ibid.

64 "Perhaps it was violent": Bacon, quoted in Richard Cork, presenter, *A Man Without Illusions*, Radio 3, BBC archives, May 16, 1985.

64 Unlike W. H. Auden: Doyle, "Looking for Christopher Isherwood's Berlin."

64 Instead, Harcourt Smith: Bacon, interviewed in *The Brutality of Fact, Arena*.

64 But you wouldn't have seen me: This exchange is recorded in David Plante, "Bacon's Instinct," *The New Yorker*, November 1, 1993.

64 At an early age: Bacon in multiple interviews. In his interviews with David Sylvester, for example, Bacon spoke of seeing *Battleship Potemkin* "almost before I started to paint." Sylvester, *Interviews with Francis Bacon*, 34.

64 Berlin was: Ulrich Gregor, *Berlin 1910–1922* (New York: Rizzoli, 1982), 171.

64 One critic said the story: Ibid., 178.

64 It became a living symbol: Fritz Lang's *Metropolis* was first released in January 1927; Bacon could easily have seen it several months later.

65 The story of a mutiny: Information on the banning of the film can be found at Ronald Bergan, "Original Potemkin Beats the Censors after 79 Years," www.theguardian.com.

65 *Battleship Potemkin* was one of the early: Bacon in numerous interviews. See Sylvester, *Interviews with Francis Bacon*, 34.

65 Bacon later spoke: Peppiatt, *Francis Bacon*, 38.

65 Bacon later claimed: Andrew Sinclair, *Francis Bacon: His life and Violent Times* (London: Sinclair-Stevenson, 1993), 51. For Bacon on German expressionism, see Bacon, in Cork, *A Man Without Illusions*.

65 It became a must-see: The authors are indebted to the research of art curator Nadine Söll for all information on the original show in Berlin.

65 "It always had too much": Bacon, in Cork, *A Man Without Illusions*.

66 Founded and run: The information on the Bauhaus movement comes primarily from Gregor, *Berlin, 1910–1922*, 32.

66 In 1930 *The Studio*: W. Gaunt, "A Modern Utopia? Berlin—the New Germany—The New Movement," *The Studio* magazine, vol. 98, 859. Bound volumes, V&A library.

67 John Richardson called him: Richardson, interview with Stevens, March 3, 2008.

67 He was "a brute": Bacon, quoted in Michael Peppiatt, *Francis Bacon in Your Blood: A Memoir* (New York: Bloomsbury, 2015), 92.

67 A picture of Bacon: Barry Joule, interview with Annalyn Swan, November 5, 2017. Bacon had not realized that the pioneering photographer Lerski was the one who photographed him in Berlin.

67 Bacon wryly observed: Peppiatt, *Francis Bacon*, 39.

68 He had even once: Barry Joule, email with Annalyn Swan, March 29, 2020.

68 "I didn't keep myself to myself": Peppiatt, *Francis Bacon*, 52.

68 At an exhibition: Anne-Marie Crété de Chambine, "Un hôte singulier/A Very Special Guest," in Majid Boustany, ed., *Francis Bacon Mb Art Foundation* (Monaco: Francis Bacon Mb Art Foundation, 2005), 83. All of the following detail comes from this reminiscence.

68 "I was then six": Ibid. Bacon was of average height but seemed tall to the six-year-old.

5 MARVELOUS WOMEN

69 The Bocquentins resembled: Anne-Marie Crété de Chambine, "Un hôte singulier/A Very Special Guest," in Majid Boustany, ed., *Francis Bacon Mb Art Foundation*, 2nd ed. (Monaco: Francis Bacon Mb Art Foundation, 2017), 83.

69 The family, said Anne-Marie: Crété de Chambine, interview for Adam Low, director, *Francis Bacon*, Arena documentary, BBC Four archive, March 19, 2005.

69 A photograph: Crété de Chambine, "Un hôte singulier," *Francis Bacon Mb Art Foundation*, 2nd ed. (2017), 82.

70 "My mother would conduct": Ibid., 83.

70 They would retreat to: Ibid.

70 "My mother told me": Crété de Chambine, *Francis Bacon*, Arena interview.

70 "He was so talented": Ibid.

71 So charming did Bacon: Michael Peppiatt, *Francis Bacon: Anatomy of an Enigma* (London: Constable and Robinson, 2008), 41. The sister's name was Geraldine Luntley. Valerie Beston papers. Estate of Francis Bacon archive.

71 The young Bacon's round face: Crété de Chambine, *Francis Bacon*, Arena interview.

71 He was—"in the moon": Ibid.

71 "I saw him always": Ibid.

71 Madame Bocquentin was the first: Peppiatt, *Francis Bacon*, 40.

71 Bacon, still young himself: Crété de Chambine, "Un hôte singulier," in Baustang, *Francis Bacon—Mb Art Foundation*, 2nd ed., 83.

71 Two were by Eduard Fuchs: All of the books in Bacon's studio and bedsit were cataloged after his death. Hugh Lane, Dublin, archive.

71 *Fuchs' Erotic Art*: The authors are indebted to Nadine Söll, Berlin-based art curator and historian, for her research on Fuchs's books. All of the subsequent information on the books comes from Soll. September 2013.

72 He would later purchase: Catalog of books and publications, Hugh Lane archive.

72 In the end, it numbered: Ibid. See hughlane.ie/Bacons books.

72 He often spoke: David Sylvester, *Interviews with Francis Bacon* (New York: Thames and Hudson, 1987), 35.

72 He owned A. Radclyffe Dugmore's: Catalog of books and publications, Hugh Lane archive.

72 *Phenomena of Materialisation*: For more on Schrenck-Notzing and the medium Eva Carrière, see "Policing Epistemic Deviance: Albert von Schrenck-Notzing and Albert Moll," *Medical History* (Cambridge Journals) April 2012.

73 It was probably Madame Bocquentin: Crété de Chambine, *Francis Bacon*, Arena interview.

73 Madame Bocquentin was a talented: Ibid.

74 In the summer of 1927: "Giorgio de Chirico," www.guggenheim.org.

74 Documents, for example: See Dawn Adès and Simon Baker, eds., *Undercover Surrealism: Georges Bataille and Documents* (Cambridge: MIT Press, 2006).

74 The critic Dawn Adès: Adès, in Richard Cork, presenter, *A Man Without Illusions*, Radio 3, BBC archives, May 16, 1985.

74 Madame Bocquentin "knew all about": Crété de Chambine, *Francis Bacon*, Arena interview.

74 "Cent Dessins": Anne Baldassari, *Bacon, Picasso: The Life of Images* (Paris: Flammarion, 2005), 39. Bacon recalled six decades later that the show "had a huge effect on me." Michel Archimbaud, *Francis Bacon: In Conversation with Michel Archimbaud* (New York: Phaidon Press, 2004), 33.

74 Another major show: Ibid, 34–5.

74 "The Galerie Rosenberg used": Ibid.

75 Founded by the art critic Christian Zervos: See "Christian Zervos," www.metmuseum.org.

75 The final issue of 1927: Baldassari, *Bacon, Picasso*, 36.

75 In 1929, Cahiers d'Art published: Ibid.

75 The result was the same: Martin Harrison, "Diana Watson's Diary," in *Inside Francis Bacon: Francis Bacon Studies III* (London: The Estate of Francis Bacon Publishing, in association with Thames & Hudson, 2020), 69.

75 Bacon underwent: Ibid.

75 Bacon later denied having attended: Crété de Chambine, quoted in Peppiatt, *Francis Bacon*, 41.

75 Bacon would return home: Ibid.

75 His sister Ianthe: Ianthe Knott interview for *Francis Bacon*, Arena.

75 Two in particular attracted: See "Academie Colarossi," www.tate.org.uk.

75 Henry Moore had done: See "Academie Colarossi," www.artbiogs.co.uk.

75 Among those who made their way: Peter Adam, *Eileen Gray: Architect/Designer* (New York: Harry N. Abrams, 1987), 28.

76 "We were so hedged in": Ibid., 40.

76 Anne-Marie Crété de Chambine recalled: Crété de Chambine, *Francis Bacon*, Arena interview.

76 Ianthe remembered: Ianthe Knott, interviews with Mark Stevens, March 5 and 6, 2008.

76 "Ladies with long cigarette holders": Ibid.

76 He brought home playful gifts: Crété de Chambine, quoted in Peppiatt, *Francis Bacon*, 41.

76 He would send similar gifts: Knott, interview with Stevens.

76 Madame Bocquentin understood: The Bocquentin family knew that Bacon's next stop was Montparnasse. Crété de Chambine, "Un hôte singulier," 84, *Francis Bacon Mb Art Foundation*, second edition.

76 Montparnasse, concentrated: For a lively history of Montparnasse, especially in the 1920s and 1930s, see Billy

Kluver and Julie Martin, *Kiki's Paris: Artists and Lovers 1900–1930* (New York: Harry Abrams, Inc, 1989).

77 Isadora Duncan and Man Ray: "Isadora Duncan," fr.usembassy.gov/fr.

77 At the head of the street: "Edward Titus," Leonard Lauder Research Center, www.metmuseum.org.

77 Its American owner, Edward Titus: "Edward Titus," www/findingaids.library.emory.edu.

77 Bacon, continuing to read avidly: Peppiatt, *Francis Bacon*, 46.

77 Bacon also discovered, read and liked: Ibid.

77 Le Select, where Bacon had noted: Ibid., 52. He described going around with a male prostitute to places like Le Select, "which was one of the big homosexual cafés at the time."

77 One of the representative figures: Kluver and Martin, *Kiki's Paris*, 167.

77 "Kiki's Paris": Ibid., 11.

77 Bacon himself: Harrison, "Diana Watson's Diary," *Inside Francis Bacon*, 86.

78 Hemingway, with comic hyperbole: Ibid.

78 "All of his life": Crété de Chambine, *Francis Bacon*, *Arena* interview.

78 In a chatty letter: The Estate of Francis Bacon archive. The letter was dated August 22, 1966.

78 "He asked me": Ibid.

79 The opulence and orientalism: In his introduction to Christopher Wilk, *Marcel Breuer: Furniture and Interiors* (New York: The Museum of Modern Art, 1981), J. Stewart Johnson provided an excellent overview of the rapid changes in interior design. "As it happened, the 1925 Exposition not only signaled the triumph of the Art Deco style, but also turned out to be its high-water mark," he wrote. "Art Deco would persist, though increasingly compromised, for fifteen years. From 1925 on, however, it rapidly lost ground to its rival style, modernism; and this was due largely to that second, private event of the year: Marcel Breuer's creation in Dessau of the first chair to be made out of bent steel tubes." Wilk, *Marcel Breuer*, 9.

79 An apartment she created: Philippe Garner, *Eileen Gray: Design and Architecture 1878–1976* (Kohn: Benedikt Taschen, 1993), 7.

79 The boundaries between fashion: The convergence of fashion, art, and design in Paris in the 1920s is at the heart of an extended essay, "Paris to Providence: French Couture and the Tirocchi Shop," by Susan Hay, curator of Costume and Textiles at the Museum of Art, Rhode Island School of Design (RISD). As Hay wrote, "It seemed that everyone [in the 1920s] looked to Paris for fashion, for art, for contemporary life. Now, artists in all media were flocking to Paris from around the world, forever changing art, as well as fashion, which converged as never before during these years."

79 Coco Chanel knew Picasso: Elisabetta Povoledo, "Chanel, the Woman Who Reads," *The New York Times*, September 22, 2016. For Schiaparelli see "Schiaparelli and Dalí Artistic Collaboration," www.thedaliuniverse.com.

79 The painter Marie Laurencin: Lisa Cohen, *All We Know: Three Lives* (New York, Farrar, Straus & Giroux, 2012), 251.

80 Peter Adam, a biographer of Eileen Gray: Adam, *Eileen Gray*, 120.

80 By the time he arrived in Paris: As Peter Adam noted in his biography of Gray, she was in the south of France building her first house, called E.1027, after herself and her then-partner, the architect Jean Badovici, while Bacon would have been in Paris. "While Jean Désert fought for survival, Eileen, for almost three years, led a very solitary existence, living in the south of France, on site or in a little hotel room," wrote Adam. The house was finished in 1929, so this period—1926 to 1929—would have coincided almost exactly with Bacon's Paris trip. Adam, *Eileen Gray*, 191.

81 Garland was a second remarkable woman: Most of the information about Garland that follows comes from Lisa Cohen's portrait in *All We Know: Three Lives*.

81 Like Bacon, she suffered: Ibid., 212.

81 Cecil Beaton, then eager: Julie Kavanagh, *Secret Muses: The Life of Frederick Ashton* (New York: Pantheon Books, 1996), 71–2.

81 Madge Garland helped to dress: Cohen, *All We Know*, 255, 269.

81 Bacon later mentioned: Bacon, in Peppiatt, *Francis Bacon*, 91.

82 Woolf herself described: Cohen, *All We Know*, 269.

82 Beaton, more waspish: See "The 1920s lesbian power couple who transformed *Vogue*," www.dazeddigital.com.

82 The novelist Rebecca West: Cohen, *All We Know*, 247.

82 Garland loved all things French: Ibid., 214. Galleries also respected her artistic judgment. "Her eye for art impressed the directors of the Leicester Galleries and Agnew's, who introduced her to the work they owned and represented, gave her lists of paintings to look at in London and abroad, and quizzed her on what she had seen when she returned." Cohen, *All We Know*, 252.

82 "In the 1920s": Cohen, *All We Know*, 277.

82 Just before Bacon came to Paris: See ibid., 269–73, for details of the firing and its aftermath in the lives of Todd and Garland.

82 In 1927 and 1928: John Richardson, interview with the authors, June 28, 2012.

83 "Madge was the sort of woman": Ibid.

83 In a narrow street: Adam, *Eileen Gray*, 61–3.

83 Wyld's letters: The papers of Elizabeth Eyre de Lanux, Archives of American Art, Smithsonian, Washington, D.C.

Specifically: Series 1: Diaries (Box 1) Series 2: Correspondence (Boxes 4 and 6) Series 6: Box 11.

83 Eyre de Lanux: Rita Reif, "Elizabeth Eyre de Lanux, 102, Art Deco Designer" (obituary), September 10, 1996, www.nytimes.com.

83 The drawings that he: The papers of Eyre de Lanux at the Smithsonian contain a two-page illustrated magazine story from the early 1920s in which the women wear cloche hats and stylish sports clothes that seem similar to the fashionable period illustrations that Bacon brought home to Ireland on visits. There is no record of which magazine ran the story.

83 Born in Paris, Ivan: See "Juan da Silva Bruhns," www.blouinartinfo.com. Most of the information on da Silva Bruhns comes from this biographical note.

84 In contrast to: See "Ivan da Silva Bruhns," www.phillips.com.

84 In 1928, Bacon made designs: Clive Rogers and Jean Manuel de Noronha, "Rugs of the Young Francis Bacon," draft form of published article (unedited) from *Hali Magazine* 162 (winter 2009), www.orient-rug.com.

84 Two early Bacon rugs: Ibid.

84 Many of her signature chairs: Adam, *Eileen Gray*, 207. As Adam wrote, "Many of her chrome designs preceded those of Le Corbusier (who showed his first chrome furniture in 1928), Mies van der Rohe, Marcel Breuer, and Charlotte Perriand."

84 "There seems to have been an instant recognition": J. Stewart Johnson, introduction, in Wilk, *Marcel Breuer*, 10–11.

84 Robert Mallet-Stevens (1886–1945): For more on Mallet-Stevens, see Jean-Francois Pinchon, ed., *Rob. Mallet-Stevens: Architecture, Furniture, Interior Design* (Cambridge, Mass: The MIT Press, 1990).

85 He spoke with rare passion: Terence Conran, interview with Mark Stevens, July 7, 2011.

85 Ruhlmann, who opened: David Netto, "All Hands on Deco," *The Wall Street Journal*, updated April 9, 2011.

85 An early resumé: Undated resume, Marlborough Gallery archive.

85 He also knew of weavers: See "Francis Bacon Rugs Remain an Enigma after Second Withdrawal," *Antiques Trade Gazette*, www.antiquestradegazette.com. See also "Francis Bacon," www.orient-rug.com.

86 He told David Sylvester: Bacon, in David Sylvester, *Interviews with Francis Bacon* (New York: Thames and Hudson, 1987), 186.

86 Many artists have been reluctant: Neither Roy de Maistre nor Graham Sutherland wanted, later in their lives, to discuss their early design work. Before leaving his native Australia, Roy de Maistre did quite a bit of design and decorating. See Heather Johnson, *Roy de Maistre: The English Years* (Roseville East, New South Wales: Craftsman House,

1995), 57–9. His one commission after arriving in London seems to have been painting murals on the walls of Lady de Clair's dining room in Carrington House, Hartford Street, London. Her husband "had been governor of New South Wales from 1925 to 1929, so they were part of the old Australian world," as Johnson wrote. In Roger Berthoud, *Graham Sutherland: A Biography*, Berthoud quoted from a January 1980 letter that Sutherland wrote him: "You should remember the climate of the time. It was a very fortunate one in that field, so what was done by me and a few others could hardly be considered commercial art. It was more a question of gouaches literally copied, often by hand." Berthoud, *Graham Sutherland* (London: Faber and Faber, 1982), 67.

87 Shortly before leaving for London: Just how Bacon knew of, or was invited to the party for Toto Koopman's twentieth birthday is something of a question. The missing connector may well be Madge Garland, who would, of course, have known Koopman through the world of *Vogue* and haute couture. See also Jean-Noël Liaut, *La Javanaise* (Paris: Robert Laffont, 2011). The authors are grateful to James Norton for his translations from Liaut's biography.

6 GALLANT MEN

88 On July 15, 1929, Eric Allden: All of the information about Eric Allden and Bacon comes from Allden's 1929 diary, which the researcher James Norton discovered while helping the authors research Bacon's early life. The diaries are now part of The Estate of Francis Bacon archive.

88 Two weeks later: Ibid.

88 When his amanuensis, the critic David Sylvester: Bacon, quoted in David Sylvester, *Looking Back at Francis Bacon* (London: Thames and Hudson, 2000), 231.

88 Asked if he ever went: Ibid.

89 He had located a place: Eric Allden diary, October 8, 1929. The Estate of Francis Bacon archive.

89 Many of Madge Garland's friends: In vol. 97 of *The Studio*, the influential magazine of arts and design, there was an unsigned piece titled "New Designs for Wilton Rugs by E. McK Kauffer and Marion V. Dorn: A Conversation with a 'Studio' Representative." Probably written by Garland, it was a rave for Wilton Rugs. When asked about their craftsmanship, Kauffer replied, "Wilton rugs, I must say, are superb in craftsmanship and provide the finest texture obtainable." Garland was especially close to Kauffer and Dorn: she was infatuated with Dorn and spent time with them in France at the home of Vanessa Bell. Lisa Cohen, *All We Know: Three Lives* (New York: Farrar, Straus & Giroux, 2012), 271.

89 Allden described going with Bacon: Allden diary, August 1, 1929.

89 A shipment of glassware: Ibid., August 14, 1929.

89 Well aware of the importance of design: Ibid., October 24, 1929.

89 Bacon's dream as he returned to London: Bacon's first studio, at 17 Queensberry Mews, was remarkably similar in feeling and sensibility to Jean Désert.

90 Allden was a key figure: Allden's diaries in the 1930s and 1940s contain a number of references to Bacon's mother long after he and Bacon were no longer living together. On one occasion, he and a friend visited Mrs. Bacon after the Bacons moved to England from Ireland, settling in Bradford Peverell near the south coast of England. Allden diary, April 29, 1936.

91 Several months later: Allden, diary October 29, 1929.

91 Eric Allden grew up: The authors are indebted to James Norton for his research into the family and background of Eric Allden. Ancestry.co.uk proved valuable in further fleshing out details of the Allden family, as did Allden's photo albums, part of The Estate of Francis Bacon archives. See Francesca Pipe, "Bacon's First Patrons: Eric Allden's Diary," in *Inside Francis Bacon: Francis Bacon Studies III* (London: The Estate of Francis Bacon Publishing, in association with Thames & Hudson, 2020), 12–61.

91 His father, John Horatio Allden: *UK & Ireland Medical Directories, 1845–1942*.

91 Later, Eric's father and Peruvian-born mother: See "Northgate House, Beccles, Suffolk," www.britishlisted-buildings.co.uk. John Allden and Francisca Maria Stubbs were married on September 8, 1885. *London, England, Church of England Marriages and Births, 1754–1932*, ancestry.co.uk.

91 The family albums: The previous owners of the Allden diaries were kind enough to show family photographs to Mark Stevens and James Norton on a visit in November 2010.

91 Like many other graduates: All of the information about Allden in this paragraph comes from James Norton's research.

91 On his return to London: Ibid.

92 Initially, he found: Allden diary, July 31, 1929.

92 A photograph of Bacon: See the opening page of Part I, "I," for a reproduction of the photograph.

92 Having left the main: In later years Ianthe Knott stayed, on at least one visit to London, with Nanny in Pimlico. Ianthe Knott, interviews with Mark Stevens, March 5 and 6, 2008. Nanny Lightfoot kept her boarding house at least through 1939. Harrison, ed., *Catalogue Raisonné Francis Bacon*, vol. I, 81.

92 On an early visit: Allden diary, July 31, 1929.

92 The man was Guy Brunton: See "Guy Brunton," giza.fas.harvard.edu.

92 Only two or three weeks: Allden diary, August 2, 1929.

93 The irascible Major groused: Knott, interview with Stevens.

93 Decades later: Harry McDowell, genealogist and historian, Celbridge, County Kildare, Ireland.

93 In later years: Caroline Blackwood, quoted by Daniel Farson, in *The Gilded Gutter Life of Francis Bacon* (New York: Pantheon Books, 1993), 19. Blackwood told Farson that Bacon "developed a neurotic attack of asthma on the plane whenever he tried to get there. He could fly to any country in the world without physical mishap, but any flight to his homeland always proved disastrous."

93 He had now done his duty: Ianthe Knott recalled periodic visits by her brother. Ianthe Knott, interviews with Mark Stevens, South Africa, March 5 and 6, 2008.

93 "He wants me to remain": Allden diary, August 19, 1929.

93 "The cottage has": Ibid.

94 He entered a clinic: Allden diary, August 11, 1929.

94 In addition to being: For this and Arthur Conan Doyle, see "New Light in the Final Days of Sir Arthur Conan Doyle," *Psypioneer* 2, no. 7 (July 2006).

94 It was yet another time: Bacon's interest in seances and spirits—he owned a copy of Baron von Schrenck Notzing's *Phenomena of Materialisation*, published in 1920 (see chapter 5)—may have been underscored by his interaction with Fielding-Ould. Later, Bacon and the poet Thomas Blackburn, along with Blackburn's wife, Rosalie de Meric, conducted seances together in the early 1950s. Julia Blackburn, *The Three of Us: A Family Story* (New York: Vintage Books, 2009), 57–9.

94 Fielding-Ould's diagnosis: Allden diary, August 11, 1929.

94 The cure was: Ibid.

94 "I found him looking": Allden diary, August 14, 1929.

94 On subsequent days: Ibid.

94 Foremost among them: Allden catalogued Bacon's books in his diary entry of September 24, 1929.

94 "In the 1920s and 1930s": Stephen Spender, *World Within World: The Autobiography of Stephen Spender* (New York: The Modern Library, 2001), 370–9.

95 Allden was astonished: Allden diary, September 1, 1929.

95 No doubt Bacon was already prone: Michael Peppiatt, *Francis Bacon: Anatomy of an Enigma* (London: Constable and Robinson, 2008), 58.

95 They were concerned: Allden diary, September 1, 1929.

95 "The Kingston Yacht Club": Ibid.

95 "He took me through": Ibid.

95 On the way: Ibid., September 4, 1929.

95 The rural cottage: Ibid., August 21, 1929.

96 Allden admired: All quotations in this paragraph and the next come from Allden's diary, September 4, 1929.

96 On most days: Details of the local adventures of the two all come from Allden's diary entries, September 5–September 17, 1929.

96 Dr. Gogarty, an on-and-off: See "Dr. Oliver St. John

Gogarty Dies," *The New York Times*, September 23, 1957. The rest of the quotations about the Gogartys come from Allden's diaries.

97 "Mrs. Bacon, née Watson": Ibid., September 5, 1929.

97 She was "anxious to understand": Ibid., September 24, 1929.

97 "I cannot see that any of his characteristics": Ibid.

97 "He is as selfish": Ibid.

97 Both Francis and his older brother Harley: Ibid., September 5, 1929.

98 "I have been here three weeks": Ibid., September 24, 1929.

98 "He can cook admirably": Ibid.

98 He noted cheerfully: Ibid., October 6, 1929.

98 "Last night I walked down to the sea": Ibid., September 28, 1929.

98 Allden found: Ibid., October 23 and 27, 1929. Details of the new flat all come from these diary entries.

99 To a remarkable degree: See "The Great Depression," historic-uk.com.

99 He knew: Allden's diaries contain numerous references not only to plays but to actors, including Ernest Thesiger and John Gielgud.

99 "She is quite young": Allden diary, October 8, 1929.

99 In October, Bacon wanted to show: Allden diary, October 29, 1929.

100 "Both are most strange": Ibid.

100 A few days later: Ibid., November 1, 1929.

100 At the time: Ibid., September 24, 1929.

100 It was a mélange: Ronald Alley, ed., *Francis Bacon* (London: Thames and Hudson, 1964), 26. This was the first catalogue raisonné of Bacon's work.

100 "They have made them up beautifully": Allden diary, October 8, 1929.

101 Allden's diary recorded a lunch: Ibid., August 30, 1929. Allden may have misremembered the name. An Arundell Clarke, a designer and good friend of Madge Garland's, would soon become an important figure in Bacon's life.

101 On their first day: Ibid., October 29, 1929.

101 "This put him in a mood": Ibid.

101 "South Kensington was enormously respectable": John Richardson, interview with the authors, June 28, 2012.

101 "South Kens was known": Farson, *The Gilded Gutter Life*, 156.

101 "That Bacon chose": Richard Shone, "Francis Bacon in 1930: An Early Exhibition Rediscovered," *The Burlington Magazine*, April 1996, 253–5.

101 Bacon settled on 17 Queensberry Mews: The source for the garage is "The 1930 Look in British Decoration," *The Studio* 100 (September 1930), 140–5.

102 Its main purpose, however: Converting mews houses into chic residences was just coming into vogue in London

in the late 1920s. Michael Peppiatt, *Francis Bacon: Anatomy of an Enigma* (London: Constable & Robinson), 58.

102 One major source: Ibid.

102 Dedicated to Frank Lloyd Wright: Paul Frankl, *New Dimensions: The Decorative Arts of Today in Words & Pictures* (New York: Payson & Clarke Ltd., 1928), 26, 33.

102 Frankl reserved: Ibid., 78.

103 Above all: Photographs of the interior of Jean Désert and Bacon's studio show a strikingly similar esthetic at work, including the central feature, the molded, curving staircase. "The 1930 Look in British Decoration," 140–5.

103 His glass-topped circular tables: Philippe Garner, *Eileen Gray: Design and Architecture 1878–1976* (Kohn: Benedikt Taschen, 1993), 85.

103 Bacon sent his mother a photo: Winnie passed along her old clippings to Ianthe Knott when she died. Ianthe showed them to Mark Stevens on a visit to South Africa, March 5 and 6, 2008.

103 Another armchair had very thick: Jean-François Pinchon, publishing director, *Rob. Mallet-Stevens: Architecture, furniture, Interior Design* (Cambridge, Mass: The MIT Press, 1990). See full-page photographs of Mallet-Stevens's designs.

103 A large cabinet: Ibid.

7 STAGE SETS

104 Founded in London: See "Studio: a brief history," www.studiointernational.com.

105 Articles were devoted: Volumes 97 to 100 of the magazine—the year 1930—revealed an extraordinary range of topics. V&A library archives, London.

105 The six-page spread: Madge Garland, "The 1930 Look in British Decoration," *The Studio* (August 1930), 190–5.

105 But the surprise of the package: Ibid.

105 After her extended stays: Lisa Cohen, *All We Know: Three Lives* (New York: Farrar, Straus & Giroux, 2012), 274.

105 "Rebecca West told her": Ibid.

105 One signed article: Madge Garland, "Interiors by Eyre de Lanux," *The Studio* 99 (October 1930), 263–5.

105 Garland never acknowledged: Lisa Cohen, phone interview with Annalyn Swan, November 4, 2011.

106 Garland was in love . . . : Ibid.

106 While the couple's work: "New Designs for Wilton Rugs by E. McK Kauffer and Marion V. Dorn: A Conversation with a 'Studio' Representative," *The Studio* 97, 1930, 35–9.

106 No other young artists or designers: A review of *The Studio* magazine at the V&A library revealed no other pieces on young designers from vol. 97, MCMXXIX (1929) through vol. 100 (end of 1930).

106 "Francis Bacon is a young English designer": Garland, "The 1930 Look in British Decoration," 140–1.

106 "We have been perhaps slower": Ibid.

106 "The appeal of steel and glass": Ibid.

106 These same curtains: Michael Peppiatt, *Francis Bacon* (London: Constable & Robinson, 2008), 59.

107 "His rugs are particularly representative": Garland, "The 1930 Look in British Decoration."

107 "Francis Bacon, today internationally famous": Madge Garland, *The Indecisive Decade: The World of Fashion and Entertainment in the Thirties* (London: Macdonald, 1968), 14.

107 "The staircase leads up": Francis Bacon, undated letter to his mother, collection of Ianthe Knott. Estate of Francis Bacon archive.

108 (She would have been dumbfounded): Paul Frankl, *New Dimensions: The Decorative Arts of Today in Words and Pictures* (New York: Payson & Clarke Ltd., 1928), 27.

109 Two years later: Ianthe Knott, interview for Adam Low, director, *Francis Bacon, Arena* documentary, BBC Four archive, March 19, 2005.

109 Bacon sent the Easter eggs: Bacon postcard to Ianthe Knott, cited in Harrison, ed., *Francis Bacon Catalogue Raisonné*, vol. I, 78.

109 Bacon was less appreciative: Martin Harrison, "Diana Watson's Diary," in *Inside Francis Bacon: Francis Bacon Studies III* (London: The Estate of Francis Bacon Publishing, in association with Thames & Hudson, 2020), 73.

109 The artist H. M. Sutton: Marlborough Gallery archives, London. Sutton's letter, dated November 17, 1984, was wrong in recalling the year of his visit to 17 Queensberry Mews as the summer of 1928. It would have been the summer of 1930, as Bacon had not moved to Queensberry Mews until January of that year.

109 Bacon also prepared: Richard Shone, "Francis Bacon in 1930: An Early Exhibition Rediscovered," *The Burlington Magazine*, 253–5.

110 Like Bacon, de Maistre was: Much of the biographical information on de Maistre comes from Heather Johnson, *Roy de Maistre: The English Years* (Roseville East, New South Wales: Craftsman House, 1995) and *Roy de Maistre: The Australian Years* (Roseville East, New South Wales: Craftsman House, 1988). Johnson is de Maistre's great-niece.

110 Like Bacon: Caroline de Mestre Walker, interview for *Francis Bacon, Arena*.

110 He was remembered: Andrew Sinclair, *Francis Bacon: His Life and Violent Times* (London: Sinclair-Stevenson, 1993), 61.

110 De Maistre grew up: Johnson, *Roy de Maistre: The English Years*, 11.

110 He liked to imply: Ibid., 16.

110 It belonged: Ibid.

110 De Maistre served dinner: Ibid., 14.

110 He doted over: Ibid.

110 In the end, he found that: De Maistre's royal aspirations and social pretensions put him at odds with many in his family, who felt that he condescended to them. Caroline de Mestre Walker, *Arena* interview. Also interview with Annalyn Swan, October 18, 2013.

111 Like Wassily Kandinsky: Ossian Ward, "How Wassily Kandinsky's synaesthesia changed art," *The Telegraph*, December 16, 2014. See also "Roy de Maistre," www.artgallery .nsw.gov.au.

111 Eventually, de Maistre created: See his "Colour Harmonizing Chart," "Colour Music in Australia: de-mystifying De Maistre," www.colourmusic.info.

111 His most famous painting: See "Artist Profile: Roy de Maistre," www.artgallery.nsw.gov.au.

111 The Colour in Art show: "Colour Music in Australia," www.colourmusic.info.

111 One of the purposes of his Colour Harmonizing Disc: Sinclair, *Francis Bacon*, 62.

111 No sooner did he arrive: Johnson, *Roy de Maistre: The English Years*, 11.

111 The gallery had been founded: See "Lessore, Helen 1907–1994," www.artbiogs.co.uk.

111 Bacon would later say: Bacon and Lessore remained close friends throughout his life. "Francis respected her; she loved him." Daniel Farson, *The Gilded Gutter Life of Francis Bacon* (New York: Pantheon, 1994), 99.

111 Bacon met de Maistre: Johnson, *Roy de Maistre: The English Years*, 11.

111 The connection was almost certainly: In his diary Eric Allden noted, on November 5, 1929, that Bacon was dining "with a Mrs. MacDermot and going to the Gate Theater." The connection to the Bacon family might well have come from Australia—Bacon's paternal grandmother, Alice Lawrence Bacon, was Australian. MacDermot also knew Roy de Maistre well from Australia. During her time in Sydney, MacDermot had been associated with a bohemian café, patronized by artists and intellectuals, whose modernist interior had been designed by de Maistre. De Maistre also featured a room from Mrs. MacDermot's house in an important interior design show held at the Burdekin House just before he left. David Marr, *Patrick White: A Life* (London: Jonathan Cape, 1991), 148.

112 He became enamored of Bacon: De Maistre's two relatives, Caroline de Mestre Walker and Heather Johnson, have no knowledge that the two were ever romantically involved. Johnson also interviewed several of his close friends for her biography of de Maistre. They "stated categorically," as she put it, that the two never had an affair. Johnson, *Roy de Maistre: The English Years*, 21.

112 De Maistre's one passionate affair: Ibid., 26.

112 It was probably then that Bacon and de Maistre: Bacon was once thought, on the basis of his vague recollections, to have exhibited his work in a show in 1929. But

in 1929 he did not have his studio in place, and he was only beginning to fabricate his furniture and rugs. The exhibition he organized was in November of 1930.

112 And so Bacon thought of a third artist: Most of the information on Jean Shepeard comes from her niece Doreen Kern, interview with Annalyn Swan, November 17, 2012, as well as a chronology and short account of her aunt's life compiled by Kern. See also "Jean Shepeard 1904–1989," www.portrait.gov.au and Shone, "Francis Bacon in 1930," *The Burlington Magazine*, 253–5.

113 Like de Maistre, Shepeard was more established: Kern, interview with Swan.

113 A critic in 1931 wrote: The article, which Shepeard kept, is unsigned and no information exists about where it appeared.

113 Shepeard was never without her sketchbook: Kern, interview with Swan.

113 She once toured: Ibid.

113 Shepeard may have met Bacon: Information on R. O. Dunlop comes from Doreen Kern, interview with Swan.

113 Dunlop's background would have interested: See "Ronald Ossory Dunlop, 1894–1973," www.howgill-tattershall.co.uk.

113 Or, possibly: Eric Allden's photo albums and diary contain references to both Thesiger and Noël Coward. The Estate of Francis Bacon archives.

113 In her biography of Ivy Compton-Burnett: Hilary Spurling, *Ivy: The Life of Ivy Compton-Burnett* (London: Richard Cohen books, 1974), 242–3.

114 Shepeard provided: Much of the information on the 1930 show comes from Shone, "Francis Bacon in 1930," *The Burlington Magazine*, 253–5.

114 De Maistre contributed: Ibid. A well-known surviving portrait of the young Bacon by de Maistre is sometimes assumed to be the portrait included in the 1930 show. But through the end of 1930 de Maistre spelled his name—and signed his paintings—Roi de Mestre. His name in the small catalog of the show is spelled "Roi de Mestre," and he signed one extant painting from the same show with that spelling of his name. The spelling on the surviving portrait is "Roy de Maistre," and it probably dates instead to c. 1935, after de Maistre had re-established himself in London following several peripatetic years on the continent. The existing portrait also depicts Bacon with some makeup and lipstick—certainly not his look while he was with Eric Allden in 1930. (A keen observer, Allden would have been sure to note makeup, as both Patrick White and Caroline de Mestre did later in the 1930s.)

The far more likely candidate for the "portrait" of 1930 was reproduced in a 1964 article in Australia. The picture depicted Bacon's Queensberry Mews studio, complete with the same furnishings—and Jacques Adnet seagull—that de Maistre included in other depictions of Bacon's studio

that year. But here the young artist himself is incorporated into the painting, thereby making the title *Portrait of Francis Bacon* from the catalog to the 1930 show plausible. The authors are indebted to Andrew Gaynor, a PhD candidate at Australian National University who has made de Maistre his subject, for bringing this painting to our attention. It has since disappeared. The authors are also indebted to Heather Johnson, correspondence of October 12, 2013, and Caroline de Mestre Walker, interview of October 18, 2013. Bacon himself exhibited: Shone, "Francis Bacon in 1930," *The Burlington Magazine*, 253–5.

114 Just one Bacon picture: It is impossible to tell for certain whether the painting blandly retitled (in Bacon's non-descriptive style) *Painting 1929* is the same as *Trees by the Sea*, although it appears likely from the fact that the painting depicts tree trunks against a distant beach.

114 The painting resembled: See "Jean Lurçat, Paysage a Smyrne," mutualart.com.

114 Some rugs were hung: One photograph in the *Studio* article shows a blocky, cubistic rug hanging prominently on the wall between two signature, rounded mirrors by Bacon.

114 Before the opening: The card is reproduced in Shone, "Francis Bacon in 1930," *The Burlington Magazine*, 253–5.

114 He also made up: The authors are grateful to Richard Shone for providing the catalog and other background information on the 1930 show. Richard Shone interview with the authors, February 17, 2011.

115 The reviewer praised: The review, unsigned and undated, was provided to the author and to Richard Shone by Doreen Kern, Shepeard's niece.

115 "Transported": Ibid.

116 In one picture: The lesser-known *Interior*, reproduced in Richard Shone's piece in *The Burlington Magazine*, is in the collection of Manchester City Art Galleries.

116 She portrayed him: The authors are indebted to Doreen Kern and to Richard Shone for reproductions of Shepeard's drawing of Bacon.

117 In the months after: Harrison, "Diana Watson's Diary," 80.

117 In 1931, as Bacon took up the life: Ibid., 74, 76.

117 *Les Enfants Terribles*: Ibid., 70.

118 In 1931, Bacon visited his cousin: Ibid., 76. In this diary entry, Watson appears to be looking back to an earlier time, seeming to suggest that, while the later Bacon may claim that such ideas left him "indifferent," the young man who used to visit her in Yorkshire often brought them up.

118 In December of 1931: Electoral rolls, researched by James Norton.

118 "We would simply adore": Bacon, letter to his mother, cited in Martin Harrison, ed., *Francis Bacon Catalogue Raisonné* vol. I (London: Estate of Francis Bacon, 2016), 78.

118 Allden eventually moved: Allden was photographed on November 24, 1935, in his flat at Egerton Gardens, with

Bacon furniture and paintings sprinkled in among the more traditional furnishings. The photograph is reproduced in Harrison, ed., *Francis Bacon Catalogue Raisonné*, vol. I, 78.

8 STARTING OVER

120 Why not share a flat: Martin Harrison, "Diana Watson's Diary," in *Inside Francis Bacon: Francis Bacon Studies III* (London: The Estate of Francis Bacon Publishing, in association with Thames & Hudson, 2020), 81.

120 During the early 1930s: Heather Johnson, *Roy de Maistre: The English Years* (Roseville East, New South Wales: Craftsman House, 1995), 12–13, 18.

120 A recent émigré: At least three photographs exist of the space at Carlyle Studios, taken by Eric Megaw. See Francis Bacon MB Art Foundation, www.mbartfoundation.com. That Bacon used this space as an occasional showroom, and that he continued to produce rugs, seems clear from a letter that Bacon sent his mother in Ireland. He included with his letter a picture of a rug—its design much like its predecessors—that he dated 8 April, 1932. Roy de Maistre might also have painted his 1933 *Still Life*, which depicted elements of Bacon's design (a hanging rug, a round table), in this space.

120 By the time of his Queensberry: Angus Stewart, interview with James Norton, February 9, 2016. Stewart met Bacon in 1962, when both were looking at paintings in the National Gallery. A member of the Royal Society of Arts, Stewart is known for curating exhibitions on twentieth-century British artists and the English arts and crafts movement, among many others. Stewart also lived near Bacon and spoke with him often.

120 Not surprisingly—in the small world: Clarke and Garland both moved to Bruton Street after Royal Hospital Road and were neighbors there. Research by James Norton.

121 During the late 1920s: Street directories for 1930 and 1931 show Arundell Clarke at 71 Royal Hospital Road. Research by James Norton.

121 One was Misha Black: Angus Stewart, interview with James Norton. For more on Black, see http://arts.brighton.ac.uk/collections/designarchives/.

121 The second was Richard Levin: Stewart, interview with James Norton.

121 Levin would become: Philip Purser, "Richard Levin: Designer Who Gave the BBC Its Visual Identity and Revolutionized Programme Presentation," *The Guardian*, July 9, 2000.

121 His daughter, the artist Gill Levin . . . : Conversation with James Norton, February, 2016.

121 In addition to occasional work: John Richardson, interview with the authors, June 28, 2016.

121 He later told: Miriam Gross, "Bringing Home Bacon," *The Observer Review*, November 30, 1990, 29, 31.

121 An exception was Diana Watson: Harrison, "Watson's Diary," 76.

121 "He seems to be without": Ibid., 77.

121 Mrs. Watson, said her daughter: Ibid., 64.

122 As Francis set out: John Richardson lived across from Diana and her mother on Thurloe Place. Interview with Richardson.

122 Diana had always found: Harrison, "Watson's Diary," 76, 82.

122 In a diary she kept: Harrison, Ibid. In publishing Diana Watson's diary, Martin Harrison and The Estate of Francis Bacon have opened an essential window onto Bacon's life and sensibility as a young artist in the 1930s, a period when information on Bacon is otherwise scarce; Bacon went to great lengths in later life to conceal his early years. It is important to note that the entries that survive are not Watson's original versions, but were copied later in her life. Watson may have been reviewing her diary with the intention of either publishing a version of the entries or a piece that described her perspective on Bacon's early life. Bacon himself was aware of the existence of the diary. (Watson observes, "He wants this diary to be finished.") The language used in the Watson diaries suggests that, at certain points, Watson is commenting from her present vantage point on Bacon's life many years before. Indeed, it is not always clear when she is commenting and when she is copying. These are, in short, both diary entries and, occasionally, "reflections inspired by a diary entry." There is little doubt that Watson, when she was older, sensed Bacon looking over her shoulder as she revisited her early observations. In particular, Watson would have known that Bacon did not want certain aspects of his early life presented to the world—especially his life as a designer, with which she was familiar. Watson and her mother were often in London during Bacon's brief career as a designer, and Watson herself purchased some of his pieces. Although it is possible that Watson began her diary only in late 1931, just as Bacon committed himself to being an artist, it seems more likely—though it must remain speculation unless other diary entries are found—that she also kept a diary in the late 1920s. Few things would have been more exciting to a restless and isolated young woman from Yorkshire than her cousin's exotic and shockingly modern London showroom. In her diaries, however, she makes only one oblique reference to Bacon's work in design, which suggests that during her later review she left out that part of his life. Watson also makes no obvious mention of Eric Allden and rarely brings up Eric Hall. (And Bacon was probably not shy about recounting his personal life before the cousin-confessor of his childhood.) It seems possible that, in the end, Bacon discouraged her effort to record his early life. Her descrip-

tion of a struggling and vulnerable young artist eager for success who worked very hard for most of the 1930s does not conform to the picture of his youth that Bacon himself presented to the world.

122 "Francis was now "separated": Ibid., 64.

122 "The painting was more serious": Ibid., 77.

122 The two "went to music halls": Ibid., 64.

122 Francis informed her: Ibid., 74.

122 Her cousin was being led into: Ibid., 69.

122 "Everything was done": Ibid., 76.

122 Sometimes, they went: Ibid., 80.

122 At the Corner House in Coventry Street: Lyons Corner House—"The Lily Pond," www.historicengland.org.uk/.

122 In a "darkened empty teashop": Harrison, "Watson's Diary," 74.

123 She noted that her cousin's "freedom": Ibid., 80.

123 Francis "always had contacts": Ibid., 77.

123 "His mind seldom moved": Ibid., 72.

123 He loved the visceral physics: Ibid., 71.

123 The arm holding the brush: Ibid.

123 A thick neck: Ibid., 76.

123 He wondered what the refined: Ibid., 72.

123 He would look for models: Ibid., 70.

123 He hoped to find: Ibid.

123 The ordinary surface: Ibid., 70.

123 "A thing has to arrive": Ibid.

123 Once, after the camera: Ibid., 73.

123 He took Diana to see: Ibid., 70.

123 He admired the legendary: Ibid., 81.

123 To provide the brutal facts: Ibid., 70.

124 "Everything is given": Ibid., 76.

124 "He always had a feeling": Ibid., 77.

124 He once became angry: Ibid., 69.

124 In 1932, Diana watched: Ibid., 70.

124 He saved almost nothing: Ibid.

124 "At tea," wrote Diana: Ibid., 74.

124 She called it: Ibid., 71.

124 One Christ figure: Ibid., 69.

124 On his studio wall: Ibid., 69.

124 Occasionally, he worked without brushes: Ibid., 70.

124 If the picture became a mess: Ibid., 71.

124 He sought power: Ibid.

125 Early in the summer of 1932: Ibid., 80.

125 Her cousin "liked": Ibid. The rest of the quotations about Paris come from Watson's diary.

125 They took photographs: Ibid., 65.

125 In 1932, Arundell Clarke: Street directories show that Clarke left 71 Royal Hospital Road in 1932 and Garland the following year. Research by James Norton.

125 The famous couturier: Lisa Cohen, *All We Know: Three Lives* (New York: Farrar, Straus & Giroux, 2012), 274–5.

125 In October of 1933: "Gets Downtown Building," *The New York Times*, October 10, 1933. A ship full of the titled had sailed to New York for the suitably stylish opening of the building in 1932. "English Nobility Here for Ceremony," *The New York Times*, July 2, 1952.

125 By 1947, "former": "Work of Noted Textile Designers Put on View at New Showroom," *The New York Times*, February 27, 1947. In 1949, Clarke "showed several new patterns by each of the designers he represents" at the American Institute of Decorators annual awards ceremony. Among them was Philip Johnson (*The New York Times*, March 23, 1949). In a room designed by Clarke for a national furnishings show in 1957, *The New York Times Magazine* (September 8, 1957) noted that "pleated leather covers the walls, except that adorned with Ellsworth Kelly's vivid abstraction, in this room in which all background surfaces are white." Bacon had designed a similarly all-white room for Madge Garland. Photographs of Clarke's New York showroom taken in 1935 also show a vanity that has the same large, rounded mirror, curved bench, glass top and squared-off lines as did Bacon's own furniture. Archives, Museum of the City of New York.

125 Clarke was fond: Eric Allden went to Arundell Clarke's flat on Bruton Street, where Nanny Lightfoot often cooked, to wish her happy birthday. Allden diary, July 1, 1934. Estate of Francis Bacon archive.

125 When Clarke's elderly father: Edward John Arundell Clarke, Arundell Clarke's father, died on June 19, 1932. *England and Wales, National Probate Calendar*, ancestry.co.uk. James Norton also supplied information on rate books and street directories for 71 Royal Hospital Road.

126 By the autumn of 1932: Ray de Maistre dated one of his pictures of Bacon's studio to 1932. The same studio appears in later images when Bacon was known to be at 71 Hospital Road, which suggests that Bacon was already working there in 1932.

126 A later friend of Bacon: Michael Wishart, *High Diver* (London: Blond and Briggs, 1977), 7–8.

126 "Artists really were here": Margaret Fenton, interview with Annalyn Swan, July 5, 2011.

126 At the time: Richard Shone, "Francis Bacon in 1930: An Early Exhibition Rediscovered," *The Burlington Magazine*, April 1996, 253–5.

126 "Later, when I lived": Quentin Crisp, *The Naked Civil Servant* (New York: Penguin Books, 1997), 54.

126 "It was," said Fenton: Fenton, interview with Swan.

127 The writer Radclyffe Hall: Ianthe Knott, interview for Adam Low, director, *Francis Bacon*, Arena documentary, BBC Four archive, March 19, 2005.

127 When a well-known Chelsea house: "5,000 Pound Chelsea House Now On Sale for 8.5 Million," *Evening Standard*, July 4, 2011.

127 Next door at 27 Ormonde Gate: Geoffrey Gilbey lived at 27 Ormonde Gate from 1930 to 1940. London rate books, researched by James Norton. He is also listed there in the *London City Directory* of 1930. Ancestry.co.uk.

127 After founding: See "1872—Gilbey's Gin Established," www.diffordsguide.com.

127 He sometimes wrote pieces: Books by Geoffrey Gilbey, including *She's and Skis* and *Not Really Rude*, are still for sale on the internet. *Pass It On: Religious Essays* was published in 1931.

127 He was the author: His *Horse Racing for Beginners* was published in London by Grant Richards in 1923.

127 He kept a stable: Alan Yuill Walker, *The Scots & the Turf: Racing and Breeding—The Scottish Influence* (Edinburgh: Black and White Publishing, 2017), ch. 15, 2.

127 Like many public school men: See "Geoffrey Hall and Gilbey," www.thepeerage.com.

127 He had an affair: Sean O'Connor, *Straight Acting: Popular Gay Drama from Wilde to Rattigan* (London: Bloomsbury, 2016), 129.

128 "Rattigan was probably not: Christopher Tyerman, *A History of Harrow School, 1324–1991* (Oxford: Oxford University Press, 2000), 447.

128 Geoffrey's first cousin: Gerard Noel, "Obituary: Monsignor Alfred Gilbey," *The Independent*, March 28, 1998.

128 Bacon's old friend: A. L. Jayne, 1993 reminiscence in the annual Old Decanian House Journal, *The Decanian News*, Dean Close School, a year after Bacon's death. The authors are indebted to Charles Whitney, head archivist, Dean Close School Archives Department for providing the reminiscence.

128 In what sounds like a highly fanciful: Ibid.

128 Gilbey's next-door neighbor: Eric Hall was listed in the *London Electoral Registers* as living at 26 Ormonde Gate from 1926 through 1930. Gilbey moved next door in 1930. Hall and his family moved in 1931 to Tennyson Mansions off Lordship Place, an eleven-minute walk away. ancestry.co.uk.

128 It was thought: "Jeeves and Wooster Part 4: The Drones Club," www.parbakeandprose.com.

128 It was the most natural thing: Bacon told Michel Archimbaud that he met Eric Hall in the late 1920s—although Bacon's dating was notoriously unreliable. *Francis Bacon: In Conversation with Michel Archimbaud* (New York: Phaidon, 2004), 24.

129 His father, a surveyor: The authors are indebted to James Norton for his research into Eric Hall's family and background.

129 Like Wellington: Many graduates fought in WWI and WWII, and 457 were killed. "The Chapel," *Old Malvernian* newsletter. no. 23 (May 2000).

129 In the fall of 1909: Biographical research by James Norton.

129 He chose to pursue: All of the information on Hall's academic career comes from Clare Hopkins, archivist, Trinity College, Cambridge, to James Norton, October 2012.

129 "To modern eyes": Ibid.

129 In September 1914: Records, War Office, National Archives. Research by James Norton.

129 Like Bacon's father, Hall succeeded: Ibid.

129 "On the morning of July 1st 1916": Ibid. All further quotes about Hall's war experiences and wounding are taken from Hall's written testimonial at the War Office.

130 The operation left: Hall's military record notes that he wore a built-up shoe because his left leg became an inch shorter than his right following the surgery.

130 Hall married: *England and Wales, Civil Registration Marriage Index, 1916–2005*, ancestry.co.uk.

130 Barbara Preston: Research by James Norton.

130 In a wedding photograph: The authors are grateful to James Norton for supplying the photograph, which was given to him by Béatrice Mitchell, Hall's granddaughter.

130 After he left the army: Research by James Norton. Peter Jones, on Sloane Square, was within easy walking distance of Eric Hall's house on Ormonde Gate.

131 He would spend over three decades: Ibid.

131 Hall possessed: All photographs were taken from family albums. Research by James Norton. The dates of his children's births come from *England and Wales, Civil Registration Birth Index, 1916–2007*, ancestry.co.uk.

131 He liked the fashionable Bath Club: James Norton research.

131 The wife of one of Hall's friends: Diana Keast, interview for Adam Low, director, *Francis Bacon*, Arena.

131 In the 1920s, Hall inherited: Hall's family background and civic record comes from the research of James Norton.

131 He was the kind of man: Ibid.

131 "One day he came": Bacon, in Archimbaud, *Francis Bacon*, 24.

131 The Englishman who marched: Ivan Hall, Eric Hall's son, thought that Bacon felt guilty in later years about spending so much of his father's money on Bacon. Swan, email correspondence with Heather Johnson, Roy de Maistre's great-niece, October 2013. As Heather Johnson wrote in *Roy de Maistre: The English Years*, after interviewing Ivan Hall, "De Maistre also expressed disapproval of Bacon's lifestyle in the later 1930s—of doing little else but gambling and of running gambling houses—and of being a partner with Eric Hall in wasting away most of the latter's inheritance instead of preserving what should have been passed on to Hall's son." Heather Johnson, *Roy de Maistre: The English Years* (Roseville East, New South Wales: Craftsman House, 1995), 28–9.

132 Eric Hall, said John Richardson: Richardson, interview with the authors, June 28, 2012.

132 John Richardson acknowledged: Ibid.

132 The young Australian novelist: Patrick White, *Flaws in the Glass: A Self-Portrait* (New York: The Viking Press, 1981), 63.

132 In September 1933: Allden diary entry, September 18, 1933.

132 Some months later, Allden and de Maistre: Ibid.

132 Hall recalled with nostalgia: Harrison, "Watson's Diary," 72.

133 Oh, those Greeks: Friedrich Nietzsche, *The Gay Science* (New York: Vintage, 1974), 38.

133 At mid-decade, de Maistre painted: The portrait is now owned by The Estate of Francis Bacon.

134 Bacon once observed to Diana: Harrison, "Watson's Diary," 79.

134 In 1931, Amédée Ozenfant: See "Amédée Ozenfant," www.guggenheim.org/.

134 It helped Bacon: The 1931 edition is included on the complete list of books found in Bacon's studio and bedsit after his death, Hugh Lane Gallery archive.

135 "Purism": See "Amédée Ozenfant," www.guggenheim.org.

135 The relation was also close: Anne Baldassari, *Bacon, Picasso: The Life of Images* (Paris: Flammarion, 2005), 76. There were also hints of Lurcat, Léger and Souverbie, as in some of Bacon's other early works. Interestingly, at just the moment when Ozenfant and Le Corbusier were collaborating on their seminal *La Peinture modern* (1925), Ozenfant was also collaborating with Léger; Léger and Ozenfant were two of the four founders, in 1924, of a free studio of art in Paris. (Another founder was Marie Laurencin, Madge Garland's close friend in Paris.) There is no record of Bacon attending the school, but he was an early devoteé of Ozenfant and may well have known Laurencin through Madge Garland. The figures on Bacon's screen also echo a contemporaneous book jacket design by Madge Garland's great friend E. McKnight Kauffer for T.S. Eliot's book of poems *Triumphal March*, published in 1931. Bacon admired Eliot and might well have seen Kauffer's jacket in advance. In a further connection, Valerie Eliot, T.S. Eliot's wife, later purchased Bacon's *Watercolour* of 1929 shown in the 1930 Queensberry Mews exhibition. She may well have known of an early connection between Eliot, Kauffer, and Bacon.

135 "It was only after": Amédée Ozenfant, *Foundations of Modern Art*, trans. by John Rodker (New York: Dover Publications, 1952), 64.

135 Ozenfant gave credit to Dada: Ibid., 117.

135 "The turn of thought of the Surrealists": Ibid., 23.

135 "At certain of my lectures": Ibid., 212.

135 Not only did art: Ibid., 287.

136 Ozenfant's book contained: Ibid., 154.

136 He would say that "observing": Bacon, interviewed for Pierre Koralnik, director, *Francis Bacon,* Radio Television Suisse Romande, Geneva, 1964.

136 "It is somewhat surprising": Ozenfant, *Foundations of Modern Art*, 53—55. Ozenfant may well have been the very first to pique Bacon's interest in Rodin.

136 The novelist Patrick White, who came to know: White, *Flaws in the Glass*, 63.

136 John Rothenstein, the director: John Rothenstein, *Time's Thievish Progress* (London: Cassell, 1970), 93—5. This is the third volume of Rothenstein's autobiography.

136 To enter his studio at 13 Ecclestone Street: White, *Flaws in the Glass*, 63.

137 To Rothenstein, the "theater": Rothenstein, *Time's Thievish Progress*, 93—5.

137 "Roy's studio was a work": Ibid.

137 "Friends reported dinner parties": Johnson, *Roy de Maistre: The English Years*, 16.

137 De Maistre's friend Geoffrey Houghton Brown: Ibid. See also James Lees-Milne, "Obituary: Geoffrey Houghton Brown," www.independent.co.uk.

138 De Maistre's friends and patrons: "De Maistre's most beneficent patrons were Rab Butler and his first wife Sydney Courtauld/Butler," wrote Heather Johnson in *Roy de Maistre: The English Years*, 39. "The Butlers met de Maistre in Australia in 1927 while on a honeymoon world tour following their marriage in 1926. De Maistre renewed his friendship with them as soon as he arrived in London and this spread to the extended Butler/Courtauld family."

138 "I believe his faith": White, *Flaws in the Glass*, 63.

138 In the early 1930s, de Maistre became: For more on Mitrinovic, see the New Atlantis Foundation Dimitrije Mitrinovic archive: archiveshub.jisc.ac.uk.

138 "There is no record": Johnson, *Roy de Maistre: The English Years*, 77.

139 Bacon later said: Ibid., Johnson interview with Francis Bacon, 1988, cited in endnotes.

139 When de Maistre was asked: Ibid., Johnson interview with Ronald Alley, 1988, cited in endnotes. At one point de Maistre did tell his great friend John Rothenstein, however, that he was shocked that Bacon "knew nothing whatsoever about the technical side of painting and had scarcely drawn at all." See John Rothenstein, *Modern English Painters. Volume Three: Hennell to Hockney* (London: Macdonald & Co., 1984), 152.

139 Thirty years later: Terry Danziger Miles, interview for Adam Low, director, *Francis Bacon, Arena.*

139 "Each of its huge issues": Geoffrey Grigson, quoted in Nigel Vaux Halliday, *More Than a Bookshop: Zwemmer's and Art in the 20th Century* (London: Philip Wilson Publishers, 1991), 46.

139 Picasso's Dinard series: Johnson, *Roy de Maistre: The English Years,* 19—21.

139 Bacon himself emphasized: Bacon, quoted in Jean Clair, "Pathos and Death: Interview with Francis Bacon by Jean Clair," *Le Monde,* May 2, 1992. The interview appeared in English in the exhibition catalog for *The Body on the Cross* at the Musée Picasso in Paris, 1992.

140 The figures in the Dinard series: Michael Peppiatt, "Francis Bacon: Reality Conveyed by a Lie," *Art International* (Fall 1987), 30.

140 He and de Maistre would have: Bacon was in Paris at the time of the show. See Harrison, ed., "Diana Watson's Diary," 80.

140 In 1932, de Maistre asked: It was suggested, in the catalog of the Australian exhibition *Francis Bacon: Five Decades* (Art Gallery, New South Wales, 2012) that de Maistre's paintings of Bacon's studio in 1932 and 1933 following the well-known ones of his 17 Queensberry Mews space were not of Bacon's studio at all, but of de Mestre's. (See catalog endnotes, 222). But the painting of 1932 titled *Francis Bacon's Studio* was displayed at the Tate at the time of Bacon's first retrospective there in 1962. (See "Roy de Maistre, Important Australian Art, 24 November 2008," www.sothebys.com.) It is unlikely that either Bacon or de Maistre would have allowed the painting to be displayed with that title had it not been of his actual studio. It is also unlikely that de Maistre was painting a picture of his own studio in 1932 and 1933, as he only returned to live in London full-time in the fall of 1933. In the autumn of 1933, Eric Allden noted in his diaries that de Maistre, newly back from extended stays in France, was intending to settle at 21 Moor Street: "He uses his room as a studio," Allden wrote. It was only in April 1934 that de Maistre finally settled into more permanent space. Allden visited him at 104 Ebury Street and wrote that de Maistre "has got quite an attractive studio there." De Maistre's final, and best-known, studio was at 13 Eccleston Street.

142 The painting was titled *New Atlantis*: The second painting that de Maistre made of the space, *New Atlantis* of c. 1933, has exactly the same distinctive physical features as in the earlier painting: it is demonstrably the same space. What's more, one of the central features of this *New Atlantis* painting (and of a subsequent one of the same space) is the large round mirror that Bacon designed, and that followed him all the way to his Reece Mews studio almost three decades later.

9 EARLY SUCCESS

143 The Tate Gallery did not purchase: www.tate.org.uk. As the Tate's own gallery label of the painting noted, "This surprising flower painting by Picasso reveals a lot about the tastes of the Tate Gallery Trustees in the early twentieth century. In 1933 Picasso was already an established avant-garde artist, but the decision to buy this conservative early work shows that the Trustees were resisting the more radical developments in modern art."

143 Kenneth Clark, the art historian: Clark, quoted in Nigel Vaux Halliday, *More Than a Bookshop: Zwemmer's and Art in the 20th Century* (London: Philip Wilson Publishers, 1991), 11.

143 "About very modern": Sydney Courtauld, letter to Rab Butler, November 26, 1925. Butler archive, Trinity College, Cambridge.

144 Located at 78 Charing Cross Road: Halliday, *More Than a Bookshop*, 12.

144 The aging wooden shelves: Ibid., 10.

144 T. S. Eliot located: Ibid., 101.

144 Clark, who had become director: Ibid., 84–5.

144 Zwemmer himself usually had: Ibid., 52.

144 Clark later recalled: Ibid., 11.

144 When Zwemmer went to Paris: Ibid., 12.

144 At first, he intended: Heather Johnson, *Roy de Maistre: The English Years* (Roseville East, New South Wales: Craftsman House), 1995, 64.

145 The son of: Ibid., 89.

145 "Robert Wellington's meticulously": Ibid., 64.

145 In 1933: Ibid.

145 The two almost immediately: Ibid.

145 In 1932, the year: Halliday, *More Than a Bookshop*. Ibid.

145 He mounted the first: Ibid., 101–2. For more on Hamnett, see "Nine Hamnett," www.npg.org.uk.

145 Art met the martini glass: Halliday, *More Than a Bookshop*, 101–2.

145 Like Wellington, he was exceptionally: John Richardson, interview with the authors, June 28, 2012.

145 "He was the most charming man": Lindy Guinness, Marchioness of Dufferin and Ava, interview with Annalyn Swan, March 18, 2013.

146 "He knew all these young peers": Richardson, interview with the authors, June 28, 2012.

146 When that gallery folded: Information on Mayor's career in the 1920s comes from James Mayor, interview with Annalyn Swan, March 12, 2013.

146 The most significant: The following biographical information on Cooper comes from John Richardson, *The Sorcerer's Apprentice: Picasso, Provence and Douglas Cooper* (Chicago: University of Chicago Press, 2001), 19–32.

146 Cooper had studied at the Sorbonne: Ibid.

146 He had already begun: Information on Cooper's art collection comes from Richardson, interview with the authors.

146 Mayor, raised in France: "Classics," *The Daily Express*, February 21, 1933, Mayor Gallery archive.

147 *The Daily Express* dubbed: Ibid.

147 Mayor and Cooper selected: Not surprisingly, O'Rorke was included in Madge Garland's *The Indecisive Decade: The World of Fashion and Entertainment in the Thirties.* (London: Macdonald, 1968), 61–3. Arundell Clarke may also have helped design the gallery space. Martin Harrison, ed., *Francis Bacon Catalogue Raisonné,* vol. I (London: The Estate of Francis Bacon, 2016), 80.

147 *The Daily Mail*: "The Vermilion Lure," *The Daily Mail*, April 13, 1933.

147 The *Daily Mail*'s critic: P. G. Konody, "Gayest Art Show: Last Word in Modernism Presents a Puzzle," *The Daily Mail*, April 20, 1933.

147 The inaugural exhibit: Exhibition catalog, Mayor Gallery archive, London.

147 Hanging beside: Ibid.

147 Affixed to the Hillier: "Too, Too Symbolic," *Daily Sketch*, April 20, 1933.

147 Not only was Bacon: Tristram Hillier, born in 1905, was the only other artist under the age of thirty included in the inaugural show.

147 Personal connections: James Mayor confirmed his father's close friendship with Roy de Maistre. Mayor, interview with Swan. De Maistre was also given his own one-man show at the Mayor Gallery in 1934. (Heather Johnson, *Roy de Maistre: The English Years* (Roseville East, New South Wales: Craftsman House, 1995) 70–1.

147 The most important link: Cooper had a large number of "country cousins" on his mother's side. Richardson, interview with the authors.

148 Cooper even commissioned: Ibid.

148 In the summer of 1932: Eric Allden mentioned, in a diary entry of May 23, 1939, that Bacon and Cooper had been in Paris together at one point in the 1930s, and that Cooper had introduced Bacon there to the painter Pavel Tchelitchew. Estate of Francis Bacon archive.

148 Bacon "wanted success very badly": Martin Harrison, "Diana Watson's Diary," in *Inside Francis Bacon*, Francis Bacon Studies III (London: The Estate of Francis Bacon Publishing, in association with Thames & Hudson, 2020), 78.

148 (In 1931, Diana observed): Harrison, "Diana Watson's Diary," 80.

148 The critic for *The Times*: "Art Exhibitions, The Mayor Gallery," *The Times*, April 22, 1933. Mayor Gallery archives.

148 But Mayor was: Edward Crankshaw, "Art, Recent Paintings by English, French and German Artists at the Mayor Gallery, Ltd., 18, Cork Street, W.1." *Week End Review*, April 29, 1933. Mayor Gallery archive.

148 *Time and Tide* reported: G. Raverat, *Time and Tide*, May 6, 1933.

148 *The Observer* thought: P. G. Konody, April 23, 1933.

148 *Harper's Bazaar* described: June, 1933. Mayor Gallery archive.

149 Bacon was also attracted to: In her diary, Watson mentions that Bacon gave her a book on Bonnard. (In later years Bacon would also mention Bonnard with admiration.) See Harrison, "Watson's Diary," 75.

149 So was de Maistre: *Figure by Bath* is reproduced in Johnson, *Roy de Maistre: The English Years.*

149 The two artists possessed: Adrian Mibus, a London art dealer, wrote that Bacon and de Maistre shared a long-necked stuffed creature whose likeness would show up in the paintings of each. Mibus, letter of March 14, 1984 to

Daniel Thomas at the National Gallery of Australia, Canberra, cited in Johnson, Ibid, 22–4.

149 Bacon in 1934 also made: Anne Baldassari, *Bacon, Picasso: The Life of Images* (Paris: Flammarion, 2005), 96.

149 Bacon studied them: Baldassari, *Bacon, Picasso*, 148.

149 This one, the so-called: As Baldassari points out, not only Bacon but de Maistre was inspired by Matthias Grünewald's *Crucifixion*. Ibid., 134.

149 Six different Picasso drawings: Ibid.

149 Later that year: Eric Allden, diary, December 10, 1933.

149 He owned a book called: Harrison, "Watson's Diary," 73.

150 Following "Recent Paintings": Mayor Gallery archive.

150 An energetic young man: Information on Read's early life can be found at "Sir Herbert Read," library.leeds.ac.uk.

150 Read was phenomenally prolific: Heather Johnson, *Roy de Maistre*, 68–70.

150 In the foreword he wrote: Herbert Read, *Art Now: an introduction to the theory of modern painting and sculpture* (London: Faber and Faber, 1933). A copy of the original 1933 edition is in the Mayor Gallery archives.

151 Read made a remarkable: John Richardson wrote, in *The Sorceror's Apprentice*, that it was Douglas Cooper, more than Herbert Read himself, who argued for Bacon's early *Crucifixion* to be included in the show and reproduced in *Art Now*. *Sorceror*, 14.

151 The *Art Now* show opened: The information on the show comes from the Mayor Gallery archive.

151 Read's book was: See Herbert Read, *Art Now: An Introduction to the Theory of Modern Painting and Sculpture* (London: Faber & Faber, 1933).

151 "London's Strangest Art Show": "By our Art Critic," "London's Strangest Art Show," *The News Chronicle*, Oct. 21, 1933.

151 The critic of *The Sunday Times*: Frank Rutter, "Gangster Art: A Hold-up in Cork Street," *Sunday Times*, Oct. 15, 1933.

151 Geoffrey Grigson wrote in *The Bookman*: Geoffrey Grigson, "Henry Moore and Ben Nicholson," *The Bookman*, November 4, 1933.

152 "Lunched at the Carlton and afterwards": Eric Allden, diary, October 25, 1933. In the catalog of the "Art Now" show, Bacon's painting was titled *Composition*, not *Crucifixion*. The titles of Bacon's early paintings were often changed, some multiple times.

152 The small reproduction: Richardson, *The Sorceror's Apprentice* (Chicago: University of Chicago Press, 2001), 14.

152 "On the way home": Ibid, 11–12.

152 And then: Sir Michael Sadler: John Russell, *Francis Bacon* (New York: Thames and Hudson, 1985), 17.

152 From 1911 to 1923: See Sir Michael Sadler, library.leeds.ac.uk.

152 At the time of the Mayor Gallery: Ibid.

153 Writing in *The Spectator*: John Piper, quoted in Tracey Hebron, "Sir Michael Sadler," *Memories of Barnsley*, Winter, 2015, traceyhebron.co.uk.

153 "I've discovered a new painter": Kenneth Clark: Clark, *Another Part of the Wood: A Self-Portrait* (London: HarperCollins, 1975), 200, 201.

153 Eric Allden noted in his diary: Diary entry, Oct. 19, 1933.

153 On November 28, five weeks after: Ibid.

154 "For Bacon to engage": John Russell, *Francis Bacon* (London: Thames and Hudson, 1993), 17.

154 Or perhaps Bacon dropped: The Mayor Gallery continued to promote the other artists who had exhibited with Bacon, including Roy de Maistre. Mayor Gallery archive. Also see Heather Johnson, *Roy de Maistre: The English Years*, 67-72. Another artist who benefited from the Mayor Gallery's interest—and Douglas Cooper's in particular—was Graham Sutherland, who met Cooper around 1936–37. In the next few years the gallery would sell some dozen of his watercolors and gouaches. See Roger Berthoud, *Graham Sutherland, A Biography* (London: Faber and Faber, 1982), 85. Interestingly, de Maistre was also dropped, over time, by the Mayor Gallery, and Patrick White named Cooper as his nemesis. De Maistre was a close friend of John Weyman, a one-time boyfriend of Cooper's, which triggered intense jealousy in Cooper—a "lot of hate," in White's words. De Maistre's ongoing friendship with Bacon might have been a factor as well. See Johnson, *de Maistre*, 72–4.

154 He began to refer: Richardson recalled the nickname "the alderman." John Richardson, interview with the authors, June 28, 2012.

154 In April of 1934: Eric Allden stopped by the gallery on April 7. Allden diary, April 8, 1934.

154 "He was an absolute": Mayor, interview with Swan.

155 The feud with Bacon: Bacon reciprocated. Decades later, he refused to have anything to do with Cooper. Once, Cooper's literary heir asked to interview Bacon about Cooper. Valerie Beston, Bacon's longtime "minder" at the Marlborough Gallery, wrote a note that said, "FB does not want to reply. Hasn't spoken to [Cooper] for 30 years." Marlborough Gallery archive.

155 Later in 1934: Allden diary, July 29, 1934. Cooper's treatment of Bacon's desk was recalled by Richardson, interview with Mark Stevens, Mar. 3, 2008.

155 After he moved: Richardson, interview with the authors, June 28, 2012.

155 He spread it around: Richardson, *The Sorceror's Apprentice*, 14.

155 To outsiders: Ibid.

155 But to his homosexual friends: Ibid.

155 Located on Curzon Street: Sunderland House was described in admiring detail in American newspaper accounts of rich Americans abroad. See "Duke and Duchess of Marlborough the First to Build a Palace on the Thoroughfare and Americans Follow," *The San Francisco Call*, July 10, 1904.

155 In December of 1930: "Trade Gets New Mansion," *The New York Times*, December 8, 1930. 7.

155 Arundell Clarke, a close friend: Madge Garland, *The Indecisive Decade: The World of Fashion and Entertainment in the Thirties* (London: Macdonald, 1968), 23–5.

156 Bacon and Hall: Allden diary, February 22, 1934.

156 He was torn between: Harrison, "Watson's Diary," 72.

156 Money was no object: Ibid., 71.

156 He included seven large: Martin Harrison, ed., *Francis Bacon: Catalogue Raisonné* (London: Estate of Francis Bacon, 2016), vol. I, 80.

156 Diana Watson immediately: Ronald Alley, ed., John Rothenstein, introduction, *Francis Bacon: Catalogue Raisonné* (London: Thames and Hudson, 1964); see also the second catalogue raisonné.

156 One was *Composition (Figure)*: Allden, diary entry dated July 1, 1934.

156 John Russell later wrote: Russell, *Francis Bacon*, 17.

156 The exhibit seemed to Diana Watson: Harrison, "Watson's Diary," 71–2.

156 Like many people: Ibid., 71.

156 A friend, probably Allden: Ibid., 72.

157 He said, "I may never: Ibid.

157 The exhibit opened: Allden, diary entry, Feb. 22, 1934.

10 EARLY FAILURE

158 No one came: Martin Harrison, "Diana Watson's Diary," in *Inside Francis Bacon*, Francis Bacon Studies III (London: The Estate of Francis Bacon publishing, in association with Thames & Hudson, 2020), 72.

158 The *Daily Mail*: Martin Harrison, ed.; *Francis Bacon Catalogue Raisonné*, vol. 2, 80.

158 *The Times* began: "Mr. Francis Bacon," *The Times*, February 16, 1934. Marlborough Gallery archive.

158 "Does it, as a matter of cold fact": Ibid.

158 A week after the opening: Eric Allden, diary entry, February 22, 1934. The Estate of Francis Bacon archive.

158 Skeaping was a well-established: "John Skeaping," www.sculpture.gla.ac.uk.

158 Allden reported: Eric Allden, diary entry, February 22, 1934. The Estate of Francis Bacon archive.

158 Allden could not get accustomed: Ibid.

158 Eventually, Allden asked: Ibid, July 1, 1934.

159 "I cannot wait till": Ibid.

159 Once, during the course: Harrison, "Watson's Diary," 71.

159 After the show closed: Ibid.

159 He regretted its loss: John Russell, John Russell, *Francis Bacon* (London: Thames and Hudson, 1985), 17.

159 Diana reported "flaming forms": Harrison, "Watson's Diary," 72.

159 She did not immediately: Ibid.

159 He was now taking: Ibid., 78.

159 His relationship with Eric: Ibid., 77.

159 Bacon mentioned to Diana: Ibid., 77.

160 And in late 1932 or early 1933: John MacDermot, quoted in Anthony Bond, ed., *Francis Bacon: Five Decades*, exhibition catalog (Sydney: Art Gallery of New South Wales, 2000), 35.

160 The Butlers were redecorating: Papers of Richard Austen Butler, Trinity College, Cambridge: RAB.

160 A friend wrote Sydney a letter: Letter of Doreen, Lady Brabourne, to Sydney Courtauld Butler, July, 8, 1934. Ibid.

160 The writer—probably Madge Garland: There is no identification of the publication or writer on the article that Bacon sent his mother. But it depicts the Butlers' dining room as described by Patrick White, who later bought the furniture. Bacon designed an impressively large glass table for the Butlers with a heavy top that rested on a base of two parallel chrome bars and legs. But the chrome base was off-center, giving to the table the effect of floating glass. Instead of chairs, Bacon's dining room featured the same laminated, backless stools that he had shown in his Queensberry Mews showroom. They were, in turn, close in design to ones produced by Eileen Gray. See Bond, ed., *Francis Bacon: Five Decades*, 36. Ianthe Knott kindly provided the article.

160 In the autumn of 1934: Bacon's desire to leave London and move to Berlin indefinitely was probably precipitated by the knowledge that he would have to leave his studio at 71 Hospital Road, a studio he was unlikely to give up by choice. Diana recorded that he moved out of the studio in late October and departed for Berlin in early November 1934. Payment of rates for 71 Royal Hospital Road remained in Arundell Clarke's deceased father's name through 1935. No doubt his son kept paying the rates in the building after his father's death: the family may well have had a long lease on it. But as Clarke's focus turned toward New York, he no longer needed the property and probably turned over the property to someone else at the beginning of 1935.

161 Bacon now sometimes spoke: Harrison, "Watson's Diary," 78.

161 As early as December, 1933: Ibid., 81.

161 In the spring of 1934: Ibid., 82.

161 (It would be awful): Ibid., 81.

161 "Amid the clatter of Hitlerism: Ibid.

161 At the end of October, 1934: Ibid., 82.

161 He planned to stay: Ibid., 82.

162 It was not long, however: Ibid., 78. Watson has an entry from 1934, in which a month is not listed, that reports: "He's decided to settle in London again and look for a flat." If Bacon left for Berlin in early November, Watson's entry date of 1934 suggests that he was back by the turn of the new year in 1935 unless there was an extended and unreported trip from earlier in 1934. By March of 1935, Bacon was moving from room to room without a long-term address.

162 In March of 1935: *Francis Bacon Catalogue Raisonné*, vol. I, 80–1.

162 She was sometimes "in a temper": Harrison, "Watson's Diary," 81.

162 Such a life: Ibid., 78.

162 Now, reported Diana: Ibid.

162 It was during 1935: Sophie Pretorius, "A Pathological Painter: Francis Bacon and the control of suffering," in *Inside Francis Bacon*, Francis Bacon Studies III (London: The Estate of Francis Bacon publishing, in association with Thames & Hudson, 2020), 165.

162 She had first known him: Harrison, "Watson's Diary," 76.

162 Then, when he determined: Ibid.

162 "I had become convinced: Ibid., 81.

163 She possessed a photograph: Ibid., 79.

163 By 1935, Bacon was telling: Ibid., 78.

163 No doubt Francis regaled her: Ibid., 79.

163 He said something revealing: Ibid., 77.

163 During the 1930s: Michael Peppiatt, *Francis Bacon: Anatomy of an Enigma* (London: Constable and Robinson, 2008), 30.

164 The year before, after returning from Berlin: Harrison, "Watson's Diary," 78.

164 Earlier in the decade: The Hall family moved from Ormonde Gate to 4, Tennyson Mansions, in 1931, a short walk from Ormonde Gate.

164 It was probably late in 1935: Diana Watson reported Bacon hard at work in a studio at that time of year. Harrison, ed., "Watson's Diary," 74.

164 The building was on: Mollie Craven, quoted in Daniel Farson, *The Gilded Gutter Life of Francis Bacon* (New York: Pantheon Books, 1993), 37. Craven lived below Bacon at 1 Glebe Place.

164 Hall probably arranged: Ibid. Mollie Craven recalled taking weekly rent to Bacon. Research by James Norton indicated that the London rate books of 1936 list Bacon's name at 1 Glebe Place, which suggested that he was more than a tenant passing through. In the 1950s, while he was in Tangier, he wrote to Denis Wirth-Miller that he was being sued over Glebe Place, an indication that he held a lease of at least twenty years. "I am being sued for dilapidations for about 1200 pounds for the home I had in Chelsea and assigned the lease to a house agent like a fool I didn't go to a solicitor and I have been taken for a big ride as he has been screwing the rents from the house for 11 years and now refuses to pay the dilapidation and the landlords have

the right to come down on me," he wrote. Bacon, undated [1957] letter to Wirth-Miller from Tangier, quoted in Jon Lys Turner, *The Visitor's Book: In Francis Bacon's Shadow: The Lives of Richard Chopping and Denis Wirth-Miller* (London: Constable, 2016), 185.

164 Offered the chance to lease: Harrison, "Watson's Diary," 82.

165 Diana said Francis lived: Ibid., 78.

165 In early October 1935: Ibid., 74.

165 Francis was interested in the idea: Ibid., 73, 74.

165 He imagined a party: Ibid., 74.

165 He even quoted Nietzsche: Ibid.

165 Mollie saw many "river-and-leaves": Craven, in Farson, *The Gilded Gutter*. 38–9.

165 Craven also vividly remembered: Ibid., 38.

165 In 1925, at the suggestion: Johnson, *Roy de Maistre: The English Years*, 65. For Roger Fry's pivotal role, see: London-artists-association, www.artbiogs.co.uk/2/societies.

166 In 1934, Roy de Maistre: Much of the information on the collective and the artists chosen to participate comes from Johnson, ibid., 64-67, unless otherwise noted. See also Roger Berthoud, *Graham Sutherland, a biography* (London: Faber and Faber, 1982), 84–6.

166 The organizers kept detailed records: Johnson, *Roy de Maistre*, 64-67.

166 In the end, money was difficult: Johnson, *Roy de Maistre*, 67, and Berthoud, *Graham Sutherland*, 86.

166 Important surrealist shows: John Russell, "In 1936 Surrealism Ruled the Creative Roost," *The New York Times*, March 30, 1986, 25.

166 The idea for a London show: Berthoud, *Sutherland*, 83.

166 According to Penrose, Gascoyne: Sir Roland Penrose, interview with Roger Berthoud, July, 1980, quoted in Berthoud, *Sutherland*, 83.

167 Eventually, they selected about four hundred works: The final number was around 390, according to the *International Surrealist Bulletin*, no. 4. The original catalog listed 392.

167 Picasso (the surrealist flirt): Berthoud, *Sutherland*, 83.

167 Breton wrote the preface: Ibid. For more on Herbert Read's introduction, see Hugh Davies, *Francis Bacon: The Early and Middle Years 1928–1958* (New York and London: Garland Publishing, 1978), 32.

167 On opening day: The Surrealist Exhibition, www.luxonline.org.uk/histories/1900-1949.

167 Dalí gave a talk: London International Surrealists Exhibition, www.historytoday.com/archive/months-past.

167 Penrose found his work: Penrose, quoted from an interview conducted in March 29, 1973, by Hugh Davies. Bacon spoke quite bitterly about his exclusion in later years. See Davies, *Francis Bacon: The Early and Middle Years*, 32, 33.

168 But Penrose also saw: Penrose probably saw *Abstraction from the Human Form*.

168 He may also have seen: *Abstraction*, in ibid.,140.

168 Penrose later explained: Davies, *Francis Bacon*, 32, 176fn.

168 Bacon informed friends: Craven, quoted in Farson, *The Gilded Gutter Life*, 38.

168 At a time when: Ronald Blythe, *The Age of Illusion: England in the Twenties and Thirties* (Boston: Houghton Mifflin Company, 1964), 160.

168 One was to the art dealer: Ivan Hall confirmed his father's friendship with Geoffrey Agnew. Ivan Hall described Agnew's as a "gentlemanly business which tried to treat artists in the best possible way." Heather Johnson, *Roy de Maistre: The English Years*, 100.

168 Located on Old Bond Street: See "History," www.agnewsgallery.com.

168 Agnew's occasionally organized: Johnson, *Roy de Maistre: The English Years*, 97–8.

168 All expenses: Ibid.

168 The distinguished lineup: Richard Kingzett, "An Exhibition That Failed," *The Burlington Magazine*, August 1992, 499–502.

168 Hall also brought in: Johnson, *Roy de Maistre: The English Years*, 98.

169 Of the eleven artists included: Ibid., 65–7.

169 On the favorable side: Unsigned articles in *The New English Review* and the *Jewish Chronicle*; L.B.P., "Encouraging Artists, Helpful Movement in London, Present-day Dangers," *Birmingham Mail*, January 13, 1937. All of the newspaper articles are taken from the Mayor Gallery archive.

169 Under the headline "Nonsense Art": Pierre Jeannerat, *The Daily Mail*.

169 Far more damaging than: Frank Rutter, "A New Idiom? Abstraction at Agnew's," *The Sunday Times*, January 17, 1937. In his *Daily Telegraph* article of January 14, 1937—"A New Group of Painters, Pictures by Young British Artists"—T. W. Earp was more positive about many of the painters. But the abstract painters, including Bacon, came in for criticism: "But the other exhibitors in the abstract section either feebly adapt one or other of Picasso's phases, or are content to evolve an uninspired monotony of squares and circles."

170 On the invitation itself, Hall had written: Kingzett, "An Exhibition that Failed," *The Burlington Magazine*.

170 So vexing did Hall: Eric Hall, "A New Idiom in Painting," letter to *The Sunday Times*, January 24, 1937. Sent from The Bath Club, Hall's club.

170 It was purchased by Diana: Bacon, quoted in Harrison, ed., *Francis Bacon Catalogue Raisonné*, vol. 2, 136.

171 At one point: Ibid.

171 The caption under an illustration: "The title of these three pictures, reading from left to right, are 'Abstraction from the Human Form,' 'Abstraction' and 'The Sculptor.' But, as this is Nonsense art, you might just as well read from

the right to left. Prices are from 12 to 45 guineas. That's more nonsense." *The Referee*, January 17, 1937.

171 Only two of the thirty-five: Johnson, *Roy de Maistre: The English Years*, 102.

171 The buyer of the de Maistre: Ibid.

171 At the private view: Harrison, "Watson's Diary," 75.

171 Hall himself was not demonstative: Ibid., 78.

172 Hall's weakness for gambling: Eric Allden and Roy de Maistre both commented on how worried they were that Hall was leading Bacon astray with gambling. Allden diary, April 8, 1934.

172 One time in the mid-to-late 1930s: Michael Peppiatt, *Francis Bacon: Anatomy of an Enigma* (London: Constable and Robinson, 2008), 101.

172 Throughout the 1930s and well into: Research into Eric Hall's background by James Norton, including written records of Eric Hall's many positions on the London County Council. For the Justice of the Peace title, also see David Sylvester, *Looking Back at Francis Bacon* (New York: Thames and Hudson, 2000), 254.

172 Bacon even hosted: See Heather Johnson, *Roy de Maistre: The English Years* (Roseville East, New South Wales: Craftsman House, 1995), 28–9.

173 As a child: Caroline de Mestre Walker, interview with Annalyn Swan, October 18, 2013.

173 Most members: Ibid.

173 "Eric Hall was fashionable": Ianthe Knott, interviews with Mark Stevens, March 5 and 6, 2008.

173 "I remember de Valera": Knott, interview with Stevens.

173 The deed for Straffan Lodge: Information on the house deeds comes from Marcus Beresford, 7th Baron Decies, a subsequent owner of Straffen Lodge. Email to Annalyn Swan, July 29, 2011.

173 Granny Supple had placed: Ibid.

173 Granny also left: Ibid.

174 "A friend of my mother's": Knott, interview with Stevens.

174 "When we went back": Ibid.

174 The Old Rectory, later placed: See The Old Rectory A Grade 11 Listed Building in Bardford Peverall, Dorset, britishlistedbuildings.co.uk.

174 "He was very, very keen": Knott, interview with Stevens.

174 Bacon's mother regularly sent: Mollie Craven recalled the "constant deliveries of fruit and game," at 1 Glebe Place. Farson, *The Gilded Gutter Life,* 37.

174 On December 10, 1933: Allden diary, December 10, 1933.

174 Ianthe believed the Major: Knott, interview with Stevens.

174 Ianthe remembered tramping: Ibid.

174 "We came up": Ibid.

175 The table was sloppy: Mollie Craven, Farson, *The Gilded Gutter Life*, 39.

175 "It didn't look very comfortable": Knott interview with Stevens. The following quotations come from this interview.

175 "Mrs. Bacon drove us": Allden diary, April 1936.

175 Bacon chafed: Farson, *The Gilded Gutter Life*, 20.

175 Their mother: Knott, interview for *Francis Bacon*, *Arena* documentary.

175 Bacon later claimed: Mollie Craven recalled that "he seemed to be working all the time." Farson, *The Gilded Gutter Life*, 37.

175 And Eric Allden recorded: Allden diary, May 23, 1939.

175 Once, when Bacon was ill: Farson, *The Gilded Gutter Life*, 39.

11 BREAKDOWNS

176 "Roy's relationships with either sex": Patrick White, *Flaws in the Glass: A Self-Portrait* (New York: The Viking Press, 1981), 63.

176 To White's regret: Two different versions exist of de Maistre's and White's early relationship. In his memoir, *Flaws in the Glass*, White wrote that he and de Maistre, after the "initial skirmishes," never had an affair. But in David Marr's biography, Marr wrote that they briefly had a physical relationship and quotes White as saying, "[De Maistre] himself was trying to recover from something unhappy, but said that in any case an intimate relationship of ours wouldn't have worked because he was twenty years older. It wouldn't have worked either. We were both too irritable and unyielding." Marr, *Patrick White: A Life* (New York: Vintage, 1991).

176 De Maistre had not yet recovered: His affair with Robert Wellington had ended in the early autumn of 1935, not long after White arrived in London from Cambridge. Heather Johnson, *Roy de Maistre: The English Years* (Roseville East, New South Wales: Craftsman House, 1995), 67.

176 But a "fruitful, lasting": White, *Flaws iin the Glass*, 63.

176 Not long after they met: White's inheritance has been reported at 10,000 pounds. See "Patrick White," nobel prize.org.

176 White came from a background: Ibid. All of the early biographical detail and quotations from White in the following pages comes from White, *Flaws in the Glass*, 57–63.

177 Douglas Cooper, said White: Ibid.

177 White "did not dare": Ibid.

177 Bacon "opened my eyes": Ibid.

177 "I like to remember": Ibid.

177 White, like some critics of the times: Marr, *Patrick White*, 169.

178 Calling it "the best desk": Patrick White, letter to

James Soby, July 3, 1962, written from "Dogwoods," Coach Hill, New South Wales, Australia. Museum of Modern Art, New York archive, Soby papers, JTS, 1.21. All of the information on the furniture comes from this letter.

178 "In his dedication to painting": White, *Flaws in the Glass*, 63.

178 Among intellectuals, by mid-decade: Ronald Blythe, *The Age of Illusion: England in the Twenties and Thirties* (Boston: Houghton Mifflin Company, 1964), 109.

178 The Spanish Civil War particularly: Stephen Spender, *World Within World: The Autobiography of Stephen Spender* (New York: The Modern Library, 2001), 370–9.

178 White found Spender: White, *Flaws in the Glass*, 63.

178 Spender later wrote: Spender, *World Within World*, 370–9.

179 In April 1937: See "Guernica: Testimony of War," www.pbs.org/treasuresoftheworld.

179 The completed painting—a powerful piece: Gijs van Hensbergen, *Guernica: The Biography of a Twentieth-century Icon* (London: Bloomsbury, 2004), 63.

179 The German-language guide: Ibid., 72.

179 *Guernica* arrived in London: Johnson, *Roy de Maistre: The English Years*, 113.

179 The principal organizer: Beech and Stephens, eds., *Picasso and Modern British Art*, 162–3.

179 Two years before: Herbert Read, "The Triumph of Picasso," *The Listener* XV, no. 385 (May 27, 1936).

179 Not surprisingly: Nigel Vaux Halliday, *More Than a Bookshop: Zwemmer's and Art in the 20th Century* (London: Philip Wilson Publishers, 1991), 135.

179 It was the second showing: Jan Hensbergen, *Guernica*, 95.

180 The painting created: Helen Little, "Picasso in Britain 1937–1939," in Beech and Stephens, eds., *Picasso and Modern British Art*, 162–3.

180 It was "a reminder": van Hensbergen, *Guernica*, 106.

180 Bacon would later become: Bacon, in David Sylvester, *Looking Back at Francis Bacon* (New York: Thames and Hudson, 2000), 244.

180 Twenty minutes later: Leonard Mosley, *Backs to the Wall: London Under Fire 1939–45* (London: Weidenfeld & Nicolson, 1971), 17.

181 By order of the National Service: "Conscription: The Second World War," www.parliament.uk.

181 Eric Hall, as an alderman: Eric Hall's official title was Acting Superintendent of the ARP (Air Raid Precautions) Depot, Chelsea. He was also a member of the British Red Cross Service. Martin Harrison, ed., *Francis Bacon Catalogue Raisonné* vol. I (London: Estate of Francis Bacon, 2016), 81. Hall's wife, Barbara, who was a nurse, also played an important role in the Red Cross. Margaret Fenton, interview with Annalyn Swan, July 5, 2011.

181 To ensure that the officials: Bacon's sleeping with a German shepherd dog the night before his physical is a well and often-told tale about Bacon. See Michael Peppiatt, *Anatomy of an Enigma* (London: Constable and Robinson, 2008), 101.

181 Bacon served honorably: Bacon in Sylvester, *Interviews with Francis Bacon*, 188.

181 Bacon never indicated: John Minton was a declared pacifist—see Frances Spalding, *John Minton: Dance Till the Stars Come Down* (Aldershot, Hants UK: Hodder and Stoughton, 1991), 48. He later joined the Pioneer Corps. Keith Vaughan was another conscientious objector; he later joined the St. John Ambulance service. Alan Ross, introduction, in Keith Vaughan, *Journals 1939–1977* (London: John Murray, 1989).

181 Or he might have applied: Roger Berthoud, Graham Sutherland (London: Faber and Faber, 1982), 95.

181 Graham Sutherland and Henry Moore: Ibid., 100.

181 He first served: Bacon was listed in the National Register in September of 1939 as an artist living at 1 Glebe Place and "serving in the Red Cross." Harrison, ed., *Francis Bacon Catalogue Raisonné* vol. I, 81.

182 On September 8, 1939: Eric Allden diary, September 8, 1939.

182 That Bacon was working: Conscription began with twenty- to twenty-three-year-olds and went up from there. Bacon, almost thirty, would most probably have been in a third wave of the draft, or even later. As the BBC noted, "Men aged 20 to 23 were required to register by 21 October 1939—the start of a long and drawn-out process of registration by age group." "World War Two," www.bbc.co.uk.

182 On their heads: "Steel Helmet, MKII: British Army," iwm.org.uk.

182 Stephen Spender was a fireman: Lara Feigel, *The Love-charm of Bombs: Restless Lives in the Second World War* (London: Bloomsbury Publishing, 2013), 7. For Sonia Orwell's war experiences, see Hilary Spurling, *The Girl from the Fiction Department: A Portrait of Sonia Orwell* (Berkeley: Counterpoint Press, 2004), 42–7.

182 Diana Watson joined: Allden diary, January 7, 1942.

182 Roy de Maistre served: Ibid., January 13, 1943.

182 Early on: Mosley, *Backs to the Wall*, 15.

182 "Rents had dropped": Theodora FitzGibbon, *With Love* (London: Century Publishing, 1982), 53.

182 "Back in London": White, *Flaws in the Glass*, 76–7.

183 Hall was busy: Margaret Fenton, for one, recalled Hall's wife's nursing job. Fenton, interview with Annalyn Swan, July 5, 2011.

183 Ianthe, at war's outbreak: Knott, interview with Stevens.

183 But in 1942: Harrison, ed., *Francis Bacon Catalogue Raisonné* vol. I, 82.

183 Her younger sister, Winifred: Knott, interview with Stevens.

183 Patrick White joined: White, *Flaws in the Glass*, 126–7.

183 Thickly drawn curtains: Feigel, *The Love-charm of Bombs*, 1.

183 As the writer William Sansom: William Sansom, *The Blitz: Westminster at War* (London: Faber, 2010), 49.

183 "Overhead, searchlights": J. B. Priestley broadcasts, David Welch, *World War II Propaganda: Analyzing the Art of Persuasion During Wartime* (Santa Barbara, CA: ABC-Clio, 2017), 23–5.

183 "Waiting, always waiting": Fitzgibbon, *With Love*, 25.

184 The Major suffered from: Knott, interview with Stevens.

184 "I did go home": Ibid.

184 He had witnessed: Harrison, ed., *Francis Bacon Catalogue Raisonné*, vol. I, 82.

184 Eric Hall made the arrangements: Ibid.

184 "I hope you are not": Diana Watson, letter of June 3, 1940, to Bacon. The letter was discovered by Martin Harrison in the course of researching the *Catalogue Raisonné*. The authors are indebted to Harrison for providing them with a copy of the letter.

185 "About a day before he died": Francis Bacon in Peppiatt, *Francis Bacon*, 99.

185 Bacon's mother implored: Ibid.

185 "You know, there were thirteen years": Ianthe Knott, interview for Adam Low, director, *Francis Bacon*, Arena documentary, BBC Four archives, March 19, 2005.

185 Bacon did not report: Peppiatt, *Francis Bacon*, 99.

185 Accordingly, A. E. M. Bacon was cremated: Knott interview, *Francis Bacon*, Arena.

186 The Major's estate amounted: *England and Wales, National Probate Calendar*, July 22, 1940.

186 During the Battle of Dunkirk: Mosley, *Backs to the Wall*, 43.

186 Three days later, Marshal Petain: Ibid.

186 Faculty members at art schools: Spurling, *The Girl from the Fiction Department*, 37.

186 At the Mayor Gallery: Mayor Gallery archives.

186 The final hurrah at Zwemmer's: Halliday, *More Than a Bookshop*, 159–60, quoting from the *Daily Sketch* of June 14, 1940.

186 Using their "characteristic": Ibid.

186 *The Times* observed: Ibid., 160–1, quoting from *The Times*, June 14, 1940.

186 For an asthmatic: Paul Brass, interview for *Francis Bacon*, Arena.

187 On the afternoon: Peter Stansky, *The First Day of the Blitz: September 7, 1940* (New Haven and London: Yale University Press, 2007), 1. There had been sporadic earlier attacks from the air. But the true Blitz began on September 7.

187 Hermann Göring, commander-in-chief: Mosley, *Backs to the Wall*, 94.

187 Thousands were in the streets: Ibid., 98–104.

187 About 430 Cockneys: Ibid., 121. The 1,600 wounded comes from this account as well.

187 Heavy bombs fell: Stansky, *First Day of the Blitz*, 68.

187 One resident of Chelsea: Ibid.

187 Bacon was a driver: A copy of his driver's license is reproduced as an unpaginated insert in Majid Boustany, ed., *Francis Bacon Mb Art Foundation* (Monaco: Francis Bacon MB Art Foundation, 2015).

187 Each typically began: For a detailed description of the incendiary bombs and the high-explosive bombs, see David Johnson, *The London Blitz: The City Ablaze* (New York: Stein and Day, 1981), 79–80. As Johnson wrote of the big bombs: "The blast from these bombs had a psychological, almost super-natural, aspect that went far beyond their capabilities for physical destruction. Shock waves could derail a train or wrench the steering wheel right out of a bus driver's grasp, as though an evil hand had come out of nowhere to wreak havoc among the unsuspecting."

188 "I mean, one's lived": Francis Bacon, interview for Richard Cork, presenter, BBC's *Kaleidoscope*, Radio 4, August 17, 1991. It was his last broadcast interview. Leonard Mosley described the after-shocks felt by one woman who was on an ambulance team. She "had been coming home day after day from the ambulance station with her hair and clothes covered in blood and a series of horrifying experiences with bomb-victims so much on her mind that she had felt compelled to unburden for hour after hour." Mosley, *Backs to the Wall*, 187.

188 In *Digging for Mrs. Miller*: John Strachey, *Digging for Mrs. Miller: Some Experiences of an Air-Raid Warden* (New York: Random House, 1941), 94, 83, 37–8.

188 "London became a city": *The Love-Charm of Bombs*, 4.

188 He found the visual drama: Janetta Parladé, interview with Annalyn Swan, November 2, 2017.

188 Evelyn Waugh wrote: Feigel, *The Love Charm of Bombs*, 48, quoting Evelyn Waugh, *Officers and Gentlemen*.

188 But Bacon began: Anne Dunn, interview with the authors, July 26, 2010.

188 "It was like running": Strachey, *Digging for Mrs. Miller*, 20, 83.

188 In the aftermath of an attack: John Rothenstein, *Brave Day Hideous Night. Autobiography 1939–1965* (London: Hamish Hamilton, 1966), 116.

189 About two weeks into the Blitz: Since the ARP photograph of Bacon dates to 1943, he either continued to have some relationship with his Chelsea unit, or else, and more likely, served in the Red Cross at the beginning of the war and in Air Raid Precautions later. *The Catalogue Raisonné* states that Bacon was "invalided out" of the ARP in 1943. Harrison, ed., *Francis Bacon Catalogue Raisonné*, vol. I, 82.

189 Hall first came: Diana Keast, interview for *Francis Bacon*, Arena documentary, BBC Four archive, March 19, 2005.

189 Keast was now: Ibid.

189 In January of 1940: Ken Keast, letter to his future wife, Diana, dated January 18, 1940. "That evening an old friend rang me up and took me out to 'Whose taking liberty', a slightly patriotic, but quite amusing, satirical pantomime and to a grand supper at the Café Royal. My friend is on the Education Committee of the L.C.C. and his wife was once at Bedales, so I had to tell him a lot about it all," wrote Keast. The authors are indebted to James Norton for a copy of the letters that Diana Keast provided to *Arena*.

189 Nine months later: Diana Keast, interview for *Francis Bacon, Arena*.

189 Bacon went to see: Bacon, letter of September 22, 1940, to Frederic Meier, headmaster, Bedales. Correspondence between Bacon and Meier courtesy of Bedales school archive.

189 Bacon agreed to lease: Ibid. Bacon letter to Meier, September 27, 1940.

189 "I am sure": Ibid. Bacon letter of September 22, 1940.

189 He moved: Ibid. Bacon letter of September 27, 1940. In another letter to his future wife, dated October 18, 1940, Ken Keast wrote, "Did you know that a friend of Eric Hall's had taken it? Eric Hall . . . was down for the week-end with his son, Ivan, whom I once took skiing. I had a very pleasant evening, though they insisted on discussing Bedales a lot."

12 WILDERNESS

190 The cottage was set apart: Diana Keast, interview for Adam Low, director, *Francis Bacon, Arena* documentary, BBC Four archive, March 19, 2005. The other details about the cottage come from this interview.

190 On one such visit: Ibid. The quotations in this paragraph come from the *Arena* interview.

191 "He was extremely kind": Ibid.

191 They supposed Hall: Ibid.

191 He would become, in 1943 and 1944: Information on Eric Hall's years with the London County Council comes from the research of James Norton for the authors.

191 Even school life in Steep: Diana Keast, interview for *Francis Bacon, Arena*.

191 It was twelve: Bacon's letter of September 28, 1929 to Eric Allden, which Allden quoted in his diaries, was written by someone who felt that the nature outside the door was threatening.

192 He or Nanny: The village store at the time was "quite adequate," as Diana Keast recalled.

192 The coast was less: See "Timeline for the 1930s," www.bedales.org.uk.

192 He could not abide: Bacon, quoted in Michael Peppiatt, *Francis Bacon: Anatomy of an Enigma* (London: Constable & Robinson, 2008), 102.

192 Bacon hardly ever spoke: In his extended interviews with Bacon while researching his dissertation, Hugh Davies managed to elicit from Bacon that he spent 1941 and 1942 in a cottage at Petersfield, Hampshire "and did a little painting." Hugh Davies, *Francis Bacon: The Early and Middle Years, 1928–1958* (New York and London: Garland Publishing, 1978), 42.

193 The only visible contemporary art: Kenneth Clark was in charge of hiring wartime artists. See Roger Berthoud, *Graham Sutherland* (London: Faber and Faber, 1982), 95, 99.

193 Later, Bacon said he might never: Bacon, quoted in John Russell, *Francis Bacon* (New York: Thames and Hudson, 1993), 20.

193 The library at Bedales: See www.bedales.org.uk.

193 Bacon was already well-read: At the time of his death, seven books by Nietzsche were found in his studio and bedsit, including *Human, All-Too-Human, Part One* from *The Complete Works of Friedrich Nietzsche*, published in 1924. He clearly continued to replace lost volumes. His copy of *Beyond Good and Evil* was printed in 1990, two years before he died.

193 "In his fondness": Martin Hammer, *Francis Bacon and Nazi Propaganda* (London: Tate Publishing, 2012), 131.

194 "We shall fight": This was one of Prime Minister Winston Churchill's most-repeated rallying cries during World War II. It came from a speech he delivered to the House of Commons on June 4, 1940, right after the evacuation of Dunkirk.

194 Yeats was an admirer: See Otto Bohlmann, *Yeats and Nietzsche: An Exploration of Major Nietzschean Echoes in the Writings of William Butler Yeats* (London: Palgrave MacMillan, 1982).

194 In "The Second Coming": Bacon, quoted in Richard Cork, presenter, *A Man Without Illusions*, BBC Radio Three, May 16, 1985.

194 Bacon admired Eliot's play: Bacon, quoted in Peppiatt, *Francis Bacon*, 109.

194 Stephen Spender wrote: Stephen Spender, *World Within World: The Autobiography of Stephen Spender* (New York: The Modern Library, 2001), 370–9.

194 The impact of Nietzsche on Bacon: Lucian Freud, quoted in John Rothenstein, *Time's Thievish Progress* (London: Cassell, 1970), 82–91.

195 Nietzsche "told us it's all": Bacon, quoted in "Francis Bacon: Remarks from an Interview with Peter Beard," *Francis Bacon: Recent Paintings 1968–1974* (New York: Metropolitan Museum of Art catalog, 1975), 20.

195 He probably did not: John Russell, *Francis Bacon* (New York: Thames and Hudson, 1993), 20.

195 Bacon was particularly excited: Martin Hammer explored at length Bacon's fascination with Nazi imagery during World War II. As he wrote, "Bacon seems to have been almost unique among ambitious, progressively minded artists of the period in choosing, independently of any external requirements, to make Hitler and Nazi Ger-

many one of the principal subjects of his art." Hammer, *Francis Bacon and Nazi Propaganda*, 7.

195 *The Picture Post* published: Ibid., 42.

195 Photographs stimulated: John Russell explored in detail how Bacon used photographs as a primary source but then transmogrified them into images that were almost always unrecognizable when compared to the original "source." Russell, *Francis Bacon*, 56–71.

195 "Photographs are not only": David Sylvester, *Interviews with Francis Bacon* (New York: Thames and Hudson, 1987), 30.

195 Bacon later said, "I think it's the slight": Ibid.

196 Even before the war: Patrick White, quoted in David Marr, *Patrick White: A Life* (London: Vintage, 1991), 169.

196 "Man is a rope": Nietzsche, *Thus Spake Zarathustra*, Prologue 4.

197 "I think the only thing": David Sylvester, *Looking Back at Francis Bacon* (London: Thames & Hudson, 2000), 232.

197 The four pictures that survived: Dan Farson noted that Bacon's early paintings in the 1940s were done on Sundlea wood-fiber board, since canvas was so scarce during the war. Far from a hardship, Bacon found that the board's absorbency suited him: it was so absorbent that he was initially put off, after the war, by the different texture of primed canvas. It was only after he was once forced to use the unprimed side of canvas—he had run out of new canvas and needed a surface to paint on—that he found, by accident, that the reverse side held the paint better. Daniel Farson, *The Gilded Gutter Life of Francis Bacon* (New York: Pantheon, 1993), 87–8.

197 The most finished of the figural: Bacon was already fascinated by open mouths: he himself cited, again and again, the early book on mouth diseases that he had bought in Paris during his stay there. And the open mouth and rows of teeth echo the more benign ones that had previously appeared in Bacon's "surreal" painting of 1936, *Abstraction from the Human Form*.

197 Here, perhaps for the first time: It also marks the first appearance in Bacon's art of a representational figure. The earlier, Picasso-inspired figures in the paintings of 1933–34 were far more abstract.

197 The genesis of the image: A decade after *Man in a Cap* was painted, the American art historian and writer Sam Hunter visited Bacon's studio and created several photographic montages of the images he found there. Two were from the same issue of *The Picture Post* (July 13, 1940). See Sam Hunter, "Francis Bacon: The Anatomy of Horror," *Magazine of Art*, January 1952, 11–15.

197 Bacon depicted Hitler's: The painting on the verso side of *Man Standing* is *Seated Man*. They are painted on the same fiberboard as *Man in a Cap* and are roughly the same dimensions.

197 Bacon did not regard such paintings: In many ways, *Seated Man* anticipates Bacon's famous "Men in Blue" series

of the 1950s, in which similarly seated and faceless male figures are portrayed against a dark, indeterminate and forbidding interior. But here the figure is much more terrifying. The body, in its formal suit, is massive—possibly referring again to the photograph of Hermann Göring, with his bull-like chest. And instead of a face and head there is a "gaping blackness," as Ronald Alley described it in his 1964 catalogue raisonné. The black void where the head should be also suggests a dark hood thrown over the figure—just as executioners cover the head of the accused before a hanging or a firing squad. Incongruously, Bacon included a hanging tassel that appeared in a photograph of Hitler that was also found in his studio—a motif that would appear again and again in his later paintings. While not nearly as unsettling as *Man in a Cap*, *Man Standing* is a direct forerunner of the half-human, half-beast creatures that populated Bacon's paintings of the late 1940s. Bacon would continue to work through the same motifs and images, in fact, for the rest of the decade.

198 *Landscape with Colonnade*: The rally photo ran in the same issue of *The Picture Post*, in July 1940, as the lineup of Nazi leaders that Bacon used for other paintings. Chris Stephens, cited in Hammer, *Francis Bacon and Nazi Propaganda*, 63.

198 A moment came in the summer: Frederic Meier, letter to Bacon, August 4, 1941. Bedales school archive.

198 But then what was: Ibid. "I feel much more hopeful tonight," wrote Meier to Bacon on August 19, 1941.

199 In early February of 1943: Bacon, letter to Sutherland in Martin Hammer, *Bacon and Sutherland* (New Haven: Yale University Press, 2005), 234.

199 He was thirty-nine: Much of Sutherland's early success can be attributed to Kenneth Clark's promotion. Clark was himself a wunderkind of the art world: he became the director of Oxford's august Ashmolean Museum at twenty-seven and the director of the National Gallery by the age of thirty. He liked Sutherland so much that he invited Graham and his wife, Kathy, to live with his family outside of London when World War II was declared. Roger Berthoud, *Graham Sutherland: A Biography* (London: Faber and Faber, 1982), 95.

199 Bacon knew Sutherland: See Ch. 11, "Early Failure."

200 Its author, W. B. Stanford: For a short biographical note on Stanford, see "W. B. Stanford," www.ricorso.net. All of the following biographical information comes from this source.

200 From the opening sentence: W. B. Stanford, *Aeschylus in His Style* (Dublin: Dublin University Press, 1942), 1.

200 Throughout the book: Ibid., 87.

200 His "untutored genius": Ibid., 14.

200 He had instead: Ibid., 60.

200 "At best," wrote Stanford: Ibid., 61.

200 Stanford quoted Aristotle's famous: Ibid., 13.

201 Stanford, Bacon later said: Bacon, quoted in Cork, *A Man Without Illusions*.

201 "One is reminded": Stanford, *Aeschylus in His Style*, 65–6.

13 GOOD BOYS AND BAD

202 A terraced townhouse: The attached town houses on Cromwell Place are quite grand. The information on Millais's residency there comes from Alyson Wilson, "Housed in Art History—Part I," *Art Quarterly*, Spring 1994, 23–5.

202 E. O. Hoppé: Ibid.

202 Cecil Beaton called: Ibid.

202 Another fashionable photographer: Alyson Wilson, "Housed in Art History—Part II," *Art Quarterly*, Winter, 1996, 25–9.

202 In 1943, Bacon leased: Bacon told David Sylvester that the "whole of the roof of Millais's studio had been blown in, and the room I painted in was never built as a studio. It was an enormous billiard room, like the Edwardians often used to have at the backs of their houses." David Sylvester, *Looking Back at Francis Bacon* (New York: Thames and Hudson, 1987), 189. However, E. O. Hoppé wrote in his autobiography that he relished using Millais's former studio, which he said was on the ground floor. So while the room's earliest origins may well have been as a billiard room, it had long since become a studio. The confusion probably stems from the fact that there was a smaller second studio on the floor above the ground floor that Millais used for "artificial light work." It was no doubt this smaller studio that was damaged by bombs during World War II. Bacon stored abandoned paintings in the basement. Robert Buhler, his artist friend and the next tenant after him, found the paintings and eventually sold them.

202 On the floor above: Wilson, "Housed in Art History—Part II."

202 The front: Bacon, letter to Colin Anderson from Monte Carlo, October 9, 1947, quoted in Adrian Clarke, "Francis Bacon's Correspondence with Sir Colin Anderson," *The British Art Journal* VIII, no. 1 (Summer 2007), 39–43.

202 There was also a bedroom: Ibid.

202 Nanny Lightfoot each night: Michael Wishart, among others, noted that Nanny Lightfoot slept in the kitchen. Michael Wishart, *High Diver* (London: Blond and Briggs, 1977), 61–4.

202 Margaret Fenton, who met: Margaret Fenton, interview with Annalyn Swan, February 17, 2009.

203 Bacon was still nominally: Martin Harrison, ed., *Francis Bacon Catalogue Raisonné*, vol. I (London: Estate of Francis Bacon, 2016), 82.

203 Messerschmitt: Leonard Mosley, *Backs to the Wall: London Under Fire 1939–45* (London: Weidenfeld & Nicolson, 1971), 296.

203 After the death: Eric Allden's diaries report that, as per Diana Watson, Mrs. Bacon and her younger daughter Winifred were still living in Bradford Peverall in January of 1942. Allden diary, January 7, 1942. The Estate of Francis Bacon archive.

203 But the house became: In January of 1946, Bacon asked Eric Allden if Allden could "introduce [Bacon's] mother to any people as she doesn't know many people in London." Diary, January 12, 1946. Mrs. Bacon probably moved to London sometime in 1945. Allden recorded the address elsewhere as 12 Grenville Place.

203 "Winnie at the age": Allden diary, January 7, 1942.

203 "When we left Dorset": Ianthe Knott, interviews with Mark Stevens, March 5 and 6, 2008.

203 A shipment of family: Janetta Parladé, interview with Annalyn Swan, November 2, 2017. Parladé kept the embossed serving spoon until her death. She died on July 4, 2018.

203 He was also prepared: In a letter of February 20, 1948, to Colin Anderson, Bacon wrote, "I have been trying to sell the furniture but I have not been able to get the offer of a reasonable price as they all say it is too big." Clarke, "Francis Bacon's Correspondence with Colin Anderson," *The British Art Journal*.

203 "The dowdy chintz": Wishart, *High Diver*, 61–4.

203 Two large Waterford: Ibid. Ianthe Knott recalled only one crystal chandelier, but everyone who came to 7 Cromwell Place remembered a pair of chandeliers. Knott interview with Stevens.

203 Graham Sutherland told: Cecil Beaton, *Self Portrait with Friends: The Selected Diaries of Cecil Beaton, 1922–1974*, Richard Buckle, ed. (New York: Times Books, 1979), 321.

203 "Upon a dais": Wishart, *High Diver*, 61–4.

204 He and his wife were now: Barbara Preston Hall, a nurse, is listed in the *U.K. and Ireland Nursing Registers, 1898–1968* as having no permanent address in 1948. Her "permanent" address is recorded as the National Provincial Bank. This would indicate that she and her husband had no established address together at the time. The last listing for Eric and Barbara Hall jointly at Tennyson Mansions was in 1939. From 1940 to 1944 all electoral record-keeping was suspended. See "UK electoral registers," www.bl.uk. Records of their joint attendance at their daughter Pamela's wedding come from the research of James Norton.

204 Hall's wife wrote Bacon: Ibid. Daniel Farson quoted Robert Medley's saying that Barbara Hall objected more to the money flowing to Bacon than the actual affair. Daniel Farson, *The Gilded Gutter Life of Francis Bacon* (New York: Pantheon, 1993), 33.

204 During the war, Hall became: Bacon's first letter to Graham Sutherland in February of 1943 mentioned that he still knew "one or two places where the food is not too bad." Martin Hammer, *Bacon and Sutherland* (New Haven: Yale University Press, 2005), 234.

204 Shrewdly cashing in: A few years after the war, Michael Wishart joined in the gambling. "I rashly went

'Banco' at one of these, and lost a packet: not that the wheel was fixed." Wishart, *High Diver*, 61–4.

204 As a result: Lucian Freud, in William Feaver, *The Lives of Lucian Freud: The Restless Years, 1922–1968* (New York: Knopf, 2019), 199.

204 Although the Sutherlands lived: Roger Berthoud, *Graham Sutherland, A Biography* (London: Faber and Faber, 1982), 129–32.

204 Sutherland told Cecil Beaton: Beaton, *Self-Portrait with Friends*, 321.

204 Sutherland noted Bacon's: Ibid.

205 "Dear Graham": Bacon, second letter to Sutherland in Hammer, *Bacon and Sutherland*, 234.

205 Sutherland's landscapes became: See such paintings as *Red Landscape*, 1942, or *Thorn Trees of 1945* (Albright-Knox Museum). Once Sutherland went to the Mediterranean following the war, his paintings filled with thorn trees and other jagged surfaces.

205 Sutherland had a "thoroughly conventional": Berthoud, *Graham Sutherland*, 129–32.

205 In contrast to Bacon: Ibid., 43.

205 While Bacon went to Berlin: Ibid., 115.

206 "British art had long been torn": Ibid., 43–4.

206 Bacon was an avowed: Sutherland had converted to Catholicism in 1926. Ibid., 56.

206 If Bacon was an open: "Graham was incredibly kind and gentle and charming," said Anne Dunn, who met Bacon around 1948 and knew the Sutherlands before. "A real gentleman." Anne Dunn, interview with the authors, July 26, 2010.

206 "His wife was ambitious": Ibid.

206 "Please do not send": Bacon, second letter to Sutherland in Hammer, *Bacon and Sutherland*, 234.

206 "Sutherland's correspondence": Ibid., 15–16.

206 "In Graham's battered": Berthoud, *Graham Sutherland*, 87.

207 In *A Paradise Lost*: David Mellor, *A Paradise Lost: The Neo-Romantic Imagination in Britain 1935–55*, exhibition catalog (London: Barbican Art Gallery exhibition catalog, 1987), 16.

207 By the early 1940s: Ibid. In October of 1941, all three artists showed together at Temple Newsom, Leeds, in a show that then toured throughout England into 1942. It marked "the emergence of this triumvirate as the leading senior painters in the Neo-Romantic style," as Mellor wrote.

207 As Berthoud described Sutherland's: Berthoud, *Graham Sutherland*, 76.

207 In an introduction to one booklet: Spender, quoted in Mellor, *A Paradise Lost*, 128.

208 The charm was what people often: Berthoud, *Graham Sutherland*, 19–20.

208 He introduced Sutherland to Colin: Ibid., 75.

208 While visiting Paris in February: Ibid., 89–90.

208 The dealer had recently branched out: See "Paul Rosenberg and Co," The Frick Collection, Archives Directory for the History of Collecting in America, research .frick.org.

208 Clark not only persuaded: Berthoud, *Graham Sutherland*, 89–90.

208 Sutherland's response: Ibid.

208 Seven of his paintings: Ibid., 91.

208 Promoting his protégés, Clark included: Ibid., 93.

208 When war was declared: Ibid., 95.

208 In the *New Statesman*: Ibid., 98. Raymond Mortimer's review appeared on May 10, 1940.

208 "Graham's exhibitions of 1938": Ibid., 110.

209 He wanted to join the bigger: Ibid., 118.

209 The next few years saw him: Berthoud, *Graham Sutherland*, 118.

209 Fellow artist, and critic: Hammer, *Bacon and Sutherland*, 69–70.

209 "I want you to meet": Berthoud, *Graham Sutherland*, 110–11.

209 He would describe: Ibid.

209 The second son of a wealthy: See Adrian Clark and Jeremy Dronfield, *Queer Saint: The Cultivated Life of Peter Watson, Who Shook Twentieth-Century Art and Shocked High Society* (London: John Blake Publishing, 2015).

209 He collected among others: Ibid., 133.

210 His eye then turned to English: Ibid., 150.

210 Watson bought his first Sutherland: Hammer, *Bacon and Sutherland*, 12.

210 The amiable Watson: Ibid. See also Clark and Dronfield, *Queer Saint*, 170–7.

210 The first issue appeared: Ibid.

210 It was initially: Ibid., 146. Watson did not trust Connolly to head the magazine alone; his faults included "laziness and vanity," as Clark and Dronfield wrote in *Queer Saint*. So Watson asked Stephen Spender to be the coeditor.

210 Watson was determined: Mellor, *A Paradise Lost*, 40.

210 Sonia Brownell: See Hilary Spurling, *The Girl from the Fiction Department: A Portrait of Sonia Orwell* (Berkeley: Counterpoint Press, 2003) for more details about her life in wartime London and her postwar life.

210 She would also marry: Kukula Glastris, "The Widow Orwell," *Washington Monthly*, July/August 2003.

210 "Where Cyril was short": Spurling, *The Girl from the Fiction Department*, 56–7.

210 The two Roberts, for example: Roger Bristow, *The Last Bohemians: The Two Roberts Colquhoun and MacBryde* (Bristol: Sansom & Company, 2010), 161.

210 Bacon probably went sometimes: Frances Spalding, *John Minton: Dance till the Stars Come Down* (Aldershot, Hants UK: Hodder and Stoughton, 1991), 61.

210 Watson arranged for the homeless: Feaver, *The Lives of Lucian Freud*, 140–2.

211 "Sutherland, he said": Berthoud, *Graham Sutherland*, 110.

211 He also disliked Cyril: Bacon, quoted in Michael Luke, *David Tennant and the Gargoyle Years* (London: Widenfeld and Nicolson, 1991), 181–3. "I always got on terribly badly with Cyril," Bacon said. "I think he probably hated me as much as I disliked him. I found him profoundly unsympathetic."

211 Bacon was a "Dionysian": Stanford, *Aeschylus in His Style*, 14.

211 Once a home, in the 17th: Peter Stone, *The History of the Port of London*, "The Development of Soho," www.thehistoryoflondon.co.uk.

211 This was the period of "sepia": Keith Waterhouse, "My Soho," *The Evening Standard*, April 12, 2001.

211 In the 1940s, there remained: Ibid.

211 "We fought our way in": Denton Welch, quoted in Philip Hoare, "Obituary: Gaston Berlemont," *The Independent*, November 11, 1999.

212 Soho had small one-room: Theodora FitzGibbon, *With Love* (London: Century Publishing, 1982), 109. The early Colony was a basement club, not the far more famous Colony Room presided over by Muriel Belcher that opened in the late 1940s.

212 Not too far: Ibid. Fitzgibbon wrote that her crowd would go to the back bar at the Café Royal only on "very step-up occasions." There, "Jimmy the barman presided priest-like over a vaguely literary gathering."

212 "In North Soho": Anthony Cronin, *Dead as Doornails: A Chronicle of Life* (Dublin: The Dolmen Press, 1976), 129.

212 "The sort of artist": Ibid.

212 In the mid-forties, the poet Dylan: FitzGibbon, *With Love*, 109.

212 Another was the artist: Ibid., 3.

212 "Peter always thought Francis": Ibid., 109.

213 After Oxford, he established: See "Peter Rose Pulham," www.nationalgalleries.org.

213 He did a famous: Ibid.

213 One sign of Sutherland's: Hammer, *Bacon and Sutherland*, 10.

213 He moved to Paris: Ibid., 211–12.

213 Pulham was far more cultivated: FitzGibbon, *With Love*, 14. In the mid-1940s, Pulham was also much further along in his career than Bacon. He showed at the Redfern Gallery in 1945, in a mixed show that included drawings by the French surrealist Andre Masson, who knew of and collected Pulham's work. He later showed in 1950 at the Hanover Gallery. Even after Pulham moved back to France in the early 1950s, he and Bacon kept up through their mutual close friend Isabel Rawsthorne.

213 He shared with Bacon: Hammer, *Bacon and Sutherland*, 211–12.

213 Cecil Beaton described: Ibid., 212 FN. Beaton described Pulham this way in his book *British Photographers* (London: William Collins, 1944), 44.

213 By far the wildest: See Bristow, *The Last Bohemians*. The following information in this paragraph comes from this book.

213 They "lived on": Mellor, *A Paradise Lost*, 54.

213 Not long after reaching: Bristow, *The Last Bohemians*, 112.

214 They moved through: Mellor, *A Paradise Lost*, 52.

214 The roistering Roberts: Cronin, *Dead as Doornails*, 131–2.

214 It was also now: Farson, *The Gilded Gutter Life*, 41.

214 With the exception of an exciting moment: Quentin Crisp, *The Naked Civil Servant* (New York: Penguin Books, 1997), 73–5.

214 "I met several guardsmen": John Lehmann, *In the Purely Pagan Sense* (London: GMP Publishers, 1985), 128.

214 "If it had not been": Crisp, *The Naked Civil Servant*, 132.

214 "There were goings-on": Grey Gowrie, interview with Mark Stevens, November 2011.

215 "The French Pub was filled": John Richardson, interview with Mark Stevens, March 3, 2008.

215 There were also: Dan Chapman, interview with the authors, February 12, 2011.

215 "Most of them were well-brought-up": Heather Johnson, email to Annalyn Swan, November 2, 2013.

14 SEWER BOOTS

216 One of the first was John Rothenstein: For a quick precis of Rothenstein's not uncontroversial role in British art, see arthistorians.info/rothensteinj.

216 Just three months: John Rothenstein, *Brave Day Hideous Night: Autobiography 1939–1965* (London: Hamish Hamilton, 1966), 105–6.

216 Sutherland also talked up: The correspondence between Bacon and Anderson can be read in Adrian Clark, "Francis Bacon's Correspondence with Sir Colin Anderson," *The British Art Journal* VIII, no. 1 (Summer 2007), 39–43.

216 In 1944 or early 1945: Roger Berthoud, *Graham Sutherland: A Biography* (London: Faber and Faber, 1982) 129–32.

216 Clark walked into: Ibid. Kathleen Sutherland remembered the "tightly rolled umbrella."

216 He "gave Bacon's work": Ibid.

216 Once the door closed: Ibid.

216 That same night at dinner: Ibid.

217 Although the gallery traditionally: Martin Hammer, "Francis Bacon and the Lefevre Gallery," *The Burlington Magazine*, May 2010, 307.

217 Macdonald therefore discussed: Ibid., 307–8.

217 Then Nicolson decided not: Ibid., 308.

217 "I should really prefer": Ibid.

217 In February 1945, Macdonald asked: Ibid.

217 The invitation "may have": Martin Hammer, *Francis Bacon and Nazi Propaganda* (London: Tate Publishing, 2012), 69.

218 Two and a half weeks before: Macdonald, letter of March 12, 1945, to Bacon, cited in Hammer, "Francis Bacon and the Lefevre Gallery," *The Burlington Magazine*, 308 fn.

218 On the precious new: It may well be that Sutherland procured the canvas for Bacon. As Martin Hammer wrote, "It was not just that normal materials such as canvas and the wood required for stretchers had become difficult to obtain or prohibitively expensive in the conditions of extreme deprivation and restriction that pertained in wartime Britain. Sutherland's correspondence with the WAAC [Wartime Artists' Committee] indicates that official permission was required to obtain virtually all materials." Martin Hammer, *Bacon and Sutherland* (New Haven: Yale University Press, 2005), 15–16.

218 In 1944, Graham Sutherland saw: Bacon may have begun *Three Studies* earlier, when he was in Steep, given that it was painted on fibreboard and not canvas. Bacon told Hugh Davies that he had started to paint the Eumenides "early in the 'thirties" and that the triptych was the "culmination of these studies." (Hugh Davies, *Francis Bacon: The Early and Middle Years, 1928–1958*). This could only be the case if Bacon were incorporating his "surrealist" paintings of c. 1936 into the timeline. Bacon was also influenced by Sutherland. As Martin Hammer noted, Sutherland's use of a "strongly modeled, almost sculptural form" in some of his early 1940s paintings, as well as a "flat, brightly coloured backdrop," might have shown Bacon how he could achieve "a heightened expressive charge." Hammer, *Bacon and Sutherland*, 11. Sutherland was also the first to use the high-keyed orange that Bacon made so famous. See Sutherland's *Horned Forms* of 1944, now at the Tate Gallery. There is also more than a passing resemblance between Sutherland's *Green Tree Form* of 1940 (also at the Tate) and the creatures in *Three Studies*.

219 Denton Welch published: "Sickert at St. Peter's," *Horizon* (August, 1942), 91–7. The quotations in the next two paragraphs all come from this article.

219 Its real subject, however: Bacon's highest praise for another artist was to own one of his works. At one point Bacon owned a Sickert. Richard Shone, interview with the authors, February 17, 2011.

221 Bacon relished: W. B. Stanford, *Aeschylus in His Style* (Dublin: Dublin University Press, 1942). See Ch. 13. Bacon made many references later in life to this book.

221 One phrase particularly pleased: Bacon often quoted that line of Aeschylus from Stanford's book. See Daniel Farson, *The Gilded Gutter Life of Francis Bacon* (New York: Pantheon, 1993), 133. As Farson wrote, "The 'reek of human blood smiles out at me,' also translated as 'the reek of human blood is laughter to my heart,' was a favorite quotation of his from the *Oresteia*."

222 John Russell would later call: As Russell wrote in his first, slim book on Bacon, "British art has never been quite the same since the day in April, nineteen years ago, when three of the strangest pictures ever put on show in London were slipped without warning into an exhibition at the Lefevre Gallery." John Russell, *Francis Bacon* (London: Methuen, 1964), 2.

15 "I BEGAN"

225 In April of 1945: The National Gallery's collection did not begin to return from remote storage until early May of 1945.

225 At the Lefevre Gallery: Martin Hammer, "Francis Bacon and the Lefevre Gallery," *The Burlington Magazine*, May 2010, 308.

225 Almost everything sold: Ibid. MacDonald wrote to Sutherland on April 19 that only two Sutherland paintings and two Moore drawings had not yet sold. The catalog was reprinted three times.

225 "Visitors tempted": John Russell, *Francis Bacon* (London: Methuen, 1964), 2.

225 The figures in the images: Ibid.

225 Russell fretted: Russell, "Round the Art Exhibitions," *The Listener* XXXIII, no. 848 (April 12, 1945), 412.

225 Raymond Mortimer: Raymond Mortimer, "At the Lefevre," *The New Statesman and Nation*, April 14, 1945.

226 Macdonald, the curator: Hammer, "Francis Bacon and the Lefevre Gallery," *The Burlington Magazine*, 308.

226 The painter and critic Michael Ayrton: Michael Ayrton, "Art," *Spectator*, April 13, 1945.

226 In his spectral *Shelter Drawings*: For more on Moore's wartime drawings, see "Henry Moore: Room Guide, Room 5: Wartime," www.tate.org.uk.

226 Moore became especially: Russell, *Francis Bacon*, 9.

227 "All over the country": Ibid., 9–10.

227 "I began": Bacon in John Rothenstein, introduction to Ronald Alley ed., *Francis Bacon* (London: Thames and Hudson, 1964), 11. Catalogue raisonné.

227 *Three Studies* went to Eric: Hammer, "Francis Bacon and the Lefevre Gallery," *The Burlington Magazine*, 308.

227 His cousin Diana: Alley, ed., *Francis Bacon*, 36.

227 Bacon's mother never seemed: There was no mention of Winnie ever going to Bacon's shows in the 1930s, even after the family moved back to England.

227 Bacon's sister Ianthe: Ianthe Knott, interviews with Mark Stevens, March 5 and 6, 2008.

227 The critic David Sylvester loved: David Sylvester,

Looking Back at Francis Bacon (New York: Thames and Hudson, 2000), 22.

228 Over five weeks: Brandon Taylor, "Picasso and the Psychoanalysts," in Andrei Pop and Mechtild Widrich, eds., *All from Ugliness: The Non-beautiful in Art and Theory* (London: I.B. Tauris, 2014), 59–67. The show also traveled to Manchester and Glasgow.

228 Picasso was criticized: James Beechey and Chris Stephens, eds., *Picasso and Modern British Art* (London: Tate, 2012), 186.

228 Matisse's paintings: Hilary Spurling, "Matisse v. Picasso," *The Telegraph*, April 27, 2002.

228 The critic for *The Sunday Times*: Ibid.

228 His latest paintings had "a galvanizing": Beechey and Stephens, eds., *Picasso and Modern British Art*, 17.

228 Vaughan thought Picasso: Vaughan, quoted in ibid., 186.

228 In her biography of Minton: Frances Spalding, *John Minton: Dance Till the Stars Come Down* (Aldershot, Hants UK: Hodder and Stoughton, 1991), 80.

229 What did Francis think: Eric Allden diary, January 12, 1946. The Estate of Francis Bacon archive.

229 Bacon found it: Ibid.

229 Bacon acknowledged that: "According to Bacon," Sylvester later wrote, "the particular Picasso figures which inspired those in the triptych were biomorphs on beaches turning keys in the doors of their bathing cabins. In the triptych, the eroticism and the comedy of those figures was displaced by terror." Sylvester, *Looking Back at Francis Bacon*, 19.

229 A reliance on line: Bacon spoke often and adamantly, throughout his life, against "illustration" and "decoration" in art, even claiming that Picasso's *Guernica* was just illustration. Bacon, quoted in ibid., 244.

230 David Sylvester called: Ibid., 21.

230 In *Figure Study II*: In a letter to his dealer, Duncan Macdonald at Lefevre, Bacon wrote, "These paintings are studies for the Magdalene . . . and I would like them entitled as such in the catalogue." Martin Hammer, "Francis Bacon and the Lefevre Gallery," *The Burlington Magazine*, May 2010, 308.

230 Graham Sutherland also painted: Martin Hammer, *Bacon and Sutherland* (New Haven and London: Yale University Press, 2005), 131–2.

231 Hoping to consolidate: Hammer, "Francis Bacon and the Lefevre Gallery," *The Burlington Magazine*, 307–12.

231 This time: Ibid., 309.

231 Macdonald was hoping: Ibid., 308.

231 He had earlier sold: Ibid., 308.

231 There might be: Ibid.

231 "Roger Marvell": Roger Marvell, "New Pictures," *The New Statesman and Nation*, XXXI, no. 16 (February 1946).

232 Anderson "radiated": Roger Berthoud, *Graham Sutherland, A Biography* (London: Faber and Faber, 1982), 75.

232 He admired: Ibid.

232 Since Anderson: Hammer, "Francis Bacon and the Lefevre Gallery," *The Burlington Magazine*, 309.

232 Another member: Ibid.

232 Not long before: William Feaver, *The Lives of Lucian Freud: The Restless Years, 1922–1968* (New York: Knopf, 2019), 201.

232 Francis Bacon, Freud would later say: Ibid.

232 Le Brocquy was "staggered": Louis le Brocquy, interview with Annalyn Swan, May 7, 2008.

232 Having spent: Hammer, "Francis Bacon and the Lefevre Gallery," *The Burlington Magazine*, 310–11.

233 In 1935, Soby published: James Thrall Soby, *After Picasso* (New York: Dodd, Mead & Co., 1935).

233 "For art students raised": Spalding, *John Minton*, 25–6.

233 Macdonald began sending: Hammer, "Francis Bacon and the Lefevre Gallery," *The Burlington Magazine*, 310–11.

233 The promotion: Ibid.

233 In 1946, Graham Sutherland: Jean-Yves Mock, *Memoir of Erica Brausen*, Gill Hedley, trans, www.gillhedley.co.uk. "It was Graham Sutherland who suggested that she visit Bacon's studio," wrote Mock. Mock worked for years with Brausen at the gallery. See also Mock, *Erica Bransen: Premier Marchand de Francis Bacon* (Paris: L'Echappe, 1996).

233 She was a war: Ibid. For a good portrait of Erica Brausen, see also John Moynihan, *Restless Lives: The Bohemian World of Rodrigo and Elinor Moynihan* (Bristol: Sansom and Company, 2002), 171–2.

233 She had recently joined: Mock, *Memoir of Erica Brausen*.

233 Brausen was raised: Ibid. For Brausen's background, see also Barry Joule, "Obituary: Erica Brausen," *Independent*, December 30, 1992.

233 Brausen, who was just: Ibid. "Give or take 18 months they were the same age," wrote Mock. "Bacon was the younger." The following biographical detail comes from this account as well.

234 The main figure at Redfern: See John Thompson, "Nan Kivell, Sir Rex De Charembac (1898–1977)" in the *Australian Dictionary of Biography*, adb.anu.edu.au. As Thompson wrote, "In 1925 Nan Kivell joined the Redfern Gallery. By 1931 he had assumed control as managing director. His association with the Redfern, maintained in partnership with Australian-born Harry Tatlock Miller, continued until his death. The gallery promoted contemporary art, assisting a number of British artists who became major figures. Nan Kivell helped to bring to England the work of important European painters, and he encouraged some young Australian artists, including (Sir) Sidney Nolan.

234 Nan Kivall owned: See nla. gov.au.

234 Bacon accepted: In a handwritten note, Brausen said that she bought *Painting, 1946* for 200 pounds. Tate Archive, 863/6/16. Bacon used the money to go to the South of France.

235 "She was a powerful person": Louis le Brocquy, interview with Swan, May 7, 2008.

235 Brausen sold: For the sales history of the painting, see Martin Harrison, ed., *Francis Bacon Catalogue Raisonné*, vol. II (London: Estate of Francis Bacon, 2016), 118.

235 One critic observed: "The Redfern Gallery" *The Times*, July 29, 1946.

236 The average annual English wage in 1946: See thedesignlab.co.uk.

16 THE ROAD SOUTH

238 Cyril Connolly called: Cyril Connolly, "The Coming of the Crisis—I," reprinted in *Ideas and Places* (London: Weidenfeld and Nicholson, 1953), 142. Writing in *Horizon* of a visit he had made to Paris in January of 1945, Connolly wrote, "London seemed utterly remote—a grey, sick wilderness on another planet, for in Paris the civilian virtues triumph—personal relations, adult-minded seriousness, aliveness, love of the arts." ("Comment," *Horizon*, May 1945, 295-306).

238 Stephen Spender announced: "Comment," *Horizon*, July 1945, 5. The same issue had a piece by Alan Moorehead, "Glimpses of Germany," on visiting the Belsen concentration camp. The two articles could not have been more dissimilar.

238 "There is no way now of telling": Doris Lessing, quoted in Peter Conradi, *Iris Murdoch: A Life* (New York: W. W. Norton, 2001), 214.

238 Hilary Spurling: Hilary Spurling, *The Girl from the Fiction Department: A Portrait of Sonia Orwell* (Berkeley: Counterpoint, 2003), 60.

238 By the summer: Ibid., 73.

239 Connolly was feted: Ibid., 63.

239 He could come and go: The authors are indebted to the research of James Norton into Eric Hall's personal history.

239 Early in July: A replica of Bacon's carte d'identité is included in *Francis Bacon Mb Art Foundation*, published in 2015 in Monaco by the foundation. The Francis Bacon MB Art Foundation, founded by Majid Boustany in 2014, has become a valuable resource for scholars interested in Bacon's time in France—from the early years in Paris and Chantilly, to the postwar period in Monte Carlo, to his later studio apartment in Paris in the 1970s, to his many visits over the years to the South of France and other locations in France.

239 The small group moved: Ibid. Many details come from Annalyn Swan's tour of Monte Carlo with Majid Boustany, July 2014.

240 In 1946, Picasso: See inexhibit.com, "Vallauris: ceramic art and the spirit of Picasso."

240 After the war: For information on postwar Monte Carlo, see Stanley Jackson, *Inside Monte Carlo* (London: W. H. Allen, 1975).

240 But Bacon always appreciated: Michael Wishart, *High Diver* (London: Blond and Briggs, 1977), 61–4.

240 The exchange rate was miraculous: Jackson, *Inside Monte Carlo*, 180–1.

240 He did not dismiss: Bacon, letter no. 7 to Graham Sutherland from Monte Carlo, December 30, 1946, in Martin Hammer, *Bacon and Sutherland* (New Haven and London: Yale University Press, 2005), 238–9. All of Bacon's correspondence with Sutherland is included in the appendix to Hammer's book.

240 He loved being: Bacon, letter no. 6, in Adrian Clark, "Francis Bacon's Correspondence with Sir Colin Anderson," *The British Art Journal* VIII, no. 1 (Summer 2007), 39–43.

240 He even mentioned: Bacon, letter no. 7 to Sutherland, in Hammer, *Bacon and Sutherland*, 238–9.

240 He continued to scoff: Bacon, letter of August 20, 1946 to Duncan Macdonald, in Martin Hammer, "Francis Bacon and the Lefevre Gallery," *The Burlington Magazine*, May 2010, 307–12. He made almost identical observations in letter no. 4 to Sutherland, in Hammer, *Bacon and Sutherland*, 235. He said artists turned the area into a "wonderful lesbian postcard."

240 But they "[could] only come": Letter no. 7, in Hammer, *Bacon and Sutherland*, 238.

240 "The thing I was very shocked by": Ibid.

241 Bacon found Monte Carlo: Ibid., 238–9.

241 Designed in the late nineteenth century: For history and photos of the interior, see: "The Glitz and Glamor of the Casino de Monte-Carlo," luxeadventuretraveler.com.

241 During the war: Jackson, *Inside Monte Carlo*, 178.

242 The "Place du Casino": Ibid., 180–1.

242 The capital of roulette: See "The History of Roulette," onlineroulette.org.

242 It offered: Ibid.

242 Bacon's friend Michael Wishart: Wishart, *High Diver*, 74–5.

242 Wishart recalled him: Ibid.

243 "I thought I would look around": Bacon, letter no. 5 to Sutherland, in Hammer, *Bacon and Sutherland*, 236.

243 Three months after settling: Bacon, letter of October 19, 1946 to Macdonald, in Hammer, "Francis Bacon and the Lefevre Gallery," *The Burlington Magazine*, 310.

243 "Nobody here is at all interested": Bacon, letter no. 4 to Sutherland, in Hammer, *Bacon and Sutherland*, 235.

243 "The strung man": letter no. 5 in ibid., 236.

243 Initially, he had trouble: Bacon letter to Macdonald, in Hammer, "Francis Bacon and the Lefevre Gallery," *The Burlington Magazine*, 310.

243 Before the painting left London: Bacon, letter no. 5 to Sutherland, in Hammer, *Bacon and Sutherland*, 236.

244 It was the size: Macdonald, letter of October 1, 1946, to Bacon, in Hammer, "Francis Bacon and the Lefevre Gallery," *The Burlington Magazine*, 310. All subsequent quotations in this paragraph come from the same source and page.

244 Bacon arrived: Bacon described his travel plans in letter no. 6 to Graham Sutherland, in Hammer, *Bacon and Sutherland*, 237.

244 The stone facades: Details of postwar Paris can be found in Colin Jones, *Paris: The Biography of a City* (New York: Viking, 2005). See also photographs taken by Ed Clark in 1946: "Paris Unadorned: Portraits of the City of Light, 1946," time.com.

244 Instead of staying: Bacon, letter no. 7 to Sutherland, in Hammer, *Bacon and Sutherland*, 237.

244 The exhibit was a sprawling: One newspaper account, in the *Edinburgh* (Indiana) *Daily Current* (November 8, 1946) listed the number of works and countries represented.

245 "As I have sold": Bacon, letter no. 5 to Sutherland, in Hammer, *Bacon and Sutherland*, 236.

245 Bacon judged: Ibid., 238.

245 The "Picassos": Ibid.

245 Bacon reserved higher hopes: Ibid., 237.

245 Before his 1968 retrospective: Denyse Bertoni, "Balthus: a personal view," www.tate.org.uk.

245 Peter Rose Pulham: Details about Pulham's postwar life come from Theodora FitzGibbon, *Love Lies a Loss: An Autobiography 1946–1959* (London: Century Publishing, 1985), 160–82.

245 One of Pulham's closest: The Tate Archive at Tate Britain in London has an extensive file of Isabel Rawsthorne's letters to Peter Rose Pulham. A short interview by Sarah Howell in the related Rawsthorne collection of "autobiographical and biographical material" confirms that Rawsthorne met Bacon in Paris in the 1940s, as does an autobiographical note by Rawsthorne herself. Tate Archive, 9612.6.5.

245 She had grown up: Most of the biographical information about Isabel Rawsthorne's background comes from extensive notes on her compiled by Sotheby's auction house: "Francis Bacon: Three Studies of Isabel Rawsthorne," www.sothebys.com.

246 Isabel became: Ibid. Daniel Farson, among others, claimed that Rawsthorne had a child by Epstein. Daniel Farson, *The Gilded Gutter Life of Francis Bacon* (New York: Pantheon Books, 1993), 173.

246 "Have you ever fallen in love": Sefton Delmer, *Trail Sinister: Top Newsman Remembers Europe. An Autobiography*, vol. I (London: Secker and Warburg, 1961), 241.

246 Not long after: "Francis Bacon: Three Studies of Isabel Rawsthorne," www.sothebys.com.

246 "I had an English": Giacometti, quoted in Y. Bonnefoy, *Alberto Giacometti: A Biography of His Work* (Paris: Flammarion, 1991), 250. Various versions exist about who, exactly, was Giacometti's muse for his small statues. A tall Jewish Parisian named Sonia Mosseé is another candidate. Picasso, among others, recalled Giacometti naming Mosseé as the vision behind his elongated sculptures. Laurie Wilson, *Alberto Giacometti: Myth, Magic and the Man* (New Haven: Yale University Press, 2003), 179–80.

247 She was also a close: See Carol Jacobi, "Picasso's Portraits of Isabel Rawsthorne," *The Burlington Magazine*, September 2017, 720–7.

247 "I was living with Alberto": Sarah Howell, "A Model Artist," interview conducted with Isabel Rawsthorne, Tate Archive, 9612.6.5.

247 The war forced: Jill Berk Jiminez, ed., *Dictionary of Artists' Models* (New York and London: Routledge, 2001), 447. See also Maev Kennedy, "Isabel Rawsthorne: Elusive Painter Who Led the Art World a Merry Dance," www.theguardian.com.

247 She had a dalliance: Ben Rogers, *A. J. Ayer: A Life* (New York: Grove Press, 1999), 194.

247 When she met Bacon: Jiminez, ed., *Dictionary of Artists' Models*, 447.

247 Bacon and Rawsthorne: Bacon made the claim in a very late interview (1992) with *Paris-Match*. Farson, *The Gilded Gutter Life*, 175.

247 He suffered from: See Lara Feigel, "On the Edge of Madness: The Terrors and Genius of Giacometti," *The Guardian*, April 21, 2017.

248 Not long after marrying: Isabel Rawsthorne, letter to Peter Rose Pulham, April 12, 1950, Tate Gallery archive, 9612.1.3, 36.

248 In December: Bacon, letter no. 7 to Sutherland, in Hammer, *Bacon and Sutherland*, 238–9.

248 English visitors, too: Ibid.

248 "It would be so lovely": Ibid.

248 The English art world: Ibid.

249 "I don't know how": Ibid.

250 Picasso began painting: See "*Las Meninas*, 1957 by Pablo Picasso," www.pablopicasso.org.

17 MR. HYDE

251 "About Paris": Bacon, letter no. 8 to Kathy Sutherland, in Martin Hammer, *Bacon and Sutherland* (New Haven and London: Yale University Press, 2005), 240.

251 Bacon did not come: Macdonald later wrote to Bacon saying that he regretted not seeing him that spring. Martin Hammer, "Francis Bacon and the Lefevre Gallery," *The Burlington Magazine*, May 2010, 310.

252 Through her wartime job: The wartime wedding was recorded on an Andrews Newspaper Index card, ancestry .co.uk. The marriage took place on March 14, 1942, in Chelsea.

252 After the war: Anthi-Danaé Spathoni, interview for the authors with Béatrice Mitchell, Eric Hall's granddaughter.

252 He would later: Bacon, quoted in Michael Peppiatt, *Francis Bacon: Anatomy of an Enigma* (London: Constable & Robinson, 2008), 124.

252 They had lunch: Roger Berthoud, *Graham Sutherland: A Biography* (London: Faber and Faber, 1982), 129–32.

252 They had much: Ibid., 240.

253 In May 1948: Ibid., 139. Four of the Tate's trustees were "customarily artists," as Berthoud wrote.

253 In November 1948: Letter of Sutherland to Robert Melville, dated November 20, in Robert Melville papers, Tate Archive. Cited in Hammer, *Bacon and Sutherland*, 38, 40.

253 After seeing them together: Benedict Nicolson, diary entry of February 13, 1947, cited in Richard Shone, "Benedict Nicolson: A Portrait," *The Burlington Magazine*, February 2004, 93.

253 Bacon and Nanny Lightfoot: Bacon's subsequent addresses are written on Nanny Lightfoot's carte d'identité, at the archives of the Hugh Lane Museum, Dublin, RM98F8:108. See also the chronology in *Francis Bacon Mb Art Foundation Monaco* (Monaco: Francis Bacon MB Art Foundation, 2015), 70.

253 It was decorated: All description comes from Annalyn Swan, visit to Monaco, July 2014. The authors are indebted to Majid Boustany for his tour of the city.

253 It stood on a steep hill: Bacon's later visits to the Hotel Balmoral were recorded in the diaries of Valerie Beston at the Marlborough Gallery. The Belle Époque building is no longer a hotel.

253 Bacon's recent visit: Berthoud, *Graham Sutherland*, 129–32.

254 In early April: Ibid., 132.

254 "The sound of the cicadas": Ibid.

254 The Sutherlands stayed: Ibid., 129–32. All of the information in this paragraph comes from Berthoud, *Graham Sutherland*.

255 They were given: Ibid., 133.

255 He had remained there: Stanley Jackson, *Inside Monte Carlo* (London: W. H. Allen, 1975), 169–70.

255 The Sutherlands began: Berthoud, *Graham Sutherland*, 133.

255 They also met: Ibid.

255 (In 2014): "The Most Expensive Homes for Sale in the World," www.forbes.com.

255 In his book: Roderick Cameron, *The Golden Riviera* (London: Weidenfeld and Nicolson, 1975), 298.

255 After their stay: Berthoud, *Graham Sutherland*, 134.

255 In May: Bacon, letter of May 26, 1947, to Duncan Macdonald, in Martin Hammer, "Francis Bacon and the Lefevre Gallery," *The Burlington Magazine*, May 2010, 311.

256 Nevertheless, Bacon wrote: Bacon, letter no. #2, June 20, 1947, to Colin Anderson, in Adrian Clark, "Francis Bacon's correspondence with Sir Colin Anderson," *The British Art Journal* VIII, no. 1 (Summer 2007), 40.

256 Anderson agreed: Bacon, letter no. 3, July 3, 1947, to Colin Anderson, in ibid., 40.

256 That same month: Bacon, letter of June 20, 1947, to Macdonald in Hammer, "Francis Bacon and the Lefevre Gallery," *The Burlington Magazine*, 311.

256 He mentioned: Ibid. The following quotations come from the same letter.

256 "I have a certain number": Bacon, letter no. 2 to Anderson, in Clark, "Francis Bacon's Correspondence," *The British Art Journal*, 40.

256 Bacon reported to Macdonald: Bacon, letter of May 26, 1947, to Macdonald in Hammer, "Francis Bacon and the Lefevre Gallery," *The Burlington Magazine*, 311.

256 "I will get a job": Ibid.

257 "She leaves for South Africa": Eric Allden diary, September 26, 1947. Allden's diaries were discovered by James Norton while researching the early life of Bacon for this book. The diaries are now in the Estate of Francis Bacon archive.

257 Upon his return to Monte Carlo: Bacon, letter no. 4 of October 9, 1947, to Colin Anderson, in Clark, "Francis Bacon's correspondence," *The British Art Journal*, 40.

257 Later that same day: Bacon, letter no. 5 of October 9, 1947 (second letter of the day) to Anderson, ibid.

258 But on a visit: Sophie Pretorius, "A Pathological Painter: Francis Bacon and the Control of Suffering," in *Inside Francis Bacon: Francis Bacon Studies III* (London: the Estate of Francis Bacon publishing, in association with Thames & Hudson, 2020), 169.

258 The Villa Souka-Hati: The address was written on both Bacon's and Nanny Lightfoot's identity cards.

258 Part of their appeal: Majid Boustany, conversation with Annalyn Swan, July 2014.

258 Just as Bacon set up: Berthoud, *Graham Sutherland*, 134–5. This time Lucian Freud drove down from London with them. But he left them in Aix and continued on to Monte Carlo on his own, both sides having grated on each other's nerves along the way. William Feaver, *The Lives of Lucian Freud: The Restless Years, 1922–68* (New York: Knopf, 2019), 257–8, 280.

258 Graham was "keen": Ibid., 258.

259 "I did not like": Bacon, letter no. 5 to Sutherland, in Hammer, *Bacon and Sutherland*, 236.

259 Picasso was now working: See "Vallauris: ceramic art and the spirit of Picasso," inexhibit.com.

259 The Sutherlands, during their autumn stay: Berthoud, *Graham Sutherland*, 135–6.

259 Sutherland, he thought: Roy Strong, *The Roy Strong Diaries 1967–1987* (London: Weidenfeld & Nicolson, 1997), 202–3.

259 "Graham was incredibly kind": Anne Dunn, interview with the authors, July 26, 2010.

260 He filled many sketchbooks: Berthoud, *Graham Sutherland*, 134–5.

260 In 1948 alone: Ibid., 137–8.

260 "It was a misfortune": Ibid., 137.

260 In mid-December of 1947: Ibid.

260 Early in 1948: Bacon, letter to Duncan Macdonald, January 23, 1948, in Hammer, "Francis Bacon and the Lefevre Gallery," *The Burlington Magazine*, 312.

261 "There is another thing": Ibid.

261 Bacon now turned: The correspondence between Bacon and Brausen during this period has been lost.

261 "I am so sorry": Bacon, letter no. 7 of February 20, 1948, to Colin Anderson, in Clark, "Francis Bacon's Correspondence," *The British Art Journal*, 41. All quotations in this paragraph come from the same letter.

261 She might even have intended: Two letters of 1948 from Bacon, in Monte Carlo, to Arthur Jeffress clearly show that an exhibition of his paintings was already in the works for the new gallery. The two letters also make clear, however, that Bacon would not bring any new work to London before November of that year. Clearly he would not have been a sure bet to inaugurate the new gallery. "Bacon's Letters to the Hanover Gallery," in Michael Peppiatt, *Francis Bacon in the 1950s* (Norwich: Sainsbury Centre for the Visual Arts, 2006), 144.

261 Some months earlier: Jean-Yves Mock, *Erica Brausen: Premier Machand de Francis Bacon* (Paris: L'Echoppe, 1996). Translated into English by Gill Hedley, www.gillhedley.co.uk.

262 She also brought in: Ibid.

262 Peter had gone: See Jeremy Rees, "Obituary: Peter Barker-Mill," www.independent.co.uk.

262 Jeffress had: Charles Darwent, "Buying in," www.the-tls.co.uk.

262 He owned: Ibid.

262 Since Bacon had so few: Berthoud, *Graham Sutherland*, 137–8.

262 The forward-looking Macdonald: Hammer, "Francis Bacon and the Lefevre Gallery," *The Burlington Magazine*, 312.

262 He was, wrote Berthoud: Berthoud, *Graham Sutherland*, 138.

263 The *Tribune* critic: Bernard Denvir, "Exhibitions: Graham Sutherland," *Tribune*, June 11, 1948, cited in Hammer, *Bacon and Sutherland*, 248.

263 The chatty column: "What's on in London," June 11, 1948, in ibid.

263 The legendary "Toto": Nisha Lilia Diu, "Toto Koopman: Model, Muse, Mistress—and Spy, *The Telegraph*, September 1 2013, www.telegraph.co.uk. Most of the biographical details come from this feature. The authors are also grateful to James Norton for translating salient details from Jean-Noël Liaut, *La Javanaise* (Paris: Editions Robert Laffont, 2011).

263 Bacon contributed: Martin Harrison, ed., *Francis Bacon Catalogue Raisonné* (London: Estate of Francis Bacon, 2016), Vol. II, 180.

264 Embarrassed by his debt: Bacon, letter no. 11, undated, to Colin Anderson in Adrian Clark, "Francis Bacon's Correspondence with Sir Colin Anderson," *The British Art Journal* VIII, no. 1 (Summer 2007), 42.

264 She and Toto purchased it: See Harrison, *Francis Bacon Catalogue Raisonné,* Vol. II, 178.

264 The promise was not forgotten: Bacon, letters, one undated and one dated September 30, 1948, to Arthur Jeffress in Peppiatt, *Bacon in the Fifties*, 144.

264 Soon, from Monte Carlo: Ibid.

264 At the end of September: Ibid.

18 SOHO NIGHTS

266 In 1949: James Norton, research into Eric Hall's political record.

267 He emerged: The Soho environment has been well documented. See Barry Miles, *London Calling: A Countercultural History of London since 1945* (London: Atlantic Books, 2010) and, more specifically, Sophie Parkin, *The Colony Room Club, 1948–2008: A History of Bohemian Soho* (London: Palmtree Publishers, 2013).

267 During the war: Philip Hoare, "Obituary: Gaston Berlemont," *The Independent*, November 11, 1999, www.independent.co.uk.

267 It opened: Parkin, *The Colony Room Club*, 3.

267 Wheeler's was run: Ibid.

267 In 1966: The portrait of Freud—more abstracted than usual with Bacon—was painted in 1965.

267 Informal but expensive: John Normile, interview with Annalyn Swan, November 9, 2017.

268 "He would say": Ibid.

268 The man behind: Miles, *London Calling*, 47.

268 Jeffrey Bernard: Bernard, "A Painter Who Coloured My Days," *The Sunday Independent,* May 3, 1992.

268 In December of 1948: Daniel Farson, *The Gilded Gutter Life of Francis Bacon* (New York: Pantheon, 1993), 58. As usual, Bacon was off about the year. It was 1948, not 1949.

269 It attracted a crowd: For an extended, and colorful profile of the Colony, see Daniel Farson, *The Gilded Gutter Life*, 58–63.

269 It consisted: Mike McKenzie, who was black, played there most often. Another pianist was "Granny Blackett"—"a stockbroker by day, a gay pianist by night." See also Sophie Parkin, *The Colony Room Club, 1948–2008: A History of Bohemian Soho* and Michael Wishart, *High Diver* (London: Blond and Briggs, 1977), 67–8. The artist Catherine

Shakespeare Lane, a Colony regular when she was young, recalled that Kenny Clayton, Petula Clark's music director and arranger, would sometimes play as well. Shakespeare Lane, interview with Annalyn Swan, February 12, 2009.

269 "I don't know": Bacon, quoted in Farson, *The Gilded Gutter Life*, 60.

269 When Bacon was penniless: Parkin, *The Colony Room Club*, 19.

269 "Muriel's girl Carmel": Isabel Rawsthorne, unpublished memoir, Tate Archive, 9612.2.2.

270 Muriel greeted: David Marrion, interview for Adam Low, director, *Francis Bacon*, *Arena* documentary, BBC Four archive, March 19, 2005.

270 She had been a proprietor: John Richardson, interview with the authors, June 28, 2012.

270 The "success": Rawsthorne, unpublished memoir.

270 The writer Geoffrey Wheatcroft: Wheatcroft, "Den Mother to the Louche and Famous," *The New York Times*, June 5, 2009.

270 John Moynihan, son: John Moynihan, *Restless Lives: The Bohemian World of Rodrigo and Elinor Moynihan* (Bristol: Sansom and Company, 2002), 140.

270 The club sometimes had: Several women members of the Colony spoke of Belcher's soft-heartedness behind the scenes. One was Margaret Fenton. Interview with Annalyn Swan, February 27, 2012.

270 She would lend: Belcher lent her fox fur to Henrietta Moraes. Ibid.

270 She maintained: Emelia Thorold, interview with Annalyn Swan, December 5, 2008.

270 "They'd throw a benefit": Ibid.

271 "She was a brave": Dan Farson, *The Gilded Gutter Life of Francis Bacon* (New York: Pantheon, 1993), 44.

271 Not infrequently: Bacon sent multiple letters of apology over the years to Denis Wirth-Miller in particular. See Jon Lys Turner, *The Visitors' Book* (London: Constable, 2016), 358 among others.

271 The journalist Dan Farson: Dan Farson, interview for John Christie, director, *Salvage of a Soho Photographer: The Life & Unsteady Times of John Deakin, 1912–1972*, Channel 4 documentary series, aired in 1991.

272 When Deakin noticed: Ibid.

272 Deakin was a witty: Jeffrey Bernard, in ibid.

272 "If he hadn't been": Ibid.

272 He once insulted Belcher: Ian Board, in ibid.

272 He had very large eyes: Farson, in ibid.

272 Lucian Freud said: Ibid.

272 During the day: For more on Deakin's photography career, see thejohndeakinarchive.co.uk.

272 Farson said that when he first went: Farson, in *Salvage of a Soho Photographer*.

272 Deakin was able to take: Bruce Bernard, *Salvage of a Soho Photographer*.

273 The portrait, as Bruce Bernard: Ibid.

273 Asked why he went: Bacon, quoted in Farson, *The Gilded Gutter Life*, 60.

273 If, for example: The convenience of Albany was pointed out by Christopher Gibbs, who lived there, and by John Richardson. Gibbs, interview with the authors; Richardson, interview with the authors, June 28, 2012.

273 Before the war: For a detailed description of the Gargoyle in both pre- and postwar periods, see Michael Luke, *David Tennant and the Gargoyle Years* (London: Weidenfeld and Nicolson, 1991).

273 The precocious Lucian Freud: Ibid, 169.

273 After dinner elsewhere: The description comes from Luke, *David Tennant*, 49.

274 Most people: Bacon, quoted in Luke, *David Tennant*, 49.

274 Tennant, in the 1920s: "Museum of Modern Art Shows Two Major Acquisitions," press release, Museum of Modern Art, undated, www.moma.org.

274 "He made the suggestion": Luke, *David Tennant*, 49.

274 The painter John Minton: The following information about Minton and the Gargoyle comes from Frances Spalding, *John Minton: Dance Till the Stars Come Down* (Aldershot, Hants UK: Hodder and Stoughton, 1991).

275 He had money: Spalding, *John Minton*, 8.

275 Minton was also: Moynihan, *Restless Lives*, 145–7.

275 In contrast, Moynihan wrote: Ibid.

275 "He played": Spalding, *John Minton*, 1. The following details come from Spalding's biography.

275 Bacon thought: Bacon, quoted in Luke, *David Tennant*, 182.

275 One night in 1950 or '51: Margaret Fenton, interview with Annalyn Swan, February 2, 2012. The rest of Fenton's quotes come from this interview.

276 But he was attracted: Bacon sometimes went to the Golden Lion on Dean Street when he wanted rough trade. In later years he frequented pickup bars around Piccadilly Circus. The authors are indebted to James Norton for his interview with Jeremy Reed, British poet and novelist, who was familiar with the underground scene in the 1980s.

276 Anne Dunn remembered: Dunn, interview with the authors, October 13, 2010.

277 Hall moved: E.M.G.R., "Mr. E.W. Hall," *The Times*, October 20, 1959.

277 In his last years: U.K., outward passenger lists, 1890–1960, ancestry.co.uk.

277 He died in 1959: *England & Wales, National Probate Calendar, Index of Wills and Administrations, 1858–1966, 1973–1995*.

277 Decades later: Bacon spoke fondly of Hall in numerous interviews over the years.

19 BROTHERS AND LOVERS

278 Their relationship flourished: William Feaver, *The Lives of Lucian Freud: The Restless Years, 1922–1968* (New York:

Knopf, 2019), 196. Much of the information about the young Freud comes from this book.

278 If Bacon was: Michael Luke, *David Tennant and the Gargoyle Years* (London: Weidenfeld and Nicolson, 1991), 168–9.

278 By the winter of 1939: William Feaver, *Lucian Freud* (London: Tate Publishing, 2002), 17. Exhibition catalog for the Tate Britain's *Lucian Freud* show of 2002.

278 He soon: Feaver, *The Lives of Lucian Freud*, 70.

278 It was "too much": Ibid., 71.

279 Originally located: "East Anglian School of Painting and Drawing," www.artbiogs.co.uk.

279 After a fire in 1939: Feaver, *The Lives of Lucian Freud*, 101.

279 Freud was "already": Ibid., 61. The Freud quotation comes from ibid., 97–8.

279 One of his earliest "conquests": Ibid., 86–7. As William Feaver wrote, "Certainly he dazzled Spender. 'Lucian is the most intelligent person I have met since I first knew Auden at Oxford, I think,' he wrote to a friend, Mary Elliott. 'He looks like Harpo Marx and is amazingly talented, and also wise, I think.' By Spender's account, he told T. S. Eliot that he was in love with Lucian and Eliot's response was, 'There's nothing I understand more.'"

279 The editorial secretary there: Hilary Spurling, *The Girl from the Fiction Department: A Portrait of Sonia Orwell* (Berkeley: Counterpoint, 2003), 49.

279 Spender found Freud: Phoebe Hoban, *Lucian Freud: Eyes Wide Open* (Boston: New Harvest, Houghton Mifflin Harcourt, 2013), 3.

279 By then Freud: Feaver, *Lucian Freud* exhibition catalog, 19.

279 They attended: Feaver, *The Lives of Lucian Freud*, 162.

279 Peter Watson said: Ibid.

279 They also joined: Roger Berthoud, *Graham Sutherland: A Biography* (London: Faber and Faber, 1982), 114.

280 He bought his first Bacon: Martin Harrison, ed., *Francis Bacon Catalogue Raisonné*, vol. II (London: Estate of Francis Bacon, 2016), 234.

280 Although Isabel Rawsthorne: Isabel Rawthorne, letter to Peter Rose Pulham, Tate Archive 9612/1.3.11.

280 (One of his later lovers): Anonymous, interview with Annalyn Swan, March 2012. Freud didn't like to eat alone, either, according to Freud's friend and lover.

280 Sometimes a surprise: Anne Dunn, interview with the authors, July 26, 2010. Freud wore tartan trousers when the two visited Ireland together in the late 1940s.

281 He was a great friend: Deborah Mitford, Duchess of Devonshire, *Wait for Me! Memoirs* (New York: Farrar, Straus and Giroux, 2010), 186.

281 "Being driven in London": Ibid.

281 During her brief marriage: Nancy Schoenberger, *Dangerous Muse: The Life of Lady Caroline Blackwood* (London: Weidenfeld & Nicolson, 2001), 85–6. Freud and Black-wood met in 1949 but Freud did not begin pursuing her until 1952. See also Feaver, *The Lives of Lucian Freud: The Restless Years, 1922–1968* (New York: Knopf, 2019), 369–74.

281 "Lucian was very attracted": Matthew Spender, quoted in Geordie Greig, *Breakfast with Lucian: The Astounding Life and Outrageous Times of Britain's Great Modern Painter* (New York: Farrar, Straus and Giroux, 2013) 71–2.

281 Freud admitted: Feaver, *The Lives of Lucian Freud*, 266.

281 "It was really": Stephen Spender, *Journals 1939–1983*, (London: Faber and Faber, 1985), 153.

281 Anne Dunn: Dunn, interview with the authors, July 26, 2010.

282 "As he undid his fly: Feaver, *The Lives of Lucian Freud*, 363.

282 Anne Dunn, who liked: Dunn, interview with the authors, July 26, 2010.

282 In the 1950s Freud fastened: Isabel Rawsthorne, letter to Peter Rose Pulham, Tate Archive, November 17 [unknown year], 9612/1.3.11.

283 In 1948, the "Two Roberts": Adam Low, director, *Francis Bacon, Arena*, BBC Four archive, March 19, 2005, unpublished interview with Wirth-Miller and Chopping.

283 Over the next few days: Jon Lys Turner's *The Visitors' Book: In Francis Bacon's Shadow: The Lives of Richard Chopping and Denis Wirth-Miller*. Turner (London: Constable, 2016), 66, gives a different account of the meeting. In a note by Richard Chopping from 1941, Chopping stated that Wirth-Miller "had started to get on particularly well with Francis," and that they had seen each other previously at the Gargoyle Club in London. Typed notes by Dicky Chopping for a planned autobiography seem to confirm this chronology. But Bacon himself said that he never went to the Gargoyle Club until after the war, and Chopping and Wirth-Miller observed, in the interview with Adam Low, that they did not meet Bacon until 1949. It is possible, of course, that Wirth-Miller and Bacon met each other for a brief period in 1941 during the war and then became reacquainted again eight years later. It is also possible that the "Francis" of 1941 is another Francis. The authors are grateful to Jon Lys Turner for providing excerpts from a draft of Chopping's autobiography that was based upon Chopping's own typewritten notes.

283 Bacon and Wirth-Miller: Chopping, interview with Low.

283 His father was a German: Dan Chapman, interview with the authors, February 12, 2011. Chapman was a friend of Chopping and Wirth-Miller and later a co-beneficiary and executor of their estates. See also information supplied by Chapman to David Buckman in "Denis Wirth-Miller: Bohemian Artist Who Enjoyed a Close Association with Francis Bacon" (obituary), *The Independent*, February 19, 2011.

283 But Wirth-Miller grew up: Turner, *The Visitors' Book*, 23.

284 Having left school: The authors are indebted to Dan Chapman for sharing details of Wirth-Miller's early life from a list of biographical details compiled by Wirth-Miller.

284 When he was twenty-one: For the date, see "Denis Wirth-Miller" (obituary), *The Independent*. Dan Chapman supplied to the authors the information about Sickert's studio.

284 He soon met: Chapman, interview with the authors. "Dicky always said they met at a Regent's Park garden party," said Chapman. "Garden parties were fashionable London events. Denis said they met at the Café Royal a month or so later. The Café Royal was a Regency café where literary and artistic people met and mingled. This was either 1937 or 1938."

284 Chopping came: Ibid.

284 Tall, elegant and reserved: Chopping never wanted to be stage center. Just the opposite was true of Wirth-Miller.

284 "I'd like you to meet": John Richardson, interview with Mark Stevens.

284 His publisher described: Christopher Hawtree, "Richard Chopping," *The Guardian*, June 13, 2008, www.theguardian.com.

284 Soon after they met: Turner, *The Visitors' Book*, 27.

284 Once war was declared: Ibid., 45.

284 Chopping was briefly conscripted: Ibid., 51–3.

284 The couple worked: Chapman, interview with the authors.

284 In 1941: Ibid.

285 Dicky and Denis "were": Freud, quote in Feaver, *The Lives of Lucian Freud*, 111.

285 Dicky craned above: Celia Hirst, interviews with the authors, November 2010 and February 24, 2011.

285 During the war: Turner, *The Visitors' Book*, 86–9.

285 On a visit: Ibid., 96–104.

285 In 1944: Ibid., 94–5.

285 On an early visit: Paul Rousseau, interview with Mark Stevens, November 6, 2014 and Annalyn Swan, February 17, 2020. Rousseau rediscovered nine negatives of Bacon posing in his underwear in August 2014, while researching the archive of Dicky Chopping and Denis Wirth-Miller in Wivenhoe. He was "stunned" to see Bacon in jazzy-looking underwear.

286 He had his own bedroom: Chapman, interview with the authors.

286 "Sometimes Dicky and Denis": Pam Dan, interview with the authors, February 24, 2011.

286 One Wivenhoe neighbor: Jan Richardson, interview with the authors, February 24, 2011.

286 Bacon was, said Chopping: Chopping, unpublished interview with Adam Low. Low and James Norton kindly made it available to the authors.

287 He was "a striking": Michael Wishart, *High Diver* (London: Blond and Briggs, 1977), 61.

287 He was a Gargoyle regular: Ibid., 25–6.

287 Wishart, born in 1928: For more on Freud's affair with Lorna Wishart, see Feaver, *The Lives of Lucian Freud*, 163 and following.

287 Wishart was only six years: Wishart, *High Diver*, 25–6.

287 He would later become: Philip Hoare, "Obituary: Michael Wishart," *The Independent*, July 2, 1996.

287 At one wedding: Ibid.

287 "Seated on the edge": Wishart, *High Diver*, 61–4.

287 She had met: Julia Blackburn, *The Three of Us: A Family Story* (New York: Vintage Books, 2009), 55–6.

288 In her astonishing account: Ibid., 37.

288 Not surprisingly: Ibid., 55–6.

288 But Blackburn was also: Thomas Blackburn, *A Clip of Steel* (London: MacGibbon and Kee Ltd., 1969), 81. Blackburn was drinking three or four Scotches at a time when he was seventeen.

288 He could fly: Ibid., 112 and elsewhere.

288 At their first meeting: Blackburn, *The Three of Us*, 56–7.

288 The two men collaborated: Ibid., 59.

289 His father, a clergyman: Thomas Blackburn, *A Clip of Steel*, 62–3.

289 Rosalie wanted to experiment: Blackburn, *The Three of Us*, 57–9.

289 Blackburn wrote in his notebook: Ibid., 56–7.

289 Bacon still retained: Ibid., 59–61.

290 Without question he sought: Ibid., 56–7.

290 In his notebooks: Blackburn, quoted in ibid., 59–61.

20 WILDE MAN

291 In the spring of 1949: Most of the detail about the ball in this and the succeeding paragraphs comes from Caroline Blackwood, "Francis Bacon: 1909–1992," *The New York Review of Books*, September 24, 1992, included in *The Company They Kept: Writers on Unforgettable Friendships* (New York: New York Review of Books, 2006), 201–6.

291 "All the guests": Ibid., 202.

291 But the fawning guests: Ibid.

291 The pleased princess: Ibid.

291 Others, said Freud, became: Martin Gayford, *Man with a Blue Scarf: On Sitting for a Portrait by Lucian Freud* (New York: Thames & Hudson, 2010), 209–10. Caroline Blackwood described the "buzzing of furious whispers" that followed Bacon's booing. Blackwood, "Francis Bacon: 1909–1992," *The New York Review of Books*.

291 Blackwood—the daughter of a marriage: Nancy Schoenberger, *Dangerous Muse: The Life of Lady Caroline Blackwood* (London: Weidenfeld & Nicolson, 2001), 4.

292 "'Who did that?'": *The Company They Kept*, 203.

292 Lady Rothermere: Among those who documented

Lady Rothermere's skills as a hostess was the curator Roy Strong, *The Roy Strong Diaries 1967–1987* (London: Weidenfeld & Nicolson, 1997), entry for January 30, 1973.

292 Lady Rothermere found: Freud told Martin Gayford years later that Bacon was "very drunk" the night of the ball. Gayford, *Man with a Blue Scarf*, 209–10.

292 "She had the money": Mark Amory, ed., *The Letters of Ann Fleming* (London: Collins Harvill, 1985), 42–3.

292 "Haven't seen Francis lately": Isabel Rawsthorne, letter of April 12 (no year) to Peter Rose Pulham, Tate Archive, 9612/1/3/36. Rawsthorne kept up a steady correspondence from London for years to her great friend Pulham in France.

293 "I went to see Francis": Ibid., 9612/1/3/21.

293 In August she wrote: Ibid., 9612/1/3/28.

293 One aid: The T-square can be seen in a number of photographs of Bacon's studio.

293 Photographs were not only: In 1951, the American art historian and writer Sam Hunter took photographs of the images that Bacon had scattered about his studio. The piece he subsequently wrote was "Francis Bacon: The Anatomy of Horror," *Magazine of Art*, January 1952.

293 Bacon remained interested: Bacon's copy of *Phenomena of Materialisation* was one of the original editions, published by Kegan Paul in London in 1920. The Estate of Francis Bacon, list of books both in Bacon's studio and in his bedsit.

294 "They would sit": Julia Blackburn, *The Three of Us: A Family Story* (New York: Vintage Books, 2009), 57–9.

294 Bacon cited it: David Sylvester, *Interviews with Francis Bacon* (New York: Thames and Hudson, 1987), 30–2.

294 In 1949, Denis Wirth-Miller: Bacon, in Richard Cork, presenter, "I'll Go On until I Drop," *Kaleidoscope* interview, BBC radio 4, August 17, 1991.

294 Muybridge, born in England: John Russell includes a lengthy section of background on Muybridge in his *Francis Bacon* (New York: Thames and Hudson, 1985), 59–65.

294 Muybridge created: Bacon referred to the "dictionary" of Muybridge's images in Sylvester, *Interviews with Francis Bacon*, 30.

295 be the marquee-name: Roger Berthoud, *Graham Sutherland: A Biography* (London: Faber and Faber, 1982), 153–7.

295 A retrospective: Ibid., 157.

295 Although he had no taste: Graham Sutherland, letter to Robert Melville in the Robert Melville papers, Tate archive. Quoted in Martin Hammer, *Bacon and Sutherland* (New Haven: Yale University Press, 2005), 40.

296 He introduced Sutherland: Jon Lys Turner, *The Visitors' Book* (London: Constable, 2016), 146.

296 In the end: Ibid.

296 She wrote of one meal: Isabel Rawsthorne, letter of December 30, 1950, to Peter Rose Pulham, Tate Archive, 9612/6/3/43.

296 "Am told that Lucian": Ibid., letter of April 12 (no year), Tate Archive, 9612/1/3/36.

296 "Very *Germanic*. Great detail": Ibid., letter of November 17 (no year), 9612/1/3/11.

296 "And one of the most immediate": Ibid., letter of July 3 (no year), 9612/1/3/27.

297 To Rawsthorne and Bacon: Ibid., letter of "3 Aout" (no year), 9612/1/3/32.

297 "This is what is so LACKING": Ibid.

297 He later said: Bacon, quoted in David Sylvester, *Looking Back at Francis Bacon* (New York: Thames and Hudson, 2000), 40.

297 (They were also reminiscent): The painting "has repeatedly been seen in the decades since as a prophecy of [Nazi war criminal Adolf] Eichmann's appearance in his glass cage" at his trial for war crimes." Ibid., 37.

297 It was not only Bacon: Ibid., 36.

297 "Largely a matter of texture": Rawsthorne, letter of "3 Aout" (no year) to Peter Rose Pulham, Tate Archive, 9612/1/3/32.

297 Bacon himself said: Bacon quoted in unsigned article, "Survivors," *Time*, November 21, 1949, Atlantic overseas edition, 44.

297 "You are quite right": Rawsthorne, letter of July 3 (no year) to Peter Rose Pulham, Tate archive, 9612/1/3/27.

298 "His suggestion for framing": Ibid., letter of December 31 (no year) to Peter Rose Pulham, 9612/1/3/17.

298 "And the frames!!!": Ibid., undated letter, 9612/1/3/19.

298 "No one, among all my old friends": Ibid.

298 But Francis Bacon "turned up": Ibid.

299 He placed the eyes: Martin Harrison, ed., *Francis Bacon Catalogue Raisonné* (London: Estate of Francis Bacon, 2016) Vol. II, 192.

299 Lawrence Gowing later wrote: Gowing, quoted in Daniel Farson, *The Gilded Gutter Life of Francis Bacon* (New York: Pantheon Books, 1993), 10.

300 The earthy power: The unnamed reviewer for *The Times* who covered the show ("Art Exhibitions: Mr. Francis Bacon") dismissed Robin Ironside's paintings as "a number of decorations in the rococo style, with sophisticated modern additions," November 22, 1949.

300 In his memoir: John Moynihan, *Restless Lives: the Bohemian World of Rodrigo and Elinor Moynihan* (Bristol: Sansom and Company, 2002), 171–2.

300 A friend of Toto Koopman: Jean-Noel Liaut, *La Javanese* (Paris: Robert Laffont, 2011). James Norton provided the authors with a gloss of the book.

300 "Spent evening with Francis": Rawsthorne, letter of November 25 [1949] to Peter Rose Pulham, Tate Archive, 9612/1/3/33.

300 The reviews were enticingly: For the "mutilated corpse" and "some act of violence," "Art Exhibitions: Mr. Francis Bacon," *The Times*, November 22, 1949, 7; for the

"tardily evolved creature," "Art in London: Paintings Pleasant and Unpleasant: Francis Bacon Studies," *The Scotsman*, November 26, 1949.

300 But even the critic: *The Scotsman*, ibid.

300 In *The Sunday Times*: Eric Newton, "Double Bass and Piccolo," *The Sunday Times*, November 13, 1949.

300 "Bacon is a Grand Guignol artist": Wyndham Lewis, "Round the London Art Galleries," *The Listener*, November 27, 1949.

301 "Of the younger painters": Ibid. Lewis even wrote a tantalizing, and rather poetic, preview in *The Listener* shortly before the show opened, based upon having seen *Head I* the previous summer at the Redfern Gallery.

301 John Rothenstein: John Rothenstein diary, November 8, 1949. Unpublished diaries, 1939–1990, Tate Archive, 8726/1.

301 "Show is most impressive really": Rawsthorne, letter of November 25 (no year) to Peter Rose Pulham, Tate Archive, 9612/1/3/33.

301 In a gossipy piece: "Art for the Few," *The Observer*, November 13, 1949.

301 Another gossipy item: "Good but Ghoulish," *The Daily Herald*, November 10, 1949.

302 The writer from *The Observer*: "Art for the Few," *The Observer*, November 13, 1949.

302 The piece that Melville wrote: Hammer, *Bacon and Sutherland*, 56.

302 "Every activity": Robert Melville, "Francis Bacon," *Horizon*, December 1949–January 1950, 419–23.

302 Bacon's work, he wrote: Neville Wallis, "Nightmare," *The Observer*, November 20, 1949.

302 "I felt stifled": Frances Partridge, *Diaries: 1939–1972* (London: Phoenix Press, 2001), 165–6.

303 Bacon sent: Ianthe Knott, interviews with Mark Stevens, March 5 and 6, 2008. Ianthe kept many of the newspaper clippings that Bacon had sent their mother.

303 "I think Erica is worried": Rawsthorne, letter of May 2 (no year) to Peter Rose Pulham, Tate Archive, 9612/1/3/37.

303 Now, before the opening: For details of the early sales, see individual paintings in Harrison, ed., vol. II, *Francis Bacon Catalogue Raisonné*.

303 "One of England's most original painters": "Survivors," *Time*, November 21, 1949, 44.

303 "I used to think that I heard": Sylvester, *Interviews with Francis Bacon*, 51.

304 Isabel Rawsthorne reported: Rawsthorne, letter of December 15, 1949, to Peter Rose Pulham, Tate Archive, 9612/1/3/59.

304 It had windows: Bacon, undated letter to Erica Brausen from Frontalière, Les Revoires, Monaco. Hanover Gallery records, "Correspondence 1948–1958," Tate Archive 863/6/2/2.

304 Bacon wrote to Sonia Brownell Orwell: Letter dated December 8 [1949] and headed Frontalière, Les Revoises, Monaco, telephone 027-36. Orwell archives, University College London.

304 Bryan Robertson, the future director: Robertson was famously described as "the best director the Tate Gallery never had." Instead, he became the director of the Whitechapel Gallery, which had originally been founded to bring great art to the depressed areas of East London. In 1956, the Whitechapel Gallery would mount an influential collaborative show that essentially introduced Pop Art to Britain.

304 He was amused: Bryan Robertson, quoted in Farson, *The Gilded Gutter Life*, 113.

305 "I feel I should be able": Undated letter from Bacon to Erica Brausen, Hanover Gallery, correspondence 1948–1958, Tate Archive, 863/6.2.2.

305 "There are plenty of rooms": Ibid.

305 They were joined: For more on the Judas, see Amanda Hopkinson, "Elsbeth Juda Obituary," *The Guardian*, August 4, 2014. Martin Harrison wrote of the cool modern esthetic on display at the Judas' flat in London, which attracted such painters as Richard Smith, in Martin Harrison, *Transition: The London Art Scene in the Fifties* (London: Merrill Publishers Ltd./Barbican Art Galleries, 2002), 11.

305 The Sutherlands and their party: Berthoud, *Graham Sutherland*, 144.

305 The next day: Ibid.

305 Earlier that year: Ibid., 141–2.

305 But the portrait led: Lord Beaverbrook followed, as did the Queen Mother.

305 In Sutherland, *Time* found: Ibid., 142.

305 The two artists were still friendly: John Rothenstein diary, November 8, 1949, unpublished diaries, 1939–1990, Tate Archive, 8726/1.

306 When Bacon and Sutherland: Rawsthorne, letter of November 25 [1949] to Peter Rose Pulham, Tate Archive, 9612/1/3/33.

306 Bacon made a brief trip: Harrison, ed., *Francis Bacon Catalogue Raisonné*, 83.

21 FOLLIES

308 It was still remembered: John Richardson, interview with the authors, June 28, 2012.

308 Some months earlier: Michael Wishart, *High Diver* (London: Blond and Briggs, 1977), 64.

308 "I fell in love": Ibid.

308 The daughter of: Ibid., 67.

308 "The English bit of life": Anne Dunn, interview with the authors, July 26, 2010.

308 "Anne's background was quintessentially": Wishart, *High Diver*, 67.

308 He consulted a psychiatrist: Ibid., 22.

309 She had been having: Dunn, interview with the authors, July 26, 2010.

309 "My father was spectacularly": Annie Freud, quoted in Phoebe Hoban, *Lucian Freud: Eyes Wide Open* (Boston and New York: New Houghton Mifflin Harcourt, 2013), 43.

309 Instead, on July 17, 1950: Wishart, *High Diver*, 67.

309 He painted his two: Ibid., 67–8. All of the subsequent details of Bacon's wedding reception come from *High Diver*.

310 The writer John Richardson remembered: Richardson, interview with the authors, June 28, 2012.

310 A popular piece of gossip: Not-for-attribution, interview with the authors, 2010.

310 Freud did not go: William Feaver, *The Lives of Lucian Freud: The Restless Years, 1922–1968* (New York: Knopf, 2019), 333–4.

310 "My mother had a house": Richardson, interview with the authors.

310 Wishart credited his wedding: Wishart, *High Diver*, 67–8.

310 David Tennant: Ibid.

310 The party continued: Dunn, interview with the authors, June 28, 2012.

310 Wishart wrote: Wishart, *High Diver*, 67–8.

311 The art dealer Helen Lessore: Lessore, quoted in Daniel Farson, *The Gilded Gutter Life of Francis Bacon* (New York: Pantheon Books, 1993), 99.

311 "If there is a force-field": Moraes, quoted in Patrick Cooney, "The Queen of Soho," *The Guardian Weekly*, August 22, 1998.

311 As a wedding present: Wishart, *High Diver*, 61–4.

311 In her diary: Frances Partridge, *Frances Partridge, Diaries 1939–1972* (London: Phoenix Press, 2001), 167.

311 From Frontalière: Hanover Gallery files, Tate Archive, undated letter, 863/6.2.2.

312 Vertical lines: Robert Melville, "Francis Bacon," *Horizon*, December 1949–January 1950, 419–23.

312 Melville, who visited: Melville, "The Iconoclasm of Francis Bacon," *World Review* (London), January 1951, 63–4.

313 But the mysterious: Ibid.

313 "It is far and away": Isabel Rawsthorne, letter of December 30 [1950] to Peter Rose Pulham, Tate Archive, 9612/1/3/43.

313 "The figure is at once monumental": David Sylvester, *Looking Back at Francis Bacon* (New York: Thames and Hudson, 2000), 46–9.

314 The reason, he said: David Sylvester, *Interviews with Francis Bacon* (New York: Thames & Hudson, 1987), 38.

314 He destroyed the second: In describing the creation and destruction of Bacon's series of pope paintings, certain assumptions have been made that seem justifiable. Images of the three paintings exist because they were photographed in 1950 before their presumed destruction. Since Bacon would not himself have had them formally photographed, the presumption is that his art dealer Erica Brausen had them photographed as part of her preparations for the show. The three photos were included in Ronald Alley's first Bacon catalogue raisonné, and were likely provided to Alley by Brausen who—despite being deeply hurt when Bacon left for the Marlborough Gallery—cooperated with the future organizers of his retrospectives by providing archival and documentary information. The Alley catalogue raisonné, published in 1964, reported that all three paintings were destroyed. No doubt Brausen and Bacon both believed that to be the case. But when Bacon sent the painting to a local artist supply store so that the stretchers could be reused, the original canvases were carefully removed and stored. Sylvester, *Looking Back at Francis Bacon*, 44. That Bacon preferred the first to the second pope—which he destroyed outright—is clear both from Melville's enthusiasm and Isabel Rawthorne's admiring mention of painting.

314 Brausen refused: Isabel Rawsthorne, letter of February–March [1950] to Peter Rose Pulham, Tate Archive, 9612/1/3/56.

315 Bacon clearly still liked: That he let Isabel Rawsthorne see the painting was proof of that.

315 At the end of August 1950: Rawsthorne, letter of August 29 [1950] to Peter Rose Pulham, Tate Archive, 9612/1/3/28.

316 The critic for *The Times*, however, wrote: "Hanover Gallery: Mr. Francis Bacon's Paintings," *The Times*, September 22, 1950.

316 In an undated letter: Rawsthorne, letter to Peter Rose Pulham, Tate Archive, 9612/1/3/85.

316 Stride, wrote Minton's biographer: Frances Spalding, *John Minton: Dance Till the Stars Come Down.* (Aldershot, Hants UK: Hodder and Stoughton, 1991), 147.

317 The constantly clowning: Bacon, quoted in Francis Giacobetti, "Francis Bacon: The Last Interview," *The Independent Magazine*, June 14, 2003.

317 Darwin, appointed director: Juliet Thorpe, "Darwin's Dream: The Significance of Painting and Its Collection at the Royal College of Art 1948–1998," master's thesis, RCA, 2012, 2.

317 One of Darwin's first moves: Spalding, *John Minton*, 133.

317 Moynihan was a gifted: John Moynihan's *Restless Lives* provides a marvelous behind-the-scenes look at his parents' world, which revolved around the Royal College and the Gargoyle.

317 Along with appointing new faculty: Juliet Thorpe, "Darwin's Dream," 29.

318 "Extraordinary members": Spalding, *John Minton*, 133–4.

318 "Outwardly, Minton personified": Ibid., 151–2.

318 In June 1950: Ibid.

318 He had gone to Paris: Ibid., 27.

318 "They have inaugurated": Minton, letter to Edie Lamont, July 19, 1948, quoted in Spalding, ibid., 133.

318 Bacon did not try: Ibid., 153.

318 "Have seen Francis once only": Rawsthorne, undated letter to Peter Rose Pulham, Tate Archive, 9612/1/3/63.

319 The festival, an exercise: Becky E. Conekin, *The Autobiography of a Nation: The 1951 Festival of Britain* (Manchester: Manchester Uniersity Press, 2003). See also "The Festival of Britain," www.vam.ac.uk.

319 As part of the Festival: Ibid.

319 Bacon drily told: Rawsthorne, letter of December 30 [1950] to Peter Rose Pulham, Tate Archive, 9612/1/3/43.

319 Born in 1883: Norman Miller, "The Surreal and Colourful Life of Baron Berners," *The Telegraph*, July 1, 2016, www.telegraph.co.uk. The following detail comes from this article as well.

319 He once asked his friend: Diana Souhami, "Lord Berners, the Last Eccentric," *The Independent*, March 21, 1998, www.independent.co.uk.

320 Cyril Connolly once observed: Nancy Mitford attributed the remark to Cyril Connolly, which was then widely repeated in subsequent writing about the life of Lord Berners.

320 At Faringdon: Southami, "Lord Berner," *The Independent*; Miller, "The Surreal and Colourful Life," *The Telegraph*.

320 "Lord Merlin": Miller, "The Surreal and Colourful Life," *The Telegraph*.

320 In the early 1930s, Richard Brain, Obituary of Robert Heber-Percy, on the website of Faringdon, Lord Berners's estate, www.faringdon.org. It originally appeared in *The Independent*.

320 Berners adored him and built: Miller, "The Surreal and Colourful Life," *The Telegraph*.

320 In 1942: Rachel Cooke, "A Family Saga with All the Trimmings," *The Observer*, October 19, 2014. Review of Sofka Zinovieff, *The Mad Boy, Lord Berners, My Grandmother and me*.

321 One of Lord Berners: See Rumon Gamba, "The Film Music of Constant Lambert & Lord Berners," www.allmusic.com.

321 "Social notes too long": Isabel Rawsthorne, undated letter from 1949 to Peter Rose Pulham, Tate Archive, 9612/1/3/41.

321 The party lights: Cooke, "A Family Sage," *The Observer*.

321 "How lucky you are": Michael Peppiatt, *Francis Bacon in Your Blood: A Memoir* (New York: Bloomsbury USA, 2015), 176.

321 "He, Francis": Isabel Rawsthorne, letter of January 10, 1951, to Peter Rose Pulham, Tate Archive, 9612/1/3/49.

22 HOMELESS

322 The mail boats: See Michael Grace, "Union Castle liners from Southampton to South Africa," www.cruiselinehistory.com.

322 The Union Castle ships: Ibid.

322 But he skimped: Michael Peppiatt, *Francis Bacon: Anatomy of an Enigma* (London: Constable & Robinson, 2008), 165.

322 Tourist-class passengers: See "Union Castle Liner," www.lastoceanliners.com.

322 Bacon exaggerated: Ibid.

322 The voyage to South Africa: See "Ocean Liner Sailing Schedules, Union Castle Line," ibid.

322 No doubt many passengers: See "Miscellaneous Ephemera," www.timetableimages.com.

323 Ianthe and her husband: Ianthe Knott, interviews with Mark Stevens, March 5 and 6, 2008.

323 Three years later: Ibid. From 1923 to 1964, Rhodesia was named Southern Rhodesia.

323 Bacon's mother was living: Ibid.

323 Bacon's youngest sister: Ibid.

323 The younger Winnie's marriage: Ibid.

323 Ianthe felt: Ibid.

323 Winnie had asked: Ibid.

323 "I don't think we saw": Ibid.

324 *Landscape*, 1952: Bacon particularly admired van Gogh's painterly depiction of grass. "It's true to say that when he painted a field he was able to give you the violence of grass. Think of the violence of the grass he painted." Bacon in David Sylvester, *Looking Back at Francis Bacon* (New York: Thames and Hudson, 2000), 243.

324 "He never stayed": Krott, interview with Stevens.

324 The fortified city: "Great Zimbabwe Ruins," www.greatzimbabweruins.com/.

324 Bacon wrote: Bacon, letter of February 22, 1951, to Erica Brausen, Hanover Gallery correspondence 1948–1958 with Bacon, Tate Archive, 863.

325 Anne Dunn did not consider: Anne Dunn, interview with the authors, July 26, 2010.

325 "Robert Heber-Percy has left": Bacon, letter of February 22, 1951, to Brausen, Tate Archive.

325 He still intended: Ibid.

325 He wrote: Ibid.

325 "Everyone is so terribly nice": Ibid.

326 He proposed: Bacon, letter of February 27, 1951 to Brausen, Tate Archive.

326 Two temple complexes: Homer, *The Iliad*, Book 9.

326 The celebrated sphinxes: The Avenue of the Sphinxes originally contained approximately 1,350 sphinx statues. See "Avenue of the Sphinxes, Thebes," www.ancient.eu.

326 Bacon told the painter and art dealer: Bacon, quoted in a letter from Helen Lessore to Bacon, October 29, 1985, Hugh Lane Gallery archive, Dublin (Ref. No. RM98F114:93).

326 "I always find medieval art": Bacon quoted in Sylvester, *Looking Back*, 141.

326 Researchers after Bacon's death: Bacon had far more

books in his studio and flat about ancient Egyptian art—thirty-five—than on any other topic. The Hugh Lane Gallery in Dublin, which acquired the contents of Bacon's studio (and the books from his flat) after his death, noted that there were "extensive paint accretions" in Bacon's copy of *The Art of Ancient Egypt: Architecture, Sculpture, Paintings.* It was published in 1936 by Phaidon Press in London.

327 "One characteristic letter": Isabel Rawsthorne, letter of April 15 [1950] to Peter Rose Pulham, Tate Archive, 9612/1/3/51.

327 After the bacchanal: Michael Wishart, *High Diver* (London: Blond and Briggs, 1977), 69–73.

327 The couple named: Ibid., 73.

327 Nanny Lightfoot: A copy of her death certificate is in the collection of the Hugh Lane Gallery, Dublin, RM98F105:121, © The Estate of Francis Bacon.

327 "Frances," said Wishart: Dan Farson, *The Gilded Gutter Life of Francis Bacon* (New York: Pantheon, 1993), 114.

327 Every week, for years: Ibid., 256. She may or may not have been a childhood nurse of Bacon.

327 She was the "advisor": Richardson, interview with the authors, June 28, 2012.

327 Near the end: Michel Archimbaud, *Francis Bacon: In Conversation with Michel Archimbaud* (New York: Phaidon Press, 1993), 161.

328 Diana Watson: The Watsons lived on Thurloe Place near Bacon in South Kensington for many years. His aunt Virginia died in 1974; Diana Watson then lived in Knightsbridge, off Pont Street, in her final years. Anthony-Noel Kelly, interview with Annalyn Swan, September 25, 2013. Kelly's grandmother knew Diana. "Diana and I met quite often," he said. "This was the late eighties."

328 "He was heartbroken": Richardson, interview with the authors, June 28, 2012.

328 She therefore gave them: The size listed for the painting in the catalog was the same size as the pope paintings.

328 Buhler later sold: Buhler sold at least thirteen paintings to the Piccadilly Gallery that Bacon had discarded and left behind at Cromwell Place. They dated from the war years through Bacon's experiments with heads in the late 1940s and included *Fury* of 1944, an important variant on Bacon's breakthrough *Three Studies.* Bacon, who did not want any of his discarded paintings to come on the market, considered taking legal action against Buhler, as Valerie Beston wrote years later. In a letter of April 18, 1968, Beston reported that Bacon had found out "that in English law, the contents of the basement of the house became the property of the new tenant and he had no redress." Valerie Beston, letter, Marlborough Gallery, London.

328 He sent: David Sylvester, *Looking Back at Francis Bacon,* 44. See note on page 753, "He destroyed the second."

329 He owed money to: As far back as the 1920s and '30s, when he would go home to visit his family, his "bespoke"

shirts annoyed his father. In *Restless Lives,* John Moynihan wrote that "if he was to wear a shirt, it looked as if it had been purchased at Harvie and Hudson." And in 1952, Bacon—attempting to get a loan from Colin Anderson—wrote Anderson that his tailors were suing him. (Letter no. 9, February 14, 1952) See Adrian Clark, "Francis Bacon's Correspondence with Sir Colin Anderson," *The British Art Journal* VIII, no. 1, (Summer 2007), 41.

329 He was almost one: The Royal College was near Bacon's old studio at 7 Cromwell Place.

329 Even the conservative sculptor: William Feaver, *The Lives of Lucian Freud: The Restless Years, 1922–1968,* 368.

329 It was there: John Moynihan, *Restless Lives: The Bohemian World of Rodrigo and Elinor Moynihan* (Bristol: Sansom and Company, 2002), 117.

329 Bacon meanwhile also found: Ronald Alley, ed., *Francis Bacon* (London: Thames and Hudson, 1964), 277. First catalogue raisonné.

329 About a month: John Rothenstein diary, July 30, 1951, unpublished diaries, 1939–1990, Tate Archive, 8726/1. In the end, Bacon went down a few months later.

329 He soon returned: Ibid., November 20, 1951.

330 Spectacle, as Leni Riefensthal: Riefensthal infamously (and seductively) shot highly successful propaganda movies for Hitler and the Nazis in the 1930s.

331 In the third painting: *Pope III* (1950).

331 Melville called his pictures: Robert Melville, "A Note on the Recent Paintings of Francis Bacon," *World Review,* February 1952, 31–2.

331 In 1950: Eric Newton, "An Unhappy Genius, *The Sunday Times,* September 7, 1950.

331 And in 1952, Lawrence Alloway wrote: "Points of View: Bacon and Balthus," *Art News and Review,* January 26, 1952, 7.

332 A critic from Glasglow: "Baconian Extension," *Glasgow Herald,* January 6, 1952.

332 "Jimmy" Bomford: See "Jimmy Bomford," aldbourne-heritage.org.uk.

332 Beginning with: Martin Harrison, ed., Vols. II and III *Francis Bacon Catalogue Raisonné* (London: Estate of Francis Bacon, 2016).

333 But the Fitzwilliam found: "In Memoriam Professor Francis John Anscombe," *Yale News,* October 23, 2001.

333 His views were shaped: In his diaries, Rothenstein quoted Berenson's view that "it needed only a considerable artist to appear to blow [Picasso] and [Henry Moore] sky-high!" Rothenstein himself wrote that there was "more artistic genius concentrated in the Sala del Maggior Consiglio [Higher Council Hall of Venice] than all Europe could produce. We could no more have produced that than the builders and embellishers of it could have produced a jet engine." Rothenstein unpublished diaries, Tate Archive, 8726/1.

333 Rothenstein, after a lunch: Ibid.

333 In 1951 Rothenstein "hardly knew": Rothenstein, *Brave Day Hideous Night: Autobiography 1939–1965* (London: Hamish Hamilton, 1966), 219.

333 Kenneth Clark: "Kenneth Clark," *The Burlington Magazine*, May 2014, www.burlington.org.uk.

333 One night in August of 1951: Rothenstein, *Time's Thievish Progress* (London: Cassell, 1970), 13.

333 In 1953 he would have: "Matthew Smith: Paintings from 1909 to 1952," www.tate.org.uk.

333 After dinner, the two men: Rothenstein diary, July 30, 1951, unpublished diaries, Tate Archive; *Time's Thievish Progress*, 13.

334 It proved a revelation: Ibid.

334 Bacon, he noted: Rothenstein private diary.

334 He would move: Bacon's many moves are documented in Ronald Alley, *Francis Bacon*, 277–8.

23 LOVE AND POWER

335 Bacon met: William Feaver, *The Lives of Lucian Freud: The Restless Years 1922–1968* (New York: Knopf, 2019), 98. During the war, Freud frequented Careless Talk and the Music Box. He recalled Lacy playing at Careless Talk. However, Lacy, who served in the military during the war years, did not become a Soho regular until after the war.

335 Or perhaps: John Richardson also recalled Lacy's playing at the Music Box. John Richardson, interview with the authors, June 28, 2012.

335 He dressed smartly: Fr. David Lacy and Gerald Towell, interview with the authors, February 2, 2009. Lacy and Towell are nephews of Peter Lacy.

335 He had "an extraordinary": Michael Peppiatt, *Francis Bacon: Anatomy of an Enigma* (London: Constable and Robinson, 2008), 145.

335 Behind the elegant: Daniel Farson, *The Gilded Gutter Life of Francis Bacon* (New York: Pantheon, 1993), 143.

335 The more prosaic truth: Much of the information on Peter Lacy—and the corrections of the public record—come from his nephews Fr. David Lacy and Gerald Towell, interview with the authors, March 17, 2011.

336 He had lived abroad: In the late 1940s he had lived for a time in Barbados. Bacon painted his house there from a photograph that Lacy gave him.

336 Some of Bacon's friends: Farson, *The Gilded Gutter Life*, 143.

336 "I remember he came up to me": Richardson, interview with the authors, June 28, 2012.

336 "Even his calves": Michael Peppiatt, *Francis Bacon in Your Blood: A Memoir* (New York: Bloomsbury USA, 2015).

336 During the Norman Conquest: All of the details about the history of the de Lacy family, Peter de Lacy's immediate relatives, and his childhood and young adulthood in the following pages, come from the authors' interview with his nephews David Lacy and Gerald Towell.

338 In the summer of 1938: Frederick N. Rasmussen, "Fats Waller, a 'Master of Jazz,'" *The Baltimore Sun,* February 2, 2002.

339 In 1939 Peter took: Lacy and Towell, interview with the authors.

339 Soon he began: Military records, courtesy of David Lacy and Gerald Towell.

339 Cairo and Alexandria: See Desmond Ariel, "Alexandria," glbtq Encyclopedia project, www.glbtq.archive .com.

340 He first settled, in June of 1946: Peter Lacy's identity card gave his residence as 26 Sackville Street in June of 1946. In 1947 he was on Wimpole Street in Marylebone (identity card and electoral register). He then left England for Barbados, returning in 1950. Lacy's identity card was included in an auction by Live Auctioneers in Woking, Surrey, in 2007 of items discarded by Bacon. The items were part of the so-called Robertson collection.

340 He dabbled at being a stockbroker: On the log of the *Carnaron Castle*, on which Bacon and Lacy sailed from South Africa to England, Lacy listed his occupation as "stockbroker."

340 Then, in 1948: Fr. David Lacy and Gerald Towell, interview with the authors.

340 In July of 1950: Peter Lacy sailed for Barbadoes on July 19, 1950. UK Outward Passenger Lists, accessed through ancestry.co.uk. This was the trip in which he listed his occupation as "nil."

340 Daniel Farson recalled: Farson, *The Gilded Gutter Life*, 170.

341 Partridge, in a letter: Frances Partridge, letter to Dicky Chopping, in Jon Lys Turner, *The Visitors' Book* (London: Constable, 2016), 152.

341 Bacon told Michael Peppiatt: Peppiatt, *Francis Bacon: Anatomy of an Enigma*, 145.

341 On Daniel Farson's second day: Farson, *The Gilded Gutter Life*, 79.

341 Not long after the ship: Peppiatt, *Francis Bacon in Your Blood*, 75.

342 "People came up to me": Ibid.

342 Ianthe had only vague: Ianthe Knott, interviews with Mark Stevens, March 5 and 6, 2008.

342 In the middle of May: The ship arrived on May 30, 1932. UK, Incoming Passenger Lists, accessed on ancestry .co.uk.

342 Sylvester especially disliked: See James Hyman, "Fifty Years of Hurt: The Legacy of the Battle for Surrealism," *The Guardian*, September 22, 2001, www.theguardian .com.

343 The son of a Russian-Jewish: Nicholas Wroe, "Guardian Profile: David Sylvester: Sacred Monster, National Treasure," *The Guardian*, July 1, 2000.

343 When he was not quite sixteen: Ibid.

343 "I don't have a drop": David Plante, *Becoming a Londoner: A Diary* (New York: Bloomsbury, 2013).

343 He was only twenty years old: "David Sylvester," (obituary), *The Telegraph*, June 20, 2001, www.telegraph .co.uk.

343 The arts editor Aneurin Bevan: Liz Jobey, "David Sylvester" (obituary), *The Guardian*, June 20, 2001, www .theguardian.com.

343 Henry Moore liked Sylvester's piece: Ibid.

343 He was sometimes entrepreneurial: In the early 1950s, Sylvester sold a number of Bacon paintings for him when Bacon was hard up. Bacon gave him a 20 percent commission. David Sylvester, *Looking Back at Francis Bacon* (London: Thames & Hudson, 2000), 260.

343 Despite his unusual: Wroe, "Guardian Profile/David Sylvester," *The Guardian*.

343 Instead, in 1947: "David Sylvester," (obituary), *The Telegraph*.

344 The young critic: Ibid.

344 Years later: "Interview with David Sylvester," Frieze art fair publication, September 9, 1996, frieze.com.

344 He was a champion: Hyman, "Fifty Years of Hurt," *The Guardian*.

345 Compared to the ephemeral quality: This and all subsequent quotations come from John Berger, "Francis Bacon" (Hanover Gallery exhibition review), *New Statesman and Nation*, January 5, 1952.

346 In his *Listener* piece: All subsequent quotes come from David Sylvester, "The Paintings of Francis Bacon" (Hanover Gallery exhibition review), *Listener*, January 3, 1952.

348 In a 2004: John Berger, review of Bacon's show at the Maillol Museum, Paris, May 2004, in *The Guardian*, May 29, 2004; reprinted as "A Master of Pitilessness" in John Berger, *Hold Everything Dear: Dispatches on Survival and Resistance* (New York: Vintage Books, 2007), 93.

349 "I am in a desperate": Bacon, letter no. 8 to Colin Anderson, written from 30 Sumner Place, February 5, 5[2], in Adrian Clark, "Francis Bacon's Correspondence with Sir Colin Anderson," *The British Art Journal* VIII, no. 1, (Summer 2007), 41.

349 Bacon mentioned: Letter no. 9 to Colin Anderson, dated February 14, 195[2], in ibid.

350 "I must say painting": Ibid.

350 She often complained: Arthur Jeffress, the primary financial backer, left in 1953 to start his own gallery. Isabel Rawsthorne, letter to Peter Rose Pulham, September 5 [no year], Tate Archive, 9612/1/3/37.

350 In one letter: Bacon, letter to Erica Brausen, February 9 [no year provided] from The Store House, The Quay, Wivenhoe, Essex (the house of Richard Chopping and Denis Wirth-Miller). In Hanover Gallery correspondence 1948–1958, Tate Archive, 863/6.

350 In early February: John Rothenstein, unpublished diaries, 1939–1990, Tate Archive, 8726/1. The relevant entry dates are February 8, 20, and 21.

351 Stung, astonished: Jean-Yves Mock, *Erica Brausen: Premier Marchand de Francis Bacon* (Paris: L'Echoppe, 1996. Translated into English by Gill Hedley, www.gillhedley .co.uk.

351 She even wrote about him: Helen Lessore, *Partial Testament: Essays on Some Moderns in the Great Tradition* (London: Tate Gallery Publishing, 1987), 77.

352 During 1952: Martin Harrison, ed., *Francis Bacon Catalogue Raisonné*, vol. II (London: Estate of Francis Bacon, 2016), 262–3.

352 When Brausen closed her gallery: In all, Helen Lessore bought enough work to mount a small show of Bacon paintings in December of 1953. They included two important paintings—*Study for a Portrait* (1953), which was the immediate precursor of his businessmen paintings in the 1950s, and the seminal *Study after Velazquez's Portrait of Pope Innocent X*, the most famous of all of Bacon's pope paintings.

352 Wirth-Miller reportedly helped: Ronald Alley, *Francis Bacon* (London: Thames and Hudson, 1964), 58–60. Catalog raisonné.

352 Never one to remain: When Valerie Beston, who worked closely with Bacon at the Marlborough Gallery— his gallery from 1958 to his death in 1992—queried Wirth-Miller about a dog painting, he replied; "Yes, I was around when Francis was painting the dogs—in fact helped him with the Tate one." (*Dog*, 1952, was purchased by the Tate.) Then Wirth-Miller added, "Francis very generously thought them [Wirth-Miller's dog paintings] better than his. He was always generous." No doubt Beston "heard" a slight smirk. Marlborough Gallery archive.

352 In October of 1954: Chronology in *Denis Wirth-Miller*, exhibition catalog, The Minories Gallery, Colchester Institute, 2011.

352 Bacon had stored: Dan Chapman, friend, co-executor and beneficiary of the artists' estate, interview with the authors, February 12, 2011. Chapman very kindly let the authors tour the studios of Chopping and Wirth-Miller.

353 The currish dog: Alley, *Francis Bacon*, 63.

24 THE VIOLENCE OF GRASS

354 In June of 1951: The date is listed on Lacy's National Registration Identity Card No. YD1P2472725. It was part of the "Robertson collection" of material discarded by Bacon that was auctioned by Live Auctioneers in Woking, Surrey, in 2007.

354 His sister Joan: Fr. David Lacy and Gerald Towell, interview with the authors, March 17, 2011.

354 He was not especially concerned: Ibid. Gerald Towell recalled: "I went once to the cottage at Hurst. It was quite charming. There was a collection of miniature spirit bottles

on the mantelpiece. He had a beautiful grand piano. It may well have been a thatched cottage—quite dark."

354 Early in 1952: 30 Sumner Place was the address on Bacon's letters to Colin Anderson in early 1952. Six Beaufort Gardens was the address listed on the ship's records on his second voyage to South Africa.

354 They would sometimes: The artist John Piper, one of England's most prominent artists prior and during World War II, lived at Fawley Bottom, a hamlet just north of Henley. Piper was instrumental in helping Bacon find a studio in Henley during his time there.

355 "You can leave your painting": Bacon to Michael Peppiatt, *Francis Bacon: Anatomy of an Enigma* (London: Constable and Robinson, 2008), 178.

355 Lacy "wanted to have me": Ibid.

357 In later years, Bacon claimed: Bacon, letter of December 21, 1959, to Denis Wirth-Miller from St. Ives. Courtesy of Jon Lys Turner, friend, co-executor and beneficiary of Dicky Chopping and Denis Wirth-Miller.

357 Isabel Rawsthorne breezily reported: Rawsthorne, letter of November 30 [1950] to Peter Rose Pulham, Tate Archive, 9612/1/3/73.

357 Freud never forgave: Alice Weldon, a close, longtime friend of Freud's from the late 1960s to the 1980s, recalled Freud's saying how angry he became at Peter Lacy over his violence toward Bacon. Alice Weldon, interview with Annalyn Swan, March 7, 2012.

357 Rawsthorne was no less impressed: Letter of November 30. [1950] to Pulham. "His show opens on the 9th Dec. He started painting three weeks ago." Tate Archive, 9612/1/3/73.

357 It was in that same: There is even a skull, that most old-fashioned of props, atop the cabinet. Bacon was not a great admirer of the huge painting, telling Rodrigo's son, "I don't, actually, John, believe in photography." John Moynihan, *Restless Lives: The Bohemian World of Rodrigo and Elinor Moynihan* (Bristol: Sansom and Company, 2002), 158.

358 Gimpels Fils: See Alice Correia, "Gimpel Fils, Barbara Hepworth and the Promotion of British Sculpture in the 1950s, *The Sculpture Journal* online, www.questia.com. The gallery was equally good in promoting the careers of abstract painters.

358 During the war: Roger Bristow, *The Last Bohemians: The Two Roberts Colquhoun and MacBryde* (Bristol: Sansom & Company, 2010), 177.

358 *The Studio magazine:* Ibid., 186.

358 MacBryde was now sometimes: Duncan Macmillan, "Art Review: Robert Colquhoun and Robert MacBryde," *The Scotsman*, November 29, 2014.

358 Although *Vogue* photographed: Ibid.

359 His studio was now getting: Moynihan, *Restless Lives,* 145–7.

359 I first saw him," said one student: Albert Herbert,

"Francis Bacon at the Royal College of Art, 1951–52," unpublished reminiscence, Tate Archive, 991/43.

359 "At one stage": Ibid.

359 One artist in thrall to Bacon: Keith Vaughan, *Journals, 1939–1977* (London: Faber and Faber, 2010), 99.

359 His distinctive voice: Moynihan, *Restless Lives*, 145–7.

359 "He looked smart and well-turned-out": Ibid.

360 The painter Michael Andrews: Michael Peppiatt, Francis Bacon: *Anatomy of an Enigma* (London: Constable and Robinson, 2008), 194.

360 Robert Buhler, the faculty member: Herbert, "Francis Bacon at the Royal College," Tate Archive.

360 One student: Ibid.

361 The annoying logic flustered Bacon: Ibid.

361 Bacon replied: Ibid.

361 In the fall of 1952: John Rothenstein diary, October 16, 1952, unpublished diaries 1939–1990, Tate Archive, 8726/1.

361 The painter Matthew Smith: Ibid., February 19, 1952.

362 By the early 1950s: Moynihan, *Restless Lives*, 145–7.

362 He knew: Ibid.

362 In Moynihan's *Portrait Group*: Ibid.

362 "I was once at Johnny's": David Tindle, quoted in Frances Spalding, *John Minton: Dance Till the Stars Come Down* (Aldershot, Hants UK: Hodder and Stoughton, 1991), 171–2. Bacon's usual expression was, "Champagne for my real friends, and real pain for my sham friends."

362 Denis Williams (1923–1998) was: For more on Williams—a curator and art historian in addition to an artist—see Charlotte Williams and Evelyn A. Williams, eds., *Denis Williams: A Life in Works, New and Collected Essays* (Amsterdam: Rodopi, 2010).

362 At one point: Keith Vaughan, *Keith Vaughan: Journals, 1939–1977* (London: Faber and Faber, 1988), 99.

362 "There was nothing": Ibid.

363 "I was in his studio": Ibid.

363 His earlier exhibits: Moynihan, *Restless Lives*, 145–7.

364 Bacon's dogs were "mangy": Ibid.

364 "It's all about": Ibid.

364 Not only had he championed: The discussion was covered in a piece entitled "Points of View: Bacon and Balthus," *Art News and Review*, January 26, 1952.

364 "Mr. Bacon has turned": John Russell, "Art Galleries: Reality Plus," *The Sunday Times*, December 14, 1952.

364 In addition to drinking: Gerard Schurmann, email correspondence with Nigel Bonham-Carter and the authors, November 23, 2015; March 24, 2018; and April 16, 2018.

364 It is likely: For more on Bacon's extensive use of drugs, see Sophie Pretorius, "A Pathological Painter: Francis Bacon and the Control of Suffering," in *Inside Francis Bacon: Francis Bacon Studies III* (London: The Estate of Francis Bacon, in association with Thames & Hudson, 2020), 162–215.

365 It was then that: Alan Jacobs, "The Lost World of Benzedrine," *The Atlantic*, April 15, 2012, www.theatlantic.com.

365 Whether or not they were: Schurmann, email correspondence with the authors.

365 The artists sometimes joked: Spalding, *John Minton*, 183–4.

365 Later in 1953: David Sylvester later referred back, when interviewing Bacon, to his many addresses in the early-to-mid 1950s. Margaret Fenton also recalled Sylvester and Bacon living at 9 Apollo Place. Fenton, interview with Annalyn Swan, February 17, 2009.

366 Bacon was further darkening: David Sylvester, *Looking Back at Francis Bacon* (London: Thames and Hudson, 2000), 78.

366 Two years later: Martin Harrison, ed., *Francis Bacon Catalogue Raisonné*, vol. II (London: Estate of Francis Bacon, 2016), 312.

366 They stayed at: Daniel Farson, *The Gilded Gutter Life of Francis Bacon* (New York: Pantheon, 1993), 113.

366 "Francis shinned up the drainpipe": Ibid., 113–14.

366 The gallery was founded: See Durlacher Brothers Gallery, Archives Directory for the History of Collecting in America, research.frick.org.

366 Sir Richard Wallace: See Janet Southern, "Durlacher," oxfordartonline.com.

366 By 1957, Barr was proclaiming: Alfred Barr Jr., letter of July 5, 1957, to Erica Brausen, asking the price of one of Bacon's van Gogh paintings. In it he called Bacon "England's most interesting painter." Hanover Gallery correspondence 1948–58, Tate Archive, 863/6.55. By 1960 MoMA was tentatively planning a Bacon exhibition, which never materialized. Extensive documentation can be found in the Marlborough Gallery archive.

367 The face of the pope: Ronald Alley, *Francis Bacon* (London: Thames and Hudson, 1964), 71. Catalogue raisonné.

367 They were arguably: "In 1953, when Erica Brausen could wait no longer for the pictures for his first American show, at Durlacher Bros., New York, Bacon rapidly painted a series of eight 'Popes' which looked perfunctory and slight by comparison not only with the version at Des Moines [museum] painted a few months earlier but also with a number of recent paintings that he had destroyed or abandoned. And this pattern recurred." David Sylvester, *Looking Back at Francis Bacon* (New York: Thames and Hudson, 2000), 53.

367 He also sent: Speer's monumental stadium was begun but never completed.

367 The *Art News* critic: Denis Sutton, "Art News from London: Francis Bacon," *Art News*, January 1953, 52.

367 In *Art and Architecture*: James Fitzsimmons, "Art," *Art and Architecture*, January 1954.

367 "My quarrel is with": Ibid.

368 Hunter, as if to debate: Sam Hunter, "An Acute Sense of Impasse," *Art Digest*, October 15, 1953, 16.

368 James Thrall Soby: The Museum of Modern Art, N.Y., Archive, James Thrall Soby papers, www.moma.org. Soby also reviewed Bacon's Durlacher show for *Saturday Review*.

368 Barr always claimed: Rona Roob, "From the Archives: James Thrall Soby and Francis Bacon," *MoMA* 2, no. 4 (Spring, 1990), 6–7.

369 When Bacon found: Harrison, ed., *Francis Bacon Catalogue Raisonné*, vol. I, 84.

369 "The homosexual world": Peter Wildeblood, *Against the Law* (London: Phoenix, 1955), 34–5.

369 The most celebrated victim: See Alan Cowell, "Overlooked No More: Alan Turing, Condemned Code Breaker and Computer Visionary," *The New York Times*, June 5, 2019.

369 Bacon never publicly: Several people wrote later of Bacon openly kissing a man at the Gargoyle. One was Frances Partridge. Frances Partridge, letter of February 1952 to Richard Chopping, Jon Lys Turner, *The Visitor's Book* (London: Constable, 2016), 152.

369 By 1953, the anti-homosexuality sentiment: See Keith Dockray and Alan Sutton, *Politics, Society and Homosexuality in Postwar Britain: The Sexual Offences Act of 1967 and Its Significance* (Fonthill Media, 2017).

369 The attack stemmed: See Jon Kelly, "The Era When Gay Spies Were Feared," *BBC News Magazine*, January 20, 2016, www.bbc.com.

370 The situation worsened: Wildeblood, *Against the Law*, 44–7.

370 A Muybridge photograph: Harrison, ed., *Francis Bacon Catalogue Raisonné*, vol. II, 360.

370 Sylvester, acting: Ibid.

370 Freud then purchased: Ibid.

370 Approached once by a potential buyer: Erica Brausen, letter to Richard Zeisler, December 4, 1962, Hanover Gallery correspondence, 1959–1963, Tate Archive, 863/6.4.

370 As Bacon told it: Caroline Blackwood, "Francis Bacon (1909–1992)," *The New York Review of Books*, September 24, 1992.

370 "We were convinced": Ibid.

25 SHADES OF BLUE

372 Six years older: See "John Piper," www.portlandgallery.com/artists.

372 The hotel was built: See "Henley on Thames, Oxfordshire," englishbuildings.blogspot.com.

373 With money scarce: Many of the details about Henley come from Mark Stevens, visit to Henley and interview with Paul Mainds, trustee and chief executive of the local River and Rowing Museum, and Rachel Wragg, senior curator, November 23, 2010.

373 The bar was immediately to the right: Ibid.

373 Bacon persuaded: William Feaver, *The Lives of Lucian Freud: The Restless Years, 1922–1968* (New York: Knopf, 2019), 412.

373 Sylvester called: David Sylvester, *Looking Back at Francis Bacon* (London: Thames & Hudson, 2000), 78.

374 John Piper was good friends: Annalyn Swan, telephone conversation with Georgina Stonor, the daughter of Sherman Stonor, 6th Baron Camoys. The Stonor family was an important presence in the local community. According to Stonor, her family "got hold of a disused fire station." One of the people allowed to use it was Bacon.

374 Schurmann was a protégé: See Gerard Schurmann obituary, wisemusicclassical.com.

374 (How nice that you two): Gerard Schurmann, email correspondence with Annalyn Swan, March 24, 2018, and April 16, 2018.

374 For a time: Ibid.

374 Lacy "sometimes assisted": Ibid.

374 Lacy was "apt": Ibid.

374 "I loved him dearly": Ibid.

375 He did not permit: At the time, Schurmann recalled, Bacon often took amphetamines "by the handful."

375 He wrote Brausen: Bacon, undated letter to Erica Brausen from the Imperial Hotel, Hanover Galley "Correspondence 1948–58," Tate Archive, 863/6/2/7.

375 David Sylvester contributed: David Sylvester, in "Exhibition of Works by Nicholson, Bacon, Freud," exhibition booklet for the British Pavilion at the XXVII Biennale, Venice, 1954.

376 He was "out of his mind": Anonymous interview conducted by James Norton. Further details come from a conversation with Frances Stonor Saunders, interview with the authors, November 2012.

376 He "had a beautiful": Ibid.

376 Dan Farson also believed: Dan Farson, *The Gilded Gutter Life of Francis Bacon* (New York: Pantheon Books, 1993), 97.

376 Isabel Rawsthorne, who tracked: Undated letter to Peter Rose Pulham, Tate Archive, 9612/1/3/74.

377 The intimacy: The photos are in the collection of material from Bacon's studio and bedsit at 7 Reece Mews, Hugh Lane Gallery, Dublin (Reg. No. RM98F12:17:3). © The Estate of Francis Bacon.

377 In early November: Ibid. That they drove down is evident from photos taken of Peter Lacy's car in Ostia, the port town just west of Rome where they settled.

377 At first they settled: Bacon, letter of December 13 [1954], to Erica Brausen, Hanover Gallery correspondence 1948–1958, Tate Archive, 863/6.3.9.

377 For his postal address: Ibid. Bacon told Brausen to write to him at the Hotel Inghilltera [Inghilterra], Via Bocca di Leone, Rome, as he was "not sure if letters get here." Ibid.

377 But the "American invasion": Ibid.

377 In the off-season: Ibid.

377 Their flat: There are a number of photos of the flat, both inside and on the terrace, as well as a few of a dock area and one of Lacy's Bentley. Hugh Lane Gallery, Dublin (Reg. No. RM98F12:17:3). © The Estate of Francis Bacon.

378 In November, not long: Bacon, letter of November 15, 1954, to David Sylvester, Sylvester correspondence, Tate Archive, 200816/2/2/1/1.

378 In a letter to Erica: Bacon, letter of December 13 [1954], to Erica Brausen, Hanover Gallery correspondence 1948–1958 with Bacon, Tate Archive, 863/6.

378 Bacon went: Bacon, letter of November 15, 1954, to David Sylvester, Tate Archive.

378 After the previous June's: See "UK at the Venice Biennale," venicebiennale.britishcouncil.org.

378 Bacon went to a few parties: Bacon, letter of December 13, [1954], to Brausen, Tate archive. He also wrote to David Sylvester that "I love Rome but not for too long." Bacon, letter of November 15, 1954, to Sylvester. Tate Archive, 200816/2/2/1.

378 Bacon also made a trip to Naples: Bacon, letter of December 27 [1954], to Brausen. Tate Archive, 816/2/10.

379 At one point during his stay: Sonia Orwell, letter to Bacon, in Sonia Orwell correspondence, Orwell Archive, University College London.

379 George Weidenfeld had hired Orwell: Hilary Spurling, *The Girl from the Fiction Department: A Portrait of Sonia Orwell* (Berkeley: Counterpoints Press, 2004), 104–5. "It was George Weidenfeld who secured her first as reader, then editor, for his newly founded firm of Weidenfeld and Nicolson," wrote Spurling. "Weidenfeld, who by his own account knew little about novels at this stage, relied on Sonia to lay the foundations of his fiction list. In the next five years she brought him singular success with Nigel Dennis, Sybille Bedford and Dan Jacobsen as well as a whole constellation of Americans: Saul Bellow, Mary McCarthy, Elizabeth Hardwick and Norman Mailer."

379 Bacon's response: Bacon, letter of December 13, 1954, to Sonia Orwell, Hotel Inghilterra, Via Bocca di Leone, Rome. In the Orwell Archive, University College London.

379 He was "extremely unhappy": Bacon, quoted in David Sylvester, *Interviews with Francis Bacon* (New York: Thames & Hudson, 1987), 38.

379 He claimed to "loathe": Ibid.

379 Earlier, on December 27: Bacon, letter of December 27 to Brausen, Tate Archive., 863/6/2/10.

379 On January 24: Martin Harrison, ed., *Francis Bacon Catalogue Raisonné*, vol. I (London: Estate of Francis Bacon, 2016), 85.

380 Lacy, Bacon said: Michael Peppiatt, *Francis Bacon in Your Blood: A Memoir* (New York: Bloomsbury USA, 2015), 76.

380 A so-called collective: History of the ICA, www.ica.art.

380 Two women who went: Harrison, ed., *Francis Bacon Catalogue Raisonné*, vol. II, 378.

380 In his review: Pierre Jeannerat, "He's Art's Svengali: Mayfair Looks at the Strange Creations of Francis Bacon, Painter Who Inspired Graham Sutherland," *The Daily Mail*, January 20, 1955.

380 "Bacon has increasingly of late": Ibid.

380 The *Times'* critic: Roger Berthoud, *Graham Sutherland: A Biography* (London: Faber and Faber, 1982), 161–2.

381 He visited: Sophie Pretorius, "A Pathological Painter: Francis Bacon and the Control of Suffering," in *Inside Francis Bacon: Francis Bacon Studies III* (London: The Estate of Francis Bacon, in association with Thames & Hudson, 2020), 169. The information in the rest of this paragraph comes from this essay.

381 Parladé was a celebrated: Parladé was one of the more fascinating women of her time. She was married multiple times and maintained a wide and distinguished acquaintance. Francis Partridge's *Diaries* are filled with biographical information on her. Her final marriage was to the titled Andalucian Jaime Parladé. She was a great friend of many of the writers and intellectuals of the thirties, forties, and fifties, and entertained often and well at her house on Montpelier Square. See Paul Levy, "Janetta Parladé: Literary socialite and veteran of the Bloomsbury set," July 4, 2018, www.independent.co.uk.

381 "Oh no, Francis": Janetta Parladé, interview with Annalyn Swan, November 2, 2017. The following quotations also come from this interview.

381 Not long after the opening: Peppiatt, *Bacon in Your Blood*, 76.

381 Schurmann took Bacon to see: Schurmann, email correspondence with the authors, March 24 and April 16, 2018.

381 Later, he was given: The Blake mask figures prominently in photographs of Bacon's bedsit; it sat on a wooden cupboard next to photographs of Peter Lacy, George Dyer, and John Edwards. See John Edwards introduction, Perry Ogden, photographs, *7 Reece Mews, Francis Bacon's Studio* (London: Thames and Hudson, 2001).

382 Blake's wife had not liked: "J. S. Deville's Life Mask of William Blake," note by David Bindman, lecturer in the history of art, Westfield College, University of London, on the Blake archive website, bq.blakearchive.org.

382 The face looked sealed: Jonathan Jones, "Portrait of the Week: *Study for Portrait II—After the Life Mask of William Blake, Francis Bacon* (1955)," in *The Guardian*, February 23, 2002, www.theguardian.com.

382 "Nobody wanted to talk to anyone": David Sylvester files, Tate Archive, 200816/4/2/15.

382 It was also friends who helped: In the chronology of the first catalogue raisonné, completed in 1964, Ronald Alley listed the various addresses where Bacon stayed after he returned to London in 1955.

382 It was also friends: See "28 Mallord Street, London SW3," rbkc.gov.uk.

382 Among those: Ibid.

382 At the time, the Tate Affair: See Rosalind McKever, "The Tate Affair: Then and Now," *Apollo*, August 5, 2014, www.apollo-magazine.com. For a comprehensive overview of the Tate fight, see Adrian Clark, *Fighting on All Fronts: John Rothenstein in the Art World* (Chicago: University of Chicago Press, 2018).

383 Rothenstein enjoyed: Rothenstein diary, March 24, 1955, unpublished diaries, 1939–1990, Tate Archive, 8726/1.

383 "Francis Bacon agreed": Rothenstein diary, November 1, 1956, Tate Archive.

383 At the Colony: Rothenstein diary, June 18, 1953, Tate Archive.

383 The person who confirmed: Rothenstein's diaries and autobiography are filled with his descriptions of de Maistre, and of his fondness for the artist.

383 Bacon praised: For Bacon's note on Matthew Smith, see Andrew Grighton and Lynda Morris, eds., *Towards Another Picture: An Anthology of Writings by Artists Working in Britain, 1945–1977* (Nottingham: Midland Group, 1977), 237.

383 He bought mainly tribal: "Robert and Lisa Sainsbury Collection," University of East Anglia, scva.ac.uk.

384 "Most people know": Lisa Sainsbury, transcript of an interview for Adam Low, director, *Francis Bacon*, *Arena* documentary, BBC Four archive, March 19, 2005.

384 Neither man found: David Sylvester, "Francis Bacon's Portraits of Robert and Lisa Sainsbury: An Interview with Lisa Sainsbury," in *Trapping Appearance: Portraits by Francis Bacon and Alberto Giacometti from the Robert and Lisa Sainsbury Collection* (Norwich: Sainsbury Centre for Visual Arts, 1996), 30.

384 Those few people: See Cecil Beaton, *Self Portrait with Friends: The Selected Diaries of Cecil Beaton, 1922–1974* (London: Weidenfeld and Nicolson, 1979), 321.

384 She would settle: Lisa Sainsbury, interview, *Francis Bacon*, *Arena*.

384 "He had an enormous": Ibid.

384 She replied: Ibid.

384 "I don't think I've known": Ibid.

385 Bacon then scissored: Ibid.

385 A second painting: Bacon to Roy de Maistre, Rothenstein diary, January 27, 1955, unpublished diary, Tate Archive, 8726/1.

385 Lisa Sainsbury saw little: Sainsbury, interview, *Francis Bacon*, *Arena*.

385 "What a terrific": This story is often told about Bacon. See, for example, Daniel Farson, *The Gilded Gutter Life of Francis Bacon* (New York: Pantheon Books, 1993), 95.

385 Although the Sainsburys did not consider: Lisa Sainsbury, interview, *Francis Bacon*, *Arena*.

385 Robert Sainsbury guaranteed: Bacon, letter to Robert

Sainsbury, December 19, 1955, in "Bacon's Letters to Robert and Lisa Sainsbury," in Michael Peppiatt, *Francis Bacon in the 1950s* (New Haven and London: Yale University Press, 2007), 157.

385 Then in his mid-thirties: "Peter's family were part owners of the steel firm Accles and Pollock, and he was able to afford a farm in the country as well as the flat in Battersea." Farson, *The Gilded Gutter Life*, 115–16. See also "Peter Pollock," obituary, www,independent.co.uk.

385 The flamboyant Danquah: See "Paul Danquah," andrejkoymasky.com.

386 Pollock was blond: Farson, *The Gilded Gutter Life*, 115–16.

386 Danquah, then thirty years old: See "Paul Danquah," www.imdb.com.

386 Danquah recalled Muriel: Other people recalled that it was Alfred Hecht who came up with the idea of Bacon rooming with Peter and Paul. Farson, *The Gilded Gutter Life*, 114–15.

386 Not only did Bacon sleep: In an *Observer* profile from the period, kept in the Marlborough Gallery archives, the writer described Bacon's studio room as "what the architect had intended as a smallish front bedroom. The place looked as though a dustman had stacked a lorry with oddments—canvases, easels, bunches of old paintbrushes, broken crockery, an abandoned chest of drawers, a heap of books, torn newspapers and a pile of old copies of *Paris-Match*—and dumped the lot into the room through the roof." Another article from the time noted that the dimensions of the room were only twelve feet square. Marlborough Gallery archives, folder marked "1957-1964 clips."

386 Just across the bridge: Paul Danquah, interview, *Francis Bacon, Arena*.

386 Pollock and Danquah had: Christopher Gibbs, interview with the authors, October 12, 2013.

386 "Danquah was very warm": Ibid.

386 The pair also had: Ibid.

386 Danquah nicknamed him: Ibid.

386 Sometimes, he would bring home: Danquah, interview, *Francis Bacon, Arena*.

387 He was often tense: Julia Blackburn, *The Three of Us: A Family Story* (New York: Vintage Books, 2009), 59–61. On March 20, 1955, her mother recorded in her diary, "T sees F Bacon," and on April 19, "Soho p.m. Francis Bacon attacks T. Champagne. Sick."

387 Hewett was probably acting: Hewitt was a dealer mostly of ethnographic art and antiquities. But he would buy other things as well, and in several instances one of his Bacon purchases went directly to the Bomfords. See, for example, "Three Studies of the Human Head" (1953) in Harrison, ed., *Francis Bacon Catalogue Raisonné*, vol. II, 356–60.

387 One sponsor, it was later suggested . . . : Mark Stevens and Annalyn Swan, interviews with Mary Abbott, Conrad Marca-Relli, and Ibram Lassaw, among others, for *de Kooning: An American Master* (New York: Knopf, 2004). See also Frances Stonor Saunders, "Modern Art was CIA 'Weapon,'" *The Independent*, October 22, 1995.

387 Willem de Kooning was turning: Stevens and Swan, *de Kooning*. See "Coming of Age," 301, and subsequent chapters.

389 On those days: Lisa Sainsbury, interview, *Francis Bacon, Arena*.

389 In the late spring: Rothenstein diary, July 3, 1956, unpublished diaries, Tate Archive, 8726/1.

389 Bacon immediately became: Bacon, letter from Tangier to Denis Wirth-Miller, September 7 [1956], quoted in Jon Lys Turner, *The Visitors' Book* (London: Constable, 2016), 187.

389 The timing could not: Rothenstein diary, July 3, 1956, Tate Archive.

389 "I hope you will": Bacon, letter dated June 1, 1956, to Robert Sainsbury, in Peppiatt, *London in the Fifties*, 157.

389 Bacon used 150 pounds: Ibid. Bacon wrote that the 150 pounds would be used to pay his debt for "painting materials," but probably also covered other obligations.

389 To reach Tangier: For the "queens' flight," David Lacy and Gerald Towell, interview with the authors, February 16, 2009. For the information about the flight and the canvases, Rothenstein diary, July 3, 1956, unpublished diaries, Tate Archive, 8726/1.

26 TANGIER

391 She historically: Greg A. Mullins, *Colonial Affairs: Bowles, Burroughs, and Chester Write Tangier* (Madison: The University of Wisconsin Press, 2002), 5.

391 The English maintained: See Ben Johnson, "The History of Gibraltar," historic-uk.com.

391 In 1923: Mullins, *Colonial Affairs*, 4.

391 "This 'international' status": Ibid.

391 The English expatriate community: The newspaper was called *Tangier Gazette* in the mid-1950s but, after Tangier was subsumed into Morocco, changed its name to *Morocco Mail*. The Anglican St. Andrew's Church was consecrated in 1905.

391 Some expatriates lived: The two most important areas in the city for the English abroad were "the mountain" and the Medina. The Socco Chico area was the center of pickups by Europeans of Moroccan boys, and all the rich expatriates lived on the mountain overlooking the water. Mark Stevens and Annalyn Swan, interviews with English expatriates Anthea Pender and Lawrence Myrott and Jonathan Dawson, Tangier, September 16 and 18, 2013, respectively.

391 "Everything cost nothing": Mohammed Mrabet, transcript of an interview for Adam Low, director, *Francis Bacon, Arena*, BBC Four archive, March 19, 2005.

392 Inside Tangier there flourished: In 1959, Kenneth Allsop of the *Daily Mail* came down to report on the exotic English-speaking community in Tangier. In his book *Tangier: City of the Dream,* Ian Finlayson wrote: "Bustling about, Allsop met actresses, literary agents, socialites." (He had already met Alec Waugh, Gerald Brenan, and Rupert Croft-Cooke.) Finlayson then quoted from Allsop's article: "Tangerines by adoption include Robin Maugham, Anita Ekberg, Francis Bacon, Lady Diana Cooper, Cecil Beaton, Lord May, Dawn Addams, Margaret Leighton, Errol Flynn, and a shifting, shifty population of contraband boat crews, confidence tricksters, Mayfair spivs and women with an international beat, men on the run and girls on the make." Finlayson, *Tangier: City of the Dream* (London: Harper Collins, 1992), 78–9.

392 During the 1950s: Michelle Green described David Herbert in *The Dream at the End of the World: Paul Bowles and the Literary Renegades in Tangier* (New York: Harper Collins, 1991), 58: "The second son of the fifteenth Earl of Pembroke, David was 'a most delightful, gay, alive and witty personality and companion,' in the words of his great friend Cecil [Beaton]. Like Beaton, David was a man to whom style was everything; raised at Wilton, a distinguished stately home whose rooms were hung with Rembrandts, he was passionate about interior design. He saw gardening as a form of artistic expression, and he loved to sketch ethereal creatures, including Lady Diana Cooper, the socialite and actress who was a distant relative. At forty, David seemed to be linked in some fashion to every significant mortal in the Western world. He counted Augustus John, Noël Coward, Cyril Connolly, the Mitford sisters and Prince Paul of Yugoslavia among his friends and Mrs. Cornelius Vanderbilt among his relatives."

392 A brilliant dabbler and enthusiast: "Tangier Diary," *Tangier Gazette,* April 24, 1959. All copies of the *Tangier Gazette* and the *Morocco Mail* are in the collection of TALIM, the Tangier American Legation Institute for Moroccan Studies in Tangier.

392 Tangier also took particular pride: On April 30, 1955, for example, the *Tangier Gazette* noted that "Barbara Hutton is coming to stay in her Kasbah residence."

392 The couple were nicknamed: See "When Cash Wed Cary," ew.com.

392 Hutton would occasionally arrive: The writer of the "Tangier Diary" observed crossly on August 18, 1961, that he/she had not been invited to Hutton's latest party: "I can only tell you about it from hearsay as I wasn't there, and to try to muscle in on a party of such dimensions is quite out of the question, the guards are too strict." Among the details reported were that the party lasted from 10:30 p.m. to 7 a.m.

392 Flocks of young Spanish and Moroccan: "Tangier was an especially attractive place for foreigners to live during the postwar years because of its proximity to Europe and its long history of sexual tourism and intercultural exchange. Its residents were able to experiment with and even to invent forms of promiscuity that were not available elsewhere. A thriving economy of commercial sex ensured that sexual adventure was readily available to the wealthy in Tangier and that national, cultural, and linguistic divisions were bridged through intimate physical contact." Mullins, *Colonial Affairs,* 6

393 "There were thousands": Mohammed Mrabet, interview, *Francis Bacon, Arena.* In one variant, Spanish homosexuals "went out [at night] dressed entirely as women. If you didn't know you'd look at them and you'd think a pretty girl."

393 Expatriates typically hired: The use of drugs was widespread. "Encounters between people from different nations, cultures, and religions were transacted, in part, through sexual activity and drug use, which served to break down other social and psychic barriers." Mullins, *Colonial Affairs,* 4.

393 Bacon dropped easily: "Tangier Diary," *Tangier Gazette,* June 29, 1956.

393 The profile announced: "Portrait Gallery: Francis Bacon," *The Sunday Times.* There is no date on the article except for 1956, but it reported that "This week he leaves England to spend the summer in Tangier." The authors are indebted to Majid Boustany and Aurélie Valion of the Francis Bacon MB Foundation in Monte Carlo for sharing this and other newspaper clips with us.

393 The director: Bacon, undated letter of 1956, Poste Restante, Tangiers, to Erica Brausen, Erica Brausen/Hanover Gallery letters, folder marked "Correspondence 1948–1958," Tate Archive, 863/6/2/3. "I have been very lucky as the Director of the museum in the Kasbah has let me a room to work in," he reported.

394 Lacy still kept up appearances: A photograph from c. 1958 shows Lacy in an open-necked knit sweater and linen trousers, his "silver fox" look still very much there. Photo courtesy of The Estate of Francis Bacon.

394 The writer Robert Cook: Dan Farson, *The Gilded Gutter Life of Francis Bacon* (New York: Pantheon, 1993), 147.

394 In a city full of bars: Mohammed Mrabet, interview, *Francis Bacon, Arena.*

394 Joseph Dean was a dapper: "Some Tangerinos insisted that he was Jamaican; others, that he was the son of a Frenchwoman and her well-born Egyptian consort." Green, *The Dream at the End of the World,* 46–7.

394 No one was sure: Farson, *The Gilded Gutter Life,* 144.

394 Bacon found him: Green, *The Dream at the End of the World,* 152–3.

394 Dean had been: Ibid., 46–7.

395 It was whispered: Ibid., 49.

395 Few Moroccans went to Dean's: Ibid., 46–7.

395 The talk was mostly: Mohammed Mrabet, interview, *Francis Bacon, Arena.*

395 He wrote to his wife: Mark Amory, ed., *The Letters of Ann Fleming* (London: Collins Harvill, 1985), 196–7.

395 Bacon stayed initially: Farson, *The Gilded Gutter Life*, 148. The trip to France is documented in Bacon's first letter to Erica Brausen from Tangier, post restante, British Post Office, Tangier, undated [1956] in which he told her, "I found France so expensive that I came over here." It is more than possible that Bacon initially hid from Brausen his return to Peter Lacy, as she was all too aware of their troubled history together. Tate Archive, 863/6/2/3.

396 Upon their return: Farson, ibid.

396 The Muniria was a favorite: Green, *The Dream at the End of the World*, 191.

396 He might attend: Bobby McKew, who was a smuggler during his years in Tangier, recalled the wild parties that Louise de Meuron would give. Bobby McKew, interviews with the authors, September 26, 2013, and with Annalyn Swan, October 24, 2013. "A German-Swiss who had married a French nobleman, the Countess was a quick, bird-like woman with an astringent wit. She liked to sunbathe nude on Tangier's lonelier beaches, where she startled passing fishermen, and she said absolutely anything that came to mind." Green, *The Dream at the End of the World*, 112–13. Bacon also used an outbuilding on her property as an informal art studio at one point. Swan, interviews with McKew.

396 The Café de Paris: The authors are indebted to James Norton for his phone interview with Larbi Yacoubi, October 6, 2013.

396 The playwright Joe Orton: Joe Orton, *The Orton Diaries*, ed. John Lahr (New York: Harper and Row, 1986), 187.

396 At the celebrated Café Central: On June 20, 1958, the *Tangier Times* lamented the demise of the Socco Chico and the Café Central due to the Moroccan takeover of the city. "Whereas, a little while ago, people were packed in there like sardines till far into the night, now it's only packed like those old-time chocolate boxes, all paper and few chocolates. It was the centre of old Tangier, with hotels packed around it."

396 He was impressed by the physical: Bacon, letter of September 7 [1956], from Tangier to Denis Wirth-Miller, quoted in Jon Lys Turner, *The Visitors' Book* (London: Constable, 2016), 187.

396 Gambling could be found: A casino would only be allowed—and allowed for non-Moroccans—after the take-over of Tangier by Morocco.

396 "He was broad-shouldered.": Cook, quoted in Farson, *The Gilded Gutter Life*, 147.

397 "I have learnt to swim": Bacon, letter of September 7, 1956 to Denis Wirth-Miller in Turner, *The Visitors' Book*, 186.

397 Paul Bowles first visited: Gary Pulsifer, "Paul Bowles: Obituary," *The Guardian*, November 19, 1999.

397 Jane was also: For more on Jane Bowles, see Millicent Dillon, *A Little Original Sin: The Life and Work of Jane Bowles* (New York: Holt Rinehart & Winston, 1981).

397 "Paul was very kind": Bacon, interview with Michelle Green, May 19, 1988, in Green, *The Dream at the End of the World*, 152–3.

397 Bowles, for his part: Finlayson, *Tangier: City of the Dream,* 147.

397 Bacon now wrote: Bacon, undated [1956] letter to Erica Brausen, Hanover Gallery correspondence 1948–1958, Tate Archive, 863/6/2/3.

397 Paul, a musician and folklorist: Pulsifer, "Paul Bowles: Obituary," *The Guardian*.

398 Friends nicknamed: Ibid.

398 Ahmed ben Driss el Yacoubi: Green, *The Dream at the End of the World*, 26–7.

398 He appeared to be steeped: Ibid.

398 He was a maker: "Tangier Diary," The *Tangier Gazette,* June 27, 1958.

398 When Bacon first met him: Jacoubi was known in his earlier career for "the precise, jewel-like quality" of his work in "pen and wash." Ibid., October 5, 1956.

398 Uncharacteristically: Green, *The Dream at the End of the World*, 152–3. Bowles described Jacoubi as "watching [Bacon] like a cat."

398 They communicated: Ibid. Bacon himself said that "Ahmed and I had no common language, but between my limited Spanish and French and his very good Spanish we were able to talk a lot."

398 In a letter: Bacon, undated [1956] letter to Erica Brausen, Hanover Gallery Correspondence, Tate Archive, 863/6/2/3.

399 Bacon told Erica: Ibid.

399 He or she was astonished: "Tangier Diary," *Tangier Gazette*, October 5, 1956.

399 He wrote Robert Sainsbury: Bacon, letter to Robert Sainsbury, July 14, 1956, British Post Office, Poste Restante, Tangiers, reproduced in "Bacon's Letters to Robert and Lisa Sainsbury," in Michael Peppiatt, *Francis Bacon in the 1950s* (New Haven and London: Yale University Press, 2007), 157.

399 He made a brief trip: John Rothenstein diary, July 24, 1956, unpublished diaries 1939–1990, Tate Archive, 8726/1.

399 Under the headline "Doomed Town? Boom Town": The *Tangier Gazette* began running alarming reports in 1956 of Morocco's crackdown on the city following Moroccan independence. Another piece in the spring of 1956 noted a "gold flight" to Geneva because of the "uncertainty in financial circles as to the economic future of the town when, as seems most likely, it is completely reabsorbed into the Sherifian Empire." (The *Tangier Gazette*, March 30, 1956).

399 In September, Bacon: Bacon, letter to Denis Wirth-Miller, 7 September [1956], in Turner, *The Visitors' Book*, 187. Bacon seems to have driven back up to London. "I am coming back to London with Bill/he wants a passenger," he wrote.

400 About two and a half months: No correspondence exists of this trip, but the two men made a practice of going to the Riviera during this period every Christmas. Other trips are documented.

401 In the end, Brausen sent: See Harrison, ed., *Francis Bacon Catalogue Raisonné*, Vol. II, for a list of solo exhibitions of each painting.

401 He stayed away: Bacon, undated [February 1957] note to Erica Brausen, Tate Archive, 863/6/2/8. The note is written on the invitation to the private view of Bacon's show.

401 The French response: See, for example, Luce Hoctin, "Francis Bacon: Un peintre halluciné," *Arts*, February 19, 1957, 10. The authors are grateful to Whitney Stevens for helping them with this article.

401 The artist Frank Auerbach was surprised: Frank Auerbach, interview with Mark Stevens, February 12, 2009.

401 On the day of the opening: John Moynihan, *Restless Lives: The Bohemian World of Rodrigo and Elinor Moynihan* (Bristol: Sansom and Company, 2002), 171–2.

402 At some point: Ibid.

402 Brausen was annoyed: Ibid.

402 "Just soak them": Ibid.

402 John Rothenstein found himself: Rothenstein diary, March 20, 1957, unpublished diaries, Tate Archive, 8726/I.

402 Bacon "leapt forward": Moynihan, *Restless Lives*, 171–2.

402 There was, wrote Moynihan: Ibid.

402 "The gallery is crowded": John Golding, "Lust for Death," *The New Statesman and Nation*, April 6, 1957.

402 "For better or worse": Ibid.

402 Henry Moore found: Rothenstein diary, April 2, 1957, unpublished diaries, Tate Archive.

402 Bacon's "melodrama": Ibid.

402 Bacon described Braque's late work: Ibid., March 3, 1958.

403 Bacon considered van Gogh: Miriam Gross, "Bringing Home Bacon," *The Observer Review*, November 30, 1980.

403 Erica Brausen was grumbling: Bacon, letter to Brausen, April 9 [1957], Hanover Gallery correspondence, Tate Archive, 863/6/1/4.

403 In January of 1957: Martin Gayford, "A Tale of Two Artists: John Minton: Well-Known but Not Great Enough; John Virtue: Great but Not Well-Known Enough," *The Spectator*, July 15, 2017.

403 On his easel: Laura Cumming, "John Minton: A Centenary Review—a Wildly Restless Talent," *The Observer: Art*, July 2, 2017.

27 LIMBO

405 In 1957, his debt: Letter from Michael Greenwood, Erica Brausen's assistant, to her on October 17, 1958, telling her that Bacon was leaving the gallery because he was "up to the neck in personal debt to the extent of about 5,000 pounds from gambling, etc." Hanover Gallery, records 1948–1958, Tate Archive, 863/6/130.

405 Bacon looked to banks: In a letter of June 6, 1957 to Bacon at the Hotel Cecil in Tangier, Brausen wrote, "The bank has been paid—in fact everything is going very well." Ibid, 863/6/52.

405 Brausen's wealthy partner: Gill Hedley, short biographical notes on Arthur Jeffress, www.gillhedley.co.uk. Hedley's biography of Jeffress, *Arthur Jeffress: A Life in Art*, was published in 2020 by Bloomsbury Visual Arts.

405 It did not help: Michael Greenwood letter of October 17, 1958, to Brausen, Hanover Gallery records 1948–1958, Tate Archive, 863/6/130.

405 In the mid to late 1950s: Bacon and Freud maintained the closest of friendships throughout the 1950s, even as Bacon went back and forth to Tangier and the South of France.

405 Freud was a good friend: David Somerset said that it was Freud who brought Bacon to the Marlborough. "It was entirely due to Lucian, because they were all fighting with Erica Brausen." David Somerset, interview with the authors, June 18, 2012.

405 Freud had recently been taken on: William Feaver, *The Lives of Lucian Freud: The Restless Years, 1922–1968* (New York: Knopf, 2019), 482.

406 "He'd done a painting": Freud, quoted in ibid., 495.

406 After the lunch: As Fischer wrote, "I will tell Lloyd and Somerset and I am sure both will be very happy to know that you will give us the opportunity of becoming your dealers." The letter was dated March 22, 1957. Marlborough Gallery archive.

406 During the war: Roberta Smith, "Frank Lloyd, Prominent Art Dealer Convicted in the '70s Rothko Scandal, Dies at 86," *The New York Times*, April 8, 1998. Lloyd had a small account at Lloyd's bank. But he also hoped that a more English-sounding name might provide some degree of protection.

406 Tall and fine-boned: See www.marlboroughgallery .com.

406 His best friend: Taki, "Tell Me What Happened Last Night. Were the Tarts Pretty?" (obituary of Gianni Agnelli), *The Telegraph*, January 26, 2003, www.telegraph.co.uk.

406 Somerset enjoyed the role: Somerset, interview with the authors.

407 But Somerset knew how: Marcus Williamson, "David Somerset, Society Grandee: Obituary," *The Independent*, August 22, 2017. See also Roberta Smith, "Frank Lloyd," *The New York Times*.

407 "Fischer really liked": Somerset, interview with the authors.

407 Somerset described Fischer: Ibid.

407 At Marlborough in the late 1950s: Ibid.

407 It had not escaped: Mark Stevens and Annalyn Swan, *de Kooning: An American Master* (New York: Knopf, 2004), 316–7.

408 Although he knew: Fischer, letter of May 6, 1957, to Bacon noted that "Mme. Lessore" is "to have approximately three pictures a year at cost price, and who will sell them at the same price as we do." Marlborough Gallery archive.

408 He also expressed concern: In his third letter to Bacon on June 19, 1957, Fischer told Bacon that the Marlborough had already arranged a show in New York for him at the prestigious Knoedler Gallery. Marlborough Gallery archive.

408 Early in May, 1957: Ibid.

408 Two days after Fischer: Bacon had been to the South of France in February 1957, around the time of his show in Paris. That October he was back again.

409 Perhaps because: Dan Farson, in *The Gilded Gutter Life of Francis Bacon* (New York: Pantheon, 1993), 144, says that they drove down in 1955. However, Bacon's first trip to Tangier was a year later, in 1956, and John Rothenstein's account in his private diary of Bacon's trip by airplane in July of 1956 almost certainly rules out a drive down that year. The fact that Paul Danquah was in Tangier the summer of 1957 makes the trip down that year virtually certain. (See Michelle Green, *The Dream at the End of the World: Paul Bowles and the Literary Renegades in Tangier* [New York: Harper Collins, 1991], 192–4). A letter of Bacon to Denis Wirth-Miller in September of 1957 also supports this timing. There are two references in the letter to Paul Danquah, including one in which Bacon hoped that "Paul passes [his legal exams] this time." The next year, when Danquah returned to Tangier with Peter Pollock, the *Tangier Gazette* noted that he had passed the exam ("Tangier Notes," *Tangier Gazette*, September 5, 1958). Danquah and Pollock would eventually settle in Tangier.

409 "When the Rolls": Pollock, quoted in Farson, *The Gilded Gutter Life,* 144.

409 Located on a bluff: "Tangier Notes," *Tangier Gazette*, June 8, 1956 and February 1, 1957. For more on the Hotel Cecil, see www.hotelcecil.com/.

409 "The new bar": "Tangier Notes," *Tangier Gazette*, June 8, 1956.

409 Peter Lacy hosted: Ibid., May 17, 1957.

409 Bacon told: Ibid.

409 Bacon wrote Wirth-Miller: Bacon, letter from Tangier to Wirth-Miller, July 22 [1957], quoted in Jon Lys Turner, *The Visitors' Book* (London: Constable, 2016), 187.

409 In July, Bacon rented: On August 23, 1957, the *Tangier Gazette* reported, "Francis Bacon—This renowned painter from Dublin has taken a flat in the Avenue d'Espagne." The changeover to Moroccan governance for Tangier would soon bring a name change for the avenue. Bacon's letters of 1958 show the address as Apartemento D, Piso 6eme, Blvd. Mohammed V. 105, Tangier, Morocco.

409 Lacy joined him: Ibid. In an undated letter of 1957, Bacon wrote Denis that "Peter has been staying with me but he has now taken a flat of his own and is moving there soon." Turner, *The Visitors' Book,* 185. The letter is incorrectly dated 1956, before Bacon had bought the flat.

409 The new quarters: Paul Bowles, quoted in Farson, *The Gilded Gutter Life,* 162.

409 Bacon told Bowles: Ibid.

409 Bacon was "so pleased": Bacon, undated letter of 1957 to Wirth-Miller, Turner, *The Visitors' Book,* 192.

410 At some point: Ibid., 192–3.

410 The parents of: Michelle Green, *The Dream at the End of the World: Paul Bowles and the Literary Renegades in Tangier* (New York: Harper Collins, 1991), 197–8.

410 At first it appeared: In a May 18, 1956, story, the *Tangier Gazette* reported that "the administrator of the Zone has given orders to the police not to interfere 'in any dispute between Europeans and Moroccans.'"

410 Jane Bowles had recently suffered: Bacon, letter to Sonia Orwell, June 20, 1957, in the Orwell Archive at University College, London.

410 She frequently visited: She had a second seizure in July of 1957. Green, *The Dream at the End of the World*, 197–8.

410 Lacy would drink: "He really killed himself with drink," Bacon told Michael Peppiatt. "He set out to do it, like a suicide." Peppiatt, *Francis Bacon in My Blood* (New York: Bloomsbury, 2013), 76.

410 "The one time I met": Burroughs, letter to Jack Kerouac, August 18, 1954, in Oliver Harris, ed., *The Letters of William Burroughs, 1945–1959* (New York: Picador, 1993).

411 He "proved to be": Green, *The Dream at the End of the World*, 151–2.

411 During the spring: Ibid., 190.

411 Not only was Burroughs: Ginsberg and Peter Orlovsky, a writer and Ginsberg's partner, arrived in Tangier in March of 1957. Barry Miles, *Call Me Burroughs: A Life* (New York: Hachette Publishing, 2013), 303.

411 It was known: Ibid., 288.

411 Burroughs was trying to finish: Ibid., 305.

411 Before moving: Ibid., 260.

411 But Dutch Tony: Ibid.

411 He first lived: Ibid., 282. The item appeared in "Tangier Notes," *Tangier Gazette*, December 2, 1955.

411 By the time he met: Miles, *Call Me Burroughs*, 288.

411 They also made: Green, *The Dream at the End of the World*, 192–4.

412 Burroughs sometimes behaved: *Call Me Burroughs* chronicles at length Burroughs's drug-fueled fantasies as well as his interest in sex with boys. Both Burroughs and Yacoubi were fascinated by magic. See Miles, *Call Me Burroughs*, 307.

412 He appeared to subsist: Ibid. See page 270 and his infatuation with a boy named Kiki.

412 Guns interested him: For a detailed account, see Domagoj Valjak, "Influential Writer William Burroughs Accidentally Shot and Killed His Wife While Demonstrating His 'William Tell' Act," *The Vintage News*, January 25, 2017, www.thevintagenews.com.

412 Ginsberg called him: Ginsberg, letter to Jack Kerouac, May 31, 1957, in the collection of the Harry Ransom Research Center, University of Texas at Austin, Manuscripts Collection MS-2282.

412 Ginsberg described Bacon: Bill Morgan and David Stanford, eds., *Jack Kerouac, Allen Ginsberg: The Letters* (New York: Viking, 2010), 347.

412 "I was only afraid": Green, *The Dream at the End of the World*, 192–4.

412 Once, when Yacoubi: Ibid.

413 "He said so much of it": Miles, *Call Me Burroughs*, 307.

413 Ginsberg, in turn: Bill Morgan, ed., *The Letters of Allen Ginsberg* (New York: Perseus Press, 2008), 152–3. "Locked in the magic" is not Ginsberg's phrase.

413 A painting ended: Bacon, quoted by Ginsberg in Green, *The Dream at the End of the World*, 192–3.

413 "This was before dope": Bobby McKew, interview with the authors, September 26, 2013, and with Annalyn Swan, October 24, 2013.

413 The nightlife "is an interesting": Kenneth Allsop, *Daily Mail* special report from Tangier, quoted in Ian Finlayson, *Tangier: City of the Dream* (London: Harper Collins, 1992), 78–9.

413 In Tangier: There is no record of Bacon knowing the Krays before Tangier.

413 "We were all": McKew, interviews with the authors.

413 "He wouldn't buy": Ibid.

413 Bacon became so friendly: Ibid.

414 "I stepped over him": Ibid.

414 He had a brief: Ibid.

414 In late September: Bacon, letter to Denis Wirth-Miller, in Turner, *The Visitors' Book*, 194–5.

414 "I don't want to stay": Ibid.

414 At the end of May: Bacon, letter dated May 29 [1957], to Erica Brausen, in Hanover Gallery correspondence, Tate Archive, 863.6.1.

414 Then, in early June: Harry Fischer, letter to Bacon dated June 4, 1957, Marlborough Gallery archives.

414 Brausen also wrote to Bacon: Letter of June 6, 1957, Hanover Gallery correspondence, Tate Archive, 863/6/52.

415 Bacon answered: Bacon, letter dated June 12, Hanover Gallery correspondence. 863/1/1/6.

415 Fischer immediately responded: Fischer, letter of June 19, 1957, Marlborough archives.

415 He asked Denis: Bacon, letter to Wirth-Miller in Turner, *The Visitors' Book*, 194–5.

415 He visited the Tate: John Rothenstein diary, November 7, 1957, unpublished diaries, Tate archive. 8726/1.

416 "We had a lovely week": Bacon, letter to Wirth-Miller in Turner, *The Visitors' Book*, 235. In *The Visitors' Book* this letter is attributed, along with two others, to the Christmas of 1958, not 1957. However, Bacon and Lacy were definitely in Cannes together during the Christmas holidays in 1957 as well as 1958. Bacon wrote a letter to Harry Fischer in January of 1958 while still in Cannes. Also the letter from Cannes of late 1957 has "Hotel Martinez Cannes" as the address, whereas Bacon and Lacy stayed at the "Clos Garibondy" in Cannes La Bocca from November of 1958 to February of 1959, as per Marlborough Gallery records. The following quotations come from this letter of 1957.

416 "Peter packed his bag": Ibid.

416 That January, he wrote: Bacon, letter to Fischer, Marlborough Gallery archive.

416 "He received a card": Peter Pollock, quoted in Farson, *The Gilded Gutter Life*, 171.

417 Burroughs wrote at one point: Michael Schumacher, *Dharma Lion: A Biography of Allen Ginsberg* (New York: St. Martin's Press, 1992).

417 As part of their assertion: In an unsigned editorial, the *Tangier Gazette* reported on November 1, 1957, that "British visitors from Gibraltar will need a Moroccan visa." The editorial called the move "strangulation."

417 Upon his return to Tangier: William Burroughs, letter to Allen Ginsberg, December 8, 1957, in Oliver Harris, ed., *The Letters of William S. Burroughs, 1945–1959* (London: Picador, 1993), 380.

417 Jane had also spent: Green, *The Dream at the End of the World*, 195.

417 They had accompanied: Ibid., 197–8.

417 The Bowles hired: Paul Bowles, letter to Sonia Orwell, January 24, 1958, in the Orwell Archive, University College London.

417 Concerned about being arrested: Ibid., undated letter "Sunday/Aboard the 'Alcantara,'" Orwell Archive, University College London.

417 Bacon was, said Bowles: Ibid.

417 Expatriates, who feared: "Suddenly, travel agencies were crowded with Europeans trying to arrange passage to Rome or Paris or Lisbon." Green, *The Dream at the End of the World*, 199.

417 Burroughs left: Miles, *Call Me Burroughs*, 315.

417 As he famously: Ibid., 337.

418 In early April: Bowles, letter to Sonia Orwell from Lisbon, April 6, 1958, Orwell Archive. The second letter is dated April 25, 1958.

418 At one point, Bacon even wrote: Ibid., letter of April 25, 1958.

418 Bowles wrote to Sonia Orwell: Letter written from the American Embassy, Lisbon, dated 25/iv/58, Orwell Archive.

418 Bacon did what he could: Bacon, letter to Paul Bowles, April 5, 1958, quoted in Green, *The Dream at the End of the World*, 206.

418 The dark, boozy bar: Ibid., 204.

418 The new authorities: "Tangier Diary," *Tangier Gazette*, June 27, 1958.

418 Yacoubi was released: Ibid.

418 The *Tangier Gazette* reported: Ibid.

418 He had just returned: Ibid.

419 "We are in a terrible": Erica Brausen, letter to Bacon, March 17, 1958, Hanover files, Tate Archive, 863/6/102.

419 Bacon expressed surprise: Bacon, undated letter to Brausen, in ibid., 863/6/2/5.

419 In early May: "Tangier News," *Tangier Gazette,* May 6, 1958.

419 In late May: Erica Brausen, letter to Bacon, May 29, 1958, Hanover Gallery correspondence, Tate Archive, 863/6/101.

419 The show in Mexico City: A letter dated March 15, 1958 from the Hanover Gallery informed the Antonio Souza Galería that there was not enough work for a Bacon show. Hanover Gallery records, 1948–58, Tate Archive, 863/6/101.

419 In response to Brausen's: Bacon, letter of June 8, 1958, from his apartment on Blvd. Mohammed V to Brausen, Hanover Gallery correspondence, Tate Archive, 863/6/1/6.

420 She responded affectionately: Bacon's telegram is mentioned in this letter of Erica Brausen to him dated June 26, 1958, Tate Archive, 863/6/1.7.

420 By mid-July: Much as Robert Buhler sold abandoned Bacon paintings that he found in the basement of 12 Cromwell Place, so did the painter Nicholas Brusilowski, who took over Bacon's Tangier studio from him in 1959. Five paintings made their way onto the market years later. See Martin Harrison, ed., *Francis Bacon Catalogue Raisonne*, vol. III (London: Estate of Francis Bacon, 2016), 550–8.

420 On July 18: "Tangier Notes," *Tangier Gazette,* July 18, 1958. "He was rather vague about his returning here, but will do so when he has got through a large batch of work awaiting him in London," reported the paper. "'Life is full of pleasant distractions in Tangier but I must get on with my painting,' he exclaimed."

28 BETS

421 On October 16, 1958: Contractual letter between Marlborough and Bacon, in Marlborough Gallery archives. The agreement was to begin on November 1, 1958, "and to continue for a period of ten years." All the prices to be paid for his paintings are in this agreement.

421 He received: Ibid.

421 The following day: Michael Greenwood, Erica Brausen's assistant, letter of October 17, 1958, Hanover Gallery, records 1948–1958, Tate Archive, 863/6.

421 He could have waited: Ibid.

421 He would not have done so: Ibid.

421 "He knows that you will be distressed": Ibid.

422 She sought what amounted to: Records of the threatened litigation are in the Marlborough Gallery archive of 1959.

422 Fischer wrote Bacon: Harry Fischer, letter to Bacon dated December 1, 1958, in ibid.

422 Critics alluded to: In a letter to Bacon dated June 29, 1959, Harry Fischer wrote to Bacon to tell him that Brausen's exhibition "has not done us the harm we expected. . . . as many art critics made remarks that owing to internal quarrels a real Bacon exhibition has been prevented." Marlborough Gallery archive.

422 At a dinner party: John Rothenstein diary, November 21, 1958, unpublished diaries 1939–1990, Tate Archive, 8726/1.

423 It was abandoned and found: The painting is *Figure in Sea*, which was first shown in a museum exhibition in the Hugh Lane's *A Terrible Beauty* show of October 2009–March 2010.

423 One resembled: Deakin's photographs show an older-looking Lacy, his face more careworn, posed casually in a checked shirt in Smithfield Market.

423 Freud called *Lying Figure:* Freud, quoted in Martin Harrison, ed., vol. III *Francis Bacon Catalogue Raisonné* (London: Estate of Francis Bacon, 2016), 548.

423 Bacon and Lacy booked outside Cannes: Bacon's letter of December 18, 1958, to Harry Fischer included the return address "Loge Duchlos Garibondy, Cannes-la-Bocca, France." Marlborough Gallery archive.

423 Just before he left: Bacon, undated letter to Denis Wirth-Miller, "poste restante" return address, in Jon Lys Turner, *The Visitors' Book* (London: Constable, 2016), 234–5. The letter has been thought to date to 1957 but, given Bacon's plans to work while in the South of France on this particular trip, the more likely date is 1958.

423 He wanted twelve paintings: Harry Fischer, letters to Bacon dated February 6, 1959, and February 21, 1959, Marlborough Gallery archive.

424 "I am afraid things": Undated letter, Poste Restante, Cannes, in Turner, *The Visitors' Book*, 234–5.

424 In a second letter to Wivenhoe: Letter of January 7 [1959], post restante, Cannes, in ibid., 235. The second letter clearly follows the first. In the first, Bacon wished Wirth-Miller luck in landing the Lefevre Gallery. In the second, he congratulated him on being accepted by the gallery: "I am so delighted with your news you have every reason to feel elated I am sure Lefevre are the best gallery. I cannot tell you how pleased I am." Turner, *The Visitor's Book,* 235. Wirth-Miller joined the Lefevre Gallery in 1959 and had his first show there in 1960.

424 Pained that he had not been invited: Fischer, letter to Bacon of February 21, 1959, Marlborough Gallery archive.

424 A few months earlier: See "Staging Jackson Pollock," www.whitechapelgallery.org.

424 The Museum of Modern Art: Press release, The Museum of Modern Art, May 28, 1959, www.moma.org.

425 During the *New American Painting* exhibition: Rothenstein diary, February 23, 1959, unpublished diaries 1939–1990, Tate Archive, 8726/1.

425 Bacon was interested: Bacon to Allan Ginsberg, in Ted Morgan, *Literary Outlaw: The Life and Times of William Burroughs* (New York: W. W. Norton and Co., 2012), 148.

425 The American art historian Hugh Davies: Hugh Davies, *Francis Bacon: The Early and Middle Years, 1928–1958* (New York: Garland Publishing Co., 1978), 166.

425 Under enormous personal: Harry Fischer, letter of June 29, 1959, to Bacon in Tangier, Marlborough Gallery archive.

425 In a letter that made mention: Bacon, letter to Paul Danquah, July 2 [1959], quoted in Dan Farson, *The Gilded Gutter Life of Francis Bacon* (New York: Pantheon, 1993), 166.

425 He would have: Hugh Davies, letter of February 21, 1974, to Bacon says that he is sorry to hear that Bacon has had his gall bladder removed "and thereby missed your holiday in Spain." Marlborough Gallery archive.

426 Hecht, who lived: Roger Berthoud, *Graham Sutherland: A Biography* (London: Faber and Fabert, 1982), 163–4.

426 Hecht called Paul Brass: Brass, transcript of an interview for Adam Low, director, *Francis Bacon, Arena* documentary, BBC4 Archives, March 19, 2005.

426 With Hecht: Sophie Pretorius, "A Pathological Painter: Francis Bacon and the Control of Suffering," in *Inside Francis Bacon, Francis Bacon Studies III* (London: The Estate of Francis Bacon Publishing, in association with Thames & Hudson, 2020), 166.

426 "He obviously": Brass, interview for *Francis Bacon, Arena*. The rest of the quotations in this paragraph come from this interview.

426 On July 22: Fischer, letter to Bacon, July 22, 1959, Marlborough Gallery archives.

426 "It is difficult for us: Ibid.

426 Fischer was no doubt: "Tangier Notes," *Tangier Gazette*, March 15, 1957.

426 But Lacy was deeply: One letter in particular, from Bacon to Denis Wirth-Miller, underscores Peter Lacy's unhappiness. It is written from Cornwall, where Bacon went in September of 1959. "He wrote me such terribly unhappy letters," Bacon tells Wirth-Miller. Bacon, letter to Denis Wirth-Miller, quoted in Turner, *The Visitors' Book*, 238.

427 While in Tangier: Bacon, letter to Paul Danquah, July 2 [1959], in Farson, *The Gilded Gutter Life*, 166.

427 Ron Belton was a "smudge": Christopher Gibbs, interview with the authors, October 12, 2013. Gibbs was not only an essential part of the "Swinging Sixties" scene in London, but also a frequent visitor to Tangier from the 1960s on and moved there before his death in 2018.

427 The word originated: Steve Crane, "Fleet Street Photographer Lingo," Helderberg Photographic Society website, helderbergphoto.com.

427 Like many working-class: "He was an exceptionally active man, not at all 'gay' in any conventional sense, except that I assume he was bisexual." Dan Farson, *The Gilded Gutter Life*, 117.

427 "Ron was very big": Paul Danquoh, quoted in ibid., 119.

427 Belton had also been: Ibid., 118.

428 "He was very sweet and charming": Gibbs, interview with the authors.

428 The month of his return, Ann Fleming: Ann Fleming, letter to Patrick Leigh Fermor, August 1959, in Mark Amory, ed., *The Letters of Ann Fleming* (London: Collins Harvill, 1985), 236.

428 "He would go along": Gibbs, interview with the authors.

429 "He had a sort of latent violence": Ibid.

429 But Bacon also took a paternal: Bacon, undated letter [1960] to Denis Wirth-Miller from Monaco, in which Bacon calls Ron "a really remarkable boy." Turner, *The Visitors' Book*, 249–50.

429 "Francis rather liked": Danquah, quoted in Farson, *The Gilded Gutter Life*, 118.

429 A 250-mile drive: See the Tate Museum's history of St. Ives (where the Tate has a satellite museum), "St. Ives School," www.tate.org.uk.

429 Wirth-Miller and Chopping had themselves: Turner, *The Visitors' Book*, 106–7.

429 In the 1920s and '30s: See "St. Ives School," www.tate.org.uk.

430 Among them were Ben Nicholson: Ibid.

430 The village was becoming so well-known: Emma Acker, "Artistic Identity in a Transatlantic Age: Patrick Heron, Peter Lanyon, and the New American Painting," *The British Art Journal* 10, no. 3 (Winter/Spring 2009–10), 158–70.

430 At the Sloop Inn: Martin Gayford, "How Bacon Was Cured in Cornwall," *The Telegraph*, February 3, 2007, www.telegraph.co.uk.

430 Redgrave ran: See "Peter Lanyon," www.jameshymangallery.com.

430 Redgrave offered: Gayford, "How Bacon Was Cured in Cornwall," *The Telegraph*.

430 They moved: Bacon's letter to Harry Fischer, October 19, 1959, Marlborough Gallery archive, has Seagull House as his address. For the description of his studio, see Gayford, "How Bacon Was Cured in Cornwall," *The Telegraph*.

430 "My dear Fischer": Marlborough Gallery archive.

430 "I had no idea *you*: Bacon, quoted in Farson, *The Gilded Gutter Life*, 122.

430 For his part, Heron: Heron, quoted in Gayford, "How Bacon Was Cured in Cornwall, *The Telegraph*.

431 In his journal, Redgrave described: Farson, *The Gilded Gutter Life*, 125.

431 Tonks, a surgeon: See "Henry Tonks," www.tate.org .uk.

431 With Tonkian dryness: Gayford, "How Bacon Was Cured in Cornwall," *The Telegraph*.

431 The large blocks of color: Martin Harrison, ed., *Francis Bacon Catalogue Raisonné*, vol. III (London: Estate of Francis Bacon, 2016), 574.

431 He experimented with the "flatness": Ibid.

431 Belton recalled: Ibid.

432 "This is a stronghold": Bacon, letter of Monday 16 [no month, 1959] to Denis Wirth-Miller, in Turner, *The Visitors' Book*, 238.

432 "It is terribly isolated": Ibid.

432 In December, he confessed: Bacon, letter of December 12, 1959, to Denis Wirth-Miller, in the collection of Jon Lys Turner, friend, co-executor and beneficiary of the estate of Richard Chopping and Denis Wirth-Miller. The authors are grateful to Turner for providing them Bacon's unpublished letters.

432 Stephen Spender, Fischer informed Bacon: Fischer, letter of November 20, 1959 to Bacon, in Marlborough Gallery archives.

432 "I doubt if I shall ever get": Bacon, letter of December 12, 1959, collection Jon Lys Turner.

432 "I am in the most ghastly": Bacon, letter of Monday the 16 [no year] to Wirth-Miller in Turner, *The Visitors' Book*, 238.

432 Giles Auty: Farson, *The Gilded Gutter Life*, 123.

433 When Auty and Bacon: Ibid.

433 But Lacy could also wield: The Francis Bacon studio collection at the Hugh Lane Gallery contains a number of whips—wood, a cane whip with a leather handle, and a horsewhip. Hugh Lane Gallery, Bacon studio archive, RM98F244:20, RM98F244:21, and RM98F244:22. Bacon also showed Dan Farson the weals on his back from a beating that Lacy had given him. Farson, *The Gilded Gutter Life*, 171.

433 During a fight: Peppiatt, *Anatomy of an Enigma*, 222.

433 Halfway through their stay: Bacon, letter to Denis Wirth-Miller, dated Monday 16 [no month, 1959], in Turner, *The Visitors' Book*, 238.

433 He wrote Bacon: Ibid.

433 On a trip to London: Bacon, unpublished letter of December 12, 1959 to Wirth-Miller, collection of Jon Lys Turner.

433 "If Dennis dear": Letter dated Monday 16 [no month, 1959], in Turner, *The Visitors' Book*, 238.

433 Fischer's rescheduled: Unpublished letter of December 12, 1959, collection of Jon Lys Turner.

433 The abstract painter later did: Gayford, "How Bacon Was Cured in Cornwall," *The Telegraph*.

434 "This," he had earlier written: Bacon, unpublished letter of December 12, 1959, collection of Jon Lys Turner.

434 Beaton had initially asked: Buckle, ed., *Self-Portrait with Friends*, 322.

434 "He is acclaimed": Ibid., 323.

434 "It was pointless": Ibid., 321.

435 Beaton had last had: See "Cecil Beaton," www.npg .org.uk.

435 The result flattered him: Buckle, ed., *Self-Portrait with Friends*, 321.

435 He had seen Bacon's portraits: Ibid.

435 "Francis started to work": Ibid. All of the quotations about the sitting and the resulting portrait come from Buckle, ed., *Self Portrait with Friends*. © The Literary Executor of the late Sir Cecil Beaton, 2021.

436 Not surprisingly: Earlier, in 1951, Beaton had shot Bacon in the grand and formal environment of his own flat, 8 Pelham Place in South Kensington. But the earlier portrait lacks the specificity of the 1960 series. See Cecil Beaton, "Francis Bacon," www.npg.org.uk.

437 In the end, Fischer: The Melville piece originally appeared in the exhibition catalog of the 1959 Bienal de São Paulo.

437 Melville began: Ibid. The following quotations all come from this piece.

438 At the private view: "Art Guests Toast Mr. Bacon," *The Evening Standard*, March 24, 1960.

438 The prominent: Ibid.

438 But the reporter also observed: Ibid.

438 Writer Frank Norman said: Ibid.

438 Norman, a former thief: See Frank Norman, npg.org .uk.

438 Afterward, a party was thrown: "Art Guests Toast Mr. Bacon," *The Evening Standard*.

438 "Taxies throbbed": Ibid.

439 On the eve: Harrison, ed., *Francis Bacon Catalogue Raisonné*, vol. III, 616.

29 THE FIG TREE

440 In his *Observer* piece: Stephen Spender, "At the Galleries: As Bacon Sees Us," *The Observer*, March 27, 1960.

440 Marlborough did its best: Lawrence Alloway, "Dr. No's Bacon," *Art News and Review,* April 9–23, 1960.

440 The most offbeat review came: R. B. Kitaj, "Galleries: Bacon in the Nut House Again," *London American*, April 7/13, 1960.

441 *The Evening Standard's* reviewer: David Carritt, "Bacon—The Art of Success," *The Evening Standard*, March 29, 1960.

441 For all his professed hatred: Cooper was on the Marlborough's list of Bacon buyers as of February 1, 1961. Marlborough Gallery archive.

441 Bacon began wryly: Daniel Farson, *The Gilded Gutter Life of Francis Bacon* (New York: Pantheon Books, 1993), 157.

441 Bomford was: David Somerset, interview with the authors, June 18, 2012.

441 "I was just the driver": Ibid.

441 "We brought them": Ibid.

441 Buying Bacon in bulk: Ibid.

442 Around contemporary artists: Sidney Janis, the New York art dealer, was a master showman and helped develop this approach. Mark Stevens and Annalyn Swan, *de Kooning: An American Master* (New York: Knopf, 2004), 317.

442 But Fischer and Lloyd: In a letter from Harry Fischer to Bacon of January 30, 1961, Fischer mentioned that the gallery's "program" for the next few months was Bacon shows in Zurich, Dusseldorf, and New York. Marlborough Gallery archive.

442 He had recently brought: John Rothenstein diary, May 13, 1959, unpublished diaries 1939–1990, Tate Archive. 8726/1. For the Christopher Gibbs quotation, Gibbs, interview with the authors, October 12, 2013.

442 The book on Bacon: Rothenstein originally proposed the book in November of 1956 (Rothenstein diary, November 1, 1956). In an entry dated June 16, 1961, he noted that Bacon "liked idea of a short lib. Vol on him—but he's off to Tangiers for two months." Unpublished diaries, Tate Archive.

443 Even so: Letter from A. W. Bell of Lund Humphries, dated November 13, 1959, to Monroe Wheeler at the Museum of Modern Art. James Thrall Soby papers, 1930–1979, Series I, "Subject Interest Material: Artists and Movements, 1930s–1960s, MoMA archive.

443 A close personal friend: "James Thrall Soby Bequest on View at the Museum of Modern Art," press release, Museum of Modern Art, March 1979, www.moma.org.

443 He was a prolific writer: Ibid.

443 In December 1959: Fischer, letter of December 14, 1959, to Soby, Soby papers, MoMA archive.

443 To gather background material: Soby, letter to Fischer dated December 13, 1959, in ibid.

444 Fischer and Melville determined: In a letter of January 25, 1960, to Soby, Fischer described the dinner. Soby papers, ibid.

444 "He made many references": Ibid. All of the succeeding quotations come from the same letter.

445 Bacon always took pains: Bacon's careful placement of himself outside the English "visionary" painters is a recurring theme in his interviews. Once, in Paris, Raymond Mason said that he thought Bacon followed on "from artists like Hogarth, Blake, Ford Maddox Brown and Stanley Spencer." Bacon firmly contradicted him. Raymond Mason, *At Work in Paris: Raymond Mason on Art and Artists* (London: Thames & Hudson, 2003), 173.

445 Soby could not have been pleased: Soby, letter to Fischer dated March 1, 1960, in Soby papers, MoMA archive.

445 When Soby ventured to Fischer: Letter from Fischer to Soby dated November 2, 1960, in ibid.

445 After telling Soby: Letter from Fischer to Soby dated May 13, 1960, in ibid.

445 "FB said going": John Rothenstein is the source on Bacon's hospitalization in June of 1960: Rothenstein diary, June 22, 1960, Tate Archive, 8726/1. Harry Fischer is the source of the hospitalization in January of 1961. A list of Fischer's expenses, dated February 1, 1961, indicates Fischer sent Bacon a book on the Prado while "in hospital." Marlborough Gallery archives.

445 He would say to a friend: Richard Buckle, ed., *Cecil Beaton, Self-Portrait with Friends: The Selected Diaries of Cecil Beaton* (New York: Times Books, 1979), 323.

445 He spontaneously gave: Frank Auerbach, interview with Mark Stevens, February 12, 2009.

446 Anne Dunn noted: Anne Dunn, interview with the authors, July 26, 2010.

446 They booked on the *Kenya Castle*: Bacon, undated letter to Denis Wirth-Miller with the heading "Union-Castle-Line, S.S. 'Kenya Castle,'" quoted in Jon Lys Turner, *The Visitors' Book* (London: Constable, 2016), 248–9.

446 Denis Wirth-Miller, who also fancied: Ibid.

446 "I am sorry": Ibid. The rest of the quotations about the trip come from this same letter.

447 There was an evocative mention: Letter from Bacon to Paul Danquah, quoted in Dan Farson, *The Gilded Gutter Life of Francis Bacon* (New York: Pantheon Books, 1993), 165.

447 But in the end: A new municipal casino had opened in 1958, as the *Tangier Gazette* reported in an item dated June 27, 1958. During Bacon's time in Tangier in 1960 and 1961 he went gambling there with Timothy Leary and Gregory Corso. Michelle Green, *The Dream at the End of the World: Paul Bowles and the Literary Renegades in Tangier* (New York: Harper Collins, 1991), 238–41.

447 Bacon wrote: Bacon to Wirth-Miller, in Turner, *The Visitors' Book*, 249–50.

447 Only then did he report: Ibid.

447 He noted: Sophie Pretorius, "A Pathological Painter: Francis Bacon and the Control of Suffering," in *Inside Francis Bacon, Francis Bacon Studies III* (London: The Estate of Francis Bacon publishing, in association with Thames & Hudson, 2020), 173.

448 At the end of November 1960: Harry Fischer, letter to Messrs. Theodore Goddard & Co. solicitors, November 29, 1959, Marlborough Gallery archives.

448 By Christmas: In a note to Robert Savage dated May 19, 1960, Fischer alluded to the lengthy negotiations that had taken place over months, beginning around Christmastime. Marlborough Gallery archives. Fischer wrote to Savage at 65 Old Brompton Road, his central business

establishment. For more on Savage, see "Robert Savage" at National Portrait Gallery, www.npg.org.uk.

448 Over the years, Savage: Ibid.

448 On the first floor: The layout of 7 Reece Mews, now well-known because of the reconstruction of Bacon's studio at the Hugh Lane Gallery in Dublin, did not change from the time when Bacon signed the lease in 1961. See the photographic documentation in Perry Ogden, *7 Reece Mews: Francis Bacon's Studio* (London: Thames and Hudson, 2001), which contains photographs of every space in 7 Reece Mews as Bacon left it.

448 In May, with Bacon at "the end": Harry Fischer, letter dated May 11, 1961, to Messrs. Theodore Goddard & Co. Marlborough Gallery archives.

448 Savage then agreed: By June 3, 1961, the lease had been signed. Messrs. Theodore Goddard & Co., letter to Harry Fischer in ibid.

448 Danquah enjoyed attending: Danquah, quoted in Dan Farson, *The Gilded Gutter Life*, 116.

448 As Danquah put it: Ibid.

449 In the fall of 1960, he had delicately: Fischer, letter to Soby, October 21, 1960. Marlborough Gallery archives.

449 Early in 1961: In a letter from Peter Selz, then MoMA's curator of painting and sculpture, to Frank O'Hara on January 6, 1961, Selz wrote, "I just spoke to Jim Soby, who will be glad to work with you on the Bacon show." Selz had included Bacon in his first important show at MoMA, *New Images of Man* of 1959, which featured figurative art at a time when abstract expressionism was still dominant. (See Alex Greenberger, "Peter Selz, Curator and Art Historian Committed to the New, Is Dead at 100," *Art News*, June 22, 2019.) On Nov. 3, 1961, O'Hara's assistant, Renee S. Neu, sent material about the "progress made during these months" on "the Francis Bacon exhibition" and told him O'Hara had suggested she visit Soby at his home in Connecticut to work on the show. Soby papers, MoMA archive.

449 Fischer wrote Soby: Fischer, letter to Soby dated May 31, 1961. Marlborough Gallery archives.

449 He emphasized that "It is of": Ibid.

449 He was a perceptive admirer: Rothenstein unpublished diary, November 5, 1958, Tate Archive, 8726/1.

449 In June of 1961: Ibid.

449 He asked him a second time: Ibid.

450 This time Bacon "liked": Ibid.

450 Not long before seeing Rothenstein: Bacon, quoted in Michael Peppiatt, *Francis Bacon in Your Blood: A Memoir* (New York: Bloomsbury USA, 2015), 76.

450 Bacon knew: Ibid.

450 In 1964, he would marry: See "London fashion model Sheila Reeve, one of the top London models, with her husband Ronald Belton," Alamy.com.

450 "But there was this Arab boy": Peppiatt, *Bacon in Your Blood*, 76.

451 "Peter came back just then": Ibid.

451 "Even though there was nothing": Ibid.

451 For the rest of the visit: Fischer, in a letter of July 13, 1961, to James Soby, told Soby that Bacon was at this address. Marlborough Gallery archive.

451 The two briefly shared: Larbi Yacoubi, interview with James Norton, October 6, 2013.

451 But Bacon did not: Bacon left on Friday, August 12, 1961, according to an item in the August 18, 1961, issue of *Morocco Mail*.

451 The night before Bacon left: Ibid.

451 The last guests: Ibid.

30 SUCH ARDOUR

452 In the autumn of 1961: Rothenstein wrote that he had "lunch [with] Fischer for thorough discussion of Bacon exhibition." John Rothenstein diary, November 19, 1961 unpublished diaries, 1939–1990. Tate Archive, 8726/1.

452 They were fairly conservative: Like Rodrigo Moynihan—who was a great friend—William Coldstream painted fairly traditional portraits that were, in every sense, the opposite of Bacon's portraits. In his early days, Coldstream had been associated with the conservative Euston Road School of Art, which opposed much of European Modernism. See Sir William Coldstream, www.tate.org.uk.

452 The trustees noted that Marlborough: Rothenstein diary, January 10, 1962, unpublished diaries. Tate Archive. He foresaw "endless discussion and delay."

452 Rothenstein was flattered: Ibid. After his lunch with Harry Fischer on November 19, 1961, Rothenstein noted Fischer's flattering response to his ideas for the exhibition. Fischer found them "most helpful." Ibid, November 19, 1961.

452 Rothenstein assured the trustees: Rothenstein diary, December 21, 1961.

452 That led the trustees: Ibid. Fischer was "very upset and angry" when Rothenstein told him about the trustees' stalling on the question of a Bacon exhibition.

452 In January of 1962, John Witt: Ibid., January 10, 1962.

452 The chairman of the board: Colin Anderson had of course helped to support Bacon for quite a few years. See Ch. 15. Bacon turned to Anderson multiple times in the late 1940s for money to cover his debts while he was living in Monte Carlo.

452 On January 15: Rothenstein diary, January 15, 1962, unpublished diaries, Tate Archive.

452 The next day: Ibid., entry of January 16, 1962.

452 Rothenstein immediately went: Ibid.

452 He also: Ibid. It was, Rothenstein noted, a "Marathon day" for him—"no lunch at all."

453 The following week: Ibid., January 24, 1962.

453 He persuaded a somewhat: On January 25, Rothenstein noted "endless complications," including over Erica Brausen's role. Rothenstein diary, January 25, 1962.

453 She arrived for a working: Ibid., January 30, 1962.

453 And, in the hope of obtaining: Ibid,

453 But Bacon—"wishing perhaps: Ibid.

453 "I had only a moment": Ibid.

453 In early February: Ibid., February 7, 1962.

454 He was rereading Nietzsche: Fischer, letter of November 13, 1961, to Soby. Marlborough Gallery archives.

454 Sometimes, he suffered: Rothenstein diary, May 2, 1962, unpublished diaries, Tate Archive.

454 He had a "massively": Sophie Pretorius, "A Pathological Painter: Francis Bacon and the Control of Suffering," in Inside Francis Bacon, Francis Bacon Studies III (London: The Estate of Francis Bacon Publishing, in association with Thames & Hudson, 2020), 195.

454 He kept an expensive electric radiator: Rothenstein diary, February 27, 1962.

454 At one point, Rothenstein: John Rothenstein, Time's Thievish Progress (London: Cassell, 1970), 82–91.

455 He wrote: Ibid.

455 Bacon was moved to tears: Rothenstein diary, April 27, 1962, unpublished diaries, Tate Archive.

455 Rothenstein felt "touched": Ibid.

455 The introduction was: John Richardson made this point in an attack upon Rothenstein's piece, which in modified form appeared as the Introduction to the first catalogue raisonné, by Ronald Alley, in 1965. John Richardson, "Tragedian," The New York Review of Books, March 25, 1965.

455 Instead, he wrote: Rothenstein, Francis Bacon exhibition catalog, Tate Gallery May 24–July 1, 1962 (London: Tate Gallery, 1962), 5–12.

456 Not only did Bacon reflect: Ibid.

456 "The element of Grand Guignol": Ibid.

456 The show filled five large galleries: Fischer, letter to Soby, May 22, 1962, Marlborough Gallery archive.

456 Bacon came to the press preview: Rothenstein diary, May 23, 1962.

456 Black leather would increasingly: Bacon was photographed many times in the sixties, seventies, and eighties before the openings of his exhibitions wearing either a short leather jacket or a long black leather trenchcoat that looked vaguely like a throwback to Nazi Germany. See photograph by Jean-Loup Cornet, Hugh Lane Gallery, Dublin (Reg. No. RM98F23:42B), © The Estate of Francis Bacon. Bacon liked the leathermaker Zilli; a tag for the manufacturer is in the Hugh Lane Gallery collection. See also fashiongear.fibre2fashion.com.

456 The three owners of Marlborough: Rothenstein diary, May 23, 1962, unpublished diaries, Tate Archive.

456 For La Maison Prunier, see See Debra Kelly and Martyn Cornick, eds., A History of the French in London: Liberty, Equality, Opportunity (London: School of Advanced Study, University of London, Institute of Historical Research, 2013), 320.

456 Bacon, noted Rothenstein: Rothenstein diary, May 18, 1962, unpublished diaries, Tate Archive.

457 "He'd see something": Paul Danquah, interview for Adam Low, director, Francis Bacon, Arena documentary, BBC Four archive, March 19, 2005.

457 When Rothenstein returned: Rothenstein, Time's Thievish Progress, 82–91.

457 "At a few paces distant": Ibid.

457 "Such ardour": Rothenstein diary, May 24, 1962, unpublished diaries, Tate Archive.

457 The paper's unsigned piece: "The Horrific Vision of Mr. Francis Bacon," The Times, May 24, 1962.

457 "The emotional shock": Ibid.

457 Writing in: David Sylvester, "Francis Bacon," The New Statesman, June 22, 1962.

458 Figure and ground did not always: Ibid.

458 The earlier "smoky, tonal paintings": Ibid.

458 In the later paintings, however: Ibid.

458 It was this formal breakage: "The Horrific Vision of Mr. Francis Bacon," The Times.

458 "This triptych is probably": Sylvester, "Francis Bacon," The New Statesman.

458 On May 24: Rothenstein diary entry, May 29, 1962, unpublished diaries, Tate Archive.

458 The answering telegram: Lacy died on May 23, 1962. England and Wales, National Probate Calendar (Index of Wills and Administration) 1858–1995, ancestry.co.uk.

458 His "pancreas exploded": Bacon, quoted in Michael Peppiatt, Bacon in Your Blood: A Memoir (New York: Bloomsbury USA, 2015), 76.

458 Bacon suspected: Rothenstein diary, May 29, 1962, unpublished diaries, Tate Archive.

459 Lacy's estate: National Probate Calendar, ancestry.co.uk.

459 Impeccably mannered: Fr. David Lacy and Gerald Towell, interview with the authors, March 17, 2011.

459 On a trip: Peppiatt, Bacon in Your Blood, 72.

459 He "spoke movingly": John Goldsmith, ed., Stephen Spender Journals 1939–1983 (London: Faber and Faber, 1985), 231.

459 "Dined with Francis Bacon": Ibid.

459 "Certain friends," he said: Ibid.

459 Before he died: Ibid.

459 Landscape Near Malabata: Bacon told Ronald Alley, the editor of the first Bacon catalogue raisonné, that he had tried to paint Malabata—an area of rugged coast near Tangier—many times, "but all his other attempts were unsuccessful." Ronald Alley, ed, Francis Bacon (London: Thames and Hudson, 1964), 152.

460 One of the forms: Martin Harrison, ed., Francis Bacon

Catalogue Raisonné, vol. 3 (London: The Estate of Francis Bacon, 2016), 720.

460 Thirty-five years later: Sidney Bigman, letter to the Tate, February 2, 1998, kept in David Sylvester files, Tate Archive, 200816/2/1. The subsequent details all come from this interview.

461 In a feverish period: Bacon, quoted in David Sylvester, *Interviews with Francis Bacon* (New York: Thames & Hudson, 1987), 13. See also Rothenstein diary, February 27, 1962, unpublished diaries, Tate Archive.

31 SETTLING IN

463 Nearly 100,000 people: Harry Fischer, letter to James Soby following the end of Bacon's retrospective, Marlborough Gallery archive.

463 Even Picasso: John Rothenstein, *Time's Thievish Progress* (London: Cassell, 1970), 91.

463 He made: Both skylights can be seen in Perry Ogden, *7 Reece Mews: Francis Bacon's Studio* (London: Thames & Hudson, 2001).

464 The bedroom: See the photographs in ibid., 102–15. For John Rothenstein's recollection of 7 Reece Mews, see Rothenstein, *Time's Thievish Progress*, 82–91. Alice Weldon, a close friend of Lucian Freud's for many years, remembered the incongruous grey velvet curtains in particular. Alice Weldon, interview with Annalyn Swan, March 12, 2012.

464 Perhaps the most distinctive feature: Rothenstein, *Time's Thievish Progress*, 82–91.

464 Otherwise it was long: Alice Weldon, interview with Swan.

465 But the galley kitchen also included: The artist Anthony Zych recalled that Bacon made him several meals in the five years before his death, and that each time Bacon cleared a spot on the small dining-room table in his bedsit for them to eat. Anthony Zych, interview with Annalyn Swan, November 10, 2017.

465 His studio he allowed: See Ogden, *7 Reece Mews*, 14–89.

465 He rubbed dust: In an interview with David Sylvester, Bacon mentioned mixing dust with paint in some of his work, including his early *Figure in a Landscape* of 1945. David Sylvester, *Interviews with Francis Bacon* (New York: Thames & Hudson, 1987), 22.

465 "When I went to the studio": Gilbert Lloyd, interview with Mark Stevens, November 2, 2012.

465 Bacon himself was invariably scrubbed: Michael Wishart, *High Diver* (London: Blond and Briggs, 1977), 61–4.

465 The only cozy touches: Ogden, *7 Reece Mews*, 90–101.

466 Later, he placed photographs: Ibid., 106–7.

467 The round, oracular Sylvester: Sylvester was famous for his profound silences before beginning to speak. Sarah Whitfield, close to Sylvester for the last two decades of his life, noted that there was "an interesting Jewish side of David. He enjoyed a high level of conversation, serious conversation." Whitfield, interview with Mark Stevens, December 7, 2018.

467 The critic had recently: James Finch, "David Sylvester: A British Critic in New York," Tate Research Feature, July 2015, www.tate.org.uk.

467 In 1960, when he was: Ibid.

467 In October of 1962: Francis Bacon and David Sylvester, "Francis Bacon—Interview," BBC Archives, March 23, 1963.

468 "Well, I never thought of it": Ibid.

468 "One of course always loves": Ibid.

468 In contrast to Sylvester: John Russell and his third wife, Rosamund Bernier, were part of the art and social scenes of New York as well as in Europe. See William Grimes, "John Russell, Art Critic for the Times, Dies at 89," *The New York Times,* August 24, 2008, www.nytimes.com.

468 It presented: See John Russell, *Francis Bacon* (London: Methuen, 1964).

468 Like Sylvester, he would certainly: Russell was discreet. In his voluminous writing about Bacon the critic never referred to the artist's periodic nervous attacks or other personal troubles. But he certainly knew about them. In 1968, Russell wrote a note to Valerie Beston at the Marlborough saying that Bacon had vanished; they had been scheduled to meet and he never showed up. "Could you tell me where he is?" Russell asked. "Is he at the health place, where he meant to go, or is there trouble of a new (or familiar) kind?" Marlborough Gallery archives, August 25, 1968.

469 In the fall of 1963: See *Francis Bacon* exhibition catalog (New York: Solomon R. Guggenheim Foundation, 1963), www.guggenheim.org/publications.

469 Bacon did not come: David Sylvester, "Enter Bacon, with the Bacon Scream," *The New York Times Magazine*, October 20, 1963.

469 The Marlborough Gallery would have: As James Soby wrote to Alfred Barr at MoMA on Aug. 14, 1962, "The show at the Guggenheim (and what a horrible blunder to let them have the first big American show of an artist they've never done anything about; just in terms of box office it's so stupid, Bacon having attracted nearly 100,000 people to the Tate—according to Fischer)." Museum of Modern Art, James Thrall Soby papers, 1930–1979, Series I, "Subject Interest Material: Artists and Movements, 1930s–1960s, MoMA archive.

469 It was the Guggenheim: In a letter to Fischer on June 8, 1962, Soby wrote that he wanted to buy the new *Crucifixion* triptych for the Museum of Modern Art. Marlborough Gallery archives.

469 MoMA could not figure out: "We have only one fund

in the Museum for pictures as costly as this, and it may be that its donor, an elderly but extraordinarily generous woman, will be alarmed by the triptych's ferocious subject matter," Soby wrote to Fischer in June of 1962. Ibid.

469 The title of Brian O'Doherty's: O'Doherty, "On the Strange Case of Francis Bacon," *The New York Times*, October 30, 1963.

469 Irving Sandler: Sandler, "In the Art Galleries," *The New York Post*, October 27, 1963.

469 The photographer and art critic Max Kozloff: David Sylvester correspondence, personal papers, Tate Archive, 200816.

470 Bacon's art dealers agreed: John Rothenstein, September 21, 1962, unpublished diaries, Tate Archive, 8726/1, 1939–1990.

470 In 1963, the year: The Marlborough-Gerson Gallery opened in New York in October of 1963. In a story in *The New York Times* that was published on October 2, 1963, the critic Brian O'Doherty wrote of the Marlborough opening that "The colossus has entered the arena." See www.marlboroughgallery.com.

470 During the 1960s and '70s: Gilbert Lloyd, interview with Mark Stevens, November 2, 2012.

470 According to Gilbert Lloyd: Ibid. On August 4, 1965, Fischer wrote Bacon a letter that began, "I was grieved to hear from my 'secret informers' that you thought I really never looked properly at your paintings. How can you think these things when I tell you that since 1949 I have studied and admired every stroke of your brush?" Marlborough Gallery archive.

471 Employees tended to come: "She was like the mum of the gallery," said David Russell, who began driving for the Marlborough and opening and shutting the gallery in February of 1980. "If you had a problem you'd go and see her. She'd say, 'Forget it.'" David Russell, interview with the authors, March 6, 2012.

471 According to Harriet Lane: Harriet Lane, "Valerie at the Gallery," *The Guardian*, January 28, 2006, www.theguardian.com.

471 He collected Rolls-Royces: Ibid. James Kirkman, a longtime member of the Marlborough Gallery, recalled that Beston's father was in the newspaper business, not the book business. James Kirkman, interview with Mark Stevens, April 24, 2012.

471 He and Dulcie then boarded: Lane, "Valerie at the Gallery," *The Guardian*, January 28, 2006.

471 "Inheriting a quantity": Ibid. All of the following biographical material on Valerie Beston and quotations comes from Lane's article.

472 In her twenties, it was whispered: Kirkman, interview with Stevens.

472 It was rumored: Lloyd, interview with Stevens.

472 "I think I can say": Ibid.

472 She did not invite: Terry Danziger Miles, interview with Mark Stevens, March 20, 2014.

472 She would go out of her way: Ibid. Once, Miss Beston asked Miles, who had joined the gallery as a young driver, whether he was going away on holiday. He told her that he couldn't afford it. "The next day she came in and gave me these keys and said, 'I have this house on the beach in Kent and it's yours for whenever you want to go. Just let me know.'"

472 "Dear Mr. Bacon," she began: Valerie Beston, letter of January 28, 1963 to Bacon. Marlborough Gallery archives.

473 "On a normal day": Miles, interview with Stevens, March 20, 2014.

473 Frank Auerbach was also: Ibid.

473 She organized his household: Miss Beston was quite jealous when, in later years, Bacon gave John Edwards a key to his studio and the two of them threw out sacks of garbage together. She noted in her diary, February 11, 1981, "Feel responsible to art world. So many important references lost." Beston, unpublished diaries. The Estate of Francis Bacon archive.

473 Miss Beston did not discuss: Ibid. In her diaries, however, she would often note her opinion of a new painting. On January 19, 1981, for example, she called one new painting "superb" and added, "FB back on form."

473 "If you wanted to be": Miles, interview with Stevens.

473 He gave her a nickname: All of Bacon's closer-in friends heard him refer to her as "Valerie from the Gallery." Bacon was the only one who called her "Valerie." "Everybody else called her Miss Beston, including Gilbert Lloyd." The Duke [David Somerset] called her Miss Beston," said Miles. Ibid.

473 "Sometimes he would bring": John Normile, interview with Annalyn Swan, November 9, 2017.

474 "It was as if": Lane, "Valerie at the Gallery," *The Guardian*, January 28, 2006.

474 Very occasionally she would join: Her diaries are dotted with references to the occasional dinner. "FB/VB dinner out Carlton Tower," reads an entry of May 13, 1984, for example. Beston, unpublished diaries.

474 Otherwise she typically remained: Miles, interview with Stevens.

474 Most evenings she dined there: Ibid.

474 It later morphed: See Winston Chesterfield, "An Italian in St. James," www.riddlemagazine.com.

474 Not infrequently: On Sunday, January 25, 1987, Beston wrote in her diary, "FB/VB to Tate to see 2 Bunuel films, 'L'Age d'Or' and 'Le Chien Andalou.' Wonderful." Beston, unpublished diaries.

474 On several occasions: Ibid., January 7, 1990.

474 Miss Beston's greatest value: Beston would prod Bacon to show her his latest paintings. In a diary entry of January 22, 1982, she noted: "FB says Triptych almost

finished. I can see it in a few days." Beston, unpublished diaries.

474 In late 1963: Bacon and Dyer met around this time.

475 During the postwar period: See Lionel Abel, "The Genius of Jean Genet," *The New York Review of Books*, October 17, 1973. It recounts a postwar lunch in New York in which Sartre praised Genet extravagantly to a gathered group of American intellectuals.

475 John Rothenstein: The break-in happened sometime before April 27, 1962, when Rothenstein recorded it in his unpublished diaries, Tate Archive.

475 George was indeed: Lee Dyer, George's brother, vividly recalled how the old council estate housing in the East End had external drainpipes, which George would nimbly climb to access his sister's flat. Lee Dyer, interview for *Francis Bacon, Arena*.

475 George's relatives termed: Ronnie Dryden, interview with James Norton, May 26, 2009.

475 Bacon and Dyer met: Lucian Freud, quoted in William Feaver, *The Lives of Lucian Freud: The Restless Years 1922–1968* (New York: Knopf, 2019), 570. George's brother Lee Dyer thought the break-in was a cover story: "I think personally he may have made that story up because he probably didn't want to say to my mother how he'd met him. I think because of the attitude of people in those early years [about homosexuality]." Lee Dyer, interview for *Francis Bacon, Arena*.

475 Bacon even lost a few: "I remember Francis going with Denis to Monte Carlo in the early seventies and winning a lot of money," said John Normile, Bacon's friend from Wheeler's. "He went and bought a Swiss watch—a Patek gold watch, very thin, with a blue face." Not long afterward, the watch went missing, never to be found again. Normile believed that Bacon had hidden it from one of his one-night stands in an old can of paint and had then thrown it out. John Normile, interview with Swan.

475 "Francis was terribly pleased": Feaver, *The Lives of Lucian Freud*, 570.

475 "We all lived": Ronnie Dryden, interview with James Norton, May 26, 2009.

476 "My father wasn't the father": Rita Isaacs, interview with Norton, May 22, 2009.

476 The eldest boy, Ronnie Dryden: Dryden, interview with Norton.

476 In the early sixties: Oliver Smith, "The Krays in London: 15 Sites Associated with the Twins," *The Telegraph*, September 15, 2015.

476 Ronnie Dryden was tough: Dryden, interview with Norton.

476 "He was just a loveable rogue": Miles, interview with Stevens.

476 Lucian Freud, who could be famously: Feaver, *The Lives of Lucian Freud*, 570.

476 "And when he was drunk": Normile, interview with Swan.

476 Ianthe Knott: Ianthe Knott, interviews with Mark Stevens, March 5 and 6, 2008.

476 "He was a gentleman, George": Lee Dyer, interview for *Francis Bacon, Arena*.

477 He was part: Feaver, *The Lives of Lucian Freud*, 570.

477 Bacon later: Ibid.

477 George had few: Lee Dyer, interview for *Francis Bacon, Arena*.

477 "How he got up there": Ibid.

477 "And what do *you* do?" George Dyer, quoted in Feaver, *The Lives of Lucian Freud*, 571.

477 A favorite was the Jack of Clubs: Ronnie Dryden, interview with Norton.

477 It was at the Jack of Clubs: Wendy Leigh, *Bowie: The Biography* (New York: Gallery Books/Simon and Schuster, 2014), 40–1.

477 Once, he was badly: Lee Dyer, interview for *Francis Bacon, Arena*.

477 "One of them give": Dryden, interview with Norton.

477 To teach him a lesson: Ibid.

478 When Ronnie was not around: Ibid.

478 Nosher was a former boxer: James Morton, "Nosher Powell Obituary," *The Guardian*, April 26, 2013, www.theguardian.com.

478 "I found out that he was drinking": Dryden, interview with Norton.

478 "I had a drink with them": Ibid.

478 Terry Miles thought: Miles, interview with Stevens.

478 "In days when Britain": Giles Auty, "Out of Decay, Immortality," *The Spectator*, May 2, 1992.

478 "Almost as I did so": Ibid.

479 In fact, there was news: Lee Dyer, interview for *Francis Bacon, Arena*.

32 YOUNGER CROWDS

480 George could sit: Terry Danziger Miles, interview with Mark Stevens, March 20, 2014. Dyer was paid sixty pounds a month. Marlborough Gallery archives, note dated February 17, 1969.

481 "You simply can't bring off": John Russell, *Francis Bacon* (New York: Thames and Hudson, 1993), 105.

482 John Russell praised: Ibid. Rawsthorne was frequently around Soho in the 1960s, as she was doing a drawing project at the Royal Opera nearby. See Maev Kennedy, "Isabel Rawsthorne: Elusive Painter Who Led the Art World a Merry Dance," *The Guardian*, March 26, 2013.

482 David Sylvester believed: Sylvester, quoted in Richard Cork, presenter, "A Man Without Illusions," BBC archives, May 16, 1985.

482 The triptych was partly a sardonic: David Sylvester, *Interviews with Francis Bacon* (New York: Thames & Hudson, 1989), 46–7.

483 John Russell believed that: Russell, *Francis Bacon,* 165.

483 While some portraits: Ibid.

483 Dyer, Russell added: Ibid.

483 George fancied braces: A photograph taken of Dyer and Bacon attending an opening of Isabel Rawthorne's in 1967 shows the two elegantly dressed in suits, with George looking a bit like a model. Photograph by John Deakin. © The Estate of Francis Bacon.

484 In 1960, Parliament passed: See "1960: Game on for British Betting Shops," news.bbc.co.uk.

484 He liked Crockford's: John Normile, interview with Annalyn Swan, Nov. 9, 2017.

484 "He thought the patterns": Anne Dunn, interview with the authors, October 13, 2010.

484 He knew about the one-offs: Bacon himself was not immune to the odd quick pick-up, particularly in his later years. Jeremy Reed, a flamboyant poet and novelist who met Bacon in 1983, spoke of his quickie sexual encounters around Piccadilly Circus. Reed, interview with James Norton, September 28, 2011.

485 Dyer, said Terry Danziger Miles: Miles, interview with Stevens.

485 Bacon's doctor, Paul Brass: Paul Brass, interview for Adam Low, *Francis Bacon, Arena* documentary, BBC4 archive, March 19, 2005.

485 He began to take elocution: Lee Dyer, interview for *Francis Bacon, Arena.*

485 One of George's brothers: Ibid.

486 George himself, said his brother: Dyer, interview for *Francis Bacon, Arena.*

486 His older brother Ronnie Dryden: Ronnie Dryden, interview with James Norton, May 26, 2009.

486 "I'm marking up the board": Ibid.

486 They would always stress: Ibid. Also Lee Dyer, interview for *Francis Bacon, Arena*; and Rita Isaacs, interview with James Norton, May 22, 2009.

486 Bacon regularly accompanied: Lee Dyer, Ibid.

486 In 1962, Robert Fraser: Harriet Vyner, *Groovy Bob: The Life and Times of Robert Fraser* (London: Heni Publishing, 2017), 82–108.

486 Fraser loved: Clive Barker, interview with Annalyn Swan, June 27, 2016.

486 A few years later: Vyner, *Groovy Bob,* 114.

486 In Chelsea: Diana Melly, interviewed by Peter Stanford, "London: The Swinging Sixties," *The Independent,* October 30, 2005, www.independent.co.uk; and for "And in 1963," Harry Mount, "Why There'll Always Be an Annabel's," *The Telegraph,* January 20, 2015, www.telegraph.co.uk.

487 "That period after the war": Barker, interview with Swan.

487 He apologized to Sonia: Bacon, letter to Sonia Orwell dated June 26, 1968, in the Orwell Archive, University College London.

487 Gibbs was adept: Sam Roberts, "Christopher Gibbs,

Avatar of 'Swinging London,' Dies at 80, *The New York Times,* August 3, 2018, www.nytimes.com.

488 Bacon's head would swivel" Christopher Gibbs, interview with the authors, October 12, 2013.

488 "Let's get out": Ibid.

488 "The thing was": Barker, interview with Swan.

488 "Everybody came": Ibid.

488 Portraiture was thought: Russell, *Francis Bacon* (New York: Thames & Hudson, 1993), 107.

488 The *Sunday Times* magazine editor: Martin Gayford, *Modernists and Mavericks: Bacon, Freud, Hockney and the London Painters* (London: Thames and Hudson, 2008), 249. See also Paul Rousseau, "John Deakin: Wheeler's Lunch," Francis Bacon MB Art Foundation Monaco, www.mbartfoundation.com.

488 It wasn't a real lunch: Auerbach, quoted in Gayford, *Modernists and Mavericks,* 249. Ibid.

488 And Wyndham's story: Ibid.

489 They convened at Wheeler's: Ibid.

489 At the end, Behrens: Ibid, 250.

489 A number of shows: Frank Auerbach, quoted in Michael Peppiatt, "Frank H. Auerbach: Going Against the Grain," *Art International,* No. 1, Autumn, 1987.

489 There was no longer talk: "Reaching the nervous system directly" was one of the most-cited ambitions of the American abstract expressionist painters.

490 In 1967, they traveled to Paris: William Feaver, *The Lives of Lucian Freud: The Restless Years, 1922–1968* (New York: Knopf, 2019), 574.

490 Moraes, a sometimes: Henrietta Moraes, *Henrietta* (London: Hamish Hamilton, 1994), 25.

490 "Soho was alive": Ibid., 30–1.

490 "Lucian's hypnotic eyes": Ibid.

490 She had a fling: Ibid.

490 Upon meeting her: Dan Farson, *The Gilded Gutter Life of Francis Bacon* (New York: Pantheon, 1993), 53.

490 Early in 1963: Maraes, *Henrietta,* 71–3.

490 Moraes later told: Caroline Bowler, interview with Annalyn Swan, June 16, 2010.

490 She would eventually: In her memoir, Moraes described taking heroin and cocaine and becoming addicted to amphetamines. She also became addicted to methedrine, and finally, in 1966, began taking acid. Moraes, *Henrietta,* 76–93.

491 "Open up your arms": Ibid., 71–3.

491 Moraes protested: Ibid.

491 "Francis said": Ibid.

491 She submitted: Ibid.

491 Bacon called it: Bacon, quoted in Martin Harrison, ed., *Francis Bacon Catalogue Raisonné,* vol. III (London: The Estate of Francis Bacon, 2016), 904.

492 Deakin "was furtively": Moraes, *Henrietta,* 73.

492 He chain-smoked": Peppiatt, *Francis Bacon,* 259.

492 In July of 1964: Letter dated July 14, 1964, from David

(Somerset) to Harry Fischer at the Marlborough Gallery describing the purchase. Marlborough Gallery archives.

492 The seller was: James Page-Roberts, "A Compressed Life," *Jim P-R's Blog*, February 28, 2019, webpageroberts.blogspot.com.

492 "I telephoned: Ibid.

492 Page-Roberts then: Ibid.

492 Fourteen months later: Letter of October 15, 1965, from Theodore Goddard and Co., solicitors to Harry Fischer at the Marlborough Gallery. Marlborough Gallery archives.

492 In April 1964: Feaver, *The Lives of Lucian Freud*, 572.

493 In May of 1965: Harrison, ed., *Francis Bacon Catalogue Raisonne*, vol. I, 88. John Deakin dated his photographs as well.

493 Deakin himself: Deakin was stationed during the war in Malta, in the British army's Film and Photography unit. See thejohndeakinarchive.co.uk. Earlier, when he was the boyfriend of the rich collector (and later gallery owner) Arthur Jeffress, he had also spent time in the Mediterranean region.

493 Bacon, who feared the water: Bacon was decidedly not interested in swimming. He had learned to swim a bit while in Tangier but essentially disliked the sea. Bacon, letter to Denis Wirth-Miller, September 7, 1956, Courtesy of Jon Lys Turner. The authors are indebted to Turner for sharing the unpublished letters with them.

493 All that George and Bacon did: Dan Farson reported that Bacon and Dyer were asked to leave the hotel in Chania because of their violent fights. Farson, *The Gilded Gutter Life*, 184.

494 Freud took weeks: Michael Wishart said that posing for Freud was like submitting to "delicate eye surgery," as sitters were required to assume a pose for hours on end without moving. Wishart, quoted in Martin Gayford, *Modernists and Mavericks*, 114.

494 He told his biographer: Feaver, *The Lives of Lucian Freud*, 570.

494 He had a "hand-washing": Ibid.

494 "George was the sort of person": Ibid., 572.

494 "His face absolutely": Ibid., 571.

494 In late October of 1965: Ibid.

494 She was the 28th: For a good overview of Jane Willoughby's family and estates, see "Handed On: Drummond Castle, Perthshire," handedon.wordpress.com. Also see the National Portrait Gallery's photographs of Willoughby, including one of her as a maid of honor at the coronation of Queen Elizabeth in 1953.

494 The trip was principally: Ibid. Lee Dyer, George's brother, recalled that he stayed in Scotland around six weeks to dry out, and that he also went on other occasions to detox facilities—one for six weeks not long before his death in Paris in 1971. Lee Dyer, interview for *Francis Bacon, Arena*.

494 In Glenartney: Feaver, *The Lives of Lucian Freud*, 571.

494 From Scotland, George wrote: Dyer letter, quoted in

494 Dyer, interview for *Francis Bacon, Arena*.

494 "I like it here very much": Ibid.

495 George had the time: Ibid.

495 "We get very good": Ibid.

495 The couple went to Tangier: Harrison, ed., *Francis Bacon Catalogue Raisonné*, vol. I, 89.

495 George especially liked France: John Rothenstein diary, December 21, 1964, Tate Archive, 8726/1.

495 They traveled to the Midi: *Francis Bacon Letters to Michel Leiris, 1966–1989* (New York: Gagosian Gallery, 2006), 10.

495 Dunn and Michael Wishart: Michael Wishart, *High Diver* (London: Blond and Briggs, 1977), 145.

496 Moynihan and Dunn: Ibid.

496 "George was so sweet": Ibid.

496 One evening: Ibid.

496 And so Bacon continually: Ibid.

496 Bacon first took Dyer: Jon Lys Turner, *The Visitors' Book* (London: Constable, 2016), 262–3.

497 Dicky and Denis liked to concoct: Ibid. Also, interviews by the authors with Dan Chapman, co-executor, beneficiary, and longtime friend of Chopping and Wirth-Miller, February 12, 2011, and Celia Hirst and Pam Dan, local residents and friends of Chopping and Wirth-Miller, February 24, 2011.

497 Friends would drive: "Sometimes Dicky and Denis had really posh luncheons," said Pam Dan. "A touch of the aristocracy. D&D knew Bloomsbury. These very up-market people came in elegant cars, Rolls Royces. And sometimes Denis would tell me who had been at the luncheon parties. They had quite a few. They did them brilliantly. And cars would come back and pick up the guests." Hirst and Dan, interview with the authors.

497 The house frequently filled: Turner, *The Visitors' Book*, 122–4, 219–22.

497 Denis was a brilliant: Chapman, interview with the authors.

497 Even the celebrity chef: Jan Richardson, interview with the authors, November 2010.

497 "I remember once": David Wallace, interview with Mark Stevens, March 27, 2014.

497 Sometimes, Bacon holed up: Dan Chapman, interview with the authors.

497 To others, when Bacon: Wirth-Miller "kept records of [Bacon's] sayings." Rothenstein diary, July 23, 1960, unpublished diaries, Tate Archive.

498 In the late fall of 1965: A letter of December 7, 1965, from Harry Fischer to Theodore Goddard and Co. said that Marlborough wanted to "buy the 97-year lease of this studio in the name of Marlborough Fine Art Ltd and rent it to Francis Bacon." The amount the gallery agreed to offer was 7,500 pounds. Bacon wanted to be able to use the studio,

said Fischer, by "the middle of January." Marlborough Gallery archives.

498 Originally designed: See "South Kensington in Retrospect," www.british-history.ac.uk.

498 Bacon's particular flat: A report by Weatherall, Green and Smith on Bacon's proposed flat prior to its purchase mentioned three skylights in the right-hand roof slope "which are likely to give constant trouble because they are old, partly constructed of timber and show damp stains through leaks or condensation." Marlborough Gallery archives.

498 With Miss Beston's: Various correspondence mentions grey velvet curtains being ordered, as well as a carpet dyed to match in "a beige-toned gray." Ibid.

498 The space, Bacon told Sylvester: Bacon, quoted in David Sylvester, Interviews with Francis Bacon (London: Thames and Hudson, 1988), 191.

498 Bacon soon signed over: A letter of February 13, 1968, confirms the transfer of the "above Leasehold property" to George Dyer. Marlborough Gallery archives.

498 The flat had: Ianthe Knott, interviews with Mark Stevens, March 5 and 6, 2008.

498 A small flight of stairs: Flat C, Bacon's flat, was described in a real estate agent's listing as comprising "a studio with gallery, bedroom, kitchenette and bathroom." Marlborough Gallery archive.

498 He now ordered: The oval divan was purchased from London Bedding Centre. It cost 151 pounds. Ibid.

498 Not long after moving: Lee Dyer, interview for Francis Bacon, Arena.

498 (Lee was 10 years younger): James Norton, interview notes with Lee Dyer for Francis Bacon, Arena.

498 They brought home: Ibid.

498 When Lee finally said: Ibid.

498 "Anyway": Ibid.

33 ANCIENT RHYMES

500 The writer André Malraux: For a good overview of the career of André Malraux, see John Wightman, "Malraux: Behind the Mask," The New York Review of Books, October 6, 1966, www.nybooks.com.

500 Important figures: Sartre continued to write influential philosophical essays through the late 1980s; Beckett continued to write plays throughout the 1970s and into the early '80s; Lacan gave public seminars and lectures throughout the '70s.

500 The show would include: See "1966: Gigantic Picasso Show for Paris Grand Palais," iht-retrospective.blogs.nytimes.com.

501 In 1966, Marlborough planned a show: In a letter to M. Jean Clay at the Galerie Maeght dated August 18, 1966, Valerie Beston said that the Marlborough would be sending "eight large paintings, two medium and four sets of three heads (studies for portraits)." Marlborough Gallery archives.

501 In 1965, when a retrospective: Daniel Farson, The Gilded Gutter Life of Francis Bacon (New York: Pantheon Books, 1993), 173–5.

501 Bacon first took Giacometti: Ibid., 173–5.

501 At dinner Bacon fell into: Ibid. Leiris later described Giacometti and Bacon's extended evening as a "Homeric discussion." Michael Peppiatt, Francis Bacon: Anatomy of an Enigma (London: Constable and Robinson, 2008), 287.

501 Giacometti "shouted": Farson, The Gilded Gutter Life, 173–5.

501 Bacon had previously met Leiris: Bacon said that Sonia Orwell had introduced the two in Paris in the 1960s. Michel Archimbaud, Francis Bacon: In Conversation with Michel Archimbaud (London: Phaidon Press, 1994), 122.

501 In the 1920s, Leiris: "Michel Leiris, 89, French Writer on Surrealism and Anthropology" (obituary), The New York Times, October 3, 1990.

501 He had also been a contributor: Jeremy Biles, "Correspondence: Georges Bataille and Michel Leiris," Rain Taxi Review of Books, www.raintaxi.com.

501 In 1931, he joined: Tim Watson, "The Horticulturalist of the Self," Public Books website, December 22, 2017, www.publicbooks.org.

501 He was the mission's: Ibid.

502 According to Kwame Anthony Appiah: Appiah, "Surreal Anthropology," The New York Review of Books, March 8, 2018, www.nybooks.com.

502 He had once studied: "Leiris, Julian Michel and Louise," in "Index of Historic Collectors and Dealers of Cubism," Leonard A. Lauder Research Center for Modern Art at the Met, www.metmuseum.org.

502 The issue of Documents: It was published in November of 1929 by Georges Bataille.

502 After his mission: "Index of Historic Collectors," Leonard Lauder Research Center for Modern Art at the Met.

502 The scholar James Clifford called: James Adam Redfield, "The Surreal Effect of L'afrique fantôme: A Preliminary Descriptive Analysis," www.academia.edu.

502 The American poet: John Ashbery, interview with the authors, July 1, 2010.

502 The evenings she hosted: Michael Peppiatt, Francis Bacon in Your Blood: A Memoir (New York: Bloomsbury U.S.A., 2015), 64–8. Sonia Orwell gave a series of dinner parties in London that included the Leirises and Bacon and that cemented their new friendship.

502 Six months after: Bacon, letter to Michel Leiris dated January 25, 1966, in Valentina Castellani, Mark Francis, and Stefan Ratibor, eds., Francis Bacon: Letters to Michel Leiris 1966–89 (New York: Gagosian Gallery, 2006), 23.

503 His influence stemmed: See Leiris entry in "Index of Historic Collectors," Leonard Lauder Research Center at the Met, in ibid.

503 Kahnweiler was modernist: See "Kahnweiler, Daniel-Henry (born Heinrich Kahnweiler, also Henry Kahnweiler) in ibid.

503 Since he had failed: Ibid.

503 During World War II: Ibid.

503 In 1944, for example: "Desire Caught by the Tail," in "El Blog del Museu Picasso de Barcelona," January 24, 2014, www.blogmuseupicassobcn.org.

503 Albert Camus directed: "Desire Caught by the Tail," www.cocosse-journal.org.

503 Maeght exhibited: See "Jules Maeght Gallery," www.julesmaeghtgallery.com.

503 In the year before: See "Derrière le Miroir."

503 To mark: See "Bacon, Francis. "Derrière le Miroir," No. 162, www.manhattanrarebooks.com.

504 "Michel," he wrote: Bacon, letter of November 11, 1966, Letters to Michel Leiris, 9.

504 First, he went to gamble: Ibid. 7–8.

504 Sonia Orwell and Isabel Rawsthorne: David Plante, "Bacon's Instinct," The New Yorker, November 1, 1993.

504 Dyer, overshadowed: Ibid.

504 They planned to spend: Ibid.

504 The day after the opening: Ibid, 100

504 Two or three days later: All of the following information and quotations about the trip come from David Plante's article in The New Yorker.

505 He would paint: There are seven self-portraits from the decade recorded in Martin Harrison, ed., vol. III Francis Bacon Catalogue Raisonné (London: Estate of Francis Bacon, 2016). Five are small heads and two are large paintings.

505 The crackdowns: Alan Cowell, "Overlooked No More: Alan Turing, Condemned Code Breaker and Computer Visionary," The New York Times, June 5, 2019. The result was the Conservative Government's Wolfenden Report. Parliamentary Papers, British Library, www.bl.uk. For more on the trials of Peter Wildeblood and Lord Montagu, see Peter Wildeblood, Against the Law (London: Phoenix, 1955).

505 An indication of how touchy: See "Wolfenden Report," lgbthistoryuk.org.

505 After reading the Wolfenden Report: John Rothenstein diary, April 13, 1960, unpublished diaries, 1939–1990, Tate Archive, 8726/1.

506 Many years later: Plante, correspondence with the authors, May 2011.

506 Bacon also had life-affirming: Plante, "Bacon's Instinct," The New Yorker.

506 Always a dutiful: Bacon's mother wrote to her son frequently, and he wrote—and very occasionally called—less frequently, but enough to maintain a connection. Years after she moved to Africa, she still sent her son cakes through the mail every few weeks. Barbara Dawson, email to Annalyn Swan, July 6, 2011.

506 He felt guilty: Bacon, letter to Ianthe Knott dated June 19, 1962. The Estate of Francis Bacon Archive.

506 In 1967, Bacon wrote: Bacon, letter to his mother dated January 4, 1967. Ibid.

506 "He landed at the airport": Harley Knott, interview with Mark Stevens, March 7, 2008.

507 By then, Winnie had outlived: Ianthe Knott, interviews with Mark Stevens, March 5 and 6, 2008.

507 "I enjoyed the few days": Bacon, letter to Sonia Orwell dated March 16 and on "Edinburgh Castle" stationery, in the Orwell Archive, University College London.

507 His latest show at Marlborough: On March 15, 1967, Harry Fischer wrote to Sonia Orwell thanking her for translating the preface to the catalog for Bacon's show. "As you know, Francis' exhibition is the greatest success imaginable—people are queuing in the street every day to get into the Gallery to see it." Marlborough Gallery archive.

507 Leiris had written: Michael Peppiatt, Anatomy of an Enigma (London: Constable, 2008), 287.

507 After attending the opening: Frances Partridge, Frances Partridge, Everything to Lose: Diaries 1945–1960 (New York: Little, Brown, 1986), 524.

508 He gave Ianthe's: Ianthe Knott, interviews with Stevens.

508 Ianthe told him: Ibid.

508 Ianthe and her husband: Ibid.

508 As a good host: Keith Knott, interview with Stevens.

508 "He enjoyed that": Ianthe Knott, interview with Stevens.

508 Nor did subsequent efforts: George's brother Lee recalled that George had a number of drying-out stays as the 1960s went on. Lee Dyer, interview for Adam Low, Francis Bacon, Arena documentary, BBC Four archive, March 19, 2005.

508 Bacon tried to persuade him: Bacon offered him "20,000 pounds . . . on condition that he live in Brighton," recalled Dan Farson. "Francis must have known this was a hopeless situation, for George was bound to come back." Farson, The Gilded Gutter Life, 183.

508 To no avail: Valerie Beston sent payments in 1969 to George at the Hotel Metropole in Brighton. Marlborough Gallery archives.

508 "Of course": Rita Isaacs, interview with James Norton, May 22, 2009.

509 He saw his mother: Ibid.

509 "He laid on the settee": Isaacs, interview with Norton.

509 "It was awfully tragic, really": Lucian Freud, quoted in William Feaver, The Lives of Lucian Freud: The Restless Years 1922–1968 (New York: Knopf, 2019), 572.

509 Bacon—who used: Once, when John Normile was doing repairs at Reece Mews—after leaving his job as barman at Wheeler's he opened his own construction

business—he offered to replace the cracked mirror. Bacon adamantly refused. John Normile, interview with Annalyn Swan, November 9, 2017.

509 Bacon, when he came home: Terry Miles, interview for *Francis Bacon, Arena.*

509 "And of course": Ibid.

510 "He said, 'Yeah, yeah'": Ibid.

510 Bacon could open: Ibid.

510 About a week later: Clive Barker, interview with Annalyn Swan, June 27, 2016.

510 "Funny that you say": Ibid.

510 When the thief saw Bacon: Bacon told a few friends that he suspected that Ron Belton was involved with the theft of the paintings. "He [Ron] stole some pictures," Paul Danquah said later. "Don't forget Ron was a sort of petty crook—Francis rather liked that sort of thing, and the Kray Twins lot." Farson, *The Gilded Gutter Life,* 118. A few years earlier, Robert Fraser had stolen *Portrait Head of 1959* "when he was on drugs," as a letter at the Marlborough Gallery recorded. Marlborough Gallery archive.

510 Later, when a friend: Barker, interview with Swan.

510 Not only did the show in New York: Marlborough Gallery correspondence confirms the paintings included. Marlborough Gallery archives.

510 Lawrence Gowing, an influential: John Russell, "Sir Lawrence Gowing, a Painter, Writer, Curator and Teacher, 72" (obituary), *The New York Times,* February 7, 1991.

511 "In London this year": Lawrence Gowing, "The Irrefutable Image," *Francis Bacon: Recent Paintings,* exhibition catalog (Marlborough Gerson Gallery, N.Y., 1968), 7–18.

511 Miss Beston, aware of: She asked that the room be "away from the traffic side" of the hotel, Marlborough Gallery archives. See "About the Algonquin: The Ten-Year Lunch: The Wit and Legend of the Algonquin Round Table," *American Masters,* PBS, www.pbs.org.

511 At a luncheon: John Richardson, interview with Mark Stevens, March 3, 2008.

511 Informed that McCoy: Ibid. Also Jason McCoy, conversation with the authors, April, 2008.

511 Meanwhile, America was erupting: See Clay Risen, "The Legacy of the 1968 Riots," *The Guardian,* April 4, 2008, www.theguardian.com.

512 He loathed fashion: See Peter Schjeldahl, "PostScript: Hilton Kramer," *The New Yorker,* March 28, 2012.

512 Too fierce: Hilton Kramer, "The Problem of Francis Bacon," *The New York Times,* November 17, 1968, www.nytimes.com.

512 Kramer saluted: Ibid. All subsequent quotations come from this same article.

512 A night or so: Richardson, interview with Stevens.

512 It was "sort of": Ibid.

512 "George said, Cockney voice": Ibid.

513 Bacon carried strong sleeping pills: Bacon used sleeping pills throughout his adult life and needed them in par-

ticular at times of high stress, such as gallery or museum openings. Paul Brass, interview for *Francis Bacon, Arena* documentary. For the librium, see Sophie Pretorius, "A Pathological Painter: Francis Bacon and the Control of Suffering," in *Inside Francis Bacon, Francis Bacon Studies III* (London: The Estate of Francis Bacon Publishing, in association with Thames & Hudson, 2020), 176.

513 "If I don't hide": Bacon, quoted in Feaver, *The Lives of Lucian Freud: The Restless Years 1922–1968* (New York: Knopf, 2019), 572.

513 Miss Beston wrote: Valerie Beston, letter to Lawrence Gowing, November 25, 1968, Marlborough Gallery archive.

513 With the help of Dicky Chopping: Jon Lys Turner, *The Visitors' Book* (London: Constable, 2016), 288.

513 He was so grateful: See Maev Kennedy, "Painting Bacon Gave as Rent May Fetch 9 Million Pounds," *The Guardian,* September 4, 2007, www.theguardian.com/uk.

513 In July of 1969, as Bacon continued: Marlborough Gallery archives. Clive Barker saw Bacon during his summer stay at the Royal College. "He said, 'They're on holiday and I have the whole place by myself. I'm in the studio. Reworking *Bullfight.* So come there.'" Barker, interview with Swan.

514 In September of 1969: Theodore Goddard solicitors completed the paperwork on October 2, 1969. Marlborough Gallery archives.

514 "I have bought": John Russell, *Francis Bacon* (New York: Thames and Hudson, 1985), 169.

514 The center: Ben Johnson, "Narrow Street London," *Historic U.K.,* www.historic-uk.com.

514 Bacon renovated: Terry Miles, interview with Mark Stevens, March 20, 2014.

514 The large, spacious main room: A photograph of the Narrow Street flat can be seen in Martin Harrison, *In Camera* (London: Thames & Hudson, 2005), 135.

514 "He did one or two": Miles, interview with Stevens.

514 "I think she spent": Ibid.

514 That was perhaps: Russell, *Francis Bacon,* 169.

514 Narrow Street was changing: Ibid.

515 A young woman named: See Carol Bristow, *Central 822: The Remarkable Story of One Woman's Thirty-Year Fight Against Crime* (London: Transworld Publishers/Bantam Books, 1999), 59.

515 Then George telephoned: Ibid., 59.

515 The two met: Ibid.

515 George kept a stash: Bacon himself knew of George's stash, although he pretended to the police that someone had just placed it there without his knowledge. Dalya Alberge, "Tapes Reveal Francis Bacon's Shock at 1968 Drug Bust," *The Guardian,* May 6, 2018.

515 "There was silence": Bristow, *Central 822,* 60.

515 She "brushed past him": Ibid.

515 A power broker: See Anthony Blond, "Obituary: Lord Goodman," *The Independent,* May 15, 1995.

515 The satirical: Geoffrey Bindman, "The Almighty Lawyer," *New Law Journal*, September 27, 2007.

515 He was "infinitely": Roy Strong, *The Roy Strong Diaries 1967–1987* (London: Weidenfeld & Nicolson, 1997), 123.

516 When she finally told him: Bristow, *Central 822*, 60.

516 "I walked into": Ibid., 60–1. All of Bristow's subsequent quotations come from *Central 822* as well.

516 During the jury trial: "Artist Faces Drug Charge," newspaper clipping, 1971, no byline or date, Francis Bacon MB Art Foundation Monaco, archive.

516 "Bacon told the court": Bristow, *Central 822*, 62.

517 Bacon had arranged: Ianthe Knott, interview for *Francis Bacon*, *Arena*.

517 "He told us he was having": Ibid.

517 Her husband now told her: Ben Knott told Ianthe that Bacon was homosexual only on this trip. Knott, interview with Stevens.

34 HOMMAGE À BACON

518 Early in 1969: Bacon, letter dated March 3, 1969, to Michel Leiris in Valentina Castellani, Mark Francis, and Stefan Ratibor, eds., *Francis Bacon Letters to Michel Leiris 1966–8* (New York: Gagosian Gallery, 2006), 11.

518 Bacon was "hardly": Jacques Dupin, interview for Adam Low, director, *Francis Bacon*, *Arena* documentary, BBC 4 Archive, March 19, 2005.

518 The Musée des Arts: John Rothenstein diary, September 21, 1962, unpublished diaries, 1939–1990, Tate Archive, 8726/1.

518 Only Graham Sutherland: Dan Farson, *The Gilded Gutter Life of Francis Bacon* (New York: Pantheon, 1993), 201. After some accounts of Bacon's retrospective at the Grand Palais reported that he was the first living British artist to have a retrospective in Paris, Graham Sutherland wrote a letter to *The Standard* saying that actually he, Sutherland, had been the first British painter since Gainsborough to be honored with a retrospective in Paris.

518 In July of 1969: Bacon, letter dated July 16, 1969, in *Letters to Leiris*, 13.

518 Bacon found him: Ibid.

518 A new minister: André Malraux was appointed minister of cultural affairs in 1958 by Charles de Gaulle and held the position for a decade. See www.britannica.com.

518 Bacon told Leiris: Bacon, letter dated March 3, 1969, in *Letters to Leiris*, 11.

518 The impetus: Letter dated January 25, 1966 in ibid., 5.

518 Bacon was still working: Most of the paintings done at the Royal Academy had yellow backgrounds in common. Martin Harrison, ed., *Francis Bacon Catalogue Raisonné*, vol. III (London: Estate of Francis Bacon, 2016), 896.

519 He hosted: Bacon, undated letter to Sonia Orwell, Orwell Archive, University College London.

519 He also invited: Ibid. In another undated letter to Orwell Bacon wrote, "I am seeing Gautier on the morning of April 15th/Isabel is coming over at the same time. Love Francis."

519 He asked Ann Fleming: Ann Fleming, letter to Nicholas Henderson, December 24, 1969, in Mark Amory, ed., *The Letters of Ann Fleming* (London: Collins Harvill, 1985), 400.

519 Calming things down: Ibid.

519 The Grand Palais: See "Grand Palais," www.britannica.com.

519 Above the grand staircase: See "Quadrigas," www.grandpalais.fr/en. The actual title of the quadriga is "Immortality Outstripping Time."

519 Over the years: "Grand Palais," www.britannica.com.

519 He did not abandon: There is a reflection of George's face in two mirrors in *Three Studies of the Male Back* of 1970. He painted a small diptych of Dyer in 1971 and also a dark, rather tortured-looking *Study of George* in 1969. In 1971, he painted a final, full-size *Study of George Dyer*.

520 In his *Triptych* of 1970: Dyer's "latent jealousy exploded when he discovered that Francis had a new friend, the model for the *Triptych 1970*. . . . As with all Bacon portraits, the face and sleek black hair are instantly recognizable, especially in the right-hand panel in which he poses naked." Farson, *The Gilded Gutter Life*, 188.

520 In the late spring: Harrison, ed., *Francis Bacon Catalogue Raisonné*, vol. I, 91. Lee Dyer also recalled that George had been sent to dry out not long before the show. Dyer, interview for *Francis Bacon*, *Arena*.

520 The catalog essay: Bacon, cable to Leiris dated May 15, 1971, in *Letters to Leiris*. 14.

520 He might have stayed: Terry Danziger Miles, interview with Mark Stevens, March 20, 2014.

520 "We all went to that hotel: Janetta Parladé, interview with Annalyn Swan, November 2, 2017. Parladé stayed at the St. Père a week later. Sonia Orwell told her all about Dyer's suicide on that trip.

520 Fearing that he would be: Dr. Paul Brass, interview for *Francis Bacon*, *Arena*.

520 French president Georges Pompidou: Michael Peppiatt, *Francis Bacon: Anatomy of an Enigma* (London: Constable & Robinson, 2008), 288.

520 His wife was hosting: Jon Lys Turner, *The Visitors' Book* (London: Constable, 2016), 294.

521 The day before: Miles, interview with Stevens.

521 "She was 15": Ibid.

521 The day before the formal: Turner, *The Visitors' Book*, 295.

521 As they passed: Ibid.

521 Bacon was initially: Ibid.

521 He returned to his room: Ibid., 295–6.

521 Neither Bacon nor George: Miles, interview with Stevens.

521 Bacon left: Turner, *The Visitors' Book*, 296.

521 When he returned.: Miles, interview with Stevens.

521 "I thought": Ibid.

521 "George has brought home": Ibid.

521 Early the next morning: Ibid. The rest of the quotations about finding George's body are from the Terry Miles interview with Mark Stevens.

522 Miss Beston, however, saw: Ibid.

522 Afterward, a grand dinner: For photographs of the dinner, see those of the photographer André Morain.

522 "They called the [hotel] manager": Miles, interview with Stevens.

522 Nadine Haim rode: Nadine Haim, interview with James Norton, April 19, 2014.

522 A large sign: The sign hung over the grand entrance stairs. See the photos of André Morain.

522 There was Salvador Dalí: Peppiatt, *Francis Bacon*, 290.

523 The Leirises had offered: Peppiatt, *Francis Bacon*, 293. The Leirises, Sonia Orwell, and Marguerite Duras, a close friend of Orwell, underwrote the dinner. Ibid., 437.

523 He had often been to Le Train Bleu: When Bacon and Dyer took the train down from Paris to Montpellier after the 1966 Galerie Maeght show to join Stephen Spender and David Plante at the Spenders' house there, they would have traveled from the Gare de Lyon station and might well have eaten at Le Train Bleu restaurant, which Bacon liked to do before traveling south.

524 At the end of the evening: Peppiatt, *Francis Bacon*, 294.

524 He spent the night: Miles, interview with Stevens.

524 *The Times* called the success: Patrick Brogan, "Francis Bacon Paintings Boost Britain: French Critics Acclaim a Great Artist Whose Works Disturbed and Amazed Paris," *The Times*, January 11, 1972, 5.

524 To many in England: Similarly, Terence Mullaly's article in *The Daily Telegraph*, which incorporated both the Bacon show in Paris and a Henry Moore retrospective in Germany, also noted the boost to Britain, not just Bacon. It was headlined "Exhibitions Emphasise British Prestige," *The Daily Telegraph*, October 26, 1971.

524 Andrew Causey: Causey, "Francis Bacon's European Retrospective," *Illustrated London News*, February 1972, 62–3.

524 The exhibition also marked: Louis le Brocquy, letter to Francis Bacon, undated, Hugh Lane Gallery, Dublin, LBCOPY1.

524 "Perhaps you yourself": Ibid.

524 The critic John Berger: Berger, "The Worst Is Not Yet," *New Society*, January 6, 1972, 22–3.

524 The first substantial book: John Russell's book was mentioned in a number of reviews of Bacon's show. See Pierre Schneider, "The Savage God," *The Sunday Times*, November 7, 1971.

525 After Paris, the show: Peppiatt, *Francis Bacon*, 300.

525 Even before the Grand Palais: H.C., "Grande Pre-mière à Paris de Francis Bacon No. 1 de l'Index '71" *Connaissance des arts*, October 1971.

525 The French novelist: Marguerite Duras, "Marguerite Duras s'entretient avec Francis Bacon," *La Quinzaine littéraire,* November 30, 1971, 16–17.

525 "To work I must be": Ibid.

525 And in an interview: Bacon, interview with Jean Clair (with the participation of Maurice Eschappase and Peter Malchus), *Chroniques de l'art vivant 1971*, October 25, 1971.

525 The Italian director: See "Last Tango in Paris," italian.vassar.ed.

525 He brought his leading man: Bertolucci, quoted in Peppiatt, *Francis Bacon*, 300.

526 The American critic: Paul Richard, "Francis Bacon and His Art: Mirrors of a Horrific Life," *The Washington Post*, March 21,1975.

35 A TOAST TO DEATH

529 The note of poignant farce: Ronnie Dryden, interview with James Norton, May 26, 2009.

529 Francis Chappell & Sons: Ibid.

529 "He had to go up": Ibid.

529 Bacon, who paid: Ibid.

529 Bacon always got along well: Lee Dyer, interview for Adam Low, director, *Francis Bacon*, *Arena*, BBC Four archive, March 19, 2005.

529 Bacon purchased: Dryden, interview with Norton.

529 "George was the first one there": Ibid.

529 A relative told her: Rita Isaacs, interview with James Norton, May 22, 2009.

530 Rita Isaacs called it: Ibid.

530 Bacon arrived: Dyer, interview for *Francis Bacon*, *Arena*.

530 "The little church": John Russell, *Francis Bacon* (New York: Thames and Hudson, 1993), 151.

530 He behaved "with a stoicism": Ibid.

530 At the graveside: Dyer, interview for *Francis Bacon*, *Arena*.

530 "We was close, me and him": Dryden, interview with Norton.

530 "I was going to give him": Ibid.

530 When Rita walked up: Isaacs, interview with Norton.

530 "Bacon paid": Dyer, interview for *Francis Bacon*, *Arena*.

530 In the end, said Rita: Isaacs, interview with Norton.

530 The proceeds, said Rita: Ibid.

530 "He was shattered": Anne Dunn, interview for *Francis Bacon*, *Arena*.

531 Not long after: David Plante, *Difficult Women: A Memoir of Three* (New York: New York Review Books, 2017), 76–7.

531 "You don't understand": Ibid.

531 Sonia wrote to Michel Leiris: Hilary Spurling, *The Girl*

from the Fiction Department: A Portrait of Sonia Orwell (Berkeley: Counterpoint, 2003), 155–6.

531 The death of a lover: Helen Lessore, quoted in Dan Farson, *The Gilded Gutter Life of Francis Bacon* (New York: Vintage Books, 1994), 217.

531 But a constitution: Dyer, interview for *Francis Bacon, Arena.*

531 Sonia Orwell, who read: Janetta Parladé, interview with Annalyn Swan, November 17, 2017.

531 And Paul Brass: Paul Brass, interview for *Francis Bacon, Arena.*

531 Brass believed: Ibid.

531 The autopsy determined: Dyer, interview for *Francis Bacon, Arena.*

532 When *The New Statesman:* Letter from Theodore Goddard solicitors to *The New Statesman,* November 9, 1971, Marlborough Gallery archives.

532 Michael Peppiatt, who met: Michael Peppiatt, *Francis Bacon in Your Blood: A Memoir* (New York: Bloomsbury USA, 2015), 192.

532 Along with Librium: See Sophie Pretorius, "A Pathological Painter: Francis Bacon and the Control of Suffering," in *Inside Francis Bacon, Francis Bacon Studies III* (London: The Estate of Francis Bacon Publishing, in association with Thames & Hudson, 2020), 176. For the Caves des France, see John Preston, "London Calling by Barry Miles: Review," www.telegraph.co.uk.

532 When he tried to move: Bobby Hunt, quoted in Dan Farson, *The Gilded Gutter Life of Francis Bacon* (New York: Pantheon, 1994), 259. Hunt confused which eye was involved (it was Bacon's left eye). Peter Beard took a photograph of Bacon in his studio in 1972 not long after the accident, in which the stitches and bruise can clearly be seen. Rebecca Daniels, "Francis Bacon and Peter Beard: The Dead Elephant Interviews and Other Stories," in *Francis Bacon: A Terrible Beauty* (exhibition catalog for the Hugh Lane show of October 28, 2009–March 7, 2010), 140–1.

532 To exorcise George's ghost: François Salmon, interview for *Francis Bacon, Arena.*

532 Bacon appeared to Salmon: Ibid.

533 "I think it's something": Ibid.

533 It may have been: David Wallace, interview with Mark Stevens, March 27, 2014. All of the subsequent quotations come from this interview.

534 Helen Lessore: Helen Lessore, *A Partial Testament: Essays on Some Moderns in the Great Tradition* (London: The Tate Gallery, 1986), 77.

534 In 1972, he visited: Janetta Parladé, interview with Annalyn Swan, November 2, 2017.

534 "Francis said he was fed-up": Jeffrey Smart, *Not Quite Straight: A Memoir* (Port Melbourne, Victoria, Australia: William Heinemann Australia, 1996), 425.

535 A figure climbs: T. S. Eliot, "Ash Wednesday."

535 And in *The Waste Land:* T. S. Eliot, *The Waste Land,* www.poetryfoundation.org.

536 Bacon later told the art historian: Hugh Davies, May 29, 1973 interview for *Francis Bacon: The Early and Middle Years, 1928–1958* (New York: Garland Publishing Co., 1978. The typed transcripts of the interviews are contained in Martin Harrison, ed., *Francis Bacon: New Studies* (Göttingen, Germany: Steidl, 2009), 89–123.

537 Wendy Knott, the wife: Wendy Knott, interview with Mark Stevens, March 7, 2008.

537 Bacon took pride: Peppiatt, *Francis Bacon in Your Blood,* 207.

537 "He told us to come": Harley Knott, interview with Stevens.

537 "He took me": Ibid.

537 "The first place": Ibid. All of the rest of the quotes come from this interview.

538 He mixed his real: Both Harley and Ianthe described their trips to Wivenhoe in their interviews with Mark Stevens.

538 Ianthe twice accompanied: Ianthe Knott, interviews with Mark Stevens, March 5 and 6, 2008.

538 "We went over to the boats": Ibid.

539 "We had the most extraordinary": Pam Dan, interview with the authors, February 24, 2011.

539 There was even a Wivenhoe Arts Club: See "Wivenhoe Arts club 1966–1976," www.wivenhoehistory.org.uk.

539 "Half of Fleet Street": Dan, interview with the authors.

539 Still, the unstable family triangle: For more on Celia Hirst, see www.wivencyclopedia.org.

539 "Three men each": Dan, interview with the authors.

539 According to Hirst: Celia Hirst, interview with the authors, February 24, 2011.

539 During the scenes between Dicky and Denis: Dan, interview with the authors.

539 Only rarely was Bacon: Ibid.

539 Sometimes, when Bacon wanted: Terry Danziger Miles, interview with Mark Stevens, March 20, 2014.

539 The chef Robert Carrier: See "Who Was Robert Carrier," hintleshamhall.co.uk.

539 Carrier was "what is now known": Miles, interview with Stevens.

540 "Our company had this big": Ibid.

540 "It would start with me": Ibid. The rest of the quotations from Miles come from this interview.

540 Auntie was a homosexual: Ibid.

540 "It was always a big palaver": Ibid.

540 The group might then continue: For more on Annie Ross, see James Gavin, "Annie Ross: A Free-Spirited Survivor Lands on her Feet," *The New York Times,* October 3, 1993.

540 He seemed "slight": Annie Ross, interview with Mark Stevens, April 25, 2014.

540 Whenever Ross was performing: Miles, interview with Stevens.

540 "Bacon had the most impeccable": Ross, interview with Stevens.

541 "I think I told a story": Ibid.

541 "The minute you drop in": Miles, interview with Stevens.

541 One day, Freud came: Harley Knott, interview with Stevens.

541 Later, they went: Ibid.

541 One time: Tim Behrens, letter to Adam Low, for *Francis Bacon, Arena*.

541 "Theirs was a deep love": Annie Freud, quoted in Phoebe Hoban, *Lucian Freud: Eyes Wide Open* (Seattle: Icon Books/Amazon Publishing, 2017), 66.

541 "I'll tell you something": Ibid.

542 "Francis was there": Ibid.

542 Anne Dunn believed: Anne Dunn, interview with the authors, July 26, 2010.

542 She considered Freud's portrait: Ibid.

542 His obsessive womanizing: The London art world was seemingly split into two camps over what many saw as Freud's almost frantic womanizing and his social climbing. As the painter Lindy Dufferin—herself the Marchioness of Dufferin and Ava—put it rather drily, "I would see Lucian out and about: he was very friendly with rich people." Dufferin, interview with Annalyn Swan, March 21, 2013. Dufferin used the name Lindy Guinness for her artwork.

542 According to James Kirkman: James Kirkman, interview with Mark Stevens, April 24, 2012.

543 In 1972, he sent Freud: Bacon cable to Freud, December 10, 1972. Marlborough Gallery archives.

543 "Your show looks": Ibid.

543 Freud left: See "Chronology," Lucian Freud Archive, lucianfreud.com.

543 Two years later: Ibid.

543 Freud had been viewed: Anthony D'Offay, quoted in Hoban, *Lucian Freud*, 95.

543 Christopher Gibbs: Christopher Gibbs, interview with the authors, October 12, 2013.

543 Freud "shunned dutifulness": Alice Weldon, interviews with Annalyn Swan, March 7 and 12, 2012.

544 When Valerie Beston: Freud, 1985 letter to Valerie Beston, hand-printed, Marlborough Gallery archives.

544 When his close, longtime friend: Weldon, interviews with Swan.

544 Muriel did not usually: Miles, interview with Stevens.

544 "Most of the time": David Marrion, interview for *Francis Bacon, Arena*.

544 The old-timers: Farson, *The Gilded Gutter Life*, 209.

544 "He would say 'hello': Marrion, interview for *Francis Bacon, Arena*.

544 When Denis told him: Turner, *The Visitors' Book*, 306.

544 Bacon's own sense of mortality: Paul Brass, interview for *Francis Bacon, Arena*.

545 A few months after: Michael Peppiatt, *Francis Bacon: Anatomy of an Enigma* (London: Constable & Robinson, 2008), 299.

545 After he underwent: Ibid.

545 He came from "before": Deakin was part of the Soho scene from the end of the war, even before Muriel Belcher opened The Colony Room. See Gordon Comstock, "John Deakin: Champagne and Sulphur in Soho," *The Guardian*, April 7, 2014, theguardian.com.

545 He did not seek fame: Eddie Gray, interview with Mark Stevens, October 2013.

545 It was ninety-nine and 99 hundredths percent: Weldon, interview with Swan.

545 In Brighton: Peppiatt, *Francis Bacon*, 299.

545 Deakin informed the hospital: Ibid.

545 It was the last: Farson, *The Gilded Gutter Life*, 198.

545 He traveled: Peppiatt, *Francis Bacon*, 299.

545 Later, at the Colony: John Christie, director, *The Life and Unsteady Times of John Deakin*, 1991.

545 In full flutey register: Ibid.

545 Bacon began complaining: Davies, interviews for *Francis Bacon: The Early and Middle Years*.

545 Not long after George's death: Julia Blackburn, *The Three of Us: A Family Story* (New York: Vintage Books, 2009), 59–61.

546 "Then Francis entered": Ibid.

36 AN ENGLISHMAN ABROAD

548 "Parisian art-lovers": Raymond Mason, *At Work in Paris: Raymond Mason on Art and Artists* (London: Thames and Hudson, 2003), 171–2.

548 During the summer of 1973: Mark Lancaster, interview with the authors, May 9, 2010.

548 The eponymous gallery: Mason, *At Work in Paris*, 94.

548 During the 1970s: Ibid.

549 "We went out a lot": Nadine Haim, telephone interview with James Norton, May 10, 2009.

549 In 1971: See "Balthus, biographie," www.claude-bernard.com.

549 Neither liked the other's: Michael Peppiatt, *Francis Bacon: Anatomy of an Enigma* (London: Constable & Robinson, 2008), 349. Balthus did the same to Raymond Mason. Mason, *At Work in Paris*, 350.

549 Sometime around: Haim, interview with Norton.

549 Bacon allowed: Michel Soskine, interview with Annalyn Swan, October 1, 2011.

549 In fact, Raymond Mason: Mason, *At Work in Paris*, 174.

549 Balthus was appreciated: Ibid, 75.

549 When a deeply tanned: Ibid., 174–5.

549 In February of 1973: The trip is recorded in Jeffrey Smart, *Not Quite Straight: A Memoir* (Port Melbourne, Victoria, Australia: William Heinemann Australia, 1996), 424–5.

550 Balthus had spent: See "Balthus," www.villamedici.it /en.

550 When a limousine: Smart, *Not Quite Straight,* 424–5. The rest of the information comes from this same passage. For more on Jeffrey Smart, see www.artgallery.nsw.gov.au.

550 Now, in 1975: David Sylvester, *Interviews with Francis Bacon* (London: Thames and Hudson, 1975; New York: Pantheon Books, 1975).

551 Sarah Whitfield: Sarah Whitfield, interview with Mark Stevens, December 7, 2010. In 1980, an expanded version of the interviews was published. Several Marlborough Gallery employees later recalled that Valerie Beston had copies of the interviews and helped with the language.

551 However, one of Bacon's earliest admirers: Sam Hunter, "Francis Bacon: The Anatomy of Horror," *Magazine of Art,* January 1952, 11–15.

551 In March of 1973: Hugh Davies's first interview with Bacon was on March 17, 1973, in London; the last was on August 17, 1973. Davies, *Francis Bacon: The Early and Middle Years, 1928–1958* (New York and London: Garland Publishing, 1978). Davies kindly provided the authors with the typewritten transcripts of the interviews. See also Martin Harrison, ed., *Francis Bacon: New Studies* (Göttingen, Germany: Steidl, 2009), 89–123.

551 Davies became the friend: Ibid.

551 There was even one memorably: Jon Lys Turner, *The Visitors' Book* (London: Constable, 2016), 304.

551 He had been born: For a detailed overview of Beard, see Leslie Bennetts, "African Dreamer," *Vanity Fair,* November 1996, www.archive.vanityfair.com.

552 Beard was welcome: Ibid.

552 His first marriage: Ibid.

552 Beard and Bacon: Nejma Beard, email correspondence with Annalyn Swan, July 2016.

552 Later that year: Ibid.

552 Beard believed: "Peter Beard," www.taschen.com.

552 One day he was photographing: Bennetts, "African Dreamer," *Vanity Fair.* In the article, Bennetts quotes an entry in Andy Warhol's diary from the 1970s: "Mick arrived so drunk from an afternoon with Peter Beard and Francis Bacon that he fell asleep on my bed."

552 Beard photographed: Bacon's work diary is in the collection of The Estate of Francis Bacon.

552 In the end: Bacon would paint numerous portraits inspired by Beard throughout the 1970s, many not identified directly by name.

552 "It's the last house": Beard, Hugh Lane Gallery archive, Dublin, RM98F130:45.

552 "Peter was a lovely": John Normile, interview with Annalyn Swan, November 9, 2017.

553 Terry Danziger Miles: Miles, interview with Mark Stevens, March 20, 2014.

553 MoMA was becoming: See "William Rubin biography," assets.moma.org.

553 The only possibility: During the tenure of flamboyant director Thomas Hoving, from 1967 to 1977, the museum founded a contemporary art department and became much more serious about showing, and acquiring, twentieth-century art. See Randy Kennedy, "Thomas Hoving, Remaker of the Met, Dies at 78," *The New York Times,* December 10, 2009.

553 In June of 1971: Henry Geldzahler, letter to Frank Lloyd, June 3, 1971. Metropolitan Museum of Art (MMA) archive.

553 To counter an argument: See Griselda Pollock, "The Missing Future: MoMA and Modern Women," www .moma.org.

553 His controversial exclusion: Laurie Wilson, *Louise Nevelson: Light and Shadow* (New York: Thames and Hudson, 2016), 285–6.

553 Given his close friendship: David Hockney had painted Geldzahler and his partner, Christopher Scott, in a huge double portrait in 1969. See Natasha Gural, "'Totally Hypnotizing' Hockney Portrait of Famous Gay Couple Could Fetch $38 Million at Christie's," forbes.com.

554 Bacon was thrilled: Bacon, letter to Henry Geldzahler, July 1, 1971, MMA archive.

554 The Grand Palais exhibit: Text of Henry Geldzahler's opening night speech. MMA archive.

554 We were both overwhelmed: Thomas Hoving, letter to Henry Geldzahler, December 5, 1974, MMA archive.

554 Hilton Kramer: Hilton Kramer, "Signs of a New Conservatism in Taste," *The New York Times,* March. 30, 1975.

554 "I don't want": Pierre Levai, interview with Mark Stevens, June 8, 2008.

554 When Rousseau afterwards: Theodore Rousseau, letter to Bacon, June 14, 1972, MMA archive.

554 "I did so much hope": Bacon, letter to Theodore Rousseau, August 30, 1973, Marlborough Gallery archive.

554 Rousseau responded: Theodore Rousseau, letter to Bacon, September 22, 1972, Marlborough Gallery archive.

554 Geldzahler initially envisioned: Henry Geldzahler, letter to Bacon, Ocober. 19, 1971, MMA archive.

554 Altogether, he wrote: Bacon, letter to Theodore Rousseau, September 25, 1973, MMA archive.

555 Bacon also made: Ibid.

555 Bacon told Geldzahler: Bacon, letter to Henry Geldzahler, June 3, 1974, MMA archive.

555 In the end: Gilbert Lloyd, letter of November 20, 1974, to Henry Geldzahler, and another letter the same day to the finance department at the Met, MMA archive.

555 Beard had spent: Turner, *The Visitors' Book,* 306.

555 It would include: The *Village Voice* article, or at least a large portion of it, was included in the "Peter Beard" room

at the Hugh Lane Gallery (Dublin) show *Francis Bacon: A Terrible Beauty*, October 28, 2009–March 7, 2010. The article is dated December 29, 1975.

556 He was friends: Bennetts, "African Dreamer," *Vanity Fair*. See also "Peter Beard: Montauk's Shindig Extraordinaire," whalebonemag.com.

556 On the back: Hugh Lane Museum archive, RM98F98:23.

556 In the final version: "Francis Bacon: Remarks from an Interview with Peter Beard, edited by Henry Geldzahler," *Francis Bacon: Recent Paintings 1968–1974* (New York: The Metropolitan Museum of Art, 1975), 18.

556 Terry Miles preceded: Miles, interview with Stevens. The rest of Miles's quotations come from this interview.

557 Bacon was on best: Gilbert Lloyd, interview with Mark Stevens, November 2, 2012.

557 In London, the week: David Sylvester, "Francis Bacon: A Kind of Grandeur," *The Sunday Times Magazine*, March 23, 1975.

557 Lee Radziwell: Bacon, quoted in Michel Archimbaud, *Francis Bacon: In Conversation with Michel Archimbaud* (London: Phaidon Press, 1994), 46.

557 John Russell: Miles, interview with Stevens.

557 Geldzahler arranged: Grace Glueck, "Briton Speaks About Pain and Painting," *The New York Times*, March 20, 1975.

557 Amei Wallach of *Newsday*: Amei Wallach, "Capturing Nightmares on Canvas," *Newsday*, March 28, 1975.

558 About four hundred people: Paul Richard, "Francis Bacon and His Art: Mirrors of a Horrific Life," *The Washington Post*, March 21, 1975.

558 Willem de Kooning: Wallach, "Capturing Nightmares," *Newsday*.

558 Several prominent: Ibid.

558 Andy Warhol: Ibid.

558 He maintained: Several reviews and articles about the show included Bacon's putdown of Pollock. As Tom Hess wrote in *New York Magazine*, "He recently called the Metropolitan Museum's notable Pollock 'lace curtain,' a clever bit of bitchiness that reflects somewhat more on Bacon than on Pollock, who, as everyone knows, was born McCoy." Thomas Hess, "Blood, Sweat and Smears," *New York Magazine*, April 21, 1975.

558 Christopher Gibbs recalled: Christopher Gibbs, interview with the authors, October 12, 2013. For background on La Popote, see Gerard Noel, "Bursting out of the closet," www.spectator.co.uk.

558 During the opening: Wallach, "Capturing Nightmares," *Newsday*.

558 Some friends: Bacon bought Helen Lessore's ticket. Miles, interview with Stevens.

558 But Bacon disappeared: Levai, interview with Stevens.

558 Gilbert Lloyd said: Lloyd, interview with Stevens.

559 Norman Canedy wrote: Canedy, "Francis Bacon at the Metropolitan Museum," *The Burlington Magazine*, 117, no. 867 (June, 1975), 425–6, 428.

559 He began: Henry Geldzahler, "Introduction," in *Francis Bacon: Recent Paintings, 1968–1974*, March 20–June 29, 1975 (New York: Metropolitan Museum of Art, 1975), 5.

559 They introduced: Ibid., 7.

559 Hilton Kramer: Kramer, "Signs of a New Conservatism in Taste," *The New York Times*.

560 Rosenberg reported: Harold Rosenberg, "The Art World: Aesthetics of Mutilation," *The New Yorker*, May 12, 1975.

560 Hess's review: Hess, "Blood, Sweat and Smears," *New York Magazine*.

560 Although "superficially": Ibid.

560 "In the past few weeks": Ibid.

560 "The British always love": Ibid.

560 One month into its run: Henry Geldzahler, letter to Bacon, April 21, 1975, MMA archive.

560 The show was extended: Henry Geldzahler, letter to Bacon, June 10, 1975, MMA archive; the attendance figure comes from Carter Wiseman, "Agony and the Artist," *Newsweek*, January 24, 1977.

560 The writer Susan Sontag: Susan Sontag, "Francis Bacon: 'About Being in Pain,'" *Vogue*, March 1975.

561 "Bacon is one of": Ibid.

561 "Bacon's work seems": Ibid.

561 Bacon spent a further: Miles, interview with Stevens.

561 He visited: See "Andy Warhol: A Factory," www.guggenheim.org.

561 The waspish Dicky: Turner, *The Visitors' Book*, 310.

561 He admired: David Sylvester, *Looking Back at Francis Bacon* (New York: Thames & Hudson, 2000), 246.

562 "I also think": Sylvester, interview with Bacon.

562 Warhol cheerfully confessed: Wiseman, "Agony and the Artist," *Newsweek*.

562 Before the opening: Miles, interview with Stevens. All of the following quotes come from this interview.

562 Another friend: Ibid. All of the quotes from Miles below come from this interview.

562 "I don't like the idea": Bacon, quoted in ibid.

563 Suddenly, from under: Ibid.

37 ECHOES

564 In 1974: Michael Peppiatt, *Francis Bacon: Anatomy of an Enigma* (New York: Constable & Robinson, 2008), 316.

564 Peppiatt found: Michael Peppiatt, *Francis Bacon in Your Blood: A Memoir* (New York: Bloomsbury USA, 2015), 215.

564 "The apartment was on": Vladimir Veličković, phone interview with James Norton, 2004.

564 "The size and light": Peppiatt, *Francis Bacon*, 318.

564 In September: Peppiatt, *Francis Bacon in Your Blood*, 242–3.

565 The architect: Peppiatt, *Francis Bacon*, 319.

565 The art dealer Claude Bernard: Raymond Mason, *At Work in Paris: Raymond Mason on Art and Artists* (London: Thames and Hudson, 2003), 170–2.

565 Using traditional craftsmen: Michel Cosperec, interview for Adam Low, director, *Francis Bacon, Arena* documentary, BBC Four archive, March 19, 2005.

565 "I arranged it a little": Nadine Haim, interview with James Norton, May 10, 2009.

565 The result was: Terry Danziger Miles, interview with Mark Stevens, March 20, 2014.

565 "He was exceptional": Cosperec, interview for *Francis Bacon, Arena*.

565 "This caused consternation": Mason, *At Work in Paris*, 170–2.

565 In 1975, for example: Danny Moynihan, interview with the authors, February 28, 2011.

565 "He came round every day": Ibid.

566 Once, when the gambling: John Normile, interview with Annalyn Swan, November 9, 2017.

566 One morning, after writing: Bacon's letter is in the Tate Archive, 200816/2/1/368.

566 Dicky and Denis: Theodore Goddard, solicitors, letter recording the sale of 80 Narrow Street on October 21, 1975, to Mr. and Mrs. E. B. Fisher for 27,000 pounds. The amount after expenses (26,100 pounds) was put in Bacon's bank account at the National Westminster Bank on Kensington High Street. Marlborough Gallery archives.

566 "Francis *really* intends": Jon Lys Turner, *The Visitors' Book* (London: Constable, 2016), 311.

566 It had not always: Ibid.

566 He "liked it": Bill Wendon, interview with James Norton, February 26, 2015.

566 "So they bought champagne": Ibid.

566 In the middle of June: Madame Maristella Veličković, interview with Anthi-Danaé Spathoni, May 16, 2016.

566 The truck also: For photographs of the rue de Birague studio, see the publications *Francis Bacon MB Art Foundation* (Italy: Castelli Bolis Poligrafiche Spa, 2015 and 2017).

566 He appeared delighted: Peppiatt, *Francis Bacon*, 310.

566 Raymond Mason: Mason, *At Work in Paris*, 170–2.

567 "F and D off to see": Dicky Chopping diary, August 1975, in Turner, *The Visitors' Book*, 312.

567 The purchase, in August of 1975: Ibid.

567 In 1975: Marlborough Gallery archives.

567 "Francis Bacon, whose pictures": "Bacon Makes a Modest Move," *Daily Express*, September 7, 1976.

567 "To my amazement": Turner, *The Visitors' Book*, 314.

568 It still echoed: Michel Archimbaud, *Francis Bacon: In Conversation with Michel Archimaud* (New York: Phaidon Press, 1993), 32.

568 He was "almost the only": David Sylvester, *Looking Back at Francis Bacon* (New York: Thames and Hudson, 1993), 109.

568 John Russell wrote at the time: John Russell, *Francis Bacon* (New York: Thames and Hudson, 1993), 109.

568 "The thing about the French": Michael Clark, interview with Annalyn Swan, December 18, 2015.

568 Bacon read Racine: A list of all Bacon books, in the collection of the Hugh Lane Gallery, Dublin, contains a number of books in French.

569 Bacon enjoyed French conversation: Russell, *Francis Bacon*, 109.

569 Bacon also liked: Emelia Thorold, interview with Annalyn Swan, December 5, 2008.

569 "You know, he's an artist": Christopher Gibbs, interview with the authors, October 12, 2013.

569 "He talked about painters": Jacques Dupin, interview for *Francis Bacon, Arena*.

569 They would have lunch: Eddy Batache and Reinhard Hassert, interview with Mark Stevens, June 2016.

570 Bacon would sometimes: Peppiatt, *Francis Bacon in your Blood*, 111.

570 "I really can't see: Peppiatt, *Francis Bacon*, 325.

570 Bacon enjoyed, said Haim: Haim, interview with Norton.

570 It was run by: See "Fabrice Emauer," obituary, www.andrejkoymasky.com.

570 "You didn't have to be": Andy Thomas, "Nightclubbing: Guy Cuevas and the Paris Disco Scene," *Red Bull Music Academy Daily*, January 28, 2016, daily.redbullmusicacademy.com.

570 So well-known: Peppiatt, *Francis Bacon*, 348. In Andy Thomas's interview with Guy Cuevas, Cuevas mentioned Bacon as one of the star regulars at Le Sept. "It was a really fabulous crowd with a lot of the fashion people there, so people like Karl (Lagerfeld), Yves Saint Laurent, Kenzo, Claude Montana and Thierry Mugler alongside actresses like Claudia Cardinale and the artist Francis Bacon." Thomas, "Nightclubbing," daily.redbullmusicacademy.com.

570 "He really loved eating": Haim, interview with Norton.

571 The staff was: Anne Madden, interview with Annalyn Swan, May 7, 2008.

571 Bacon also developed: Madame Maristella Veličković, interview with Anthi-Danaé Spathoni. All of the subsequent quotations in this paragraph come from this interview.

571 Bacon remained fundamentally: Ibid. Bacon had actually met Peter Brook years before. Bacon, in Michel Archimbaud, *Francis Bacon*, 95.

571 The dinner lasted: Madame Maristella Veličković, interview with Spathoni.

571 Bacon did not try: Ibid.

571 "He would let": Ibid.

572 Batache, who lived: Eddy Batache, "Francis Bacon: An Intimate View," in Martin Harrison, ed., *Francis Bacon: La France et Monaco/France and Monaco* (Paris: Editions Albin Michel, 2016), 187–8. All of the quotations in this paragraph come from this piece.

572 Perhaps Bacon would like: Brett Whiteley had done a portrait of Francis Bacon a few years earlier. Ibid., 187.

573 They gathered first: Batache, "Francis Bacon: An Intimate View," *Francis Bacon*, 188.

573 Then they walked: Bofinger's figured prominently in Bacon's life in the Marais. Peppiatt, *Francis Bacon*, 321.

573 "Francis was a man": Eddie Batache, interview with James Norton, November 23, 2010.

573 Bacon took: Batache, "Francis Bacon: An Intimate View," *Francis Bacon*, 188–9.

573 Crevel was also a man: See "Rene Crevel," www.goodreads.com.

573 Although Eddy and Reinhard: Batache and Reinhard, interview with Stevens.

573 "Francis was one": Ibid.

573 Bacon loved taking the train: Ibid.

574 Eddy was a Lebanese: See "Reinhard Hassert and Eddy Batache," www.francis-bacon.com.

574 Reinhard was born: Ibid.

574 The young men: Ibid. The rest of the details come from the interview with Stevens.

574 Eddy was dark-haired: See, for example, a photograph of Batache taken by Reinhard Hassert at Hostellerie du Chateau de Fère, Fère-en-Tardenois, France, in July 1978. Michael Cary, ed., *Francis Bacon: Late Paintings* (New York: Gagosian Gallery, 2015), 154.

574 Reinhard, slender: Ibid. *Francis Bacon: Late Paintings* also has a number of photographs of Hassert.

574 His asthma was reasserting: Dr. Paul Brass, interview for *Francis Bacon*, *Arena*.

574 "He believed there was": Batache, quoted in Janet Hawley, "Dark Night of the Soul," *Sydney Morning Herald*, November 3, 2012.

574 "Francis tried": Ibid.

574 Bacon filled many hours: Batache and Reinhard, interview with Stevens.

575 The three went: Batache, "Francis Bacon: An Intimate View," *Francis Bacon*, 190. The following quotes came from this piece.

575 "What he loved": Ibid.

575 If Bacon did feel: Batache and Reinhard, interview with Stevens.

575 "What do you": Mason, *At Work in Paris*, 104.

575 "His astonishment": Ibid.

576 One was a "palatial": Ibid., 99.

576 The party might include: Ibid.

576 Bernard himself: Ibid., 94. In the early days of his gallery Claude Bernard kept an organ downstairs on which he frequently played.

576 At his country estate: Ibid., 102–3. The rest of the details about La Besnardière come from these pages as well.

576 An exhibit of Bacon's recent art: The exhibit, called "Francis Bacon: oeuvres récentes," opened on July 9, 1976.

577 "I love Paris": Archimbaud, *Francis Bacon*, 168.

577 The big table: Hassert, "Dark Night of the Soul," *Sydney Morning Herald*.

577 He acquired: The artist Michael Clark, who visited Bacon at 7 Reece Mews in the 1970s and '80s, described Bacon mixing pigment in a frying pan. Michael Clark, interview with Annalyn Swan, December 18, 2015.

577 Bacon struggled: Batache, "Francis Bacon: An Intimate View," *Francis Bacon*, 199.

577 Reinhard Hassert: Ibid.

577 "Francis came round": Batache, ibid.

578 In November of 1975: Ianthe Knott, interviews with Mark Stevens, March 5 and 6, 2008.

578 Ben and Francis always: Keith Knott, interview with Mark Stevens, March 7, 2008.

578 It was a "terrible shock": Peppiatt, *Francis Bacon in Your Blood*, 248.

578 Bacon rushed to London: Ibid.

578 He paid: Marlborough Gallery archives.

578 In April of 1976: Bacon, letter in Valentina Castellani, Mark Francis, and Stefan Ratibor, eds., *Francis Bacon Letters to Michel Leiris, 1966–1989* (London: Gagosian Gallery, 2006), 23.

578 The Musée Cantini: See "Cantini Museum," www.museu.ms/.

578 The building was constructed: See "The Musée Cantini," www.marvellous-provence.com.

579 Bacon liked the longtime: See "Gaston Defferre," www.britannica.com. Defferre had been mayor of Marseilles even earlier, in 1944–1945.

579 Before the show: Turner, *The Visitors' Book*, 316–17.

579 "Dicky and Denis": James Birch, interview with the authors, December 8, 2008.

579 A surprising number: Ibid.

579 The Marlborough gallery: Pierre Levai, interview with Mark Stevens, June 8, 2008.

579 Only three of the large images: Martin Harrison, ed., *Francis Bacon Catalogue Raisonné*, vol. IV (London: Estate of Francis Bacon, 2016).

579 More important: Ibid.

579 Lucian Freud hosted: Birch, interview with the authors.

579 After the opening: Levai, interview with Stevens.

580 David Sylvester wrote: Sylvester, *Looking Back at Francis Bacon*, 156.

580 Bacon once said: Andrew Carduff Ritchie, ed., *The*

New Decade: 22 European Painters and Sculptors (New York: Museum of Modern Art, 1955), 63.

580 The triptych, said a friend: Helen Lessore, *A Partial Testament: Essays on Some Moderns in the Great Tradition* (London: Tate Publishing, 1986), 94.

38 SPECTACLE

581 One afternoon: John Edwards said that the two met in 1976. John Edwards, "Foreword," and Perry Ogden, photographer, *7 Reece Mews: Francis Bacon's Studio* (London: Thames & Hudson, 2001), 10. Except for Edwards's foreword, the book is composed solely of Ogden's photographs.

581 "So you're": Edwards's account of the meeting comes from Brian Clarke, interview with Annalyn Swan, February 9, 2020.

581 Sometime before: Joan Littlewood was friendly with both Bacon and Belcher. A postcard from Littlewood to Bacon in 1967 asks him to come visit her theater in Stratford. The postcard was part of the so-called Robertson Collection of studio refuse that was auctioned by Ewbank Fine Art Auctioneers and Valuers near Woking, Surrey in 2007. See Charlotte Higgins, "It's Trash but It's Bacon's Trash—and It's Sold for Almost £1 Million," *The Guardian*, April 25, 2007, www.theguardian.com/uk.

581 To make the trip: *7 Reece Mews*, 10.

581 John Edwards, then twenty-six or twenty-seven: Edwards was born on October 9, 1949. Questionnaire for passport, Marlborough Gallery archives.

581 "I do think": Paul Brass, interview for Adam Low, director, *Francis Bacon, Arena* documentary, BBC Four archive, March 19, 2005.

582 Bacon would not entirely: John Edwards, quoted in Daniel Farson, *The Gilded Gutter Life of Francis Bacon* (New York: Pantheon 1993), 218.

582 "Francis fell for John": Brian Clarke, interviews with Annalyn Swan, June 3, 2016 and February 9, 2020.

582 David Marrion: David Marrion, interview for *Francis Bacon, Arena*.

582 Bacon found: Michael Peppiatt, *Francis Bacon in Your Blood: A Memoir* (New York: Bloomsbury USA, 2015), 227.

582 But there Bacon stood: Ian Board, quoted in Farson, *The Gilded Gutter Life*, 219.

582 As usual: See David Plante, "Bacon's Instinct," *The New Yorker*, November 1, 1993.

582 He typically refused: Michael Dillon, interview with Annalyn Swan, October 24, 2013.

582 "I think he felt very free": John Edwards, quoted in an unsigned obituary, *The Daily Telegraph*, March 7, 2003.

582 "John," said his friend: Clarke, interviews with Swan.

582 Edwards was born: *East London Advertiser*, March 7, 2002. The same article has details about Edwards's father.

582 His mother: Philip Mordue, email correspondence with Brian Clarke and Annalyn Swan, March 7, 2017 and March 11, 2020.

582 The family was: Ibid.

582 "He could read certain things: Clarke, interviews with Swan.

583 John "bunked off": *East London Advertiser*, March 7, 2002.

583 At fourteen, he dropped out: Clarke, interviews with Swan.

583 "He was incapable": Ibid.

583 His older brothers Leonard and David: Mordue, correspondence with Clarke and Swan.

583 He was arrested: Ibid.

583 The fourth time: Ibid.

583 "John had very few jobs": Ibid.

583 "John didn't need": Clarke, interview with Swan.

583 Bacon became: David Marrion, quoted in Farson, *The Gilded Gutter Life*, 219.

583 Edwards "was a young man": Marrion, interview for *Francis Bacon, Arena*.

583 Marrion recalled: Ibid.

584 In the beginning: Although John Edwards later claimed that his relationship with Bacon was not physical, those who knew Edwards best said that at the beginning the affair was, indeed, sexual. Not-for-attribution interview.

584 It would remain: Clarke, interviews with Swan.

584 Bacon did not intend: He gave both of his portraits of Leiris to his friend. See Martin Harrison, ed., *Francis Bacon Catalog Raisonné*, Vol. IV (London: The Estate of Francis Bacon, 2016), 1116.

584 The likeness was less: John Russell, *Francis Bacon* (London: Thames and Hudson, 1993), 172.

584 "It is less literally": Bacon, quoted in David Sylvester, *Interviews with Francis Bacon* (New York: Thames & Hudson, 1987), 146–7.

584 And so Marlborough sold: Harrison, ed., *Francis Bacon Catalogue Raisonné*, vol. IV, 1092, 1106, 1110. In 1974, an air waybill for Swissair shows fifteen paintings being shipped to Zurich by T. Rogers and Co., packers. By 1980, checks for Bacon were regularly being deposited in his National Westminster Bank account from T. Rogers and Co. Bacon's payments were officially coming, then, not from Marlborough in London but presumably from Marlborough elsewhere, through the packing company. Marlborough Gallery archive. The UK's Value-Added Tax had begun the year before and would have meant a far greater amount of taxes owed for any painting sold in the UK.

585 "They [Bernard and Bacon] were great friends": David Somerset, interview with the authors, June 18, 2012.

585 The international edition: Carter Wiseman and Edward Behr, "Agony and the Artist," *Newsweek International*, January 24, 1977.

585 "For weeks": Ibid.

585 "Bacon's grisly visions": Ibid.

585 "The whole neighborhood": Michel Soskine, interview with Annalyn Swan, October 1, 2011.

585 That would: Raymond Mason, *At Work in Paris: Raymond Mason on Art and Artists* (London: Thames & Hudson, 2003), 104.

586 Three rooms: Soskine, interview with Swan.

586 A "contingent": Mason, *At Work in Paris*, 104.

586 Now the concentration: Soskine, interview with Swan.

586 A French minister: Eddy Batache and Reinhard Hassert, interview with Mark Stevens, June 2016.

586 For the punks: See Geoff Bird, producer, "How France Gave Punk Rock Its Meaning," *Liberty, Fraternity, Anarchy*, Radio 4, March 3, 2011, www.bbc.com.

586 They strode barbarously: Peppiatt, *Francis Bacon in Your Blood*, 278.

586 *Paris Match* estimated: Sabine de la Bosse, "Francis Bacon: 8000 Parisiens en un jour pour le pentre le plus cher du monde," *Paris Match,* February 4, 1977.

586 Not only did Reinhard: Hassert, interview with Stevens.

586 Bacon noticed: Ibid.

586 Bernard capped: Madame Maristella Veličković, interview with Anthi-Danaé Spathoni, May 16, 2016.

586 He commandeered: Soskine, interview with Swan, Oct. 1, 2011.

586 At the dinner: Veličković, interview with Spathoni.

586 Two days later: Ibid.

586 "The best exhibition": Richard Cork, "Home Thoughts from an Incurable Surrealist," *The Times Saturday Review*, March 16, 1991.

587 "Powerful like Rembrandt": Unsigned, undated notice for the show, *Le Quotidien de Paris*.

587 Bacon wrote Somerset: Letter from Bacon to David Somerset, February 2, 1978, Hugh Lane Gallery archive, RM98F23:54.

588 Glimcher brought: Rachel Wolff, "Fifty Years of Being Modern," *New York Magazine*, February 6, 2009, nymag.com. See also Paul Lancaster, "Pace Gallery 50th Anniversary: Arne Glimcher," *The Daily Beast*, July 14, 2017.

588 At the time Marlborough: Judith H. Dobrzynski, "A Betrayal the Art World Can't Forget; the Battle for Rothko's Estate Altered Lives and Reputations," *The New York Times*, November 2, 1998, www.nytimes.com.

588 In 1975: Ibid.

588 In 1977: Ibid.

588 Bacon came wearing: Arnold Glimcher, interview with Mark Stevens, March 4, 2019.

588 "We had such": Ibid. All of the following quotes come from this interview.

588 On the flight home: Arnold Glimcher, letter of March 4, 1978, to Bacon, Hugh Lane Gallery archive, RM98F22:74.

589 "He was very nervous": Glimcher, interview with Stevens.

589 Years later, Glimcher attributed: Steve Boggan, "I Wooed Bacon with Claridge's Champagne, but London Gallery Cheated Me, Says Dealer," *The Independent*, November 28, 2001.

589 In the 1960s and '70s: Richard Evans, "How Labour Will Take Tax Rates Back to the 1970s," *The Telegraph*, June 3, 2017, www.telegraph.co.uk.

589 In 1980, the records of Marlborough: Profit-and-loss statement for the year ended April 5, 1980, Marlborough Gallery archive.

589 Many high earners simply: Philip Johnston and Ian Cowie, "Labour Remains Haunted by the Sound of Squeaking Pips," *The Telegraph*, June 21, 2003.

589 Even after the Labour Party: Ibid.

589 As a result, tax games: Ibid.

589 Peter Beard alluded: In a letter to Bacon dated September 28 [probably either 1984 or 1987, as Bacon had upcoming shows both of those years] Beard wrote, "I know you're on the final count-down for another Swiss-account-shattering Paris show . . ." The letter was displayed in a "Peter Beard Detritus Box," in "Francis Bacon: A Terrible Beauty," Hugh Lane Gallery exhibition, October 2009.

589 Over the years: On April 14, 1982, for example, Bacon flew to Zurich before heading to Paris. Valerie Beston diaries, The Estate of Francis Bacon archive. Probably not coincidentally, Marlborough London had Swiss secretaries. James Kirkman, interview with Mark Stevens, April 24, 2012.

589 He was likely: Ianthe Knott said that Bacon had generously given money to her sons, for example, which they invested in a farm in Zimbabwe—only to have it confiscated in the ongoing land appropriation by the government. Ianthe Knott, interviews with Mark Stevens, March 5 and 6, 2008.

589 Martin Summers: Martin Summers, interview with Mark Stevens, April 23, 2012.

589 Andrew Graham-Dixon reported: Andrew Graham-Dixon, "Profile: Francis Bacon, Confounder of Art Critics," *The Independent*, September 24, 1988.

589 Grey Gowrie, Margaret Thatcher's: Gowrie, interview with Mark Stevens, November 2011.

590 The year before: John Lelliott Ltd. builders, letter to Valerie Beston, August 23, 1977, Marlborough Gallery archive.

590 Not long after: In a letter of April 20, 1978, to the builders, Beston noted that Bacon had seen some of the men leafing through his magazines and was upset. Marlborough Gallery archive.

590 "Although Mr. Bacon": Ibid.

591 Bacon did not notice: Valerie Beston's diary records in detail the process of getting back the painting. On October 16, 1978, she rang the detective "for news of missing picture." The Estate of Francis Bacon archive.

591 He was reminded: Ibid. Valerie Beston noted in her diary on July 17, 1979, that the "Mafia" triptych was delivered to the gallery. Eight days later, she records that the "center panel of Mafia Triptych returned to artist to destroy."

591 "I think the most attractive": David Somerset, interview with the authors.

591 Bacon liked to be in places: Clive Barker, interview with Annalyn Swan, June 27, 2016.

591 Lucian Freud: Alice Weldon, interviews with Annalyn Swan, March 7 and 12, 2012.

591 The thief fell: A "Detective Constable Lunn" met with the unsuspecting thief on October 20, offering a 2,500 pound reward for the return of the painting. The thief accepted and was arrested. He was formally charged with the theft on October 23. Beston diary, October 23, 2012. The Estate of Francis Bacon archive.

591 He was subsequently: Ibid., November 13, 2012. The trial was at the Lower Court, South London. The thief was given probation for two years.

39 FRIENDS AND RIVALS

592 It was never easy: Edwards was born in 1949, the year that Bacon booed Princess Margaret.

592 In 1977: Louisa Buck, "Denis Wirth-Miller: A Partial Memory," in Denis Wirth-Miller, 1915–2010 exhibition catalog (The Minories Gallery, Colchester Institute, Colchester, United Kingdom, 2011), 17.

593 Sometime before: Jon Lys Turner, The Visitors' Book (London: Constable, 2016), 322.

593 Francis "was terribly kind": Ibid.

593 Denis walked outside: Ibid., 323.

593 Bacon "began to rock": Ibid.

593 Dicky often told Denis: James Birch, interview with the authors, December 8, 2008.

594 He destroyed most: James Birch quoted in Buck, "Denis Wirth-Miller: a partial memory."

594 He blamed problems: Louisa Buck, interview with Dan Chapman, in "Denis Wirth-Miller: A Partial Memory." Also Pam Dan, interview with the authors in Wivenhoe, February 24, 2011.

594 In December of 1978: Turner, The Visitors' Book, 327.

594 A Christmas feast: Ibid.

594 "I tried to deter": Ibid.

594 Fewer than six weeks: Ibid.

594 "I wanted it to be a landscape": David Sylvester, Looking Back at Francis Bacon (London: Thames & Hudson, 2000), 175.

594 In 1981, he explained: Bacon, letter of November 20, 1980, to Michel Leiris, published in Valentin Castellani, Mark Francis, and Stefan Ratibor, eds., Francis Bacon: Letters to Michel Leiris 1966–1989 (New York: Gagosian Gallery, 2006), 30.

596 Attracted by Bacon's: As Freud told his biographer William Feaver, "Francis opened my eyes in some ways. His work impressed me, but his personality affected me." William Feaver, The Lives of Lucian Freud: The Restless Years, 1922–1968 (New York: Knopf, 2019), 358.

596 "When each one": David Somerset, interview with the authors, June 18, 2012.

596 Freud later said: Freud to Sebastian Snee, art critic of The Boston Globe, quoted in Phoebe Hoban, Eyes Wide Open (Boston: New Harvest, Houghton Mifflin Harcourt, 2013), 65–6.

596 "I remember his complaining": James Kirkman, interview with Mark Stevens, April 24, 2012.

596 "Lucian took the view": Somerset, interview with the authors.

596 He told the art critic: Martin Gayford, Man with a Blue Scarf: On Sitting for a Portrait by Lucian Freud. (New York: Thames & Hudson, 2010), 188.

596 Bacon could be: William Feaver, quoted in Janet Hawley, "Dark Night of the Soul," Sydney Morning Herald, November 3, 2012.

596 Bacon called: Danny Moynihan, interview with the authors, February 28, 2011. "I remember my mother saying that she had bumped into Bacon after seeing the Freud retrospective at the Hayward Gallery and Bacon had said, 'It's far too expressionist for my liking.'"

596 To Kirkman: Kirkman, interview with Stevens.

597 In the early 1980s: David Russell, interview with the authors, March 6, 2012.

597 John Edwards once set up: Geraldine and Michael Leventis, interview with Annalyn Swan, November 11, 2017.

597 "He was my": Ibid.

597 Michael, who was Greek: Ibid.

598 "Lucian made no effort": Ibid.

598 "You're in the restaurant": Ibid.

598 Graham Greene famously: Julian Evans, "Graham Greene," Prospect Magazine, September 26, 2004.

598 At a restaurant once: Eddy Batache and Reinhard Hassert, interview with Mark Stevens, June 2016.

598 In July 1978: Beston diary, Estate of Francis Bacon archive.

598 The three travelers: Eddy Batache, interview with James Norton, November 23, 2010.

598 There would often be: Eddy Batache, "Francis Bacon: an Intimate View," Francis Bacon: La France et Monaco/France and Monaco (Paris: Albin Michel/Francis Bacon MB Art Foundation, 2016), 192.

598 The following year: Batache, interview with Norton.

598 Castres had a lovely: See "Goya museum," www.amis -musees-castres.asso.fr/en.

598 Bacon wanted to see: Batache, interview with James Norton.

599 "Some friends of Francis": Ibid.

599 "He thought it": Ibid.

599 It was only once: Batache, "Bacon: An Intimate View," *Francis Bacon*, 193.

599 He granted permission: Ibid., 188–9.

599 "His models": Ibid., 189.

599 Bacon even asked: Ibid.

599 And so he shaved it off: Ibid., 197.

600 It took Bacon three weeks: Batache, quoted in Hawley, "Dark Night of the Soul," *Sydney Morning Herald*.

600 The color in the portraits: While Bacon was painting the double portrait of Batache and Hassert, the three spent time together at the Louvre, where Bacon studied a Chardin self-portrait intently. Batache couldn't understand why until he realized later "that he had found in Chardin the secret of the multiple reflections that enliven the lenses of spectacles." (Hassert wore glasses.) Batache, "Bacon: An Intimate View," *Francis Bacon*, 190.

600 Bacon and Barker maintained: Clive Barker, interview with Annalyn Swan, June 27, 2016.

600 Bacon told Barker: Ibid. That Bacon's interest was piqued is immediately evident in several of his works from 1978 and '79 that incorporate the "figure-on-a-rail" motif into his paintings. One, a preliminary, large-scale sketch— *Seated Figure*—that dates from roughly 1978, is a virtually direct translation of Bacon's figure-on-a-rail idea. Here a male figure is seated on a rail, his right leg drawn up in front of him and his left arm flung back, as if in motion. Sketched in thin oil paint, it is one of the very few larger-scale studies to survive in Bacon's work. A powerful painting of 1978 attests to Bacon's fascination at the time with both sculptural figures and monumental bodies in motion. *Figure in Movement, 1978* is clearly inspired by the Discus Thrower, or Discobolus, of Myron, one of the most famous of all ancient Greek sculptures. In Bacon's version, the figure—his torso doubled over, his lower body coiled in upon itself, his arms outspread—has so much centripetal force that he threatens to spin right out of the painting. Henry Geldzahler's description, in his catalog essay for Bacon's 1975 show at the Metropolitan Museum, of Bacon's mid-seventies paintings comes to mind—the "image of speed, the contorted body which can hold its position only for the moment it is pictured."

600 "He had been looking": Barker, interview with Swan.

600 Bacon would have to lie: Ibid. The rest of the quotations come from this interview.

600 And so Bacon "lay": Ibid.

600 Bacon proved an ideal: Ibid.

601 "He did them in Paris": Ibid.

601 "I remember": Ibid.

601 The next time: Ibid.

601 "He was in the Hotel Westminster": Louis le Brocquy, interview with Annalyn Swan, May 7, 2008.

601 The idea of painting: Madame Maristella Veličković, interview with Anthi-Danaé Spathoni, May 16, 2016.

601 "He would sometimes share": Eddy Batache, "Bacon: An Intimate View," *Francis Bacon*, 199.

601 "The only possibility": David Sylvester, *Interviews with Francis Bacon* (New York: Thames & Hudson, 1987), 148.

601 Bacon told Batache: Batache, "Francis Bacon: An Intimate View," *Francis Bacon*, 200.

601 "I did not realize": Ibid.

602 Batache and Hassert felt: Ibid.

602 In August of 1977: Francis Bacon, letter of July 22, 1977, to the Royal Hospital outlining Winnie's travel arrangements, and requesting that an ambulance meet her flight from Salisbury when it arrived at Heathrow Airport on August 16th. Marlborough Gallery archive.

602 Bacon never had: Ianthe Knott, interviews with Mark Stevens, March 5 and 6, 2008.

602 "Eventually Winnie": Knott, interview with Stevens.

602 Not only did Bacon arrange: Letter of July 22, 1977, to the Royal Hospital. Marlborough Gallery archive.

602 Bacon made certain: Letter, Royal Hospital and Home for Incurables to Bacon. The year's rental was 73 pounds 44 pence. Marlborough Gallery archive.

602 Muriel Belcher began: Turner, *The Visitors' Book*, 307.

603 Bacon paid her medical: Ibid.

603 In the spring of 1977: Hilary Spurling, *The Girl from the Fiction Department: A Portrait of Sonia Orwell* (Berkeley: Counterpoint, 2003), 162.

603 "She rented": Ibid.

603 In 1979, at the Colony: Wirth-Miller, letter to Richard Chopping quoted in Turner, *The Visitors' Book*, 336. "Francis is terribly saddened by her obvious breaking up," he wrote.

603 Only Robert Carrier: Ibid.

603 Soon, she was bedridden: Michael Clark drew and painted several portraits of the bedridden Belcher in her final months. See www.michaelclark.info/colonyroom.html. The two also had long conversations: "I certainly got Muriel to talk. I said to Muriel, 'There's something quite extraordinary how you've had so many extraordinary people who have come to the Club.' I mentioned a range of them— Freud, Auerbach, Giacometti. And of course Francis. And I said, 'What do you think draws them to the Club?' And she paused and she looked up from her sickbed and said, 'I think it's my CHARM dear.'" Clark, interview with Annalyn Swan, December 18, 2015.

603 Valerie Beston was also there: Valerie Beston diary, August 8, 1979, The Estate of Francis Bacon archive.

603 Eventually, Belcher moved: Ibid., July 9, 1979.

603 "When Ian [Board] told": Clark, interview with Swan.

603 Bacon regularly visited: Eddy Batache and Reinhard Hassert, interview with Mark Stevens, June 2016.

603 In one memorably: Bacon visited Muriel on July 13, 1979, and Winnie two days later. Beston diaries.

603 She was cremated: Beston diary, November 6, 1979. "Muriel cremated Golders Green Cemetery," Beston noted. "George Melly gives short address. No religious service."

603 "In order to transfer": Brian Clarke, interview with Annalyn Swan, June 3, 2016.

603 In 1980, Sonia Orwell: Spurling, *The Girl from the Fiction Department*, 172.

603 "Sonia came back": Ibid., 174.

604 "Mary McCarthy sent": Ibid.

604 In the end, Orwell spent: Ibid.

604 It was Bacon who brought: Dan Farson, *The Gilded Gutter Life of Francis Bacon* (New York: Pantheon, 1993), 256.

604 Valerie Beston ordered: Beston diary, entry of July 24, 1980.

604 "He used to have": Dr. Paul Brass, interview for Adam Low, director, *Francis Bacon, Arena* documentary, BBC Four archive, March 19, 2005.

604 But Bacon visited: Spurling, *The Girl from the Fiction Department*, 175.

604 One night in December: "Sonia died in the night at St. Stephens." Beston diary, December 11, 1980.

604 Bacon's closest French friends: Ibid., December 18, 1980.

604 Valerie Beston visited: Ibid., March 16, 1981.

604 Her son John Stephenson arrived: Ibid., March 23, 1981.

604 "Francis came": Clark, interview with Swan.

605 "Francis was very, very jealous": Michael Dillon, interview with Annalyn Swan, October 24, 2013. The following quotations come from this interview.

605 In her diary: Beston diary, February 28, 1980.

605 Bacon regularly: Valerie Beston's diaries are filled with back-and-forth trips in the late 1970s and '80s.

605 David Plante: Plante, unpublished diaries, Tate Archive, 200816/4/2/15/2.

605 "Francis said": Ibid.

606 "Nikos and I": Ibid. The rest of the quotations in this paragraph come from the Plante diaries.

606 Among the drinkers: Ibid. The rest of the quotations in this paragraph come from the Plante diaries.

40 LOVE AND MONEY

607 Early in his relationship: Dr. Paul Brass, interview for Adam Low, director, *Francis Bacon, Arena* documentary, BBC Four archive, March 19, 2005.

607 "I mean": Ibid.

607 He ordered a vanity plate: Brian Clarke, interview with Annalyn Swan, June 3, 2016. License read "847 BOY"—VIP BOY.

607 In 1981: Valerie Beston recorded in her diary that Bacon gave Edwards the key to Reece Mews on April 4, 1981. The day before she had noted, "Troubling about keys." The Estate of Francis Bacon archive.

608 And he trimmed: See Martin Harrison, ed., *Francis Bacon Catalogue Raisonné*, vol. IV (London: Estate of Francis Bacon, 2016), 1194.

608 Avedon photographed: Avedon photographed Bacon in Paris on April 11, 1979. See "Richard Avedon," www.phillips.com.

608 Now that John was "with": Valerie Beston diary, The Estate of Francis Bacon archive. The entries that included John became regular after February 1980.

608 Bacon paid all: David Marrion, interview for *Francis Bacon, Arena*.

608 If Francis was wearing: Michael Clark, interview with Annalyn Swan, December 18, 2015. Clarke described the watches in detail.

608 "They were a similar age": Philip Mordue, correspondence with Brian Clarke and Annalyn Swan, March 7, 2017.

608 "Both my older brother": Emine Saner, "So Where's Bacon's 'Missing Millions'?" *The Evening Standard*, September 1, 2004, www.standard.co.uk.

608 After being a successful: Ibid. David's business was called Seabrook Antiques and was in Long Melford. Daniel Farson, *The Gilded Gutter Life of Francis Bacon* (New York: Pantheon, 1993), 219.

608 In 1976, David and John Tanner: Saner, "So Where's Bacon's 'Missing Millions'?" *The Evening Standard*. See also Martin Newell, "Joy of Essex: Cockneys on the Move," *East Anglian Daily Times*, August 10, 2013.

609 Not only did Dicky and Denis: For more on Cavendish Hall, see www.landmarktrust.org.uk.

609 Cavendish Hall had recently: Ibid.

609 Bacon's nickname: John Normile recalled John Tanner's nickname. Normile, interview with Annalyn Swan, November 9, 2017.

609 Bacon liked to sing: Alexis Parr, "Bring Home the Bacon: This Marble-Lined Suffolk Mansion—Built with the Legacy of Francis Bacon—Is for Sale at 3.5 Million," May 10, 2011, *Mail Online*, www.dailymail.co.uk.

609 What Bacon's next-door: John Spero, interview for *Francis Bacon, Arena*.

609 "He was just a wonderful": Ibid.

609 "You know": Ibid.

609 "I never really figured": Wendy Knott, interview with Mark Stevens, March 7, 2008.

609 "I knew he was gay": Ibid.

609 Even though Bacon: Ibid.

610 "I knew sometimes": Marrion, interview for *Francis Bacon, Arena*.

610 "Francis was always frantic": Ibid.

610 He "had his own": Ibid.

610 In a typical diary entry: Beston diary, July 6, 1981, The Estate of Francis Bacon archive.

610 Gilbert Lloyd: Gilbert Lloyd, interview with Mark Stevens, November 2, 2012.

610 "John was a good": David Russell, interview with the authors, March 6, 2012.

610 Michael Dillon: Michael Dillon, interview with Annalyn Swan, October 24, 2013.

610 Stephen Spender: Marrion, interview for *Francis Bacon, Arena*.

611 Toward the end of 1981: Jon Lys Turner, *The Visitors' Book* (London: Constable, 2016), 334.

611 They had lunch: In her diary Valerie Beston recorded their lunch on February 22, 1982, and a trip to Chartres on February 10, 1983, that ended in Brittany. The trio returned to Wivenhoe on March 3. "Hung over," notes Beston. Estate of Francis Bacon archive.

611 In May of 1983: Turner, *The Visitors' Book*, 334.

611 Chopping observed: Ibid.

611 "Francis didn't": Pam Dan, interview with the authors, February 24, 2011.

611 Bacon and Edwards packed up: Beston diary, June 18, 1982.

611 That September, he wrote: Bacon, letter dated September 24, 1983, in Turner, *The Visitors' Book*, 338.

611 This one ended: Ibid.

611 He tried: Beston diary, April 23.

611 "It was very difficult": Clarke, interview with Swan.

612 It was probably during: Beston recorded their return on May 6, 1981.

612 He wrote Leiris: Bacon, letter to Michel Leiris, August 29, 1981, in Valentina Castellani, Mark Francis, and Stefan Ratiber, eds., *Francis Bacon: Letters to Michel Leiris 1966–1989* (Gagosian Gallery), published for the exhibition *Francis Bacon: Triptychs*, June 20–August 4, 2006, Gagosian Gallery, London, 28.

612 Bacon expressed a dislike: Eddie Gray, interview with Mark Stevens, October 2013.

612 He would lament: Ibid.

612 "I seem to recall": Knott, interview with Stevens.

612 Early in 1981: "JE [John Edward] friend at Old Bailey," Beston diary, January 25, 1981.

612 "I think I owe you the promise": Mordue, undated letter to Bacon from HM Prison Coldingly, Bisley, Woking, Surrey. Bacon correspondence. The Estate of Francis Bacon archive.

612 On March 6, 1981: Turner, *The Visitors' Book*, 334.

612 A few months later: David Plante, "Bacon's Instinct," *The New Yorker*, November 1, 1993.

613 John joined the table: Ibid.

613 Then Edwards leaned: Ibid.

613 By the end of the year: Beston diary, December 12, 1981.

613 In March of 1982: Beston diary, March 30, 1982.

613 It happened: Clarke, interview with Swan.

613 Bacon telephoned Valerie Beston: Beston diary, March 30, 1982.

613 When Edwards assured: Ibid. March 31, 1982.

613 "He wouldn't have wanted": Marrion, interview for *Francis Bacon, Arena*.

613 In September of 1982: Valerie Beston wrote in her diary on September 13, 1982, "Decides to take the flat—gives deposit."

613 "It was a lovely": Ianthe Knott, interviews with Mark Stevens, March 5 and 6, 2008.

614 "It soon contained": Barry Joule, interview with Annalyn Swan, November 5, 2017.

614 Early in 1982: On January 8, Valerie Beston wrote in her diary, "FB hoping for news from JE and brother about Pub." Kevin Moran, who eventually wound up with the pub, identified it as the Nag's Head. Kevin Moran, interview with the authors, September 26, 2013.

614 "I do hope": Philip Mordue, undated letter from Coldingley prison to Francis Bacon. The Estate of Francis Bacon archive.

614 Moran was: Kevin Moran, interview with the authors. The personal detail comes from this interview.

614 Tom Baker, an actor: Ibid.

614 Sometimes Bacon spent: Ibid.

614 "I would close": Ibid.

614 "I got to know": Ibid. The rest of Moran's quotes in this paragraph come from this interview.

614 "Running a pub": Clarke, interview with Swan.

614 To console John: John Edwards flew to Las Vegas on June 10, 1982. Beston diaries, The Estate of Francis Bacon archive.

614 Edwards liked: Saner, "So Where's Bacon's 'Missing Millions'?" *The Evening Standard*. The Estate of Francis Bacon archive has the information on Edwards's stay in Florida.

615 On a visa application: Marlborough Gallery archive.

615 A typical Valerie Beston: Beston diary, August 9, 1982.

615 John had a salesman's: Russell, interview with the authors.

615 In August of 1982: On August 23, Valerie Beston recorded in her diary, "JE caught very drunk carrying milk bottle. Charged. To appear in November."

615 Bacon became concerned: The solicitors Theodore Goddard were called in to help with the case. In a letter of November 3, 1982, they wrote Bacon that Edwards had been extremely drunk and high on marijuana, holding a broken milk bottle and cursing the police. They referred in their letter to Edwards's "reasonably long criminal record." Marlborough Gallery archive.

615 A few years after Muriel: Clarke, interview with Swan.

615 He used the windfall: Ibid.

615 The house was called: Marlborough Gallery archive.

615 It was a small: Ibid. The address was "The Old School, the Green, Sudbury, Suffolk."

615 "Francis did": Clarke, interview with Swan.

615 Valerie Beston: Beston diary, March 15, 1983.

615 A young friend: David Wallace, interview with Mark Stevens, March 27, 2014.

615 Whenever Edwards walked: Paul Conran, interview with Mark Stevens, February 12, 2011.

615 "He insisted": Ibid.

616 Edwards began to spend: Clarke, interview with Swan.

616 "They may have been": John Spero, interview for *Francis Bacon, Arena.*

616 In the evenings: Ibid.

616 So did Bacon: Ibid.

616 John would sometimes: Ibid.

616 Often Bacon ate: Felice Pollano, interview with Annalyn Swan, February 20, 2020.

616 Invariably, he ordered: Ibid.

616 Pollano occasionally: Ibid.

616 There was "never enough": Ibid.

616 The young man: Barry Joule, interview with Annalyn Swan, June 15, 2016.

616 He was often: Ibid.

616 A friend of Joule "had": Barry Joule, interview with Swan, November 5, 2017.

617 Joule "would go": Ibid.

617 He "got to Maud Gosling": For more on Gosling, see "Maud Lloyd," *The Telegraph*, December 1, 2004, www.telegraph.co.uk.

617 "Nureyev and I": Joule, interview with Swan, November 5, 2017.

617 By the mid-1980s: Ibid.

617 If Bacon wanted to go: Ibid.

617 At one point in the early: Ibid. The following quotes all come from this interview.

617 At a Galerie Maeght-Lelong: The Galerie Maeght became the Galerie Maeght-Lelong in 1981, upon Aime Maeght's death. "Jacques Dupin, Jean Fremon, and myself first founded the Galerie Maeght-Lelong," said Lelong in an interview with Donatien Grau. It eventually became the Galerie Lelong, but in the interim period it continued the connection with Maeght. Grau, "Daniel Lelong," www.flashartonline.com.

617 "Edwards had gone out": Pierre Levai, interview with Mark Stevens, June 8, 2008.

617 The show was "literally mobbed": Peppiatt, *Francis Bacon in Your Blood*, 374.

617 Nadine Haim: Nadine Haim, interview with James Norton, May 10, 2009.

617 Maeght was safe: Bacon even painted Dupin's portrait. When Jack Lang became minister of culture under French President Francois Mitterand, the government commissioned a series of portraits by leading artists. Bacon chose Dupin. Dupin, interview for *Francis Bacon, Arena*.

617 Four months later: The show at Marlborough New York ran from May 5 to June 5.

618 Bacon "loved seeing": Geraldine and Michael Leventis, interview with Annalyn Swan, November 11, 2017.

618 He and John stayed: Geraldine Leventis, interview with Swan.

618 "We went to shops": Michael Leventis, interview with Swan.

618 "Francis loved students": Geraldine Leventis, interview with Swan.

618 "He came running back": Michael Leventis, interview with Swan.

618 Between 1975 and 1980: In the fiscal year 1974–75, Marlborough Gallery records show that Bacon made 73,000 pounds from his paintings, roughly equivalent to 577,000 pounds in 2019. By 1980 that had doubled. T. Rogers, the shipping company that began to pay Bacon instead of Marlborough, put 145,000 pounds into his bank account that year. Marlborough Gallery archive. For the triptych, see Rita Reif, "At Auction Wallets Were Close to the Vest," *The New York Times*, May 21, 1981.

618 By the end of the decade: Rita Reif, "Pollock Price Among Records at Sotheby's," *The New York Times*, May 3, 1989, nytimes.com.

618 "Alfred Hecht": Russell, interview with the authors.

618 By the early 1980s: See *Study of the Human Body, 1981–82* in Harrison, ed., *Francis Bacon Catalogue Raisonné*, vol. IV, 1234.

619 In the mid-1980s: Geraldine and Michael Leventis, interview with Swan.

619 "When Francis heard": Michael Leventis, interview with Swan.

619 In 1985, Valerie Beston: Beston diary, January 13, 1985.

619 Once Bacon began: David Somerset, interview with the authors, June 18, 2012.

619 Previously a key figure: Rory Ross, "Finger on de Botton," *The Tatler*, March 2000. Ross's article provides a good overview of de Botton.

619 It was from: Ibid.

619 De Botton was known: David Landau, "Gilbert de Botton: Self-Made Financier Who Reveled in Money, Markets and Modern Art," *The Guardian*, September 19, 2000, www.theguardian.com.

619 For example, he wooed: Ibid.

620 Bacon often talked: Geraldine and Michael Leventis, interview with Swan. The young painter Anthony Zych recalled Bacon telling him about de Botton. Anthony Zych, interview with Annalyn Swan, November 10, 2017.

620 Eventually, as if: See *Study for Portrait of Gilbert de Bot-*

ton (1986), in Harrison, ed., *Francis Bacon Catalogue Raisonné*, vol. IV, 1316. Unlike many of Bacon's portraits of friends—including Michel Leiris—the portrait of de Botton is large-scale.

620 In the mid-1980s: John Spero, interview for *Francis Bacon, Arena*.

620 The elegant backwater: In the mid-1980s, London and New York saw the biggest urban building boom in their histories. The Canary Wharf development in London brought increasing numbers of bankers and other wealthy financial types into London; South Kensington and Chelsea became extremely desirable places to live. See Andrew Tallon, *Urban Regeneration in the U.K.* (London: Routledge, 2013), 47.

620 "Everybody knew everybody": John Spero, interview for *Francis Bacon, Arena*.

620 The law firm: Theodore Goddard letter, November 3, 1982. Marlborough Gallery archive.

620 In October 1983: Marlborough Gallery archive, folder titled "Francis Bacon 1985, Th. Goddard/Reece Mews."

620 Not only: Ibid.

621 "For a while": John Spero, interview for *Francis Bacon, Arena*.

621 Next door to Bacon: Ibid.

621 Bacon was worried: Ibid. He wrote to Michel Leiris about his concerns. Bacon, letter to Leiris, November 23, 1982, *Francis Bacon: Letters to Michel Leiris 1966–1989*, 37.

621 In August, 1984: Marlborough Gallery archive.

621 It would be a disaster: Alan Bowness, letter dated August 17, 1984 in ibid.

621 Somerset wrote a short: David Somerset, letter dated August 17, 1984 in ibid.

621 His letter had the luster: Marcus Williamson, "David Somerset, Society Grandee," *The Independent*, August 22, 2017, www.independent.co.uk.

621 Gowrie, the minister for the arts: See Grey Gowrie," montylitfest.wordpress.com.

621 His great-uncle: Grey Gowrie, interview with Mark Stevens, November 2011.

621 "In fact, he exaggerated": Ibid.

621 Patrick Kinmonth, who came: Patrick Kinmonth, "Francis Bacon," *Vogue*, May 1985.

621 Both Bacon's: John Spero, interview for *Francis Bacon, Arena*.

41 PERFORMANCE ARTIST

623 He confided to Leiris: Bacon wrote, "I have finally been able to start working. It has been a very bad year for asthma, as a result of the amount of pollen." Letter of July 11, 1982, in Valentina Castellani, Mark Francis, and Stefan Ratibor, eds., *Francis Bacon: Letters to Michel Leiris 1966–1989*, 182.

623 From June of 1984: Valerie Beston noted on June 10 that Bacon had "bad asthma"; on August 25, "FB on penicillin—recovering from bronchitis"; and on August 28, that Bacon was "still suffering from asthma," and that he "sounds miserable and depressed on phone. Not painting at the moment." Valerie Beston, Beston diaries, The Estate of Francis Bacon archive.

623 On one occasion: Ibid.

623 On another: Ibid.

623 A heavy cold: Ibid. On December 16 she recorded, " 9 p.m. FB ill with heavy cold and asthma. Dr. Brass puts him into hospital. Cromwell Hospital."

623 Bacon visited: Sophie Pretorius, "A Pathological Painter: Francis Bacon and the Control of Suffering," in *Inside Francis Bacon, Francis Bacon Studies III* (London: The Estate of Francis Bacon publishing, in association with Thames & Hudson, 2020), 182.

623 The flamboyant poet: *The Independent*'s description is cited in numerous places, among them Reed's own website, www.jeremyreed.co.uk. His connection to Bacon is also touted there.

623 At around 6 p.m.: Jeremy Reed, interview with James Norton, September 2011. According to his account, Reed met Bacon in 1983.

624 At one point, he became: Ibid.

624 Bacon favored: Eddie Gray recalled that Bacon liked Jonathan's, a gay club near Leicester Square. Bacon also took the Leventises to a homosexual club at Leicester Square. Eddie Gray, interview with Mark Stevens, October 2013; Geraldine and Michael Leventis, interview with Annalyn Swan, November 11, 2017.

624 Bacon and Reed met: Reed, interview with Norton. The following quotations are all taken from the Reed interview.

624 Barbituates and tranquilizers: Pretorius, "A Pathological Painter," 177.

624 Beckett wrote: See "Samuel Beckett, Quotable Quote," www.goodreads.com.

624 What Anne Madden called: Madden, quoted in Joanna Pitman, "The Many Faces of Bacon," *The Times*, August 30, 2008.

624 "Death," he said to Reed: Reed, interview with James Norton.

624 "Perhaps he had": Jacques Dupin, interview for Adam Low, director, *Francis Bacon, Arena* documentary, BBC Four archive, March 19, 2005.

624 Toward the end: Raymond Mason, *At Work in Paris: Raymond Mason on Art and Artists* (London: Thames and Hudson, 2003), 174.

625 Then, as Mason: Ibid.

625 "At the sight": Ibid.

625 At Rules: Ibid., 175.

625 He informed the group: Ibid.

625 "I was sitting opposite": James Birch, interview with the authors, December 8, 2008.

625 The art historian Sarah Whitfield: Whitfield, interview with Mark Stevens, December 7, 2010.

625 If a waiter appeared indifferent: Michael Peppiatt, quoted in Peter Conrad, "The Power and the Passion," *The Observer*, August 9, 2008, www.theguardian.com.

625 He once said to Anne Madden: Madden, quoted in Pitman, "The Many Faces of Bacon, "*The Times*.

626 Sylvester referred: Richard Cork, presenter, *A Man Without Illusions*, BBC Radio 3, BBC Archive, May 16, 1985.

626 The French art dealer: Daniel Lelong, interview with Anthi-Danaé Spathoni, March 25, 2017.

626 A German reporter: "An Unloved Artist," *Frankfurter Allgemeine Zeitung*, July 7, 1985.

626 Sometimes, he babied: Hugh Lane Gallery, Dublin, archives.

626 A photograph taken: The photograph is reproduced in Michael Cary, ed., *Francis Bacon: Late Paintings* (New York: Gagosian Gallery, 2105), 8; published on the occasion of the exhibition of the same name.

626 Bacon is dressed: Jeremy Reed recalled that Bacon liked cashmere sweaters. Reed, interview with James Norton.

626 He confided: Michael Peppiatt, quoted in Peter Conrad, "The Power and the Passion," *The Guardian*, August 10, 2008.

626 Daniel Lelong called him: Lelong, interview for Adam Low, *Francis Bacon*, Arena.

626 Grey Gowrie said: Grey Gowrie, interview with Mark Stevens, November 2011.

626 Geordie Greig wrote: Geordie Greig, "Bacon: Still Honing the Razor's Edge," *Now!* October 10, 1980.

627 For *The Times* in 1983: Peter Lennon, "A Brush with Ebullient Despair: The Times' Profile: Francis Bacon," *The Times*, September 15, 1983.

627 Michael Wojas: Louisa Buck, "Artists' Colony," *The Times Magazine*, September 12, 1998.

627 Anthony Zych: Anthony Zych, interview with Annalyn Swan, November 10, 2017.

627 "It's a bloody nuisance": Lennon, "A Brush with Ebullient Despair," *The Times*.

627 "After that": Ibid.

627 The photographer Neil Libbert: See "Neil Libbert: The Faces that Came to Define an Era—in Pictures," www.theguardian.com.

627 The small spit curl: The artist Michael Clark recalled how Bacon would carefully arrange his hair in the mirror of the Colony Club. Michael Clark, interview with Annalyn Swan, December 18, 2015.

627 Drue Heinz, the patron: Drue Heinz, interview with Mark Stevens, October 2009.

628 Peter Conrad, who taught: Conrad, "The Power and the Passion," *The Observer*.

628 "He looked eruptive": Ibid.

628 Now and then: In a note to Valerie Beston dated August 25, 1968, John Russell reported that Bacon had vanished; they had been scheduled to meet. "Could you tell me where he is?" he asked. "Is he at the health place, where he meant to go, or is there trouble of a new (or familiar) kind?" Marlborough Gallery archive.

628 The rumor would float: Michael Clark, quoted in Conrad, "The Power and the Passion," *The Observer*.

629 "He was marvelous company": Anne Madden, quoted in Pitman, "The Many Faces of Bacon," *The Times*.

629 He took to calling: Sutherland, quoted in Daniel Farson, *The Gilded Gutter Life of Francis Bacon* (New York: Pantheon, 1993), 202.

629 "There was this little boy": Pam Dan, interview with the authors, February 24, 2011. The rest of the quotes in this paragraph come from this interview.

629 In 1982, Bacon's mordant: Bacon had dinner with Burroughs at MR CHOW on October 6, before the interviews at Reece Mews. There were two interview sessions, one on October 4 and the next a week later. Beston diary, entries of October 4 and October 11, 1982.

629 On the street: See the series of photographs of the two by John Minihan. "Francis Bacon," johnminihan.blogspot.com.

630 Paul Conran: Conran, interview with Mark Stevens, February 12, 2011.

630 He told Lucian Freud: Alice Weldon, interviews with Annalyn Swan, March 7 and 12, 2012.

630 "Mirrors are the doors": Jean Cocteau, quoted in Peter Bradshaw's *Orphée* review, "Cocteau's Classic Never Looks Back," October 18, 2018, www.theguardian.com.

630 "As a portraitist": Gilles Deleuze, *Francis Bacon: The Logic of Sensation* (New York and London: Continuum, 2003), 15.

630 In a chapter titled: Ibid., 41–2.

630 "The extraordinary agitation": Ibid.

631 He began his book: Michel Leiris, *Full Face and in Profile*, John Weightman, trans. (New York: Rizzoli, 1987), 5.

631 Bacon's "clean-shaven face": Ibid., 19.

631 He ended: Ibid., 19.

632 "Wishing to show": Eddy Batache, "Francis Bacon: An Intimate View," in Martin Harrison, ed, *Francis Bacon La France et Monaco / France and Monaco* (Paris: Albin Michel and Francis Bacon MB Art Foundation, 2016), 186–203.

632 During the next three years: Martin Harrison, ed., *Francis Bacon Catalogue Raisonne*, vol. IV (London: Estate of Francis Bacon, 2016), 1234.

632 "I would like": Bacon, in David Sylvester, *Interviews with Francis Bacon* (London: Thames and Hudson, 1975), 114. See 108–14 for a lengthy discussion of Bacon's sculptural ambitions.

633 To Eddy Batache: Batache, "Francis Bacon: An Inti-

mate View," in Harrison, ed., *Francis Bacon: La France et Monaco/France and Monaco*.

633 To Reinhard Hassert: Reinhard Hassert, interview with Mark Stevens, June 2016.

633 Raymond Mason thought: Raymond Mason, *At Work in Paris: Raymond Mason on Art and Artists* (London: Thames and Hudson, 2003), 175–6.

633 Like Mason, Timothy Behrens: Timothy Behrens, letter to Adam Low, director, for *Francis Bacon*, *Arena*.

633 The writer Colm Tóibín: Colm Tóibín, "Late Francis Bacon: Spirit and Substance," in Michael Cary, ed., *Francis Bacon: Late Paintings* (New York: Gagosian Gallery/Rizzoli, 2015), published on the occasion of the exhibition of the same name.

634 Late one night: John Eastman, interview with Mark Stevens, August 19, 2015. Eastman was with Bacon at the time.

634 "Oh, Rothko": Bacon to Anne Madden. Madden, interview with Annalyn Swan, May 7, 2008.

42 THE LAST PICTURE SHOW

635 He shamed Edy de Wilde: Bacon, letter to Edy de Wilde dated December 19, 1983, Marlborough Gallery archive.

635 He tried flattery: Bacon, letter to Claes Oldenberg dated December 19, 1983, Marlborough Gallery archive.

635 He "admired": "Francis Bacon: An Art of Anguish?" *The Economist*, May 23, 1985.

635 No artist likes: Elaine de Kooning, Willem de Kooning's wife, wrote for *ArtNews* while Hess was the editor there. (She also had an affair with him.) She recalled that this was a favorite phrase of his.

635 When they first met: Richard Francis, "Working with Francis Bacon," Michael Cary, ed., *Francis Bacon: Late Paintings* (New York: Gagosian Gallery/Rizzoli, 2015), published on the occasion of the exhibition of the same name.

635 "He was a generous": Ibid. The rest of the quotations in this paragraph come from Francis, "Working with Francis Bacon," *Francis Bacon: Late Paintings*, 85–90.

636 Through catalog entries: Ibid., 88.

636 It could not have pleased: Marina Vaizey, "Bacon: Genius Who Walks Alone," *The Sunday Times*, May 26, 1985.

636 Once Bacon read: Francis, "Working with Francis Bacon," *Francis Bacon: Late Paintings*, 89.

636 He convened a summit: Ibid.

636 "If one entry": Ibid., 89–90.

636 Bacon told Richard Francis: Ibid., 90.

636 Bacon "threatened to withhold": Ibid., 89. No doubt Bacon far preferred the catalog for his 1971 exhibition at the Grand Palais, which included, along with reproductions (mostly in color) of his paintings only an essay by Michel Leiris, a short chronology of biographical dates, and a bibliography.

636 He would sometimes throw back: Ibid., 88.

637 He approved: Francis, Ibid., 85.

637 Three days later: Dan Farson, "A Cause for Celebration," *Spectator*, May 11, 1985.

637 "VB gets blame": Valerie Beston diary, May 14, 1985, The Estate of Francis Bacon archive.

637 On the 16th and 17th: Ibid.

637 Michael Blackwood made: Blackwood, director, Alan Yentob, producer, *The Brutality of Fact*, *Arena* documentary, BBC TV archive, November 16, 1984.

637 Richard Cork arranged: Richard Cork, presenter, *A Man Without Illusions*, BBC radio 3, BBC Archive, May 16, 1985.

637 He was "remarkably dressed": Patrick Kinmonth, "Francis Bacon," *Vogue*, May 1985.

637 At Wheeler's: Ibid.

637 "His ageless": Ibid.

637 Just before the retrospective: Beston diary, May 8, 1985.

637 The retrospective was very large: There were 126 paintings in the Tate show versus 130 in the Grand Palais show.

637 The Tate's main exhibition spaces: Francis, "Working with Francis Bacon," *Francis Bacon: Late Paintings*, 85.

637 In *The Sunday Times Magazine*: Grey Gowrie, "Francis Bacon: Artist of Endgame," *The Sunday Times Magazine*, May 19, 1985.

637 His piece was illustrated: Ibid. The photograph, in which Bacon looks more hawklike than usual, was shot by Don McCullin.

638 Alan Bowness: Bowness in *Francis Bacon, Tate Gallery*, exhibition catalog (London: Tate Publishing Ltd.), 1985.

638 Not only that: Ibid.

638 Two nights before: Marlborough Gallery archive.

638 He did not forget: List of Bacon's invitations, Marlborough Gallery archive. The information on Ivan Hall comes from Michael Peppiatt, *Bacon in Your Blood: A Memoir* (New York: Bloomsbury USA, 2015), 276.

638 Before the dinner: Sarah Whitfield, interview with Mark Stevens, December 7, 2010. The rest of this recollection comes from the same interview. Global Asset Management's sponsorship of the show was written up in an unsigned article, "GAM'n Bacon," *Unit Trust Management*, August 1985.

638 Bacon was "lovely and tender": Friends of José Capelo, interviews with the authors, December 2017 and February 2020.

638 Among those on the tour: Ibid.

638 Bacon learned, for example: Ibid.

638 After the informal: Geraldine and Michael Leventis, interview with Annalyn Swan, November 11, 2017. Among

the collectors was Jerome Stern. Stern was an American financier and collector. See Melanie Gerlis, "Adventurous Art Collection of Ellen and Jerome Stern Comes to Sotheby's," *The Art Newspaper*, September 20, 2017, www.theartnewspaper.com.

638 In his celebratory review: Robert Hughes, "Singing Within the Bloody Wood," *Time*, July 1, 1985.

638 The praise for Bacon: Perhaps the best-argued, and most thoughtful, negative review was by John Spurling in the *New Statesman*. He began by lauding the early work, calling Bacon's work of the forties and fifties "exciting and energetic." But then had come the big, theatrical, grand statements of such later triptychs as the 1981 *Oresteia*. Bacon, he wrote, "gave up the struggle to remake the world in a new image," settling for "the partial gain of his intense fascination with the human body, naked and exposed to the light, bunched up tightly like a sausage within the stocking of its own skin ." John Spurling, "Gilt-Framed," *The New Statesman*, May 31, 1985.

638 "A genius? I say rotten": Bernard Levin, *The Times*, June 28, 1985.

639 Even Bacon's great admirers: Speaking of Bacon's "mastery of the physical side of painting," Robert Hughes wrote in his *Time* review that "the one thing it [Bacon's command of the paint] cannot reliably do is fix the extreme disjuncture between Bacon's figures and their backgrounds. The contrast of the two—the intense plasticity of the figures, the flat staginess of the rooms and spaces in which they convulse themselves—is what gives rise to the charge of 'illustration.'" Hughes, "Singing Within the Bloody Wood," *Time*.

639 The most original: Emmanuel Cooper, "Sad social commentary," *Tribune*, June 28, 1985. Cooper was an important gay rights activist as well as a writer, teacher, and potter. See David Horbury, ed., *Making Emmanuel Cooper* (Chicago: University of Chicago Press, 2020).

639 The crowds came: Michael Fraser, letter to Francis Bacon, May 31, 1985. Marlborough Gallery archive.

639 "We ate nothing": Steve Busfield, "Melvyn Bragg and the South Bank Show: Five Moments to Savor," *The Guardian*, May 6, 2009.

640 The novelist Julian Barnes: Julian Barnes, "Bringing Home the Bacon," *The Observer*, June 16, 1985.

640 With Bacon's money: Brian Clarke, interview with Annalyn Swan, June 3, 2016.

640 He gave it to his mother: Ibid.

640 John's new place: The Estate of Francis Bacon archive.

640 It consisted of: Philip Mordue, correspondence with Brian Clarke and Annalyn Swan, March 7, 2017 and March 11, 2020.

640 John and Philip resembled: In August of 1987, Edwards and Mordue invited a friend they had met on a cruise in the States to see the farm. As she later wrote to

them, "I want to thank you for a wonderful time at your lovely farm in Suffolk. It's an extremely interesting 'farm,' and your building plans should make it spectacular. I would love to see it when the shrubs you planted are in bloom and the conservatory is in place." Letter to Edwards and Mordue, August 30, 1987. The Estate of Francis Bacon archive.

640 They must convert the barn: Daniel Farson, *The Gilded Gutter Life of Francis Bacon* (New York: Pantheon, 1993), 278.

640 They would have a conservatory: Edwards and Mordue built the conservatory in the fall of 1987. The Estate of Francis Bacon archive. The shrubs caught the attention of Dan Farson on a visit in the early 1990s. Farson, *The Gilded Gutter Life*, 278.

640 A Wurlitzer organ?: The organ they were interested in cost 3,500 pounds. The Estate of Francis Bacon archive.

640 A snooker room?: David Plante described the snooker room on a visit to Dales Farm around the late 1980s. David Plante, "Bacon's Instinct," *The New Yorker*, November 1, 1993.

640 Around the property: Andrew Sinclair, "Last Days of the Rage," *The Sunday Times*, September 5, 1993. The conservatory cost 6,765 pounds, which Bacon paid. The Estate of Francis Bacon archive.

640 A stone heron: Farson, *The Gilded Gutter Life,* 278. James Birch recalled the Japanese koi. Birch, interview with the authors.

641 The small farmhouse: Clarke, interview with Swan, February 9, 2020.

641 Although John himself: Valerie Beston has references in her diaries to John buying furniture, John driving furniture to the country, and his brother picking up furniture at Reece Mews. Beston diaries, Estate of Francis Bacon.

641 Around the time of the retrospective: Francis, "Working with Francis Bacon," *Francis Bacon: Late Paintings*.

641 Parked in the driveway: Birch, interview with the authors.

641 "If they got pissed": Ibid.

641 "I had been told": Farson, *The Gilded Gutter Life*, 278.

641 Hanging inside: Ibid.

641 James Birch recalled: Birch, interview with the authors.

641 Sometimes, the Leventises: Geraldine and Michael Leventis, interview with Swan.

641 In one room, for example: Plante, "Bacon's Instinct," *The New Yorker*.

641 "Denis, who at around seventy": Ibid.

642 Shortly afterwards: Ibid.

642 "Then the door opened": Ibid. The following quotes come from Plante's piece.

642 In 1985 John and Philip: A letter from Maxine Wyers on August 30, 1987, noted that, two summers before, John and Philip had been with her in Malibu and Palm Springs. The Estate of Francis Bacon archive. Valerie Beston

recorded in her diary on May 2, 1987, that "JE and Philip to US for 4 weeks. 1 week NY, 3 wk. Malibu."

642 They traveled: For the trips to Kenya, Greece, and India, Philip Mordue, correspondence with Clarke and Swan; for the cruises, a "Bonnie and Steve" letter to John and Philip on October 6, 1988, on Sun Line Stella cruise ship stationery. The Estate of Francis Bacon archive.

642 Valerie Beston's diaries: On April 15, 1988, for example, Beston noted, "JE in London." John Edwards also went to the wedding in London of Michael Leventis's nephew and a second celebration in Athens that year. Other than that, the only mention of Edwards is when he goes to Moscow to represent Bacon at his show there. Beston diary, September 21, 1988, The Estate of Francis Bacon archive.

642 In 1984, Bacon spent: Geraldine and Michael Leventis, interview with Swan.

642 In 1987, Beston's single: Beston diary, May 2, 1987, The Estate of Francis Bacon archive.

642 The previous year: Gilbert Lloyd, interview with Mark Stevens, November 2, 2011.

642 The version of the retrospective: Hans-Joachim Müller, "Die Leideform Mensch" ("Man as a Suffering Agent"), Die Zeit, 1 November 1, 1985.

643 Built in the: See Dr. Steven Zucker and Dr. Beth Harris, "The Pergamon Altar," smarthistory.org.

643 "You know, we'll have to go": Lloyd, interview with Stevens.

643 At lunch afterwards: Ibid. The rest of the quotations come from this interview.

643 Institutions now competed: The University of St. Andrews, for one, offered him an honorary degree as early as December of 1973. He had four offers of honorary degrees in the years 1973 and 1974 alone. Marlborough Gallery archive.

643 He turned all of them down: The records of the Marlborough Gallery show a constant stream of prizes offered to Bacon in the latter part of the 1980s—the Golden Rose Award from Palermo, in 1988, for example—as well as invitations to the Queen's Garden Party (1987) and the Royal Academy of Arts Annual Dinner. Marlborough Gallery archive.

643 The awards were like: Farson, The Gilded Gutter Life, 7.

643 Two years before: Sir Philip Moore, letter of October 26, 1983, from Buckingham Palace to Bacon, Marlborough Gallery archive.

643 Established in 1902: Josh Warwick, "Order of Merit: Who Deserves Membership of the Most Exclusive Club in the World?" The Telegraph, December 13, 2013, www.telegraph.co.uk.

643 "As I am sure": Sir Philip Moore, letter to Bacon.

643 In 1963: Mark Hudson, "Henry Moore, The Man Behind the Myth," The Telegraph, February 18, 2010, www.telegraph.co.uk. See also "Timeline," www.henry-moore.org.

643 So did Lucian Freud: Warwick, "Order of Merit," The Telegraph.

644 "The only thing better": Richard Eden, "Sir Clement Freud and Brother Lucian Freud in Feud as Latter Rejects Knighthood," The Telegraph, June 28, 2008, www.telegraph.co.uk.

644 Bacon sent regrets: As he wrote Sir Philip Moore, "Would you please convey to Her Majesty the Queen how honoured I feel in being offered the Order of Merit, but I regret that I am unable to accept this honour." Marlborough Gallery archive.

644 In the late 1970s: See "Interview with The National Gallery's Colin Wiggins," www.artmap.london.

644 The elderly Bacon was: David Sylvester, Looking Back at Francis Bacon (New York: Thames and Hudson, 2000), 252.

644 In the mid-1980s, however: Ibid.

644 From the Renaissance: Bacon's selections are contained in the National Gallery publication The Artist's Eye: Francis Bacon: an Exhibition of National Gallery Paintings Selected by the Artist (London: The National Gallery, 1985).

644 He told Melvyn Bragg: Bacon, quoted in Francis Bacon, Melvyn Bragg, interviewer, David Hinton, producer, The South Bank Show, London Weekend Television, 1985.

644 Ingres did the same: Ibid.

644 Not least, he included Turner's: "I think [Turner] is a remarkable painter," Bacon told Michel Archimbaud, "but generally I don't like landscapes. It's a genre that doesn't interest me much." Michel Archimbaud, Francis Bacon: In Conversation with Michel Archimbaud (London: Phaidon Press, 1993), 39.

645 Lawrence Gowing: Anthony Zych, interview with Annalyn Swan, November 10, 2017.

645 Bacon remarked: Michael Peppiatt, Francis Bacon: Anatomy of an Enigma (London: Constable and Robinson, 2008), xxi.

645 In 1982, Bacon gave: Farson wrote Bacon on October 30, 1982, telling him that the book was off and thanking him for his "generous gift." The Estate of Francis Bacon, letters to Bacon.

645 Five years later: Bruce Bernard, "The Book That Bacon Banned," The Independent Magazine, May 2, 1992.

645 John was so often away: "The relationship would be somewhat restored for the remainder of Bacon's life, although the quarrels returned as a constant feature," wrote Jon Lys Turner in The Visitors' Book (London: Constable, 2016), 338.

645 Bacon took a holiday: Valerie Beston recorded in her diary on June 4, 1986 their trip down to Monte Carlo. They stayed twelve days.

645 He spent two weeks there with the Leventises: Geraldine and Michael Leventis, interview with Swan.

645 Bacon gambled and visited: Anne Dunn, interview with the authors, July 26, 2010.

645 He went to Aix-en-Provence: Geraldine and Michael Leventis, interview with Swan.

645 Edwards and Geraldine Leventis: Ibid.

645 He visited: Ibid.

645 Even so, Bacon remained: Valerie Beston noted in her diary that they flew to Nice on October 6, 1986.

645 "It was just Francis": Ianthe Knott, interviews with Mark Stevens, March 5 and 6, 2008.

646 "Francis and I could always": Ibid.

646 One evening: Ibid. The rest of the quotations in this paragraph come from this interview.

43 FRESH FACES

647 "The cordoned-off street": The description of Berlemont's retirement comes primarily from Eve MacSweeney, "Angst of the Spirit," *Harper's Bazaar*, October 1989.

647 Gaston had assumed control: Richard Boston, "Gaston Berlemont: Landlord of the French Pub, Bohemia's Favorite Watering Hole," *The Guardian*, November 3, 1999, www.theguardian.com.

647 Margaret Fenton: Margaret Fenton, interview with Annalyn Swan, February 27, 2012.

647 "We used to bow": Ibid. The following quotations also come from this interview.

648 He was wearing: *Farewell to Gaston July 14th 1989 pt2,* YouTube, the Museum of Soho Mosoho, August 16, 2013.

648 He had befriended: Michael Clark, interview with Annalyn Swan, December 18, 2015.

648 "How old are you": Clark, interview with Swan.

648 In 1979: Clare Shenstone, interview for Adam Low, director, *Francis Bacon, Arena* documentary, BBC Four archive, March 19, 2005.

648 He left his number: Ibid.

648 On her first visit. Ibid. The rest of the quotations from Shenstone come from this interview.

649 Three years or so after: Anthony Zych, interview with Annalyn Swan, November 10, 2017. Zych knew Gowing through the Slade: Gowing was the head of the Slade School of Fine Art when Zych was a student there.

649 Gowing "said that he'd": Zych, ibid.

649 Gowing then called Bacon: Ibid.

649 Zych had been given: Ibid.

649 Saatchi would later buy: See "Top 200 Collectors: Charles Saatchi," artnews.com.

649 "He was my idol": Ibid. The quotations in the next paragraph come from this interview.

649 "By 1987 and 1988": Ibid. Zych knew that he was learning from a master, but he was also giving up more than he understood at the time. Young artists can be easily over-whelmed by powerful older figures who, in the end, make it more difficult for them to develop an independent outlook. Zych adapted to Bacon's habits but was not, for example, a natural or experienced drinker: "I'd remember so much more except for the alcohol. He got people drunk. That was his defense." Zych also adopted, at great cost to his career, Bacon's indifference to practical matters. Bacon and Gowing both told Zych (as did the critic Brian Sewell) to leave the gallery that had given him such a tremendous start to his career—the Bernard Jacobson gallery. It proved a disastrous decision.

650 "One reason": Ibid.

650 In the evenings Zych sometimes: Ibid. The rest of the quotations and information in this paragraph come from this interview.

650 Zych asked a friend: Ibid. John Ginone had a business filming and photographing body-builders in poses with homosexual overtones. Ginone made some colored photographs of Zych that included mirrors. The images themselves likely did not interest Bacon, but the fleshiness could seed his imagination. See Martin Harrison, ed., *Francis Bacon Catalogue Raisonné*, vol. IV (London: Estate of Francis Bacon, 2016), 1374.

650 In the late 1980s: Terence Conran, interview with Mark Stevens, July 7, 2011.

650 The elder Conran liked: Ibid.

651 "I had more in common": Katrine Boorman, interview with the authors, February 28, 2011.

651 "Little tidbits": Ibid.

651 "The kitchen was all": Ibid.

651 His parents: James Birch, interview with the authors, December 8, 2008.

651 As a young man: Ibid.

651 Birch endeared himself to Bacon: Ibid.

651 "My father was": Ibid.

651 In March of 1985: James Birch, email exchange with Annalyn Swan, November 29, 2017. For more on Robert Chenciner, see "Robert Chenciner," *Cornucopia, The Magazine for Connoisseurs of Turkey*, www.cornucopia.net.

652 Relations between: See "Perestroika," www.history com.

652 Birch decided to pursue: Birch, email with Swan.

652 He first met: Ibid.

652 Birch asked: Ibid.

652 At the time: Birch founded his new gallery in Soho with Paul Conran in 1986. James Birch, "Francis Bacon Exhibition Moscow 1988," Francis Bacon MB Art Foundation, andrewsolomon.com.

652 When Gorbachev began talking: Sergei Klokov did meet Bacon on a visit to London, however. James Birch, interview for *Francis Bacon, Arena*.

652 It was the "charming": Andrew Solomon, "Exhibitions: Francis Bacon," *Contemporanea* (Nov.–Dec. 1988).

652 His reasoning: Sergei Klokov, "Letter from Moscow: Francis Bacon," *Apollo*, December 1988.

653 At Birch and Conran's: Birch, interview with the authors.

653 "Francis, what would": Ibid.

653 "The idea thrilled": Ibid.

653 He had completed: Harrison, *Francis Bacon Catalog Raisonné*, vol. IV.

653 Having twice failed: In 1969 he painted *Study for Bullfight No. 1, Study for Bullfight No. 2,* and *Second Version of Study for Bullfight No. 1.*

653 According to Jacques Dupin: Jacques Dupin, interview for *Francis Bacon, Arena.*

654 Bacon was inspired: Ibid.

654 Sánchez died: Borja Hermosa, "Sánchez Mejías, January 11, 2018, elpais.com.

654 Although he had finally: Madame Maristella Veličković, interview with Anthi-Danaé Spathoni, May 16, 2016.

654 *Le Figaro* and *Le Matin*: Michel Nuridsany, "L'Un des plus grands peintres vivant expose ses dernières toiles galerie Daniel Lelong," *Le Figaro*, September 29, 1987; Maiten Bouisset, "Bacon: Je suis juste un homme qui fait des images," *Le Matin*, October 1, 1987.

654 So did *Le Monde:* Geordie Grieg, "Storming of the Bastion of Art: Paris Fêtes Bacon as London Shows a French Revolutionary Face," *The Sunday Times*, October 4, 1987.

655 On this occasion: Daniel Lelong ("Art Biz," *Flash Art*) for liking the dimensions and white walls; also Daniel Lelong, interview with Anthi-Danaé Spathoni, June 29, 2016.

655 "With the secretaries": Dupin, *Francis Bacon, Arena.*

655 On opening night: Greig, "Paris Fetes Bacon," *The Sunday Times.*

655 Ianthe was present: Marlborough Gallery archive.

655 Then, suddenly: Lelong, interview with Spathoni.

655 Dr. Brass believed: Brass, interview for *Francis Bacon, Arena.*

655 Then through the silence: Bacon was extremely grateful to Dr. Lachenal. Bacon subsequently wrote to thank him, and also to ask if the doctor would send him three or four of the Berodual inhalers. See "Berodual," www.boehringer-ingelheim.com. Marlborough Gallery archive.

655 Valerie Beston later wrote: Undated letter to Jacques Dupin, Marlborough Gallery archive.

44 SUDDENLY!

656 In August of 1987: All of the information about the planning of the dinner party comes from Barry Joule, interview with Annalyn Swan, November 5, 2017.

656 "I learnt very quickly": Ibid.

656 Bacon was by now: Ibid.

656 "First I phoned Freddie": Ibid. The rest of the quotes in this paragraph come from this interview.

656 José maintained: Biographical details about Capelo come from a number of friends in Madrid, among them Cristina Pons and Patricia Ferrer. Pons, interview with Annalyn Swan, November 13, 2017; Ferrer, interview with Swan, October 2, 2011.

657 "For Jose, the draw": Joule, interview with Swan.

657 Afterwards, he wrote: Bacon, quoted in Daniel Farson, *The Gilded Gutter Life of Francis Bacon* (New York: Pantheon, 1993), 274.

657 His partner of many years: Martyn Thomas was killed in an automobile accident in 1985. Julie Kavanagh, *Secret Muses: The Life of Frederick Ashton* (New York: Pantheon, 1996), 555.

657 In the late 1950s and early '60s: Ashton, Bacon, and Cecil Beaton had all been dining with Ann Fleming in the late 1950s on the evening when Fleming persuaded Bacon to bring Ron Belton to meet them: "Last London evening a grouse celebration with Beaton, Bacon and Ashton—Francis was restless for he had a date with a Ted at Piccadilly Circus." Ann Fleming letter to Patrick Leigh Fermor, August 1959, in Mark Amory, ed., *The Letters of Ann Fleming* (London: Collins Harvill, 1985), 236. Ian Fleming's description of "her favorite coterie" is from Kavanagh, *Secret Muses*, 411.

657 "He was the master": Ibid., 412.

657 At the dinner party: Ashton was born in Ecuador in 1904. Ibid., 5.

657 Bacon brought with him: Joule, interview with Swan.

658 "Ashton," said Joule: Ibid.

658 Among his other failures: Ibid.

658 "We managed to get him": Ibid.

658 Parladé maintained: Parladé and Bacon had remained friends over the years even though they rarely saw each other. She would send Bacon postcards, for example, when she was traveling. One from Florence on August 15 (no year) read, "I've seen an enormous number of simply marvelous faces but had a very peaceful life on a hill just outside Florence. A great many people but they all go into the cathedral and the Uffizi Gallery and luckily nowhere else. I'll be in London in September and hope there will be a chance of seeing you. Love Janetta." Hugh Lane archive, RM98F129:4.

658 Francis "wanted": Janetta Parladé, interview with Annalyn Swan, November 2, 2017.

658 Her husband: Parladé was a celebrated interior designer in Spain. For more on Parladé, see Michael Peppiatt, "Jaime Parladé Creates a Spanish Country Home in Andalucia," *Architectural Digest*, September 2008, www.architecturaldigest.com.

658 The word came back: Parladé, interview with Swan.

658 "On his bedside table": Paul Brass, interview for

Adam Low, director, *Francis Bacon*, *Arena* documentary, BBC Four archive, March 19, 2005.

658 He was unusually: Cristina Pons, interview with Annalyn Swan, November 13, 2017.

658 "Sometimes": Ibid.

658 Pons regarded: Ibid.

658 José won: Friends of José Capelo, interviews with the authors, December 2017 and February 2020.

658 The terms: Ibid.

659 Mitt Romney: Ibid.

659 He moved into a flat: Joule, interview with Swan.

659 Now, when she visited: Pons, interview with Swan.

659 He introduced her: Ibid.

659 Pons described: Ibid.

659 Unfailingly polite and fairly reserved: Ibid.

659 José sometimes insisted: Friends of Capelo, interviews with the authors.

660 Bacon might typically respond: Ibid.

660 Not long after: On October 18, 1987, Valerie Beston recorded in her diary, "FB to Madrid with José Capel (sp) Blanco." Estate of Francis Bacon archive.

660 Bacon liked the celebrated Bar Cock: Patricia Ferrer, interview with Annalyn Swan, October 3, 2011.

660 "We say 'Central' ": Ibid.

660 "Fifty percent": Ibid.

660 After World War II: Maricruz Bilbao, interview with Annalyn Swan, October 1, 2011.

660 Bar Cock developed: Ibid.

661 So did the occasional: Even the Spanish royal family frequents Bar Cock. After royal wedding festivities in 2011, "The royals came in at 2 in the morning," said Ferrer. "All day it had been formal. Then we got a call from the royal house. And they came in their jeans. You can't close the bar at 3 [as usually done] when the royals are here. They were here until 4."

661 Bacon and José typically: Ferrer, interview with Swan.

661 Even so, the couple: Ibid.

661 "Sometimes": Ibid.

661 Other than a taste: Friends of Capelo, interviews with the authors.

661 In Madrid, he liked: Bilbao, interview with Swan.

661 Bacon usually wore: Ferrer, interview with Swan. The following quotes also come from this interview.

661 He was already friendly: Elvira González and Isabel Mignoni, interview with Annalyn Swan, November 15, 2017.

661 "Julián Gallegó wrote": Mignoni, interview with Swan.

661 Bacon "liked flamenco": González, interview with Swan.

661 "At that moment": González, interview with Swan.

662 "The ring has stairs": Mignoni, interview with Swan.

662 Inside Bacon there remained: Eddy Batache, interview with Mark Stevens, June 2016.

662 The elderly Bacon: Friends of José Capelo, interviews with the authors, December 2017 and February 2020.

662 Sex, he told friends: Ibid.

662 "I was never bored": Ibid.

662 Bacon might say: Ibid.

663 "He never opened up: Joule, interview with Swan.

663 Well-versed: Friends of Capelo, interviews with the authors.

663 Gill Hedley: For more on Hedley's role, see www.gill-hedley.co.uk.

663 That displeased: James Birch, interview with the authors, December 8, 2008.

663 The British Council would not: Ibid.

663 "Francis was worried": Ibid.

663 In the end: Birch, email exchange with Annalyn Swan, November 29, 2017.

664 In late June of 1988: Beston, diary, June 23, 1988, The Estate of Francis Bacon archive.

664 "They had to persuade": Birch, interview with the authors.

664 "Francis could have pulled": Ibid.

664 Bacon wrote an official: Facsimile letter in the catalog for *Francis Bacon,* exhibition September 23–November 6, 1988 (London: British Council and Marlborough Gallery, 1988), 5. The original statement, dated June 4, 1988, is in the Marlborough Gallery archive.

664 "In one of van Gogh's": Ibid.

664 "Francis wanted to take": Birch, interview with the authors.

665 But then David Sylvester: Ibid.

665 In April of 1988: Beston diary, April 29, 1988.

665 Then he had the idea: Paul Brass, interview for *Francis Bacon, Arena.*

665 "He was terrified": Ibid.

665 "The run-up": Ibid.

665 A little more than a month: Bacon informed the British Council on August 18 according to Beston's diary, August 18, 1988.

665 Four days later: Ibid., August 22, 1988.

665 Bacon also disliked: Ibid.

666 "Francis gave me": Birch, interview with the authors.

666 The official press release: "Francis Bacon Exhibition, Moscow 22nd September—7th November 1988," The British Council press release, July 18, 1988.

666 On the morning: Birch, email exchange with Annalyn Swan, November 29, 2017.

666 Ibid.

666 The exhibition opened: British Council press release.

666 It was a "mini retrospective": Ibid.

666 The ceremonies were: Brandon Taylor, "The Taste for Bacon," *Art News*, January 1989, 57.

666 "The opening reception": Birch, email exchange with Swan.

666 The first Secretary: Andrew Graham Dixon, "Bekon

[in Cyrillic] in Moscow." *The Independent*, October 1, 1988.

666 It was: Ibid.

666 He flew first class: Birch, interview with the authors.

666 "I'd go into": Ibid.

666 "The present writer": Mikhail Sokolov, "Tragedies Without a Hero: The Art of Francis Bacon," *Art Monthly* no. 121 (November 1988), 3–5.

667 "The British admire": Grey Gowrie, "Bacon in Moscow: A Small Gloss on Glasnost," *Modern Painter* 1, no. 4 (Winter 1988–89), 34–9.

667 "The horrifying thing": Ibid.

667 "'Mr. Bacon's paintings'": Dixon, "Bekon in Moscow," *The Independent*.

667 Nine hours before the show: Geordie Greig, "Bacon's Art Gets the Red-Carpet Treatment," *The Sunday Times*, September 25, 1988.

667 In an interview with Greig: Ibid.

667 The writer underscored: Ibid. The following quotes come from this article.

667 Grey Gowrie, who was interviewed: Gowrie, "Bacon in Moscow: A Small Gloss on Glasnost," *Modern Painters*.

667 The print run: Farson, *The Gilded Gutter Life*, 245. In an amusing footnote to the show, the ever-resourceful Gilbert Lloyd of the Marlborough Gallery wrote to the Union of Artists nine months later requesting the "8,395 rubles collected from the sale of 3,650 catalogues." (Presumably the rest of the catalogues sold after that—or Farson had the wrong number in sales.) Marlborough wanted to recoup whatever it could against the costs of underwriting the show—which, of course, had mostly been underwritten by Bacon himself. Marlborough Gallery archive.

667 Bacon was so grateful: Birch, interview with the authors.

667 Klokov quickly sold: Ibid.

667 During the opening celebrations: She died on September 24, 1988. See "Louise Leiris (1902–1988)," www.universalis.fr.

668 Always "a lady": Anthony-Noel Kelly, interview with Annalyn Swan, September 25, 2013. Most of the details on Diana Watson's later years come from this interview.

668 "You realized": Ibid.

668 In 1986, Diana still sometimes: Beston diary, August 13, 1986.

668 By 1988: Kelly, interview with Swan.

668 Meanwhile, Bacon took practical: This story, like that of George Dyer breaking through the skylight at 7 Reece Mews, is so widely known, and retold, that few question its authenticity. However, Bacon's sister Ianthe Knott disputed the truth of the story. The money at the end of Diana Watson's life, she said, came from selling the portrait of her that Bacon painted in 1957.

668 She died: Martin Harrison, ed., *Francis Bacon Catalogue Raisonne*, vol. I (London: Estate of Francis Bacon, 2016), 100.

668 Bacon often escaped: Valerie Beston's diaries recorded trips to Seville in December of 1988 and, in 1989 and 1990, to Paris, Toulouse, Aix, and Venice.

668 In London, José also helped: Parladé, interview with Swan. Another great friend of Janetta's, who had seen Bacon in the 1950s and '60s when he intersected more with the literary world, was Mougouch (Agnes) Fielding, the widow of the painter Arshile Gorky; she later married the writer Xan Fielding. Like Janetta, Mougouch was part of the world of Bloomsbury artists and writers; she was particularly close to Cyril Connolly. Bacon would come to parties at her house on Chapel Street in the 1960s. Mougouch Fielding, interview with the authors, March 3, 2011.

668 He began to see: Friends of Capelo, interview with the authors.

668 Once, the two went: Friends of Capelo, interviews with the authors.

668 "He was really charming": Robert Sainsbury, quoted in Farson, *The Gilded Gutter Life*, 269.

668 "Out of his friends": Jacques Dupin, interview for *Francis Bacon*, Arena.

669 Although most of Bacon's: Friends of Capelo, interviews with the authors.

669 José noticed: Ibid.

669 José once arranged: Ibid.

669 What José most wanted: Ibid.

669 Bacon so admired one suit: Ibid.

669 Sometimes, they went: Ibid.

669 Bacon once mentioned: Bacon, letter to Wirth-Miller, no date, "4:30 Thursday morning," collection of Jon Lys Turner, friend, co-executor and beneficiary of the estates of Dicky Chopping and Denis Wirth-Miller.

669 He told him: Friends of Capelo, interviews with the authors.

670 Bacon announced his intention: Harrison, ed., *Francis Bacon Catalogue Raisonné*, vol. IV, 1356.

670 Bacon completed: Ibid.

670 It followed Bacon's direction: Eddy Batache, "Francis Bacon: An Intimate View," in Martin Harrison, ed., *Francis Bacon: La France et Monaco* (Paris: Albin Michel/Francis Bacon MB Art Foundation, 2016), 194.

670 In the interim: Michel Archimbaud, interview with Anthi-Danaé Spathoni, March 8, 2018.

670 Bacon and Boulez: Ibid. The rest of the information on Bacon and Boulez's friendship and the details of the one-night fête come from Spathoni's interview.

670 For one night, then: Ibid.

670 So did the wife of French president: Ibid.

670 Boulez displayed: Michel Archimbaud kindly supplied photographs of the musical score to Danae Spathoni.

671 Bacon dedicated: Ibid.

45 CURTAIN CALLS

672 The gathering of fifty-nine: See Martin Harrison, *Francis Bacon Catalogue Raisonné* (London: The Estate of Francis Bacon, 2016), vol. V, 1521.

672 Nor did the selection: The Hirshhorn retrospective included only twenty-two paintings from the 1970s and '80s, among them two triptychs from the '70s and three from the '80s. A far greater percentage of the paintings overall thus came from the earlier decades.

672 In *The Washington Post*: Paul Richard, "Art: Bacon's Sublime Screams," *The Washington Post*, October 12, 1989.

672 The artist's earliest images, he wrote: Alan G. Artner, "The World According to Francis Bacon," *Chicago Tribune*, October 29, 1989.

672 And yet, Artner argued: Ibid.

672 "But the fact": Ibid.

673 In *The Nation*: Arthur Danto, "Art," *The Nation*, July 30, 1990. The rest of the quotations come from this review.

673 Bacon's intentionally provocative: Bacon, quoted in David Sylvester, *Interviews with Francis Bacon* (New York; Thames and Hudson, 2004), 50.

674 In London: "Francis Bacon Shrinks from Birthday Bash," *Iberian Daily Sun* (Madrid), November 5, 1989.

674 "We expected him": Ibid.

674 Glum headlines appeared: "Bacon Reaches Eighty on a Low Note," in ibid; Daniel Farson, "Francis Bacon Celebrates at 80 Without Pomp," *The Sunday Telegraph*, October 23, 1989.

674 "I was startled": Farson, "Francis Bacon Celebrates at 80 Without Pomp," *The Sunday Telegraph*.

674 "It's very nice": Ibid.

674 "He was very worried": Paul Brass, interview for Adam Low, director, *Francis Bacon*, Arena documentary, BBC Four archive, March 19, 2005.

674 The doctor called a nephrectomy: Ibid.

674 He told only: Bacon, letter of apology to Denis Wirth-Miller, dated Sunday morning, 3rd December, quoted in Jon Lys Turner, *The Visitors' Book* (London: Constable, 2016), 358. The letter reads, "when I came in for the operation I only mentioned it to Valerie [Beston] and José it was only after the operation which I did not expect to come through I asked Paul to let John know." The letter is incorrectly dated December of 1991, based upon Denis Wirth-Miller's notation on the envelope. (Wirth-Miller was not always reliable about dates.)

674 Dr. Brass went to see him: Brass, interview for *Francis Bacon*, Arena.

674 Perhaps the best indication: Bacon's letter to Denis Wirth-Miller also contained an apology: "When I telephoned yesterday evening the very last thing I wanted was to be rude to you—all I asked was not to mention that I was in hospital as I do not want my sister coming over to see me . . . I do hope I shall see you soon as I think of you as one of few friends."

675 An ordinary patient: Friends of José Capelo, interviews with the authors, December 2017 and February 2020.

675 Only three weeks after: Valerie Beston diary, December 28, 1989, The Estate of Francis Bacon archive.

675 The Sunday after his return: Beston diary, January 7, 1990.

675 Miss Beston found him: Ibid.

675 He was cheered: Ibid.

675 During the first nine months: Records of these trips come from Beston's diaries, from Eddy Batache and Reinhard Hassert, from Barry Joule, and from friends of José Capelo.

675 After a successful: Ibid. Friends of Capelo, interviews with the authors.

675 He told friends: Ibid.

675 Bacon was "jolly ill": Paul Brass, interview for *Francis Bacon*, Arena. After the nephrectomy, Bacon was hospitalized several more times, but for asthma-related illnesses. In the final year of his life, Bacon went in and out of heart failure repeatedly. According to Dr. Brass, Bacon had suffered for years from valvular heart disease and an incompetent aortic valve and had severe hypertension. "Towards the end of his life, his asthma played a huge part in conjunction with heart failure," said Brass. Interview for *Francis Bacon*, Arena.

676 Two months after a trip: Beston diary, July 11 and July 19, 1990.

676 In a letter of August 2: Ibid.

676 No sooner had he arrived: Ibid., July 26, 1990.

676 "Francis said to them": Jacques Dupin, interview for *Francis Bacon*, Arena.

676 The photographs represented: Ibid.

676 Dupin was the sort of man: "Jacques Dupin, Art Scholar and Poet, Dies at 85," www.nytimes.com.

676 "I thought": Dupin, interview for *Francis Bacon*, Arena. On June 1, Valerie Beston noted in her diary that "Dupin sees his portrait. Likes it."

676 A trip to Italy: Friends of Capelo, interviews with the authors. The trip began with a flight to Venice by way of Zurich. Bacon might have been picking up money for the trip. More likely he was meeting with his bankers about settling money on his family. Beston diary, September 19, 1990. In Venice they saw a major Titian show. (See Michael Kimmelman, "An Artist and His City: Titian in Venice," *The New York Times*, July 1, 1990). They then went to Naples.

676 It concluded: Friends of Capelo, interview with the authors.

677 It was astonishing: Barry Joule, interview with Annalyn Swan, November 4 and 5, 2017. Joule shared with the authors a photograph of Bacon on the hydrofoil.

677 But he was far more subject: It was the maneuvering of Barry Joule that led to a warming of the relationship. At one point Joule helped organize an exhibition, at the Photographer's Gallery in London, of the work of the celebrated fashion photographer and portraitist George Hoyningen-Huene. One of his most famous models was Toto Koopman, who was featured in a number of his iconic shots. Koopman came to a talk at the gallery given by Horst, Hoyningen-Huene's protégé. That gave Joule a chance to befriend Toto. "After the lecture ended"—Koopman had identified herself during Horst's talk—"she grabbed my arm," said Joule. "'Who are you, you marvelous man?' she asked. 'We are having a cocktail party. Would you like to come?'" They went skiing in the Alps. She invited him to Panarea and the exquisite compound of small houses overlooking the sea named Sette Mulini (the Seven Millers' Houses) that she and Brausen had spent years, since the 1960s, renovating. Joule became a regular at Sette Mulini and at their apartment in London at 74 Eaton Place, a fashionable address in Belgravia.

677 "Bacon became intrigued": Barry Joule, interview with Swan.

677 One day in the late 1980s: Ibid.

677 He also introduced Eddy and Reinhard: Friends of Capelo, interviews with the authors.

677 One evening he took: Ibid.

677 Their relationship belonged: Ibid.

677 Leiris chose to sit: Ibid.

678 After missing: Both Valerie Beston's diaries and multiple interviews document Edwards's infrequent appearances in London. As Anthony Zych said, "John Edwards had almost stopped going to Reece Mews by 1987/88." Anthony Zych, interview with Annalyn Swan, November 10, 2017. Barry Joule also said that Edwards was hardly there by 1987. Joule, interview with Swan.

678 "John did come occasionally": Brass, interview for *Francis Bacon*, *Arena*.

678 "We knew Francis": Geraldine and Michael Leventis, interview with Annalyn Swan, November 11, 2017.

678 Valerie Beston had taken note: Beston diary, January 8, 1990.

678 Then, after Bacon: Beston diary, March 6 and 9, 1990.

678 It seemed irrational to José: Friends of Capelo, interviews with the authors.

678 He had grown accustomed: Ibid.

679 In a letter from Naples: Estate of Francis Bacon archive.

679 "I remember Francis": Janetta Parladé, interview with Annalyn Swan, November 2, 2017.

679 Although Capelo disliked: Friends of Capelo, interviews with the authors.

679 The two men continued: Ibid.

679 In August 1990: Bacon, letter to Denis Wirth-Miller, collection of Jon Lys Turner, friend, co-executor and beneficiary of the estate of Wirth-Miller and Chopping.

679 Bacon was not very productive: *Man at a Wash Basin* harks back to 1970, and to the painting *Three Studies of the Male Back* of that year, the first of what might best be called Bacon's Muscle Beach paintings. In *Three Studies*, Bacon had painted three nude male figures seated on swivel pedestal chairs with their backs to the viewer, their shoulders and legs heavily muscled to the point of caricature. It was a particular, exaggerated take on male beauty that would resurface periodically from then on in Bacon's work—in *Study from the Human Body (Man Turning on Light)* of 1973, in *Figure Writing Reflected in Mirror* and *Figure at a Washbasin* of 1976. When Hugh Davies queried Bacon in 1973 about the original *Three Studies of the Male Back* painting, Bacon told him that it was not so much an attempt to paint portraiture without showing the face—as Davies had speculated—as about his fascination with highly developed bodies. "I had a paratrooper staying here who was a magnificent specimen, taking all the exercises etc.," said Bacon. "They came just from looking at him." Hugh Davies, transcripts of interviews for his dissertation, *Francis Bacon: the Early and Middle Years, 1928–1958* (New York and London: Garland Publishing, Inc., 1978). The transcripts have been published as "Interviewing Bacon, 1973," in Martin Harrison, ed., *Francis Bacon New Studies* (Göttingen, Germany: Steidl, 2009), 104.

679 It was not for lack: Two small portraits of Capelo and one of Bacon were given by Bacon directly to Capelo and not recorded by Marlborough. They were stolen from Capelo's apartment in Madrid in June 2015. Harrison, ed., *Francis Bacon Catalogue Raisonné*, vol. IV, 1399.

680 That could be inhibiting: Bacon had numerous photographs of Capelo that he could use for reference that were taken on their trips together. After Bacon's death, they were returned to him. Friends of Capelo, interviews with the authors.

680 José agreed: Beston diary, June 2, 1990.

680 Dr. Brass persuaded him: Brass, interview for *Francis Bacon*, *Arena*. The rest of the quotations in this paragraph come from the *Arena* interview.

680 Dr. Brass would often: Ibid. The following quotations in this paragraph come from this interview.

681 During a period: Barry Joule, email to Annalyn Swan, February 19, 2018.

681 Bacon enjoyed riding: Ibid.

681 They saw a movie: Ibid.

681 And they stayed: Ibid.

681 At Tate Liverpool: Ibid. *Francis Bacon: Paintings Since 1944* was curated by Richard Francis, who had curated Bacon's 1985 retrospective at the Tate (and had to deal with a prickly Bacon). He was now the chief curator of Tate Liv-

erpool. See Michael Kimmelman, "From Liverpool's decay a New Tate Gallery Rises," *The New York Times*, April 23, 1989, www.nytimes.com.

681 Bacon told Joule: Joule, email to Swan.

681 Once back in London: Beston diary, July 6, 1990.

681 Capelo left: Friends of Capelo, interviews with the authors.

681 He became briefly: Danny Moynihan, interview with the authors, February 28, 2011. Also Richard Shone diary, November 18, 1990.

681 It wasn't: Danny Moynihan, interview with the authors.

681 It was probably: Harrison, ed., *Francis Bacon Catalogue Raisonné*, vol. IV, 1380.

682 Valerie Beston noted: Beston diary, December 8, 1990.

682 On December 12: Joule, interview with Swan.

682 José went: Friends of Capelo, interviews with the authors.

682 Even so, José: Ibid.

682 He had meanwhile completed: The diptych of Capelo was photographed by Marlborough on December 18, 1990. Harrison, ed., *Francis Bacon Catalogue Raisonné*, vol. IV, 1378.

682 He did not seriously: This was true of virtually all of Bacon's paintings of those who meant a great deal to him— Peter Lacy, George Dyer, John Edwards, and the portraits of Peter Beard painted in 1975 and 1976.

682 Bacon gave: Harrison, ed., *Francis Bacon Catalogue Raisonné*, vol. IV, 1378. The diptych was titled "Two Studies for a Portrait," 1990.

682 On Christmas Day itself: Joule, email to Swan, February 19, 2018.

683 Later, they took: Ibid.

683 David Sylvester once told: Friends of Capelo, interviews with the authors.

683 Bacon mournfully informed: Daniel Farson, *The Gilded Gutter Life of Francis Bacon* (New York: Pantheon, 1993), 274.

683 Like a lover who cannot: Ibid., 273.

683 "He was clearly": Barry Joule, interview with Swan, November 4 and 5, 2017.

683 They went to Paris in January: Friends of Capelo, interviews with the authors.

683 In Paris they were invited: Michel Archimbaud, interview with Anthi-Danaé Spathoni, March 8, 2018. *Explosante Fixe* was first performed in 1991 as a work in progress; the world premiere was in 1993. See "Explosante Fixe," www.universaledition.com.

683 The piece, still a work: See "Explosante Fixe," music inmovement.eu.

684 It was recorded arriving: Harrison, ed., *Francis Bacon Catalogue Raisonné*, vol. IV, 1386.

684 When an interviewer later: Richard Cork, presenter, "I'll Go On until I Drop," *Kaleidoscope*, BBC Radio 4, August 17, 1991.

46 BORROWED TIME

685 He broke with the devoted: Geraldine and Michael Leventis, interview with Annalyn Swan, November 11, 2017.

685 Barry Joule arranged: Joule, interview with Annalyn Swan, November 4 and 5, 2017.

685 He also broke: Anthony Zych, interview with Annalyn Swan, November 10, 2017.

685 But everyone: Ibid.

685 Ianthe did not like John: Ianthe Knott, interviews with Mark Stevens, March 5 and 6, 2008.

685 The maître d': Elena Salvoni, interview with Annalyn Swan, October 31, 2012.

685 Caroline de Mestre Walker: Caroline de Mestre Walker, interview with Annalyn Swan, October 18, 2013.

685 Sometimes Bacon ate: Bacon enjoyed going to Bibendum to the very end. Terence Conran, interview with Mark Stevens, July 7, 2011.

685 Unlike many friends: Danny Moynihan recalled Bacon coming faithfully for his once-a-week portrait session in the 1970s with his father. Moynihan, interview with the authors, February 28, 2011.

685 Moynihan was cremated: Richard Shone diary, November 18, 1990.

686 Bacon and Anne Dunn: Ibid.

686 "No one introduced anyone": The rest of the quotations from Shone come from this diary entry.

686 After dinner, the young: Moynihan, interview with the authors.

686 Bacon spat: Shone, interview with the authors.

686 The venom astonished: Moynihan, interview with the authors.

687 She was reliably: Friends of José Capelo, interviews with the authors, December 2017 and February 2020.

687 There were things: Ibid.

687 Peter Lacy was "the real": Knott, interviews with Stevens.

687 She visited: Ibid.

687 On a trip to Madrid: Manuela Mena, interview with Annalyn Swan, October 4, 2011.

687 An English voice: Ibid.

687 He wanted to spend: Ibid. The Velázquez show of the year before had proved so crowded that it was difficult to see. At times, the museum had to close the doors to keep more than five hundred people from being in the nine rooms of the exhibition at any one time. (Alan Riding, "Prado Opens the Largest Show of Velázquez's Work Ever Held," *The New York Times*, January 25, 1990.) People stood in line outside the museum for five and six hours at a stretch in the wintry weather to gain entry.

687 The Prado's guards: Mena, interview with Swan.

687 "We opened that door": Ibid. The rest of the quotations in this paragraph come from this interview.

687 "Freud was very different": Ibid.

688 For the hour and a half: Ibid.

688 His aging flesh: Bacon sometimes found Michelangelo's obsession with male flesh almost embarrassing in its palpable longing. David Sylvester, *Looking Back at Francis Bacon* (New York: Thames and Hudson, 2000), 238.

688 "I recall that he looked": Mena, interview with Swan.

688 After his visit: Ibid.

688 José reassured: Friends of Capelo, interviews with the authors.

688 In an August, 1990: Bacon, quoted in Richard Cork, presenter, "I'll Go On until I Drop," *Kaleidoscope*.

688 "Yes, stronger": Ibid.

688 "On a good day": John Russell, *Francis Bacon* (London: Thames and Hudson), 182.

689 The Irish poet Paul Durcan: Durcan, "The King of Snails," in David Sylvester, curator, *Francis Bacon in Dublin* (London: Thames & Hudson/Hugh Lane Gallery, 2000), 27–32.

689 "Francis in the Colony Room": Ibid., 28.

689 He wrote about it: In the poem, "Putney Garage," Bacon is eighty. He turned eighty on October 28, 1989. So the encounter would have been the following autumn, in 1990.

689 Maricruz Bilbao: Maricruz Bilbao, interview with Annalyn Swan, October 1, 2011.

689 "And the first thing": Ibid. The rest of the quotations about Cruz's interview at Marlborough come from Bilbao.

690 True to form, he left: Friends of Capelo, interviews with the authors.

690 Bacon had developed: Michel Archimbaud, *Francis Bacon: In Conversation with Michel Archimbaud* (New York: Phaidon Press, 2004), 44.

690 Bacon and José also visited: Friends of Capelo, interviews with the authors.

690 The next day: Ibid.

690 The neighboring vineyard: Bacon would indeed design their label in the fall of 1991. Marlborough Gallery archive.

690 The two had remained: Archimbaud, interview with Anthi-Danaé Spathoni, March 8, 2018.

690 Over the next months: Francis Giacobetti, "Francis Bacon: The Last Interview," *The Independent Magazine*, June 13, 2003.

691 Initially, Giacobetti did not use: See Fiona Mahon, "Seven Seminal Images, by Francis Giacobetti," www.hungertv.com.

691 In a rental studio: Giacobetti, "Francis Bacon: The Last Interview," *The Independent*.

691 Bacon asked Archimbaud: Ibid.

691 Giacobetti was for years: Mahon, "Seven Seminal Images." hungertv.com.

691 In late December: For background on Baroness de Rothschild, see "Baroness Philippine de Rothschild," (obituary), *The Telegraph*, August 27, 2014, www.telegraph.co.uk/. On May 18, 1993, the Baroness gave a delightful little toast at the Marlborough for Bacon. "A year and a half ago I met Francis Bacon in London," she said. "I met a delightful, witty, charming young gentleman, and I believe we got on quite well. In December 1991 he brought me, with the utmost modesty, this amazing painting, in, of all things, a plastic bag. At the end of March 1992, we all at Mouton decided to use it for this label." Marlborough Gallery archive.

691 Bacon, if he lived long enough: In the end, the wine was sent to John Edwards. Marlborough Gallery archive.

692 That same month: Bilbao, interview with Swan.

692 He sat beside her: Henrietta Moraes, quoted in Peter Lennon, "Francis and Me," *Weekend Guardian*, May 2–3, 1992. The following quotes come from this article.

692 "Freud had a tray": Joule, interview with Swan, November 4 and 5, 2017. The rest of the quotations about Freud come from this interview.

692 Michel Archimbaud once saw: Archimbaud, interview with Spathoni.

692 When the painter Zoran Mušič: Zoran Mušič, quoted in Michael Peppiatt, *Francis Bacon: Anatomy of an Enigma* (London: Constable & Robinson, 2008), 391.

692 He was not living: Russell, *Francis Bacon*, 182.

692 Dr. Brass found: Brass, interview for *Francis Bacon, Arena*.

693 "I have a sort": Ibid.

693 Bacon's nephew Harley Knott: Harley Knott, interview with Mark Stevens, March 7, 2008.

693 Bacon explained: Brass, interview for *Francis Bacon, Arena*.

693 In late December of 1991: Russell, *Francis Bacon*, 193.

693 Bacon packed: Ibid. His bag, wrote John Russell, was "one of the heaviest pieces of hand luggage that had ever been taken aboard an aircraft."

693 At Charles-de-Gaulle: Ibid. All of the details on Bacon's collapse comes from Russell's book.

693 Russell and Bernier: Ibid.

47 AN ERRAND

694 On January 18, 1992: Barry Joule, interview with Annalyn Swan, November 6, 2017.

Annalyn "I managed": Ibid.

694 The doctor rushed: Ibid.

694 "He started": Ibid.

694 He saw the Leventises: "We saw him a few times before he went to Spain," said Geraldine and Michael Leventis. "There was a mending of fences. Also we went with Barry Joule and Francis to Bibendum. At the end of the

meal Barry said that they had to leave because they were seeing Rudolf Nureyev. Barry Joule knew him. We said, 'We'll drop you there.' When we arrived at the house they were staying in, Bacon said to Barry, 'Unless Michael and Geraldine come up with me, I'm not coming up.' Barry Joule clearly didn't want us. Francis wouldn't get out of the car unless we accompanied him." Geraldine and Michael Leventis, interview with Annalyn Swan, November 11, 2017.

694 He reconciled: Anthony Zych, interview with Annalyn Swan, November 10, 2017.

694 Afterwards, as Zych stepped: Ibid.

694 Denis Wirth-Miller: Friends of José Capelo, interviews with the authors, December 2017 and February 2020.

694 Bacon took the time: "At the end of 1991 it was one of his great pleasures to think of a forthcoming exhibition at the Musée Picasso in Paris which was to be called 'The Body on the Cross,'" wrote John Russell. Bacon must have been both intrigued and amused by the topic of Regnier's essay—"that wonderful thing called sin"—published in the catalog under his longstanding nom de plume, Jean Clair. John Russell, *Francis Bacon* (New York: Thames and Hudson, 1985), 193. For an English-language catalog of the show, see *The Body on the Cross*, chief curator Gérard Régnier, editor; translated by Neil Kroetsch and Jeffrey Moore (Paris: Réunion des musées nationaux, 1992).

695 The previous year: Richard Cork, presenter, "I'll Go On until I Drop," *Kaleidoscope*, BBC Radio 4, August 17, 1991. The following quotations are taken from this interview.

695 In addition to granting: This interview by Francis Giacobetti was the last major interview that Bacon granted, along with his series of interviews with Michel Archimbaud. It ran in an English-language version as Francis Giacobetti, "Francis Bacon: The Last Interview," *The Independent Magazine*, June 13, 2003. The piece was published to coincide with a show of Giacobetti's portraits of Bacon at the Marlborough gallery in London. The cover art was a striking close-up photograph of one of Bacon's wrinkled hands covering his face, with the exception of one eye that seems lost in thought. Even that one eye alone is enough to identify Bacon's highly distinctive face.

695 As you get older: Michel Archimbaud.

695 He emphasized his lifelong: Ibid. He called himself, yet again, a "desperate optimist" to Giacobetti.

695 He acknowledged: Ibid.

695 "During my childhood": Ibid.

695 And still he loved: Eddy Batache and Reinhard Hassert, June 2016, interview with Mark Stevens.

695 In his eighties: Giacobetti, "Francis Bacon: The Last Interview," *The Independent*.

695 "Passion": Ibid.

695 "I also think": Ibid. The rest of the quotations in this paragraph come from this article/interview.

696 Dr. Brass noted: Paul Brass, interview for Adam Low, director, *Francis Bacon*, *Arena* documentary, BBC Four archive, March 19, 2005.

696 He continued to wear. Michel Archimbaud was also struck by Bacon's youthful clothing when they first met in 1987. Archimbaud, interview with Anthi-Danaé Spathoni, March 8, 2018. Bacon told Valerie Beston as far back as 1981 that his tailors suggested a size larger. Valerie Beston diary, September 7, 1981. The Estate of Francis Bacon archive. Bacon was buying his new suit that year at the French couturier Lanvin.

696 José was impressed: Friends of Capelo, interviews with the authors, December 2017 and February 2020.

696 "This chicken": Ibid. Bacon's loss of taste was due to some of the medications that Brass had prescribed.

696 In late February: Bacon mentioned the upcoming performance of *Pelléas et Mélisande* in Michel Archimbaud, *Francis Bacon: In Conversation with Michel Archimbaud* (New York: Phaidon Press, 2004), 91.

696 "The first night": John Rockwell, "Boulez and Stein Stage 'Pelléas' with Modern Nuances in Wales," *The New York Times*, February 24, 1992.

696 Two weeks later: Brass, interview for *Francis Bacon*, *Arena*.

696 "He was flushed": Ibid.

696 Dr. Brass suspected: Ibid.

696 "Paul," Bacon reminded: Ibid.

696 He gasped: Michael Peppiatt, *Francis Bacon in Your Blood: A Memoir* (New York: Bloomsbury USA, 2015), 383.

696 "So he was getting": Brass, interview for *Francis Bacon*, *Arena*.

697 "I didn't recognize": Michael Clark, interview with Annalyn Swan, December 18, 2015.

697 "But the thing is, Michael": Ibid.

697 On Easter Saturday: Barry Joule, interview with Annalyn Swan, November 5, 2017. All of the quotations in this and the next paragraph come from this interview, with the exception of Joule's recollection of Bacon as "agitated," which appeared in a lengthy interview with Joule that ran in "Bacon: A Personal Memoir," *Art Review*, December/January 1999. "He was not the strong Francis I had known but weak and agitated," wrote Joule in the article of that morning.

697 Earlier, said Joule, Bacon had given: Ibid. "He had first given it to me in June of 1982," said Joule. "Then he took it back. It disappeared for ten years. Then he re-gifted it to me. He said that it reminded him of his own youth." The early portrait was not included in the catalogue raisonné.

697 As for the piles: Ibid. "We had been through this code before," said Joule.

697 It was, said Joule: Ibid.

698 And so, Joule took: Barry Joule, email to Annalyn Swan, April 5, 2018.

698 A photo taken: Juan Guardiola and Francisco Rivas, "El ultimo martini en Madrid," *El Europeo* (Madrid/Barcelona), October 1992.

698 The owner of Bar Cock: Ferrer, quoted in Victoria Burnett, "Francis Bacon: Seduced by Madrid," *The New York Times*, February 19, 2009.

698 He made plans: Anna Gamazo, interview with Annalyn Swan, November 13, 2017.

698 "That's one": Bacon to Gamazo, ibid. Gamazo and her husband, Juan Abelló, had met Bacon earlier in 1992, at a gallery opening for Janetta Parladé's oldest daughter, Nicky Loutit. Bacon was quite insistent, she recalled, that he wanted the painting of Beard back.

698 Jose took him: Friends of Capelo, interviews with the authors.

698 The Clinica Ruber: Maricruz Bilbao, interview with Annalyn Swan, October 1, 2011. Also Gamazo, interview with Swan.

698 Bedside check-in: Gamazo, interview with Swan.

698 Bacon was placed: Annalyn Swan, visit to the Clinica Ruber, renamed the Hospital Ruber Juan Bravo, November 15, 2017.

698 On the left: Ibid. All of the description comes from the above visit.

699 When he and William Burroughs: "Art, Death and Immortality over a Naked Lunch," *Weekend Guardian*, May 2–3, 1992.

699 But Bacon was not oppressed: After Bacon's death, some accounts of his stay in Madrid described him as being surrounded by nuns at the end and in a spare, almost monastic hospital setting. That was definitely not the case. Nor was he ever in intensive care. Swan, visit to the Clinica Ruber and discussion with hospital staff.

699 Some nuns worked: Bilbao, interview with Swan.

699 Sister Mercedes: Her full name was Sr. Mercedes Moreno Martín, but like most nuns she used only her first name. Swan, visit to the Clinica Ruber.

699 The hospital catered: Sr. Mercedes, interview for Adam Low, director, *Francis Bacon, Arena*.

699 José visited Bacon: Friends of Capelo, interviews with the authors.

699 He cancelled: Ibid.

699 Bacon intended to fly: Ibid.

699 Bacon liked: Nicolas Díaz-Toledo Delgao and Yolanda Vázquez Garnocho, Clinica Ruber, interview with Swan, November 15, 2017.

699 His shortness of breath: Guardiola and Rivas, "El ultimo martini en Madrid," *El Europeo,* October, 1992.

699 "And by having": Delgao and Garnocho, interview with Swan. The suite where Bacon spent his final days is filled with light and is very airy, given its corner location.

699 "In April, Francis": Eddy Batache, quoted in Janet Hawley, "Dark Night of the Soul," *Sydney Morning Herald,* November 3, 2012.

699 Bacon improved: Guardiola and Rivas, "El ultimo martini en Madrid," *El Europeo.*

700 He looked sad: Friends of Capelo, interviews with the authors.

700 The pharmaceutical regimen: Sr. Mercedes, interview for *Francis Bacon, Arena.*

700 "If you are breathless": Ibid.

700 "He couldn't really": Ibid.

700 At around 8:30 a.m.: Ibid.

700 The cardiac arrest unit: Ibid.

700 "Many people came": Ibid.

701 Bacon was declared: Ibid.

701 The hospital, with no record: Gamazo, interview with Swan.

701 The hospital also tried: Ibid.

701 José telephoned: Friends of Capelo, interviews with the authors.

701 At first, the gallery: Bilbao, interview with Swan.

701 "And you don't have to": Ibid.

701 The British Consulate: Guardiola and Rivas, "El ultimo martini en Madrid," *El Europeo.*

701 Bilbao sent: Bilbao, interview with Swan.

701 When they finally did: Ibid.

701 Someone surreptitiously took: The photo ran in the *El Europeo* article by Guardiola and Rivas.

701 Eventually, the photograph: Catherine Shakespeare Lane, interview with Annalyn Swan, February 12, 2009.

701 Valerie Beston bought: Ibid. "When this came out in collage form I was advised to go see Valerie Beston," said Lane. "She came out to see me. This was '93 or so. She was not scary—a bit nannyish. Having got over this little problem of borrowed images she said, 'I would like to buy this from you. How much would you like?' I was encouraged by that and made it into a print." See also Nick Mathiason and Vanessa Thorpe, "The First Dark Image of Bacon's Death," *The Observer*, December 7, 2008.

701 On April 30: Guardiola and Rivas, "El ultimo martini en Madrid," *El Europeo*. All of the following detail on Bacon's cremation comes from this article.

701 There was a single: The French House remembered Francis, who had made a point of coming to Gaston Berlemont's retirement party even though he was clearly suffering and subdued that day.

702 "No friends, by request": Edward Owen and Nicholas Watt, "No Friends, by Request, at Bacon's Farewell," *The Times*, May 1, 1992.

702 "No mourners": Tim Brown and Jenny Rees, "No Mourners at Artist's Funeral," *The Daily Telegraph*, May 1, 1992.

702 Within hours: Craig Brown, "Much Rambling but Little Juicy Action," *The Sunday Times*, May 3, 1992. "Are you real?" a drunk Bacon asked Bragg—equally inebriated—at one point, during a discussion of trying to capture reality in art. "To me, you are absolutely *real*." Critics deemed the

show must-watch television—Bacon flirting with Bragg and generally acting his droll best. A. N. Wilson, then the television critic of *The Sunday Telegraph*, deemed it "gripping" and wrote: "Bacon always insisted that he was a realist, and when the camera moved into the Colony Club in Soho, you saw what he meant. The strange contorted figures at the bar, with their swollen, hideous features, sometimes bulbous and brightly coloured, sometimes little more than a grey smudge in the middle of the screen, seemed like animated Bacon canvases." A. N. Wilson, "Hawking's Hot Line to the Mind of God," *The Sunday Telegraph*, May 3, 1992.

702 The word "dandy": John McEwen, "Terrible Beauty or Dirty Mac Decadence?" *The Sunday Telegraph*, May 3, 1992.

702 Bacon, while relentlessly modern: Ibid.

702 McEwen was once: Ibid.

702 Tom Lubbock in *The Independent:* Tom Lubbock, "So Much for Bacon the Man: What of the Work?" *The Independent on Sunday*, May 3, 1992.

702 "Just a pile": Michael McNay, "Just a Pile of Paint and a Nightmare of Chic Thrills," *Weekend Guardian*, May 2–3, 1992.

703 "The greatest British painter": Paul Johnson, "Myth of the Modern," *Sunday Telegraph*, May 3, 1992.

703 His creation: Although Oscar Wilde's paternal grandmother and great-grandmother were "Irish Irish," Wilde considered himself Anglo-Irish. See Richard Ellmann, *Oscar Wilde* (New York, Knopf, 1988).

704 He expected to die: Paul Brass, interview for *Francis Bacon, Arena*.

704 John Edwards entered: According to Barry Joule, a number of people visited 7 Reece Mews—and a number of parties happened there—following Bacon's death. Joule, interview with Swan, November 5, 2017. What's more, *Study of a Bull* (1991), Bacon's final "finished" painting, was never photographed by Marlborough, which indicates that the gallery did not handle it in the usual way and that it might have been a private sale. But the painting was known, at least to Valerie Beston, according to Martin Harrison. In the *Catalogue Raisonné*, Harrison says that Bacon discussed the painting with her. Harrison, ed., *Francis Bacon Catalogue Raisonné*, vol. IV (London: Estate of Francis Bacon, 2016), 1392.

704 The second: *Study of a Bull* went unrecorded until the *Catalogue Raisonné* was published. See Mark Brown, "Francis Bacon: Final Painting Found in 'Very Private' Collection," *The Guardian*, February 23, 2016, www.theguardian.com.

705 One evening: The detailed description comes from Danny Moynihan and Katrine Boorman, interview with the authors, February 28, 2011.

Documentation

The number of books, articles, catalogs, and films about Bacon is immense. Readers are encouraged to consult the catalogue raisonné, which contains the most complete account of the response to Bacon's art: Martin Harrison, editor, *Francis Bacon Catalogue Raisonné* (London: Estate of Francis Bacon, 2016). The Estate of Francis Bacon also maintains a robust website filled with overviews and photographs of Bacon and his world, and a comprehensive list of all paintings: www.francis-bacon.com/estate. Two other major research centers exist for Bacon scholars. The Hugh Lane Gallery, Dublin, is the repository of Bacon's 7 Reece Mews studio and its contents. The Francis Bacon MB Art Foundation in Monaco has extensive material covering Bacon's numerous ties to, and times in, France (although its collection of Bacon material also covers other aspects of his career and life, notably his early years). See www.mbart foundation.com.

The documentation below is selective, but the authors do not intend any judgment of worth or value. It contains only the sources of those quotations, information, and ideas that are, usually, directly cited in the biography.

STATEMENTS BY THE ARTIST

Rather than write about his art, Bacon chose to convey his thoughts through a series of interviews, with David Sylvester in particular. (See David Sylvester, *Interviews with Francis Bacon* (London: Thames and Hudson, 1987) and *Looking Back at Francis Bacon* (London: Thames and Hudson, 2000). Multiple printings exist of each book. For the rest, Bacon wrote an early catalog note about Matthew Smith and two notes for his own exhibitions, one in Japan and one in Russia.

For the Matthew Smith note, see "Matthew Smith: A Painter's Tribute," in *Matthew Smith: Paintings from 1909 to 1952*, exh. cat., Tate Gallery, London, Sept.–Oct. 1953.

The text of Bacon's note for his show in Japan is contained in the catalog to the show: *Francis Bacon: Paintings 1945–1982*, National Museum of Modern Art, Tokyo, June 30–Aug. 14, 1983, 7. A copy is also in the Marlborough Gallery archive, London.

The text of Bacon's note for his Moscow show appeared in the catalog to the show: *Frensis Beckon: zhivopis': katalog vystavki*, Central House of Artists, Moscow, Sept. 23–Nov. 6, 1988, 5. It was originally dated June 4, 1988. A copy is also in the Marlborough Gallery archive, London.

Additionally, Bacon's correspondence with Michel Leiris contains ideas about art and refers to Bacon's extensive reading. See Valentina Castellani, Mark Francis, and Stefan Ratibor, eds., *Francis Bacon Letters to Michel Leiris, 1966–1989* (London: Gagosian Gallery, 2006), published at the time of Francis Bacon: Triptychs, June 20–August 4, 2006.

In general, Bacon strongly resisted explaining himself, in an effort to avoid being pinned down. "It's also always hopeless talking about painting—one never does anything but talk around it—because, if you could explain your painting, you would be explaining your instincts." Bacon to Sylvester, Interviews with Francis Bacon, 100.

MAJOR FILMS, TV DOCUMENTARIES, AND RADIO INTERVIEWS

A Man Without Illusions. Richard Cork, presenter; Judith Bumpus, producer. BBC Radio 3, first aired May 16, 1985.

The Brutality of Fact. Michael Blackwood, director. Produced by Alan Yentob for *Arena*, BBC Television, first aired Nov. 16, 1984.

Francis Bacon. Melvyn Bragg, interviewer; David Hinton, director and producer. *The South Bank Show*, first aired 1985.

Francis Bacon: A Brush with Violence. Richard Curson Smith, director. BBC Two, first aired Jan. 2017.

Francis Bacon: Fragments of a Portrait. David Sylvester, interviewer; Michael Gill, director and producer. BBC One, first aired Sept. 18, 1966.

Francis Bacon, Peintre Anglais. Pierre Koralnik, director; Alexandre Burger, producer. Radio Television Suisse Romande, Geneva, 1964.

Francis Bacon: Three Studies of Figures at the Base of a Crucifixion. Richard Cork, presenter. BBC Two, first aired Apr. 5, 1982.

Francis Bacon, Arena. Adam Low, director. Co-produced by BBC Television and the Estate of Francis Bacon for BBC *Arena*, first aired on BBC Two Mar. 19, 2005.

Interviews with Francis Bacon. David Sylvester, interviewer. *Aquarius*, London Weekend Television for ITV, 1975.

"I'll Go On Until I Drop." Kaleidoscope. Richard Cork, presenter; John Goudie, producer. BBC Radio 4, first aired Aug. 17, 1991.

Love Is the Devil: Study for a Portrait of Francis Bacon. Feature film directed and written by John Maybury, based on Dan-

iel Farson's *The Gilded Gutter Life of Francis Bacon.* Derek Jacobi as Bacon and Daniel Craig as George Dyer. Premiered at Toronto Film Festival, Sept. 16, 1998.

SELECTED ARTICLES BY WRITERS WHO INTERVIEWED BACON

Behr, Edward. "I Only Paint for Myself." *Newsweek,* Jan. 24, 1977.

Bell, Raymond. "Bacon at Eighty: The Man in the Brown Leather Bomber Jacket." *Irish Press,* Oct. 29, 1989.

Clair, Jean, with Maurice Eschapasse and Peter Malchus. "Entretien avec Francis Bacon." *Chroniques de L'Art vivant 1971,* December 26, 1971–January 1972.

Cork, Richard. "Home Thoughts from an Incurable Surrealist." *Times Saturday Review,* Mar. 16, 1991.

Davies, Hugh. "Interviewing Bacon, 1973," in Martin Harrison, ed., *Francis Bacon New Studies* (Göttingen, Germany: Steidl, 2009).

Duras, Marguerite. "Marguerite Duras s'entretient avec Bacon." *La Quinzaine Littéraire,* Nov. 16–30, 1971.

Fallon, Brian. "Francis Bacon: The Man Behind the Myths." *Irish Times,* Aug. 9, 1989.

Farson, Dan. "Francis Bacon Celebrates at 80 Without Pomp." *Sunday Telegraph,* Oct. 23, 1989.

Giacobetti, Francis. "The Last Interview." *Independent Magazine,* June 14, 2003.

Gilder, Joshua. "I Think About Death Every Day." *Flash Art,* May 1983.

Glueck, Grace. "Briton Speaks About Pain and Painting." *New York Times,* Mar. 20, 1975.

Greig, Geordie. "Bacon's Art Gets the Red-Carpet Treatment." *Sunday Times,* Sept. 25, 1988.

———. "Bacon: Still Honing the Razor's Edge." *Now!,* Oct. 10, 1980.

Gross, Miriam. "Bringing Home Bacon." *Observer Review,* Nov. 30, 1980.

Gruen, John. "Francis Bacon: Night's Journey and a Day." *Vogue,* Oct. 15, 1971.

Guppy, Shusha. "The Images of a Master." *Telegraph Sunday Magazine,* Nov. 4, 1984.

Haselden, Rupert. "Art, Death and Immortality over a Naked Lunch." Interview with Bacon and William Burroughs. *Weekend Guardian,* May 2–3, 1992.

Kimmelman, Michael. "The Art of Ordered Chaos." *Times,* Sept. 2, 1989. Also "Francis Bacon at 80: Unnerving Art." *New York Times Magazine,* Aug. 20, 1989.

Kinmonth, Patrick. "Francis Bacon." *Vogue* Spotlight. *Vogue,* May 1985.

Lennon, Peter. "A Brush with Ebullient Despair." Profile. *Times,* Sept. 15, 1983.

Maubert, Franck. "Sa dernière interview: Je poursuis la peinture car je sais qui'il n'est pas possible de l'atteindre." *Paris Match,* May 14, 1992.

Melly, George. "Streaky Bacon." *Punch,* June 19, 1985.

No byline. "Portrait Gallery: Francis Bacon." *Sunday Times,* 1956.

No byline. "Survivors." *Time,* Nov. 21, 1949, Atlantic edition.

Perlez, Jane. "Daily Closeup: There Are Three Things . . ." *New York Post,* Mar. 20, 1975.

Pitman, Joanna. "The Many Faces of Bacon." *The Times,* Aug. 30, 2008.

Plante, David. "Bacon's Instinct." *New Yorker,* Nov. 1, 1993.

Richard, Paul. "Francis Bacon and His Art: Mirrors of a Horrific Life." *Washington Post,* Mar. 21, 1975.

Sylvester, David. "The Exhilarated Despair of Francis Bacon." *Art News,* May 1975.

———. "Francis Bacon: A Kind of Grandeur." *Sunday Times Magazine,* March 23, 1975.

———. "My Brushes with Bacon." *Observer Magazine,* May 21, 2000.

UNPUBLISHED INTERVIEWS, CONVERSATIONS, AND EMAILS WITH THE AUTHORS

Included are interviews conducted on behalf of the authors by James Norton and Anthi-Danaé Spathoni.

Archimbaud, Michel. Interview with Anthi-Danaé Spathoni, March 8, 2018.

Ashbery, John. Interview with the authors, July 1, 2010.

Auerbach, Frank. Interview with Mark Stevens, February 12, 2009.

Barker, Clive. Interview with Annalyn Swan, June 27, 2016.

Batache, Eddy. Interview with James Norton, November 23, 2010, and with Mark Stevens, June 2016.

Beard, Peter and Nejma. Email correspondence with Annalyn Swan, July 2016.

Beresford, Marcus and Edel (7th Baron Decies). Interview with the authors on a visit to Straffan Lodge on November 10, 2010, and subsequent emails.

Bilbao, Maricruz. Interview with Annalyn Swan, October 1, 2011. Multiple emails, 2011–2020.

Birch, James. Interview with the authors, December 8, 2008, and email exchange with Annalyn Swan, November 29, 2017.

Boorman, Katrine. Interview with the authors, February 28, 2011.

Boustany, Majid. Interviews with Annalyn Swan, July 2014.

Bowler, Caroline. Interview with Annalyn Swan, June 16, 2010.

Chapman, Dan. Interview with the authors, February 12, 2011.

Clark, Michael. Interview with Annalyn Swan, December 18, 2015.

Clarke, Brian. Interviews with Annalyn Swan, June 3, 2016 and February 9, 2020.

Cohen, Lisa. Interview with Annalyn Swan, November 4, 2011, and emails of November 20 and December 20, 2011, and February 16 and April 9, 2012.

Conran, Jasper. Phone interview with Annalyn Swan, April 2014.

Conran, Paul. Interview with Mark Stevens, February 12, 2011.

Conran, Terence. Interview with Mark Stevens, July 7, 2011.

Corcoran, Desmond. Interview with Mark Stevens, December 2008.

Crété, Patrice. Conversation with Anthi-Danaé Spathoni, March 24, 2020.

Dahl, Felicity. Interview with Annalyn Swan, April 2, 2008.

Dalton, Robin and Lisa. Interview with the authors. November 14, 2010.

Dan, Pam. Interview with the authors, November 2010.

Davies, Hugh. Conversation with the authors, May 1, 2009, and subsequent emails.

Dawson, Barbara. Email to Annalyn Swan, July 6, 2011.

Dawson, David. Interview with the authors, December 2013, and subsequent conversations.

Dawson, Jonathan. Interview with the authors, September 18, 2013.

Delgado, Nicolás Díaz-Toledo, Hospital Ruber Juan Bravo. Interview with Annalyn Swan, November 15, 2017.

Dillon, Michael. Interview with Annalyn Swan, October 24, 2013.

Dobbs, Lem. Conversation with Mark Stevens, 2008.

Dryden, Ronnie. Interview with James Norton, May 26, 2009.

Dunn, Anne. Interview with the authors, July 26, 2010.

Eastman, John. Conversation with Mark Stevens, August 19, 2015.

Eden, Clarissa (Countess of Avon). Interview with the authors, February 2011.

Eliot, Jacquetta. Interview with Mark Stevens, November 4, 2014.

Feaver, William. Conversation with Annalyn Swan and Alice Hayward, June 20, 2014 and email correspondence, May 14, 2014, and May 9, 2015.

Fenton, Margaret. Interviews with Annalyn Swan, February 17, 2009, July 5, 2011, and February 27, 2012.

Ferrer, Patricia. Interview with Annalyn Swan, October 2, 2011.

Fielding, Agnes (Mougouch) Magruder. Inteview with the authors, March 3, 2011.

Friends of José Capelo. Interviews with the authors, December 2017 and February 2020.

Gamazo, Ana. Interview with Annalyn Swan, November 13, 2017.

Garnocho, Yolanda Vazquez, Hospital Ruber Juan Bravo. Interview with Annalyn Swan, November 15, 2017,

Gaynor, Andrew. Email correspondence with Annalyn Swan, April 30, 2019, and December 18 and 19, 2019.

Gibbs, Christopher. Interview with Mark Stevens and Annalyn Swan, October 12, 2013.

Glimcher, Arnold. Interview with Mark Stevens, March 4, 2019.

González, Elvira. Interview with Annalyn Swan, October 4, 2011, and November 15, 2017.

Gowrie, Grey (2nd Earl of Gowrie). Interview with Mark Stevens, November 2011.

Gray, Eddie. Interview with Mark Stevens, October. 2013.

Greenhalgh, Paul. Interview with Mark Stevens, November 25, 2010.

Dufferin, Lindy (Marchioness of Dufferin and Ava, also known as Lindy Guinness). Interview with Annalyn Swan, March 18, 2013.

Haim, Nadine. Phone interview with James Norton, April 19, 2014.

Hammer, Martin. Conversations and emails with the authors, June 2009, May 4, 2010, July 17, 2010, and February 24, 2011.

Harrison, Martin. Emails with the authors, November 20, 2011; September 4, 2013; April 26, 2014; January 16, 2016.

Haslam, Nicky. Interview with the authors, October 28, 2010.

Hassert, Reinhard. Interview with Mark Stevens, June 2016.

Heinz, Drue. Interview with Mark Stevens, October 2009.

Hirst, Celia. Interview with the authors, November 2010 and February 24, 2011.

Hopkins, Clare, archivist, Trinity College Cambridge. Email exchange with James Norton, October 2012.

Isaacs, Rita. Interview with James Norton, May 22, 2009.

Johnson, Heather. Multiple emails, October 2013, April 2019, and October 2020.

Jones, David. Telephone conversation with Annalyn Swan, 2011.

Joule, Barry. Interviews with Annalyn Swan, June 15, 2016 and November 4 and 5, 2017. Also numerous emails from 2016 through 2020.

Kandell, Jonathan. Interview with Mark Stevens, May 26, 2010.

Kelly, Anthony-Noel. Interview with Annalyn Swan, September 25, 2013.

Kern, Doreen. Interview with Annalyn Swan, November 17, 2012.

Kirkman, James. Interview with Mark Stevens, April 24, 2012.

Knott, Harley. Interview with Mark Stevens, March 7, 2008.

Knott, Ianthe. Interview with Mark Stevens, March 5 and 6, 2008.

Knott, Wendy. Interview with Mark Stevens, March 7, 2008.

Lacy, Fr. David. Interview with the authors, February 16, 2009, and subsequent emails of January 2, 2011, and June 25, 2014.

Lambton, Anne. Interview with James Norton, March 2004.

Lancaster, Mark. Interview with the authors, May 9, 2010.

Lane, Catherine Shakespeare. Interview with Annalyn Swan, February 12, 2009.

Le Brocquy, Louis. Interview with Annalyn Swan, May 7, 2008.

Leighton, Christine, Cheltenham College archivist. Email correspondence with Annalyn Swan, February 14 and February 23, 2011.

Lelong, Daniel. Interview with Anthi-Danaé Spathoni, June 29, 2016.

Lenox-Conyngham, Melosina. Interview with Annalyn Swan, May 2008.

Levai, Pierre. Interview with Mark Stevens, June 8, 2008.

Leventis, Geraldine and Michael. Interview with Annalyn Swan, November 11, 2017.

Levin, Gill. Conversation with James Norton, February 2016.

Lewis, Clarissa Piper. Interview with James Norton, May 30, 2011.

Lloyd, Gilbert. Interview with Mark Stevens, November 2, 2012.

Loftus, Gerald (TALIM: Tangier American Legation Institute for Moroccan Studies). Interview with Annalyn Swan, September 17, 2013.

Lombrail, Francis. Interview with Anthi-Danaé Spathoni, October 25, 2016.

Madden, Anne. Interview with Annalyn Swan, May 7, 2008.

Mainds, Paul and Wragg, Rachel. Interview with Mark Stevens, November 23, 2010.

Mayor, James. Interview with Annalyn Swan, March 12, 2013.

McCoy, Jason. Conversation with the authors, April 2008, at the Jason McCoy Gallery.

McDermott, Eugene. Interview with Annalyn Swan, September 10, 2010.

McDowell, Harry. Extended interview with the authors, November 8–11, 2010.

McKew, Bobby. Interview with the authors, September 26, 2013, and with Annalyn Swan, October 24, 2013.

Mena, Manuela. Interview with Annalyn Swan, October 4, 2011.

Micklewright, Rosie, the Lefevre Gallery. Email exchanges of April 1, September 17, and October 20, 2014.

Mignoni, Isabel. Interview with Annalyn Swan, November 15, 2017.

Miles, Terry Danziger. Interview with Mark Stevens, March 20, 2014, and subsequent conversations.

Mitchell, Béatrice. Interview with Anthi-Danaé Spathoni, March 17, 2020.

Moores, James. Conversation with Mark Stevens, October 2014.

Moran, Kevin. Interview with the authors, September 26, 2013.

Mordue, Philip. Q&A with Brian Clarke and Annalyn Swan, March 7, 2017 and March 11, 2020.

Moynihan, Danny. Interview with the authors, February 28, 2011.

Normile, John. Interview with Annalyn Swan, November 9, 2017.

Parladé, Janetta: Interview with Annalyn Swan, November 2, 2017.

Parton, Geoffrey. Conversations with Mark Stevens, 2009.

Pender, Anthea and Lawrence Mynott. Interview with the authors, September 16, 2013.

Plante, David. Interview with the authors, February 18, 2011, and mail correspondence, May 14, 2011.

Pons, Cristina. Interview with Annalyn Swan, November 13, 2017.

Prior-Wandesforde, Phyllis. Interview with the authors, November 9, 2010.

Reed, Jeremy. Interview with James Norton, September 28, 2011.

Reichardt, Tony. Interview with Mark Stevens, June 2016.

Richardson, Jan. Interview with the authors, November 2010.

Richardson, John. Interview with Mark Stevens, March 3, 2008, and with the authors, June 28, 2012.

Robinson, David. Interview with Mark Stevens, June 8, 2008.

Root, Doreen: Interview with Annalyn Swan, November 17, 2012.

Ross, Annie. Interview with Mark Stevens, April 25, 2014.

Rousseau, Paul. Interview with Mark Stevens, November 6, 2014, and subsequent conversations.

Russell, David. Interview with the authors, March 6, 2012.

Salvoni, Elena. Interview with Annalyn Swan, October 31, 2012.

Saunders, Frances Stonor. Interview with the authors, October 30, 2012.

Schurmann, Gerard. Email correspondence between Schurmann, Nigel Bonham-Carter, and Annalyn Swan, November 23, 2015 and March 24, 2018.

Shenstone, Clare. Interview with Mark Stevens, February 2009.

Shone, Richard. Interview with the authors, February 17, 2011.

Söll, Nadine. Conversation and emails with Annalyn Swan, September, 2013.

Somerset, David (11th Duke of Beaufort). Interview with the authors, June 18, 2012.

Soskine, Michel. Interview with Annalyn Swan, October 1, 2011.

Spurling, Hilary. Email exchanges with Annalyn Swan, June 6, 2012, and October 3, 2013.

Stephens, Chris. Conversation with the authors at the time of the 2009 Bacon retrospective at the Tate Britain, September 11, 2008–January 4, 2009, and email December 1, 2013.

Stewart, Angus. Interview with James Norton, February 9, 2016.

Stonor, Georgina. Interview with James Norton, June 2009, and telephone conversation with Annalyn Swan, May 2010.

Summers, Martin. Interview with Mark Stevens, April 23, 2012.

Thorold, Emelia. Interview with Annalyn Swan, December 5, 2008.

Towell, Gerald. Interview with the authors, February 16, 2009.

Turner, John Lys. Conversation with Mark Stevens, February 2013 and ongoing emails with Stevens and Swan, 2015 to 2020.

Valery, Anne (Valaoritis). Interview with Annalyn Swan, October 10, 2011.

Veličković, Mme. Maristella Vladimir. Interview with Anthi-Danaé Spathoni, May 16, 2016.

Veličković, Vladimir. Interview with James Norton, October 2004.

Verran, Virginia. Interview with Mark Stevens, April 12, 2012, and subsequent conversations.

Walker, Caroline de Mestre. Interview with Annalyn Swan, October 18, 2013.

Wallace, David. Interview with Mark Stevens, March 27, 2014.

Weisberg, Jacob. Email exchange with Annalyn Swan, May 2, 2011.

Weldon, Alice (Hayward). Interviews with Annalyn Swan, March 7 and 12, 2012, and February 15, 2020.

Weldon, Bill. Interview with James Norton, February 26, 2015.

Whitfield, Sarah. Interview with Mark Stevens, December 7, 2010.

Whitney, Rev. Charles, archivist, Dean Close School. Interview with Annalyn Swan, June 17, 2010, and subsequent emails.

Yacoubi, Larbi. Interview with James Norton, October 6, 2013, and short interviews with Annalyn Swan, September 17, 2013.

Zych, Anthony. Interview with Annalyn Swan, November 10, 2017.

UNPUBLISHED SOURCES

Includes artists' files in museums and galleries, unpublished letters and correspondence and unpublished interviews.

Archives of American Art, Smithsonian

Eyre de Lanux, Elizabeth. Papers.

Arena Interviews

In 2005, BBC Television and the Estate of Francis Bacon co-produced the documentary *Francis Bacon, Arena* for BBC One. While segments of interviews aired, the written transcripts of interviews contain more information than appeared on air. Background interviews consulted by the authors include:

Brass, Dr. Paul
Chambine, Anne-Marie Crété de
Cosperic, Michel
Danquah, Paul
Dupin, Jacques
Dyer, Lee
Keast, Diana
Lelong, Daniel
Marrion, David
Martin, Sr. Mercedes Moreno
Miles, Terry Danziger
Mrabet, Mohammed
Sainsbury, Lisa
Salmon, François
Shenstone, Clare
Spero, John

Bedales School, Petersfield

Correpondence between Bacon and the headmaster of Bedales, Frederic Meier. Bacon left London in early October 1940, not long after the Blitz began, to live in a rented cottage on the campus of Bedales School. He lived there for most of 1941 and 1942 and was still using the cottage in the early months of 1943.

Cheltenham College, Cheltenham

Records of Edward Bacon's time at the school and final illness, family addresses and other information. Although Bacon later said that his younger brother Edward went to Dean Close School in Cheltenham along with him, Edward went to the better known Cheltenham College.

Dean Close School, Cheltenham

Records of Francis Bacon's time at the school, including his academic career and interests, family addresses, and other information, and a history of the school during the 1920s when he attended. Bacon's only formal schooling was at Dean Close School from the fall of 1924 to the spring of 1926.

Estate of Francis Bacon

Bacon, Francis. Letters to his mother, Winifred Bacon Mavor, and his sister Ianthe Knott.

Bacon, Francis. Letters and telegrams to Bacon from Sonia Orwell, Daniel Farson, Hans Werner Henze, Roald Dahl, and others.

Bacon, Francis. Notes to John Edwards and Philip Mordue.

Beston, Valerie. Diaries of 1978–90, which include multiple entries per month on Bacon's art, life, and concerns.

Beston, Valerie. Letter to Bacon's mother, Winifred Bacon Mavor.

Edwards, John. Correspondence, business and social, and personal records pertaining to Edwards.

Mordue, Philip. Letter to Bacon from HM Prison, Woking, Surrey.

Additionally, the diaries of Eric Allden, Bacon's early companion, together with multiple photo albums, were recently acquired by the Estate of Francis Bacon. They were originally discovered by James Norton while he was researching the early years of Bacon's life for the authors.

Francis Bacon MB Art Foundation

Comprehensive library of Bacon books and newspaper and magazine articles; detailed information on Bacon's residences and life in Monte Carlo during the late 1940s and his later studio in Paris; and information about his lifelong interest in France more generally. The foundation has a particularly impressive collection of early Baconiana, including paintings, rugs, and furniture, at its research center in Monte Carlo. It has also published several volumes of information about Bacon in France and more generally and has a great deal of information on its website, mbartfoundation. com. Individual citations in footnotes.

Hugh Lane Gallery, Dublin

In 1998, Bacon's 7 Reece Mews studio was removed in its entirety to the Hugh Lane Gallery, Dublin, where it was painstakingly reassembled. The Hugh Lane Gallery has a comprehensive database of every item found in the studio. The database has entries on approximately 570 books and catalogs, 1,500 photographs, 100 slashed canvases, 1,300 leaves torn from books, 2,000 artist's materials, and 70 drawings. Other categories include the artist's correspondence, magazines, newspapers, and vinyl records. There are also cataloged books, photographs, apparel, and other items from Bacon's rooms at 7 Reece Mews. Individual citations in footnotes.

Marlborough Gallery

Detailed personal and business folders on Francis Bacon and his art, beginning with volume I, 1957–59, and continuing until his death. Early correspondence with Harry Fischer of Marlborough is particularly revealing, as is the control Bacon exercised over his exhibitions. Also included in the Marlborough records are early résumés, bound volumes of Bacon newspaper reviews and interviews dating back to 1933, and cables and correspondence between Bacon and his sister Ianthe Knott and about his sister Winifred Stevenson. Records of his extensive restaurant bills underscore Bacon's near obsession with always treating his friends. Also included are detailed records of his purchase and renovation of 45 Roland Gardens and his purchase of 7 Reece Mews, as well as his subsequent battle against developers threatening his studio. Individual citations in footnotes.

Mayor Gallery, London

Newspaper articles and reviews of early shows. Articles about "Freddie" Mayor, the founder of the gallery. Old photos. Records of sales.

Metropolitan Museum of Art, New York

Numerous letters between Francis Bacon, Harry Fischer of Marlborough, and Ted Rousseau and Henry Geldzahler of the Met during the extended planning of Bacon's 1975 show there, as well as a comprehensive record of newspaper and magazine articles and reviews. Individual citations in footnotes.

Museum of Modern Art, New York

Collection of James Thrall Soby papers. Of particular interest is unpublished correspondence between Soby and Harry Fischer at Marlborough in the late 1950s and early '60s. Much of it regards a planned book about Bacon that was never published, as well as records of museum purchases and discussions about a possible Bacon exhibition.

Orwell Archive, University College London

Letters to Sonia Orwell from Francis Bacon, Anne Dunn, Paul Bowles, Lucian Freud, Janetta Parladé, and Peter Beard.

St. John's College, Cambridge University

The collected papers of Richard Austen (RAB) Butler and his wife, Sidney Courtauld Butler. The Butlers were great friends of the painter Roy de Maistre, one of Bacon's close friends in the 1930s. They commissioned Bacon to design the dining room of their London home before the war. Sid-

ney Courtauld came from art world royalty: her father was the great collector Samuel Courtauld.

Tangier American Legation Institute for Moroccan Studies (TALIM)

Old newspaper records from the mid- to late 1950s and early '60s, when Bacon was frequently in Tangier. Located in the historic American Legation building in the Old Medina of Tangier, TALIM has bound volumes of the old newspapers that served the expatriate English-speaking community when Tangier was an international zone. The *Tangier Times*—later renamed the *Morocco Mail,* once Morocco assumed political control of Tangier—covered the comings and goings of the local British and American residents and visitors, including a number of mentions of Francis Bacon.

Tate Archive

The authors drew extensively on the research center at the Tate. Among the most valuable resources for information about Bacon:

Allen, Herbert. "Francis Bacon at the Royal College of Art, 1951–52." Personal reminiscence.

Hanover Gallery correspondence and records. The personal letters between Erica Brausen and Francis Bacon, and between Bacon and her partner Arthur Jeffress, have been published. (See *Francis Bacon in the 1950s,* exh. cat., text by Michael Peppiatt.) But Brausen's letters to collectors and museums and general management of Bacon's career are also revealing. Individual citations in footnotes.

Plante, David. Personal diary, account of a dinner with Francis Bacon and John Edwards. Appeared in a different form in "Bacon's Instinct" in the *New Yorker,* on Nov. 1, 1993.

Rawsthorne, Isabel. Unpublished letters in the 1940s and '50s from Rawsthorne to the artist Peter Rose Pulham in France. Also autobiographical fragment by Rawsthorne and "Profile: A Model Artist," by Sarah Howell.

Rothenstein, John. Unpublished diaries, 1939–90. Rothenstein was the director of the Tate at the time of Bacon's 1962 retrospective.

Sylvester, David. Letters and other documents.

Turner, Jon Lys

Many of Bacon's letters to his close friends Richard Chopping and Denis Wirth-Miller are included in Jon Lys Turner's *The Visitor's Book: In Francis Bacon's Shadow: The Lives of Richard Chopping and Denis Wirth-Miller* (London: Constable, 2016). Turner's collection contains several more that have not been published. Turner is the co-executor and beneficiary of the estate of Chopping and Wirth-Miller.

MONOGRAPHS

(In the case of multiple printings, the authors cite the edition they used, along with information about the original edition.)

7 Reece Mews: Francis Bacon's Studio. London: Thames & Hudson, 2001. Foreword by John Edwards; photographs by Perry Ogden; captions by Margarita Cappock.

Alley, Ronald, ed., and John Rothenstein, introduction, *Francis Bacon.* London: Thames & Hudson; New York: Viking Press, 1964. First catalogue raisonné of Bacon's work.

Archimbaud, Michel. *Francis Bacon in Conversation with Michel Archimbaud.* London: Phaidon Press, 2004. It was originally published in 1993.

Arya, Rina. *Francis Bacon: Painting in a Godless World.* Farnham, Surrey: Lund Humphries, 2012.

Baldassari, Anne. *Bacon, Picasso: The Life of Images.* Paris: Flammarion, 2005.

Brighton, Andrew. *Francis Bacon.* London: Tate Publishing, 2001.

Cappock, Margarita. *Francis Bacon's Studio.* London and New York: Merrell, 2005. Includes foreword and introductory chapter, "Francis Bacon's Studio: The Dublin Chapter," by Barbara Dawson.

Davies, Hugh. *Francis Bacon: The Early and Middle Years, 1928–1958.* London and New York: Garland Publishing, 1978. The book is a published version of Davies's dissertation at Princeton University, Dept. of Art and Archaeology, 1975 and draws upon interviews conducted with Bacon on March 6, May 29, June 26 and August 7, 1973.

———. *Francis Bacon: The Papal Portraits of 1953.* San Diego: Museum of Contemporary Art, 2001.

Davies, Hugh, and Sally Yard. *Francis Bacon.* Modern Masters series. New York: Abbeville Press, 1986.

Deleuze, Gilles. *Francis Bacon: The Logic of Sensation.* Trans. Daniel Smith. London and New York: Continuum, 2003. It was first published in 1981 as *Francis Bacon: logique de la sensation.*

Farson, Daniel. *The Gilded Gutter Life of Francis Bacon.* New York: Pantheon Books, 1993.

Francis Bacon: La France et Monaco/France and Monaco. France: Albin Michel/Francis Bacon MB Art Foundation, 2016. Edited by Martin Harrison.

Francis Bacon MB Art Foundation. Italy: Castelli Bolis Poligrafiche Spa, 2015 and 2017. Edited by Majid Boustany, the founder of the MB Art foundation.

Hammer, Martin. *Bacon and Sutherland.* New Haven, London: Yale University Press, 2005.

———. *Francis Bacon and Nazi Propaganda.* London: Tate Publishing, 2012.

Harrison, Martin. *In Camera: Francis Bacon: Photography, Film and the Practice of Painting.* London: Thames & Hudson, 2005.

Harrison, Martin, ed. *Francis Bacon Catalogue Raisonné.* London: The Estate of Francis Bacon, 2016.

———. *Francis Bacon: New Studies; Centenary Essays.* Gottingen: Steidl, 2009.

Harrison, Martin, and Rebecca Daniels. *Francis Bacon: Incunabula.* London: Thames & Hudson, 2008. Foreword by Barbara Dawson.

Hunter, Sam. *Francis Bacon.* Modern Masters series. Barcelona: Ediciones Poligrafa, 2009.

Inside Francis Bacon. Francis Bacon Studies III. London: The Estate of Francis Bacon Publishing / Thames & Hudson, 2020. Foreword by Martin Harrison. Among the essays consulted by the authors are: Francesca Pipe, "Bacon's First Patrons: Eric Allden Diaries"; Martin Harrison, "Bacon's First Patrons: Diana Watson's Diary"; and Sophie Pretorius, "A Pathological Painter: Francis Bacon and the Control of Suffering."

Leiris, Michel. *Francis Bacon: Full Face and in Profile.* Trans. John Weightman. New York: Rizzoli, 1988. It originally appeared as *Francis Bacon: face et profil.* Paris: Albin Michel, 1983.

Peppiatt, Michael. *Francis Bacon: Anatomy of an Enigma.* London: Constable & Robinson, 2008. The book was originally published by Weidenfeld & Nicholson in London in 1996.

———. *Francis Bacon in the 1950s.* Norwich: Sainsbury Centre, 2006.

———. *Francis Bacon in Your Blood: A Memoir.* New York: Bloomsbury USA, 2015.

Russell, John. *Francis Bacon.* London: Methuen, 1964.

———. *Francis Bacon.* New York: Thames & Hudson, 1993. Russell's book was originally published in 1971 by Thames & Hudson in the UK and by the New York Graphic Society in the U.S.

Sinclair, Andrew. *Francis Bacon: His Life and Violent Times.* London: Sinclair-Stevenson, 1993.

Sylvester, David. *Looking Back at Francis Bacon.* London: Thames & Hudson, 2000.

———. *Interviews with Francis Bacon.* London: Thames & Hudson, 1987. The book has gone through multiple printings and editions from the original publication by Thames and Hudson in the UK and Pantheon Books in New York in 1975.

SELECTED MUSEUM AND GALLERY CATALOGS OF BACON SOLO AND GROUP EXHIBITIONS

(The following includes catalogs that the authors found useful, or that served as milestones in Bacon's career. No other judgment of value is intended.)

Note: Bacon's earliest gallery shows did not have formal catalogs, only handouts.

1955

Francis Bacon. ICA, London, January 20–February 19, 1955. Text by Max Clarac-Serou, translated by Peter Watson.

1957

Francis Bacon. Galerie Rive Droite, Paris, February 12–March 10, 1957. Exhibition catalog, foreword by Roland Penrose; David Sylvester, "Some Notes on the Paintings of Francis Bacon."

1960

Francis Bacon: Paintings 1959–60. Marlborough Fine Art Ltd., London, March–April 1960. Text by Robert Melville, "Francis Bacon."

1962

Francis Bacon. Tate Gallery, May 24–July 1, 1962. Text by John Rothenstein; catalog entries by Ronald Alley.

1963

Francis Bacon. Guggenheim Museum, New York, October 18, 1963–January 12, 1964. Text by Lawrence Alloway.

Francis Bacon: Recent Work. Marlborough Fine Art, July–August 1963. Interview, "Francis Bacon: Talking to David Sylvester." The interview was subsequently reprinted as "Interview 1" in David Sylvester, *Interviews with Francis Bacon,* first published in 1975 by Thames and Hudson in London and Pantheon Books in New York and in subsequent editions.

1967

Francis Bacon: Recent Paintings. Marlborough New London Gallery, March 8–April 14, 1967. Text by Michel Leiris, "Ce que m'ont dit les peintures de Francis Bacon" (English translation by Sonia Orwell); interview with David Sylvester. The interview was subsequently reprinted in Sylvester's *Interviews with Francis Bacon.*

1971

Francis Bacon. Grand Palais, Paris, October 26, 1971–January 10, 1972. Text by Michel Leiris, "Francis Bacon aujourd'hui," subsequently reprinted in *Francis Bacon: face et profil* (Paris: Albin Michel, Bibliotheque Idees, 2004), 25–50, and in *Francis Bacon: Full Face and in Profile* (Madrid: Ediciones Poligrafa, Spain, 1983).

1975

Francis Bacon: Recent Paintings 1968–1974. Metropolitan Museum of Art, New York, March 20–June 29, 1975. Text by Henry Geldzahler; interview, "Francis Bacon: Remarks from an Interview with Peter Beard, Edited by Henry Geldzahler."

1976

Francis Bacon: oeuvres récentes. Musée Cantini, Marseilles, July 9–September 30, 1976. Text by Gaëtan Picon, "Le cercle et le cri."

1977

Francis Bacon: oeuvres récentes. Galerie Claude Bernard, Paris, January 19–March 26, 1977. Text by Michel Leiris, "Le grand jeu de Francis Bacon."

1984

Francis Bacon: peintures récentes. Gallerie Maeght-Lelong, Paris, January 18–February 25, 1984. Text by Jacques Dupin, "Fragments dans les marges d'un texte de Michel Leiris. David Sylvester, "Francis Bacon and David Sylvester: An Unpublished Interview."

Francis Bacon: Three Triptychs. Thomas Gibson Fine Art, London, June 1984. Text by David Sylvester, later published in a different version in Sylvester, *Looking Back at Francis Bacon* (London: Thames & Hudson, 2000).

1985

The Artist's Eye: Francis Bacon. National Gallery, London, October 23–December 15, 1985.

Francis Bacon, Tate Gallery, London, May 22–August 18, 1985. Exh. cat. (London: Tate Gallery, in association with Harry Abrams, New York, 1985). Texts by Dawn Adès, "Web of Images"; Andrew Forge, "About Bacon"; and Andrew Durham, "Notes on Technique." A second publication with notes on select works and a brief biography was compiled and written by Richard Francis, curator (London: Tate Publishing, Ltd., 1985).

1987

Frrancis Bacon: peintures récentes. Galerie Lelong, Paris, September 30–November 14, 1987. Text by Jacques Dupin, "Notes sur les dernières peintures," interview with David Sylvester (undated), "Entretien de Fancis Bacon avec David Sylvester."

1988

Frensis Bekon: zhivopis': Katalog vy Stavki, Central House of Artists, Moscow, September 23–November 6, 1988. Catalog organized and published by the British Council and Marlborough Gallery, London. Note by Francis Bacon; texts by Grey Gowrie ("Francis Bacon") and Mikhail Sokolov.

1989

Francis Bacon, Hirshhorn Museum and Sculpture Garden, Washington, October 12, 1989–January 7, 1990. Exh. cat. (Washington: Smithsonian Institution in association with London: Thames & Hudson, 1990). Exhibition organized by James Demetrion. Text by Lawrence Gowing, "Francis Bacon: The Human Presence"; and Sam Hunter, "Metaphor and Meaning in Francis Bacon."

1990

Francis Bacon: Paintings since 1944. Tate Liverpool, February 20, 1990–January 13, 1991. Texts by Richard Francis, "Memory Traces"; and Andrew Durham, "Notes on Technique."

1992

Corps crucifix. Musée Picasso, Paris, November 17, 1992–March 1, 1993. Bacon interview with Jean Clair, "Le pathos et la mort."

1995

From London: Bacon, Freud, Kossoff, Andrews, Auerbach, Kitaj. Scottish National Gallery of Modern Art, Edinburgh, July 1–September 5, 1995. Main texts by Richard Calvocoressi, David Cohen, and Bruce Bernard.

1996

Francis Bacon. Centre Georges Pompidou, Paris, June 27–October 14, 1996. Texts by David Sylvester, "Un parcours" Jean-Claude Lebensztejn, "Notes sur Bacon"; Fabrice Hergott, "La chambre de verre"; Herve Vanel, "L'imagination technique"; and Yves Kobry, "Bacon, vu de France."

Trapping Appearance: Portraits by Francis Bacon and Alberto Giacometti from the Robert and Lisa Sainsbury Collection. Sainsbury Centre for the Visual Arts, University of East Anglia, Norwich, June 25–September 15, 1996. Texts by David Sylvester, "Bacon and Giacometti: Likeness and Difference," and "Francis Bacon's Portraits of Robert and Lisa Sainsbury," interview with Lisa Sainsbury.

1998

Francis Bacon: The Human Body. Hayward Gallery, London. Text by David Sylvester, "Images of the Human Body." Sylvester also curated the show.

1999

Francis Bacon: The Papal Portraits of 1953. Museum of Contemporary Art, San Diego, January 17–March 28, 1999. Text by Hugh Davies, "Bacon's Popes: *Ex Cathedra* to *In Camera.*" There is also an until then unpublished interview by Davies from the series of interview he conducted in London with Bacon in 1973.

2000

Francis Bacon in Dublin. Hugh Lane Gallery, Dublin, June 1–August 31, 2000 (Thames & Hudson, in association with Hugh Lane Gallery, 2000). Texts by Grey Gowrie, "Documentaries of Stress"; Louis le Brocquy, "The Mystery of Fact"; Anthony Cronin, "An Irish Fear of Death?"; and Paul Durcan, "The King of Snails." Catalog by Margarita Cappock and David Sylvester.

2005

Bacon: Picasso: la vie des images. Musée Picasso, Paris, March 1–May 30, 2005 (Editions Flammarion; translated from the French by David Radzinowicz). Text by Anne Baldassari, curator; English edition, *Bacon Picasso: The Life of Images.*

2006

Francis Bacon in the 1950s. Norwich, University of East Anglia, September 26–December 10, 2006 (New Haven: Yale University Press, in association with the Sainsbury Centre for Visual Arts, 2006). Text by Michael Peppiatt, "Bacon's Eyes" and "Francis Bacon in the 1950s." The catalog includes Bacon's letters to Erica Brausen at the Hanover Gallery and to Lisa and Robert Sainsbury.

Francis Bacon: Portraits and Heads. National Galleries of Scotland in association with the British Council, June 4–September 4, 2005. Text by Richard Calvocoressi,

"Bacon: Public and Private"; and Martin Hammer, "Clearing Away the Screens."

2008

Francis Bacon. Tate Britain, London, September 11, 2008–January 4, 2009 (London: Tate Publishing, 2008). Text by Matthew Gale and Chris Stephens, "On the Margin of the Impossible"; Gary Tinterow, assisted by Ian Alteveer, "Bacon and His Critics"; Martin Harrison, "Bacon's Paintings"; David Alan Mellor, "Film, Fantasy, History in Francis Bacon"; Simon Ofield-Kerr, "Comparative Strangers"; and Victoria Walsh, "Real Imagination Is Technical Imagination." A further catalog was published when the exhibition traveled to the Metropolitan Museum in New York, May 18–August 16, 2008 (New York: Metropolitan Museum of Art and Skira Rizzoli, 2009).

2009

Francis Bacon: A Terrible Beauty. Hugh Lane Gallery, Dublin, October 28, 2009–March 7, 2010. Texts by Logan Sisley, "Catalogue of Paintings"; Martin Harrison, "Unfinished Paintings"; Barbara Dawson, "Francis Bacon: A Terrible Beauty"; Jessica O'Donnell, "The Street . . . the Only Valid Field of Experience: Francis Bacon and the Photography of John Deakin"; Marcel Finke, " 'I Don't Find It At All Violent Myself' "; Rebecca Daniels, "Francis Bacon and Peter Beard: The Dead Elephant Interviews and Other Stories"; and Joanna Shepard, "A Game of Chance: The Media and Techniques of Francis Bacon." The catalog includes reproductions of handwritten notes by Bacon.

2012

Francis Bacon: Five Decades. Art Gallery of New South Wales, November 17, 2012–February 24, 2013. Text by Anthony Bond, "Francis Bacon: Five Decades"; Martin Harrison and Rebecca Daniels, "Australian Connections"; Margarita Cappock, "Francis Bacon's Studio"; and Ernst van Alphen, "Making Sense of Affect."

Picasso & Modern British Art. Tate Britain, London, February 15–July 15, 2012. Main text by Chris Stephens, "Francis Bacon and Picasso."

2013

Francis Bacon/Henry Moore: Flesh and Bone. Ashmolean Museum, Oxford, September 12, 2013–January 19, 2014. Texts by Richard Calvocoressi, "Prologue" and "Moore and Bacon: Affinities"; Martin Harrison, "Bacon and Sculpture"; Francis Warner, "The Bones and the Flesh: Henry Moore and Francis Bacon."

2015

Francis Bacon: Late Paintings. Gagosian Gallery, New York City, November 7–December 12, 2015. Texts by Richard Calvocoressi, "Francis Bacon: Leaving Out"; Colm Tóibín, "Late Francis Bacon: Spirit and Substance"; Richard Francis, "Working with Francis Bacon"; Mark

Stevens, "Blood on Pavement"; "Martin Harrison in Conversation with Richard Calvocoressi"; and Eddy Batache, "Francis Bacon and the Last Convulsions of Humanism."

2016

London Calling: Bacon, Freud, Kossoff, Andrews, Auerbach, and Kitaj. The J. Paul Getty Museum, Los Angeles, in association with Tate, London, July 26–November 13, 2016. Text by Elena Cripp, "The Human Condition: Six Modern Painters Reinvent Reality"; and Catherine Lampert, "An Intensification of Reality."

ARTICLES AND REVIEWS ON BACON, AND ESSAYS IN PUBLISHED BOOKS

Alberge, Dalya. "Tapes Reveal Francis Bacon's Shock at 1968 Drug Bust." *Guardian,* May 6, 2018.

Alloway, Lawrence. "Dr. No's Bacon." *Art News and Review,* April 9–23, 1960.

———. "Points of View: Bacon and Balthus." *Art News and Review,* January 1952.

Artner, Alan G. "The World According to Francis Bacon." *Chicago Tribune,* October 29, 1989.

Auty, Giles. "Out of Decay, Immortality." *Spectator,* May 2, 1992.

Barnes, Julian. "Bringing Home the Bacon." *The Observer,* June 16, 1985.

Batache, Eddy. "Francis Bacon: An Intimate View." In *Francis Bacon: La France et Monaco/France and Monaco.* Paris: Editions Albin Michel, 2016.

Beaton, Cecil. "Sitting for Two Portraits, 1960." In Richard Buckle, ed., *Self-Portrait with Friends: The Selected Diaries of Cecil Beaton 1922–1974.* New York: The New York Times Book Company, 1982.

Berger, John. "Francis Bacon." Hanover Gallery exh. rev. *New Statesman and Nation,* January 5, 1952.

———. "Prophet of a Pitiless World." Musée Maillol exh. rev. *Guardian,* 29 May 29, 2004.

———. "The Worst Is Not Yet" Grand Palais exh. rev. *New Society,* January 6, 1972.

Bernard, Bruce. "The Book That Bacon Banned." *Independent Magazine,* May 2, 1992.

Bernard, Jeffrey. "Memories of Francis Bacon: A Painter Who Coloured my Days." *The Sunday Independent,* May 3, 1992.

Bindman, Geoffrey. "The Almighty Lawyer." *New Law Journal,* September 27, 2007.

Blackwood, Caroline. "A Big House in Ireland." Review of David Thomson's *Woodbrook. Listener,* December 12, 1974.

———. "Francis Bacon, 1909–1992." *New York Review of Books,* September 24, 1992. Also included in Robert B.

Silvers and Barbara Epstein, eds., *The Company They Kept: Writers on Unforgettable Friendships* (New York: New York Review of Books, 2006).

Bouisset, Maïten. "Bacon: Je suis juste un homme qui fait des images." *Le Matin,* October 1, 1987.

British Council. "Francis Bacon Exhibition, Moscow 22nd September–7th November 1988." British Council press release, July 18, 1988.

Brogan, Patrick. "Francis Bacon Paintings Boost Britain: French Critics Acclaim a Great Artist Whose Works Disturbed and Amazed Paris." *The Times,* January 11, 1972.

Brosse, Sabine de la. "Francis Bacon: 8000 Parisiens en un jour pour le pentre le plus cher du monde." *Paris Match,* February 4, 1977.

Brown, Craig. "Much Rambling but Little Juicy Action." *Sunday Times,* May 3, 1992.

Brown, Mark. "Francis Bacon: Final Painting Found in 'Very Private' Collection." *Guardian,* February 23, 2016.

Brown, Tim, and Jenny Rees. "No Mourners at Artist's Funeral." *Daily Telegraph,* May 1, 1992.

Buck, Louisa. "Artists' Colony." *Times* magazine, September 12, 1998.

Burnett, Victoria. "Francis Bacon: Seduced by Madrid." *New York Times,* February 19, 2009.

Busfield, Steve. "Melvyn Bragg and the South Bank Show: Five Moments to Savor." *Guardian,* May 6, 2009.

Canedy, Norman W. "Francis Bacon at the Metropolitan Museum." *Burlington Magazine,* June 1975.

Carritt, David. "Bacon—The Art of Success." *Evening Standard,* March 29, 1960.

Causey, Andrew. "Francis Bacon's European Perspective." Grand Palais exh. rev. *Illustrated London News,* February 1972.

Clark, Adrian. "Francis Bacon's Correspondence with Sir Colin Anderson." *British Art Journal,* Summer 2007.

Conrad, Peter. "The Power and the Passion." *Observer,* August 9, 2008.

Cooper, Emmanuel. "Sad Social Commentary." *Tribune,* June 28, 1985.

Crété de Chambine, Anne-Marie. "Un hôte singulier / A very special guest." In Majid Boustany, ed., *Francis Bacon MB Art Foundation.* Monaco, 2005.

Cronin, Anthony. "An Irish Fear of Death." In *Francis Bacon in Dublin.* London: Thames & Hudson, 2000. Published in association with the Hugh Lane Gallery.

Danto, Arthur. "Art." *Nation,* July 30, 1990.

Dixon, Andrew Graham. "Art: A Retrospective of Francis Bacon's Work Has Just Opened in Moscow." *Independent,* October 1, 1988.

Farson, Daniel. "Francis Bacon Celebrates at 80 Without Pomp." *Sunday Telegraph,* October 23, 1989.

Fitzsimmons, James. "Art." *Art and Architecture,* January 1953.

Francis, Richard. "Working with Francis Bacon." In *Francis Bacon: Late Paintings,* Gagosian Gallery, New York, exh. cat.; published on the occasion of the exhibition "Francis Bacon: Late Paintings," 2015.

Furst, Herbert ("Perspex"). "Current Shows and Comments on the Significance of a Word." *Apollo,* May 1945.

Garland, Madge. "The 1930 Look in British Decoration." *The Studio* magazine, August 1930.

Gayford, Martin. "How Bacon Was Cured in Cornwall." *Telegraph,* February 3, 2007.

Glueck, Grace. "Briton Speaks About Pain and Painting." *New York Times,* March 20, 1975.

Golding, John. "Lust for Death." *New Statesman and Nation,* April 6, 1957.

Golson, Jordan. "WWI Zeppelins: Not Too Deadly, but Scary as Hell." *Wired,* October 3, 2014.

Gowing, Lawrence. "The Irrefutable Image." Catalog essay in *Francis Bacon: Recent Paintings,* exh. cat., Marlborough-Gerson Gallery, 1968.

Gowrie, Grey. "Bacon in Moscow: A Small Gloss on Glasnost." *Modern Painters,* Winter 1988–89.

——. "Francis Bacon: Artist of Endgame." *The Sunday Times Magazine,* May 19, 1985.

Graham-Dixon, Andrew. "Bekon [in Cyrillic] in Moscow." *The Independent,* October 1, 1988.

——. "Profile: Francis Bacon, Confounder of Art Critics." *The Independent,* September 24, 1988.

Greig, Geordie. "Bacon: Still Honing the Razor's Edge." *Now!* October 10, 1980.

——. "Bacon's Art Gets the Red Carpet Treatment." *The Sunday Times,* September 25, 1988.

——. "Storming of the Bastion of Art: Paris Fêtes Bacon as London Shows a French Revolutionary Face." *The Sunday Times,* October 4, 1987.

Guardiola, Juan, and Francisco Rivas. "El ultimo martini en Madrid." *El Europeo,* October 1992.

H.C., "Grande première à Paris de Francis Bacon No. 1 de l'Index CDA 1971." *Connaissance des Arts,* October 1971.

Hammer, Martin, "Francis Bacon and the Lefevre Gallery." *Burlington Magazine,* May 2010.

Harrison, Martin. "Diana Watson's Diary." *Inside Francis Bacon: Francis Bacon Studies III.* London: The Estate of Francis Bacon publishing, in association with Thames & Hudson, 2020.

Hawley, Janet. "Dark Night of the Soul." *Sydney Morning Herald,* November 3, 2012.

Hess, Thomas. "Art: Blood, Sweat and Smears." *New York Magazine,* April 21, 1975.

Higgins, Charlotte. "It's Trash, but It's Bacon's Trash—and It's Sold for Almost £1 Million." *The Guardian,* April 25, 2007.

Hoctin, Luce. "Francis Bacon: Un peintre halluciné." *Arts.* February 19, 1957.

Holohan, Renagh. "An Irishwoman's Diary." *Irish Times,* October 6, 2009.

Hughes, Robert. "Singing Within the Bloody Wood." *Time,* July 1, 1985.

Hunter, Sam. "An Acute Sense of Impasse." *Art Digest,* October 15, 1953.

———. "Francis Bacon: The Anatomy of Horror." *Magazine of Art,* January 1952.

Jayne, A. L. "The Decanian News." *Old Decanian House Journal,* 1993.

Jeannerat, Pierre. "He's Art's 'Svengali': Mayfair Looks at the Strange Creations of Francis Bacon." ICA exh. rev. *Daily Mail,* January 20, 1955.

Johnson, Paul. "Myth of the Modern." *Sunday Telegraph,* May 3, 1992.

Kennedy, Maev. "Painting Bacon Gave as Rent May Fetch 9 Million Pounds." *Guardian,* September 4, 2007.

Kinmonth, Patrick. "Francis Bacon." *Vogue* Spotlight. *Vogue,* May 1985.

Kitaj, R. B. "Galleries: Bacon in the Nut House Again." *London American,* April 7–13, 1960.

Klokov, Sergei. "Letter from Moscow: Francis Bacon." *Apollo,* Deember 1988.

Kramer, Hilton. "The Problem of Francis Bacon." *New York Times,* November 17, 1968.

———. "Signs of a New Conservatism in Taste." *New York Times,* March 30, 1975.

Lennon, Peter. "A Brush with Ebullient Despair: The Times' Profile: Francis Bacon." *The Times,* September 15, 1983.

———. "Francis and Me." Interview with Henrietta Moraes. *Weekend Guardian,* May 2–3, 1992.

Levin, Bernard. "A Genius? I Say Rotten." *The Times,* June 28, 1985.

Lewis, Wyndham. "Round the London Art Galleries." *Listener,* November 27, 1949. Lewis also wrote a tantalizing, and rather poetic, preview in the *Listener* shortly before the show opened, based on having seen *Head I* the previous summer at the Redfern Gallery.

Libbert, Neil. "Neil Libbert: The Faces That Came to Define an Era—in Pictures." *Guardian,* September 15, 2012.

Lubbock, Tom. "So Much for Bacon the Man: What of the Work?" *Independent on Sunday,* May 3, 1992.

Mathiason, Nick, and Vanessa Thorpe. "The First Dark Image of Bacon's Death." *Observer,* December 6, 2008.

McEwen, John. "Terrible Beauty or Dirty Mac Decadence?" *Sunday Telegraph,* May 3, 1992.

McNay, Michael. "Just a Pile of Paint and a Nightmare of Chic Thrills." *Weekend Guardian,* May 2–3, 1992.

Melville, Robert. "Francis Bacon." *Horizon,* December 1949–January 1950.

———. "A Note on the Recent Paintings of Francis Bacon." *World Review,* February 1952.

Mortimer, Raymond. "At the Lefevre." *The New Statesman and Nation,* April 14, 1945.

Mullaly, Terence. "Exhibitions Emphasize British Prestige." *Daily Telegraph,* October 26, 1971.

Müller, Hans-Joachim. "Die Leideform Mensch" ("Man as a Suffering Agent"). *Die Zeit,* November 1, 1985.

Newton, Eric. "Double Bass and Piccolo." *Sunday Times,* November 13, 1949.

———. "An Unhappy Genius." *Sunday Times,* September 7, 1950.

No byline. "Art, Death and Immortality over a Naked Lunch." *Weekend Guardian,* May 2–3, 1992.

———. "Art Exhibitions: Mr. Francis Bacon." Hanover Gallery exh. rev. *Times,* November 22, 1949.

———. "Art for the Few." *Observer,* November 13, 1949.

———. "Art Guests Toast Mr. Bacon." *The Evening Standard.* March 24, 1960.

———. "Art in London: Paintings Pleasant and Unpleasant: Francis Bacon Studies." *Scotsman,* November 26, 1949.

———. "Baconian Extension." *Glasgow Herald,* January 6, 1952.

———. "Bacon Makes a Modest Move." *Daily Express,* September 7, 1976.

———. *Evening Standard,* March 24, 1960.

———. "Francis Bacon: An Art of Anguish?" *Economist,* May 23, 1985.

———. "Francis Bacon Shrinks from Birthday Bash." *Iberian Daily Sun,* November 5, 1989.

———. "GAM'n Bacon." *Unit Trust Management,* August 1985.

———. "Good but Ghoulish." *Daily Herald,* November 10, 1949.

———. "Hanover Gallery: Mr. Francis Bacon's Paintings." *Times,* September 22, 1950.

———. "The Horrific Vision of Mr. Francis Bacon." *Times,* May 24, 1962.

———. "Mr. Francis Bacon." *Times,* February 16, 1934.

———. "Painter Who Inspired Graham Sutherland." *Daily Mail,* January 20, 1955.

———. "Portrait Gallery: Francis Bacon." *Sunday Times,* n.d.

———. "Survivors." *Time,* November 21, 1949.

———. "An Unloved Artist." *Frankfurter Allgmeine Zeitung,* July 7, 1985.

Nuridsany, Michel. "L'Un des plus grands peintres vivant expose ses dernières toiles galerie Daniel Lelong." *Le Figaro,* September 29, 1987.

O'Doherty, Brian. "On the Strange Case of Francis Bacon." *New York Times,* October 30, 1963.

Owen, Edward, and Nicholas Watt. "No Friends, by Request, at Bacon's Farewell." *The Times,* May 1, 1992.

Parr, Alexis. "Bring Home the Bacon: This Marble-Lined Suffolk Mansion—Built with the Legacy of Francis Bacon—Is for Sale at 3.5 Million." *Mail Online,* May 10, 2011.

Peppiatt, Michael. "Francis Bacon: Reality Conveyed by a Lie." *Art International,* Fall 1987.

Pipe, Francesca. "Bacon's First Patrons: Eric Allden's Diary." *Inside Francis Bacon, Francis Bacon Studies III.* London: The Estate of Francis Bacon publishing, in association with Thames & Hudson, 2020.

Pitman, Joanna. "The Many Faces of Bacon." *Times,* August 30, 2008.

Plante, David. "Bacon's Instinct." *New Yorker,* November 1, 1993.

Pretorius, Sophie. "A Pathological Painter: Francis Bacon and the Control of Suffering." In *Inside Francis Bacon, Francis Bacon Studies III.* London: The Estate of Francis Bacon publishing, in association with Thames & Hudson, 2020.

Purser, Philip. "Richard Levin: Designer Who Gave the BBC Its Visual Identity and Revolutionized Programme Presentation." *The Guardian,* July 9, 2000.

Richard, Paul. "Art: Bacon's Sublime Screams." *Washington Post,* Oct. 12, 1989.

———. "Francis Bacon and His Art: Mirrors of a Horrific Life." *Washington Post,* March 21, 1975.

Richardson, John. "Tragedian." *New York Review of Books,* March 25, 1965.

Rogers, Clive, and Jean Manuel de Noronha. "Rugs of the Young Francis Bacon." Draft form of published article (unedited), *Hali Magazine,* Winter 2009.

Roob, Rona. "From the Archives: James Thrall Soby and Francis Bacon." *MoMA,* Spring 1990.

Rosenberg, Harold. "The Art World: Aesthetics of Mutilation." *New Yorker,* May 12, 1975.

Russell, John. "Art Galleries: Reality Plus." *Sunday Times,* December 14, 1952.

———. "Round the Art Exhibitions." *Listener,* April 12, 1945.

Sandler, Irving. "In the Art Galleries." *New York Post,* October 27, 1963.

Saner, Ermine. "So Where's Bacon's 'Missing Millions'?" *Evening Standard,* September 1, 2004.

Schneider, Pierre. "The Savage God." *Sunday Times,* November 7, 1971.

Shone, Richard. "Francis Bacon in 1930: An Early Exhibition Rediscovered." *Burlington Magazine,* April 1996.

Sinclair, Andrew. "Last Days of the Rage." *Sunday Times,* September 5, 1993.

Sokolov, Mikhail. "Tragedies Without a Hero: The Art of Francis Bacon." *Art Monthly,* November 1988,.

Solomon, Andrew. "Exhibitions: Francis Bacon." *Contemporanea: International Art Magazine,* November–December 1988.

Sontag, Susan. "Francis Bacon: 'About Being in Pain.'" *Vogue,* March 1975.

Spender, Stephen. "At the Galleries: As Bacon Sees Us." *Observer,* March 27, 1960.

Spurling, John. "Gilt-Framed." *New Statesman,* May 31, 1985.

Sutton, Denys. "Art News from London: Francis Bacon." *Art News,* January 1953.

Sylvester, David. "A Farewell to Bacon." Note printed in Paula Weideger, "Preaching Art." *The Independent,* May 11, 1992.

———. "Enter Bacon, with the Bacon Scream." *New York Times Magazine,* October 20, 1963.

———. "Francis Bacon." *New Statesman,* June 22, 1962.

———. "Francis Bacon: A Kind of Grandeur." *Sunday Times Magazine,* March 23, 1975.

———. "The Paintings of Francis Bacon." Hanover Gallery exh. rev. *Listener,* January 3, 1952.

Taylor, Brandon. "The Taste for Bacon." *Art News,* January 1989.

Tóibín, Colm. "Late Francis Bacon: Spirit and Substance." In *Francis Bacon: Late Paintings* (New York: Gagosian Gallery/Rizzoli, 2015).

Unknown author. Art review in the *Pall Mall Gazette,* April 9, 1885. In his review of the paintings of Charles Mitchell, the heir to a shipbuilding fortune in Newcastle who later married Bacon's great-aunt Eliza Watson Mitchell, the critic of the *Pall Mall Gazette* praised Mitchell as exemplifying "all the good and none of the bad qualities" of French painting.

Unknown author. "Lady Charlotte Bacon: The Earldom of Oxford." *The Advertiser,* March 19, 1925.

Vaizey, Marina. "Bacon: Genius Who Walks Alone." *Sunday Times,* May 26, 1985.

Vergano, Dan. "Fear of Floating." *Smithsonian Air & Space Magazine,* July 2009.

Wallach, Amei. "Capturing Nightmares on Canvas." *Newsday,* March 28, 1975.

Wallis, Neville. "Nightmare." Hanover Gallery exh. rev. *Observer,* November 20, 1949.

Weideger, Paula. "Preaching Art." Interview with David Sylvester. *Independent,* May 11, 1992.

Wiseman, Carter, and Edward Behr. "Agony and the Artist." *Newsweek,* Jan. 24, 1977.

RELATED BOOKS AND ARTICLES

Abel, Lionel. "The Genius of Jean Genet." *New York Review of Books,* October 1973.

Acker, Emma. "Artistic Identity in a Transatlantic Age: Patrick Heron, Peter Lanyon, and the New American Painting." *British Art Journal,* Winter/Spring 2009–10.

Adam, Peter, *Eileen Gray.* New York, Harry Abrams, 1987.

Adès, Dawn, and Simon Baker, eds. *Undercover Surrealism: Georges Bataille and Documents.* Cambridge: MIT Press, 2006.

Adlon, Hedda. *Hotel Adlon: The Life and Death of a Great Hotel*. London: Barrie Books, 1958.

Amory, Mark, ed. *The Letters of Ann Fleming*. London: Collins Harvill, 1985.

Appiah, Kwame Anthony. "Surreal Anthropology." *New York Review of Books*, March 8, 2018.

Ayrton, Michael. "Art." *Spectator*, April 13, 1945.

Beard, Peter. Contents of Detritus Box in *Francis Bacon: A Terrible Beauty*. Exh. cat., Hugh Lane Gallery, Dublin, 2009.

Beaton, Cecil. "Sitting for Two Portraits, 1960." In *Self Portrait with Friends: The Selected Diaries of Cecil Beaton 1922–1974*. Ed. Richard Buckle. New York: Times Books, 1979.

Beckett, J. C. *The Anglo-Irish Tradition*. Ithaca, New York, Cornell University, 1976.

Beechey, James, and Chris Stephens, eds. *Picasso and Modern British Art*. Exh. cat., Tate. London, 2012.

Bennetts, Leslie. "African Dreamer." *Vanity Fair*, November 1996.

Berger, John. *Hold Everything Dear: Dispatches on Survival and Resistance*. New York, 2007.

Bernard, Jeffrey. "A Painter Who Coloured My Days." *Independent on Sunday*, 1992.

Berthoud, Roger. *Graham Sutherland, A Biography*. London: Faber and Faber, 1982.

Biles, Jeremy. "Correspondence: Georges Bataille and Michel Leiris." *Rain Taxi Online Edition,* Winter 2008/2009.

Bindman, Geoffrey. "The Almighty Lawyer." *New Law Journal,* September 27, 2007.

———. "J. S. Deville's Life Mask of William Blake." *Blake*, December 15, 1969.

Bird, Geoff, producer, "How France Gave Punk Rock Its Meaning." *Liberty, Fraternity, Anarchy*, BBC Radio 4, March 3, 2011.

Blackburn, Julia. *The Three of Us: A Family Story*. New York: Vintage Books, 2009.

Blackburn, Thomas. *A Clip of Steel*. London: MacGibbon and Kee Ltd., 1969.

Blackwood, Caroline. "A Big House in Ireland." *The Listener,* December 12, 1974.

Blond, Anthony. "Obituary: Lord Goodman." *The Independent,* May 15, 1995.

Blythe, Ronald. *The Age of Illusion: England in the Twenties and Thirties*. Boston: Houghton Mifflin Company, 1964.

Boger, Alnod J. *The Story of General Bacon*. London: Methuen and Co., 1903.

Boggan, Steve. "I Wooed Bacon with Claridge's Champagne, but London Gallery Cheated Me, Says Dealer." *Independent,* November 28, 2001.

Bohlmann, Otto. *Yeats and Nietzsche: An Exploration of Major Nietzschean Echoes in the Writings of William Butler Yeats*. London: Palgrave MacMillan U.K., 1982.

Bonnefoy, Yves. *Alberto Giacometti: A Biography of His Work*. Paris: Flammarion, 1991.

Boston, Richard. "Gaston Berlemont: Landlord of the French Pub, Bohemia's Favorite Watering Hole." *Guardian,* November 3, 1999.

Boustany, Majid. *Francis Bacon MB Art Foundation*. Monaco, 2015 and 2017.

Brain, Richard. "Lord Berners: Obituary of Robert Heber-Percy." www.faringdon.org.

Brighton, Andrew, and Lynda Morris, eds. *Towards Another Picture: An Anthology of Writings by Artists Working in Britain, 1945–1977*. Nottingham: Midland Group, 1977.

Bristow, Carol. *Central 822: The Remarkable Story of One Woman's Thirty-Year Fight Against Crime*. London: Bantam Press, 1999.

Bristow, Roger. *The Last Bohemians: The Two Roberts Colquhoun and MacBryde*. Bristol: Sansom and Company, 2010.

Buck, Louisa. "Denis Wirth-Miller: A Partial Memory." In *Denis Wirth-Miller, 1915–2010*. Exh. cat. Minories Gallery, Colchester Institute, 2011.

Buckman, David. "Denis Wirth-Miller: Bohemian Artist Who Enjoyed a Close Association with Francis Bacon." *Independent*, February 19, 2011.

Burroughs, William. *The Letters of William Burroughs, 1945–1959*. Ed. and with an introduction by Oliver Harris. New York: Penguin Random House, 1993.

Butler, Hubert. *The Independent Spirit*. New York: Farrar, Straus and Giroux, 2000.

"By Our Art Critic." "London's Strangest Art Show." *News Chronicle,* October 21, 1933.

Cameron, Roderick. *The Golden Riviera*. London: Weidenfeld & Nicholson, 1975.

Clark, Adrian. *Fighting on All Fronts: John Rothenstein in the Art World*. Chicago: The University of Chicago Press, 2018.

———. "Francis Bacon's Correspondence with Sir Colin Anderson." *British Art Journal*, Summer 2007.

Clark, Adrian, and Jeremy Dronfield. *Queer Saint: The Cultivated Life of Peter Watson, Who Shook Twentieth-Century Art and Shocked High Society*. London: John Blake Publishing, 2015.

Clark, Kenneth. *Another Part of the Wood: A Self-Portrait*. London: Harpercollins, 1975.

Cohen, Lisa. *All We Know: Three Lives*. New York: Farrar, Straus & Giroux, 2012.

Comstock, Gordon. "John Deakin: Champagne and Sulphur in Soho." *The Guardian*. April 7, 2014.

Conekin, Becky E. *The Autobiography of a Nation: The 1951 Festival of Britain*. Manchester: Manchester University Press, 2003.

Connolly, Cyril. "The Coming of the Crisis—I." Reprinted in *Ideas and Places,* London: Harper and Brothers, 1953.

———. "Comment." *Horizon*, May 1945.

Conradi, Peter. *Iris Murdoch: A Life*. New York: W. W. Norton & Co., Inc., 2001.

Cooke, Rachel. "The Mad Boy, Lord Berners, My Grand-

mother and Me Review: A Family Saga with All the Trimmings." *Observer,* October 19, 2014.

Cooney, Patrick. "The Queen of Soho." *Guardian Weekly,* August 22, 1998.

Correia, Alice. "Gimpels Fils, Barbara Hepworth and the Promotion of British Sculpture in the 1950s." *Sculpture Journal,* July 2015.

Cowell, Alan. "Overlooked No More: Alan Turing, Condemned Code Breaker and Computer Visionary." *New York Times,* June 5, 2019.

Crane, Steve. "Fleet Street Photographer Lingo." Helderberg Photographic Society website, helderbergphoto.com.

Crankshaw, Edward. "Art, Recent Paintings by English, French and German Artists at the Mayor Gallery, Ltd., 18, Cork Street, W.I." Unknown newspaper, April 1933.

Crisp, Quentin. *The Naked Civil Servant.* New York: Penguin Books, 1997.

Cronin, Anthony. *Dead as Doornails: A Chronicle of Life.* Dublin: The Dolmen Press, 1976.

Cumming, Laura. "John Minton: A Centenary Review—a Wildly Restless Talent." *Observer,* July 2, 2017.

Dahl, Roald. *Roald Dahl's Cookbook.* London: Penguin Books, Limited, 1996.

Delmer, Sefton. *Trail Sinister, Top Newsman Remembers Europe. An Autobiography.* Vol. I. London: Secker & Warburg, 1961.

Denis Wirth-Miller. Exh. cat., The Minories Galleries, Colchester Institute, 2011.

Dillon, Millicent. *A Little Original Sin: The Life and Work of Jane Bowles.* New York: Anchor, 1981.

Diu, Nisha Lilia. "Toto Koopman: Model, Muse, Mistress—and Spy." *Telegraph,* September 1, 2013.

Dobrzynski, Judith H. "A Betrayal the Art World Can't Forget; the Battle for Rothko's Estate Altered Lives and Reputations." *New York Times,* November 2, 1998.

Dockray, Keith, and Alan Sutton. *Politics, Society and Homosexuality in Post-War Britain: The Sexual Offenses Act of 1967 and Its Significance.* Oxford: Fonthill Media, 2017.

Doyle, Rachel B. "Looking for Isherwood's Berlin." *New York Times,* April 12, 2013.

Dugmore, A. Radclyffe. *Camera Adventures in the African Wilds: Being an Account of a Four Months' Expedition in British South Africa.* London: William Heinemann, 1910.

Durcan, Paul. "The King of Snails." In *Francis Bacon in Dublin,* exh. cat., London/Hugh Lane Gallery, 2000.

Earley, Ryan, Lawrence Blumer, and Matthew Grober. "The Gall of Subordination: Changes in Gall Bladder Function Associated with Social Stress." The Royal Society, November 24, 2003, www.ncbi.nlm.nih.gov.

Earp, T. W. "A New Group of Painters, Pictures by Young British Artists." *Daily Telegraph,* January 14, 1937.

Eden, Richard. "Sir Clement Freud and Brother Lucian Freud in Feud as Latter Rejects Knighthood." *Daily Telegraph,* June 28, 2008.

El Blog del Museo Picasso de Barcelona. "*Desire Caught by the Tail* by Picasso in the Reading Club." January 24, 2014, www.blogmuseupicassobcn.org.

Eliot, T. S. *Triumphal March.* Published in the *Ariel* poetry series with artwork by E. McKnight Kauffer. London: Faber and Faber, 1931.

Evans, Julian. "Graham Greene." *Prospect Magazine,* September 26, 2004.

Evans, Richard. "How Labour Will Take Tax Rates Back to the 1970s." *Daily Telegraph,* June 3, 2017.

Feaver, William. *The Lives of Lucian Freud: The Restless Years, 1922–1968.* New York: Knopf, 2019.

Feigel, Lara. *The Love-Charm of Bombs: Restless Lives in the Second World War.* London: Bloomsbury Press, 2013.

———. "On the Edge of Madness: The Terrors and Genius of Giacometti." *Guardian,* April 21, 2017.

Finch, James. "David Sylvester: A British Critic in New York." Tate Research Feature, July 2015, https://www.tate.org.uk/research/features/sylvester-british-critic-ny.

Finlayson, Iain. *Tangier: City of the Dream.* London: HarperCollins, 1992.

FitzGibbon, Theodora. *Love Lies a Loss: An Autobiography 1946–1959.* London: Century, 1985.

———. *With Love.* London: Century Publishing, 1982.

Fleming, Ann. *The Letters of Ann Fleming.* Ed. Mark Amory. London, 1985.

Frankl, Paul. *New Dimensions: The Decorative Arts of Today in Words & Pictures.* New York: Payson & Clarke Ltd., 1928.

Fuchs, Eduard. *The History of Erotic Art: The Individual Problem.* Germany: Lyundorf Publishing, 1923.

Garland, Madge. *The Indecisive Decade: The World of Fashion and Entertainment in the Thirties.* London: Macdonald, 1968.

———. "Interiors by Eyre de Lanux." *Studio,* October 1930.

———. "New Designs for Wilton Rugs by E. McKnight Kauffer and Marion V. Dorn: A Conversation with a 'Studio' representative." *Studio,* 1929.

Garner, Philippe. *Eileen Gray: Design and Architecture 1878–1976.* Kohn: Benedikt Tascher, 1993.

Gaunt, W. "A Modern Utopia? Berlin—The New Germany—The New Movement." *Studio,* 1929.

Gavin, James. "Annie Ross: A Free-Spirited Survivor Lands on Her Feet." *The New York Times,* October 3, 1993.

Gay, Peter. *Weimar Culture: The Outsider as Insider.* New York: W. W. Norton & Company, 2001.

Gayford, Martin. "A Tale of Two Artists: John Minton: Well-Known but Not Great Enough; John Virtue: Great but Not Well-Known Enough." *The Spectator,* July 15, 2017.

———. *Man with a Blue Scarf: On Sitting for a Portrait by Lucian Freud.* New York: Thames & Hudson, 2010.

———. *Modernists and Mavericks: Bacon, Freud, Hockney and the London Painters.* London: Thames & Hudson, 2018.

Gerlis, Melanie. "Adventurous Art Collection of Ellen and

Jerome Stern Comes to Sotheby's." *Art Newspaper,* September 20, 2017.

Gilbey, Geoffrey. *Horse Racing for Beginners.* London: E. Grant Richards Ltd., 1923.

———. *Not Really Rude.* London: John Long, 1938.

———. *Pass It On: Religious Essays.* London: The Lane Publications, 1931.

———. *She's and Skis.* London: Hutchinson, 1937.

Ginsberg, Allen. *The Letters of Allen Ginsberg.* Ed. Bill Morgan. New York: Da Capo Press, 2008.

Glastris, Kukula. "The Widow Orwell." *Washington Monthly,* July/August 2003.

Golson, Jordon. "WWI Zeppelins: Not Too Deadly, but Scary as Hell." *Wired,* October 3, 2014.

Gordon, Mel. *Voluptuous Panic: The Erotic World of Weimar Berlin.* Port Townsend, Wash.: Feral House, 2008.

Green, Michelle. *The Dream at the End of the World: Paul Bowles and the Literary Renegades in Tangier.* New York: Harper-Collins Publishers, 1991.

Greenberger, Alex. "Peter Selz, Curator and Art Historian Committed to the New, Is Dead at 100." *Art News,* June 22, 2019.

Gregor, Ulrich et al. *Berlin 1910–1922.* New York: Rizzoli International, 1982.

Greig, Geordie. *Breakfast with Lucian: The Astounding Life and Outrageous Times of Britain's Great Modern Painter.* New York: Farrar, Straus and Giroux, 2013.

Grigson, Geoffrey. "Henry Moore and Ben Nicholson." *The Bookman,* November 4, 1933.

Grimes, William. "John Russell, Art Critic for the *Times,* Dies at 89." *New York Times,* August 24, 2008.

Gural, Natasha. " 'Totally Hypnotizing' Hockney Portrait of Famous Gay Couple Could Fetch $38 Million at Christie's." December 16, 2018. www.forbes.com.

Hall, Eric. "A New Idiom in Painting." Letter to *The Sunday Times,* January 24, 1937.

Halliday, Nigel Vaux. *More Than a Bookshop: Zwemmer's and Art in the 20th Century.* London: Philip Wilson Publishers, 1991.

Hawtree, Christopher. "Richard Chopping." *Guardian,* June 13, 2008.

Hay, Susan, ed. *From Paris to Providence: Fashion, Art, and the Tirocchi Dressmakers' Shop, 1915–1947.* Providence, Rhode Island: Museum of Art/Rhode Island School of Design, 2000.

Hebron, Tracey. "Sir Michael Sadler." *Memories of Barnsley,* Winter 2015.

Hensbergen, Gijs van. *Guernica: The Biography of a Twentieth-Century Icon.* London: Bloomsbury, 2004.

Hermosa, Borja. "Sánchez Mejías, the Intellectual Bullfighter, Returns to the Arena." *El País,* January 11, 2018.

Hoare, Philip. "Gaston Berlemont." *Independent,* November 11, 1999.

———. "Obituary: Michael Wishart." *Independent,* Jul 1996.

Hoban, Phoebe. *Lucian Freud: Eyes Wide Open.* Boston: N Harvest, Houghton Mifflin Harcourt, 2013.

Holohan, Renagh. "An Irishwoman's Diary." *The Irish T* October 6, 2009.

Hopkinson, Amanda. "Elsbeth Juda Obituary." *Guar* August 4, 2014.

Horbury, David, ed. *Making Emmanuel Cooper.* Chicago: U versity of Chicago Press, 2020.

Howell, Sarah. "A Model Artist." Profile and int. with Isa Rawsthorne. Tate Archive, 9612.6.5.

Hudson, Mark. "Henry Moore, the Man Behind the My *Daily Telegraph,* February 18, 2010.

Hyman, James. "Fifty Years of Hurt: The Legacy of the I tle for Surrealism." *The Guardian,* September 22, 200

Jackson, Stanley. *Inside Monte Carlo.* London: W. H. A 1975.

Jacobi, Carol. "Picasso's Portraits of Isabel Rawsthor *Burlington Magazine,* September 2017.

Jacobs, Alan. "The Lost World of Benzedrine." *Atla* April 15, 2012.

Jeannerat, Pierre. "Nonsense Art." *Daily Mail,* April 193

Jiminez, Jill Berk, ed., *Dictionary of Artists' Models.* New Yo 2001.

Jobey, Liz. "David Sylvester." *Guardian,* June 20, 2001.

Johnson, David. *The London Blitz: The City Ablaze.* New Yo Stein and Day, 1981.

Johnson, Heather. *Roy de Maistre: The Australian Years.* R eville East, New South Wales: Craftsman House, 198

———. *Roy de Maistre: The English Years.* Roseville East, N South Wales, 1995.

Johnston, Philip, and Ian Cowie. "Labour Rema Haunted by the Sound of Squeaking Pips." *Telegra* June 21, 2003.

Jones, Colin. *Paris: The Biography of a City.* New York: Viki 2005.

Jones, Jonathan. "Portrait of the Week: *Study for Portrait I. After the Life Mask of William Blake, Francis Bacon* (195 *Guardian,* February 23, 2002.

Joule, Barry. "Obituary: Erica Brausen." *Independent,* Dece ber 30, 1992.

Kavanagh, Julie. *Secret Muses: The Life of Frederick Ashton.* N York: Pantheon Books, 1996.

Kearney, Tony. "Special Status for War Memorial to Arth 'Patch' Watson Who Lost His Life at Battle of Pa chendaele." *Durham Times,* July 28, 2017.

Kelly, Debra, and Martyn Cornick, eds. *A History of the Fre in London: Liberty, Equality, Opportunity.* London: School Advanced Study, University of London, Institute of H torical Research, 2013.

Kelly, Jon. "The Era When Gay Spies Were Feared." *B News Magazine,* January 20, 2016.

Kennedy, Maev. "Isabel Rawsthorne: Elusive Painter Who Led the Art World a Merry Dance." *Guardian,* March 26, 2013.

Kennedy, Randy. "Thomas Hoving, Remaker of the Met, Dies at 78." *New York Times,* December 10, 2009.

Kingzett, Richard. "An Exhibition that Failed." *Burlington Magazine,* August 1992.

Klüver, Billy, and Julie Martin. *Kiki's Paris: Artists and Lovers 1900–1930.* New York: Harry Abrams, 1989.

Konody, P. G. "Gayest Art Show: Last Word in Modernism Presents a Puzzle." *Daily Mail,* April 20, 1933.

Kramer, Hilton. "Henry James and the Life of Art." *New Criterion,* April 1993.

Laster, Paul. "Pace Gallery 50th Anniversary: Arne Glimcher." *Daily Beast,* July 14, 2017.

Landau, David. "Gilbert de Botton: Self-Made Financier Who Reveled in Money, Markets and Modern Art." *Guardian,* September 19, 2000.

Lane, Harriet. "Valerie at the Gallery." *Guardian,* January 28, 2006.

L. B. P. "Encouraging Artists, Helpful Movement in London, Present-Day Dangers." *Birmingham Mail,* January 13, 1937.

Lees-Milne, James. "Obituary: Geoffrey Houghton Brown." *Independent,* February 10, 1993.

Lehane, Brendan. *The Companion Guide to Ireland.* Suffolk: Companion Guides, 2001.

Lehmann, John. *In the Purely Pagan Sense.* London: GMP Publishers, 1985.

Leigh, Wendy. *Bowie: The Biography.* New York: Gallery Books, 2014.

Leiris, Julian Michel, and Louise Leiris. In the "Index of Historic Collectors and Dealers of Cubism." The Metropolitan Museum of Art, Leonard A. Lauder Research Center for Modern Art, www.metmuseum.org.

Lessore, Helen. *Partial Testament: Essays on Some Moderns in the Great Tradition.* London: Tate Gallery Publishing, 1987.

Liaut, Jean-Noël. *La Javanaise.* Paris: Robert Laffont, 2011.

Loyau, George E. *Notable South Australians; or, Colonists—Past and Present.* Adelaide: Carey, Page & Co., 1885.

Luke, Michael. *David Tennant and the Gargoyle Years.* London: Weidenfeld and Nicolson, 1991.

Macmillan, Duncan. "Art Review: Robert Colquhoun and Robert MacBryde." *Scotsman,* November 29, 2014.

MacSweeney, Eve. "Angst of the Spirit." *Harper's Bazaar,* October 1989.

Marr, David. *Patrick White: A Life.* London: Jonathan Cape, 1991.

Marvell, Roger. "New Pictures." *New Statesman and Nation,* February 16, 1946.

Mason, Raymond. *At Work in Paris: Raymond Mason on Art and Artists.* London: Thames and Hudson, 2003.

McDowell, R. B. *Land & Learning: Two Irish Clubs.* Dublin: Lilliput Pr Ltd., 1993.

McKever, Rosalind. "The Tate Affair: Then and Now." *Apollo,* August 5, 2014.

Mellor, David. *A Paradise Lost: The Neo-Romantic Imagination in Britain 1935–55.* Exh. cat. London: Barbican Art Gallery, 1987.

Melly, Diana. "London: The Swinging Sixties." *Independent,* October 30, 2005.

Melville, Robert. "The Iconoclasm of Francis Bacon." *World Review,* January 1951.

Miles, Barry. *Call Me Burroughs: A Life.* New York: Grand Central Publishing, 2013.

———. *London Calling: A Countercultural History of London Since 1945.* London: Atlantic Books, 2010.

Miller, Norman. "The Surreal and Colorful Life of Baron Berners." *Daily Telegraph,* July 1, 2016.

Mock, Jean-Yves. *Erica Brausen: Premier Marchand de Francis Bacon.* Paris: Échoppé, 1996. Online translation by Gill Hedley, www.gillhedley.co.uk.

Moraes, Henrietta. *Henrietta.* London: Hamish Hamilton, 1994.

Morgan, Ted. *Literary Outlaw: The Life and Times of William Burroughs.* New York: W. W. Norton and Company, 2012.

Mortimer, Raymond. "At the Lefevre." *New Statesman and Nation,* April 14, 1945.

Morton, James. "Nosher Powell, Obituary." *Guardian,* April 26, 2013.

Mosley, Leonard. *Backs to the Wall: London Under Fire 1939–45.* London: Weidenfeld & Nicolson, 1971.

Mount, Harry. "Why There'll Always Be an Annabel's." *Daily Telegraph,* January 20, 2015.

Moynihan, John. *Restless Lives: The Bohemian World of Rodrigo and Elinor Moynihan.* Bristol: Sansom and Company, 2002.

Mullins, Greg. *Colonial Affairs: Bowles, Burroughs, and Chester Write Tangier.* Madison: The University of Wisconsin Press, 2002.

"Museum of Modern Art Shows Two Major Acquisitions." Press release, Museum of Modern Art, n.d.

Myers, Dennis. "Personal Reminiscence of the 1920s." Tate Archive, TGA968.6.2.

Netto, David. "All Hands on Deco." *Wall Street Journal,* updated April 9, 2011.

Newell, Martin. "Joy of Essex: Cockneys on the Move." *East Anglian Daily Times,* August 10, 2013.

Nietzsche, Friedrich. *The Gay Science.* New York: Vintage, 1974.

No byline. "5,000 Pound Chelsea House Now on Sale for 8.5 Million," *Evening Standard,* July 4, 2011.

———. "Anthony Bacon." *Australian Dictionary of Biography,* Vol I (MUP), 1966.

———. "Art Exhibitions, the Mayor Gallery." *Times,* April 22, 1933.

———. Article on John Edwards in the *East London Advertiser,* March 7, 2002.

———. "Baroness Philippine de Rothschild, Obituary." *Daily Telegraph,* August 27, 2014.

———. "Classics." *The Daily Express,* February 21, 1933.

———. "David Sylvester." *Daily Telegraph,* June 20, 2001.

———. "Dr. Oliver St. John Gogarty Dies." *The New York Times,* September 23, 1957.

———. "Duke and Duchess of Marlborough the First to Build a Palace on the Thoroughfare and Americans Follow." *San Francisco Call,* July 10, 1904.

———. "English Nobility Here for Ceremony." *New York Times,* July 2, 1952.

———. "Gets Downtown Building." *New York Times,* October 10, 1933.

———. "In Memoriam Professor Francis John Anscombe." *Yale News,* October 23, 2001.

———. "Interview with David Sylvester." Frieze art fair publication, September 9, 1996.

———. "John Loxley Firth." *Sheffield Morning Telegraph,* December 27, 1897.

———. "Kenneth Clark." *Burlington Magazine,* May 2014.

———. "Lavish Gowns Seen at a Preview Here: Creations of the Couturier to British Queen Shown." *New York Times,* February 21, 1940.

———. "Maud Lloyd." *Telegraph,* December 1, 2004.

———. "Michel Leiris, 89, French Writer on Surrealism and Anthropology." *New York Times,* October 3 1990.

———. *Morocco Mail,* August 18, 1961.

———. "New Light on the Final Days of Sir Arthur Conan Doyle." *Psypioneer,* July 2006.

———. *Old Malvernian* newsletter, "The Chapel," May 2000.

———. "Sir Michael Sadler's Collection, Leicester Galleries (Art)", January 14, 1944.

———. *Tangier Gazette.* News notes: December 2, 1955; May 18, 1956; June 8, 1956; June 29, 1956; October 5, 1956; February 1, 1957; March 15, 1957; August 23, 1957; November 1, 1957; June 27, 1958; July 18, 1958; April 24, 1959.

———. "Too, Too Symbolic." *Daily Sketch,* April 1933. Article on the opening show at the Mayor Gallery in 1933.

———. "Trade Gets New Mansion." *New York Times,* December 8, 1930.

———. "The Vermilion Lure." *Daily Mail,* April 13, 1933.

———. "Viewing the Moderns." *Sunday Dispatch,* April 23, 1933.

———. "Work of Noted Textile Designers Put on View at New Showroom." *New York Times,* February 27, 1947.

Noel, Gerard. "Obituary: Monsignor Alfred Gilbey." *Independent,* March 28, 1998.

O'Connor, Sean. *Straight Acting: Popular Gay Drama from Wilde to Rattigan.* London: Bloomsbury, 2016.

Ozenfant, Amédée. *Foundations of Modern Art.* Trans. John Rodker. New York: Dover Publications, 1952.

Ozenfant, Amédée, and Charles-Édouard Jeannerat. *La Peinture moderne.* Paris: Les Éditions G. Cres., 1925.

Page-Roberts, James. "A Compressed Life." Jim P-R's Blog, February 28, 2019. webpageroberts.

Paris to Providence: French Couture and the Tirocchi Shop. Exh. cat., edited by Susan Hay. Rhode Island: Museum of Art/Rhode Island School of Design, 1999.

Parkin, Sophie. *The Colony Room Club 1948–2008: A History of Bohemian Soho.* London: Palmtree Publishers, 2013.

Partridge, Frances. *Diaries of Frances Partridge.* London: Phoenix Press, 2001.

Peppiatt, Michael. "Jaime Parladé Creates a Spanish Country Home in Andalucia." *Architectural Digest,* September 2008.

———. *The School of London: Six Figurative Painters.* London: The British Council Visual Arts Publications, 1999.

Picasso Black and White. Exh. cat., Guggenheim Museum, ed. Carmen Giménez. New York, 2012.

Pinchon, Jean-François, ed. *Rob. Mallet-Stevens: Architecture, Furniture, Interior Design. A Collective Work Presented by the Delegation a l'Action Artistique de la Ville de Paris on the Occasion of the Centenary of the Birth of Mallet-Stevens.* Cambridge, Mass.: The MIT Press, 1990.

Plante, David. *Difficult Women: A Memoir of Three.* New York: New York Review Books Classics, 2017.

Pollock, Griselda. "The Missing Future: MoMA and Modern Women." In Cornelia H. Butler and Alexandra Schwartz, eds., *Modern Women: Women Artists in the Collection of the Museum of Modern Art.* New York: Museum of Modern Art, 2010. www.moma.org.

Pop, Andrei, and Mechtild Widrich. *Ugliness: The Non-Beautiful in Art and Theory.* London: I. B. Tauris, International Library of Modern and Contemporary Art, 2014.

Povoledo, Elisabetta. "Chanel, the Woman Who Reads." *New York Times,* Sept. 22, 2016.

Preston, John. "London Calling by Barry Miles: Review." *The Telegraph,* March 7, 2010.

Priestley, J. B. *London Speaks* broadcast. New York: Harper & Brothers, 1940.

Pulsifer, Gary. "Paul Bowles: Obituary." *Guardian,* November 19, 1999.

Purser, Philip. "Richard Levin: Designer Who Gave the BBC Its Visual Identity and Revolutionized Programme Presentation." *Guardian,* July 9, 2000.

Ranvaud, Donald, and Enzo Ungari. *Bertolucci by Bertolucci.* London: Plexus, 1987.

Rasmussen, Frederick N. "Fats Waller, a 'Master of Jazz.'" *Baltimore Sun,* February 2, 2002.

Raverat, G. No headline [description of the opening of the Mayor Gallery]. *Time and Tide,* May 6, 1933.

Read, Herbert. *Art Now: An Introduction to the Theory of Modern Painting and Sculpture.* London: Faber and Faber, 1933.

———. "The Triumph of Picasso." *Listener,* May 27, 1936.

Redfield, James Adam. "The Surreal Effect of L'afrique fantome: A Preliminary Descriptive Analysis," https://www.academia.edu.

Reif, Rita. "At Auction Wallets Were Close to the Vest." *New York Times,* May 21, 1981.

Richardson, John. *The Sorcerer's Apprentice: Picasso, Provence and Douglas Cooper.* Chicago: University of Chicago Press, 2001.

Riding, Alan. "Prado Opens the Largest Show of Velázquez's Work Ever Held." *The New York Times,* January 25, 1990.

Risen, Clay. "The Legacy of the 1968 Riots." *Guardian,* April 4, 2008.

Ritchie, Andrew Carnduff, ed. *The New Decade: 22 European Painters and Sculptors.* New York: Museum of Modern Art, 1955.

Roberts, Sam. "Christopher Gibbs, Avatar of 'Swinging London,' Dies at 80." *New York Times,* August 3, 2018.

Rockwell, John. "Boulez and Stein Stage 'Pelleas' with Modern Nuances in Wales." *New York Times,* February 24, 1992.

Rogers, Ben. *A. J. Ayer: A Life.* New York: Grove Press, 1999.

Ross, Rory. "Finger on de Botton." *Tatler,* March 2000.

Rothenstein, John. *Brave Day Hideous Night. Autobiography 1939–1965.* London: Hamish Hamilton, 1966.

———. *Modern English Painters.* London: Macdonald & Co., 1984.

———. *Time's Thievish Progress.* London: Cassell, 1970.

———. Unpublished diaries, 1939–1990. Tate Archive, 8726/1.

Russell, John. "Art View: The Time and the Place for Velazquez." *New York Times,* April 1, 1990.

———. "In 1936 Surrealism Ruled the Creative Roost." *New York Times*, March 30, 1986.

———. "Sir Lawrence Gowing, a Painter, Writer, Curator and Teacher, 72." *New York Times,* February 7, 1991.

Rutter, Frank. "Gangster Art: A Hold-up in Cork Street." *Sunday Times,* October 15, 1933.

———. "A New Idiom? Abstraction at Agnew's." *Sunday Times,* January 17, 1937.

Sansom, William. *The Blitz: Westminster at War.* London: Faber and Faber, 2011.

Schjeldahl, Peter. "Post-Script: Hilton Kramer." *New Yorker,* March 28, 2012.

Schoenberger, Nancy. *Dangerous Muse: The Life of Lady Caroline Blackwood.* London: Weidenfeld & Nicolson, 2001.

Schrenck-Notzing, Baron von. *Phenomena of Materialisation.* Trans. E. E. Fournier d'Albe. London: Kegan Paul, 1920.

Shone, Richard. "Benedict Nicolson: A Portrait." *Burlington Magazine*, February 2004.

Schumacher, Michael. *Dharma Lion: A Biography of Allen Ginsberg.* New York: St. Martin's Press, 1992.

Smart, Jeffrey. *Not Quite Straight: A Memoir.* Melbourne: Wililam Heinemann Australia, 1996.

Smith, Oliver. "The Krays in London: 15 Sites Associated with the Twins." *Daily Telegraph,* September 15, 2015.

Smith, Roberta. "Frank Lloyd, Prominent Art Dealer Convicted in the '70s Rothko Scandal, Dies at 86." *The New York Times,* April 8, 1998.

Soby, James Thrall. *After Picasso.* New York: E. V. Mitchell, 1935.

Sommer, Andreas. "Albert von Schrenk-Notzing and Albert Moll: Policing Epistemic Deviance." *Journals of Medical History, Cambridge,* April 2012.

Souhami, Diana. "Lord Berners, the Last Eccentric." *Independent,* March 21, 1998.

Spalding, Frances. *John Minton: Dance Till the Stars Come Down.* Alershot, Hants: Holder and Stoughton, 1991.

Spender, Stephen. "Comment." *Horizon,* July 1945.

———. *Journals 1939–1983.* Ed. John Goldsmith. London: Faber and Faber, 1985.

———. *World Within World: The Autobiography of Stephen Spender.* New York: Modern Library, 2001.

Spurling, Hilary. "Matisse v. Picasso." *Daily Telegraph,* April 27, 2002.

———. *The Girl from the Fiction Department: A Portrait of Sonia Orwell.* Berkeley: Counterpoint, 2004.

———. *Ivy: The Life of I. Compton-Burnett.* London, 1974.

Stanford, W. B. *Aeschylus in His Style.* Dublin: Dublin University Press, 1942.

Stansky, Peter. *The First Day of the Blitz: September 7, 1940.* New Haven and London: Yale University Press, 2007.

Stone, Peter. *The History of the Port of London: A Vast Emporium of All Nations.* London: Pen and Sword History, 2007.

Strachey, John. *Digging for Mrs. Miller: Some Experiences of an Air-Raid Warden.* New York: Random House, 1941.

Strong, Roy. *The Roy Strong Diaries 1967–1987.* London: Weidenfeld & Nicolson, 1997.

Stuart, Donald Clive. *The Development of Dramatic Art.* New York and London: Dover Publications, 1928.

Sylvester, David. *Looking at Giacometti.* New York: Holt Paperbacks, 1997.

Taki. "Tell Me What Happened Last Night. Were the Tarts Pretty?" *Daily Telegraph,* January 26, 2003.

Tallon, Andrew. *Urban Regeneration in the U.K.* London: Routledge, 2013.

Taylor, Brandon. "Picasso and the Psychoanalysts." In Andrei Pop and Mechtild Widrich, eds. *All from Ugliness: The Non-beautiful in Art and Theory.* London: I.B. Tauris, 2014.

Thomas, Andy. "Nightclubbing: Guy Cuevas and the Paris Disco Scene." *Red Bull Music Academy Daily*, January 28, 2016.

Thompson, John. "Self-Made: Towards a Life of Rex Nan Kivall." In *Paradies Possessed: The Rex Nan Kivall Collection,* exh. cat. Canberra, Australia, 1998.

Thorpe, Juliet. "Darwin's Dream: The Significance of Painting and Its Collection at the Royal College of

Art 1948–1998." Master's thesis, Royal College of Art, 2012.

Transition: The London Art Scene in the Fifties. Exh. cat., text by Martin Harrison. Barbican Art Galleries, London, 2002.

Tyerman, Christopher. *A History of Harrow School 1324–1991.* Oxford: Oxford University Press, 2000.

Valjak, Domagoj. "Influential Writer William Burroughs Accidentally Shot and Killed His Wife While Demonstrating His 'William Tell' Act." *Vintage News,* January 25, 2017.

Vaughan, Keith. *Keith Vaughan, Journals 1939–1977.* Intro. Alan Ross. London: Faber and Faber, 2010.

Vergano, Dan. "Fear of Floating." *Smithsonian Air & Space Magazine,* July 2009.

Vyner, Harriet. *Groovy Bob: The Life and Times of Robert Fraser.* London: Heni Publishing, 2017.

Walker, Alan Yuill. *The Scots & the Turf: Racing and Breeding—the Scottish Influence.* Edinburgh: Black and White Publishing, 2017.

Ward, Ossian. "How Wassily Kandinsky's Synesthesia Changed Art." *Daily Telegraph,* December 16, 2014.

Warwick, Josh. "Order of Merit: Who Deserves Membership of the Most Exclusive Club in the World." *Daily Telegraph,* December 13, 2013.

Waterhouse, Keith. "My Soho." *Evening Standard,* April 12, 2001.

Watson, Tim. "The Horticulturalist of the Self." December 22, 2017, www.publicbooks.org.

Weightman, John. "Malraux: Behind the Mask." *New York Review of Books*, October 6, 1966.

Welch, David. *World War II Propaganda: Analyzing the Art of Persuasion During Wartime.* Santa Barbara: ABC-Clio, 2017.

Welch, Denton. "Sickert at St. Peter's." *Horizon,* August 1942.

Wheatcroft, Geoffrey. "Den Mother to the Louche and Famous." *New York Times,* June 5, 2009.

White, Patrick. *Flaws in the Glass: A Self-Portrait.* London: Jonathan Cape, 1981.

Whitney, Charles, *At Close Quarters: Dean Close School, 1884–2009.* Little Logaston, UK, 2009.

Wildeblood, Peter. *Against the Law.* London: Phoenix, 1955.

Wilk, Christopher. *Marcel Breuer: Furniture and Interiors.* Exh. cat. New York: Museum of Modern Art, 1981.

Williams, Charlotte, and Evelyn A. Williams, eds. *Denis Williams: A Life in Works, New and Collected Essays.* Amsterdam: Rodopi, 2010.

Williamson, Marcus. "David Somerset, Society Grandee: Obituary." *Independent,* August 22, 2017.

Wilson, A. N. "Hawking's Hot Line to the Mind of God." *Sunday Telegraph*, May 3, 1992.

Wilson, Alyson. "Housed in Art History—Parts I and II." *Art Quarterly,* Spring 1994 and Winter 1996. Wilson, Laurie. *Alberto Giacometti: Myth, Magic and the Man.* New Haven: Yale University Press, 2003.

Wishart, Michael. *High Diver.* London: Blond and Briggs, 1977.

Wolfenden Report. Parliamentary Papers, British Library, www.bl.uk.

Wolff, Rachel. "Fifty Years of Being Modern." *New York Magazine,* February 6, 2009.

Wroe, Nicholas. "Guardian Profile: David Sylvester: Sacred Monster, National Treasure." *The Guardian*, July 1, 2000.

Index

Page numbers in *italics* refer to illustrations. FB refers to Francis Bacon.

Abelló, Juan, 698, 811
abstract art, 151, 342, 358, 387–8, 424, 430, 431, 437, 489, 554, 634, 733
abstract expressionism, 358, 387, 469, 489, 560, 777
Abstraction (Figure) (Picasso), 118
Académie Colarossi (Paris), 75–6
Académie Julian (Paris), 75–6
Adam, Peter, 80
Adès, Dawn, 74
Adnet, Jacques, 108, 724
Aeschylus, 200–1, 209, 211, 215, 219, 221, 454, 464, 493, 580, 681
Aeschylus in His Style: A Study in Language and Personality (Stanford), 200–1, 742
After Picasso (Soby), 233
After the Bath, Woman Drying Herself (Degas), 483, 644
Aga Khan, 43
Agar, Eileen, 233
The Age of Illusion: England in the Twenties and Thirties (Blythe), 55, 178
Agnelli, Gianni, 406
Agnew, Geoffrey, 168, 733
Agnew gallery. *See* Thomas Agnew & Sons gallery
Air Raid Precautions (ARP) program, 181–2, *182*, 203, 735, 736
Alex Reid & Lefevre gallery (London), 117
Algonquin Hotel (New York), 511, 513, 558
Allden, Eric: background of, 91–2; characterization of FB by, 92, 19; Diana Watson and, 153; diaries of, 720, 721, 724, 746; Douglas Cooper and, 147–8, 153, 154; Eric Hall and, 129, 132; on FB's artistic inspirations, 149; on FB's *Crucifixion,* 152; FB's family and, 174, 175, 257, 721; FB's illnesses and, 94, 162; FB's works owned by, 100, 114, 119, 157, 158–9, 171, 724–5; friendships of, 113; in Ireland with FB, 93–8, 173; photo of, *88*; relationship with FB, 88–91, 98–100, 102, 106, 118–19, 120, 124, 155, 215, 229, 328, 659; Roy de Maistre and, 132, 136, 729; on *Transition* exhibition, 157, 158; travels with FB, 109; on Winnie Bacon's marriage, 203
Allden, Francisca Maria Stubbs, 91
Allden, John Horatio, 91
Allen, Herbert, 360–1
Alley, Ronald, 100, 114, 367, 453, 738, 753
Alloway, Lawrence, 331, 440

All Quiet on the Western Front (Remarque), 95
Allsop, Kenneth, 413, 763
All We Know: Three Lives (Cohen), 82, 105
Almudena Cemetery (Cementerio de Nuestra Señora de La Almudena, Madrid), 701
The Ambassador (journal of textiles and fashion), 305
Amis, Kingsley, 497, 539
Amory, Mark, 292
Anderson, Colin, 208, 216, 232, 235, 240, 256–8, 261, 264, 303, 306, 349–50, 452, 739, 772
Andrews, Michael, 360, 477, 488, 489
Anglo-Irish: Bacon family as, 4, 13–14, 38; estates in Ireland owned by, 40; Irish "bad times" and, 35, 37, 38; schools and, 46; social standing in Ireland of, 14, 21, 43, 96
The Anglo-Irish Tradition (Beckett), 35
Annabel's nightclub (London), 486, 660
Anscombe, F. J., 333
Anthony, Gordon, 202
Anthony d'Offay Gallery (London), 543, 596
anti-Semitism, 193, 280, 406
Apollo Magazine, 3
Appiah, Kwame Anthony, 502
The Apple Cart (Shaw), 99
Archimbaud, Michel, 670, 690–1, 692, 694, 695, 696, 810
Armstrong, John, 100, 147, 167
Armstrong, William George, 20, 30
Armstrong Mitchell & Co., 20, 29
Armstrong Siddeley, 339
Art and Architecture, 367
art deco, 79, 84, 100, 107, 108, 719
"The Artist's Eye" series (National Gallery), 644
Artner, Alan, 672, 673
ArtNews, 367, 636, 666, 799
art nouveau, 79
Art Now (Read), 150–3, 167, 206, 233, 235, 283, 730
Art Now exhibition, 150–2, 167, 730
Arts Council, 260, 319, 452, 515, 590
Arundell-Brown, Tom, 101
Ash, Joseph, 337
Ash & Lacy, 337
Ashbery, John, 502
Ashcroft, Peggy, 113
Ashmolean Museum (Oxford), 738
Ashton, Frederick, 81, 428, 656, 657–8, 803
Ash Wednesday (Eliot), 535
Asquith, H. H., 710
Association of Oaks (Sutherland), 209

Astor, Michael, 384

Athenaeum club (London), 333, 453

Atlas-Manuel des maladies de la bouche, du pharynx, et des fosses nasales (Grünwald), 72

At the Sign of the Black Manikin bookstore (Paris), 77

Auden, W. H., 6, 61, 64, 178, 210, 281, 662, 709

Auerbach, Frank, 401, 445–6, 473, 488, 489, 542, 595, 611, 686, 793

Auntie Mary's (Suffolk), 540

Australia, 16, 81, 110, 111, 146, 176, 183, 574, 723, 724

Auty, Giles, 432–3, 478

Avedon, Richard, 557, 608, 691

Ayer, A. J., 247

Ayrton, Michael, 209, 226, 358, 361

Backs to the Wall: London under Fire 1939–45 (Mosley), 187

Bacon, Alice Lawrence (FB's grandmother), 28, 712, 723

Bacon, Anthony (FB's great-great-great-grandfather), 16–17

Bacon, Anthony (FB's great-great-grandfather), 16–17

Bacon, Anthony, General (FB's great-grandfather), 15–16, 26, 185, 710

Bacon, Anthony Edward (Eddy) Mortimer, Major (FB's father): birth and early life of, 15, 16; at Bradford Peverell, 174; character of, 14–15, 17, 25, 32, 49, 97; deaths of sons and, 58, 59, 93, 97; education of, 18, 41, 129; family background of, 15–17; foxhunting and, 33, 713; horses as interest of, 13, 18, 21, 25, 27, 33, 39, 110, 128, 711; illness and death of, 184, 185–6; Ireland and, 20–1, 36, 38–9, 173; marriage of, 9, 19, 20–1, 32; military career of, 18–19, 28, 181; relationship with FB, 13, 24–7, 33, 34, 46, 49, 59–60, 68, 90, 93; relationship with Granny Supple, 42; view of homosexuality, 50, 51

Bacon, Charlotte Harley (FB's great-grandmother), 14, 15–16, 17, 185

Bacon, Christina Winifred (Winnie) Firth (FB's mother): births of children of, 23, 27, 28, 32; at Bradford Peverell, 174, 739; cooking skill of, 33; death of, 517; death of husband and, 185, 203; death of son and, 58; emigration to South Africa, 257, 323; family background of, 18, 29, 715–16; with FB and Eric Allden, 96–7, 174; FB's asthma and, 13; FB's Berlin trip and, 60; FB's design career and, 107–9; financial support for FB, 89–90, 93, 98, 120, 164, 252; ill health of, 506–7; indifference to FB's art, 174, 175, 227, 742; marriage of, 19, 20–2, 32, 93, 97; photos of, *22*, *506*; relationship with FB, 24, 93, 95, 780; view of homosexuality, 50, 51, 173

Bacon, Edward (FB's brother), 15, 28, 32, 44–5, 57–8, 93, 712, 714, 716

Bacon, Edward (FB's grandfather), 17

Bacon, Francis: acting ambition of, 44, 45, 52; aesthetic tastes of, 76, 85, 116, 123–4, 203, 205; alcohol use by, 5, 7, 122, 191, 214, 271, 355, 360, 364, 370, 376, 410, 414, 444, 454, 457, 492, 532, 537–8, 571, 624, 695, 786, 802; animals and, 13, 25–6, 34, 50, 72, 107, 222, 280; appearance of, 5–6, 43, 48, 55, 67, 68, 71, 88, 92, 132, 172–3, 191, 239, 275, 287, 377, 394, 412, 431, 532, 626, 627, 628, 629–30, 631, 637, 686, 690, 724, 798; as asthma sufferer, 5, 7, 13, 20, 26, 27, 29, 34, 38, 43, 51, 58, 93, 177, 181, 184–5, 186, 193, 365, 370, 411, 455, 487, 571, 574, 617, 623, 655, 665, 674, 676, 689–90, 709–10, 721, 797; attire of, 71, 173, 377, 412, 456–7, 483, 569, 572, 586, 616, 626, 627, 637, 661, 667, 669, 696, 701, 750, 755, 773, 777, 798, 810; awards refused by, 643–4, 801; baptism of, 23; in Berlin, 55, 59–68, 85, 161–2, 642–3, 732; birth of, 4, 23; book proposals about, 443–5, 550–1, 555, 644–5, 771; as businessman, 117; cannabis arrest of, 515–17, 781; in Cannes, 396, 400, 416, 423–4, 767; as celebrity, 7, 9, 520, 525, 534, 558, 567, 570, 574, 586, 592, 617, 618, 656, 663; character of, 4–9, 51–2, 155, 191, 199, 211, 279–80, 325, 624–30, 686–90, 695, 702; childhood of, 23–7, 34, 53, 711; as conversationalist, 70, 73, 435, 541–2, 569, 657, 689–90, 694–5, 702; cooking skill of, 33, 55, 98, 165, 175, 296, 464, 466, 474, 650, 675; death of, 4, 701–5, 811, 812; at death of brothers, 58–9; at death of father, 185–6; at death of Nanny Lightfoot, 327–8; as designer, 78–9, 83–6, 88–9, 99, 100–3, 104–9, 114–17, 120, 121, 132, 160, 178, 203, 311, 464, 725–6, 732; drug use by, 7, 27, 159, 162, 364–5, 370, 381, 447, 513, 520, 532, 624, 681, 760, 781; early exposure to art, 29, 47–8, 64, 65–6, 75, 99–100; education of, 5, 29, 38, 40–1, 45–9, 192, 211, 568; in Egypt, 326–7; eightieth birthday of, 674, 678, 809; erotica collected by, 71–2; estate of, 678–9, 755; family background of, 13–23; family relationships of, 537–8, 791 (*see also individual family members*); fascism as interest of, 161, 737, 738; film as interest of, 64–5, 118, 213, 293, 330, 474, 533; finances of, 89–90, 93, 98, 120, 132, 133, 153, 160, 162, 164, 166, 173, 235, 236, 240, 251–2, 255–9, 261, 264, 311, 316, 325–6, 329, 334, 349–50, 389, 399, 405–6, 414, 420, 421, 432, 447, 587–90, 619, 762, 765, 772, 790–1, 806; friendships of, 8, 30, 34, 35, 43–4, 177, 182, 210–14, 362, 374–5, 544, 565–6, 592–8, 638, 647–51, 662, 671, 685–7, 694, 695, 699, 810 (*see also specific individuals*); friends' illnesses and, 602–5; funeral preference of, 692; as gambler, 172, 204, 206, 240–2, 251, 255, 256, 303–4, 343, 349, 350, 366, 377, 387, 396, 416, 418, 447, 484, 493, 504, 537, 566, 590, 594, 616, 646, 734, 739, 771, 776; homosexuality of, 4, 5, 6, 7, 8, 9, 13, 49, 50–1, 54–5, 61, 64, 67, 86, 90, 155, 173, 199, 206, 233, 280, 290, 369, 444, 469, 505–6, 517, 562, 595, 639, 666, 680, 759, 782, 797; humor of, 237, 355, 440, 540; as hustler, 121, 162, 164; intelligence of, 41, 42; interviews with, 467–8, 695–6; Ireland and, 23–7, 30, 34, 36–8, 53, 94–8, 174, 695; isolation/loneliness of, 26, 34, 37, 42, 44, 50, 54, 147, 176, 192, 645, 649, 662, 685, 691; jobs held by, 55–6, 128, 164, 316–18;

languages spoken by, 68, 70, 76, 86, 89, 161, 522, 586, 594, 598, 658; long-term relationships of, 748 (*see also* Allden, Eric; Belton, Ron; Capelo, José; Dyer, George; Edwards, John; Hall, Eric; Lacy, Peter); mental health of, 94, 118, 381, 445–6, 447; in Monte Carlo, 239–44, 248–9, 251, 252, 253, 257, 264, 278, 289, 303–5, 329, 366, 492–3, 601; in New York, 511–13, 556–63, 618; as oenophile, 204, 598, 616, 625, 650, 657, 690, 691; opinions on other artists, 596, 629, 686, 702, 742, 787, 792; in Paris, 65, 68, 69–87, 120, 125, 134, 148, 192, 244–5, 501, 503, 504, 548–9, 564–7, 568–71, 611–12, 654, 677, 693; photos of, *11, 22, 39, 67, 182, 223, 278, 285, 376, 378, 395, 398, 483, 493, 506, 521, 523, 527, 556, 572, 581, 597, 599, 618, 628, 647, 698*; physical health of, 7, 26, 93, 94, 162, 184–5, 186, 189, 192, 203, 258, 370, 425–6, 454, 545, 604, 623, 674–6, 678, 680–1, 691–3, 694, 696–701, 769, 806; politics of, 487, 506, 629, 665; portraits of, 114, 116, *117,* 133–4, *134,* 173, 332, *332,* 600–1, *648,* 724; privacy of, 175, 496; public image of, 7, 86–7, 444, 466–7, 522, 525–6, 703; reading habits of, 41–2, 71, 88, 92, 94, 117, 193, 464, 569, 573; religion and, 6, 8, 40, 42, 58, 124, 138, 206, 226, 244, 454, 533–4, 702; reputation of, 243, 266, 292, 303, 311, 317, 343, 361, 393, 402, 421, 423, 424–5, 442, 448–9, 456, 548, 555, 561, 639; in Rome, 377–9; at Rothermeres' ball, 291–2, 308, 395, 750; at Royal College of Art, 316–18, 342, 357–61; self-confidence of, 159, 176, 192, 199, 211, 215, 253, 595; sexual attractions for, 49–50, 55, 67, 90, 112, 163, 276, 356, 397, 414, 427, 484, 485, 543, 624, 683, 748; sexual experiences of, 60, 64, 67, 77, 90, 121, 215, 386–7, 428, 715, 777; shyness of, 5, 27, 34, 41, 43, 46–7, 68, 280, 571, 655; social class and, 13–14, 62, 122, 280, 428, 484, 711; social skills of, 43–4, 48, 53, 69, 90, 191, 266, 540–1, 593, 669; Soho life of, 212, 214, 215, 228, 243, 266–77, 311, 334, 382, 415, 484, 488, 566, 648, 688–9; in South Africa, 321, 322–5, 341–2, 352, 506–8; spiritualism and, 72, 94, 150, 289, 294, 303–4, 315, 547, 721; sports and, 43, 47, 778; in St. Ives, Cornwall, 429–34, 435, 437, 445, 464; success and, 151–4, 227, 305; in Tangier, 393–9, 405, 408–14, 417–18, 419, 424, 426–7, 446–7, 450–1, 459, 495, 763, 764, 766; views on death, 58, 59, 327, 454, 531, 534–6, 545, 546–7, 624, 653–4, 675–6, 680, 692, 699, 703–4; views on hunting, 52, 133; views on love, 163, 286, 290, 336, 525, 574; views on modern art, 413, 558; views on sex, 683; wartime service of, 181–3, 186–9, 735, 736; wine label designed by, 691, *692,* 809; women as influences on, 70, 81, 87, 90, 490, 498, 548; worldview of, 124, 162–3, 194–5, 389, 714; World War II effect on, 193–8, 201, 209

Bacon, Francis, as artist: ambition of, 88, 148, 155, 192–3, 197; catalogue raísonné, 100, 114, 170, 264, 367, 401, 442, 452, 453, 645, 649, 722, 753, 761, 773; collectors of work by, 216, 232, 332, 383–5, 387, 441; commissions for work by, 153–4, 160, 178, 384, 416; destruction of own work by, 8, 148, 159, 165, 195, 231, 264–5, 303, 305, 314, 365, 384–5, 436, 591, 615, 633, 634, 646, 682, 697, 753; draftsmanship of, 76, 149, 165, 229, 329, 596, 606, 632; early work by, 95, 96, 100, 109–10, 112, 114, 116, 134, 136; as figurative painter, 125, 192, 197, 286, 292, 293–4, 296–7, 425, 431, 434, 437–8, 443, 470, 481, 488, 512, 559, 560, 633–4, 703, 738; frames for paintings of, 124, 231, 232, 296, 297–8, 331–2, 618, 637; imagery used by (*see* imagery in FB's work); influences on, 6, 9, 50, 53, 71–4, 78–9, 81, 84, 100, 123, 134–40, 149, 150, 161, 195–6, 206, 445 (*see also* Gogh, Vincent van; Nietzsche, Friedrich; old masters; Picasso, Pablo; Sutherland, Graham; Velázquez, Diego); landscape painting by, 601, 633, 639; life masks and, 381, 405, 443, 600–1, 761; in London school of painters, 488–9; modernism and, 85, 106, 107, 134, 136, 148, 151, 206, 346–7, 438, 525–6, 555, 703; in 1960s art world, 487–8, 489, 497; photography as influence on, 195–6, 198, 220, 272, 282, 285–6, 293–4, *295,* 330, 346–8, 356, 367–8, *368,* 456, 490, 491, 671, 676, 737; as portrait painter, 431, 434–6, 481–2, 488, 499, 584, 599–600, 630, 797; pricing and, 301, 385, 406, 421, 585, 619, 768; sales and, 156, 157, 166, 170, 171, 232, 234–5, 303, 316, 332–3, 352, 378, 387, 388, 389, 419, 441, 470, 567, 618, 743, 757, 791, 796; scholarly interest in, 9, 551, 744; self-criticism by, 8, 159, 176, 199, 249, 384, 431, 550; self-portraits by, 286, 459, 505, 532, 545, 558, 579, 584, 608, 653, 680, 681–2; sizes of paintings by, 244, 299, 312, 316, 350, 367, 577; style of, 117, 123, 135, 148, 159, 195, 198, 201, 360, 560, 631–4, 672–3; surrealism and, 166–8, 170, 218, 445, 697, 742; techniques used by (*see* techniques in FB's work); themes of (*see* themes in FB's work); training of, 75–6, 86, 117, 123, 134, 139, 141, 165, 192, 205, 293, 318, 444, 728; work ethic of, 7, 165, 183, 211, 241, 267, 305, 363, 365, 367, 399, 400, 414, 419, 430, 432, 454, 484, 683, 694, 695, 705

Bacon, Francis, exhibitions: at Agnew gallery (1937), 169–71, 199; in *Art Now* exhibition (1933), 151; at Beaux Arts Gallery (1953), 352, 375; at Durlacher (1953), 366–9, 408, 414, 415, 419, 759; at Galeria Theo (1977), 661; at Galerie Claude Bernard (1977), 584–7; at Galerie Lelong (1987), 653, 654–5, *654*; at Galerie Maeght (1966), 501, 503–4, 506, 510, 586; at Galerie Maeght-Lelong (1984), 617; at Galerie Rive Droite (1957), 399–403; Grand Palais retrospective (1971), 518–26, 531, 534–5, 554, 572, 635, 637, 782, 783, 799; Guggenheim retrospective (1963), 469–70, 774; at Hanover Gallery (1949), 292, 298–303, 422; (1950), 304, 312–16; (1951), 332, 343; (1952), 357, 363–4; (1957), 402, 406; (1959), 422; Hirshhorn Museum retrospective (1989), 669–71, 672–4, 806; Institute of Contemporary Arts retrospective (1955), 380–1; in Italy (1958), 419; at Knoedler Gallery (1959; canceled), 423,

Bacon, Francis, exhibitions (*continued*):
424, 425; at Lefevre Gallery (1945), 3–4, 217–19, 221, 225–8, 298, 304; (1946), 231, 234; at Marlborough Fine Art Gallery (1960), 434, 442, 445; (1965), 552; 1967, 507; at Marlborough-Gerson Gallery (1968), 510, 511–12; at Mayor Gallery (1933), 147, 148, 174; at Metropolitan Museum of Art (1975), 553–63, 618; in Moscow (1988), 652–3, 663–7, 805; at Musée Cantini (1976), 576, 578–9; at Queensberry Mews (1930), 113–16, 723–4; at Redfern Gallery (1948), 263; at Tate Gallery (1962 retrospective), 452–62, 463, 620, 621, 635–40, 642, 657, 672; (1985), retrospective, 620, 621, 635–40, 642, 672; at Tate Liverpool (1990), 681; at Transition Gallery (1934), 155–7, 158–9, 297, 634; for UNESCO (1946), 244–5; at Venice Biennale (1954), 375, 378

Bacon, Francis, works: *Abstraction*, 168, 170, 171; *Abstraction from the Human Form*, 168, 170, 171; *After Picasso, "La Danse,"* 140, 153; black triptychs, 559, 579, 681, 688; *Blood on Pavement*, 634; *Chimpanzee*, 385; *Composition (Figure)*, 156; *Composition (Figures)*, 156; *Crucifixion*, 151–3, 167, 206, 218, 235, 256, 283, 456, 730; *Dark Child*, 114; *Dog*, 352–3, 757; *Figure at a Washbasin*, 807; *Figure in a Landscape*, 218, 219, 221, 227–8, 230, 234, 300, 333, 774; *Figure in Mountain Landscape*, 400–1, 416; *Figure in Movement*, 579, 793; *Figure in Sea*, 768; *Figures in a Garden*, 170–1; *Figure Study I*, 230, 232, 332, 633–4; *Figure Study II*, 230–1, 232, 303; *Figure with Meat*, 380; *Figure with Monkey*, 332, 333; *Figure Writing Reflected in Mirror*, 807; final, unfinished painting (untitled), 704; *Fragment of a Crucifixion*, 315, 353; *Fury*, 230, 755; *Head*, 280; *Head I, 2*, 263–4, 265, 266, 292, 297, 298, 347, 752; *Head II*, 264, 298, 303; *Head III*, 298–9, 303; *Head IV (Man with a Monkey)*, 299, 303; *Head V*, 299, 303; *Head VI*, 299, 303, 306–7, 312; *Head in Ecstasy*, 156, 157, 158–9; *House in Barbados*, 356–7, 427, 433, 450; *In Memory of George Dyer*, 534–5, 559; *Interior of a Room*, 148–9; *Jet of Water*, 602, 633, 664, 666; *Landscape* (1952), 324, 352; *Landscape* (1978), 594–5, 601, 633; *Landscape near Malabata, Tangier*, 459–60, 595; *Landscape with Colonnade*, 198; *Lying Figure*, 423, 434; "Mafia triptych," 591, 792; *Man at a Washbasin*, 807; *Man Carrying a Child*, 459; *Man in a Cap*, 197, 738; *Man in Blue I*, 380; *Man in Blue* series, 373, 375, 378, 738; *Man Standing*, 197, 738; *Painting* (1929–30), 114; *Painting* (1950), 315–16; *Painting 1929*, 724; *Painting 1946*, 234, 235, 236–7, 243–4, 252, 256, 266, 312, 315, 366, 635, 636, 743; *Pope I*, 332; *Pope with Owls*, 420; *Portrait of a Dwarf*, 578, 579; *Portrait of George Dyer Riding a Bicycle*, 481; *Portrait of Isabel Rawsthorne Standing in a Street in Soho*, 296, 498–9, 510; *Portrait of Jacques Dupin*, 676, 679; *Portrait of Michel Leiris*, 584, 678; *Portrait of R. J. Sainsbury*, 384; *Reclining Figure*, 431; *Sand Dune* (1981), 633; *Sand Dune* (1983), 633; *The Sculptor*, 171; *Seated Figure*, 439, 793; *Seated Man*, 738; *Second Version of Triptych 1944*, 670–1, 673–4, 684; *Self-Portrait, 1987*, 671; *Self-Portrait with Injured Eye*, 532; *Sketch for a Portrait of Lisa*, 385

Sleeping Figure, 619; *Sphinx*, 380; *Sphinx—Portrait of Muriel Belcher*, 604–5; *Study from Portrait of Pope Innocent X*, 670; *Studies from the Human Body* (1975), 577; *Studies of the Human Body* (1979), 632; *Studio Interior*, 697; *Study after Velázquez's Portrait of Pope Innocent X*, 757; *Study for a Portrait* (1953), 366, 757; *Study for a Portrait* (1979), 607; *Study for a Portrait of John Edwards* (1988), 664; *Study for a Portrait of John Edwards* (1989), 667; *Study for Bullfight No. #1*, 519; *Study for Portrait*, 299, 390; *Study for Portrait of P.L.*, 416; *Study for Portrait of van Gogh I*, 388, 400; *Study for Portrait of van Gogh II*, 403–4; *Study for Self-Portrait*, 605; *Study for Three Heads*, 459, 680; *Study from the Human Body*, 299, 301, 303, 807; *Study of a Baboon*, 368, 443; *Study of a Bull*, 704, 812; *Study of a Nude*, 384; *Study of George*, 782; *Study of George Dyer*, 782; *Study of the Human Body, 1981–82*, 632–3; *Three Figures and Portrait*, 578, 579; *Three Figures in a Room*, 482–3, 518, 523; *Three Portraits—Posthumous Portrait of George Dyer; Self-Portrait; Portrait of Lucian Freud*, 536, 680; *Three Studies for a Crucifixion*, 461–2, 469, 644; *Three Studies for a Portrait*, 682; *Three Studies for a Portrait of John Edwards*, 607–8; *Three Studies for Figures at the Base of a Crucifixion*, 3, 141, 149, 219, 221–2, 226, 227, 229, 230, 232, 234, 235, 266, 288, 298, 300, 304, 312, 315, 375, 454, 455, 462, 632, 666, 670, 691, 742, 755; *Three Studies for Self-Portrait, 1980*, 608; *Three Studies of Henrietta Moraes*, 491; *Three Studies of Lucian Freud*, 518; *Three Studies of the Male Back*, 782, 807; *Trees by the Sea*, 114, 724; *Triptych* (1970), 520, 782; *Triptych* (1991), 680–4; *Triptych, 1976*, 578–80, 586, 691; *Triptych, 1987*, 653–4, 681, 682; *Triptych August 1972*, 536, 664, 681, 682; *Triptych May–June 1973*, 536, 546–7, 559; *Two Americans*, 378; *Two Figures (The Wrestlers)*, 280, 370, 371, 380, 541, 543–4, 596, 635; *Two Figures, 1975*, 578; *Two Figures in the Grass*, 380; *Watercolour*, 100, 135, 728; *Woman in the Sunlight*, 147, 148; *Wound for a Crucifixion*, 156, 159, 160, 634

Bacon, Francis (statesman-philosopher), 15, 17, 41, 142
Bacon, Harley (FB's brother), 14, 23–4, 26, 28–9, 33, 49, 59, 93, 97, 713
Bacon, Ianthe (FB's sister). *See* Knott, Ianthe Bacon
Bacon, Nathaniel, 17
Bacon, Nicholas, 17
Bacon, Picasso: The Life of Images (Baldassari), 74
Bacon, Winifred (FB's sister). *See* Stephenson, Winifred Bacon
Bacon and Sutherland (Hammer), 206, 217–18
Badovici, Jean, 719
Bagshaw Museum (West Yorkshire), 232
Baigneuse (Picasso), 118
Bailey, David, 616
Bailey, James, 336
Bain & Company, 658–9, 675, 678, 679, 683
Le Bain Turk (The Turkish Bath; Ingres), 632, 644
Baker, Tom, 614
Balanchine, George, 319

Baldassari, Anne, 74, 135
Ballets Russes, 143
Balniel, Lord (David Lindsay), 166
Balthus, 240, 245, 247, 262, 548, 549–50
Balzac, Honoré de, 83, 568
Bamburgh Castle (Northumberland), 29–30, 283–4
Bang to Rights (Norman), 438
Barbados, 336, 340, 356, 394, 427, 450, 756
Barbette, 123
Bar Cock (Madrid), 660–1, *660, 698, 698,* 804
Bar Escoba (London), 681, 686
Barker, Clive, 486, 487, 488, 489, 591, 600–1, 781
Barker-Mill, Elsa, 262
Barker-Mill, Peter, 262
Barnes, Djuna, 77
Barnes, Julian, 640
Barr, Alfred, 166, 366, 368, 402, 443, 549, 759, 774
Bart, Lionel, 616, 621
Barthes, Roland, 569
Batache, Eddy, 572–5, *572,* 577, 594, 598–602, 632, 633, 648, 662, 670, 677, 693, 699, 789, 793
Bataille, Georges, 74, 123, 247, 501, 569
Bath Club (London), 128
Bathers at Asnières (Seurat), 690
Bathers at the Beach Hut (Picasso), *140*
Battersea Park (London), 384, 385–6, 399, 400, 401, 415, 429, 436, 448, 479
Battleship Potemkin (film), 65, 73, 299, 306, 400, 664, 717
Baudelaire, Charles, 568, 624, 702
Bauhaus, 66, 79, 232
BBC Radio, 180, 467–8, 637
BBC Television, 121, 702; *Arena* series, 637; *Kaleidoscope,* 688, 695
Beard, Peter, 551–3, *551,* 555–6, 557, 568, 577, 580, 589, 608, 698, 784, 786, 808
Beardsley, Aubrey, 325
Beatles, 486
Beaton, Cecil, 5, 81, 82, 202, 203, 204, 213, 223, 382, 392, 422, 428, 434–6, 438, 451, 481, 657, 691, 763, 770, 803
Beat writers, 410–11
Beauvoir, Simone de, 503
Beaux Arts Gallery (London), 111, 351, 352, 365, 366, 375, 387
Beckett, J. C., 35
Beckett, Samuel, 7, 500, 624, 627, 631, 779
Beckmann, Max, 632
Bedales school, 130, 189, 190, 191, 193, 198, 737
Bedford College, University of London, 81
Bedford Gardens (London), 285
Behrens, Timothy, 488, 489, 541, 633
Belcher, Muriel, 269–73, *269,* 310, 340, 349, 366, 386, 466, 482, 484, 489, 523, 538, 540, 544, 581, 602–3, 604–5, 615, 741, 748, 793–4

Bell, Clive, 233, 345
Bell, Graham, 145
Bell, Vanessa, 105, 113, 146, 168, 720
Bell, Walter Loraine, 20, 21, 22, 31, 711
Bellingham-Smith, Elinor, 270, 275, 317, 753
Bellony-Rewald, Alice, 564
Belton, Ron, 427–8, 431, 432–4, 446–8, 450, 463, 464, 481, 484, 769, 781, 803
Benson, E. F., 392
Bent, Ian, 550
Benton End (Essex), 279, 285
Bérard, Christian (Bébé), 435
Berenson, Bernard, 333
Beresford, Edel, 7th Baroness Decies, 714
Beresford, Marcus, 7th Baron Decies, 36, 714
Berger, John, 344–6, 348–9, 368, 524–5
Berlemont, Gaston, 267, 647, 811
Berlemont, Victor, 211, 267
Berlin, Germany: art in, 65–6; character of, 54, 55, 161; film industry in, 64–5; homosexuality and, 63–4
Bernard, Bruce, 273, 645
Bernard, Claude. *See* Haim, Claude Bernard
Bernard, Jeffrey, 268, 545
Bernard Jacobson gallery (London), 649, 802
Berners, Lord. *See* Tyrwhitt-Wilson, Gerald Hugh
Bernier, Rosamond, 557, 693, 774
Berthoud, Roger, 205–9, 232, 254, 255, 260, 262, 426
Bertolucci, Bernardo, 525
Beston, Daisy Mary (Dulcie), 471, 472
Beston, Ernest, 471, 775
Beston, Valerie: background of, 471–2; Diana Watson and, 668; on FB's eightieth birthday, 674; FB's finances and, 589, 619; at FB's Galerie Claude Bernard exhibition, 587; at FB's Galerie Lelong exhibition, 655; at FB's Grand Palais retrospective, 520, *521,* 521–2; FB's illnesses and, 623, 665, 676, 692; FB's Moscow exhibition and, 663, 664; FB's painting and, 680, 755, 757, 775, 811; FB's studio renovation and, 498; FB's Tate retrospective and, 637; FB's travels and, 511, 513; George Dyer and, 508, 512, 529, 530, 780; John Edwards and, 584, 603, 605, 608, 610, 613, 615, 642, 678, 775; José Capelo and, 682; Lucian Freud and, 544; at Marlborough gallery, 470–1, 731, 775; purchase of Lane's *Homage, 1994,* 701; at Reece Mews, 514, 590–1; relationship with FB, 472–4, 479, 675, 775; Sonia Orwell's illness and, 604
Betjeman, Penelope, 320
Betting and Gaming Act, 484
Bevan, Aneurin, 343
Bibendum restaurant (London), 650, 661, 685, 688, 808, 810
Bigge, John, 147
Bigman, Sidney, 460–1
Bignou Gallery (New York), 232
Bilbao, Maricruz, 660, 689–90, 692, 701

Birch, James, 579, 625, 630, 641, 651–3, 663, 664, 666, 802–3

Bishopscourt (County Kildare, Ireland), 43

Bishopthorpe Garth, Yorkshire, 30, 118, 121

Black, Misha, 121

Blackburn, Julia, 288, 294, 545–6

Blackburn, Rosalie de Meric, 287–8, 289, 294, 303, 721

Blackburn, Thomas, 287–8, 294, 303, 387, 545–6, 721

Blackett, Leonard "Granny," 271, 309, 747

Black Museum of London, 651

Blackwood, Caroline, 13, 35, 93, 273, 281, 291, 370, 434, 686, 749, 750

Blackwood, Michael, 637

Blake, William, 156, 157, 163, 167, 206, 381–2, 405, 443, 445, 600, 761

Bletchley Park, 247, 472

Bloomsbury, 56, 82, 105, 106, 112, 113, 126, 143, 145, 146, 168, 273, 302, 381, 686, 778, 805

The Blue Angel (film), 61

Blunt, Anthony, 370

Blythe, Ronald, 55, 57, 178

Board, Ian, 366, 538, 544, 582, 603, 614, 641

The Boat Sheds, in Violet Red Key (de Maistre), 111

Bocquentin, Pierre, 69–70

Bocquentin, Yvonne, 68–71, 73, 74, 76, 78, 638

Bocquentin family, 69, 70

The Body on the Cross exhibition (proposed), 694

Bofinger restaurant (Paris), 573

Boisgeloup suite (Picasso), 149

Bomford, Brenda, 332, 387, 441

Bomford, H. J. P. (Jimmy), 332, 387, 441

Bonnard, Pierre, 149, 433, 435, 730

The Bookman, 151

Boorman, John, 651

Boorman, Katrine, 651, 705

Boulez, Pierre, 670–1, 683–4, 690, 696

Boustany, Majid, 258, 744

Bowen, Elizabeth, 13, 36

Bowie, David, 477, 589

Bowles, Jane, 397, 410, 417, 418, 699

Bowles, Paul, 397–8, 409, 410–11, 412, 417, 418

Bowness, Alan, 621, 638

Bradford Peverell (Dorset), 174, 175, 183, 184, 203, 287, 309, 721, 739

Bragg, Melvyn, 639, 644, 702, 812

Brancusi, Constantin, 83

Brando, Marlon, 525

Braque, Georges, 74, 75, 146, 147, 208, 245, 402–3

Brass, Paul, 162, 258, 381, 426, 466, 485, 520, 531, 532, 545, 581, 604, 607, 623, 655, 658, 665, 674, 678, 680–1, 692–3, 694, 696–7, 704, 806

Brass, Stanley, 162, 364–5, 370, 381, 446, 447

Brasserie Lipp, 504

Brausen, Erica: Ahmed Yacoubi and, 398, 399; as art dealer, 576, 586; background of, 233–4, 283, 422; FB's American shows and, 411; FB's Galerie Rive Droite show and, 401, 402; FB's gallery switch and, 408, 415, 421–2, 432; FB's letters to, 379, 397, 414; FB's productivity and, 305, 306, 400; FB's Tate retrospective and, 453, 753; Festival of Britain show and, 319, 328; financial support of FB, 311, 325–6, 350, 405–6, 419–20, 765; as Gargoyle Club member, 273; Hanover Gallery and, 261–3, 299–300, 304, 314, 315, 332, 375; *Head I* purchase by, 264; *House in Barbados*, purchase by, 433; Isabel Rawsthorne and, 296, 298; London art world and, 442; *Painting 1946* purchase by, 234, 235, 243, 256, 743; photo of, 262; relationship with FB, 463, 551, 676, 743; sales of FB's paintings and, 303, 351–2, 366, 378, 389, 403, 419; Toto Koopman and, 87, 263, 807; *Two Figures* (1953) and, 370

Brave Day Hideous Night (Rothenstein), 333

Brecht, Bertolt, 61

Breton, André, 73, 77, 167, 501, 573, 683

Breuer, Marcel, 66, 79, 84, 719, 720

Brideshead Revisited (Waugh), 268

Bright Young Things, 56, 146, 270

Brin, Irene, 378

Brind, Bryony, 656, 658

Bristow, Carol, 515–17

Britain, Battle of, 180–1, 335, 339

Britannia and Eve magazine, 105

British Abstract Art exhibition, 358

British Council, 260, 423, 663, 665, 666

British War Advisory Scheme, 207

Britten, Benjamin, 284, 497, 560

Brocquy, Louis le, 232, 235, 524, 571, 601

Brompton Oratory, 92, 119

Brontë, Emily, 117

Brook, Peter, 571, 788–9

Brown, Barney, 562

Brownell, Sonia. *See* Orwell, Sonia Brownell

Brunton, Guy, 92

Brusilowski, Nicolas, 426, 768

The Brutality of Fact (documentary), 637

Bryanston school, 278

Buchenwald, 225

Buhler, Robert, 275, 328, 329, 350, 360, 755, 768

bullfighting, 50, 518–19, 653–4, 659, 661–2

Buñuel, Luis, 213, 474

Burgess, Guy, 385

The Burlington Magazine, 101, 114, 150, 253, 559, 686, 724

Burra, Edward, 636

Burroughs, William S., 396, 397, 410–13, 411, 417–18, 551, 629, 699, 766, 798

Butler, Mollie, 505

Butler, R. A. (Rab), 138, 143, 160, 166, 171, 178, 505, 728, 732

Butler, Sydney Courtauld, 138, 143, 160, 166, 178, 505, 728, 732

Butterflies in Britain (Chopping), 284

Byron, George Gordon, Lord, 15, 16, 122, 702

The Cabinet of Dr. Caligari (Robert Wiene film), 64

Cacarella, Don Felipe, 418

Cadogan House (Chelsea), 187

Café Central (Tangier), 418

Café de Flore (Paris), 239, 504

Café de la Rotonde (Paris), 77

Café de Paris (Tangier), 396

Café Royal (London), 189, 212, 284, 741, 750

Cahiers d'Art, 75, 139, 144, 207

Calder, Alexander, 503

Camberwell School of Arts and Crafts, 274, 275, 362

Cambridge University, 91, 128, 136, 176

Camera Adventures in the African Wilds (Dugmore), 72, 552

Cameron, Roderick (Rory), 254, 255, 259

Camus, Albert, 7, 503

Canedy, Norman, 559

Cannes, 396, 400, 416, 423–4, 767

Cannycourt (later Kennycourt, Kilcullen, Ireland), 22–5, 28, 31, 32, 33

Capelo, José, 638, 656–7, *656*, 658–63, 665–6, 668–9, 674, 675–6, 677, 678–80, 681–4, 687, 688, 690, 696, 698, 699, 701, 807

Cape Town, South Africa, 322, 323, 325, 326, 342

Capote, Truman, 552

Carcass of Beef (Rembrandt), 235

Car Crash (Warhol), 561

Careless Talk nightclub (Soho), 335, 756

Carlton Club (London), 92

Carlyle Studios, 120, 127, 329, 725

Carnaby Street (London), 121, 487

Carnalway Lodge (County Kildare, Ireland), 38

Carrier, Robert, 497, 539–40, 567, 603, 604

Carrière, Eva, 72

Carroll, Lewis, 167

Casablanca (film), 394

Catholic Emancipation of 1829, 35

Catholicism. *See* Roman Catholics, Catholicism

Causey, Andrew, 524

Cavendish, Deborah, Duchess of Devonshire (Debo), 281

Cavendish Hall, 38, 44, 609, 713

Caves de France bar (Soho), 532

Cazalet, Thelma, 169

Cent Dessins exhibition (Picasso), 79, 718

Central 822 (Bristow), 515

Central House of the Union of Artists (Moscow), 666

Central School of Art and Design, 275, 278

Cézanne, Paul, 135, 136, 169

Chamberlain, Neville, 179, 180

Chanel, Coco, 79

Chantilly, France, 69, 71, 73, 75, 76, 85, 86

Chapman, Dan, 284, 749, 750

Chardin, Jean-Baptiste-Siméon, 600, 793

Charles, Prince of Wales, 669

Charlie Chesters casino (Soho), 484, 537, 683

Charterhouse School, 91

Château Lafite Rothschild vineyard, 690

Château Mouton Rothschild vineyard, 690, 691, *691*, 809

Chekhov, Anton, 99

Chelsea (London), 81, 101, 120, 125–7, 131, 162, 164, 181, 182, 187, 382, 405, 488, 698, 726, 797

Cheltenham, England, 39, 42, 45, 58, 128, 715

Cheltenham College, 45–6, 58, 714

Cheltenham Racecourse, 39, 128

Chenciner, Robert, 651–2

Chermayeff, Serge, 105

Chesterton, G. K., 6

Chicago Tribune, 672

Chieveley (Berkshire Downs), 492, 495, 498

Childe Harold's Pilgrimage (Byron), 15

Chirico, Giorgio de, 74, 100, 114, 209, 262, 378

Chopping, Richard (Dicky): background of, 284–5; entertaining by, 310, 778; FB's letters to, 424; FB's portraits of, 482, 520; FB's visits to Wivenhoe and, 423, 496–7, 539, 540; Frances Partridge and, 302, 341; Graham Sutherland and, 296; James Birch and, 651; in London with FB, 555, 612; in New York with FB, 558; in Paris with FB, 521, 579; photo of, 618; relationship with Denis Wirth-Miller, 284–5, 286, 574, 593, 641; relationship with FB, 283, 566, 567, 611, 645, 749, 750; at Royal College of Art, 513; St. Ives and, 429, 432; travels with FB, 599, 611; on Warhol's Factory, 561; Wivenhoe studio of, 352

Christ Carrying the Cross (Spencer), 99–100

Christchurch, Oxford, 127

Christianity, 45–6, 193, 462. *See also* Crucifixion

Churchill, Winston, 5, 194, 227, 305, 380, 737

Church of Ireland, 14, 31, 40, 46

Cimabue, 416, 445, 461

City of London Cemetery, 529

Clair, Jean (Gérard Régnier), 525, 694, 810

Clark, K. C., 294

Clark, Kenneth, 143, 144, 153, 166, 168, 181, 193, 207–8, 209, 216, 219, 248, 249, 306, 319, 331, 333, 468, 542, 570, 595, 636, 737, 738

Clark, Michael, 568, 603, 648, 697, 789

Clarke, Arundell, 120–1, 122, 125–6, 127, 145, 146, 147, 155–6, 161, 256, 722, 725, 726, 729; Arundell Clarke, Ltd., 125

Clarke, Brian, 582–3, 603, 612, 613, 614, 615, 616, 641

Clarke, Edward John Arundell, 125, 726, 732

classicism, 632

Clayton, Kenny, 748

Clermont Club (Mayfair), 552

Clifford, James, 502

Clínica Ruber (Madrid), 698–701, *700*

cockneys, 57, 187, 310, 414, 427, 428, 438, 473, 475–6, 478, 483, 488, 581, 608–9, 610

Cocteau, Jean, 79, 117–18, 630

Cohen, Lisa, 82, 83, 105

Coldstream, William, 275, 351, 452, 772

Cold War, 369, 387, 643, 664

Colefax, Sybil, 160

Colony Room (Soho): Christmas at, 683; comparison with Dean's in Tangier, 394; description of, 269–71, 741, 812; FB at, 311, 325, 334, 383, 387, 488, 532, 537, 544, 627, 689; George Dyer at, 477; Giacometti at, 501; John Edwards at, 581, 584, 615; Lucian Freud at, 269, 541–2, 793; members/patrons of, 270, 271–3, 310, 386, 490, 491, 540, 545, 565, 592, 605, 614, 648, 701, 793; Muriel Belcher and, 269–70, 340, 603, 605; musicians at, 309, 540–1, 747; photo of, *296*; staff at, 366, 627, 641

colorists, 149, 158

Colour Harmonizing Disc (de Maistre), 111

Colour in Art exhibition (Sydney), 111

Colquhoun, Robert, 209, 210, 213–14, 228, 231, 273, 283, 285, 358–9

Communism, 665

Comper, Ninian, 23

Compton-Burnett, Ivy, 113

conceptual art, 489

Connaissance des Arts, 525

Connemara, Ireland, 95–6, 98

Connolly, Cyril, 210, 211, 212, 238, 239, 320, 740, 744, 754, 763, 805

Conrad, Joseph, 580

Conrad, Peter, 628

Conran, Paul, 615, 630, 652, 653, 802–3

Conran, Terence, 497, 650

Conran, Tom, 650–1, 705

Constable, John, 206, 567

Constable, W. G., 168–9

Contemporary Art Society (London), 208, 232, 303, 332, 333, 663

Contemporary Painters (Soby), 233

Cook, Robert (Robin), 394, 396–7

Cooper, Daniel, 146

Cooper, Diana, 239, 763

Cooper, Douglas, 146, 147–8, 150–2, 153, 154–5, 177, 178, 382–3, 441, 730, 731, 770

Cooper, Duff, 239

Cooper, Emmanuel, 639

Copland, Aaron, 397

Corbusier, Le, 135, 728

Cork, Richard, 637, 695

Cornwall Gardens (London), 659

Corso, Gaspero del, 378

Cosperec, Michel, 565

Count St. Genois d'Anneaucourt (Schad), 65–6

Courtauld, Samuel, 138, 153, 165

Courtauld, Sydney. *See* Butler, Sydney Courtauld

Courtauld Institute (London), 138, 169

Coward, Noël, 113, 273, 291, 669, 724, 763

Cox, Trenchard, 169

Crabtree Meadow House (Hope Valley, England), 21

Crankshaw, Edward, 148

Craven, Mollie, 164, 165, 167, 168, 174, 175, 732, 734

Craxton, John, 207, 209, 210, 211, 228, 231, 273, 279, 358

Crété de Chambine, Anne-Marie, 68–71, 75, 76, 78, 83

Crevel, René, 573

Crisp, Quentin, 51, 57, 126, 214

Crockfords casino (Mayfair), 484, 537

Cromwell, Oliver, 336

Cromwell Place (South Kensington), 202–5, *202*, 216, 219, 228, 251, 252, 256, 257, 283, 287, 309–11, 313, 318, 327, 328, 360, 370, 738, 768

Cronin, Anthony, 212

Crucifixion: Grünewald's altarpiece and, 149, 226, 598, 730; in Passion Play, 109; as Picasso theme, 149, 694; in Rembrandt's painting, 235; *see also* imagery in FB's work

Crucifixion (Cimabue), 416, 445

The Crucifixion (Picasso), 149

Crucifixion (Sutherland), 243, 244, 252

Cruz, Juan, 689–90

cubism, 76, 79, 83, 84, 100, 103, 106, 116, 135, 136, 139, 144, 146, 151, 233, 302, 313, 503

Cuevas, Guy, 570, 788

Cunard, Nancy, 273

the Curragh (County Kildare, Ireland), 22, 25, 43

Curtis Moffat gallery (London), 105–6, 146

Cushing, Minnie, 552

Dada, 74, 135

Dahl, Felicity, 709

Dahl, Roald, 8, 709

Daily Express, 127, 147, 246, 263, 318, 567

Daily Herald, 301

Daily Mail, 147, 158, 169, 380, 413, 637

The Daily Sketch, 147, 186

Daily Telegraph, 628, 702

Daintrey, Adrian, 47

Dales Farm (Suffolk), 640–1, *640,* 800

Dalí, Salvador, 79, 144, 145, 320, 522

Damp Tree Roots (Sutherland), 210

Dan, Pam, 286, 539, 611, 629, 778

Dance till the Stars Come Down (Spalding), 210

Danquah, Paul, 223, 385–6, 409, 416, 427, 429, 448, 457, 575, 675, 766, 781
Danto, Arthur, 673
Darwin, Charles, 317
Darwin, Robin, 317, 318
da Silva Bruhns, Ivan, 83–4
Daughters of Wisdom, 29, 38
Daumier, Honoré, 302, 445, 449, 450
David Tennant and the Gargoyle Years (Luke), 274
Davies, Hugh, 63, 168, 425, 536, 545, 551, 769
Dead as Doornails (Cronin), 212
Deakin, John, 23, 271–3, *272*, 282, 423, *480*, 481, 488, 489, 490–2, *490*, 493–4, *493*, 542, 545, 605, 691, 711, 768, 778, 785
Dean, James, 403
Dean, Joseph, 394–5, *395*, 409, 418, 763
Dean Close School, 45–9, *45*, *47*, 55, 58, 128
Dean's club (Tangier), 394–5, 396–7, 410, 418
Death of a Salesman (Miller), 374
de Botton, Gilbert, 619–20, 638, 797
Decline of the West (Spengler), 94
deconstructionism, 673
Defferre, Gaston, 579
Defferre, Marie-Antoinette, 579
Degas, Edgar, 483, 644
de Kooning, Elaine, 799
de Kooning, Willem, 387, 407, 424, 425, 467, 558
Delacroix, Eugène, 632
Deleuze, Gilles, 630
Deliverance (film), 651
Delmer, Sefton, 246, 247
de Maistre, Roy: as artist, 110–11, 140–2, *142*, 724, 725, 729, 731; background of, 110; Carlyle Studios and, 120; character of, 136–8, 723; design work of, 720, 723; Eric Hall and, 132, 133–4; exhibitions of works by, 112, 114–16, 151, 169, 171, 245, 730; John Rothenstein and, 383; London Artists' Association and, 166, 168; news photos as interest of, 196; Patrick White and, 176, 177, 183, 734; Rab and Sydney Butler and, 138, 728; relationship with FB, 112, 138–42, 215, 685, 723, 730; Robert Wellington and, 145, 166, 176, 734; sexuality of, 173; studio of, 137, *137*, 177, 178, 729; support of FB, 147, 176, 205, 216, 449, 453; wartime service of, 182
de Mestre, Caroline. *See* Walker, Caroline de Mestre
de Mestre, Count Joseph, 110
de Mestre/de Maistre family, 110, 173
Demetrion, James, 672
de Meuron, Louise, 396, 764
Derain, André, 74, 246
Derrière le miroir (DLM), 503–4
Design Research Unit, 121
Desire Caught by the Tail (Picasso), 503

De Stijl, 79
de Valera, Éamon, 173
Devastation in An East End Street (Sutherland), 207
The Development of Dramatic Art (Stuart), 95
de Wylde, Edy, 635
D H Evans department store, 275
Diaghilev, Sergei, 143
Dickens, Charles, 514
Dietrich, Marlene, 63
Die Zeit, 643
Digging for Mrs. Miller (Strachey), 188
Dillon, Michael, 605, 610
Dine, Jim, 558
Dinesen, Isak, 552
Dingo Bar (Paris), 77
Disney, Walt, 524–5
Dix, George, 415, 419
Dix, Otto, 61, 62, 65
Documenta exhibition, 423
Documents journal, 74, 501, 502
d'Offay, Anthony, 543, 596
Dorn, Marion, 106, 145, 720
Dostoevsky, Fyodor, 242, 653
Doucet, Jacques, 79
Douglas, Lord Alfred, 51
Douglas, David, 12th Marquess of Queensberry, 497
Doyle, Arthur Conan, 94
Driberg, Tom, 259
Dryden, Ronnie, 475–6, 477–8, 486, 529, 530, 608
Dublin, Ireland, 4, 14, 95
Dubuffet, Jean, 548, 571, 588
Duff, Juliet, 145
Dufferin, Lindy, Marchioness of Dufferin and Ava (Lindy Guinness), 145, 785
Dufresne, Charles, 143
Dugmore, A. Radclyffe, 72, 552
Duncan, Isadora, 77
Dunkirk, Battle of, 186, 737
Dunlop, Ronald Ossory, 113
Dunn, Anne, 14, 206, 259, 269, 273, 276, 278, 281, 282, 308–11, 317, 325, 327, 446, 484, 495–6, 512, 530–1, 542, 565, 645, 651, 685–6
Dunn, Fischer & Co., 308
Dunn, Irene, 308
Dunn, Sir James, 308
Dupin, Jacques, 518, 519, 569, 617, 624, 653–4, 655, 668–9, 676, 679, 796
Duras, Marguerite, 525, 571
Durcan, Paul, 689
Durham Light Infantry, 18, 28
Durlacher Brothers gallery (London and New York), 366, 408, 414–15, 419, 759
A Dwarf Sitting on the Floor (Velázquez), 577

Dyer, George: alcohol use by, 508–9, 513, 778, 780; background of, 475–8; death of, 521–4, 526, 529–34, 544, 545, 568, 611, 671, 681, 782; family of, 475–8, 608, 776; FB's paintings of, 480–3, 518, 519–20, 534–6, 546–7, 559, 586, 618, 680, 688, 782, 808; John Edwards comparison, 582, 610, 614, 642; Lucian Freud painting of, 494–5; Peter Lacy comparison, 484–5; photos of, *480, 483, 493*; as police informant, 514–17; relationship with FB, 478–9, 483–6, 487, 492, 495, 497–8, 506, 509–10, 519, 565, 662, 777, 778; travels with FB, 492–4, 495, 504–5, 511–13, 520–1, 558

Dyer, Leonard (Lee), 476, 477, 485–6, 498, 529, 530, 776, 778, 780, 782

Dyer, Mag, 476, 486, 529, 530

Eagle's Nest bar (New York), 562–3

Earl of Oxford and Earl Mortimer (Harley family title), 15, 17, 18, 710

East Anglian School of Painting and Drawing, 279, 284–5

East End, London, 122, 187, 310, 386, 413, 428, 475–6, 477, 484, 485, 514, 534, 582, 609, 610, 642, 649, 659

Edward VII, King of England, 643

Edwards, Beatrice (Beatty), 582, 640

Edwards, Colleen, 582

Edwards, David, 581, 582, 583, 608, 614–15, 637

Edwards, John: alcohol use by, 615, 796; background of, 582–3, 790, 792; FB's death and, 704; FB's eightieth birthday and, 674; FB's estate and, 678–9; FB's friends and, 592, 597, 603, 611, 651, 801; FB's illnesses and, 623, 678; FB's paintings of, 607–8, 641, 664, 671, 680, 808; George Dyer comparison, 610; homosexuality of, 608; Ianthe Knott and, 685; lack of employment, 614–15, 683; photo of, *581*; relationship with FB, 581, 584, 605–6, 607–16, 617–18, 640–3, 645, 646, 649–50, 662, 663, 665–6, 675, 679, 681, 683, 775, 790, 801–2, 807; relationship with Philip Mordue, 583, 605, 612–13, 615, 800

Edwards, Leonard, 582, 583

Edwards, Michael, 582

Edwards, Patricia, 582

Egypt, 325, 326–7, 339, 435, 755

Eichmann, Adolf, 751

Eisenstein, Sergei, 65, 213, 299, 306, 533, 664

Eldorado club (Berlin), 63, *63*

Electric Chair (Warhol), 561

Eliot, T. S., 113, 144, 194, 209, 230, 456, 535, 568, 728, 749

Eliot, Valerie, 728

Elizabeth, Queen Mother, 291

Elizabeth I, Queen of England, 17, 801

Elizabeth II, Queen of England, 643

El Minzah (Tangier), 394–5, 396

Éluard, Paul, 167

Emaer, Fabrice, 570

The Enamel Saucepan (Picasso), 228

The End of the Game (Beard), 552

England: figurative painting in, 524; modernism in, 150, 151, 210; portraiture in, 482; postwar art in, 216–17, 219, 248–9, 292, 319, 345, 560, 636; realism in, 342–3, 358; taxation in, 589–90; visionary tradition in, 157, 771; World War II and, 180–9, 213

The Entombment (Michelangelo), 644

Entrance to a Lane (Sutherland), 210

Epstein, Jacob, 246

Ernst, Julia, 656, 657, 659

Ernst, Max, 74, 147, 148, 150, 234

Esmeralda's Barn (Mayfair), 476

Estève, Maurice, 245

Eton, 15, 127, 172

Euston Road School, 596–7, 772

Evening Standard, 127, 438, 441

existentialism, 7, 302, 538, 653, 672, 673, 695

Explosante-fixe (Boulez), 683–4, 808

Exposition Internationale des Arts Décoratifs et Industriels Modernes (Paris), 79

expressionism, 65, 348, 407, 632

Eyre de Lanux, Elizabeth, 83, 105, 720

Eywood, 15, 16, 17–18, *18,* 20

The Family Reunion (Eliot), 194

Fantastic Art, Dada and Surrealism exhibition, 166

Faringdon House, 319–21, 324

Farmleigh (County Laois, Ireland), 22, 31, 32, 33, 35, 38, 42

Farson, Daniel, 101, 214, 271–2, 340, 341, 366, 376, 386, 409, 427, 490, 501, 637, 641, 645, 665, 674, 683

fascism, 161, 179, 193–4, 196, 198, 227, 233

fashion design, 76, 79, 81, 82, 83, 113, 305, 720

Faubourg Saint-Honoré (Paris), 79–80

fauves, 136, 519

Feaver, William, 278, 494, 509, 596

Feigel, Lara, 188

Female Bather with Raised Arms (Picasso), 151

Fenton, Margaret, 126, 202, 275–6, 647

Fernandez, Lourdes, 701

Ferrer, Patricia, 660–1, 698

Fester, Dickie, 409

Festival of Britain exhibition (1951), 319, 328, 358

Fielding, Mougouch (Agnes), 805

Fielding-Ould, Dr. Robert, 94, 162, 721

figurative painting, 99, 297, 318, 344, 360, 403, 430, 431, 437–8, 452, 470, 488, 489, 500, 512, 520, 524, 553, 663, 772

Figure by Bath (de Maistre), 149

Finnegan's Wake (Joyce), 77

Firth, Edward Loxley, 20

Firth, John Loxley, 19, 20, 711

Firth, Leslie Loxley, 20, 21, 28, 32, 38, 43, 173, 609

Firth, Mark, 20

Firth, Pamela. *See* Matthews, Pamela Firth

Firth, Peter, 59, 716

Fischer, Harry, 406–8, 414–16, 418, 419, 422–6, 429, 430, 432, 433, 434, 437, 441–5, 448–9, 452, 456, 463, 470, 472, 554, 555, 765, 766, 768, 771, 775, 780

Fischer Fine Art, 554

Fitzgerald, F. Scott, 77

FitzGibbon, Theodora, 182, 183–4, 212–13

Fitzrovia (London), 211, 212, 214, 228

Fitzsimmons, James, 367, 368

Fitzwilliam Museum (Cambridge), 333

5 Wounds (Clark), 697

Flaws in the Glass: A Self-Portrait (White), 176

The Flaying of Marsyas (Titian), 688

Fleming, Ann (Lady Rothermere), 292, 308, 310–11, 360, 395, 428, 432, 466, 483, 519, 657, 750–1, 803

Fleming, Ian, 284, 292, 395, 657

Fletcher, Dudley, 40

Fletcher, Lionel, 40, 200

The Fly (Chopping), 284

Flynn, Errol, 395

The Foundations of Modern Art (Ozenfant), 134

Fowler, Norman, 366

foxhunting, 14, 17–22, 25, 31, 33, 35, 49–50, 91, 133, 233

France, 180, 184, 185, 186, 213, 238, 239, 302, 399, 495–6, 500, 676, 690

Francis, Richard, 635–8, 645, 808

Francis Bacon (Russell), 468–9

Francis Bacon: Face et profil (Leiris), 627, 630–1

Francis Bacon: Paintings Since 1944 exhibition (Tate Liverpool), 681, 808

Francis Bacon: Recent Paintings, 1968–1974 exhibition (New York), 558–63

Francis Bacon: The Logic of Sensation (Deleuze), 630

Francis Bacon and Nazi Propaganda (Hammer), 193

Francis Bacon Catalogue Raisonné (Harrison), 170, 264, 401

Francis Bacon MB Art Foundation (Monte Carlo), 258

Francis Bacon retrospective (Tate Gallery), 452–62, 463, 466, 467, 469

Francis Bacon's Queensberry Mews Studio (de Maistre), 114

Francis Bacon's Studio (de Maistre), 141, *142*, 729

Franco, Francisco, 179, 658

Frankenthaler, Helen, 430

Frankl, Paul T., 102–3, 108

Fraser, Antonia, 438, 668

Fraser, Robert, 486, 488, 576, 600, 613

Frêle bruit (Leiris), 580

Fremon, Jean, 796

French Academy (Rome), 549

French House pub. *See* York Minster Pub

Freud, Annie, 309, 541

Freud, Kitty Epstein, 278, 309, 351

Freud, Lucian: background of, 278–81, 283; character of, 341, 687, 749, 785; at the Colony, 269, 541–2, 793; Erica Brausen and, 350–1, 405–6, 421; exhibitions of works

by, 231, 375, 378; on FB's character, 5, 232; FB's paintings of, 267, 319, 332, 481, 518, 536; FB's *Two Figures* and, 280, 370, 371, 541, 543–4, 596; gambling and, 204, 343, 492–3; at the Gargoyle, 269, 273; George Dyer and, 475, 476, 494, 508, 509; gossip about, 668; on John Deakin, 272; on Kray twins, 591; in London school of painters, 488, 489; lovers of, 273, 279, 280, 281–2, 287, 309, 310, 490, 494; marriages of, 278, 281, 291, 309, 370, 434, 749; on Nietzsche, 194; Order of Merit given to, 643–4; paintings by, 282, 296, 319, 332, 350–1, 494, 596 (*see also specific titles*); painting style of, 542–3; Peter Watson and, 210, 211; photos of, *278, 597*; relationship with FB, 278–9, 281–2, 291, 292, 360, 370, 380, 382, 405–6, 408, 413, 422, 453, 484, 490, 538, 541–4, 579, 592, 595–8, 605, 657, 686, 692, 758, 765, 792; reputation of, 361, 543; sexuality of, 281, 371, 543; with the Sutherlands, 746

Freud, Sigmund, 278, 288

Fry, Christopher, 560

Fry, Jennifer, 321

Fry, Roger, 82, 113, 165, 233, 345

Fuchs, Eduard, 71

functionalism, 66

furniture design, 84–5, 103, 106–9, 114, 116, 125, 178, 732

Fuseli, Henry, 445

Gale, George, 539

Galería Theo (Madrid), 661

Galerie Claude Bernard (Paris), 548–9, 565, 575, 578, 584–7, 617

Galerie Jean Désert (Paris), 79–81, *80*, 82, 83, 89, 103, 105, 107, 109, 244, 719, 721, 722

Galerie Lelong (Paris), 653, 654–5, *654*

Galerie Louise Leiris (Paris), 503

Galerie Maeght (Paris), 501, 503, 506, 510, 518, 548, 586, 779, 796

Galerie MaeghtLelong (Paris), 617, 796

Galerie Paul Rosenberg (Paris), 74, 75, 79, 86

Galerie Rive Droite (Paris), 399

Galeries Georges Petit (Paris), 125, 140, 147

Gallego, Julian, 661

Gallery One (London), 438

Gamazo, Ana, 698, 811

gambling: in London, 476; as means of support, 343; in Monte Carlo, 240, 241–3, 255; in Tangier, 396, 418

Gardner, Ava, 395

Gargoyle Club, 56–7, 273–6, 278, 287, 308, 309, 316, 317, 325, 328, 334, 341, 362, 383, 491, 749

Garland, Captain Ewart, 81

Garland, Madge, 81–3, 85, 87, 89, 103, 105–6, 113, 120, 121, 122, 125, 127, 144, 145, 147, 160, 474, 719, 720, 725, 726, 728

Garnier, Charles, 241

Gascoyne, David, 166–7

Gauguin, Paul, 77, 170, 389

Gaulle, Charles de, 500
Gautier, Blaise, 518, 519
Gay, Peter, 61
Gayford, Martin, 489, 596
Geldzahler, Henry, 553–5, 557, 558–9, 560, 562, 786
Genet, Jean, 397, 475, 624, 776
George V, King of England, 50
Germany: design influences in, 89; fascism in, 161, 178–9, 193–4, 233, 305, 737; primitive school in, 149; twentieth-century history of, 642; Weimar-era culture in, 61; in World War II, 180–1, 185, 186, 187, 198, 199, 213, 227
Gertler, Mark, 145
Geschichte der erotischen Kunst: Das Individuelle Problem (Fuchs), 71
Giacobetti, Francis, 49, 690–1, 695, 810
Giacometti, Alberto, 151, 238, 239, 246, 247, 296, 297, 344, 383, 500, 501, 502–3, 519, 541, 542, 549, 693, 745, 779, 793
Giacometti, Annette, 501, 503
Giacometti, Diego, 542
A Giacometti Portrait (Lord), 551
Gibbs, Christopher, 17, 386, 428, 429, 442, 487–8, 527, 543, 558, 569, 748, 769
Gielgud, John, 113, 722
Gilbey, Alfred, 127
Gilbey, Geoffrey, 127–8, 146, 164, 726, 727
Gilbey, Monsignor Alfred, 128
Gilbey's Gin, 127
The Gilded Gutter Life of Francis Bacon (Farson), 271
Gimpel Fils gallery (Paris), 358
Ginner, Charles, 145
Ginone, John, 650, 802
Ginsberg, Allen, 396, 411–13, 417, 766
The Girl from the Fiction Department (Spurling), 210, 603
Girl with a White Dog (Freud), 350–1
Giroud, Françoise, 585
Glasgow School of Art, 213
Glebe Place (Chelsea), 164, 174–5, 186, 195, 199, 201, 732, 734
Glimcher, Arnold (Arne), 588–9, 619
Goebbels, Joseph, 197
Gogarty, Oliver St. John, 96
Gogh, Vincent van, 144, 226, 349, 388–9, 402, 403, 415, 422–3, 425, 454, 456, 632, 754
The Golden Riviera (Cameron), 255
Goldfinger (Fleming), 284
Golding, John, 402
Goldsmiths, University of London, 205, 279
González, Elvira, 661
Goodman, Arnold Abraham, 515–16, 517
Gorbachev, Mikhail, 652
Göring, Hermann, 161, 171, 187, 197, 738
Gorse on Sea Wall (Sutherland), 210

Gosling, Maude, 617, 656, 658
Gowing, Lawrence, 278, 279, 299, 510–11, 512, 645, 649
Gowrie, Grey, 40, 41, 42, 51, 215, 589–90, 621, 626, 637–8, 667
Goya, Francisco, 302, 368, 457, 559, 569, 598–9
Graham, W. S., 210
Graham-Dixon, Andrew, 589, 666, 667
Grand Guignol, 221, 225, 300, 303, 345, 347, 364, 367, 378, 456, 469, 531, 547, 586, 636
Grand Palais (Paris), 518–21, 523, 524, 525, 535, 538, 544, 548, 553, 554, 572, 635, 637, 782
Grant, Cary, 392
Grant, Duncan, 105, 113, 146, 168, 686
Gray, Eileen, 75, 76, 79–81, 82, 84, 85, 89, 103, 105, 109, 116, 117, 719, 720, 732
Great Depression, 99, 125, 143, 248, 407
Greco, El, 201, 445
Greece, 117, 493, 534
Green, Michelle, 411
Greenberg, Clement, 425
Greene, Graham, 598
Green Tree Form (Sutherland), 742
Greenwood, Michael, 421
Gregor, Ulrich, 64
Greig, Geordie, 626–7, 654–5, 667
Gresham's School, 284
Grigson, Geoffrey, 139, 151
Gris, Juan, 75
Gropius, Walter, 66
Gross, Miriam, 121
Grosz, George, 65
Groult, André, 82
Groult, Nicole, 82
Grünewald, Matthias, 149, 154, 226, 234, 598, 730
Grünwald, Ludwig, 72
The Guardian, 349, 471, 620, 702
Guernica (Picasso), 149, 179–80, 226, 228, 743
Guernica, Spain, 179
Guernica: The Biography of a Twentieth-Century Icon (van Hensbergen), 180
'*Guernica*' *with 67 Preparatory Paintings, Sketches and Studies* exhibition, 179
Guggenheim Museum (New York), 469–70, 553, 774
Gutmann, Francis Julian, 92

Haim, Claude Bernard, 522, 548–9, 550, 565, 573, 575–6, 585, 586, 604, 789
Haim, Nadine, 522, 548–9, 564–5, 570, 573, 604, 617, 661
Haizelden, Clem, 234
Hall, Barbara Preston, 130, 739
Hall, Eric: background of, 128–9; at Café Royal, 212; care for FB's health, 184, 189; character of, 191; cooperative

exhibition organized by, 168–70; death of, 277; dispute with Douglas Cooper, 154; family life of, 130–2, 171–2, 204, 252, 276, 638, 727, 732, 737, 739; financial support of FB, 133, 156, 184, 192, 204, 251; as gambler, 128, 132, 172, 204, 251, 734; in Monte Carlo with FB, 239, 248, 255, 260; painting of, *133*; photo of, *131*; political career of, 131, 132, 172, 191, 734; relationship with FB, 128–34, 159–60, 163, 164, 171–2, 173, 183, 190, 191, 204, 215, 251–2, 266, 276–7, 328, 447, 481, 496, 659, 727, 748; support of FB's art, 133, 134, 155, 171, 227, 261, 276; wartime service of, 129–30, 181, 187, 195, 727, 735

Hall, Ivan, 131, *131*, 172, 252, 638, 727, 733

Hall, Pamela, 131, *131*, 204, 252, 739

Hall, Radclyffe, 127

Hamilton, Richard, 488, 489, 653

Hammer, Martin, 193, 206, 217

Hamnett, Nina, 145

Hanover Gallery (Mayfair): Ahmed Yacoubi's exhibition at, 417; FB's break with, 421–3; FB's exhibitions at, 264, 292, 298–303, 304–5, 312–16, 332, 343, 357, 363–4, 375, 402, 406, 422, 747; FB's financial problems and, 329, 350, 352, 405, 408, 415; FB's Paris retrospective and, 400; FB's *Study for Portrait of van Gogh I* and, 389; Isabel Rawsthorne's exhibition at, 296, 298; Lucian Freud and, 350–1; opening exhibition at, 262–3; partners in, 262; Peter Rose Pulham's exhibition at, 741

Harcourt-Smith, Alice Edith Watson, 20, 54, 59, 715–16

Harcourt-Smith, Highat Cecil, 20, 59–68, 127, 128, 643, 711

Harcourt-Smith, Simon, 60

Harcourt-Smith, Ursula Maud Wyndham Cook, 59–60

Hardy, Thomas, 382

Harley, Robert, Earl of Oxford and Earl Mortimer, 15, 710

Harmsworth, Esmond Cecil, 2nd Viscount Rothermere, 291, 292

Harper's Bazaar, 148, 213, 647

Harrison, Martin, 170, 264, 299, 306, 401, 431, 460, 632

Harrison, Rex, 598

Hartigan, Grace, 425

Hartnell, Norman, 125, 155

Hassert, Reinhard, 572–5, *572*, 577, 586, 594, 598–602, *599*, 633, 648, 662, 677, 693, 789, 793

Hayward Gallery (London), 543, 596

Heart of Darkness (Conrad), 580

Heber-Percy, Robert (Mad Boy), 320–1, 322–5, 446

Hecht, Alfred, 296, 426, 487, 618

Hedley, Gill, 663

Helft, Jacques, 208

Hemingway, Ernest, 77, 78, 552

Henley-on-Thames, 354, 364, 372–6, 379, 394, 758

Hensbergen, Gijs van, 180

Hepworth, Barbara, 158, 317, 319, 358, 430

Herbert, David, 392, 395, 396, 434, 763

Heron, Patrick, 430, 431, 433

Hertford College, Oxford, 338

Hess, Thomas, 560, 635, 799

Hewett, Kenneth John, 387, 762

Hillier, Tristram, 147, 730

Hilton, Roger, 431

Himmler, Heinrich, 197

Hintlesham Hall (Suffolk), 539–40, 567, *618*

Hirschfeld, Magnus, 62

Hirshhorn, Joseph, 441

Hirshhorn Museum (Washington, DC), 669–71, 672, 806

Hirst, Damien, 649

Hitchens, Ivon, 145, 169, 171

Hitler, Adolf, 161, 178, 179, 181, 194, 197, 198, 695, 737, 738

Hockney, David, 553, 554, 786

Hodgkins, Frances, 153, 217, 225

Holocaust, 642, 695

Homage, 1994 (Lane), 701

Hommage à Pablo Picasso exhibition, 500, 504

homosexuality: in art, 369, 370, 371, 639; Berlin and, 63–4; at the Colony, 271; as crime, 280, 369–70, 505–6; French vs. Irish view of, 70; during interwar period, 57; London and, 122, 211, 214–15; military and, 284; Nazis and, 161; in New York, 562; in Paris, 570, 719; social class and, 484; societal view of, 50–1, 475, 703, 776; in Soviet Union, 664, 666; in Tangier, 391, 392–3, 395, 410, 417–18, 763; theater and, 99; *see also* Bacon, Francis, homosexuality of; lesbianism

Hopkins, Clare, 129

Hopkinson, Simon, 650

Hoppé, E. O., 202

Hopper, Edward, 563

Horizon magazine, 210–11, 219, 238, 239, 279, 302, 381

Horizontal Stripe Painting: November 1957–January 1958 (Heron), 431

Horned Forms (Sutherland), 742

horses, horse racing, 13, 14, 15–16, 18, 21, 22, 25, 50, 59, 110, 127, 128, 146

Hotel Adlon (Berlin), 62, 65

Hôtel Balmoral (Monte Carlo), 253

Hotel Cecil (Tangier), 409

Hôtel Delambre (Paris), 77

Hôtel des Saints-Pères (Paris), 520–2, 532–3, 535, 611

Hôtel Lenox (Paris), 77

Hôtel Re (Monte Carlo), 239–40, 241, 243, 251, 253, 258

Hôtel Saint-Romain (Paris), 244

Hôtel Victoria (Monte Carlo), 366

Houghton-Brown, Geoffrey, 137–8

Hoving, Thomas, 554, 786

Howard, Brian, 268, 392

Hoyningen-Huene, George, 87, 807

Hughes, Robert, 638, 800

Hugh Lane Gallery (Dublin), 772

Hugo, Valentine, 503
Huis Clos (No Exit; Sartre), 348
The Human Figure in Motion (Muybridge), 294
Hunter, Sam, 367–8, 551, 738, 751
Hurst, Celia, 539
Hutton, Barbara, 392, 451, 763
Hutton, John, 386
Huxley, Aldous, 113
Hypatia (Mitchell), 712

The Illustrated London News, 524
Illustrierte Sittengeschichte vom Mittelalter bis zur Gegenwart (Fuchs), 71
imagery in FB's work: animals, 74, 356, 363–4; blood, 9, 50, 123, 156, 221, 226, 634, 653; bullfighting, 50, 518–19, 653–4, 704; businessmen, 373–4, 384, 388, 390, 456; Christian, 244, 263–4, 298; Crucifixion, 6, 9, 109, 124, 148–54, 156, 157, 218, 221, 226, 230, 234, 236, 256, 315, 347, 416, 453–4, 458, 461, 462, 694; eyes, 299, 306; mouths/screaming, 65, 73, 74, 168, 171, 177, 197, 209, 222, 231, 299, 306, 313–14, 330, 331, 347, 673, 738; popes, 6, 244, 250, 251, 299, 306–7, 312–15, 319, 328, 329–32, 348, 365, 367, 373–4, 388, 415–16, 456, 468; searchlights, 30; theatrical, 198, 236, 330, 331, 367, 380, 578, 580, 653; violence, 66, 201; wounds, 156, 157, 158, 159, 219, 221, 633, 653; x-rays, 150, 152, 153, 294
Imperial Hotel (Henley-on-Thames), 372–3, 372
impressionism, 99, 143, 167, 226, 407
The Indecisive Decade: The World of Fashion and Entertainment in the Thirties (Garland), 107, 160
The Independent, 589, 623, 666, 702
Ingres, Jean-Auguste-Dominique, 490, 525, 549, 632, 644
InHarmoniques, 670
Institute of Contemporary Arts (ICA), 364, 380
Institute of Sexology, 62–3
interior design, 79, 111, 115, 160, 719
International Centre for Theatre Research, 571
International Surrealist Exhibition, 166–8, 171, 697
Interviews with Francis Bacon (Sylvester), 468, 551, 557
In the Purely Pagan Sense (Lehmann), 214
IRCAM, 670, 683
Ireland: Bacon family in, 13–14, 20–1, 27, 31, 173; Lacy/de Lassy family in, 7–8, 336; literary renaissance in, 113; the "bad times" in, 35–9, 95, 96, 98, 695; weavers in, 85
Irish Derby, 22
Irish Free State, 38
Irish Republican Army (IRA), 35–8, 64, 180
Irish Town (Naas), 40
Ironside, Robin, 300, 301, 751
Isaacs, Rita, 476, 486, 508, 509, 529, 530
Isenheim Altarpiece (Grünewald), 149, 226, 598, 730
Isherwood, Christopher, 54, 61, 63, 64, 210
Italy, 377–9, 419, 676–7, 688

Jack of Clubs (Soho), 477, 478
Jackson, Martha, 441
Jagger, Bianca, 556, 570
Jagger, Mick, 552, 556, 570, 786
James, Philip, 260
Janis, Sidney, 407, 771
Jayne, A. L., 47, 48, 128
Jeannerat, Pierre, 169
Jeffress, Arthur, 262, 264, 303, 325, 350, 405, 747, 757
Jesmond Towers, 29, 38, 712
J. Lyons & Co. teashops, 122
Johannesburg, South Africa, 323, 324, 325, 342
John, Augustus, 113, 145, 233, 382, 763
John Lelliott Ltd., 590–1
Johns, Jasper, 585
Johnson, Heather, 137, 138, 145, 215
Johnson, J. Stewart, 84
Johnson, Paul, 702–3
Johnson, Philip, 125
Jolas, Eugene, 77
Jouffroy, Alain, 571
Joule, Barry, 616–17, *618*, 656–8, 660, 663, 677, 679, 681, 682, 683, 685, 692, 693, 694, 697–8, *807*, 810–11, 812
Jowitt, William, 351
Joyce, James, 77, 78, 96
Joynson-Hicks, William (Jix), 57
Juda, Elsbeth, 305, 752
Juda, Hans, 305, 752

Kafka, Franz, 347
Kahnweiler, Daniel-Henry, 146, 238, 503
Kaleidoscope (BBC program), 688, 695
Kandinsky, Wassily, 111, 151, 152, 154
Kauffer, E. McKnight, 106, 145, 720, 728
Kavanagh, Julie, 81
Keast, Diana, 190–1, 737
Keast, Ken, 189, 190, 191, 212, 737
Kelly, Anthony-Noel, 668
Kenmare, Lady, 254, 259
Kennedy, Maeve (Billie), 43
Kennycourt. *See* Cannycourt
Kern, Doreen, 112
Kerouac, Jack, 410
Keynes, John Maynard, 146, 165, 166
Kierkegaard, Søren, 538
Kiki's Paris: Artists and Lovers 1900–1930 (Kluver and Martin), 77–8
Kildare, County, Ireland, 22, 31–2, 43, 621
Kildare Street Club, 14
Killary Bay (Ireland), 95, 96
Kinmonth, Patrick, 621, 637
Kipling, Rudyard, 161
Kirkman, James, 542, 543, 596

Kitaj, R. B., 8, 440–1

kitchen-sink school, 343, 344, 345, 351

Klee, Paul, 148, 209, 407

Klein, Yves, 448

Kline, Franz, 467

Klokov, Sergei, 652, 665, 667, 802

Kluver, Billy, 77, 78

Knightsbridge (London), 478, 614

Knoedler Gallery (New York), 318, 414, 415, 423, 424, 425, 766

Knoll Associates, 125

Knollys, Eardley, 254, 255

Knott, Benjamin, 183, 323, 507, 508, 517, 578

Knott, Harley, 506, 508, 537–8, 541, 693

Knott, Ianthe Bacon (FB's sister): birth of, 32; childhood of, 13, 23–4; debut of, 175; emigration to South Africa, 51; on Eric Hall, 173; on FB and family heirlooms, 203; with FB in London, 517, 538, 721; with FB in Paris, 520–1, 578, 655; with FB on Riviera, 645–6; on FB's art education, 75, 76, 83; FB's visits to, 323, 324, 342, 507–8; on George Dyer, 476; on Glebe Place, 174–5; Ireland and, 96, 174; namesake of, 15; photos of, 39, 506; relationship with FB, 685, 687; relationship with mother, 52; view of homosexuality, 51, 127, 486, 517; wartime service of, 183, 184, 185

Knott, Keith, 508, 537, 578, 609

Knott, Mary, 508, 520–1

Knott, Wendy, 537, 609–10, 612

Konody, P. G., 147

Koopman, Toto, 87, 263, 263, 264, 300, 321, 351, 414, 415, 676, 683, 720, 807

Kossoff, Leon, 686

Kozloff, Max, 469–70

Kramer, Hilton, 511–12, 554, 559–60

Kray, Reggie, 429, 476, 477, 510, 515, 591, 781

Kray, Ronnie, 413–14, 429, 477, 485, 515, 591, 781

Kunsthalle (Dusseldorf, Germany), 525

Kurfürstendamm (Berlin), 64

La Besnardière (Tours, France), 576

Lacan, Jacques, 500, 571, 779

Lachenal, François, 655, 803

La Coupole café (Paris), 77

Lacy, Anthony, 337

Lacy, David, 338, 339, 340

Lacy, James Stanislaus, 337, 338, 340

Lacy, Joan, 337, 354, 459

Lacy, John de, 336

Lacy, John Pierce, 337

Lacy, Peter: alcohol use by, 8, 342, 410, 451, 458–9; appearance of, 335–6, 768; background of, 336–41, 756; death of, 458–61, 463, 523, 531, 595; FB's portraits of, 400, 416, 423, 425, 439, 459, 481, 680, 808; George Dyer comparison, 484–5; as musician, 335, 337, 338, 339–40, 394, 418; Peter Beard comparison, 568; photos of, 335, 377, 393; relationship with FB, 7–8, 336, 341–2, 352, 354–7, 358, 362, 364, 369, 372–81, 387, 405, 416, 417, 422, 423–4, 426–7, 428, 445, 450–1, 460–1, 475, 481, 496, 659, 662, 687, 758, 769; Ron Belton and, 432–3, 447; sexuality of, 335, 338, 339, 340–1, 356, 371, 485, 506; in Tangier, 389, 391–9, 409, 416, 420, 426, 433, 459, 763, 766; travels with FB, 377–8, 418–19, 446, 550, 756, 760, 765, 767; wartime service of, 335, 336, 339, 756

Lacy, Peter de, Count 336

La Fiorentina (Monte Carlo), 255, 259

L'Afrique fantôme (Leiris), 502

La Frontalière (Monte Carlo), 304, 311

Lagerfeld, Karl, 570, 645, 788

Lambert, Constant, 145, 247, 248, 321, 374

"Lament for Ignacio Sánchez Mejías" (Lorca), 654

L'Amour fou (Breton), 684

Lancaster, Mark, 548

Lancaster, Osbert, 354

Land, Peter, 175

Landseer, Edwin Henry, 363–4

Lane, Catherine Shakespeare, 701, 748, 811

Lane, Harriet, 471, 472, 474

Lane, Hugh, 768, 772

Lang, Fritz, 64

Lang, Jack, 676, 796

Lanux, Pierre de, 83

Lanyon, Peter, 430

La Palette café (Paris), 565, 571

La Popote restaurant (London), 558

La Quinzaine Littéraire, 525

Large Interior W11 (after Watteau) (Freud), 596

Las Meninas (Picasso), 250

L'Assemblée de la Compagnie royale des Philippines (Goya), 598–9

The Last September (Bowen), 36

Last Tango in Paris (film), 525

La Touche, Rose, 23

La Trainera restaurant (Madrid), 661

Laughing Torso (Hamnett), 145

Laurencin, Marie, 74, 79, 82, 728

Law, Michael, 490

Lawrence, Alice, 16

Lawrence, T. E., 382

Leach, Bernard, 429

Le Carré, John, 472

Le Crapouillot, 72

Le Dôme Café (Paris), 77, 144, 246

Le Duc restaurant (Paris), 571

Leeds Arts Club, 152

Leeds University, 152

Lefevre Gallery (Mayfair), 3, 216–18, 221, 225–8, 231, 262, 275, 283, 298, 301, 304, 424, 589, 742, 768

Le Figaro, 654

Léger, Fernand, 74, 75, 100, 578, 728

Le Grand Vfour restaurant (Paris), 570

Lehmann, John, 214

Leibowitz, René, 247

Leicester Galleries (London), 100, 208, 352, 719

Leiris, Louise (Zette), 503, 507, 522, 523–4, 549, 570, 571, 604, 667, 677–8

Leiris, Michel, 238, 247, 501–4, 507, 518, 519, 520, 522, 523–4, 531, 549, 556, 569–71, 573, 580, 584, 594, 604, 611–12, 617, 623, 627, 630–1, 653, 673, 676, 677, 779, 790, 797, 799

Leleu, Jules, 84

Lelong, Daniel, 626, 796

Le Matín, 654

Le Monde, 654

Lennon, Peter, 627

Le Peinture moderne (Ozenfant and Le Corbusier), 728

Le Récamier restaurant (Paris), 569

Lerner, Karen, 556

Lerski, Helmar, 67, 717

lesbianism, 81, 82, 127, 233

L'Escargot restaurant (London), 685

L'Escargot restaurant (Paris), 78

Les Deux Magots (Paris), 239, 504

Le Select café (Paris), 77, 719

Les Enfants terríbles (The Holy Terrors; Cocteau), 117–18

Le Sept nightclub (Paris), 570, 788

Les Halles (Paris), 247

Lessing, Doris, 238

Lessore, Frederick, 111

Lessore, Helen, 111, 311, 326, 351–2, 365, 370, 375, 387, 408, 421, 558, 576, 757, 766

Le Train Bleu restaurant (Paris), 522, 523, 573, 783

Lett-Haines, Arthur, 279

Levai, Pierre, 554, 579, 617

Leventis, Geraldine, 597–8, 616, 617–18, 641, 642, 645, 678, 685, 694, 810

Leventis, Michael, 597, 616, 617–18, 619, 641, 642, 645, 678, 685, 694, 810

Levin, Bernard, 639

Levin, Gill, 121

Levin, Richard, 121

Lévi-Strauss, Claude, 500

Lewis, Wyndham, 95, 300–1, 752

Libbert, Neil, 627

Life magazine, 195

Lightfoot, Jessie (Nanny): background of, 24, 711; with Bacon family in London, 28, 29, 721; character of, 24, 428; death of, 327–8; eye problems of, 251, 257; with FB and Allden in Ireland, 96–9; with FB in Monte Carlo, 239, 253, 258, 260, 264, 304; FB's gambling parties and, 172; FB's memories of, 447; FB's residences and, 92, 162, 164, 190, 192, 195, 202, 204, 310, 464, 473, 662, 739;

as hired cook, 125, 726; loyalty to FB, 276; photo of, 24; sales of FB's paintings and, 303

Limehouse (London), 514, 649

Linton Hall (Gloucestershire), 39, 44, 714

Lismany estate (Ballinasloe, Ireland), 22

The Listener, 179, 300, 345, 346, 364, 365, 752

Littlewood, Joan, 581, 790

Lloyd, Frank (Franz Kurt Levai), 406, 407, 408, 422, 440, 441–2, 448, 456, 470, 472, 474, 553, 555, *556,* 585, 587–9, 619, 765

Lloyd, Gilbert, 465, 470, 472, *556,* 557, 558, 610, 643, 663, 775, 805

L'Obelisco gallery (Rome), 378

the Lodge (in Steep), 189, 190–9, *190,* 203, 218

Loeb, Pierre, 146

London: art influences in, 134, 143–7, 332, 442, 500; art market in, 405, 407; casinos in, 484; design influences in, 81–2, 85, 106; Great Depression in, 143; Irish government in, 35; in 1960s, 486–7; in 1980s, 618; Picasso's audience in, 118, 144, 179; post–World War I, 54; post–World War II, 5, 225, 228, 238, 251, 263, 291; surrealism and, 166–7; theater in, 99; in World War II, 181–4, 186–9, 202, 203; *see also specific districts*

London Artists' Association, 146, 165–6

London Blitz, 187–9, 202, 203, 226, 736

London County Council, 131, 172, 187, 189, 191, 239, 266, 734

London school of painters, 488–9, 500

London Spiritualist Alliance, 94

The Lonely Crowd (Riesman, Glazer, and Denney), 374

Long Cottage (Henley-on-Thames), 354, 355, 356, 357, 369, 372, 374, 379–80, 757

Lorca, Federico García, 654

Lord, James, 246, 551

Loutit, Nicky, 698, 811

Louvre (Paris), 235, 244, 575

The Love-charm of Bombs: Restless Lives in the Second World War (Feigel), 188

Love in a Cold Climate (Mitford), 320

Lowell, Robert, 291

Lubbock, Tom, 702

Luce, Henry, 195

Lui magazine, 691

Luke, Michael, 56, 273–4, 278

Lund Humphries publisher, 443

Luntley, Geraldine, 79, 718

Lurçat, Jean, 84, 114

Lust for Life (film), 389, 400, 402

Lust for Life (Stone), 389

Lyons Corner Houses, 122, 123

MacBryde, Robert, 209, 210, 213–14, 228, 231, 273, 283, 285, 358–9

MacCarthy, Charles, 686

MacDermot, Gladys, 111, 160, 723
Macdonald, Duncan, 216–18, 226, 231, 232–3, 234–5, 243, 244, 255, 256, 257, 261, 262, 305, 350, 743, 745
Maclean, Donald, 370
Macleay, Ronald, 91
MacSweeney, Eve, 647
Madame Moitessier Seated (Ingres), 644
Madden, Anne, 571, 624, 625–6, 629
Madrid, Spain, 399, 418–19, 660–1, 675, 678, 683, 687, 689, 690, 691, 697–701, 704
Maeght, Aimé, 796
The Magic Mountain (Mann), 61
Mallet-Stevens, Robert, 84–5, 103, 116, 117
Malraux, André, 500, 518, 779
Malvern College, 129
Man in a Blue Shirt (Freud), 494
The Man in the Gray Flannel Suit (Wilson), 374
Man in the Moon pub (London), 614
Mann, Thomas, 61
Man Ray, 74, 77, 79, 213
Manson, J. B., 145
A Man Without Illusions (radio program), 637
Manzo, Sandro, 550
Mao Tse-tung, 570
Margaret, Princess, Countess of Snowdon, 4, 5, 291, 395
Marlborough Fine Art (London): corporate atmosphere of, 576; David Russell at, 597, 775; Diana Watson's visits to, 668; FB's death and, 701; FB's eightieth birthday and, 674; FB's exhibitions at, 434, 436–9, 440, 445, 507, 552; FB's finances and, 493, 587–90, 619; FB's Moscow exhibition and, 663, 805; FB's New York exhibitions and, 470, 553; FB's Paris exhibitions and, 501, 503, 617; FB's studio and, 620, 621, 778–9; FB's Tate retrospectives and, 452, 456, 463, 466, 636; FB's triptychs and, 619, 682, 684; Lucian Freud represented by, 405, 542, 543; Madrid branch of, 689, 691; representation of FB, 405–8, 414, 415, 416, 421–3, 432, 441–3, 470, 567, 584–5, 757, 765, 768; Terry Danziger Miles at, 139, 473, 565; Valerie Beston at, 470–4, 590
Marlborough-Gerson Gallery (New York), 470, 510, 511–12, 562, 618, 775
Marquis of Granby pub (London), 283
Marrion, David, 544, 582, 583–4, 610, 613
Mars Resting (Velázquez), 688
Martin, Agnes, 588
Martin, Julie, 77, 78
Martin, Mercedes Moreno (Sister Mercedes), 699, 700, 701, 811
Marvell, Roger (Roger Manvell), 231
Masaccio, 644
Mason, Raymond, 548, 549, 565, 566–7, 575, 576, 586, 624–5, 633, 771
Massacre of the Innocents (Poussin), 73
Masson, André, 74, 147, 523, 741

Matisse, Henri, 6, 74, 75, 144, 146, 207, 208, 228, 229, 239, 259, 274, 315, 317, 333, 445, 519
Matthews, Pamela Firth, 32, 38, 609, 713
Matthews, Tom, 713
Maugham, Somerset, 255, 259, 302, 305
Mavor, James, 507
Maxwell, Marius, 72, 552
Maya (Gantillon), 99
Mayfair (London), 57, 125, 126, 127, 146, 147, 155, 163, 167, 301, 476, 484, 566
Mayor, Fred (Freddy), 145–7, *145*, 150, 151, 154, 155, 165–6, 730
Mayor, James, 155, 730
Mayor, Pamela, *145*
Mayor Gallery, 47, 146, 148, 150–5, 161, 167, 174, 186, 370, 731
McCarthy, Mary, 604
McCoy, Jason, 511
McEwen, John, 702
McKenzie, Mike, 438, 747
McKew, Anna, 414
McKew, Bobby, 413–14, 764
McNay, Michael, 702
Medley, Robert, 145, 169
Megaw, Eric, 120, 725
Meier, Frederic, 198
Mellor, David, 207, 210, 213, 214
Melville, Robert, 253, 302, 312–15, 331, 437, 440, 443, 444, 453
Mena, Manuela, 687–8, 690
Mercury, Freddie, 656
Metropolis (film), 64, 67, 717
Metropolis triptych (Dix), 61
Metropolitan Museum of Art (New York), 553–63, 618, 663, 786
Michals, Duane, 557
Michaux, Henri, 78
Michelangelo, 149, 644, 688, 809
Mies van der Rohe, Ludwig, 66, 720
Mignoni, Isabel, 661, 662
Mikheyev, Mikhail, 652
Miles, Terry Danziger, 139, 473, 476, 478, 485, 509–10, 514, 520, 521–2, 524, 535, 539–41, 553, 556–7, 562–3, 565, 775
Millais, John Everett, 202, 739
Miller, Arthur, 374
Miller, Harry Tatlock, 743
Miller, Henry, 77
Miller, Lee, 213
minimalism, 489, 512
Minnelli, Vincente, 389, 400
Minotaure, 149, 207
Minton, John, 181, 209, 210–11, 228, 274–5, 285, 316–17, 318, 329, 350, 358, 359, 361–2, 364, 365, 383, 386, 403, 735

Miró, Joan, 144, 207, 209, 233, 522
Miroir de la tauromachie (Leiris), 518
Mitchell, Béatrice, 252
Mitchell, Charles Henry, 29
Mitchell, Charles William, 20, 29, 712
Mitchell, Eliza Highat Watson, 20, 29, 38, 54, 283, 712
Mitchell, Mabel, 58
Mitford, Nancy, 320
Mitrinović, Dimitrije, 138, 141–2
Modern Art in the United States: A Selection from the Collection of the Museum of Modern Art, New York exhibition, 387, 400
modernism: in America, 125, 443, 553; in architecture, 147; Continental, 144, 207, 333, 382, 772; critical works on, 75, 134–6, 347; in England, 106, 151, 165, 207, 210, 305; in France, 146, 206, 209, 332, 503; in interior design, 719; irony in, 250; market for, 407; the past and, 331; photography as influence in, 330; Picasso as master of, 139, 149; in rug design, 84
Modernists and Mavericks: Bacon, Freud, Hockney and the London Painters (Gayford), 489
Modigliani, Amedeo, 146, 153, 262
Moffat, Curtis, 105–6, 145, 146
Molony, Doreen Mills, 43, 50
Mona Lisa (Leonardo da Vinci), 692
Monet, Claude, 229, 240, 437, 445, 673
Montagu of Beaulieu, Lord, 370, 505
Monte Carlo, 239–44, 248–9, 251, 252, 253, 257–60, 264, 278, 289, 303–4, 329, 366, 492–3, 564, 599, 601, 645, 678
Montgomery, William (Joss), 257, 507
Montparnasse, Kiki de, 77, 78
Montparnasse (Paris), 68, 76–8, 79, 87, 125, 144, 233
Moore, Henry, 3, 75, 145, 147, 153, 154, 166, 177, 181, 199, 207, 208, 210, 217, 225, 226, 249, 253, 297, 317, 319, 343, 351, 402, 425, 443, 449, 560, 561, 644, 742, 783
Moore, Philip, 643
Moraes, Henrietta, 311, 490–2, *490*, 508, 520, 692, 748, 777
Moran, Kevin, 614, 795
Mordue, Philip, 582, 605, 607, 608, 612–15, 640, 642, 800
Moreau, Gustave, 575
More Than a Bookshop (Vaux Halliday), 186
Morocco Mail, 420, 451, 762
Morris, Cedric, 279, 285
Mortimer, Raymond, 208, 225
Moscow, 651–3, 663–7
Mosley, Leonard, 187
Mossé, Sonia, 745
Motherwell, Robert, 430
Moynihan, Danny, 565, 651, 686
Moynihan, John, 270, 275, 329, 359, 362, 363–4, 401–2
Moynihan, Rodrigo, 270, 275–6, 317, 318, 329, 350, 357, 358, 359, 383, 495–6, 565, 566, 579, 645, 651, 685–6, 753, 772, 808

Mrabet, Mohammed, 392, 393, 395
MR CHOW restaurant (London), 600, 605, 610, 798
Müller, Hans-Joachim, 643
Munch, Edvard, 426
Murdoch, Iris, 458
Musée Cantini (Marseille), 576, 578–9, 586
Musée Condé (Chantilly, France), 73
Musée des Arts Décoratifs (Paris), 518
Musée Goya (Castres, France), 598–9
Musée National d'Art Moderne (Paris), 244, 295, 518
Musée Nationale Gustave Moreau (Paris), 575
Musée Picasso (Paris), 694, 810
Museum of Modern Art (MoMA; New York), 166, 233, 274, 366, 368–9, 402, 424, 442, 443, 449, 469, 553, 635, 669, 772, 774
Mušič, Zoran, 692
Music Box nightclub (Soho), 335, 336, 340, 756
Muybridge, Eadweard, 123, 294, *295*, 315, 370, 482, 550, 562, 751
Myers, Dennis, 56
Myers, Dolly, 340

Naas, Ireland, 32, 36, 40, 69, 85
Nags Head, The, pub (Knightsbridge), 614, 795
Naked Lunch (Burroughs), 411, 413
Nan Kivell, Rex, 234, 262, 743
Narrow Street (London), 514, 537, 538, 551, 552, 555, 564, 565, 566, 567, 649, 788
Nash, Paul, 145, 166, 167, 233
The Nation, 673
National Gallery (London), 143, 144, 166, 199, 207, 216, 252, 333, 364, 483, 644, 690, 738, 742
National Gallery of Victoria (Melbourne, Australia), 303
National Museum of Photography, Film & Television (Bradford, England), 681
National Portrait Gallery (London), 259, 381
Nazis, Nazism, 161, 162, 171, 178, 180, 184, 193–4, 196, 197, 198, 225, 305, 642, 737, 738
neo-expressionism, 618
neo-romanticism, 206–11, 226, 228, 234, 318, 358, 362, 387, 636, 740
Netto, David, 85
Nevelson, Louise, 553, 588
New American Painting exhibition, 424–5
New Atlantis (Bacon), 142
New Atlantis (de Maistre), 141–2, 729
New Burlington Galleries (London), 166, 179
Newbury Racecourse, 492
Newcastle upon Tyne, 19, 20, 29, 38
New Dimensions: The Decorative Arts of Today in Words & Pictures (Frankl), 102, 108
New English Review, 169
New Images of Man exhibition, 772

Newman, John Henry (Cardinal), 337

Newmarket Racecourse, 609

New Objectivity (*Neue Sachlichkeit*) paintings, 65

News Chronicle, 151

Newsday, 557

New Statesman, 208, 458, 532

The New Statesman and Nation, 344, 345, 402

Newsweek, 585

Newton, Eric, 300, 331

New York: Arundell Clarke's shops in, 125; homosexuality and, 469, 470; influence in art world, 387, 400, 403, 408, 442, 467, 470, 500; modernism in, 443, 553; in 1980s, 618; post–World War I, 54

The New Yorker, 511

New York Painting and Sculpture: 1940–1970 exhibition, 553

New York School, 424

The New York Times, 125, 155, 469, 511, 554, 557, 560, 696

New York World's Fair (1939), 208

Nice, France, 327, 504, 599, 646

Nicholson, Ben, 113, 145, 147, 166, 217, 231, 319, 358, 375, 378, 430

Nicolson, Benedict, 253, 333

Nierendorf, Karl, 65

Nietzsche, Friedrich, 3, 6, 53, 117, 132–3, 165, 193–6, 199, 211, 280, 312, 360, 388, 393, 408, 453, 454, 487, 538, 631, 653, 673, 695, 737

Night Fishing at Antibes (Picasso), 229

Nighthawks (Hopper), 563

Nine Poems of William Blake (Schurmann), 381

Nobel Prize, 136, 177

Nolan, Sidney, 743

Norman, Frank, 438

Normile, John, 268, 474, 476, 566, 616, 776, 780–1, 794

Northgate House (Suffolk), 91

Nott-Bower, John, 369

Now!, 626

Nureyev, Rudolf, 570, 617, 656, 810

Oberammergau, Germany, 109

The Observer, 148, 301, 302, 440

O'Doherty, Brian, 469

Oedipus and the Sphinx (Ingres), 632

O'Hara, Frank, 449, 469, 772

old masters, 6, 79, 135, 168, 244, 249, 250, 330, 331, 438, 458, 553, 561, 636, 644

Old Rectory (Dorset, England), 174, 203

Omega Workshops, 113

Onassis, Jacqueline Kennedy, 552, 556

Open Window (Picasso), 74

Oratory School, 337, 338

Order of Merit (OM), 643, 801

Orient Express, 493

Orlovsky, Peter, 412, 766

Ormonde Gate (London), 59–60, 127, 128, 131, 164, 726, 727, 732

O'Rorke, Brian, 147, 729

Orpheus (Cocteau), 630

Orton, Joe, 396

Orwell, George, 178, 210, 304, 343, 603

Orwell, Sonia Brownell, 182, 210, 238–9, 279, 304, 379, 410, 418, 487, 495, 502, 504, 507, 517, 519, 522, 524, 531, 537, 551, 564–5, 571, 573, 584, 603–4, 605, 670, 760, 779, 780, 782

Osborne, John, 343

Ostia, Italy, 377–8, 544, 550, 760

Owen, David, 514

Oxford University, 129, 130, 152, 338

Ozenfant, Amédée, 134–6, 138, 151, 728

Pace Gallery (New York), 588–9, 617

Page-Roberts, James, 492

The Painter on the Road to Tarascon (van Gogh), 388, 400, 402, 404

Pallinsburn (Cornhill-on-Tweed), 29

Palmer, Edward, 539

Palmer, Hally, 539

Palmer, Samuel, 206, 318

Palmerston House School, 44–5

Palm Leaves (Sutherland), 260

Palm on Wall (Sutherland), 260

A Paradise Lost: The Neo-Romantic Imagination in Britain, 1935–55 (Mellor), 207, 210, 213

Paris, France: booksellers in, 72; British *Vogue* and, 82; café life in, 77, 79, 238–9, 244, 245, 246, 504, 677; character of, 54, 161; as cultural center, 68, 73–4, 125, 238, 343–4, 500, 501, 568, 719; declining art influence of, 470; design influences in, 79–80, 83–5, 89; expatriate community in, 82, 238; FB's reputation in, 548; modernist art world in, 146; in World War II, 186; *see also* Montparnasse

Paris Exposition (1937), 179

Paris Match, 435, 586

Parladé, Jaime, 534, 658, 697, 698, 701, 761, 804

Parladé, Janetta Woolley, 203, 381, 382, 520, 534, 658, 662, 679, 697, 698, 761, 782, 803, 805

Parr, Henry, 127

Parr, Walter, 127

A Partial Testament: Essays on Some Moderns in the Great Tradition (Lessore), 351–2

Partridge, Frances, 302–3, 311, 341, 342, 381, 507, 759

Partridge, Ralph, 303

Pasmore, Victor, 145, 166, 169, 274–5, 318, 358

Paysage à Smyrne, l'arbre mort (Lurcat), 114

Pelléas et Mélisande (Debussy), 696, 810

Pembrokeshire, England, 207, 209, 260, 279

Penrose, Roland, 166–7, 168, 179

Peppiatt, Michael, 46, 58, 68, 102, 164, 185, 341, 355, 450, 458, 532, 564–5, 570, 617, 625, 645, 696
Pergamon Museum (Berlin), 65, 643
Perriand, Charlotte, 719
Pétain, Marshal Philippe, 186
Peter Jones department store (London), 130–1
Phenomena of Materialisation (Schrenck-Notzing), 72, 721, 751
Philip IV of Spain (Velàzquez), 644
Phoney War, 181, 189, 208
photography: for fashion magazines, 272; figurative painting and, 293; immediacy of, 282, 671; in journalism, 195–6, 348; in 1940s, 213; as way of seeing, 456
Picasso, Pablo: bullfighting and, 653; Coco Chanel and, 79; collectors of works by, 209; Crucifixion imagery and, 149, 150, 694; at Curtis Moffat gallery, 146; David Sylvester on, 344; Deakin photo of, 272–3; Dinard series, 74, 75, 78–9, 117, 139–40, 140, 218, 250, 294, 535; Dora Maar portrait by, 262; exhibition with Matisse, 228, 229, 317; on FB's retrospective, 463; at Galerie Rosenberg, 74, 86, 208; Gertrude Stein painted by, 481–2; at Grand Palais, 519; *Guernica,* 149, 179–80, 226, 228, 743; influence of, 75, 83, 95, 117, 138–40, 149, 151, 159, 170, 180, 209, 226, 346, 347, 445, 636, 688, 743; Isabel Rawsthorne and, 247; Leirises and, 503; London reaction to, 118, 144, 179; in Madrid exhibition with FB, 661; as modernist, 147, 207, 209, 382, 500; in Paris, 77, 78, 239, 542, 568; posters by, 315; Pulham photographs of, 213; retrospectives, 125, 140, 147, 500, 504; on the Riviera, 240, 259; in surrealist exhibition, 167; at Tate Gallery, 143; in UNESCO exhibition, 245; works at Musée Cantini, 578
Picasso and Matisse exhibition, 228, 229, 317
Piccadilly Circus (London), 167, 174, 188, 189, 212, 215, 267, 428, 484, 623–4, 648, 689, 748, 777
Piccadilly Gallery (London), 755
Picture Post, 195–6, 196, 197, 221, 252, 738
Pignon, Édouard, 245
Pink Vine Pergola (Sutherland), 260
Pinter, Harold, 668
Piper, John, 153, 169, 207, 209, 210, 217, 248, 319, 351, 354, 372, 374, 376, 758
Piper, Myfanwy, 372
Pius XII, Pope, 330
Plante, David, 55, 504–6, 605, 606, 612, 636, 641–2
Plato, 94
Playboy Club (London), 565–6
Poetics (Aristotle), 200
Poiret, Paul, 82
Pollano, Felice, 616
Pollock, Jackson, 387, 424, 449, 511, 558, 685, 694, 787
Pollock, Peter, 223, 385–6, 409, 416, 429, 448–9, 575, 675, 766
Pompidou, Georges, 520, 523
Pons, Cristina, 658, 659

Pont Royal hotel (Paris), 693, 697
pop art, 469, 488, 489, 512, 554, 653, 752
Pope-Hennessy, James, 212
Portrait Group (The Teaching Staff of the Painting School, Royal College of Art, 1949–50) (Moynihan), 317, 357, 362
Portrait of Francis Bacon (de Maistre), 114, 133–134, 724
Portrait of Innocent X (Velázquez), 244, 249–50, 251, 299, 306, 312, 314, 330, 379, 544
Portuguese Civil War, 15–16
Positioning in Radiography (Clark), 294
postexpressionist painting, 65
post-impressionist painting, 82, 165, 167, 407
postmodernism, 250, 367, 488, 512, 649, 673, 674, 703
Potter's Asthma Cure, 13, 27, 710
Potts, Paul, 689
Pound, Ezra, 77
Powell, Nosher, 478
Prado (Madrid), 660, 687–8, 690, 808–9
Prescott House (Cheltenham), 42, 714
Pretorius, Sophie, 454
Priestley, J. B., 183
Prior-Wandesforde, Doreen, 51
Prior-Wandesforde, Phyllis, 51
Proust, Marcel, 569
Psychological Studies (Jung), 94
Pulcinella restaurant (London), 616
Pulham, Mary, 245
Pulham, Peter Rose, 182, 212–13, 214, 245, 247–8, 293, 296–8, 300, 303, 321, 327, 376, 741, 751
Punchestown Racecourse, 21
purism, 135
"Putney Garage" (Durcan), 689

Quant, Mary, 486
Queen magazine, 488–9
Queensberry Mews (South Kensington): de Maistre painting of, 112, 115, 138, 140, 724; design of, 102–3, 109, 156, 274, 464, 721, 722, 724; FB's move from, 118, 119, 121, 160; FB's move to, 723; first exhibition at, 113–15, 117, 120, 148, 723–4; invitation card for exhibition at, 114; location of, 101–2; Nanny Lightfoot at, 162; *Studio* magazine feature on, 106, 107
Queneau, Raymond, 503
Quinn, Edward, 626

Racine, Jean, 568
Radziwell, Lee, 552, 557
Rain, Steam and Speed (Turner), 644
Rattigan, Terence, 127–8
Ravensbrück concentration camp, 263, 677
Rawsthorne, Alan, 245, 374, 519
Rawsthorne, Isabel: as artist, 296–8, 301, 303, 776; background of, 245–7; at the Colony, 269–70; on FB's art,

313, 315, 357; at FB's Galerie Maeght exhibition, 504; FB's paintings of, 481–2, 498–9, 520; at the Gargoyle, 273; George Dyer and, 522; Giacometti and, 297, 501, 519; Lucian Freud and, 280, 282; marriages of, 245, 321, 374; messy housekeeping of, 494; Peter Rose Pulham and, 247–8, 295, 741, 751; photo of, *296*; relationship with FB, 292–3, 295–8, 300, 304, 318–19, 327, 377, 481, 745

Raymond, Derek (Robin Cook), 394

Read, Herbert, 145, 150–3, 154, 167, 169, 179, 233, 235, 283, 380, 730

Recent Paintings by English, French and German Artists exhibition, 147, 150

Recent Paintings by Francis Bacon, Frances Hodgkins, Henry Moore, Matthew Smith, Graham Sutherland exhibition, 225

Récipon, Georges, 519

Red Cross, 181, 182, 187, 735, 736

Redfern Gallery (London), 113, 233, 234, 235, 244, 245, 261–2, 263, 741, 743, 752

Redgrave, Mary, 434

Redgrave, William, 430, 431–2, 434

The Red Studio (Matisse), 274

Reece Mews (South Kensington): after FB's death, 704, 713, 718, 754–5, 812; alleged break-in at, 474–5; alternatives to, 514, 564, 565; cannabis bust at, 515–16; champagne stored at, 681; description of, 453, 463, 464–6, 651, 772, 774; family visits and, 537; FB's illnesses and, 658, 675, 676, 692–3, 694; FB's late-life isolation at, 628, 645, 649, 667; FB's move to, 448, 464; FB's paintings stored at, 615, 697; George Dyer at, 492, 497, 509; John Edwards at, 607, 612–13, 616, 649, 794; location of, 464; Lucian Freud at, 541, 597; Michael Clark's visit to, 648; photographs stored at, 748; photos of, *463, 465, 466*; redevelopment proposed for, 620–2; studio at, 464, 465, 577, 578, 601; untidiness of, 464, 573, 577, 590–1, 674, 762, 781; Valerie Beston and, 473, 590–1; William Burroughs's visit to, 629, 798

Reed, Jeremy, 623–4, 648, 777

The Referee, 171

Régnier, Gérard, 525, 694

Reithorst, Anthony (Dutch Tony), 411, 417

Relton Mews (London), 92

Remarque, Erich Maria, 95

Rembrandt, 229, 235, 346–7, 445, 468, 481, 505, 569, 587, 599, 636, 644, 703

Renoir, Pierre-Auguste, 240

Renvyle House (Ireland), 96

Répons, 671

Restless Lives (Moynihan), 300, 359

The Resurrection, Cookham (Spencer), 99–100

Reynolds, Joshua, 482

Rhodesia. *See* Zimbabwe

Rhythmic Composition in Yellow Green Minor (de Maistre), 111

Richard, Paul, 526, 672

Richards, Ceri, 445

Richardson, Jan, 286

Richardson, John, 60, 67, 82, 83, 101, 132, 146, 152, 191, 215, 310, 327, 328, 336, 512, 561, 748, 773

Richter, Sviatoslav, 576

Riefenstahl, Leni, 198, 330, 755

Riley, Bridget, 488

Riopelle, Jean-Paul, 503

Rivers, Larry, 558

Riviera, French, 184, 189, 239–42, 252, 254–5, 258–60, 265, 276, 304, 315, 359, 376–7, 400, 433, 599, 645

Roaring Twenties, 56

Robbe-Grillet, Alain, 500

Robert Fraser Gallery (Mayfair), 486, 488

Robertson, Bryan, 304, 752

Rockingham club (London), 442–3

Rockwell, John, 696

Rodin, Auguste, 136, 482–3, 728

Rodriguez, Luis, Dr., 698, 700

Roland Gardens (South Kensington), 498, 514, 530, 604, 779

Rolling Stones, 486, 556, 589

Roman Catholics, Catholicism: Eric Allden as, 92; as FB theme, 244; Graham Sutherland as, 206, 740; in Ireland, 14, 35; John Rothenstein as, 453; Peter Lacy as, 337–8; Roy de Maistre as, 110, 138; in Spain, 658

Rome, Italy, 377–9, 549–50

Romney, Mitt, 659

Rosenberg, Harold, 425, 560

Rosenberg, Paul, 208

Rosenberg and Helft Gallery (London), 208

Rosenquist, James, 558

Ross, Annie, 540–1

Rothenstein, Alice Mary, 145

Rothenstein, John, 136, 137, 188, 216, 301, 305, 333–4, 350–1, 361, 382–3, 402, 415, 422, 438, 442–3, 445, 449–50, 452–7, 464, 467, 470, 475, 715, 728, 741, 755, 772

Rothermere, Lady. *See* Fleming, Ann

Rothko, Mark, 430, 562, 588, 590, 634

Rothschild, Philippe de, Baron, 691

Rothschild, Philippine de, Baroness, 691, 809

Rothschild, Robert de, Baron, 69

Rouault, Georges, 153, 186

Rousseau, Theodore, 554Royal Academy of Dramatic Art, 112

Royal Air Force (RAF), 335, 336, 339

Royal Ballet, 202, 656

Royal College of Art (RCA), 81, 145, 275, 316–18, 328, 329, 342, 350, 357–61, 363, 513, 518, 648, 782

Royal Irish Constabulary, 36–7

Royal Opera House, 616–17, 628, 656

Rubens, Peter Paul, 445

Rubin, William, 553

Rubinstein, Helena, 77
rue de Birague studio (Paris), 564–6, *572*, 573, 576–7, 587
rug design, 78, 83–4, 85, 88, 89, 90, 103, 106, 107, 108–9, 114, 116, 724, 725
Ruhlmann, Émile-Jacques, 84, 85
Rules restaurant (Covent Garden), 625
Ruskin, John, 23, 219
Russell, Bertrand, 200
Russell, David, 597, 610, 615, 618, 775
Russell, John, 3–4, 61, 154, 156, 222, 225, 226, 227, 232, 245, 364, 402, 468–9, 482, 483, 488, 514, 524, 530, 557, 568, 584, 688, 692, 693, 774, 798
Rutherford, Roy, 409
Rutter, Frank, 169–70

Saatchi, Charles, 649, 650
Saatchi Gallery (London), 656, 659
Sacks, Oliver, 668
Sadler, Michael, 144, 152–3, 154, 232, 235
Sainsbury, Alan, 383–5
Sainsbury, Lisa, 383–5, 387, 389, 435, 481, 482, 499
Sainsbury, Robert, 383–5, 387, 389, 399, 435, 452, 668
Saint Laurent, Yves, 626, 788
Saint-Simon, Duc de (Louis de Rouvroy), 568
Salahov, Tair, 666
Salmon, Françoise, 532–3
Salvoni, Elena, 685
Sánchez Mejías, Ignacio, 654
Sandler, Irving, 469
Sandwich, Lord, 208
Sansom, William, 183
São Paulo Biennial (1959), 423
Sardi's restaurant (New York), 558
Sargent, John Singer, 127
Sartre, Jean-Paul, 7, 239, 247, 302, 348, 500, 503, 776, 779
The Saturday Review of Literature, 443
Savage, Robert, 448
Schad, Christian, 62, 65
Schiaparelli, Elsa, 79
Schiele, Egon, 407
Schnabel, Julian, 618
the Schoolhouse (Suffolk), 615, 640
Schrenck-Notzing, Baron Albert von, 72, 293, 721
Schrimpf, Georg, 65
Schurmann, Gerard, 374–5, 381, 520
Scott, Christopher, 786
The Scream (Munch), 426
The Seagull (Chekhov), 99
Second Anglo-Boer War, 18
"The Second Coming" (Yeats), 194
Selz, Peter, 772
Senna, Ayrton, 684
Seurat, Georges, 445, 632, 644, 690

Sévigné, Madame de (Marquise de), 568
Seville, Spain, 675, 678
Shakespeare, William, 17, 41, 568
Shakespeare and Company bookstore (Paris), 77
Shariffe, Hussein, 438
Shaw, George Bernard, 99, 113, 382
Sheffield, England, 19, 20, 21
Shelter Drawings (Moore), 226
The Sheltering Sky (Bowles), 397
Shenstone, Clare, 648–9
Shepeard, Jean, 112–14, 115, 116, 117
Shone, Richard, 101, 114, 126, 686, 724
Sickert, Walter, 143, 168, 169, 217, 219–21, 284, 351, 636, 742
Since Cézanne exhibition, 146
Sitwell, Edith, 113
Sitwell, Osbert, 320, 321
60 Paintings for '51 exhibition, 319
Skeaping, John, 158, 329
Slade School of Fine Art, 112, 649
Sloane Square (Chelsea), 126, 131, 187
Smart, Jeffrey, 534, 550
Smith, Matthew, 217, 225, 333, 361, 383, 443, 686
Snowdon, Anthony (Armstrong-Jones), Lord, 625, 691
Soby, James Thrall, 232–3, 368, 443–4, 445, 449, 467, 468, 469, 553, 772, 774–5
Soho (London), 56, 211–15, 228, 243, 266–77, 279, 311, 333, 335, 340, 341, 382, 415, 427, 477, 484, 487, 488, 489–90, 499, 566, 647–8, 688–9
Sokolov, Mikhail, 666–7
Solidor, Suzy, 415
Some of Britain's Moths (Chopping), 284
Somerset, David, Duke of Beaufort, 405, 406–8, 421, 441, 456, 585, 587–8, 596, 619, 621, 765, 775
Somerville, Lilian, 260
Somme, Battle of the, 129–30, 131, 181, 271
The Somnambulist (Ironside), 301
Sontag, Susan, 560–1
Soskine, Michel, 549, 585–6
South Africa, 33, 49, 97, 183, 321, 322–5, 341–2, 352, 506–8
The South Bank Show (TV program), 639–40, 702
South Kensington (London), 101, 122, 126, 202, 203, 305, 354, 464, 498, 503, 620, 638, 656, 685, 692, 698, 797
Soutine, Chaim, 234, 262, 445, 595–6, 632
Soviet Union, 651–3, 663–7
Spain, 534, 658, 659–62, 694, 696
Spalding, Frances, 210, 228, 233, 275, 316, 318, 362
Spanish Civil War, 178, 179, 233
Spear, Ruskin, 309, 317, 350
The Spectator, 153, 292, 432, 539
Speer, Albert, 198, 367
Spencer, Gilbert, 317
Spencer, Stanley, 99–100, 143, 245, 317, 449
Spender, Matthew, 281

Spender, Natasha, 281, 504, 604, 668, 709
Spender, Stephen, 57, 61, 64, 94, 145, 177, 178, 182, 194, 207, 210, 238, 279, 360, 382, 432, 437, 438, 440, 459, 504–6, 523, 568, 604, 610, 662, 668, 709, 740, 749
Spengler, Oswald, 94
Spero, John, 609, 616, 617, 620, 621
spiritualism, 72, 94, 150, 289, 294, 303–4, 315, 547
Spurling, Hilary, 113, 210, 228, 238, 603, 604
Spurling, John, 800
Stalking Big Game with a Camera in Equatorial Africa (Maxwell), 72, 552
Stanford, W. B., 200–1, 211, 221
Stangos, Nikos, 605, 606, 612, 636, 641–2
Stanhope Gardens, 613–14, 616
Stanhope Hotel (New York), 558
Stedelijk Museum (Amsterdam), 635
Stein, Gertrude, 77, 397, 482
Stein, Peter, 696
Steinberg, Saul, 503
Steiner, Rudolf, 138
Stephenson, Jane, 507
Stephenson, John, 604
Stephenson, Susan, 604
Stephenson, Winifred Bacon (FB's sister), 15, 33, *39*, 52, 96, 183, 185, 203, 323, 507, 508, 602–5, 739
Stern, Jerome, 800
Sternberg, Josef von, 61
Stewart, Angus, 725
St. George's Gallery (London), 234
Still Life (de Maistre), 725
St. Ives, Cornwall, 429–34, 435, 437, 445, 464
St. Matthew's Church (Northampton), 243, 244, 252
Stock Market crash (1929), 99
Stone, Irving, 389
Stonor, Sherman, 6th Baron Camoys, 374
the Storehouse (Wivenhoe), 285, 497, 538. *See also* Wivenhoe
Storran Gallery (London), 234
St. Patrick's Church of Ireland, 23
Strachey, John, 188
Straffan House (Naas), 40, 62
Straffan Lodge (Naas), 32, 36, 37, 38, 39, 40, 42, 51, 58, 118, 173
Strand School, 189
Stravinsky, Igor, 320
Stride, Ricky, 316
Strike (film), 664
Strindberg, August, 77
Strong, Roy, 259, 515, 751
Stuart, Carmel, 269–70, 538, 603
Stuart, Donald Clive, 95
The Studio magazine, 66, 104–9, *104, 108,* 109, 111, 113, 115–16, 147, 358
Suffolk, England, 38, 44, 539, 540, 609, 615, 640

Summers, Martin, 589
Sunday Express, 127
The Sunday Telegraph, 539, 702
The Sunday Times, 151, 169–70, 228, 232, 300, 331, 364, 393, 468, 488, 557, 637, 654
Sunderland House (Mayfair), 155, 158
Supple, Kerry Leyne, 31, *31,* 33, 36–7, 38, 39, 712
Supple, Winifred Watson (Granny Supple): character of, 32, 42–3; death of, 59, 93; FB's relationship with, 30, 42–3, 474, 498; FB's visits to, 36, 37, 42, 44, 62; home of (*see* Straffan Lodge); Irish "bad times" and, 36–7, 39; marriages of, 20, 31; move to Ireland and, 21, 22, 23; photo of, *31*
surrealism, 73–4, 78, 79, 123, 124, 135, 139, 144, 149, 151, 165, 166–7, 186, 218, 348, 445, 469, 697
Sutherland, Graham: comparison with FB, 211, 402; Denis Wirth-Miller and, 296; design work of, 720; exhibitions by, 169, 225, 231, 245, 260, 262–3; FB's influence on, 244, 380–1; FB's letters to, 240, 243, 248–9, 739; influence on FB, 444, 742; John Rothenstein and, 382; Kenneth Clark as champion of, 636, 738; Lucian Freud and, 279; Michael Wishart and, 287; in Monte Carlo, 253–5, 258–60, 305, 740; photo of, *205*; portraits painted by, 305, 350, 380; relationship with FB, 199, 201, 203, 204–9, 252, 281, 294, 305–6; reputation of, 3, 213, 217, 425, 560; retrospectives of, 359, 380, 443, 518, 782; in Roy de Maistre's salon, 177; sales of, 166, 210, 731, 742; Somerset Maugham and, 302, 305; support for FB, 216, 217, 232, 233, 253, 295, 333, 629, 742; as wartime artist, 181
Sutherland, Kathleen (Kathy), 199, 206, 208, 248, 251, 252, 253–5, 258–9, 305, 738
Sutton, H. M., 109, 723
Swan pub (Stratford), 581, 583, 614
Sylvester, David: as art dealer, 350, 351, 352, 370, 757; books on FB and, 550–1; as conversationalist, 774; critical support for FB, 342–9, 364, 375, 402–3, 440, 453, 457–8, 469, 568, 570; with FB in National Gallery, 644; on FB's blue period, 373; on FB's *Figure in a Landscape,* 227–8; on FB's *Fury,* 230; on FB's landscape painting, 594, 595, 601, 633; FB's Moscow exhibition and, 663, 665; on FB's *Painting 1946,* 313–14; FB's Paris retrospective and, 519; on FB's personality, 8, 382, 625, 626; on FB's portrait painting, 482; on FB's sculptural painting, 632; FB's *Study for a Portrait* bought by, 366; FB's Tate retrospective and, 637, 638; on FB's *Triptych, 1976,* 580; on FB's *Triptych, 1987,* 654; on FB's use of spaceframe, 297, 371; on FB's use of X-rays, 294; Giacometti and, 501; interviews with FB, 33, 88, 467–8, 504, 555, 673; John Berger and, 344–6, 348, 368; John Edwards and, 584, 683; José Capelo and, 669; personal relationship with FB, 365, 385, 467, 685, 759; photo of, *344*; at Royal College of Art common room, 318, 358, 392; sale of FB's *Sleeping Figure,* 619

Symposium (Plato), 94–5
synesthesia, 331

Taeuber-Arp, Sophie, 151
Tal-Coat, Pierre, 245
Tangier, Morocco, 379, 381, 389–90, 391–9, *392*, 400, 405, 408–14, 417–20, 424, 426–7, 433, 434, 446–7, 450–1, 458, 459, 495, 531, 564, 762, 763, 764, 766, 771
Tangier Gazette, 393, 399, 409, 418, 420, 762, 764
Tanner, John, 608, 609, 615, 794
Tarr (Lewis), 95
Tate Gallery (London): American exhibitions at, 387, 424; Balthus retrospective at, 245; directors of, 136, 145, 188, 216, 301, 438, 621; FB retrospectives and, 442, 443, 449, 452–8, 460, 461, 520, 523, 620, 621, 635–40, 642, 657, 672, 772, 808; FB's paintings purchased by, 333, 351, 757; FB's visits to, 99, 415; Giacometti retrospective at, 501; Graham Sutherland as trustee of, 253, 382; Graham Sutherland retrospective at, 295, 359, 380–1; Graham Sutherland's paintings purchased by, 208; Picasso painting purchased by, 143, 729; power struggle at, 382–3
Tate Liverpool, 681, 808
Tchelitchew, Pavel, 207, 730
techniques in FB's work: brushwork, 8, 124, 205, 234, 388; color use, 148–9, 158, 197, 209, 222, 236, 250, 256, 356–7, 373, 401, 425, 562, 632, 742, 782; control of paint on canvas, 139, 347; dust in paint, 465, 774; painting surface and, 197, 206, 218, 243, 260, 297, 738, 742; painting vs. drawing, 165, 229; pigment mixing, 577, 789; rendering of figures, 197, 286, 482, 793; as sculptural, 632, 793; spaceframe, 297, 312, 313, 331, 371, 431; synesthesia, 331
Tennant, David, 56, 273, 274, 309, 310
Tennant, Pauline, 273, 287
Tennant, Stephen, 273
Tennyson Mansions (Chelsea), 164, 727, 732, 739
A Terrible Beauty exhibition, 768
Territorial Force (British military), 28, 31
Thames & Hudson publishers, 636
Thatcher, Margaret, 506
Theatre Royal (Stratford), 581
themes in FB's work: chance, 123; death, 653–4, 704; despair, 390, 673; masks, 66, 235, 293, 381–2, 405, 443, 605, 630, 676, 681–2, 684, 703; morality of the artist, 388–9; power/authority, 4, 6, 124, 133, 161, 177, 198, 215, 229, 250, 306, 307, 312, 313, 330, 356, 373–4, 487; sacrifice/suffering, 9, 50, 74, 124, 218, 348; terror, 347
Thesiger, Ernest, 113, 722, 724
The Thinker (Rodin), 482–3
Thirty Years of Picasso exhibition, 117
Thomas, Caitlin, 212
Thomas, Dylan, 182, 210, 212, 214, 269
Thomas Agnew & Sons gallery (London), 168–71, 172, 199, 719
Thomas Firth & Sons, 19–20

Thorn Tree (Sutherland), 260
Thorold, Emelia, 270, 569
Thorold, Marilyn, 270
Three Dancers (Picasso), 140
The Three of Us: A Family Story (Blackburn), 545–6
The Threepenny Opera (Brecht/Weill), 61
Three Sisters (Chekhov), 99
Thyssen-Bornemisza, Baron Hans Heinrich, 597
Tiegs, Cheryl, 552
Time and Tide, 148
Time magazine, 303, 305, 306, 638
The Times (London), 121, 148, 179, 186, 316, 380, 457, 458, 524, 627, 638, 702
Titian, 458, 688
Titus, Edward, 77
Todd, Dorothy, 81–2, 105, 121
Tóibín, Colm, 633
Toklas, Alice B., 397
Tonks, Henry, 431
Tootal Broadhurst Lee, 284
Toulouse-Lautrec, Henri de, 170, 302
Towell, Gerald, 337, 339, 340, 757
transition (literary journal), 77, 156
Transition Gallery, 155–7, 158–9, 161, 164, 165, 174, 219, 297, 329, 634
Tree, Jeremy, 616
Trevelyan, Julian, 169, 231, 248
Tribune, 263, 343, 639
Trinity College (Cambridge), 91
Trinity College (Dublin), 14, 95, 200
Trinity Hall, Cambridge, 343
triptych, as art form, 6, 32, 61, 221, 455, 461, 482, 520, 579
Triumphal March (Eliot), 728
The Triumph of Neptune (Balanchine), 319
Turing, Alan, 369, 505
The Turkish Bath (*Le Bain Turk;* Ingres), 632, 644
Turner, J. M. W., 437, 636, 644, 801
Turner, Jon Lys, 286, 593
Tyrwhitt-Wilson, Gerald Hugh (Lord Berners), 319–21, *320,* 754
Tzara, Tristan, 77

Ulysses (Joyce), 96
UNESCO exhibition, 243, 244–5
United States: art market in, 407; attention to FB in, 469–70, 511–12, 553, 559–60; influential art in, 387, 388, 400, 411, 424
University College, Oxford, 152, 153
University College School (London), 343, 452
University of Edinburgh, 150
University of Essex, 539

Valois, Ninette de, 202
Vanderbilt, William, 155

Vaughan, Keith, 181, 209, 228, 358, 362, 735

Vaux Halliday, Nigel, 186

Veder, Thérèse, 120

Velázquez, Diego, 231, 244, 249–50, 251, 297, 299, 306, 312, 314, 330, 361, 379, 403, 445, 468, 541, 544, 569, 577, 636, 644, 660, 687, 688, 690, 808–9

Veličković, Maristella, 571–2, 586, 601, 654

Veličković, Vladimir, 564, 571–2, 586, 654

Venice Biennales: (1952), 295; (1954), 375–6, 378, 393

Victoria, Queen of England, 17, 78

Victoria and Albert Museum (London), 20, 59, 65, 150, 202, 228, 229, 259, 294, 317, 711

Vic-Wells Ballet, 202

View of Toledo (El Greco), 445

Village Voice, 555

Villa Medici (Rome), 550

Villa Minerve (Monte Carlo), 253, *253*, 258

Villa Muniria (Tangier), 396, 411, 412

Villa Souka-Hati (Monte Carlo), 258

Vine Pergola (Sutherland), 260

The Virgin and Child (Masaccio), 644

The Visitor's Book (Turner), 286, 593

Vogue magazine, 81, 82, 105, 121, 258, 272, 525, 569, 621, 637

Vreeland, Diana, 569

Vuillard, Édouard, 262

Wade, Hugh, 340

Wadsworth, Edward, 147

Wait for Me! (Cavendish), 281

Walker, Caroline de Mestre, 173, 685, 724

Wallace, David, 497, 533

Wallace, Richard, 366

Wallace Collection, 169

Wallach, Amei, 557, 558

Waller, Fats, 338, 340, 354, 394, 484

Wallis, Neville, 302

Walsh, Bernard, 267, 382

War Arts Advisory Committee (WAAC), 206, 742

Ward, Jean, 638, 693

Warhol, Andy, 412, 488, 525, 543, 552, 556, 557, 558, 561–2, 652

War Pictures by British Artists, Second Series: Air Raids, 207

Washington Post, 560, 672

The Waste Land (Eliot), 194, 535, 624

Waterhouse, Keith, 211

Waterloo, Battle of, 15, 185

Watson, Arthur Toward, 44

Watson, Diana (FB's cousin): decline of, 667–8; diaries of, 725–6; Eric Allden and, 99; on FB's aesthetic, 124, 134, 156, 159, 165, 219; on FB's ambition, 148, 197; FB's homosexuality and, 173; on FB's isolation, 147; FB's works owned by, 156, 157, 158, 170, 171, 227, 805; financial support of FB, 184–5; German lessons with FB, 89, 161;

London life of, 53, 54, 122, 152, 164, 755; in Monaco with FB and Denis Wirth-Miller, 594; in Paris with FB, 120, 125, 148; photo of, *121*; relationship with FB, 30, 43, 44, 45, 121–3, 162–3, 328, 474, 724; wartime service of, 182; in Yorkshire, 118, 121

Watson, John, 30, 711

Watson, Peter, 209–11, 213, 214, 231, 238, 248, 279, 366, 380, 740

Watson, Virginia, 54, 152, 164, 755

Waugh, Evelyn, 56, 188, 268, 320

The Week End Review, 148

Weeping Magdalene (Sutherland), 230

Weidenfeld, George, 379, 760

Weidenfeld & Nicolson publishers, 379, 760

Weill, Kurt, 61

Weimar Culture: The Outsider as Insider (Gay), 61

Weimar Republic, 61

Welch, Denton, 211, 219–21

Weldon, Alice (Hayward) 464, 543, 544, 758, 774

Wellesley, Lady Gerald, 105

Wellington (school), 18, 129

Wellington, Hubert, 145

Wellington, Robert, 112, 144–5, 147, 166, 168, 176

The Well of Loneliness (Hall), 127

Wells, H. G., 320

Welsh National Opera, 696

West, Rebecca, 82, 105

West End, London, 476

Western civilization/culture: artist as moral figure in, 388–9; despair in, 390; history painting and, 579; masculine authority in, 312, 374; meaninglessness in, 673; world wars and, 194, 218, 227

Weyman, John, 731

Wheatcroft, Geoffrey, 270

Wheeler's restaurant (Soho), 267–8, 273, 278, 370, 382, 474, 476, 484, 488–9, 491, 532, 541, 543, 582, 603, 635, 637, 661

Whistler, James McNeill, 127

White, Patrick, 132, 136, 138, 175, 176–8, 182–3, 191, 196, 227, 377, 724, 731, 732, 734

Whitechapel Gallery (London), 179, 304, 424, 445, 449, 752

Whiteley, Brett, 572, 789

White Tower restaurant (London), 252

Whitfield, Sarah, 551, 625, 638

Whitney, Charles, 46, 48

Wiene, Robert, 64

Wiener Werkstätte, 79

Wigoder, Basil, 516

Wilde, Oscar, 51, 127, 233, 495, 703

Wildeblood, Peter, 369, 370, 505

Williams, Denis, 362–3, 364

Williams, Tennessee, 302, 397

Willoughby, Jane, 28th Baroness Willoughby de Eresby, 494–5

Wilton Royal Carpet Factory, 89, 106, 720

Wiltons restaurant (London), 470, 474, 638, 651, 657

Wirth-Miller, Denis: as artist, 352, 566, 567, 592–4, 605, 757; background of, 283–4; character of, 386, 750; entertaining by, 310, 778; FB's last illness and, 694; FB's letters to, 397, 399, 409–10, 414, 416, 424, 446, 447, 679, 732, 748, 768, 806; FB's paintings of, 482, 520, 595; FB's religious experience and, 533–4; FB's visits to Wivenhoe, 423, 496–7, 538–40; FB's Wivenhoe house and, 567–8, 611; Frances Partridge and, 302–3, 311; Graham Sutherland and, 296; James Birch and, 651; landscape painting and, 352, 593; in New York with FB, 558; in Paris with FB, 521, 579; photographs of FB taken by, 285–6; photo of, *618*; relationship with Dicky Chopping, 284–5, 539, 574; relationship with FB, 282–3, 294, 413, 539, 543, 544, 551, 555, 592–5, 610–11, 641, 645, 675, 749, 750, 776; St. Ives and, 429, 432; travels with FB, 599, 611

Wishart, Francis, 327

Wishart, Lorna, 287, 310

Wishart, Michael, 126, 203, 242, 286–7, 308–11, 317, 327, 495, 739, 778

With Love (FitzGibbon), 182

Without Stopping (Bowles), 398

Witt, John, 452

Wivenhoe (Essex): as artists' haven, 429; David Wallace in, 533; Dicky and Denis's house in, 285, 352, *496*, 609; Dunn-Wishart wedding and, 310; FB's house in, 566–7, 587, 590, 610, 611; FB's visits to, 286, 296, 423, 496–7, 538–40, 551, 566; poor people in, 629

Wivenhoe Arts Club, 539, 592–3, 594

Wodehouse, P. G., 128

Wojas, Michael, 627

Wolfenden, John, 505–6

The Wonder Book of Electricity, 149

Woolf, Virginia, 81–2, 113, 200, 273

Woolman, David, 411

Woolsington Hall (Newcastle), 20, 31

World War I: aftermath of, 56; aristocracy after, 407; Bacon family and, 30, 31; Eric Hall as soldier in, 129–30, 131; Ernest Thesiger as soldier in, 113; historical view of, 193, 194; homosexuality during, 28, 30, 31, 50–1; prelude to, 28; unemployment after, 55; War Refugees Committee, 91

World War II: artistic reactions to, 3, 193, 195–8, 201, 205, 207, 302, 368; England in, 179–86; homosexuality during, 214–15; justification for, 227; Nietzschean thought and, 193–4; RAF in, 335; rural areas and, 191; start of, 213

World Within World (Spender), 57

Wormwood Scrubs Prison, 285

Worsthorne, Peregrine, 497, 539

Worthington-Evans, Laming, 91

Wuthering Heights (Brontë), 117

Wyld, Evelyn, 81, 82–3, 105

Wyndham, Francis, 327, 488

X-rays, 150, 152, 153, 294

Yacoubi, Ahmed ben Driss el, 398–9, *398*, 410, 412, 417–18, 451, 764, 766

Yacoubi, Larbi, 451

Yeats, W. B., 113, 194, 209, 382, 555, 568

York Minster pub (the French House), 211–12, 215, 267, 273, 311, 484, 537, 627, 647, 701, 811

Yorkshire, 117, 118, 121, 150

Young British Artists (YBAs), 649

zeppelins, 30, 180

Zervos, Christian, 75

Zimbabwe, 323, 324, 325, 508, 791

Zurbarán, Francisco de, 445, 690

Zweig, Stefan, 63

Zwemmer, Anton, 144

Zwemmer's bookstore/gallery (London), 144–5, 166, 186

Zych, Anthony, 627, 649–50, 685, 692, 694, 774, 802

The Hugh Lane Gallery, collection and images on pages 272, 335, 376, 377, 378, 493, and 657, © Hugh Lane Gallery, Dublin. © The Estate of Francis Bacon. All rights reserved.

The authors are also grateful to the Francis Bacon MB Foundation Monaco for supplying images from their collection and providing the authors with background information on certain photographs. The Francis Bacon MB Foundation has amassed a stellar collection of photographs of Francis Bacon and published, in 2019, *Francis Bacon: Study for a Portrait,* which contained over 180 photographs of him.

Additionally, the authors wish to thank the following for generously allowing us to include their photographs in this book: the family of Anne-Marie Crété de Chambine; Ianthe Knott and the Knott family; Richard Shone; Caroline de Mestre Walker; Belinda Price; Doreen Kern; Béatrice Mitchell; the Mayor Gallery; Bedales School (Ian Douglas); Marlborough Fine Arts; Jon Lys Turner; Dan Chapman; Paul Rousseau; Barry Joule; Michael Clark; Eddy Batache and Reinhard Hassert; José Astiarraga; Nejma Beard; Cheryl Rossum; Dean Close School (Charles Whitney and Grace Pritchard-Woods); Chateau Mouton Rothschild.

In the case of the few unknown photographs, every effort was made to trace their provenance.

2: *Head I,* 1948. © The Estate of Francis Bacon. All rights reserved
11: Photograph by Francis Julian Gutmann, London (courtesy MB Art Collection)
18: Matthew Beckett/Lost Heritage (www.lostheritage.org.uk)
22: Courtesy of The Estate of Francis Bacon
24: Courtesy of The Estate of Francis Bacon
31: Courtesy of The Estate of Francis Bacon
39: Courtesy of The Estate of Francis Bacon
45: Courtesy of the Dean Close Foundation
47: Courtesy of the Dean Close Foundation
63: Bundesarchiv, Bild 183-1983-0121-500/CC-BY-SA-3.0 DE (https://creativecommons.org/licenses/by-sa/3.0/de/deed.en)
67: Photograph by Helmar Lerski, © Estate Helmar Lerski, Museum Folkwang, Essen (MB Art Collection)
70: Courtesy of the family of Anne-Marie Crété de Chambine

80: This image is reproduced with the kind permission of the © National Museum of Ireland
88: Courtesy of The Estate of Francis Bacon
104: Courtesy Studio International, www.studiointernational.com
108: Courtesy of Ianthe Knott
114: Courtesy of Richard Shone. The card illustrated his article "Francis Bacon in the 1930s: An Early Exhibition Rediscovered," in *The Burlington Magazine,* April, 1996
115: © Caroline de Mestre Walker and Belinda Price. Courtesy of de Mestre Walker
117: Courtesy of Doreen Kern
121: Courtesy of The Estate of Francis Bacon
131: Courtesy of Béatrice Mitchell
133: © Caroline de Mestre Walker and Belinda Price; collection The Estate of Francis Bacon
134: © Caroline de Mestre Walker and Belinda Price, collection The Estate of Francis Bacon
137: © Caroline de Mestre Walker and Belinda Price. Courtesy of de Mestre Walker
140: © 2020 Estate of Pablo Picasso / Artists Rights Society (ARS), New York. Image license © RMN-Grand Palais / Art Resource, NY
142: © Caroline de Mestre Walker and Belinda Price. Private collection
145: Courtesy of the Mayor Gallery, London
167: *Abstraction from the Human Form,* c. 1936. © The Estate of Francis Bacon. Photograph © The British Library Artwork
182: Courtesy of The Estate of Francis Bacon
190: Courtesy of Bedales Archive
196: John Frost Newspapers/Alamy Stock Photos
202: Anabell Lang/Alamy stock photo
205: Photo by Edward Quinn, ©edwardquinn.com
223: © The Cecil Beaton Studio Archive at Sotheby's
241: © Editions Giletta-Nice Matin (Courtesy MB Art Collection)
253: Courtesy MB Art Collection
262: Ida Kar © National Portrait Gallery, London
263: George Hoyningen-Huene Estate Archives
267: The John Deakin Archive. © John Deakin/John Deakin Archive/Bridgeman Images
269: The John Deakin Archive. © John Deakin/John Deakin Archive/Bridgeman Images
272: Francis Bacon, photograph of John Deakin, 1950s (detail). Collection and image © Hugh Lane Gallery,

Dublin (Ref. #RM98F1A:195). © The Estate of Francis Bacon. All Rights reserved

278: Photograph by Dan Farson. © Marlborough Fine Art Ltd

283: © Jon Lys Turner Archive, courtesy of Jon Lys Turner

285: © Dan Chapman, courtesy Dan Chapman and Paul Rousseau

295: Leaf torn from Eadweard Muybridge, *The Human Figure in Motion.* London, Chapman and Hall, 1901

296: © Nigel Henderson Estate. Photo © Tate.

320: © Hulton Deutsch/Corbis Historical via Getty Images

332: Private collection. © The Lucian Freud Archives/ Bridgeman Images

335: Collection and image © Hugh Lane Gallery, Dublin (Reg. No. RM98F12: 17:4). © The Estate of Francis Bacon. All Rights reserved

344: © National Portrait Gallery, London

368: Photography by Sam Hunter, Courtesy Private Collection

372: cc-by-sa/2.0 - © Kurt C - geograph.org.uk/p/1471083 (https://creativecommons.org/licenses/by-sa/2.0/)

376: Collection and image © Hugh Lan Gallery, Dublin (Reg. No. RM98F12:17:36). © The Estate of Francis Bacon. All rights reserved

377: Collection and image © Hugh Lane Gallery, Dublin (Reg. No. RM98F12:17:4). © The Estate of Francis Bacon. All rights reserved

378: Collection and image ©: Hugh Lane Gallery, Dublin (Reg. No. RM98F12:17:12). © The Estate of Francis Bacon. All rights reserved

392: Period postcard of Socco Chico, Tangier. Private collection

393: Courtesy of The Estate of Francis Bacon

395: Fred G. Mossman, Dean and Francis Bacon outside Dean's Bar, Tangier, c. 1957 © Marlborough Fine Art Ltd

398: Courtesy of The Estate of Francis Bacon

411: Unknown photographer, photograph of William Burroughs. Private collection

463: Photo by Perry Ogden. © The Estate of Francis Bacon

465: Photo by Perry Ogden. © The Estate of Francis Bacon

466: Photo by Perry Ogden. © The Estate of Francis Bacon

480: Photograph by John Deakin. Collection: The Estate of Francis Bacon

483: Photograph by John Deakin. Collection: The Estate of Francis Bacon

490: Photograph by John Deakin. Collection: The Estate of Francis Bacon

493: Photograph by John Deakin, 1965. Collection & image © Hugh Lane Gallery, Dublin (Reg. No. RM98F149: 33L). © The Estate of Francis Bacon. All rights reserved

496: © Jon Lys Turner Archive. Courtesy of Jon Lys Turner

506: Courtesy of The Estate of Francis Bacon, and of the family of Ianthe Knott

521: © André Morain, Paris

523: © André Morain, Paris

527: © André Morain, Paris

551: © Peter Beard. Courtesy Peter Beard Studio, www .peterbeard.com

556: © Cheryl Rossum 1975

572: © Eddy Batache (courtesy MB Art Collection)

581: Photo by Edward Quinn. © Edward Quinn Archive

597: Photograph by Harry Diamond. © National Portrait Gallery (MB Art Collection)

599: © Eddy Batache (courtesy MB Art Collection)

618: © Barry Joule. Courtesy of Barry Joule

628: Photograph by Neil Libbert. © Neil Libbert

640: Courtesy of The Estate of Francis Bacon

647: © Dan Farson (courtesy MB Art Collection)

648: Prudence Cuming Associates/Bridgeman Images.© Michael Clark, Collection The British Museum

654: Photo © Michel Nguyen (MB Art Collection)

657: Collection and image © Hugh Lane Gallery, Dublin (Reg. No. RM98F194:16). © The Estate of Francis Bacon. All rights reserved

660: © Pedro Martinez de Albornoz

692: Original work by Francis Bacon for the 1990 Château Mouton Rothschild label. Art © The Estate of Francis Bacon. Courtesy of Chateau Mouton Rothschild

698: Courtesy of José Astiarraga, Bar Cock, Madrid

700: © Private Collection

700: © Private Collection

707: Photo by Perry Ogden. © The Estate of Francis Bacon

COLOR INSERT CREDITS

A NOTE ABOUT THE AUTHORS

Mark Stevens has been the art critic for *Newsweek, The New Republic,* and *New York* magazine and has also written for *The New Yorker, Vanity Fair,* and *The New York Times.*

Annalyn Swan is the former arts editor of *Newsweek* and an award-winning music critic. She teaches biography at the Graduate Center of the City University of New York as well as at Middlebury Bread Loaf School of English.

Stevens and Swan won the 2005 Pulitzer Prize and the National Book Critics Circle award for their biography *De Kooning: An American Master.* They live in New York.

A NOTE ON THE TYPE

The text of this book was set in Requiem, a typeface designed by Jonathan Hoefler (born 1970) and released in the late 1990s by the Hoefler Type Foundry. It was derived from a set of inscriptional capitals appearing in Ludovico Vicentino degli Arrighi's 1523 writing manual, *Il Modo di Temperare le Penne*. A master scribe, Arrighi is remembered as an exemplar of the chancery italic, a style revived in Requiem Italic.

COMPOSED BY NORTH MARKET STREET GRAPHICS, LANCASTER, PENNSYLVANIA

PRINTED AND BOUND BY LSC COMMUNICATIONS, CRAWFORDSVILLE, INDIANA

DESIGNED BY MAGGIE HINDERS